A Dictionary of

Modern and Contemporary Art

D1581691

SEE WEB LINKS

Many entries in this dictionary have recommended web links.
When you see the above symbol at the end of an entry go to the
dictionary's web page at http://www.oup.com/uk/reference/
resources/modernandcontemporaryart, click on **Web links** in
the Resources section and locate the entry in the alphabetical list,
then click straight through to the relevant websites. Additional
web links are available in an appendix.

Ian Chilvers is a freelance writer and editor. He is author of *The
Oxford Dictionary of Art and Artists* and co-editor of *The Concise
Oxford Companion to Classical Literature*. His books have been
translated into eight languages.

John Glaves-Smith has 25 years' experience as a lecturer in the
history and theory of modern art at Staffordshire University
and Rochdale College of Art. He has contributed to *Art Monthly,
Art Quarterly,* and *Artscribe*. In 1992 he organized the acclaimed
exhibition *Reverie, Myth, Sensuality: Sculpture in Britain 1880–
1910*, which was shown in Stoke-on-Trent and Bradford.

Oxford Paperback Reference

The most authoritative and up-to-date reference books for both students and the general reader.

ABC of Music
Accounting
Allusions
Animal Behaviour
Archaeology
Architecture and Landscape
 Architecture
Art and Artists
Art Terms
Arthurian Literature and
 Legend
Astronomy
Battles*
Better Wordpower
Bible
Biology
British History
British Place-Names
Buddhism
Business and Management
Card Games
Catchphrases
Century of New Words
Chemistry
Christian Art
Christian Church
Classical Literature
Classical Myth and Religion
Classical World
Computing
Contemporary World History
Countries of the World
Dance
Dynasties of the World
Earth Sciences
Ecology
Economics
Education
Encyclopedia
Engineering*
English Etymology
English Folklore
English Grammar
English Language
English Literature
English Surnames
Environment and
 Conservation
Euphemisms
Everyday Grammar
Family and Local History
Finance and Banking
First Names
Food and Drink
Food and Nutrition
Foreign Words and Phrases
Geography
Humorous Quotations
Idioms
Internet

Irish History
Islam
Kings and Queens of Britain
Language Toolkit
Law
Law Enforcement
Linguistics
Literary Terms
London Place-Names
Mathematics
Medical
Medicinal Drugs
Modern Design
Modern Quotations
Modern Slang
Music
Musical Terms
Musical Works
Nicknames
Nursing
Ologies and Isms
Philosophy
Phrase and Fable
Physics
Plant Sciences
Plays
Pocket Fowler's Modern
 English Usage
Political Quotations
Politics
Popes
Proverbs
Psychology
Quotations
Quotations by Subject
Reverse Dictionary
Rhymes
Rhyming Slang
Saints
Science
Scientific Quotations
Scottish History
Shakespeare
Ships and the Sea
Slang
Sociology
Space Exploration
Statistics
Superstitions
Synonyms and Antonyms
Weather
Weights, Measures, and
 Units
Word Histories
World History
World Mythology
World Religions
Zoology

*forthcoming

A Dictionary of

Modern and Contemporary Art

SECOND EDITION

IAN CHILVERS AND
JOHN GLAVES-SMITH

OXFORD
UNIVERSITY PRESS

Great Clarendon Street, Oxford OX2 6DP

Oxford University Press is a department of the University of Oxford.
It furthers the University's objective of excellence in research, scholarship,
and education by publishing worldwide in

Oxford New York

Auckland Cape Town Dar es Salaam Hong Kong Karachi
Kuala Lumpur Madrid Melbourne Mexico City Nairobi
New Delhi Shanghai Taipei Toronto

With offices in

Argentina Austria Brazil Chile Czech Republic France Greece
Guatemala Hungary Italy Japan Poland Portugal Singapore
South Korea Switzerland Thailand Turkey Ukraine Vietnam

Oxford is a registered trade mark of Oxford University Press
in the UK and in certain other countries

Published in the United States
by Oxford University Press Inc., New York

© Oxford University Press 1998, 1999, 2009

British Library Cataloguing in Publication Data

Data available

Library of Congress Cataloging in Publication Data

Data available

Typeset by SPI Publisher Services, Pondicherry, India
Printed in Great Britain
on acid-free paper by
Clays Ltd, St Ives plc

ISBN 978-0-19-923965-8 (hbk.)
 978-0-19-923966-5 (pbk.)

1 3 5 7 9 10 8 6 4 2

Contents

Introduction vi

Dictionary 1

Bibliography 773

Abbreviations

ARA	Associate of the Royal Academy
ASL	Art Students League
DNB	*Dictionary of National Biography*
ICA	Institute of Contemporary Arts
MoMA	Museum of Modern Art
NG	National Gallery
NPG	National Portrait Gallery
OED	*Oxford English Dictionary*
PRA	President of the Royal Academy
RA	Royal Academy or Royal Academician
RCA	Royal College of Art
TLS	*Times Literary Supplement*
V&A	Victoria and Albert Museum

Introduction

A Dictionary of 20th-Century Art by Ian Chilvers appeared in 1998 and was widely welcomed for its breadth of coverage and accessible style. Ten years on, however, the world of art has changed—and so the book must change if it is to continue to be useful. It is with this in mind that I set out to make a full-scale revision and updating of the original text, still with the intention of covering artistic practice since about 1900. The result is, in total, about a fifth longer than the original, although the quantity of new and substantially revised material is considerably larger, amounting to about a third of the book. Obviously there are artists present who could not have been included in the first edition because their work or reputations were not then of sufficient substance.

However, I have also sought to change the overall balance of the book towards developments still likely to be in the living memory of readers and, further, to reflect a more international viewpoint, appropriate to an age of easier travel and the internet. To achieve this it has been necessary to abridge or cut altogether certain entries in the first edition, but I have tried, as far as possible, to ensure that these fall where material is less likely to be of interest to a reader today or on entries which deal with matters covered elsewhere in the book.

A particular issue that I have had to consider has been the inclusion of photography. It would seem inconceivable to me and, I should imagine, most readers, if this book were to have no entries on, for instance, Cindy Sherman or Jeff Wall. Photographically based work has had a growing role in fine art practice since the 1970s and there is no question of excluding it here. More problematic is the inclusion of photography in its more traditional role as something considered as having a value in its own right but rather apart from the traditional media. My solution has been to provide entries on those figures most likely to be of interest to readers concerned with the visual arts generally: I have included especially those who, I would judge, would be as likely to be sought for in a book labelled 'art' as in one labelled 'photography'.

The issue of photography is but one aspect of a larger one which some readers may find still more contentious. To many observers of the contemporary art scene—here I include myself—it is no longer plausible to define art in terms of particular media. This is not to say that painting, sculpture, and printmaking have no further value, only that they are but an aspect of what we now mean by 'art'. Especially in the last forty years or so, since the emergence of Conceptual and Minimal art, much, though not all, of what has made the greatest impact has departed from traditional media. When giving a basic description to begin a biographical entry, it seemed most appropriate in many cases simply to say 'artist', rather than painter, sculptor, or even 'installation artist'. The most relevant terms for characterizing the practice of many artists are now to be found not in the medium with which they work or in the style or tendency with which they might be identified, but in the themes with which they engage. A recent book, *Art & Today* (2008) by Eleanor Heartney, is typical of current thinking. Instead of categorizing

contemporary art by reference to 'isms' or to geography, it is organized into chapters with titles such as 'Art & popular culture', 'Art & the quotidian object', and so forth.

While the boundaries of art may be hard to define, books, alas even very long ones, must have an end. Inclusions and exclusions will inevitably raise hackles: in this field personal feelings can be bruised; even financial and professional interests may be marginally affected. My principle and that of my predecessor has been to be guided by what we believe will be of interest to the likely reader, even if the results may not appear 'fair' to certain artists and their supporters. I have not consciously excluded any artist because I dislike or disapprove of their work, although I admit that, in the more marginal decisions about inclusion, personal preferences might have played a small part. As with anything else today, artists' reputations are measured in 'league tables', which can be (and are) constructed by counting exhibitions, presence in public collections, and published references. The problem with using such systems as the basis for a book of this type is that the results tend to be so counter-intuitive that one would be tempted to 'correct' them anyway. The reason is not hard to find: what is 'measured' is actually no more than current standing in the professional modern art world. This is certainly of interest to the assiduous gallery goer, but it is only one among several kinds of reputation. An artist may have considerable fame or notoriety with a wide public because of coverage in non-specialist media. An artist may have a popularity with private collectors not reflected in public collections. An artist who is not currently 'hot' may nonetheless have some appreciable historical significance or still be remembered by older observers of the modern art scene. An artist's reputation may derive primarily from work in public spaces. An artist may not be feted by critics or public but have some standing as an 'artist's artist'. Any of these kinds of reputation might cause a reader to wish to look the artist up. Some kind of formula that takes account of all these factors might, in theory, be possible to devise but would probably still lead to strange anomalies. Therefore I have tended to rely in my choices on a certain intuition, although I hope it is a well-informed one, combined with the aim of trying to cover a wide variety of artistic practices from the conservative to the avant-garde. The problem of selection becomes more acute the nearer we approach the present day, but I consider that it is worth taking the risk of annoying some readers with my choices and of appearing dated in years to come, so as to give proper coverage to contemporary practice. Therefore I have not employed any cut-off date to exclude younger artists: I have simply considered whether a reputation was well enough grounded for an artist to remain of interest to readers in the near future. For the record, the youngest artist in the book is Cao Fei (born 1978), which seems appropriate in view of the brilliant contribution made by Chinese artists in recent years.

My predecessor was commendably open about his preference for more traditional forms of art and his distaste for many aspects of the contemporary art scene. I owe it to readers to be equally frank about my own views, which are in marked contrast, and which may affect what I have written, if not what I have decided to write about. Tradition in art has, I believe, no value for its own sake: Balthus, Edward Hopper, Käthe Kollwitz, and more recently Paula Rego are of significance not because they draw on figurative skills but because of the way they deploy those skills to illuminate the condition of their times. Video, Performance, and installation are vital aspects of the contemporary scene and must be considered fully and seriously. It may be a cliché that

what is most challenging today is what is classic tomorrow, but it is one that is borne out by the experience of all those who have had a long engagement with the art of their time. When dealing with controversial art I have tried to give, within the limitations of space, an honest indication of just why a particular kind of work might cause heated debate, whatever my own opinion. Where some personal comment intrudes, the reader will, I trust, find dissent and agreement equally enjoyable.

A few words of explanation are necessary about certain usages. Cross-references from one entry to another are indicated by an asterisk (*) within the main part of the text or by the use of SMALL CAPITALS when the formula 'see so-and-so' is used. Names of all people who have their own entries are automatically asterisked on their first mention in another entry, and this is also the policy with groups and movements, but cross-references are used more selectively for art media, technical terms, etc., and given only when further elucidation under that heading might be helpful. Locations are usually given for works of art cited, but with recent art it is not always practical or useful to do so. There are examples in which works belong to a series, dispersed among various collections, whilst others, such as sculptures and photographs, may not be unique pieces. Installation and performance works may have a purely ephemeral existence. The increasing tendency for museums of modern art to become brands as much as buildings makes precision about location more difficult. A work owned by Tate might be displayed in London (at Tate Britain or Tate Modern), Liverpool, or St Ives. At the time of writing a branch of the Pompidou Centre is due to open in Metz.

I owe a great debt to Ian Chilvers, who initially suggested this new edition and who has been a constant support. He has provided detailed and sometimes astringent comments on my efforts, giving me the benefit of his high professional standards and years of experience. Nonetheless, I take final responsibility: the extra weight given to more experimental and avant-garde forms and the more academic tone of certain entries are entirely my decisions. I must also thank Joanna Harris, Rebecca Lane, and Chantal Peacock of Oxford University Press for their encouragement, assistance, and above all patience: the book has taken longer and the new material is far more extensive than originally anticipated. I am likewise indebted to the proofreader, Diana Artley: she worked unflaggingly on the very long text (almost 600,000 words) and in addition to correcting errors and ironing out inconsistencies, she made numerous suggestions for improvements to clarity and style. The internet has reduced the dependence of the writer of reference works on extended correspondence for routine fact checking. I am nonetheless grateful to Professor Michael Craig-Martin, the Gagosian Gallery, the Barbara Gross Gallery, and Charles-Hossein Zenderoudi for providing information. My father and stepmother, Frank and Ursula Glaves-Smith, have been enormously supportive, as has my sister, Ann Glaves-Smith, whose provision of hospitality in London has considerably aided the research process. Jules Glaves-Smith has taken in good heart his father's absorption in the task and cheerfully accepted that the computer has often been 'out of bounds'. The book is dedicated to him.

John Glaves-Smith
Burslem May 2009

AAA *See* ALLIED ARTISTS' ASSOCIATION; AMERICAN ABSTRACT ARTISTS.

Aalto, Alvar (1898–1976) Finnish architect, designer, sculptor, and painter. Aalto is principally renowned as one of the greatest architects and furniture designers of the 20th century, but he was also an abstract sculptor of some distinction. His outstanding work in this field is his memorial (1960) for the Battle of Suomussalmi, a leaning bronze pillar on a stone pedestal set up in the arctic wastes of the battlefield (a Finnish victory against the Soviet Union in 1939–40).

Aaltonen, Wäinö (1894–1966) Finnish sculptor, born at Marttila, near Turku, the son of a village tailor. He became deaf in childhood and took up art as a way of overcoming his disability, studying painting at the School of Drawing of the Turku Art Association, 1910–15, and then turning to sculpture. Following the period in which Finland declared itself independent from Russia, endured civil war, and established itself as a republic (1917–19), Aaltonen made a name for himself as a sculptor of war memorials, and by 1927, when he had a large exhibition in Stockholm, he was regarded as an embodiment of the Finnish national character and way of life. His most typical works are tributes to national heroes such as the monument to the runner Paavo Nurmi (1925, the best-known cast is outside the Olympic Stadium in Helsinki) and the bust of the composer Sibelius (1928, various casts exist). In addition to bronze he worked in stone (particularly granite) and various other materials, including glass. His style was heroic and basically naturalistic, although sometimes touched with *Cubist stylizations.

Abakanowicz, Magdalena (1930–) Polish abstract sculptor, the pioneer and leading exponent of sculpture made from woven fabrics. She was born in Felenty into an aristocratic family and studied at the Academy in Warsaw, 1950–55. Initially she worked in conventional media in painting and sculpture, but from 1960 (the year of her first one-woman show at the Galerie Kordegarda, Warsaw) she concentrated on textiles, using hessian and rope (in some works she has also incorporated wood). Sometimes she obtained her raw materials by visiting Poland's Baltic harbours and collecting old ropes, which she then unravelled and dyed. At first she made reliefs, but soon moved on to large three-dimensional works. In 1962 she first exhibited in the West (at the International Tapestry Biennial in Lausanne) and thereafter her work appeared regularly outside Poland in both solo and group shows, winning her an international reputation, accompanied by numerous awards, including a gold medal at the São Paulo *Bienal in 1965. In the same year she began teaching at the School of Art in Poznań, and in 1974–90 she was a professor there. She writes of her work: 'My intention was to extend the possibilities of man's contact with a work of art through touch and by being surrounded by it. I have looked to those slowly growing irregular forms for an antidote against the brilliance and speed of contemporary technology. I wanted to impose a slower rhythm on the environment as a contrast to the immediacy and speed of our urban surroundings.' Examples of her work are in several Polish collections, notably the Museum of Textiles at Łódź, and in the Museum of Modern Art, New York. *See also* FIBRE ART.

Abate, Alberto *See* PITTURA COLTA.

Abbal, André *See* DIRECT CARVING.

Abbott, Berenice (1898–1991) American photographer, born in Springfield, Ohio. In about 1920 she went to New York, where she met *Dadaists including Marcel *Duchamp and *Man Ray. In 1921, she moved to Paris, where, knowing nothing of photography, she became assistant in Man Ray's studio. She

eventually set up a successful portrait practice of her own and photographed many of the leading figures in intellectual life, including James Joyce. She also met Eugène *Atget and was fascinated by his evocative street scenes. It was Abbott who was responsible for ensuring that his work was preserved after his death. In 1929 she returned to New York, inspired by the fascination of the Parisian avant-garde with the city of skyscrapers, and set about recording the rapid transformations of the city. From 1935 onwards her work was funded by the Works Progress Administration (*see* FEDERAL ART PROJECT). The results were published in 1939 as *Changing New York*. Introducing the book, the critic Audrey McMahon wrote that Berenice Abbott hates 'everything that is sentimental, devious or tricky' and described the work as 'straight photography'. Examination of the photographs today hardly bears out the image of simple neutral craft at work. Abbott's camera produces dramatic perspectives of the skyscrapers from above and below; the old and the new are put in pointed contrast to each other. Susan Platt (*Art Journal*, vol. 58, no. 2, 1999) has argued that political comment was intended. She notes that the left-wing *American Artists' Congress displayed an Abbott photograph, *Gunsmith and Police Headquarters*, framed and angled so that the gun pointed directly at the Police Station.

abjection *See* KRISTEVA, JULIE.

Abrahams, Ivor (1935–) British sculptor and printmaker, born in Wigan. He studied at *St Martin's School of Art and the Central School of Art, London, and made his reputation with colourful sculptures of hedges and garden walls. The imagery was taken from popular gardening magazines and 'prescriptions for the nouveau [sic] bourgeoisie' published in the 19th century on how to organize house and garden. He used fibreglass and flock, the latter to evoke the texture of greenery. In 1973 he said, 'I was able to think of shapes that would, in fact, only come to life when they were treated with this sort of skin or fibre.' He has also applied flock to his prints, again to simulate texture. The results both in sculpture and print have a quality of the uncanny.

Further Reading: S. Raikes, *By Leafy Ways* (2008)

Abramović, Marina (1946–) Serbian *Performance and *Body artist. Born in Bel-

grade, she moved to Amsterdam and now lives and works in New York. Her performances have taken to an extreme danger, physical ordeal and confrontation with the audience. 'If you're really afraid of an idea—that's the kind of idea I like', she told an audience at Tate Modern. When she was young her parents tried to have her sent to a mental institution because of her performance work. In *Rhythm O* (1974), performed in Naples, she stood surrounded by various objects including a gun, a scalpel and a rose. The visitors were allowed to use these on her in any way they chose. When one spectator finally held a loaded gun to her head there was a fight and the performance was terminated. Far less physically dangerous but still highly provocative was *Impondrabilia* (1977). She and her partner and collaborator Ulay stood naked on either side of a door. The public had to pass between them, touching their bodies in order to enter the exhibition. Some of her later work has reflected directly on the wars in her home country. At the 1997 Venice *Biennale, in an installation called *Baltic Baroque*, she sat in a white dress on top of a heap of cow bones, scrubbing them clean while singing folk songs. She began the process as a kind of 'rejuvenating ritual', but as the performance proceeded Abramović became increasingly distraught. As RoseLee Goldberg reported, 'Weeping and exhausted, Abramović created an unforgettable image of grief for our times.'

Absalon *See* ENVIRONMENT ART.

abstract art Art that does not depict recognizable scenes or objects. Much decorative art can thus be described as abstract, but in normal usage the term refers to works of painting and sculpture which make little or no reference to the visual world. Abstract art in this sense was born and achieved its distinctive identity in the decade 1910–20 and is often regarded as the most important development of early 20th-century art. It has evolved into many different types, but certain basic tendencies are recognizable. In 1936 Alfred H. *Barr, 'at the risk of grave oversimplification', divided abstraction into two main currents: the first (represented by Kasimir *Malevich) he described as 'intellectual, structural, architectonic, geometrical, rectilinear and classical in its austerity and dependence upon logic and calculation'; the second (exemplified by Wassily *Kandinsky) he described as 'intuitional or emotional rather

than intellectual; organic or *biomorphic rather than geometrical in its forms; curvilinear rather than rectilinear, decorative rather than structural, and romantic rather than classical in its exaltation of the mystical, the spontaneous and the irrational' (*Cubism and Abstract Art*). There are problems with Barr's distinction. The use of geometric forms may be determined as much by intuition as calculation and an apparently spontaneous expression may be highly premeditated. Taking account of practice since Barr was writing, it is possible to identify several strands in abstract art: (i) the reduction of natural appearances to radically simplified forms, as in the sculpture of Constantin *Brancusi (one meaning of the verb 'abstract' is to summarize or concentrate); (ii) the construction of works of art from non-representational basic forms (often simple geometric shapes), as in Ben *Nicholson's reliefs, or more curvilinear elements as in the work of Jean *Arp and the later Kandinsky; (iii) gestural expression, as in the *Action Painting of Jackson *Pollock; (iv) the interest in the visual or physical qualities of material or process, as in texture painters such as *Tàpies or *Minimalists such as Robert *Ryman or Marthe *Wéry; (v) an art dependent upon the power of pure colour, as in the final work of *Matisse, the *Colour Field paintings of Mark *Rothko, or the *Post-Painterly Abstraction of Morris *Louis or Kenneth *Noland; (vi) art, usually painting, which suggests light, space, and atmosphere without referring to any specific object (what Clement *Greenberg called 'homeless representation'), as practised especially by Parisian painters in the 1950s such as Jean *Bazaine. Some artists and critics dislike the term 'abstract' (Arp, for example, hated it, insisting on the word *'Concrete') but the alternatives they prefer, such as non-figurative, non-representational, and *Non-Objective, although perhaps more precise, are often cumbersome.

The basic premise of abstract art—that formal qualities can be thought of as having a value independent of visual likeness—existed long before the 20th century. Ultimately the idea can be traced back to Plato, who in his dialogue *Philebus* (*c*.350 BC) puts the following words into Socrates' mouth: 'I do not mean by beauty of form such beauty as that of animals and pictures...but understand me to mean straight lines and circles, and the plane or solid figures which are formed out of them by turning-lathes and rulers and measures of angles; for these I affirm to be not only relatively

beautiful, like other things, but eternally and absolutely beautiful.' This statement has been cited by advocates of abstract art such as Alfred Barr, but is really applicable only to the geometric variety. A more exact basis for 20th-century theory and practice can be found in the 19th century. In 1846 Charles Baudelaire (*see* MODERNISM) wrote that 'painting is interesting only in virtue of line and colour'. In 1896 the philosopher George Santayana (1863–1952) proposed 'a new abstract art, an art that should deal with colours as music does with sound'. Painters such as J. M. W. Turner (1775–1851) and Claude *Monet pressed their representation of light effects almost to the point where the object dissolves.

Many of the leading painters of the late 19th century—notably the *Symbolists—stressed the expressive properties of colour, line, and shape rather than their representative function. In 1890—in a much quoted remark—Maurice *Denis said: 'Remember that a picture—before being a war horse or a nude woman or an anecdote—is essentially a flat surface covered with colours assembled in a certain order.' James McNeill *Whistler gave his paintings musical titles, a practice continued by some early 20th-century painters, notably František *Kupka and Kandinsky, as they approached total abstraction. At the same time, the flat linear plant forms typical of *Art Nouveau were sometimes only a short step away from abstraction, as in a painting such as *Composition* (*c*.1902; Stadtmuseum, Munich) by Hans Schmithals (1878–1964). The major avant-garde movements of the first decade of the 20th century—notably *Cubism, *Expressionism, and *Fauvism—further emphasized that a painting was first and foremost a two-dimensional object.

So in the early years of the 20th century abstract art seemed a logical path forward to some artists, and it developed more or less simultaneously in various countries. Kandinsky is often cited as the first person to paint an abstract picture, but no single artist can in fact be singled out for the distinction. A work by Kandinsky once known as *First Abstract Watercolour* (Pompidou Centre, Paris) is signed and dated 1910, but it is now accepted that it is later and was inscribed by Kandinsky some years after its execution. This kind of problem arises not only with Kandinsky: several early abstract artists were keen to stress the primacy of their ideas and were not above backdating works (see, for example,

RAYONISM). However, by 1913 Kandinsky was making paintings which appear to most spectators as entirely abstract—although careful analysis reveals residual figurative imagery. Other candidates for 'first abstract painter' have been put forward with various degrees of plausibility, including Francis *Picabia and Arthur *Dove. The problem is one of definition as much as documentation. Sometimes there were close links with developments in the decorative arts, as with Duncan *Grant and Vanessa *Bell in England or Sonia *Delaunay in France. Kupka, Robert *Delaunay, and Giacomo *Balla all came close to abstraction with cosmic subjects. Mechanistic imagery, as with the *Futurists and Fernand *Léger, by taking the artist from the natural world, was also a force in the direction of total abstraction. In fact the important issue is not really who painted the first abstract painting. Instead, it is more useful to concentrate on when, how, and why artists achieved a coherent practice of abstraction, which could be developed across a series of works, and set up the potential for a practice that could be developed by other artists. In this respect the crucial year was 1915. It was then that in Russia Malevich exhibited his *Suprematist paintings and Vladimir *Tatlin his first abstract constructions. In the same year Piet *Mondrian painted his *Pier and Ocean*, an important influence on the Dutch De *Stijl group founded two years later. Early abstraction was not just a matter of a new style but a search for a way to express a new vision of the world. Kandinsky and Mondrian shared an almost mystical attitude towards art. Although their paintings are at virtually opposite poles of abstraction—Kandinsky's free-flowing and emotional, Mondrian's rigorously geometrical—both artists were influenced by theosophy, an ancient philosophical system that became a modern cult with the foundation of the Theosophical Society in New York in 1875. Theosophists believe that the universe is essentially spiritual in nature; their idea that a deep harmony underlies the apparent chaos of the world had strong appeal to artists such as Kandinsky and Mondrian, who thought that their paintings could help bring about a spiritual revival in the materialistic West. They thought that abstract art could penetrate external appearances to reveal a greater truth beneath. Mondrian believed that his art of clarity and balance would lead to a society in which life would be governed by a universal visual harmony.

Among the other pioneers of abstract art who were influenced by mystical ideas were Malevich, who tried to paint the 'supreme reality', and Theo van *Doesburg, Mondrian's principal colleague in De Stijl. Van Doesburg was extremely active in promoting the group's ideas, and in the period between the two world wars its severely geometrical style was one of the most influential currents in abstraction, together with the technologically orientated *Constructivism (they came together in the *Bauhaus). A characteristic of thinking about abstraction in the interwar years was that there was a close connection between the forms of abstract art and those of modern design and architecture. This was argued in Herbert *Read's *Art and Industry* (1934) and in the New York *Museum of Modern Art exhibition 'Machine Art' (1934), curated by the architect and historian Philip Johnson.

Paris was the main centre of abstract art at this time, partly because it attracted so many refugee artists from Germany and Russia, where abstract art was banned in the 1930s under Hitler and Stalin. There was also a strong abstract element in *Surrealism, which was born in Paris. When Surrealist artists, most notably Joan *Miró and André *Masson, came closest to abstraction, it was generally the result of the application of *automatism. The spontaneous processes tended to work against the ideal geometric forms of other abstractionists of the time. The first exhibition devoted solely to abstract art was held in Paris by the *Cercle et Carré group in 1930. Its successor, the *Abstraction-Création association, founded in 1931, brought together a large number of abstract artists of various types and provided a focus for their activities. In general, however, figurative art was dominant in the interwar period and abstract art won little public acceptance. It was very much a minority taste in Britain and the USA, for example, in spite of such outstanding individual contributions as the sculptures of Alexander *Calder and Barbara *Hepworth, and the efforts of groups such as *Unit One (founded in 1933) and *American Abstract Artists (founded in 1936).

After the Second World War abstract art achieved wider acceptance and entered a new phase. With the burgeoning of *Abstract Expressionism in the USA and its European equivalent *Art Informel, expressive values were being emphasized above order and geometry. By about 1960 abstract art was not only widely accepted but on the verge of becoming the dominant

orthodoxy in Western art. It no longer seemed to need philosophical justification of the kind given by Kandinsky and Mondrian (although several of the Abstract Expressionists were equally high-minded in approach). However, abstraction was sometimes still invested with a moral and political dimension as an embodiment of Western freedom of thought, as opposed to the totalitarianism that had banned avant-garde art in Nazi Germany and Soviet Russia (*see* DEGENERATE ART and SOCIALIST REALISM). In France in 1945 the Louvre curator Germain Bazin (1901–90) argued that collaborators with the occupation among artists came only from the *Fauves and the realists because 'abstraction is a position of liberty, which engages man completely and will admit to no pact with power'. It is significant that many of the Abstract Expressionists were influenced by European Surrealists who had fled to New York during the Second World War to escape the fear of repression. In the USA, support for abstract art could be regarded almost as a form of patriotism—Clement *Greenberg used the term 'American-Type Painting' as an alternative to Abstract Expressionism, and one of the standard books on the movement (Irving Sandler's *Abstract Expressionism*, 1970) is subtitled *The Triumph of American Painting*. However, especially during the height of anti-Communist feeling in the early 1950s, there were also influential voices such as that of senator George Dondero who agitated against it on the grounds that it was politically subversive.

Later abstract art often reacted against the emotional fervour of Abstract Expressionism and cultivated a 'cool' aesthetic which it shared with aspects of *Pop art. New forms of abstraction included *Post-Painterly Abstraction and *Minimal art, both of which flourished in the 1960s. These frequently jettisoned as unnecessary baggage the spiritual or social basis for abstraction. As Frank *Stella put it, 'My painting is based on the fact that only what can be seen there *is* there' (B. Glaser, 'Questions to Stella and *Judd', *Art News*, September 1966). The *appropriation of *ready-made images and signs in the work of artists such as Jasper *Johns and Andy *Warhol started to make the issue of abstraction versus figuration a secondary one. A painter like Richard *Diebenkorn or a sculptor like David *Smith could move between abstract and figurative modes without it seeming to be a major issue for artist or spectator.

Some exponents and supporters of abstract art have argued that it can reach the same heights as the greatest art of the past, and indeed go beyond it, by virtue of a kind of universal language based on colour and form. Kandinsky, for example, wrote that 'The impact of the acute angle of a triangle on a circle produces an effect no less powerful than the finger of God touching the finger of Adam in Michelangelo's *Creation*' (*Cahiers d'art*, 1931). The general charge against abstract art, sometimes but by no means always, coming from left-wing supporters of *Socialist or *Social Realism, has been that it lacks a certain 'human content'. For instance in 1935 Kenneth *Clark, hardly a figure generally identified with the political left, accused abstract painters of contracting 'spiritual beri-beri'. A further criticism is that abstract art provides insufficient challenge to the artist, who is no longer required to juggle the contradictory demands of representation and design. In 1958 E. H. *Gombrich, for whom the psychology of representation was central, wrote: 'when I seriously compare my reaction to the best "abstract" canvas with some work of great music that has meant something to me, it fades into the sphere of the merely decorative.' A more persuasive basis for a critique might come from the practice of Pablo *Picasso, who never, apart from a few small drawings, made a totally abstract work.

In recent years the greatest challenge to abstraction has come not from artistic conservatives but from developments in theory. The dominant issue has no longer been abstraction against figuration but the status of the art object (*see* CONCEPTUAL ART). Because of the impact on art theory of semiology (*see* BARTHES, ROLAND), the idea that form and colour can have some kind of 'intrinsic' value or 'universal meaning', apart from language and culture, seems far less plausible. The 'neutrality' of the formal values of abstract art is no longer taken for granted. For Peter *Halley, geometry is a metaphor, not for some underlying order, but for coercion and confinement. Looking today at the work of a Kandinsky, a Malevich, a Mondrian, perhaps even a Pollock, the spectator might well be moved as if by the expression of some lost religious faith.

Further Reading: B. Fer, *On Abstract Art* (1997)

E. H. Gombrich, *Meditations on a Hobby Horse* (1963). The case for the prosecution is eloquently put.

Tate Gallery, *Towards a New Art: Essays on the Background to Abstract Art* (1980)

Abstract Classicism *See* HARD-EDGE PAINTING.

Abstract Expressionism The dominant movement in American modern art, principally painting, in the late 1940s and the 1950s, characterized by large scale and *gestural handling. It was the first major development in American art to achieve international status and influence, and it is often reckoned the most significant art movement anywhere since the Second World War. Certainly, more than any other movement, it was responsible for the replacement of Paris by New York as the world capital of modern art. Leading figures included Jackson *Pollock, Willem *de Kooning, Mark *Rothko, Barnett *Newman, Robert *Motherwell, Clyfford *Still, Adolph *Gottlieb, Franz *Kline, and Philip *Guston.

The phrase 'Abstract Expressionism' had originally been used in 1919 to describe certain paintings by Wassily *Kandinsky, and it was used in the same way by Alfred H. *Barr in 1929. In the context of modern American painting it was first used by the *New Yorker* art critic Robert Coates (1897–1973) in 1946 and it had become part of the standard critical vocabulary by the early 1950s. The painters embraced by the term worked mainly in New York and there were various ties of friendship and loose groupings among them, but they shared a similarity of outlook rather than of style—an outlook characterized by a spirit of revolt against tradition and a belief in spontaneous freedom of expression. The stylistic roots of Abstract Expressionism are complex, but despite its name it owed more to *Surrealism—with its stress on *automatism and intuition—than to *Expressionism. A direct source of inspiration came from the European Surrealists who took refuge in the USA during the Second World War. The work of Arshile *Gorky, who was strongly supported by André *Breton, is often regarded as the essential link between Surrealism and Abstract Expressionism. Also important in this context was *Matta, who promoted what Meyer *Schapiro called the 'idea of the canvas as a field of prodigious excitement, unloosed energies'. The war also brought Peggy *Guggenheim back to America, and during its brief lifetime (1942–7) her Art of This Century gallery was the main showcase for Abstract Expressionism during its formative period.

The work of the Abstract Expressionists varied greatly and was sometimes neither abstract (de Kooning's *Woman* series) nor Expressionist (Rothko). It ranges from the explosive energy of Pollock's *Action Painting to the serene contemplativeness of Rothko's *Colour Field Painting. Even within these two polarities, however, there are certain qualities that are basic to most Abstract Expressionist painting: the preference for working on a huge scale; the emphasis placed on surface qualities so that the flatness of the canvas is stressed; the adoption of an *all-over type of treatment, in which the whole area of the picture is regarded as equally important. Quite apart from these visual technical characteristics, there was a certain unity of fundamental attitudes: the glorification of the act of painting itself; the conviction that abstract painting could convey significant meaning and should not be viewed in *formalist terms alone; and a belief in the absolute individuality of the artist (for which reason most of the Abstract Expressionists disliked being labelled with an 'ism', preferring *New York School as a group designation).

Almost without exception, the artists who created Abstract Expressionism were born between 1900 and 1915 and most of them struggled during their early careers, which coincided with the Depression. Apart from Motherwell, the major artists began as figurative painters, but generally moved towards abstraction in the late 1930s or early 1940s. The idea that these artists were beginning to create a new movement took shape in about 1943, and in 1945 Peggy Guggenheim mounted an exhibition called 'A Problem for Critics', almost as a challenge for someone to come up with a name for this movement. By 1948, when de Kooning had his first one-man show and Pollock first exhibited his drip paintings, it was approaching maturity. Initially the new way of painting was found perplexing or outlandish by many people, but during the 1950s the movement became an enormous critical and financial success. The influential writers Clement *Greenberg and Harold *Rosenberg suggested opposing interpretations of the movement. Greenberg emphasized its role in the formal and technical development of *Modernism, while Rosenberg took the view that the 'action painter' (*see* ACTION PAINTING) was involved in a kind of existentialist affirmation of human freedom.

Abstract Expressionism had passed its peak by 1960 and a reaction had taken place in the form of the cooler aesthetic of *Pop art and

*Post-Painterly Abstraction, but several of the major figures continued productively after this and a younger generation of artists carried on the Abstract Expressionist torch. Sculptors as well as painters were influenced by Abstract Expressionism, the leading figures including David *Smith, Ibram *Lassaw, Seymour *Lipton, and Theodore *Roszak. Some commentators, such as Eva Cockcroft in her article 'Abstract Expressionism, a Weapon of the Cold War' (*Artforum* June 1974), have argued for links between the international success of the movement and Cold War politics. The painter could be presented so as to exemplify American freedom as against the restrictions of the Communist world with its state directives for *Socialist Realism. Therefore the organization of an international tour for 'The New American Painting' in 1958 to 1959, by the International Programme of the New York *Museum of Modern Art, had a decided political dimension. Alfred H Barr's catalogue introduction said that the artists 'defiantly reject the conventional values of the society which surrounds them but they are not politically engagés'. In fact the personal political allegiances of the Abstract Expressionists varied enormously: the group included an anarchist (Newman) and a rightwing supporter of Senator McCarthy (Still), while the one-time Trotskyite Clement Greenberg described, with a measure of regret, Jackson Pollock as a 'god dam Stalinist'.

The early impact of Abstract Expressionism, at least for its admirers, was well put by the British painter and critic Andrew Forge (1923–2002). In 1974 he recalled how 'it seemed to me that painting had made a totally new definition of freedom. The structures I was looking at owed nothing, or so it seemed, to the closed, self-consistent notions of composition and pictorial syntax that my experience up to then had taught me to regard as mandatory' (Ashton). Although the movement was in decline by the end of the 1950s its legacy can be seen in most important American art of the following two decades, for instance in the preoccupation with overwhelming the spectator through scale.

Further Reading: Anfam (1990)

D. Ashton, *American Art Since 1945* (1982)

T. J. Clark, 'In Defence of Abstract Expressionism', *October*, no. 69 (summer 1994)

F. Frascina (ed.), *Pollock and After* (2000)

Sandler (1970)

D. and C. Shapiro (eds.), *Abstract Expressionism: A Critical Record* (1990)

Abstract Impressionism A term coined by Elaine *de Kooning to describe paintings that resemble certain late *Impressionist pictures (notably those of *Monet) in their brushwork but have no representative content: 'Retaining the quiet uniform pattern of strokes that spread over the canvas without climax or emphasis, these followers keep the Impressionist manner of looking at a scene but leave out the scene.' In 1956 the critic Louis Finkelstein applied the term to Philip *Guston's paintings to distinguish them from the more exuberant type of *Abstract Expressionism known as *Action Painting, and in 1958 Lawrence *Alloway used the term as the title of an exhibition he organized in London; the artists represented included Bernard and Harold *Cohen, Sam *Francis, Patrick *Heron, and Nicolas de *Staël. The term has also been applied to various French abstract painters of the same period, for example *Bazaine and *Manessier.

abstraction 'In the fine arts, the practice or state of freedom from representational qualities; a work of art with these characteristics' (*OED*). Some critics prefer to restrict the term to those types of *abstract art that have their starting-point in the external world—in other words, those in which the image is 'abstracted' or distilled from the appearance of some real object or scene. Usually, however, the term is used as a convenient synonym for abstract art as a whole.

Abstraction-Création An association of abstract painters and sculptors formed in Paris in February 1931 in succession to the short-lived *Cercle et Carré group, whose mailing list the new association took over. The prime movers behind Abstraction-Création were Jean *Hélion, Auguste *Herbin, and Georges *Vantongerloo, who all practised the type of abstract art in which works are constructed from completely non-representational, usually geometrical, elements, rather than derived from natural appearances. Although geometrical abstraction was especially well represented in the association, it was open to abstract artists of all persuasions and the membership at one time rose to as many as 400. Artists of numerous nationalities joined, among them *Arp, *Gabo, *Kandinsky, *Lissitzky, *Mondrian, and *Pevsner. Many members had left the totalitarian regimes in Nazi

Germany and Stalinist Russia, where avant-garde art was outlawed, and their presence in Paris helped to make it the most important centre for abstract art in the 1930s. Also included in the membership were artists who were never permanently resident in Paris, such as Barbara *Hepworth and Ben *Nicholson. The association operated by arranging group exhibitions and by publishing an illustrated annual entitled *Abstraction-Création: Art non-figuratif*, which appeared from 1932 to 1936, with different editors for each issue.

Abstraction Lyrique See LYRICAL ABSTRACTION.

Abstract Sublime A term coined *c*.1960 by the American art historian Robert Rosenblum (1927–2006) to characterize the feelings of vastness and solitude suggested by certain *Abstract Expressionist paintings, for example those of *Newman, *Rothko, and *Still. Newman had earlier used the word 'sublime' in connection with his own work ('The Sublime is Now', *Tiger's Eye*, December 1948). Rosenblum first used the term 'Abstract Sublime' in print as the title of an article in the February 1961 issue of *Art News*, and two years later Lawrence *Alloway coined the term 'American Sublime' to describe the same quality ('The American Sublime', *Living Arts*, June 1963). Rosenblum developed his ideas at book length in *Modern Painting and the Northern Romantic Tradition: Friedrich to Rothko* (1975), in which he related Abstract Expressionism to a wider western tradition of the Romantic landscape. In 1994 David *Sylvester referred to the 'cosmic grandeur' of Newman, the 'cosmic energy' of *Pollock, and the 'cosmic pathos' of Rothko.

Abts, Tomma (1967–) German painter, born in Kiel. She moved to London in 1995 and has established a considerable reputation with a distinctive form of abstract painting. She uses a consistent format, always working on vertical canvases of 48 × 38 cm. The scale and vertical alignment tend to confront the spectator in the manner of a portrait. The titles of the paintings are all taken from a dictionary of regional German names, so enhancing the sense of a human presence. As the critic Jan Verwoert points out, unlike the travels into outer space and the future offered by early abstract painters such as El *Lissitzky, Abts' work takes abstraction 'down from heaven'. Although her paintings appear precise in their execution, they are the result, not of exact preplanning, but of a gradual process of adaptation and accretion. This sometimes results in quasi-illusionistic effects of space or light and shade, occasionally in close approximations of actual objects. The layers of accretions of thin paint recording the changes to the picture are just visible in relief. Abts was awarded the *Turner Prize in 2006.

(⊕) SEE WEB LINKS

• Tomma Abts in conversation with Jan Verwoert, Turner Prize artist's talk, Tate website.

académie A French term for a private art school, several of which flourished in Paris in the late 19th and early 20th centuries. Entry to the official École des *Beaux-Arts was difficult (almost impossible for foreigners, who from 1884 had to take a vicious examination in French), and teaching there was conservative, so private art schools, with their more liberal regimes, were often frequented by progressive young artists. Three académies are particularly important in this context.

The **Académie Carrière** was opened in 1890 by Eugène Carrière (1849–1906), a painter of portraits, religious pictures, and—his speciality—scenes of motherhood. His characteristic style was misty, monochromatic, and vaguely *Symbolist. *Rodin was a great admirer of his work. There was no regular teaching at the school, though Carrière visited it once a week. It was here that *Matisse met *Derain and *Puy, thus expanding the nucleus of the future *Fauves.

The **Académie Julian** was founded in 1873 by Rodolphe Julian (1839–1907), whose work as a painter is now forgotten. The school had no entrance requirements, it was open from 8 am to nightfall, and it was soon the most popular establishment of its type. Julian opened several branches throughout Paris, one of them for women artists, and by the 1880s the student population was about 600. Although the Académie Julian became famous for the unruly behaviour of its students, it was regarded as a stepping-stone to the École des Beaux-Arts (Julian had astutely engaged teachers from the École as visiting professors). Among the French artists who studied there were *Bonnard, *Denis, *Matisse, *Vallotton, and *Vuillard. The list of distinguished foreign artists who studied there is very long.

The **Académie Ranson** was founded in 1908 by Paul Ranson (1864–1909), who had

studied at the Académie Julian. After Ranson's early death, his wife Marie-France took over as director, and his friends Denis and *Sérusier were among the teachers. Among later teachers at the school the most important was Roger *Bissière, who in the 1930s influenced many young painters in the direction of expressive abstraction: his pupils included *Le Moal, *Manessier, and *Vieira da Silva. The Académie Ranson remained a popular training centre for foreign artists up to and after the Second World War.

Further Reading: J. Milner, *The Studios of Paris* (1988)

Académie de la Grande Chaumière,
Paris. *See* BOURDELLE, ÉMILE-ANTOINE.

Académie de l'Art Moderne (later Académie de l'Art Contemporain), Paris.
See LÉGER, FERNAND.

Académie Montparnasse, Paris. *See* LHOTE, ANDRÉ.

Accardi, Carla (1924–) Italian painter and installation artist, a founder member of the *Forma Uno group in Rome in 1947. After the group dissolved in 1951 she went through a period of self-doubt but started painting again in 1953. Her early painting resembled automatic script on a monochrome ground in the manner of *Tobey's 'white writing', but she later moved away from this kind of *Art Informel to more deliberately planned compositions. This was in line with the tenets of the *Continuità group, which she joined in 1960. In 1965 she began painting on a transparent plastic called sicofoil, which at first she mounted on canvas but later mounted on wooden stretchers so that both support and the wall beneath would be visible. Subsequently she made the sicofoil into free-standing rolls. This use of the material was extended into installation in *Orange Environment* (1966–8), in which a painting on the wall is brought together with objects such as a bed, a tent, and a parasol, all in sicofoil with orange squiggles. Her work has been associated with *feminist artists in America, such as Joyce *Kozloff, who were concerned with *Pattern and Decoration, although she had little contact with activities on the other side of the Atlantic. She has stated that 'the artistic message is intrinsic to art itself, and its form when properly expressed is independent of the life of the artist'.

Further Reading: J.-P. Criqui, 'Carla Accardi', *Artforum International* (April 2002)

Acconci, Vito (1940–) American *Body and *Performance artist, born in New York. His background was not in the visual arts but in literature. In the 1960s he wrote poetry and his earliest performances were an extension of this practice. Rather than writing a poem about 'following', he enacted *Following Piece* (1969), in which he followed random passersby until they went into a building. He sought a way to make such acts more public, but this underlined their introspective nature. In *Telling Secrets* (1971) he stood in a dark deserted shed on the Hudson River in the small hours of the morning whispering to late-night visitors secrets about himself 'which could have been totally detrimental to me if publicly revealed'. *Seedbed* (1971), probably his best-known work, had Acconci lying invisible under a ramp in the Sonnabend Gallery, New York. While there, he masturbated to fantasies concerning the unseen visitors above him. Acconci was influenced by the theories of the psychologist Kurt Lewin about the 'power fields' radiated by each individual. The audience became part of the physical space in which he moved. Although Acconci's activities are aligned to Performance and Body art, this idea of the engagement of the viewer with the work also brings him close to the preoccupations of some of the *Minimalist art of the period. Acconci stopped performing in 1974. In later years he has worked as an experimental architect.

Ackermann, Franz (1963–) German painter and installation artist, born in Neumarkt St Veit. He makes large semi-abstract works on the theme of travel and tourism. Sometimes these incorporate actual travel posters, as in his installation piece *Bologna* (2000). Sometimes there is simply a suggestion of fragments of buildings or landscape caught up in a great vortex. The critic Marco Meneguzzo has described the effect as 'a feeling of something slipping and sliding by, as if someone were looking out a train window, trying to scrutinize not so much the passing urban landscape as the very feeling of both absence and uniformity' (*Artforum International*, April 2001).

Ackling, Roger (1947–) British artist. Born in Isleworth, London, he lives and works in Norfolk. He graduated from *St Martin's School of Art in the late 1960s, at the time of

questioning about the nature of sculpture. His practice has some affinity with that of Richard *Long, in that it involves an active engagement with nature. Ackling makes works by using the effects of the sun through a magnifying glass to burn series of dots, which become lines on pieces of found wood.

acrylic A modern synthetic paint, made with a resin derived from acrylic acid, that combines some of the properties of oils and watercolour. It was the first new painting medium in centuries and has become a serious rival to oil paint. Acrylics are a refined version of paints developed for industrial use and can be applied to almost any surface with a variety of tools (brush, *airbrush, knife, sponge, and so on) to create effects ranging from thin washes to rich impasto and with a matt or gloss finish. Various additions can be used to modify the appearance. Most acrylic paints are water-based, although some are oil compatible, using turpentine as a thinner. Thinly applied paint dries in a matter of minutes, thickly applied paint in hours—much quicker than oils. Colours, which include fluorescent and metallic tints, are characteristically clear and intense. Acrylic paint first became available to artists in the 1940s in the USA and certain American painters discovered that it offered them advantages over oils. Colour stain painters (*see* COLOUR FIELD PAINTING) such as Helen *Frankenthaler and Morris *Louis, for example, found that they could thin the paint so that it flowed over the canvas yet still retained its full brilliance of colour. David *Hockney took up acrylic during his first visit to Los Angeles in 1963; he had earlier tried and rejected the medium, but American-manufactured acrylic was at this time far superior to that available in Britain, and he felt that the flat, bold colours helped him to capture the strong Californian light. Hockney used acrylic almost exclusively for his paintings until 1972, when he returned to oils because he had come to regard their slowness in drying as an advantage: 'you can work for days and keep altering it as well; you can scrape it off if you don't like it. Once acrylic is down you can't get it off.' In spite of these differences in properties, the finished appearance of an acrylic painting is sometimes more or less indistinguishable from an oil, and some artists (for example Richard *Estes) have often combined the two techniques in the same painting. In addition to being versatile, acrylics are less susceptible to heat and damp than traditional media, but since the 1990s some doubts have been expressed about their permanence.

Action *See* AKTION.

Action Painting A type of dynamic, impulsive painting, practised by certain *Abstract Expressionists, in which the artist applies paint with energetic *gestural movements—sometimes by dribbling or splashing—and with no preconceived idea of what the picture will look like. Sometimes the term has been used loosely as a synonym for Abstract Expressionism, but this usage is misleading, as Action Painting represents only one aspect of the movement. The term was coined by the critic Harold *Rosenberg in an article entitled 'The American Action Painters' in *Art News in December 1952. Rosenberg saw Action Painting as a means of giving free expression to the artist's instinctive creative forces and he regarded the act of painting itself as more significant than the finished work: 'At a certain moment the canvas began to appear to one American painter after another as an arena in which to act—rather than as a space in which to reproduce, re-design, analyze or "express" an object, actual or imagined. What was to go on the canvas was not a picture but an event.' Although the term 'Action Painting' soon became established, many critics were unconvinced by Rosenberg's idea of the canvas being 'not a picture but an event': Mary McCarthy, for example, wrote that 'you cannot hang an event on a wall, only a picture'.

Rosenberg's article did not mention individual painters and was not illustrated, but the artist who is associated above all with Action Painting is Jackson *Pollock, who vividly described how he felt when working on a canvas laid on the floor: 'I feel nearer, more a part of the painting, since this way I can walk around it, work from the four sides and literally be *in* the painting . . . When I am *in* my painting, I am not aware of what I'm doing. It is only after a sort of "get acquainted" period that I see what I have been about. I have no fears about making changes, destroying the image, etc., because the painting has a life of its own. I try to let it come through.' However, in a statement made to a less sympathetic audience (the listeners to a radio interview), Pollock was anxious to allay the suspicions of those who viewed his work as without skill by playing down the role of chance. 'When I am painting I have a general notion as

to what I am about. I *can* control the flow of the paint; there is no accident.' The German-born photographer Hans Namuth (1915–90), who documented Pollock's method in a famous series of pictures, wrote of seeing him at work: 'It was a great drama—the flame of explosion when the paint hit the canvas; the dance-like movement; the eyes tormented before knowing where to strike . . . my hands were trembling.'

There have been numerous accounts of how Pollock came to develop his drip technique, including an unlikely story that the idea came to him when he accidentally kicked over a can of paint. A theory that has been much discussed is that he was influenced by sand paintings of the Navajo Indians of New Mexico, who in certain rituals pour coloured earth on to the ground to form elaborate patterns. While Pollock may have been attracted by the ritualistic aspects of the sand paintings, which were destroyed as soon as they were completed, *Surrealist *automatism was probably the more immediate inspiration. Whatever his sources, Pollock used Action Painting to produce what are generally regarded as some of the greatest abstract pictures ever created. In the work of lesser artists, however, the technique could easily degenerate into messy self-indulgence, and it gave rise to a good deal of outrage and mockery, especially after the British painter William Green (1934–2001) took to riding a bicycle over the canvas. This feat, which was imitated by the comedian Tony Hancock in the film *The Rebel* (1961), inspired a poem in the journal *Studio*:

Where Pollock spilled, now others ride,
Anxious to show they've nothing to hide.
Not even talent need get in the way,
When you're hep on a bike with nothing to say.

In a similar vein, in 1955–6, various members of the *Gutai Group in Japan produced Action Paintings through highly unorthodox means: one of them painted with his feet whilst hanging from a rope, for example, and another used a remote-controlled model car rigged with a can of paint. Others who turned painting into a kind of theatrical performance include Georges *Mathieu and William *Ronald. The *Happenings of Allan *Kaprow were also inspired by the idea of Action Paintings, as were the bloody rituals of the *Vienna Actionists. The process was given a *feminist turn by the Japanese artist Shigeko Kubota (1937–), who in 1965 in New York performed a red 'vagina painting'.

Activists A Hungarian artistic, literary, and political group, active from about 1914 to about 1926. It was the most important of the associations that emerged after the break-up of The *Eight, Hungary's pioneering avant-garde group. The Eight and the Activists had one member in common, Lajos Tihanyi (1885–1938), but the Activists were more radical in outlook and agitated for the creation of a socialist society. Stylistically, the Activists were influenced by several recent movements, including *Cubism, *Expressionism, and *Futurism, and later *Dada and *Constructivism. An important stimulus to the group was provided by an exhibition of Expressionist and Futurist art at the National Salon in Budapest in 1913 (previously shown at the *Sturm Gallery in Berlin). The Activists formed only a loose grouping, but a focus for their activities was provided by the journal *MA* (Hungarian for 'today'), founded in 1916 by the writer and artist (painter, sculptor, printmaker, collagist) Lajos Kassák (1887–1967). Kassák had previously published (1915–16) an anti-war periodical *A Tett* ('The Deed'), which had been banned by the authorities as 'propaganda hostile to the nation'. The first issue of *MA* included an essay by Kassák entitled 'The Poster and the New Painting', in which he argued that painting should aspire to the same kind of vivid communication as the political poster. Several Activists did in fact produce posters during the brief Communist regime in Hungary in 1919. This regime banned *MA*, but Kassák began publication again in Vienna after he moved there in 1920. *MA* ran until 1926, when Kassák returned to Hungary.

Actual art *See* ARTE POVERA.

Adami, Valerio (1935–) Italian painter and graphic artist, his country's leading exponent of *Pop art and one of the few non-American or non-British artists to achieve international success in the field. He was born in Bologna and from 1953 to 1957 studied at the Brera in Milan, the city that has been the main centre of his activities (in 1961–2 he worked in London and in 1962–4 in Paris). Initially he painted abstracts, but in the 1960s he turned to figuration. Characteristically his pictures resemble frames from comic strips, with firm outlines and flat colours. His subject-matter has been drawn largely from advertising, but he has also used literary, philosophical, and political themes. The images are often

fragmented and his work sometimes has an air of fantasy recalling *Surrealism.

Adams, Ansel (1902–84) American landscape photographer, born in San Francisco. He had originally intended to become a pianist and initially took up photography as a profession in the context of his membership of the Sierra Club, a conservation organization. It was their bulletin that first published his photographs, and he remained an active environmental campaigner for all his life. He was especially noted for his depictions of the mountainous regions in the Yosemite. Images such as the sheer rock face of *Monolith, the Face of Half Dome, Yosemite Valley, California* (c.1927) are part of an American tradition of the sublime that can be traced from a landscape painter like Frederick Edwin Church (1824–1900) to the expansive abstracts of Mark *Rothko and Barnett *Newman. Adams was especially noted for his technical virtuosity. He published ten instructional manuals and developed the 'zone system', a highly complex method of grading tones. His exclusion of the human presence from his pictures, doubtless one of the reasons for the popularity of his work, was not universally approved. Henri *Cartier-Bresson once said, 'The world is falling to pieces and all Adams and *Weston photograph is rocks and trees.'

Adams, Robert (1917–84) British sculptor, born in Northampton. He studied (mainly part-time) at Northampton School of Art, 1933–44, whilst working at various jobs including engineering and printing. After the Second World War he moved to London, where he taught at the Central School of Arts and Crafts, 1949–60. His mature work was completely abstract and he was regarded as one of the leading British exponents of *Constructivism, alongside Anthony *Hill, Kenneth and Mary *Martin, and Victor *Pasmore. Adams worked in stone and wood and from about 1955 also in metal and concrete. His most characteristic works were reliefs, but he also made freestanding pieces featuring metal blocks interspersed with rods. Among his major commissions were a large concrete relief for the Municipal Theatre, Gelsenkirchen, Germany (1959), and reliefs for the liners *Canberra* and *Transvaal Castle* (1961). From about 1970 he worked mainly in bronze.

Ader, Bas Jan (1942–75) Dutch artist. He is sometimes described as a *Conceptual artist,

but the term seems especially inappropriate to one for whom the physical acting out of the idea was so vital. He was born in Winschoten; his parents were both pastors. In 1944 his father was executed by the Nazis for harbouring Jews, a dramatic circumstance which has sometimes been related to some of the self-destructive elements of his later career. Leaving his studies at the Rietveld Academy unfinished, he arrived in California in 1963, after the yacht on which he had been serving as a deckhand was shipwrecked, In California he studied art and philosophy. In 1970 he made his first film, *Fall 1*. This shows him perched on the roof of his house, seated on a chair. He leans to one side, falls off the chair and rolls off the roof. Falling and gravity were a theme of subsequent films. *Broken Fall (Organic)* (1971) was filmed in a park in Amsterdam. The tall, gangly figure of the artist is seen hanging from a branch that overhangs a stream. He sways from side to side. At the end he lets go, either deliberately or because he can hang no longer. The movement of the figure in the water becomes less significant than the ripples in the stream or the bouncing of the branch. Richard Dorment has suggested that the fate of his father, who was shot in the woods, was a point of reference. His best-known film is the ten-minute long *I'm too sad to tell you*, in which he is seen in close-up, weeping. As with the films about falling, questions are raised as to how far we are seeing a calculated act and how far something out of the artist's control. Ader's final work was entitled *In Search of the Miraculous*. It followed a piece in which he had been recorded walking, dangerously and illegally, along the freeways of southern California. Ader undertook a solo trans-Atlantic crossing in what would have been the smallest craft ever to achieve such a voyage. The night before his departure there was a performance of sea shanties at the gallery of his Los Angeles dealer. A similar performance was planned for his arrival in Falmouth, which he had calculated would be anything between sixty and ninety days later. After thirty days radio contact was lost. The boat eventually turned up half-sunk and empty. The exact circumstances of Ader's death are unknown.

Further Reading: R. Dorment, 'The artist who sailed to oblivion', *The Daily Telegraph* (9 May 2006)

Adler, Jankel (1895–1949) Polish painter. He was born at Tuszyn, near Łódź, and studied in Germany at the School of Arts and Crafts in Barmen (now part of Wuppertal), 1913–14.

In about 1922 he settled in Düsseldorf, where he became a friend of Paul *Klee and painted several murals, including frescos for the Planetarium. He left Germany in 1933 because of the rise of Nazism and travelled widely in the next few years, living mainly in Paris, where he worked with *Hayter at Atelier 17. On the outbreak of war he joined the Polish army in France and in 1940 was evacuated to Britain, where he lived for the rest of his life, first in Scotland and then from 1943 in London. Adler was primarily a figure painter, best known for his portrayals of Jewish life in Poland (as a youth he had considered becoming a rabbi). His style in his mature work was eclectic and expressionistic, influenced by Klee and *Picasso. In turn his cosmopolitanism was a stimulus against wartime isolation for several young British artists, notably *Colquhoun and *MacBryde (in the mid-1940s Adler shared a house with them in Bedford Gardens, London).

Adrian-Nilsson, Gösta (1884–1965) Swedish painter (sometimes known—from his initials—as GAN), a pioneer of modernism in Scandinavia. From 1912 he made visits to Berlin, where he came into contact with *Cubism and *Futurism and developed a semi-abstract style (typically expressed in dynamic cityscapes) influenced by *Kandinsky and *Marc. By 1919 he was painting completely non-figurative works—these are often said to be the first pure abstracts by a Swedish artist, although *Eggeling probably contests the distinction with him. In the 1930s Adrian-Nilsson turned to *Surrealism and became the focus of a group of Surrealists at Halmstad, a city on the south-western coast of Sweden. Examples of his work are in the Moderna Museet, Stockholm.

adversary spaces *See* NAUMAN, BRUCE.

aerograph *See* AIRBRUSH.

Aeropittura Movement in Italian art, a development of *Futurism, in which artists attempted to depict the sensation of flight (the term is Italian for 'air painting'). *Marinetti published a manifesto of Aeropittura in 1929 and there were exhibitions in Italy in 1931, Paris in 1932, and Berlin in 1944, but no important works emerged from the movement, which virtually came to an end with Marinetti's death in 1944. The artists associated with Aeropittura included the painter Gerardo Dottori (1884–1977) and the sculptor Bruno Munari (1907–98).

affichiste Name (literally 'poster designer') taken by the French artists and photographers Raymond Hains (1926–2005) and Jacques Villeglé (1926–), who met in 1949 and during the early 1950s devised a technique of making *collages from fragments of torn-down posters. They called these works, which they first exhibited in 1957, *affiches lacérées* (torn posters). Villeglé manipulated the posters to create particular images and effects, but Hains left them more or less as he found them in an attempt to demonstrate the aesthetic bankruptcy of the advertising world. Both artists became associated with *Nouveau Réalisme. Other artists adopted a similar technique in the 1950s, notably the Italian Mimmo *Rotella and the German Wolf *Vostell.

Afro (Afro Basaldella) (1912–76) Italian painter and stage designer, brother of the sculptors Dino Basaldella and Mirko Basaldella (who like Afro preferred to be known simply by his first name; *see* MIRKO). Afro was born in Udine, the son of a decorative painter, and he studied in Florence and Venice. He had his first one-man exhibition at the Galleria del Milione, Milan, in 1932, and in 1938 moved to Rome, where he lived for most of the rest of his life. During the Second World War he served in the Italian army and fought with the Resistance. After the war he joined the *Fronte Nuovo delle Arti in 1947 and the Gruppo degli Otto Pittori Italiani in 1952. From 1950 he often visited the USA; he had regular exhibitions at the Catherine Viviano Gallery in New York and he taught at Mills College in Oakland, California. Afro's early work, which included landscapes, portraits, and still-lifes, was influenced by *Cubism, but after the war he developed a loose improvisatory abstract style influenced by *Abstract Expressionism and he came to be regarded as one of the leading Italian artists working in this *Art Informel idiom. He painted a mural entitled *The Garden of Hope* for the restaurant of the UNESCO Building in Paris (1958).

Agam, Yaacov (Jacob Gipstein) (1928–) Israeli sculptor and *Kinetic artist, active mainly in Paris, where he settled in 1951. He was born in Rishon-le-Zion and studied at the Bezalel School, Jerusalem, 1947–8, the Giedion Art School, Zurich, 1949, and the Atelier d'Art Abstrait, Paris, 1951. In 1953 he had his

first one-man show at the Craven Gallery, Paris, and in 1955 he took part in the exhibition 'Le Mouvement' at the Denise *René Gallery. From this time he established a reputation as one of the most inventive figures in the kinds of abstract art that lay stress on movement and spectator participation. Agam often uses light and sound effects in conjunction with his sculptures, and sometimes the components of the works can be rearranged by the spectator. He has had several major public commissions in France, among them the design of a square in the Défense quarter of Paris (1973).

Agar, Eileen (1899–1991) British painter, born in Buenos Aires, the daughter of a British businessman who made a fortune there. She moved to England as a child and studied with Leon *Underwood, 1924, at the *Slade School, 1925–6, and in Paris, 1928–30. During the 1930s she became one of the leading British exponents of *Surrealism, taking part in several of the major international exhibitions of the movement (although she was never much concerned with its polemical side). As well as paintings she made mixed-media *objects such as *Angel of Anarchy*, an imaginary portrait of Herbert *Read (1940, Tate). In the 1940s and 1950s she changed direction, painting cool *Tachiste abstracts, although her work still retained Surrealist elements. She published an autobiography, *A Look at My Life*, in 1988; the book is full of famous names, for she knew many eminent artists and writers. It concludes with the words: 'I hope to die in a sparkling moment.'

agitprop art (agitational art) Art used to manipulate ideological beliefs, specifically to spread the ideals of Communism in Russia in the period immediately following the 1917 Revolution. The term 'agitprop' (an abbreviation for *agitatsionnaya propaganda*: 'agitational propaganda') was first used soon after the Revolution, and a Department of Agitation and Propaganda was established by the Communist Party in 1920. Agitprop art took numerous forms, ranging from spectacular theatrical performances (such as a re-enactment of the storming of the Winter Palace, performed in Petrograd in 1920 with a cast of 10,000) to the design of sweet wrappers. In the visual arts, one of the most remarkable expressions of agitprop came in the decoration of 'agit-boats' and 'agit-trains', sometimes with

*Suprematist designs, in which Alexandra *Exter played a leading part.

Ahtila, Eija-Liisa (1959–) Finnish video artist, born in Hämeenlinna. Originally she made short films which could be seen on television or in cinemas. Later she used multi-screen projection to match the divided psyche of her subjects. Her work is presented in meticulously planned installations, her specifications including the colour of walls and draperies as well as the provision of seating. The fractured experience provided by the different screens matches the fractured vision of her subjects who totter on the edge of madness. In *The House* (2002) routine domesticity gradually becomes disrupted by, for instance, the appearance of a cow, originally seen on television, which wanders through the room, and a car that traverses the wall.

Further Reading: M. Vertrocq, 'Eija-Liisa Ahtila is not going crazy', *Art in America* (October 2002)

AIA *See* ARTISTS' INTERNATIONAL ASSOCIATION.

Aiken, John *See* SLADE SCHOOL.

Aillaud, Gilles (1928–2005) French painter, born in Paris. He was one of the French painters who in the 1960s used a *Pop style to make left-wing political comments in their work. In 1965 he worked with Eduardo *Arroyo and Antonio Recaltati (1938–) on a controversial set of paintings showing the assassination of Marcel *Duchamp, whose withdrawal from political commitment they attacked. In 1966 he exhibited paintings of zoo animals which were seen as comments on alienation under capitalism. His best-known work is probably *Vietnam, la Bataille du riz* (1968). Derived from a newspaper photograph, this shows an American soldier being taken prisoner by a Vietnamese woman against a background of rice fields.

airbrush An instrument for spraying paint or similar substance (ink, dye, or varnish) by means of compressed air. It looks rather like an outsize fountain pen and is held in a similar fashion, the pressure of the forefinger on a lever regulating the air supply. It can be controlled so as to give large areas of flat colour, delicate gradations, or a fine mist. Originally the air compressors used to power the brushes were cumbersome, noisy, and expensive, but modern versions are quiet and

portable; small cans of compressed air can also be used, but these are not suitable for prolonged use. A primitive 'paint distributer' was constructed in 1879 by Abner Peeler, an American jeweller and inventor; after various refinements had been made, this was marketed by 'The Airbrush Manufacturing Company'. The airbrush as it is recognized today was created in 1891 by another American, Charles Burdick, who in 1893 moved to England, where he set up a company to manufacture his invention. He adopted the tradename Aerograph, which for many years was used as a general term for airbrushes (like Biro for ballpoints): *Man Ray called paintings he did with an airbrush 'aerographs'. In the early 20th century airbrushes were used mainly for photographic retouching, and their principal use is now in commercial art. Artists who have made distinctive use of them in this field include the British designer Abram *Games, who created many memorable posters for the War Office during the Second World War, and the Peruvian-born Alberto Vargas (1896–1982), whose pictures of pin-up girls appeared regularly in *Playboy* magazine from 1960 to 1978. Fine artists have from time to time used the airbrush, notably the abstractionist Bernard *Cohen and the Pop artist Peter *Phillips.

Aitchison, Craigie (1926–) British painter, born in Edinburgh. He studied at the *Slade School, 1952–4, and has spent most of his life in London, but he has not forgotten his Scottish roots, and the Isle of Arran has inspired some of his best landscape paintings. As well as landscapes, he paints portraits, still-lifes, animals, and religious subjects. His style is flat (sometimes with an almost heraldic simplicity of image) and whimsical; admirers find it luminous and poetic, detractors find it twee and poorly drawn. Aitchison himself writes: 'My pictures are always of something; they're not just "planes of colour" or anything posh like that. When I do a still-life or a portrait, I place the object or the person in front of the colour that is to appear in the picture. It may take hours of fiddling about with different backdrops of paper or cloth to get the colour right. You can't get the composition right if the colour's wrong. I suppose what most irritates me is if someone says I'm a "naive" painter.' Aitchison is a colourful character, a well-known figure in Soho.

Ai Weiwei (1957–) Chinese multimedia artist, born in Beijing. His family was sent into exile a year after he was born and his contempt for the political system led him in 1981 to exile in New York, where he discovered *Dada. Under its influence he made objects such as *Safe Sex* (1986), a blue raincoat with a condom attached. He returned to China in 1993, initially to visit his sick father, but stayed when he discovered that new elements on the cultural scene provided a more promising context for his practice as an artist. In 2000 he organized a mixed exhibition in Shanghai entitled 'Fuck Off!', the name signalling not so much obscenity as refusal to cooperate. The exhibition was deliberately chaotic and without a curatorial brief, as an alternative to the dominance of cliques around leading artists and critics in China. Some of the provocative Dadaist aspect of his work remains. He has made a series of works in which museum-quality antique vases have been covered with garish paint and commercial logos and in one instance dropped from a great height. He is combining the Western legacy of *Duchamp (who probably did not really mean it when he said 'Use a Rembrandt as an ironing board') with a specifically Chinese resonance. Ai Weiwei's generation was instructed by Mao to 'Smash the old'. In China he is sometimes referred to as a 'Renaissance man' because of his breadth of activity. He has experience as an architect, and this was brought to the fore in a piece made for Liverpool in 2007 when he presented an illuminated version of Vladimir *Tatlin's *Monument to the Third International*. In *documenta in the same year he created a work entitled *Fairytale* in which 1001 Chinese people who had never previously left the country would be guests in Kassel. To complement this Ai installed 1001 chairs from the Qing dynasty. He was the artistic consultant for the 'bird's nest' stadium at the 2008 Beijing Olympics, but he subsequently distanced himself from the project, refusing to be photographed beside it, claiming that the pomp of the Olympics was being used to mask the true nature of Chinese society.

Aizenberg, Roberto (1928–96) Argentinian painter and draughtsman, one of South America's leading painters in the *Surrealist tradition. His most characteristic works (including highly finished drawings as well as paintings) depict headless figures or mysterious towers, motifs which recall Salvador *Dalí

and Giorgio *de Chirico. Dawn Ades comments that 'Aizenberg's work tends to order rather than disorder, and holds a delicate balance between an almost geometrical abstraction and symbolism.' In 1977 he moved to Paris and in 1981 to Tarquinia in Italy.

Akasegawa, Genpei *See* NEO-DADA ORGANIZERS; HI-RED CENTER.

AKhRR A Russian artists' association founded in Moscow in 1922. Its first group show, held in that year, was entitled 'Exhibition of Pictures by Artists of the Realist Direction in Aid of the Starving', but it then adopted the name Assotsiatsiya Khudozhnikov Revolyutsionnoi Rossii (Association of Artists of Revolutionary Russia), which was abbreviated to AKhRR. The primary aim of its members was to present revolutionary Russia in a realistic, documentary manner by depicting the everyday life of the proletariat, the peasantry, the Red Army, and so on; in their desire for authenticity many members visited such places as factories, railway depots, and shipyards. They were fervently opposed to *Futurism and other modernist trends, and stylistically were much indebted to the academic realism that had characterized much 19th-century Russian painting (*see* SOCIALIST REALISM). Many of the older members had indeed been brought up in this tradition, notably Abram Arkhipov (1862–1930), Nikolai Kasatkin (1859–1930), and Konstantin Yuon (1875–1958). Artists of a younger generation included Isaak Brodsky (1884–1939), Alexander *Gerasimov, and Boris Ioganson (1893–1973). By the mid-1920s AKhRR was the most influential body of artists in Russia, having affiliations throughout the country, its own publishing house, and direct government support. In 1928 its name was changed to Assotsiatsiya Khudozhnikov Revolyutsii (Association of Artists of the Revolution), abbreviated to AKhR, and in 1929 it established its own journal, *Iskusstvo v massy* (Art for the Masses). In 1932, together with all other art and literary groups, AKhR was dissolved by Stalin.

Aktion A word, meaning 'activity' or 'process', used in German-speaking countries in the context of modern art to refer to works that in Britain and the USA would generally be described as *Happenings or *Performance art (the plural is 'Aktionen', but the word is sometimes anglicized as 'Action', with the plural 'Actions'). Some German-speaking artists prefer it to the English alternatives not only because it is native to their language, but also because it has a feeling of greater seriousness, without the suggestion of art as entertainment conveyed by the English terms. The artists to whose work the word has particularly been applied include Joseph *Beuys and the *Vienna Actionists.

Aktionismus *See* VIENNA ACTIONISTS.

Albers, Josef (1888–1976) German-born painter, designer, writer, and teacher, who became an American citizen in 1939. He was born at Bottrop, Westphalia. From 1908 to 1918 he worked intermittently as a schoolteacher, and he studied art at the Royal Art School, Berlin (1913–15), the School of Arts and Crafts, Essen (1916–19), the Munich Academy (1919–20), and the *Bauhaus at Weimar (1920–23). From 1923 to 1933 he was a teacher at the Bauhaus (in Weimar, Dessau, and Berlin), his wide-ranging activities including stained glass, typography, and furniture design. When the Bauhaus was closed by the Nazis in 1933, Albers emigrated to the USA—he was one of the first of the Bauhaus teachers to move there and one of the most active in propagating its ideas. From 1933 to 1949 he taught at *Black Mountain College, and from 1950 to 1959 he was head of the department of design at Yale University (the art gallery there has an outstanding collection of his work); he lectured at many other places and received numerous academic awards.

Although Albers had made lithographs and woodcuts in his student days, it was not until he settled in the USA that he took up oil painting. Some of his student prints had been *Expressionist, but as a painter he worked in an entirely different vein, developing an art of intellectual calculation. From 1949 until his death he worked on a long series of paintings called *Homage to the Square* and it is for these uncompromisingly abstract pictures that he is best known; they consist of three or four squares of carefully planned size set inside one another, painted in flat, usually fairly subdued colours. He favoured the square so much because he believed that of all geometrically regular shapes it best distanced a work of art from nature, emphasizing its man-made quality. The colours in which they were painted often demonstrated the tendency of colours placed in proximity to expand or

contract, advance or recede, in relation to each other. Albers's research in this area appeared in *Interaction of Color* (1963), the most important of his numerous publications (which also included a book of poems, 1958). His rational approach and disciplined technique were influential on geometrical abstract painters such as *Op artists. America's leading Op artist, Richard *Anuszkiewicz, studied under him at Yale.

Albers's wife, **Anni Albers** (1899–1994), whom he met when she was a student at the Bauhaus, was a weaver; her rectilinear designs have something of the severe economy of her husband's paintings. From 1963 she also made prints in various techniques.

Albright, Ivan Le Lorraine (1897–1983) American painter (and occasional sculptor), born in Chicago, the son of **Adam Emory Albright** (1862–1957), a painter, popular for his depiction of street urchins, who had studied under *Eakins. From 1915 to 1917 Ivan studied architecture at Northwestern University and the University of Illinois, whilst painting in his spare time. After the USA entered the First World War in 1917, he served in France as a medical illustrator in an army hospital, making drawings and watercolours of wounds. The meticulous detail and clinical precision of this work anticipated his later paintings, which show a morbid obsession with death and corruption: sagging, almost putrescent flesh (which he described as 'corrugated mush'), decrepit, decaying objects, and lurid lighting are typical of his work. Often it evokes a feeling of melancholy for a beauty that is past. Albright came from a wealthy family and his financial independence allowed him to work slowly, producing a fairly small number of elaborate, highly finished pictures. He was an individual figure who stood apart from mainstream movements (although he has sometimes been called a *Magic Realist). For most of his life he lived in or near Chicago, and the city's Art Institute has the best collection of his works. It includes the painting Albright did for the Hollywood film (1945) of Oscar Wilde's *The Picture of Dorian Gray*, showing the loathsomely corrupted title figure. Albright also wrote poetry, which the art historian Richard Calvocoressi says 'makes excruciating reading'. One verse dedicated to a favourite model begins "Tis Ida, the holy maiden I dream of'.

Alechinsky, Pierre (1927–) Belgian painter and graphic artist. He was born in Brussels, where he studied book illustration and typography at the École Supérieure d'Architecture et des Arts Décoratifs, 1944–8. In 1947 he became a member of the *Jeune Peinture Belge association and in 1949 he joined the *Cobra group. He organized a Cobra exhibition in Liège in 1951, but soon after this the group disbanded and in the same year Alechinsky moved to Paris to study printmaking under a French government grant. In 1952 he studied with *Hayter at Atelier 17 and at about this time he became fascinated by Japanese calligraphy—in 1955 he visited the Far East and produced a prizewinning film entitled *Calligraphie japonaise*. From 1960 he travelled widely in Europe, the USA, and Mexico, but he continued to live and work mainly in France. His paintings are in a style of vigorous, even violent, expressive abstraction. They retain residual figurative motifs and their vein of turbulent fantasy shows a strong debt to his countryman *Ensor. Alechinsky is regarded as one of the leading Belgian artists of the 20th century and has an international reputation: in 1976 he was the first recipient of the Andrew W. Mellon Prize and this award was accompanied by a major retrospective exhibition at the Museum of Art, Carnegie Institute, Pittsburgh, in 1977. A further retrospective was mounted at the Musées Royaux des Beaux-Arts in Brussels in 2007–8.

Alfelt, Else *See* PEDERSEN, CARL-HENNING.

Alix, Yves (1890–1969) French painter, born in Fontainebleau. He was one of the French painters who was most influenced by *Expressionism. His best-known painting, *The Master of the Harvest* (1921, Pompidou Centre, Paris), presenting an aggressive, snarling figure, can be thought of as a kind of militant alternative to the celebration, common in French culture of the time, of the peasantry as a conservative force. In the 1930s Alix became a strong supporter of the left-wing Popular Front and his paintings sometimes had a strongly satirical bent in their depiction of the wealthy classes. In the 1950s he painted in a *Lyrical Abstract manner. He also worked as a theatre designer.

Alliance of Youth *See* UNION OF YOUTH.

Allied Artists' Association (AAA) A society of British artists formed in 1908 by the

critic Frank *Rutter and artists in *Sickert's circle for the purpose of organizing annual exhibitions in the jury-free manner of the French *Salon des Indépendants. The association, which represented a reaction to the relatively conservative values of the *New English Art Club, held its first exhibition in the Albert Hall, London, in 1908. More than 3,000 works were displayed, each artist being allowed to show up to five (subsequently reduced to three) on payment of a subscription. Six more annual exhibitions followed at the Albert Hall, then five smaller shows at the Grafton Galleries between 1916 and 1920. The *Camden Town Group, founded in 1911, was made up largely of members of the Allied Artists' Association. The exhibitions also included the work of foreign artists: *Brancusi (1913), *Kandinsky (1909), and *Zadkine (1913) received their first British showings at these events.

Allington, Edward (1951–) British sculptor, draughtsman, and writer, born in Troutbeck Bridge, Westmorland. He studied at Lancaster College of Art and the Central School of Art, London. He arrived at art school with the intention of studying ceramics and with a fascination with Greek art and philosophy. This interest is apparent in his sculpture: it draws on classical statuary and architecture as a source. These subjects are presented in brilliant synthetic colours or as repeated motifs. We are reminded that the origin of standardized production lies, not in the Industrial Revolution, but in the sanctified classical orders of architecture. Drawings, reminiscent in their thick, curved outlines of the late work of Giorgio *de Chirico, show relics stranded in expansive interiors like deserted museums. In one sculpture a gilded ornate tripod supports a pile of excrement. Elsewhere there is an unlikely link between classical imagery and a certain *Pop sensibility, as in *Fruit of Oblivion* (1982, Leeds City Museum and Art Gallery), in which a gaudily coloured cornucopia of grapes appears to be pouring out of a golden horn but actually supports it. In the 1980s works such as this were related by critics to the classical revival of such painters as Stephen *McKenna, but Allington does not appear to share the same faith in the idea of the language of classicism as a living form of communication. He has more in common with the object sculptors such as Tony *Cragg who are his contemporaries. As Michael Newman puts

it, 'the debasement of the classical ideal in the tourist souvenirs of the "plastic Parthenon" undermined the foundation of classicism by suggesting that it too was a form of tourist nostalgia'. Allington has described sculpture as 'looking at real things by making real things' and 'making poetry with solid objects' ('A Method for Sorting Cows', 1997, in J. Wood, D. Hulks, and A. Potts, *Modern Sculpture Reader*, 2007).

Further Reading: M. Newman, 'Edward Allington', in Grenier (1988)

all-over painting A term used for a type of painting in which the whole surface of the work is treated in a relatively uniform manner and traditional ideas of composition—of the picture having a top, bottom, or centre—are abandoned. The term was first used in the 1950s of the 'drip' paintings of Jackson *Pollock, and it has subsequently been applied to other works that avoid any obvious composition or grouping of forms, whether they rely on colour, as with *Colour Field painters, or on texture, as with the 'scribbled' pictures of Cy *Twombly.

Alloway, Lawrence (1926–90) British art critic and curator, active for much of his career in the USA. He suffered from tuberculosis in his childhood and had little formal education, but he attended classes in art history at London University. After working as a lecturer at the National Gallery and the Tate Gallery, he moved to the *Institute of Contemporary Arts, where he became assistant director, and was one of the leading figures in the *Independent Group, founded there in 1952. The group was one of the sources of British *Pop art: Alloway argued that 'acceptance of the mass media entails a shift in our perception of what culture is. Instead of reserving the word for the highest artefacts and noblest thoughts of history's top ten, it needs to be used more widely as a description of what a culture does.' He was opposed to the anti-Americanism dominant in British intellectual and artistic circles during the early years of the Cold War, and in particular was a strong supporter of *Abstract Expressionism. In his book *Nine Abstract Artists* (1954) he argued against the association between abstraction and an idealist social philosophy that been a feature of much pre-war writing on the subject; for him, a taste for geometric form was a taste like any other, not to be buttressed by reference to a Platonic

(*see* ABSTRACT ART) world view. He was equally critical of the tendency in Britain to domesticate abstract art by associating it with the natural world: 'Landscape is the tender trap of British art', he wrote in 1959. In the light of such views, his emigration to the USA in 1961 seemed an obvious step. He was appointed a curator at the *Guggenheim Museum in New York in 1964 but resigned two years later over a disagreement about the artists chosen for the US Pavilion at the 1966 Venice *Biennale. Subsequently he became professor of art history at the State University of New York at Stony Brook, Long Island, 1968–81. He organized several major exhibitions and his books include *The Venice Biennale: 1895–1968* (1968), *American Pop Art* (1974), and *Topics in American Art since 1945* (1975). From 1963 to 1971 he was art critic to the *Nation*.

He was married to the British-born painter Sylvia *Sleigh, who settled with him in the USA. Alloway became, like her, an outspoken supporter of *feminist art.

Altman, Natan (1889–1970) Russian painter, stage-designer, and graphic artist, born at Vinnitsa. He studied at the Odessa Art School, 1901–7, and the Académie Russe in Paris, 1910–12. From 1912 to 1921 he lived in St Petersburg; he was in Moscow 1921–8, in France 1928–35, and then again in St Petersburg (or Leningrad as it had now been renamed) for the rest of his life. In the 1910s he was active in the *Union of Youth and took part in many avant garde exhibitions, including those of the *Knave of Diamonds. He painted portraits, landscapes, and still-lifes, his most famous work being the dazzling portrait of the poet Anna Akhmatova (1915, Russian Museum, St Petersburg), one of the masterpieces of Russian *Futurism.

Alÿs, Francis (1959–) Belgian Performance artist and painter, born in Antwerp. He has worked principally in Mexico. He studied architecture, and initially went to Mexico after graduating in 1986 in order to assist in reconstruction after the earthquake of the previous year. His work is marked by an edgy, rather threatening humour. A common response is frequently uneasy laughter. In *Re-enactments* (2000), two videos run side by side. One shows the artist purchasing a gun and walking the streets of Mexico City with it on open display until he is arrested. The other shows a 'faked'

restaging of the event with the same police playing the same role. It is not made clear to the viewer which is 'real'. A persistent theme is futility and failure. A video entitled *The Last Clown* (1995–2000, Tate) is an animation in a one-minute loop in which a walking man perpetually falls over to the sound of canned laughter. Walking reappears regularly as a motif. *The Collector* (1991) was a performance piece in which he dragged a magnetized metal animal model around Mexico City picking up detritus. Reference was made to the extreme poverty of much of the city, visibly manifested in scavenging and stray animals. The artist's best-known project is *When Faith Moves Mountains* (2002). Five hundred volunteers were given a shovel to move a hill just outside Lima, Peru, four inches. As Eleanor Heartney points out, it was a kind of parody of the grandiose earthworks of Robert *Smithson but also a comment on the plight of the landless who live on the city's outskirts. Alÿs has also worked as a painter. He has commissioned the sign painters of Mexico City to make their own copies of his pictures, adapting them to their own styles.

Further Reading: Musée Picasso, Antibes, *Francis Alÿs* (2001)

⊕ SEE WEB LINKS
- S. Feeke, 'Francis Alÿs: Walking distance from the Studio', *Papers of Surrealism*, no. 3 (spring 2005).

Amaral, Tarsila do (1886–1973) Brazilian painter, sculptor, and art critic, born in São Paulo, the daughter of a wealthy rancher. She is regarded as one of the major figures in 20th-century Brazilian art, the creator of a style that combined nationalism with modernism. Initially she studied sculpture, but in 1917 she turned to painting. In 1920–22 she studied at the *Académie Julian, Paris, but it was not until she returned to Brazil that she became thoroughly converted to modern art, after becoming friendly with Malfatti (*see* SEMANA DE ARTE MODERNA) and the avant-garde writer and social agitator Osvald de Andrade, whom she later married. She spent most of 1924 in Europe, this time studying with *Gleizes, *Léger, and *Lhote, and she returned to Brazil with the Swiss poet Blaise Cendrars. With Cendrars and Andrade she began exploring historic towns and started to paint pictures that combined the exotic colour of folk art with the distortions of *Cubism, to which she later

added elements of *Surrealism. This *Pau-Brasil* (Brazilwood) approach developed into the movement called *Antropofagismo* (Anthropophagy or Cannibalism), named after a manifesto entitled *Antropófago* that Andrade published in 1928. 'The central tenet of Anthropophagy was that the Brazilian artist must devour outside influences, digest them thoroughly and turn them into something new' (Edward *Lucie-Smith, *Latin American Art of the 20th Century*, 1993). This phase of Tarsila's career was brief, but it is generally thought to be her most creative period. In 1930 Gutúlio Vargas assumed power in Brazil after a revolution and his dictatorship (1930–45) was unsympathetic towards modern art. During this period, influenced partly by a visit to Russia in 1931, Tarsila took up *Social Realist themes. After the Second World War she returned to the vivacious colours of her work of the 1920s. Large retrospective exhibitions of her work were held in 1950 (in São Paulo) and 1969 (in Rio de Janeiro and São Paulo). In addition to painting and sculpting, she wrote art criticism for many Brazilian newspapers and journals.

American Abstract Artists (AAA) An

association of abstract painters and sculptors formed in New York in 1936 with the aim of promoting members' work and fostering public understanding of it. The group held annual exhibitions (the first in 1937) and disseminated information by lectures and publications. Balcomb *Greene was the first president, and among the other early members were Josef *Albers, Ilya *Bolotowsky, Willem *de Kooning, Jackson *Pollock, and David *Smith. In 1940 members picketed the *Museum of Modern Art, demanding that it should show American art, but after the Second World War abstract art received the recognition they had sought and the activities of the association dwindled. It continued to stage exhibitions, however, and in the 1950s it revived other activities and built up a membership of more than 200.

American Artists' Congress An associa-

tion of American artists formed in 1936 'to demand increased public aid to artists, to protest censorship and other attacks on civil liberties, and to condemn Fascism in Italy and Germany' (Irving *Sandler, *Abstract Expressionism*, 1970). More than 300 painters, sculptors, designers, and photographers assembled in New York in 1936 for the first meeting, which was entitled American Artists' Congress Against War and Fascism. They were addressed by the sociologist Lewis Mumford, who said that 'The time has come for the people who love life and culture to form a united front...to be ready to protect and guard—if necessary fight for—the human heritage which we, as artists, embody.' Stuart *Davis was one of the founder members and became national secretary and chairman, but he resigned in 1940 because the Congress was increasingly insisting on using art as a propagandist tool. Communist members 'pressured artists not only to devote full time and energy to politics but also to adopt a *Social Realist position...even though the Congress was supposed to be nonpartisan in aesthetic matters and was joined by artists who worked in every existing style' (Sandler). The Congress broke up soon after Davis left.

American Place, An See STIEGLITZ, ALFRED.

American Scene Painting A very broad

term applied to the work of various painters who in the 1920s and 1930s depicted aspects of American life and landscape in a naturalistic, descriptive style. The term probably derives from a book entitled *The American Scene* (1907), a collection of essays and impressions by the novelist Henry James; it was first used in the context of the visual arts in the early 1920s. It does not signify an organized movement, but rather an aspect of a general tendency for American artists to move away from abstraction and the avant-garde in the period between the two world wars. Part of this tendency was a patriotic repudiation of European, specifically French, influence: in 1933 Edward *Hopper declared that 'we are not French and never can be and any attempt to do so is to deny our inheritance and to try to impose upon ourselves a character that can be nothing but a veneer upon the surface'. Apart from Hopper, the best-known exponent of American Scene Painting is Charles *Burchfield; in an essay on Burchfield published in 1928, Hopper wrote that he captured 'all the sweltering, tawdry life of the American small town, and...the sad desolation of our suburban landscapes'. The term also embraces the *Regionalists, who were more self-conscious in their nationalism.

American Sublime *See* ABSTRACT SUB-LIME.

Amiet, Cuno (1868–1961) Swiss painter (and occasional sculptor), a leading exponent of *Symbolism and *Post-Impressionism in his country. He was born in Solothurn and studied locally, then at the Munich Academy, 1886–8, and the *Académie Julian, Paris, 1888–91. After a year at Pont-Aven working with members of *Gauguin's circle, he returned to Switzerland, living at Basle and then Solothurn before settling at Oschwand in 1898. Thereafter he drew much of his inspiration from the surrounding countryside. He was a friend of *Hodler and like him had a high reputation in German-speaking countries in the period leading up to the First World War. In 1906 he was invited to join Die *Brücke and thereafter contributed regularly to the group's exhibitions, although he did not meet the other members until 1912, when he was in Cologne for the *Sonderbund exhibition. In 1918 he took up sculpture (mainly portrait heads) and he also did a few murals. Up to the outbreak of the Second World War he made regular visits to Paris.

Amsterdam, Stedelijk Museum *See* STEDELIJK MUSEUM.

Anatsui, El (1944–) Ghanaian sculptor, born in the Ewe-speaking region. He has lived in Nigeria since 1975. He is best known for gigantic wall hangings. At a distance they look like glittering capes but they are actually made from metal bottle tops and seals. They were exhibited at the 2007 Venice *Biennale, where they made a great impression hanging from the arches of the Arsenale. A touring international exhibition of his work was entitled 'Gawu', which combines the Ewe words for metal and cloak. In spite of its splendour there is a darker aspect of the artist's work. The brand names on the bottle caps include 'Dark Sailor' and 'Black Gold', reminders of the time that sailing ships brought liquor and took away slaves. El Anatsui has also worked in wood and clay. He is represented in the British Museum.

Further Reading: B. Pollack, 'El Anatsui, a sculptor who starts from scrap', *Washington Post* (23 March 2008)

Anderson, Laurie (1947–) American *Performance artist, poet, and musician, born in Chicago, the daughter of a wealthy paint manufacturer. In 1967 she moved to New York, where she gained a BA in art history from Barnard College in 1969 and an MFA from Columbia University (where she trained in painting and sculpture) in 1972. She also studied privately with Sol *LeWitt. In 1972 she gave her first performance piece, *Automotive*, an outdoor concert for car horns, and by 1976 was well known in the USA and Europe. Her performances include numerous audio and visual effects (including slide projection and films) combined with spoken and sung elements (she is a singer and violinist, and since 1974 has been making her own instruments, notably a modified violin with an internal loudspeaker). Her sense of humour and endearing stage presence have been much admired. Anderson's major work is *United States*, 'an eight-hour opus of song, narrative and sleights of hand and eye' (RoseLee Goldberg, *Performance Art*, 1988). It is in four parts, and was first performed complete in 1983 at the Brooklyn Academy of Music over two nights. A song from the show, 'O Superman', was released on record in 1981 and got to number 2 in the British singles' chart. Her first album, *Big Science*, was released in 1982. In 1997 she was director of the Meltdown Festival in London, an annual concert series that specializes in unusual musical events and collaborations.

Andre, Carl (1935–) American sculptor and poet, one of the best-known exponents of *Minimal art and one of the few happily to accept the label. He was born in Quincy, Massachusetts, and from 1951 to 1953 attended Phillips Academy at Andover, in the same state, where he became a close friend of his fellow pupil Frank *Stella. It was Stella who drew Andre's attention to the idea that the uncarved sides of his pieces were as much sculpture as the one which was worked. For the next decade he was variously employed (in the US Army and as railroad brakeman and conductor, for example), before beginning to exhibit sculpture in New York in the mid-1960s, notably at the '*Primary Structures' show in 1966. Typically he produces his sculptures by placing identical ready-made commercial units (bricks, cement blocks, metal plates, etc.) in simple geometrical arrangements without adhesives or joints; the works are dismantled when not on exhibition. His most characteristic pieces abjure height and are arranged as horizontal configurations on the floor ('more like roads than buildings',

in his own words); some of the metal pieces are even intended to be walked upon. Sculpture becomes a matter of 'place' as much as 'object'. However, Andre has also used three-dimensional 'natural' products such as logs or bales of hay as his units, and in addition has made 'scatter pieces' consisting of randomly spilled bits of plastic. The effect of the organization of the materials into simple mathematical systems is paradoxically to demonstrate the 'non-standardized' quality of industrial materials.

Andre was an outspoken supporter of the *Art Workers' Coalition. Their policies were, in fact, insufficiently radical for Andre who, in 1969, demanded a complete withdrawal of artists from the 'art world', that is to say the ambience of museums, critics, and the art market, and that they deal only with collectors through personal contact. Andre hardly maintained this stance and, only a year later, he had a major exhibition at the *Guggenheim Museum, New York. It would be easy to accuse the artist of insincerity, inconsistency, or at the very least, adopting in a moment of enthusiasm a revolutionary stance he was not willing to carry through. This risks missing a deeper point about his art, which is based on a practice in which the physical actions of the artist are central, rather than the institutional context. This is quite distinct from the sense in the work of many of his contemporaries that the intellectual structures which define art (as with Joseph *Kosuth) or the institutional confines of art (as with Marcel *Broodthaers and Hans *Haacke) are central to its definition. Andre puts this succinctly: 'Art is what we do. Culture is what is done to us.' As David *Sylvester pointed out, 'whatever the medium, it is always evident that at some stage or stages a human hand has been at work'. For this reason he placed Andre as having a position among minimalists as 'a romantic among neo-classicists' (*Artforum International*, December 1997). In Britain, Andre is best known for the sensational publicity accompanying 'the Tate bricks' episode in 1976. His *Equivalent VII* (1966), consisting of 120 firebricks arranged two deep in a rectangle, was vandalized and there was an outcry about the alleged waste of public money on its purchase by the *Tate Gallery (which had occurred some four years earlier). Others were more outraged that the journalist Fyffe Robertson (1902–87) was allowed to sit on the work and take out a brick for the sake of an easy laugh

on television. Andre made headlines again in 1985, when he was charged with murdering his wife, the artist Ana *Mendieta, who died after falling from a window. He was acquitted of the charge in 1988, claiming that Mendieta had committed suicide.

Further Reading: I. Cole (ed.), *Carl Andre and the Sculptural Imagination* (1996)

Andrews, Michael (1928–95) British painter. He studied art part-time in his native Norwich and then at the *Slade School under *Coldstream, 1949–53. A slow, fastidious worker, he concentrated on ambitious figure compositions, subtly handled and often with an underlying emotional tension. He shunned publicity and was little known to the public until an *Arts Council exhibition of his work in 1980, after which he achieved a considerable reputation, although some critics found his work rather plodding. In the mid-1980s he had a change of direction with a series of huge, brilliantly coloured landscapes featuring Ayers Rock in Australia.

Angry Penguins An Australian avant-garde quarterly journal (1940–46) devoted to art and literature, published first in Adelaide and then from 1943 in Melbourne. It was founded by the poet and critic Max Harris (1921–96), the title coming from a line in one of his poems. Harris was joined in Melbourne by John Reed (1901–81), a solicitor and art patron, and his wife, Sunday Reed (1905–81). The magazine encouraged and provided a focus for a group of young painters who worked in an *Expressionist vein and were attempting at this time to create an authentic Australian art free from European dominance; among them were Arthur *Boyd, Sidney *Nolan, John *Perceval, and Albert *Tucker. They were opposed by a group of *Social Realists, including Noel *Counihan, Victor O'Connor (1918–), and Yosl Bergner (1920–), an Austrian-born painter who moved to Australia in 1937 and settled in Israel in 1950. The debate waged between the two factions helped to make Melbourne a lively artistic centre in the early 1940s. Nolan later recalled that 'For the preceding seven years, I'd been building up a stock of knowledge and impressions about modern art and modern writing, and *Angry Penguins* was the chance to put all this into practice, to have poems published and articles written. We felt we were a kind of Paris in

Melbourne; we were like James Joyce or Rimbaud or Lorca.'

John Reed is described in the *Oxford Companion to Australian Literature* (1985) as 'one of the most influential proponents of modernism in Australian art'. He was president of the *Contemporary Art Society, Melbourne, 1940–43 and 1953–8, and he founded and directed the Museum of Modern Art and Design of Australia, Melbourne, which existed from 1958 to 1966. Its collections formed the nucleus of the Museum of Modern Art at Heide, Bulleen, Victoria, established in 1981.

Angus, Rita (1908–70) New Zealand painter, mainly of portraits and landscapes. Angus was born at Hastings, near Napier, and studied at Canterbury School of Art, Christchurch, 1927–31. She was considered one of the leading figures in New Zealand art, particularly in the 1940s, and with Colin *McCahon and Toss *Woollaston she was a pioneer of modernism in her country. Working in both oils and watercolours, she painted in a forthright, brightly coloured style. She also painted under her married name, Rita Cook. Te Papa, Wellington, has the best collection of her work.

Annesley, David (1936–) British sculptor, painter, and printmaker, born in London. He studied at *St Martin's School of Art and was one of the young sculptors featured in the 1965 *New Generation exhibition. His best-known works are large colourful steel sculptures, which, like those of Anthony *Caro, rest on the floor. *Swing Low* (1964, Tate), which combines an angled box-like structure in yellow with a blue curvilinear shape something between a ribbon and a spring, which both supports and divides it, is typical. Later sculptures were based on the form of the mandala, which he discovered in the psychoanalytic writings of Carl Gustav Jung.

Annigoni, Pietro (1910–88) Italian painter (and occasional sculptor), the only artist of his time to become internationally famous as a society and state portraitist. He was born in Milan and spent most of his life in Florence, where he studied at the Academy. In 1949 he became well-known in Britain when a self-portrait was voted 'Picture of the Year' at the *Royal Academy's summer exhibition, and in 1954 an exhibition of his work at the dealers Wildenstein's in London was a huge success with the public. This led to a commission from the Worshipful Company of Fishmongers to paint a portrait of Queen Elizabeth II (1954–5), the work that secured his fame (it was reproduced endlessly, notably on the postage stamps and banknotes of various countries; the jacket blurb of Annigoni's autobiography—*An Artist's Life*, 1977—claims that it made him 'the most famous artist in the world—not excluding even *Picasso'). Subsequently he painted many other celebrity sitters, including several other members of the British royal family, Presidents Kennedy and Johnson, and Pope John XXIII. In style and technique he based himself on the masters of the Italian Renaissance, placing great stress on draughtsmanship and often working in tempera. Characteristically his work was very smoothly finished and detailed, melodramatic in lighting, and melancholy in mood. Annigoni also painted religious works (including frescos in Italian churches) and ambitious allegorical scenes, and he regarded these as more important than his portraits. Critics often dismissed his work as portentously inflated and tasteless, but his first royal portrait was highly popular with the general public. In 1969 he painted a second portrait of the Queen, commissioned by the National Portrait Gallery, London, and more than 200,000 people went to see it during the two weeks it was first exhibited at the gallery in 1970; however, it has never been as widely reproduced or as popular as the first.

Anquetin, Louis (1861–1932) French painter, designer, and writer. He was born and brought up in Normandy and moved to Paris in 1882. Early in his career he moved in circles that included some of the outstanding avant-garde painters of the day, most notably his close friend Toulouse-Lautrec, and he was a pioneer of *Cloisonnism. After about 1895, however, Anquetin's work became much more traditional. A collection of his writings on art, *De l'Art*, was published in 1970.

Anrep, Boris (1883–1969) Russian-born mosaicist and painter, active mainly in England. He studied law in his native St Petersburg, but developed a passion for Byzantine art and travelled widely to see it—in Russia, the Near East, and Italy. He studied at the *Académie Julian, Paris, in 1908, and at the Edinburgh College of Art, 1910–11, and in 1912 he organized the Russian section of Roger *Fry's second *Post-Impressionist

exhibition. After the First World War, in which he served in the Russian army, he settled in London, although he lived for a time in Paris after his wife left him for Fry in 1926. He came to specialize in mosaic pavements, the best-known examples being in Tate Britain, representing William Blake's *Proverbs* (1923), and in the National Gallery—four floors on and around the main staircase, executed between 1926 and 1952. The subjects are *The Awakening of the Muses, The Modern Virtues, The Labours of Life*, and *The Pleasures of Life*; portraits of many well-known contemporaries are incorporated in them, for example the philosopher Bertrand Russell representing 'Lucidity' and the film actress Greta Garbo as Melpomene, the Muse of Tragedy (*see also* SITWELL). They were paid for by Samuel *Courtauld and other benefactors. Anrep, who said he had been inspired by pavement artists, commented: 'I got in on the ground floor, while the other pavement artists, poor beggars, are still outside the Gallery.'

Anselmo, Giovanni (1934–) Italian artist, born in Borgofranco d'Ivrea. He has lived and worked in Turin and on the volcanic island of Stromboli. It was there that Anselmo had the revelation in August 1965 that he says led him away from painting towards the kind of art that was to be identified as *Arte Povera. While he was climbing up the mountain, the sun rose behind him and he realized that his shadow was cast not on the ground but in the air around him. Anselmo's work is concerned with invisible energies. In *Direzione* (1967–9, Pompidou Centre, Paris) a granite slab is laid on the floor with a tiny compass embedded. *Untitled: Sculpture that Eats* (1968, Pompidou Centre) features a smooth granite block to which a smaller block is attached by a loose wire. Between them is a lettuce. If this is allowed to dry out there will be insufficient tension to keep the work together and the smaller block will drop. Therefore the work must be constantly renewed with new lettuce if it is to retain its integrity. Anselmo has also worked with slide projections of single words.

Anshutz, Thomas Pollock *See* EAKINS, THOMAS.

Antes, Horst (1936–) German painter, sculptor, and printmaker. He was born in Heppenheim and studied at the Academy in Karlsruhe, 1957–9. His early paintings were influenced by *Abstract Expressionism,

especially *de Kooning, but from about 1960 his style became more firmly structured. He is best known for his 'Headfooter' paintings, featuring clumsy, heavily stylized figures without torsos, their huge heads—characteristically seen in profile—attached to the top of their legs. With their almond-shaped staring eyes, the figures are reminiscent of Egyptian sculpture.

anti-art A loosely used term that has been applied to works or attitudes that debunk traditional concepts of art. It has been applied to the 'ready-mades' of Marcel *Duchamp and to many products of the international *Dada movement. Later examples might include *Miró's desire to 'destroy painting' or Gustav *Metzger's proposal that artists should go on strike in protest against the political abuse of their work. A genuinely coherent anti-art stance is virtually impossible to maintain. Not only do the artefacts tend to acquire aesthetic 'beauty' over time, as with the collages of *Arp, but the very challenge of utterly rejecting artistic value itself demands a rigour that creates the quality which is supposedly being denied.

anti-form A term, originating in the late 1960s, applied to certain types of works that react against traditional forms, materials, and methods of artistic creation—*Arte Povera, *Land art, some kinds of *Conceptual art, and the early 'provisional, non-fixed, elastic' sculptures of Richard *Serra, for example. Robert *Morris, who wrote an article entitled 'Anti-Form' in the April 1968 issue of *Artforum*, defined the term as an 'attempt to contradict one's taste'. The nature of the material means that the form itself is no longer exactly fixed or determined. This is also central to the work of certain *Kinetic artists such as Lygia *Clark and Mira *Schendel.

Anti-Minimalism *See* POST-MINIMALISM.

Antin, Eleanor (1935–) American Performance and multimedia artist, born in New York. Her work, which frequently addresses specifically *feminist issues, has constantly told of real and invented histories. This has distanced her from the more austere *Conceptual artists of her generation and she has described herself as 'post-conceptual'. In one work, *100 Boots* (1971–3), she sent postcards of the adventures of a set of boots to art professionals around the world. The work was, on

one level, a parody of military adventurism. One set of photographs from the work was called *The Boots go to War*. Antin addressed issues of feminine identity in *Carving a Traditional Sculpture* (1972), in which photographs recorded the effects of a 36-day-long diet. In performance, Antin has sometimes put on a beard to enact the part of the King, a benevolent but ultimately impotent ruler. *The Battle of the Bluff*, a performance piece presented at the Venice *Biennale in 1976, was described by Antin as 'a sweet hippie tale of how I led the old people and the very young people of Solana Beach against the developers and almost won'. Another flawed protagonist is Florence Nightingale in Antin's 1977 performance installation *Angel of Mercy*, visualized, as Christopher Knight puts it, as an 'adult version of a child's imaginative dressing-up games' (*documenta 12 catalogue).

SEE WEB LINKS

- Eleanor Antin interview with Linda Montano.

Anti-Object art *See* CONCEPTUAL ART.

Antipodeans (Antipodean Group) The name adopted by a group of Australian painters (Arthur *Boyd and John *Perceval were the best known) who held an exhibition in Melbourne in 1959; the catalogue contained a manifesto of their aims, attacking abstraction and championing figurative art. The manifesto, written by the art historian Bernard Smith (1916–), has been described by Robert *Hughes (*The Art of Australia*, 1970) as 'the most controversial document in recent Australian painting'.

Antonakos, Stephen (1926–) American sculptor. He was born in St Nicholas in southern Greece, 'up in the mountains and hard to locate exactly', according to the artist. He moved with his family to New York in 1930. In the early 1960s, after working with different types of collage while earning his living in an advertising agency by daytime, he began making pillows on which buttons were sewn. On one of his pillows he used a neon tube spelling out 'dream'. By 1965 neon became his only medium. The early examples had timers which switched them on and off, but Antonakos discovered that viewers would not stay to look long enough to follow the complete programme. Unlike *Flavin's fluorescent components, they are not standardized items but custom-made for the artist. In work of the late 1990s onwards Antonakos has tended to use neon for its glow rather than as an object, placing it behind a painting. He has also designed a number of chapels.

Further Reading: I. Sandler, *Stephen Antonakos* (1999)

Antoni, Janine (1964–) American sculptor, born in the Bahamas. She has made sculpture out of food. *Gnaw* (1992, MoMA, New York) consists of three 600 pound cubes of lard and chocolate which she had nibbled herself. They stand on pedestals as if, in the words of Ewa Lajer-Burcharth, 'parading *Minimalism undone by a fit of voracious passion'. In a case next door there are lipsticks and kitschy boxes cast from what she had spat out. Leja-Burkoff argues that what Antoni was doing was revisiting the Minimalist preoccupation with the relationship to the body. She makes special reference to Robert *Morris, in the light of her difference as a woman artist, and 'addresses femininity as a construct of consumer culture'. In *Loving Care* (1993) she once again looks at an aspect of modernist practice, and presents it as something gender-specific by a performance in which she made an *Action Painting with her long hair dipped in dye.

Further Reading: E. Lajer-Burcharth, 'Antoni's Difference', *Differences* vol. 10, issue 2 (1998)

Antropofagismo *See* AMARAL, TARSILA DO.

An Túr Gloine (The Tower of Glass) Stained-glass workshop founded in Dublin in 1903 by the highly successful portrait painter Sarah Purser (1848–1943) and the playwright Edward Martyn (1859–1923), an ardent nationalist in the arts who had written articles attacking cheap commercial furnishings in Irish churches. The workshop was in purpose-built premises at 24 Upper Pembroke Street. Purser was the main shareholder and her role was chiefly administrative, although she also did some designing. Most of the leading Irish stained-glass artists of the day worked there at one time or another, among them Wilhelmina Geddes (1887–1955), Michael Healy (1873–1941), and Evie *Hone. The first major commission was for Loughrea Cathedral, County Galway, and many others followed throughout Ireland. Purser ran the company until she died at the age of 94 in 1943; it was dissolved the following year.

Anuszkiewicz, Richard (1930–) American painter, his country's leading exponent of *Op art. He was born in Erie, Pennsylvania,

and studied at the Cleveland Institute of Art, 1948–53, and then at Yale University under Josef *Albers, 1953–5. Albers stimulated his interest in the effects of colour on perception, but it was not until about 1960 that he started to address this in his painting. 'My work,' he says, 'is of an experimental nature and has centered on an investigation into the effects of complementary colors of full intensity when juxtaposed and the optical changes that occur as a result.' His painting is distinct from that of the two most famous exponents of Op art: whereas Bridget *Riley's pictures are often aggressively dazzling and Victor *Vasarely's often contain suggestions of a third dimension, Anuszkiewicz's are concerned with radiating expanses of lines.

Apollinaire, Guillaume (Wilhelm Apollinaris de Kostrowitzky) (1880–1918)

French poet and art critic, a major figure in the avant-garde world of Paris in the early 20th century. He was born in Rome, the illegitimate son of a high-class Polish courtesan, Olga Kostrowitzky, whose surname he used until 1902, when he adopted his pseudonym; his father was probably an Italian nobleman, although Apollinaire liked to hint he was the offspring of a high-ranking clergyman. He was brought up in Monte Carlo and received his education in French. From about 1900 he lived in Paris, where he earned his living mainly with journalism, especially art criticism—he was, indeed, one of the prototypes of the modern journalistic critic, his writing containing much that is superficial and gossipy. His importance stems not so much from the quality of his writing as from his brilliance as a propagandist on behalf of those artists he most admired. In particular he championed *Picasso (his first substantial articles, in 1905, were on him) and later the *Cubists in general (including the *Orphists, whose name he coined). Among the other artists whose reputations he either established or consolidated were *Chagall, *de Chirico, *Derain, *Matisse, and *Rousseau. His view of Cubism was essentially that it was a form of visual music; he emphasized its proto-abstract elements, in contrast to other early theorists like *Gleizes and *Metzinger or Kahnweiler, who were concerned with it as a form of representation. He was also influential on *Dada (his friend Marcel *Duchamp's interest in visual punning was partly inspired by Apollinaire's love of jest and linguistic acrobatics) and on *Surrealism

(he coined the term in 1917 and his suggestion that artists should explore 'interior universes' stimulated André *Breton, who dedicated the first Surrealist manifesto to his memory). The less impressive aspects of his career include his failure to understand *Brancusi and his over-rating of Marie *Laurencin (his lover), whom he placed on the same level as Picasso.

Apollinaire enlisted in the French army in 1914 and was discharged in 1916 after being wounded in the head; weakened by this, he died of influenza two years later. The only book on art he published in his lifetime was *Méditations esthétiques: Les peintres cubistes* (1913), but a collected edition of his criticism appeared in 1960 under the title *Guillaume Apollinaire: Chroniques d'Art 1902–18* (an English translation was published in 1972 as *Apollinaire on Art: Essays and Reviews 1902–18*). John Golding described him as a 'weather-vane which responded to the slightest intellectual vibration' and 'a cardinal figure in creating the artistic climate of Paris early this century—a climate in which anything and everything was thought possible'. *See also* GUILLAUME.

Further Reading: J. Golding, 'Guillaume Apollinaire: The Painters' Friend' in *Visions of the Modern* (1994)

F. Steegmuller, *Apollinaire: Poet Among the Painters* (1986)

Appel, Karel (1921–2006)

Dutch painter, sculptor, graphic artist, designer, ceramicist, and poet, regarded as the most powerful of the post-war generation of Netherlandish artists. He was born in Amsterdam, where he studied at the Academy, 1940–43, and he had his first one-man exhibition at Het Beerenhuis in Groningen in 1946. At this time he was influenced by *Dubuffet and was attempting to work in the spirit of children's drawings. In 1948 he helped to found Reflex, the experimental group of Dutch and Belgian artists from which the *Cobra group sprang, and in 1949 he painted a mural in the cafeteria of Amsterdam City Hall which caused such controversy that it was covered for ten years. The following year he settled in Paris, where he found an influential supporter in the critic Michel Tapié, who organized exhibitions of his work. By the end of the decade he had an international reputation, having travelled widely and won the UNESCO Prize at the Venice *Biennale in 1954, the International Painting Prize at the São Paulo Bienal in 1959, the Guggenheim International Award

in 1960, and several other honours. He first visited New York in 1957 and subsequently divided his time mainly between there, Paris, and Monaco.

His most characteristic paintings are in an extremely uninhibited and agitated *Expressionist vein, with strident colours and violent handling, the paint applied with very thick impasto. Sometimes the colour retains the worm-like form in which it leaves the tube—'like a rocket which describes its own space,' he once commented. The images usually look purely abstract at first glance, but they often retain suggestions of human masks or of animal or fantasy figures, sometimes fraught with terror as well as a childlike naivety: Herbert *Read wrote that in looking at his pictures one has the impression of 'a spiritual tornado that has left these images of its passage'. Appel said that 'If I paint like a barbarian, it's because I live in a barbarous age.' In 1968 Appel began produced to make relief paintings, followed by painted sculptures in wood and then aluminium. He also made ceramics and produced a varied range of design work, including carpets, stained glass, and the scenery for a ballet, *Can we Dance a Landscape?*, for which he also wrote the plot; it was performed at the Opéra Comique in Paris in 1987.

appropriation The use of pre-existing objects or images with little transformation. It is a practice that is often associated with a critique of the notions of originality and authenticity, central to some definitions of art. Roland *Barthes's 1968 essay 'Death of the Author' encouraged the idea that originality was impossible anyway and that all that could be done was to rearrange existing signs. To some extent the history of art backs this up in that even the most innovative artists can usually be shown to have borrowed images from their predecessors. One need only think of Manet's (*see* MODERNISM) 'appropriations' of Titian and Velázquez. However, the issue takes a far more radical turn early in the 20th century, with *collage and the *ready-mades of Marcel *Duchamp. From then on one can trace a history of appropriation art in the photomontages of *Heartfield and certain sculptures by *Picasso. Even here, however, the point was very much the way that the identity of the image or object had been transformed.

It was with *Neo-Dada and *Pop that the practice of appropriation became central,

and part of the challenge that these movements presented lay in doubts as to how far the artist had really contributed to the final result. *Rauschenberg's paint-splattered bed-cover or Jasper Johns' painterly recreations of targets and flags still bore traces of traditional artistic activity, but when the impersonal facture of mass production was adopted it was far more problematic. With hindsight, useful distinctions can be made. In the case of *Lichtenstein's cartoon-inspired paintings, comparison with the original sources shows that the artist always took his own decisions based on design criteria in the final painting, usually reducing narrative information for the sake of visual impact. *Warhol, on the other hand, relied on the accidents of process to give the work some kind of distinction from its source, so his procedures tended to be closer to full appropriation. The untransformed use of materials by *Minimalists, notably Carl *Andre, encouraged an attention to previously unnoticed aspects of those materials. In the 1970s *Photorealists presented their sources untransformed except through scale and medium. More recent examples of appropriation have been the photographs of Richard *Prince, extracted from advertisements. Far more problematic for many, because of the artistic value of the source material, have been Sherrie *Levine's photographic copies of classic images by revered photographers such as Walker *Evans. Appropriation art was the subject of an influential exhibition, entitled 'Pictures', organized by the critic Douglas Crimp (1944–) in Artists' Space in New York in 1977. Crimp argued that electronic and mechanical reproduction has led to a situation in which we have 'an infinitude of indistinguishable copies, and the notion of an original is lost'. He was here taking further the arguments presented in the 1930s by Walter *Benjamin. Since the 1980s the interest of artists in consumerism has also resulted in practices such as that of Sylvie Fleury (1961–), who turns shopping for luxury goods into an art form, or that of Jeff *Koons. Sometimes the art of appropriation involves a considerable degree of craftsmanship. The paintings of Glenn Brown (1966–) meticulously render in totally flat paint the tortured surfaces of the work of artists such as Karel *Appel and Frank *Auerbach.

Ultimately, total appropriation is as much a myth as total originality. In order to signal the art status of the object or image, some kind of

procedure apparent to the senses of the viewer must be enacted, even if this is only the addition of a label or a change in context. Even Duchamp's *Fountain* was placed on its side and given an inscription. If any work were to be pure appropriation, there would be no way anyone other than the artist could know it. Even the act of naming or pointing involves some kind of change in perception. The idea of appropriation has tended to be most interesting when it has worked against the grain of the dominant orthodoxy, as with Duchamp, Warhol, or *Broodthaers, rather than when transformed into an academic or art market dogma.

Further Reading: R. Barthes, *Image–Music–Text* (1977) D. Crimp, 'About Pictures', *Flash Art* (March–April 1979)

a.r. (revolutionary artists) See BLOK; STRZEMIŃSKI.

Araeen, Rashid (1935–) Pakistani artist, writer, and curator. He studied engineering at the University of Karachi, and moved to London in 1964. He was self-taught as an artist and began making abstract sculptures. These were colourful cage-like structures close to the systemic work of an American *Minimalist such as Sol *LeWitt. Concern at the racism of the art world led Araeen towards radical politics, and in 1972 he joined the Black Panther Movement. He founded the magazine *Black Phoenix*, which explored the relationship between contemporary art and racial politics. In 1987 it became *Third Text*, a more academic journal that addressed issues of culture and post-colonialism. In 1989 he organized the exhibition 'The Other Story', which was held at the Hayward Gallery (*see* ARTS COUNCIL) and Manchester Art Gallery; it showed the wealth of art produced by artists of Afro-Asian descent in Britain, including Francis *Souza and Sonia *Boyce, and also raised issues about their marginalization. Araeen's work as an artist has also concentrated on such issues. *Green Painting 1* (1984–5, Arts Council collection) is organized on a nine-part grid like a piece of Western abstraction (a *Reinhardt black painting, for instance). There are four panels painted green, a colour associated with Islam and also that of the Pakistani flag. The other panels show blood on the streets: these depict a Muslim animal-slaying festival. There are also headlines in Urdu that describe events in Pakistan such as the visit of Richard Nixon. Brandon Taylor comments that a competent spectator of the work, that is, someone who understood the cultural significance of the photographs, read Urdu, and was familiar with Minimal art, would have 'no single or simple identity behind which to hide' (*Art of Today*, 1995).

Aragon, Louis (1897–1982) French poet and art critic, born and active in Paris. He was involved with Paris *Dada and was one of the earliest members of the *Surrealist movement. It was as such that he wrote one of the key documents of Surrealist art, *La Peinture au défi* (1930). Originally composed to accompany an exhibition of collage that included work by *Picasso and *Miró, Aragon's essay was a scabrous attack on painting as a precious commodity, and both revived the Dada attacks on the traditional forms of art and anticipated the critiques of the *Conceptual art of the 1960s. Shortly afterwards he broke with the Surrealists after deciding that the movement was incompatible with his political commitment to Communism. His subsequent career as a writer on art was closely tied to his political life. In 1935 he tried to get the support of French painters for a *Socialist Realist position with his lecture *Pour un réalisme socialiste*. After the Second World War he wrote in support of the Communist painters *Fougeron and *Taslitzky and even, in spite of being an admirer of *Picasso and *Matisse, expressed praise for Soviet Socialist Realism. In 1953, however, he attacked in print Fougeron's *Civilisation Atlantique* (Tate), an anti-American painting. It is quite likely that this stance was just as politically motivated as his previous support. The French Communist Party by then found it more expedient to make the most of high-profile members such as Picasso and Léger, than to exploit the very limited propaganda value of paintings such as those of Fougeron. In later years, while still a party member, he became far more critical of the official line, and his writing on art dealt with figures such as *Chagall or Matisse. A collection of his art criticism was published in 1981 under the title *Écrits sur l'art moderne*.

Arakawa, Shusaku See NEO-DADA ORGANIZERS.

Arbeitsrat für Kunst (Workers' Council for Art) See NOVEMBERGRUPPE.

Arbus, Diane (1923–71) American photographer. She was born in New York as Diane Nemerov. Her father owned a Fifth Avenue department store and her earliest photograph-

ic assignments were fashion shoots. Her fame rests on the photographs she took on her own initiative. They deal with outsiders and eccentrics, nearly always photographed from a certain distance. She took her subjects from fairgrounds and freak shows as well as from the street. Sometimes they perform to the camera. This could be something quite spontaneous, like the boy with a toy grenade pulling a face, or a practised act, as in the haunting image of the albino sword swallower, head back, and with arms stretched as in a crucifixion. For Arbus her subjects were 'aristocrats', because of what they had survived. As Miles Orvell points out, in the context of the counter-culture of the late 1960s and 1970s, 'the outcast from society seemed to embody a kind of heroic status, an emblematic sainthood'. Yet some of the photographs have a strong element of the ridiculous. There is the image of the pasty young man at a pro-war rally. Do we assume a lack of sympathy because of the political statement he makes, or is there something in the image itself that encourages a sense of superiority? Arbus committed suicide and her photographs only became widely known when they were published after her death. A film on her life, entitled *Fur*, with Nicole Kidman as Arbus, was released in 2006.

Arcevia, Bruno d' *See* PITTURA COLTA.

Archipenko, Alexander (1887–1964) Russian-born sculptor who became an American citizen in 1928. He studied at the art school in his native Kiev from 1902 to 1905, when he was expelled for criticizing the academic attitudes of his teachers. In 1906 he moved to Moscow and in 1908 to Paris, where he left the École des *Beaux-Arts after two weeks' study, again showing his impatience of discipline. Instead, he studied ancient and medieval sculpture in the Louvre, and some of the work of his early years in Paris (mainly female figures) is in a primitivistic manner recalling Egyptian art. In about 1910, however, he was introduced to *Cubism by *Léger (whose studio was near his own) and he became one of the outstanding sculptors of the movement. In works such as the bronze *Walking Woman* (Denver Art Museum, 1912) he analysed the human figure into geometrical forms and opened it up with concavities and a central hole to create a

contrast of solid and void, thereby ushering in a new sculptural idiom. In the same year, with *Médrano I* (destroyed), Archipenko began making sculptures that were assembled from pieces of commonplace materials, paralleling the work of *Picasso; *Médrano II* (1913, Guggenheim Museum, New York) is made of painted tin, wood, glass, and painted oilcloth. (Médrano was the name of a circus in Paris much frequented by artists; these two figures represented performers there.)

Archipenko quickly built up a reputation in France and elsewhere, particularly in Germany. In 1912 he had a one-man exhibition at the Folkwang Museum in Hagen and in 1913 one at the *Sturm Gallery in Berlin; also in 1913 his work was included in the *Armory Show in New York. His rise to international prominence was interrupted by the First World War, during which he lived in Cimiez, a suburb of Nice; his work of this period included a number of sculpto-paintings, a type of work he created in which forms project from and develop a painted background. After the war he soon relaunched his career, organizing an exhibition of his work that toured widely in Europe in 1919–21 (Athens, Brussels, Geneva, London, Munich, among several other cities). He also exhibited at the Venice *Biennale in 1920, on which occasion his work was condemned by a Venetian cardinal. His first one-man show in the USA was given by the *Société Anonyme in New York in 1921.

From 1921 to 1923 Archipenko lived in Berlin, where he ran an art school, then emigrated to the USA. He lived, worked, and taught in various places, but chiefly in New York, where he directed his own school of sculpture from 1939 until his death. The work he did in America did not compare in quality or historical importance with that of his European period, but he continued to be highly inventive. His work was influential in both Europe and America, notably in the revival of polychromy, in the use of new materials, and in pointing the way from the sculpture of solid form towards one of space and light.

Ardon, Mordecai (originally **Max Bronstein)** (1896–1992) Polish-born Israeli painter. He was born in the village of Tuchów, the son of a Jewish watchmaker. From 1920 to 1925 he studied at the *Bauhaus, where he became a friend of his teacher *Klee. In 1926 he moved to Munich, then taught at *Itten's

art school in Berlin from 1929 to 1933, when he fled to Jerusalem because of Nazi persecution. He taught at the Belazel School of Arts and Crafts in Jersualem, 1935–52 (he was the school's director, 1940–52), and he was artistic adviser to the Israeli Ministry of Education and Culture, 1952–62. From 1965 he spent much of his time in Paris. Ardon's obituary in the *Independent* described him as 'Israel's best-known artist internationally' and said that he brought the country into contact with 'the leading European art movements of the early Thirties—at a time when Palestine was a far outpost of the Ottoman empire'. His work of this time was strongly influenced by *Expressionism and often concerned with Jewish religion and mysticism. From the 1950s his style became more abstract. His major works include a stained-glass window representing *Isaiah's Vision of Eternal Peace* (1982–4) at the Jewish National University and Library, Jerusalem. There are examples of his paintings in the Tate collection, the Museum of Modern Art, New York, and many other collections of modern art.

Arenal, Luis *See* TALLER DE GRÁFICA POPULAR.

Arensberg, Walter (1878–1954) and **Louise** (1879–1953) American collectors and patrons, husband and wife. Both came from wealthy families and were thus able to devote themselves to artistic pursuits. They married in 1907 and from 1914 to 1921 they lived in New York, where their home formed a kind of salon for the *Dada movement in America; *Picabia's wife recalled that 'at any hour of the day or night one was sure of finding sandwiches, first-class chess players, and an atmosphere entirely free from conventional and social prejudices'. In particular, the Arensbergs were the main patrons of Marcel *Duchamp, who acted as their art adviser as well as selling them his own work. They collected non-Western art as well as avant-garde work. In 1921 they settled in Los Angeles; at this point they graciously sold Duchamp's unfinished *Large Glass* to Katherine *Dreier so that he could continue to work on it. In Los Angeles their collection expanded greatly, reaching a total of about 1,500 works. They initially concentrated on a brief period from about 1910 to 1914, and especially on *Cubist works, but later they expanded their interests to include *Surrealism, for example. Their art collection was bequeathed to the Philadelphia

Museum of Art, where it went on display in 1954, soon after the death of both donors. Up to this time the collection had been little known, but its public availability now contributed greatly to a revival of interest in Duchamp's work.

Argan, Giulio Carlo *See* CONTINUITÀ.

Arikha, Avigdor (1929–) Romanian-born Israeli painter, draughtsman, printmaker, designer, and writer on art who has worked mainly in France. He moved to Israel in 1944, and from 1949 to 1951 studied at the École des *Beaux-Arts in Paris, where he settled in 1954. Initially he made his name as a book illustrator, then from 1957 to 1965 he was primarily an abstract painter, working in an *Art Informel vein. Between 1965 and 1973 he abandoned painting for drawing and etching, his work of this period including a series of portraits of the writer Samuel Beckett, who was a close friend. When he resumed painting in 1973, he concentrated on working from the life, his subjects including landscapes, interiors, still-lifes, and portraits, among which are a few commissioned portraits (*Queen Elizabeth, the Queen Mother*, 1983, NPG, Edinburgh). Arikha has also written on art and has organized exhibitions at the Houston Museum of Fine Arts on the work of Poussin (1982) and Ingres (1986). A large collection of his work on paper was presented by the artist to the British Museum and exhibited there in 2006.

Arkhipov, Abram *See* AKHRR.

Arman (Armand Fernandez) (1928–2005) French-born sculptor who settled in New York in 1963 and became an American citizen in 1972. He was born in Nice and studied briefly in Paris at the École des Arts Décoratifs and the École du Louvre. In 1957, with his friend Yves *Klein, he decided to be known by his first name only, and the form 'Arman' was adopted in 1958 as the result of a printer's error on the cover of a catalogue. Like Klein he was interested in Japanese culture, particularly Zen Buddhism, and (again like Klein) he worked for a time as a judo instructor. In the early 1960s Arman gained a reputation as one of the leading exponents of *Nouveau Réalisme and he is best known for his *assemblages of junk material. These range from modest collections of household debris (*Accumulation of Sliced Teapots*, 1964, Walker Art

Center, Minneapolis) to a huge tower (about 20 metres high) of 60 automobiles embedded in cement (*Long-Term Parking*, 1982, Cartier Museum, Jouy-en-Josas).

Armfield, Maxwell (1881–1972) British painter, illustrator, and writer. He was born in Ringwood, Hampshire, and studied at Birmingham School of Art, 1899–1902, then in Paris at the Académie de la Grande Chaumière. In 1905 he moved to London and from 1915 to 1922 lived in the USA. He worked in a traditional style, often using tempera paint, on which he wrote two books—*A Manual of Tempera Painting* (1930) and *Tempera Painting Today* (1946). His subjects included portraits and figure compositions, often on literary themes. Armfield was also a book illustrator, wrote poetry, composed music, and took an active interest in the theatre (in 1909 he married the playwright Constance Smedley, with whom he worked closely until her death in 1941; their best-known collaborative project is *The Flower Book*, published in 1910). He had been born into a Quaker family, but he became a Christian Scientist under his wife's influence, and after her death he became interested in mysticism and eastern religions, writing on these subjects under pseudonyms. He was virtually forgotten for many years after the Second World War, but he lived long enough to see a revival of interest in his work, expressed particularly in an exhibition 'Homage to Maxwell Armfield' at the Fine Art Society, London, in 1970.

Armitage, Kenneth (1916–2002) British sculptor and graphic artist, born in Leeds. He studied at Leeds College of Art, 1934–7, and at the *Slade School, 1937–9. After serving in the army throughout the Second World War, he was head of the sculpture department at the newly founded *Bath Academy of Art, Corsham, 1946–56 (during this period he was also Gregory Fellow at Leeds University, 1953–5). His first one-man exhibition was at Gimpel Fils, London, in 1952 and in the same year his work was well received at the Venice *Biennale (*see* GEOMETRY OF FEAR), marking the beginning of an international reputation. At the 1958 Biennale he won the David E. Bright Foundation award for the best sculptor under 45, and the following year he had a retrospective exhibition at the Whitechapel Art Gallery, London, by now firmly established as one of the leading British sculptors of his

generation—a position he maintained, with numerous exhibitions in Europe, the USA and Japan.

Armitage's pre-war work consisted mainly of carvings (most of which he later destroyed), but soon after the war he began to work in bronze, which remained a favourite material for what he described as 'the fluid, unifying and sensual quality it can give'. Bronze was also much more suitable than carving for the spindly-legged, slab-bodied shapes that were characteristic of his figures at this time. He depicted them singly or in groups, in everyday attitudes, with a sense of affection and often humour: 'I find most satisfying work which derives from careful study and preparation but which is fashioned in an attitude of pleasure and playfulness.' *People in the Wind* (1951, Tate) is a well-known example from this phase of his career and one of the first works in which he achieved a distinctively individual style. From the mid-1950s his figures became more hieratic, less playful in character, and often larger in scale, as in *Diarchy* (1957, Tate). In 1965 he exhibited a series of sculptures entitled *The Legend of Skadar*, based on an ancient Slav story, first encountered in a folk song, about a woman walled up as a sacrifice. A characteristic of his work was the equation between the figure and architecture. The plaster is sometimes treated to appear like a battered wall surface. From the late 1960s he became more unconventional in technique, combining sculpture and drawing in figures of wood, plaster, and paper. In the 1970s he returned to bronze and began to explore non-human subject-matter, especially trees. He also worked in fibreglass.

Further Reading: T. Wollscombe, *Kenneth Armitage* (1997)

Armleder, John (1948–) Swiss artist, born in Geneva. He studied at the École des Beaux-Arts in Geneva. In the 1960s and 1970s he was involved in the *Fluxus movement and his work retains an air of irreverence. It is also very difficult to classify, although his sculptures of the early 1980s, bits of discarded furniture painted with *Suprematist forms, can be related to the *Neo-Geo movement. These were arranged as a tableau and unsold pieces were simply returned to the streets. The problems of pinning his work down were emphasized in two exhibitions he held in 2006–7. One, at Tate Liverpool, was an installation involving scaffolding, mirrors, television sets

and, as was appropriate to the time of year it was held, Christmas trees. The other was an exhibition of drawings at the South London Art Gallery entitled 'About Nothing'. This was hardly a straightforward presentation. Hundreds of drawings from 1962 onwards were displayed from floor to ceiling in the kind of wide open space more normally associated with large sculpture or installations. (The usual procedure for the display of such work would be to break the space with panels.) The drawings were generally abstract, making reference to *Constructivism and *Minimalism.

Further Reading: C. Darwent, 'Can he be Serious?', *The Independent on Sunday* (11 February 2007)

Armory Show An exhibition (officially entitled the International Exhibition of Modern Art) held in New York, 17 February–15 March 1913, at the Armory of the National Guard's Sixty-Ninth Regiment, Lexington Avenue, Manhattan. It was a daring presentation of new and still controversial art on a mammoth scale (about 1,300 works by about 300 artists) and is regarded as the most important exhibition ever held in the country and one of the milestones in 20th-century American culture. The initiative for it came from a group of artists, several of them from the circle of Robert *Henri, who in 1911 formed an organization called the Association of American Painters and Sculptors to find exhibition space for young artists. The breadth of vision with which the show was conceived was primarily due to the Association's president, Arthur B. *Davies, whose enthusiasm for presenting a comprehensive picture of current European movements largely overshadowed the original idea of an exhibition of American art. Davies was influenced in this direction by the great international *Sonderbund exhibition in Cologne in 1912. Walt *Kuhn saw this exhibition and he later joined in Europe by Davies; together they were mainly responsible for borrowing works from artists and dealers. John *Quinn was their legal adviser.

The Armory Show was in effect two exhibitions in one. The American portion presented a cross-section of contemporary art from the USA, heavily weighted in favour of younger and more radical artists. The foreign section, which was the core of the exhibition and became the main centre of controversy, traced the evolution of modern art, showing work by Goya, Delacroix, Courbet, and the *Impres-

sionists and *Post-Impressionists, as well as leading contemporary artists including *Kandinsky, *Matisse, and *Picasso. French artists were best represented, and there was comparatively little German art. From New York a reduced version of the exhibition went to Chicago (Art Institute, 24 March–16 April) and Boston (Copley Hall, 28 April–19 May). More than a quarter of a million visitors paid to see it, and its impact was enormous on a public that generally knew little of Post-Impressionism, let alone *Fauvism, *Cubism, or *abstract art (the Metropolitan Museum, New York, bought a *Cézanne at the Show and this was the first picture by the artist to enter an American public collection). There was a good deal of ridicule and indignation. This was directed particularly at Marcel *Duchamp's *Nude Descending a Staircase*, but also at the sculpture of Joseph Bernard (*see* DIRECT CARVING), regarded in France as a relatively traditional figure. However, there were also many supportive reviews and the show stirred up public interest in art and created a climate more favourable to experimentation. It had a profound effect on many American artists, for example Stuart *Davis, who regarded it as the turning point of his career. Several important patrons and collectors made their first tentative purchases of modern art at the show, notably Lillie P. *Bliss and Katherine *Dreier, and some artists could count the exhibition a notable financial success (Jacques *Villon, for example, sold all nine of his pictures that were included).

Armstrong, Elizabeth See FORBES, STANHOPE.

Armstrong, John (1893–1973) British painter and designer. He was born in Hastings, the son of a clergyman, a factor which may have had an impact on his subsequent interest in religious subjects. He originally studied law, then in 1913–14 attended St John's Wood Art School. After wartime service in the Royal Field Artillery, in which his record was significantly more distinguished than that as a student, he embarked on a career as a theatre designer in London. It was through his friendship with the actors Elsa Lanchester and Charles Laughton that he attracted a number of patrons for his painting. Lillian Courtauld, the wife of Samuel *Courtauld, commissioned him to decorate a room in their home at 20 Portman Square. He held his first solo

exhibition at the *Leicester Galleries in 1928 with paintings of doll-like figures that reminded the critic Anthony Bertram of the model theatre. He joined the *Unit One group in 1933; his contribution to their exhibition was a series of highly textured semi-abstract paintings in tempera, a technique which he preferred for much of his life. During this period he was one of many distinguished artists who designed posters for Shell; he also worked as a designer on films, including costumes for *Rembrandt* (1936). In the late 1930s he began working on the paintings for which he is best known, precisely delineated dream-like images influenced by *Surrealism and French *Neo-Romanticism. *Pro Patria* (1938, Imperial War Museum, London), showing a devastated town with a peeling political poster, was his comment on the Spanish Civil War. Armstrong's pacifist convictions were apparent in much of his later work, in images like *The Storm* (1951), in which clowns hack at each other with swords—an allegory of the futility of war.

Further Reading: Royal Academy of Arts, *John Armstrong* (1975)

Arnason, H. Harvard (1909–86) American art historian and administrator. He was born in Winnipeg, Canada, and studied there at the University of Manitoba, and subsequently at Northwestern and Princeton Universities. From 1947 to 1960 he was professor of art history at the University of Minnesota, from 1951 concurrently holding the post of director of the Walker Art Centre, Minneapolis. He is best known by a wider public for his major publication *A History of Modern Art*. First published in 1969, this appeared in a second edition in 1977. Since Arnason's death a number of further editions have appeared, revised and updated by other hands, the most recent (the 5th) in 2004. Covering the mid-19th century to the present day and including over 1000 illustrations, it is the most comprehensive account in English in a single volume.

Arnatt, Keith *See* VIDEO ART.

Arneson, Robert *See* FUNK ART.

Arnold, Ann and **Graham** *See* BROTHERHOOD OF RURALISTS.

Arp, Jean (Hans) (1886–1966) French sculptor, painter, and poet who was prominently involved with several major avant-garde groups and movements in the first half of the 20th century. He was born in Strasbourg, then under German rule, and he spoke French and German with equal fluency (he wrote poetry in both languages and the double version of his name reflects a dual identity). His initial training was at the School of Arts and Crafts in Strasbourg, after which he studied at the Weimar Academy and briefly at the *Académie Julian in Paris (1908). He spent the next few years mainly in Switzerland, working in isolation, but in 1912 he met Robert and Sonia *Delaunay in Paris and *Kandinsky in Munich, where he participated in the second *Blaue Reiter exhibition. In 1915 he moved to Zurich, where he was one of the founders of the *Dada movement and met his future wife, Sophie *Taeuber (they married in 1922), with whom he collaborated on cutout paper compositions and *collages (*see* AUTOMATISM). During the war years in Zurich he also made his first abstract polychrome relief carvings in wood (*Dada Relief*, 1916, Kunsthaus, Basle). In 1919–20 he lived in Cologne, where he continued his Dada activities in collaboration with his friend Max *Ernst. Arp's Dada works can look today surprisingly innocuous, given the nihilist reputation of the movement. However, for Arp 'Dada was more than a kettle-drum, a big noise and a joke. Dada protested against the stupidity and vanity of mankind.' The collages cut, not with scissors but mechanically with a guillotine, the reliefs not carved but sawn from plywood, above all the collages 'according to the laws of chance'—these challenged the traditional power of the artist to control and, in Arp's view, brought the processes of art closer to nature. He recalled a conversation with *Mondrian, who made a clear distinction between art, which was artificial, and nature. 'I do not share his opinion,' Arp wrote. 'Art is of natural origin and is sublimated and spiritualized through the sublimation of man.'

From 1920 Arp worked mainly in Paris and in 1928 he settled at nearby Meudon. From 1925 he participated in the *Surrealist movement, his work including experiments with chance arrangements. However, he later became much closer to the abstract artists. He joined *Cercle et Carré in 1930 and he was a founder member of *Abstraction-Création in 1931. Also in 1931 he took up sculpture in the round (previously he had made only reliefs) and began to produce what are now his most familiar and distinctive works—sensuous

abstract pieces (usually in bronze or marble) that convey a suggestion of organic forms without reproducing actual plant or animal shapes (*Growth*, 1938, Guggenheim Museum, New York). 'I tried to make forms grow,' he wrote, 'I put my trust in the example of seeds, stars, clouds, plants, animals, men, and finally in my innermost being.' Of the abstractionists in Paris he was closer to Brancusi and the later more organic Kandinsky than the geometric artists.

During the Second World War Arp fled to Grasse on the French Riviera, where he and his wife lived with Sonia Delaunay and Alberto *Magnelli, 1941–2: 'For two years we lived in that wonderful place . . . Despite the horror of those years, I look back on this period of work with my friends as one of the finest experiences of my life. Never was there a trace of vanity, arrogance, rivalry.' By 1942, however, the south of France was becoming unsafe, so Arp fled to Switzerland, where his wife died in an accident in 1943. Arp suffered from depression after this and for a time his activities slowed down. He returned to Meudon in 1946 and in 1959 bought a house near Locarno in Switzerland (coinciding with his happy second marriage to Marguerite Hagenbach, a Swiss collector of his work). There was little further stylistic development in his later work and what had once been provocative now seemed elegant and stylish. Nonetheless, some of his most beautifully achieved sculpture comes from his final years. He won many honours and prestigious public commissions: in 1954, for example, he was awarded the International Sculpture Prize at the Venice *Biennale, and in 1958 he made a relief for the UNESCO Building in Paris. Large retrospective exhibitions of his work were held at the Museum of Modern Art, New York, in 1958 and the Musée National d'Art Moderne, Paris, in 1962. His home in Meudon is now a foundation dedicated to his work.

Further Reading: S. Fauchereau, *Arp* (1988)

Arroyo, Eduardo (1937–) Spanish painter, sculptor, printmaker, stage designer, potter, and film-maker, active mainly in France. He was born in Madrid and was largely self-taught as an artist. In 1958 he left Spain to avoid military service, living in Paris until 1968, then spending four years in Milan before returning to Paris in 1973. He was among the artists who took a studio in La *Ruche after it reopened in 1978. Arroyo's work has been varied, but typically he uses imagery in a *Pop art vein to satirize targets in the world of art or politics or aspects of Spanish life. In one painting a white-faced woman, with colourful earrings and no hair, weeps. The title informs the viewer that this is the wife of a miner whose head has been shaved by the police (*Sama de langreo (Atsuries) September 1963*, 1970).

Art abstrait See JEUNE PEINTURE BELGE.

Art & Language A loose organization of mainly British artists and art theorists operating since the late 1960s. Through their journal *Art-Language*, the first issue of which was published in Coventry in May 1969, and through exhibitions, they have explored the linguistic and social dimensions of art. Their activities can conveniently be classified as a form of *Conceptual art, but, at least in the early days of their activities, they regarded it as a question still to be decided as to whether they were producing art at all. The original members were Terry *Atkinson, David Bainbridge (1941–), Michael Baldwin (1945–), and Harold Hurrell (1940–). Joseph *Kosuth soon joined as American editor of the journal, and in the early 1970s membership rose to about 30; it then fell rapidly, however, with only Baldwin remaining of the original members by 1977. Since then, the main figures involved, along with Baldwin, have been Mel Ramsden (1944–) and the art historian and critic Charles Harrison (1942–). They have worked from a combination of linguistic philosophy—especially Wittgenstein—and Marxism. They reject the idea that they should make immediately accessible political statements—indeed some of their work is more or less impenetrable to outsiders. The 1981 essay 'Art History, Art Criticism, and Explanation' (*Art History*, vol. 4, no. 4) provides a useful entry point to their preoccupations for those who feel more confident in their knowledge of art than of philosophical and political theory. Since about 1979 members of Art & Language have produced paintings, but not in order to celebrate a return to tradition, rather to continue their intellectual explorations. The theoretical basis is that what a picture is 'of' has to be understood in terms of a work of art's causes rather than in terms of what it looks like or might make a spectator 'feel'. It needs to be emphasized that the idea is not just to reinstate 'the artist's intention' or 'artistic

personality' as the core of meaning but to examine the resources and competences which are brought to a work by artist and viewer. An example is *Portrait of Lenin with a Cap in the Style of Jackson Pollock 1* (1979). At first sight this appears as very efficient pastiche of a Pollock drip painting. Without the title it would probably remain as such for most viewers. Even with its aid, Lenin is hard to detect. The work brings together apparently opposing political and artistic traditions in a single image, not to reconcile them, but to question assumptions about the 'expressive' and 'communicative' functions of art. In 1991 Harrison published *Essays on Art & Language*.

Art and Letters *See* RUTTER, FRANK.

Artaud, Antonin (1896–1948) French actor, writer, and artist, born in Marseilles. After the First World War he became an actor. He joined the *Surrealist movement in 1924, contributing to *La Révolution surréaliste*. He broke with the movement in 1927 and founded a theatre company, the 'Théatre Alfred Jarry'. As an actor he can still be seen in a handful of films, above all as a hauntingly gaunt presence as the monk who guides Joan towards her death in Carl Dreyer's *The Passion of Joan of Arc* (1928). In 1932 he published his manifesto for the 'Theatre of Cruelty'. Overwhelmed by a display of Balinese dancing he had seen in 1931, he argued for a theatre which went beyond verbal language and engaged with the spectator on a physical level, with overwhelming physical impact. His 1935 production of Shelley's *Les Cenci*, which attempted to embody these ideas, was a commercial failure. After trips to Mexico and to Ireland, Artaud, by then addicted to drugs and mentally unstable, was committed to a series of institutions. In his final year in an asylum he filled books with drawings. When released in 1946 he continued to draw; in charcoal, he depicted skeletal heads. When these drawings were exhibited in 1947 Artaud wrote 'The human face is an empty force . . . a field of death.' The drawings were seen at the time in the context of discussions on art and madness, both in the wake of the Nazi equation of *'degenerate art' with insanity and Dubuffet's preoccupation with *Art Brut. Artaud died in poverty, after a drug overdose, having been diagnosed with cancer. His influence has lived on in the work of artists who have challenged social norms, such as the *Vienna

Actionists and (early in his career) Georg *Baselitz.

Further Reading: S. Wilson, 'Paris Post War: In Search of the Absolute', in Morris (1993)

Art Autre A term coined by the French critic Michel Tapié (1909–87) in his book *Un Art autre* (1952) to describe a type of art that he regarded as appropriate to the turbulent mood in France in the post-war period—an art that worked through 'paroxysm, magic, total ecstasy'. The term is a vague one and is sometimes used synonymously with *Art Informel (also coined by Tapié). However, Art Autre can be seen as a broader term, for it embraces figurative art (for example that of *Dubuffet) as well as abstract art. In using the phrase 'art autre' (other art) Tapié claimed that post-war art showed a complete break with the past. In addition to Dubuffet, Tapié cited *Mathieu, *Matta, and *Wols as leading representatives of Art Autre.

Art Brut (French: 'Raw Art') Term coined by Jean *Dubuffet for the art produced by people outside the established art world—people such as solitaries, the maladjusted, patients in psychiatric hospitals, prisoners, and fringe-dwellers of all kinds. Dubuffet claimed that such art—'springing from pure invention and in no way based, as cultural art constantly is, on chameleon- or parrot-like processes'—is evidence of a power of originality that all people possess but which in most has been stifled by educational training and social constraints. He may have become interested in the subject as early as 1923, but he did not begin collecting Art Brut until 1945, following a visit to Switzerland, where there were already collections of works by the mentally ill in psychiatric hospitals. Thereafter he devoted a good deal of his energies to promoting Art Brut, through writing, lecturing, and organizing exhibitions. From 1948 to 1951 he ran an association called the Compagnie de l'Art Brut, the aims of which he specified as 'To seek out the artistic productions of humble people that have a special quality of personal creation, spontaneity, and liberty with regard to convention and received ideas; to draw the public's attention towards this sort of work, to create a taste for it and encourage it to flourish'. The best-known of the exhibitions he organized was probably 'L'Art Brut Préféré aux Arts Culturels' at the Galerie René Drouin, Paris, in 1949; it featured more than 200 works by 63 artists.

In 1972 Dubuffet presented his own collection (by then numbering more than 5,000 items) to the city of Lausanne, where it was opened to the public at the Château de Beaulieu in 1976. Among the artists represented were the French painter, draughtsman, sculptor, and writer Gaston Chaissac (1904–64), who used rough and ready materials and was influenced by child art, Madge Gill (*see* AUTOMATISM), the Swiss draughtsman and painter Louis Soutter (1871–1942), who after contracting typhoid was plagued by years of ill health and eccentric behaviour, Scottie *Wilson, and the Swiss draughtsman, collage maker, writer, and musician Adolf Wölfli (1864–1930), who was institutionalized in 1895 after committing a series of sex offences. Nearly half the collection was produced by patients in psychiatric hospitals, usually schizophrenics, but Dubuffet repudiated the concept of psychiatric art, claiming that 'there is no art of the insane any more than there is an art of the dyspeptics or an art of people with knee complaints'. He also distinguished Art Brut from *naive art on the more questionable ground that naive painters remain within the cultural mainstream, hoping for public recognition, whereas Art Brut artists create their works for their own use as a kind of private theatre.

In English the term 'outsider art' (Roger Cardinal used the term as the title of a 1972 book), is generally used to cover this type of work. It was Cardinal, in collaboration with Victor Musgrave, who organized the first major exhibition of 'outsider art' in Britain at the Hayward Gallery, London, in 1979. Exhibitions have also been held that draw together the work of 'outsiders' and professional modernist artists, at the Los Angeles County Museum of Art in 1992 and the Whitechapel Gallery, London, in 2006. In the latter, entitled 'Rough Magic', the distinction between the two groups was perhaps more clear-cut than the organizers had intended, the superior sense of design of artists such as *Miró and *Klee nearly always winning out over the outsiders' obsession with filling every possible space.

Further names have been added to the roster of outsider artists since Dubuffet. Most artistically remarkable are the drawings of Bill *Traylor. Probably the most sinister figure is Henry J. Darger (1892–1973), a Chicago cleaner who produced an immense collection of secret writings and drawings concerning the lives of the 'Vivian girls'. These contain continuous scenes of torture and cruelty to children. The figures are traced rather than drawn (Darger had no knowledge of anatomy), but delicately coloured almost in the manner of Arthur *Rackham.

Further Reading: C. Rhodes, *Outsider Art* (2000)

Art d'aujourd'hui *See* BLOC, ANDRÉ.

Art Concret (Konkrete Kunst) *See* CONCRETE ART.

Art Deco

The most fashionable style of design and decoration in the 1920s and early 1930s in Europe and the USA, characterized by sleek geometrical or stylized forms and bright, sometimes garish colours. The name comes from the 'Exposition Internationale des Arts Décoratifs et Industriels Modernes' held in Paris in 1925—the first major international exhibition of decorative art since the end of the First World War (it was originally planned for 1915). The emphasis of the exhibition was on individuality and fine craftsmanship (at the opposite extreme from the contemporary doctrines of the *Bauhaus), and Art Deco was originally a luxury style, with costly materials such as ivory, jade, and lacquer much in evidence. Perhaps partly because of the effects of the Depression, materials that could easily be mass-produced—such as plastics—were adapted to the style.

Art Deco owed something to several of the major art movements of the early 20th century—the geometry of *Cubism (it has been described as 'Cubism tamed'), the bold colours of *Fauvism, and the machine forms of *Constructivism and *Futurism. Similarly, although the term is not often applied to painting or sculpture, the Art Deco style is clearly reflected in the streamlined forms of certain artists of the period, for example the painter Tamara de *Lempicka and the sculptor Paul *Manship. There was a revival of interest in Art Deco during the 1960s (it was then that the name was coined) and its bold, bright forms have a kinship with *Pop art. It was parodied in certain works by Patrick *Caulfield and Roy *Lichtenstein.

Arte Povera (Art Povera)

Term (Italian for 'poor' or 'impoverished art') coined in 1967 by the Italian critic Germano Celant (1940–). It is sometimes used just to describe a type of work in which the materials used—such as soil, twigs, and newspaper—are deliberately chosen for their 'worthlessness' as a reaction

against the commercialization of the art world, but actually the connotations are considerably wider. According to Celant, 'Arte Povera expresses an approach to art which is basically anti-commercial, precarious, banal and anti-formal, concerned primarily with the physical qualities of the medium and the mutability of the materials. Its importance lies in the artists' engagement with actual materials and with total reality and their attempt to interpret that reality in a way which, although hard to understand, is subtle, cerebral, elusive, private, intense.' The term was inspired by the 'poor theatre' of the Polish director Jerzy Grotowski. In practice the 'povera' element should not be taken too literally. Many of the works were technically very elaborate, using expensive materials. As Caroline Tisdall points out, 'The context of *Arte Povera* was and is, after all, the gorgeous *palazzi* and high ceilinged white spaces of the art world, not the turmoil of the streets' (Braun, 1989). It is now usual to apply the term to a group of artists working in Italy from the mid-1960s onwards, with Piero *Manzoni as a kind of founding father. Other major figures include Mario *Merz, Pino *Pascali, Michelangelo *Pistoletto, Jannis *Kounellis, Luciano *Fabro, and Gilberto *Zorio. They were exhibited together by the Turin dealer Enzo Sperone. Zorio said about him: 'It was Sperone who made things happen; he knew how to seize every opportunity to carry forward an art born in individuals' own personal homes and studios, guiding it towards the public'. Celant's 1969 book *Arte Povera* (it was translated into English the same year as *Art Povera: Conceptual, Actual or Impossible Art?*) took the concept further and included many non-Italian artists, such as Joseph *Beuys, Carl *Andre, Eva *Hesse, and Richard *Long, among others, who would be more usually associated with *Minimal, *Conceptual, or *Land Art. In this volume he offered various alternative names for the trend or movement, including Actual Art, Impossible Art, Micro-emotive Art (*see* GILARDI), Raw Materialist Art, and *Anti-Form. An already elastic concept was being stretched to breaking point. Some way out of the confusion of definition is to suggest that what Celant was doing was to define the art of the late 1960s in a radically different way from that implied by Lucy *Lippard in her phrase 'the dematerialization of the art object'. For Lippard the point was the idea, for Celant it was matter. *Conceptual Art takes language as a tool, Arte Po-

vera tries to evade language or at least remove it from its normal functions by treating it as just another object. Looking back on the movement in 2001, Francesco Bonami suggested that 'even in 1967 Celant did not want to destroy traditional artistic language. Instead he brilliantly suggested a way for artists to smuggle it through the collapse of postwar Italy.'

Further Reading: R. Flood and F. Morris, *Zero to Infinity: Arte Povera 1962–1972* (2001)

Art for the Masses (*Iskusstvo v massy*)
See AKHRR.

Artforum Periodical (ten issues a year) devoted to contemporary art, founded in San Francisco in 1962. The place of publication moved to Los Angeles in 1965 and to New York in 1967, and the title changed to *Artforum International* in 1982. It is the leading American journal in its field, well produced and illustrated, attracting contributions from many well-known avant-garde artists, and often serving as an arena for controversy. The critics particularly associated with *Artforum* include Michael *Fried, who is important for developing the *formalist arguments of Clement *Greenberg. However, by the 1970s the journal became associated with the reaction against formalism and frequently paid as much attention to photography as painting. Nonetheless, its approach was insufficiently radical for some critics, who founded an alternative journal, *October*, in 1976. A collection of pieces from *Artforum* was published as *Artforum Anthology* in 1984.

Art Front *See* DAVIS, STUART.

Artigas, Josep Llorens *See* MIRÓ, JOAN.

Art Informel Term coined by the French critic Michel Tapié to describe a type of spontaneous abstract painting popular among European artists in the 1940s and 1950s, roughly equivalent to *Abstract Expressionism in the USA. Tapié popularized the term in his book *Un Art autre* (1952), and these two terms—*Art Autre and Art Informel—are sometimes used more or less synonymously. They are rarely used with any precision, but some critics regard Art Informel as a narrower term, representing only one aspect of the broader trend of Art Autre (which includes figurative as well as abstract work). In English the term 'Informalism' is sometimes used as an equivalent to Art Informel, but the word

'informel' (which Tapié himself devised) might be translated as 'without form' rather than 'informal'. Following suggestions made by *Kandinsky, Tapié argued that expressive, non-geometrical abstract art is a method of discovery and of communicating intuitive awareness of the fundamental nature of reality. *See also* TACHISME.

'Art is Life' *See* MAKOVETS.

Artist's book *See* LIVRE D'ARTISTE.

Artists' Congress *See* AMERICAN ARTISTS' CONGRESS.

Artists International Association (AIA) An association of left-wing British artists founded in London in 1932 with the aim of achieving 'the unity of artists against Fascism and war and the suppression of culture'. Originally it was called Artists International, but it added the word 'Association' to its name when it was reconstituted in 1935. It continued until 1971, but abandoned its political objectives in 1953, thereafter existing as an exhibiting society. Initially there were 32 members, mainly commercial artists and designers, although they also included the German-born Marxist art historian Francis Klingender (1907–55), who described his work as 'theoretical and historical studies designed to elucidate the role of art as one of the great value-forming agencies in the social structure and social change'. The first chairman was the industrial designer Misha Black (1910–77), who later played an important role in the *Festival of Britain. At the outset the position of the group was avowedly Marxist and its activities included producing pamphlets, posters, and other propaganda material (making use of facilities at the Central School of Art, where one of the founder members, James Fitton (1899–1982), taught lithography). Modern art, with its 'negation of content', was viewed with some suspicion as a sign of bourgeois decadence, but after the Association was reconstituted in 1935 it became much less doctrinaire and attracted support from artists working in a wide range of styles. Its exhibition 'Artists against Fascism and War' (1935), for example, included work by Robert *Medley, Henry *Moore, and Paul *Nash, and by the end of the Second World War the Association had more than a thousand members. In addition to holding exhibitions, the AIA published a journal (sporadically and under different titles

and formats, beginning as Artists International *Bulletin*, 1934–5) and also a book of essays entitled *5 on Revolutionary Art* (1935). This was edited by the sculptor Betty *Rea and the five contributors were Eric *Gill, the ethnomusicologist A. L. Lloyd, Klingender, Herbert *Read who gamely made the case, unpopular in the AIA, for the avant-garde against realism, and the writer Alick West.

Most of the Association's early exhibitions were held in its premises in Charlotte Street, although numerous other venues were used, including the basement canteen of the John Lewis department store for the 1943 show 'For Liberty'. Among its other exhibitions was 'The Engineer in British Life', arranged for the Amalgamated Engineering Union to celebrate its Silver Jubilee in 1945. Klingender wrote that this was 'the first art exhibition sponsored by a British trade union' and that it gave him the idea for his most famous book, *Art and the Industrial Revolution* (1947); his other books included *Marxism and Modern Art* (1942). The Association had the broadest support at the time of the wartime alliance between Britain and the Soviet Union. The Cold War and especially the problems created by the Communist opposition to modern art (*see* FORMALISM and SOCIALIST REALISM) led to an erosion of that support. In 1947 Claude *Rogers found new premises in Lisle Street and the AIA Gallery was opened there that year; the Association dissolved when the lease expired in 1971. Distinguished foreign artists sometimes showed work at the later exhibitions, notably *Léger and *Picasso.

The Artists International Association is not to be confused with the International Artists' Association (founded 1952), an affiliated organization of UNESCO; Richard *Carline was chairman of both associations.

Further Reading: L. Morris and R. Radford, *The Story of the Artists International Association 1933–1953* (1983)

Artists Placement Group *See* LATHAM, JOHN.

Art-Language *See* ART & LANGUAGE.

Art moderne *See* LIBRE ESTHÉTIQUE.

Art Monthly British art magazine founded in 1976 by Peter Townsend (1919–2006), formerly editor of *Studio International*, and the American collector Jack Wendler, who had previously run a small London gallery dedicated to *Conceptual art. Although they were

credited as co-editors, in practice Townsend provided the publishing expertise and also frequently the trenchant editorials, and Wendler the financial backing. It was initially printed on cheap paper with few illustrations, looking from the outside more like a political and literary journal, such as the *New Statesman*, than an art magazine. It became associated with highly politicized debates about contemporary art. Townsend's radical past (he had been a supporter of the Chinese revolution and met Mao Zedong and Zhou Enlai) may have had something to do with this, but it also reflected a strong current, especially among the young, on the London art scene. An important early contributor was Peter *Fuller, who conducted aggressive interviews with leading contemporary artists including Anthony *Caro and Jasper *Johns, as well as the art dealer Leslie Waddington, identified by art world radicals in the late 1970s as the epitome of what they opposed (September/October 1977). Looking at the interview years later, what impresses is Waddington's frankness and honesty in the face of Fuller's hostility. Townsend was dismissed as editor in 1992 after also having founded and edited an Australian version. The magazine is still published today and has long survived its glossy and expensive rival *Studio International*. It has organized events including public interviews with Hans *Haacke and Gustav *Metzger in collaboration with *Tate.

Further Reading: A. Brighton 'Peter Townsend' (obituary), *The Independent* (4 July 2006)

((⊕)) **SEE WEB LINKS**

• Website of *Art Monthly*, contemporary art magazine.

Art News (ARTnews) American journal, first published in 1902 as *Hyde's Weekly Art News*. In 1904 the title changed to *American Art News*, in 1923 to *The Art News*, in 1941 to *ART News*, and in 1969 to *ARTnews*. On the way the journal changed from a newspaper to a magazine and from a weekly to a monthly (there are now eleven issues a year). It has by no means been devoted entirely to modern art, but as the oldest and most widely read art magazine in the USA it has played an important role in recording and sometimes shaping events; from the first it campaigned for the recognition and popularization of American art. The journal was prominent in promoting the work of the *Abstract Expressionists and it

had its greatest prestige and influence in the period of their dominance. It was in the magazine's pages that Harold *Rosenberg first used the term *Action Painting in print (December 1952); 'Pollock Paints a Picture' (May 1951), accompanied by some now celebrated photographs by Hans Namuth, helped to define Jackson *Pollock's public image (similar articles on other artists in the movement followed).

Art News was also the title of a British periodical, the journal of the *Allied Artists' Association, edited by Frank *Rutter and launched in 1909. It soon merged with *Art Chronicle*.

Art Nouveau Decorative style flourishing in most of Western Europe and in the USA from about 1890 to the First World War. As the name suggests, it was a deliberate attempt to create a new style in reaction against the imitation of historical forms that had been such a prominent feature of 19th-century architecture and design. Its most characteristic theme was the use of sinuous asymmetrical lines based on plant forms; flower, leaf, and tendril motifs are common features, as are female figures with abundant flowing hair. At their most typical these motifs are found in the decorative and applied arts, such as interior design, metalwork, glassware, and jewellery, but Art Nouveau also had a major vogue in illustration and poster design and its influence can be seen to varying degrees in much of the painting and sculpture of the period—in a fairly pure form in the work of Alfred *Gilbert and Jan *Toorop, for example, and in certain aspects of such diverse artists as *Munch (his penchant for undulating lines) and *Matisse (the flat arabesque forms of the trees in some of the landscapes of his *Fauve period).

The style takes its name from a shop called La Maison de l'Art Nouveau opened in Paris in 1895 by the German-born art dealer Siegfried Bing (1838–1905), a leading propagandist for modern design. Paris was one of its most important centres, but its origins were diverse (Celtic and Japanese art have been cited as influences) and its roots were less on the Continent than in England, where the Arts and Crafts movement had established a tradition of vitality in the applied arts. In France, indeed, Art Nouveau is sometimes known by the name 'Modern Style', reflecting these English origins. In Germany the style was called Jugendstil (from the Munich journal *Die Jugend*, founded in 1896); in Austria,

Sezessionstil (after the Vienna *Sezession); in Spain, Modernista; and in Italy, Stile Liberty (after the Regent Street store that played so large a part in disseminating its designs). The style was truly international, its archetypal exponents ranging from *Mucha, a Czech whose most characteristic work was done in Paris, to the designer Tiffany in New York, and to the Spanish architect Antoni Gaudí (1852–1926) in Barcelona, the centre of a distinctive regional version of the style characterized by exaggerated bulbous forms. This cosmopolitanism was encouraged by the great international exhibitions that flourished during this period, and the style perhaps reached its apogee at the Paris 'Exposition Universelle' of 1900. It nowhere survived the outbreak of the First World War to any extent, but it played a significant part in shaping modern aesthetic attitudes: its significance as a source for *abstract art is apparent in the work of *Kandinsky, *Kupka, and *Picabia among others.

Art of the Real A term applied to a broad trend in American art in the 1950s and 1960s in which works of art were presented as irrefutable physical objects making no attempt at representation and no allusion to the perceived world by symbol, metaphor, or suggestion. The trend represents a reaction against the subjectivity of *Abstract Expressionism and embraces several more precisely defined styles or movements such as *Hard-Edge Painting, *Minimal art, and *Op art. The term was given wide currency by an exhibition at the Tate Gallery, London, in 1969: 'The Art of the Real: An Aspect of American Painting and Sculpture 1948–1968.' Among the artists represented in the exhibition were Donald *Judd, Ellsworth *Kelly, Sol *LeWitt, Robert *Morris, Kenneth *Noland, Larry *Poons, and Frank *Stella.

Art of This Century gallery, New York. *See* GUGGENHEIM, SOLOMON R.

Arts and Crafts movement *See* CRANE, WALTER.

Artschwager, Richard (1923–) American sculptor and painter, born in Washington, DC, the son of a German immigrant botanist. After taking a degree in chemistry and mathematics at Cornell University, he moved to New York in 1949 and studied for a year under *Ozenfant, whose preference for stark, geometrical forms greatly influenced Artschwager. In the 1950s

he took various jobs to support himself and in 1953 he began designing and manufacturing furniture, but he returned to painting after a fire destroyed his workshop in 1958. However, he continued to make furniture, and a commission from the Catholic Church in 1960 to produce altars for ships led him to the kind of work for which he is best known—sculptures that mimic the appearance of mundane objects such as tables in a simplified, almost comic-book manner. Typically they are blocklike in form but bright in colour, combining elements of *Minimal art and *Pop art (*Table and Chair*, 1963–4, Tate). Artschwager says of such works: 'I'm making objects for non-use . . . By killing off the use part, non-use aspects are allowed living space, breathing space.' Examples were shown in his first one-man exhibition, at Leo *Castelli's gallery, New York, in 1964. Artschwager has also continued to produce paintings, typically monochromatic depictions of buildings.

Arts Council An organization established in 1945 and incorporated by Royal Charter in 1946 'to preserve and improve standards of performance in the various arts'. It was a successor to the Council for the Encouragement of Music and the Arts (CEMA), a wartime organization that had operated from 1940 to 1945. The economist and art patron John Maynard Keynes (1883–1946) was the first chairman of both bodies. Originally it was called the Arts Council of Great Britain, with separate committees for Scotland and Wales, but in 1994 the Scottish and Welsh Arts Councils became autonomous bodies, and the main organization was renamed the Arts Council of England (the 'of' was dropped in 2001 and it is now Arts Council England). There is also an Arts Council of Northern Ireland (likewise a successor to CEMA), and the Republic of Ireland has an Arts Council, founded in 1951. Funding for the Arts Council of England comes from the Department of National Heritage and the other Arts Councils function in similar ways. Their main activities in connection with the visual arts consist of the organization of exhibitions, many of which are accompanied by scholarly catalogues. Two galleries in London were set up by the Arts Council for such exhibitions: the Hayward Gallery (now rebranded as The Hayward)—a large, rather grim concrete building opened in 1968 as part of the South Bank arts complex alongside the Thames; and the much smaller

and prettier Serpentine Gallery in Kensington Gardens, which was originally an Edwardian tea-house and was opened as a gallery in 1970. The Serpentine Gallery is almost entirely dedicated to contemporary art. For its first few years it opened only in the summer months with mixed exhibitions of younger artists, but it has now became an important venue in which artists of international standing are exhibited. Although the two galleries are now separately run, they retain close links with the Arts Council. Before the opening of the Hayward, the major Arts Council exhibitions were usually held at the Tate Gallery. Many exhibitions travel to other venues in Britain. The Arts Council inherited from CEMA the policy of purchasing works by living artists and it has built up a large collection of 20th-century British art. There is no permanent home for the collection, but many works are on long-term loan to municipal galleries, universities, and other institutions. The Arts Council also makes grants directly to artists and galleries. It is the most important source of public art patronage in Britain, but it has been frequently attacked for alleged shortcomings, including too much bureaucracy, too little vision, and, in recent years, an over-servile response to government policy. For most of its history, at least in theory, the 'arm's length' principle has been applied as far as government intervention is concerned, but the extent that this is actually possible or even desirable has been a matter for persistent debate.

Artscribe Bi-monthly magazine of contemporary art, founded in London in 1977. Originally it was very basic (sometimes erratic) in production and had a reputation for being more radical than the established art glossies, but it became much more polished in presentation, being for a time supported by the dealer Leslie Waddington. During its early years it tended to promote abstract painting and sculpture and opposed the highly politicized stance at that time common among many critics, especially those who wrote for *Studio International*. In 1986 the title changed to *Artscribe International*. It ceased publication in 1991.

Art Students League of New York An art school established in 1875 when that of the National Academy of Design temporarily closed because of financial difficulties. Unlike the Academy School (which reopened in 1877), the Art Students League had no entrance requirements and no set course. Its more progressive teaching methods soon attracted many students—at the turn of the century the enrolment stood at nearly a thousand. By this time it was the most important art school in the country, and its teachers and students have included some of the most illustrious names in 20th-century American art. The first two important teachers were Walter Shirlaw (1838–1919), who was there from the beginning, and William Merritt *Chase, who arrived in 1878. Those who followed included Thomas *Eakins, Robert *Henri, Augustus *Saint-Gaudens, and John *Sloan.

Art Workers' Coalition (AWC) A short-lived association of art activists founded in New York in 1969. One of the founders, Carl *Andre, explained that the term 'art worker' was chosen in preference to 'artist' because it included all those who made 'a productive contribution to art'; other leading figures of the association included Lucy *Lippard, Robert *Morris, and Robert *Smithson. In February 1969 the AWC presented a list of '13 Demands' to the *Museum of Modern Art, New York, dealing with issues of artists' rights and the representation of female and ethnic minority artists. The association soon broadened its scope to include protests against the Vietnam War. It organized demonstrations and pickets of various kinds, including the New York Art Strike Against War, Racism, Fascism, Sexism and Repression, which closed the city's museums for a day in May 1970. Such activities encouraged two smaller but more militant American groups, Art Workers United and Guerrilla Art Action, as well as a related group in Britain, the International Coalition for the Abolition of Art, which disrupted the opening of the *'Young Contemporaries' exhibition in 1970. Opponents of the AWC included Donald *Judd, who thought that 'citizens are equal', but not artists. Several of the association's members became disenchanted with its militancy and it broke up in the early 1970s.

Art Workers' Guild *See* ROYAL COLLEGE OF ART.

Art Workers United *See* ART WORKERS' COALITION.

Ashcan School A term retrospectively applied to a number of American painters (not a formal group) active in New York in the

decade before the First World War in reference to their shared interest in subject-matter from everyday urban life; the term was first used in print in 1934 in a book entitled *Art in America in Modern Times*, edited by Holger Cahill and Alfred H. *Barr. The painters embraced by the term were inspired largely by Robert *Henri (one of whose dictums was that 'Art cannot be separated from life') and the four central figures—*Glackens, *Luks, *Shinn, and *Sloan—were all members of The *Eight, a short-lived group founded by Henri in 1908. (The two terms are often confused, but 'The Eight' has a precise meaning, whereas 'Ashcan School' is a broader and vaguer notion; there is overlap between them, but some of the members of The Eight did not paint Ashcan-type subjects.) Before settling in New York (between 1896 and 1904) the four central Ashcan artists had all been artist-reporters on *The Philadelphia Press*. At a time when the camera had not come into general use for newspaper work, the job of making rapid sketches on the spot for subsequent publication demanded a quick eye and a rapid hand, and encouraged an interest in scenes of everyday life. However, in style and technique the artists of the Ashcan School are now seen to have differed less from contemporary academic painting than they themselves believed. Although they often painted slum life and outcasts and were referred to as the 'revolutionary black gang', they were interested more in the picturesque aspects of their subjects than in the social issues they raised; it was not until the 1930s that *Social Realism became a major force in American art. Among the other painters who have been described as members of the Ashcan School are George *Bellows, Edward *Hopper, and Jerome *Myers.

Asher, Michael (1943–) American installation artist, born in Los Angeles. His work generally consists of interventions within the museum and gallery space and in this respect his work can be compared to that of Hans *Haacke, as a kind of 'institutional critique'. However, in the case of Asher's work these interventions are so subtle they can easily pass unnoticed. In 1972 at the Lisson Gallery, London, the work consisted simply of a groove incised along the base of the wall in the main exhibition space. It could be regarded as an extreme piece of *Conceptual art, in that he showed how it was possible to produce a work without introducing any object into the gallery

or making any kind of mark-making gesture. In 1979 his contribution to the 73rd American exhibition at the Art Institute of Chicago was the removal of a bronze bust of George Washington from its accustomed position at the main entrance to the 18th-century period room where, of course, it belonged historically. The point lay in the way that Asher underlined how, in its normal situation, the bust functioned outside history as a mark of authority and heritage. This would obviously not be apparent to any but regular visitors to the museum, but Asher had at the entrance a perspex box with leaflets directing viewers to the 18th-century period room. Only when they reached this would they find another box with leaflets explaining that this was an installation by Asher. His work might be regarded as an exemplar of the ideas in Rosalind *Krauss's 1979 essay 'Sculpture in the Expanded Field', except that Asher has gone beyond activities such as *Land art in making the field itself, not only its material components but also its history and function, the materials of his art.

Further Reading: B. Buccloch, 'Michael Asher and the Conclusion of Modern Sculpture', in Wood, Hulks, and Potts (2007)

Ashington Group A group of British amateur painters, active in Ashington, Northumberland, from 1934 to 1983. The group originated when Robert Lyon (1894–1978), master of painting at King's College, Newcastle upon Tyne (then part of Durham University), was asked to run an extra-mural class in art appreciation in the nearby mining town of Ashington under the auspices of the Workers' Educational Association (founded 1903). About twenty people, all miners or associated with the pits, generally attended the classes. The art appreciation lessons were quickly dropped in favour of practical instruction, and the group held its first exhibition at the Hatton Gallery, Newcastle, in 1936. Lyon, who was regarded as an inspiring teacher, encouraged the members of the Ashington Group to 'paint what you know', and their pictures mainly featured scenes of their working, domestic, and social lives. Their work soon became known outside their immediate locality, partly because it attracted the attention of Mass-Observation (founded 1937), 'an early endeavour to apply a form of casual social anthropology to the contemporary culture of Britain' (Charles Harrison, *English Art and Modernism*, 1981). In 1938 the Ashington

painters featured prominently in the 'Unprofessional Painting' exhibition organized by Mass-Observation in Gateshead (Alfred *Wallis was among the other artists shown), and in the same year an article on them by Lyon appeared in the Penguin book *Art in England*, edited by R. S. Lambert.

Lyon left Newcastle in 1942 to become principal of Edinburgh College of Art, but the Ashington Group continued to flourish through changing times and fluctuating membership, holding several substantial exhibitions outside the region, including one at the Whitechapel Art Gallery, London, in 1973. There were even exhibitions of the group's work outside Britain, including one in Beijing in 1980. The best-known figure in the group was Oliver Kilbourn (1904–93), a founder member who was still working as a painter at the time of revival of interest in the group in the 1970s. It disbanded in 1983, but in 1991 a permanent collection of its work was established at the Woodhorn Colliery Museum, Ashington.

assemblage Term describing works of art made from fragments of natural or preformed materials, such as household debris. It was coined in 1953 by Jean *Dubuffet, who originally applied it to some of his own two-dimensional works ('assemblages d'empreintes') made by cutting and pasting together sheets of paper; these have been seen as extensions of the *Cubist *collage. However, Dubuffet soon extended the meaning of the word 'assemblage' to cover small sculptures he made from such materials as sponge and scraps of wood. Subsequently some critics have maintained that the term should apply only to three-dimensional found material and not to collage, but it is not usually employed with any precision and has been used to embrace *photomontage at one extreme and room *environments at the other. Allan *Kaprow's book *Assemblage, Environments & Happenings* (1966) attempted to clarify the terminology, but the vague usage continues.

In its broadest sense, assemblage has its roots in the sculptural experiments of *Picasso, in *Dada (particularly the work of *Schwitters), and in *Surrealism (many of whose exponents made *objects from diverse materials), but it was not until the 1950s that a vogue for this kind of work began. The term itself gained wide currency with an exhibition called 'The Art of Assemblage' at the *Museum of Modern Art, New York, in 1961. The exhibits included *ready-mades by Marcel *Duchamp, boxed constructions by Joseph *Cornell, 'sacking' pictures by *Burri, compressed automobile bodies by *César, tableaux by *Kienholz, collages by a wide range of artists, sculptures by *Nevelson and *Tinguely, and much else besides. In the introduction to the catalogue, the exhibition organizer, William C. Seitz, described assemblage as 'an appropriate vehicle for feelings of disenchantment with the slick international idiom that loosely articulated abstraction has tended to become, and the social values that this situation reflects.' During the 1960s assemblage was much used by *Pop artists and it has continued to be a favoured technique with many sculptors.

Association of American Painters and Sculptors *See* ARMORY SHOW.

Association of Artists of Revolutionary Russia *See* AKHRR.

Atelier *See* STUDIO, THE.

Atelier 17 *See* HAYTER, S. W.

Atget, Eugène (1857–1927) French photographer. He recorded the streets of Paris, including modern and historic buildings. The plate on his door said 'documents pour artistes' and he sold his work to painters such as *Utrillo, but also to museums and libraries as well as the shopkeepers whose premises he recorded. There is no human presence in his photographs and no obvious attempt to create 'atmosphere'. Indeed, the photographs are remarkable for their clarity. Walter *Benjamin praised Atget as 'an actor who, repelled by his profession, tore off his mask and then sought to strip reality of its camouflage'. Atget was also much admired by the *Surrealists, especially *Man Ray, who published two of his photographs in *La Révolution surréaliste*. Some of his photographs have a hallucinatory quality comparable to the best paintings of de *Chirico. By the end of his life some of the Paris world he was documenting had disappeared. In 1920 he wrote: 'I can truthfully say that I possess the whole of old Paris.' After Atget's death his photographs were acquired and published by Berenice *Abbott. There are substantial collections in the *Museum of Modern Art, New York, and the Bibliothèque Nationale, Paris.

Further Reading: Jeffrey (1996)

a

Atkinson, Lawrence *See* EVANS, MERLYN.

Atkinson, Terry (1939–) British artist and art theorist, born in Thurscoe, Yorkshire. He was associated with the early years of the *Art & Language group, which he left in 1975. The value of the group's work for him was that it 'presupposes not just an active spectator but an active artist trying to be as self-conscious as possible about a given set of exchanges'. This is an approach which rejects the ideology of spontaneity in art in favour of a more theoretical approach. However, he is best known, not for his *Conceptual work, but for his paintings and drawings with political themes. These, he has said, are 'strategically aimed at an audience', that audience which is theoretically aware. He has examined the First World War, nuclear weapons and the situation in Northern Ireland. His work is critical, not just of larger social issues, but of the institutions of art. In 2003 he wrote: 'If the work I have made over the last 40 years . . . has a characteristic concern running through it, it is a concern with making a critique of art rather than a celebration of it.'

Atl, Dr (Gerardo Murillo) (1875–1964) Mexican painter and art administrator. He was an ardent nationalist and a pioneer of the 20th-century renaissance of his county's art—chapter 1 of MacKinley Helm's book *Modern Mexican Painters* (1941) is entitled 'Dr Atl, the Saint John Baptist of Mexican Art'. He travelled and studied in Europe, 1897–1903, obtained a doctoral degree in philosophy and law at Rome in 1898, and adopted the name Atl—an Aztec word for 'water'—in 1902. After his return to Mexico he became a teacher at the Academy of San Carlos in Mexico City, where his pupils included *Orozco, *Rivera, and *Siqueiros. In 1910 he organized an exhibition of Mexican art as a counterblast to the European art promoted by the country's president, Porfirio Díaz. Atl went to Europe in 1911, after the outbreak of revolution, but he returned to Mexico in 1913 and rallied artists to the cause of Venustiano Carranza, who became president in 1917. In 1920 Carranza was murdered and was succeeded by Alvaro Obregón, under whose relatively peaceful and liberal regime there was a cultural efflorescence; in the government post of director of the department of fine arts, Atl promoted the mural decoration of public buildings that was Mexico's greatest contribution to 20th-century art.

He painted murals himself, but his talent in this field was modest, and as an artist he is better known for his landscapes, particularly those featuring volcanoes, a subject in which he was passionately interested. He often worked in 'Atl-colour' (a kind of wax crayon). Late in life—already a semi-legendary figure—he became a recluse. Adolfo López Mateos, president of Mexico 1958–64, declared Atl 'the nation's beloved son'.

Atlan, Jean-Michel (1913–60) French painter, lithographer, and poet, born in Algeria of Jewish-Berber ancestry and active mainly in Paris, where he settled in 1930. Atlan took a degree in philosophy at the Sorbonne and was self-taught as an artist. He began painting in 1941 but was arrested by the German occupying forces in 1942 because of his activities in the Resistance; he saved his life by feigning madness and was confined to an asylum (where he was allowed to paint) until the Liberation of Paris in 1944. In that year he had his first one-man exhibition at the Galerie de l'Arc-en-Ciel. His early work was violently expressionistic and semi-figurative, but after the war he developed an abstract style featuring rhythmical forms in deep, rich colours, often enhanced by thick black outlines. Initially he was successful with this work, but from 1948, following his break with his dealer, the Galerie Maeght, he went through a period of neglect and poverty. His fortunes were re-established with a one-man show at the Galerie Bing, Paris, in 1956, and thereafter his work was widely exhibited in France and elsewhere.

Further Reading: M. Ragon, *Atlan* (1962)

Auerbach, Frank (1931–) German-born painter and printmaker who was sent to England by his Jewish parents as a refugee in 1939 (he never saw them again) and became a British citizen in 1947. He studied in London at *St Martin's School of Art, 1948–52, the *Royal College of Art, 1952–5, and at evening classes under David *Bomberg, whom he found an inspiring teacher. Auerbach's paintings are in the *Expressionist vein of Bomberg's late work and they are notable for their use of extremely heavy impasto, so that the paint at times seems modelled rather than brushed. His favourite subjects include portraits (particularly of people he knows well), nudes, townscapes, and the building site. The poet Stephen Spender has characterized the figures in his

paintings as 'people who seem burdened with perhaps terrible experience...like refugees conscious of concentration camps' and he has suggested that Auerbach's fascination with building sites reflects the destruction he saw around him in his childhood. From the mid-1950s Auerbach has also made prints (drypoints, etchings, and screenprints), his subjects including nudes and portraits. There was a major *Arts Council exhibition of Auerbach's work in 1978, and in 1986 he represented Britain at the Venice *Biennale—indications of the high reputation he enjoys. As early as 1961, when Auerbach was only 30, David *Sylvester wrote of him: 'It is because of the subtle and profound way in which Auerbach's work gives expression and coherence to the complexity of our perceptions of simple things that he is for me the most interesting painter in this country.' Some critics, however, find his paintings muddy and overworked.

Aujame, Jean See NÉO-RÉALISME.

Ault, George See PRECISIONISM.

Auto-destructive art See METZGER, GUSTAV.

automatism Method of producing paintings or drawings (or writing or other work) in which the artist suppresses conscious control over the movements of the hand, allowing the unconscious mind to take over. There are various precedents for this kind of work, most notably the 'blot drawings' of the 18th-century English watercolourist Alexander Cozens, who stimulated his imagination by using accidental blots on the paper to suggest landscape forms. Cozens himself remarked that 'something of the same kind had been mentioned by Leonardo da Vinci', and slightly before Leonardo, Leon Battista Alberti (in his treatise *De Statua*, c.1460) gives an imaginative account of the origins of sculpture, describing ancient peoples observing 'in tree trunks, clumps of earth, or other objects of this sort, certain outlines which through some slight changes could be made to resemble a natural shape'. Alberti's version of events may be not far from the truth, for scholars of prehistoric art have found examples of such spontaneous discovery of representational images in chance natural formations on cave walls. However, automatism in its fully developed form is a 20th-century phenomenon. The *Dadaists made some use of the idea, although they were more interested in chance effects than in automatism as such. In 1916–17, for example, *Arp made a series of *Collages with Squares Arranged According to the Laws of Chance*, in which he said he arranged the pieces of paper 'automatically, without will', and in 1920 *Picabia published an ink blot labelled 'La Sainte Vierge' in his magazine *391*. However, it was the *Surrealists who first made automatism an important part of their creative outlook; whereas the Dadaists used the idea dispassionately, to the Surrealists exploration of the unconscious through such methods was deeply personal.

In the first Surrealist manifesto (1924) André *Breton discussed automatism in a passage that refers to literary composition but could equally well apply to drawing or painting: 'Secrets of Surrealist magical art...have someone bring you writing materials, once you have got into a position as favourable as possible to your mind's concentration on itself. Put yourself in the most passive, or receptive, state you can. Detach yourself from your genius, your talent, and everyone else's talent and genius.' Later, in *Le Surréalisme et la peinture* (1928), he wrote: 'The fundamental discovery of Surrealism' is that 'without any preconceived intention, the pen which hastens to write, or the pencil which hastens to draw, produces an infinitely precious substance all of which is not perhaps immediate currency but which at least seems to bear with it everything emotional that the poet harbours within him.' According to René Passeron (*Concise Encyclopedia of Surrealism*, 1984), 'the true inventor of "automatic" Surrealist drawing' was André *Masson: 'in about 1923 or 1924 his drawings developed into "wandering lines" which here and there suggested perhaps the outlines of a beast or a bird.' Masson soon developed a more elaborate automatic technique in which he drew on the canvas with an adhesive substance, then added colour by sprinkling coloured sands.

Other Surrealists devised different methods, and some of them regarded the use of dream imagery (as in the work of *Dalí) as a kind of psychological—as opposed to mechanical—automatism. Sometimes they used chance—rather than strictly automatic—methods to provide the initial image as with *decalcomania, frottage (*see* ERNST, MAX), and fumage (*see* PAALEN, WOLFGANG). The Surrealist interest in automatism had a strong influence on the *Abstract Expressionists, some of whom took

their ideas further. With Surrealists, once an image had been formed by automatic or chance means, it was often exploited deliberately with fully conscious purpose, but with *Action Painters such as Jackson *Pollock, automatism in principle permeated the whole creative process.

Other types of automatism are those in which the artist works under the influence of drugs (*see* MICHAUX) or by alleged occult means. The British painter Austin Spare (1886–1956) claimed to be able to conjure up horrific survivals of man's pre-human ancestry from deep within his mind, but more usually the artist is said to work under the inspiration of a beneficent spirit guide (a notion not necessarily to be taken lightly, as no less an artist than William Blake claimed to have direct inspiration from his dead brother).

Unlike Blake, most psychic artists of this kind have no particular artistic gifts or inclinations in their 'normal' life. An example is Madge Gill (1882–1961), an uneducated British housewife who became interested in spiritualism after a series of traumatic events (two of her children died tragically and she lost an eye through illness). From 1919 she produced hundreds of ink drawings while in a trance-like state, allegedly directed by her spirit guide 'Myrninerest' (one acquaintance said unkindly that the spirit which really guided her was gin). From 1932 she exhibited regularly at shows for amateur artists at the *Whitechapel Art Gallery, London. Her drawings ranged from postcard-sized sketches to works more than 20 feet wide. In 1926 her son Laurie issued a broadsheet entitled *Myrninerest, the Spheres*, in which he described the range of his mother's automatic activities: 'Spiritual or Inspirational drawings, Writings, Singing, Inspired Piano-Playing, making knitted woollen clothes and weaving silk mats in beautifully blended colours.'

Automatistes, Les A radical group of Canadian abstract painters active in Montreal from 1946 to about 1954; the name was taken from their interest in *automatism deriving from *Surrealism. The dominant figure was Paul-Émile *Borduas, who was appreciably older than the other six original members: Marcel Barbeau (1925–), Roger Fauteux (1920–), Pierre Gauvreau (1922–), Fernand Leduc (1916–), Jean-Paul Mousseau (1927–91), and Jean-Paul *Riopelle. Five of these (Borduas, Gauvreau, Leduc, Mousseau, and Riopelle) had exhibited together in New York in January 1946, and all seven first showed their work as a group in an office lent by Gauvreau's mother on Amherst Street, Montreal, in April of that year. This was the first exhibition by a group of abstract artists to be held in Canada. In 1948 the group published *Refus global* ('Total Refusal'), an anarchic manifesto attacking various aspects of Canadian life and culture, including the Church. Borduas was largely responsible for this document, which expressed his commitment to a free and creative life. It caused outrage and has been described as 'the single most important social document in Quebec history and the most important aesthetic statement a Canadian has ever made' (Dennis Reid, *A Concise History of Canadian Painting*, 1973). Two group exhibitions were held after this, in 1951 and 1954, but by the time of the first, Leduc and Riopelle were living in Europe and the group identity was breaking up.

Automne, Salon d' *See* SALON D'AUTOMNE.

avant-garde A term originally used to describe the foremost part of an army advancing into battle (also called the vanguard) and now applied to any group, particularly of artists, that considers itself innovative and ahead of the majority; as an adjective, the word is applied to work characteristic of such groups. In its original sense the term is first recorded in English in the late 15th century (in Malory's *Morte d'Arthur*). Some critics and historians now prefer to use it exclusively in relation to the early 20th century, but to insist on this creates the problem of depriving the language of art of a useful piece of shorthand of more general application. It was probably first applied to art by the French political theorist Henri de Saint-Simon. Regarded as the founder of French socialism, he thought that science and technology could solve most problems and that artists could help lead the way to a more just and humane society. In his *Opinions littéraires, philosophiques et industrielles* (1825), he has the artist say to the scientist: 'It is we, the artists, who will serve as your avant-garde [i.e., as the prophets of future events].' Francis Haskell has shown that, during the 19th century, the idea that the artist could be some kind of prophet of the future became widespread. Thoré-Burger, a one-time follower of Saint-Simon, wrote in 1865 that 'art must be judged from the point of

view of the future . . . because art is the spontaneous feeling which precedes thought.' H. W. Janson (1913–82) has argued that the 19th century was especially propitious for the production of an artistic avant-garde because there was 'a social environment sufficiently set in its traditions and taste to be disturbed and offended by works of art that abandon accepted standards in the search for new form and meaning'. The term continued to be associated particularly with radical political thought, but from the early 20th century it was frequently used more neutrally to denote cultural innovators of any persuasion; the earliest quotation in the *Oxford English Dictionary* to illustrate this sense ('The pioneers or innovators in any art in a particular period') dates from 1910. Many 20th-century writers, however, continued to use the word with more social connotations, often suggesting that the avant-garde has an exalted role. In his book *Concerning the Spiritual in Art* (1912), *Kandinsky argued that the artist was at the very apex of a triangle that led mankind upwards to greater spirituality. There are some affinities here with the Leninist notion of an elite vanguard party without whose leadership and organization the proletariat cannot take power. The writings of Herbert *Read claimed a vital role for art in the 'evolution of consciousness'. He saw, as did Clement *Greenberg, avant-garde art as necessarily in opposition to mass culture.

It has been argued that the term should be applied only to modern art that actively challenges not just the traditional forms of art but also its status in society. Therefore groupings such as the *Dadaists and the *Surrealists who had a subversive political agenda would qualify, as might De *Stijl with their project to transform the whole of life. On the other hand most of the later work of *Picasso or *Braque would not qualify. Neither would political content alone be a sufficient qualification, if unaccompanied by artistic innovation. This is very much the viewpoint of Peter Bürger, writing in 1974, who would confine the term to politically motivated activities that attacked the idea of the 'autonomy' of art. A number of writers have noted parallels between the aspirations of the avant-garde to transform life and that of extreme totalitarian political movements in spite of the fact that artistic avant-gardes, whether in Nazi Germany or Stalin's Soviet Union, found themselves in conflict with the regimes under which they operated. As Tzvatan Todorov put it, 'What dictators and avant-garde artists have in common is their radicalism, their fundamentalism. Both are prepared to start ex-nihilo, to take no account of what already exists, in order to construct a work based solely on their own criteria.'

An opposing view of the relationship between the avant-garde and politics is that of Clement Greenberg in his 1939 essay 'Avant-garde and *Kitsch'. Under the influence of Leon Trotsky's position in favour of an independent revolutionary art (*see* BRETON; SURREALISM) he argued for an avant-garde that was in opposition to the kitsch of the mass culture. The latter would inevitably be cultivated by dictators as a convenient means to flatter the tastes of the masses they oppressed. Avant-garde art would instead look to its own means and inevitably have no point of contact with a wide public. Nor would it concern itself with the business of restructuring the rest of life. An example of this in practice was Greenberg's idea of 'Modernist Painting', orienting itself towards the flatness of the picture surface. Paradoxically, in Greenberg's terms, a true avant-garde rests on a tradition, albeit a dynamic and self-critical one.

The issue of the 'difficulty' of avant-garde art was explored with great subtlety in Leo *Steinberg's 1962 essay 'Contemporary Art and the Plight of its Public'. Instead of basing his argument upon a simple relationship between artists and a lay public 'out there', he proposes that artists themselves are an important element of this public and are as likely to be shocked as anyone else. In fact their discomfort is often deeper because it comes out of a greater commitment. So when *Matisse exhibited *The Joy of Life* (1906, Barnes Foundation) he affronted not only traditionalist artists and spectators but also the previous avant-garde *Neo-Impressionists, who saw their own hard-won gains put into question. He in turn was shocked by Picasso's *Cubism and threatened to 'expose him'. Then Steinberg goes on to describe his own difficulties with the work of Jasper *Johns—which he came to admire—quoting a well known abstract painter as saying 'If this is painting I might as well give up.' 'There are people,' he writes, 'for whom an incomprehensible shift in art, something that really baffles or disturbs is more like a drastic change—or better a drastic reduction in the daily ration on which one has

come to depend.' He describes 'a feeling that one's accumulated culture or experience has been hopelessly devalued, leaving one exposed to spiritual destitution'. Steinberg's theory was borne out by subsequent events. Some of the most vehement opponents of the *Neo-Expressionist painting of the 1980s were the supporters of the *Conceptual and *Minimal art which had held sway as the most advanced forms in the previous decade.

In 1994 Bruce Altshuler wrote that, 'considered as part of the history of *modernism, the avant-garde seems to have disappeared with the arrival of the cultural, social, and economic changes that together have been designated "*postmodern"'. Today young artists do not much use the term, burdened as it is with such notions as complete originality and faith in 'artistic progress'. Scepticism about the 'institutionalization' of the avant-garde was put wittily in Saul *Steinberg's 1973 drawing in which a troop of identical bearded long-haired men are shown marching with military precision in front of 'The National Academy of the Avant-Garde'. A more ambivalent view was put forward in the catalogue to the exhibition held in 1991 at the Wexner Center for the Arts at Ohio University. It was entitled *Breakthroughs: Avant-Garde Artists in Europe and America, 1950–1990*. 'What is a breakthrough in an era besieged by novelty-for-novelty's sake?', Robert Stearns, the centre's director, asked, before going on to standard phrases to describe vanguardism, such as 'groped for the future' and even 'cutting edge'. The American art historian Hal Foster has used the expression 'neo-avant-garde' to describe the works of certain American and European artists of the 1950s and 1960s who reprised avant-garde devices such as collage and assemblage. The term 'post-avant-garde' is also sometimes employed to distinguish more recent advanced art from the historical avant-garde of the early 20th century.

If avant-garde art is judged merely by its ability to shock, alienate, disgust, or dismay members of the public (and certain critics), then it still seems to be alive. Journalistically the term is certainly still sometimes used in this sense, for instance, in discussion of the *'Sensation' exhibition of British art held in 1997. The issue is whether the cultivation of shock value alone does not represent a trivialization of the idea of the avant-garde as developed from Saint-Simon to Greenberg. The Italian critic Francesco Bonami, introducing a

series of books entitled *Supercontemporanea*, reassures his readers with the words 'even with contemporary art the worst that can happen is for you not to like it . . . like anything else in life it's just a matter of taste'. What is potentially most shocking here is the diminished level of commitment to the significance of art implied: the frisson of novelty is all that is on offer. A less rosy formulation of the same situation would be that provided by Victor *Burgin: 'Vanguardism in art has become just another way of offering the consumer a choice' (*Studio International* March/April 1976).

Further Reading: B. Altshuler, *The Avant-Garde in Exhibition: New Art in the Twentieth Century* (1994)

P. Bürger, *Theory of the Avant-Garde* (1984)

D. D. Egbert, *Social Radicalism and the Arts: Western Europe* (1970)

H. Foster, *The Return of the Real* (1996)

C. Greenberg, 'Avant-garde and Kitsch' in *The Collected Essays and Criticism*, vol. 1 (1986)

F. Haskell, 'Art as Prophecy' in *History and its Images* (1995)

H. W. Janson, 'The Myth of the Avant-Garde' in *Art Studies for an Editor: 25 Essays in Memory of Milton S. Fox* (1975)

L. Steinberg, *Other Criteria* (1972)

T. Todorov, 'Avant-gardes and Totalitarianism', *Daedalus*, vol. 136 no. 1 (2007)

Avery, Milton (1885–1965) American painter. He was born in Altmar, New York, spent most of his early life in Connecticut, and settled in New York City in 1925. Although he studied briefly at the Connecticut League of Art Students, he was essentially self-taught as an artist, and in his early years he supported himself with a variety of night jobs so he could paint during the day. It was only after his marriage in 1926 that his wife's earnings (she was an illustrator) allowed him to concentrate full-time on painting. (Avery's wife, the noted illustrator Sally Michel (1902–2003), was considerably younger than him and it was perhaps to improve his chances in courting her that he took eight years off his age; his date of birth is often given as 1893, but there is good evidence to indicate that he was born in 1885.)

Avery was an independent figure, described by Robert *Hughes as 'a mild, unassuming man who disliked publicity and at best made a bare living from his work . . . a man of absolute dedication and conviction, a painter who did almost nothing but paint'; if he was asked to discuss his work his usual reply was 'Why talk when you can paint?' At a time when most of his leading contemporaries were working in

fairly sober, naturalistic styles (*see* AMERICAN SCENE PAINTING), he followed the example of *Matisse in using flat areas of colour within flowing outlines. He was the main and practically only channel through whom this subtle colouristic tradition was sustained in America until a new interest was taken in it in the 1940s by younger artists such as *Rothko (his close friend) and *Gottlieb. Rothko in particular acknowledged the debt that he and other abstract painters owed to the 'sheer loveliness' of Avery's work, in which he had 'invented sonorities never seen nor heard before'. Although Avery himself never abandoned representation (his favourite subjects included landscapes and beach scenes), some of his later works are so broadly conceived and ethereally painted that they can at first glance be mistaken for abstracts (*Spring Orchard*, 1959, Smithsonian American Art Museum, Washington).

Axis A magazine devoted to contemporary art, published in London 1935–7, edited by the writer Myfanwy Evans assisted by her husband John *Piper. In the first issue (January 1935) *Axis* was described as 'a quarterly review of contemporary abstract painting and sculpture', but the quarterly intervals became almost half-yearly; the last issue (the 8th) appeared in winter 1937. Evans was encouraged by the French abstract painter Jean *Hélion and it was originally intended that *Axis* should parallel the concerns of the Paris-based *Abstraction-Création group. In later issues, however, the commitment to abstraction was abandoned in favour of a *Neo-Romantic nostalgia for the English landscape tradition. The impressive list of contributors included Paul *Nash and Herbert *Read. Although short-lived, the magazine was influential in introducing knowledge of contemporary European trends to Britain.

Ayres, Gillian (1930–) British abstract painter, born in London, where she studied at Camberwell School of Art, 1946–50. Tim Hilton described her as one of the British painters of her generation who were 'impatient with landscape, the life-room, or *neo-romanticism'. She was one of the first British painters to be influenced by American *Abstract Expressionism and *Colour Field Painting, and was among the artists who first achieved prominence at the *'Situation' exhibition in 1960. Some of her work of the late 1950s made use of *Pollock's drip techniques (she was more influenced by the photographs of Pollock at work than her experience of the paintings themselves) and in the 1960s she did some lusciously coloured stain paintings. From 1977 when she returned to the use of oil paint, after several years of working with acrylic, her paint surfaces became richer and thicker. Ayres taught at *Bath Academy of Art, Corsham, 1959–66, *St Martin's School of Art, 1966–78, and Winchester School of Art (as head of painting), 1978–81. She then moved to Wales and devoted herself full-time to painting. She now lives and works in London and Cornwall. A retrospective exhibition at the Serpentine Gallery in 1983 enhanced her standing as a leading figure in British abstract painting. She was elected as a *Royal Academician in 1992.

Further Reading: Arts Council of Great Britain, *Gillian Ayres* (1983). Catalogue introduction by Tim Hilton.

Aycock, Alice *See* LAND ART.

Ayrton, Michael (1921–75) British painter, sculptor, theatre designer, graphic artist, filmmaker, writer, and broadcaster, born in London, son of the poet Gerald Gould and the Labour politician Barbara Ayrton. After leaving school at the age of fourteen, he studied at Heatherley's and St John's Wood Schools of Art and travelled extensively in Europe, sharing a studio with John *Minton in Paris in 1939. In 1942 he was invalided out of the RAF and for the next two years taught theatre design at Camberwell School of Art. From 1944 to 1946 he was art critic of the *Spectator* (succeeding John *Piper), in which position he was a leading (and provocative) spokesman for *Neo-Romanticism. His own painting at this time was often turbulent and melodramatic, featuring anguished figures in strange landscapes (*The Temptation of St Anthony*, 1942–3, Tate), but it later grew more restrained. After the Second World War he became a regular radio broadcaster; later he also made television documentaries. Encouraged by Henry Moore, he took up sculpture in 1954.

Apart from portraits, his work tended to revolve around certain recurring ideas and themes. In particular he was obsessed with the myth of Daedalus and Icarus, which he treated as analogous to his own artistic endeavours: 'I find myself involved in this legend and strangely aware of the relationship between the creative Daedalus and his son, who, lacking his father's talent, compensated

for this lack in one superb and pathetic moment of suicidal action.' The most extreme expression of his obsession is the enormous maze of brick and stone (1968) he built for Armand Erpf, an eccentric American millionaire, at Arkville in New York State, imitating the labyrinth Daedalus built for King Minos of Crete at Knossos. Ayrton's books include *The Testament of Daedalus* (1962), which is a mixture of prose and verse, and two novels, *The Maze Maker* (1967) and *The Midas Conse-* *quence* (1974). The latter deals with a celebrated modern artist named Capisco who is based partly on *Picasso and partly on Ayrton himself.

Further Reading: P. Cannon-Brookes, *Michael Ayrton* (1978)

Ayshford, Paul (Lord Methuen) *See* BATH ACADEMY OF ART.

Azbe, Anton *See* KANDINSKY, WASSILY.

B, Franko *See* PERFORMANCE.

Bach, Elvira (1951–) German painter, born in Neuenhain, who has lived and worked principally in Berlin. She was associated with the *Neo-Expressionist tendency of the 1980s and achieved great acclaim at the 1982 *documenta exhibition. She specializes in images of women who, as more than one commentator has noted, are remarkably like her, with a proclivity for big earrings and thick lipstick. 'Women aren't like snakes, they are snakes', she told an interviewer. She quickly capitalized on her documenta success with designs for wine labels, biscuit tins, and a tea service, activities which may have led to a decline in her reputation in the art world.

Bacon, Francis (1909–92) British painter, a descendant of the Elizabethan writer and statesman of the same name, born in Dublin of English parents. As a child he suffered from severe asthma and he had little conventional schooling. His father, a race-horse trainer, was a puritanical figure who sent his son away from home when he was sixteen, after he was discovered trying on some of his mother's underwear. He spent about two months in Berlin and then about eighteen months in Paris (where he was powerfully impressed by an exhibition of *Picasso's work at the Paul *Rosenberg Gallery in 1928) before settling in London in 1929. Initially he made a living there designing furniture and rugs. He had no formal training as an artist, but he began making drawings and watercolours in 1926 and painting oils two or three years later. In 1933 he began exhibiting in London commercial galleries, and in the same year one of his paintings was reproduced in Herbert *Read's book *Art Now*. However, he destroyed much of his early work and in the later 1930s he

virtually gave up painting for several years, supporting himself with various odd jobs, including running an illegal casino (he had inherited a love of gambling from his father). He returned to painting seriously in the Second World War (during which he worked for a time in Civil Defence, excused military service because of his asthma), and he burst into prominence in April 1945 when his *Three Studies for Figures at the Base of a Crucifixion* (1944, Tate) was exhibited in a mixed show at the Lefevre Gallery and made him overnight the most controversial painter in the country. Some have seen in this nightmarish work a response to the agonies of war-torn Europe, but those familiar with the artist's life have observed a reflection of his sado-masochism.

Bacon's imagery later became more naturalistic, but at the same time the emotional impact of his work was increased by a change in technique, as he moved away from fairly impersonal brushwork to develop a highly distinctive handling of paint, by means of which he smudged and twisted faces and bodies into ill-defined jumbled protuberances suggestive of slug-like creatures of nightmare fantasy: 'Art is a method of opening up areas of feeling rather than merely an illustration of an object...I would like my pictures to look as if a human being had passed between them, like a snail, leaving a trail of the human presence and memory trace of past events as the snail leaves its slime.' Characteristically his paintings show single figures in isolation or despair, set in a bleak, sometimes cage-like space, and at times accompanied by hunks of raw meat: 'we are all meat, we are potential carcasses', he said in 1966. Often his work was based on his own everyday world (he did numerous self-portraits), but he also used imagery from photographs and film-stills as a starting point. In particular he based a series of paintings (begun in 1951) on Velázquez's celebrated portrait of Pope Innocent X (1650, Galleria Doria Pamphili, Rome), but in place

of the implacable expression of the original, he sometimes gave the pope a screaming face derived from a still from Sergei Eisenstein's film *The Battleship Potemkin*, as in *Study after Velázquez's Portrait of Innocent X* (1953, Des Moines Art Center). Bacon regarded Velázquez as a 'miraculous' and 'amazingly mysterious' painter who could 'unlock the greatest and deepest things that man can feel', and he tried 'to paint like Velázquez but with the texture of a hippopotamus skin'.

From 1946 to 1950 Bacon lived mainly in Monte Carlo and thereafter in London. From 1949 he had fairly regular one-man exhibitions (first in London, then in New York, Paris, and elsewhere). In 1962 a retrospective exhibition of ninety of his paintings was held at the Tate Gallery, London, subsequently touring to several venues on the Continent, and this event firmly established him as a major figure. Thereafter his international reputation grew rapidly, and in the catalogue of a second major retrospective exhibition at the Tate, in 1985, the director of the Gallery, Alan *Bowness, wrote that Bacon was 'surely the greatest living painter; no artist in our century has presented the human predicament with such insight and feeling'. Many critics at the time concurred in this judgement, although others found his despairing vision—his view of life as a 'game without reason'—hard to take. He thought that 'man now realizes he is an accident, that he is a completely futile being' and that 'art has now become completely a game by which man distracts himself'. Peter *Fuller was among those who opposed this outlook: 'Bacon is an artist of persuasive power and undeniable ability; but he has used his expressive skills to denigrate and degrade. He presents one aspect of the human condition as necessary and universal truth . . . Bacon's skills may justly command our admiration; but his tendentious vision demands a moral response and, I believe, a refusal.' David *Sylvester, however, did not see Bacon's vision as totally despairing. 'The paintings are a huge affirmation that human vulnerability is countered by human vitality. They are a shout of defiance in the face of death.' A more succinct view was that of Margaret Thatcher, who referred to him as 'that artist who paints those horrible pictures'. (Paradoxically, alongside *Gilbert & George, he was one of the few non-traditional British artists openly to support her.) Perhaps what most disturbs his detractors and exhilarates his admirers is the sense that, just as much as *Matisse, Bacon was an artist who painted what he loved.

Alongside his reputation as one of the giants of contemporary art, Bacon built up a sulphurous personal legend on account of his promiscuous homosexuality, hard drinking, and heavy gambling. Two of his lovers, Peter Lacey and George Dyer, committed suicide, the latter less than 48 hours before a major retrospective opened at the Grand Palais, Paris. In spite of the huge amount of attention he has attracted, his work has had comparatively little stylistic effect on his contemporaries: it is so personal that it has been difficult for other artists to absorb it without producing a mere pastiche.

Controversy did not end at Bacon's death. His estate engaged in an acrimonious legal dispute with his long-term dealer *Marlborough Fine Art. This was resolved out of court only a few days before going to trial. More troubling to admirers and scholars of Bacon was the issue of the 'Joule' documents. The artist always maintained he made no preparatory drawings. In 1953 he had written that 'painting today is pure intuition and luck and taking advantage of what happens when you splash the stuff down'. Yet in 1999 a handful of works on paper were seen at the Tate Gallery which appeared to have the status of preliminary studies. The authenticity of these is unquestioned, but far more problematic has been the large amount of studies often consisting of overpainted photographs in the possession of his friend Barry Joule. Initially these were treated sceptically, but part of the collection was seen at the Irish Museum of Modern Art, Dublin, in 2000 and the Barbican Centre in London in 2001. In 2004, much of the material entered the Tate archive.

Further Reading: D. Farson, *The Gilded Gutter Life of Francis Bacon* (1993)

J. Russell, *Francis Bacon* (1993)

D. Sylvester, *Interviews with Francis Bacon: The Brutality of Fact* (1988)

'Bad Painting' Exhibition curated by Marcia Tucker in 1978 at the New Museum of Contemporary Art in New York. The paintings, according to the catalogue, 'mixed classical and popular art historical sources'. Artists included Neil *Jenney and William *Wegman. In the context of the late 1970s the idea of 'painting' was as much an affront to many as the idea of 'bad'. The point was not just that the work might challenge notions of good taste

and technical competence but that the *modernist notion of progress was to be bypassed in the name of freedom. This emphasis on the 'end of progress' was to become something of a *leitmotif* for *Postmodern critics in the following decade but not necessarily accompanied by the same cheery optimism. The critic John Perreault commented on the exhibition that 'there are bound to be at least several works that even the most open-minded art-lover will hate with grim passion'.

Baer, Jo (1929–) American painter, born in Seattle, Washington. She studied psychology and an interest in perception informs much of her painting. In the 1950s her work was strongly influenced by *Abstract Expressionism, but she is best known for the *Minimalist paintings of the 1960s and 1970s. These were in a sense a riposte to the theories of artists such as *Judd and *Morris that painting was outdated because it was too tied to illusionism. Refuting Morris in a letter of 1967 she wrote: 'A painting is an object which has an emphatic frontal surface. On such a surface, I paint a black band which does not recede, a colour band which does not obtrude, a white square or rectangle which does not move back or forth, to or fro, or up or down; there is also a painted white exterior frame band which is edged round the edge to the black.' Following such works she embarked on the 'wrap-around' series. These were almost entirely monochrome except for the sides and edges. They demanded, therefore, to be viewed from different angles, the experience unfolding in time, like a sculpture. Following considerable acclaim for these paintings, culminating in a retrospective at the Whitney Museum of American Art in 1975, she moved to Ireland and then to Amsterdam. At the same time she repudiated non-objective art. Her later work has been less seen. It uses superimpositions of mechanical, body, and landscape imagery to denounce the greed and cruelty of the powerful.

(⊕) SEE WEB LINKS

• 'Jo Baer: The Minimalist Years 1960–75': essay by Lynne Cooke on the Dia art foundation website.

Bainbridge, David *See* ART & LANGUAGE.

Baj, Enrico (1924–2003) Italian painter, sculptor, graphic artist, and writer on art, born in Milan, where he studied art part-time at the Brera Academy whilst reading for a law degree. In 1951 he helped found the Nuclear Art Movement. This was basically a form of *Tachisme but made reference to contemporary fears about nuclear war. He wrote 'From the first atomic bomb, I felt that humanity was living in a constant state of alert and fear, and that, more than ever, annihilation hung over our heads.' His concern with the issue even led him to describe one technique of enamel paint and distilled water as 'heavy water'. From 1955 he began making use of collage in works which parallel both *Pop art and *Nouveau Réalisme. A passionate anarchist, he bitterly satirized the powerful, especially the military, in works such as the series of *Generals*, described by Christopher Masters as 'ludicrous characters made . . . out of buttons, belts, and military medals'. In other works he used Meccano or wittily inserted gnome-like figures into cheap paintings of landscapes or glamorous bodies suggesting some kind of alien invasion. *Beings from other Planets Violate our Women* is the title of one from 1959. André *Breton was a supporter of his work and included him in the final 1965 edition of *Le Surréalisme et la peinture*. His large painting *Funeral of the Anarchist Pinelli* (1972) was forcibly removed from public view after the assassination of the police chief widely assumed to be responsible for Pinelli's 'accidental' death by defenestration.

Further Reading: C. Masters, obituary, *The Guardian* (9 July 2003)

Bakst, Léon (originally **Lev Rosenberg)** (1866–1924) Russian painter, graphic artist, and stage designer, active for much of his career in Paris. He was born at Grodno and studied at the St Petersburg Academy, 1883–7, and then in Paris, at the *Académie Julian and elsewhere. In 1898 he was a founder member of the *World of Art group in St Petersburg. Originally he made his name as a portraitist, but from about 1902 he turned increasingly to stage design and is now remembered above all for his costumes and sets for *Diaghilev's Ballets Russes, his work playing a major part in the tremendous impact the company made in the West. The Diaghilev ballets for which he made designs include some of the most celebrated works in the history of dance, notably *The Firebird* (1910, music by Stravinsky), *L'Après-midi d'un faune* (1912, music by Debussy), and *Daphnis and Chloe* (1912, music by Ravel). In 1909 he had been exiled from St Petersburg as a Jew without a residence

permit and from then he lived mainly in Paris, where he worked for Ida Rubinstein's ballet company as well as Diaghilev, designing for her *The Martyrdom of St Sebastian* (1911, music by Debussy). Bakst's work revolutionized stage design. His costumes and sets are remarkable for their sheer uninhibited splendour, combining Oriental fairy-tale magnificence with the gaudy colours of Russian peasant art (he believed that colour could have a significant emotional effect on spectators). There are examples of his designs in the Victoria and Albert Museum, London.

Baldessari, John (1931–) American painter and *Conceptual artist, born in National City, California. He initially studied art criticism but became more interested in art practice. In 1968 he held an exhibition in Los Angeles consisting of paintings containing only words. These were executed by a sign painter to ensure the maximum degree of impersonality in their making. They were statements concerning the paintings themselves. One stated 'EVERYTHING HAS BEEN PURGED FROM THIS PAINTING BUT ART...NO IDEAS HAVE ENTERED THIS WORK.' Baldessari was attacking the *formalist idea that art was purely visual, just as were, at the same time, *Kosuth and *Weiner. However, his work has generally been less austere than that of other conceptualists. He approaches the problem of defining art sideways, by ironic narrative, rather than with the instruments of philosophical analysis. Combinations of word and image are frequently combined with a certain humour. In 1970 he exhibited an urn containing the ashes of his early paintings with a commemorative plaque, 'Will I feel better?' *The Pencil Story* (1972–3) has close-up photographs of a blunt and sharpened pencil with a caption, neatly handwritten in capitals, about Baldessari's increasing irritation with seeing the blunt pencil on the dashboard of his car. Eventually he sharpens it and concludes that this might be something to do with art. In 1972 he gave a performance where he sang Sol *LeWitt's statements on Conceptual art to various tunes, contrasting the intellectual austerity and rigour of the ideas with the lush romanticism of the music. Baldessari has since worked with photographs and images from the mass media combined with paint. He has also been an influential teacher at the California Institute of the Arts.

Further Reading: C. Miles, '9 to 5', *Tate etc.*, no. 13 (summer 2008)

Baldwin, Michael *See* ART & LANGUAGE.

Balkenhol, Stephan (1957–) German sculptor, born in Fritzlar, Hesse. He began by making *Pop art and *assemblages, but for most of his career he has worked on figurative sculptures in painted wood, both free-standing and in relief. They are rough hewn: splinters and cracks remain visible as though the wood itself is a kind of analogy to the process of life. However, compared to the carvings of *Neo-Expressionists like *Baselitz, they are relatively naturalistic. There is sometimes an element of fantasy. In a carving of 1990 a man climbs the neck of a giraffe. When shown in a group, the sculptor's play with effects of scale becomes apparent. The full-length figures are interspersed with giant heads. Poses tend to be casual and relaxed in contrast to the usual conventions of statuary. Jeff *Wall has described them as like convalescents, not yet quite ready to go out into the world.

Ball, Hugo *See* CABARET VOLTAIRE.

Balla, Giacomo (1871–1958) Italian painter and designer, one of the leading *Futurist artists. He was born in Turin and was mainly self-taught as an artist. In 1895 he moved to Rome, where he spent most of the rest of his life. He visited Paris in 1900–01 and brought back to Italy a feeling for colour and light that he passed on to *Boccioni and *Severini. His early works included landscapes and portraits, and after the turn of the century he became more interested in painting aspects of modern industrialized life. In 1910 he signed the two Futurist manifestos of painting, but he was initially cautious over his involvement with the movement and did not show his work in a Futurist group exhibition until 1913. By this time, however, he was becoming one of the most original and inventive of Futurist artists. His paintings showed a preoccupation with the characteristic Futurist aim of portraying motion, but unlike other members of the movement, Balla was not interested in machines and violence, his paintings tending rather towards the lyrical and the witty. The most famous is the delightful *Dynamism of a Dog on a Leash* (1912, Albright-Knox Art Gallery, Buffalo), in which the blurred multiple impressions of the dog's legs and tail convey movement in a manner that later became a cartoon convention. In 1913–16 Balla went beyond the principles of the Futurist manifesto, painting pictures that approach pure

abstraction, having only the most residual resemblance to the observations in reality that inspired them (*Abstract Speed—The Car Has Passed*, 1913, Tate). After the First World War, most of the other leading Futurists abandoned the movement, but Balla stayed true to its ideals and became its leading figure. In 1929 he signed the manifesto of its offshoot movement *Aeropittura, but from 1931 he reverted to a more traditional figurative style.

Ballets Russes *See* DIAGHILEV.

Balthus (Count Balthazar Klossowski de Rola) (1908–2001) French painter and stage designer, born in Paris of Polish parents, both of whom painted. He had no formal artistic training, but taught himself mainly by copying Renaissance paintings in the Louvre and in Italy. He was also encouraged by *Bonnard, *Derain (of whom Balthus painted a memorable portrait, 1936, MoMA, New York), and the Austrian poet Rainer Maria Rilke, all family friends. One of the first paintings in which he showed a strong personal vision was *The Street* (1933, MoMA, New York), a carefully structured urban view with figures, two of which—a man caressing a girl—looked forward to the erotic imagery that was soon to dominate his work. Balthus tended to prefer not to interpret his paintings, but S.W. *Hayter, who helped in the preparation of the canvas, maintained that it derived from Lewis Carroll's *Alice in Wonderland*, a *Surrealist favourite. More plausible is the attempt to analyse it as a highly formalized geometric structure in the manner of Piero della Francesca, an artist especially revered by Balthus. *The Street* was one of the works shown at his first one-man exhibition, at the Surrealist-inclined Galerie Pierre, Paris, in 1934, which caused a scandal because of the sexual content of the pictures. *The Guitar Lesson*, a lesbian-themed picture which drew upon the erotic parallels between playing an instrument and fondling a body, was placed in a back room and shown only to selected visitors. None of the works sold, but Balthus made a living with portraits and stage designs. He had further connections with Surrealism when his illustrations for *Wuthering Heights*, a book loved by the Surrealists for its celebration of *amour fou*, were published in *Minotaure* in 1935. Ever since, the relationship with Surrealism has been a problem for critics. Patrick Waldberg, in *Surrealism* (1962), placed him

among those artists ignored by Breton who nonetheless 'centred on the Marvellous'.

At the beginning of the Second World War Balthus joined the French army, but he was soon discharged on medical grounds and spent the years 1943–6 in Switzerland. He then returned to Paris and built up an international reputation. In 1954 he moved to the Château de Chassy near Autun, and from 1961 to 1977 he was director of the French Academy in Rome. From then he lived mainly in seclusion in Switzerland. His output is small (he worked slowly) and he shunned publicity, but his highly distinctive, poignantly erotic images made him internationally famous, indeed something of a cult figure. He could also be very protective about any biographical revelations. He threatened to cancel his 1968 Tate retrospective unless some details about his life were removed from the catalogue. His favourite theme was the adolescent girl awakening to sexual consciousness; characteristically these girls are shown languidly sprawled or kneeling awkwardly over books in claustrophobic interiors such as *The Living Room* (1941–3, Minneapolis Institute of Arts). A remarkable example is *The Room* (1952–4), a painting frequently reproduced but seldom seen in public, in which a sinister gnome-like child (or possibly dwarf) opens a curtain to illuminate a still sleeping naked woman under the gaze of one of Balthus's characteristically half-human cats. George Heard *Hamilton writes that 'No other painter has so shockingly depicted the stresses of adolescence, just as few others have had the courage to adapt traditional realism to contemporary purposes on such a monumental scale.' The treatment of childhood sexuality has, however, been problematic for some. *Girl with Cat* (1937) was used by Penguin as a cover for Nabokov's notorious novel about paedophilia, *Lolita*. The use of the image, which displeased the artist intensely, might well have been inspired by Linda Nochlin's attack on the 'representation of young women in sexually perverse and provocative situations' (*Women, Art and Power*, 1989). He complained that journalists had sometimes made connections with his marriage to a Japanese woman 34 years his junior. Nervousness around this issue may well be responsible for the fact that, despite his enormous reputation and the support of high-profile admirers such as the rock stars David Bowie and Bono (who sang at his funeral), there has not been a major showing of his

work in London in a public institution since 1968.

Further Reading: N. Fox Weber, *Balthus: A Biography* (1999)

Baltic Centre for Contemporary Art, Gateshead. Public gallery opened in 2002, one of the world's largest venues for the display of contemporary art. It is housed in a huge industrial structure, the former Baltic Flour Mills, which opened in 1950 and ceased production in 1981. The building remained unused for more than a decade, before Gateshead Council decided in 1992 to convert it into an arts centre. In 1994 a competition for the reconstruction was won by Ellis Williams Architects, and work on site began in 1998. The following year, while the building was still a shell, it was used as the setting for an enormous installation by Anish *Kapoor (the 50-metre long, trumpet-like *Taratantara*, in red PVC), signalling Baltic's intentions to attract work by leading contemporary artists. There is no permanent collection, but there is a varied programme of temporary exhibitions and other activities. In addition to its vast display spaces, the Baltic has various other facilities, including artists' studios, a cinema/lecture theatre, and a library/archive. Most of the exhibitions have been devoted to what its website calls 'innovative and provocative new art', including projects commissioned for the venue, but there was also one on Beryl *Cook in 2007—the largest survey of her work to date.

Funding for the Baltic comes from the *Arts Council, the National Lottery, and other sources. Its creation was part of the regeneration plan that—from the early 1990s—has transformed the previously decaying Quayside area of Gateshead and Newcastle upon Tyne (its neighbour on the opposite bank of the River Tyne) into a showplace for modern architecture. The nearby Millennium Bridge (1997–2001) and Sage Music Centre (1997–2004) are the most spectacular products of this building boom.

Banham, Reyner See INDEPENDENT GROUP.

Banksy (1974?–) British artist, well known for spray-painted stencils applied clandestinely in public places. His real name is uncertain but he has been identified as Robert or Robin Banks or Robin Gunningham (*Daily Mail*, 14 July 2008). His identity is kept secret, supposedly because of the illicit nature of his activities, but purported photographs have been published in British newspapers. The work usually has some political significance, as in his well-known image of a demonstrator throwing a flower where one would expect to find a Molotov cocktail. He makes witty use of the illusionistic properties of stencil against wall. One of the best, on a sexual health clinic in Bristol, believed to be Banksy's native city, shows a naked man clinging from a window ledge. Banksy's works have been further disseminated by popular books on his work such as *Wall and Piece* (2005). He has also introduced works surreptitiously into museums. The British Museum was the involuntary host for a picture of a cave man with a shopping trolley, which it subsequently accessioned. Banksy has made more marketable works which have been collected by film stars such as Brad Pitt. They include parodies of the paintings of others, such as a version of *Vettriano's *Singing Butler* set on a polluted beach. He has shown extraordinary skill in keeping himself in the news with such activities as smuggling a man dressed in the orange costume of a Guantanamo Bay inmate into Disneyland. For his Los Angeles exhibition 'Barely Legal' in 2006 he introduced an elephant painted to match the wallpaper. The explanation was that it represented the 'elephant in the room', the issues we choose to ignore such as poverty in the developing world.

Further Reading: S. Hattenstone, 'Something to Spray', *The Guardian* (17 July 2003)

Bänninger, Otto See RICHIER, GERMAINE.

Baranoff-Rossiné, Vladimir (1888–1944) Russian painter, sculptor, musician, and experimental artist, born at Kherson in Ukraine. After studying painting in St Petersburg he spent the years 1910 to 1916 in Paris, where he moved from *Post-Impressionism to *Cubism. An example of his sculpture of this period is *Symphony No. 1* (1913, MoMA, New York), a witty figure of a musician made of polychrome wood, cardboard, and crushed eggshells; it looks rather like a junk *Archipenko. After the Russian Revolution Baranoff-Rossiné taught at various art institutions in Petrograd (St Petersburg) and (from 1919) Moscow. His work of this time included abstract paintings and constructions, some of them made from manufactured bits and pieces such as old gutter pipes, bedsprings, etc. He also constructed a 'colour piano' or 'opto-phonic piano' (1923, Pompidou Centre)

on which he gave 'visual' concerts intended to demonstrate a synthesis of music and the visual arts. After leaving Russia in 1925 he settled in Paris; he was arrested there by the Gestapo in 1943 and died in a prison camp the following year.

Barbeau, Marcel *See* AUTOMATISTES.

Barker, Clive *See* POP ART.

Barlach, Ernst (1870–1938) German sculptor, printmaker, and writer, a leading figure of *Expressionism. He was born at Wedel, near Hamburg, the son of a doctor, and studied at the School of Arts and Crafts in Hamburg, 1888–91, the Dresden Academy, 1891–5, and the *Académie Julian, Paris, 1895–6. After his return to Germany he spent the next decade working variously in and around Hamburg and in Berlin. During this period he worked as much on ceramics as on sculpture in a fairly derivative *Art Nouveau style, but a turning point in his career came in 1906 when he went to Russia to visit a brother who was working for an industrial company in Ukraine. The vast empty landscape and the sturdy Russian peasants made a great impact on Barlach, as his sketchbooks show. These hardworking people, with their simple faith, symbolized for him 'the human condition in its nakedness between Heaven and Earth' and helped inspire him to create a massively powerful figure style through which he expressed a wide range of emotion. He was influenced also by medieval German carving, with which he recognized both a spiritual and a technical affinity—he preferred to carve in heavy, close-grained woods, but even when his figures were modelled in clay and cast in bronze they retain the broad planes and sharp edges typical of woodcarving.

In 1907 Barlach became financially secure when he signed a contract with the Berlin dealer Paul *Cassirer, agreeing to sell him his entire output for a fixed salary. In 1910 he moved to Güstrow, a small town near Rostock, where he was to spend the rest of his life, and by this time he had created his mature style, which changed little thereafter. His most characteristic works are massive, blocklike, heavily robed single figures or pairs of figures symbolizing some aspect of the human condition (*The Solitary One*, 1911 Kunsthalle, Hamburg). George Heard *Hamilton writes that 'Whether in wood or plaster the forms are sometimes so tightly compact that their emotional charge

seems about to explode'. Barlach also produced several monuments commemorating the First World War and he was a prolific maker of lithographs and woodcuts, particularly of illustrations to his own plays. The first of these to appear was *Der tote Tag* (The dead day), published by Cassirer's Pan-Presse in Berlin in 1912; the text was accompanied by a separate portfolio of 27 lithographs. He published six more plays, the last in 1929; they are sombre works, typically showing the individual wrestling with the ties of the material world in search of God, but they sometimes have a grotesque humour not seen in his sculpture.

After the First World War (in which he served briefly in the army) Barlach was much honoured. He was made a member of the Berlin Academy in 1919, for example, and of the Munich Academy in 1925, and in 1924 was awarded the Kleist Prize (for literature). His autobiography, *Ein selbsterzähltes Leben*, was published in 1928 and his 60th birthday in 1930 was marked by a large exhibition of his work at the Berlin Academy. After the Nazis came to power in 1933, however, he was declared a *degenerate artist; 381 of his works were confiscated from museums and his war memorials at Güstrow, Kiel, and Magdeburg were dismantled. In 1937 he wrote: 'A pimp or a murderer is better off. He at least gets a legal hearing and can defend himself. But we are simply repudiated, and whenever possible purged.' He died the following year. After the war, his memorial in Güstrow Cathedral was restored and a copy made for the Antoniterkirche in Cologne; it takes the form of a hovering bronze angel and is considered by many to be his most deeply spiritual work. There are museums dedicated to Barlach in Güstrow, Hamburg, and Ratzeburg. His collected writings have been published in three volumes (1956–9) and his letters in two volumes (1968–9).

Barnard, George Grey (1863–1938) American sculptor, an independent, original, and controversial figure. He was born in Bellefonte, Pennsylvania, and after studying briefly at the Art Institute of Chicago he moved to Paris in 1883. After years of hardship there he returned to the USA in 1894 (against the advice of *Rodin, to whom his vigorous style was much indebted) and settled in New York. In 1902 he received the largest commission given to an American sculptor up to that date—a

vast scheme of allegorical decorations for the Pennsylvania State Capitol at Harrisburg. He returned to France to work on this. In 1906 there was a scandal in Harrisburg over misuse of public funds, bringing payment to Barnard to an end, but he continued the project at his own expense and it was unveiled—on a much smaller scale than originally envisaged—in 1911. His final major work was a bronze statue of Abraham Lincoln, set up in Lytle Park, Cincinnati, in 1917. It caused a furore: Barnard had attempted to show the national hero as an ordinary man in deep thought, but some thought it made him look like a 'dishevelled dolt' and Lincoln's son described the statue as 'grotesque and defamatory'. However, it also had strong supporters, including the former president Theodore Roosevelt, who said 'The greatest statue of our age has revealed the greatest soul of our age', and Barnard's one-time pupil Jacob *Epstein.

Barnes, Dr Albert C. (1872–1951) American drug manufacturer, art collector, and patron, born in Philadelphia. He made a fortune with the antiseptic Argyrol, which he invented in 1901 (its success is said to have depended largely on its being adopted as the standard anti-venereal treatment of the French army), and by about 1912 he was devoting his life to collecting. Around this time, William *Glackens, an old school friend, encouraged him to turn his attention from the Barbizon School to *Impressionism and *Post-Impressionism; thereafter modern French painting remained his chief field of interest, although he also collected Old Masters and primitive art. In 1922 he established the Barnes Foundation at Merion, Pennsylvania, to house his collection and to provide education in art appreciation. His collecting habits had sufficient economic impact on the Paris art world for one magazine to tell struggling artists 'Courage boys! Barnes is back in town!' He wrote and lectured on art (his books include *Art in Painting*, 1926), but the museum he created was not open to the public during his lifetime, partly because he had a grudge against critics and the art establishment in general after his collection received a hostile reception when it was shown at the Pennsylvania Academy of the Fine Arts in 1923. In addition to collecting works, Barnes commissioned *Matisse to paint a mural decoration for the Foundation in 1931, and when it turned out to be unusable because of an error in the measurements he

had been given, Matisse did a new version. The abortive scheme, *The Dance I* (1931–2), is in the Musée d'Art Moderne de la Ville de Paris, and the second scheme, *The Dance II* (1932–3), is *in situ* in the Barnes Foundation. The collection of Matisse's work is one of the best in the world, and *Cézanne, *Picasso, and *Renoir are among the other artists who are particularly well represented.

Joseph Alsop describes Barnes as 'perhaps the greatest single art collector of the twentieth century'. Alsop writes that he used 'shameless flattery' to gain admission to the Foundation in 1929, when he was a nineteen-year-old student, and several other visitors who managed to gain access commented on the shortcomings in Barnes's personality. According to Kenneth *Clark, for example, he was 'not at all an attractive character. His stories of how he had extracted Cézannes and Renoirs from penniless widows made one's blood run cold.' Jacob *Epstein wrote that he had 'a reputation for boorishness of which, on my visit to see him, I found no trace', but added that 'I was told that dictaphones were installed in the walls, so that critics who were facetious or too frank could be instantly reported and told to go'. Among the distinguished artists and art historians who were refused admission to the Foundation were *Le Corbusier, Meyer *Schapiro, and John Rewald (1912–94), author of celebrated histories of Impressionism (1946, 4th edn, 1973) and Post-Impressionism (1956, 3rd edn, 1978).

After Barnes's death (in a car accident), a lengthy campaign was carried out—led by the publisher of *The Philadelphia Inquirer*, Walter Annenberg—to try to force the trustees of the Foundation to open the collection to the public or lose its tax-exempt status. An agreement was reached in 1960 allowing restricted public access, but the collection retained its almost legendary aura as a virtually inaccessible treasure trove. In his will Barnes had stipulated that his paintings should remain exactly as he left them. However, in 1991 a court ruled that this directive could be overturned in order to raise money necessary for the maintenance of the building in which they were housed. In 1993–4 a selection of pictures consequently went on tour to Paris, Tokyo, and several American cities. The catalogue of the exhibition reproduced many of the paintings in colour for the first time, for the Foundation had previously forbidden this. *See also* GUILLAUME, PAUL.

Barney, Matthew (1967–) American sculptor, Performance artist, draughtsman, and film-maker. His early performance *Physical Restraint* turned the act of drawing into a kind of endurance test. In this sense he was working in the tradition of earlier *Body artists such as Vito *Acconci and Chris *Burden. He was interested in the idea of hypertrophy, the process whereby the body is actually damaged by exertion in order, ultimately, to make it stronger. His best-known work is a series of five films made between 1994 and 2002, the *Cremaster* cycle. Although these have been screened in both museums and cinemas, they are only issued complete on DVD in a special limited edition. The title refers to the muscle which controls the raising and lowering of the testicles. One of the themes is sexual differentiation and it is in some way a response to *feminist art and theory that a male artist now places sexual difference at the centre of his work. The films are visually exhilarating and also highly confusing. They contain references to legends and Masonic rituals, featuring human oddities and feats of physical prowess. Characters include the magician Harry Houdini and the condemned murderer Gary Gilmore, who may have been Houdini's grandson, and who in the film dies not by firing squad but in a rodeo on a bull. Barney has said that he originally thought of the series of films in terms of their locations, almost a kind of *Land art. For instance, the first to be filmed, *Cremaster 4*, was set on the Isle of Man and constructed around the famous TT motorcycle race. Barney has also made sculpture and this frequently references the *Cremaster* films, as in *The Cabinet of Baby Fay La Foe* (2000, MoMA, New York), a vitrine of objects associated with one of the characters.

(⊕) SEE WEB LINKS

• Interview with Matthew Barney, *Tate Magazine*, no. 2, Tate website.

Barr, Alfred H., Jr. (1902–81) American art historian and administrator who played an enormously important and controversial role in establishing an intellectual and institutional framework for the study and appreciation of modern art. He was born in Detroit, the son of a Presbyterian minister, and studied art and archaeology at Princeton University, graduating in 1922 and taking an MA degree the following year. After several months travelling in Europe, he returned to the USA and taught art history in several leading institutions including Wellesley College, where he taught the first course at an American college devoted solely to 20th-century art. In 1929 he was appointed director of the newly founded *Museum of Modern Art, New York. Over the next four decades he was largely responsible for building the museum's collections and reputation (he resigned as director in 1943 so he could devote more time to writing, but he continued as director of research, and retired in 1967 with the title of director of museum collections). After his retirement he compiled a massive catalogue of all the paintings and sculptures that were in the permanent collection at the end of his 38 years of service; this was published in 1977 as *Painting and Sculpture in the Museum of Modern Art 1929–1967*, containing entries for 2,622 works by 999 artists. An important aspect of his catholic and systematic approach was that he widened the traditional concept of the art museum to embrace visual arts as a whole, including architecture, industrial design, photography, and motion pictures.

Barr organized more than 100 exhibitions at the Museum of Modern Art, including such famous shows as 'Cubism and Abstract Art' and 'Fantastic Art, Dada, Surrealism' (both 1936), and he did much to create the modern idea of an art exhibition, through such means as special lighting, expository wall captions, and scholarly, fully illustrated catalogues. He wrote numerous books and catalogues himself, setting impressive standards of scholarship but presenting his findings in an accessible style. His two most highly regarded books are probably *Picasso: Fifty Years of his Art* (1946) and *Matisse: His Art and his Public* (1951). The latter was long regarded as a standard work; indeed, in 1985 John *Golding described it as 'in many respects still the most satisfactory monograph on any major twentieth-century artist'. *Cubism and Abstract Art* (1936) has survived less well. Its famous diagrammatic representation of the history of modern art as a collection of movements linked by arrows became a consistent object of mockery in the 1980s, when art historians attacked its implicit view of modern art as a kind of self-sustaining development that had abstraction as an inevitable goal.

Barr was, even in his time, a controversial figure. In 1936 his internationalist approach also brought him into conflict with the chairman of the Board of Trustees, Conger

Goodyear, who insisted on employing an American architect for the museum's new building rather than Barr's choice of Mies van der Rohe (see BAUHAUS). He was attacked within the world of modern art as well as by conservatives. In 1936 he was criticized by Meyer *Schapiro for presenting the development of abstract art as independent of historical conditions. Some critics thought that the museum he created had too powerful an influence in shaping—rather than reflecting—the course of modern art: in 1960, for example, John *Canaday described Barr in *The New York Times* as 'the most powerful tastemaker in American art today and probably in the world'. Barr replied that he was a 'reluctant' tastemaker, moving at a discreet distance behind the development of art. Indeed in 1954 the executive director of *Art News*, Thomas B. Hess, accused Barr of being 'late on *Abstract Expressionism'. Nonetheless Barr could sometimes back his personal judgement with a considerable degree of daring, as when he acquired for the museum three paintings by Jasper *Johns at his first solo exhibition in 1958. A fourth work, a flag painting, was bought on his behalf by the architect and collector Philip Johnson, as Barr was worried that it would be politically contentious. Johnson then refused to cede the painting, which he had grown to like, although he eventually gave it to the museum anyway in tribute to Barr.

Further Reading: A. Cohen-Solal, 'The Ultimate Challenge for Alfred H. Barr Jr.: Transforming the Ecology of American Culture, 1924–1943' in J. Marter (ed.), *Abstract Expressionism: The International Context* (2007)

Barré, Martin (1924–93) French painter, born in Nantes. His abstract paintings, always the result of the work of a single session, tend to expose the elements of painting, especially the process of making. This to some extent distinguished him from other post-war French abstractionists who were more concerned with the exercise of taste and 'fine painting'. For instance, some of Barré's paintings consist of repeated lines of equal length but differentiated by the accidents of the dragging of the brush along the surface of the canvas. In other works he used paint applied with the knife or the aerosol can. In some works the composition is determined by the mathematical division of the canvas, but the paintings have a kind of instability which the critic Jean Clay compared to the operations of the dream. Because of his somewhat austere approach to painting, he was relatively little known for a

long time but he became more successful in the 1970s, partly owing to the interest in American painters who were similarly preoccupied with process.

Further Reading: Musée d'Art Moderne de la Ville de Paris, *Martin Barré* (1979)

Barry, Robert See CONCEPTUAL ART.

Barthes, Roland (1915–80) French critic, known principally as a literary theorist but who has also exercised considerable impact on thinking about the visual arts. His work was based on semiology, the study of signs, and his project was first and foremost to uncover the workings of the sign. The idea that works of visual art should be understood as bearers of meaning is, of course, nothing novel. The iconological analysis of Panofsky (see FORMALISM) and his school was based on the idea that images could be decoded to reveal the mindset of the world which produced them. However, Panofsky dealt primarily with images from the past. Barthes in *Mythologies* (1956) looked at popular culture in contemporary France as it negotiated its way to a consumer society. Barthes's approach did not assume that the representations he analysed were consciously intended by their producers to communicate meaning, although they might have been. Whether he was talking about all-in wrestling or the new model Citroën DS 19, with which the French motor industry was cautiously attempting to compete with American product styling, Barthes's point was that these myths were experienced as collective representations. In his analysis of the Citroën car Barthes was obviously aware that the meanings he found were in some way calculated by designers and marketing men. The point was that they existed quite independently of their intentions. Their power lay in the fact that they appeared perfectly 'natural', indeed quite unlike representations which bore the obvious marks of being constructed to produce an effect. The socially critical view of the mass media proposed by Barthes inspired an exhibition held in Paris in 1964 entitled 'Everyday Mythologies', which showed the work of artists such as *Erró and Hervé *Télémaque, whose style was close to *Pop but far more politically critical.

He also wrote an influential text on photography, *Camera Lucida* (1981). Here he celebrates the accidental aspect of a photograph

which resounds in the mind of the viewer. This he calls the *punctum*. He opposes this to the *studium*, the structured message borne by the photograph. The effect of this is to take discussion of the photograph away from concentrating on meaning, which has been deliberately built into the photographic image, towards those aspects that evade the control of the photographer. This also coincided with his own tastes in painting, which favoured those artists, such as *Réquichot and *Twombly, whose work seemed to evade the structures of language. *See also* APPROPRIATION.

Further Reading: S. Sontag (ed.), *A Roland Barthes Reader* (2000)

Bartlett, Jennifer (1941–) American painter, born in Long Beach, California. She was included in the important *New Image Painting exhibition of 1978 with her painting installation *Rhapsody* (1975–6, MoMA, New York). This consists of 987 steel plates, silkscreened with a grid system, and then painted in baked enamel. The work, which stretches to over 150 feet in length, runs systematically through various combinations of images, forms, and styles. It starts with the basic shapes of circle, square, and triangle, which are combined in different ways and different scales, before figurative elements such as houses and trees are introduced. Her systematic approach was intended, she said, to put herself 'in a position where taste is not an issue'. Her work anticipated the cultivation of stylistic pluralism which was a feature of the 1980s. Seeing the work once again in 1999 Marcia Vertrocq wrote that 'Even though critical absolutism is largely a relic of the past, Bartlett's informed ecumenism remains no less liberating today' (*Art in America*, April 1999). Bartlett has continued to use a grid format in her later work and mixed abstract and figurative modes.

Basaldella, Dino *See* MIRKO.

Baselitz, Georg (1938–) German painter, printmaker, draughtsman, and sculptor, born at Deutschbaselitz, Saxony. He began his training in East Berlin, where he was expelled from the academy for 'ideological immaturity', then moved to West Berlin in 1956 and studied at the Academy. It was at this time that he gave up his original surname, Kern, and adopted a name derived from his place of birth. In West Germany he found abstraction as unpromis-

ing a prospect as the *Socialist Realism which had been imposed in the East. He found an alternative in a kind of painting which combined the wild handling of *Tachisme with a fragmented or distorted treatment of the figure. In 1961 he had the first of two exhibitions in collaboration with Eugene *Schönebeck, for which they produced their *Pandemonium* manifesto. This document was strongly influenced by the violent language of Antonin *Artaud, whom Baselitz admired. The most notorious of the early pictures is *The Great Piss-Up* (also called *Big Night Down the Drain*, Museum Ludwig, Cologne, 1962–3); it shows a man with an enormous penis (it was inspired by a story about the Irish writer Brendan Behan exposing himself while drunk), and it was seized by the police when it was first shown in Berlin in 1963. In 1965 Baselitz spent time in Florence on a scholarship. There he was impressed by the distortions of the figure found in Mannerist painting. A large painting of that year, *The Great Friends* (Museum Ludwig, Cologne), is an early instance of Baselitz's preoccupation with German history. Two figures, wearing shorts with undone flies, stand in the middle of a ruined townscape. At their feet lies a discarded red flag. In 1967–8 there followed a series of paintings in which the subjects, woodcutters and the forest, again a characteristically German motif, were torn up and reconstituted.

In 1969 Baselitz discovered the device that has served him ever since. The paintings were made with the subject upside-down. This created a situation whereby, although there was still a visible subject, it became less significant than the application of paint. The upside-down method, however, by the 1980s, seemed to function increasingly as an act of aggression. The painter said: 'An object painted upside-down is of use for painting because it's no use as an object ... My relation to the subject is random.' He also began working as a sculptor and he first become well-known outside Germany when his wood carving *Model for a Sculpture* (1980, Museum Ludwig, Cologne) was seen at the Venice *Biennale. This aroused instant controversy because of its alleged associations. The raised right hand could be interpreted as a Nazi salute. In 1981 a number of Baselitz's paintings were seen at the *Royal Academy's exhibition 'A New Spirit in Painting'. He appeared then as one of the leading figures in *Neo-Expressionism and as

such took many of the attacks which were visited on that tendency. In 2007 his art returned to the RA for a retrospective exhibition. Much of the original debate as to the merits of the work had died down and he was accepted by most critics as an important figure, although there was a general view that the most recent paintings, in which he visited the themes of his classic work ('remixes' was his description), represented a certain falling-off of power.

Further Reading: Royal Academy of Arts, *Baselitz* (2007) Whitechapel Art Gallery, *Georg Baselitz Paintings 1960–83* (1983)

Baskin, Leonard (1922–2000) American sculptor, printmaker, draughtsman, and book designer, born in New Brunswick, New Jersey, the son of a rabbi. He had a long and varied training, studying first with the sculptor Maurice Glickman, 1937–9, then at the universities of New York, 1939–41, and Yale, 1941–3. After serving in the US Navy during the Second World War, he continued his studies at the New School for Social Research in New York, graduating in 1949, then at the Académie de la Grande Chaumière in Paris, 1950, and the Academy in Florence, 1951. On his return to the USA he began teaching at Smith College, Northampton, Massachusetts, in 1953. Baskin said that 'man and his condition have been the totality of my concern', and his belief that art should express moral and social concerns was at odds with the prevailing abstraction of the 1950s. His most characteristic sculptures are brooding, full-length, standing figures (in bronze, stone, or wood) portraying 'anxiety-ridden man imprisoned in his ungainly self' (*Man with a Dead Bird*, 1951–6, MoMA, New York). They have a kinship with the graphic art of *Barlach and *Kollwitz—the two modern artists Baskin admired most. Baskin himself was a prolific printmaker, especially of woodcuts, many of which were used as book illustrations. His interest in books encompassed the whole of their design, including typography and binding, and in 1952 he founded the Gehenna Press to produce limited editions.

Further Reading: I. Jaffe, *The Sculpture of Leonard Baskin* (1980)

Basquiat, Jean-Michel (1960–88) American painter, a key figure in the transition of *Graffiti art from a street phenomenon to the world of galleries and mainstream modern art. He was born in Brooklyn, New York, to a

Haitian father and a Puerto Rican mother. From 1977, when he definitively left home after a patchy school career, he worked on the streets in New York in collaboration with Al Diaz writing slogans with felt-tip, always with the signature SAMO©. As a publicity tactic this was enormously effective. In 1980 he met Andy *Warhol and Henry *Geldzahler and his work was praised in the influential publication *Art in America*. In 1981 he had his first solo exhibition at the Annina Nosei Gallery, which for a period also became the studio for the homeless artist. International success followed, his work corresponding very much to the tendency of the period towards *Neo-Expressionism. He also made works in collaboration with Warhol. His early death from a drug overdose was followed by critical reassessment, and the enormous impact his paintings had made when first seen was sometimes ascribed to clever marketing. Robert Hughes described his story as 'the tale of a small untrained talent caught in the buzz saw of art-world promotion, absurdly overrated by dealers, collectors, critics, and, not least, himself'. However, there have also been serious attempts to assess his work in the light of interest in black culture. His work has constant references to jazz and African sculpture. Richard Powell points out the recurring motif of the 'see-through man', which 'spoke to the notion that anatomy had a theatrical quality that, when paired with blackness, was a radical attack on society's superficiality and deepseated racism'. Despite its origins in the street, Basquiat's art was very different from the subway graffiti which, in the early 1980s, were beginning to get serious academic and market attention. Instead of the smooth contours and shadings of the spray can, Basquiat's paintings have a raw violence. They knowingly refer to an idea of an African heritage mediated through modernist artists such as *Picasso and *Dubuffet. Some of the paintings have highly complex surfaces mixing colour photocopies with the paint. In 1996 a film about his life was released, directed by Julian *Schnabel.

Bataille, Georges (1897–1962) French critic, antiquarian, and novelist, born in Puy-de-Dome. He was the editor of the journal *Documents*, which ran from 1929 to 1930. It was intended by its backer to be a luxurious and scholarly art journal. However, Bataille, as well as being an expert in numismatics, had a second life as the anonymous author of a

pornographic novel, *The Story of the Eye*. He wrote 'I challenge any collector to love a painting as much as a fetishist loves a shoe.' Under his editorship *Documents* became a journal which threatened the authority of André *Breton by providing an alternative space for those disenchanted with his version of *Surrealism. *Documents* combined illustrations of contemporary art, including the first ever publication of a work by *Dalí, with art images of the art of the past, film stills and photography. Bataille treated these as all on the same level, making a journal which contrasted to the sober appearance of *La Révolution surréaliste*. A notable feature was the photography of Jacques-André Boiffard (1902–61) depicting carnival masks and a series on the big toe. Despite the fact that *Documents* was so short-lived, it has been increasingly realized by historians of Surrealism that many important Surrealist artists including *Giacometti, *Miró, and *Masson owed as much to Bataille's thinking as to Breton's. The philosophy of the two was profoundly different. Bataille proposed a kind of radical materialism which sought out the base of things, sometimes in quite literal terms. He was also fascinated by violence, which he associated with the idea of sacrifice, and he had witnessed, when young, the death of a bullfighter (the event is commemorated in *The Story of the Eye*). *Documents* reproduces photographs of slaughterhouses taken by Eli Lotar (1905–69), later to be one of Giacometti's habitual models. Bataille's conception of base materialism, the 'formless', has also provided support for a kind of alternative history of *modernism which is radically opposed to the idea of purity of form and medium. The exhibition 'Informe', held at the Pompidou Centre in 1996 and organized by Rosalind *Krauss and Yves-Alain Bois, linked Bataille with developments in post-war art that rejected precise form in favour of the power of matter, such as the earthworks of Robert *Smithson, the works in burnt plastic of Alberto *Burri, and the bubble machines of David *Medalla.

Further Reading: Ades and Baker (2006)

Bateau-Lavoir (Washerwomen's Boat) A cluster of tumbledown studios in the rue Ravignan, Montmartre, Paris, where several artists who later became famous lived and worked in the early years of the 20th century, most notably *Picasso. He lived there from 1904 to 1909 and held on to his studio until

1912. Others who lived there at the same time included van *Dongen, *Gris, and briefly *Modigliani. The building had begun life as a piano factory and was converted into studios in 1889. Rents were cheap, reflecting the primitive conditions (there was no gas or electricity), and it became a place of seedy allure, associated for a time with anarchist activity. Largely under the influence of Picasso's personality it became a literary and artistic centre and it is usually regarded as the birthplace of *Cubism (it was here that Picasso painted *Les Demoiselles d'Avignon*). Among the writers who lived there were the poets Max *Jacob and André *Salmon, both of whom have been credited with coining its name—a reference to the fact that in windy weather parts of the rickety building would sway like laundry boats moored in the Seine. In 1969 André *Malraux declared the Bateau-Lavoir a historical monument, but it burned down the following year. A new complex of artists' studios was erected on the site, now 13 Place Émile-Goudeau.

Bateman, H. M. (Henry Mayo) (1887–1970) British cartoonist, designer, and painter, born in Australia of English parents. His family returned to England when he was a baby, and he later studied in London at Westminster School of Art and at *Goldsmiths College. He first had his work published in 1903, in *Scraps*, and the following year he began his long association with the *Tatler* magazine, one of the many periodicals for which he worked. Bateman became famous for his 'The Man Who . . . ' cartoons, a long-running series illustrating social gaffes based on middle-class aspirations and snobbery. In the interwar years, he was said to be the highest-paid cartoonist in Britain, and he was also in demand as a designer of advertising posters (notably for Guinness beer and Kensitas cigarettes). About a dozen books of his drawings were published and he illustrated books by many other people.

Further Reading: M. Bateman, *The Man who Drew the 20th century* (1969)

Bath Academy of Art Art school established in 1946 at his home Corsham Court, Wiltshire (about eight miles from Bath), by Paul Ayshford, Lord Methuen (1886–1974), a painter of landscapes and architectural and figure subjects (examples of his work are in Tate). It incorporated an earlier school that

had been in existence since 1832. The Academy attracted distinguished teachers and quickly achieved a high reputation as a centre for a quite distinct 'West country' branch of modernism which took cognizance of advanced French artists such as *Dubuffet. Kenneth *Armitage was the first head of sculpture and the teachers of painting have included William *Scott, Gillian *Ayres and Howard *Hodgkin.

Bauchant, André (1873–1958) French *naive painter. He was a market gardener until 1914 and did not begin painting until 1919, when he was demobilized after war service (in the army he had shown a talent for drawing and had been trained as a mapmaker). In 1921 his work was shown at the *Salon d'Automne, and he soon became one of the best-known painters of his type. He was promoted by Wilhelm *Uhde, the leading impresario in the cult for the naive, and his admirers and patrons included *Diaghilev (who in 1928 commissioned him to design costumes and sets for the ballet *Apollo Musagète*, to music by Stravinsky), *Le Corbusier, *Lipchitz, and *Ozenfant. Bauchant's favourite subjects were history and mythology, for which he found inspiration in old illustrated books; two examples are in the Tate (*Greek Dance in a Landscape*, 1937; and *Funeral Procession of Alexander the Great*, 1940).

Baudelaire, Charles See MODERNISM.

Baudrillard, Jean (1929–2007) French sociologist, highly influential on *Postmodernist thinking, born in Reims. He taught at the University of Nanterre, regarded in the 1960s as one of the most politically radical of French universities. His first book, *The System of Objects* (1966), was strongly influenced by Roland *Barthes' semiotic analysis of contemporary commercial imagery, which Baudrillard applied to consumer products. *Simulcra and Simulation* (1981), which argued that real life was being taken over by a simulation produced by the media, was his most influential book on art theory and practice. Its impact on the art world coincided with the success of artists such as Richard *Prince and Haim *Steinbach who were engaged in *appropriation. His ideas were taken to validate the concept that the artist could not engage with the 'real' because it no longer existed. Baudrillard had an ambivalent attitude to the art world attention he received. He was happy to know

that his ideas operated in areas outside academe, but he found that the 'play on quotations' in recent art was boring for him.

Further Reading: C. Francblin, 'Interview with Jean Baudrillard', *Flash Art*, no. 130 (October–November 1986)

Bauhaus A school of art and design founded by Walter *Gropius in Weimar in 1919 and closed by the Nazis in 1933 after moving successively to Dessau (1925) and Berlin (1932); in spite of its short life, it was the most famous art school of the 20th century, playing key roles in establishing the relationship between design and industrial techniques and in breaking down the hierarchy that had previously divided 'fine' from 'applied' arts.

The Bauhaus was created when Gropius was appointed head of two art schools in Weimar in 1919 and united them in one: they were the Kunstgewerbeschule (Arts and Crafts School) and the Hochschule für Bildende Kunst (Institute of Fine Arts). He gave his new school the name Staatliches Bauhaus in Weimar (Weimar State 'Building House'), coining himself the word 'Bauhaus' (an inversion of 'Hausbau'—house construction). His manifesto formulated three main aims for the school: first, to unite the arts so that painters, sculptors, and craftsmen could in future embark on co-operative projects, combining all their skills harmoniously; secondly, to raise the status of the crafts to that enjoyed by the fine arts; and thirdly, to establish 'constant contact with the leaders of the crafts and industries of the country' (an important factor if the school were to survive in a country that was in economic chaos after the war).

All students had to take a six-month preliminary course (Vorkurs) in which they studied the principles of form and colour, were acquainted with various materials, and were encouraged to develop their creativity. After that they moved on to workshop training in the field of their choice. Each workshop—in carpentry, metalwork, stained glass, weaving, typography, and so on—was run by two people, a Werkmeister (Workshop Master—a craftsman) and a Formmeister (Master of Design—an artist): 'The former would teach method and technique while the latter, working in close co-operation with the craftsmen, would introduce students to the mystery of creativity and help them achieve a formal language of their own' (Frank *Whitford). In theory the Werkmeister and Formmeister had equal status, but in practice the Formmeister were

regarded as more important. Students were known as 'journeymen' and then (after moving to the workshop stage) as 'apprentices', emphasizing the craft-based nature of the school.

Gropius brought together a remarkable collection of teachers at the Bauhaus. The first head of the preliminary course was Johannes *Itten, and when he left in 1923 he was succeeded by László *Moholy-Nagy, who replaced Itten's rather metaphysical approach with an austerely rational one. The Formmeister included some illustrious painters, most notably *Kandinsky and *Klee. Lyonel *Feininger was the only teacher to be on the Bauhaus staff for its entire history (although he did little actual teaching for much of that time). Among the few women teachers the most important was the weaver Gunta Stölzl (1897–1983) (see FIBRE ART). Admission was difficult for students and many who did get in were rejected after the preliminary course. On average there were about a hundred students at the Bauhaus at any one time, the total enlistment in its fourteen-year history being about 1,250. Several students went on to become teachers at the school, notably Josef *Albers and the designer Herbert Bayer (1900–85).

In 1924 right-wingers gained power in the provincial elections and cut funding to the Bauhaus, which consequently moved to Dessau the following year; it was housed in a group of new buildings designed by Gropius (built 1925–6). The school now styled itself a Hochschule für Gestaltung (Institute for Design), teachers were called professors (a term Gropius had previously avoided because it smacked of academicism), and the dual Werkmeister–Formmeister system was abandoned. Gropius had envisaged this last change from the start, for now former students were available to teach both theory and practice: 'a new previously unavailable type of collaborator for industry, craft, and building, who is the master equally of technique *and* form'.

The Bauhaus had been involved in architectural commissions from the outset (Gropius's manifesto had begun by saying 'the ultimate aim of all creative activity is the building'), but it was only in 1927 that an architectural department was established. Students who chose to specialize in this subject after their preliminary course were not obliged to acquire any craft skill. The Swiss architect Hannes Meyer (1889–1954) was appointed first professor in this department, and when Gropius resigned suddenly a year later to de-

vote himself to private practice he named Meyer as his successor as director. It was an unpopular choice with the staff, as Meyer was a Marxist and instituted a sociological approach that changed the whole tone of the school, with politics occupying an important place in the curriculum. Moholy-Nagy resigned immediately and Bayer soon afterwards. Meyer wanted the Bauhaus to supply 'the needs of the people instead of the needs of luxury' and encouraged the workshops to make mass-produced goods. His approach earned considerable funds for the school but disaffected most of the staff, who hated the idea of advertising dominating aesthetics. In 1930 Meyer was forced to resign and was replaced by Ludwig Mies van der Rohe (1886–1969), one of the greatest architects of the 20th century.

Mies's main task was to rid the school of its political associations and thereby make it a less easy target for its right-wing opponents (the Nazi party was gaining strength throughout Germany). However, there were now a good many committed left-wing students at the school and one of their noisy meetings almost degenerated into a riot. Mies banned all political activity on threat of expulsion, but in 1932 the Dessau parliament closed the school. In an attempt to keep it alive Mies rented a disused factory in Berlin and reopened the Bauhaus there as a private enterprise, but it was closed by the Nazis in April 1933, soon after Hitler assumed power.

In its last few years the Bauhaus was dominated by architecture, but it produced a great range of goods, with many of them (furniture, textiles, and electric light fittings in particular) being adopted for large-scale manufacture. They were highly varied in appearance, but the style that is generally thought typical of the Bauhaus was severe, geometric, and undecorated. The school published a journal (*Bauhaus*, 1926–31) and a series of books, and its ideas were spread also by the emigration of many of its teachers before and during the Second World War (an exhibition was devoted to the Bauhaus at the Museum of Modern Art, New York, in 1938, and the fact that the school had fallen victim to the Nazis enhanced its status in the democratic world). It has had an enormous influence on art education in the Western world and on visual creativity in general: 'The look of the modern environment is unthinkable without it. It left an indelible mark on activities as varied as

photography and newspaper design...[and] achieved a language of design liberated from the historicism of the previous hundred years' (Frank Whitford).

After the Second World War Dessau became part of East Germany and the Bauhaus buildings were left derelict. In 1976 the school was faithfully restored for the 50th anniversary of its opening in Dessau, and after the reunification of Germany in 1990 it was reopened as a design institution.

Further Reading: F. Whitford, *Bauhaus* (1984)

Baumeister, Willi (1889–1955) German abstract painter. Unlike most significant German painters of his time, he stood outside the ambit of *Expressionism and is regarded as the most 'European' in spirit of his contemporaries. He was born in Stuttgart, where he trained as an interior decorator and then studied at the Academy under *Hölzel. Between 1911 and 1914 he had several stays in Paris (sometimes in company with his close friend Oskar *Schlemmer) and his early work was influenced by *Cubism. After military service in the First World War, he began to develop a personal style in a series (1919–23) of *Mauerbilder* ('wall paintings'), so called because he added sand, putty, etc., to his pigments to give a textured effect. In the mid-1920s his work became more figurative in a manner recalling *Léger and the *Purists (he met Léger, *Le Corbusier and *Ozenfant when he revisited Paris in 1924), and his work met with considerable acclaim in France. In 1928 he was appointed professor of typography at the Städel School in Frankfurt, but in 1933 he was dismissed by the Nazis, who declared his work *degenerate. From then until the end of the Second World War he worked in obscurity in Stuttgart. During this time his work became freer, with suggestions of primitive imagery, creating a kind of abstract *Surrealism. His interest in imagery from the subconscious was described in his book *Das Unbekannte in der Kunst* (The Unknown in Art), written in 1943–4 and published in 1947. After the war Baumeister became a hero to a younger generation of German abstract artists. From 1946 until his death he was a professor at the Stuttgart Academy.

Bawden, Edward (1903–89) British watercolour painter, illustrator, and designer of posters, wallpaper, tapestries, and theatre decor, born at Braintree, Essex. From 1919 to 1922

Bawden studied at Cambridge School of Art, and from 1922 to 1925 at the *Royal College of Art, where his teachers included Paul *Nash and he was a close friend of Eric *Ravilious. He was an *Official War Artist in the Second World War (in France and the Middle East) and painted numerous murals (for example, at Queen's University, Belfast, 1965), but he is best known for his book illustrations. Most of them were done in pen and ink in an incisive economical style, but he also worked with linocut, lithography, and stencil.

Bay Area Figuration (West Coast Figuration) A term applied to the work of a number of American painters active in the San Francisco Bay area in the 1950s whose paintings were figurative but strongly influenced by the broad and vigorous brushwork of *Abstract Expressionism. The main artists involved were Elmer Bischoff (1916–91), Richard *Diebenkorn, and David Park (1911–60), all of whom had either studied or taught at the California School of Fine Arts (where *Rothko and *Still had been teachers in the late 1940s).

Bayes, Gilbert (1872–1953) British sculptor, born in London, the son of **Alfred Walter Bayes** (1832–1909), a painter and etcher. A leading exponent of the *New Sculpture, he concentrated on romantic themes taken from such sources as medieval chivalry and Wagner, and his work was much admired by conservative critics. One such critic, Herbert Maryon, wrote that Bayes's small bronze *Sigurd* (*c.*1910, Tate), judged as a 'decorative composition', was 'unsurpassed by any other equestrian group in existence' (*Modern Sculpture*, 1933). Bayes's other works include the stone relief of sporting figures (1934) outside Lord's cricket ground, London, and the design of the Great Seal of King George V. He wrote *Modelling for Sculpture: A Book for the Beginner* (1930).

His brother, **Walter Bayes** (1869–1956), was a painter and writer on art. He was art critic of the *Athenaeum* from 1906 to 1916 (succeeding Roger *Fry), a founder member of the *Camden Town Group (1911) and of the *London Group (1913), and a highly regarded teacher as principal of Westminster Art School, 1919–34, and director of painting at the Lancaster School of Arts and Crafts, 1944–9. His work as a painter consisted mainly of figure subjects, landscapes, and decorations. He wrote several books, including *The Art of Decorative Painting* (1927)

and *A Painter's Baggage* (1932). **Jessie Bayes** (1876–1970), their sister, was a painter, noted for her work as a miniaturist.

Bazaine, Jean (1904–2001) French painter and designer, born in Paris. His early love was sculpture, which he studied at the École des *Beaux-Arts, but in 1924 he abandoned it for painting, which he studied at the *Académie Julian. From 1931 he exhibited at the *Salon d'Automne, and in 1932 he had his first one-man show. This was seen by *Bonnard, who encouraged Bazaine. His work of this time was figurative and mildly *Expressionist, but after the Second World War he gained an international reputation as one of the leading exponents of *Lyrical Abstraction. However, he continued to base his compositions on natural appearances and denied that his work was abstract; his principle, in his own words, was that 'an essential quality of the object devours the complete object'. He set out his ideas on art in his book *Notes sur la peinture d'aujourd'hui* (1948). His work also included stained-glass windows for the church at Assy (1944–6), a ceramic mural for the church at Audincourt (1948–51), and a mosaic for the UNESCO Building in Paris (1960).

Baziotes, William (1912–63) American painter, one of the minor masters of *Abstract Expressionism. He was born in Pittsburgh and studied at the National Academy of Design, New York, 1933–6. From 1936 to 1941 he worked for the *Federal Art Project, and during the Second World War he became interested in *Surrealism and experimented with various types of *automatism. He had his first one-man exhibition at Peggy *Guggenheim's Art of This Century gallery in New York in 1944. In 1948–9 he collaborated with *Hare, *Motherwell, *Newman, and *Rothko in running the *Subjects of the Artist School in New York and from this grew a meeting centre of avant-garde artists known as The Club. In the early 1950s Baziotes developed his characteristic style, which was not fully abstract but used strange *biomorphic shapes, akin to those of *Miró, suggesting animal or plant forms in an underwater setting (*Mammoth*, 1957, Tate). He said: 'It is the mysterious that I love in painting. It is the stillness and the silence. I want my pictures to take effect very slowly, to obsess and to haunt.'

Beal, Jack (1931–) American *Superrealist painter, born in Richmond, Virginia, and active mainly in New York. Like Alfred *Leslie, he is unusual among Superrealists in that he concentrates on narrative or allegorical subjects, rather than scenes from the banal everyday world. He believes that art should have a didactic message and in 1979 said: 'I think that what we have to try to do . . . is to make beautiful paintings about life as we live it.' His works are often ambitious in scale and composition, notably four panels on *The History of Labor in America* (1976–7) in the Department of Labor Building, Washington DC.

Bearden, Romare (1912–88) American painter, collagist, writer, and lecturer. Bearden is regarded as a leading figure in black American culture, but it was only fairly late in life that he achieved widespread recognition, especially following a retrospective exhibition at the Museum of Modern Art, New York, in 1971. He was born in Charlotte, North Carolina, grew up there, in Pittsburgh, and in Harlem, and read mathematics at New York University, 1932–5, before studying under George *Grosz at the *Art Students League, 1936–7. During the Second World War he served in the US Army, and from 1950 to 1954 he lived abroad, travelling in Europe and north Africa (in 1951 he studied art history and philosophy at the Sorbonne, Paris). His work up to this time had been varied in style (sometimes approaching abstraction) and had often used African imagery, but Jonathan Fineberg writes that 'It was the Civil Rights movement in the early sixties, together with his discovery of black Caribbean culture on the island of St Martin in 1960, that seems to have galvanized him into focusing his artistic gifts on the complexity of the black experience, with all its heritage and adaptations, in late twentieth-century America' (*Art Since 1940*, 1995). From 1964 his most characteristic works were collages combining fragmented photographic images with vivid flat areas of colour; their busy collisions and contrasts of pattern have evoked comparisons with jazz music (in which Bearden—like Stuart *Davis, who influenced him—had a great interest). Bearden was visiting lecturer in African and Afro-American art at Williams College, Massachusetts, in 1969; he also lectured elsewhere, wrote several articles, and co-authored two books: *The Painter's Mind* (1969, with Carl *Holty) and *Six Black Masters of American Art* (1972, with Harry Henderson).

Beardsley, Aubrey *See* STUDIO, THE.

Beaton, Sir Cecil *See* SITWELL.

Beaudin, André (1895–1979) French painter, sculptor, graphic artist, and designer. He was born at Mennecy, Seine-et-Oise, and studied at the École des Arts Décoratifs, Paris, 1911–14. The most important event in his artistic development was his meeting in 1922 with Juan *Gris, who introduced him to *Cubism. Combining this with something of *Matisse's decorative use of colour, he evolved a poetic style characterized by limpid colours and clearly patterned structures. He often painted in series, returning again and again to the same theme (*Horses, Rivers, Villas, The Bicycle*) until he felt he had exhausted it. In 1930 he took up sculpture, using block-like Cubistic forms, and he also made designs for tapestry.

Beaux-Arts, École Nationale Supérieure des, Paris. The chief of the official art schools of France. The origins of the École des Beaux-Arts go back to 1648, the date of the foundation of the Académie Royale de Peinture et de Sculpture, but it was not established as a separate institution until 1795, during the administrative reforms of the French Revolution. It controlled the path to traditional success with its awards and state commissions, and teaching remained conservative until after the Second World War. Entry was difficult—among the artists who failed the examinations were *Rodin and *Vuillard—and students often preferred the private *académies.

Beaux Arts Gallery, London. *See* LESSORE, HELEN.

Becher, Bernd (1931–2007) and **Hilla** (1934–) German photographers, husband and wife, born in Siegen and Berlin respectively. Bernd's background was in graphic design, although he took up painting in the 1950s, giving it up for photography in 1957. Hilla was trained as a photographer and had worked in advertising. They met in 1959 when Hilla was studying and teaching at the Düsseldorf Academy and they embarked on a series of works documenting industrial buildings, which had already been the theme of Bernd's paintings. Much of what they were documenting was vanishing, but where the work goes beyond meticulous record is in its presentation. Photographs of the same type of structure, for instance *Coal Bunkers* (1974, Tate), in different locations are arranged in a grid. The different items have a certain 'family likeness', but the viewer is also invited to reflect upon and appreciate their differentiation. The Bechers' work achieved wide international recognition in the early 1970s at the very time when *Minimalist artists such as Carl *Andre and Sol *LeWitt were using grid systems and *Conceptual artists such as Victor *Burgin were using photography in preference to painting. For Bernd what they were doing was 'documenting the sacred buildings of Calvinism. Calvinism rejects all forms of art and therefore never developed its own architecture. The buildings we photograph originate directly from this purely *economical thinking*.' They were also enormously influential teachers at the Düsseldorf Academy, their pupils including Andreas *Gursky and Thomas *Struth.

(((●))) SEE WEB LINKS

• C. Tittel, 'High Precision Industrial Age Souvenirs', *Sign and Sight* (2 September 2005).

Beckett, Sister Wendy *See* MODERN PAINTERS.

Beckmann, Max (1884–1950) German painter and graphic artist, one of the most powerful and individual of *Expressionist artists. He was born in Leipzig, the son of a flour merchant, and studied at the Weimar Academy, 1900–03. After spending five months in Paris, he settled in Berlin in 1904. At the beginning of his career Beckmann painted figure subjects in a conservative, more or less *Impressionist style, with which he built up a successful career, but his experiences as a medical orderly in the First World War completely changed his outlook and style. The horrors he witnessed affected him so badly that he was discharged in 1915 after a nervous breakdown. He settled in Frankfurt, where he initially worked mainly on drawings and drypoints; it was only after the war that painting became predominant again. Although he rarely depicted scenes from the war itself, his works became full of horrifying imagery, and his forms were expressively distorted in a manner that reflected the influence of German Gothic sculpture. The brutal intensity and element of social criticism in his work led him for a time to be classified with the artists of the *Neue Sachlichkeit, with whom he exhibited at the Kunsthalle, Mannheim, in

1925, but Beckmann differed from such artists as *Dix and *Grosz in his concern for allegory and symbolism and in his highly personal blend of the real and the visionary. His paintings were intended as depictions of lust, sadism, cruelty, etc., rather than illustrations of specific instances of those qualities at work; he ceased to regard painting as a purely aesthetic matter, and thought of it as a moral necessity.

Beckmann was appointed a professor at the Städelsches Kunstinstitut, Frankfurt, in 1929, and from this time began to spend each winter in Paris. In 1933 he was dismissed from his post by the Nazis, and at this time he was working on *Departure* (MoMA, New York), the first of a series of nine great triptychs that occupied him for much of the rest of his life and in which he expressed his horror at man's cruelty. He moved to the Netherlands in 1937 (leaving Germany the day after he witnessed Hitler opening the House of German Art in Munich—*see* NATIONAL SOCIALIST ART). Originally he had intended moving to Paris, but he lived in Amsterdam until 1947. In 1938 he travelled to London for the exhibition of 'Twentieth-Century German Art' put on at the New Burlington Galleries as a reply to the Nazi *'Degenerate Art' exhibition. At the London exhibition Beckmann delivered a lecture *My Theory of Painting* (*Meine Theorie der Malerie*), which was published in 1941. In 1947 he emigrated to the USA, where he spent the remaining three years of his life; he taught at various art schools, mainly in St Louis and New York. Apart from his allegorical figure compositions, he is best known for his portraits, particularly his numerous self-portraits, in which he charted his spiritual experiences. His work forms one of the most potent commentaries on the disorientation of the modern world.

Beecroft, Vanessa (1969–) Italian Performance artist, born in Genoa and active in New York. She organizes tableaux of nude or semi-nude women in a museum context. The models are expected to hold the pose—'think of themselves as objects in a painting'—while the viewer observes but does not interact with them. Her first exhibition, in 1993, was based on a diary which recounted her bulimia, and some writers have speculated that her fascination with the body is linked to this. For an exhibition in Berlin in 2005 she used 100 women of different ages, naked except for see-through tights, with hair in the colours of

the German flag. There is a link between Beecroft's work and the fashion industry and in 2005 she made a work to mark the opening of a new Louis Vuitton store in Paris. She has expressed her admiration for the German photographer Helmut Newton (1920–2004), who in his erotic nude photographs, according to Beecroft, 'makes [women] into beautiful objects which are horrible at the same time'. Not surprisingly the voyeuristic appeal of the work has been attacked by *feminists and there has also been controversy about her attempt to adopt Sudanese children. One of the rare occasions on which she appears in her own work is in a photograph of herself in a white dress with two black children at her breast.

Further Reading: L. Harding, 'Take 100 nudes', *The Guardian* (11 April 2005)

'Beggarstaff, J. & W.' (the 'Beggarstaff Brothers') *See* NICHOLSON, WILLIAM; PRYDE, JAMES.

Behan, John *See* KELLY, OISÍN.

Bell, Clive (1881–1964) British writer on art, born at East Shefford, Berkshire, the son of a civil engineer. He studied history at Trinity College, Cambridge, then spent a year in Paris, 1903–4, looking at art and enjoying the company of painters. In 1910 he met Roger *Fry (by chance, on a train) and—immediately discovering they were kindred spirits—he became Fry's chief apostle in helping to spread an appreciation of the *Post-Impressionist painters in Britain. Bell helped with the organization of Fry's first Post-Impressionist exhibition (1910), and he chose the British section of the second one (1912), including work by his wife, Vanessa *Bell, Fry himself, and Duncan *Grant among *Bloomsbury Group artists, with Spencer *Gore and Wyndham *Lewis representing the more radical wing. His aesthetic ideas, expressed most fully in his book *Art* (1914), were much concerned with the theory of 'significant form'. He invented this term to denote 'the quality that distinguishes works of art from all other classes of objects'—a quality never found in nature but common to all works of art and existing independently of representational or symbolic content. The book is not now taken seriously as art theory, and it contains some absurd statements ('The bulk of those who flourished between the high Renaissance and the contemporary

movement may be divided into two classes, virtuosi and dunces'); however, it is written with fervour, and his ideas were undoubtedly influential in spreading an attitude that placed emphasis on the formal qualities of a work of art (see FORMALISM). Bell was a great Francophile; his other books include *An Account of French Painting* (1931) and a study of the writer Marcel Proust (1928). He was made a chevalier of the Legion of Honour but received no comparable distinction from his own country.

Quentin Bell (1910–96), the son of Clive and Vanessa Bell, was a painter, sculptor, potter, and author, probably best known for his writings on art, mainly on the Victorian period and the Bloomsbury Group. Between 1962 and 1975 he was a professor successively at the universities of Leeds, Hull, and Sussex. Quentin's daughter, **Cressida Bell** (1959–), is a designer, mainly of textiles, and his son, **Julian Bell** (1952–), is a painter and writer on art, author of a book on *Bonnard (1994).

Bell, George (1878–1966) Australian painter, draughtsman, teacher, and critic. In 1903–20 he lived in Europe (he was an *Official War Artist in the First World War), then returned to his native Melbourne. He started teaching privately in 1922 and in 1925 founded the Bell-Shore School with Arnold Shore (1897–1963). By this time Bell was a well-established painter working in an uncontroversial *Impressionist style, but he was plagued by doubts about the validity of his work, thinking that he should be trying to extract the 'underlying truth' from visual appearances rather than merely recording them. He came under the influence of the writings of Roger *Fry and Clive *Bell and in 1934–5 he made another visit to Europe, this time specifically to study modern painting (he was the first Australian artist to do so): *Braque, *Cézanne (above all), *Matisse, and *Picasso were among the artists to whom he paid the most attention. He was less distinguished as a painter than as a teacher—a seminal figure in the development of modernism in Australia: Robert *Hughes (1970) calls him 'arguably the most influential single teacher who ever worked in Australia'. Russell *Drysdale was his most famous pupil. Bell was art critic for the *Melbourne Sun News-Pictorial*, 1923–48.

Bell, Graham (1910–43) British painter and art critic, born in South Africa. After studying at Durban Art School he moved to London in 1931 and became a pupil of Duncan *Grant. In the early 1930s he painted abstracts (he exhibited with the *Objective Abstractionists in 1934), but from 1934 to 1937 he abandoned painting for journalism, writing art criticism in a socialist vein for *The Left Review*, *The Listener*, and *The New Statesman* (he also wrote a pamphlet called *The Artist and his Public*, 1939). When he returned to painting it was in the soberly naturalistic style associated with the *Euston Road School. His work included portraits, landscapes, interiors, and still-lifes; his best-known picture is probably *The Café* (1937–8, Manchester Art Gallery). Bell volunteered for war service in 1939 and was killed in a crash during an RAF training flight. In the introduction to *Paintings of Graham Bell*, published in 1947, Kenneth *Clark wrote: 'his critical intelligence was extremely acute . . . I think he would have become a very good painter. There is an air of largeness and essential truth in his best work which only needs filling out and enriching in order to become great.'

Bell, Julian See BELL, CLIVE.

Bell, Larry (1939–) American abstract sculptor. He was born in Chicago and studied at the Chouinard Art Institute, Los Angeles, 1957–9. In the early 1960s he turned from painting to making glass sculptures of refined simplicity, his work representing an extreme development of the tendency among certain young Californian artists of the time to dematerialize the art object and work with pure qualities of light. His virtually invisible glass panels (subtly coated to create varying degrees of opacity and reflection) were the most novel works shown at the exhibition 'Spaces' at the Museum of Modern Art, New York, in 1970. In 1972 he began to make outdoor sculptures of coated glass.

Bell, Quentin See BELL, CLIVE.

Bell, Robert Anning (1863–1933) British painter, sculptor, designer, illustrator, and teacher, born in London. His highly varied artistic training began with two years in an architect's office, continued at the *Royal Academy and the Westminster School of Art, and was rounded off with stays in Paris and Italy. He gained some of his sculptural expertise by sharing a studio for a while with Sir George *Frampton. Bell's interest in the architectural setting of art helped him to win numerous decorative commissions for mosaics, stained glass, and

relief sculpture. His clear, linear style, influenced by Italian Renaissance art, was well suited to this type of work. Examples of his mosaics are in Westminster Cathedral and the Houses of Parliament, and his stained glass includes the Shakespeare window in Manchester Reference Library. His second wife, **Laura Anning Bell** (1867–1950), was a portraitist, mainly in pastel.

Bell, Vanessa (1879–1961) British painter and designer, born in London into a distinguished literary family: her younger sister became famous as the novelist Virginia Woolf. She studied at the *Royal Academy, 1901–4, and in 1905 founded the Friday Club. Initially a discussion group for artists, it continued as an exhibiting society until 1922. In 1907 she married Clive *Bell, and their house at 46 Gordon Square became one of the focal points of the *Bloomsbury Group. Her early work, up to about 1910, and her paintings produced after the First World War, are tasteful and fairly conventional, in the tradition of the *New English Art Club, but in the intervening period she was briefly in the vanguard of progressive ideas in British art. At this time, stimulated by the *Post-Impressionist exhibitions organized by Roger *Fry (with whom she had an affair), she worked with bright colours and bold forms, and by 1914 she was painting completely abstract pictures. Her designs for Fry's *Omega Workshops include a folding screen (1913–14, V&A, London) clearly showing the influence of *Matisse (Gertrude *Stein had introduced her to Matisse and *Picasso in Paris in January 1914).

From 1916 Bell lived with Duncan *Grant, with whom she had a daughter in 1918. However, she remained on good terms with her husband, who was lavish in his praise of both her and Grant's work. Bell and Grant spent a good deal of time in London and travelling abroad, but they lived mainly at Charleston Farmhouse, at Firle, Sussex, and did much painted decoration in the house, now restored as a Bloomsbury memorial. Bell's independent work included portraits, landscapes, interiors, and figure compositions. She also did a good deal of design work, including covers for books published by the Hogarth Press, founded by Virginia Woolf and her husband, Leonard Woolf, in 1917. After the Second World War, her work—like that of Grant—went out of fashion, but she continued painting vigorously into her old age.

Further Reading: F. Spalding, *Vanessa Bell* (1984)

Bellany, John (1942–) Scottish painter, working in a vigorous—at times rather tormented—*Expressionist style. He was born and brought up in the fishing village of Port Seton, near Edinburgh, and the imagery of his work is often derived from the sea, although it is transformed into a kind of personal mythology. From 1960 to 1965 he studied at Edinburgh College of Art, and from 1965 to 1968 at the *Royal College of Art, London. His most characteristic works are large compositions involving hybrid human and animal forms, painted with explosive brushwork and suggesting some vague menace. An example is *Mizpah* (1978, NG of Modern Art, Edinburgh), of which Christopher Johnstone writes: 'Mizpah has the form of a crucifixion. The boat's mast and furled sail are the cross; a fish (an ancient symbol for Christ) hangs from the man's neck. As the sea washes over the deck a creature plays an accordion and a bird with breasts looks on. The effect is of a modern Ship of Fools. Biblical names for fishing boats are still quite common since religion plays an important role in fishing communities. The Hebrew word Mizpah appears in Genesis . . . The word appears in several of Bellany's paintings where it takes on the characteristics of a highly personal talisman' (*Fifty 20th Century Artists in the Scottish National Gallery of Modern Art*, n.d.). Bellany himself says of his work: 'I'm trying to say something deep about the human condition . . . My heroes are not bores like Andy *Warhol . . . I prefer meat on the bone to facile statements by graphic designers.' In addition to his allegorical compositions, Bellany has painted many portraits, including a well-known one of the cricketer Ian Botham (1985, NPG, London). In the late 1980s Bellany became seriously ill and he had a liver transplant in 1988; after his recovery his work became more optimistic in spirit. This is expressed in the coloured etchings he began to produce in the early 1990s as well as his paintings. His work has been widely exhibited in Britain, Europe, and the USA.

Belling, Rudolf (1886–1972) German sculptor, born in Berlin, where he studied at the Academy, 1911–12. In 1918 he joined the *Novembergruppe and during the 1920s he was influential in introducing *Cubist and *Futurist ideas to Berlin. His own work was strongly influenced by *Archipenko, notably in its alternation of solids and voids. However, his style became more self-consciously formalized

than Archipenko's, as in *Sculpture* (1923, MoMA, New York), a robot-like head in polished metal. From 1937 to 1966 Belling taught in Istanbul, then settled at Krailling, near Munich.

Bellingham Smith, Elinor *See* MOYNIHAN, RODRIGO.

Bellmer, Hans (1902–75) German-French graphic artist, painter, sculptor, photographer, and writer, all of whose work is explicitly erotic. He was born in Kattowitz, Germany (now Katowice, Poland). In 1922–4 he studied engineering in Berlin (compelled by his tyrannical father), but he gave up the course after becoming friendly with *Dix and *Grosz and began working as a typographer and bookbinder, then as a draughtsman in an advertising agency. In 1933 he constructed an articulated plaster figure of a young girl, inspired partly by an infatuation with his fifteen-year-old cousin Ursula and partly by memories of secret sexual encounters of his adolescence. He photographed his creation in various attitudes and states of dismemberment (sometimes partly clothed) and published a collection of the photographs as *Die Puppe* ('The Doll') in Karlsruhe in 1934; a French edition, *La Poupée*, was published in Paris in 1936. Bellmer sent samples of the photographs to André *Breton in Paris, and the *Surrealists were highly excited by these striking images of 'vice and enchantment'. In 1938, in danger of arrest by the Nazis, Bellmer fled to Paris to join the Surrealists. He was interned at the beginning of the war (with Max *Ernst), then lived in the South of France, 1942–6, before returning to Paris. He then 'began a long series of drawings and etchings which further developed the violent eroticism of his dolls...these are often ambiguous superimposed images conjuring up visions of far-from-innocent little girls taking part in advanced sexual exercises, or strange anatomical inventions made up of of sexual apertures and throbbing organs. These exciting, honest, and totally unprurient creations are always executed in a marvellously refined and elegant technique, culminating in the large and highly complex two-colour etchings entitled *Petit Traité de la Morale* (1968), which illustrate the sexual dreams of young girls and at the same time the sexual fantasies of their author. These ten prints constitute one of the finest expressions of eroticism in 20th-century art,

and they show the uniqueness of Bellmer's erotic art in that they are *non-naturalistic*, graphic transcriptions of mental images relating to erotic desire' (Peter Webb, *The Erotic Arts*, 1975). Bellmer also produced paintings and sculpture in a similar vein. As with many Surrealist representations of the female form, the work of Bellmer has been attacked by some *feminists. Hal Foster has defended his treatment of the body as a critique of Nazi ideals of the perfect form.

Further Reading: H. Foster, *Compulsive Beauty* (1993)

Bellocq, E. J. (1873–1949) American photographer. Little is known about his life. The traditional image of him as a hydrocephalic dwarf, a kind of grotesque Toulouse-Lautrec figure, is almost certainly incorrect. He took up photography, initially as a hobby, in the 1890s, after dropping out of Jesuit college. He is remembered entirely for a set of photographs which survived only in glass negative form (he may never have printed them himself), of women, usually assumed to be prostitutes, in the Storyville area of New Orleans, taken just before the First World War. (The popular name for the area came from Alderman Sydney Story who tried to 'clean up' the area by restricting the trade to a small district.) The quality of the images has been compared to the paintings of Vermeer. Certainly few other artists in any medium and addressing such a limited social environment can have achieved such a variety of images of women that combine visual beauty with a sense of inner life which overrides any trace of objectification. The 89 surviving negatives, some severely damaged, were discovered by the photographer Lee *Friedlander in 1966 and published in 1970.

Further Reading: N. Goldin, 'Bellocq Époque–E. J. Bellocq', *Artforum International* (May 1997)

Bellows, George Wesley (1882–1925) American painter and lithographer, born in Columbus, Ohio. He studied at Ohio State University before moving in 1904 to New York, where he was a pupil of Robert *Henri and became associated with the *Ashcan School. An outstanding athlete in his youth and noted for his hearty, outgoing character, Bellows is best known for his boxing scenes. The most famous of them is *A Stag at Sharkey's* (1907, Cleveland Museum of Art), remarkable for its vivid sense of movement and energetic, sketchy brushwork: he said 'I don't

know anything about boxing [a 'stag' was a boxing match held in a private club]; I'm just painting two men trying to kill each other'. Such works rapidly won him a reputation, and in 1909—aged 27—he became the youngest person ever elected an associate member of the National Academy of Design. He took a highly active part in the art life of his day and was one of the organizers of the *Armory Show in 1913. After this, his work tended to become less concerned with movement, placing more emphasis on formal balance. He was a man of strong social conscience, and his work included scenes of the urban poor—of which the most famous is the crowded tenement scene *Cliff Dwellers* (1913, Los Angeles County Museum of Art)—and a series of paintings and lithographs about First World War atrocities. He did not take up lithography until 1916, but in the nine remaining years of his life he produced almost 200 prints, and he is accorded a high place among modern American printmakers; his *A Stag at Sharkey's* (1917), in which he reworked the composition of his celebrated painting, has been described by Carey and Griffiths as 'the most famous American print of this century'. In the last five years of his life Bellows turned to landscapes and portraits and was considered one of the finest American portraitists of his day. His early death was caused by a ruptured appendix.

Further Reading: F. Carey and A. Griffiths, *American Prints 1879–1979* (1980)

Belzile, Louis *See* PLASTICIENS.

Ben (Benjamin Vautier) *See* BODY ART.

Beneš, Vincenc *See* GROUP OF PLASTIC ARTISTS.

Benglis, Lynda (1941–) American sculptor, born in Lake Charles, Louisiana. She was one of the relatively small number of women artists who received mainstream recognition in the 1960s and 1970s. Her sculptures in poured latex and polyurethane, like those of Eva *Hesse, were seen as a kind of feminine alternative to the harsh geometry of *Minimal art in their flowing forms. Benglis was a controversial figure, especially among *feminists, for the photographs she used to publicize her work. One showed her, almost naked, in a classic pin-up pose. The most notorious of all, published in *Artforum* in 1974, showed her wearing only sunglasses with a dildo between her legs.

Benjamin, Karl *See* HARD-EDGE PAINTING.

Benjamin, Walter (1892–1940) German writer, regarded as one of the leading cultural critics of the 20th century. He was born in Berlin into an intellectual Jewish family and studied successively at the universities of Freiburg, Berlin, Munich, and Berne, where he obtained a PhD in 1919. For most of his career he made a precarious living as a journalist in Berlin. In 1933 he left Germany because of the rise of Nazism and settled in Paris. After the German invasion of France he fled to Spain and committed suicide at the border in a moment of despair when he was denied entry for trivial bureaucratic reasons. Benjamin's writings are 'a curious mixture of esoteric, sometimes mystical Jewish thought, artistic modernism and unorthodox Marxism' (Terry Eagleton in *The Fontana Dictionary of Modern Thinkers*, 1983). In the context of the visual arts, his most important essay is 'Das Kunstwerk im Zeitalter seiner technischen Reproduzierbarkeit' (The work of art in the age of mechanical reproduction), originally published in 1936 in *Zeitschrift für Sozialforschung*, which was operating in exile in New York. In this he 'argues that the "aura" of the original unique work of art is lost to reproducibility; but that this, far from being something to mourn, opens up progressive possibilities' (Harrison and Wood). He believed that technical change could encourage a progressive popular art: 'Mechanical reproduction of art changes the reaction of the masses toward art.' The essay was frequently cited in the 1970s when artists were looking to media such as photography to communicate a political message to a wider audience. It was also invoked by John *Berger in *Ways of Seeing* as a basis for the argument that the experience of original art had been supplanted by that of the reproduction.

Benois, Alexandre (1870–1960) Russian painter, stage designer, art historian, and critic, a leader and spokesman of the *World of Art group. Born in St Petersburg of Franco-Italian descent, he was largely self-taught as an artist. He was a close friend and collaborator of *Diaghilev, both in Russia and later in Paris, and he is best known for his stage designs for the Ballets Russes, in which he harmonized the tradition of Russian folk art with French Rococo elements, one of the most notable examples being Stravinsky's *Petrushka*

(1911). Following a difference of opinion with Diaghilev he worked at Stanislavsky's Moscow Arts Theatre, 1912–14. After the Revolution he was appointed curator of paintings at the Hermitage in Leningrad, Russia's greatest museum. He held this post from 1918 to 1925, then settled permanently in Paris, where he continued to work as a stage designer. His writings include several volumes of memoirs and books on art, including works translated into English as *The Russian School of Painting* (1916), *Reminiscences of the Russian Ballet* (1941), and *Memoirs* (1960).

Benoit, Rigaud *See* HYPPOLITE, HECTOR.

Benson, Frank W. *See* TEN, THE.

Benton, Thomas Hart (1889–1975) American painter, the great-nephew of a famous American statesman of the same name. He was born in Neosho, Missouri, and studied at the Art Institute of Chicago, 1907–8, and at the *Académie Julian, Paris, 1908–11. In Paris he became a friend of the *Synchromist Stanton *Macdonald-Wright, and after his return to the USA (he settled in New York in 1912) he painted in the Synchromist manner for some years. Having failed to win success working in an avant-garde style, he abandoned modernism around 1920 and gained fame as one of the leading exponents of *Regionalism and the movement's chief spokesman. He claimed that the success enjoyed by himself, John Steuart *Curry, and Grant *Wood came from the fact that they 'symbolized esthetically what the majority of Americans had in mind—America itself'. Benton's style in his Regionalist work was richly coloured and vigorous, with restlessly energetic rhythms and rather flat, sometimes almost cartoonish figures. His work included several murals, notably scenes of American life (1930–31) at the New School for Social Research in New York. Their popularity encouraged government support for such wall paintings, although Benton himself never did any work for the *Federal Art Project. In 1935 he left New York to become director of the City Art Institute and School of Design in Kansas City, Missouri, and he lived in that city for the rest of his life. He continued to paint murals as well as a variety of easel pictures, including landscapes, portraits, and a novel kind of work in which he introduced American types into representations of Greek myths or biblical stories (*Susanna and the Elders*, 1938, California Palace of the Legion of Honor).

Bérard, Christian (1902–49) French designer, painter, and draughtsman. He was born in Paris and studied at the *Académie Ranson (under *Vuillard) and the *Académie Julian. With *Berman and *Tchelitchew he was the leading representative of *Neo-Romanticism in French painting, but his career was devoted mainly to design, particularly for the theatre and also for the cinema and the fashion world. His first notable success was the design of the ballet *Les Elves* (1924) for Michel Fokine, and subsequently he worked for many other leading choreographers. He also had a fruitful relationship with Jean *Cocteau, whom he met in 1926 and whose portrait he painted in 1928 (MoMA, New York). Bérard made designs for several of his plays and three of his films, most famously *Beauty and the Beast* (1946), which was perfectly suited to his gift for fantasy and 'may be considered in some respects almost as much the achievement of Bérard as of Cocteau' (*Oxford Companion to Film*, 1976). His other work included fashion drawings in such magazines as *Harper's Bazaar* and *Vogue*. 'Bérard, a ubiquitous personality in the theatre world, was a short dishevelled man with an unruly beard whose appearance belied the stunning beauty of his stage designs' (Tom Mikotowicz in *The Cambridge Guide to World Theatre*, 1988).

Bergen, Edgar de *See* HAMNETT, NINA.

Berger, John (1926–) British writer and broadcaster, well known both as a left-wing art critic and as a novelist. He was born in London, where he studied at the Central School of Art and Chelsea School of Art, and began his career as a painter and teacher of drawing. From 1952 to 1961 he wrote regularly for *The New Statesman*, and this was the period of his greatest influence as a critic of contemporary art. His support for realist painters, notably *Bratby and the other members of the *Kitchen Sink School, was combined with political sympathies for the Communist Party. Although he never slavishly followed the party line in uncritical praise for *Socialist Realism, he attacked contemporary art in the West as being over-concerned with *formalism. In 1958 he published his first novel, *A Painter of Our Time*, in which he explored the dilemma of the Communist artist in the West, particularly after the Soviet invasion of

Hungary in 1956; the book was loosely inspired by László (or Peter) Peri (1899–1967), a Hungarian-born sculptor and painter who emigrated from Germany to England in 1933. A collection of Berger's criticism appeared in book form in 1960 as *Permanent Red: Essays in Seeing* (in the USA it was given the significantly less politicized title *Toward Reality*), but he stopped writing regular criticism the following year. By this time, many of those he had supported had turned away from realism and the success of *Abstract Expressionism represented a defeat for his values.

Subsequently Berger achieved fame as a novelist (he won the Booker Prize for *G* in 1972), but he continued to write on art, producing several controversial books, including *Success and Failure of *Picasso* (1965), which emphasized the artist's anarchist roots and examined the failure of the Communists to make real use of one of their most celebrated adherents. His most famous book is *Ways of Seeing* (1972, originating in a television series of the same name, 1969), in which he challenged the whole tradition of Western art, linking it to political, economic, and sexual exploitation, particularly through advertising. The views he expressed were initially strongly contested (Lawrence *Gowing said that Berger was managing to 'interpose himself... between us and the visible meaning of a good picture'), but the book's arguments at one time became a complacently accepted orthodoxy in art colleges. Berger's other books include monographs on *Guttuso (1957) and *Léger (1966) and *Art and Revolution: Ernst *Neizvestny and the Role of the Artist in the USSR* (1969). In the 1970s Berger moved to France, living in a peasant farming community in the Jura. Introducing a 1979 reprint of *Permanent Red*, he concluded that 'I now believe that there is an absolute incompatibility between art and private property, or between art and state property—unless the state is a plebeian democracy.' *See also* FULLER.

Bergh, Richard (1858–1919) Swedish painter, writer, and art administrator, born in Stockholm, son of a landscape painter, Edvard Bergh (1828–80). From 1878 to 1881 he studied at the Academy in Stockholm, where his father was a professor, then spent the next three years in Paris. His work was strongly influenced by French open-air painting and *Symbolism, but he made them the basis of a distinctive Swedish national romanticism, as in his most famous work, *Nordic Summer Evening* (1899–1900, Konstmuseum, Gothenburg). It shows a man and a woman on a veranda looking out over a lake in an atmosphere heavy with psychological tension. Bergh was also a fine portraitist, notably of his artist and intellectual friends. He took a keen interest in political and social issues and was a founding member (1885) of the Artists' Union, which revolted against the conservatism of the Stockholm Academy. In 1915 he was appointed director of the Nationalmuseum in Stockholm, which he reorganized into a modern, dynamic institution. Collections of his articles on art were published in 1908 (revised 1919) and (posthumously) in 1921.

Berghe, Frits van den (1883–1939) Belgian painter, born in Ghent, where he studied (1897–1904) and later taught (1907–11) at the Academy. While teaching in Ghent he lived at nearby *Laethem-Saint-Martin, where he was a member of a colony of artists including *Permeke and de *Smet. He also worked with de Smet in Holland when they fled there during the First World War. It was at this time that his work turned decisively from *Impressionism to *Expressionism, and he is regarded as one of Belgium's leading exponents of the style. He returned to Belgium in 1922 and settled permanently in Ghent in 1925. Initially his Expressionist work was vaguely derived from *Cubism, with block-like forms and matt surfaces, but from the mid-1920s his paintings took on a more fantastic quality in the tradition of *Ensor and Hieronymus Bosch. These works have been seen by some as an anticipation of *Surrealism. His subjects included landscapes, portraits, nudes, and allegories of the human condition. His best-known work is probably *Sunday* (1924, Museum of Modern Art, Brussels), a satirical image showing three clergymen, taking their rest on the river bank, apparently as indifferent to the religious associations of the day as the boatmen and the wealthy family who pass behind them.

Bergman, Anna-Eva *See* HARTUNG, HANS.

Bergner, Yosl *See* ANGRY PENGUINS.

Berman, Eugene (1899–1972) Russian-born painter and stage designer who became an American citizen in 1937. He was born in St Petersburg, the son of a prosperous banker, and fled with his family during the Revolution, settling in Paris in 1918 and studying at the

*Académie Ranson. During the 1920s, with *Tchelitchew (another Russian emigré) and *Bérard, he was a leading exponent of *Neo-Romanticism, painting dreamlike scenes with mournful drooping figures. In 1935 he emigrated to New York, where he worked mainly as a designer for ballet and opera, in which field he was considered one of the outstanding artists of his day. In particular he often collaborated with the Russian-born choreographer George Balanchine, from *Concerto Grosso* (for American Ballet Caracan) in 1941 to *Pulcinella* (for New York City Ballet) in 1972. He continued painting, however, his style showing the influence of *Surrealism. In both his paintings and his stage designs he often featured architectural ruins. In his later life Berman spent much of his time in Italy and he died in Rome.

Bernard, Émile (1868–1941) French painter and writer, born in Lille. As a young man he studied in Paris alongside van Gogh and Toulouse-Lautrec, and between 1888 and 1891 he worked closely with *Gauguin. Bernard seems to have had a stimulating effect on his great colleague, but thereafter his work as a painter declined in importance and he became of interest chiefly for his activities as a writer. In 1890 he helped to organize the first retrospective exhibition of van Gogh's work (soon after his death), he published much journalism and criticism on *Cézanne, *Redon, and other artists, and his correspondence with some of the leading painters of the time has been a rich quarry for art historians (much of it published in *Lettres de Vincent van Gogh, Paul Gauguin, Paul Cézanne . . . à É. Bernard*, 1926; new edn, 1942). Bernard travelled in the Near East and Egypt, 1893–1904, then settled in Paris, where he founded and edited the journal *La Rénovation esthétique*, 1905–10; it expressed what by this time had become his reactionary views on art and politics.

Bernard, Joseph *See* DIRECT CARVING.

Bernheim-Jeune French family of art dealers and publishers. **Alexandre Bernheim-Jeune** (1839–1915), the son of an artists' supplier, opened a gallery in Paris in 1865 and was succeeded by his sons **Joseph** (known as Josse) (1870–1941) and **Gaston** (1870–1953), who was himself an artist, painting under the name Gaston de Villers. (Although they have the same year of birth, the brothers were not twins: Joseph was born in January, and Gaston

in December.) By the 1890s the gallery was dealing in the work of leading *Impressionists, including *Monet, *Pissarro, and especially *Renoir, who painted five portraits of the family (the other artists who painted the family included *Bonnard and *Vuillard; there are examples by all three artists in the Musée d'Orsay, Paris). From about the turn of the century the gallery began showing an interest in more avant-garde work, and in 1901 it held a major retrospective exhibition of van Gogh's work (*see* EXPRESSIONISM). Its links with a younger generation of artists were reinforced when Félix *Vallotton married Alexandre's daughter in 1899 and when Félix *Fénéon became a director in 1906. He remained with the Galerie Bernheim-Jeune until 1925, in charge of its modern section; in this role he dealt particularly in the work of *Neo-Impressionists such as Henri-Edmond *Cross and the *Fauves (including *Matisse), but he also, for example, arranged the first group exhibition of the *Futurists in France (1912) and showed the work of the *Synchromists in 1913. The firm published monographs on several of the artists in which it dealt and also issued a periodical, *Bulletin de la vie artistique*.

Bertini, Gianni *See* MEC ART.

Bertoia, Harry (1915–78) Italian-born sculptor and designer who settled in the USA in 1930 and became an American citizen in 1946. He studied at the Detroit Society of Arts and Crafts, then at the Cranbrook Academy of Art, Michigan; in 1939 he began teaching metalwork at Cranbrook. His colleagues there included the architect and designer Charles Eames (1907–78), and in 1943 Bertoia moved to California to join him in designing a series of chairs. In 1950 he moved to Bally, Pennsylvania, where in 1952 he designed the Bertoia chair, which features an elegant moulded mesh of chromium-plated steel wire. It was well suited to the open planning becoming popular in American homes and offices and was marketed with great success by Knoll Associates Inc. By this time, however, Bertoia was turning increasingly to sculpture, and in 1953 he received his first large sculptural commission—a screen for the General Motors Technical Center in Detroit. Many other major commissions followed, including a fountain (1967) at the Civic Center, Philadelphia. Typically his sculptures are sensitively related to their architectural setting and

combine strong abstract forms with intricately worked detail (sometimes deriving from plant tendrils and other organic forms) in which he demonstrated his skill as a metalworker (the materials he used included brass, bronze, and steel). From 1960 until the end of his life, Bertoia also experimented with incorporating sound effects in his sculpture, generally by employing metal rods that strike against one another.

Beskin, Osip *See* FORMALISM.

Beuys, Joseph (1921–86) German sculptor, draughtsman, *Performance artist, and teacher, one of the leading figures in art in Europe from the 1960s to the 1980s, and central to debates about the role of the artist in the political sphere.

Beuys was born in Krefeld and spent most of his early life in or near Kleve. He had intended being a paediatrician, but because of the outbreak of the Second World War he went virtually straight from school into the German air force. During his service he was wounded five times and he ended the war as a prisoner. Later in his career a story was published that after being shot down in the Crimea he was kept alive by nomadic Tartars who kept him warm with fat and felt, materials that later figured in his sculpture. The details have been contested, although the crash itself was certainly real, and the significance of the tale is in the way that Beuys used the materials of his life to produce a kind of personal mythology. On a level of symbolic myth it stands both for personal resurrection and also the resurrection of Germany after the Nazi era, and how this is achieved, not through the 'economic miracle' but through a spiritual regeneration. In 1946–51 he studied at the Düsseldorf Academy. He was a student of Ewald *Mataré who, like many artists given important teaching positions in post-war Germany, had been persecuted under the Nazis. Mataré, although unsympathetic to Beuys' brooding temperament, was an important example to Beuys for his animal sculpture. However, far more significant in forming Beuys's conception of sculpture was the *Expressionist Wilhelm *Lehmbruck, whose work he had discovered when it was condemned as 'decadent' in the Nazi years. In the 1950s he worked as a monumental sculptor and it was in this field that in 1961 he was appointed professor at the Düs-

seldorf Academy, where his teaching was both controversial and charismatic.

In 1962 Beuys became a member of *Fluxus. He shared its rejection of conventional art, but ultimately had a quite different conception of art, which he saw as spiritually and politically redemptive. This was embodied in his theory of 'social sculpture'. It implies that art has a responsibility to society but goes beyond the idea of art as a kind of social service, although it might include this as one of its manifestations. Sculpture itself, with its moulding of form, is a kind of model for how society should develop. Sculpture is not primarily an issue of form, but of the *forming* of materials which are significant not just for their appearance, but their capacity for change—hence the interest in fat and felt for their characteristics of fluidity and warmth. The objective truth or otherwise of the Tartar story is secondary. The important point was that fat was vital to life and not associated with art. With this conception of sculpture, it is quite inappropriate to make a clear division of his work on grounds of medium. The drawing, the sculpture, the performance, the political activity, and the teaching need to be understood as a whole. In 1967 he founded the German Student Party. The following year his international fame as an artist began as a result of his exposure at *documenta 4. Beuys's sombre installation was a striking contrast to the dominance of American Pop in the exhibition. His 'presumptuous political dilettantism' was condemned by several of his colleagues at the academy, notably Norbert *Kricke, and in 1972 he was dismissed from his professorship because of his insistence on admitting every student who wished to attend. Beuys turned his departure from the building under the eyes of the police into an artwork. He issued a photograph of the event ironically captioned 'democracy is happy'. The protests that followed included a strike by his students, and a settlement was eventually reached whereby he kept his title and his studio, but his teaching contract was ended. For his appearance at documenta the same year he opened an office in which he campaigned for what he called 'direct democracy', a system in which parliamentary party politics would be replaced by direct participation. Many of his ideas attracted hostility from the left as naive as well as from the political right. There were also admirers of his art who considered that activities such as appearing singing (very badly) in a pop video protesting

against nuclear weapons did his reputation no favours. In 1982 he embarked on an ecological project to plant 7,000 oak trees. Each would be planted beside a granite block. Many can be seen to this day in Kassel, a permanent reminder of the artist who more than any other was identified with documenta. As the tree grows the granite remains. Yet the granite itself becomes over the years a site of life as lichen takes hold. It is a powerful instance of Beuys's conception of sculpture not as stasis but as change.

The conventional distinction between 'admirers' and 'detractors' is inadequate for understanding Beuys's reputation. It is also necessary to make a distinction between 'admirers' who appreciate the aesthetic quality of his output and 'followers' who regard his life and work as exemplary. He is, at the very least estimate, the creator of some of the most haunting images in 20th-century art. It is quite possible to be deeply impressed by his achievements as an artist while feeling that his ambition to change society through art is wishful thinking. The concept went beyond the issue of art as a tool for political action towards a sense that the conception of art should be expanded to include it. His self-mythologizing has struck many observers as over-individualistic. What it certainly represented was a radical departure from most previous notions of political art which are based on submission to the collective. Beuys's exposure of his own wounds argued for a politics and an aesthetics which derive from the unique experience of the individual put in the service of society as a whole.

Further Reading: C. Kuoni (ed.), *Energy Plan for Western Man: Joseph Beuys in America* (1990)
H. Stachelhaus, *Joseph Beuys* (1991)

Bevan, Robert (1865–1925) British painter and lithographer, born in Hove, Sussex. He studied briefly at Westminster School of Art under Fred *Brown (1888), then at the *Académie Julian in Paris. During the 1890s he travelled a good deal (including visits to Spain and Tangier) and he had two lengthy stays in Pont-Aven, where he met *Gauguin in 1894. In 1900 he settled in London, where he became a member of *Sickert's circle in 1908 and was a founder member of the *Camden Town Group (1911) and the *London Group (1914). His work was much influenced by Gauguin's strong colour and flat patterning, and in his last years his style became increasingly simplified and schematic. He is best known for paintings featuring horses (*The Cab Horse*, c.1910, Tate) and he also painted landscapes and market scenes. Frank *Rutter described his work as 'sober, sincere and unspectacular' (*Modern Masterpieces*, 1940) and thought that for this reason his work had been undervalued by the wider public. Even today, Bevan generally receives less attention than some of his Camden Town colleagues.

Bevan's wife, the Polish-born Stanislawa de Karlowska (1876–1952), whom he married in 1897, was also a painter. He made several visits to Poland with her.

Bickerton, Ashley (1959–) British/American sculptor, born in Barbados. He studied at the California Institute of Arts, well known for the engagement of many of its students in the imagery of popular culture. In 1986 he exhibited alongside Peter *Halley, Jeff *Koons, and the Venezuelan-born Meyer Vaisman (1960–) in an exhibition at the Sonnabend Gallery, New York, which helped to define the *Neo-Geo movement. *Le Art* (1987) is an aluminium box covered with corporate logos. Rather than present a critique of such things, Bickerton said that he was interested in utilizing 'the process of corruption as a poetic form' and that 'we're all riding the monster train and we can't get off'. Following an art market recession at the beginning of the 1990s, Bickerton moved to Brazil and then to Bali, where he now lives and works. An exhibition in New York of 2006, in which he showed grotesque images on the theme of sexual tourism, was reviewed by Holland Cotter in the following terms: 'It offers a worldview that is basically an end-of-the-world view, beyond solution, beyond revulsion, blissed-out on the terrible wonder of it all' (*New York Times*, 26 May 2006).

Biederman, Charles (1906–2004) American abstract artist and art theorist, born in Cleveland, Ohio, of Czech immigrant parents. He trained in Cleveland as a commercial artist, 1922–6, then studied at the Art Institute of Chicago School, 1926–9. In 1936–7 he lived in Paris, where he met *Léger, *Mondrian, and *Pevsner, amongst other leading artists. After returning to the USA he lived in New York until 1940, then after two years in Chicago settled in Red Wing, Minnesota, in 1942. From 1937 he abandoned painting and concentrated on coloured geometric reliefs, to

which for some years he applied the word 'Structurist' (*Structurist Relief, Red Wing No. 20*, 1954–65, Tate): 'a Structurist work is neither painting nor sculpture, but a structural extension of the two.' His promotion of such works in his book *Art as the Evolution of Visual Knowledge* (1948) had an important influence on British *Constructivists, notably Anthony *Hill, Kenneth and Mary *Martin, and Victor *Pasmore, each of whom corresponded with Biederman. He wrote other books and many articles on art theory. In his writings, particularly *Art as the Evolution of Visual Knowledge*, Biederman argued that from the beginning art had been dominated by two conflicting aims—the imitation of natural appearances and the exercise of the 'inventive' or 'creative' faculty. This faculty had led artists to depict the typical or generic or to search for the 'ideal', rather than literally recording 'the uniquely particular or individual characteristics of the objective world'. Because the camera can perform the recording function more efficiently, artists were now free to give themselves up wholly to 'invention'. He then went on to argue that since illusion is no longer necessary, the illusion of three-dimensional space must also be abandoned. This line of reasoning can hardly be described as watertight, but it had a strong appeal for many abstract artists of the time, especially those who held it a virtue to present their works as real things in the real world.

Further Reading: Arts Council of Great Britain, *Charles Biederman* (1969)

Biennale (or Bienal or Biennial) An art exhibition held every two years, particularly a large and prestigious exhibition of international scope. The first to be founded and still the most famous is the Venice Biennale, instituted in 1895 as the 'International Exhibition of Art of the City of Venice', and claiming to represent 'the most noble activities of the modern spirit without distinction of country'. It was organized to celebrate the 25th wedding anniversary of King Umberto I and Queen Margherita of Savoy, but in fact took place two years after the event. At this first Biennale, artists from sixteen different nations were represented, 516 works were exhibited, and there were more than 200,000 visitors. The exhibition soon acquired worldwide prestige, and after the Second World War it became a leading forum for establishing international careers. Henry *Moore, for example, set the

seal on his reputation when he won the International Sculpture Prize in 1948.

The Biennale is centred in the Giardini Pubblici (Public Gardens), where a number of pavilions have been built by the countries that take part in the exhibition. These structures are permanent (although there has been much rebuilding over the years) and their styles provide an interesting array of national self-images. There is often controversy over the selection of artists to represent each country (entrusted to or sponsored by bodies such as the British Council in Britain and the Smithsonian Institution in the USA) and the press frequently carries rumours of intrigue or corruption surrounding the awarding of prizes (the jurors are usually distinguished figures in the art world, more likely to be susceptible to flattery than bribery). Lawrence *Alloway (who resigned from the Guggenheim Museum, New York, because of a disagreement over the choosing of American artists for the 1966 Biennale) published a history of the exhibition in 1968 (*The Venice Biennale: 1895–1968*). He writes that 'here are more artists, dealers, collectors, and writers in one place at one time than can be found anywhere else in the world . . . The 1966 Biennale showed 2,785 works by artists from thirty-seven countries, with eight hundred art critics, journalists, and free-wheelers in addition.' Since then the Biennale has grown still further in size and now spills over from the Giardini Pubblici into numerous other sites in the city. In 2007 there were 77 national and regional pavilions. From 1895 to 1909 the Biennale was held in odd-numbered years, but the 9th Biennale was advanced a year and held in 1910. Thereafter it was held in even years (with gaps in 1916, 1918, 1944, and 1946 because of the two world wars) until 1990. The Biennale was not held in 1992 and from 1993 has been in odd years (this change was made so that the exhibition could be held in the centenary year of the original event).

Several other biennales have been instituted on the Venice model, some of them general and others devoted to a specific category of art, such as *naive painting or printmaking. The one with the highest prestige next to Venice is the São Paulo Bienal, founded in 1951. A more recent institution is the Liverpool Biennial, founded in 1999. There are also triennial exhibitions, held every three years.

Bigaud, Wilson (1931?–) Haitian *naive painter, born into a poor family in Port-au-Prince. He was encouraged by Hector

*Hyppolite, who was a neighbour, and in 1946 he began studying at the Centre d'Art in Port-au-Prince; this had been established two years earlier by the American teacher DeWitt Peters (1902–66) as a place where artists could attend classes and exhibit their work. Bigaud rapidly established a reputation as an artist of outstanding talent, hailed as the 'Raphael' of Haitian painting because of the limpid beauty of his work, in which he combined lush detail with clarity of design. His output included portraits and everyday life scenes, as well as religious subjects (both Christian and Voodoo). When he was only 21, he became the first Haitian to have a picture accepted for the *Carnegie International Exhibition—*Earthly Paradise* (1952, Musée d'Art Haitien, Port-au-Prince). This success was almost immediately followed by a commission to paint a large *Marriage Feast at Cana* for Holy Trinity Cathedral, Port-au-Prince, which is often cited as his masterpiece. In 1957, however, he suffered a series of mental breakdowns, said to have been caused by Voodoo powers because he had devoted too much of his efforts to glorifying Christianity (it has been remarked that in Haiti, ninety per cent of the population is Catholic, but one hundred per cent is Voodoo). According to the *World Encyclopedia of Naive Art* (ed. O. Bihalji-Merin and N.-B. Tomašević, 1984), Bigaud 'eventually became the puppet of a Mambo (Voodoo priestess). She kept him in the backwoods churning out worse and worse paintings, which she would subsequently sell for a few dollars on her trips to Port-au-Prince.'

Bigge, John *See* UNIT ONE.

Bijl, Guillaume (1946–) Belgian installation artist, born in Antwerp. He works in the tradition of René *Magritte and Marcel *Broodthaers, questioning the identity of art with striking images. In 1979 he produced a manifesto, in terms which were ambiguous about how far he was being ironic, calling for the replacement of art centres by 'useful' activities. In the first of these a gallery became a garage. At *documenta 9 in 1992 he created a shop-window display of waxwork figures from the history of the exhibition. At the *Münster Sculpture Project of 2007 he staged a mock excavation of a Romanesque church, the spire of which, complete with weathercock, had been uncovered and was visible from above. An exhibition in Ghent in 2008 consisted of a series of 'museums', including a collection of *lederhosen* supposedly belonging to deceased celebrities such as the conductor Herbert von Karajan.

Bill, Max (1908–94) Swiss painter, sculptor, architect, designer, teacher, and writer, born in Winterthur. He trained as a silversmith at the Zurich School of Arts and Crafts, 1924–7, but after hearing a lecture by *Le Corbusier he decided to turn to architecture. From 1927 to 1929 he studied at the *Bauhaus, then returned to Switzerland, where he lived mainly in Zurich. He regarded himself primarily as an architect, but he was active in a variety of fields, his ultimate aim being to establish a unity among the individual branches of the visual arts—he once defined art as the 'sum of all functions in harmonious unity'. However, he has probably become best known for his sculptures, which characteristically employ smooth, elegant, spiralling abstract forms in stone or polished metal. He took the term *'Concrete art' from van *Doesburg to describe his work in this vein and popularized the term in Switzerland in place of 'abstract'. In 1941 he visited Argentina and Brazil, introducing the concept of Concrete art there, and he was a vigorous publicist of his ideas (he wrote several books and numerous articles, in English as well as German, and he organized exhibitions of abstract art). His sculptures have been considered precursors of *Minimal art, but in fact they represent a subtle blending of mathematics and intuition, and some Minimalists, including Donald *Judd and Robert *Morris, have denied his influence. Outside Switzerland his work and ideas have had most impact in Argentina and Italy, where he was the inspiration for a number of associations of Concrete art. As an architect Bill's work included his own house in Zurich (1932–3) and the much-praised Hochschule für Gestaltung (College of Design) in Ulm (1951–5), where, working on a limited budget, he created an austerely elegant complex of buildings delicately placed in a romantic setting. He was co-founder of the school and head of the departments of architecture and produce design from 1951 to 1957.

Billingham, Richard (1970–) British photographer and video artist, born in Birmingham. He studied painting at the University of Sunderland, graduating in 1994, but discovered that the photographs of his family he was taking as

source material attracted greater interest than the paintings. In 1996 they were exhibited at the Anthony Reynolds Gallery in London and a year later in the *'Sensation' exhibition. Taken spontaneously with cheap camera and film they nonetheless make a powerful visual impact when blown up and mounted in a gallery environment. The family situation they depict is a difficult one. The father, Ray, is an alcoholic, Richard's brother is addicted to drugs and video games, and his mother, a massive figure whose tattoos are a striking visual motif of the series, evidently has a stormy relationship with the father. In spite of all this the works have a considerable aesthetic appeal which derives partly from the colourful accumulation of visual clutter, partly from Billingham's great skill in capturing the moment. Nancy Roth has commented that 'The results that Billingham achieves by taking his camera into the turbulent terrain of his own family are arguably as estranging and demanding of their viewers as an alien landscape.' A book of photographs, *Ray's a Laugh* (the title refers to a 1950s radio comedy), was also published in 1996. Billingham has also worked as a landscape photographer.

Further Reading: N. Roth, 'Closeness as Metaphor', *Afterimage*, vol. 28 (2000)

Bing, Siegfried *See* ART NOUVEAU.

biomorphic A term applied to forms in abstract art that derive from or suggest organic (rather than geometric) shapes, as for example in the sculpture of Henry *Moore or the later works of *Kandinsky. This kind of form is often found in the works of artists such as *Miró and *Arp who have allegiances to both *Surrealism and *abstract art.

Birolli, Renato *See* CORRENTE.

Bischoff, Elmer *See* BAY AREA FIGURATION.

Bishop, Isabel (1902–88) American painter and etcher. She was born in Cincinnati, Ohio, and raised in Detroit. In 1918 she moved to New York to study at the School of Applied Design for Women, originally intending to be an illustrator. From 1922 to 1924 and again in 1926 she studied at the *Art Students League, where her teacher Kenneth Hayes *Miller helped to form her preference for urban themes. Most of her subject-matter is drawn from New York street life, particularly working-class women going about their everyday business. They are depicted in a sensitive and unsentimental way, in an unusual technique—using thin washes of paint—that recalls the oil sketches of Rubens. Bishop—a quiet but distinctive voice in *American Scene Painting—also did female nudes. She worked slowly, averaging about three paintings a year, and her total output amounts to fewer than 200 pictures. In 1937 she became the first full-time woman teacher at the Art Students League, and she won numerous awards for her work.

Bissier, Julius (1893–1965) German painter and designer, born at Freiburg. After studying briefly at the Academy in Karlsruhe he served in the First World War and afterwards resumed painting without further formal training. His early style was representational and had affinities with *Neue Sachlichkeit, but in the 1930s he turned to abstraction. This was partly because of the influence of *Baumeister (with whom he was friendly from 1929) and of *Brancusi (whom he met in Paris in 1930) and partly because of the influence of Chinese calligraphy and hieroglyphics (he had been introduced to Chinese culture by the Orientalist Ernest Grosse). He used abstract shapes that he called 'signs of bipolar life', which were intended to induce meditation. Most of his early work was destroyed in 1934 by a fire at the University of Freiburg, where Bissier taught, 1929–34. After the Second World War he developed a more painterly style, exploring unusual colour combinations in small, precisely executed watercolours or egg tempera paintings (sometimes irregularly shaped). It was these works that first brought him widespread recognition. He took part in many international exhibitions and won the Museum of São Paulo Prize at the 1960 Venice *Biennale. Apart from painting, he also designed carpets and fabrics, which were woven by his wife.

Bissière, Roger (1886–1964) French painter, sculptor, teacher, and writer on art. He was born in Villeréal in the province of Lot-et-Garonne and studied at the École des Beaux-Arts in Bordeaux, the nearest large city. His early works consisted mainly of landscapes of the local countryside. In 1910 he moved to Paris, where he earned his living as a journalist for some time while continuing to paint. He did not exhibit his work until 1920, first at the *Salon d'Automne, then at the *Salon des Indépendants. At this time he was influenced by *Cubism, which he attempted to 'humanize' (in 1920–21 he wrote articles for *L'Esprit*

nouveau (*see* OZENFANT), in which he espoused the classical rigour of great French painters of the past—Corot, Ingres, and Seurat; he also wrote the first monograph to be published on *Braque, in 1921. From 1925 to 1938 he taught at the *Académie Ranson, where he was a popular and influential figure among his students, who included *Le Moal, *Manessier, and *Vieira da Silva.

Although Bissière played an important part in shaping the careers of his students, he had still not found a distinctive artistic voice of his own and remained little known as a painter. In 1938 he retired to Lot and the following year he contracted an eye ailment that left him unable to paint. During the Second World War he worked as a farmer, but he also made totemistic sculptures (sometimes carved, sometimes put together from old agricultural machinery) and collaborated with his wife in producing primitivistic compositions made from patchwork materials. He started painting again in 1945 and an operation in 1948 partially restored his sight. Thereafter he worked with renewed vigour and from the early 1950s he belatedly achieved an international reputation. His mature paintings are rich and glowing tapestry-like compositions. Representational elements were gradually submerged in scintillating patterns of colour, but Bissière said that they were always based on natural appearances and refused to accept the term 'abstract' for his work.

(⊕) SEE WEB LINKS

• The official website for the artist.

Bisson, Henri *See* RIOPELLE, JEAN-PAUL.

Black, Dorrit *See* LINOCUT.

Black, Sir Misha *See* ARTISTS INTERNATIONAL ASSOCIATION; FESTIVAL OF BRITAIN.

Blackadder, Elizabeth (1931–) British painter and printmaker. She was born in Falkirk and studied at Edinburgh College of Art and Edinburgh University, 1949–55. She works in oil and watercolour 'with no particular preference' (in her own words). 'The work falls into two main areas, landscape and still life—occasionally figures . . . I like to work on several paintings at the same time, but work slowly, and each painting, watercolours included, may take months to complete.' Duncan Macmillan (*Scottish Art 1460–1990*, 1990) describes her paintings of flowers and plants

as 'based on a description that is so fastidious it becomes poetic'. Blackadder is also a prolific printmaker and has occasionally executed portrait commissions.

Black Mountain College American art educational establishment at Black Mountain, North Carolina, founded in 1933 by a group of progressive academics led by John Andrew Rice (1888–1968) and closed in 1957 after long-standing financial problems. It was owned and administered by the teaching staff, with no outside control, and was kept deliberately small (with an average of about 50 students a year) to reduce administration; a variety of arts were taught and interaction between them was encouraged. It formed a crucial link with the European avant-garde especially through Josef *Albers, who arrived there with his wife, Anni (who taught weaving), soon after it opened and stayed until 1949. He brought *Bauhaus ideas about the training of perception and challenged American subservience to classical and European culture. Other illustrious figures who taught at Black Mountain include Robert *Motherwell and the composer John *Cage, whose ideas on chance and indeterminacy in the arts were widely influential. In 1952 he organized there a partly programmed performance (involving paintings and readings) that has subsequently been designated as the first *Happening. Famous former students of the college include John *Chamberlain, Kenneth *Noland, Robert *Rauschenberg, and Cy *Twombly.

Further Reading: M. E. Harris, 'Black Mountain College', in Joachamides and Rosenthal (1993)

Bladen, Ronald (1918–88) Canadian-born American sculptor and painter. Born in Vancouver, he studied at Vancouver School of Art and California School of Fine Arts. In the 1950s he worked as an *Abstract Expressionist painter but he turned to three-dimensional work in bolted plywood or metal. Pieces such as *Three Elements* (1965, fabricated 1966–7, North Carolina Museum of Art), which consists of three aluminium blocks at angles to the ground, are early instances of *Minimal art. However, there is no relationship between Bladen's intentions and the more militantly prosaic ideology of certain Minimalists. He was far closer to the ideal of the *Abstract Sublime, saying that he was looking for 'that area of excitement belonging to natural phenomena such as a gigantic wave before it makes its fall, or

man-made phenomena such as a the high bridge spanning two different points'.

Blake, Sir Peter (1932–) British painter, sculptor, and designer, a leading exponent of *Pop art. He was born in Dartford, Kent, and studied at Gravesend School of Art, 1949–51, then after two years in the RAF at the *Royal College of Art, 1953–6. In 1956–7 a Leverhulme scholarship enabled him to travel extensively on the Continent studying folk and popular art (this had been an interest since his teenage years, stimulated by visits to fairgrounds). His early work was meticulously painted and often featured items of popular ephemera, particularly magazine covers (*On the Balcony*, 1955–7, Tate). From 1959 he moved more into the mainstream of Pop with pictures of pop singers and film stars, painted in a much broader manner and often featuring collage elements, and within a few years had become established as one of the leading figures of the movement in England (in 1961 he won first prize in the Junior Section of the *John Moores Liverpool Exhibition and the following year he was featured in Ken Russell's television film *Pop Goes the Easel*, which did as much as anything to arouse public interest in Pop art). During the 1960s the pop music world continued to be a major source of inspiration (his most famous work is the cover design for the Beatles LP *Sgt Pepper's Lonely Hearts Club Band*, 1967), and his other favourite images of the time included fairground wrestlers and striptease dancers.

In 1969 Blake moved to Wellow, near Bath, and in 1975 he was one of the founders of the *Brotherhood of Ruralists, a seven-strong group of painters who took as their inspiration 'the spirit of the countryside'. A series of winsome fairy paintings are characteristic of his Ruralist phase. They show something of the combination of sophistication and naivety that often occurs in his work as well as his penchant for imagery drawn from childhood (his two daughters have often featured in his work). He returned to London in 1979 and since then he has continued to paint both contemporary and fantasy subjects. In 1994–6 he was Associate Artist at the National Gallery, London. In 1983 he had a major retrospective exhibition at the Tate Gallery, London—it proved a great popular success, showing how fondly his early work is regarded by many people for its colourful evocation of the 'swinging sixties'—and in 2007 one at Tate

Liverpool. This included a series of paintings in homage to Marcel *Duchamp, whom he sent on a kind of pictorial world tour as a gesture of gratitude. He was elected RA in 1981 and was responsible for the hanging of the summer exhibition in 2001. Introducing controversial young artists such as Tracey *Emin and Sarah *Lucas, this was widely attacked at the time but very much set the pattern for later exhibitions. He resigned from the Academy in 2005.

Further Reading: N. Rudd, *Peter Blake* (2003)

Blanchard, Maria (1881–1932) Spanish-French painter, born at Santander, Spain, of a Spanish father and a Franco-Polish mother. After studying in Madrid she moved to Paris in 1906 and was introduced by van *Dongen into the *Cubist circle. From 1913 to 1916 she lived in Spain, then settled permanently in Paris. Although she became closely linked with the Cubists, she took from them structural mannerisms rather than a commitment to the intellectual principles of the movement. Indeed, her approach was emotional rather than cerebral; she was best known for her scenes of everyday life, and her depictions of sad or solitary children are particularly memorable— a reflection perhaps of the fact that she was herself crippled from childhood.

Blanche, Jacques-Émile (1861–1942) French painter, born in Paris, the son of Émile Blanche, a noted pathologist. He grew up in a cultured atmosphere and became a well-known figure in artistic and society circles—he was a friend of *Degas, *Renoir, *Whistler, the writers Henry James and Marcel Proust, and many other celebrities. His best-known works are stylish portraits of people from this milieu. Blanche lived mainly at Offranville, near the Channel port of Dieppe (the local church has decorative painting by him), and he was a frequent visitor to Britain, painting numerous views of London (the Tate has an example). He wrote several books of criticism and reminiscence, including *Mes Modèles* (1928), *Portraits of a Lifetime . . . 1870–1914* (1937), and *More Portraits of a Lifetime . . . 1918–38* (1939).

Blast See VORTICISM.

Blaue Reiter, Der (The Blue Rider) A loosely organized association of artists founded in Munich in December 1911 as a splinter group from the *Neue Künstlervereinigung

(NKV). It held only two exhibitions (poorly received by press and public) and was broken up by the First World War, but its brief life is considered to mark the high point of German *Expressionism. The founders of the Blaue Reiter were Wassily *Kandinsky (the driving force), Franz *Marc, and Gabriele *Münter, who together resigned from the NKV early in December 1911 in protest against its growing conservatism and organized a rival exhibition that opened on the same day as the NKV's last show (18 December) in the same venue (the Moderne Galerie Thannhauser, Munich). The new group's exhibition was entitled 'First Exhibition by the Editorial Board of the Blue Rider', a reference to an *Almanac* (a collection of essays and illustrations) that Kandinsky and Marc had been planning for some time and which appeared in May 1912 (it was originally intended to be an annual, but this was the only issue that ever appeared); the cover featured a drawing by Kandinsky of a blue horseman (blue was the favourite colour of Marc, who regarded it as particularly spiritual, and the horse was his most cherished subject; Kandinsky, too, often painted horses with riders, evoking ideas of medieval knights or warrior saints).

The first Blaue Reiter exhibition, which obviously had to be arranged at very short notice, featured only 43 works by fourteen artists. Apart from the three founders they were: the American painter Albert Bloch (1881–1961), David and Vladimir *Burliuk, Heinrich *Campendonk, Robert *Delaunay, Elizabeth Epstein (1879–1956), Eugen Kahler (1882–1911), August *Macke, Jean Bloé Niestlé (1884–1942), the recently deceased Henri *Rousseau, and the composer Arnold Schoenberg (1874–1951), who was a friend of Kandinsky and Marc and a talented amateur painter. In March 1912 the exhibition travelled to Berlin to inaugurate the *Sturm Gallery, and it was also shown (with some additions) in Cologne, Frankfurt, and Hagen. The second Blaue Reiter exhibition was held at the dealer Hans Goltz's gallery in Munich in February–April 1912. It included only watercolours, drawings, and prints, but was larger and broader in scope than the first show, featuring 315 works by thirty-one artists, among them (in addition to many of those who took part in the first exhibition) *Braque, *Derain, *Goncharova, *Klee, *Larionov, *Picasso, *Vlaminck, and the artists of the *Brücke group. This was the last exhibition to bear the Blaue Reiter name, but four of the 'core'

artists—Kandinsky, Klee, Macke, and Marc—were also represented at two of the greatest exhibitions of the era—the *Sonderbund exhibition in Cologne in 1912 and the 'First German *Salon d'Automne' at the Sturm Gallery in Berlin in 1913. Although *Jawlensky's work was not included in either of the two official group shows, he did exhibit alongside Kandinsky, Klee, Macke, and Marc at the Sturm Gallery in 1913 and he is generally considered part of the Blaue Reiter circle; indeed, it is to these five that the idea of a Blaue Reiter 'group' chiefly applies. *Feininger, also, showed his work with this group at the Sturm exhibition.

Unlike the members of Die Brücke, the main artists associated with the Blaue Reiter were not stylistically unified, although their work tended towards the spiritual (rather than the more earthy concerns of the Brücke) and also towards abstraction. They had no artistic or social programme and no plans for communal activities apart from exhibitions. According to a statement in the catalogue of the first exhibition, their aim was 'simply to juxtapose the most varied manifestations of the new painting on an international basis . . . and to show, by the variety of forms represented, the manifold ways in which the artist manifests his inner desire'. Their urge for freedom of expression, unrestricted by the normal conventions of European art, comes out clearly in the *Almanac*, which was dominated by Kandinsky's interest in the relationship between painting and music (Schoenberg contributed an article) and by Marc's enthusiasm for various types of *'primitive' art. In this last respect, it reproduced a remarkable variety of works, including folk art from Germany and Russia, Japanese prints, African and Oceanic art, medieval sculpture, *naive paintings by Rousseau, and children's drawings. (This was one of the first instances of the reproduction of children's art; *see* CIŽEK.) The essential idea behind this outlook was Nietzsche's dictum that 'Who wishes to be creative . . . must first blast and destroy accepted values'.

Further Reading: *The Blaue Reiter Almanac* (2005) [English translation of the original]

Blaue Vier, Die (The Blue Four) A group of four painters—*Feininger, *Jawlensky, *Kandinsky, and *Klee—formed in 1924 at the instigation of the German art dealer Galka Scheyer (1889–1945) with the aim of promoting their work abroad (where there was a better market for art than in economically depressed

Germany). The four had all been associated with the *Blaue Reiter, and Scheyer chose the name 'Blaue Vier' because 'a group of four would be significant though not arrogant . . . the colour blue was added because of the association with the early group of artists in Munich that founded the "Blue Horseman" . . . and also because blue is a spiritual colour'. In addition, Kandinsky wanted a name that did not suggest an 'ism'. The artists signed an agreement on 31 March 1924 and Scheyer embarked for the USA in May, taking with her a selection of their works. She staged several Blaue Vier exhibitions at various venues over the next decade, together with lectures; the venture was a moderate financial success and an important factor in spreading the reputation of the four artists. Scheyer settled in the USA and became an American citizen. Her own collection of paintings by the Blaue Vier is now in the Norton Simon Museum, Pasadena, California.

Bleyl, Fritz See BRÜCKE, DIE.

Bliss, Lillie P. (1864–1931) American collector and patron, born into a wealthy Boston family. She was a friend of Arthur B. *Davies, who stimulated her interest in modern art. At the *Armory Show (1913), masterminded by Davies, she bought pictures by *Degas, *Redon, and *Renoir, and later developed a taste for more avant-garde work. In 1929 she was one of the founders of the *Museum of Modern Art, New York, and when she died two years later she left the bulk of her collection to the Museum. Her bequest included eleven oils and eleven watercolours by *Cézanne (her favourite artist) and works by *Derain, *Gauguin, *Modigliani, *Picasso, *Rousseau, and other major figures. The gift formed the foundation of the permanent collection and, because her will stipulated that certain paintings could be sold or exchanged, it made possible further enhancement of the collection.

Bloc, André (1896–1966) French sculptor, designer, writer, editor, and exhibition organizer, born in Algiers. After studying architecture and engineering in Paris he became a friend of *Le Corbusier and founded the periodical *Architecture d'aujourd'hui*. He took up sculpture in 1940, initially being influenced by *Laurens. In 1949 he turned to abstract sculpture, and launched the periodical *Art d'aujourd'hui*, which ran until 1954. It was the first periodical to be devoted solely to abstract art. Bloc used a wide variety of materials and techniques in his work, but he is more important as an editor and exhibition organizer than as a creative artist. *See also* GROUPE ESPACE.

Bloch, Albert See BLAUE REITER.

Bloch, Martin See MAISTRE, ROY DE.

Blok A group of Polish avant-garde artists, active in Warsaw from 1924 to 1926; Blok was also the name of the group's quarterly magazine, which ran to eleven issues. The most important members of the group were Vladislav *Strzemiński, his wife, Katarzyna Kobro, and the painter Henryk Stażewski (1894–1988). Although Blok's outlook was essentially *Constructivist, there were doctrinal splits among some of the members, and the group ceased its activities in 1926. Many of the members, including the three named above, joined its successor, Praesens, which ran from 1926 to 1939; it, too, published a magazine with the same name as the group. In 1929 Strzemiński, Kobro, and Stażewski left to found another group, a.r. (revolutionary artists), which continued until 1936.

Blomfield, Sir Reginald See MODERNISMUS.

Bloom, Barbara See INSTALLATION.

Bloomsbury Group A loose association of writers, artists, and intellectuals that was a distinctive force in British cultural life during the early decades of the 20th century. Leading members of the group included the writers E. M. Forster, Lytton Strachey, and Virginia Woolf, and the economist John Maynard Keynes (*see* ARTS COUNCIL), who was also a notable patron; among the artists and critics were Clive *Bell, Vanessa *Bell, Dora *Carrington, Roger *Fry, Duncan *Grant, and Henry *Lamb. They often met at the houses of Clive and Vanessa Bell, or of Vanessa's sister, Virginia Woolf, in the Bloomsbury district of London, which had long been a favourite area for artists, musicians, and writers (the British Museum, the University of London, various learned institutions, and numerous publishers' offices are all in the locality). The original meeting place, from about 1905, was 46 Gordon Square, at that time the home of Vanessa and Virginia Stephen (as they were before their marriages).

The association stemmed from student friendships formed at Cambridge University: most of the 'Bloomsberries' had been at either King's College or Trinity College and many

had been 'Apostles'—members of an exclusive, semi-secret intellectual club. However, the Bloomsbury Group had no formal membership and no common social or aesthetic ideology. The members were united mainly by their belief in the importance of the arts and—in revolt against the restrictions of Victorian society—by their frankness and tolerance in sexual matters (several of them were homosexual or bisexual and their love lives were often complexly intertwined). A key book for them was *Principia Ethica* (1903) by the Cambridge philosopher G. E. Moore, in which it is argued that 'By far the most valuable things...are...the pleasures of human intercourse and the enjoyment of beautiful objects...it is they that form the rational ultimate end of social progress'.

In the visual arts, the Bloomsbury Group made its most significant impact in the 1910s, after it had been joined by Roger Fry (he had lived in New York from 1906 to 1910). Fry was highly influential in promoting an awareness of modern art—through his writing and lecturing, through his two *Post-Impressionist exhibitions (1910 and 1912), and through his founding of the *Omega Workshops (1913). It was at this time, too, that Vanessa Bell and Duncan Grant were at their most adventurous, both of them producing pure abstracts by 1914. From the 1920s the members of the group were no longer in the forefront of ideas, but Duncan Grant was at this time at the peak of his popularity. The richly coloured figurative style in which he and Vanessa Bell worked in the period between the two world wars is considered the 'typical' Bloomsbury style. By the early 1930s the Bloomsbury Group had ceased to exist in its original form; the death of Lytton Strachey in 1932 is sometimes taken as a convenient terminus, although it was perhaps the suicide of Virginia Woolf in 1941 that really marked the end of an era. After the Second World War, Bloomsbury ideas fell out of fashion and the members of the group were attacked as dilettantist and elitist. However, from the late 1960s there has been a great revival of interest in all aspects of the group, marked by the publication of numerous biographical and critical studies.

Blow, Sandra (1925–2006) British abstract painter, born in London. She studied at *St Martin's School of Art under Ruskin *Spear, 1942–6, and the Academy in Rome, 1947–8. In 1961 she won second prize for painting at the *John Moores Liverpool Exhibition and in the same year began teaching at the *Royal College of Art. She worked in a number of abstract styles, including *gestural abstraction and *Colour Field Painting. At one time she was the lover of Alberto *Burri and like him used the materials of wood and tar. She considered herself an 'academic abstract painter', primarily concerned with such problems as balance and proportion—'issues that have been important since art began'. John *McLean described her as a 'true colourist' who deserved to be put alongside *Matisse and *Miró.

Further Reading: M. McNay and J. McLean, obituaries, *The Guardian* (23 August 2006)

Blue Four *See* BLAUE VIER.

Blue Rider *See* BLAUE REITER.

Blue Rose (Golubaya Roza) Group of Russian painters active in the first decade of the 20th century, named after an exhibition held in Moscow in 1907. Their acknowledged inspiration was Victor Borisov-Musatov (1870–1905), celebrated for his paintings of languid young women in 18th-century costume, and their style was essentially *Symbolist, although there was also influence from *Fauvism and an interest in *primitivism. (The origin of the name is uncertain, but the colour blue was particularly significant for Symbolists, associated with the sky and spirituality, and the rose has many symbolic associations: in 1904 an exhibition called the Crimson Rose or Scarlet Rose (Alaya Roza) had been held in Saratov, Borisov-Musatov's home town, and the Blue Rose was a successor to this.) Borisov-Musatov's most talented follower was Pavel Kuznetsov (1878–1968); other members of the group included the Armenian Martiros Saryan (1880–1972) and the Greek-born Milioti brothers, Nikolai (1874–1955) and Vasily (1875–1943). Georgy Yakulov (1882–1928), best known as a stage designer, was not a formal member, but he shared the group's concerns and was invited to contribute to their retrospective exhibition in 1920. The group was promoted by and exhibited under the auspices of the journal *Golden Fleece* which was published in Moscow from 1906 to 1909.

Blume, Peter (1906–92) American painter. Born in Russia, he was brought to the USA as a child in 1911 and trained at various art

colleges in New York, including the *Art Students League. He used the meticulous technique of the *Precisionists, but combined this with bizarre imagery in a way that won him a reputation as one of the first American *Surrealists. In 1934 he came to prominence when his *South of Scranton* (1931, MoMA, New York) won first prize at the *Carnegie International Exhibition, and in 1939 he caused controversy when his most famous painting, *The Eternal City* (1934–7, MoMA, New York), was rejected for exhibition at the Corcoran Gallery Biennial in Washington because it was considered too inflammatory. Blume had visited Italy in 1932–3 and the painting is a satirical attack on Fascism, showing Mussolini as a gruesome, green-headed jack-in-the-box. Although Blume used the imagery of Surrealism, the appeal for him was intellectual and not, as with most European Surrealists, to associations of the unconscious mind: he said that 'Since I am concerned with the communication of ideas I am not at all ashamed of "telling stories" in my paintings, because I consider this to be one of the primary functions of the plastic arts'. His working method was slow and painstaking, so his output was small. In 1970 he began making sculptures.

Blumenschein, Ernest *See* TAOS COLONY.

Blunt, Anthony (1907–83) British art historian and spy. He was born in Bournemouth and grew up mainly in Paris, where his father was chaplain at the British embassy. From 1926 to 1930 he studied at Trinity College, Cambridge, initially reading mathematics, then switching to modern languages, and in 1932 he became a fellow of the college. In 1936 he joined the staff at the Warburg Institute, London, and at about the same time he started lecturing at the recently founded *Courtauld Institute of Art. During the 1930s Blunt wrote a good deal on modern art, mainly in the form of articles and reviews in *The Spectator*, for which he was the regular art critic for several years; in this capacity he argued for a politically motivated realist art. One of his attacks was on *Picasso's *Guernica*, which he thought was 'not the right way to commemorate a great human and revolutionary tragedy', being 'merely an expression of his [Picasso's] private sensation of horror'. These views (which he later repudiated) brought Blunt into dispute with Herbert *Read, 'though in a friendly man-

ner because we happened to be members of the same club'.

In 1939 Blunt became deputy director of the Courtauld Institute and from 1947 to 1974 he was director. After the war, his publications were mainly on 17th-century French and Italian art, although he wrote occasionally on Picasso and Rouault. In 1979, it was sensationally announced in Parliament that Blunt had been a spy for the Soviet Union during the Second World War (when he worked for MI5). He had confessed in 1964, being offered immunity from prosecution in return for the information he provided. The revelation caused a huge scandal, for Blunt was not only a highly distinguished academic, but also a former senior royal servant (Surveyor of the Queen's Pictures). He coped calmly with the disgrace (which included being stripped of his knighthood) and continued his scholarly work until the end of his life. *See also* SEWELL, BRIAN.

Boccioni, Umberto (1882–1916) Italian *Futurist painter, sculptor (the only major one in the movement), and art theorist. He was born in Reggio Calabria and in 1899 moved to Rome, where he worked as a commercial artist. In 1901 he met *Balla, who introduced him to *Divisionism. Balla's studio was a forum for Rome's artistic and literary avant-garde and it was there that Boccioni met *Severini, who became a close friend. In 1906 he visited Paris and Russia, then after brief stays in Padua and Venice he settled in Milan in 1907. Over the next two years he experimented with various styles, but it was only after he joined the Futurists in 1909 that his career took off, and all his important work was done in the seven years between then and his premature death. He signed the two Futurist manifestos of painting (both 1910), wrote the one on sculpture (1912), and became the most energetic member of the group. Advocating a complete break with the art of the past, Boccioni was centrally concerned with the two main preoccupations of the Futurists—the production of emotionally expressive works and the representation of time and movement. In his early Futurist works he often showed an interest in social themes, particularly big city life, but later (especially after a visit to Paris in 1912, when he was influenced by *Cubism) he tended to use his paintings more as vehicles for his theories than as comments on life around him.

Eventually this tendency led him close to abstraction, in pictures such as *Dynamism of a Human Body* (1913, Galleria d'Arte Moderna, Milan).

Boccioni's ideas were set out most fully in his book *Pittura scultura futuriste: Dinamismo plastico* (1914). In this he proposed that whereas the *Impressionists painted to perpetuate a single moment of vision, Futurism synthesizes in a picture all possible moments; and in contrast to the objective outlook of Cubism, he claimed that Futurist painting aspires also to express 'states of the soul'. In common with the other Futurists (following the ideas of the contemporary French philosopher Henri Bergson), he believed that physical objects have a kind of personality and emotional life of their own, revealed by 'lines of force' with which the object reacts to its environment. This notion is perhaps best shown in Boccioni's most famous piece of sculpture, *Unique Forms of Continuity in Space* (1913, casts in Tate, MoMA, New York, and elsewhere), which vividly expresses bodily movement. His ideas about sculpture were extremely forward-looking. He advocated the use of materials such as glass and electric lights and the introduction of electric motors to create movement. However, he died in an accident whilst serving in the Italian army before most of his ideas could be put into practice. In some of the paintings done near the end of his life he in any case seemed to be turning away from Futurism to a more sober figurative style recalling the work of *Cézanne (*Portrait of Ferruccio Busoni*, 1916, Galleria Nazionale d'Arte Moderna, Rome).

Boch, Anna See LUMINISM.

Bochner, Mel (1940–) American artist, born in Pittsburgh. He moved to New York in 1963. The exhibition which he held in 1966 at the School of Visual Arts, New York, entitled 'Working Drawings and Other Visible Things on Paper Not Necessarily Meant To Be Viewed as Art', has been described as the first *Conceptual art exhibition. Bochner himself disliked the term on the grounds that it set up a too easy dichotomy with 'perceptual'. His works actually address the issue of perception and how it might be modified. *Measurement Room* (1969) uses tape and Letraset to mark out the measurements of walls, doors, and windows. *Measurement Series* (1967) sets the growth of a plant against a wall chart.

Bochner challenges the idea of 'boundaries' and 'stable properties' of things. This stands in opposition to the *formalist theory of art. If our perception of things is so dependent on accident and contingency, then the art object can hardly ever be perceived in the one true way that formalism demands. The actual experience of the room or the plant will always be more than its measurements. Bochner has also made work using photography, which explores the mechanics of artistic representation such as perspective and scale.

Böcklin, Arnold See HODLER, FERDINAND.

Bode, Arnold See DOCUMENTA.

Body art A type of art in which the artist uses his or her own body as the medium; it is closely related to *Conceptual art and *Performance art, and flourished mainly at the same time that these forms of expression were at their peak—the late 1960s and 1970s. Sometimes the work is executed in private and communicated by means of photographs or video recordings; sometimes the execution of the 'piece' is public. The performance may be pre-choreographed or extemporaneous. Spectator participation is occasionally invited, as in certain work by Magdalena *Abramović. The leading exponents of Body art, including Vito *Acconci, Chris *Burden, and Gina *Pane, have often been concerned with self-inflicted pain or ritualistic acts of endurance.

Although the 1970s marked the heyday of Body art, there was something of a revival in the 1990s, one of the best-known exponents being the French artist *Orlan, who has undergone plastic surgery in the cause of art. She comments 'As my friend the French artist Ben Vautier says, "art is a dirty job but somebody's got to do it."' (Benjamin Vautier (1935–), who works under the name Ben, is a painter and Performance artist whose work has included *Vomit Pictures*, consisting of black canvasses on to which he vomited, and performances in which he banged his head against a wall.) Outside the art world, the term 'body art' is more commonly used to mean permanent modifications to the body, usually for decorative purposes, such as tattooing or piercing.

Further Reading: L Vergine, *Body Art and Performance: The Body as Language* (2000)

Boetti, Alighiero (1940-94) Italian artist, born in Turin. He had no formal art training but became interested in contemporary art

through exhibitions seen in his native city. He had his first solo exhibition in 1967 and later that year took part in the *Arte Povera exhibition in Genoa, the first occasion that the tendency was identified. Of the artists associated with it, Boetti was the most concerned with ideas and closest to *Conceptual art. The *Yearly Lamp* (c.1966) is programmed to switch itself on at random for just eleven seconds every year. In *Manifesto* (1967) he printed out the names of fifteen Italian artists and placed beside them a series of symbols. The meaning of these symbols, Boetti said, had been deposited with a lawyer and would be revealed to anyone who paid a fee. Despite extensive research, the lawyer has never been tracked down. *Gemelli* (Twins) (1968) is a postcard sent to friends and associates which uses *photomontage to show Boetti walking hand in hand with himself. From 1972 onwards Boetti signed all his work 'Alighiero e Boetti' as though it was the product of two joined personalities. He said: 'Alighiero is the more infantile side, more external . . . Boetti is more abstract, precisely because a surname is a category.' One of Boetti's projects was a publication listing the longest rivers in the world. This turned out to be more problematic and less objective than might be expected because of 'partial information', the problems of language, and 'the intangible nature of water'. Boetti spent much time in the 1970s in Afghanistan before the Soviet invasion. He was introduced to the local craft of embroidery and it was in collaboration with craft-workers there and in Pakistan that he made the maps of the world which are his most celebrated works. Each country is identified totally with its flag, a device which emphasizes the arbitrary nature of national boundaries. Boetti died in Rome from a brain tumour.

Further Reading: Whitechapel Art Gallery, *Alighiero e Boetti* (1999)

Bogart, Bram (1921–) Dutch/Belgian painter, born in Delft. He moved to Belgium in 1960, acquiring Belgian nationality in 1969. He is one of the chief exponents of *Matterism, making paintings so thick as almost to constitute reliefs. He works with a complex technique involving large quantities of pigment purchased in powder form, combined in two separate mixtures with water and oil, then mixed with plaster or cement to make it malleable. The result is colour of remarkable clarity and splendour.

Boguslavskaya, Kseniya *See* POUGNY, JEAN.

Boiffard, Jacques-André *See* BATAILLE, GEORGES.

Bois, Yves-Alain *See* BATAILLE, GEORGES.

Boldini, Giovanni (1842–1931) Italian painter, one of the most renowned society portraitists of his day. His dashing brushwork and gift for making his sitters look poised and graceful recalled the work of his even more successful contemporary, John Singer *Sargent, and like Sargent he had an international career. Together with another flamboyant portraitist, Antonio Mancini (1852–1930), he was probably the best-known Italian artist at the turn of the century. Apart from portraits, Boldini's work includes some excellent street scenes of Paris, where he spent most of his career. There is a Boldini museum in his native Ferrara; the collection includes a self-portrait (1911) regarded as one of his finest works. As with Sargent, his work went out of favour after his death, being considered merely glossy and superficial (*Sickert referred to his 'wriggle-and-chiffon' style).

Bolotowsky, Ilya (1907–81) Russian-born painter who became an American citizen in 1929. His family fled revolutionary Russia in 1920 and in 1923 settled in New York, where he studied at the National Academy of Design, 1924–30. In the early 1930s his work was *Expressionist (he was a member of The *Ten), but in 1933 he was deeply impressed by paintings by *Mondrian and thereafter became one of America's most committed exponents of geometrical abstraction. He wrote: 'After I went through a lot of violent upheavals in my early life, I came to prefer a search for an ideal harmony and order which is still a free order, not militaristic, not symmetrical, not goose-stepping, not academic', and 'In my paintings I avoid all associations. I try for perfect harmony, using neutral elements. I want things absolutely pure and simple.' Bolotowsky was a founding member of *American Abstract Artists in 1936 and his mural for the Williamsburg Housing Project, New York, of that year was one of the first abstract murals to be commissioned. After the Second World War he taught at various art schools, notably *Black Mountain College, 1946–8. In spite of his reverence for Mondrian, his approach was far from cerebral and he had a love of intense, sensuous colour (*Vibrant Reds*,

1971, Smithsonian American Art Museum, Washington). He also made painted constructions.

Boltanski, Christian (1944–) French sculptor, painter, installation artist and filmmaker, born in Paris on the day of the Liberation. His Jewish father had spent the Occupation hiding under the floorboards. Boltanski left school aged eleven and spent his time painting. His father's anxieties about anti-Semitism meant that he was not allowed to leave the house alone until he was eighteen. His work is in a variety of media but is always concerned with death, memory, and loss. *L'homme qui tousse* (1969) is a film in which he crouches in the corner of a tiny room and coughs until blood streams out of his mouth. Sometimes he juxtaposes photographs with lamps, as in *20 Dead Swiss* (1990, Kemper Art Museum). These photographs are printed in high contrast to suggest skulls. In other works everyday possessions are presented in vitrines, as if trapping the ephemera of ordinary life. His preoccupation with death has meant that his work has been frequently related to the Holocaust, with the assumption that his photographs are of victims. One of his themes is, in fact, the uncertainty involved in reading photographs of people. An installation entitled *Sans Souci* shows photographs of the domestic lives of those who happen to be Nazi war criminals. Another work brings together without comment the photographs of murderers and their victims without identifying which is which. He is married to the artist Annette *Messager, who, he says, 'never comes to my studio'. Nonetheless it is hard not to notice an affinity in both artists' love for hanging marionettes. Some of Boltanski's most striking installations have cut-out figures, often skeletons and skulls, lit to cast giant shadows on the walls around them. As something of an antidote to the perceived grimness of much of his work, Boltanski has tended to present a rather nonchalant image: 'I come to my studio every day at 10.30 and I stay and do nothing . . . It's a good life being an artist because you do what you want.'

Further Reading: R. Caines, 'Christian Boltanski: representation and the performance of memory', *Afterimage* (July–August 2004)

'Christian Boltanski', *Tate Magazine*, no. 2 (2002)

Bolus, Michael (1934–) South African/British sculptor. Born in Cape Town, he moved to England in 1957 and studied at *St Martin's School of Art under Anthony *Caro. He took part in the 1965 *'New Generation' exhibition. His work is characteristic of that exhibition. It is made of flat plates of aluminium and painted in bright colours. In the exhibition catalogue his work was identified by Ian Dunlop as especially radical. Dunlop wrote that 'it presents a challenge to even the most broadminded among us to free our minds from all preconceptions of what we believe sculpture should look like.' The works were the closest to painting of all the works in the exhibition. Colour took on a vital role in defining the form. The issue of polychromy was identified by Michael *Fried as the most significant element in Bolus's sculpture. Reviewing his work in 1971 he pointed to the intense experience of the coloured surfaces in contrast to the comparative conventionality of the structure.

Further Reading: Fried (1998)

Bomberg, David (1890–1957) British painter and teacher. He was born in Birmingham of Polish-Jewish immigrant parents and grew up in the Whitechapel area of London, where his father was a leather-worker. In 1908 he gave up an apprenticeship as a lithographer to devote himself to painting, encouraged by *Sargent, who had noticed him drawing in the Victoria and Albert Museum. He studied under *Sickert at Westminster School of Art (1908–10) and—with support from the Jewish Education Aid Society—at the *Slade School (1911–13), where he won a prize for a drawing of his fellow-student Isaac Rosenberg (1890–1918). Whilst still a student Bomberg showed an advanced understanding of avant-garde Continental painting, particularly *Cubism and *Futurism (he visited Paris with *Epstein in 1913), and his work has much in common with that of the *Vorticists, although he turned down Wyndham *Lewis's invitation to join the group. His best-known work of this time is probably *In the Hold* (1913–14, Tate), a large, dazzlingly coloured abstraction of fragmented geometric forms, based on the subject of men working in the hold of a ship in the docks. It was one of the most discussed works at the first exhibition of the *London Group in 1914, and in the same year Bomberg's first one-man show, at the Chenil Gallery, London, was well received critically (although sales were poor). In 1915 he enlisted in the Royal Engineers, then transferred to the King's Royal Rifles as a sapper, and in 1918 he was commissioned

by the Canadian War Memorials Fund to make a large painting of *Sappers at Work: A Canadian Tunnelling Company*. His first version (1918–19, Tate) was turned down as being too avant-garde, so he replaced it with a more conventionally naturalistic picture (1919, NG, Ottawa).

In the years immediately after the First World War Bomberg continued to receive respectful press notices but still had difficulty selling his work. Dismaying of achieving success in Britain, he moved to Palestine in 1923 (at the suggestion of Muirhead *Bone, whose advice he had sought) and for the next four years he lived mainly in Jerusalem, where he worked for the Zionist Organization, producing illustrations for newspapers and pamphlets. He returned to Britain in 1927 but continued to travel widely. In his illustrations for the Zionist Organization he had of necessity worked in a fairly naturalistic style and in his paintings he began moving away from abstraction to a heavily worked, somewhat *Expressionist figurative style, painting mainly portraits and landscapes. Much of his later career was devoted to teaching at various London colleges, most notably Borough Polytechnic, 1945–53. Many of his pupils, among them Frank *Auerbach and Leon *Kossoff, found him an inspiring teacher. Auerbach recalls that in his classes 'there was an atmosphere of research and radicalism that was extremely stimulating'. Bomberg's pupils exhibited together under the name Borough Group, 1947–50, and then as the Borough Bottega, 1953–6. In spite of the admiration he received from those who knew him well, Bomberg was by this time becoming increasingly embittered at the lack of general recognition for his work (John *Rothenstein writes that during his lifetime he was 'the most neglected major British artist of his time'), and in 1954 he moved to Spain. He returned to England shortly before his death. Subsequently his reputation soared, especially after an *Arts Council exhibition of 1967.

Further Reading: R. Cork, *David Bomberg* (1988)

Bombois, Camille (1883–1970) French *naive painter, born at Venarey-les-Laumes, the son of a boatman. He spent his childhood on canal barges until he became a farmhand at the age of twelve. Later he was a road labourer and a wrestler in travelling circuses. From 1907 he lived in Paris, where after working as a porter on the Métro, a navvy, and a docker, he took a night job in a printing establishment so that he could paint during the day. He served in the French army during the First World War and was awarded a Military Medal. In 1922, when he was painting outdoors in Montmartre, a journalist noticed his work and he came to the attention of Wilhelm *Uhde and other critics. With their encouragement he was able to devote all his time to painting and he became one of the best-known naive painters of his day, exhibiting his work widely. His paintings include landscapes, townscapes, portraits, hefty female nudes (inspired by his wife), and scenes of circus life. It is for his circus pictures that he is now best known; they have great strength and vigour and sometimes an unconscious *Surrealist air. For example, in *Carnival Athlete* (*c*.1930, Pompidou Centre) some of the bowler-hatted figures are similar to those seen in *Magritte's paintings.

Bone, Sir Muirhead (1876–1953) British draughtsman, printmaker, and occasional painter, mainly of architectural subjects, born in Glasgow, the son of an architect. From 1890 to 1894 he trained to be an architect, while taking evening classes at *Glasgow School of Art. He moved to London in 1901. In the years before the First World War he built up a considerable reputation as a printmaker (drypoint was his favourite medium), and his success enabled him to live abroad for several years. He was not interested in traditional picturesque views, however, finding nothing in Florence to inspire him; 'Every cat in the world had been there and the plate had been licked clean.' Instead, his 'special province was the rendering of great masses of buildings under construction or demolition, with all the attendant paraphernalia, in such a manner that out of superficial chaos there emerged a beautiful and ordered design' (Robert Cumming in *Country Life*, 23 February 1978). This ability to combine an overall sense of structure with a wealth of detail has been attributed to a peculiarity of Bone's eyesight: he was short-sighted in one eye and long-sighted in the other. Although his own work was traditional in style, he was sympathetic to modern art and was forthright in defending his friend *Epstein from attacks by conservative critics. Among the other avant-garde artists he admired was David *Bomberg, who moved to Palestine on Bone's advice.

In 1916 Bone was the first person to be appointed an *Official War Artist. A collection

of his lithographs was published in 1917 in two volumes as *The Western Front*, with a text by the journalist C. E. Montague. Bone's enthusiasm played an important part in the founding of the Imperial War Museum, and he served as an Official War Artist again in the Second World War and was a member of the War Artists' Advisory Committee. Bone was a trustee of the National Gallery and the Tate Gallery, and was knighted in 1937.

Bonn, Kunst- und Ausstellungshalle der Bundesrepublik Deutschland See HULTEN, PONTUS.

Bonnard, Pierre (1867–1947) French painter, lithographer, and designer, born at Fontenay-aux-Roses, near Paris. His father, an official in the War Ministry, insisted that he study law, but from 1888 he also attended classes at the École des *Beaux-Arts and at the *Académie Julian, where he met several young artists (including his lifelong friend *Vuillard), who formed a group of *Symbolist painters called the *Nabis. After doing military service, 1889–90, he abandoned law and became a full-time artist, initially sharing a studio in Paris with *Denis and Vuillard. His first one-man exhibition was at *Durand-Ruel's gallery in 1896. At this time, as well as painting, he was producing posters and coloured lithographs, and designing for the stage: he worked on the original production of Alfred Jarry's *Ubu-Roi* (1896), considered the first work of the Theatre of the Absurd. He prospered steadily in his career and by 1912 was sufficiently distinguished to be offered the Legion of Honour (he declined, as did Roussel, *Vallotton, and Vuillard at the same time). In the same year he bought a house at Vernonnet in the Seine Valley and from then until the Second World War he divided his time mainly between this house and the South of France. In 1925 he bought a house called 'Le Bosquet' at Le Cannet, near Cannes, and spent his final years there. His life was quiet and uneventful, although he travelled a good deal before the First World War.

Like Vuillard, Bonnard is best known for intimate domestic scenes to which the term *Intimiste is applied. He generally painted on a larger scale than Vuillard, however, and with greater richness and splendour of colour. His favourite model was his wife, and some of his most characteristic pictures are those in which he depicted her in the bath (she had an obses-

sion with personal cleanliness and spent much of her time in the bathroom). His other subjects included flowers and landscapes. He also did numerous self-portraits. The late ones show his desolation after the death of his wife in 1940, but in general his work radiates a sense of warmth and well-being. This quality and his lively broken brushwork make him one of the most distinguished upholders of the *Impressionist tradition. In the catalogue of a large exhibition of his work at the Royal Academy, London, in 1966, Denys Sutton referred to Bonnard as 'the most important "pure" painter of his generation' and wrote that 'His paint has something almost edible about it, and it was hardly fortuitous that he so often painted meals and food on the table'.

After the death of his wife, Bonnard faked a will in her name to avoid certain legal complications. This went undetected during his lifetime, but after his own death it caused lengthy lawsuits, as a result of which his substantial collection of his own work was sequestered from public view for many years.

Further Reading: T. Hyman, *Bonnard* (1998)

Bontecou, Lee (1931–) American sculptor and printmaker, born at Providence, Rhode Island. She studied under William *Zorach at the *Art Students League, 1952–5, and then worked in Rome on a Fulbright Fellowship, 1957–8. In 1959 she had her first one-woman show (of bronzes), at the 'G' Gallery, New York, and in the same year she began making *assemblages. Typically they were constructed from grey canvas or tarpaulin, cut into irregular shapes and affixed to a support in faceted planes by means of wire with protruding hooks and barbs, creating a deliberately brutal air; often they also incorporated welded steel and miscellaneous scrap. She continued to be inventive in her use of materials: some of her work in painted plaster relief and free-standing or hanging plastic, for example, explored a fairyland of imaginary flora and fauna. From the late 1960s she concentrated on printmaking.

Bonvicini, Monica (1965–) Italian artist, born in Venice and active in Berlin. She studied with the Conceptual and installation artist Michael *Asher. Her work, which takes the form of video, installation, and sculpture, is a critique of modernist architecture and explores the element of aggression within the purity. Bullet holes and chains are regular

motifs in her work. An example is *Built for Crime*, installed at Tate Liverpool in 2006. The title is spelt out in lights and the work is made of shatterproof glass, which has received sufficiently strong blows to make it crack. Glass was the classic material of the great pioneers of modern architecture Gropius and Mies van der Rohe (*see* BAUHAUS). With the aid of steel-frame construction theirs was a new kind of building, supposedly lighter and more open. Now glass is the line of defence in an increasingly aggressive society. Bonvicini sees in such architecture a kind of fetishism of material. *Don't Miss a Sec* (2003–4) is a public toilet encased in a see-through enclosure. This referred to the idea of the social reformer Jeremy Bentham (1748–1832) concerning the Panopticon, the prison in which the inmates could at no moment be sure that they were not being watched. It had a particular significance when it was displayed in a London square which Bentham had once proposed as the site for such a prison.

(⊕) SEE WEB LINKS

• Monica Bonvicini interview with Massimiliano Gioni, 'Destroy she Says', *Flash Art* website.

book art A term applied to books produced as a kind of *Conceptual art, valued for the ideas they embody rather than for their appearance or literary content. This type of work originated in the 1950s (Dieter *Roth began issuing such books in 1954), although there are precedents for the making of one-off 'book-objects' or 'object-books' (see OBJECT) in the work of the *Surrealists, and in 1920 Suzanne *Duchamp received—as a wedding present from her brother Marcel—instructions for a proto-Conceptual work involving a book. The first exhibition devoted to books of the type defined above was probably 'Book as Art-work' at the Nigel Greenwood Gallery, London, in 1972, and the term 'book art' began to be used soon afterwards. Among the artists who have made something of a speciality of book art is Ed *Ruscha. Hamish *Fulton and Richard *Long have both used the book as one means of documenting their walks. The type is very different from the *livre d'artiste, a very luxurious kind of illustrated book.

Borduas, Paul-Émile (1905–60) Canadian painter, active mainly in Montreal but also in Paris and New York. He trained as a church decorator under Ozias *Leduc, then studied at the École des Beaux-Arts, Montreal. In 1928 he went to Paris, where he studied briefly with Maurice *Denis, and in 1930 returned to Montreal, where he opened a studio for mural decoration. This met with little success, so he supported himself by working as an art teacher. In the early 1940s, under *Surrealist influence, he started to produce 'automatic' paintings (*see* AUTOMATISM) and he was the driving force behind the radical abstract group Les *Automatistes. The group's anarchistic manifesto, *Refus global*, published in 1948, led to his dismissal from his teaching post. Serious ill-health and in 1951 the breakup of his marriage increased his problems. In 1953 he moved to New York, where he met several leading *Abstract Expressionists (although communication was difficult as Borduas spoke little English), and in 1955 he settled in Paris. In his final years he achieved an international reputation, and at the time of his death (of a heart attack) the Stedelijk Museum in Amsterdam was planning a 'mid-career' retrospective that turned into a memorial tribute. His mature work has an *all-over surface animation recalling the work of Jackson *Pollock, although the only American influence Borduas acknowledged was that of Franz *Kline. He ranks with *Riopelle as one of the most important Canadian abstract painters of the post-war years, and like Riopelle he was widely influential in his country.

Borès, Francisco (Francisco Borès Lopez) (1898–1972) Spanish painter, active mainly in France. He was born in Madrid, where he studied at a private academy, and moved to Paris in 1925. For a time he was influenced by the *Cubism of Juan *Gris, with his combination of fragmentation and flatness. Characteristically he used a flat pastel-coloured background against which he arranged groups of familiar objects in black outline. Later work has a decorative calligraphic quality more reminiscent of Henri *Matisse and Georges *Braque, applied to the middle-class domestic interior.

Borglum, Gutzon (1867–1941) American sculptor of Danish descent, born at Bear Lake, Idaho. In the 1890s he worked in Paris (where he studied at the *Académie Julian) and London, then settled in New York in 1902. He made his name with large-scale public works, notably the statues of the twelve Apostles for the Cathedral of St John the Divine, New York (1905), and a six-ton marble

head of Abraham Lincoln (1908) for the US Capitol in Washington. Following their successful reception, he took still further the American cult for the colossal (what his wife called 'the emotional value of volume') when he was commissioned to carve a portrait of the Confederate general Robert E. Lee into the rock of Stone Mountain, near Atlanta, Georgia. Work began in 1917, but the project was aborted in 1925 after a dispute between Borglum and the commissioners. However, the project led to his most famous work (begun 1927), the 'carving' (he used dynamite and pneumatic drills) of a huge cliff at Mount Rushmore in the Black Hills of South Dakota with colossal portrait busts of Presidents Washington, Jefferson, Lincoln, and Theodore Roosevelt. Washington's head was completed in 1930, Jefferson's in 1936, Lincoln's in 1937, and Roosevelt's in 1939; the final details were added in 1941, after Borglum's death, by his son Lincoln. The project was sponsored by the US Government and cost more than $1,000,000.

Borisov-Musatov, Victor *See* BLUE ROSE.

Borofsky, Jonathan *See* NEW IMAGE PAINTING.

Borough Group and **Borough Bottega** *See* BOMBERG, DAVID.

Boshier, Derek (1937–) British painter, sculptor, designer, and experimental artist, born in Portsmouth. He studied at Yeovil School of Art, 1953–7, Guildford College of Art, 1957–9, and the *Royal College of Art, London, 1959–62. His contemporaries at the RCA included David *Hockney, Allen *Jones, R. B. *Kitaj, and Peter *Phillips, and like them Boshier is regarded as one of the leading British exponents of *Pop art. His work of the early 1960s was much concerned with the manipulative forces of advertising, treating the human figure in the same way as mass-produced goods and blending them together. One painting's title quotes Vance Packard's *The Hidden Persuaders* (1957), an influential study warning of the manipulative power of advertising. Others look critically at the space race and the relationship between Britain and the USA. *England's Glory* (1961) shows the eponymous matchbox being invaded by the stars and stripes. However, although Boshier's interest in advertising later resurfaced in his work, his involvement in Pop art was short-lived. In 1962 he spent a year in India, and this introduced Hindu symbolism into his work; soon afterwards he began producing *Hard-Edge geometrical abstracts with shaped canvasses. These incorporated perspective devices to create spatial illusion, to suggest the neon and billboards of the modern city. In 1966 he abandoned painting for sculpture in perspex and neon, then turned to photography, film, and *installation art. He took up painting again in 1979 and in the following year moved to Houston, Texas, as assistant professor of painting at the university. He now lives in Los Angeles.

Botero, Fernando (1932–) Colombian painter and sculptor, born in Medellín. He studied in Madrid and Florence, has travelled extensively, and since the early 1970s has lived mainly in New York and Paris. His early work was influenced by various styles, including *Abstract Expressionism, but in the late 1950s he evolved a highly distinctive style in which figures look like grossly inflated dolls; sometimes his paintings are sardonic comments on modern life, but he has also made something of a speciality of parodies on the work of Old Masters. Botero has acquired an international reputation for such works, accompanied by huge prices in the saleroom. In the early 1970s he began making sculpture in a similar vein to his paintings, and he has made several public monuments in bronze, notably *Broadgate Venus* (1990, Exchange Square, London). In 2004 he embarked on a series of paintings with a more explicitly political agenda, dealing with the accounts of torture of prisoners which had emerged from Abu Ghraib prison in Iraq. His work is well represented in the Museo de Arte Moderno in Bogotá.

Boty, Pauline (1938–66) British painter and actress, born in Croydon. She studied at Wimbledon School of Art and the *Royal College of Art, London, where she took the stained-glass course, although by that time this was frequently taken by those whose primary interest was painting. In 1962 she appeared alongside Peter *Blake and Derek *Boshier in Ken Russell's film *Pop Goes the Easel*, which alerted for the first time a wider public in Britain to the *Pop art phenomenon. Her early work consisted of collages more concerned with nostalgia than contemporary popular culture, but by the time she had her first solo exhibition at the

Grabowski Gallery in 1963, her paintings reflected topical issues as filtered through the mass media. *Scandal '63* (presumed lost) referred to the Christine Keeler affair by including a widely reproduced image of Keeler. The affair, involving a prostitute, the cabinet minister John Profumo, and a Russian spy, was widely regarded as having exposed the corruption of the existing British establishment, so providing a catalyst for the social changes of which *Pop was a symptom. Boty's paintings have been interpreted as offering a *feminist perspective on pop culture. Her best-known painting, *The Only Blonde in the World* (1963, Tate), shows the film star Marilyn Monroe, who had died tragically the previous year, trapped in a semi-abstract pattern reminiscent of the paintings of Richard *Smith. Her paired paintings *It's a Man's World* (1963–5) contrast gender stereotypes. The males (including politicians and scientists) are associated with grandiose Baroque architecture, the women (all naked) with a luxuriant tropical beach. Boty died young from cancer and her paintings disappeared from view for many years but were rediscovered in the early 1990s.

(⊕) SEE WEB LINKS

- A. Smith *Now you see her* (2002), biography of Pauline Boty.

Boucher, Alfred *See* RUCHE, LA.

Bourdelle, Émile-Antoine (1861–1929) French sculptor, born in Montauban, the son of a cabinet-maker. His family was very poor, but in 1876 he was given a grant by the town of Montauban to study at the École des Beaux-Arts in Toulouse. From there he went on to the École des *Beaux-Arts in Paris, 1884–6, and he worked as an assistant to *Rodin, 1893–1908. His first major independent commission (1897–1902) was a monument commemorating the Franco-Prussian War for Montauban (now in the Place Bourdelle). It conveyed the brutality of war without the conventional heroic trappings expected of such monuments and attracted more abuse than praise; Rodin, however, described it as 'an epic work, one of the great achievements of sculpture today'. Bourdelle's first unqualified public success was the bronze *Heracles the Archer* (1909, various casts exist; the Bourdelle Museum in Paris has an example, as it does of virtually all his work). After it was exhibited to great acclaim in 1910, he was generally regarded as the outstanding sculptor in France apart from Rodin himself.

Bourdelle's work has been somewhat overshadowed by his association with Rodin, but he was already an accomplished artist when he began working for him and he developed an independent style; he revered his master, but said 'all my tendencies and my experiences as well run counter to the laws that rule his art'. The energetic, rippling surfaces of early work such as *Beethoven: Grand masque tragique* (1901, Musée Bourdelle) owe something to Rodin, but his flat rhythmic simplifications of form, recalling Romanesque art, were to be the aspect of his art most influential on French monumental sculptors. The fusion of classical and medieval sources was to be a visual language for public art appropriate to the conservative reconciliation of church and state in France after the First World War, in reaction to the militant secularism of the early years of the Third Republic. In particular, the gigantic *Virgin of the Offering* (1922) recalls the massive Virgin and Child sculptures set up during the Second Empire. He was particularly interested in the relationship of sculpture to architecture, and his reliefs for the Théâtre des Champs-Élysées (1910–13), inspired by the dancing of Isadora Duncan, are among his finest works. Bourdelle had many other prestigious public commissions and he made numerous portraits of distinguished contemporaries. He also achieved great distinction as a teacher at the Académie de la Grande Chaumière from 1909 until his death. One of his students there, Vera *Mukhina, described him as 'A little Nibelung, shorter than myself, with an enormous shining high forehead, thick, bushy brows and a black wedge-shaped beard'. He was a talented painter and draughtsman as well as a sculptor. His house and studio in Paris have been converted into a museum of his work; the first part opened in 1961 to mark the centenary of his birth. It is now a thriving institution which includes exhibitions of contemporary art in its programmes as well as providing an atmospheric evocation of the sculptor's living and working space.

Further Reading: P. Curtis, 'Émile-Antoine Bourdelle: the Statuaire's Status', *Gazette des Beaux-Arts* (May–June 1993)

C. Mitchell, 'Entrepreneurs of the New Order: Bourdelle in the Park', *Oxford Art Journal*, vol. 13, no. 2 (1990)

Bourgeois, Louise (1911–) French-born American sculptor. She began her artistic training in the family craft of tapestry

restoration, then studied at various art academies and in *Léger's studio. In 1938 she married the American art historian Robert *Goldwater and settled in New York. She first made a name as an abstract painter, but turned increasingly to sculpture in the 1940s. Her first one-woman show, at the Bertha Schaefer Gallery, New York, in 1945, included drawings, prints, and wood sculpture. Her drawings of that period were *Surrealist-influenced images of female bodies with the upper parts replaced by houses. Her first exhibition devoted solely to sculpture—consisting mainly of painted vertical wooden forms arranged in groups—was held at the Peridot Gallery, New York, in 1949. Her breakthrough piece was *The Blind Leading the Blind* (1947–9), precariously balanced black and tapered planks only able to stand upright by virtue of their linkage at the top. This 'easily toppled' quality was characteristic of much of her early sculpture. Ann Gibson, perhaps with the hindsight of feminist theory, describes her sculpture at this stage as 'work whose parody swung between feminine vulnerability and warlike machismo' (*Abstract Expressionism: Other Politics*, 1997). Subsequently Bourgeois has worked in various materials, including stone, metal, and latex. 'The material itself does not interest me', she told the critic Donald Kuspit. It is a means to an end. Indeed, the sculpture frequently resembles body parts, and in 1965 she was included in Lucy *Lippard's 'Eccentric Abstraction' exhibition, a show which opposed the supposed impersonality of mainstream abstraction with a more eroticized form. The increased interest in women artists has led to her work being revalued in the 1970s and seen from a specifically feminist angle. When an exhibition of her work was held at the New York Museum of Modern Art in 1982 she included in the catalogue an autobiographical statement which told of her pain when young at her father's affair with her governess. This invited a certain personal interpretation of such works as *The Destruction of the Father* (1974), a red-lit environment described as lethal by the artist. In 1993 she represented the USA at the Venice *Biennale and she has continued to be active in her nineties. In the 1990s she made environments of wood, sometimes with old furniture reminiscent of her early life or with multi-coloured glass bulbs evocative of a mad scientist's laboratory. In 2000 Tate Modern showed at its opening three spectacular towers which

visitors were invited to climb, as well as her monumental spider sculpture *Maman* (1999).

Further Reading: F. Morris and M.-L. Bernadec, *Louise Bourgeois* (2007)

Boussingault, Jean-Louis (1883–1943) French painter, designer, and graphic artist, born in Paris into academic circles, his grandfather, Jean-Baptiste Boussingault, being an eminent chemist. His training included periods at the École des Arts Décoratifs and at the *Académie Julian, where he met his lifelong friend *Dunoyer de Segonzac (they shared a studio from 1906 to 1908). Among his early works were poster designs (he was a skilled lithographer) and illustrations for popular journals. He cultivated a poetic and elegant style, with subtle and sumptuous colour (*see* NÉO-RÉALISME). His paintings included still-lifes, portraits, nudes, and scenes of fashionable life, and he illustrated a number of books. Late in his career he also did several large murals (for example at the Théâtre du Palais de Chaillot, Paris, 1937) and designed cartoons for tapestries.

Bowery, Leigh (1961–94) Australian-born Performance artist who lived and worked in London. Coming out of the club scene of the 1980s, he adorned his substantial body in extreme costumes and make-up which eventually achieved the status of art works, with a presentation at the leading art dealer Anthony d'Offay. In a typical appearance his shaved head was entirely painted and covered with drips of molten wax. He was also a model for Lucian *Freud. He died of AIDS.

Bowie, David *See* MODERN PAINTERS.

Bowness, Sir Alan (1928–) British art historian and administrator, son-in-law of Barbara *Hepworth and Ben *Nicholson. He studied modern languages at Cambridge University and history of art at the *Courtauld Institute, London. After working for the *Arts Council, he taught at the Courtauld Institute, 1957–79, then was director of the *Tate Gallery, 1980–88, a period that saw the opening of Tate Liverpool and the inauguration of the *Turner Prize. In addition he served on numerous committees, including that of the *Contemporary Art Society. His writings, all on late 19th-century or 20th-century art, include two highly regarded introductory surveys—*Modern Sculpture* (1965) and *Modern European Art* (1972)—as well as numerous

more specialist studies, notably on Hepworth and *Moore. He has also organized and catalogued several major exhibitions.

Boyce, Sonia (1962–) British painter, born in London to West Indian immigrant parents. She studied at East Ham College of Art and Technology, 1979–80, then at Stourbridge College of Art, near Birmingham, graduating in 1983. In 1982 she attended the first national conference of black artists, where she met the Tanzanian-born painter Lubaina Himid (1954–), who has been a leading figure in encouraging and promoting the work of black women artists—in 'making ourselves more visible by making positive images of black women'. Boyce's paintings and mixed media images of contemporary black life have been widely exhibited and have won her a considerable reputation. In 1989 she was included in a large exhibition of work by Afro-Asian artists in Britain, entitled 'The Other Story', at the Hayward Gallery, London, and was praised by Brian *Sewell, who wrote that 'Sonia Boyce matches perfectly the subtle delicacy of pastel to strident colour, sculptural form and robust imagery, so that her work is decorative and profound, sophisticated and primitive, beautiful and urgently political'. Since then Boyce has moved increasingly towards work with photography and installation. In 1995 she made an intervention in the 'Cultures' gallery in the Brighton Museum and Art Gallery in which cases were converted into translucent vitrines with thin coloured paper. By converting the museum display into 'peep shows', she emphasized the element of voyeurism in the museum's presentation of 'other' cultures.

Boyd, Arthur (1920–99) Australian painter, printmaker, sculptor, designer, and ceramicist, born in Murrumbeena, near Melbourne. He was the most famous member of a dynasty of artists founded by his grandfather, **Arthur Merric Boyd** (1862–1940), and grandmother, **Emma Minnie Boyd** (1858–1936), both of whom were landscape painters. His father, **William Merric Boyd** (1888–1959), was a sculptor and potter, and his mother, **Doris Boyd** (*c*.1883–1960), was a painter and potter, but he was largely self-taught as an artist. In 1937, when he was only-seventeen, he had his first one-man show, at the Westminster Gallery, Melbourne, but his career was interrupted by the Second World War, during which he served in the Australian army as a cartographer. During the 1950s he became one of the best-known artists in the country, scoring notable successes with his large ceramic 'totem pole' at the Olympic Pool, Melbourne (for the Olympic Games of 1956), and his series (twenty pictures) *Love, Marriage and Death of a Half-Caste* (1957–9), concerned with the life and death of an aboriginal stockman and his half-caste bride. These paintings, done in a style combining elements of *Expressionism and *Surrealism, were made the subject of a film, *The Black Man and his Bride*, which won an award in the experimental section of the 1960 Australian Film Festival. Bernard Smith (*Australian Painting 1788–1990*, 1991) writes that 'In these paintings Boyd succeeded better, perhaps, than any other member of the original *Angry Penguin circle in elevating an Australian theme to a universal level, endowing it with a breadth of reference and feeling beyond the limits of nation or region'.

In 1959 Boyd moved to London, where he made his name with a one-man show at the *Zwemmer Gallery in 1960 and a retrospective show at the Whitechapel Art Gallery in 1962. From then on he consolidated his reputation, and Sidney *Nolan is probably the only Australian artist who has exceeded him in international fame. Boyd returned to Australia in 1971, but he continued to spend a good deal of time in England and also in Italy. In 1971 he bought a house at Shoalhaven on the south coast of New South Wales, followed soon afterwards by another property nearby. He presented these to the nation in 1993 and he gave many of his works to the National Gallery of Australia, Canberra. Apart from paintings, Boyd's large output included sculpture, ceramics, designs for the stage, and prints (mainly etchings and lithographs).

Boyle, Mark (1934–2005) British sculptor, painter, and *Performance artist, born in Glasgow. He served in the army, 1950–53, and studied law at Glasgow University, 1955–6, then worked at a variety of jobs (clerk, labourer, waiter), before turning to art—untrained—when he met the painter Joan Hills (1936–) in 1958. Thereafter they lived and worked together, based in London, and in the 1980s they were joined in their artistic endeavours by their children Georgia (1962–) and Sebastian (1964–), collaborating as the Boyle Family. In the early 1960s Boyle and Hills were involved in performances or *Happenings, one of which was 'Theatre' (1964). In this they 'led a group of

people down London's Pottery Lane to a dilapidated rear entrance marked "Theatre". Once inside, Boyle and Hills invited their company to be seated on kitchen chairs ranged before a set of blue plush curtains, which opened upon a performance composed of nothing more, nor less, than the ongoing, everyday activity of the street outside' (Daniel Wheeler, *Art Since Mid-Century*, 1991). In 1967–8 they worked on lightshows for rock musicians, including Jimi Hendrix, and after 1969 they devoted much of their energies to a long-running project called 'Journey to the Surface of the Earth'. This has involved making minutely detailed replicas in fibreglass of small areas (usually about 2 × 2 metres) of the earth's surface at sites chosen at random by having blindfolded friends or members of the public throw darts at a map of the world: 'The aim is to produce as objective a work as possible.' Exhibitions of these works, which are hung on the wall like pictures, have been held at the Hayward Gallery, London (1986), and elsewhere.

Bramley, Frank *See* NEWLYN SCHOOL.

Brancusi, Constantin (1876–1957) Romanian sculptor, active for almost all his career in Paris (he became a French citizen in 1952), one of the most revered and influential of 20th-century artists. He was born in the village of Hobitza into a peasant family and learnt woodcarving whilst working as a shepherd in the Carpathian Mountains. In 1896 he won a scholarship to the Bucharest School of Fine Arts, and in 1903 he moved to Munich, then in 1904 to Paris, where he endured several years of poverty. (According to his own romanticized account, Brancusi made his way to Paris entirely on foot, but this has been doubted.) The first works he exhibited in Paris (at the *Salon d'Automne in 1906) were influenced by *Rodin, but when Rodin offered to take him on as an assistant, Brancusi refused with the famous comment, 'No other trees can grow in the shadow of an oak.' Soon he rejected Rodin's surface animation, and in 1907 he began creating a distinctive style, based on his view that 'what is real is not the external form but the essence of things. Starting from this truth it is impossible for anyone to express anything essentially real by imitating its exterior surface.'

From this time his work (in both stone and bronze) consisted largely of variations on a small number of themes (heads, birds, a couple embracing—*The Kiss*) in which he simplified shapes and smoothed surfaces into immaculately pure forms that sometimes approach complete abstraction. He was particularly fond of ovoid shapes—their egg-like character suggesting generation and birth and symbolizing his own creative gifts. His woodcarvings, on the other hand, are usually rougher—and closer to to African sculpture. Some themes were confined to one material (*The Kiss* is always stone). Others, such as the bird and the fish, change character according to material. When Brancusi used bronze he chose a highly polished surface. This led some commentators, including Lewis Mumford (*Technics and Civilisation*, 1932), to equate his sculpture with a machine aesthetic. It is certainly not difficult to draw parallels with the 'streamlining' of a designer like Raymond Loewy. Later historians have, by contrast, emphasized the 'Romanian Brancusi', with a love of folk tales and music. Certainly, impressive visual evidence can be produced for the importance of folk art. There are other debates which still surround his work. Should his sculpture be seen as timeless platonic form or as paradoxical and ambiguous? What is the role of the base in his sculpture and should they be seen as sculptures in their own right or as beautifully crafted objects which nonetheless have as their chief role the establishment of a correct viewing height?

In 1913 five of Brancusi's sculptures were shown at the *Armory Show in New York. This helped to establish his name (John *Quinn, legal representative of the exhibition, became an important patron of his work), and the following year *Stieglitz gave him a one-man show. During the 1920s he became known to a wider public when he was involved in two celebrated art scandals. In 1920 his *Princess X* was removed by police from the *Salon des Indépendants because it had been denounced as indecent (there is a clear resemblance to a phallus); and in 1926 he became involved in a dispute with the US Customs authorities. They attempted to tax his *Bird in Space* (one of his most abstract works) as raw metal, rather than treat it as sculpture, which was duty-free. Brancusi was forced to pay up to get the work released for exhibition at the Brumner Gallery, New York, but he successfully sued the Customs Office, winning the court decision in 1928. By this time he had a growing international reputation and he travelled

widely in the 1930s, including making a visit to India from December 1937 to January 1938 to discuss plans for a Temple of Meditation for the Maharajah of Indore. This was never built, but in the same period Brancusi did carry out his largest work, a complex of sculpture for the public park at Tirgu Jiu near his birthplace. The main elements of the scheme (which was inaugurated in October 1938) are the enormous *Endless Column* (about 30 metres high), which is a funerary monument to soldiers who died in the First World War (he made four other versions of this work), the *Table of Silence*, and the *Gate of the Kiss*. By his final years he was widely regarded as the greatest sculptor of the 20th century. He was rather vain and enjoyed the attention his status as a living legend gave him; he even took to talking about himself in the third person. Although he had many friends in the art world (Marcel *Duchamp and the composer Erik Satie were among the closest), he was secretive about his private life (only in the 1990s did it become generally known that he had had a son with a British pianist), and this increased his legendary aura.

Brancusi's importance for later sculpture has been immense. He was one of the pioneers of *direct carving. He introduced *Modigliani to sculpture, *Archipenko and *Epstein owed much to him, and *Gaudier-Brzeska was his professed admirer. Later, Carl *Andre claimed to have been inspired by *Endless Column*, converting its repeated modules into his horizontal arrangements of identical units. For Minimal artists, Brancusi demonstrated how conceptually simplified forms might be, in terms of meaning and perception, extraordinarily complex. More generally, Henry *Moore wrote of Brancusi: 'Since the Gothic, European sculpture had become overgrown with moss, weeds—all sorts of surface excrescences which completely concealed shape. It has been Brancusi's special mission to get rid of this undergrowth and to make us once more shape-conscious.' However, although his work is so central to the history of modern art, John *Golding writes that 'as an artist he always managed to stand somewhat apart. When he was presented with a chart of "isms" drawn up by Alfred *Barr and published in Michel *Seuphor's *Art abstrait* in 1949 and saw that he didn't fit into any of them, he was delighted.'

Brancusi was a perfectionist and became increasingly reluctant to part with his work.

He spent a good deal of his time arranging it in his studio and photographing it, sometimes documenting works in progress. His friend *Man Ray helped him to improve his camera technique. On his death he bequeathed the studio and its contents to the French Government; it included versions of most of his best works and more than a thousand photographs. As Sydney Geist observed, 'the sculptures often need each other, but they do not need the sculptor or his personality'. The studio was reconstructed first at the Palais de Tokyo, where close visitor access was possible, and subsequently at the *Pompidou Centre in Paris, where it is entirely encased in glass. There is another outstanding Brancusi collection in the Philadelphia Museum of Art.

Further Reading: S. Geist, *Brancusi* (1983)
S. Miller, *Constantin Brancusi: A Survey of his Work* (1995)
F. Teja Bach et al., *Brancusi* (1995)

Brandt, Bill (1904–83) Anglo-German photographer, born in Hamburg. He worked in *Man Ray's studio before moving to London in 1930. He made his name with photographs for the picture magazines *Lilliput* and *Picture Post*. His two books, *The English at Home* (1936) and *London at Night* (1938), emphasize a Britain still thoroughly class-ridden. During the Second World War he documented underground bomb shelters. His later work was more abstract and atmospheric, including nude figures made strange by stark contrast and extreme close-up. One of his most famous single images is of Francis *Bacon walking solitary as the artist's paintings of van Gogh, over a deserted heath with an incongruously isolated, bent lamppost.

Brangwyn, Sir Frank (1867–1956) British painter, graphic artist, and designer, born in Bruges, the son of a Welsh architect who specialized in church furnishings. The family returned to Britain in 1875 and from 1882 to 1884 Brangwyn was apprenticed to the great designer–craftsman William Morris, after which he travelled the world for several years before settling in London. He considered himself self-taught as a painter, but he was influenced by Morris's romantic medievalism and like his master was active in a wide variety of fields. He was an *Official War Artist in the First World War, for example, he was a skilful etcher and lithographer, and he made designs for a great range of objects (furniture, textiles, ceramics, glassware, jewellery, and so on), but

he became best known as a mural painter. This was his main field of activity from 1902 (when he began his first such commission, for Skinners' Hall, London: scenes relating to the fur trade) to 1937 (when he completed further work in the same building). During the First World War he took up temporary residence in Ditchling, Sussex, and in 1924 he settled there permanently, his large studio providing space for even his biggest works. His most important commission was a series of eighteen panels on the theme of the British Empire for the House of Lords. They were begun in 1924 and rejected as too flamboyant for their setting in 1930, a decision that caused great controversy. Offers for the panels came from all over the world, and in 1934 they were installed in the Guildhall in Swansea in a specially constructed room named after the artist. Today they are probably his most admired achievement. His work at its most characteristic was floridly coloured, crowded with detail and incident, and rather Rubensian, although it became somewhat flatter, lighter, and more stylized later in his career. From middle age he suffered a good deal of ill-health, but he lived to be 89 and remained highly prolific. In old age he became something of a recluse. The enormous reputation he achieved in his lifetime declined steeply after his death but has recently revived somewhat. There is a museum dedicated to him in Bruges.

Braque, Georges (1882–1963) French painter, graphic artist, and designer, celebrated as the joint creator (with *Picasso) of *Cubism. His father and grandfather were skilled painter-decorators, and Braque was brought up to follow their profession. Although he was anti-academic, he had a reverence for good craftsmanship and even ground his own pigments. In 1900 he moved from his family home in Le Havre to Paris to complete his professional training, and in 1902–4 he took lessons in painting and drawing at various art schools, including briefly the École des *Beaux-Arts. Through friendship with his fellow students *Dufy and *Friesz he was drawn into the circle of the *Fauves, and in 1905–7 he painted in their brightly coloured impulsive manner. In 1907, however, two key events completely changed the direction of his work: first, he was immensely impressed by the *Cézanne memorial exhibition at the *Salon d'Automne; secondly, the dealer *Kahnweiler (with whom he signed a contract

in that year) introduced him to *Apollinaire, who in turn introduced him to Picasso. In Picasso's studio he saw *Les Demoiselles d'Avignon*; initially he was disconcerted by it, but he soon began experimenting with the kind of dislocation and fragmentation of form it had introduced. His initial response was the near life-size *Grand Nu* (1907–8, Pompidou Centre, Paris). John *Richardson has argued that just like *Les Demoiselles d'Avignon* the painting is not entirely successful because 'one is too conscious of the artist's agonizing attempts to arrive at a viable idiom'. Such a judgement implies, of course, a certain Apollonian view of art which values most highly the repression of all evidence of struggle. Braque and Picasso worked closely together over the next few years—most closely in the period 1910–12—as they created the revolutionary new style of Cubism. It was Braque who made what could be the earliest recorded theoretical statement about Cubism from an artist: 'I couldn't portray a woman in all her natural loveliness . . . I haven't the skill. No one has. I must therefore create a new form of beauty, the beauty that appears to me in terms of volume, of line, of mass, of weight and through that beauty interpret my subjective impression.' At times it is difficult to tell the work of the two artists apart, but John *Golding detects a considerable difference in approach, seeing Picasso as 'linear and sculptural' and Braque as more painterly, poetic, and preoccupied, unlike the other major Cubists, with the quality of light. Braque's craft background was certainly significant in his introduction of stencilled letters, fake wood graining, and combed surfaces. His use of *collage tended to be more restrained than that of Picasso.

In 1914 Braque enlisted in the French army. He served with distinction, twice being decorated for bravery, before being seriously wounded in the head in 1915 and demobilized in 1916. His first important work after recovery was *The Musician* (1917–18; Kunstmuseum, Basle), showing the influence of *Gris in its use of broad planes of colour. From now on Braque's work diverged sharply from that of Picasso. Whereas Picasso went on changing style restlessly, Braque's painting became a series of sophisticated variations on the heritage of his pre-war years. His style became less angular, tending towards graceful curves, and he used subtle muted colours, sometimes mixing sand with his paint to produce a textured effect. A series of monumental

nudes, partly inspired by late Renoir, such as *Nude Woman with a Basket of Fruit* (1926, NG, Washington), were a notable contribution to the *Neoclassical tendency of the post-war years. In 1922 an exhibition of his work at the Salon d'Automne celebrated his 40th birthday, and by this time he was well-established and prosperous. In the 1930s his reputation became international, and thereafter he accumulated an impressive list of prizes and honours, including the main prize for painting at the 1948 Venice *Biennale. Still-life and interiors remained his favourite subjects. He had a special love for musical instruments, which provided a rich source of curves and angles and also spoke of his own enthusiasm for music. In spite of Braque's reputation for sobriety, there are eruptions of fantasy in his paintings, such as the folding surface of *The Billiard Table* (1944, Pompidou Centre). *Patience* (1942, Goulandris Collection), a poignant image of a woman seated alone with cards and whisky bottle, can be read as an allegory of the waiting period in the later part of the German occupation. It employs to dramatic purpose Braque's characteristic device of splitting the body between side view and three-quarter face, leaving one side entirely in the dark. While she plays cards on her own, the chequerboard, site for the two-handed game, remains unused. Many critics regard his *Studio* series, begun in 1947 and based on his own working environment, as the summit of his achievement. The divisions between the objects in the paintings and the space around them become deeply ambiguous. While working on the series, he told John Richardson: 'Objects do not exist for me except in so far as a harmonious relationship exists between them and myself.' Elsewhere he wrote: 'Forget about things and consider only their relationships.' In his final years he also painted numerous landscapes.

In addition to the type of painting for which he is best known, Braque also did much book illustration, designed stained glass and stage sets and costumes, and did some decorative work, notably the ceiling of the Etruscan Gallery in the Louvre, 1952–3. He was made a Commander of the Legion of Honour in 1951, and ten years later had the honour of being the first living artist to have his work exhibited in the Louvre with a show of jewellery. After this came the final accolade of a state funeral held in the Cour Carré of the Louvre—an occasion that seemed at odds with his life of unassuming dedication to his art.

Further Reading: J. Golding, *Georges Braque* (1966)
J. Golding and S. Bowness, *Braque: Still lifes and Interiors* (1990)
J. Leymarie, *Braque* (1961)
J. Richardson, *Braque* (1959)

Brassaï (Gyula Halász) (1899–1984) Hungarian-born photographer, draughtsman, sculptor, and writer who became a French citizen in 1948. He was born in Brasso, Transylvania (now Brasov, Romania), the son of a professor of French literature, studied art in Budapest and Berlin, settled in Paris in 1924, and adopted his pseudonym (from the name of his native town) in 1925. At this time he was a sculptor and draughtsman, but in 1926 he was introduced to photography by his fellow-countryman André *Kertész, and although Brassaï continued to draw and make sculpture intermittently, it was as a photographer that he achieved international fame. In 1933 he published his first book, *Paris de nuit*, a haunting portrait of the city at night that made his reputation. The people and places of his adopted home continued to be his favourite subjects, and the American writer Henry Miller called him 'the eye of Paris'. For the journal *Minotaure* (1933–9) he produced numerous photographs of artists in their studios, and this began a lifelong friendship with *Picasso (who admired his drawings and encouraged him to continue making them). In 1948 Brassaï published *Sculptures de Picasso*, with a text by *Kahnweiler (English translation 1949), and in 1964 he published *Conversations avec Picasso* (translated as *Picasso and Company*, 1966). Picasso in turn wrote an introduction to a book of photographs of graffiti that had attracted Brassaï as he roamed around Paris—*Graffiti de Brassaï* (1961). Brassaï illustrated many other books, including John *Russell's *Paris* (1960).

Bratby, John (1928–92) British painter (of portraits, landscapes, figure compositions, and still-life), designer, and writer. He was born in London and studied at Kingston School of Art, 1949–50, and the *Royal College of Art, 1951–4. In 1954 he had his first one-man show at the Beaux Arts Gallery, London, and with a number of other painters who exhibited there he formed the *Kitchen Sink School, named after their scenes of drab domestic life (although in Bratby's case they

were often painted with rather bright colours). One significant feature is that, well in advance of *Pop art, the paintings frequently included conspicuous branded packaging. In the same vigorously impasted style he painted the pictures used in the film *The Horse's Mouth* (1959), in which the main character is an artist, Gulley Jimson, played by Alec Guinness. Later Bratby's style became lighter and more exuberant, his work including some colourful flower pieces. In the 1960s he painted several murals, including *Golgotha* in St Martin's Chapel, Lancaster (1965), and in 1984 he did paintings for another film, *Mistral's Daughter*. Among his publications are the novel *Breakdown* (1960) and a book on Stanley *Spencer (1970). Bratby had a talent for self-promotion (he appeared on radio and television and circulated celebrities to see if they might want their portraits painted) and he became one of the best-known British artists of his generation. From 1953 to 1975 he was married to the painter Jean Cooke (1927–2008). They often depicted each other in their work.

Brauer, Erich *See* FANTASTIC REALISM.

Brauner, Victor (1903–66) Romanian painter, sculptor, and draughtsman, active mainly in France, where he was a member of the *Surrealist movement. His father dabbled in spiritualism, and from an early age Brauner was interested in the occult and the weird. He studied briefly at the School of Fine Arts in Bucharest and had his first one-man exhibition at the Galerie Mozart there in 1924. In 1930 he moved to Paris, where he became friendly with his countryman *Brancusi. Through Brancusi he met *Tanguy, and through Tanguy he joined the Surrealist movement in 1933; the following year he had an exhibition at the Galerie Pierre, for which André *Breton wrote the preface to the catalogue. From 1935 to 1938 he lived in Romania, then returned to Paris. Soon afterwards, on 27 August 1938, he lost an eye when he was struck by a bottle during a brawl at a party in Óscar *Domínguez's studio. This caused amazement and gave him a reputation for clairvoyance, because for several years his paintings had shown a preoccupation with the theme of mutilated eyes; he had even painted a self-portrait in 1931 depicting himself with one eye bleeding. During the Second World War he fled Paris and lived for a time in the Pyrenees and then the Hautes-Alpes. Unable to find painting materials, he worked with other techniques, including *collage and fumage (*see* PAALEN). In 1945 he returned to Paris. Three years later Breton expelled him from the Surrealists, but his work continued to be Surrealist in style. From 1961 he lived mainly at Varengeville, near Dieppe. In 1966, the year of his death, he represented France at the Venice *Biennale.

Brauner was an eclectic artist whose work shows influences from many of the leading Surrealists with whom he came into contact, as well as from other contemporaries, including *Klee and *Picasso. Typically he painted figure compositions, often with magical themes. His best-known work, however, is probably not one of his paintings, but the sculpture or *object *Wolftable* (private collection, 1947), in which a stuffed wolf's head and tail are mounted on a table that forms the animal's body and legs.

Bravo, Manuel Álvarez (1902–2002) Mexican photographer, born in Mexico City. He embarked on photography in 1924, taking it up professionally in 1929. His photographs were notable for displaying Mexico as more than the picturesque fantasy presented by European photographers. As Val Williams put it, 'Bravo's Mexico was a more complicated place, where the ancient symbolism of blood and death and religion lived uneasily alongside the brave rhetoric of a new progressive state.' This is clear in two of his best-known photographs, *The Striking Worker Assassinated* (1934) and *Angel of the Earthquake* (1957), the image of a shattered statue. Ian Jeffery makes an illuminating comparison to Courbet in his preoccupation with the nature of sentience. Jeffrey writes: 'he attends to touch, sound, appetite, vision, both in actuality, and in symbol—through patterns of musical instruments, "a box of visions", the serrated leaves on an agave, feet on stone, treading with care, squirming, balancing'. When Bravo depicts the partial body, as in *The Threshold* (1947), two bare feet on a marble doorstep, it is not to dehumanize it but to make the sense of physical experience more acute.

Further Reading: V. Williams, obituary, *The Independent* (21 October 2002)

Brecheret, Victor *See* SEMANA DE ARTE MODERNA.

Brecht, George *See* FLUXUS.

Breitner, George Hendrik *See* SLUIJTERS, JAN.

Breker, Arno (1900–91) German sculptor, printmaker, and architect, born in Elberfeld, the son of a stonemason. He trained locally, then at the Academy in Düsseldorf, 1920–25. From 1927 to 1933 he lived in Paris, where he became a friend of *Despiau and *Maillol, then spent a year in Rome. In 1934 he settled in Berlin, where he became a professor at the Hochschule für Bildende Kunste in 1937. Breker's early work had included abstracts, but he turned to heroic figure sculpture, influenced by the antique and Renaissance art he had seen in Rome, and the gigantic musclebound warriors in which he specialized brought him enormous success in Nazi Germany (*see* NATIONAL SOCIALIST ART). Hitler's favourite sculptor, he was provided with a castle, vast studio, and prisoner-of-war labourers, and was known as the 'German Michelangelo'. His work included many state commissions, most of which were destroyed after the Second World War as they were considered such potent symbols of Nazism. Breker himself was reckoned fortunate to escape with no more than a caution for his involvement with Hitler, and for some time after the war he kept a low profile and was virtually forgotten to the art world. He settled in Düsseldorf in 1950 and returned to full-time work as a sculptor in 1960. Although he made some figures in his earlier idiom, his later sculptures were mainly portrait busts. To many critics, these had little more than curiosity value, but Peter *Ludwig, who was one of his patrons, described Breker as 'a great portraitist whose achievement has been buried beneath a mountain of tendentious slogans'.

Bremmer, H. P. *See* KRÖLLER-MÜLLER, HELENE.

Breton, André (1896–1966) French poet, essayist, critic, and editor, the founder of the *Surrealist movement and its chief theorist and promoter. He was born at Tinchebray, Orne, and studied medicine in Nantes, intending to specialize in mental disorders; his work with the insane was one of the sources of his interest in irrational imagery. During the First World War he served as an orderly in a military hospital; the suffering he saw appalled him and encouraged him to turn to writing, for he believed that emotional and imaginative forces could be used to offset the bankruptcy of science and rationalism. After his military service, Breton settled in Paris, where he became one of the editors of the review *Littérature* (1919–24), which encouraged new talent and in particular supported the *Dada movement (Marcel *Duchamp became one of his heroes at this time). In 1920 he published *Les Champs magnétiques* (Magnetic Fields), containing texts he had produced with a writer friend, Philippe Soupault, by the method of free association—the first published examples of the techniques of *automatism that were to become so important to Surrealism. This was followed in 1924 by Breton's *Manifeste du surréalisme* (dedicated to the memory of his friend *Apollinaire), which marked the official launch of the movement. The manifesto was concerned mainly with the literary aspects of Surrealism, but Breton was deeply interested in painting: in 1925 he helped organize the first Surrealist exhibition ('La Peinture surréaliste', Galerie Pierre, Paris) and when he took over as editor of *La Révolution surréaliste* in the same year he greatly increased its visual material. The first issue edited by Breton (no. 4) contained the first instalment of his most important statement on painting, *Le Surréalisme et la peinture*, which appeared in slightly expanded form as a book in 1928 (partly translated in *What is Surrealism?*, 1936, and fully translated as *Surrealism and Painting*, 1972). There had previously been some disagreement as to whether painting had a valid place in Surrealism, for automatism—so central to the movement—depended on a rapid flow of ideas, whereas painting is inherently static. Breton's, argument was that vision was the most powerful of the senses and that painting can fix visual images. Therefore painting was important to Surrealism but, alongside other areas of Surrealist activity, as an "expedient" in the service of revolution, producing a crisis in consciousness, rather than as an art form. He always thought of painting (as well as poetry) as a way of understanding and releasing our true natures, rather than as an aesthetic end in itself, and it dismayed him that the success of some Surrealist painters (especially *Dalí) led the public to think of Surrealism as primarily a matter of style (Dalí was one of several leading figures whom he expelled from the movement at various times for doctrinal reasons).

In the final issue of *La Révolution surréaliste* (no. 12, 1929) Breton published his *Second*

Manifeste du surréalisme, and the following year he launched another magazine, *Le Surréalisme au service de la révolution* (1930–33). He was interested in revolutionary ideas in politics as well as art and in 1927 he had joined the French Communist Party. Communism had attracted him as a bold endeavour to change humanity, but he became disenchanted with Stalin and transferred his Marxist political sympathies to Trotsky, whom he met when he made a lecture tour of Mexico in 1938. They jointly wrote a manifesto entitled *Pour un art révolutionnaire indépendant*, which appeared under the names of Breton and Diego *Rivera (Trotsky thought it expedient to substitute the Mexican painter's name for his own); it appeared in translation as 'Towards a Free Revolutionary Art' in the leftwing American journal *Partisan Review* (autumn 1938) and soon afterwards in *The London Bulletin* (*see* MESENS). In 1939 Breton was drafted into the medical corps of the French army, but he was released the following year and in 1941 he emigrated to the USA, where he spent the remainder of the Second World War. In New York he formed part of a group of expatriate Surrealists who had an important influence on the genesis of *Abstract Expressionism, and he helped David *Hare to produce the magazine *VVV*; its first issue (June 1942) contained (in French and English) Breton's 'Prolégomène à un troisième manifeste du Surréalisme ou non' ('Prolegomena to a third manifesto of Surrealism or else').

In 1946 Breton returned to Paris, where he continued to be regarded as the 'Pope of Surrealism'. By this time, however, the movement was no longer a central force in intellectual life, and his death in 1966 was regarded by many as marking its end.

Breton himself did not paint, but he made *objects and collaborated in *cadavre exquis drawings. He was interested in many aspects of art that lay outside the Western tradition, including *naive painting (notably the work of Hector *Hyppolite) and psychotic art, owned a good collection of Polynesian artefacts, and had numerous enthusiasms ranging from Gothic novels to butterflies. Much of his collection is now displayed in the *Pompidou Centre.

Further Reading: A. Breton, *What is Surrealism?: Selected Writings* ed. F. Rougemont (1978)

J. Golding, 'The Blind Mirror: André Breton and Painting' in *Visions of the Modern* (1994)

M Polizzotti, *André Breton: Revolution of the Mind* (1995)

Brianchon, Maurice *See* NÉO-RÉALISME.

Brik, Osip and **Lili** *See* MAYAKOVSKY, VLADIMIR.

Brisley, Stuart (1933–) British artist, active in various fields, including photography, video, and sculpture, but most celebrated as a *Body or *Performance artist. He was born in Haslemere and studied at Guildford School of Art, 1949–54, the *Royal College of Art, 1956–9, the Munich Academy (on a Bavarian State Scholarship), 1959–60, and Florida State University, Tallahassee (on a Fulbright Travel Award), 1960–62. Subsequently he taught part-time at several art schools, including the *Slade School. He has won much publicity for his performances concerned with self-inflicted pain and humiliation. The best known is probably *And for today . . . nothing*, performed at Gallery House, German Institute, London, in 1972 as part of the show 'A Survey of the Avant-Garde in Britain'. In this he lay in a bath of water for several days in a room in which the floor was scattered with pieces of rotting meat. Eventually the other artists participating in the show asked him to stop. According to Frances Spalding (1986), 'his discomfort obliges an anaesthetized, depoliticized society forcibly to consider the isolation and alienation of the individual'.

Brockhurst, Gerald Leslie (1890–1978) British-born painter and etcher who became an American citizen in 1949. He was born in Birmingham and studied—at a precocious age—at the School of Art there, 1901–7, and then at the *Royal Academy Schools, 1907–13. An excellent draughtsman and a fine craftsman, Brockhurst won several prizes at the Academy Schools and went on to have a highly successful career as a society portraitist, first in Britain and then in the USA, where he settled in 1939, working in New York and New Jersey. He is best known for his portraits of glamorous women, painted in an eyecatching, dramatically lit, formally posed style similar to that later associated with *Annigoni. As an etcher Brockhurst is remembered particularly for *Adolescence* (1932), a powerful study of a naked girl on the verge of womanhood staring broodingly into a mirror. The model for this work—one of the masterpieces of 20th-century printmaking—was Kathleen ('Dorette') Woodward, whom Brockhurst met in 1928, when she was 16 and he was 38; their relationship led to the break-up of Brockhurst's marriage and a

protracted divorce case, much sensationalized in the press. Brockhurst and Kathleen eventually married in 1947.

Brodsky, Isaak *See* AKHRR.

Broglio, Mario *See VALORI PLASTICI.*

Broodthaers, Marcel (1924–76) Belgian artist, writer, photographer, and film-maker, born in Brussels. He later lived and worked in Düsseldorf and London, and died in Cologne. In his early career, he worked mainly in the literary world as a poet, journalist, lecturer, and bookseller. He contributed to the Surrealist journal *Fantomas* and for a short period was a member of the Belgian Communist Party. He was one of the few to be honoured as a 'living art work' without qualification and without payment by Piero *Manzoni. He remained committed to a conception of modern art which had its origins as much in poetry as the visual arts, especially Charles Baudelaire and Stéphane Mallarmé. His early poems are an important reference point for the understanding of his work as an artist. In 1964 he held his first exhibition at the Galerie St Laurent in Brussels. It included *Pense-Bête*, in which unsold volumes of his poems were encased in plaster. Turned into an object and rendered illegible, they became a sculpture and a marketable commodity. On the invitation card, Broodthaers mused that at the age of 40 he wondered 'if he could not sell something and succeed in life'. Plaster was a material of topical significance. Broodthaers had been struck by the plaster life casts of George *Segal when they had been seen in Paris the previous year.

Over the next few years he produced a series of objects which have something of the mixture of blandness and enigma of René *Magritte. The best-known example is *Casserole and Closed Mussels* (1965, Tate), an arrangement of mussel shells bursting in a neat column from a pot. Its appeal may be that it combines the straightforwardness of American *Pop with a certain sense of nostalgia. The casserole of mussels is the Belgian national dish. Pop art privileges the package above the content, as in *Warhol's soup cans; here the package is part of the 'natural' origin of the subject, an ironized European response to American cultural imperialism. Another motif was coal, a substance redolent of both the economic strength and the social misery of Belgium and northern France in the late 19th and early 20th centuries.

In 1968 Broodthaers was involved in the political and cultural turmoil of the time, taking part in the occupation of the Palais des Beaux Arts, Brussels. Later that year he mounted his own 'Museum of Modern Art' (Department of Eagles) in his Brussels apartment. This showed packing cases on which were projected slides of paintings by 19th-century artists. On the walls were postcards of their works. The museum, he argues, provides no refuge from the commoditization of art. At the same time he showed in Paris his 'industrial paintings', plastic plaques, which frequently referred to the museum. The selection of artists represented—David, Ingres, Courbet, and Wiertz—says something of his conception of the origins of modern art. This was, for him, not primarily a stylistic or formal development but a process by which the artist, while claiming freedom from the state, as Courbet did, becomes 'moulded' ('moule' has the double meaning of mussel and mould) by the market. Antoine Wiertz was a 19th-century Belgian painter, little known outside his own country, whose studio, now a museum, was a short distance from Broodthaers's apartment. His cultivation of large-scale work with sensational subject-matter in a studio provided by the Belgian state was a notable contrast to the direction modernist art actually took, with its dependence on the private market.

Broodthaers closed his museum in 1972 but had already extended his activities into public museums and institutions. 'Décor. A Conquest by Marcel Broodthaers', held at London's Institute of Contemporary Arts in 1975, was one of the most significant. By that time the institute had moved into Nash House, an early 19th-century building which overlooks Horse Guards Parade, and the exhibition was held in summer to coincide with the Trooping of the Colour, a military parade visible from the windows. The exhibition was staged across two rooms, one standing for the 19th, the other for the 20th century. In the first, the floor space was occupied by cannons and hand guns. Napoleon and Wellington (in the guise of crab and lobster) faced each other across a table. Around the walls were items of luxurious furniture from the period of the building. The adjoining room was dominated by a table with beach chairs; on the table the Battle of Waterloo had become a jigsaw puzzle, but around the walls were modern machine guns. The pleasant contemplation of past conflicts is still framed by violence. The

museum has become instrumental in the seduction of society by leisure.

Broodthaers also made films and books. The films differed radically from commercial narrative cinema, taking a form which demanded to be decoded by the spectator. Broodthaers was fascinated by the idea of the book as an object, as in *A Voyage on the North Sea* (1974), with its unopened pages.

Although, like Joseph *Beuys, he was concerned to extend the technical and physical boundaries of art, the outlook of the two artists could hardly be more different. The German artist looked to human creativity to achieve some kind of redemption from the conditions of industrial capitalism. For Broodthaers art was moulded by language, the institution and the market place, so its capacity for intervention was limited. Out of this grim vision he made a black comedy of borrowed images.

Further Reading: A. Hakkens (ed.), *Marcel Broodthaers par lui-même* (1998)

R. Krauss, *A Voyage on the North Sea: Art in the Age of the Post-Media Condition* (2000)

Brooks, James (1906–92) American painter, born in St Louis, Missouri. He studied at Dallas Art Institute, 1925–6, and at the *Art Students League, New York, 1927–31. During the 1930s and early 1940s he worked with the *Federal Art Project in a *Social Realist vein, creating some impressive murals. The largest one, the 70-metre-long *Flight* (1942) at La Guardia Airport, New York, was painted over in the 1950s but was restored in 1980. Brooks served in the US Army, 1942–5, and when he resumed painting in 1945 he took up *Cubism. In 1946 he became a friend of Jackson *Pollock and in the 1950s he was one of the minor masters of the *Abstract Expressionist movement. A typical work of this period is *Boon* (1957, Tate) which Brooks described as 'completely abstract—having been developed from a purely improvised start and held into a non-figurative channel'. The art critic Thomas Hess argued that the relationships in his painting were a metaphor for the 'conflict between spontaneous and deliberate behaviour'. In 1963 he was artist in residence at the American Academy in Rome.

Brooks, Romaine (1874–1970) American painter, active mainly in Paris. She was born Romaine Goddard in Rome to wealthy American parents, and in her early life she lived variously in England, France, Italy, and Switzerland, her main training as a painter being in Rome, 1899–1900. In 1903 she made a marriage of convenience to John Ellingham Brooks, an English homosexual, believing that she would have greater freedom as a married woman. She separated from her husband the following year and thereafter was part of a close circle of lesbian friends; they included Radclyffe Hall, whose novel *The Well of Loneliness* (1928) was banned in Britain because of its frank treatment of love between women.

Brooks's main work was done in Paris between 1905 and 1936, after which she virtually abandoned painting. She was a successful society portraitist, her work being glamorous in an unconventionally strong and sombre way; she said she was in love with 'the mystery of greys', and her friend the Italian writer Gabriele d'Annunzio described her as 'the most profound and wise orchestrator of greys in modern painting'. There is often a decadent, slightly morbid quality in her portraits, and this is seen more fully in her eerily erotic, almost necrophiliac portrayal of the dancer Ida Rubinstein in *The Crossing* (c.1911, Smithsonian American Art Museum, Washington): Rubinstein (with whom Brooks had an affair) is shown lying naked on a mysterious white shape seemingly floating in a dark void (the Russian painter Valentin *Serov also did a remarkable nude portrait of her). Brooks lived in Florence, 1940–67, then moved to Nice, where she died.

Brotherhood of Ruralists A group of seven British painters formed in 1975 when all the members were living in the predominantly rural west of England (their definition of 'ruralist' being 'someone who is from the city who moves to the country'). They were Ann Arnold (1936–) and her husband, Graham Arnold (1932–), Peter *Blake, the American-born Jann Haworth (1942–), who was married to Blake, 1963–81, David Inshaw (1943–), Annie Ovenden (1945–), and her husband, Graham Ovenden (1943–).

The Ruralists first exhibited as a group at the Royal Academy summer exhibition in 1976 and last showed together (minus Haworth) at Blake's retrospective at the Tate Gallery in 1983. In between they had several other group exhibitions, took working holidays together, and divided among themselves a commission to design the covers for the

37-volume New Arden edition of Shakespeare's plays. However, they shared ideals rather than a common style. They attracted a good deal of attention (a BBC film 'Summer with the Brotherhood' was broadcast in 1977). Many critics found their paintings insufferably twee and self-conscious, especially those involving fairies—one review of a 1981 touring exhibition was headed 'Tinkerbell lives'.

Apart from Blake, the best known of the members of the Brotherhood are probably David Inshaw and Graham Ovenden. Inshaw specializes in tightly handled enigmatic landscapes with figures, such as *Our Days were a Joy and our Paths through Flowers* (1971–2, City Art Gallery, Bristol). Ovenden is best known for pictures of prepubescent girls, which have sometimes been attacked as pornographic. In 1977 he published a book called *Nymphets and Fairies*, and in 1979 he wrote: 'My work is the celebration of youth and spring—the fecundity of nature and our relationship to it. This is why the subject-matter of my work tends towards the girl child (more often than not at the point of budding forth) and the English landscape in all its richness and mystery.'

Brouwn, Stanley (1935–) Dutch artist, born in Paramaribo, Suriname. From 1957 onwards he worked as an artist in Amsterdam. He provides no biographical information, gives no interviews and does not permit reproduction of his work. He only says that 'the work provides the interviews', writes the biography'. Since 1960 he has been preoccupied with the idea of measurement and the relationship to the body's movements. The series of drawings *this way brouwn*, made from 1961 onwards, was based on directions provided by passers-by. These were then impressed with a printed rubber stamp bearing the title. Certain ideas are worked out only in writing. 'Walk during a few minutes very consciously in a certain direction; simultaneously a vast number of microbes within the circle are moving in a vast number of different directions.' He has devised his own systems, such as the sb-foot, using these in conjunction with other systems including obsolete ones. For instance, in an exhibition at the Centro Andaluz de Arte Contemporáneo in 2005 he used the old Castilian foot abolished in 1849 when the metric system was made compulsory in Spain. R. H. Fuchs writes of

him: 'The work is not imagination; it is fact' (*Dutch Painting*, 1978).

Further Reading: Van Abbe Museum, Eindhoven, *Stanley Brouwn* (2005)

Brown, Frederick (1851–1941) British painter and teacher, born in Chelmsford, the son of a painter. A founder member of the *New English Art Club in 1886, he was responsible for drawing up the rules of the club and was amongst the most energetic in its campaign against the conservatism of the *Royal Academy. After teaching at Westminster School of Art for fifteen years, he was made professor at the *Slade School in 1892 and presided over its golden period, retiring in 1917. Brown had hated the mechanical teaching methods of his own student days (at the National Art Training School, which later became the *Royal College of Art) and he aimed to develop the individuality of his pupils. Soon after becoming professor, he appointed *Tonks (another outstanding teacher) as his assistant, and he also recruited *Steer to the staff. He made a fine collection of his contemporaries' and pupils' work. Examples of his own work, including a late self-portrait (1932), are in Tate.

Brown, Glenn *See* APPROPRIATION.

Brown, Oliver *See* LEICESTER GALLERIES.

Brown, Ralph (1928–) British sculptor, born in Leeds. He studied and subsequently taught at the *Royal College of Art and first came to attention for vigorously realist sculptures of everyday life. Two of these were sited in Harlow New Town as part of the architect Frederick Gibberd's project for popularizing public art. The more prominent is the massive *Meat Porters* (1960), which graces the shopping centre. In later years, Brown has concentrated on the female nude, usually with smooth surfaces quite unlike the rugged quality of his early sculpture and sometimes eerily lacking a face.

Browse, Lillian (1906–2005) British art historian, dealer, collector, and exhibition organizer. She trained as a ballet dancer, but gave up this career in 1931 and from then until 1939 worked for the Leger Galleries, one of the leading London dealers in Old Masters and British watercolours. During the Second World War she organized exhibitions for several institutions, most notably the National Gallery, where they complemented the

famous wartime recitals given by the pianist Dame Myra Hess (the first exhibition was 'British Painting Since Whistler', which opened in March 1940). In 1945 she went into partnership with two German-born dealers, Henry Roland (1907–93) and Gustav Delbanco (1903–97), to found the firm of Roland, Browse & Delbanco, which ran a gallery in Cork Street, London, dealing mainly in British figurative painters. Among the artists it helped to establish were Prunella *Clough, Bernard *Dunstan, Joan *Eardley, and Josef *Herman. The firm was renamed Browse & Darby in 1977 and its gallery still operates in Cork Street under this name. Browse wrote several books, including *Augustus *John Drawings* (1941), *Degas Dancers* (1949), *Forain, the Painter* (1978), and two monographs on *Sickert (1943 and 1960; she also organized the Sickert exhibition commemorating the centenary of his birth at the Tate Gallery, London, in 1960). She made an impressive art collection of her own, consisting mainly of British and French painting and sculpture of the late 19th and 20th centuries. In 1983 she presented most of it to the *Courtauld Institute of Art. She published her autobiography, *Duchess of Cork Street*, in 1999.

SEE WEB LINKS
• Obituary of Lillian Browse by Dennis Farr in the Courtauld Institute of Art newsletter.

Bruce, Patrick Henry (1881–1936) American painter, born at Long Island, Virginia. After studying with Robert *Henri in New York, 1902–3, he went to Paris, where he remained for almost the whole of the rest of his life. He studied under *Matisse and became a friend and follower of *Delaunay, working closely with him from about 1912 to 1915. Thus he was moving towards abstraction at the same time as two other Americans in Paris: the *Synchromists Stanton *Macdonald-Wright and Morgan *Russell. For a time, in a series of pictures entitled *Compositions* (1916–17), Bruce was fairly close to them in style, but then in a series of *Formes* (1917–36) he developed a more geometric style featuring thickly pigmented blocks of bright colour based on still-life forms (there is a kinship with the hard-edged forms of *Purism, but Bruce was more subtle and inventive than *Le Corbusier and *Ozenfant, its chief exponents). In both series Bruce showed outstanding gifts as a colourist. His work was exhibited at the *Armory Show in 1913, but he remained almost unknown in the USA. Disillusioned by his lack of success, he destroyed most of his paintings in 1932. He returned to the USA in 1936 and committed suicide a few months later.

Brücke, Die (The Bridge) Group of German *Expressionist artists founded in Dresden in 1905 and disbanded in Berlin in 1913 (its full name was 'Die Künstlergruppe Brücke'—'The Artists' Group of the Bridge'). The founders were four architecture students at the Dresden Technical School: Fritz Bleyl (1880–1966), Erich *Heckel, Ernst Ludwig *Kirchner, and Karl *Schmidt-Rottluff. The name was suggested by Schmidt-Rottluff, because of their admiration for the philosopher Nietzsche, who in *Also sprach Zarathustra* wrote that 'What is great about man is that he is a bridge and not a goal'; it indicated their faith in a happier, more creative future, to which their own work would act as a bridge. Kirchner—at 25 the oldest of the group and the only one to have had any professional training as a painter—was the dominant figure; it was he who wrote the group's short manifesto (1906) and cut it in wood so it could be issued as a broadside. It reads: 'With a belief in progress and in a new generation of creators and supporters, we summon all youth together. As youth we carry the future and want to create for ourselves freedom of life and movement in opposition to the well-established older forces. Everybody belongs to our cause who reproduces directly and passionately whatever urges him to create.' This document typifies the vagueness of their aims, for no clear programme emerged from any of their publications; however, in essence they were in revolt against passionless middle-class conventions and wished to create a radically new style of painting that would be in tune with modern life.

The Brücke artists often worked in close collaboration, although they never lived together as a community. Initially they rarely signed their work, and one member would sometimes use a print by one of the others as a basis for a painting. This group solidarity and interchange of ideas meant that critics sometimes had difficulty telling one member's work from another's. Their subjects were mainly landscapes and figure compositions (a favourite theme being nudes in the open air); they were treated in an emotional style

characterized by strong (and often unnatura-
listic) colour and simplified, energetic, angular
forms. Although there is some kinship of spirit
with *Fauvism (founded in the same year),
notably in the bold colour and sense of spon-
taneity, the work of the Brücke artists was
markedly different in feeling and technique:
in place of exuberance there was restlessness
and anxiety, and in place of French sophisti-
cation there was the crude vigour of artists
who had had almost no formal tuition as
painters. They were influenced not only by
late medieval German art, which is often ex-
tremely intense emotionally, but also by art
from German colonies in Africa and Oceania,
of which the Museum of Ethnology in Dresden
had a substantial collection

The Brücke artists promoted their work by
more than twenty exhibitions; the first was
held in the Seifert Lamp Factory in Dresden
in October 1906, but later ones were usually in
more traditional gallery spaces. Exhibitions
that consisted only of graphic art generally
travelled to several venues. They attached
great importance to printmaking and played
a major role in the revival of the woodcut that
was such a feature of early 20th-century
graphic art. Like their paintings, their prints
often had a harsh, untutored intensity, with
the forms sometimes almost hacked into the
block. The prints were sold not only at exhibi-
tions, but also by means of annual portfolios,
issued to subscribers (or 'honorary mem-
bers'), of whom there were 68 in 1910 (they
all came from German-speaking countries,
apart from a Miss Edith Buckley of Crawley,
Sussex, about whom unfortunately nothing is
known). By this time the original membership
of Die Brücke had changed. Bleyl had dropped
out in 1909 and several other artists had
joined, although some of them were really
'corresponding members' whose contribu-
tions were marginal. The most committed re-
cruits were Max *Pechstein, who joined in
1906, and Otto *Müller, who joined in 1911.
Emil *Nolde also took up an invitation to join
in 1906 (surprisingly, given the fact that he was
a loner by instinct), but he left the following
year. Four foreign artists whose work was
admired by the founders also became
members, although they had nothing in
common with the Germans stylistically: they
were the Swiss Cuno *Amiet, the Dutch-born,
French-resident Kees van *Dongen, the Finn
Akseli *Gallen-Kallela, and the Czech Bohumil
*Kubišta.

By 1911 all the German members of Die
Brücke had moved to Berlin, where there was
a more vigorous cultural scene (the group had
made an impact at the first exhibition of the
Neue *Sezession there in 1910). Pictures
showing the stress of urban life now became
increasingly important in their work, often
conveying a nightmarish sense of claustropho-
bia and depravity. They were now beginning
to achieve national recognition, but they were
also losing their group identity as their indi-
vidual styles emerged more clearly. In 1912
Pechstein was dismissed for exhibiting outside
the group, and other personal differences
emerged. To try to reaffirm their cohesion,
the remaining members decided to publish a
Chronicle of their activities, written by Kirch-
ner. It had the opposite effect from the one
intended, for the other members objected to
certain of Kirchner's statements and the asso-
ciation was dissolved by mutual agreement in
1913. A museum of the group's work opened
in Berlin in 1967, funded by Schmidt-Rottluff.

Further Reading: J. Lloyd, *German Expressionism: Primi-
tivism and Modernity* (1991)

Brus, Günter (1938–) Austrian Perfor-
mance artist, draughtsman, and painter. Born
in Ardning, he was one of the leading *Vienna
Actionists. As with his colleagues *Nitsch and
*Muehl, his activities were designed to stretch
the endurance of the performer and the toler-
ance and strong stomach of the spectator.
Performances focused on the degradation
and mutilation of his own body. The most
notorious was the *Test to Destruction*, carried
out in Munich in 1970. In this work he knelt in
a slip and high heels on a white sheet. After
cutting his shaved head he called in a calm
voice for a glass, into which he urinated
(green) and drank the urine. The entire action
lasted about 25 minutes, after which he passed
through the audience on the way to the toilets.
Following this, Brus considered that he could
take these actions no further and his
subsequent artistic activities were in the form
of exquisitely crafted drawings, sometimes
with a fairy-tale atmosphere which almost re-
calls Arthur *Rackham, but with a sinister as-
pect. Self-castration is a recurrent theme.
From 1969 onwards Brus edited the journal
Die Schastrommel (Shit Drum) to document
the activity of himself and the other actionists.
Its subtitle, 'organ of the Austrian Government
in Exile', reflected the legal persecutions the
Actionists had suffered in their own country.

(Brus had left after a performance which involved masturbating in front of the Austrian flag.) He once said: 'Art is beautiful but it is hard like a religion without a purpose' (Stiles and Selz).

Brusselmans, Jean (1884–1953) Belgian painter, born in Brussels. After training as a commercial lithographer-engraver, he studied painting at the Brussels Academy. His early works were naturalistic, in the tradition of late 19th-century French painting, but he developed a heavy, austere *Expressionist style, which he displayed in peasant scenes, landscapes, still-lifes, and interiors. He was little appreciated in his lifetime, but he is now regarded as one of the leading Belgian painters of his time. He has been described by W. Vanbeselaere as 'the dourest, most unyielding of expressionists'. Vanbeselaere went on to argue that it was only after his death that 'the world discovered that the intentional sparseness of form, the coarse bread Brusselmans offers us has a rare and pure taste…His work is poor and monotonous in appearance only. It shines with life, jubilantly soaring up from its own limitations' (W. Vanbeselaere, *Moderne Vlaamse Schilderkunst*, 1966, translated in the catalogue of the exhibition 'Ensor to Permeke: Nine Flemish Painters, 1880–1950', Royal Academy, London, 1971).

Brymner, William See CANADIAN ART CLUB.

Buffet, Bernard (1928–99) French painter, etcher, lithographer, designer, and occasional sculptor, born in Paris, where he studied at the École des *Beaux-Arts, 1944–5. Highly precocious, he had his first one-man exhibition in 1947, at the Galerie des Impressions d'Art in Paris, and the following year, aged only twenty, he was awarded the Prix de la Critique jointly with the much older Bernard Lorjou (see HOMME-TÉMOIN). By this time Buffet had already established his distinctive style, much influenced by the less commercially successful Francis *Gruber and characterized by elongated, spiky forms with dark outlines, sombre colours, and an overall mood of loneliness and despair. He used it for a wide range of subjects, including religious scenes, landscapes, still-lifes, and portraits (*Self-portrait*, 1956, Tate). His work seemed to express the existential alienation and spiritual solitude of the post-war generation, and he enjoyed enormous success in the 1950s. In his early work

he addressed important religious and political themes, as in as a series on the *Horrors of War* (1954). In 1958 Claude Roger-Marx described him as 'a painter fit to resume like Kafka, Kirkegaard, *Sartre, the insecurity and deprivations of his childhood'. Later, as he found himself overwhelmed with commissions, his work became more stylized and decorative, losing much of its original impact, although his paintings, especially his bullfighters and townscapes, became extremely popular in reproduction. Andy *Warhol's praise for him as the 'last great painter of Paris' was surely double-edged. A museum devoted to him opened in Shizuoka Prefecture, Japan, in 1973, but in spite of his fame there has never been a retrospective exhibition in any important French museum. He killed himself after becoming incurably ill with Parkinson's disease and unable to paint.

Further Reading: Centre Pompidou, *Cher Peintre* (2002)

Bugatti, Rembrandt (1885–1916) Italian sculptor and draughtsman, son of Carlo Bugatti (1856–1940), who is best known as a furniture designer but who also painted, and brother of the famous automobile designer Ettore Bugatti (1881–1947). He was born in Milan and worked mainly in Paris (where his family settled in 1904) and Antwerp (where he lived from 1907 until the outbreak of the First World War). He was precociously gifted but he had no formal training in art. His speciality was bronze animal sculptures (the zoo in Antwerp encouraged animal artists), in which he moved from an impressionistic style to a more abstracted idiom. He was one of the most acclaimed artists of the day in his field (he was made a Chevalier of the Legion of Honour when he was only 26), but he committed suicide because of a combination of illness, depression (partly caused by a failed love affair), and financial problems (the war had ruined his market).

Buhler, Robert See SPEAR, RUSKIN.

Bulatov, Eric (1933–) Russian painter, associated with *Sots art, born in Sverdlovsk. His father was a dedicated Communist who had fought in the civil war but who, nonetheless, was arrested and imprisoned for a time in 1937. As a student, he seemed to be heading for a brilliant official career (one of his paintings was acquired in 1956 by the Tretyakov Gallery), but this was ended when he led a

student revolt against the policies of the Moscow School of Fine Arts. However, he left with the necessary technical skills to work in the *Socialist Realist manner and, to gain some economic independence, worked for some years as a book illustrator. As an *'unofficial artist' he took part in the open-air exhibition in Moscow in 1974 which was bulldozed by the authorities after a mere two hours. The previous year the French dealer Dina Vierny (*see* MAILLOL) had exhibited his work and during the following years it was increasingly visible outside the Soviet Union. He now lives and works in Paris.

The work is generally highly critical of the society in which he grew up. *Self-Portrait* (1968, Fondation Dina Vierny, Musée Maillol, Paris) shows the artist's face twice, a smaller version superimposed upon a larger within a kind of anonymous white shell, to suggest the kind of concealment of the self made necessary by the political system. Later work uses the devices of Socialist Realist propaganda to attack it. *Krasikov Street* (1977, State University of New Jersey) shows a group of modern-day Russians walking forwards quite indifferent to the giant image of Lenin striding purposefully towards them. Illusionistic scenes with powerfully suggestive perspective depths are overlaid with slogans which forbid entrance. Parallels have been drawn with certain Western artists, especially Ed *Ruscha. His paintings in the West continue to employ a photographic style and retain a satirical edge, although now the target is consumerism.

Further Reading: D. Vierny et al., *Erik Boulatov* (2000)

'Bulldozer Show' *See* UNOFFICIAL ART.

Bulletin de l'Effort Moderne *See* ROSENBERG, LÉONCE.

Bunny, Rupert (1864–1947) Australian painter, active in Paris for most of his career. He was born in Melbourne, the son of a judge, and moved to Europe in 1884, studying first in London, then in Paris, where he settled in 1886. His work became deeply French in spirit and was well received in his adopted country; he also exhibited with success at the *Royal Academy during his frequent visits to London. Bunny's paintings included landscapes, portraits, and mythological subjects, but he is best known for leisurely scenes involving elegant, beautifully dressed women (*Returning from the Garden*, 1906, Art Gallery of New South

Wales, Sydney). In 1911 he visited Australia, and in the same year his work was shown in Pittsburgh and Rome. At this time he was at the height of his career, but the First World War ended the carefree world of parasols and lace he loved to depict. He remained in France until 1933, when he returned to Australia following the death of his French wife, and settled near Melbourne. Although he continued to work, he was little appreciated in Australia until an exhibition at the National Gallery of Victoria held a few months before he died showed the range of his work.

Burchfield, Charles (1893–1967) American painter, mainly in watercolour. He was born in Ashtabula Harbor, Ohio, and studied at the Cleveland School (now Institute) of Art, 1912–16. In 1921 he settled permanently in Buffalo, where he worked as head designer in a wallpaper factory until he was able to devote himself full-time to art in 1929. Burchfield's work divides into three clear phases. Up to about 1918 he painted scenes of nature that have an obsessive, macabre quality, often based on childhood memories and fantasies. In his second phase—during the 1920s and 1930s—he was one of the leading *American Scene Painters, portraying the bleakness of small-town life and the grandeur and power of nature. In the early 1940s he became disenchanted with realism, however, and changed his style again, reviving the subjective spirit of his youthful work but in a more monumental vein, as he turned to a highly personal interpretation of the beauty and mystery of nature (*The Sphinx and the Milky Way*, 1946, Munson-Williams-Proctor Institute, Utica). 'His last paintings are filled with chimerical creatures—butterflies and dragonflies from another world. Few American artists have ever responded with such passion to the landscape or have made it such a compelling repository as well as a mirror of their intimate feelings' (Baigell). The Burchfield Penney Art Center, Buffalo, possesses his papers and a good collection of his paintings.

Burden, Chris (1946–) American artist, born in Boston. He studied at the University of California, during which time he made *Minimalist sculpture. However, he came to attention with a series of disturbing, potentially dangerous actions, which raised issues about the limits of art. The first of these was *Shoot* (1971), in which he had a friend fire at

him with a rifle. The intention was that it should only graze his arm, but Burden actually sustained a flesh wound. In other works he risked electrocution and was crucified on the roof of a car. In *Through the Night Softly* (1973) he crawled through 50 feet of broken glass by night.

These events had, principally, a kind of underground reputation, being seen by few. A blurred eight-second film and a rather longer audio tape are all that can now be experienced of *Shoot*, but by the mid-1970s Burden had moved into the mainstream gallery world. In *White Light/White Heat* (1975) a platform was built ten feet high in the Ronald Feldman Gallery, New York. To the visitor it would appear no different from a piece of Minimal sculpture. However, on the ledge, completely unseen, lay Burden for the length of the entire exhibition, fasting. The critic Robert Horvitz described the effect in these terms: 'The assumption that he is there alters everything—but I don't know for a fact that he really *is* there. I become "it" in an unannounced game of hide-and-seek. I listen for any telltale rustling, any breathing noises. The many small sounds that fill the gallery are magnified by my attention' (*Artforum*, May 1976). Horvitz admitted that Burden raised moral questions about art that he could not answer but found that to be part of the value of his work.

Some of Burden's later work, such as *The Flying Steamroller* (1996), reflects his interest in machinery and engineering. The steamroller is raised on one end of a beam which can rotate. On the other end there is a counterweight. When the roller is driven at a certain speed a hydraulic press raises it from the ground and it appears to fly. Even more technologically elaborate was the *Ghost Ship*, a project of 2005 which consisted of a boat that was programmed to sail unmanned from Fair Isle in Scotland to Newcastle upon Tyne to coincide with a nautical race.

Further Reading: P. Schjeldahl, 'Performance: Chris Burden and the limits of art', *New Yorker* (14 May 2007)

Burdick, Charles *See* AIRBRUSH.

Buren, Daniel (1938–) French painter and *installation artist. He was born in Boulogne-Billancourt and studied in Paris at the École Nationale Supérieure des Métiers d'Art, 1956–60. In 1965 he began painting with pre-printed pieces of linen he found in the Marché St Pierre in Montmartre. These became a

standardized type, always white with a single colour in bands 8.7 cms wide, almost in parody of the 'signature style' which a successful French painter was expected to adopt. However, Buren was of the generation who established their careers in a situation when the market for Parisian painters had been severely damaged by the successive waves of American art. He was also deeply affected by the political and philosophical debates which surrounded the beginnings of *Conceptual art. By using an image that did not change, he exposed not just the work itself but the context in which it was shown, its social identity as well as its visual one. Buren's work is therefore, in the most extreme sense, *site-specific, in that it takes its meaning entirely from its situation. The works were often accompanied by verbal statements that explained this thinking. In 1968 the stripes were paraded on boards by sandwich-men in the streets or pasted over posters. In the same year an exhibition in Milan consisted of sealing off the gallery with his distinctive white and green stripes. The motivation behind such work was highly political. Like the *Dadaists before him, Buren saw art as the safety valve of a repressive society. The problems which this created for the traditional museum were dramatically revealed by Buren's contribution to the *Guggenheim International Exhibition in 1971. Buren's *Peinture/Sculpture* was his cloth suspended from the ceiling of Frank Lloyd Wright's famous building. Buren considered that the design, architectural masterpiece that it was, tended to distract the viewer's attention from the actual works. He produced a piece that cancelled this effect. The work was removed by the museum authorities after only a few hours, partly as a result of pressure from other artists, especially Dan *Flavin, who said that Buren's work was obstructing the view of their own. Buren has continued to work with stripes, the results being increasingly spectacular and concerned with visual appeal as well as political comment. Later work has included the French Pavilion for the 1986 Venice *Biennale, widely acclaimed as the most beautiful pavilion that year, and installations at the Solomon R. Guggenheim Museum in 2005, which he called *Eye of the Storm* in acknowledgement of the controversy that had surrounded his last exhibition there.

(((∰))) SEE WEB LINKS

• The official website for the artist.

Burgin, Victor (1941–) British artist and art theorist, born in Sheffield, who has worked with language and photography. He studied at the *Royal College of Art, 1962–5, and Yale University, 1965–7. While in America, he discovered *Minimal art, at that time little known in Britain. This raised issues not only about the form but the nature of art and Burgin was one of those artists on both sides of the Atlantic who developed *Conceptual art. *Pathway* (1969) consisted of an exact photographic reproduction to scale of the floor beneath it. On one level this was an attempt to make an object which was both 'here and not here', a phrase from Robert *Morris. It was also an ephemeral work, one which had no meaning or value outside its context and therefore was outside the system of collecting. Burgin's subsequent activities both as artist and theorist have been informed by *psychoanalysis, semiology (*see* BARTHES), and politics. *Lei Feng* (1973–4) consists of a series of panels. The visual element is the same in each, an advertisement for sherry which promotes the product as part of a luxurious successful lifestyle. Accompanying it there is a narrative from Communist China, the tale of Lei Feng, told as a parable to instill a quite contrasting set of values. The third element is an essay on how meanings are constructed. Burgin's aim is to instill a critical approach to the way the spectator reads the meanings from images and texts. He has continued to combine photography and text in his work. One series of works is based on Edward *Hopper's famous painting *Office at Night*. Other works have drawn on film. A series inspired by Hitchcock's *Vertigo* links its motifs to the history of art, notably Millais's *Ophelia*, and draws out the psychoanalytic subtext.

Further Reading: V. Burgin, *Relocating* (2002)

Burle Marx, Roberto (1909–94) Brazilian artist, best known as one of the outstanding landscape architects and garden designers of the 20th century, but also active as a painter, sculptor, and designer of fabrics, jewellery, and stage sets. He was born in São Paulo to a Brazilian mother of French descent and a German-born father. In 1928–9 his family lived in Berlin, where he attended art classes at the Academy and developed an interest in Brazilian plants through visits to the city's Botanic Gardens. Back in Brazil he enrolled at the School of Fine Arts in Rio de Janeiro in 1930, studying painting under *Portinari, whom he

later assisted with tiled murals at the Ministry of Education in Rio (1937). In 1933 Burle Marx completed the first of the many garden projects that made him one of the most celebrated and best-loved artists in his country. He used colourful tropical plants arranged as sculptural groups within free-flowing patterns and succeeded in creating 'a style of landscape design that is at once essentially Brazilian and wholly of the 20th century' (*Oxford Companion to Gardens*, 1986). Many of his designs were skilfully harmonized with examples of Brazil's striking modern architecture, for example his garden and roof terraces (1938) for the Ministry of Education in Rio (the architect was Lucio Costa, later famous for his work at the new capital Brasilia). Burle Marx also designed gardens in other counties in Latin America and in the USA.

Burliuk, David (1882–1967) and **Vladimir** (1886–1917) Russian painters, brothers, leading members of the avant-garde in the period leading up to the First World War. They were born in Ukraine and both of them had varied artistic educations, including a period in Munich. Some of their early work was in *Neoprimitive vein close to that of *Goncharova and *Larionov. In 1909 they were among the founders of the *Knave of Diamonds group, and they were among the first exponents of *Futurism in Russia, *c*.1911. In Munich they had become friendly with *Kandinsky, and through him they participated in the second *Neue Künstlervereinigung exhibition in 1910 and in the first *Blaue Reiter exhibition in 1911. David wrote an article on the state of Russian painting for the Blaue Reiter *Almanac*, translated into German by Kandinsky as 'Die Wilden Russlands' (The Russian Savages). Vladimir, who was considered by Kandinsky to be the more talented of the two, was killed in action in the First World War. David settled in New York in 1922 and became an American citizen in 1930. He edited an art magazine, *Color Rhyme*, and ran an art gallery. There was another painter brother, **Nikolai** (1890–1920), and two painter sisters, **Lyudmila** and **Nadezhda**.

Burne-Jones, Sir Edward *See* PRE-RAPHAELITISM.

Burra, Edward (1905–76) English painter, draughtsman, and occasional stage designer, one of the most eccentric and individual figures in the history of British art. From childhood he

was ravaged continuously by ill-health (he had arthritis and anaemia) and he lived almost all his life in the genteel Sussex seaside town of Rye (he called it an 'overblown gifte shoppe'), but he travelled indomitably and had a tremendous zest for life that comes out in his chaotically misspelt letters as well as his paintings. His life and work, in fact, represent a revolt against his repectable middle-class background (his father was a barrister), for he was fascinated by low-life and seedy subjects, which he experienced at first hand in places such as the streets of Harlem in New York and the dockside cafés of Marseilles. From 1921 to 1925 Burra trained in London at Chelsea Polytechnic and the *Royal College of Art, and he had his first one-man exhibition at the *Leicester Galleries, London, in 1929. By this time he had already formed a distinctive style, depicting squalid subjects with a keen sense of the grotesque and a delight in colourful detail. Usually he worked in watercolour, but on a larger scale than is generally associated with this medium and using layer upon layer of pigment so that—in reproduction at any rate—his pictures appear to have the physical substance of oil paintings.

Burra's work has been compared with that of George *Grosz, whom he admired. While Grosz bitterly castigated evil and ugliness, Burra concentrated on the picturesque aspects of his subjects, but the humour can still be savage. Particularly well known are his Harlem scenes of 1933-4, with their flamboyant streetwise dudes and other shady characters (examples are in Tate and the Cecil Higgins Art Gallery, Bedford). Burra's style changed little, but around the mid-1930s his imagery underwent a radical change as he became fascinated with the bizarre and fantastic (*Dancing Skeletons*, 1934, Tate). Many of his recurrent images—such as the bird-man—and his manner of juxtaposing incongruous objects have a *Surrealist air, and although he generally kept aloof from groups he exhibited with the English Surrealists (he was also a member of *Unit One, organized by his friend Paul *Nash in 1933). The Spanish Civil War and the Second World War evoked a sense of tragedy in Burra that found expression in occasional religious pictures, and during the 1950s and 1960s his interest turned from people to landscape. By this time he had achieved critical and financial success, but he reacted with sardonic humour towards his growing fame.

Further Reading: J. Stevenson, *Edward Burra: Twentieth Century Eye* (2007)

Burri, Alberto (1915-95) Italian painter, collagist, and designer, born at Città di Castello in Umbria. In 1940 he took a degree in medicine at Perugia University, and in 1943 he was captured while serving as a doctor with the Italian army in north Africa. He was held as a prisoner of war in Hereford, Texas, and it was there that he began to paint in 1944, using whatever materials were to hand, including sacking. After his repatriation he settled in Rome in 1946 and abandoned medicine for art; he had his first one-man exhibition (of *Expressionist landscapes and still-lifes) at the Galleria La Margherita, Rome, in 1947. In 1948 his work became abstract, and in 1949 he began incorporating sacking in his pictures as collage elements; often he splashed red paint on the cloth in a way that suggested blood-soaked bandages (*Sacking with Red*, 1954, Tate). From the late 1950s he also began to use more substantial materials in his pictures, such as pieces of wood or rusted metal, and he sometimes burnt parts of the work, suggesting his experience of the carnage of war. Burri was among the first to exploit the evocative force of waste materials in this way, and his work looked forward to *Arte Povera in Italy and *Junk art in the USA. His pictures were first shown in America at a one-man exhibition at the Frumkin Gallery, Chicago, in 1953, and he subsequently spent a good deal of time in the country, particularly in Los Angeles, the birthplace of his wife, a dancer with Martha Graham's company. Among his American admirers was Robert *Rauschenberg, who visited his studio in 1953 (Rauschenberg's combine paintings, begun in 1955, were perhaps influenced by Burri's work). In the 1960s he worked with torn and burnt transparent plastic. Introducing these at their first London showing (Marlborough New London Gallery) in 1963, Cesare Brandi drew attention to the function of the material in the packaging of books or fruit and the way it forces us to 'see and not touch' and our consequent desire to tear it apart. Like the exponents of *Pop and *Nouveau Réalisme, Burri was responding to the consumer society.

Burri was a fairly reclusive character, but from the 1960s he was among the most internationally famous of Italian artists and he won numerous prestigious awards, including the Grand Prix (jointly with *Vasarely) at the São Paulo *Bienal in 1965. Apart from paintings and collages, his work included stage decor

for La Scala in Milan and other theatres and the design of the poster for 'Italia 90' (the 1990 football World Cup, which was held in Italy). In 1991 he settled an the French Riviera. There is a foundation devoted to his work in Castello, Umbria.

Burroughs, Betty *See* MARSH, REGINALD.

Bury, Pol (1922–2005) Belgian sculptor, painter, and designer, best known as one of the leading exponents of *Kinetic art. He was born in Haine-St-Pierre and studied at the Academy in Mons. During the Second World War he was a member of the Belgian Resistance. He was a founder member of the *Jeune Peinture Belge group in 1947 and of the *Cobra group in 1949. In 1953, however, he abandoned painting for Kinetic sculpture and took part in the 'Mouvement' exhibition at the Galerie Denise *René, Paris, in 1955, regarded as a key event in the birth of a Kinetic movement. His early works could be rotated at will, inviting spectator participation, but from about 1957 he began to incorporate electric motors. The movement was usually very slow and the impression made was humorous and poetic but uncanny, in contrast to the violent effects of *Tinguely. Bury also made films and stage designs. After 1961 he lived mainly in Paris.

Bush, Jack Hamilton (1909–77) Canadian painter, one of his country's leading exponents of abstract art. He was born in Toronto and spent most of his life there. Initially he worked in the tradition of the *Group of Seven (*Village Procession*, 1946, Art Gallery of Ontario, Toronto), but in the early 1950s, inspired by Jock *Macdonald and *Borduas's work, he began to experiment with *automatism. In 1952 he made the first of what became regular visits to New York. The influence of these, together with that of his fellow members of *Painters Eleven, brought him by the mid-1950s to a type of *Abstract Expressionism. Later, however, he developed a more individual style, exploring the unaffectedly emotional use of colour, as in his most famous picture, *Dazzle Red* (1965, Art Gallery of Ontario), which Dennis Reid describes as 'one of the most monumentally beautiful paintings of the decade—there is a boldness that is in no way brash. It is a huge great living banner of colour in which Bush has even managed to infuse naturally cool blue and green with vital human warmth. It reflects the open joy of

personal fulfilment.' Bush worked as a commercial designer for most of his career and did not paint full-time until 1968. By this time, however, he was acquiring an international reputation (he had a one-man exhibition in New York in 1962, quickly followed by two more there, and another in London in 1964, and in 1967 he represented Canada at the São Paulo *Bienal).

Butler, Reg (1913–81) British sculptor, draughtsman, and printmaker, born at Buntingford, Hertfordshire. He was an architect by training (his work included the clocktower of Slough Town Hall, 1936), but he began making sculpture in 1944, without formal tuition. He had his first exhibition in London in 1949. In 1953 he suddenly came to prominence on being awarded the first prize (£4,500) in the international competition for a 'Monument to the Unknown Political Prisoner' (defeating *Calder, *Gabo, and *Hepworth among other established artists). The competition was financed by an anonymous American sponsor, now known to be John Hay *Whitney, with probable assistance from the CIA, and organized by the *Institute of Contemporary Arts. It intended to promote interest in contemporary sculpture and 'to commemorate all those unknown men and women who in our time have been deprived of their lives or their liberty in the cause of human freedom'. Butler's design was characterized by harsh, spindly forms, suggesting in his own words 'an iron cage, a transmuted gallows or guillotine on an outcrop of rock'. The monument was never built (one of the models is in Tate), but the competition established Butler's name and he won a high reputation among the British sculptors of his generation.

Butler had learned iron-forging when he worked as a blacksmith during the Second World War (he was a conscientious objector) and iron was his favourite material. His early sculpture is remarkable for the way in which he used his feeling for the material to create sensuous textures. Pieces such as *Woman* (1949, Tate) were strongly influenced by *Surrealism, especially Max *Ernst. His later work, which was more traditional (and to many critics much less memorable), included some bronze figures of nude women, realistically painted and with real hair, in contorted poses, looking as if they had strayed from the pages of 'girlie' magazines. Butler was a

sensitive draughtsman and made drawings as independent works. He also produced a few lithographs and wood engravings. From 1951 to 1980 he taught at the *Slade School. Five lectures he delivered there in 1961 were published in book form the following year as *Creative Development*. These were subsequently chiefly remembered for their sour comments on women artists.

Further Reading: Tate Gallery, *Reg Butler* (1983)

Byam Shaw, John *See* SHAW, JOHN BYAM.

Cabaret Voltaire A club founded in Zurich in February 1916 by the German poet, musician, and theatrical producer Hugo Ball (1886–1927); it was one of the chief breeding grounds of the *Dada movement. A press announcement on 2 February read: 'Cabaret Voltaire. Under this name a group of young artists and writers has been formed with the object of becoming a centre for artistic entertainment. The Cabaret Voltaire will be run on the principle of daily meetings where visiting artists will perform their music and poetry. The young artists of Zurich are invited to bring along their ideas and contributions.' It opened on 5 March. Among the leading figures were the singer Emmy Hennings (later Ball's wife), the poets Tristan Tzara and Richard Hülsenbeck, and the artists Jean *Arp, Marcel *Janco, and Hans *Richter. The Cabaret Voltaire was, in Richter's words, 'an overnight sensation', but it was forced to close early in 1917 because of 'the complaints of respectable citizens outraged by the nightly excesses'. An account of a typical night was given by Georges Hugnet, a Surrealist poet: 'On the stage someone thumped keys and bottles to make music until the audience, nearly crazy, protested . . . A voice from beneath an enormous hat shaped like a sugarloaf declaimed Arp's poems. Hülsenbeck bellowed his poems, while Tzara emphasized the rhythms and crescendos by banging on a bass drum.' After the closure Ball and Tzara rented a gallery, opened in March 1917 as the Galerie Dada, to which they transferred their activities.

Cabaret Voltaire was the name of the first Dada publication—a pamphlet edited by Ball issued on 15 June 1916.

cadavre exquis A game in which a small group of people contribute in turn to make up a sentence or a drawing, no member of the group being aware of what the others have contributed (in the case of a drawing, the paper is usually folded in such a way that the edge of the previous participant's work—meaningless in itself—is visible, providing a starting-point for the next person). This old party game, usually called 'consequences', was given a new seriousness and significance by the *Surrealists as a device for tapping the collective unconscious or exploiting the element of chance that they believed to be a path to creativity. In *Breton's *Dictionnaire abrégé du surréalisme* (1938) it is described as follows: 'A game with folded paper. Every participant makes a drawing without knowing what his predecessor has drawn, because the predecessor's contribution is concealed by the folded part of the paper. The example which has become a classic, and to which the game owes its name, was the first sentence produced by this method [in 1925]: "Le cadavre exquis boira le vin nouveau" [The exquisite corpse will drink the new wine].' An example of a cadavre exquis drawing from 1926 is in the Museum of Modern Art, New York, the participants having been Breton, *Tanguy, and four others.

Cadell, F. C. B. (Francis Campbell Boileau) (1883–1937) Scottish painter. He studied at the *Académie Julian, Paris, 1899–1902, and lived in Munich, 1906–8, before settling in his native Edinburgh. Unlike the other *Scottish Colourists, he was initially less influenced by *Post-Impressionism and *Fauvism than by the tradition of virtuoso brushwork stemming from Manet. Cadell's *The Black Bottle* (1903, NG, Edinburgh), for example, could in reproduction be mistaken for a late Manet, and in *The Model* (c.1910, NG of Modern Art, Edinburgh) his luscious handling of paint is at least as close to that of certain northern European painters, such as *Liebermann or *Zorn, as it is to anything in contemporary French painting. From about 1920, however, Cadell's work became brighter and bolder (and less subtle)—closer to that of his friend *Peploe. Like Peploe, Cadell is now

particularly well known for landscapes painted on the island of Iona, which he visited regularly from 1919, after he returned from active service in the First World War.

Cadmus, Paul (1904–99) American painter and draughtsman. Both his father and mother were commercial artists. He studied in his native New York at the National Academy of Design, 1919–25, and the *Art Students League, 1928–30, then worked for an advertising agency before travelling in Europe, 1931–3. On his return to New York in 1933 he started work for the Public Works of Art Project (*see* FEDERAL ART PROJECT) and in the following year was involved in the first of a series of scandals that characterized his career and established him in the public eye. It was caused by his painting *The Fleet's In!* (1934, Naval Historical Center, Washington), portraying sailors on shore leave. The painting was described by the secretary of the navy as 'a most disgraceful, sordid, disreputable, drunken brawl, wherein apparently a number of enlisted men are consorting with a series of streetwalkers and denizens of the red-light district', and was withdrawn from the first Public Works of Art exhibition at the Corcoran Gallery, Washington. In its brutal satire and frankness in portraying carnal desires (he was particularly good at showing sexual hunger and loneliness), the picture is typical of Cadmus's work. The other salient features of his style are his sheer gusto and his complete rejection of modern methods—he often used the poses and compositional devices of the Old Masters and he painted with an extremely meticulous technique, usually in egg tempera. Because of his high polish and precision he is sometimes described as a *Magic Realist. He worked slowly and his output as a painter was small. However, he was a comparatively prolific draughtsman, because—as he said—'drawings are more saleable than paintings—they're less expensive'.

Further Reading: L. Kirstein, *Paul Cadmus* (1992)

Cage, John (1912–92) American composer, philosopher, writer, teacher, printmaker, and draughtsman. Cage is principally famous as a composer, but he had a deep interest in the visual arts, collaborated with and influenced many of his artist friends, and late in life acquired a reputation as a printmaker. He was born in Los Angeles into a cultured family (his father was an engineer and inventor and his mother a journalist). After being a star pupil at high school, he went to Pomona College, California, in 1928, but he dropped out of his course in 1930 and spent a year and a half travelling around Europe, studying art and architecture as well as music. He tried his hand at abstract painting, but after his return to the USA he concentrated on music; his training included a period of study (1935–7) with Arnold Schoenberg, who himself was interested in painting (*see* BLAUE REITER). After a period of varied activity (including a spell as a dance-class accompanist), Cage settled in New York in 1942 and became a prominent figure in avant-garde circles, his artist friends eventually including Marcel *Duchamp, Max *Ernst, Jasper *Johns, and Robert *Motherwell.

Cage's music is extremely unorthodox, cultivating random and chance effects and experimenting with unusual sound sources, including electronic devices and the 'prepared piano' (Cage's invention), in which a piano is transformed into a percussion instrument by the insertion of various objects between the strings. For him, random sounds could have the same value as organized musical notes. In 1948–9 Cage lectured at the *Subjects of the Artist School on 'Indian Sand Painting or the Picture that is Valid for One Day', and from 1948 to 1952 he spent the summers teaching at *Black Mountain College, where in 1952 he organized an event that has been described as the first *Happening. Among the students he met at Black Mountain College was Robert *Rauschenberg, who was one of the artists most directly influenced by Cage's example in using unconventional materials and procedures. Cage often treated his scores as visual compositions (they have been exhibited in galleries), and from 1978 he began making prints (mainly etchings). In the 1980s he also took up drawing seriously.

Further Reading: J. Cage, *Silence* (1973)

Cahiers d'art Art journal published in Paris from 1926 to 1960. Several issues appeared every year, but the frequency varied; publication was suspended in 1941–3. It was produced by the Greek-born writer Christian Zervos (1889–1970) in collaboration with his wife, Marion (1905–70). The journal covered a wide range of subjects, including poetry, music, film, architecture, and Mediterranean archaeology, but it concentrated on modern art, and in particular published many articles on Zervos's friend *Picasso. In 1937, for example, a special number was devoted to his painting *Guernica*, with photographs by Dora *Maar showing it in various stages of progress.

The colour illustrations in the journal were of high quality and sometimes consisted of original lithographs. Zervos also edited and published the standard catalogue of Picasso's works (33 volumes, 1932–78). *Cahiers d'art* provided many artists outside France, including David *Smith and Graham *Sutherland, with vital visual material.

Cahill, Holger *See* FEDERAL ART PROJECT.

Cahun, Claude (1894–1954) French photographer and writer, born in Nantes as Lucy Schwob. She adopted her androgynous name partly from her grandmother Mathilde Cahun, with whom she lived for much of her childhood, because of the mental illness of her mother. In the early 1920s she moved to Paris, where she established herself as a writer and photographer. Her best-known works are the self-portrait photographs she made, sometimes dressed in male costume with shaved or closely cropped hair, sometimes made up like a doll. In one of the images, *What do You Want From Me?* (1928), photomontage transforms Cahun into a two-headed figure. Cahun was a lesbian and her works have been frequently analysed from the point of view of gender identity, especially in relation to *Surrealism. She was friendly with André *Breton, who gave her considerable encouragement. In the 1930s she became increasingly involved with left-wing anti-Fascist movements and in 1937 she moved to Jersey with her step-sister and lifelong companion Suzanne Malherbe. As a result of clandestine activities during the German occupation, they were both imprisoned and narrowly escaped execution. They remained in Jersey after the war, but Cahun's health was broken.

Further Reading: D. Ades, 'Surrealism, Male–Female', in Mundy (2000)

Cai Guo-Qiang (1957–) Chinese multimedia artist, born in Guanzhou City. Unlike some contemporaries such as *Xu Bing, he escaped the worst excesses of the Cultural Revolution, about which he now expresses diplomatically ambivalent attitudes. He began his career as an artist in Japan, having obtained a visa to study stage design, and since 1995 he has had a studio in New York. His trademark as an artist is the spectacular use of gunpowder. Cai relates this to his experience as a child of seeing the air attacks on each side during the Taiwan Straits war. The *Project to Extend the Great Wall of China by 10,000 Metres* (1993) took place at the west end of the Great Wall and was watched by 50,000 local people. Cai has also made drawings and events using gunpowder explosions. As with some other contemporary Chinese artists, his work is often politically ambiguous. The most significant example of this ambivalence was the work he presented at the 1999 Venice *Biennale. This was a recreation of the once famous *Socialist Realist sculpture *The Rent Collector's Courtyard* made by a team of sculptors about 1965, which portrayed in life-size figures the alleged iniquities visited on the peasant in pre-revolutionary days. Cai brought over traditionally trained Chinese sculptors to reconstruct it as exactly as possible. Those who saw it recall its impact as 'fascinating', but in the photographs documenting the event it looks forlorn and dwarfed by the grand space of the Arsenale. He also draws on earlier aspects of Chinese history and myth. *Borrowing your Enemy's Arrows* (1998) is an old hulk of a boat bristling with about 3,000 arrows. This relates to an old tale of a general who used an army of dummy soldiers to draw the enemy's fire and so replenish his own armoury. For his retrospective at the Guggenheim Museum, New York, in 2008 entitled *I Want to Believe*, Cai suspended a number of cars from the top of Frank Lloyd Wright's famous building. These sprouted sprays of coloured lights suggesting a car bomb explosion. It was an impressive sight, although the turning of such an event into a romantic aesthetic spectacle might arouse some moral qualms. Cai has commented: 'Before igniting an artwork, I am sometimes nervous, yet terrorists face death unflinchingly. Along with the sympathy we hold for the victims, I also have compassion for the young men and women who commit the act.' Although he is now based in the West, Cai retains links with China and was responsible for the planning of the opening ceremony at the 2008 Beijing Olympics.

Further Reading: P. Schjedahl, 'Gunpowder Plots', *New Yorker* (25 February 2008)

Caillebotte, Gustave *See* IMPRESSIONISM.

Calder, Alexander (1898–1976) American sculptor and painter, born in Lawnton, Pennsylvania (now part of the city of Philadelphia); he is famous as the inventor of the *mobile and thereby as one of the pioneers of *Kinetic art. His grandfather, **Alexander Milne Calder**

(1846–1923), and his father, **Alexander Stirling Calder** (1870–1945), were sculptors, and his mother, **Nanette Lederer Calder** (1866–1960), was a painter, but he began to take an interest in art only in 1922, after graduating in mechanical engineering in 1919 and working at various jobs. From 1923 to 1926 he studied painting at the *Art Students League, New York, where his teachers included George *Luks and John *Sloan. Calder and his fellow students made a game of rapidly sketching people on the streets and in the subway, and Calder was noted for his skill in conveying a sense of movement by a single unbroken line. From this he went on to produce wire sculptures that were essentially line drawings in space; the earliest, made on a visit to Paris in 1926, were amusing, toylike figures of animals, and from these he developed a miniature circus, with which he began giving performances in 1927 (again in Paris). He also made much larger works in this manner, including the well-known group *Romulus and Remus* (1928, Guggenheim Museum, New York), which features a wolf about 3 metres long. His first exhibition of such works was at the Weyhe Gallery, New York, in 1928.

From now on Calder divided his time between the USA and France, and he knew several leading avant-garde artists in Paris, most notably *Miró, who became his lifelong friend. In 1931 Calder joined the *Abstraction-Création group, and in the same year he produced his first abstract moving construction. In 1932 Marcel *Duchamp baptized these constructions 'mobiles' and *Arp suggested 'stabiles' as a name for the non-moving constructions. Calder's first mobiles were moved by hand or by motor-power, but in 1934 he began to make the unpowered mobiles for which he is most widely known. Constructed usually from pieces of shaped and painted tin suspended on thin wires or cords, these were light enough to respond to the faintest air currents. They were described by Calder as 'four-dimensional drawings', and in a letter to Duchamp in 1932 he spoke of his desire to make 'moving *Mondrians'. Calder was in fact greatly impressed by a visit to Mondrian's studio in 1930, and no doubt envisaged himself as bringing movement to Mondrian-type geometrical abstracts. However, the personalities of the two men were very different: Calder's delight in the comic and fantastic, which can often be seen even in his largest works, was at the opposite pole to the messianic seriousness of Mondrian.

In 1952 Calder won first prize for sculpture at the Venice *Biennale and after this carried out numerous public commissions—both mobiles and stabiles—in the USA, France, and elsewhere. Some of his later works are very large: the motorized hanging mobile *Red, Black, and Blue* (1967) at Dallas Airport is 14 metres wide. Calder also worked in a variety of other fields, painting gouaches and designing, for example, rugs and tapestries, but his mobiles are far and away his most important works. For all his importance as inventor of the mobile, the generation of Kinetic artists who emerged in the 1960s looked more to the *Constructivists and to Duchamp as antecedents, tending to find Calder too whimsical. Guy Brett, a critic in close contact with many of these younger artists, wrote that 'His sculptures are superb, but his sculpture has perhaps had a small influence because his work, being strongly representational, has not suggested comparable linguistic possibilities to be developed' (*Kinetic Art*, 1968).

Further Reading: Royal Academy of Arts, *Alexander Calder* (1994)

Calderon, Frank *See* NEWTON, ALGERNON.

Calle, Sophie (1953–) French artist, born in Paris. Her work is usually described as *Conceptual in that it is highly dependent on documentation, but it is also very much a reflection of *feminist preoccupations with autobiography and gender identity. Angelique Chrisafis described her as the 'Marcel *Duchamp of dirty laundry'. Her technique is to set up situations which directly relate to her own life or those of others, sometimes raising awkward questions about privacy. In a work of 1981, a private detective was hired by her mother, at Calle's request, to follow and photograph the artist. In *L'Homme au carnet* (1983) she followed up the leads in an address book she had found to build up a picture of an unknown man. The results were published in the newspaper *Libération*. The man in question, who turned out to be a film-maker, retaliated by finding a nude photograph of the artist and publishing it. At the Venice *Biennale of 2007 Calle showed a work called *Take care of yourself*. Calle took the text of a letter sent by her lover bringing their relationship to an end and gave it to 107 women, including a clown, an expert on etiquette, and a forensic psychologist to provide a professional response. She has made work in collaboration with the

philosopher Jean *Baudrillard, who found in her work confirmation for his ideas about seduction. Calle has also worked in cinema. A semi-documentary entitled *No Sex Last Night* about a trip around America was released in 1996.

Further Reading: A. Chrisafis, 'He loves me not', *The Guardian* (16 June 2007)

Camberwell College of Arts *See* ST MARTIN'S SCHOOL OF ART.

Cambridge, Kettle's Yard *See* EDE, H. S.

Camden Town Group
Group of British painters formed in 1911 who took their name from the drab working-class area of London (as it was then) made popular as a subject by *Sickert. In addition to being the prime inspiration of the group, Sickert suggested the name, saying that the district had been so watered by his tears that something important must come from its soil. The group lasted only two years and held only three exhibitions, but the name is also used in a broader sense to characterize a distinctive strain in British painting from about 1905 to 1920; many of its most characteristic works predate the founding of the group.

When Sickert settled in England in 1905 after spending most of the previous two decades in France, he said he wanted to 'create a *Salon d'Automne milieu in London', where progressive artists could discuss, exhibit, and sell their work. To this end he kept open house every Saturday afternoon at his studio at 8 Fitzroy Street (this is in Bloomsbury, but he lived at Mornington Crescent, in the borough of Camden, less than a mile away). In 1906 several of his disciples rented premises at 19 Fitzroy Street that were used as a showroom for their work, and the name 'Fitzroy Street Group' has been applied to the artists who met there. Many of these artists also showed their work at the exhibitions of the *Allied Artists' Association, founded in 1908, and several of them also did so at the *New English Art Club, but for some of them these institutions were not progressive enough, which led to the decision to form the Camden Town Group in 1911. Women were excluded and it was decided to limit the membership to sixteen, who were originally Walter *Bayes, Robert *Bevan, Malcolm *Drummond, Harold *Gilman, Charles *Ginner, Spencer *Gore (president), J. D. *Innes, Augustus *John, Henry *Lamb, Wyndham *Lewis,

Maxwell Gordon Lightfoot (1886–1911), J. B. *Manson (secretary), Lucien *Pissarro, William Ratcliffe (1870–1955), Sickert himself, and John Doman Turner (*c*.1873–1938), an amateur painter who had been a pupil of Gore. Lightfoot resigned after the first exhibition and committed suicide a few months later; he was replaced by Duncan *Grant.

These artists varied considerably in their aims and styles, but their paintings are generally small, unpretentious, and based on everyday life. Their subjects included not only street scenes in Camden Town, but also landscapes, informal portraits, still-lifes, and nudes in shabby bed-sitters (Sickert wrote in 1908: 'Taste is the death of a painter . . . His poetry is the interpretation of everyday life'). Several of the Camden Town artists painted with a technique that can loosely be described as *Impressionist, with broad, broken touches, but particularly after Roger *Fry's *Post-Impressionist exhibitions of 1910 and 1912, the use of bold, flat areas of colour became characteristic of others, notably Bevan, Gilman, Ginner, and Gore. These four best represent a distinctive Camden Town 'style', one that was much imitated by painters of the urban scene up to the Second World War and beyond.

The Camden Town Group held two exhibitions at the Carfax Gallery, London, in 1911 and a third in 1912. They were financially disastrous, and as the gallery then declined to put on more exhibitions, the members joined with a number of other artists to form the *London Group in November 1913. The new body organized a collective exhibition in Brighton at the end of 1913, and although it was advertised under the name of the Camden Town Group, it may be regarded rather as the first exhibition of the London Group.

Among the artists associated with Camden Town painting in the broader sense are: Sylvia *Gosse; Nina *Hamnett; Thérèse *Lessore; William *Rothenstein and his brother Albert (1881–1953), who changed his surname to Rutherston in 1914; and Ethel *Sands.

Cameron, Sir David Young (1865–1945)
Scottish painter, etcher, and draughtsman, born in Glasgow, the son of a clergyman. He abandoned brief unhappy careers in commerce and law to study at *Glasgow School of Art and the Royal Scottish Academy in Edinburgh. Most of his work consisted of landscapes (especially scenes of mountains)

and architectural views, and he is best known for his etchings of buildings, including Gothic churches on the Continent—rich and sombre works with which he established a reputation as one of the outstanding printmakers of the day. As a painter his work included First World War scenes done in 1917–18 as an *Official War Artist for the Canadian government. He was knighted in 1924.

Camnitzer, Luis (1937–) Uruguayan artist and writer. Born in Lübeck, Germany, he emigrated to Uruguay in 1939. He now lives and works in New York. His work, which comes out of *Conceptual art, is highly political and makes continuous reference to torture and repression in his home country. *Leftovers* (1970, Tate) is a stack of bandaged bloodstained boxes and refers to the violent events of the period in Uruguay when martial law was imposed after a series of labour disputes. A series of photographic works of 1983, *Uruguayan Torture* (University of Texas, Austin), refers elliptically to the subject implied by the title: for instance a glass of water stands for fear of thirst, as though to indicate that the horror of torture lies not just in physical pain, but in its power to induce fear in everybody. Camnitzer stresses the ethical role of the artist. He stated in 1987: 'In order to survive ethically we need a political awareness that helps us understand our environment and develop strategies for our actions. Art becomes the instrument of our choice to implement these strategies' (*New Art Examiner*, June 1987). He has been a prolific writer on art, discussing the work of other political artists including Jimmie *Durham and Ana *Mendieta. He is also the author of works on art history, *The New Art of Cuba* (2003) and *Conceptualism in Latin American Art* (2007).

(((●))) SEE WEB LINKS

• Website of Lehman Gallery retrospective Camnitzer exhibition.

Camoin, Charles (1879–1965) French painter, born in Marseilles. In 1896 he moved to Paris, where he studied at the École des *Beaux-Arts alongside *Manguin, *Marquet, and *Matisse. With them he became a member of the *Fauves, but although he shared their liking for pure and bright colour, his work was less extreme. In 1916 he met *Renoir, whose paintings greatly impressed him, and from this time Camoin's work belongs more to the *Impressionist tradition than to any of the revolutionary movements of the 20th century. *Bonnard was another major influence on him. His work was varied in subject, his large output including portraits, still-lifes, interiors, landscapes, and nudes, all painted with an air of freshness and spontaneity.

Campbell, Steven (1953–2007) Scottish painter, born and mainly active in Glasgow. After leaving school he worked for seven years as a maintenance engineer and steel fitter, and it was not until 1978, when he was 25, that he enrolled as a student at *Glasgow School of Art. Initially he was interested in *Performance art, but he turned to painting and soon made up for his late start, winning a Fulbright Scholarship that took him to New York in 1982, within months of graduating. He remained in New York until 1986 and as early as 1983 had two one-man shows, at Barbara Toll Fine Arts and the John Weber Gallery. These were well received and his success was an inspiration for younger Scottish artists: after his return to Scotland in 1986, Campbell became the focal point of a flourishing group of figurative painters in Glasgow (*see* GLASGOW SCHOOL), and 'his achievement has done much to shape the evolution of Scottish painting in recent years' (Duncan Macmillan). The painter himself went further: he was reported as saying, 'I'm the only one doing Scottish Painting.' Campbell's paintings—often very large in size—typically show bulky figures of offbeat or outlandish appearance placed in strange settings, and he had a taste for unconventional titles (*The Building Accuses the Architect of Bad Design*, 1984, Laing Art Gallery, Newcastle upon Tyne). 'His tweed-clad, mainly male cast of characters roam the countryside and become embroiled in bizarre, nonsensical occurrences. Birds, beasts, and men compete in a hostile garden environment, performing strange rituals which defy nature's logic' (catalogue of the exhibition 'Scottish Art Since 1900', NG, Edinburgh, 1989).

Further Reading: S. N. Moffat, obituary, *The Guardian* (2 September 2007)

Campendonk, Heinrich (1889–1957) German painter and designer, born at Krefeld, where he studied under *Thorn Prikker at the Arts and Crafts School. In 1911 he moved to Bavaria and in that year exhibited with the *Blaue Reiter in Munich. His paintings at this time showed the influence of *Macke's interpretation of *Orphism combined with a taste

for Bavarian folk art. In 1914 he met *Chagall, and Campendonk's later work, which included numerous stained-glass windows, often has something of Chagall's sense of dreamlike fantasy. Campendonk taught at various art schools in the 1920s, and in 1933 he was dismissed from his post at the Düsseldorf Academy by the Nazis, his work being declared *degenerate. He then moved to Amsterdam, where he taught at the Academy for most of the rest of his life.

Campigli, Massimo (1895–1971) Italian painter, born in Florence. He trained as a journalist in Milan (where he associated with the *Futurists) and was self-taught as a painter. In the First World War he fought in the Italian army and was taken a prisoner of war; after his release he settled in Paris, where he lived from 1919 to 1933. As Campigli himself said, *Léger and *Picasso were major influences on his early work, but after seeing an exhibition of Etruscan art on a visit to Rome in 1928 his style was completely transformed: he abandoned perspective and his figures became two-dimensional and hieratic (although they have an air of dolls rather than of ancient presences). In the 1930s he began to establish an international reputation and received several commissions for large murals, to which his flat figures with their exaggerated gestures were well suited; examples are in the Palace of the League of Nations in Geneva (1937), the Palazzo di Giustizia, Milan (1938), and the Palazzo del Liviano, Padua (1939–40). In 1933 Campigli had returned to Milan; he spent the Second World War there and in Venice, and afterwards lived variously in Milan, Paris, Rome, and St-Tropez (where he died). By the middle of the century he was perhaps the best known internationally among contemporary Italian painters, and his work is represented in many public collections of Europe and America. His reputation has faded somewhat since his death.

Canaday, John (1907–85) American writer, born in Fort Scott, Kansas. He studied at the University of Texas at Austin (BA, 1929), then at Yale (MA in the history of art, 1933), and after private study in Paris for several years taught at various colleges in the USA. During the Second World War he served in the marines. From 1953 to 1959 he was director of educational activities at the Philadelphia Museum of Art, and from 1959 to 1977 he was art news editor for *The New York Times*. In this position he often attacked contemporary art, particularly *Abstract Expressionism, and he became a controversial figure. In March 1961 a group of 49 artists, critics, dealers, and so on sent a joint letter to the *Times* deploring his writings, particularly his use of words such as 'charlatan' and 'fraud'. Nonetheless, response to the incident, as reported in the newspaper, indicated considerable public support for Canaday. He was a noted gourmet and from 1974 worked as restaurant critic for the *New York Times*. He also wrote novels.

Canadian Art Club A private exhibiting society of Canadian artists active in Toronto from 1907 to 1915. The main instigators of the Club were the painters Edmund Morris (1871–1913) and Curtis Williamson (1867–1944), who were 'deeply disturbed by the tired, old-fashioned look of Canadian art as seen in the various annual exhibitions' (Reid) and attempted to establish higher standards through small, carefully hung shows. Membership of the Club was by invitation only. Homer Watson (1867–1944) was the first president, and other members included the Scottish-born William Brymner (1855–1925), who had studied in Paris at the *Académie Julian, Maurice *Cullen, and J. W. *Morrice. The work of these artists was varied in style and subject, but generally it showed influence from *Impressionism and *Whistler. Their eight exhibitions were well received, but the Club disbanded in 1915, having lost some of its momentum because of the death (by drowning) of Morris in 1913 and because of the distractions of the First World War (there were also personality clashes among some of the members). However, the Club helped to prepare the way for the *Group of Seven.

Canadian Group of Painters (CGP) A group of Canadian painters formed in Toronto in 1933 as a successor to the *Group of Seven, whose last exhibition had been in 1931. Two former members of the Group of Seven—A. Y. *Jackson and Arthur Lismer—were among the leading figures of the new organization. The CGP regarded itself as 'a direct outgrowth of the Group of Seven' and aimed 'to encourage and foster the growth of art in Canada which has a national character'; although landscape continued to be the dominant subject among the members of the group, it recognized 'the right of Canadian artists to find beauty and character in all things' and encouraged 'more

C

modern ideas of technique and subject'. Its first exhibition was held in Atlantic City, New Jersey, in summer 1933 and its second at the Art Gallery of Toronto the following November; thereafter an annual November exhibition became the norm. The Group soon expanded (Montreal and Vancouver were the other two main centres of its activities) and many of the best-known Canadian artists exhibited with it up to the time it disbanded in 1969.

Canogar, Rafael (1935–) Spanish painter. He was born in Toledo and studied in Madrid, where in 1957 he was a founder member of the group *El Paso, which was hostile to the Franco regime. His work at this time had developed from *Social Realism to aggressively expressive abstraction, but in the 1960s he reintroduced representational elements, with overtones of humour and satire, through which he expressed human alienation in the modern world: 'The protagonist of my work, man, is a clear denunciation of industrial society, which enslaves our urban existence and reduces the human being to pure functionalism, incapable of the most elementary coexistence and brotherhood.' Canogar has travelled and exhibited widely and is regarded as one of the leading Spanish painters of his generation. In 1971 he won the Grand Prix at the São Paulo *Bienal.

Cao Fei (1978–) Chinese video artist. She was born in Guandong Province, China's economic powerhouse. According to Karen Smith, she is 'an appealing representative of China's new hybrid society, defined by the twin poles of an ever expanding industrialization and a rapacious consumerist culture'. *Rabid Dogs* (2000) featured office workers acting like dogs. The artist commented that 'We are surely a miserable pack of dogs and we are willing to act as beasts that are locked in the trap of modernization.' Whereas an older generation of Chinese artists had scores to settle with Mao Zedong and his personality cult, Cao Fei draws on the impact of mass consumer culture on society. *COSPlayers* (2004) reflects the lives of those young Chinese who dress up as characters from Japanese manga cartoons, living out fantasies of unreal magical powers within a drab environment.

In 2006 she received a commission from Siemens, the German electronic company, which has manufacturing plants across China. The result was *Whose Utopia? What are you doing here?* Set in an electric light bulb factory, it contrasts the day-to-day repetitive lives of the workers with their fantasies.

Further Reading: H. Orbist, 'Cao Fei', *Artforum* (January 2006)

Capa, Robert (1913–54) Hungarian photographer, born in Budapest as Endre Ernó Friedman. He is best known as a war photographer, especially for his images of the Spanish Civil War. One of these has become an icon for the entire conflict, the *Death of a Loyalist Soldier* (1937), published in *Life* magazine. The authenticity of this image, which appears to show the moment of death as the soldier is struck by a bullet, has been disputed, although research has now shown that it probably represents what it purports to. He also documented the Japanese invasion of China in 1938, the Second World War and the creation of Israel. He was killed by a land mine in Indo-China. Ian Jeffrey has stated that Capa was more than a newsman. He had 'a positive vision of man as heroic and fraternal'. He became an American citizen in 1946.

Čapek, Josef (1887–1945) Czech painter, graphic artist, stage designer, and writer, born at Hronov in Bohemia, the son of a doctor. His career was many-sided, but he regarded himself primarily as a painter. Like *Filla and *Gutfreund, he was one of the earliest artists outside France to work in a *Cubist idiom, and with them he was one of the founders of the *Group of Plastic Artists, established in Prague in 1911 with the object of combining Cubism and German *Expressionism into a new national style. Later the Expressionist current in his work prevailed, revealing his deep concern with fundamental moral and social questions (*Bad Conscience*, 1926, Moravian Gallery, Brno). His humanist outlook was shared by his more famous younger brother, the writer Karel Čapek, several of whose books he illustrated. Both of them fervently opposed the threat from Nazi Germany in the 1930s; Karel died the year before the outbreak of the Second World War, but Josef lived to see its full horrors and died in Belsen concentration camp. His work as a writer included poetry, a novel, and plays written in collaboration with Karel, most notably *The Insect Play* (1920), a comic fantasy satirizing greed and selfishness.

Cappuccio, Antonella *See* PITTURA COLTA.

Carline, George F. (1855–1920) British painter and illustrator, the head of a family of artists. He studied in London, Antwerp, and Paris (at the *Académie Julian), and his work consisted mainly of landscapes, portraits, and genre scenes in an accomplished but unexceptional style. His wife, **Annie** (1862–1945), took up painting when she was in her sixties; Sir John *Rothenstein writes that 'Certain of her paintings are reminiscent of *Lowry's (which she is unlikely to have seen); others show the influence of *Cubism, originally interpreted.' They had three painter children: **Sydney** (1888–1929), **Hilda** (1889–1950), and **Richard** (1896–1980), all of whom studied at the *Slade School. One of Sydney's fellow-students there was Stanley *Spencer, to whom Hilda was married from 1925 to 1937. An exhibition held in Kenwood House, London, in 1999 suggested to some critics that her talent was comparable to that of her husband's.

Sydney's paintings were mainly landscapes and portraits; he also made etchings and designed medals. During the First World War he served with the army and RAF and was an *Official War Artist in 1918. In 1921 he became Master of Drawing at the Ruskin School, Oxford, a post he held until his death. Richard also fought during the First World War and was the youngest of all Official War Artists, working for the RAF in 1918–19. He wrote *Draw They Must* (1968), a history of art education, and *Stanley Spencer at War* (1978). Richard's wife, **Nancy Carline** (1909–2004), was also a painter.

Carmichael, Frank *See* GROUP OF SEVEN.

Carnegie International (Pittsburgh International) A large exhibition of contemporary art held at the Museum of Art, Carnegie Institute, Pittsburgh, at regular intervals since 1896. The institute had been founded the previous year by the Scottish-born industrialist and philanthropist Andrew Carnegie (1835–1919), who intended that its permanent collection should grow out of wide-ranging exhibitions of contemporary art: 'The field for which the gallery is designed begins this year.' The Carnegie Internationals were originally held annually and later triennially. The prizes awarded at the exhibition carry great prestige. Among the artists who have won them are *Matisse (1927), *Braque (1937), *Calder (1958), *Giacometti (1961), and *Miró (1967). Many important works have entered the Carnegie Museum of Art's permanent collection by way of the exhibition.

Caro, Sir Anthony (1924–) British sculptor, one of the most influential figures in postwar British art. He was born in New Malden, Surrey, and studied engineering at Christ's College, Cambridge, 1942–4. After war service in the Fleet Air Arm, he studied sculpture at Regent Street Polytechnic, 1946, and the *Royal Academy, 1947–52. From 1951 to 1953 he worked as part-time assistant to Henry *Moore, who was 'very generous with his help; when I had no studio he encouraged me in my own time to make my own art in his studio'. Caro's early works were figures modelled in clay, but a radical change of direction came after he visited the USA and met David *Smith in 1959. This followed contact with Clement *Greenberg, whom he and other sculptors had invited to London to see their work and challenge the American's belief that there were no 'decent sculptors in England'. In 1960 he began making abstract metal sculpture, using standard industrial parts such as steel plates and lengths of aluminium tubing, as well as pieces of scrap, which he welded and bolted together and then generally painted a single rich colour. The colour helped to unify the various shapes and textures and often set the mood for the piece, as with the bright and optimistic red of *Early One Morning* (1962, Tate). This, like many of Caro's sculptures, is large in scale and open and extended in composition; it rests directly on the ground. 'I think my big break in 1960 was in challenging the pedestal, killing statuary, bringing sculpture into our own lived-in space. And doing that involved a different kind of looking. These sculptures of mine incorporated space and interval so that you could not grasp them from a single view; you had to walk along to take them in.' The novelty of his work was quickly realized: his first one-man show after setting off on his new path (at the Whitechapel Art Gallery, London, in 1963) was greeted by *The Times* with the headline 'Out-and-out originality in our contemporary sculpture'. In 1965 Clement Greenberg wrote that 'He is the only new sculptor whose sustained quality can bear comparison with Smith's . . . the first sculptor to digest Smith's ideas instead of merely borrowing from them'.

Caro taught part-time at *St Martin's School of Art, 1953–79, and he had a major influence

on several of the young sculptors who trained under him, initiating a new school of British abstract sculpture (*see* NEW GENERATION). In spite of its total abstraction, the work of Caro and his students shared something of the sensibility of the *Pop artists of the period in its colourful surfaces and general mood of optimism. Peter *Fuller's negative judgement on Caro's sculpture of the 1960s, that it was 'nothing if not of its time: it reflected the superficial, synthetic, urban, commercial American values which dominated the 1960s', is itself a reflection of the reaction against that period's values in the more puritanical climate of the 1970s.

In 1969 Caro held his most important museum exhibition to date, at the Hayward Gallery, London (*see* ARTS COUNCIL), a recently opened space which could have been designed expressly to show large-scale abstract work such as his to its best advantage. At the time of the show he commented in a letter to Greenberg that 'The known areas are the very ones I want to strike away from in my own sculpture.' In the 1970s his work became much more massive and rougher in texture, sometimes incorporating huge chunks of metal. The finest works of this period, such as *Tundra* (1975, Tate), a great wall of metal which appears to be constantly liable to fold under its own weight, have an extraordinary physical presence, quite unlike the lightness of the early work. In the 1980s he returned to more traditional materials and techniques and began making figurative (or semi-abstract) works in bronze, including (in the early 1990s) a series inspired by the Trojan War. In 1991 he made a work called *Tower of Discovery* that included a staircase, an example of what he called 'sculpitecture'. He has also made sculptural versions of work by painters he admires such as Manet. A retrospective at Tate Britain in 2005 included a gigantic environmental piece of dark wood and steel entitled *The Last Judgement* (1995–9, Collection Würth, Künzelsau), which has struck observers as an indictment of human cruelty. Almost simultaneously, a *Beuys exhibition was at Tate Modern. At one time these two artists might have seemed as diametrically opposed as possible, the arch *formalist and anti-formalist. Here they came together in their vision of the life in dead materials and light emerging through darkness. Caro has continued to explore the relationship between sculpture and architecture. *South Passage* (2005), a structure in galvanized and painted

steel, is not physically penetrable; the 'way in' is barred by a slanting rectangular plate, but nonetheless suggests doors and windows.

Further Reading: I. Barker, *Anthony Caro: Quest for the New Sculpture* (2004)
P. Moorhouse (ed.), *Anthony Caro* (2005)

Carolus-Duran *See* SARGENT, JOHN SINGER.

Carr, Emily (1871–1945) Canadian painter of *Expressionist landscapes, born in Victoria, British Columbia. She felt the urge to paint from an early age, but her artistic development was slow and halting, interrupted by ill-health and the need to undertake other work to earn a living. Her training was principally in San Francisco, 1889–95, England (mainly at Westminster School of Art), 1899–1904, and Paris, 1910–11. During her stay in France she probably studied briefly with the New Zealand painter Frances *Hodgkins, but the main influence on her at this time was the work of the *Fauves. After her return to Canada she painted the landscape of British Columbia with passionate feeling for the power of nature, executing much of her work out of doors. She had little success, however, and discouraged by years of neglect, she had almost ceased to paint when in 1927 she first saw the work of the *Group of Seven in Toronto. The effect was overwhelming: 'Oh, God, what have I seen? Where have I been? Something has spoken to the very soul of me, wonderful, mighty, not of this world. Chords way down in my being have been touched. Dumb notes have struck chords of wonderful tone. Something has called out of somewhere. Something in me is trying to answer . . . Jackson, Johnson, Varley, Lismer, Harris—up-up-up-up-up!' Thereafter she worked with renewed energy and deepened spirituality, overcoming her earlier neglect to attain the status of a national heroine. She wrote several autobiographical books, including *The House of All Sorts* (1944), describing her experiences as the owner of a boarding house, and *Growing Pains* (1946). Her work is well represented in the National Gallery of Canada in Ottawa.

Carr, Thomas *See* OBJECTIVE ABSTRACTIONISTS.

Carrà, Carlo (1881–1966) Italian painter and writer on art, a prominent figure in both *Futurism and *Metaphysical Painting. He was born in Quarguento in Piedmont and began his training at the age of twelve with a local

decorative painter and stucco-worker. In 1895 he settled in Milan, where he continued to work as a decorative artist and from 1904 attended classes at the School of Applied Arts and then at the Brera Academy. He later destroyed his early paintings, so little is known of his work at this time. In 1908 he met *Boccioni and *Russolo and in 1910 he signed the two Futurist manifestos of painting. On a visit to Paris in 1911 he met *Braque and *Picasso and this introduced a *Cubist element into his work. The previous year he had begun his best-known painting, *The Funeral of the Anarchist Galla* (MoMA, New York), and after his return from Paris he reworked it to assimilate Cubist fragmentation of form into the dynamic Futurist vision. In 1917 Carrà met de *Chirico whilst both were in the military hospital in Ferrara and he was converted to Metaphysical Painting, producing about twenty works with de Chirico's paraphernalia of posturing mannequins, half-open doors, mysterious interiors, etc., though generally without his typically sinister feeling. In 1919 Carrà published a book entitled *Pittura metafisica*, but in the same year he broke with de Chirico and abandoned the style. In the 1920s and 1930s he adhered to the classical principles of the *Novecento Italiano, championing the return to traditional values in the journal *Valori plastici* and also in the Milan newspaper *L'Ambrosiano*, of which he was art critic from 1921 to 1938. From 1941 to 1952 he was professor of painting at the Brera Academy. In his work after the Second World War his style became somewhat looser, with freer brushwork. A collected edition of his writings, *Tutti gli scritti*, was published in 1978.

Carrière, Eugène *See* ACADÉMIE.

Carrington, Dora (1893–1932) British painter and designer, born in Hereford into a comfortable middle-class family. She studied at the *Slade School, 1910–14, and from 1917 lived with the writer Lytton Strachey, one of the leading figures of the *Bloomsbury Group. Her emotional life was complex and often distressing, for Strachey was a homosexual and Carrington married another man (Ralph Partridge) and had numerous affairs. Nevertheless, she was utterly devoted to Strachey and she committed suicide a few weeks after his death. Carrington painted portraits, landscapes, and figure compositions, did designs for the *Omega Workshops and for the

Hogarth Press (owned by Leonard and Virginia Woolf), and in her later life put a good deal of time into decorative work at her house Ham Spray in Wiltshire, where she lived with her husband and Strachey from 1924. She also devoted much of her energy to a voluminous correspondence, which she illustrated with delightful drawings. Her work was seldom exhibited during her lifetime and she was virtually forgotten for years afterwards. A collection of her letters and extracts from her diaries was published in 1970, marking the beginning of a revival of interest in her. Her brother **Noel Carrington** (1895–1989) was a publisher and book designer.

Carrington, Leonora (1917–) British-born painter and writer (in French) who took Mexican nationality in 1942. She was born in Lancashire, the daughter of a wealthy textile manufacturer, and from an early age was used to moving in sophisticated society. After being expelled from two convent schools, she went to finishing schools in Florence and Paris, then in 1936 became the first student to enrol at *Ozenfant's art academy in London. In 1937 she met Max *Ernst and settled in France with him; in the following year she began exhibiting with the *Surrealists in Paris. After the outbreak of war in 1939 and Ernst's internment, she fled to Spain, where she suffered a nervous breakdown, recounted in her book *En Bas* (1943, translated as *Down Under*, 1944). From Spain she went via Portugal to New York and then settled in Mexico in 1942, following a marriage of convenience to the Mexican poet Renato Leduc. After divorcing him, she married Imre Weisz, a Hungarian photographer. She became a close friend of Remedios *Varo, another woman Surrealist who had settled in Mexico, and has spent most of her life there.

As a painter and writer Carrington has remained a dedicated Surrealist. Her pictures typically feature insect-like humanoids, and her stories deal with an imaginary world where hyenas go to the ball and white rabbits feed on human flesh. A retrospective exhibition of her work was held at the Serpentine Gallery, London, in 1992.

Cartier-Bresson, Henri (1908–2004) French photographer, film-maker and painter, born in Chanteloup. He studied painting under André *Lhote and became interested in *Surrealism. In 1932 he acquired a Leica

camera and began his career in photography in earnest. His friend Robert *Capa advised him to concentrate on photojournalism and renounce the label of Surrealist photographer: 'If not you will fall into mannerism, keep surrealism in your little heart, my dear.' Indeed the trace of Surrealism in Cartier-Bresson's work is crucial to its character. He tended to pick out the unexplained or surprising incident, rather than the one which clearly told a story. Two men in Brussels peer through a canvas screen. Another, in Paris, implausibly leaps over an outsize puddle. The latter photograph is a striking example of the speed with which Cartier-Bresson worked. He entitled a book about his work *The Decisive Moment* (1952). This he defined as 'the simultaneous recognition, in a fraction of a second, of the significance of an event as well as the precise organisation of forms which give that event its proper expression'. An exhibition at the New York *Museum of Modern Art in 1947 helped establish his reputation as one of the greatest photographers of the 20th century. He gave up photography professionally in 1975.

Further Reading: A. Bernstein, 'The Acknowledged Master of the Moment', *The Washington Post* (5 August 2004)

CAS See CONTEMPORARY ART SOCIETY.

Cascella, Pietro (1921–2008) Italian sculptor, painter, ceramicist, and designer. He was born at Pescara and studied at the Academy in Rome. The son of a traditional sculptor, he showed a preference for carving in stone (including marble) that was unusual in artists of his generation. Initially, however, he worked mainly as a painter and he did not start to concentrate on sculpture until the late 1950s. His work is abstract and has an archaic simplicity and grandeur well suited to the public monuments with which he established a reputation as one of the leading Italian sculptors of the post-war era.

His brother **Andrea** (1919/20–90) was also a sculptor and often assisted Pietro on his major commissions, notably the Martyrs Monument at Auschwitz in Poland (1958–67). His independent works are smaller in scale than Pietro's and often elegant in form.

Casorati, Felice (1883–1963) Italian painter, born at Novara. He was a talented musician and took a law degree in 1906, but he decided to become a painter and studied at the Academies of Padua, Naples, and Verona. After serving in the Italian army during the First World War he began to teach at the Turin Academy in 1918 and soon became a leading figure in the city's intellectual and artistic circles. His early work, influenced by *Art Nouveau, was dominated by hard outlines and strong colours. In the 1920s he was influenced by *Metaphysical Painting, producing pictures emphasizing the volume and substance of the figures and often using strange perspective effects to heighten the air of unreality (*Midday*, 1922, Galleria d'Arte Moderna, Trieste). As well as figure paintings he did numerous commissioned portraits. In the 1930s he adopted a lighter palette and a more rhythmic type of composition. He won a prize at the Venice *Biennale in 1938 and again in 1952. In addition to painting, Casorati did much set and costume design, notably for La Scala, Milan, and also made prints and sculpture.

Cassandre See CUBISM.

Cassatt, Mary (1844–1926) American painter and printmaker who worked mainly in Paris in the circle of the *Impressionists (she was a friend particularly of *Degas). She specialized in everyday life scenes, her favourite theme being a mother with her child or children. Her early paintings were thoroughly Impressionist in style, but from about 1890 her forms became more solid and firmly outlined. She was an outstanding pastellist and printmaker, her finest prints being in colour and in a combination of techniques (aquatint, drypoint, etching). Their bold flattened forms and unconventional viewpoints were influenced by an exhibition of Japanese prints she saw in Paris in 1890. Cassatt's eyesight began to fail when she was in her fifties and she had virtually stopped working by 1914. She came from a wealthy family and had an important influence on American taste by urging her rich friends to buy Impressionist works. *See also* FEMINIST ART.

Further Reading: G. Pollock, *Mary Cassatt, Painter of Modern Women* (1998)

Cassinari, Bruno See FRONTE NUOVO DELLE ARTI.

Cassirer, Paul (1871–1926) German art dealer and publisher. He studied art history at Munich University, then moved to Berlin, where he played an important role in promoting contemporary art, both as a dealer and a

publisher. In 1908 he founded the Verlag Paul Cassirer, which published belles-lettres, including *Expressionist drama, and in 1910 he established the Pan-Presse, through which he encouraged artists to take up printmaking. These included *Barlach, who illustrated his own plays with lithographs, and *Chagall, who made his first etchings in 1922 as illustrations to his autobiography. (Because of difficulties in trying to translate his quirky literary style into German, the text was not published, but the illustrations were issued in 1923 as a portfolio entitled *Mein Leben.*) Cassirer was a friend of Paul *Durand-Ruel and also promoted the work of the French Impressionists. His gallery and publishing firm continued after his death (he committed suicide) until they were closed by the Nazis in 1933. His cousin **Bruno Cassirer** (1872–1941) was also a dealer and publisher.

Casson, A. J. See GROUP OF SEVEN.

Casson, Sir Hugh See FESTIVAL OF BRITAIN; ROYAL ACADEMY OF ARTS.

Castelli, Leo (1907–99) Italian-born American art dealer. He was born in Trieste, studied law at Milan University, and initially worked in banking and insurance. In 1939 he opened the René Drouin Gallery in Paris, later important for its support for *Dubuffet and other French painters in the post-war period, and in 1941 he emigrated to New York. The gallery he opened there introduced to New York the French system by which artists were paid a stipend in exchange for their work. Finding the market for European works dominated by more established dealers, he turned to American art, and in 1958 he first showed work by Jasper *Johns and Robert *Rauschenberg, the two artists with whom he was most closely identified. He was especially associated with the promotion of *Pop artists including *Lichtenstein, *Oldenburg, and *Warhol, and *Minimalists including Robert *Morris and *Serra.

Catlett, Elizabeth (1915?–) American sculptor and printmaker, an important figure in the development of Afro-American art. After being denied entry to the Carnegie Institute of Technology on the grounds of her race, she studied at the University of Iowa under Grant *Wood, who encouraged her to 'make what you know best'. Her work has concentrated on the experience of women of colour. She won first prize at the 1940 Columbian exhibition with her *Mother and Child* and in

1943 studied in New York with Ossip *Zadkine. At that time, she became engaged in radical politics and in 1946 she moved to Mexico. Her decision to remain there was almost certainly partially motivated by the climate of the Cold War: she had been involved in organizations which were stigmatized as 'Communist front'. While in Mexico she worked with the *Taller de Gráfica Popular and she identified strongly with their collectivist approach. Some of her best-known works are the linocuts she produced with them, such as *Sharecropper* (1952), a powerful image of stoicism and resolution. *I Have a Special Fear for my Loved Ones* (1946) dealt with the theme of lynching. In 1962 she became a Mexican citizen but continued to address subjects related to the struggle of Afro-Americans in the USA. *Homage to my Young Black Sisters* (1968) is a wood carving which, close in style to Henry *Moore, showing a figure giving a Black Power salute. Catlett regained her American citizenship in 2002. A retrospective exhibition was held at the Art Institute of Chicago in 2005.

Further Reading: M. A. Herzog, *Elizabeth Catlett: In the Image of the People* (2005)

Cattelan, Maurizio (1960–) Italian sculptor and installation artist, born in Padua. He worked at various jobs and made furniture before starting his career as an artist (he had no professional artistic training). His provocative work often takes the form of bad-taste jokes. His most celebrated work is probably *Ballad for Trotsky* (1996), a horse suspended from the ceiling. *Bidibidobidiboo* (1996) is a stuffed squirrel which has apparently shot itself at a table. In *The Ninth Hour* (1999) a realistically modelled figure of the Pope has been struck by a meteorite. The icons of modern art are also subjected to irreverence. In 1998 Cattelan hired an actor to stand outside the New York Museum of Modern Art wearing a giant *Picasso head. He sometimes includes models of himself in his work. *We Are the Revolution* (2000) takes its title from Joseph *Beuys: it is the caption of a photograph of the German artist striding purposefully forward. Cattelan presents a dummy of himself hanging from a coat rack wearing a felt suit, another reference to Beuys. Nor were his dealers exempt, one being taped to the wall of his gallery for a day, another being dressed as a pink rabbit. In one case a work by Cattelan provoked a violent public reaction. In 2004, in

Milan, Cattelan hung from a tree three models of children with nooses around their necks. A man was injured when he attempted to cut them down. Cattelan's iconoclastic mockery of religion, politics, and art makes most sense against a background of the ideological earnestness of a previous generation. The violence from both left and right which marked the political struggles in Italy can hardly provoke the glow of nostalgia many feel for the May 1968 events in Paris. An early installation by Cattelan directly referred to the terrorism of the past by using a blow-up of a newspaper page showing the Italian Prime Minister Aldo Mori, kidnapped and murdered by the Red Brigades in 1978. The artist changed the star above the head of Mori, the Communist emblem of the kidnappers, into the Christmas Star of Bethlehem.

Further Reading: F. Manacarda, *Maurizio Cattelan* (2006)

Caulfield, Patrick (1936–2005) British painter and printmaker, born in London, where he studied at Chelsea School of Art, 1956–9, and the *Royal College of Art, 1959–63. In 1963 he began teaching at Chelsea School of Art and in 1965 he had his first one-man exhibition at the Robert Fraser Gallery, London. His work has been linked with *Pop art, although when introducing his work in 1964 he invoked, not the currently fashionable mass media theorists, but the Catholic poet and mystic Gerard Manley Hopkins. However, his work shared with artists such as Peter *Blake and David *Hockney a sense that the imagery was 'in quotation marks', so undermining the division between abstract and figurative art. The flat colour and black outlines of his painting (in his early work the impersonal surface was achieved by the use of gloss paint on board) were sometimes compared to Roy *Lichtenstein, although the American painter's work was unknown to him when Caulfield first established his style. The principal sources of his work lay in *Cubism. He looked to *Léger and especially *Gris, to whom he paid tribute in an early imaginary portrait and more subtly in *Santa Margherita Ligure* (1964). In this work he draws on the way in which Gris combined interior and exterior within the same plane. Discussing his painting in the 1964 *New Generation catalogue, David Thompson argued that Caulfield was interested in 'devalued' motifs, the way in which a painting by Delacroix or a device from Cubism or early abstraction could become

'vulgarized'. When these early pictures are seen in the light of Caulfield's painting over the subsequent 40 years this seems to be putting things in reverse. What Caulfield was actually doing was using a highly accessible and apparently simple pictorial language, not out of irony, but to achieve effects of the utmost refinement. Although on the surface his style changed comparatively little, the uses to which he put it were extraordinarily varied. Some commentators have detected in his later work a strong sense of melancholy and mortality communicated through the pristine surfaces. He took up *screenprinting in 1964 and the following year won a prize for graphics at the Paris *Biennale. Subsequently print was an important part of his output. He also made designs for the Royal Ballet. An exhibition was devoted to his work at the Tate Gallery, London, in 1981 and another at the Hayward Gallery in 1999, but he never achieved the international reputation many of his admirers believed that he deserved.

Further Reading: M Livingstone, obituary, *The Independent* (1 October 2005)

Cavalcanti, Emiliano di (1897–1976) Brazilian painter, draughtsman, and writer, born in Rio de Janeiro, a pioneer of modern art in his country. He trained for a career in law, but turned seriously to art after a successful exhibition of his caricatures in São Paulo in 1917. In 1922 he helped to organize the *Semana de Arte Moderna in São Paulo, which is regarded as a turning-point in Brazilian culture; it included dance spectacles, poetry readings, and an art exhibition. From 1923 to 1925 he was based in Paris as a correspondent for the newspaper *Correio de Manha*; during this time he got to know many leading avant-garde artists, including *Braque, *Cocteau, *Léger, *Matisse, and *Picasso, and he travelled widely in Europe. He returned to Europe in 1938–40. His work draws on a wide range of influences, including *Cubism, *Fauvism and Picasso's *Neoclassicism of the 1920s, which he blended into an extravagantly colourful style, well suited to the high-keyed Brazilian subjects he favoured: sensuous mulatto women, carnival and festival scenes, poor fishermen, and prostitutes were among his favourite themes. His cheerful, conservative brand of modernism and his preference for local subjects won him great popularity in Brazil. He published two volumes of memoirs (1955 and 1964).

Celant, Germano *See* ARTE POVERA.

Celmins, Vija (1938–) Latvian/American painter. Born in Riga, she migrated with her family to the United States when she was ten. Her paintings are generally based on black and white photographs, often derived from newspapers and magazines. She thinks of the photograph as something which she reinvents when she paints, as 'another layer that creates distance'. As with Gerhard *Richter, her paintings tend to emphasize not so much the idea of photography as a mirror of the world but the extent to which the photograph is radically different from perception. *Freeway* (1966) depicts the road ahead and is derived from a photograph taken from the wheel of the artist's car. As the critic Barry Schwabsky points out, its clarity is quite at odds with our normal experience. In such a situation we would normally perceive a distinction between the other vehicles, travelling at our speed, and the relative blur of the road passing us by.

Further Reading: Arts Council of England, *The Painting of Modern Life* (2007)

CEMA *See* ARTS COUNCIL.

Central Saint Martins College of Art and Design, London. *See* ST MARTIN'S SCHOOL OF ART.

Central School of Arts and Crafts (later Central School of Art and Design), London. *See* ST MARTIN'S SCHOOL OF ART.

Centre Pompidou *See* POMPIDOU CENTRE.

Cercle et Carré (Circle and Square) A discussion and exhibition society for abstract artists formed in Paris in 1929 by the critic Michel *Seuphor and the painter Joaquín *Torres García. They published a journal of the same name (3 numbers, 1929–30): 'The choice of the circle and square as both title and cover illustration reflected, Seuphor later felt, a certain order in the world and evoked the ancient Chinese symbols for heaven and earth, yin and yang; the world of the senses and the world of the mind' (Anna Moszynska, *Abstract Art*, 1990). Although Seuphor and Torres García aimed to promote geometrical abstraction, the association was in fact open to abstract artists of various persuasions. It held only one exhibition, at Galerie 23 in April 1930. This was the first exhibition ever devoted solely to abstract art; forty-six artists showed work, including *Mondrian and *Vantongerloo but also such non-geometricians as *Kandinsky and *Schwitters. This broadness of approach was attacked by the single-minded van *Doesburg, who in 1930 launched his own review *Art Concret* (*see* CONCRETE ART) as a counterblast. In 1931 Cercle et Carré was superseded by the larger and longer-lived *Abstraction-Création association, but it had a sequel in Uruguay: in 1935 Torres García formed an Asociación de Arte Constructivo in Montevideo and he edited a journal *Círculo y Cuadrado* (7 numbers, 1936–8).

César (César Baldaccini) (1921–98) French sculptor and experimental artist, born in Marseilles of Italian parents. He studied at the École des Beaux-Arts, Marseilles, 1935–9, and the École des *Beaux-Arts, Paris, 1943–8. His work was highly varied, but he became best known for his ingenious use of scrap material. In the mid-1950s he began to make sculptures from objects that he found in refuse dumps—scrap iron, springs, tin cans, and so on—building these up with wire into strange winged or insect-like creatures. In spite of the materials from which they were made, these had closer affinities with the work of Germaine *Richier than with the California school of *Junk sculpture. His use of ready-made commercial objects was shared by several other French artists of the time, and the term *Nouveau Réalisme was coined for their work in 1960. In the same year César began making works consisting of car bodies crushed with a hydraulic press into dense packages (he called sculptures in this genre *Compressions*) and it is on these that his international reputation is mainly based (*The Yellow Buick*, 1961, MoMA, New York). Pierre Restany claimed that these works proclaimed 'A new age of metal which goes beyond American neo-dadaist provocation'. In 1965, César began working with plastics, creating, for example, giant shiny images of parts of the human body that bring him within the orbit of *Pop art (*Thumb*, 1965, Tate; this is in red plastic—there are also casts in bronze and other materials). In 1967, as a counterpart to his *Compressions*, he began making *Expansions*, using plastics that expand rapidly and quickly solidify; sometimes he made such works in public as a kind of *Happening. He explored this technique further in the 1970s, using materials such as glass. In 1975 he designed the French film trophies which are now invariably known as 'Césars'. *Centaur* (1985),

a homage to Picasso, is installed in the Carrefour de la Croix-Rouge, Paris. In 1997 a retrospective was held at the Galerie Nationale du Jeu de Paume in Paris. The catalogue described Cesar as 'le plus médiatique des artistes français' and his popular fame in his own country has never been quite matched by art world acceptance outside it.

Further Reading: Galerie Nationale du Jeu de Paume, *César* (1997)

P. Restany, *César* (1960)

Cézanne, Paul (1839–1906) French painter, a figure of central importance in the development of 20th-century art. He was born in Aix-en-Provence, the son of a hat dealer who became a prosperous banker, and his financial security enabled him to survive the indifference to his work that lasted until the final decade of his life. Much of his early career was spent in Paris in the circle of the *Impressionists (he participated in the first and third of their eight group exhibitions), but after the death of his father in 1886 and his inheritance of the family estate (the Jas de Bouffan, which figures in many of his paintings), Cézanne lived mainly in Aix. His goal, in so far as he verbalized it, was to create an art combining the classical tradition of formal structure with a rigorous honesty about perception, and he summed up this aim in two much-quoted remarks: that it was his ambition 'to do Poussin again after nature' and that he wanted to make of Impressionism 'something solid and enduring like the art of the museums'. He devoted himself mainly to certain favourite themes—portraits of his wife, Hortense, still-lifes, and above all the landscape of Provence, particularly the Mont Sainte-Victoire (in 1896 he remarked 'When one was born down there . . . nothing else seems to mean anything'). His painstaking analysis of nature differed fundamentally from *Monet's exercises in painting repeated views of objects such as *Haystacks* or *Poplars*. Cézanne was interested in underlying structure, and his paintings rarely give any obvious indication of the time of day or even the season represented. The third dimension is created less through perspective or foreshortening than by precise variations of tonality; by ordinary standards the paintings appear distorted in the cause of pictorial balance, although prolonged acquaintance reveals a precision of observation and attention to perception found in few other painters. In his final decade his work included three large pictures of *Bathers* (female nudes in a landscape setting) that are among his greatest and most radical achievements. The first two (Barnes Foundation, Merion, Pennsylvania, and NG, London) were probably begun in about 1895 and 1900 respectively and worked on intermittently up to his death; the third (Philadelphia Museum of Art) was perhaps entirely painted in 1906. In these majestic works he sacrificed anatomical accuracy for pictorial structure, the simplified forms of the figures echoing the broad sweeps of the tree trunks.

Cézanne worked in comparative obscurity until he was given a one-man show in Paris by Ambroise *Vollard in 1895. It made little impact on the public but excited many younger artists, and because Cézanne was rarely seen he began to acquire a legendary reputation. By the end of the century he was revered as the 'Sage' by many of the avant-garde and in 1904 the *Salon d'Automne gave him a special exhibition. A memorial exhibition of his work at the same venue in 1907, the year after his death, was a major factor in the genesis of *Cubism, and his subsequent influence has been profound, varied, and enduring. For *Braque and *Picasso he showed a way of combining indications of depth with absolute respect for the integrity of the picture plane. Less bold contemporaries such as *Derain and *Friesz were still enormously influenced by his modelling with colour, which was a key factor in their development from *Fauvism to a more solidly constructed kind of painting. For the *Neoclassicists of the 1920s, with their 'Return to Order' agenda, which was not without a nationalist and conservative streak, it was Cézanne who was most impressive for his monumentality. For Mondrian the broken slabs of colour in Cézanne were a tool for reaching *abstract art. A radically different view of Cézanne was proposed by Barnett *Newman. He argued that Cézanne was a complete Impressionist who insisted, more than any other, on his 'full dependence on sensation'. He argued that the other Impressionists maintained that the edges of objects were illusory, and that therefore they should not be represented, but that for Cézanne, this illusion was part of his sensation and so must be painted as sensation. 'Has no one ever looked at his watercolours, where the entire picture is the study of the representation of an edge?' (*Art News*, 1951; reprinted in *Selected Writings and Interviews*, 1990).

Cézanne was a laboriously slow painter—he is said to have had over a hundred sittings for

a portrait of Ambroise Vollard (1899, Petit Palais, Paris) before abandoning it with the comment that he was not displeased with the shirt front—but he left a substantial body of work (drawings and watercolours as well as oils). His studio in Aix is now a Cézanne museum, reconstructed as it was at the time of his death and displaying personal mementoes such as his hat and clay pipe. Cézanne is now immensely popular with the public: the official attendance figure for his exhibition at the Tate Gallery in 1996 was 408,688—at the time, a record for any show at the gallery.

Further Reading: R. Fry, *Cézanne: A Study of his Development* (1989; originally published 1927)

W. Rubin, *Cézanne: The Later Work* (1977)

Chabot, Hendrik (1894–1949) Dutch painter, sculptor, and graphic artist. He was born at Sprang and spent most of his life in Rotterdam, where he studied at the Academy. In his early work he experimented with *Cubism, but he turned to *Expressionism and became one of his country's leading exponents of the style. He is best known for his paintings depicting the Netherlands during the German Occupation in the Second World War. His subjects included refugees, prisoners of war, and Resistance fighters, depicted with great pathos. The bombardment of Rotterdam in May 1940 destroyed his studio and many of his works. After the war his paintings became lighter in colour and spirit. There is a museum of his work near Rotterdam.

Chadwick, Helen *See* FEMINIST ART.

Chadwick, Lynn (1914–2003) British sculptor, born in London. He began his career as an architectural draughtsman, but after the Second World War (during which he served as a pilot), he took up sculpture without any formal training. In 1950 he had his first one-man exhibition at *Gimpel Fils, London, and after that he rapidly made a name for himself. Initially he concentrated on *mobiles, often derived from insect forms (*Dragonfly*, 1951, Tate), and these were followed by ponderous, bristling, rough-finished metal structures supported on thin legs. He combined jewel-like raw glass with welded iron in pieces such as *The Inner Eye* (1952, MoMA, New York). It was with this kind of work that he attracted attention at the 1952 Venice *Biennale (*see* GEOMETRY OF FEAR). In 1953 he won an Honourable Mention in the competition for the Monument to the Unknown

Political Prisoner (*see* BUTLER, REG) and in 1956 he won the International Sculpture Prize at the Venice Biennale. By this time he had changed his technique and was working from an iron armature filled in with a mixture of cement and iron filings. The resulting sculptures would suggest human figures or animals. He spoke of his work largely in technical terms, refusing to analyse too much intellectually for fear of interfering with the 'subconscious source'. Herbert *Read discussed his sculpture in terms of a 'demonic force'. His reputation declined in the 1960s and most critics consider that his work became repetitive. Reviewing an exhibition shortly after his death, Richard *Cork found that the later figures 'entirely lack the sinister, animal potency of his 1950s sculpture' (*New Statesman*, 23 September 2003).

Further Reading: A. Bowness, *Lynn Chadwick* (1962)

Chadwick, Whitney *See* GUERRILLA GIRLS.

Chagall, Marc (1887–1985) Russian-born painter and designer, active mainly in France. He was born in Vitebsk of a deeply religious Jewish family, and trained in St Petersburg, 1906–9 (this included a short period under *Bakst). In 1910–14 he lived in Paris, where he was a member of an avant-garde circle including *Apollinaire, *Delaunay, *Léger, *Modigliani, and *Soutine. After going to Berlin in 1914 for his first one-man show (at the *Sturm Gallery) he visited Russia and had to remain because of the outbreak of war. After the Revolution in 1917 he was appointed Fine Arts Commissar for the province of Vitebsk, where he founded and directed an art academy. *Malevich was among the other teachers there, and after disagreements with him Chagall moved to Moscow in 1920 and there designed for the newly founded Jewish Theatre. He returned to Paris in 1923 at the invitation of *Vollard, who commissioned much work from him, including illustrations for Gogol's *Dead Souls*, La Fontaine's *Fables*, and the Bible (eventually published by *Tériade in 1948, 1952, and 1956 respectively). In 1941 he moved from occupied France to the USA, where he lived for the next seven years. This period of exile was often painful personally (his first wife died in 1944), but he was honoured as an artist and in 1946 had a retrospective in New York (MoMA) and Chicago (Art Institute). He returned to Paris in 1948 and from 1949 lived near Nice, working

to the end of his very long life—the last survivor of the generation of artists who had revolutionized painting in the years leading up to the First World War.

Chagall was prolific as a painter and also as a book illustrator and designer of stained glass (in which he did some of his most impressive late work) and of sets and costumes for the theatre and ballet. His work was dominated by two rich sources of imagery. One of these was memories of the Jewish life and folklore of his early years in Russia (the Jewish community in which he grew up was far less assimilated than those of Western Europe). The other was the Bible. Meyer *Schapiro has pointed out how far Chagall's choice of themes here emphasizes the Jewish dimension. He derived some of his spatial dislocations and prismatic colour effects from *Cubism and *Orphism, but he created a highly distinctive style, remarkable for its sense of folktale fantasy, his figures sometimes floating or hovering in the air. Chagall has sometimes been claimed for *Surrealism because of the fantastic element of his work. Certainly, of the Parisian artists working before the First World War, more than any other, he showed how Cubism could be used to escape everyday appearances and evoke worlds of memory. However, his work has a strong nostalgic and celebratory element and frequently invokes religion, as in the Bible illustrations, and tradition in a way quite foreign to the Surrealist ethos. Ultimately his work is about conscious memories and nostalgia for an uncomplicated village life. There is a strong autobiographical strain in his work but it is about conscious rather than unconscious association. *The Birthday* (1915, MoMA, New York), showing Chagall's fiancée surprising him with a gift of flowers, represents a view of love far removed from Surrealist erotics. *The Apparition* (1917–18), a depiction of the painter at work which draws on the imagery of the Annunciation, proposes divine inspiration as a source for art in a way that would horrify any true Surrealist.

There is a museum devoted to Chagall's religious art in Nice. The work there does not always show him at his best, for he could be sentimental and overblown, but his finest paintings, usually the ones made relatively early in his career, have won him an enduring reputation as one of the greatest masters of the *École de Paris. *See also* CASSIRER.

Further Reading: S. Compton, *Marc Chagall* (1985)

M. Schapiro, 'Chagall's Illustrations for the Bible', in *Modern Art: 19th and 20th Centuries* (1978)

Chaissac, Gaston *See* ART BRUT.

Chamberlain, John (1927–) American sculptor, born at Rochester, Indiana. He studied at the Chicago Art Institute School, 1950–52, and at *Black Mountain College, 1955–6, then moved to New York in 1957. His early sculpture, made largely from metal pipes, was influenced by that of David *Smith, but in 1957 he began introducing scrap metal parts from cars in his work and from 1959 he concentrated on sculpture made entirely from crushed automobile parts welded together. Usually he retains the original colours, and the expressive energy of his work, with its twisted planes and crumpled surfaces, has been compared to that of *Action Painting. Many of his compositions are intended for wall hanging rather than to stand on the ground. An example is *Dolores James* (1962, Guggenheim Museum, New York); Chamberlain has described how this work never felt quite right until one night he threw a sledgehammer at it, 'all the pieces went chink, chink, chink', and it shifted into shape.

Although he has continued with work of this type, which has been widely acclaimed since the early 1960s, Chamberlain has also experimented with other types of sculpture and other media. In 1966, for example, he started using urethane foam, as in *Koko-Nor II* (1967, Tate). 'The foam is very interesting to me. I thought it was very funny. And you can see the humor. I mean it's really instinctive and sexual. I tried working it several ways and I returned to the first way, which was tying and squeezing it.' He has also done abstract paintings and made experimental films.

Chapman, Jake (1966–) and **Dinos** (1962–) British artists, brothers, born in Cheltenham and London respectively. Graduates of the *Royal College of Art, they have worked as a team since the early 1990s. They are among the most controversial figures associated with the *Young British Artists. In the *'Sensation' exhibition of 1997 they exhibited fibreglass figures of pubescent girls fused into each other and with penises for noses. They also made a life-size three-dimensional version of one of the most horrific images from Goya's *Disasters of War*. They have also made works based on the mutilation of other works: notoriously, a set of Goya's prints was given grotesque mask-like faces. Their work is undeniably memorable and striking, especially the set of tableaux exhibited in glass cases entitled

Hell (1999) and depicting atrocities. (It was praised, unexpectedly for any work by artists of their generation and inclination, by Brian *Sewell.) This was destroyed in the Momart fire of 2004 (*see* SAATCHI) and they made a second version, exhibited at *White Cube in 2008, this time entitled *Fucking Hell*. Their press release announced:

> HELL hath no fury
> Like a chapman spurned,
> So come see the second,
> 'Cos the first one burned.

The Chapmans have claimed the inspiration of Georges *Bataille and that their work is an attack on the values of the Enlightenment of which Goya was an exemplar. They were roundly attacked by the journalist Johann Hari for this (*The Independent*, 7 February 2007). He argued that the attack on the Enlightenment was ultimately 'Fascist' in that it represented a return to unquestioned authority. (The same claim could be made about the actual implications of the thinking of Bataille, in spite of his anti-Fascist record.) The Chapmans' response that this was 'a cheap fat ugly four eyed shot' did not encourage confidence in the intellectual seriousness of their project. The critic Eleanor Heartney's comment that 'they seem more interested in entertainment than existential angst' may be near the mark. *See also* ROYAL ACADEMY OF ARTS.

Chase, William Merritt (1849–1916) American painter, born in Williamsburg, Indiana. He was a versatile and prolific painter, but is remembered chiefly as the most important art teacher of his generation in the USA. His principal posts were in New York—at the *Art Students League, 1878–94, and at his own Chase School, 1896–1908—but he also taught in Chicago, Philadelphia, and elsewhere. From 1891 to 1902 he ran the Shinnecock Summer School on Long Island, the first important school of open-air painting in America, and he also pioneered study trips abroad (he visited Europe regularly throughout his career). Apart from teaching, he made his living mainly through portraiture, but he was often in financial difficulties. His other subjects included still-lifes, interiors, and landscapes. He took great joy in the process of painting, and the vigorous brushwork and fresh colour that characterize much of the best American painting of the early 20th century owe much to his example.

His students included Charles *Demuth, Marsden *Hartley, Edward *Hopper, Rockwell *Kent, Georgia *O'Keeffe, and Charles *Sheeler.

Chekrygin, Vasily *See* MAKOVETS.

Chelsea Art School *See* JOHN, AUGUSTUS.

Chia, Sandro (1946–) Italian painter, born in Florence, where he studied at the Academy. In the early 1970s he worked with *Conceptual and *Performance art, but he returned to painting in 1975 and by the end of the decade he had adopted the style with which he has become one of the best-known Italian painters of his generation, characteristically featuring muscle-bound figures in pseudo-heroic situations parodying the Old Masters. As the senior member of the group, he acquired something of the status of leader of the *Transavantgarde Italian painters. He was also the one who demonstrated the sheerest virtuosity in his handling of the figure, drawing on Poussin and classical sculpture. Norman Rosenthal has argued that Chia is above all preoccupied with the idea of the artist as heroic figure. He reads *Audacious Raft* (1982, Marx Collection, Berlin) as 'The artist-hero himself . . . asleep on a raft steered by two giants floating down a river, perhaps towards poetic immortality, perhaps towards oblivion'. Evidently aware as to how far the whole notion of the artist as 'all-conquering hero' had become suspect in the wake of *feminist criticism, Rosenthal is careful to emphasize a degree of self-awareness in Chia's stance. The artist wrote in 1983: 'I am a lion tamer among his beasts and I feel close to the heroes of my childhood, close to Michelangelo, Titian and Tintoretto.' Not all critics have taken Chia at his own valuation. Robert *Hughes described his figures as 'ladylike coal-heavers expelling wind while floating in postures vaguely derived from classical statuary'. Chia has also made bronze sculpture in a similar vein to his paintings.

Further Reading: Braun (1989)

Chicago, Judy (1939–) American painter, sculptor, and installation artist, born Judy Cohen in Chicago, from which she takes her adopted name. She studied at the University of California, Los Angeles, 1960–64, and has worked mainly in California. Probably the most famous of *feminist artists, she was co-founder (1971) with Miriam *Schapiro of the Feminist Art Program at the California Institute of the Arts, Valencia. She is best known for

her sculpture or installation *The Dinner Party* (1974–9, Brooklyn Museum, New York), which has been seen by large audiences at several venues in the USA and elsewhere (its first showing was in San Francisco in 1979, when it attracted 100,000 visitors in three months). In a publicity leaflet for its appearance at the 1984 Edinburgh Festival it was described as: 'an open triangular banquet table, 48 feet on each side, with 39 place settings, each representing a woman of achievement in Western civilization. Plates of delicate china-painted porcelain rest on elaborate cloth runners of needlework typical of each woman's era. The table rests on the Heritage Floor of porcelain tiles inscribed with the names of 999 other women who have made significant contributions to our cultural development.' More than one hundred women (and a few men) worked on the project, one of Chicago's aims being to elevate crafts that were traditionally associated with women to the mainstream of art. She has written books on *The Dinner Party* (1979), *The Birth Project* (1985), and *The Holocaust Project* (1993), and also *Through the Flower: My Struggle as a Woman Artist* (1975) and *Beyond the Flower* (1996).

Chicago Museum of Contemporary Art *See* MUSEUM OF CONTEMPORARY ART, CHICAGO.

children's art *See* CIŽEK, FRANZ.

Chillida, Eduardo (1924–2002) Spanish sculptor in iron, born in the Basque city of San Sebastian. He studied architecture at Madrid University, 1943–7, but soon afterwards turned to drawing and sculpture. In 1948–51 he lived in France, then returned to Hernari, near his birthplace, and carried on the tradition of sculpture in wrought iron initiated by his older compatriots *Gargallo and *González. Chillida's sculptures, however, are abstract rather than figurative, developing from jagged skeletal or ribbon-like forms (*From Within*, 1953, Guggenheim Museum, New York) to much more solid pieces, often characterized by twisting, interlocking shapes (*Modulation of Space I*, 1963, Tate). There is usually no suggestion of figuration, however remote, and no trace of modelling or carving. The impact of the works depends partly on the obscure emotional appeal of the contorted shapes in a stubborn material. Chillida was widely regarded as the greatest Spanish sculptor of his day. He also had a distinguished career as a printmaker, his work including etchings, lithographs, and woodcuts.

Chirico, Giorgio de *See* DE CHIRICO, GIORGIO.

Chirino, Martín *See* EL PASO.

Christo (Christo Javacheff) (1935–) and **Jeanne-Claude (**née **Denat)** (1935–) Sculptors and *environmental artists, husband and wife, respectively Bulgarian- and French-born, who settled in New York in 1964 and became American citizens in 1973. Since 1994 the official name of the artists has been 'Christo and Jeanne-Claude'. Christo was born in Gabrovo, the son of an engineer–chemist who ran a textile factory, and studied at the Academy in Sofia, 1952–6. After brief periods in Prague, Vienna (where he studied sculpture with *Wotruba), and Geneva, he moved to Paris, where he lived from 1958 to 1964. Jeanne-Claude was born in Casablanca of a military family. The pair met when the impoverished Christo painted Jeanne-Claude's mother's portrait. Soon after his arrival in Paris, Christo invented 'empaquetage' (packaging), a form of expression he has made his own and for which he has become world-famous. It consists of wrapping objects in materials such as canvas or semi-transparent plastic and dubbing the result art. He began with small objects such as paint tins from his studio (in this he had been anticipated by *Man Ray), but they increased in size and ambitiousness through trees and motor cars to buildings and sections of landscape. His first one-man exhibition was at the Galerie Haro Lauhus, Cologne, in 1961. From 1961 onwards the couple worked together, their first public project being a stack of oil barrels at Cologne harbour. This was followed in 1962 by the blocking with barrels of Rue Visconti in Paris for eight hours. Since then their projects have often been on a vast scale, sometimes involving the wrapping of buildings. The first of these to be achieved was the Kunsthalle, Berne (1968), followed by the Museum of Contemporary Art, Chicago (1969), the Pont-Neuf in Paris (1985, after nine years of negotiations), and the Reichstag in Berlin (1995). Among the landscape projects they have carried out are the packaging of a mile of coastline near Sydney, Australia (1969), Valley Curtain across Rifle Gap, Colorado (1972), and Running Fence, something like a fabric equivalent of the Great Wall of China, undulating through 24 miles of Sonoma and Marin Counties, California (1976). They spend

a great deal of time and effort negotiating permission to carry out such work and then (if negotiations are successful), in planning the operations, which can involve teams of professional rock-climbers as well as construction workers. The task of setting the project up is an important aspect of the work in that it engages many people who would not normally come into contact with contemporary art. The enterprises are financed through the sale of smaller works. They do not accept sponsorship. Christo says of the work: 'You can say it's about displacement. Basically even today I am a displaced person, and that is why I make art that does not last . . . I make very stimulating things. Unlike steel, or stone, or wood, the fabric catches the physicality of the wind, the sun. They are refreshing. And then they are quickly gone.' *See also* ENVIRONMENTAL ART.

(⊕) SEE WEB LINKS
• The artists' official website.

Chromatic Abstraction *See* COLOUR FIELD PAINTING.

Chryssa (Chryssa Vardea Mavromichaeli) (1933–) Greek-born American sculptor, a leading exponent of *Light art. She was born in Athens, studied at the Académie de la Grande Chaumière, Paris (1953–4), and the California School of Fine Arts, San Francisco (1954–5), then settled in New York. There she experimented with various kinds of work, and she was one of the first to explore the kind of banal subject-matter associated with Jasper *Johns and Andy *Warhol, sometimes using words or letters as the entire content of a piece. In her early years in New York she was 'utterly alone, broke and very happy', and she became fascinated with the bright lights of Times Square: 'America is very stimulating, intoxicating for me. Believe me when I say that there is wisdom, indeed, in the flashing of the lights of Times Square. The vulgarity of America as seen in the lights of Times Square is poetic, extremely poetic. A foreigner can observe this, describe this. Americans feel it.' In 1962 she began incorporating neon tubing in her work (she is said to have been the first American do to this) and she soon moved on to pieces that consisted entirely of neon tubing apart from the necessary wiring and casing. In 1964–6 she produced *The Gates to Times Square* (Albright-Knox Art Gallery, Buffalo), a huge, brilliantly coloured work, that is generally regarded as one of the most impressive light sculptures ever made; it is in the shape of a giant letter 'A', symbolizing America. Her work is sometimes categorized as *Minimal art, and it is also placed within the orbit of *Pop art because it takes its inspiration from advertising signs.

Chuikov, Semyon *See* SOCIALIST REALISM.

Circle A collective manifesto of *abstract art published in London in 1937, edited by the architect Sir Leslie Martin (1908–99), the painter Ben *Nicholson, and the sculptor Naum *Gabo. Sub-titled 'International Survey of Constructive Art', it is nearly 300 pages long with numerous illustrations and was originally intended as an annual. The volume contains an editorial by Gabo entitled 'The Constructive Idea in Art', Piet *Mondrian's essay 'Plastic Art and Pure Plastic Art', and a short statement by *Moholy-Nagy on 'Light Painting'. There are also essays or statements by, amongst others, *Hepworth (who took much of the responsibility for the layout and production), *Le Corbusier, *Moore, and *Read. The book stood for a unity between advanced tendencies in fine art, architecture, and design and was, almost certainly, intended as a riposte to the public success of the International *Surrealist Exhibition held in London the previous year. The rivalry between the two tendencies marked the end of the unity between different branches of modernist art in Britain which distinguished *Unit One. The artists illustrated included (in addition to those already mentioned) *Malevich, *Lissitzky, and *Pevsner, together with artists whose work was less geometric in orientation, among them *Brancusi, *Braque, *Giacometti, and *Picasso. *Circle* was reprinted in 1971.

Further Reading: J. Lewison (ed.), *Circle: Constructive Art in Britain 1934–40* (1982)

Čiurlionis, M. K. (Mikolajus Konstantinas) (1875–1911) Lithuanian composer and painter, a strange personality whose highly idiosyncratic paintings have sometimes been claimed as the first examples of *abstract art. He was born in Varena, the son of an organist, and had a varied musical training, notably at the Warsaw Music Institute and the Leipzig Conservatory. His compositions include numerous piano pieces, chamber music, and orchestral poems. These works are romantic and nationalist in spirit, sometimes inspired by Lithuanian folklore. He began making pastels in 1902, influenced by *Redon's work, and

took up painting seriously in 1905. Although he briefly attended the Warsaw Academy, he was essentially self-taught. After suffering a mental collapse he died in an asylum near Warsaw. In 1912 the *World of Art group devoted a section of its exhibition to his paintings, one of several tributes that helped to establish his fame.

About 300 paintings by Čiurlionis survive, all dating from a short period (c.1905–9) and mainly preserved in the museum named after him in Kaunas. Through visual art, he tried to express a transcendental mysticism that he felt he could not fully communicate through music. He gave his pictures musical titles, such as *Fugues* and *Sonatas*, and composed them in accordance with musical principles. Melody was expressed by line, tempi by flowing curves or short zigzags, and pitch by nuances of colour. These paintings clearly have precedence in date to the first abstracts of such acknowledged pioneers as *Dove, *Kandinsky, and *Kupka, but it is doubtful to what extent Čiurlionis's pictures can be regarded as abstracts rather than stylizations of natural motifs.

Cižek, Franz (1865–1946) Austrian painter and teacher, a key figure in the history of children's art education. He was born in Leitmeritz (now Litoměřice in the Czech Republic) and studied at the Academy in Vienna, the city where he spent most of his career (he was a member of the Vienna *Sezession and of the *Wiener Werkstätte). Initially he worked as a painter of portraits and genre scenes, but from 1897 he was primarily a teacher. In that year he founded a school called the Jugendkunstklasse ('Children's art class') for children from the age of three upwards, and in 1904 it was incorporated into the Vienna School of Arts and Crafts (Kunstgewerbeschule), where he taught until 1934 (*Kokoschka was among his adult pupils). Cižek was the originator of the idea that children's art is a special branch of art (extending up to the age of about fourteen, after which he thought the freshness and spontaneity were lost): 'People make a great mistake in thinking of child art merely as a step to adult art. It is a thing in itself, quite shut off and following its own laws, and not the laws of grown-ups.' He regarded education as 'growth and self-fulfilment' and urged teachers to 'Make your schools into gardens where flowers may grow as they grow in the garden of God'. His ideas became well known

through lectures (he spoke at educational conferences in London in 1908 and Dresden in 1912) and through exhibitions of the work of his pupils, which he toured in England and the USA (these helped to popularize *linocut as a technique specially suited to children). His work also helped to bring child art to the attention of avant-garde artists, among whom it had something of a vogue in the years immediately before the First World War. The first occasion on which children's art was shown alongside professional adult art was the Mostra d'Arte Libera in Milan in 1911 (the exhibition in which *Futurist painting made its public debut); in 1912 *Stieglitz held an exhibition of children's work in New York, and in the same year *Kandinsky and *Marc reproduced children's drawings in their *Blaue Reiter *Almanac.

Clark, Kenneth (Lord Clark of Saltwood) (1903–83) British art historian, administrator, patron, and collector, born in London into a wealthy family whose fortune had been made in thread-manufacturing: 'My parents belonged to a section of society known as "the idle rich", and although, in that golden age, many people were richer, there can have been few who were idler.' He was educated at Winchester and Trinity College, Oxford (where he studied history), then spent two years working in Florence with Bernard Berenson, the famous connoisseur of Italian art. From 1931 to 1934 he was keeper of fine art at the Ashmolean Museum, Oxford, then was director of the National Gallery, London (1934–45), at the same time holding the position of Surveyor of the King's Pictures (1934–44). During the Second World War he was chairman of the War Artists Advisory Committee (*see* OFFICIAL WAR ART), and after the war he was chairman of the *Arts Council (1953–60) and the first chairman of the Independent Television Authority (1954–7). In addition, he served on numerous boards and committees, and in particular was a key figure in the *Contemporary Art Society, of which he was a committee member from 1937 to 1953. The part he played as a patron and collector is less well known, but was of considerable importance. He inherited substantial wealth from his parents and his purchases of the work of *Moore, *Pasmore, *Piper, and *Sutherland in the 1920s and 1930s helped to establish their reputations (he also made a regular allowance—in strict secrecy—to several artists). His power

in supporting contemporary art was most effective in his promotion of *Neo-Romanticism in the 1940s. He did not care much for abstract art, however, summing it up as 'somewhat monotonous, somewhat prone to charlatanism, but genuinely expressive of our time'.

Clark was a polished television performer as well as an elegant and stimulating writer, and he did a great deal to popularize art history, most notably with his television series *Civilisation* (1969, also published then as a book), which was broadcast in over 60 countries. Although his major books were on Renaissance art or on general topics (notably *Landscape into Art*, 1949, and *The Nude*, 1956), he also wrote on 20th-century art (for example *Henry Moore Drawings*, 1974) and he was editor of the 'Penguin Modern Painters' series, founded in 1943. His two volumes of autobiography—*Another Part of the Wood* (1974) and *The Other Half* (1977)—are highly entertaining (*see* MANSON), if not always accurate in detail, but some of the pot-boilers that appeared in his old age would have been better left unpublished.

Further Reading: M. Secrest, *Kenneth Clark* (1985)

Clark, Lygia (1920–88) Brazilian sculptor, painter, and Kinetic artist, born at Belo Horizonte. She studied in Rio de Janeiro under Roberto *Burle Marx and then in Paris, 1950–52, under *Léger. After her return to Brazil she became a leading figure in the country's vogue for *Concrete art (or Neo-Concrete art as it tended to be called there). In 1959 she turned from painting to sculpture, making pieces that could be manipulated by the spectator. She did this by creating sculptures out of hinged metal plates or of non-rigid material. An example is *Rubber Grub* (1964, remade by the artist 1986, Museu de Arte Moderna do Rio de Janeiro), a hanging arrangement of corrugated rubber. In 1964 she initiated 'vestiary' sculpture, designed to be worn. Clark rejected the cult of the unique work and wanted her sculpture to be industrially fabricated. An object which was no longer precious could be the subject of bodily participation, not passive contemplation. She subsequently extended this idea to *environmental art. *The House is a Body* (1968) was entered through a tunnel. Inside were cubicles with elastic strips, plastic bags which opened when the participant passed by, and balloons to produce sensations as tactile as visual. This interest in participation was shared by her Brazilian contemporaries *Schendel and *Oiticica. In Clark's case, this preoccupation

was linked to her work as a practising psychologist. It was also associated by the artist with specifically female experience. She wrote in 1969 'I only know that my way of linking up to the world consists in being fertilised and then ovulating'. Clark was one of the most internationally known of Brazilian artists: she received many awards and represented her country at the Venice *Biennale in 1960, 1962, and 1968.

Further Reading: J. V. Aliaga, 'Lygia Clark', *Frieze* (May 1998)

Clarke, Geoffrey (1924–) British sculptor, designer, and printmaker, born at Darley Dale, Derbyshire. He studied at Preston School of Art and Manchester School of Art before serving in the RAF, 1943–7, then had his main training at the *Royal College of Art, 1948–52. He was in the exhibition of eight young British sculptors at the Venice *Biennale in 1952 (*see* GEOMETRY OF FEAR) and in the same year was commissioned to make an iron sculpture for the Time–Life building in Old Bond Street, London. His sculpture is mainly in forged, welded, and cast metal, initially iron and lead and then aluminium (in 1958 he installed an aluminium foundry at his studio in Suffolk). Unusually for an artist working in such a modern idiom, he has devoted a good deal of his career to religious commissions, including a number of works for Coventry Cathedral (1953–62) and a pulpit (1966) in Chichester Cathedral, made of stone-faced reinforced concrete and cast aluminium. Such works have been praised for showing the potentialities of modern art in a religious setting: in *Church Furnishing and Decoration in England and Wales* (1980) Gerald Randall describes his high altar cross in Coventry Cathedral as 'abstract, but vividly conveying the agony and contortion of crucifixion'. Clarke's secular work includes commissions for numerous public buildings, notably for several universities, and reliefs for the liners *Canberra* and *Oriana*. He has worked in various media other than sculpture, including enamel, mosaic, stained glass, and etching.

Clarke, Harry (1889–1931) Irish artist, chiefly famous as one of the 20th century's greatest designers of stained glass, but also a mural painter, textile designer, and book illustrator. He was born in Dublin, the son of a church decorator, and had his main training at the Dublin Metropolitan School of Art, 1910–13.

Scholarships then enabled him to study medieval glass in France. He took over the family business on his father's death in 1921 and had a large output in spite of his short life (he died from tuberculosis). The Harry Clarke Stained Glass Studios Ltd continued in business until 1973. Clarke's glass was sumptuous and often rather bizarre in style—in the spirit of French *Symbolist painters. As an illustrator he had a taste for the macabre and is particularly remembered for his black-and-white drawings for an edition of Edgar Allan Poe's *Tales of Mystery and Imagination* (1923). His wife, **Margaret Clarke** (née Crilley) (1888–1961), whom he married in 1914, was a painter. She studied under *Orpen and was strongly influenced by him, although her posthumous portrait of her husband (*c.* 1932, NG, Dublin) is in a more decorative, highly coloured style. After Harry's death she became director of the stained-glass studios.

Classical Revival *See* NEOCLASSICISM.

Claudel, Camille (1864–1943) French sculptor and painter, born in Fère-en-Tardenois. Her family moved to Paris in 1881. She studied sculpture under Paul Dubois and worked in *Rodin's studio from 1885. Claudel became Rodin's lover and model as well as his assistant. She was to claim that Rodin used many of her ideas, especially in relation to *The Burghers of Calais* (1884–6). Rodin's defenders have argued that her contribution was no more than would have been normal in the semi-industrial conditions in which sculpture was produced at the time. Claudel's proponents have pointed to a perceived decline in Rodin's creativity after she left his studio in 1893. In that year she exhibited *La Valse* (Musée Rodin, Paris) at the Salon Nationale in Paris. The sense of the figures almost defying the laws of gravity, suggesting, as Claudine Mitchell puts it, 'release from the material world', is somewhat marred by the drapery added in order to satisfy the requirements of a state commission. No such censorship was applied to Rodin's *The Kiss*, implying that the problem was that such an erotic piece was produced by a female sculptor.

Claudel's best-known sculpture is *L'Age Mur* (1894–9, Musée d'Orsay, Paris). An imploring woman, reminiscent of mourners in funerary sculpture, is helpless as an old woman pulls away a man from her grasp. This has generally been read as autobiographical, signifying

Claudel's failure to separate Rodin from his long-term companion, Rose Beuret. Yet to see the piece as a more generalized and detached treatment of the subject of mortality would be in accord with the intellectual, *Symbolist milieu in which Claudel worked. Her smaller-scale sculptures made inventive use of materials, especially coloured marble. *La Vague* (1900, Musée Rodin, Paris) combines bronze and green onyx.

From 1897 onwards her mental state gave rise to increasing alarm. In 1912 her brother, the writer Paul Claudel, had her forcibly removed to a mental hospital. She spent the rest of her life in confinement and died in obscurity. Her modern reputation began with an exhibition at the Musée Rodin in 1951. Paul Claudel contributed a vitriolic attack on her lover to the catalogue and to this day the extent, if any, to which Rodin was to blame for her tragic end remains a matter for passionate debate. What is certain is that Rodin continued to use his influence to support her professionally long after their split. The catalogue of the 1982 exhibition 'De Carpeaux à Matisse' (Association des Conservateurs de la Région Nord-Pas-de-Calais) expressed the hope that the reputation of the female 'artiste maudit' would give way to a proper appreciation of her work. In the years since, fascination with her biography, manifested above all in a popular film (1988) starring Isabelle Adjani and Gérard Depardieu, has tended to elevate the victim above the artist. The Musée Rodin holds a substantial collection of her work and organized further major exhibitions in 1984, 1991, and 2008.

Further Reading: C. Mitchell, 'Intellectuality and Sexuality: Camille Claudel, the Fin de Siècle Sculptress' *Art History*, vol. 11, no. 4 (December 1989)

J. A. Schmoll, *Auguste Rodin and Camille Claudel* (1994)

Claus, Emil *See* LUMINISM.

Clausen, Sir George (1852–1944) British painter (mainly of landscapes and scenes of rural life), born in London, the son of an interior decorator of Danish descent. His training included a few months at the *Académie Julian, Paris, in 1883 and his work was influenced by French plein-air painting. He was preoccupied with effects of light, often showing figures set against the sun, but he always retained a sense of solidity of form. With other like-minded painters he was a founder of the *New English Art Club in

1886. From 1904 to 1906 he was professor of painting at the *Royal Academy. His lectures were published as *Six Lectures on Painting* (1904) and *Aims and Ideals in Art* (1906); a collected edition appeared as *Royal Academy Lectures on Painting* in 1913. In them he urged the traditional study of the Old Masters. From 1881 (after his marriage) he lived mainly in Berkshire and then Essex, using his surroundings as material for many of his paintings. He also occasionally painted portraits (a self-portrait, 1918, is in the Fitzwilliam Museum, Cambridge), nudes, and interiors, and he did some large decorative commissions, including a mural on *The Reading of Wycliffe's Bible in English* for St Stephen's Hall, Westminster, in 1927.

Clavé, Antoni (1913–2005) Spanish painter, graphic artist, theatrical designer, and sculptor, born in Barcelona, where he studied at the School of Fine Arts in the evenings while apprenticed to a sign-writer and poster artist. In 1939 he moved to Paris, where he was initially influenced by the *Intimisme of *Bonnard and *Vuillard. From the mid-1940s, however, his painting became more expressive, with affinities to the rich and vibrant manner of *Rouault. In the late 1950s he began to do the works for which he is best known—*Lyrical Abstractions featuring paint over damask tapestry collages. In addition to painting, Clavé had much success as a graphic artist, particularly with coloured lithographs, and as a designer of theatrical sets and costumes, notably for Roland Petit's ballet company. In the 1960s he took up metal sculpture, making plaques and free-standing abstract compositions.

Clemente, Francesco (1952–) Italian painter, born in Naples, one of the leading figures of the *Transavantgarde. His work is less overtly expressionistic than that of *Chia and *Cucchi, being more thinly painted and as much dependent on its imagery as its handling for its force. A considerable amount of his work is in watercolour: he only produced his first large-scale oils, a series entitled *The Fourteen Stations*, in 1981–2, after he had already successfully exhibited at the Venice Biennale in 1980. Most unusually for a contemporary painter, he has also worked in fresco, a technique which leaves no room for mistakes and changes of mind. He is also less tied to the legacy of European culture than the other Transavantgarde painters, having spent much

of the 1970s in India and derived considerable inspiration from its art. While there he studied theosophy and his subsequent work has drawn on Hindu imagery. In 1981–2 he visited New York and in 1983 he established a studio there. In an interview he emphasized both his roots and his affinity with Asian culture. 'As a Neapolitan I'm deeply suspicious of "thought" and of those who "think". Naples is poisoned by the East, and in the East the image of creation is this primeval tree on which one bird eats while another looks on and starves.' He has collaborated with Jean-Michel *Basquiat and Andy *Warhol and on books with the 'beat' poet Alan Ginsberg.

Further Reading: G. Politi, 'Francesco Clemente interviewed', *Flash Art* (April–May 1984)

Clemente, Rodriguez *See* POPULAR PRINTS.

Clert, Iris (1917?–86) Greek-born dealer whose Paris gallery exhibited many of the most provocative artists of the 1950s and 1960s, especially those who were associated with *Nouveau Réalisme. A flamboyant figure, said to have had powerful political connections, she was noted for staging events more newsworthy than commercial, such as Yves *Klein's *Le Vide*, a completely empty space, and *Arman's 1960 response *Le Plein*, in which the gallery was entirely filled with rubbish and impossible to enter. After her gallery closed, she took to the streets, exhibiting art in a transparent-sided lorry. Her autobiography, *Iris Time*, also the name of the journal she used to publicize her artists, was published in 1978.

Cloisonnism Style of painting associated with some of the painters who worked at the artists' colony at Pont-Aven in Brittany in the 1880s and 1890s, characterized by dark outlines enclosing areas of bright, flat colour, in the manner of stained glass or cloisonné enamel (*cloison* is French for 'partition'). *Anquetin and *Bernard first developed the style, and *Gauguin also worked in it. The term was coined by the critic Édouard Dujardin (1861–1949) in an article on Anquetin published in 1888 and has remained in use for work in a similar style done in the 20th century.

Close, Chuck (1940–) American painter. He was born in Monroe, Washington, and studied at Yale University, graduating in 1964. His early work was *Abstract Expressionist, but

he soon turned to *Superrealism, becoming well known for huge portrait heads, seen frontally like gigantic passport photographs—his self-portrait (1968) in the Walker Art Center, Minneapolis, is almost 3 metres high. Originally he worked in black-and-white, but in about 1970 he turned to colour. He works from photographs, dividing them into a grid and then transferring the grid to the canvas. In some of his later work he has deliberately emphasized the grid, creating 'low resolution' images resembling a computer scan or a face seen through frosted glass. Most of Close's portraits depict friends, but he says he regards the human figure as a 'source of information', rather than a vehicle for 'outworn humanist notions'. In 1988 Close was partly paralysed following an injury to a spinal blood vessel, but he resumed painting with the aid of a brace support on his wrist.

Clough, Prunella (1919–99) British painter, born in Chelsea, London. Her father was a civil servant; more significantly, her aunt was the important modern designer Eileen Gray. Clough studied painting at Chelsea School of Art and Camberwell School of Art, holding her first solo exhibition at the Leger Gallery, London, in 1947. In the war years and after, she was closely linked with representatives of *Neo-Romanticism such as Robert *Colquhoun, Keith *Vaughan, and John *Minton. Later she associated with left-wing supporters of *Social Realism such as Derrick *Greaves, John *Berger, and especially the sculptor Ghisha Koenig (1921–93). Her early paintings combine two tendencies: the Neo-Romantic 'spirit of place'; and concern with the 'particular and the vivid' representation of working lives which was an aim of Social Realism. This is most notable in her series of fishermen, such as *Lowestoft Harbour* (1951, Arts Council), but she also depicted urban and factory workers. These paintings demonstrated some of the *Picasso–influenced stylization common in British painting of the period, but in place of strident colour Clough preferred a more restricted atmospheric range, with dominant greys and telling touches of ochres and rusty browns. From the late 1950s she worked in an increasingly abstract manner, more under the influence of contemporary French than American painting. According to Patrick *Heron she always had 'profound affinities with the visual culture of Paris'. Both abstract and figurative paintings are united by a common purpose expressed by the artist as early as 1949 when she wrote: 'Whatever the theme it is the nature and structure of an object—that, and seeing it as if it were strange and unfamiliar, which is my chief concern.' Reference points remain to organic forms and weathered industrial environments as in *Electrical Landscape* (1960, Scottish National Gallery of Modern Art, Edinburgh). During her lifetime she had the reputation of something of a 'painter's painter', not obtaining the public recognition of some of her contemporaries, but, shortly before her death, she was awarded the Jerwood Prize for Painting, an award given to more traditional forms of art as an alternative to the *Turner Prize.

Further Reading: B. Tufnell, *Prunella Clough* (2007)

Club, The *See* SUBJECTS OF THE ARTIST SCHOOL.

Coates, Robert *See* ABSTRACT EXPRESSIONISM.

Coates, Wells *See* UNIT ONE.

Cobra A group of artists formed in Paris in 1948 by a number of Dutch, Belgian, and Scandinavian artists. The name derived from the first letters of the capital cities of the three countries of the artists involved—*Co*penhagen, *Br*ussels, *Am*sterdam. The Dutchman Karel *Appel, the Belgian *Corneille, and the Dane Asger *Jorn were the leading figures among the founders, and the artists who later joined included *Constant, Pierre *Alechinsky, Jean *Atlan, and William *Gear. The main spokesman was Christian *Dotremont, who suggested the group's name. The aim of the Cobra artists was to give free expression to the unconscious, unimpeded and undirected by the intellect. In their emphasis on spontaneous gesture, they had affinities with the American *Action Painters, but they differed in their strange and fantastic imagery, related in some instances to Nordic mythology and folklore, in others to various magical or mystical symbols of the unconscious. Their approach was similar to that of the *Art Informel painters *Fautrier and *Wols, but more savage and vigorous. It represented an implicit attack on what they viewed as authoritarian principles. These included *Socialist Realism, *Surrealism of the illusionistic variety, and especially geometric abstraction. Constant once said 'Let us fill *Mondrian's virgin canvas even if only with

our misfortunes!' The group published a journal and various pamphlets and short monographs. It arranged Cobra exhibitions in Copenhagen (1948), Amsterdam (1949), and Liège (1951), but the members soon went their own ways and the group disbanded in 1951.

Further Reading: P. Shields, *COBRA* (2003)

Coburn, Alvin Langdon *See* VORTICISM.

Cocteau, Jean (1889–1963) French writer, film director, designer, painter, and draughtsman. One of the most dazzling figures of his time in the intellectual avant-garde, he was the friend of leading painters such as *Modigliani and *Picasso, and in his work for the theatre he collaborated with, for example, *Diaghilev and the composers Erik Satie and Igor Stravinsky. His work included poetry, novels, plays, films, and a large number of paintings, drawings, theatrical designs, and pottery articles. He was self-taught as an artist. In his painting and drawing he was much influenced by Picasso, and his favourite themes included the figures of Harlequin, embodying the theatre, and Orpheus, the personification of the poet. His most lasting achievement was in the cinema, his reputation resting mainly on his beautiful adaptation of the famous story of Beauty and the Beast (*La Belle et la Bête*, 1946, with design by Christian *Bérard), and on three films dealing with the role of the artist and the nature of his inspiration—Cocteau's recurrent preoccupation—*Le Sang d'un poète* (1930), *Orphée* (1950), and *Testament d'Orphée* (1960).

There is a Cocteau museum at Menton on the Côte d'Azur where he also decorated the room reserved for civil marriages in the town hall. Michael Jacobs and Paul Stirton comment that 'The place would make an excellent setting for a high-class confectioner's' (*Mitchell Beazley Traveller's Guides to Art: France*, 1984). Other examples of Cocteau's decorative work include paintings (1960) of the *Crucifixion, Annunciation*, and *Assumption* in the church of Notre Dame de France, Leicester Place, London.

Further Reading: F. Steegmuller, *Jean Cocteau* (1986)

Cohen, Bernard (1933–) British abstract painter, born in London of Polish-Russian parents. He studied at *St Martin's School of Art, 1950–51, and the *Slade School, 1951–4, then in 1954–6 lived in France, Italy, and Spain on a travelling scholarship. Cohen is

regarded as one of the leading British abstract artists of his time and his work has been individual and varied. In the 1960s some of his paintings looked like arrangements of what has been called 'highly coloured spaghetti' (*In That Moment*, 1965, Tate); later his work has generally been less densely packed, with galaxies of coloured patches and spots floating against a light background. He has taught at several art schools: from 1988 to 2000 he was professor at the Slade School. His brother, **Harold Cohen** (1928–), is also an abstract painter and a noted exponent of *computer art. *See also* SITUATION.

Coker, Peter *See* KITCHEN SINK SCHOOL.

Cold art (Kalte Kunst) A term sometimes used as a synonym for *Cool art and sometimes applied more specifically to works that rely on mathematical systems and formulae for either their conception or their development. It was in the latter sense that the term was used by the Swiss painter Karl Gerstner (1930–) in his book *Kalte Kunst* (1954). A follower of Max *Bill, Gerstner helped (like Richard *Lohse) to extend Bill's idea of mathematical programming into the realm of colour.

Coldstream, Sir William (1908–87) British painter, mainly of portraits, but also of landscapes, nudes, and still-lifes. He was born at Belford, Northumberland, the son of a doctor, and studied at the *Slade School, 1926–9. After working in documentary films for the GPO, 1934–7, he returned to full-time painting and in 1937 was one of the founders of the *Euston Road School, which helped to establish a tradition of sober figurative painting of which he was one of the main representatives. In 1939 he joined the Royal Artillery and in 1943–5 he was an *Official War Artist, working in the Near East and then Italy. After the war he taught at Camberwell School of Art, 1945–9, then was professor at the Slade School from 1949 to 1975. He exerted an important influence not only through his teaching there but also through his appointment as chairman of the National Advisory Council on Art Education in 1959. The 'Coldstream Reports' of 1960 and 1970 helped to change the structure of art school teaching in Britain, introducing the compulsory study of art history for art students and eventually leading to degree status being awarded to recognized art school courses. Not all art students approved: one

poster opposing his proposals bore the words 'You are old Father William'.

Sir Kenneth *Clark had been an early supporter (he gave Coldstream financial assistance in the 1930s), but he came to see his attitude to art as one of 'dismal rectitude'. Indeed, Coldstream's work as an artist was austere and always based on direct observation. In an article 'How I Paint' in *The Listener*, 15 September 1937, he wrote: 'I find I lose interest unless I let myself be ruled by what I see.' Sitters for portraits, often distinguished establishment figures, had to be prepared for many sittings, ninety-six in the case of the architect Colin St John Wilson. The visible marks of the measuring process were left on the canvas, suggesting that whatever was there was always a work in progress which could be constantly developed. Given Coldstream's laborious methods, 'what I see' could only mean 'what is static and posed'. The conception of 'realism' is therefore limited to what can be represented within the confines of his painting practice, in the case of the figure, a posed model. Within these limitations, he could, like his teacher Henry *Tonks, who had a similarly austere view of the artist's role, reach a kind of poetry attained through the rigorous pursuit of prose, as in *Reclining Nude* (1974–6, Tate). Adrian *Stokes wrote of his work 'We witness in these paintings the gradual accumulation of images that are majestic yet unforced'.

Further Reading: L. Gowing and D. Sylvester, *The Paintings of William Coldstream 1908–1987* (1990)

Cole, Rex Vicat *See* SHAW, JOHN BYAM.

Coleman, James *See* VIDEO ART.

Colla, Ettore (1896–1968) Italian sculptor, painter, printmaker, art dealer, editor, and critic. Born in Parma, he studied at the Academy there, then in 1921 moved to Paris, where he met several leading sculptors, notably *Bourdelle, in whose studio he worked. In 1924 he was assistant to *Lehmbruck in Munich, and after a year of odd jobs, including being an elephant trainer's assistant in Vienna, he settled in Rome in 1926. Initially he worked on the gigantic monument to Vittorio Emanuele II, which had been begun in 1885 but with its hundreds of marble figures took decades to finish. In the 1930s he made a name with portrait busts and nude figures showing the influence of Bourdelle and Arturo

*Martini. During the Second World War Colla temporarily abandoned sculpture, working as an art dealer, editor, and critic. In about 1948 he started painting in a geometrical abstract style, and in 1950 he opened a gallery called Origine, where exhibitions were devoted to *Balla and *Vantongerloo amongst others. From 1952 to 1958 he edited the review *Arti Visive*, which sometimes included examples of his screenprints, either as the cover or bound-in with the text. In 1952 he returned to sculpture, but in an abstract rather than figurative style. Initially he made reliefs in wood and iron, and in 1955 he began using welded iron, usually assembled from scrap material such as old machine parts. Typically his work evokes a feeling of new life rising from rubble and ruin and sometimes it has a fetishistic suggestion. He gained an international reputation and had several large commissions, including the 10-metre-high *Gran Spirale*, made for the 1962 Spoleto Festival and now outside the Galleria Nazionale d'Arte Moderna, Rome.

collage A term applied to a type of picture (and also to the technique used in creating such pictures) in which objects such as photographs, news cuttings, and pieces of printed paper are pasted on to a flat surface, often in combination with painted passages (the word comes from the French *coller*, 'to gum'). Long popular as a leisure-time occupation for children and amateurs (in scrapbooks, for example), it first became an acknowledged artistic technique in the early 20th century, when it drew much of its material from the proliferation of mass-produced images in newspapers, advertisements, cheap popular illustrations, etc. The *Cubists were the first to make collage a systematic and important part of their work. *Picasso began using the technique in 1912, one of the earliest examples being *Still Life with Chair Caning* (1912, Musée Picasso, Paris) in which the caning is represented by a piece of oilcloth printed with a lattice pattern. *Braque soon followed with his own distinctive type of collage, the *papier collé, in which he applied strips or fragments of paper to a painting or drawing. Picasso also extended the principle of collage to three dimensions, making sculptures from scrap materials that influenced *Tatlin's creation of *Constructivism and stand at the beginning of the tradition of constructed sculpture that leads on to David *Smith and Anthony *Caro.

Subsequently collage has been used in many major art movements, for example *Dada, *Surrealism, and *Pop art. For some artists—notably Kurt *Schwitters—it has been the central concern of their work, and others have created personal versions of it. Examples are Max *Ernst, with his 'collage novels', *Matisse with his late *gouaches decoupées* (paper cut-outs), Alberto *Burri with his 'sacking' pictures, and Lee *Krasner, who created collages by cutting up and re-using her own drawings and paintings.

Beyond this purely material definition, it can be claimed that collage, in its wider sense, as the use of pre-existing materials and images, is one of the crucial principles of modernist art. Many Cubist paintings are not in a literal sense collages, but they employ fragments from the outside world in terms of lettering or textures such as marble and wood. The startling juxtapositions of much Surrealist painting are achieved by a basic collage principle of bringing together images from multiple sources, as in works by Max Ernst such as *Celebes* (1921, Tate). *See also* MONTAGE; PHOTOMONTAGE.

Collin, Raphaël *See* FOUJITA, TSUGOUHARU.

Collins, Cecil (1908–89) British painter of visionary subjects, born in Plymouth. He studied at Plymouth School of Art, 1923–7, and at the *Royal College of Art, 1927–31. In 1936 he took part in the International *Surrealist Exhibition in London, but he quickly repudiated Surrealism. He had a mystical outlook and was influenced by the prophetic writings of William Blake and by the American artist Mark *Tobey, who introduced him to the Baha'i religion and to the art and philosophy of the Far East (Tobey was artist-in-residence at Dartington Hall, a progressive school in Devon, 1931–8, and Collins taught there, 1939–43). In 1947 Collins settled in Cambridge and in that year published his book *The Vision of the Fool*, in which he explains his philosophy of art and life. He attacks the 'great spiritual betrayal' of the modern world, 'the betrayal of the love and worship of life by the dominance of the scientific technical view of life in practically all the fields of human experience'. The artist, together with the poet and the saint, 'is the vehicle of the continuity of that life, and its guardian, and his instrument is the myth, and the archetypal image'. His own archetypal image was the Fool, who represented purity and spontaneity in contrast to modern com-

mercialism and materialism. In 1940 he began a long series of paintings and drawings, originally entitled 'The Holy Fool' but later renamed 'The Vision of the Fool' in accordance with the title of his book; *The Sleeping Fool* (1943, Tate) is an example. His work also included the design of a large Shakespearean tapestry (1949) for the British embassy in Washington and an altarpiece (1973) for Chichester Cathedral. A retrospective exhibition of his work opened at the Tate Gallery a month before his death. His wife, **Elizabeth Collins** (née Ramsden) (1904–2000), was also a painter. During her husband's lifetime, her work was largely subsumed by his, but in the final decade of her life she exhibited paintings which have been described as 'having affinities with the Russian folkloric art of *Chagall, *Larionov, and early *Kandinsky' (England). She made a major bequest to the National Art Collections Fund through which works by Cecil Collins were presented to galleries around the United Kingdom.

Further Reading: J. Collins, *Cecil Collins* (1989)
J. England, obituary of Elizabeth Collins, *The Independent* (8 February 2000)

Cologne, Ludwig Museum *See* LUDWIG.

Colour Field Painting A type of abstract painting in which the whole picture consists of large expanses of more or less unmodulated colour, with no strong contrasts of tone or obvious focus of attention. Sometimes Colour Field Paintings use only one colour; others use several that are similar in tone and intensity. This type of painting developed in the USA in the late 1940s and early 1950s, leading pioneers including Barnett *Newman and Mark *Rothko. It is thus an aspect of *Abstract Expressionism (developing the Field Painting of Jackson *Pollock), and it has also been seen as a type—or precursor—of *Minimal art. Many of the leading American abstract painters of the 1950s and 1960s were exponents of Colour Field Painting, among them Ellsworth *Kelly and Jules *Olitski. From 1952 Helen *Frankenthaler developed Colour Field Painting by soaking or staining diluted paint into unprimed canvas, so that the paint is integral with the surface rather than superimposed on it. The term **Colour Stain Painting** is applied to works of this type. Frankenthaler's work was influential on many artists, including Morris *Louis.

Colquhoun, Ithell (1906–88) British painter and writer. Born in Assam, India, the

daughter of a civil servant, she moved to England as a child. She studied painting at the *Slade School, London, from 1927 to 1931. While a student she engaged in multi-figure narrative compositions. *The Judgement of Paris* (1930, Hove Museum and Art Gallery) shows an attempt to reconcile *Art Deco stylization with the solid construction of the human body demanded by the Slade. The almost Valkyrian figure of Athena strides forward with helmet and spear, very definitely the goddess of war rather than of wisdom; Juno and Aphrodite are equally self-possessed and unalluring; the seated Paris is almost an afterthought. In 1931 she encountered *Surrealism in Paris. After the 1936 London International Surrealist exhibition she came under the influence of Salvador *Dalí. The work of this period shows a preoccupation with analogies between the body and the landscape. *Scylla* (1939, Tate) has a bay which can be read as two legs. The disturbing *Gouffres Amers* (1939, Hunterian Art Gallery, Glasgow) shows a male reclining nude, decaying but still alive. Whitney Chadwick points out that the pose is derived from that historically associated with the seductive female figures of painters such as Cranach. Colquhoun joined the Surrealists in 1939, only to leave in 1940 because of her refusal to abandon occultism, more problematic for the British than the French group. Later paintings were less illusionistic, drawing more on the automatist aspects of Surrealist painting. Her interest in the occult continued in her later career and she achieved a reputation as an authority on the subject. In 1975 she published a biography of MacGregor Mathers, one of the founders of the Order of the Golden Dawn. In the 1940s she moved to Cornwall, where she died in a fire.

Further Reading: W. Chadwick, *Women Artists and the Surrealist Movement* (1985)

M. Remy, *Surrealism in Britain* (1999)

(⊕) SEE WEB LINKS

• A useful brief biography by Matthew Gale, Tate website.

Colquhoun, Robert (1914–62) British painter, graphic artist, and designer. He was born in Kilmarnock and in 1933–8 studied at *Glasgow School of Art, where he became the inseparable companion of his fellow student Robert *MacBryde (their personal and artistic relationship was thereafter so close that they

are—very unusually—given a joint entry in the *Dictionary of National Biography*). After Colquhoun was invalided out of the army they settled in London in 1941 (MacBryde was exempt from military service because of tuberculosis); Colquhoun was an ambulance driver in the Civil Defence Corps by day and painted by night. Within a few years the studio of the Roberts (as they were generally known) at 77 Bedford Gardens, Campden Hill, had become a centre for a group of young artists and writers, including Rodrigo *Moynihan and Keith *Vaughan. The Polish immigrant Jankel *Adler took a studio in the same building in 1942 and was an important influence on Colquhoun's work. Colquhoun's first one-man exhibition was at the Lefevre Gallery, London, in 1943, and after that he soon developed a reputation as one of the outstanding British painters of his generation; his characteristic angular figure compositions owed something to *Cubism, but had an expressive life of their own. After he and MacBryde were evicted from their studio in 1947, his fortunes began to decline and he died (of a heart attack) in relative obscurity, even though there had been a major retrospective exhibition of his work at the Whitechapel Art Gallery four years earlier. The Roberts had always been fond of the bottle, and after Colquhoun's death MacBryde drank more than ever and led an aimless existence; he was knocked over and killed by a car in Dublin. Apart from painting, both Colquhoun and MacBryde produced many lithographs and worked together on stage designs.

Colville, Alexander (1920–) Canadian painter, born in Toronto. He trained in the Fine Art Department at Mount Allison University, Sackville, 1938–42, then joined the army, being commissioned as an *Official War Artist in 1944. His duties included a trip to Belsen to make records of the mass graves. After his discharge in 1946 he began teaching at Mount Allison, remaining until 1963, when he was able to devote himself full-time to painting. He is regarded as a leading exponent of sharp-focus *Magic Realism, his work showing a remarkable ability to infuse a sense of haunting mystery into mundane situations. *Horse and Train* (1954, Art Gallery of Hamilton) was inspired by a poem by Roy Campbell which contains the phrase 'a dark horse against an armoured train', a protest against the conformism of militarism. The horse gallops along the railway lines to

impending disaster in a frozen moment reminiscent of a film still. Dennis Reid has drawn comparison between Colville and popular film-makers, especially Alfred Hitchcock, who was noted for his ability to conjure suspense out of the mundane. He wrote: 'It is the unfulfilled desire to touch and become involved in the painting, half realized in anticipation but discouraged by the "distant" quality of his pictures, that gives his work its poignant ambiguity.' Less typical work by Colville has included a mural, *History of Mount Allison* (1948), for Mount Allison University, and the designs for the special issues of Canadian coinage commemorating the centenary of Confederation (1967). In 1973 Colville settled in Wolfville, Nova Scotia.

(SEE WEB LINKS)
- The site of a major exhibition held by the National Gallery of Canada in 2000.

combine painting *See* RAUSCHENBERG, ROBERT.

composite media *See* MIXED MEDIA.

computer art Art produced with the aid of a computer or more specifically art in which the role of the computer is emphasized. Artists first began to experiment with computers in the 1950s and a Computer Arts Society was founded in Britain in 1969 after the 'Cybernetic Serendipity' exhibition was mounted at the *Institute of Contemporary Arts, London, in 1900. At this time the art produced with computers was usually graphic material, in which, for example, specified geometric shapes were printed in random combinations. However, the development of the 'light pen' or stylus in the 1970s allowed the artist to work interactively with a display on a screen. Among the well-known artists who have experimented with such technology are Richard *Hamilton and David *Hockney. As well as enabling artists to use relatively direct 'painting' techniques, computers have been programmed to produce extremely complex images. Harold *Cohen is highly skilled in this field, developing his own program to generate abstract drawings that he then enlarges and colours by hand (*Socrates' Garden*, 1984, Buhl Science Center, Pittsburgh). Computers have also been used, for example, to control the movements of *Kinetic sculpture. Computerization has also played a role in *video art, for instance in the work of Gary Hill and Feng

Mengbo (1966–). The digital manipulation of the photographic image has been a tool in the work of many artists, including Jeff *Wall, Andreas *Gursky, and *Orlan. The term 'digital art' is also used, and it tends to signal the writer's conviction that something more fundamental has happened than the simple adoption of a new tool.

The internet has been an important means by which artists, even if not technically inclined, can publicize their work and by which museums can increase access to their collections. Beyond this, the interactive possibilities which it offers have begun to be exploited. The Indian artist Shilpa Gupta (1976–) has been notably inventive in exploring its potential in work such as *Blessed Bandwidth* (2003, commissioned by Tate Modern) in which the virtual visitor is invited to receive an online blessing according to a number of major faiths.

Further Reading: C. Paul, *Digital Art* (2008)

Conceptual art A term now widely used for almost any form of art which cannot be placed in the traditional categories. At its origins in the late 1960s it had a more specific connotation as a type of art in which the idea or ideas that a work represents are considered its essential component and the finished 'product', if it exists at all, is regarded primarily as a form of documentation rather than as an artefact. The characteristic medium is verbal language, although anything can in theory be used and generally visual appeal is regarded as a distraction. Conceptual artists tend to trace the origins of their practice back to Marcel *Duchamp. His *Fountain* (1917), a urinal with minimal alteration (*see* SOCIETY OF INDEPENDENT ARTISTS), can be considered the classic proto-Conceptual work in that it derived its identity as art principally from the artist's decision to make it so. Certain artists of the 1950s and 1960s produced work which raised questions about the nature of art itself; among them was Robert *Rauschenberg, who in 1960— when invited to participate in an exhibition of portraits at the Iris *Clert Gallery—sent a telegram saying 'This is a portrait of Iris Clert if I say so'. However, it was not until the later 1960s that Conceptual art became a recognizable movement and acquired its name. The expression 'Concept art' was used by the American 'anti-artist' Henry Flynt (1940–) in 1961, but the term 'Conceptual art' did not gain currency until Sol *LeWitt's article

'Paragraphs on Conceptual Art' appeared in *Artforum* in 1967. LeWitt wrote that 'In Conceptual art the idea or concept is the most important aspect of the work...all planning and decisions are made beforehand and the execution is a perfunctory affair. The idea becomes the machine that makes the art.'

Important early exhibitions included 'When Attitudes Become Form' in Berne and London (1969) and 'Idea Structures' at the Camden Arts Centre, London (1970). Conceptual art was part of a larger tendency to reject the preciousness of the art object, also found in *Body Art, *Land Art, and *Arte Povera, that Lucy *Lippard described as 'The dematerialization of the art object'. This broader tendency makes the exact boundaries of 'Conceptual art' hard to define, but there is much to be said for the sake of clarity in not applying the term to artists such as Joseph *Beuys or Carl *Andre, for whom the sensuous relationship with materials remains important, or to artists such as Barbara *Kruger, in whose work visual impact is crucial.

The sculptor and critic Ursula Meyer (1915–2003) stressed the antimaterialistic qualities of Conceptual art: 'The shift from object to concept denotes disdain for the notion of commodities—the sacred cow of this culture. Conceptual artists propose a professional commitment that restores art to artists, rather than to the "money vendors".' However, as Lippard put it in 1973, 'art and artist in a capitalist society remain luxuries', and Conceptual art has proved susceptible to commercial exploitation just like other forms of art, with dealers selling the documentation of Conceptual works to collectors and museums. Such documentation takes varied forms, including photographs, sound and video cassettes, texts, maps, diagrams, and sets of instructions, but some Conceptual works may not have any physicality at all, an example being *Telepathic Piece* (1969) by the American artist Robert Barry (1936–), consisting of a statement that 'during the exhibition I will try to communicate telepathically a work of art, the nature of which is a series of thoughts that are not applicable to language or image'. Barry has also made works in which inert gases are released into the atmosphere. The resulting photographic documentation requires total faith from the viewer, as the gases are entirely invisible. Lawrence *Weiner produced concepts such as 'Turbulence induced within a body of water,' which can be

executed (or not) by anyone. Douglas Huebler (1924–97) stated 'The world is full of objects, more or less interesting; I do not wish to add to them.' He claimed that his work was 'beyond perceptual experience' and therefore depended on a system of documentation. The implication of this was that the documentation was not the artwork itself.

As well as the economic and political rationale for Conceptual art, there was also the argument, put most forcefully by Joseph *Kosuth, that art had reached a point when it could no longer be defined as a particular kind of physical object, but could only be defined in analytical terms. The preoccupation with the definition of art was shared by the British *Art & Language group. Kosuth presents the most extreme version of the argument for Conceptual art: that traditional painting and sculpture are no longer valid art forms. A more common assumption among Conceptual artists was simply that art should not be defined by traditional media. As Mel *Bochner put it, 'The "history of art" and the "history of painting and sculpture" are not the same, but merely coincident at some points.'

A quite distinct form of Conceptual art evolved in Latin America in the work of artists such as Luis *Camnitzer and Cildo *Meireles. Here it became a form of quite specific political intervention, which tended to bypass the gallery system altogether. It drew on a tendency in Latin American *Kinetic art, as in the work of Mira *Schendel and Lygia *Clark, to devalue the individual art object. In Japan the Mono-ha (school of things) artists, never a formal group, who operated between 1968 and the early 1970s, rejected the traditional object in favour of ephemeral structures. Their work also had affinities with *Arte Povera.

Exponents and admirers of Conceptual art saw its activities as provocatively expanding the boundaries of art, or at least defining them with greater clarity. Robert *Morris, for example, wrote in 1970 that 'The detatchment of art's energy from the craft of tedious object production...refocuses art as an energy driving to change perception'. Robert Barry said in 1969: 'We are not really destroying the object, but just expanding the definition.' Richard *Cork, introducing a 1973 exhibition, 'Beyond Painting and Sculpture', wrote that the artists 'all defy in their various ways the orthodoxy of media which Western art has followed ever since the Renaissance.' For

Keith *Vaughan writing in 1972, however, 'the term is a contradiction in itself, art being the realization of concepts, not just having them'.

The loss of demand for technical skill was, in practice, replaced by the intellectual rigours and hard reading in philosophy, lingustics and political theory demanded from public and artist alike. Conceptual art grew international-ly with great speed but is usually considered to have passed its peak by the late 1970s. It is open to debate as to whether this was the result of a more buoyant art market preferring more marketable objects such as the paintings of the *Neo-Expressionists or whether this was the natural consequence of the potential of Conceptual art being more limited than its advocates proposed.

There was a substantial revival of interest in it in the mid-1980s (for example in the work of some of the exponents of *Neo-Geo). The term 'Neo-Conceptual' is sometimes applied to this revival. The expression 'conceptualist' is often used today for any art which is unconventional in material, such as that of Tracey *Emin. This is misleading if taken too literally, as the phys-ical existence of such work can often be of great importance. However, it is at least argu-able that, even if it is no longer appropriate to use the label in the strictest sense, Conceptual art, as much as anything else, marks the boundaries between the *modern and the *contemporary, as identified by many critics today, and that the relative marginalization of traditional media was as significant a fact for art in the late 20th century as abstraction was for its early years. Alternative names that have been proposed for Conceptual art include Anti-Object art, Dematerialized art, Idea art, and Post-Object art.

Further Reading: T. Godfrey, *Conceptual Art* (1998)

Kettle's Yard, Cambridge, *Mono-ha—School of Things* (2001)

Lippard (1973)

Meyer (1972)

R. Smith, 'Conceptual Art', in N. Stangos (ed.), *Concepts of Modern Art* (1994)

Concrete art Term applied to abstract art that is intended to be totally autonomous, repudiating all figurative reference and sym-bolic associations. The name was coined by Theo van *Doesburg, who in Paris in 1930 issued a manifesto called *Art Concret* (it took the form of the first number of a periodical with this title, but no other numbers were issued). In this he declared: 'The work of art ... should receive nothing from nature's

formal properties or from sensuality or sentimentality ... A pictorial element has no other significance than "itself" and therefore the picture has no other significance than "it-self". The construction of the picture, as well as its elements, should be simple and control-lable visually. Technique should be mechani-cal, that is to say exact, anti-impressionistic.' Van Doesburg died the following year, but his ideas were developed by the *Abstraction-Création group. One of its members, Max *Bill, was important in helping Concrete art survive beyond the Second World War (he lived in neutral Switzerland). After the war, several new associations of Concrete art were formed, notably in Italy and in South America (which Bill visited in the 1950s), and it was later influential on *Op art. Bill, who organized international exhibitions of Concrete art in Basle in 1944 and in Zurich in 1960, gave the following definition: 'Concrete painting elim-inates all naturalistic representation; it avails itself exclusively of the fundamental elements of painting, the colour and form of the surface. Its essence is, then, the complete emancipa-tion of every natural model: pure creation.'

Concrete poetry A type of poetry in which the physical appearance of the words embo-dies or extends their meaning and which is therefore considered a visual as well as a liter-ary art. It can sometimes take a physical mate-rial form, almost like sculpture. The term was devised about 1955, and it was soon after this that a Concrete poetry movement began, but the idea of a coincidence or interaction be-tween meaning and appearance goes back much further. For example, this type of writing had something of a vogue during the English Renaissance and there are well-known exam-ples shaped like an altar and a pair of angel's wings by the devout 17th-century poet George Herbert. In 1897 the French *Symbolist poet Stéphane Mallarmé used different type sizes in *Un Coup des dés* (A Throw of Dice), in 1918, *Apollinaire wrote 'Il pleut' (It Rains), in which the arrangement of the lines suggests drops of rain falling down the page, and the *Dadaists and *Futurists experimented freely with typo-graphy. Concrete poetry, as the term is now understood, goes beyond the silhouetting of Herbert's 'Easter Wings' and Apollinaire's 'Il pleut', often dispensing with conventional syntax and arrangement of lines.

There is some uncertainty about who coined the term Concrete poetry, and it

seems to have come into use in several places more or less simultaneously around 1955. Among the first to use it were the Swiss Eugen Gomringer and the Brazilian Décio Pignatari. Gomringer was at this time working as secretary to Max *Bill, whose *Concrete art provided a model of self-sufficient abstract forms. An exhibition of Concrete art in São Paulo in 1956 was the launching-pad for Concrete poetry as a movement, and in a manifesto published in 1958 the Noigandres group of poets (to which Pignatari belonged) characterized a concrete poem as an object 'in and by itself'. The movement quickly became international and flourished throughout the 1960s, with many anthologies, magazines, and exhibitions devoted to it (the exhibitions included 'Between Poetry and Painting' at the Institute of Contemporary Arts, London, in 1965). In the 1970s much of the group activity petered out, but individual poets continued working in the vein. The best-known British exponent of Concrete poetry was Ian *Hamilton Finlay. Another leading figure was the poet and painter Kenelm Cox (1927–68), whose life was cut short by a car crash. He combined poetry and movement in *Kinetic sculpture. In America those who have worked with Concrete poetry include John *Cage.

Conder, Charles (1868–1909) British painter and occasional printmaker, born in London, a direct descendant of the great 18th-century sculptor Roubiliac. In 1884 he emigrated to Australia to work for his uncle, a surveyor, but he gave this up for art. He mainly painted landscapes at this time and was influenced by Tom *Roberts, whom he met in Melbourne, where Conder lived from 1888 to 1890 (*see* HEIDELBERG SCHOOL). Then he returned to Europe, briefly visiting England before moving to Paris, where he studied at the *Académie Julian and became part of a circle of artists, including *Anquetin, *Bonnard, and Henri de Toulouse-Lautrec (1864–1901). He appears in two of Lautrec's paintings of the Moulin Rouge, and like Lautrec was notoriously dissipated; his friend William *Rothenstein said he was 'often without a sou, but . . . never without a lady'. In 1897 Conder settled in London, but he made frequent visits to Dieppe and Paris. His work was seen in numerous exhibitions, including one-man shows, and he became a well-known figure in the art world, but he fell seriously ill in 1906 from syphilis and stopped painting. He

is best known for landscapes, arcadian fantasies, and painted fans; Frank *Rutter wrote that 'As a water-colour painter on silk, as the creator of the most exquisite fans, Conder not only had no rival in his life-time, but no superior in the past or the present'. He also painted portraits and made a few lithographs and etchings. His work, which is well represented in Tate, is often tinged with a feeling of *fin de siècle* decadence. He was influenced by *Whistler, but Rothenstein commented that 'Whistler never liked Conder and didn't care for his work . . . He probably thought him too involved with his ladies of Montmartre, too fond of his absinthe.'

Conner, Bruce *See* JUNK ART.

Conroy, Stephen (1964–) Scottish painter. He was born at Helensburgh, near Dumbarton, and studied at *Glasgow School of Art, 1982–7. Even before starting his postgraduate year (1986–7), he had achieved considerable success, and he was soon being hailed as the boy wonder of Scottish painting. In 1986 he won first prize for painting at the *Royal Academy's British Institute Fund Awards and his degree show sold out. In 1987 he was the youngest artist included in 'The Vigorous Imagination', the main exhibition at the Edinburgh Festival, in 1988 he was interviewed in *Vogue* magazine, and in 1989 he had a one-man exhibition at *Marlborough Fine Art, one of the most prestigious London dealers. This rapid rise to fame was not without its problems, for he became embroiled in a legal dispute (eventually settled out of court) over a contract he regretted signing with a management firm, evoking comparisons with the tribulations of certain pop singers: 'I tried so hard to avoid "hype" and commercialization', he said. Conroy had begun his studies at Glasgow School of Art just as Steven *Campbell was leaving it for America in a blaze of glory, and he was influenced by him in his choice of enigmatic figurative subjects. Conroy, however, differs from Campbell in various ways: he works more slowly and deliberately, making detailed preparatory drawings, typically uses softer handling and warmer lighting, and employs more formal poses (his figures sometimes wear evening dress, recalling the theatre pictures of *Degas or *Sickert). Duncan Macmillan has perceptively compared 'his young men with their uniform appearance and dead-pan faces and the vague echo that

they carry of belonging to another time' to *Gilbert & George (*Scottish Art in the 20th Century*, 1994).

Consagra, Pietro (1920–2005) Italian sculptor and occasional painter. He was born at Mazara del Vallo, Sicily, and studied at the Academy of Fine Arts, Palermo, 1938–44. In 1944 he settled in Rome, where he started to make abstract sculpture soon afterwards and joined the groups *Forma in 1947 and *Continuità in 1961. In the 1950s he began making what he called *ferri trasparenti* ('transparent irons')—double-sided low reliefs pierced with jagged holes—and it is for these that he is best known. Although he usually worked in metal, he also used marble and wood. Consagra is regarded as one of the leading figures in post-war Italian sculpture and won several awards, notably the International Sculpture Prize at the 1960 Venice *Biennale; his public commissions include a large fountain for the Piazzale della Farnesina in Rome (1966). He wrote numerous articles on art and in 1952 published the book *Necessità della scultura*, a response to Arturo *Martini, who had declared that sculpture was dead.

Constant (Constant A. Nieuwenhuys) (1920–2005) Dutch painter, sculptor, draughtsman, and printmaker, born in Amsterdam, where he studied at the Academy, 1939–42. He was a member of the *Cobra group, but from the early 1950s he turned more to *Constructivist sculpture. From 1956 to 1969 he devoted much of his time to work on an ideal urban project, *Nieuw Babylon* (New Babylon), for which he made many designs and models. In the 1970s he returned to painting. He died in Utrecht.

Constructivism A movement in abstract art that originated in Russia in about 1914, became dominant there for a few years after the 1917 Revolution, and in the 1920s spread to the West, where it has subsequently been influential on a wide spectrum of artists. Constructivism is typically characterized by the use of industrial materials—such as glass, plastic, and standardized metal parts—arranged in clear formal relationships, but the meaning to be attached to the word varies according to context, and some writers prefer to use the terms 'Soviet Constructivism' (or 'Russian Constructivism') and 'European Constructivism' (or 'International Constructivism') to make a distinction between the original movement and its much more diffuse aftermath. Even in the context of Revolutionary Russia, however, the meaning of the word is far from clear-cut.

The originator of Constructivism was Vladimir *Tatlin, who visited Paris in 1914 and on his return to Russia began making abstract *Relief Constructions* using materials such as sheet metal, wood, and wire. He was influenced by the sculptural experiments of *Picasso, who had used a variety of ingeniously assembled odds and ends, and perhaps also by the *Futurist sculptural manifesto (1913), in which *Boccioni similarly advocated a move away from the traditional techniques of modelling and carving in favour of sculpture that was constructed from various new materials—this was the essential idea behind Constructivism. From his reliefs Tatlin went on to develop openwork structures (sometimes placed across the corners of rooms), and several other artists, including Alexander *Rodchenko, created similar works in the years immediately after the 1917 Revolution. The Revolution created a ferment of enthusiasm in Russia for the building of a better society, with machinery seen as a liberating force, and in this climate Tatlin's idea of investigating and exploiting industrial materials and machine production came into its own. Soviet Constructivism, as opposed to the Pre-Revolutionary variety, was inseparable from politics. According to Aaron Scharf, the aim was 'not political art, but the socialization of art'. The most heroic celebration of this faith in a Communist society was intended to be Tatlin's gigantic Monument to the Third International; it never progressed beyond a wooden model, exhibited in 1920, but it has become the great symbol of Soviet Constructivist ideals. Several other major projects remained unrealized because of lack of funds and materials, but the new spirit was fervently expressed in a whole range of objects and activities, including the decoration of propaganda boats and trains (*see* AGITPROP ART). This revolutionary zeal for socially useful art led many Soviet artists to conclude that traditional 'fine art' was dead. In 1921, for example, Rodchenko and several associates signed a joint declaration in which they acknowledged 'self-sufficient easel painting as extinct and our activities as mere painters useless', and the following year Rodchenko and his wife, Varvara Stepanova, published the 'Programme of the First Working Group of

Constructivists', in which they declared 'uncompromising war on art'. Alexei Gan (1889–1942) used equally blood-curdling language in *Constructivism* (1922), writing that 'The proletarian revolution is not a word of flagellation but it is a real whip which expels parasitism from man's practical reality in whatever guise it hides its repulsive being...The fact that all so-called art is permeated with the most reactionary idealism is the product of extreme individualism.' A concept that had originated in Tatlin's modest reliefs had taken on an ideological weight and subsequently was expanded to embrace the whole of applied art. By 1925 Constructivism had become 'a blanket term for any angular designs applied to furniture, fabrics, porcelain or theatre sets' (Robert Auty and Dimitry Obolensky, eds., *An Introduction to Russian Art and Architecture*, 1980).

Many artists who were not prepared to abandon traditional art for industrial design left Russia at this time. Among them were the brothers Naum *Gabo and Antoine *Pevsner, who left in 1922 and 1923 respectively. Although they wanted to reflect modern technology in their work, they rejected the idea that art must serve an obvious social purpose: they thought that 'fine art' could make an important contribution to society by being spiritually uplifting, and they conceived a purely abstract type of sculpture that used industrial materials such as plastic and glass. Their ideas were expressed in the *Realistic Manifesto*, which they published in Moscow in 1920; in this they appealed for 'the construction of the new Great Style' and wrote that 'Space and time are the only forms on which life is built and hence art must be constructed.' It is from their work that European or International Constructivism derives, and each of them played an important part in spreading their ideals. Pevsner spent the rest of his life in Paris, which was the main centre of abstract art in the inter-war years (*see* ABSTRACTION-CRÉATION), and Gabo lived successively in Germany, France, England, and the USA. In England he was co-editor of *Circle* (1937), in which he published his essay 'The Constructive Idea'. The subtitle of *Circle* is *International Survey of Constructive Art*, an indication of the 'international constructive tendency' that was recognized at this time. Among the other contributors to the volume, *Moholy-Nagy was one of the outstanding representatives of this tendency, and was particularly influential in the spread of Constructivism through his teaching at the *Bauhaus and elsewhere.

The fate of Constructivism in the Soviet Union was very different. *Socialist Realism killed off most forms of experimental art, although it can be argued that some of the ideas of Constructivism survived in the 1930s in the photomontages and graphic design of artists such as Rodchenko and Gustav *Klutsis. Official disapproval was summed up by the article 'Konstruktivizm' in the second edition of the *Great Soviet Encyclopedia*, 1949–60, which begins: 'A *formalistic tendency in bourgeois art, which developed after the First World War, 1914–18. Anti-humanistic by nature, hostile to realism, Constructivism appeared as the expression of the deepest decline of bourgeois culture in the period of the general crisis of capitalism.'

Gabo's concept of Constructivism, as expressed in his essay in *Circle*, was vague, being equated with 'creative human genius' in art, science, or any other sphere, and since the Second World War the term has been applied to a very broad range of work. Sometimes it is used as a rough equivalent of 'geometrical abstraction'—George *Rickey's book *Constructivism: Origins and Evolution* (1968), for example, encompasses *Hard-Edge Painting, *Minimal art, and much else besides. An example of the problems of definition is the case of Gabo himself. Historians of Russian Constructivism sometimes balk at applying the description to his work because it was frankly aesthetic rather than utilitarian in its aims. However, Gabo is a central figure in the development of international Constructivism. In Britain the word is often used to refer specifically to a type of work—reliefs and freestanding constructs in industrial materials such as metal or perspex—that became popular with a group of abstract artists in the 1950s and 1960s. These artists were influenced by Charles *Biedermann's book *Art as the Evolution of Visual Knowledge* (1948), and one of them—Anthony *Hill—wrote that Biedermann had helped them to 'accept the construction as the successor to the old domain of painting and sculpture'. Apart from Hill, the other British Constructivists of this time included Robert *Adams, Adrian *Heath, Kenneth and Mary *Martin, and Victor *Pasmore, who showed their work as a group at the 'British Abstract Art' exhibition at the AIA Gallery, London, in 1951. Three years later John Ernest (1922–94) and Stephen *Gilbert joined the group, which maintained its identity until about 1960. Their work frequently had

a mathematical basis and employed industrial materials including plastics. In addition to making their characteristic small constructions, these artists sometimes had the opportunity to work on an architectural scale—for example Mary Martin at Musgrave Park Hospital, Belfast, and Pasmore at Peterlee New Town. Their work and teaching influenced many artists of the next generation, including Peter Lowe (1938–) and Gillian Wise (1936–), who were among the members of a Constructivist association called Systems Group, founded in 1969, which aimed to provide an objective mathematical logic for art. *Kinetic art, especially when it engages with science and technology can also be seen as part of a Constructivist tradition.

Further Reading: Bann (1974)

A. Grieve, *Constructed Abstract Art in England After the Second World War: A Neglected Avant Garde* (2005)

Lodder (1985)

A. Scharf, 'Constructivism', in N. Stangos (ed.), *Concepts of Modern Art* (1994)

contemporary art An imprecise term applied to art that has been made fairly recently and which is considered 'of its time' in spirit. For most of the 20th century, the term was somewhat elastic. Rather than defining a specific period of time it tended to move forward to reflect the vantage point of those who define it (*see* CONTEMPORARY ART SOCIETY). Today a distinction is sometimes made between *'modern' and 'contemporary' art on the basis that *'modernism' has come to an end, although there is no clear agreement as to when that happened. For instance the *Pompidou Centre describes its collection as being of 'modern and contemporary art' as though they are separate entities. Robert Atkins, in *Art Speak: A Guide to Contemporary Ideas, Movements, and Buzzwords* (1990), proposes that the term 'contemporary' should be used to cover the period since the Second World War. Jonathan Law, editor of *European Culture: A Contemporary Companion* (1993), is broadly in agreement, his book containing 'entries only for those figures who have emerged, or added significantly to their achievement, since 1945'. The *Museum of Contemporary Art, Los Angeles, covers a similar time range, 1940 being its notional starting point. Christie's, the auction house, however, defines 'contemporary art' as starting in 1970. The *New Museum of Contemporary Art, New York, is restricted to the art made within the past ten years. This last notion of 'contemporary' means that such a museum can never have a permanent collection in the normal sense, as works will so quickly lose their contemporary status.

In terms of the actual development of art rather than convenient round numbers, it makes much sense to place the turning point as roughly the beginnings of *Conceptual art in the late 1960s. Broadly speaking, the argument would be that in the 'modern' period the crucial issue was the conflict between *abstract art and figuration and that since then it has been the challenge to the traditional media of painting and sculpture. It would also roughly coincide with the transition between modernity and *Postmodernity. A further distinction is that 'modern' art has often been defined in terms of 'isms', which tend to designate groups of artists united by style, ideology, and, usually social, and professional ties. Today, it is more usual for critics to group 'contemporary' art around broader thematic categories, usually determined by the critics themselves.

Predictably, the word 'postcontemporary' has been introduced by those whose love of a journalistic tag and compulsion to identify a new trend override any sense of linguistic logic.

Contemporary Art Society (CAS) A society formed in London in 1910 to promote contemporary art and to acquire works by living artists for gift or loan to public museums in Britain (and later in the Commonwealth and occasionally elsewhere). It was envisaged as the counterpart, in the modern field, of the National Art Collections Fund, which had been founded in 1903 to assist public collections in purchasing works of art. Originally it was planned to call the society the Modern Art Association, but the present name had been adopted by the time the CAS was formerly inaugurated on 18 May 1910 at 44 Bedford Square, the home of Philip Morrell, a Liberal MP, and his wife, Lady Ottoline Morrell (1873–1938), a celebrated hostess and patron of the arts. They were members of the original committee, which also included Charles Aitken (then director of the *Whitechapel Art Gallery, later director of the *Tate Gallery), Clive *Bell, Roger *Fry, and D. S. *MacColl. Later members of the committee have included many distinguished figures in the art world, notably Kenneth *Clark, whose energy and financial

generosity were important in helping the society to survive the Second World War. It now operates with support from *Arts Council England as well as private funding and offers art consultancy services for individual collectors and the corporate sector.

Other countries have established Contemporary Art Societies, although not invariably with the same type of purpose as the British CAS. In Australia, a CAS was formed in Melbourne in 1938 in opposition to the Australian Academy of Art, founded the previous year, which was considered by its opponents to be a bastion of conservatism. Opposition to the Academy was led by George *Bell, who issued a leaflet entitled *To Art Lovers*, in which he proposed forming 'a society which will unite all artists and laymen who are in favour of encouraging the growth of a living art, who are determined both to prevent any dictatorship in art and to nullify the effect of any official recognition acquired by a self-constituted Academy'. In its early years the CAS was split by disputes among members, but it established branches in Sydney and Adelaide and then in other states and through its exhibitions became the main channel for transmitting knowledge of avant-garde art. In 1961 the Contemporary Art Society of Australia was formed.

In Canada, a Contemporary Art Society was founded in Montreal in 1939 by the painter John Lyman (1886–1967) and ran until 1948. It held annual exhibitions and aimed to promote an international outlook in contrast to the nationalistic concerns of the *Group of Seven and the *Canadian Group of Painters. The artists who exhibited with the Canadian Contemporary Art Society included *Borduas and *Riopelle.

Contemporary Group The name of two associations of Australian artists—one in Sydney, the other in Melbourne—founded to encourage an appreciation of modern art in their country; they were separate but existed at the same time. The first was founded in Sydney in 1925; its two prime movers were George Lambert (*see* LAMBERT, MAURICE), the most successful Australian portraitist of his day, and his former pupil Thea Proctor (1879–1966), a watercolourist. Participants in its exhibitions included several artists influenced by *Post-Impressionism, among them Margaret *Preston and Grace Cossington *Smith. The Melbourne Contemporary Group was founded by

George *Bell in 1932 and was short lived because in 1938 he turned his energies to the *Contemporary Art Society.

Contemporary Style A term describing a trend in British art, architecture, and particularly design, in the late 1940s and early 1950s characterized by a light, spiky, spindly look, often combined with bright or cheerful colours. The style was popularized by the *Festival of Britain in 1951 and is sometimes known as 'Festival Style' or 'South Bank Style' (another term that has been used for it is 'New English Style'). One source was molecular diagrams from scientific publications. Although it is not generally associated with painting or sculpture, there are clear analogies in the stringed sculptures of Barbara *Hepworth and the spiky figures of the *Geometry of Fear sculptors, as well as in some of the abstract painting of the time.

Contimporanul *See* JANCO, MARCEL.

Continuità A group of Italian artists formed in Rome in 1961 with the critic Giulio Carlo Argan (1909–92) as its spokesman. Several members had previously belonged to the group Forma, notably Carla *Accardi, Pietro *Consagra, Piero *Dorazio, Gastone Novelli (1925–68), Achille Perilli (1927–), and Giulio *Turcato. Other members included Lucio *Fontana and Arnaldo and Giò *Pomodoro. In the exposition of their aims the name 'Continuità' was given a twofold meaning. On the one hand, they called for an overhauling of current Italian painting and sculpture in order to reestablish continuity with the great Italian art of the past. On the other hand, they stood for continuity or greater structural rigour within the work of art as opposed to the looseness of *Art Informel. Some members also held that there should be continuity of the work of art with its spatial environment, in accordance with Fontana's doctrines.

Cook, Beryl (1926–2008) British *naive painter who was born in Surrey and grew up in Reading. She took up painting seriously in early middle age: 'I was happily settled at home, and with my son away at college I had plenty of spare time. There was also the incentive of all the bare walls in our cottage [at Looe in Cornwall], and the driftwood from the beach provided an ideal material to paint on.' Soon she was 'painting compulsively'. In 1975 she had her first exhibition, at the

Plymouth Arts Centre, and it was a great success. Within a few years she was well known through other exhibitions, television appearances, and the publication of the first of several collections of her work in book form (*The Works*, 1978), with the paintings accompanied by her own amusing captions. Her chubby, usually jovial characters have also been much used on greetings cards and even inspired two animated films entitled *Bosom Pals*. She habitually added three stones to all her figures to avoid having to spend too much time on the background, which she found boring to paint. Cook's subjects are taken from everyday life and often involve the kind of saucy humour associated with seaside holidays (she used to run a boarding house in Plymouth) and with tabloid Sunday newspapers (sometimes she incorporated real pieces of newsprint in her pictures as a collage element). Edward *Lucie-Smith described her as 'the nicest thing to happen to British painting for years', but the public following was not usually matched by critical acclaim. Brian *Sewell, who described her work as without 'the intellectual honesty of an inn sign for the Pig and Whistle', was forgiven by Cook for his dismissal because she found him so entertaining. As with other artists in this situation, there has been much discussion as to how far she should be represented in public collections. When the *Gallery of Contemporary Art opened in Glasgow in 1996, the director Julian Spalding signalled his commitment to a populist approach by controversially acquiring three of Cook's paintings.

Further Reading: V. Horwell, 'Beryl Cook' [obituary], *The Guardian* (28 May 2008)

Cook, Rita *See* ANGUS, RITA.

Cooke, Jean *See* BRATBY, JOHN.

Cool art A term that has been applied to various types of abstract art characterized by such qualities as calculation, detachment, and impersonality. Usually the art referred to is geometrical, and often it is made up of repetitive structures or units. The term was evidently first used in print by the critic Irving Sandler in 1965 (in an article in *Art in America*), but the term 'Cool School' had been used a year earlier (in an article in *Artforum* by Philip Leider). The art historian Barbara Rose has referred to the term as a synonym for *Minimal art, which she describes as 'an art whose blank, neutral,

mechanical impersonality contrasts so violently with the romantic, biographical *Abstract Expressionist style which preceded it that spectators are chilled by its apparent lack of feeling or content'. Historically the interest of the concept is that it unites two apparently opposed tendencies of the 1960s, *Pop and *Post-Painterly Abstraction, under a single sensibility. *See also* COLD ART.

Coolidge, Cassius Marcellus *See* POPULAR PRINTS.

Cooper, Douglas (1911–84) British art historian and collector. He lived in France for much of his life and was severely critical of the British for what he regarded as their failure to appreciate or patronize modern art. Born in London, the son of wealthy parents, he read modern languages at Trinity College, Cambridge, then briefly attended the Sorbonne in Paris and the University of Freiburg, studying art history. His main interest was *Cubism, and in 1932 he decided to devote part of his inheritance to forming a collection of *Picasso, *Braque, *Gris, and *Léger, whom he regarded as its four leading protagonists, in its greatest period, 1907–14. It is some measure of his combination of foresight and persuasiveness that these four figures are now generally taken as dominant. (In the inter-war years *La Fresnaye was sometimes referred to as one of the leading exponents.) Cooper later added works by other artists to his collection, but the Cubists remained the core. In the Second World War he worked in intelligence and helped to identify, protect, and repatriate works of art. In 1949 he discovered the dilapidated Château de Castille in Argilliers, near Avignon, in southern France, and this became his main home. Picasso was a neighbour and visitor, but their friendship turned to hostility. Cooper, indeed, had a notoriously difficult temperament and enjoyed controversy; in the 1950s he became particularly well known for his attacks on the *Tate Gallery and its director Sir John *Rothenstein. These culminated in a notorious incident at the French embassy when, after some goading from Cooper, Rothenstein punched him to the floor. Cooper's writings include books on Gris and Léger. He also organized exhibitions, among them two major Cubist shows: 'The Cubist Epoch' at Los Angeles County Museum and the Metropolitan Museum, New York, in 1970, and 'The Essential Cubism' at the Tate Gallery,

London, in 1983. By the time the latter was held his approach to Cubism, with its emphasis on a few major figures, was rejected by many younger scholars. After the death of Cooper's companion and adopted son, the interior designer William A. McCarty Cooper, his collection was sold at Christie's in New York in 1992 for a total of $21 million, a healthy sum in the context of a period in which the art market was depressed. The works sold included Braque's *Studio VIII* (1955), which was described by John *Richardson at the time as 'one of the greatest 20th century works left in private hands'.

Copnall, Edward Bainbridge (1903–73) British sculptor and painter. Born in Cape Town, South Africa, he moved to England at an early age. As a young artist he was drawn to the practice of *direct carving, working on allegorical and religious subjects such as the enormous relief *Evening*, a stylized mother and child. The critic Kineton Parkes actually preferred his work to that of *Moore, *Hepworth, and *Skeaping because of his respect for natural proportion, avoiding 'elephantiasis of form'. Copnall became known chiefly for architectural and decorative sculpture, including wood panels for the first-class restaurant on the ocean liner the *Queen Mary* and, familiar to many visitors to London's West End, the relief carvings on the Warner (now Vue) cinema in Leicester Square. These depict the spirits of sight and sound. He became president of the Royal Society of Sculptors and was the author of *A Sculptor's Manual* (1971). His son **John Copnall** (1928–2007) was an abstract painter.

Further Reading: K. Parkes, *The Art of Carved Sculpture* (1931)

Cork, Richard (1947–) British art critic and art historian. During the 1970s, he created something of a stir as art critic for the mass circulation London newspaper the *Evening Standard* by his support for *Conceptual art. He also became strongly in favour of a highly politicized practice of art, believing that this would bring art closer to a wide public. This idea was manifested in the Serpentine Gallery (*see* ARTS COUNCIL) exhibition he organized in 1977, entitled polemically 'Art for whom?', which promoted murals and *agitprop as the future for British art. This earned him predictable attacks from the political right on the grounds that he was reducing art to propaganda, and the spectre of *Socialist Realism was invoked by his opponents. More surprisingly, he also had many critics on the political left, such as the *Art & Language group and Peter *Fuller, who regarded his ideas as naive. Cork is also an authority on the history of 20th-century British art: his publications include *A Bitter Truth* (1994), an account of the impact of the First World War on art.

Corinth, Lovis (1858–1925) German painter, printmaker, and writer, born in Tapiau, East Prussia. He studied at the Academies of Königsberg and Munich, then in 1884–7 at the *Académie Julian, Paris, and he was strongly influenced by the painterly brushwork of recent French artists such as Courbet and Manet, as well as by Old Masters such as Frans Hals, Rembrandt, and Rubens. After his return to Germany he lived first in Königsberg, then from 1891 in Munich, and from 1901 in Berlin. With *Liebermann and *Slevogt (both of whom also lived in Berlin) he was recognized as one of the leading German exponents of *Impressionism and in the first decade of the century he was a great fashionable success. However, in 1911 he was partially paralysed by a stroke and when he began to paint again (with great difficulty) it was in a much looser and more powerful *Expressionist manner, to which he had previously been strongly opposed (he has been described as 'an eleventh-hour convert to modernism'). He was varied and prolific as a painter and printmaker. His paintings included landscapes, portraits, and still-lifes, and he had a fondness for voluptuous allegorical and religious subjects (*The Temptation of St Anthony*, 1908, Tate). His prints were mainly drypoints and in his later years lithographs (which he used for the numerous commissions he had for book illustrations). He also made a few etchings and woodcuts. An edition of his writings, *Gesammelte Schriften*, was published in 1920, and a collection of autobiographical notes was published posthumously in 1926 as *Selbstbiographie mit Bildnissen*. After the Nazis came to power in 1933 his later works were declared *degenerate. *Kirchner said of Corinth, 'In the beginning, he was only of average stature; at the end he was truly great.'

Further Reading: P. K. Schuster, *Lovis Corinth* (1996)

Corneille (Corneille Beverloo) (1922–) Belgian painter, active mainly in Paris. Born in Liège, he studied drawing at the Amsterdam

Academy, 1940–43, but he was self-taught as a painter. In 1948 he was one of the founders of the *Cobra group and in 1950 he moved to Paris with his fellow member Karel *Appel. His work of this time was typical of the Cobra style—brilliant in colour and vigorous in brushwork, with child-like imagery suggesting mythical beings. During the 1950s he gradually abandoned figurative references for a swirling abstract style, but in the 1960s he reintroduced the imagery of his Cobra period.

Cornell, Joseph (1903–72) American sculptor and film-maker, one of the pioneers and most celebrated exponents of *assemblage. He was born in Nyack, New York, and after leaving Phillips Academy in Andover, Massachusetts, in 1921, he worked for a while as a salesman in his father's textile firm. In 1929 he settled at Flushing, New York, where he lived quietly for the rest of his life, becoming rather reclusive in his later years. He had no artistic training, but had a strong interest in the arts in general and began frequenting the Julien Levy Gallery—which became a major venue for *Surrealism—soon after it opened in New York in 1931. He was also a keen collector of old books, engravings, and other articles of historical interest, and influenced by Surrealism—especially Max *Ernst—he began to make collages, using his own hoard as source material. In 1932 his work was included in a show at the Levy Gallery, and by 1936 he was well enough known to be included in a major exhibition at the *Museum of Modern Art—'Fantastic Art, Dada and Surrealism'. By this time Cornell had developed his distinctive form of expression—small boxes, usually glass-fronted, in which he arranged collections of photographs, magazine illustrations, trinkets, and all manner of bric-à-brac. His work is sometimes compared with that of *Schwitters, but whereas Schwitters was fascinated by refuse, Cornell concentrated on fragments of once beautiful and treasured possessions, using the Surrealist technique of irrational juxtaposition to evoke a feeling of nostalgic reverie. From the late 1940s—perhaps influenced by *Mondrian, whom he much admired—his work began to become more abstract. Cornell also painted, and from the 1930s he made several Surrealist films: the most notable, *Rose Hobart* (1936), consists entirely of tinted fragments of a forgotten Hollywood film, *East of Borneo*, edited to hallucinatory effect. Towards the end of his life a number of major exhibitions were devoted to his work, notably one at the *Guggenheim Museum, New York, in 1967.

Further Reading: D. Waldman, *Joseph Cornell: Master of Dreams* (2006)

Corpora, Antonio (1909–2004) Italian painter, born in Tunis of Sicilian parents. He trained at the Tunis Academy under Armand Vergeaud (1876–1949), who had been a fellow-student of *Dufy and *Matisse, then lived in Paris from 1930 to 1937. In 1939 he settled in Rome, where he became a member of the *Fronte Nuovo delle Arti in 1946 and one of the Gruppo degli Otto Pittori Italiani in 1952. From *Cubist and *Fauvist influences in his early work Corpora developed to expressive abstraction and by the end of the 1940s he was painting in a *Tachiste manner akin to that of Jean *Bazaine and other followers of Roger *Bissière who based their abstractions on nature. During the 1950s, however, he began to paint abstract colour compositions that had no basis in natural appearances. He had a solo show at the Venice *Biennale in 1960.

Corrente An anti-Fascist association of young Italian artists formed in Milan in 1938 by Renato Birolli (1906–59), a painter whose political activities were to lead to his imprisonment. *Guttuso was one of the founder members; *Afro and *Mirko were among those who joined later. The association had no fixed programme, but was opposed to the provincialism of the *Novecento. The members stood for the defence of 'modern' art at a time when the Nazi campaign against *degenerate art was spreading to Italy. Corrente arranged exhibitions in Milan in March and December 1939; older Milanese artists were included in the first, but only the younger generation participated in the second. It also published a fortnightly review of literature, politics, and the arts. This grew out of a Fascist youth journal called *Vita giovanile*, founded in Milan in January 1938; in October 1938 it was retitled *Corrente di vita giovanile* (Stream of youthful life) and by this time had become anti-Fascist in stance. From February 1939 the title became simply *Corrente*. The journal ceased publication in 1943 and the activities of the group were dissipated by the Second World War.

'Cor-Ten' steel *See* IRON AND STEEL.

Cosey Fanni Tutti *See* P-ORRIDGE, GENESIS.

Cossington Smith, Grace *See* SMITH, GRACE COSSINGTON.

Costa, Joachim *See* DIRECT CARVING.

Costakis, George (1912–90) Russo-Greek diplomat and collector. He was born in Moscow, the son of a Greek merchant who had emigrated to Russia in 1907, and he had Greek nationality throughout his life. From 1931 to 1976 he worked in various diplomatic legations in Moscow. He started collecting in the 1930s, at a time when the Soviet government was selling huge amounts of art to gain foreign currency. Originally he bought antiques and Old Master paintings, then moved on to icons, and from the late 1940s began building up a superb collection of modern Russian works, beginning with the established masters such as *Chagall and *Kandinsky and moving on to his own younger contemporaries. He researched his collection carefully, so it formed a highly important historical resource. The type of art he owned was considered dangerously subversive at a time when only *Socialist Realism was officially sanctioned, and Costakis once said that he felt as if he were 'sitting on a barrel of dynamite'. In 1978, when he retired to Greece, he was allowed to take part of his collection with him in return for presenting the bulk of it to the Tretyakov Gallery in Moscow. The works he brought out of Russia were exhibited at various venues in Europe and the USA. In Greece, Costakis continued collecting up to his death and presented numerous works to museums.

Cottingham, Robert *See* SUPERREALISM.

Council for the Encouragement of Music and the Arts *See* ARTS COUNCIL.

Counihan, Noel (1913–86) Australian graphic artist and painter, one of his country's leading exponents of *Social Realism. In 1930 he began attending evening classes in drawing at the National Art Gallery School in his native Melbourne and worked for a time as a caricaturist, but he did not begin painting until 1940. Counihan had an unhappy childhood (partly because of his father's heavy drinking) and was a man of strongly held humanistic beliefs: during the 1930s he was involved in left-wing political activities, and many of his early works were either direct political statements or personal recollections of the Depression years in Melbourne. In 1945 he won first prize in the 'Australia at War' exhibition held at the National Gallery of Victoria, and in 1949 he attended the First World Peace Conference in Paris as a member of the Australian delegation. After living for two years in England he returned to Australia in 1951, but he continued to be a great traveller, visiting Russia in 1956 and 1960, for example. During the 1960s he painted many pictures based on the life of the Australian Aborigines, as well as a series of mother and child paintings related to the Vietnam War. *See also* ANGRY PENGUINS.

Courbet, Gustave *See* MODERN ART.

Courtauld, Samuel (1876–1947) British industrialist, collector, and philanthropist. He came from a family of prosperous silk merchants and was chairman of the textile firm Courtaulds Ltd from 1921 to 1946. Although he enjoyed looking at paintings from a fairly early age, it was not until the turn of the century that art became a serious interest, and it was not until 1922 that he began collecting. He was greatly stimulated by the exhibition of Sir Hugh *Lane's collection at the *Tate Gallery in 1917, and Courtauld—like Lane—mainly bought 19th-century French paintings, chiefly works by the great masters of *Impressionism and *Post-Impressionism. His collection included, for example, choice works by *Cézanne, *Gauguin, *Monet, and *Renoir. In 1923 Courtauld gave the Tate Gallery £50,000 for the purchase of French paintings in his own area of interest (which was poorly represented), and this fund was used to buy 23 paintings over the next few years, transforming the Tate's collection. His interests also extended to living artists, and in 1925 he joined his friend Maynard Keynes (*see* ARTS COUNCIL) in founding the London Artists' Association to provide financial assistance to young painters and sculptors. In 1931 came his most famous benefaction when he endowed the Courtauld Institute of Art, London, Britain's first specialist centre for the study of the history of art. The Institute opened in 1932 in Courtauld's former home, a splendid building in Portman Square by James Wyatt and Robert Adam, and in the same year Courtauld presented most of his collection to the University of London, together with funds for a building to house them. The Courtauld Institute Galleries opened in Woburn Square in 1958,

and in 1989–90 all the Institute's activities and collections were brought together under one roof at Somerset House, fulfilling Courtauld's intention that students should work in intimate contact with original works of art.

Courteline, Georges *See* NAIVE ART.

Couturier, Robert (1905–2008) French sculptor, born in Angoulême. He moved to Paris with his parents in 1910 and originally trained as a commercial lithographer. In 1928 he met *Maillol and became his friend and disciple. Although Couturier always spoke of Maillol with respect and gratitude, he eventually threw off his influence, preferring plaster to stone, and working towards a very different ideal of sculptural form—more attenuated, more open, and more expressive. His figures grew longer and thinner, developing into the 'weightless' style with which he is chiefly associated. In 1945 he became professor of sculpture at the École des Arts Décoratifs in Paris and from the 1950s he built up an international reputation. His major commissions included stone reliefs of *The Arts* (1960) for the French Embassy in Tokyo. An exhibition to celebrate his 100th birthday was held at the Musée Maillol, Paris in 2005.

Cowie, James (1886–1956) Scottish painter of portraits, figure compositions, landscapes, and still-lifes. He was born on a farm in Aberdeenshire, and after abandoning a degree course in English literature at Aberdeen University and qualifying as a teacher, he studied at *Glasgow School of Art, 1912–14. During the First World War he was a conscientious objector and worked on road-digging and similar tasks. From 1918 he taught at Bellshill Academy, near Glasgow, then, after a year as head of painting at Gray's School of Art, Aberdeen, he was warden of Hospitalfield House, Arbroath (a summer school) from 1937 to 1948. His pupils there included Robert *Colquhoun, Robert *MacBryde, and Joan *Eardley. In 1948 he moved to Edinburgh and became secretary of the Royal Scottish Academy.

Cowie was one of the most individual Scottish painters of the 20th century. Whereas the central tradition of modern Scottish painting has been one of rich colouring and lush, free brushwork (see, for example, SCOTTISH COLOURISTS), Cowie worked in a strong, hard, predominantly linear style—highly disciplined rather than intuitive (he made many preparatory drawings and often worked on a picture

for several years). He took his subjects from what he saw around him, but he was also inspired by the Old Masters, often using their compositions as a starting-point, without actually imitating them. Among his contemporaries he was perhaps closest in spirit to John *Nash, an artist he greatly admired. They shared an ability to infuse the ordinary with a sense of the mysterious. Cowie has continued to be a much admired artist in Scotland, and in the 1980s his work was an influence on Alison *Watt.

Cox, Kenelm *See* CONCRETE POETRY.

Cragg, Tony (1949–) British sculptor. He was born in Liverpool, and after studying at the *Royal College of Art he settled in Germany in 1977. In his early work he grouped fragments of rubbish, especially discarded and colourful household plastic, to form shapes or images arranged on the floor or wall. These works have been related to the contemporary phenomenon of 'punk' culture, associated with young people who, in the late 1970s, responded to alienation and lack of economic prospects with a kind of home-made anarchism of very loud and technically crude music and provocatively aggressive dress and manners. Certainly some of Cragg's sculpture plays on the disparity between its humble material and the grandiosity of its subject, as in *Union Jack* (1981, City Art Gallery, Leeds). Later work has used more traditional materials such as stone and bronze, but Cragg has remained concerned with the associations as well as the visual qualities of material, for instance the cast-iron bollards incorporated in *Raleigh* (1986), a work made to be placed in the old Liverpool dock site, near Tate Liverpool. Cragg has a scientific background and this is represented both by works which evoke laboratory equipment and by a piece such as *The Worm Returns* (1986), which incorporates models of molecular structures. The artist has described the effect which he wants his works to produce thus: 'I just want to give them [viewers] an alternative: an alternative to looking at nature and an alternative to looking at a dull-headed industrial utilitarian reality.' In 1988 Cragg represented Britain at the Venice *Biennale and also won the *Turner Prize.

Further Reading: Arts Council of Great Britain, *Tony Cragg* (1987)

⊕ SEE WEB LINKS

• Tony Cragg interview with Jon Wood, on artist's website.

Craig, Gordon (1872–1966) British theatrical designer and graphic artist, born at Stevenage, the son of the actress Ellen Terry and the architect and theatre critic E. W. Godwin ('Craig' was a stage name he adopted in his early days as an actor, later formalized by deed poll). Tall and good-looking, Craig became a successful leading man, but in 1897 he gave up acting to concentrate on design and directing. His approach was highly unconventional, aiming for simplicity and unity in place of Victorian elaboration, and his productions tended to be admired by the avant-garde but to fail at the box-office. In 1904 he visited Berlin (where he began an affair—one of his many romances—with the dancer Isadora Duncan), and from 1907 he lived on the Continent, first in Italy and then from 1931 in France. In 1913 he founded a theatre school in Florence at which he made experiments with moving lights and scenery that give him a claim to be regarded as a pioneer of *Kinetic and *Light art. After Craig's theatre school closed in 1915 because of the First World War he concentrated more on writing. He also developed his talent as a printmaker (he had learnt wood engraving from his friends William *Nicholson and James *Pryde).

Craig-Martin, Michael (1941–) Irish artist, writer, and teacher. He was born in Dublin, moved to the USA as a child, and studied at Yale University, where he encountered an important early influence, John Cage's 'Lecture on Nothing' (1949). 'Life without structure is unseen. Structure without life is dead.' Although Josef *Albers was no longer there in person, his teaching system remained and Craig-Martin was impressed by the 'intellectual coherence' of his view of art (Tusa). In 1966 he settled in England, where he became one of the leading figures in *Conceptual art. His work was less concerned with verbal language than that of some of his contemporaries, more with developing the minimal box forms of *Judd and *Morris by introducing elements of paradox and spectator participation, as with the *Box that Never Closes* (1967, Swindon Museum and Art Gallery). The best-known of his early works is *An Oak Tree* (1973, National Gallery, Canberra). When first seen at the Rowan Gallery in London, this glass of water on a shelf was the only object in the room. It is accompanied by a witty text in the form of an interview in which Craig-Martin takes the roles of both artist and viewer. As he put it

later, 'there's the part of me that believes it and there's a part of me that's sceptical and all of these things are played out in the one' (Tusa). The artist insists that the oak tree is actually present in the glass, which is not just a symbol. 'Q. Was it difficult to make the change? A. No effort at all. But it took me years before I realized I could do it.' Some commentators have noted Craig-Martin's Catholic background and related the work to the doctrine of transubstantiation, whereby bread and wine are transformed into the body and blood of Christ without any change in the physical 'accidents'. In the Cage lecture which had so impressed Craig-Martin, Cage referred to the lecture itself as being 'like an empty glass into which anything might be poured'.

In the late 1970s Craig-Martin embarked on a series of wall-drawings in which everyday contemporary objects, familiar from home or office, were depicted on a large scale as outlines in masking tape. In a statement on these works he explored the role of 'picturing' and its distinction from the 'forming' which had been the basis for much 20th-century art. ('Picturing', *Artscribe*, no. 14, October 1978). The context of this work and theory was a tendency, especially in the English-speaking art world of the period, to be largely dismissive of abstraction in the demand for socially relevant content. At the same time he argued that this concern for 'content' was leading to an unquestioning acceptance of models borrowed from 'the authority of the past'. Craig-Martin was putting into the foreground the actual process of 'picturing', often taken for granted because of the 'constantly generated' supply of pictures from television. The objects are frequently shown from a three-quarters angle from above so as to emphasize their spatial dimension in contrast to the two-dimensionality of the black line. The objects are also superimposed and contradictory in scale. This concern with the process of picturing and perception can be related to his admiration for the art of the Italian Renaissance: 'I like the sense that you are watching them making discoveries. It's an amazing moment in human history' (interview with Rachael Thomas, 2006). The outlined pictures of objects later acquired brilliant colours. A typical example is *Eye of the Storm* (2003, Irish Museum of Modern Art, Dublin), in which an open safety pin hovers above a bucket and a long-handled garden fork is propped against a light bulb.

Craig-Martin has also had a distinguished career as a teacher. At *Goldsmiths College in London he has been the mentor of several of the *Young British Artists who became prominent in the 1990s, including Damien *Hirst and Sarah *Lucas. Public works include *Big Fan* (2003, Regent's Place, London), a giant light box.

Further Reading: R. Thomas, *Interviews with Michael Craig-Martin* (2006)

Michael Craig-Martin interviewed by John Tusa, BBC website.

Crane, Walter (1845–1915) British illustrator, designer, painter, writer, and administrator. He was the son of a miniaturist and trained as a wood engraver. His career was very varied, but he is best remembered today as an illustrator of children's books, a field in which he was prolific throughout his life. He took this work very seriously, believing that 'We all remember the little cuts that coloured the books of our childhood. The ineffaceable quality of these early pictorial and literary impressions affords the strongest plea for good art in the nursery and the schoolroom.' Originally he worked in black and white, but he adapted well to the photomechanical colour processes that came in at the end of the 19th century and was one of the pioneers of the full-colour picture book for children. He was also one of the first illustrators to treat a double-page spread as a visual unity. His work for adults included designing wallpaper, and he was a leading figure in the Arts and Crafts movement that tried to rehabilitate good design and craftsmanship. Like William Morris (1834–96), the leading figure of this movement, Crane was a Socialist, and he illustrated A. A. Watts's *The Child's Socialist Reader* (1907).

Further Reading: G. Smith and S. Hyde, *Walter Crane 1845–1915: Artist, Designer and Socialist* (1989)

Cravan, Arthur *See* DADA.

Craven, Thomas *See* REGIONALISM.

Crawford, Ralston *See* PRECISIONISM.

Craxton, John (1922–) British painter, graphic artist, and theatre designer, born in London. In 1939 he studied briefly in Paris and then for the next three years in London, at Westminster School of Art, the Central School of Art, and *Goldsmiths College. He was a friend of Graham *Sutherland and in his early work was one of the leading exponents of *Neo-Romanticism, depicting visionary landscapes peopled with solitary poets and shepherds. Craxton said that these pictures (often heavily worked drawings) 'were my means of escape and a sort of self-protection . . . I wanted to safeguard a world of private mystery, and was drawn to the idea of bucolic calm as a kind of refuge.' In 1946 he visited Greece and since then has spent much of his time in the Aegean (he has also travelled extensively in other parts of the world). He is now perhaps best known for his portraits. Typically they are marked by clear drawing (with mild *Cubist stylization), subtle low-key colouring, and nervous sensitivity of characterization; there is a kinship of feeling with the early work of Lucian *Freud (Craxton shared a studio with him in 1942–4). As a theatre designer Craxton is best known for his costumes and sets for the 1951 Sadler's Wells Ballet production of Ravel's *Daphnis and Chloe*, choreographed by Frederick Ashton.

Creed, Martin (1968–) British sculptor and installation artist. He was born in Wakefield, grew up in Scotland, and studied at the *Slade School of Art. His works are generally sparse in their material form and are identified only by numbers so as not to impose associations. (For this reason his numbering system avoids the portentous No. 1.) He is best known for the work for which he was awarded the *Turner Prize in 2002, *Work no. 227* (2000, MoMA, New York). An entire room is alternately lit and darkened by electric light. It is a way of making a work of art which has no material existence: the light and the darkness are not themselves the art, only the change between them. This is a work which has entered the mythology of 'modern art' stories: the river boat guide tells the tourists (quite incorrectly) as they pass *Tate Modern: about the empty room inside with the single light bulb. Creed himself tends to be reticent about interpreting his work, but Maurizio *Cattelan has viewed *no. 227* in quite poetic terms. 'It has the ability to compress happiness and anxiety within one single gesture.' In 2008, Creed made a work specifically for *Tate Britain, *Work no. 850*: runners dash down the long Duveen Gallery 'as if their lives depended on it'. There is some affinity with the work of the *Conceptual artist Lawrence *Weiner in that the art consists of a set of instructions rather than a specific object, except that in Creed's case it is important that the idea can be and is executed. One piece can

be seen as a kind of manifesto for the artist's activities: *Work no. 300* (2003), which consists of the words 'The whole world + the work = the whole word'. Creed is looking for ways of making the greatest art content with the minimum material presence.

Further Reading: R. Campbell-Johnston, 'Is Martin Creed a Genius?', *The Times* (16 January 2008)

Cremer, Fritz (1906–93) German sculptor, born in Arnsberg. During the Nazi era Cremer's work was sufficiently conservative in style to be acceptable to the system. However, he had strong Communist convictions and had been a party member between 1929 and 1934. A relief of 1936, *Mourning Women*, was privately dedicated to Käthe *Kollwitz, officially rejected because of her political beliefs. The prize he won for this took him to London, where he was able to meet exiles such as Bertolt Brecht. Between 1946 and 1950 he was Professor of Sculpture in Vienna, but in 1950 he returned to East Germany to become the leading monumental sculptor, adept at using a moderately *Expressionist manner to serve the propaganda requirements of the regime. His most celebrated work has also proved to be his most controversial, the figures for the memorial to the concentration camp at Buchenwald. Although this was liberated by the Americans, a day before they arrived the inmates themselves had managed to escape under Communist leadership, providing, as Sergiusz Michalski points out, 'a handy myth which featured in propaganda about ant-Fascist resistance'. The memorial is, therefore, not to the victims and their suffering, but to the liberation, and figures appear like workers at a rally rather than as people who have suffered the extremes of privation. Furthermore the monument was deliberately sited, at Brecht's suggestion, so that the group would face the lands to the south, then part of West Germany, supposedly to liberate them from the clutches of what the East German government claimed as the 'neo-fascism' of the Adenauer regime.

It was as a loyal Communist that in 1961 Cremer offered his support to 'difficult young artists'. He gave them an exhibition which triggered a storm of indignation, and he had to resign the post of secretary to the Deutsche Akademie der Künste.

Further Reading: S. Michalski, *Public Monuments* (1998) B. Taylor and W. van der Wijl (eds.), *The Nazification of Art* (1990)

Crimp, Douglas *See* APPROPRIATION.

Crimson Rose *See* BLUE ROSE.

Crippa, Roberto (1921–72) Italian painter and sculptor. He was born in Monza and studied at the Brera Academy in nearby Milan, *Carrà being one of his teachers. His work was very varied. Early in his career he painted geometrical abstractions, then in the late 1940s and early 1950s he was involved in the *Spatialism movement of his friend *Fontana, whilst at the same time producing the first *Action Paintings by an Italian artist (in his series of calligraphic spiral paintings of 1949–52). In the mid-1950s he turned to various types of three-dimensional work, including cast-iron sculpture and relief collages incorporating materials such as wood and newspaper. Their expressive quality is far removed from the cool objectivity of Spatialism, but he continued to see himself as a colleague of Fontana. Crippa was a qualified pilot and died when an aeroplane he was flying crashed.

Criton, Jean *See* RÉQUICHOT, BERNARD.

Cross, Henri-Edmond (1856–1910) French painter, mainly of landscapes. He worked in an *Impressionist and then a *Neo-Impressionist style, and his use of large dots of bright colour had a brief but important influence on the early work of the *Fauves, notably *Matisse, who in 1904 visited him at his home at Le Lavandou on the Mediterranean coast when he was spending the summer at St-Tropez, near *Signac.

Crotti, Jean *See* DUCHAMP, SUZANNE.

Crown Point Press *See* PRINT RENAISSANCE.

Crumb, Robert *See* GUSTON, PHILIP.

Cruz-Diez, Carlos (1923–) Venezuelan painter and *Kinetic artist, resident in Paris since 1960. He was born in Caracas, where he studied at the School of Fine Arts, 1940–45, and from 1946 to 1951 he was director of the Venezuelan branch of the McCann Erickson Advertising Agency. In 1953–5 he was an illustrator for the newspaper *El Nacional* and taught typography, and in 1955–6 he lived in Spain; he made two visits to Paris during his stay in Europe and it was at this time that he became interested in optical phenomena. He returned to Venezuela in 1957 and became

assistant director of the School of Fine Arts in Caracas and professor of typographical design at the Central University of Venuezuela. In 1960 he settled in Paris, where he became friendly with other Latin American artists, notably his fellow Kineticist *Soto, and continued the experiments with arrangements of primary colours he had started during his earlier visits. Using arrangements of thin intersecting bands he found he could create the illusion of a third or fourth colour. This led to a series of works entitled *Chromatic Induction, Chromointerference, Additive,* and *Physichromie.* In the last—low reliefs which he started making in 1959—he created shifting geometric images that emerge, intensify, change, and dematerialize as the viewer moves in front of them. He achieved this effect by using narrow strips of painted metal or plastic arranged in parallel lines or at right angles to each other (*Physichromie 113,* 1963, reconstructed by the artist 1976, Tate). His work has been featured in many international exhibitions and he has won several awards, including the International Painting Prize at the São Paulo *Bienal in 1967. He represented Venezuela at the 1970 Venice Biennale. His later work has included architectural installations, or 'chromatic environments' as he calls them, in public buildings.

Crypt Group *See* ST IVES SCHOOL.

Cubism A term describing an innovative movement in art which became the dominant form of vanguard painting and sculpture in Paris before the First World War; it had a huge influence on fine art, and also affected design and to some extent architecture. Cubism was a complex phenomenon and involved not just a new style but, as a leading exponent Juan *Gris put it, 'a new way of representing the world'. Abandoning the idea of a single fixed viewpoint and, to a lesser extent, single moment of time, that had dominated European painting for centuries, Cubists, in the words of Mark Antliff and Patricia Leighten, overturned the methods of academic illusionism by 'introducing multiple viewpoints, distortions of form and ambiguous spatial relations into their paintings, confounding viewer expectations'. Such fragmentation and rearrangement of form meant that a picture could now be regarded less as a kind of window through which an image of the world is seen, and more as an artificial structure on which a subjective response to the world is

created: painting became a matter of two-dimensional composition rather than three-dimensional illusionism.

The early development of Cubism is associated above all with Pablo *Picasso and Georges *Braque, although the assumption in the older literature that other Cubists should be thought of simply as 'followers' is no longer accepted by all historians. At the time they began their friendship in 1907, Braque had recently been overwhelmed by the memorial exhibition of *Cézanne's work at the *Salon d'Automne, and Picasso had spent much of the year working on *Les Demoiselles d'Avignon* (1906–7, MoMA, New York), in which the angular and aggressive forms owed much to the influence of African sculpture (*see* PRIMITIVISM). These two sources—Cézanne and African art—were of great importance in the genesis of Cubism. Cézanne's late work, with its subtle overlapping patches of colour, had shown how a sense of solidity and pictorial structure could be created without traditional perspective or modelling. Former Fauve colleagues of Braque such as *Vlaminck, *Derain, and *Friesz had been drawn towards this sense of solidity but were ultimately unprepared or unable to produce paintings so difficult and challenging. African art offered an example of expressively distorted forms and freedom from inhibition. In *Les Demoiselles d'Avignon*, two of the figures are not only given faces resembling African masks, but also are twisted so that more of them is visible than could be seen from a single viewpoint. Like others who saw the picture at this time, Braque was shocked. He is recorded as saying 'in spite of your explanations, you paint as if you wanted to make us eat wick or drink gasoline' (P. Leighten, *Re-ordering the Universe,* 1989; this writer points out that this could refer to bomb-making materials). The impact of Picasso on Braque's work was immediate: in the winter of 1907–8 Braque painted a *Large Nude* (Pompidou Centre, Paris) that is virtually a variant of one of the figures in *Les Demoiselles d'Avignon*.

The pictures to which the term 'Cubism' was first applied were a group of landscapes painted by Braque in the summer of 1908, when he was staying at L'Estaque, near Marseilles. They were rejected by the *Salon d'Automne later that year, and a member of the selecting jury (*Matisse, according to some sources) is said to have remarked slightingly that they were composed of 'petits cubes'.

(According to Frank *Rutter, citing Léonce *Rosenberg as his authority, the word 'cubisme' itself was uttered on this occasion.) Soon afterwards these pictures were shown at *Kahnweiler's gallery, and in reviewing this exhibition in *Gil Blas* (14 November 1908), Louis *Vauxcelles made reference to Braque's way of reducing 'everything—sites, figures, and houses—to geometric outlines, to cubes'. The following March, describing some Braques shown at the *Salon des Indépendants, Vauxcelles used the expression 'bizarreries cubiques' (cubic eccentricities), and by 1911 the term 'Cubism' had entered the English language. The word is undoubtedly apposite for the block-like forms in some of the Braque landscapes that occasioned Vauxcelles's jibes, such as *Houses at L'Estaque* (1908, Kunstmuseum, Berne), and in a few similar works by Picasso, but it is not really appropriate to their mature Cubist pictures, in which the forms tend to be broken into facets rather than fashioned into cubes. However, they soon accepted the term, as did others. The art historian William Rubin has argued that the significance of Braque's L'Estaque paintings lies in their capacity to suggest depth while retaining a strong sense of the picture surface. For Rubin this was the vital aspect of Cézanne's legacy. The relatively solid massing of the earliest Cubist paintings gave way to a process of composition in which the forms of the object depicted are fragmented into a large number of small, intricately hinged planes that fuse with one another and with the surrounding space. There is no sense of recession, the image seeming to be compressed into a shallow, subtly modelled continuum that stretches across the entire picture surface (Braque referred to 'tactile space' and 'manual space', and later wrote 'That is what early Cubist painting was—a research into space'). This fascination with pictorial structure led to colour being downplayed ('colour disturbed the space in our paintings', said Braque), and the typical early Cubist paintings are virtually monochromatic, painted in muted browns or warm greys. The subject tends to be indicated through identifiable fragments such as the edge of a guitar or a coil of rope. Examples—showing how close the two artists were in style at this date—are Braque's *The Portuguese* (1911, Kunstmuseum, Basel) and Picasso's *The Accordionist* (1911, Guggenheim Museum, New York).

In *The Portuguese* Braque introduced the use of stencilled lettering, a practice that

Picasso adopted soon afterwards. By the following year, Braque was experimenting with mixing materials such as sand and sawdust with his paint to create interesting textures and emphasize further the idea that the picture was a physical object with its own integrity rather than an illusionistic representation of something else. He refined this notion again by imitating the effect of wood graining, using techniques that he had learnt in his early days as a painter–decorator. Later in the same year, 1912, Picasso took this a stage further when he produced his first *collages, and Braque quickly followed with his own type of collage (the *papier collé), consisting of compositions of pieces of decorative paper. These developments led to a kind of painting in which the image is built up from pre-existing elements or shapes rather than being created through a process of fragmentation. The fragments from daily life nonetheless are still present, not only as collage, but also as drawn signs. As Christopher Green puts it, 'multi-perspectival glasses, unmistakably based on part-by-part analyses, are drawn out over cut-out paper planes, beside signs for other things'. The different phases of Cubism were influentially described by Alfred *Barr as 'analytic' (*c.*1909–11) and 'synthetic' (*c.*1912–14). The distinction registers well enough in purely visual terms as a contrast between complexity and simplicity, but, as Green has argued, does not really provide a very accurate account of the artistic process, as 'analysis' and 'synthesis' can be found in both groups of paintings.

A consequence of the concern with greater surface richness was that Braque and Picasso reintroduced colour to their paintings. Examples are Braque's *Still-life with a Violin, Glass and Pipe on a Table* (also known as *Music*, 1914, Phillips Collection, Washington) and Picasso's *Still-life with a Fruit Dish on a Table* (1914–15, Columbus Museum of Art, Ohio). Collage also involved the incorporation of images of modern life, particularly consumer culture. Newspaper cuttings appear to have been chosen for content as well as appearance. It has been noted that in Picasso's collages there are many references to the Balkan wars. The exact significance of these is not straightforward. Picasso had contacts with anarchist circles and Kahnweiler was an open supporter of the political left, but, as Green has pointed out, the cuttings in *The Bottle of Suze* (1912, Washington University Gallery of Art) come from a right-wing nationalist

newspaper. Nevertheless, for some historians this gives the lie to the notion that Cubist subject-matter was no more than a neutral vehicle for painterly exploration.

After 1912, Juan Gris played as important a role as Braque or Picasso, and by this time many other artists were identifiable as Cubists, including Fernand *Léger, who is often considered the fourth major exponent. Indeed, Cubism had become the dominant avant-garde idiom in Paris as early as 1911. In that year the movement had its first organized showing when a number of Cubists exhibited together at the Salon des Indépendants, among them *Delaunay, *Gleizes, *La Fresnaye, *Metzinger, and *Picabia. They had the support of advanced critics such as *Apollinaire, but their work was met with scorn or bewilderment by many. British and American audiences had already been introduced to Braque's and Picasso's work through Roger *Fry's second *Post-Impressionist exhibition in 1912 and the *Armory Show in 1913. However, Picasso and Braque did not take part when the others exhibited collectively. Their Cubist work was generally sold by the dealer Kahnweiler to a select group of well-informed clients rather than displayed in the open marketplace in the various salons. For this reason, the public image of Cubism in its early days was provided mainly by the so-called 'Salon Cubists' rather than Picasso and Braque.

Some art historians use the terms 'true' or 'essential' Cubism (coined by Douglas *Cooper) to distinguish the work of Braque and Picasso (and later Gris and to a lesser extent Léger) from the work of these 'Salon Cubists', whom Cooper described as 'derivative'. This was a view he shared with the dealer Kahnweiler, who showed the work of the four. The distinction is problematic even if the four 'true Cubists' are still regarded as the best and most innovative. Green has criticized 'the reduction of the Salon Cubists to the condition of historical etceteras'. A different perspective would be that these 'Salon Cubists' had distinct aims, in accordance with a different context, market, and audience. They tended to specialize in large-scale multi-figure compositions and, like more traditional Salon painters, tried to engage their public with subject as much as with style. This might be allegorical in the manner of 19th-century Salon painting, as with *Abundance* (1910–11, Gemeentmuseum, The Hague) by *Le Fauconnier. Other Cubists were acutely interested in modern life and

mechanization. Robert Delaunay painted the Eiffel tower, a subject loathed by aesthetic conservatives. Cubist subject-matter also includes bicycle races (Metzinger), football teams (Gleizes, Delaunay), and, linking topicality and French patriotism, air flight (La Fresnaye, Delaunay). On the other hand, the favourite subjects of Picasso, Braque, and Gris were still-lifes (often involving fruit bowls or musical instruments), landscapes, portraits, and figure studies (Braque being more inclined to landscapes and Picasso to figures).

Léger belongs with the Salon Cubists in that he was, before the First World War, engaged in the same kind of large-scale multi-figure composition as La Fresnaye, Gleizes, and others, although he exhibited with Kahnweiler. *Les Demoiselles d'Avignon* itself was an attempt at a large-scale Salon-type picture which Picasso may have left unfinished (historians cannot agree on this), either because of an insuperable problems or because he saw the way forward, both artistically and commercially, in terms of smaller paintings.

It was the 'Salon Cubists' who initiated the engagement with architecture and design. In 1912 they collaborated with the designer André Mare (1885–1932) on a 'Maison Cubiste' for the Salon d'Automne. The outside by Raymond *Duchamp-Villon was in the form of an 18th-century French town house but with Cubist features. As well as paintings by Léger, La Fresnaye, Metzinger, Gleizes, and others, there were decorative objects and furniture. The Cubist influence on architecture and design would almost certainly have gone ahead without the presence of Picasso and Braque.

The First World War interrupted the course of Cubism. Picasso was already becoming bored with its more austere aspects and developing it in the direction of colour and fantasy, but it re-emerged as a powerful force at the end of the war, with Léonce Rosenberg beginning a series of Cubist exhibitions at his Galerie de l'Effort Moderne in 1918. By this time Cubism had already been highly influential on avant-garde art throughout Europe and had made a significant impact in the USA. It proved immensely adaptable and was the starting-point or an essential component of several other movements, including *Constructivism, *Futurism, *Orphism, *Purism, and *Vorticism, as well as a spur to the imagination of countless individual artists. These included not only painters, but also sculptors,

who adapted Cubist ideas in various ways, notably by the opening up of forms so that voids as well as solids form distinct shapes. Picasso himself made Cubist sculpture, and other leading artists who worked in the idiom include *Archipenko (whose international success played a great part in spreading Cubist ideas), Duchamp-Villon, *Laurens, *Lipchitz, and *Zadkine. Another noted Cubist sculptor was the Czech Otto *Gutfreund, who was part of a remarkable flowering of Cubist art and design in Prague in the years immediately before the First World War. Several Czech architects, mainly members of the *Group of Plastic Artists, broke up the façades of their buildings with abstract, prismatic forms in a way that clearly recalls the fragmentation of Analytical Cubism. The best-known of these architects was probably Josef Gočár (1880–1945), who also designed Cubist furniture; several pieces by him are in the Museum of Decorative Arts, Prague. In applied arts more generally, Cubism was one of the sources of *Art Deco. It had an especially powerful influence on the design of posters, for instance in the work of the French/Ukrainian Adolphe Mouron Cassandre (1901–68).

As is only appropriate to a movement which denied single point perspective, the interpretation of Cubism, even in its early years, followed a number of lines. One was to see it as essentially a form of abstract art. Apollinaire who was, after all, close to Picasso and Braque, wrote that 'The secret aim of the young painters of the extremist schools is to produce pure painting. Theirs is an entirely new plastic art' (*The Cubist Painters*, 1913). Gleizes and Metzinger were the first painters to go into print on the subject in their 1912 book *Du Cubisme*. Translated into English only a year later, it has remained an influential account of what the Cubists thought that they were doing, in spite of the authors being relatively minor painters and the language being obscure. They see Cubism as an artistic form which will 'reach the masses', emphatically not by the populist approach of speaking their language but by imposing the artist's subjective vision. They vigorously refute the notion that Cubism represents any kind of system; indeed it represents a rejection of system. Maurice Raynal (1884–1954) in 1912 argued for a painting which was conceptual rather than perceptual, like that of the early Italian painters such as Giotto. 'Conception makes us aware of the object in all its forms', as opposed to the partial knowledge provided by mere vision. Although he did not use the term 'Cubism' or mention any painter, it was clear in the context that this was a justification for the departure by advanced painters from the devices of pictorial illusionism. Kahnweiler's *Rise of Cubism* (1916) confronts the issue through the prism of idealist philosophy. By presenting multiple views, the Cubists, by which he meant Picasso, Braque, and Gris, his own 'stable' of artists, were able to provide an essential representation of the reality beyond appearances, effectively a 'higher' form of *realism.

Because Cubism made such a radical break with established traditions, initiating a new concept of pictorial space, attempts have been made to link it with new views about the nature of reality that were coming to the fore at the same time (Einstein's Special Theory of Relativity, for example, was published in 1905). There is evidence that in Cubist circles there was a great deal of interest in concepts of the fourth dimension: Apollinaire, for instance, uses this to justify a departure from Euclidian geometry. The emphasis on intuition in the philosophy of Henry Bergson (1859–1941) has also been seen by some historians as crucial to Cubism's ideological basis. Picasso himself stressed that Cubism was fundamentally about painting: 'Mathematics, trigonometry, chemistry, psychoanalysis, music and whatnot have all been related to Cubism to give it an easier interpretation. All this has been pure literature, not to say nonsense, which brought bad results, blinding people with theories. Cubism has kept itself within the limits and limitations of painting, never pretending to go beyond it' (*The Arts*, May 1923). This statement should not, of course, be employed to close down any discussion of Cubism's relationship with intellectual and political currents of the day, only to signal that the paintings of Picasso, Braque, and Gris do not illustrate them in any direct way and were not intended to.

Cubism had a huge and varied impact on 20th-century art, becoming part of the common currency of ideas. However, the nature of that influence has been reinterpreted according to changing agendas. This is not to say that any of these interpretations are wrong, only that their strength at any given time has been in some measure a function of their expediency. The notion that Cubism was fundamentally a form of superior realism, promoted by Kahnweiler, conveniently provided an explanation

as to why 'his' artists had not proceeded towards abstract art and therefore had not been left standing by painters such as *Kandinsky and *Mondrian. It also provided a convenient alibi for leftist artists under political pressure to conform to a form of realism (*see* SOCIALIST REALISM). For a much later critic, Yves-Alain Bois, writing when art theory had been strongly influenced by semiology (*see* BARTHES), Kahnweiler's reading is the starting point for an interpretation that sees Cubism as a revelation of painting in which painting can be an arbitrary system of signs. The analysis of some historians such as Barr, who linked Cubism to the rise of abstraction, was affected by an agenda promoting a 'rational' modernist architecture and design. In the 1970s the idea of Cubism as an art which emphasized the relationship to the picture plane, as proposed above all by William Rubin, influenced by the *'formalist' writing of Clement *Greenberg, helped to validate American abstraction from Pollock onwards. Writing in 2001, Antliff and Leighten described collage as 'the most influential invention of the Cubist movement on subsequent twentieth century art'. This again served a particular set of interests; this time it was one in which the preciousness of the art object was under attack and the idea of *appropriation was of great significance to current practice. Instead of thinking of the ultimate impact of Cubism in terms of something that it 'basically' or 'essentially' is, it is more appropriate to think of it in terms of the permissions it provided both for how the world was to be represented and for what materials might be used. It was this which was to make Cubism such a fertile source not just for 'disciplined' geometric art and design but also for the iconoclasm of *Dada and the explorations of the unconscious of the *Surrealists.

Further Reading: Antliff and Leighten (2001)

Y.-A. Bois, 'Kahnweiler's Lesson' *Painting as Model* (1991)

E. F. Fry, *Cubism* (1966). This contains some of the most important contemporary documentation.

J. Golding, *Cubism: A History and an Analysis 1907–1914* (2000)

Green (2000)

W. Rubin, *Cézanne: The Late Work* (1977)

Cubist Centre *See* REBEL ART CENTRE.

Cubist-Realism *See* PRECISIONISM.

Cubo-Expressionism A term coined in the early 1970s to describe a trend in Czech avant-garde art in the second decade of the 20th century in which elements of *Cubism and *Expressionism were combined. The fusion of Cubist fragmentation of form and Expressionist emotionalism is seen particularly in the work of the members of the *Group of Plastic Artists. In a broader and vaguer sense, the term 'Cubo-Expressionism' has been used to describe other aspects of Czech avant-garde art and literature in this period.

Cubo-Futurism A term applied by *Malevich to works he showed at the *'Donkey's Tail' (1912) and *'Target' (1913) exhibitions in which he combined aspects of *Cubism and *Futurism, notably the fragmentation of form of Cubism and the sense of mechanistic movement of Futurism. The term fits some of his works of this time better than others, and it has often been used rather vaguely to refer to other aspects of Russian art of the period, literature as well as painting.

Cucchi, Enzo (1949–) Italian painter and sculptor born in Morro d'Alba in the Marches. His early work was *Conceptual, but in the late 1970s he returned to painting and became one of the leading Italian *Neo-Expressionists. He is unwilling to explain his paintings, but Norman Rosenthal has argued that they should be understood in the context of the landscape around Ancona where he grew up and where he has continued to work for much of the time. Italy, Rosenthal suggests, is for Cucchi, not its great classical past, but 'an empire burned to the ground, where even the phoenix of creative life seems to be charred' (Braun, 1989). *Stupid Picture* (1982, Marx collection, Berlin) has a gigantic sleeping head, somewhere between *Brancusi and classical sculpture, in repose on top of a giant grain silo. Like his contemporary *Paladino, Cucchi is a master of dark burning colours, here invoking a kind of apocalypse.

Cuevas, José Luis (1934–) Mexican graphic artist and painter. He was virtually self-taught and is a highly individual figure. His most characteristic works are incisive satirical drawings of grotesque creatures and degraded humanity: prostitutes, poor children, and people in institutions for the insane have been among his subjects, and he has often included self-portraits in his compositions. Although these drawings are in the tradition of Goya, they are strongly flavoured by contemporary life, including horror and detective films. Cuevas had his first exhibition in 1953 in

Mexico City, when he was only 19, followed by one the next year at the Pan American Union in Washington, which launched his career abroad. In connection with this second exhibition he gave an interview for *Time* magazine in which he criticized the 'Mexican nationalism' of *Rivera and *Siqueiros (on the other hand, he admired the satirical sense of *Orozco, the third member of the great triumvirate of Mexican muralists). After thus establishing himself as an *enfant terrible*, he continued to court controversy but also gained official recognition for his work, notably with the first international prize for drawing at the São Paulo *Bienal in 1959 for his series *Funeral of a Dictator* (1958). Apart from drawings and paintings, Cuevas's work has included stage design and prints in a variety of techniques, and he has written several autobiographical books. He is considered a leading figure in offering Mexican art an alternative to the muralist tradition that had so dominated it in the first half of the 20th century. There is a museum named in his honour in Mexico City.

(⊕) SEE WEB LINKS

• Biography of Cuevas on the Art Museum of the Americas website.

Cuixart, Modest (1925–2007) Spanish painter, born in Barcelona. In his early career, he was known as Modesto Cuixart, the Catalan form of his name being problematic because of Franco's ban on the public use of the language. He began a course in medicine at Barcelona University in 1944. In 1947 he abandoned this to devote himself to painting, having already exhibited his work with some success, and in 1948 he became a founder member of *Dau al Set alongside his cousin Antoni *Tàpies. He painted in the *Surrealist manner favoured by the group, though with anticipations of expressive abstraction, and by the mid-1950s he was working in an *Art Informel style. Like Tàpies he was very concerned with textural qualities, adding grit and straw to his canvases. In the mid-1960s his paintings began to assume a more mystical character, sometimes incorporating real objects such as lacerated dolls attached to the surface of the canvas. Although he never went into complete exile during the Franco regime, he spent much of his time in France after the dictator had tried to exploit his success by describing him as 'our contemporary Goya'.

Cuixart himself maintained that the textures of his paintings conveyed the feel of the civil war and its aftermath, although *Time* magazine accused him of making 'despair chic' with 'elegant mud pies', a characteristic American denigration of European art during the height of *Abstract Expressionism. Cuixart received the award for best painter at the São Paulo *Bienal in 1959. There is a museum devoted to his work in Barcelona.

Further Reading: P. Davison, obituary *The Guardian* (15 November 2007)

Cullen, Maurice (1866–1934) Canadian painter, whose work was influential in introducing *Impressionism to his country. He was born in St John's, Newfoundland, brought up in Montreal, and originally trained as a sculptor. From 1889 to 1895 he lived in Paris and elsewhere in France, with trips to Venice and North Africa, and it was in this period that he switched from sculpture to painting. He made two shorter trips to Europe before settling for good in Canada in 1902. His subjects included city scenes (*Old Houses, Montreal, c.*1900, Montreal Museum of Fine Arts) and landscapes on the St Lawrence River, in the Laurentian hills, at St John's, and in the Rocky Mountains. After about 1920 he lived in virtual retirement in a cabin he built at Lac Tremblant in the Laurentians. His friend J. W. *Morrice said of his work: 'he gets at the guts of things'. *See also* CANADIAN ART CLUB.

Cultured Painting *See* PITTURA COLTA.

Cuneo, Terence (1907–96) British painter and illustrator, born in London. His parents were illustrators: the American-born Cyrus Cuneo (1879–1916) and Nell Tenison (1867–1953). They gave Cuneo his initial instruction in art, but his main training was at Chelsea School of Art and the *Slade School. In the 1930s he worked primarily as an illustrator, but after the Second World War (in which he served in the Royal Engineers and was an *Official War Artist) he turned more to painting. His work included official portraits, ceremonial, military, and engineering subjects (particularly railways), and fantasy scenes (typically featuring anthropomorphized mice). His autobiography, *The Mouse and his Master*, was published in 1977 and *The Railway Painting of Terence Cuneo* in 1984. A statue to him by Philip Jackson (unveiled 2004) stands in Waterloo Station.

Cuningham, Vera *See* SMITH, SIR MATTHEW.

Cunningham, Merce *See* RAUSCHENBERG, ROBERT.

Currie, Ken (1960–) Scottish painter, the most overtly political of the *Glasgow School which emerged in the 1980s. Born in North Shields to Scottish parents, he studied at *Glasgow School of Art between 1978 and 1983. While a student he discovered a strain of socially committed realist painting in the work of *Dix, *Grosz, and *Rivera. His paintings deal with issues of working-class solidarity and self-improvement but also with despair at contemporary conditions. *Edge of the City* (1987, Manchester Art Gallery) shows an environment of derelict factories and burnt-out cars in Currie's characteristic dark colouration and *Expressionist drawing. In 1987 Currie made a series of murals on the history of workers' struggle in Glasgow for the People's Palace, Glasgow, beginning with the massacre of weavers in 1787 and concluding with a future in which enlightenment is suggested by miners' lamps. There has been some debate as to how far Currie's murals should be taken straight and unironically, which the artist appears to claim, and how far they should be regarded as parodying a past tradition of *Social Realism. Their optimistic vision is hardly reflected in more recent work which deals with the effects of death and decay on the body in a somewhat photographic manner, in contrast with his vividly graphic early style.

((()) SEE WEB LINKS

• A site that provides illustrations of Currie's murals at the People's Palace.

Currin, John (1962–) American painter, born in Boulder, Colorado. He studied at Carnegie Mellon University, Pittsburgh, and Yale University. His figure paintings, usually of women, have attracted attention and controversy. They combine cartoon-like distortion with an elaborate semi-illusionistic technique which simulates flesh by the laborious layering of colour with remarkable precision. He originally used photographs in high school year books as a source of inspiration. His work was conspicuously anti-modernist. Like the *Neoclassical painters of the 1980s, he invoked the Old Masters, but not however, for their respectable associations with allegory and history, but for their frank appeal to eroticism. Rubens and Cranach are the favoured models. The Hugh Grant character in the film *Bridget Jones: The Edge of Reason* signals his lasciviousness by his admiration for Currin, and his work first emerged in the context of anxieties about 'political correctness' which created an attractive frisson of risk around eroticized images of women by male artists. An early European showing was in the Pompidou Centre exhibition 'Cher Peintre' (2002). This sought to place him within a tradition of figurative painting that embraced 'bad taste', which originated in the notorious semi-pornographic works of *Picabia from the 1940s. He has said of his painting: 'What I do is to find a cliché and try to believe in it.'

Further Reading: D. Usborne, 'The Filth and the Fury', *The Independent on Sunday* (16 March 2008)

Curry, John Steuart (1897–1946) American painter. He was born on a farm near Dunavant, Kansas, and never forgot his Midwestern roots. After studying at the Kansas City Art Institute, 1916, and the Art Institute of Chicago, 1916–18, he worked as an illustrator for pulp magazines from 1919 to 1926, then spent a year in Europe before settling in New York, where he was encouraged and supported by Gertrude Vanderbilt *Whitney. He believed that art should grow out of everyday life and be motivated by affection, and his subjects were taken from the Midwest he loved. Two of his most famous works are *Baptism in Kansas* (1928, Whitney Museum, New York) and *Hogs Killing a Rattlesnake* (1930, Art Institute of Chicago); they show his anecdotal, rather melodramatic style (he often depicted the violence of nature)—sometimes weak in draughtsmanship, but always vigorous and sincere. In the 1930s Curry was recognized—along with Thomas Hart *Benton and Grant *Wood—as one of the leading exponents of *Regionalism, and he was given commissions for several large murals: the best known—generally regarded as his masterpieces, even though the scheme was never finished—are in the state capitol in Topeka, Kansas (1938–40), where the subjects include the activities of John Brown, the famous campaigner against slavery. In 1936 Curry was appointed artist-in-residence by the College of Agriculture at the University of Wisconsin, one of the first such posts to be created in the country. He held the position for the rest of his life.

Cursiter, Stanley (1887–1976) Scottish painter (mainly of landscapes, portraits, and

figure subjects), printmaker, administrator, and writer. He was born at Kirkwall, Orkney, and after serving an apprenticeship as a lithographer he studied at Edinburgh College of Art and the *Royal College of Art, London. His best-known paintings are a series of works he did in 1913 inspired by the *Futurists—he was one of the few British artists to try to adopt their methods for representing movement. During the First World War he served in the army in France and afterwards travelled there before settling in Edinburgh in 1920. From 1924 to 1948 he worked at the National Gallery of Scotland, first as keeper and then from 1930 as director. During his directorship he proposed the foundation of a *Scottish National Gallery of Modern Art, but this did not come into being until 1960.

Curzon Committee *See* TATE.

Dacre, Winifred *See* NICHOLSON, BEN.

Dada An international movement in art, *c.*1915–*c.*1922, characterized by a spirit of revolt against traditional values. Originally, Dada appeared in two countries that were neutral during the First World War (Switzerland and the USA), but near the end of the war it spread to Germany and subsequently to other countries. The extent to which overall coherence can be ascribed to Dada is questionable. It took on board as it travelled a range of contradictory ideologies, including nihilism, individualist anarchism, and Communism. It was unified more by what it rejected than what it believed, but all of its manifestations arose from a mood of disillusionment engendered by the war. One of its prime targets was the institutionalized art world, with its bourgeois ideas of taste and concern with market values. The Dadaists deliberately flouted accepted standards of beauty and emphasized the role of chance in artistic creation. The unprecedented carnage of the war led the Dadaists to question the values of the society that had created it and to find them morally bankrupt. Their response was to go to extremes of buffoonery and provocative behaviour to shock people out of corrupt complacency. Group activity was regarded as more important than individual works, and traditional media such as painting and sculpture were largely abandoned in favour of techniques and devices such as *collage, *photomontage, *objects, and *ready-mades, in which there was no concern for fine materials or craftsmanship. Although they scorned the art of the past, the Dadaists' methods and manifestos—particularly the techniques of outrage and provocation—owed much to *Futurism; however Dada's nihilism was very different from Futurism's militant optimism. Marcel *Janco wrote, 'We had lost the hope that art would one day achieve its just place in our society. We were beside ourselves with rage and grief at the sufferings and humiliation of mankind.'

Although certain works produced in Paris before the war by *Duchamp and *Picabia are sometimes regarded as 'proto-Dada', European Dada was founded formally in Zurich in 1915 by a group of artists and writers including Jean *Arp, Hans *Richter, and the Romanian poet Tristan Tzara (1896–1963). According to the most frequently cited of several accounts of how the name (French for 'hobby-horse') originated, it was chosen by inserting a penknife at random in the pages of a dictionary, thus symbolizing the movement's anti-rational stance. The name was first used in 1916, and Arp later wrote: 'I hereby declare that Tzara invented the word Dada on 6 February 1916, at 6 p.m. . . . it happened in the Café de la Terrasse in Zurich, and I was wearing a brioche in my left nostril.' The main centre of Dada activities in Zurich was the *Cabaret Voltaire and it was primarily a literary movement, typical manifestations including the recitation of nonsense poems (sometimes several simultaneously and to a background of cacophonous noise). Tzara edited the movement's first periodical *Dada*, the first issue of which appeared in July 1917; the last issue (number eight) was published in September 1921 at Tarrenz in Austria, entitled *Dada Intirol*. This was an unusually long life, for the many other Dada periodicals that appeared were very ephemeral. The spirit of the movement often comes out not only in the contents of these journals, but also in the eccentric typography that was typical of them, different typefaces being freely mixed together in defiance of traditional notions of design.

By the end of the war Dada was spreading to Germany, and there were significant Dada activities in three German cities: Berlin, Cologne, and Hanover. In Berlin the movement had a strong political dimension (participants were close to the Communist party during a period of violence and revolution), expressed particularly through the brilliant photomontages of *Hausmann, *Höch, and *Heartfield and

through the biting social satire of *Grosz. The culminating event in Berlin was the Dada Fair held in 1920, in which a figure with a pig's head in an officer's uniform was hung from the ceiling. This resulted in a criminal charge against the organizers. The Fair also included paintings by Otto *Dix, whose work at this point combined painting with collage and had little of the technical refinement of his later work. The event also made clear the links which existed between Dada and the *Constructivist tendencies in modern art. A placard proclaimed 'Art is dead. Long live the machine art of *Tatlin', as though the nihilism of Dada had as its ultimate destiny the establishment of a new collective art on the ruins of the old individualist culture. Dix and Grosz were to become leading figures of *Neue Sachlichkeit and, if their later work was less technically novel, it continued the social criticism of the Dada period. In Cologne a brief Dada movement (1919–20) was centred on two figures: Arp, who moved there from Zurich when the war ended; and Max *Ernst, who made witty and provocative use of collage in works which anticipate the dream-like atmosphere of *Surrealism and who organized one of Dada's most notorious exhibitions, at which axes were provided for visitors to smash the works on show. In Hanover Kurt *Schwitters was the only important Dada exponent but one of the most dedicated of all.

Dada in New York arose independently of the European movement and virtually simultaneously, and was initially associated with Alfred *Stieglitz's 291 Gallery. The anti-bourgeois stance of the leading figures, Duchamp, *Man Ray, and Picabia, was rooted in an extreme individualist anarchism, quite distinct from the Marxism of the Berlin group or the nihilism of Zurich. The relative isolation from the war of the participants accounts for the generally more ironic and detached stance of New York. The fascination with the machine and the mass-produced object, as in the *ready-mades of Duchamp, was, in part, a nod to the culture of their adopted country in opposition to the 'old Europe' which had embarked on a course of self-destruction. However, some of the deliberate shock value of the European version was still cultivated. In 1917, for example, Duchamp and Picabia arranged for Arthur Cravan (1887–1919?), who combined the careers of poet, art critic, and professional heavyweight boxer, to give a lecture on modern art to a large audience including many society ladies; Cravan arrived late and

drunk, and after mounting the platform unsteadily, he proceeded to undress and shout obscenities at the audience. Eventually he was subdued by the police. Cravan was the nephew of Oscar Wilde, whom he claimed to have met in 1913, long after everyone else thought he was dead. Cravan disappeared at sea, but there have been persistent speculations about his survival; he has even been identified as the author B. Traven, an equally mysterious figure who wrote *The Treasure of Sierra Madre*. Another remarkable figure associated with New York Dada was Elsa, Baroness von Freytag-Loringhoven (1874–1927), poet, artist's model, creator of assemblages, and living art work, who shellacked her shaven skull, painted it vermilion, and wore objects such as metal teaballs as adornments.

Picabia was the most important link between European and American Dada. He founded his Dada periodical *391 in Barcelona in 1917 and he introduced the movement to Paris in 1919. In Paris the movement was mainly literary in its emphasis. Many of its participants were involved in the foundation of the *Surrealist movement, which was officially launched there in 1924. Other Dada groups appeared in Austria, Belgium, the Netherlands, and elsewhere. There was a Dada festival in Prague in 1921, in which Hausmann and Schwitters participated, and an international Dada exhibition was held in Paris in 1922. However, by this time the impetus was flagging, and at a meeting in Weimar in 1922, attended by Arp, Schwitters, and others, Tzara delivered a funeral oration on the movement. The first Surrealists, in particular André Breton, believed that the anarchic spirit of Dada was becoming a pretext for absurdity and whimsicality for its own sake and had thus lost any critical or subversive force.

Although it was fairly short-lived and confined to a few main centres, Dada was highly influential, establishing the 'anti-art' vein in modern culture. Dada stands for the moment in *modern art when the questioning of traditional forms becomes a wider critique of the institutions in which art operates. Its creative techniques involving accident and chance were of great importance to the Surrealists (*see* AUTOMATISM) and were also later exploited by the *Abstract Expressionists. Its fascination with machine imagery was one source for *Precisionism. The spirit of the Dadaists, in fact, has never completely disappeared, and its tradition has been sustained

in, for example, *Junk sculpture and aspects of *Pop art, which in the USA was sometimes known as *Neo-Dada, not always to the satisfaction of ex-Dadas. One of them, Hans *Richter, ended his book on Dada with a withering attack on Pop. The critique of traditional conceptions of the role of the artist and the art object was of enormous importance to *Conceptual art. True to the varied nature of its activities, its example could validate both highly cerebral artists such as *Kosuth and self-conscious 'bad boys' like Jeff *Koons.

Further Reading: R. Motherwell (ed.), *The Dada Painters and Poets* (1981)

F. M. Nauman (ed.), *Making Mischief: Dada Invades New York* (1996)

H. Richter, *Dada: Art and Anti-Art* (1966)

Dado *See* SURREALISM.

Dahn, Walter (1954–) German painter, born in Krefeld. A student of Joseph *Beuys, he was a leading member, alongside the Czech-born Jiri Georg Doukopil (1954–), of the Cologne-based Mülheimer Freiheit group of *Neo-Expressionist painters in the early 1980s. The two artists frequently worked in collaboration. Generally, Dahn takes a somewhat ironic stance towards the Expressionist manner. His paintings of the early 1980s were influenced by the *primitivism of *Dubuffet's imagery without any of the French artist's refinement of handling. The style can be close to caricature, the subject-matter can have a grim humour. A smoker's leg is pierced by a burning cigarette, a drinker's head and his bottle change places. In his *Ex Voto* series of 1987 he adopted Sigmar *Polke's technique of painting with dots to depict groups of *primitivist carvings.

Dalí, Salvador (1904–89) Spanish painter, sculptor, graphic artist, designer, film-maker, and writer, born in Figueras, Catalonia. An elder brother, also called Salvador, had died a few months before Dalí's birth, and in childhood he came to identify morbidly with his namesake and had a constant craving for attention. He studied at the Academy of Fine Arts, Madrid, 1921–4 and 1925–6, being suspended for a year for insubordination and eventually expelled for indiscipline. By this time he had already had a successful one-man show in Barcelona (1925), which *Picasso had admired (Dalí visited Picasso the following year when he made his first trip to Paris). After working in a variety of styles, influenced by *Cubism, *Futurism, and *Metaphysical Painting, he had turned to *Surrealism by 1929. In that year he had a sell-out exhibition at the Galerie Camille Goemans in Paris; André *Breton wrote the catalogue preface, and this marked Dalí's official membership of the Surrealist movement. As significant as his paintings in his rise to fame was the film *Un Chien Andalou* (1929), made in collaboration with Luis Buñuel. Its notorious shocking images include an eye sliced by a razor and ants crawling out of a hand. Dalí's talent for self-publicity rapidly made him Surrealism's most famous representative—its symbol in the mind of the general public. Throughout his life he cultivated eccentricity and exhibitionism, claiming that this was the source of his creative energy (one of his most outrageous stunts was delivering a lecture at the London International Surrealist Exhibition in 1936 dressed in a diving suit to symbolize the descent into the unconscious; he almost suffocated). He adopted the Surrealist idea of *automatism but transformed it into a more positive method that he named 'critical paranoia'. This involved elaborating on the images of his dreams and fantasies and substituting them for—or merging them with—the world of natural appearances. It resulted particularly in the ambiguous double images that play such a large part in his work, in which a form can be read, for example, as part of a landscape or part of a human body.

During the heyday of Surrealism in the 1930s Dalí produced several of the best-known works of the movement, using a meticulous academic technique that was contradicted by the unreal 'dream' space he depicted and by the strangely hallucinatory character of his imagery. He described his pictures as 'handpainted dream photographs' and had certain favourite and recurring images, such as the human figure with half-open drawers protruding from it, burning giraffes, and watches bent and flowing as if made of melting wax (*The Persistence of Memory*, 1931, MoMA, New York). Dalí himself said that the melting watches—one of the most parodied images in 20th-century art—were inspired by eating a ripe Camembert cheese, but some commentators have sought deeper meanings, seeing them, for example, as expressing a fear of impotence.

In the late 1930s Dalí made several visits to Italy and adopted a more traditional style; this together with his political views (he was a

supporter of General Franco) led *Breton to expel him from the Surrealist ranks in 1939 (he had been accused of 'counter-revolutionary activities' as early as 1934). He moved to the USA in 1940 and remained there until 1948. During this time he devoted himself largely to self-publicity and making money (Breton coined the anagram 'Avida Dollars' for his name). From 1948 he lived mainly at Port Lligat in Spain, but also spent much time in Paris and New York. Among his later paintings the best-known are probably those on religious themes, although sexual subjects and pictures centring on his wife, Gala, were also continuing preoccupations. The religious paintings in particular are sometimes dismissed by critics as *kitsch, but they are highly popular with the general public: in a poll published in *The Sunday Times* in 1995, *Christ of St John of the Cross* (1951, Kelvingrove Art Gallery, Glasgow) was voted readers' eighth favourite painting.

In old age Dalí became one of the world's most famous recluses, generating rumours and occasional scandals to the end (as for example when there were newspaper stories about the appearance of series of prints signed by him but evidently not made by him). Apart from paintings and prints, his output included sculpture, book illustration, jewellery design, and work for the theatre and cinema, notably a dream sequence for Alfred Hitchcock's *Spellbound* (1944). He wrote a novel, *Hidden Faces* (1944), and several volumes of flamboyant autobiography—the first of these, *The Secret Life of Salvador Dalí* (1942), was described by George Orwell as 'a striptease act conducted in pink limelight'. Although he is undoubtedly one of the most famous artists of the 20th century, his status is controversial; many critics consider that he did little if anything of consequence after his classic Surrealist works of the 1930s. There is a museum devoted to Dalí in his birthplace, Figueras (the building contains his tomb), and another in St Petersburg, Florida.

Further Reading: D. Ades, *Dalí* (1988)
M. Gale (ed.), *Dalí: Art and Film* (2007)

Dalwood, Hubert (1924–76) British sculptor, born in Bristol. He trained as an engineer, 1940–44, and served in the Royal Navy, 1944–6, before studying under Kenneth *Armitage and William *Scott at the Bath Academy, 1946–9. From 1951 to 1955 he taught at Newport School of Art, then was the third sculptor to be awarded the Gregory Fellowship at Leeds University, 1955–8, following in the distinguished steps of Reg *Butler and Armitage. Thereafter he taught at various art schools, notably as head of sculpture first at Hornsey College of Art, 1966–73, and then at the Central School of Art, London, 1974–6. He won the first prize for sculpture at the 1959 *John Moores Liverpool Exhibition and the David Bright Prize (for a sculptor under 45) at the 1962 Venice *Biennale, and he had numerous public commissions, including several from universities (for example a fountain at Nuffield College, Oxford, 1962). Dalwood's early work was very much in the vein of the raw expressive figuration of the *Geometry of Fear sculptors. His reputation, however, was made with abstract or semi-abstract works such as *Large Object* (1959, Tate), usually in aluminium, (often painted), rather than bronze. He never attempted the radical abstract quality of the *New Generation sculptors and his work still frequently suggested organic forms or landscape space. In the late 1960s, following a stay in the USA as visiting professor at the University of Illinois (1964), he turned to bigger, shiny, columnar forms. In the 1970s he began making large room installations in wood. Dalwood's propensity for large-scale sculpture had the result that some of his most ambitious works, such as *Riders and Reflections* (1964) or *Otera* (1973), had to be destroyed after their initial exhibition.

Further Reading: Arts Council of Great Britain, *Hubert Dalwood* (1979)

Daniels, René (1950–) Dutch painter, born in Eindhoven. He made apparently simple and spontaneous paintings which were, nonetheless, full of references to literature, art, and mass media. In spite of a superficial resemblance to the *Neo-Expressionist painting which was so successful in the 1980s, he located himself more alongside such ironists as *Duchamp, *Picabia, *Magritte, and *Broodthaers. In 1985 he held an exhibition entitled 'Mooie Tentoonstellingen' (Beautiful Exhibitions), dominated by a motif which can be read both as a bow-tie and a perspectival rendering of the gallery space. In 1987 he suffered a stroke and since then has been unable to paint.

Further Reading: R. Simon, 'René Daniels', *Artforum International* (December 1999)

Darboven, Hanne (1941–) German artist, born in Munich. In 1966–8 she was in New York,

where she became friendly with Sol *LeWitt and, under his influence, made drawings on graph paper which were representations of time. Afterwards she returned to Germany and has lived and worked in Hamburg ever since. Her work is based on sequences of numbers, involving the addition of calendar dates. Lucy *Lippard has written that the content of the works was not mathematics 'so much as the process of continuation—a process which takes time to do'. Thus Darboven is actually closer to *process than *Conceptual art and she has described the use of numbers as 'a way of writing without describing'. Her later work explores two ways of marking time, both objectively as a framework which can be counted by numbers, and subjectively, by the passage of events. In the latter, time is not a simple continuum but involves memory and the interaction between past and present. Between 1975 and 1985, she constructed a work consisting of more than 4,000 sheets. This marked the passage of time with torn-off calendar pages, manually transcribed texts—Darboven loves writing but dislikes reading—and photographic sections. So the work reflects on the contemporary tensions within German society referring to terrorism, the divisions between the East and West, but also on German history, the legacies of the Nazi era, and the heritage of the Romantic cult of genius. One section, produced between August and October 1982, is dedicated to the film director Rainer Werner Fassbinder, who had died prematurely earlier that year. The period of work was also marked by major political changes in West Germany, viewed with concern by Darboven, from a social-liberal to a conservative-liberal coalition. Fassbinder's development from experimental to commercial film-making reflected that change.

Dardé, Paul See DIRECT CARVING.

Darger, Henry J. See ART BRUT.

Darwin, Robin See ROYAL COLLEGE OF ART.

Dau al Set (The Seven-Spotted Dice) An association of Spanish artists founded in Barcelona in 1948 and active until 1953 (since six is the usual maximum number of spots on the side of a dice, the name implied going beyond normal limits). The artists were in opposition to the official and academic culture of the Franco era and were active in promoting Catalan identity. The painting of the group was strongly influenced by *Klee and *Miró, drawing on imagery related to magic and the occult. The most significant members were the critic Eduardo Cirlot, the philosopher and poet Arnoldo Puig, and four painters—Modesto *Cuixart, Joan *Ponç, Antoni *Tàpies, and Joan Josep *Tharrats, who edited their journal, which outlived the group, ceasing publication in 1956. The ideology of the journal reflected existentialism (see SARTRE) and Marxism. Among other artists who became known through the journal were Jorge *Oteiza and Antonio *Saura.

Davey, Grenville (1961–) British sculptor and draughtsman, born in Launceston, Cornwall. He studied at Exeter College of Art and *Goldsmiths College, London. His sculptures steer a path between *Minimal art and *Pop, very characteristic of a generation who had become sceptical of any claims to the absolute value of pure form. So his large simple upstanding sculptures make reference to buttons or squashed cans as in *HAL* (1992). He won the *Turner Prize in 1992, unexpectedly as Damien *Hirst was also in the running that year. He is Professor of Sculpture at the University of East London.

Davie, Alan (1920–) British painter, graphic artist, poet, musician, silversmith, and jeweller, born at Grangemouth, Stirlingshire, son of a painter and etcher. Davie studied at Edinburgh College of Art, 1937–40, and after serving in the Royal Artillery, 1941–6, had his first one-man show at Grant's Bookshop, Edinburgh, in 1946. He then briefly worked as a professional jazz musician (he plays several instruments) before spending almost a year (1948–9) travelling in Europe. This gave him the chance to see works by Jackson *Pollock and other American painters in Peggy *Guggenheim's gallery in Venice, and he was one of the first British painters to be affected by *Abstract Expressionism. Other influences on his eclectic but extremely personal style are African sculpture and Zen Buddhism. His work is full of images suggestive of magic or mythology (some based on ancient forms, some of his own invention) and he uses these as themes around which—like a jazz musician—he spontaneously develops variations in exuberant colour and brushwork: 'Although every work of mine must inevitably bear the stamp of my own personality, I feel that each one must, to be satisfactory, be a

new revelation of something hitherto unknown to me, and I consider this evocation of the unknown to be the true function of any art.'

After his return to Britain in 1949, Davie settled in London, where he worked until 1953 as a jeweller. By the mid-1950s, however, he was gaining a considerable reputation as a painter (he has had regular one-man exhibitions at *Gimpel Fils Gallery since 1950), and in the 1960s this became international. His many awards have included the prize for the best foreign painter at the São Paulo *Bienal of 1963 and first prize at the International Graphics Exhibition, Cracow, in 1966. Retrospectives were held at the Barbican Art Gallery, London (1993), and Tate St Ives (2003). Since 1971 he has spent much of his time on the island of St Lucia and this has introduced Caribbean influences into his imagery.

Further Reading: A. Patrizio and S. D. McElroy, *Alan Davie: Jingling Space* (2003)

Davies, Arthur Bowen (1862–1928) American painter, printmaker, and tapestry designer, born in Utica, New York. During his lifetime he had a high reputation as an artist, but he is now remembered mainly for his role in promoting avant-garde art (even though his own work was fairly conservative). Before the First World War he specialized in idyllic, fantasy landscapes inhabited by dream-like, visionary figures of nude women or mythical animals, often arranged in flat, frieze-like compositions (*Unicorns*, 1906, Metropolitan Museum, New York).

In 1911 Davies became president of the Association of American Painters and Sculptors, formed to create the exhibition that became known as the *Armory Show (1913). His wide and liberal culture and his enthusiasm for the project were largely responsible for the scope of the show and the force of its impact. After the Armory Show his work showed superficial *Cubist influence for a while, but in the 1920s he returned to a more traditional style, devoting much of his time to lithography and designing tapestries for the Gobelins factory in Paris.

Davies, John (1946–) British sculptor, born in Cheshire. He studied painting at Hull and Manchester Colleges of Art, 1963–7, then sculpture at the *Slade School, 1967–9. His work typically consists of male figures stripped to the waist, the heads cast from the life in plaster; they wear real clothes and shoes and

have glass eyes, but their flesh is painted an ashen grey and their vacant inexpressiveness of face and posture is reminiscent of shop-window display dummies. Timothy Hyman writes that 'The effect is as though we've been made to *dream* them, figures seen through rain or tears, and to take on their burden of grief' (catalogue of the exhibition 'British Sculpture in the Twentieth Century', Whitechapel Art Gallery, London, 1981). There is indeed a poignancy in such works as *Two Figures (Pick-a-back)* (1977, Sainsbury Collection, University of East Anglia) but also an element of horror when the artist incorporates what he calls a 'device' such as the muzzle in *Dogman* (1972, Tate). When the work was first seen it was related by critics to *Superrealism. Now Davies can be seen as looking forward to some of the more imaginative and challenging play with and against illusionism in the figure sculpture of such artists as Juan *Muñoz and Ron *Mueck.

Davis, Ron (1937–) American painter, born in Santa Monica and active mainly in Los Angeles. His early work was influenced by the *Abstract Expressionist Clyfford *Still, but in the mid-1960s he emerged as a leading exponent of *Post-Painterly Abstraction, painting *Hard-Edged compositions on *shaped canvases (*Vector*, 1968, Tate). Often his pictures employ motifs such as stripes, zigzags, and chequerboard patterns to create ambiguous or self-contradictory spatial effects, so his work has sometimes been classified as *Op art. The major influence on it is Marcel *Duchamp, who used perspective illusions behind a transparent surface.

(((🌐))) SEE WEB LINKS

• B. Rose, 'Ronald Davis: Objects and Illusions', on the artist's website.

Davis, Stuart (1892–1964) American painter, born in Philadelphia. He grew up in an artistic environment, for his father was art director of *The Philadelphia Press*, a newspaper that had employed *Glackens, *Luks, *Shinn, and *Sloan—the four artists who were to form the nucleus of The *Eight (1)—and his mother, Helen Stuart Foulke, was a sculptor. After leaving High School, he moved to New York at the age of sixteen and studied with Robert *Henri, 1910–13; his early works included street and bar-room scenes in the spirit of the *Ashcan School. In 1913 Davis was one of the youngest exhibitors at the

*Armory Show, which made an overwhelming impact on him: 'All my immediately subsequent efforts went toward incorporating Armory Show ideas into my work.' He began experimenting with a variety of modern idioms, but for the next few years, 1913–16, he earned his living mainly as an illustrator for the left-wing journal *The Masses*. In 1915 he spent the first of many summers in the port of Gloucester, Massachusetts, where the bright light helped to introduce stronger colour into his work. He had his first one-man exhibition (of watercolours and drawings) at the Sheridan Square Gallery, New York, in 1917.

During the 1920s Davis achieved a sophisticated grasp of *Cubism, but it was only after spending a year in Paris in 1928–9 (funded by selling two of his pictures to Gertrude Vanderbilt *Whitney) that he forged his personal style. Using motifs from the characteristic environment of American life, he rearranged them into flat, poster-like patterns with precise outlines and sharply contrasting colours (*House and Street*, 1931, Whitney Museum, New York). In this way he became the only major artist to treat the subject-matter of the *American Scene painters—extremely popular at this time—in avant-garde terms; he was both distinctly American and distinctively modern—a rare combination that won him wide admiration. During the 1930s he worked for the *Federal Art Project and became involved in the art politics of the Depression years: in 1934 he was elected president of the Artists' Union, an organization set up that year to combat alleged discrimination in the distribution of public funds to artists (he edited its journal, *Art Front*, in 1935–6); and in 1936 he was a founder member of the *American Artists' Congress, subsequently serving as its national secretary and chairman. In 1940, however, he resigned disillusioned from the Congress, and from 1940 to 1950 he taught at the New School for Social Research, New York. His work at this time became more purely abstract, although he often introduced lettering or suggestions of advertisements, etc. into his bold patterns (*Owh! in San Pao*, 1951, Whitney Museum). The zest and dynamism of such works reflect his interest in jazz; in the early 1940s he went to concerts with *Mondrian and in 1960 he said: 'For a number of years jazz had a tremendous influence on my thoughts about art and life. For me at that time jazz was the only thing that corresponded to an authentic art in America . . . I think all my paintings, at least in part, come from this influence, though of course I never tried to paint a jazz scene.' In his later years he became a much honoured figure, and received numerous prizes and awards.

Davis is generally regarded as the most important American painter to come to maturity between the two world wars and the outstanding American artist to work in a Cubist idiom. He made witty and original use of it and created a distinctive American style, for however abstract his work became he always claimed that every image he used had its source in observed reality: 'I paint what I see in America, in other words I paint the American scene.' He was an articulate defender of abstract art, an important influence on many younger artists, including his friends *Gorky and *de Kooning, and a precursor of *Pop art.

Further Reading: K. Wilkin, *Stuart Davis* (1987)

Davringhausen, Heinrich *See* NEUE SACHLICHKEIT.

Dawson, Montague *See* POPULAR PRINTS.

Deacon, Richard (1949–) British sculptor, born in Bangor, Wales. He studied at *St Martin's School of Art, 1969–72, and the *Royal College of Art, 1974–7. As a student, he was most interested in relating his sculpture to Performance. In 1978–9 he lived in New York, and after returning to London he held various teaching posts. He was one of the leading figures among the group of *New British sculptors who emerged in the early 1980s and were preoccupied with metaphorical form. He often uses ribbons of laminated wood in layers, curved by steam treatment, sometimes allowing the glue to be seen oozing from the sides. This establishes a distinctive blend of the inorganic and the organic, as the shapes are both highly sensual and precisely balanced. Galvanized steel is another favoured material. Although abstract, his work has made reference to mythology. For instance, *Falling on Deaf Ears No. 1* (1984) is a boat-like shape which recalls the tale of Odysseus, who blocked the ears of his companions with wax so that they would not be lured to their doom by the song of the sirens. In the *UW840TC* series (2001) planks of wood take on the forms of waves. (The meaning of the title is revealed when it is spoken.)

Further Reading: R. Francis, *Richard Deacon* (1985)

Dean, Graham See SUPERREALISM.

Dean, Tacita See VIDEO ART.

De Andrea, John (1941–) American
*Superrealist sculptor, born in Denver, Color-
ado, where he has continued to live and work.
He studied at the University of Colorado, Boul-
der, 1961–5, and had his first one-man exhibi-
tion at the O. K. Harris Gallery, New York, in
1970. Since then he has established a reputation
second only to Duane *Hanson in his field. Like
Hanson's, his figures are cast from the life and
are realistic to the last detail, but De Andrea's
characteristic subject-matter is very different.
He specializes in nude figures and his models
are usually young and attractive, if rather vapid
(*Model in Repose*, 1981, NG of Modern Art,
Edinburgh). He says: 'I always work towards
some idea of beauty and I thought that if noth-
ing else comes of this at least I'm going to make
a beautiful figure...I set up my own world,
and it's a very peaceful world—at least my
sculptures are.'

Debord, Guy See SITUATIONIST INTER-
NATIONAL.

decalcomania A technique for producing
pictures by transferring an image from one
surface to another. It is thought to have been
invented by the Spanish *Surrealist Óscar
*Domínguez in Paris in about 1935, although
the term had been applied in the 19th century
to a similar idea used in ceramic design (the
word comes from the French *décalquer*, 'to
transfer', + *manie*, 'mania', and in the 1860s
there was indeed a craze for transferring pic-
tures to glass, porcelain, etc.). In Domínguez's
method, splashes of colour were laid with a
broad brush on a sheet of paper. This was then
covered with another sheet and rubbed gently
so that the wet pigment flowed haphazardly
from one surface to the other, typically pro-
ducing effects resembling fantastic grottoes or
jungles or underwater growths. The point of
the process, which had the blessing of *Breton,
was that the picture was made without any
preconceived idea of its subject or form
(*sans objet préconçu*). Several other Surrealists
adopted it, most notably Max *Ernst, who
sometimes began a picture by decalcomania
and then used this as a springboard for his
imagination. See also AUTOMATISM.

De Camp, Joseph R. See TEN, THE.

de Chirico, Giorgio (1888–1978) Italian
painter, sculptor, designer, and writer, the
originator of *Metaphysical Painting. He was
born at Volo in Greece, the son of a railway
engineer who was working there, and had an
old-fashioned training at the Athens Polytech-
nic, 1903–5, followed by a year at the Academy
in Florence, 1905–6. When his father died in
1906 his mother moved the family to Munich
for the sake of her sons' education; Giorgio
studied at the Academy and his brother, who
later adopted the name Alberto *Savinio,
continued his musical training under the com-
poser Max Reger. De Chirico found the in-
struction at the Academy boring, but he was
influenced by the *Symbolist work of Max
*Klinger and the Swiss painter Arnold Böcklin
(1827–1901), with their juxtaposition of the
commonplace and the fantastic. In 1909 he
moved to Italy (dividing his time between
Florence, Milan, and Turin) and there painted
his first 'enigmatic' pictures, which convey an
atmosphere of strangeness and uneasiness
through their empty spaces, illogical shadows,
and unexpected perspectives. In 1911 he
joined his brother in Paris, where he lived
until 1915, becoming friendly with many
members of the avant-garde, including *Apol-
linaire (who championed his work) and *Pic-
asso. During this period he developed a more
deliberate theory of 'metaphysical insight' into
a reality behind ordinary things by neutraliz-
ing the things themselves of all their usual
associations and setting them in new and mys-
terious relationships. In order to empty the
objects of his paintings of their natural
emotional significance he painted tailors'
dummies as human beings (from 1914)—an
innovation in which he was influenced by his
brother.

In 1915 de Chirico (with his brother) was
conscripted into the Italian army and sent to
Ferrara. There he suffered a nervous break-
down, and in 1917 met *Carrà in the military
hospital and converted him to his views,
launching Metaphysical Painting as a move-
ment. It was short-lived, virtually ending when
de Chirico and Carrà quarrelled in 1919, but it
was highly influential on *Surrealism, and it
was during the later 1920s, when Surrealism
was becoming the most talked-about artistic
phenomenon of the day, that de Chirico's in-
ternational reputation was established. How-
ever, it was his early work that the Surrealists
admired and they attacked him for adopting a
more traditional style in the 1920s, when his

output included some distinctive pictures featuring horses on unreal sea-shores with broken classical columns. In the 1920s and 1930s he spent much of his time in Paris (and in 1935-7 he lived in the USA) before settling permanently in Rome in 1944. He produced numerous replicas and variants of his early work, sometimes unscrupulously passing them off as earlier originals (which led to considerable controversy and more than one lawsuit). His other work included a number of small sculptures (mainly from the last decade of his life) and set and costume designs for opera and ballet; his writings include a Surrealistic novel, *Hebdomeros* (1929), and two volumes of autobiography (1945 and 1960), translated into English as *The Memoirs of Giorgio de Chirico* (1971).

For most of his life, his later more classicizing painting was comparatively disregarded: it was viewed as repetitive and overmuch concerned with technical refinement. De Chirico's personal statements, as well as his self-portraits casting himself in the guise of a 16th-century gentleman, reinforced the image of a once innovatory artist who had become disenchanted with the art of the time in which he lived. The late works, however, enjoyed something of a revival in the 1980s with the interest in a new wave of *Neoclassical painters such as *McKenna and *Mariani. His influence has also extended into recent sculpture. De Chirico's idea that statues would have a greater presence if brought off their pedestals and stood directly on the floor occupying the same space as the viewer has had a resonance for the work of such sculptors as Juan *Muñoz and Katharina *Fritsch.

Further Reading: I. Far, *De Chirico* (1976)

de Francia, Peter (1921–) British painter, teacher, and writer on art, born at Beaulieu, France. He studied at the Brussels Academy, 1938–40, and then, after army service in the Second World War, at the *Slade School. After working in Canada and the USA, 1948–51, he was in charge of planning and production of art programmes at BBC Television, 1951–3. Subsequently he taught at several art schools, notably the *Royal College of Art, where he was professor of painting, 1973–86. He writes: 'I have always worked as a figurative artist and I draw more than I paint. I frequently work in series.' His work is often concerned with social comment, and his vigorous style has been compared to those of *Grosz and *Guttuso.

He has written two books on *Léger: a short study (1969) on *The Great Parade* (Guggenheim Museum, New York) in the series 'Painters on Painting' edited by Carel *Weight; and a substantial monograph (1983).

Degas, Edgar (1834-1917) French painter, graphic artist, and sculptor, one of the outstanding figures of *Impressionism. He exhibited at seven out of the eight Impressionist exhibitions, but he stood somewhat aloof from the other members of the group and his work was Impressionist only in certain limited aspects. Like the other Impressionists, Degas aimed to give the suggestion of spontaneous and unplanned scenes and a feeling of movement, and like them, he was influenced by photography (he often cut off figures in the manner of a snapshot) and by Japanese colour prints (he imitated their use of unfamiliar viewpoints). However, he had relatively little interest in landscape (he did not paint out of doors) and therefore did not share the Impressionist concern for rendering the effects of changing light and atmosphere. The appearance of spontaneity and accidental effects in his work was an appearance only; in reality his pictures were carefully composed. He said that 'Even when working from nature, one has to compose' and that 'No art was ever less spontaneous than mine'.

Degas always worked much in pastel and when his sight began to fail in the 1880s his preference for this medium increased. He also began modelling in wax at this time, and during the 1890s—as his sight worsened—he devoted himself increasingly to sculpture, his favourite subjects being horses in action, women at their toilet, and nude dancers. These figures were cast in bronze after his death. In his later years Degas was virtually blind and led a reclusive life. He was a formidable personality and his complete devotion to his art made him seem cold and aloof (as far as is known, he never had any kind of romantic involvement). His genius compelled universal respect among other artists, however: *Renoir ranked him above *Rodin as a sculptor, and in 1883 Camille *Pissarro wrote that he was 'certainly the greatest artist of our epoch'. He was the first of the Impressionist group to achieve recognition and his reputation as one of the giants of 19th-century art has endured undiminished. His influence on 20th-century art has been rich and varied—on artists whom he knew personally, such as

*Sickert, and on later admirers. He was a superlative draughtsman and his work has appealed greatly to other outstanding draughtsmen, such as *Hockney and *Picasso. His mastery of pastel was an inspiration to *Kitaj.

Further Reading: R. Kendall, *Degas: Beyond Impressionism* (1996)

degenerate art (*entartete Kunst*) Term applied by the Nazis to all contemporary art that did not correspond to their ideology (*see* NATIONAL SOCIALIST ART). Such art, which included most avant-garde work, was systematically defamed and suppressed in Germany throughout the period when the Nazi Party ruled the country, 1933–45. The first of a number of exhibitions designed to ridicule modern art was held at Karlsruhe in 1933, soon after Hitler took power, and Hitler made his first speech against 'degenerate art' at Nuremberg in 1934. The ruthless campaign against modern ideas in art included the closing of the *Bauhaus ('a breeding-ground of cultural Bolshevism') in 1933 and culminated in 1937 with the infamous exhibition entitled 'Entartete Kunst' in the old gallery of the Hofgartenarkaden in Munich. It opened on 19 July, a day after the first annual 'Great German Art Exhibition' of officially approved art had opened in the House of German Art nearby. The works displayed as 'degenerate' were confiscated from German museums and were mocked by being shown alongside pictures done by inmates of lunatic asylums. They were grouped into sections under such headings as 'Mockery of German Womanhood', 'Destruction of the Last Vestige of Race Consciousness', and 'Vilification of the German Heroes of the World War'. The artists represented were mainly German (by birth or residence), but a few foreigners were included. Among the total of over 100 were many distinguished figures and several of the giants of 20th-century art: *Beckmann, *Ernst, *Grosz, *Kirchner, *Klee, *Kokoschka, *Marc, *Mondrian, *Picasso (the inclusion of Marc caused some embarrassment, for he had been killed in action fighting for Germany—as a volunteer—in the First World War).

As a propaganda exercise the exhibition was a huge success: more than two million people went to see it in Munich and similar huge crowds turned out when it toured other major German cities. Georg Bussmann writes that 'Never before or since has an exhibition of modern art reached a greater number of people, or found a greater resonance, than this anti-exhibition' ('German Art in the 20th Century', Royal Academy, London, 1985). The guards on duty were instructed to be on the look-out for visitors who did not appear to be suitably enraged or amused by the exhibits. One visitor is recorded as saying: 'The artists ought to be tied up next to their pictures, so that every German can spit in their faces—but not only the artists, also the museum directors who, at a time of mass unemployment, poured vast sums into the ever-open jaws of the perpetrators of these atrocities' (Richard Grunberger, *A Social History of the Third Reich*, 1971). More than 700 works were shown out of a total of about 16,000 confiscated from museums throughout the country (the worst sufferers were the National Gallery, Berlin, the Folkwang Museum, Essen, and the Kunsthalle, Hamburg, with over 1,000 works each). They were chosen by a committee led by the painter Adolf Ziegler: 'From the field of degenerate art those works are to be viewed which offend against German sentiment, destroy or distort natural form, or display obvious evidence of inadequate craftsmanship or artistry on the part of the producer.' Some of these works were sold by auction in Lucerne in 1939, Nazi officials helped themselves to others, and the 'unsaleable stock' is said to have been burnt in Berlin (although it has been doubted whether this really happened).

The attack on *entartete Kunst* was directed not only against innovative art but also against anyone who was in sympathy with it. Such people were dismissed from their posts in museums and teaching institutions and deprived of their honours. In 1935 a decree brought all exhibitions, public and private, under the control of the Reich Chamber of Culture (Reichskulturkammer). Artists who refused to conform were faced with formidable sanctions. These 'ranged from *Lehrverbot* (deprivation of the right to teach) through *Ausstellungsverbot* (deprivation of the right to exhibit) to the most crippling of all, *Malverbot* (deprivation of the right to paint). Lest the *Malverbot* should be circumvented in the privacy of an artist's home, the Gestapo would carry out lightning raids of inspection, checking up—as in Carl *Hofer's case—on whether the paint brushes were still wet. They also placed lists of proscribed artists in the paint shops, so as to cut off their supply of materials at source' (Grunberger).

The speeches and writings of Hitler and Alfred Rosenberg (the chief theoretical

spokesman of Nazism) linked artistic production with political and racial doctrines (in *Mein Kampf* Hitler wrote: 'Was there ever any filth, any form of indecency, especially in cultural life, in which at least one Jew was not involved?'), but it is significant that the artist who had the 'distinction' of having the most works confiscated as degenerate (more than 1,000, mainly graphics) was Emil *Nolde, who was racially 'pure' and had even been a member of the Nazi party. He protested in vain to Joseph Goebbels, the propaganda minister: 'My art is German, strong, austere and sincere.' The suppression of 'degenerate art' was not, therefore, simply a matter of political expediency, but also a symptom of the general antipathy to new forms of artistic expression that has been such a feature of the history of 20th-century art. In the normal course of events such hostility rarely goes beyond verbal abuse and occasional acts of vandalism, but in Nazi Germany aesthetic revulsion was armed with tyrannical power.

Degouve de Nunques, William *See* LUMINISM.

de Grey, Sir Roger *See* ROYAL ACADEMY OF ARTS.

Deineka, Alexander (1899–1969) Russian painter, sculptor, graphic artist, and designer of mosaics, born at Kursk. He studied at Kharkov Art Institute, 1914–17, and—after serving in the Red Army—at *Vkhutemas in Moscow. Deineka is described by Alan Bird (1987) as 'the artist who most successfully created a style which was entirely at one with the spirit of the proletarian revolution and the rebuilding of socialist Russia', his work concentrating on 'the heroic effort to defend the homeland and rebuild its economic strength, and on the life of the anonymous citizen caught up in great historical events'. His most famous work is *The Defence of Petrograd* (1927, Tretyakov Gallery, Moscow), which Bird describes as 'one of the great humanitarian (and proletarian) creations of the 1920s'. The flat, frieze-like arrangement of the figures—grimly determined workers-turned-soldiers—recalls *Symbolist painting, but in the 1930s Deineka's work became less innovative formally, moving within the mainstream of *Socialist Realism demanded by Stalin's oppressive regime. In spite of the restraints this imposed, his work kept its sense of honesty and humanity. The great reputation he enjoyed in Soviet Russia is indicated by the fact that—most unusually—he was allowed to exhibit his work abroad and even travel abroad himself (he won a prize at the *Carnegie International in 1932 and visited France, Italy, and the USA in 1935). Among the most notable of his later works is the mosaic ceiling decoration of Novokuznetskaya Station (1943–4) on the Moscow metro.

de Kooning, Willem (1904–97) Dutch-born painter (and latterly sculptor) who became an American citizen in 1962, one of the major figures of *Abstract Expressionism. He was born in Rotterdam, where he was apprenticed to a commercial art and decorating firm in 1916, at the age of twelve; from 1916 to 1924 he also studied at night at the Rotterdam Academy. In 1926 he went to America as a stowaway and in 1927 settled in New York. For the next few years he supported himself mainly as a housepainter, signwriter, and carpenter. In 1935–6 he worked on the *Federal Art Project and thereafter he was a full-time painter.

De Kooning's early work had been conservative, but in 1929 he met Arshile *Gorky who became one of his closest friends and introduced him to avant-garde circles. Other friends in his early days in the USA included Stuart *Davis and John *Graham; de Kooning referred to these two and Gorky as 'the three smartest guys on the scene'. During the 1930s and 1940s de Kooning experimented vigorously and was especially strongly influenced by Gorky. He said 'I am an eclectic artist by choice; I can open almost any book of reproductions and find a painting I could be influenced by.' By the time of his first one-man show in 1948 (at the Egan Gallery, New York) he was painting in an extremely energetic abstract style (often in black and white). The exhibition established his reputation (although prosperity was still some years away) and after it he was generally regarded as sharing with Jackson *Pollock the unofficial leadership of the Abstract Expressionist group.

Unlike Pollock, de Kooning usually retained some suggestion of figuration in his work. De Kooning's oft-quoted statement that flesh was the reason for the invention of oil paint certainly suggests a view of art quite at odds with *formalist theories. Clement *Greenberg in 1949 told the artist that it was now impossible to paint a face. De Kooning replied that it was impossible not to, an attitude that was very much part of his systematic rejection of all dogma, which extended to his political stance. In 1953 he caused a sensation when his *Women* series (*Women Nos. I–VI*) was

exhibited at his third one-man show, at the Sidney *Janis Gallery. *Woman I* (1950–52, MoMA, New York), a massive figure with a grotesque leer, shocked the public. Greenberg considered the series inferior to the earlier more abstract work, but New York's other most influential critic of avant-garde art—Harold *Rosenberg—supported de Kooning. *Woman I* became one of the most reproduced paintings in the USA. Part of its reputation derived from the unusual circumstances in which it was first made public. Its long gestation was made the subject of a feature in *Art News* entitled 'De Kooning paints a picture'. De Kooning's constant reworking of the painting, totally at odds with journalistic stereotypes of the Abstract Expressionist painter, was made possible by a specially devised technique which helped him keep the paint fluid over many months of work.

Irving *Sandler writes that his 'works of the late 1940s and 1950s gave rise to hundreds of imitations. Indeed, of the older Abstract Expressionists, he was the most influential on the generation that matured in the 1950s. Accountable for his leading role was the freshness of his paintings and their masterliness, his availability to younger artists, his charismatic personality, and his verbal brilliance.' His paintings continued to mix abstract and semi-figurative work and in 1969 he began making sculpture—figures modelled in clay and later cast in bronze. However, many critics consider that his best work was done by the late 1950s: in particular, controversy exists over the value which should be accorded to his final paintings, far more thinly painted and elegant, made when the artist was incapacitated by Alzheimer's disease. In 1994–5 a large retrospective was shown in Washington, DC (NG), New York (Metropolitan Museum), and London (Tate Gallery).

His wife, **Elaine de Kooning** (1919–89), was also a painter, notably of *Expressionist portraits, and a writer on art. The couple married in 1943, separated amicably in 1957, and reunited in 1975. A collection of her writings, *The Spirit of Abstract Expressionism*, was published in 1994. Many of her articles and reviews had originally appeared in *Art News*, of which she became editorial associate in 1948.

Further Reading: D. Sylvester et al., *Willem de Kooning Paintings* (1994)

Delaunay, Robert (1885–1941) French painter, born in Paris into an aristocratic fam-

ily. In 1902–4 he was apprenticed to a firm that produced theatre sets, then took up painting (in which he was essentially self-taught), first exhibiting his work in public (at the *Salon des Indépendants and the *Salon d'Automne) in 1904. Initially he painted in an *Impressionist style, but in 1906 he began the experiments with the abstract qualities of colour that were to provide the central theme of his career. His starting-point was the *Neo-Impressionism of Georges Seurat, but instead of using Seurat's pointillist technique he investigated the interaction of large areas of contrasting colours. He was particularly interested in the interconnections between colour and movement. By 1910 he was making an individual contribution to *Cubism, combining its fragmented forms with a personal use of vibrant colour and applying them to the dynamism of city life rather than to the standard Cubist repertoire of still-life and so on. In particular he did a memorable series of paintings of the Eiffel Tower, in which the huge monument seems to be unleashing powerful bursts of energy (*The Eiffel Tower*, 1910, Guggenheim Museum, New York). He had his first one-man show in February 1912 at the Galerie Barbazanges, Paris, and by the end of the year he was painting completely abstract pictures (the first French artist to do so). *Apollinaire gave the name *Orphism to Delaunay's work of this period because of its analogies with the abstract art of music.

In 1911 *Kandinsky had invited Delaunay to take part in the first *Blaue Reiter exhibition, and in 1913 he had a one-man show at the *Sturm Gallery in Berlin. His work was a major influence on German *Expressionists such as *Klee, *Macke, and *Marc, and it also powerfully affected the *Futurists in Italy and the American *Synchromists. Delaunay was notoriously competitive and fully aware of the importance of his work: at about this time he drew up a list of all the artists, however minor, he thought he had influenced. However, the period when he was a key figure in modern art was fairly brief: he lived in Spain and Portugal during the First World War and after his return to Paris in 1920 his work lost its inspirational quality and became rather repetitive. His home became a meeting-place for *Dada artists, but Delaunay's own paintings continued to be related to colour theories. His last major works (done in collaboration with his wife, Sonia *Delaunay-Terk) were large murals for pavilions in the Paris World

Fair of 1937 (his training as a scene painter gave him a lifelong taste for working on a big scale). He died following an operation for cancer.

Delaunay-Terk, Sonia (1885–1979) Russian painter, graphic artist, and designer, active in Paris, the wife of Robert *Delaunay. Her original surname was Stern, but she adopted the name Terk from a wealthy uncle who brought her up in St Petersburg. Max *Liebermann was a friend of the family and encouraged her to paint. She settled in Paris in 1905, married Delaunay in 1910 (after a short-lived marriage of convenience to Wilhelm *Uhde), and became associated with him in the development of *Orphism. During the 1920s she worked mainly as a designer of hand-printed fabrics and tapestries; she made a strong impact on the world of international fashion, designing creations for such famous women as Nancy Cunard and Gloria Swanson. The Depression affected her business, however, and in the 1930s she returned primarily to painting and became a member of the *Abstraction-Création association. After the death of her husband in 1941 she continued to work as a painter and designer. In 1963 she gave 58 of her own works and 40 of her husband's to the Musée National d'Art Moderne, Paris; they were exhibited at the Louvre the following year and she thus became the first woman to be exhibited at the Louvre during her lifetime.

Delbanco, Gustav *See* BROWSE, LILLIAN.

Deller, Jeremy (1966–) British installation, video, and Performance artist, born in London. He studied history of art at the Courtauld Institute of Art (*see* COURTAULD), where he specialized in Baroque festivities and became especially interested in the idea of art as communication. His work has been in various media but has been centred on an almost anthropological exploration of communities through their histories and artefacts. His best-known work, *The Battle of Orgreave* (2001), was the re-creation of a violent conflict between miners and police which took place during the 1984 strike. This was staged in the manner that historic battles such as those of the English Civil War are re-created by re-enactment societies. Miners and policemen involved in the original event took part and it was filmed for television, but the highly polemical tone of the film, directed by Mike Figgis, was somewhat at odds with the more

conciliatory intentions of Deller's event, which took place in an atmosphere something akin to a village fête, with police and miners exchanging roles. He was awarded the *Turner Prize in 2003.

Further Reading: C. Bishop, 'The social turn: collaboration and its discontents', *Artforum International* (February 2006)

Delvaux, Paul (1897–1994) Belgian painter and printmaker. He was born at Antheit, near Huy, the son of a lawyer, and studied at the Académie des Beaux-Arts in Brussels, 1920–24. His early work was close to *Social Realism: he was almost trying to do for the railways what *Meunier did for the mines. In the later 1920s, he was strongly influenced by the Expressionism of *Permeke and de *Smet. He discovered *Surrealism, especially the paintings of Giorgio *de Chirico, in the 'Minotaure' exhibition in Brussels in 1934. He was never formally a member of the movement, and was not in sympathy with its political aims: his personal friendships tended to be with more traditional artists. *Ensor—the two artists shared a love of skeletons—was certainly as strong an influence as any Surrealist painter. (Delvaux seems to have had rather strained relations with *Magritte, who called him 'Delvache', perhaps jealous that Delvaux could draw much better.) Nonetheless he was admired by André *Breton, who said that 'Delvaux has turned the whole universe into a single realm in which one woman, always the same woman, reigns over the great thoroughfares of the heart.' In fact, most of his paintings show nude or semi-nude women in incongruous settings. The women are always of the same type—beautiful, statuesque, unattainable dream figures, lost in thought or reverie or even in a state of suspended animation. Male figures tend to be absorbed in their newspapers, or the study of stones. The dream beauties are often placed in elaborate architectural settings, reflecting both de Chirico's strange perspectives and Delvaux's interest in the buildings of ancient Rome (he visited Italy in 1938 and 1939). The grandiosely classical centre and the suburbs of Brussels, crisscrossed by tramlines were, however, just as significant. (Delvaux had initially studied architecture rather than painting but had found the mathematics an insuperable obstacle.) The most important single source of inspiration for Delvaux was his discovery in 1932 of the Musée Spitzner, a travelling

exhibition of medical curiosities, which set up camp annually near the Gare de Midi in Brussels. This became the source for a whole series of paintings in which Delvaux explored the themes of love and death. *Sleeping Venus* (1944, Tate) is one of a number of paintings inspired by a star attraction, the waxwork of a naked woman which appeared to breathe. She is accompanied by a skeleton and one of his characteristic ladies in flowery hats. During the German occupation, the Musée Spitzner was no longer available. Grieving figures in the background may signify the agony of loss. Trains and trams are a further motif and are strongly associated with eroticism: it is hardly a coincidence that in Belgian cities the trains often pass close to the windows of the red-light districts. A large retrospective of Delvaux's work was held at the Palais des Beaux-Arts, Brussels, in 1944, and this marked the beginning of his international reputation, although his work after that time is usually considered to be of less consistently high quality. From 1950 to 1962 he taught at the École Superieure d'Art et d'Architecture in Brussels. There is a museum devoted to his work at Saint-Idesbald, Belgium.

Further Reading: D. Scott, *Paul Delvaux: Surrealizing the Nude* (1992)

Delvoye, Wim (1965–) Belgian artist, born at Wervick. He has lived and worked in Ghent and London. His art is paradoxical and provocative: he is a Belgian eccentric with a sinister edge in the tradition of René *Magritte and Marcel *Broodthaers. *Concrete Mixer* (1993) recreates the object of the title in elaborately carved and painted woodwork. He has tattooed pigskins and live pigs with Baroque patterns. *Compass Rose of Wind* (1993) consists of four bronze figures on plinths arranged at the points of the compass. They pose with their buttocks pushed back, with fingers stopping their eyes and ears. A tube, which the viewer can peer right through, extends from their mouths to their anuses. The personification of the winds, as of other natural forces, is, of course, traditional in art and mythology. What this work achieves is to resuscitate that frightening sense of the loss of human identity which such representations entail. Delvoye is concerned with the interrelationship between different systems, human, mechanical, and animal. *Cloaca* (2000) and *Cloaca Turbo* (2003) take this project to an extreme point. They are elaborate machines, constructed

with the aid of scientists from Antwerp University, which reproduce the human digestive system. (The latter example looks, paradoxically, like a series of washing machines.) Fed two meals a day, with moderate portions of alcohol and Coca-Cola to aid the digestive process, they produce real excrement. The idea of the machine taking over human functions, a dream and nightmare of modernity, has been taken to an absurd level. Delvoye has also exhibited X-ray photographs of sexual acts, reviving another tradition of allegorical representation, the *memento mori*, for the contemporary world.

Demand, Thomas See PHOTO-WORK.

Demarco, Richard (1930–) Scottish painter, printmaker, dealer, entrepreneur, writer, lecturer, and broadcaster, a many-sided and outspoken character who has done much to promote modern art in Scotland. He was born in Edinburgh and studied there at the College of Art, 1949–54. His work as an artist—mainly in the form of watercolours and prints—is fairly conventional, and he is considered of much greater significance for his other activities. From 1966–92 he ran the Richard Demarco Gallery in Edinburgh, and he organized many exhibitions at the Edinburgh Festival, introducing the work of numerous avant-garde artists, notably Joseph *Beuys, to British audiences. In addition, he has acted in feature films (including Bill Forsyth's comedy *That Sinking Feeling*, 1979), made radio and television broadcasts, and—according to his entry in *Who's Who*—'lectured in over 150 universities, art colleges, schools, and art galleries'. In 1993 he became professor of European cultural studies at Kingston University, Surrey, a post he held until 2000. Always unpredictable, he came to the defence of Jack *Vettriano, hardly an avant-garde figure, when the latter was accused of plagiarism.

De Maria, Walter (1935–) American sculptor and *Land artist. He was born in Albany, California, and studied at the University of California, Berkeley, 1953–9. In 1960 he moved to New York, where he took part in early *Happenings, worked in various media, and composed music (in 1965 he worked for a short time as drummer in the Velvet Underground rock group). An early sculpture was *Ball Drop* (1961). Superficially it looks like a work which anticipates *Minimal art in that it consists of a tall hollow wooden box. The point

of it is, however, spectator participation and so the piece makes more sense in the context of a Happening. There are two square holes, one at the top and one at waist height. The viewer is invited to take a ball from the lower and drop it through the higher. Any expectation that, while out of sight, the ball will pass through an invisible maze, is confounded by the banal truth when it almost instantly appears with a thud at the bottom. In 1968 De Maria had a one-man show at the Heiner Friedrich Gallery, Munich, at which he exhibited a room filled wall to wall with earth—1,600 cubic feet (45 cubic metres) in all. In 1969 he showed at the Dwan Gallery, New York, the most aggressive of all Minimalist installations, the *Bed of Spikes*, a group of sculptures which could potentially cause serious injury to a visitor who fell on one of them. (Visitors had to sign a document, indemnifying artist and gallery from any responsibility.) His work as a Land artist represents the genre at its most grandiose. *Mile Long Drawing* (1968) consists of two parallel chalk lines 12 feet apart in the Mojave Desert. *Lightning Field* (1977) consists of an area of one mile by one kilometre in a desert in New Mexico, with 400 polished stainless steel poles. These may possibly induce a lightning display but this is, according to the *Lightning Field* website, not crucial to the experience. It is, however, only available to those who book an overnight stay in the official cabin, so that they may spend time walking through the poles and experiencing sunrise and sunset. In *documenta 6 at Kassel, he sunk a kilometre deep hole in the Friedrichplatz which was then plugged with a kilometre of brass. The extravagance of the gesture, rumoured to have cost $300,000, raised issues about the kind of financial muscle behind the dominance of American art.

SEE WEB LINKS

• Interview with the artist on the website of the Smithsonian Institute Archives of American Art.

Demuth, Charles (1883–1935) American painter and illustrator. He was born in Lancaster, Pennsylvania, and had his main training at the Pennsylvania Academy of the Fine Arts, Philadelphia, 1904–11. He made visits to Europe in 1907–8, 1912–14, and 1921, staying mainly in Paris, and during the second of these visits he became seriously interested in avant-garde art, particularly *Cubism. Its influence was felt in his paintings of architectur-

al subjects from about 1916 and he became one of the leading exponents of *Precisionism. His distinctive output also included sinister and sexually morbid illustrations to books such as Zola's *Nana* and Henry James's *The Turn of the Screw* (these were done not on commission, but for his own enjoyment—he came from a wealthy family and could afford to indulge himself). His most personal paintings are what he called 'poster portraits' (pictures composed of words and objects associated with the person 'represented'). The most famous example is *I Saw the Figure Five in Gold* (1928, Metropolitan Museum, New York), a tribute to the poet William Carlos Williams and named after one of his poems.

Demuth was lame from childhood and in the last decade of his life was debilitated by diabetes. Often he worked on a small scale in watercolour, rather than in more physically demanding media. The fastidious taste and concentrated energy of his work is suggested by his comment: 'John *Marin [another great American watercolourist] and I drew our inspiration from the same source, French modernism. He brought his up in buckets and spilt much along the way. I dipped mine out with a teaspoon, but I never spilt a drop.'

Further Reading: A. L. Eiseman, *Charles Demuth* (1986)

Denes, Agnes (1938–) American *Land artist, born in Budapest. Her family moved to Stockholm and she settled in New York in 1954. Her studies were in science and philosophy as well as art. After working in a variety of styles, she abandoned painting altogether in 1968 and embarked on interventions in the environment which combine mathematics and philosophy. The first of these was entitled *Rice/Tree/Burial* (1968). First Denes cleared a space in Sullivan County, near New York. This was planted with rice. In adjoining forest, trees were enchained so that they would grow towards each other. In the third part of the work Denes buried a time capsule containing her poetry. Denes kept no copies herself, permanently confiding them to the soil. She has written that 'The act of burial...marks our intimate relationship to the earth.' Like much of the artist's work, this was a piece which unfolded in time. The critic Thomas McEvilley has proposed that the meaning of the work can be understood in relation to mythology. The rice crop represents Demeter, the earth mother. The confinement of the trees stands for Artemis the huntress. Athena the goddess

both virginal and maternal reconciles the two (*Art in America*, November 2004). In 1982 Denes planted a wheat field at the base of the World Trade Center, New York, in order to call attention to our 'misplaced priorities and deteriorating human values'. After the harvest the site was returned to construction. The work of Denes is deliberately planned to involve a high degree of participation by others. *Tree Mountain—A Living Time Capsule—11,000 People, 11,000 Trees, 400 Years* (1982–6) is a mountain of 11,000 trees planted in a spiral pattern (Ylöjärvi, Finland). It is intended to hold back the erosion of the land, to provide an environment for wildlife. It also had a symbolic function in representing the work and interaction of all the individuals involved who would, it was intended, continue to look after the environment after Denes had gone.

Denis, Maurice (1870–1943) French painter, designer, lithographer, illustrator, and writer on art theory. He was born at Granville and spent most of his life at St Germain-en-Laye, a suburb of Paris. In 1888 he became a student at the *Académie Julian and in the same year, with a number of fellow students including *Bonnard and *Sérusier, he founded a group of *Symbolist painters called the *Nabis. Together with Sérusier, Denis was the chief theorist of the group; he published articles in several reviews, most notably 'Définition du Néo-traditionnisme' (Definition of Neo-Traditionalism), which appeared in *Art et critique* in August 1890. This 'Manifesto of Symbolism', as Denis later called the article, contains a pronouncement that has become famous as an anticipation of the underlying principle of much modern—especially abstract—art: 'Remember that a picture—before being a war horse or a nude woman or an anecdote—is essentially a flat surface covered with colours assembled in a certain order.' Denis's early work, strongly influenced by *Gauguin, did indeed place great emphasis on flat patterning, but he did not intend to encourage non-representational art, for he was also very much concerned with subject-matter: he was a devout Catholic and wanted to bring about a revival of religious painting. Many of his easel paintings have religious subjects, and in 1899 he carried out his first large-scale religious commission—a mural in the Chapelle de la Sainte-Croix at Vésinet. Numerous others followed, and in 1919 he founded the

Ateliers d'Art Sacré with Georges Desvallières (1861–1950) to provide church decorations of various kinds, including mosaics and stained glass.

Typically Denis's style in his religious work was tender and mild, with pale colours and relaxed lines. He also did a good deal of secular decorative work, for example murals at the Théâtre des Champs-Elysées, Paris (1912), and a series of eleven large canvases on *The Story of Psyche* (1908–9) for the Moscow home of Ivan *Morozov (Denis visited Moscow in 1909 in the course of this work). Throughout his career he continued to paint small-scale works, many depicting his own family life. His most famous single picture is probably *Homage to Cézanne* (1900, Musée d'Orsay, Paris) showing Denis himself and a number of Cézanne's other admirers, including Bonnard, *Redon, Sérusier, and *Vuillard, gathered round a still-life by the master. His best paintings were done early in his career; after about 1900 they became more classical in style (influenced by visits to Italy) and increasingly bland. Denis's prolific output also included lithographs, book illustrations, and designs for the stage. He also found time to teach at the Académie Ranson, 1909–19. His critical writings are for the most part collected in *Théories* (1912) and *Nouvelles Théories* (1922). In 1939 he published *Histoire d'art religieux*, and his *Journal* was posthumously published in three volumes in 1957–9. Denis died after being hit by a lorry. The 17th-century building that was his home in St Germain-en-Laye from 1914 has been converted into the Musée du Prieuré, housing a fine collection of works by himself and his associates.

Denny, Robyn (1930–) British abstract painter, printmaker, and designer. He was born at Abinger, Surrey, and studied at *St Martin's School of Art and the *Royal College of Art, 1951–7. He was among the young British painters enormously impressed by the scale and energy of *Abstract Expressionist painting. Early paintings such as *Red Beat 6* (1958) combined *gestural handling with lettering: like the *Pop artists, Denny was fascinated by the qualities of urban space. In 1959, alongside Richard *Smith and Ralph Rumney (1934–2002), a painter with connections to the *Situationist International, he mounted 'Place' at the *Institute of Contemporary Arts in London. The paintings were organized in a kind of maze which forced the viewer up close against

them. In 1960 he helped organize the first *'Situation' exhibition, a landmark in British abstract art. One of the pictures he showed there is *Baby is Three* (1960, Tate), which is typical of the calm, meditational character of his work. The title derives from a science fiction story. In his work of the early 1960s he used very soft, muted colours applied with an immaculate flat finish within a subtle geometrical framework which tends to suggest doorways or other architectural features. Later his brushwork became more painterly. In 1973 he became the youngest artist ever to be given a Tate Gallery retrospective. He has received many public commissions, including a series of vitreous enamel panels at Embankment Underground Station in London.

Further Reading: D. A. Mellor, *The Art of Robyn Denny* (2002)

Depero, Fortunato (1892–1960) Italian painter, poet, designer, and experimental artist, born at Fondo in the South Tyrol, which was Austrian territory until 1918. In 1913 he moved to Rome, where he was befriended by *Balla and *Marinetti and became a member of the *Futurist movement. He was co-signatory with Balla of a *Manifesto for a Futurist Reconstruction of the Universe* in 1915 and continued his Futurist activities after the First World War. In 1928–30 he lived in New York, where he designed magazine covers and restaurant decor (including murals). He was also involved in stage design and advertising work, notably a campaign for Campari. For most of his later life he lived in Rovereto, near his birthplace, where a museum devoted to him was opened in 1959, a year before his death.

Derain, André (1880–1954) French painter, printmaker, theatrical designer, and sculptor, born at Chatou on the outskirts of Paris, the son of a prosperous pastrycook. In 1898–9 he studied at the *Académie Carrière, where he became a friend of *Matisse, and in 1900 he met *Vlaminck, with whom he shared a studio for a while. From 1901 to 1904 he did his military service and had little time for painting. After leaving the army he worked closely with Matisse and Vlaminck. In 1905 Ambroise *Vollard bought the entire contents of his studio and later that year he was one of the painters who gave birth to *Fauvism at the *Salon d'Automne. A good example of his Fauve period is his portrait of Matisse (1905,

Tate); Tate also has Matisse's portrait of Derain, executed at the same time, when they were painting together at Collioure, near the Mediterranean border with Spain. In the Collioure paintings Derain used the white background against which were placed slabs of colour to vividly evoke the warmth of the sun. Vollard had been impressed by the success of *Monet's paintings of London and so sent Derain there in 1905 and 1906 to work. Derain found the grimy scenes of the river especially conducive to his brilliant colour. He shared the interest of other vanguard painters in Paris in large-scale figure compositions. *L'Age d'or* (1906, Museum of Modern Art, Tehran) was his response to the tradition of representations of an ideal world of leisure also addressed by Matisse in *Luxe, calme, et volupté* (1904–5, Musée d'Orsay, Paris). *Bathers* (1907, MoMA, New York) announced the transition to a more austere manner. There is still some of the intensity of colour of the Fauve period, but it is directed towards the construction of volume in the manner of Cézanne. In 1907 Derain signed a contract with *Kahnweiler (*Braque's and *Picasso's dealer). His contacts in the Cubist circle included *Apollinaire, whose first book, *L'Enchanteur pourrissant* (1909), he illustrated with woodcuts. However, his links with Cubism were fairly short-lived and he never adopted the kind of fragmentation or distortion associated with Picasso and Braque. By 1911 he was painting pictures whose archaic stylization reflects the influence of Byzantine art. Another aspect of his involvement in the avant-garde during this period of vigorous experimentation was his interest in African sculpture—like his friend Vlaminck he was an early pioneer collector of such *primitive art (his own main contribution to sculpture is that he was one of the pioneers of *direct carving in stone).

Throughout the First World War Derain served in the French army. He was able to do very little artistic work in this period, but his first one-man show was held in 1916, at the Galerie Paul *Guillaume, Paris. After he was discharged from the army in 1919 he rapidly picked up his successful career again, beginning with the design of *La Boutique fantastique* (1919) for *Diaghilev's Ballet Russes. In the 1920s he moved away from his pre-war experimentation to a much more conservative style reflecting his admiration of the Old Masters. The works he painted in this manner (including landscapes, portraits, still-lifes, and

nudes) made him wealthy and famous (he exhibited widely abroad), but they dismayed many admirers of avant-garde art. Paul *Guillaume, however, remained a strong supporter. Derain polarized opinion so much that in January 1931 the periodical *Les Chroniques du jour* published a feature entitled 'André Derain: Pour ou Contre'. Among the people quoted in this was Jacques-Émile *Blanche, who—even though he was a fairly conservative painter himself—wrote: 'Youth has departed: what remains is a highly cerebral and rather mechanical art.' Those quoted in favour of Derain included André *Salmon. *La Chasse au Cerf* (*c*.1935, Musée d'Art Moderne de la Ville de Troyes), rigidly geometric, with a strong reference to French tapestry in its style, and appealing to a taste for aristocratic tradition in its hunting theme, is a good example of what so divided (and continues to divide) critical opinion.

In 1935 Derain bought a large country house at Chambourcy, near St Germain-en-Laye. He kept a flat in Paris (partly as a place to entertain his mistresses), but by this time he had lost touch with many of his friends from his avant-garde days. During the German occupation of France in the Second World War, his country house was requisitioned and he lived mainly in Paris. Because he was now seen as a great upholder of the classical tradition, his art was viewed sympathetically by the Nazis, who courted him for propaganda purposes. In 1941, with Vlaminck and other artists, he visited Germany, where his 'only function was to smile for the newsreel cameras under the eye of the ever-present Gestapo officers' (Jane Lee). The motives of those concerned remain controversial: it is likely that one inducement was the release of prisoners, but it harmed Derain's reputation after the war. He continued to have a versatile and prosperous career, his work including a good deal of stage design, but in his final years he became reclusive and his relationship with his wife deteriorated. They separated just before his death, which followed a stroke and a road accident.

The differences of opinion he had provoked in his life continued after his death. Many critics think that his work after the First World War was essentially a long anti-climax, but some admirers have thought extraordinarily highly of him, notably *Giacometti, who wrote in 1957: 'Derain excites me more, has given me more and taught me more than

any painter since *Cézanne; to me he is the most audacious of them all.'

Further Reading: J. Lee, *Derain* (1990)

Despiau, Charles (1874–1946) French sculptor and illustrator, born at Mont-de-Marsan, son of a master-plasterer. In 1891 he moved to Paris, where he studied at the École des Arts Décoratifs, 1891–3, and the École des *Beaux-Arts, 1893–6. For several years he endured poverty, earning his living for a time by colouring postcards, and from 1907 to 1914 he worked as one of *Rodin's assistants. After this he turned from his master's intense, vigorous style to a more static, generalized manner in the vein associated with *Maillol. His best-known works are his portrait busts, with their intimate delineation of character (*Head of Madame Derain*, 1922, Phillips Collection, Washington). He also produced full-length nude figures, standing or seated, and made several monuments, including a war memorial at Mont-de-Marsan, 1920–22. The books he illustrated included an edition of Baudelaire's *Les Fleurs du mal* (1933). In the 1920s and 1930s his reputation stood very high in France, but at the end of his life he was ostracized because of his friendship with the Nazi sculptor Arno *Breker (they had known each other since before the war and in 1942 Despiau attended an exhibition of the German's work in occupied Paris).

Despierre, Jacques *See* FORCES NOUVELLES.

De Stijl *See* STIJL, DE.

Desvallières, Georges *See* DENIS, MAURICE.

Dewing, Thomas *See* TEN, THE; TONALISM.

Dezeuze, Daniel *See* SUPPORTS-SURFACES.

Diaghilev, Sergei (1872–1929) Russian impresario, famous above all as the founder of the Ballets Russes, through which he exerted great influence on the visual arts as well as on dancing and music. He was born in Novgorod province, the son of an army officer, and became an accomplished pianist as a boy. From 1890 to 1896 he studied law in St Petersburg, where he became part of a circle of musicians, painters, and writers including Léon *Bakst and Alexandre *Benois. In 1899 he founded the magazine *World of Art*,

with the object of interchanging artistic ideas with Western Europe. When it ceased publication in 1904 he concentrated for a while on organizing exhibitions, including one of Russian painting at the 1905 *Salon d'Automne in Paris—the most comprehensive to have been seen in the West up to that time. It occupied twelve rooms in the Grand Palais, with decor designed by Bakst. In 1907 Diaghilev organized a series of concerts of Russian music in Paris, and in 1909 he brought a ballet company for the first time (this is usually described as the Ballets Russes, but the name was first used in 1911). The company was a sensational success, as much for the exotic designs of Bakst and Benois as for the music and choreography (the dancers included Nijinsky and Pavlova). Diaghilev, indeed, envisaged the visual spectacle as being just as important as the music and movement, and his designers were given great freedom to express themselves. In place of the tasteful backdrops, conventional costumes, and subdued lighting of traditional theatrical performances, they produced flamboyant and colourful designs that were an essential part of the experience of the work rather than mere embellishments.

Among the company's many triumphant performances there were also a few scandals, including perhaps the most celebrated fiasco in theatrical history—the opening night of *The Rite of Spring* (music by Stravinsky, choreography by Nijinsky, decor by *Roerich) at the Théâtre des Champs Elysées, Paris, on 29 May 1913, when a riot broke out in the audience as supporters of the avant-garde fought with shocked conservatives. For two decades, until his death in 1929, Diaghilev toured Europe and America with his ballet (he never returned to Russia after the 1917 Revolution and Paris remained the principal centre of his operations). He was often on the verge of bankruptcy, but he had a remarkable flair for spotting young talent and for integrating various interests and people, enabling him to bring together as his collaborators some of the foremost artistic personalities of his time: the painters who worked for him included *Braque, *de Chirico, *Derain, *Matisse, and *Picasso. He preferred using painters rather than artists who had trained as stage designers, as he thought specialists were likely to be too tied to old ideas.

Further Reading: L. Garafola, *Diaghilev's Ballets Russes* (1998)

Dial, The *See* MCBRIDE, HENRY.

Diaz, Al *See* BASQUIAT, JEAN-MICHEL.

Dibbets, Jan (1941–) Dutch *Conceptual artist, best known for his work with photographs of landscape, particularly his 'perspective correction' photographs. In these—utilizing the well-known phenomenon that parallel lines appear to converge as they recede from the spectator—he makes lines on the ground or floor that in reality diverge away from the camera but appear exactly parallel on the flat surface of the photographic image. He writes: 'I really believe in having projects which in fact can't be carried out, or which are so simple that anyone could work them out. I once made four spots on the map of Holland, without knowing where they were. Then I found out how to get there and went to the place and took a snapshot. Quite stupid. Anybody can do that.'

Dick, Sir William Reid (1878–1961) British sculptor, born in Glasgow, where he studied at the School of Art, 1906–7, following a five-year apprenticeship to a stonemason. In 1907 he moved to London, where he lived for the rest of his life, although he maintained links with his native country and was appointed King's Sculptor in Ordinary for Scotland in 1938. In the period between the two world wars (and for some years afterwards) Reid Dick was probably the leading sculptor of public monuments in Britain—dependable, a fine craftsman, and rather dull. His statue of Lady Godiva in Coventry (1949) has become a well-loved symbol of the city.

Dickinson, Edwin (1891–1978) American painter and draughtsman, born in Seneca Falls, New York. His training included periods at the *Art Students League, New York, and the Académie de la Grande Chaumière, Paris. From 1920 to 1944 he lived at Cape Cod, then moved to New York, where he taught at various art schools. He often treated enigmatic or disquieting subject-matter and he has been described as 'perhaps the first American artist about whom some knowledge of dream theory is essential for decoding his works' (Matthew Baigell, *A Concise History of American Painting and Sculpture*, 1984). His personal symbolism is seen at its most disturbing and provocative in his self-portraits, in which he sometimes painted himself as dead. He is best known,

however, for large compositions such as *The Fossil Hunters* (1926–8, Whitney Museum, New York). Dickinson often worked on his big pictures for a number of years and said that they were never 'really finished'. From 1959 he visited Greece several times, producing delicate pencil drawings of classical ruins. He has been called a *Surrealist and has also been seen as a sophisticated culmination of the 19th-century Romantic tradition.

Dicksee, Sir Frank (1853–1928) British painter, the best-known member of a family of artists. He specialized in romantic historical scenes (often from his own imagination rather than based on a particular event or literary source) and—in the later part of his career—portraits; he also occasionally produced scenes of modern social drama. At his best, he painted with a sumptuous technique and a feeling for bold and unusual lighting effects, but he could be rather twee. He was at the height of his esteem at the turn of the century: in 1900 he was awarded a medal at the Paris Universal Exhibition, and in the same year his pious medieval pageant *The Two Crowns* (Tate) was voted the most popular picture at the *Royal Academy summer exhibition. By the end of his career, however, he was regarded as distinctly old-fashioned, and when he was elected president of the Royal Academy in 1924, this was seen as a concession to his seniority rather than as an indication of his standing in the art world. He was strongly opposed to modernism in art and his speeches as president fit the stereotype of the old attacking the new.

Diebenkorn, Richard (1922–93) American painter, born in Portland, Oregon. His family moved to San Francisco in 1924 and he spent almost all his career in California, mainly in the San Francisco Bay area; from 1963 he lived in Santa Monica. He studied and taught at various colleges and universities, including the California School of Fine Arts, San Francisco, where he studied briefly and then taught from 1947 to 1950. His fellow teachers included Mark *Rothko and Clyfford *Still, and under their influence he abandoned the still-lifes and interiors he had been painting and adopted an *Abstract Expressionist style. In the mid-1950s, however, he moved away from the subjective emotionalism of this way of painting and developed a style in which he tried to apply the vigorous brushwork of Abstract Expressionism to studies of figures in an environment (*see* BAY AREA FIGURATION). Subsequently he moved between abstraction and figuration, his work in both modes making use of large areas of colour that owed much to the example of *Matisse (he admired his work in an exhibition in Los Angeles in 1952 and was able to study it in Soviet museums in 1965). Diebenkorn's best-known works are a series of large pictures entitled *Ocean Park*, begun in 1967 (*Ocean Park No. 96*, 1977, Guggenheim Museum, New York). They are abstract, but the tight-filled colours suggest sky, sea, and sand; Diebenkorn said that temperamentally he had always been an abstract painter.

Further Reading: Whitechapel Gallery, *Richard Diebenkorn* (1991)

Dietman, Erik (1937–2002) Swedish sculptor, born in Jönköping. Self-taught as an artist, in 1959 he left Sweden and his family to escape military service and settled in Paris where he lived for the rest of his life. There he discovered *Nouveau Réalisme and *Fluxus and he especially admired *Picabia, who became a kind of mentor from beyond the grave. After a period of *Neo-Dada objects, he began work with more conventional materials in 1978. The resulting sculpture is both darkly humorous and beautifully crafted, mixing styles, imagery, and materials. *L'Art mol et raide* (1985–6, Musée d'Art Contemporain, Lyon) includes forty-one skulls on low concrete bases, all with short iron bars sprouting from the top. Dispersed among them are bronze casts of animals. All the skulls appear to stare at a small square, perhaps some kind of parody of *Minimal art. Dietman's sense of the body as a source for grim comedy extended to his own bulky frame, which he sometimes displayed nearly naked on his exhibition invitations. Anne Rochette described him as a 'Rabelaisian artist, one of the rare sculptors to make work that is both consequential and funny'.

Further Reading: A. Rochette, 'Comedic Mass', *Art in America* (December 1994)

Digital art See COMPUTER ART.

Dijkstra, Rineke (1959–) Dutch photographer and video artist, born in Sittard. She began her career as a conventional portrait photographer but gained an international reputation with the series of beach photographs she made between 1992 and 1996. These pose the single figures against the sea from a low

angle, resulting in a remarkable psychological intensity. In the most celebrated of the series, *Kolozbreg, Poland, July 26 1992* (1992, Tate), the pose reminds many spectators of Botticelli's *Birth of Venus*. Two further series are of men and women who have just been through an intense, even life-threatening experience. The men are bullfighters, not from Spain but Portugal, where the object is to hold the bull to the ground rather than kill it. They are still in their torn and bloodied costumes. The women are mothers holding their babies, a short time after childbirth. Dijkstra embarked on this series after assisting a friend who was giving birth. Both the bullfighters and the mothers are depicted against totally white backgrounds, with no distracting documentary paraphernalia. Similarly, when photographing in Israel, she concentrated on soldiers, both male and female, immediately after undergoing stringent exercises.

Further Reading: D. Birnbaum, 'Rineke Dijkstra', *Artforum International* (April 2001)

Diller, Burgoyne (1906–65) American abstract painter and sculptor, born in New York. He grew up in Michigan but returned to New York to study at the *Art Students League, 1928–33, and privately with Hans *Hofmann. From 1935 to 1940 he was supervisor of the New York Mural Division of the *Federal Art Project, and during the Second World War he worked for the US Navy. After the war he taught at Brooklyn College and the Pratt Institute until 1964. Diller's early work was influenced by *Impressionism and *Cubism, but by 1934 he had become probably the earliest American exponent of *Mondrian's type of geometrical abstraction. He remained committed to this style for the rest of his career, in his sculpture (which is restricted to rectangular elements and primary colours) as well as his painting. He had several one-man exhibitions before and after the war, but his work attracted little public attention and it was not until the last few years of his life that he was generally acknowledged as one of the best American abstract artists of his generation.

Dine, Jim (1935–) American painter, printmaker, Performance artist, and poet, born in Cincinnati, Ohio. Both his father and his grandfather were storekeepers whose stock included painting materials. He studied at the University of Cincinnati, the School of the Museum of Fine Arts, Boston, and Ohio University, Athens, where he graduated in 1957. In 1959 he moved to New York and became one of the pioneers of *Happenings. The best known was *The Car Crash* (1960), performed in the Reuben Gallery. This involved a white-faced woman who appeared to be eight feet tall (she was sitting on a ladder in a long white robe) and a silver-clad Dine who drew anthropomorphic cars on a board amidst an increasing cacophony of voices and car sounds. He became identified as a leading figure in *Pop art both in America and in England, where he lived in 1967–71. His Pop canvases were vigorously handled in a manner recalling *Abstract Expressionism, but he often attached real objects to them—generally everyday items such as clothes and household appliances (including a kitchen sink). In addition to such *assemblages, he also made free-standing works and *environments. Characteristically, the objects employed were Dine's personal possessions and his work often has a strong autobiographical flavour. This personal element distanced him from other Pop artists such as *Warhol and *Lichtenstein. In 1967 the art historian Alan Solomon wrote an essay about him entitled 'Hot art for a cool time'.

While in London he was especially honoured when, in 1966, an exhibition of his drawings was ruled by magistrates to be indecent. His dealer Robert Fraser (1937–86), whose gallery was at the time the trendiest in London, was advised by his solicitor 'to be discreet as far as these pictures were concerned'. It is likely that the police were really searching for drugs. Since his return to the USA in 1971 he has concentrated more on conventional two-dimensional work, especially drawings (he has written and illustrated several books of poetry) and prints. His style, too, has become more traditionally figurative, under the influence of *Kitaj. He has made lithographs and *screenprints, but his favourite printmaking medium is etching. Dine's technique is not to draw direct on to the plate but to make meticulous preliminary drawings which are then transferred by tracing or photography. However, the subsequent plate may be considerably reworked.

Further Reading: F. Carey and A. Griffiths, *American Prints 1879–1979* (1980)

J. E. Feinberg, *Jim Dine* (1995)

Dion, Mark *See* INSTALLATION.

direct carving The practice of producing sculpture (particularly stone sculpture) by cutting directly into the material, as opposed to

having it reproduced from a plaster model using mechanical aids and assistants. Although this might seem a purely technical matter, in the 20th century it became associated with aesthetic, ethical, and even political issues, particularly in Britain (where it was related to the idea of *truth to materials) and in France.

During the 19th century it was customary for sculpture to be exhibited initially in plaster; it was much more expensive and time-consuming to produce bronze casts or marble carvings, so these were usually made only when firmly commissioned. A device called a pointing machine enabled the sculptor to make an exact replica or enlargement of the plaster model by taking a series of measured points on it and transferring them to the copy. It was common for both bronzes and marbles to be produced from the same model and for smaller versions to be made for the domestic market (for an example *see* JOHN, SIR WILLIAM GOSCOMBE). This situation reflected economic realities (a sculptor would want to maximize earnings from a work in which much time and effort had been invested), but it also indicated a priority of idea and subject over material—the sculptor's artistry being located in the concept and form, rather than in the handicraft. A successful sculptor could thus become the administrator of a large studio producing numerous, almost identical versions of popular works (*Rodin employed many assistants, including artists of the calibre of *Bourdelle, *Despiau, and *Pompon, and he rarely touched hammer and chisel himself, only occasionally adding final touches to his works in marble). This kind of procedure had been attacked by John Ruskin (1819–1900), the most influential British art critic of the 19th century, in his *Aratra Pentelici: Six Lectures on the Elements of Sculpture* (1872), where he denounced the 'modern system of modelling the work in clay, getting it into form by machinery, and by the hands of subordinates'. Ruskin argued that the sculptor of such works thinks in clay and not in marble and that 'neither he nor the public recognize the touch of the chisel as expressive of personal feeling and that nothing is looked for except mechanical polish'. In embryonic form he was stating two fundamental tenets of the philosophy of direct carving as it later developed: that stone, as opposed to plaster, has particular qualities of its own; and that there is a special relationship between the hand of the artist and the material he uses.

In spite of Ruskin's influence and the force of his arguments, it was not until the early years of the 20th century—when his authority as a critic and prophet was waning—that his ideas on direct carving were put into practice by sculptors in Britain. Among the most important pioneers were Jacob *Epstein, Eric *Gill, and Henri *Gaudier-Brzeska, who collectively illustrate some of the range of issues involved in the practice. For Epstein, the activity of carving was linked to his interest in sculpture from outside the Graeco-Roman tradition, such as that of Assyria and Africa, and it reflected his contact in Paris with *Brancusi and *Modigliani, who had similar interests. For Gill, a return to carving was a return to a medieval practice, through which he hoped to overcome the iniquitous effect of industrialism in dividing the work of the thinker and the maker. For Gaudier-Brzeska, carving was equated with a struggle that was both manual and creative, an aspect of a 'virile' art that contrasted with the 'feminine' modelling which had dominated the previous generation of *New Sculptors: he wrote that in the sculpture he admired 'every inch of the surface is won at the point of a chisel'. The difficult economic conditions in which he lived also influenced his working methods, for he was dependent on found or even stolen fragments of stone in odd shapes that would suggest forms and subjects.

After the First World War a number of British sculptors, including Barbara *Hepworth, Henry *Moore, and John *Skeaping, practised direct carving as a dogma, while others, such as Frank *Dobson and Leon *Underwood, worked as both carvers and modellers. Whereas academic sculptors favoured white marble, because of the smooth and detailed finish it made possible, these direct carvers used a wider variety of stone, which they exploited for its range of texture and colour (*see* HOPTON WOOD STONE; HORNTON STONE). However, direct carving was not associated exclusively with avant-garde artists; it was advocated, for example, by the conservative critic Kineton Parkes (1865–1938) in articles in *Architectural Review* and in his book *The Art of Carved Sculpture* (2 vols, 1931).

In France there was a similar development, whereby direct carving (*taille directe* in French) moved from being chiefly an avant-garde concern before 1914 to wider acceptance in the 1920s. *Brancusi and *Derain made direct carvings as early as 1907, and they were almost certainly preceded by the more traditional Joseph Bernard (1866–1931).

The issue of precedence is complicated by the existence of an artisanal tradition of stone carving in provincial France: one of the major exponents of *taille directe*, André Abbal (1876–1953), came from a family of stone-carvers working near Moissac in the south of the country.

The death of Rodin in 1917 had important consequences for public awareness of the issues involved in direct carving, for until then it had not been widely appreciated how much the most famous sculptor of the day had relied on assistants (*praticiens*) in the physical production of his work. In 1919 there was a scandal when a number of fakes of his work were revealed, leading to legal action, and the press coverage included accounts by some of Rodin's *praticiens* of the extent of their involvement. The critic Louis *Vauxcelles took advantage of the situation to attack the 'lie of modelling'—the mechanical transcription of one material into another. The scandal encouraged the acceptance of direct carving, which became such a vogue that by 1922 even the *praticien* Charles Jonchery (1873–1937), who had been implicated in the Rodin scandal, was exhibiting work described as *taille directe.*

Another factor in the growth of direct carving in France was the way in which it was stimulated by nationalist rhetoric in the wake of the First World War. For example, in his book *Modelleurs et tailleurs de pierre, nos traditions* (1921), the sculptor Joachim Costa (1888–1971) linked direct carving with medieval French cathedrals: these had suffered so much damage in the war that some patriots accused the Germans of a deliberate campaign against them. Another consequence of the war was the demand for memorials, and several of the leading exponents of this type of sculpture were direct carvers, among them Abbal, Paul Dardé (1890–1963), and Raoul Lamourdedieu (1877–1953).

Patriotic support for direct carving also came from the journal *La Douce France* (originally called *La Belle France*), published from 1919 to 1924. Its ideology went beyond conventional nationalism to propose a pure Celtic French identity associated with the north of France, in opposition to the south, in which the heritage had been corrupted by compromise with Latin invasion. (This is especially bizarre in view of the actual geographical origins of some of the carvers.) 'La Douce France' was also the name of a group of sculptors,

founded in 1913, which held six exhibitions between 1922 and 1931. These featured carving alongside the equally medieval arts of fresco and tapestry, but the group's most permanent monument is a pergola made for the Paris Exposition des Arts Décoratifs (*see* ART DECO) in 1925. It was originally intended that the pergola should be placed in a prime site in the garden behind Notre Dame Cathedral in Paris, but it has ended up in a park in Étampes, about fifty kilometres south of the capital. In this work the idea of Celtic identity is expressed in the choice of subjects from Arthurian legend, and patriotism is underlined by the use of stone from the battlefield at Verdun. However, the fact that the Russian-born *Zadkine was among the ten sculptors who worked on the pergola (others were Costa, Lamourdedieu, and Pompon) suggests that La Douce France may have been more dogmatically nationalist in theory than in practice.

In the period between the two world wars, direct carving was taken up in other countries; Fritz *Wotruba was an influential exponent in Austria, for example, and leading American adherents included John B. *Flannagan and William *Zorach. Since the Second World War the carving versus modelling debate has been rendered largely obsolete by the prevalence of newer techniques that make both procedures seem conservative. However, for many sculptors in the postwar period the sense of personal engagement with the material through carving still remained of central importance (in her later years Barbara Hepworth was concerned to conceal the extent to which assistants participated in her work). This engagement has been of special significance to artists who have worked with wood, such as David *Nash. There was something of an upsurge in raw, expressive woodcarving in the 1980s, complementing the international success of *Neo-Expressionist painting: *Baselitz and *Penck, among others, produced notable examples.

Further Reading: Golan (1995)
A. M. Wagner, *Mother Stone* (2005)

Direction 1 *See* OLSEN, JOHN.

Dismorr, Jessica (1885–1939) British painter, born at Gravesend. She studied at the *Slade School, 1902–3, and the Atelier La Palette, Paris, where her teachers included *Blanche, *Dunoyer de Segonzac, and

*Metzinger, 1910–13. In 1913 she met Wyndham *Lewis and she joined the *Vorticists the following year, signing the manifesto in the first issue of *Blast* and later taking part in all the group's key activities. After the First World War she exhibited with other ex-Vorticists as *Group X (1920) and from 1926 she was a member of the *London Group and of the *Seven & Five Society. During the 1930s her work became completely abstract (*Related Forms*, 1937, Tate). She also wrote poetry.

di Suvero, Mark (1933–) American sculptor, born in Shanghai, the son of an Italian naval officer who was stationed there. He migrated with his family to to California in 1941 and he majored in philosophy at the University of California at Berkeley, also studying at the California School of Fine Arts. In 1957 he moved to New York and had his first one-man show at the Green Gallery there in 1960. His work consists of assemblages of beams, tyres, pieces of furniture, chains, and other scrap from demolished buildings or junkyards and has tended to become increasingly large in scale. His constructions sometimes contain makeshift seats inviting the spectator to participate in the space and tension of the work. In 1964–5, following his gradual recovery from a near-fatal accident that hindered his movements, he began making large outdoor sculptures. As a protest against the USA's involvement in the Vietnam War he built a huge Peace Tower in Los Angeles in 1966. This was surrounded by paintings contributed by many leading artists including *Motherwell, *Reinhardt, and Frank *Stella. (It was later re-created for the 2006 *Whitney Biennial as a protest against the Iraq war.) In 1971 di Suvero's political views led him to move into self-imposed exile in Europe, where he exhibited in several countries. He returned to the USA in 1975 and in the same year he created a series of outdoor, environmental sculptures for five New York boroughs. His later work has tended to become more linear, with greater structural clarity, using industrially manufactured units such as I-beams. In the second edition of his *A History of Modern Art* (1977), H. H. *Arnason wrote of di Suvero that his 'unlimited imagination and originality, as well as the increasing scale and power of his works, have resulted in his emergence in the 1970s as one of the foremost monumental sculptors . . . More than any other American sculptor di Suvero, in his imaginative use of gigantic scale, is the heir of and successor to the late David *Smith.'

divisionism A method and technique of painting in which colour effects are obtained by applying small areas or dots of pure, un-mixed colours on the canvas in such a way that to a spectator standing at an appropriate distance they appear to react together, producing greater luminosity and brilliance than would have resulted if the same colours had been physically mixed together. The method was used empirically by the *Impressionists, but it was not developed systematically and scientifically until the 1880s in the work of the *Neo-Impressionists.

'Divisionism' (usually with a capital 'D') was also the name of an Italian movement, a version of Neo-Impressionism, that flourished in the last decade of the 19th century and the first decade of the 20th, initially in Lombardy (especially Milan) and Piedmont, and then in Rome. Anna Maria Damighella argues that it sought to make art an instrument of 'social illumination (*espansività sociale*) and combine this with a scientific approach. The most important exponent was Giuseppe *Pellizza da Volpedo. Divisionism strongly influenced the early work of the *Futurists, although those artists tended to aim for effects of dissonance rather than harmony.

Further Reading: A. M. Damighella, 'Divisionism and Symbolism in Italy at the turn of the Century', in Braun (1989)

Dix, Otto (1891–1969) German painter and printmaker, born at Untermhaus (now part of the city of Gera) in Thuringia. He was apprenticed to a local painter-decorator, 1905–9, then studied at the Dresden School of Arts and Crafts, 1910–14. At this time he was influenced by the *Expressionist group Die *Brücke, which had been founded in Dresden in 1905, and by an exhibition of van Gogh's work held there in 1913. During the First World War he served in the German army, witnessing the full horror of trench warfare, then took up his studies again at the Academy in Düsseldorf, 1919–22. He participated in the Berlin *Dada fair of 1920. In the 1920s he was, with George *Grosz, the outstanding artist of the *Neue Sachlichkeit movement, employing a detailed technique that showed his admiration for the masters of the German Renaissance. His work of this time conveyed disgust

at the horrors of war and the depravities of a decadent society with unerring psychological insight and devastating emotional effect. *The Match Seller* (1920, Staatsgalerie, Stuttgart), for example, is a pitiless depiction of indifference to suffering, showing passers-by ignoring a blind and limbless ex-soldier begging in the street, and Dix's fifty etchings entitled *The War* (1924) have been described by George Heard *Hamilton as 'perhaps the most powerful as well as the most unpleasant anti-war statements in modern art'. Another favourite theme was prostitution, and he also painted brilliantly incisive portraits, such as that of the journalist Sylvia von Harden (1926, Pompidou Centre, Paris), in which 'he condemned the social and spiritual values of an era, as well as of a way of life, by a merciless analysis of a particular person' (Hamilton).

In 1925 Dix moved to Berlin, then in 1927 he was appointed a professor at the Dresden Academy. Although he had no strong political views, his anti-military stance drew the wrath of the Nazis and he was dismissed from his academic post in 1933. The following year he was forbidden to exhibit, and eight of his paintings were shown in the infamous *'Degenerate Art' exhibition in 1937. They included *The Trench* (1923), a large triptych that had been his most controversial painting on account of its horrific depiction of war; it was destroyed by the Nazis in 1939, but Dix's *War Triptych* (1929–32), which is similar in treatment, survives (Gemäldegalerie Neuer Meister, Dresden). By the time the Second World War began, Dix was living quietly in the country, at Hemmenhofen near Lake Constance (he moved there in 1936), painting traditional landscapes, but he still aroused suspicion: in 1939 he was arrested on a charge of complicity in a plot on Hitler's life, but he was soon released. He was conscripted into the *Volkssturm* (Home Guard) in 1945 and was a prisoner of war in France, 1945–6, after which he returned to Hemmenhofen. From 1949 he regularly visited Dresden. His post-war work—which was much more loosely handled and often inspired by religious mysticism—did not compare in originality or strength with his great achievements of the 1920s. The house in Gera in which he was born is now a museum devoted to him.

Further Reading: Tate Gallery, *Otto Dix* (1992)

Dobell, Sir William (1899–1970) Australian painter. He was born in Newcastle, New South Wales, and originally trained as an architect. In 1923 he settled in Sydney, where he attended evening classes in art, and in 1929 he won a travelling scholarship that enabled him to study at the *Slade School in London (he also had some private tuition from *Orpen). Dobell remained in London for a decade. By the time he returned to Sydney in 1939 his style had changed from the carefully studied, solidly constructed naturalism of his early works to a much looser and more *Expressionist manner, sometimes with a satirical air. The rich colours and textures were influenced by art he saw on his travels in Europe, particularly the paintings of *Soutine.

Dobell immediately acquired a circle of admiring patrons in Sydney, some of whom commissioned portraits from him, and in 1944 he became a household name in Australia when he was involved in a *cause célèbre* for modernism. In January of that year he was awarded the 1943 Archibald Prize for portraiture, given annually by the Art Gallery of New South Wales, Sydney. His winning picture was *Portrait of an Artist* (since damaged beyond repair by fire), representing his friend and fellow painter Joshua Smith (1905–95). Two of the unsuccessful competitors contested the award in the Supreme Court of New South Wales, on the grounds that the winning work was not a portrait but a caricature—a 'pictorial defamation of character'; one witness said that 'the picture reminded him of something he had seen in a psychiatric textbook' (Christopher Allen, *Art in Australia*, 1997). The suit was dismissed and the case was regarded as a significant victory for the cause of modern art in Australia, although Dobell saw himself as something of a traditionalist. Some critics think that much of his later work shows a decline in confidence. However, he continued to be much in demand as a portraitist and he also painted landscapes, some of them inspired by visits to the highlands of New Guinea in 1949 and 1950. In 1954 (with *Drysdale and *Nolan) he represented Australia at the Venice *Biennale. He was knighted in 1966. His house at Wangi Wangi, New South Wales, was opened to the public in 1972.

Dobson, Frank (1886–1963) British sculptor, born in London, the son of an illustrator of the same name. From 1902 to 1904 he worked as an assistant to William Reynolds-Stephens (*see* NEW SCULPTURE). He then spent two

years in Cornwall, earning his living with landscape watercolours, before winning a scholarship to Hospitalfield Art Institute, Arbroath, where he studied 1906–10. After returning to London, he continued his studies at the City and Guilds School, Kennington, then again lived in Cornwall, where he shared a studio with Cedric *Morris in *Newlyn. His early work consisted mainly of paintings, the few surviving examples showing how impressed he was by Roger *Fry's *Post-Impressionist exhibitions. He made his first carving in 1913, but his first solo exhibition consisted of paintings and drawings. After the First World War, he turned increasingly to sculpture, and had his first solo exhibition as a sculptor in 1920, at the *Leicester Galleries, London.

During the 1920s and 1930s Dobson gained an outstanding reputation: in 1925 Roger Fry described his work as 'true sculpture and pure sculpture . . . almost the first time that such a thing has been even attempted in England'. The monumental dignity of his work was in the tradition of *Maillol and, like him, Dobson found the female nude the most satisfactory subject for three-dimensional composition, as in *Cornucopia* (1925–7, University of Hull). His work was more stylized than Maillol's, however, and his sophisticated simplifications of form made him one of the pioneers of modern sculpture in Britain. Indian sculpture was also a profound influence on his work. Dobson was outstanding as a portrait sculptor, his best-known work in this field being the head of Sir Osbert *Sitwell in polished brass (1923, Tate). He worked in various other materials including bronze, terracotta, and stone, and he was prominent in the revival of *direct carving. His prestige as an artist declined after his death, but since an exhibition at Kettle's Yard, Cambridge in 1981 his reputation has greatly revived and he has again been recognized as one of the outstanding figures in early 20th-century British sculpture.

Further Reading: N. Jason and L. Thompson-Pharoah, *The Sculpture of Frank Dobson* (1994)

documenta A large international exhibition of contemporary art held every four or five years since 1955 at Kassel, Germany. The first documenta exhibition, the brainchild of Arnold Bode (1900–77), a teacher at the Kassel Academy, and organized in collaboration with Werner *Haftmann, signified Germany's reacceptance of avant-garde art, which had been banned by the Nazis as *degenerate. The second documenta, in 1959, contained an American section that demonstrated the achievements of the *New York School, and the fourth, in 1968, was dominated by American *Colour Field Painting, *Minimal art, and *Pop art. Out of some 150 artists invited, 57 were from the USA and many of the works they exhibited were of huge size. Initially, the choice of Kassel had a strong political significance. It was close to the border of the Communist DDR and for the first two exhibitions, before the building of the Berlin Wall, it was possible for East Germans to visit the event and experience the culture of modern art which was prohibited in the Communist world. More recently, Kassel has been economically depressed and being the 'documenta city' every five years brings welcome visitors and prestige.

The most influential documenta was no. 5, held in 1972, curated by Harald *Szeemann. It took as its theme 'questioning reality' and, alongside the work of artists, it showed publicity and political propaganda. It had been Szeemann's intention to include examples of Russian *Socialist Realism, but the Soviet Union refused to participate, no doubt unwilling to see its 'reality' questioned. The exhibition was controversial among artists: it was attacked for its failure to include an adequate representation of women and also for forcing the works of art into a scheme determined by the curators, what Robert *Smithson called 'cultural confinement'. This was in fact the most historically significant aspect of the exhibition. It is now quite normal for mixed exhibitions of contemporary art to be justified by some curatorially determined theme. For instance 'Laughing in A Foreign Language' (Hayward Gallery, London, 2008) was an exhibition of humour in contemporary art. Szeemann also wanted the exhibition to be 100 days of events rather than just a place for the passive contemplation of artworks. This was probably best realized by the contribution of Joseph *Beuys, whose rise to star status in the contemporary art world had begun with his work at the 1968 documenta. In 1972, Beuys was present in person every day to use his space to propagate his idea of direct democracy. On the final day he fought a boxing match with a hostile critic (Beuys won on points). Ever since then, documenta has had a certain reputation for political high-mindedness.

Documenta 5 was a hard act to follow. However, it was almost equalled in significance by

documenta 7, curated by Rudi Fuchs, who had previously been a supporter of *Conceptual art. It was widely regarded as having put the seal on the international success of the revival of painting, especially *Neo-Expressionism. The exhibition is now enormously popular with visitors: 750,000 attended no. 12 in 2007, despite an unenthusiastic reception by many critics, who found the exhibition poorly displayed and muddled in concept. No doubt much of the attraction is the charm of the setting. Part of it is held in a beautiful 18th-century palace with gardens (the famous swans on the lake were used for the logo of documenta 9), providing an ambience which belies the economic condition of the city. This setting has sometimes been used brilliantly by artists. No one who saw it will ever forget Jimmie *Durham's length of bent plastic pipe peering out of the stream, mimicking the emergence of life from the sea, in 1992. However, for the committed visitor determined to see everything, a day at documenta, spread across the city as it is, has become one of contemporary art's supreme tests of stamina.

Documents *See* BATAILLE, GEORGES.

Doesburg, Theo van (1883–1931) Dutch painter, designer, writer, and propagandist, born in Utrecht. His original name was Christian Kuppers, after his biological father, a German photographer, but he called himself after his Dutch stepfather. Initially he planned to have a career in the theatre, but he had begun painting by 1899 and he had his first exhibition in The Hague in 1908. He had no formal artistic training. In 1913 he published a collection of his poems, and he was also writing art criticism at this time. His early paintings were influenced variously by *Impressionism, *Fauvism, and *Expressionism, but in 1915 he met *Mondrian and rapidly underwent a conversion to complete abstraction. In 1917 he founded De *Stijl and he devoted the rest of his life to propagating the association's ideas and the austerely geometrical style it stood for.

Up to about 1920 van Doesburg's paintings were very close in style to those of Mondrian, both of them predominantly using small, irregularly disposed rectangles of primary colour on a light background, but thereafter their paths diverged. Mondrian had returned to Paris in 1919 and van Doesburg spent much of the 1920s travelling to promote De Stijl

ideas, particularly in Germany. In 1923 he contributed an article entitled 'Elemental Formation' to the first issue of *G. In it he discussed two opposing modes of expression. The art of the past, which he called 'decorative', depended on individual taste and intuition. In contrast to this, the art of the present (by which he meant *Constructivism) he called 'monumental' or 'formative'. He claimed that Constructivist art is no longer impulsive or intuitive but done in accordance with objective aesthetic principles and that the Constructivist has 'conscious control of his elemental means of expression'.

From 1922 to 1924 he taught intermittently at the *Bauhaus, which in 1925 published a German translation—*Grundbegriffe der neuen gestaltenden Kunst*—of his most important book, *Gronndbegrippen der nieuwe beeldende Kunst* (1919). (An English translation, *Principles of Neo-Plastic Art*, appeared in 1968.) While he was in Germany van Doesburg became friendly with *Schwitters and briefly was influenced by *Dada (although this was an apparent departure from his normal work, Dada and abstraction were at the time linked by their opposition to the individualist practice of traditional art). By the mid-1920s he had abandoned the horizontal-vertical axes insisted upon by Mondrian and introduced diagonals into his paintings in a series of works entitled *Counter-compositions* (*Counter-composition in Dissonance XVI*, 1925, Gemeentemuseum, The Hague). He called this new departure *Elementarism, publishing a manifesto describing it in *De Stijl* in 1926; Mondrian dissociated himself from De Stijl because of this heresy.

In addition to painting, writing, and lecturing, van Doesburg collaborated on several architectural projects, the most important of which was the remodelling of the Café Aubette in Strasbourg (1926–8), in which he worked with Jean *Arp and Sophie *Taeuber-Arp. Contrary to what the name might suggest, the Café is a large building, part of a prominent architectural complex (in the city's main square) that dates back in part to the 13th century and has served a variety of uses. Van Doesburg was in overall charge of the project and 'also designed virtually every piece of equipment, from the electrical fuse-boards to the ash-trays and crockery' (Paul Overy, *De Stijl*, 1991). The principal room he worked on was the Cinema Dance Hall, which featured a series of very bold diagonal elements that obscured the

definition of wall and ceiling. With its bright colours, it was like a huge walk-in version of one of his paintings. When the Café reopened the public hated the decoration so much that the management had it altered or covered (restoration began in 1997), but it anticipated the kind of 'total design' seen in major corporate buildings after the Second World War. In 1929 van Doesburg moved to Paris and designed a house and studio for himself at Meudon in a stark and stripped style (1929–31): he thought that an artist's studio should resemble a medical laboratory. In 1930 he published a manifesto of *Concrete art and in February 1931 a meeting of artists in his new studio led to the formation of the *Abstraction-Création association. The following month he died of a heart attack in Switzerland, where he had gone for treatment for his chronic asthma.

Doig, Peter (1959–) British painter, born in Edinburgh. His father's work with a shipping company made for a childhood in different locations: in 1962 the family moved to Trinidad and then in 1966 to Canada. He went to London in 1979 to study art, first at Wimbledon School of Art and then at *St Martin's School of Art. Then, after a further period of supporting himself as a dresser at English National Opera, he moved back to Canada, where he worked as a scene painter in the film industry. Returning to Britain, he completed his MA at Chelsea School of Art in 1990. In 1993 he won first prize at the *John Moores Liverpool Exhibition. In 2002 he moved to Trinidad. He had a major retrospective at Tate Britain in 2008.

Doig's paintings often recall the Canadian landscape, evoking snow and reflections with a virtuosic but anti-illusionistic painting technique. In spite of an element of personal history in his work, he has insisted that he is concerned with memory in general, not just his own memory. Indeed his work has drawn on a wide range of imagery: his own photographs are one source but there is also a bohemian dandy from Daumier and a shot of a girl floating in a canoe, derived from the horror film *Friday the 13th.* A constant theme is the confrontation of human action and artefacts with the world of nature, a confrontation dramatized by contrasts of colour and technique. In one series a semi-derelict housing block by the modernist *Le Corbusier is encountered in a forest. Doig has said of his

work: 'By making a painting or by looking at a painting, we [try] to get away from the ordinary.'

Further Reading: J. Nesbitt, *Peter Doig* (2008)

Domínguez, Óscar (1906–58) Spanish painter and sculptor, active mainly in France. He was born on Tenerife in the Canary Islands, the son of a banana exporter, and was self-taught as an artist. In 1927 he first visited Paris, where he came under the spell of the *Surrealists, and in 1933 he helped organize a Surrealist exhibition on Tenerife. His early paintings were in the 'veristic' manner of *Dalí, but soon after settling permanently in Paris in 1934 he began experimenting with techniques of *automatism and he is credited with inventing *decalcomania. It is for this that he is best remembered, for the rest of his work did little more than plagiarize his more famous contemporaries. In addition to paintings, he produced Surrealist sculptures incorporating *ready-made elements.

Donagh, Rita *See* HAMILTON, RICHARD.

Donati, Enrico *See* SPATIALISM.

Dongen, Kees van (1877–1968) Dutch-born painter and printmaker who became a French citizen in 1929. He was born in Delfshaven, the son of a brewer, and studied at the Academy in nearby Rotterdam, 1894–5. In 1897 he first visited Paris, and he settled there in 1899, living in poverty for a while in the *Bateau-Lavoir (where he was a friend of *Picasso) and eking out a living with various jobs, including bill-sticker and circus wrestler. He had his first one-man show at *Vollard's gallery in 1904. His early work was *Impressionist and *Symbolist in style, but in 1906 he became a member of the *Fauves. From this time he rapidly made a name for himself in France and elsewhere: he was given contracts by *Kahnweiler in 1907 and *Bernheim-Jeune in 1908, and had numerous one-man shows, principally in Paris, in the period leading up to the First World War. The foreign exhibitions at which his work appeared included a Die *Brücke show in Dresden in 1908 and the second Golden Fleece (*see* BLUE ROSE) exhibition in Moscow in 1909. He had a reputation as a ladies' man, and his work (mainly nudes and female portraits) was often erotic in spirit: in 1913 one of his pictures was removed from the *Salon d'Automne by the police on the grounds of alleged indecency.

After the First World War van Dongen became internationally famous for his paintings of fashionable life, particularly portraits of insolently glamorous women, in which he created a feminine type that has been memorably described by the art historian Frank Elgar as 'half drawing-room prostitute, half side-walk princess'. His great facility led to repetition and banality, and it is generally agreed that most of his best work was done before 1920. From 1959 he lived in Monaco, and his work is represented in several galleries on the Riviera, notably the Nouveau Musée National de Monaco. Among his works here are not only portraits but also several large imaginative compositions, including a triptych entitled *Tango of the Archangel* featuring a near-naked girl 'dancing with a dinner-jacketed man with wings; all the decadence of high society between the wars seems captured in this work' (Michael Jacobs and Paul Stirton, *The Mitchell Beazley Traveller's Guides to Art: France*, 1984). In 1967–8 a large retrospective exhibition in honour of his 90th birthday was held at the Musée National d'Art Moderne, Paris, and the Boymans van Beuningen Museum, Rotterdam.

Donkey's Tail (in Russian: Oslinyi Khvost) Title of an exhibition organized in Moscow in 1912 by *Goncharova and *Larionov after they had dissociated themselves from the *Knave of Diamonds group in 1911. They accused the Knave of Diamonds of being too much under foreign influence, and advocated a nationalist Russian art; at this time Goncharova and Larionov themselves were painting in a *Neo-primitivist manner based partly on icon painting and peasant art. *Malevich and *Tatlin were the only other major artists who were well represented at the exhibition; *Chagall sent one picture, but otherwise the artists involved were minor figures. The title of the exhibition was an aspect of Larionov's primitivism, referring to an incident in 1910 when three pictures painted with a brush tied to a donkey's tail were shown at the jury-free *Salon des Indépendants in Paris (this stunt was devised by a journalist called Roland Dorgelès, who wanted to poke fun at modern art; the pictures were hung as works of the fictitious 'Boronali': an anagram of *aliboron*, 'jackass'). At the Moscow exhibition there was an outcry because some of the paintings on view had religious subjects—for example Goncharova's *The Four Evangelists* (1910–11, Russian Museum, St Petersburg)—and it was thought

to be irreverent to show religious works under such a title (the police ordered several to be removed). Goncharova and Larionov followed it up with the *'Target' Exhibition in 1913.

Dorazio, Piero (1927–2005) Italian painter, born in Rome. He started a course studying architecture at Rome University, but in 1946 gave this up for painting, initially producing *Social Realist subjects. In 1947, however, he turned to abstraction and joined the Forma group (like many of its members he later joined the *Continuità group). He experimented with various types of abstract work before creating a distinctive style in the 1960s with brightly luminous bands of colour—'like an heraldic flag', as he put it (*Very Sharp*, 1965, Tate). Dorazio travelled a good deal and spent several years in the USA: from 1963 to 1967 he taught at the University of Pennsylvania.

Dotremont, Christian (1922–79) Belgian writer (mainly a poet, but also a novelist) and painter. In 1947 he founded a movement called Le Surréalisme Révolutionaire in Brussels, but when it became evident that it would be impossible to co-operate with the French *Surrealists (he was opposed by their leader *Breton), he became one of the founders of *Cobra in 1948. Dotremont was the group's chief spokesman and the main editor of its periodical. He also collaborated with other Cobra artists in creating pictures in which words and images are combined. In his later paintings he used quasi-Oriental calligraphic forms that he called logograms.

Dottori, Gerardo *See* AEROPITTURA.

Douce France, La *See* DIRECT CARVING.

Douglas, Aaron (1899–1979) American painter and illustrator, probably the best known among the visual artists who were involved in the (primarily literary) *Harlem Renaissance. He was born into a working-class family in Topeka, Kansas, and studied fine art at Nebraska University, completing his degree in 1922 after service in the army in the First World War. In 1925 he moved to New York, where he met Charles Johnson, editor of *Opportunity*, the journal of the National Urban League, an association that fought racial discrimination, and also William E. B. Du Bois, a leading sociologist and editor of *Crisis*, the journal of the National Association for the Advancement of Colored People. From 1926

Douglas made illustrations for both journals, creating positive images of black history and culture that challenged the stereotype of the 'negro' familiar to white American society. His dramatic use of black-and-white was influenced by the German-born painter and graphic artist Winold Reiss (1886–1953), who taught him privately, 1925–7. In 1926 Douglas met Albert C. *Barnes, and in 1927–8 he spent a year at the Barnes Foundation, where the work he studied included *Cubist paintings and West African masks. Their influence, together with imagery from ancient Egyptian art, can be seen in Douglas's best-known work, the mural series *Aspects of Negro Life* (1934), painted for the Schomberg Library in Harlem and now in New York Public Library. The murals feature both secular and religious imagery and allude to issues such as slavery and notions of Utopia. Douglas's other work included landscapes and portraits. From 1940 to 1966 he taught at Fisk University, Nashville, Tennessee, and he lived in Nashville for the rest of his life.

Further Reading: A. H. Kirschke, *Aaron Douglas: Art, Race, and the Harlem Renaissance* (1995)

Douglas, Stan (1960–) Canadian film and *Video artist, born in Vancouver. The inspiration for his video installations tends to come from theatre and cinema: the plays of Samuel Beckett, the films of Orson Welles, and 1960s television drama have been strong influences. Nonetheless the presentation of the works is geared to the gallery rather than to cinema or television. Sometimes he uses multiple screen projection and his work is always shown on a continuous film loop, so that spectators will see the work differently depending on when they arrive. This is a deliberate effect planned by Douglas, whose videos tend to ambiguous and fractured narratives. *Win, Place, or Show* (1998, Tate) depicts an argument between two dockworkers ranging from horse racing to conspiracy theories which culminates in a fight. Each protagonist is given his own screen but the projection is timed so that a wide variety of different combinations of event is possible. *Inconsolable Memories* (1968) is set in Cuba and is loosely based on the Cuban film *Memories of Underdevelopment* (1968). Using two film loops projected simultaneously, Douglas says of it: 'You're not going to watch a film or story. You're going to a place.'

Further Reading: S. Watson, *Stan Douglas* (1998)

Dova, Gianni *See* SPATIALISM.

Dove, Arthur (1880–1946) American painter, a pioneer of abstract art. He was born in Canandaigua, New York State, studied law and art at Cornell University, graduating in 1903, then settled in New York City. For most of his career he earned his living as a commercial illustrator and he was often in great financial difficulty, even though he was championed by *Stieglitz and later supported by Duncan *Phillips, who from 1930 paid him a regular monthly stipend. He visited Europe in 1907–9, coming into contact with *Fauvism and other avant-garde movements, and in 1910–11 he painted what have been described as the first abstract pictures in American art (*Abstraction No. 1*–*Abstraction No. 6*, private collection), which are somewhat similar to *Kandinsky's work of about the same date. Dove never exhibited these pictures in his lifetime, but he displayed similar works in his first one-man exhibition at Stieglitz's 291 Gallery in 1912. Hilton *Kramer has argued that these should be seen more as 'Symbolist paintings based on motifs drawn from nature than as abstract paintings that abjure all reference to recognizable objects' (*New York Observer*, 2 November 1997). His later paintings were, in fact, often based on natural forms, suggesting the rhythms of nature through pulsating shapes (*Sand Barge*, 1930, Phillips Collection, Washington). Dove wrote 'I should like to take wind and water and sand as a motif and work with them, but it has to be simplified in most cases to color and force lines and substances just as music has done with sound'. From the mid-1930s the vestiges of representation in his work began to disappear and in the 1940s his style changed to a more geometric, hard-edged type of abstraction (*That Red One*, 1944, William H. Lane Foundation, Leominster, Massachusetts). Throughout his career Dove also made collages, among them *Portrait of Alfred Stieglitz* (1925, MoMA, New York), which features a camera lens and a photographic plate among other objects. In his later years he took a leading part in a campaign to win artists royalty rights for the reproduction of their work. From 1924 Dove was married to the painter Helen Torr (1886–1967).

Dowson, Sir Philip *See* ROYAL ACADEMY.

Dreier, Katherine S. (1877–1952) American painter, patron, and collector, a wealthy

heiress remembered chiefly for her missionary zeal in promoting modern art in the USA. She was born in New York, the daughter of immigrant German parents, and studied at the Brooklyn Art Students League and elsewhere. Her early paintings consisted of traditional portraits and still-lifes, but in 1913 the *Armory Show converted her into an ardent supporter of avant-garde art and she devoted much of the rest of her life to championing it. She did this mainly through the *Société Anonyme, which she founded in 1920 with Marcel *Duchamp and *Man Ray. 'A domineering woman of tireless energy and Wagnerian proportions, she was the antithesis of Duchamp in every possible way, and they got along famously' (Calvin *Tomkins, *The World of Marcel Duchamp*, 1966). In addition to organizing exhibitions (the main business of the Société Anonyme), she did a good deal of lecturing, and she also promoted avant-garde music and dance. Her best-known painting is her semi-abstract portrait of Duchamp (1918, MoMA, New York). She bequeathed ninety-nine works from her personal art collection to the Museum of Modern Art, New York, including examples by *Brancusi, Duchamp, *Kandinsky, *Klee, and *Mondrian.

Drevin, Alexander *See* UDALTSOVA, NADEZKA.

Drummond, Malcolm (1880–1945) British painter, born at Boyne Hill, Berkshire. He read history at Oxford University, 1899–1903, then studied at the *Slade School, 1903–7, and under *Sickert at Westminster School of Art. Like others in Sickert's circle he was a founder member of the *Camden Town Group in 1911 and of its successor the *London Group in 1913, and he is best known for paintings of this period. They are done in simplified forms and broad, flat areas of colour in a style similar to that of *Gilman or *Gore, but generally rather quieter; *19 Fitzroy Street* (c.1913–14, Laing Art Gallery, Newcastle upon Tyne), is probably his most reproduced work, partly because it is such a valuable historical record. It depicts *Ginner, Gore, and *Manson looking at a group of paintings in their showroom near Sickert's studio.

Drury, Alfred (1856–1944) British sculptor, mainly of portraits and monuments, but also of the kind of literary or symbolic figures typical of the *New Sculpture. His work includes a good deal of public sculpture in London, for example decorative figures in stone on the facade of the Victoria and Albert Museum (1905–7), four colossal bronze figures for Vauxhall Bridge (1909), and the bronze statue of Sir Joshua Reynolds in the courtyard in front of the Royal Academy (1931). His son **Paul Drury** (1903–87) was an engraver.

Drysdale, Sir Russell (1912–81) British-born Australian painter. In spite of his British roots and the fact that he trained partly in Europe, he was one of the most Australian in spirit of his country's major 20th-century artists. He was born in Bognor Regis, Sussex, into a family that had owned land in Australia since the 1820s, and he spent several years of his childhood there. The family settled in Melbourne in 1923 and in the mid-1930s Drysdale gave up farming to study art in Melbourne, Paris, and London. After moving to Sydney in 1940 he devoted himself full-time to painting. His early work had been bright and decorative, but in the 1940s it became sombre and serious. This change reflected the onset of the Second World War and also Drysdale's experience of the effects of a devastating drought in the Riverina district of New South Wales in 1940. His work revived the tradition of hardship and melancholy associated with the Australian bush that had been obscured by the much more optimistic tradition developed by the city-based painters of the *Heidelberg School. Stylistically he blended *Expressionist and *Surrealist features founded on his knowledge of contemporary European painting. His work in this vein became well known throughout Australia in the 1940s, and in 1949 Kenneth *Clark, on a visit to Sydney, encouraged Drysdale to exhibit in London. In 1950 he had a one-man show at the *Leicester Galleries, London, and this marked the beginning of a new interest in Australian art in Britain and in Europe. *Dobell and *Nolan were two other artists whose work became well known in the northern hemisphere in this period and together with Drysdale they represented Australia at the 1954 Venice *Biennale.

Of these three artists, Drysdale remained closest to the Australian soil. In the 1950s he travelled widely in the vast tract of Northern Australia, which he described as 'magnificent in dimension, old as time, curious, strange, and compelling'. As well as the landscape, he painted the life of the Aborigines, giving them greater dignity than any earlier painter. In 1957–8 Drysdale lived in London, and in

1960 he had a major retrospective exhibition at the National Gallery of Victoria, Melbourne. During the early 1960s he experienced periods of depression accentuated by the death of his son and his wife. He was knighted in 1969.

Dublin City Gallery, The Hugh Lane
See LANE, SIR HUGH.

Dublin, Irish Museum of Modern Art
See IRISH MUSEUM OF MODERN ART.

du Bois, Guy Pène *See* PÈNE DU BOIS, GUY.

Dubuffet, Jean (1901–85) French painter, sculptor, lithographer, and writer, born in Le Havre, the son of a wealthy wine merchant. In 1918 he moved to Paris, where he studied at the *Académie Julian for six months. He began to doubt the value of art and culture, however, and in 1924 he stopped painting and entered the wine trade. In 1933 he made another abortive attempt at painting, then in 1942 took up art seriously again, his first one-man exhibition coming in 1945. He was fascinated by graffiti and by *Art Brut ('raw art'), the products of psychotics or wholly untrained persons, preferring untrained spontaneity to professional skill. His own work was agressively reminiscent of such 'popular' art, often featuring subjects drawn from the street life of Paris. In 1951 he wrote: 'I believe very much in the value of savagery; I mean instinct, passion, mood, violence, madness.' This might seem to bring his attitudes close to those of Surrealists, and indeed he had some involvement with them before becoming a professional painter. Sarah Wilson has argued that the *Murs* series of paintings of 1945 specifically referred to an area of Paris known as the 'Zone', frequented by the rejects of society (Morris, 1993).

Frequently he incorporated materials such as sand, plaster, tar, and even banana skins into his paintings, and he also produced large sculptural works made from junk materials. His work initially provoked outrage, but then found acceptance and eventually reverence, and he is one of the key figures in the tendency in modern art to depreciate traditional materials and methods and, as he himself said in 1957, to 'bring all disparaged values into the limelight'. His raw treatment of the female figure had a powerful impact on certain British artists of the 1950s, notably Kenneth *Armitage and William *Scott, and his use of materials was highly influential on *junk sculpture. One theme is the undermining of the distinc-

tions between human and animal, even organic and inorganic. Bodies become raw matter but cows take on human characteristics. The distinguished Courbet scholar Petra ten-Doesschate Chu has related Dubuffet's elevation of matter over form to a tradition of *Realist rejection of the ideal (*Art Journal*, vol. 53, no. 2, 1993). Dubuffet produced a huge amount of work, constantly experimenting with new materials and styles, and although he was a champion of artistic discovery and disorder, he documented his output thoroughly: the complete catalogue of his work runs to thirty-seven volumes (1964–84). His critical writings were published in a collected edition in 1967 under the title *Écrits de Jean Dubuffet*. An anthology in English, *Asphyxiating Culture and Other Writings*, appeared in 1986.

Duchamp, Marcel (1887–1968) French-born artist and art theorist who became an American citizen in 1955. His output was small (most of his key works are in the Philadelphia Museum of Art) and for long periods he was more or less inactive, but he is regarded as one of the most potent figures in modern art because of the originality and fertility of his ideas.

Duchamp was born at Blainville, Normandy, one of six children (three sons and three daughters) of a successful notary. Their grandfather was an amateur engraver, and Marcel's two brothers and one of his sisters also became artists—Raymond *Duchamp-Villon, Jacques *Villon, and Suzanne *Duchamp. In 1904 Duchamp followed his brothers to Paris, where he studied for a year at the *Académie Julian. His early paintings were influenced by *Impressionism and then *Fauvism, and he also did humorous drawings for various journals to help earn his living. In 1909 he began exhibiting his work in public, at the *Salon des Indépendants and the *Salon d'Automne, but he had no interest in achieving conventional career success.

By 1911, Duchamp was part of the *Cubist circle, but his works were hardly orthodox examples of the style. He was interested in the possibility of using Cubist fragmentation to represent movement. *Dulcinea* (1911, Philadelphia Museum of Art) was inspired by a woman whom Duchamp saw frequently walking her dog but to whom he never spoke. The title probably refers to the woman idolized from afar by Don Quixote in the Cervantes novel. She is depicted five times in the painting in

various states of undress. The preoccupation with voyeurism recurred in subsequent work. Duchamp shared with other Cubists, notably *Léger, an admiration for the forms of the machine, but in *Coffee Grinder* (1911, Tate), instead of Cubist fragmentation he provides a diagrammatic view of the device at work. *Nude Descending a Staircase, No. 1* (1911, Philadelphia) depicts a stylized, semi-abstract figure walking down a spiral staircase, movement being suggested by the use of overlapping images, in the manner of rapid-fire multiple-exposure photography. In 1912, he painted a more sophisticated version, *Nude Descending a Staircase, No. 2* (Philadelphia), in which the figure is more machine-like and the movement more dynamic. This was shown in Barcelona and Paris in 1912, but it was in New York the following year that it first made a great impact, becoming the most discussed work in the *Armory Show. The attention it received was mainly negative (probably the most quoted comment about it was that it looked like 'an explosion in a shingles factory'), but there were also more appreciative remarks, and the publicity made Duchamp suddenly much better known in the USA than he had ever been in France. For all the fame of the work, Duchamp's masterpiece as a painter is probably the far more complex *Passage from the Virgin to the Bride* (1912, MoMA, New York), a painting less about movement than about change of state. In 1913, Duchamp produced the *Three Standard Stoppages*. These were the result of the dropping of a metre-length string from a metre's height. From the chance curves created by this process wooden templates were made, the lines reoccurring as a generative principle in subsequent works.

In 1915, after two years as a library assistant at the Bibliothèque Sainte-Geneviève in Paris, Duchamp moved to New York and spent the rest of the First World War there (he was excused military service on account of a minor heart complaint). His fame (or notoriety) from the Armory Show had not been forgotten, and he was greeted by reporters as he disembarked, and he was made welcome in intellectual circles. The art collectors Walter and Louise *Arensberg provided him with a studio, but he refused all offers from dealers to handle his work (he had a disdain for making money as an end in itself) and instead supported himself by giving French lessons. With *Man Ray and Francis *Picabia he formed the nucleus of New York's *Dada movement.

An important aspect of Duchamp's Dada activities was his development of the *ready-made, an object which achieved its status, not by the artist's actions, but by the artist's choice, although it is not clear how far Duchamp saw the ready-made as art. Sometimes his works of this type were merely chosen, but they were usually inscribed, so some kind of intervention nearly always took place, even when Duchamp did not nominate them as 'assisted ready-mades'. In 1913 he placed a bicycle wheel on top of a stool. This is usually regarded as the first ready-made (claims have also been made for the *Bilboquet* (1910, a wooden toy given to a friend after a visit to a brothel; Duchamp did not coin the term until 1915)). The most famous ready-made is the urinal which he submitted anonymously in 1917 to the New York Society of Independent Artists as *Fountain*. This was rejected, although the constitution of the organization stated that any artist who paid five dollars might enter. Duchamp did not, in fact, present the object unchanged. There was a crudely painted signature 'R. Mutt' (R. Mott was the name of a leading supplier of such products). The effect was of the 'artistic' intervention as a rude interruption of the white porcelain perfection of the manufactured object. When photographed, the object was positioned in such a way that any usage would result in urine dribbling on to the toes. In other words, the object would literally become a fountain. With the exception of the *Fountain* the ready-mades were little-known until rediscovered in the context of *Surrealist objects in the 1930s. Most are now lost and are known by reconstructions made in the 1960s. In 1918–19 Duchamp spent nine months in Buenos Aires playing chess, then returned briefly to Paris, where in 1919 he produced his most extreme piece of iconoclasm—a reproduction of the *Mona Lisa* to which he added a moustache, beard, and rude inscription, 'LHOOQ', which read phonetically sounds something like 'She has a hot tail' in French. (Picabia used a version of it on the cover of *391* in March 1920.)

From 1920 to 1923 Duchamp again lived in New York, and during this period he was engaged mainly on his most complex and ambitious work—an enigmatic construction entitled *The Bride Stripped Bare by Her Bachelors, Even*, also known as *The Large Glass* (Philadelphia; replica by Richard *Hamilton, 1965–6, in Tate). (The French title is 'La Mariée mise à nu par ses célibataires, même', which contains

a characteristic Duchampian pun, for 'même' sounds the same as 'm'aime', which would give the translation 'The bride stripped bare by her bachelors loves me'.) Duchamp's plans for this work go back as far as 1912 (important elements such as the chocolate grinder appear in other works) and he began constructing it in 1915. He abandoned it as 'definitively unfinished' in 1923, but it was damaged while being transported in 1926 (following its first public showing at the 'International Exhibition of Modern Art' at the Brooklyn Museum) and ten years later he made repairs, incorporating cracks in the shattered glass as part of the image and declaring it completed 'by chance'.

The Large Glass is a structure about nine feet high, featuring an upper and lower glass panel in an aluminium framework; each panel is painted in oil paint with lead wire and foil, dust, and varnish. The foil was placed behind the paint to keep it airtight, supposedly to preserve the colour forever in a pristine wet state. The upper panel features 'the bride's domain' and the lower panel 'the bachelor apparatus'. The mysteries of the work are partially elucidated by the elaborate notes which Duchamp published as a set of disordered and incomplete fragments as the *Green Box* (1934). The first person to attempt to make sense of them was André *Breton in his essay 'The Lighthouse of the Bride' (1934), published in *Minotaure*. Since then readings of the work have become a major scholarly industry. It is certainly, at the very least, by far the most complex of the various attempts by the early 20th-century avant-garde to represent human life in mechanical terms. It is also a work of extraordinary technical complexity incorporating highly elaborate perspectival constructions and the operation of chance in, for instance, the effects of the random fall of dust or holes drilled in the spots where paint-soaked matches were fired at it. Chance continues to operate after the work was finished. Because of Duchamp's choice of glass, the painting is not just a surface but a window and is never seen exactly the same way twice. Like many of his contemporaries he was fascinated by conceptions of the fourth dimension, and the perpetual frustration of the bachelors confined in their 'malic moulds' (special suits designed for auto-erotic purposes) may be because they are trapped in a different dimensional system in the lower section.

In 1923 Duchamp returned to Paris and lived there until 1942 (although he made several visits to New York). He devoted much of his time to his passion for chess. His obsessive devotion to the game ruined his first—rather frivolous—marriage in 1927, of which Man Ray wrote: 'Duchamp spent the one week they lived together studying chess problems, and his bride, in desperate retaliation, got up one night when he was asleep and glued the chess pieces to the board. They were divorced three months later.' Unlike Picasso, he was generally discreet about his amorous relationships. The most intense may have been with the Brazilian Surrealist sculptor Maria Martins (1900–73), the wife of a diplomat. In 1954 he made a second marriage, to Alexina Sattler, who had previously been the wife of the art dealer Pierre Matisse, son of Henri *Matisse.

Duchamp, while never fully committing himself to *Surrealism, remained active and supportive of Surrealist activity. Like *Picasso, he was a person sufficiently highly regarded by André Breton to be permitted such a half-hearted relationship without suffering terrifying anathemas. He was active in the novel installation of the Surrealist exhibitions in Paris in 1938 and in New York in 1942 (*see* INSTALLATION). In 1935 he began to assemble materials for the *Boîte-en-valise*, an edition of reproductions of all his work in miniature. (Certain privileged individuals received personalized versions. Maria Martins's box had a special work, *Paysage fautif*, painted in the artist's semen.) Also in 1935, Duchamp exhibited his *Rotoreliefs*, not in an art gallery but at a Paris trade fair. These were circular cardboard cards which created illusions of depth when rotated on a turntable, so looking forward to *Op art. Duchamp's persistent interest in optics forms an interesting parallel to the theme of voyeurism already enunciated in *Dulcinea* and the *Large Glass*, the latter containing 'Temoins oculistes' (eye witnesses). In 1942 Duchamp settled permanently in New York although he regularly visited France. By this time he seemed to have abandoned the practice of art, but he did a good deal to promote avant-garde art in France and the USA, notably through the activities of the *Société Anonyme. In his final years he was revered as a kind of patron saint of modern art, giving numerous interviews in which he showed his characteristic graciousness and wit. In 1954 the Arensberg collection became publicly available at the Philadelphia Museum of Art. In 1959, exhibitions of his work were held in London, New York, and Paris, and many others followed, including 'The Almost Complete

Works of Marcel Duchamp' at the Tate Gallery, London, in 1966.

Near the end of his life Duchamp revealed that he had been working in secret for 20 years (1946–66) on a large mixed-media construction called *Etant donnés: 1° La Chute d'eau, 2° Le Gaz d'éclairage* (Given: 1. The Waterfall, 2. The Illuminating Gas). It features a naturalistic painted sculpture of a nude reclining woman holding a lantern, with behind her a simulated landscape, including a trickle of water representing a waterfall; this elaborate tableau is viewed through peepholes in a heavy wooden door. The viewer is placed in the position of the bachelors in the *Large Glass*. Duchamp tried to prevent any reproduction of the interior for twenty years so as to preserve the surprise. He presented it to the Philadelphia Museum of Art, where it joined the majority of his other works. Duchamp died on a visit to France and was buried with other members of his family in Rouen. He composed the inscription for his gravestone, jesting to the last: 'D'ailleurs c'est toujours les autres qui meurent' (All the same, it's always other people who die). Many years after his death, his wife told an interviewer that he had literally died laughing.

Duchamp became a major influence on modern art fairly late in his life, when Robert *Rauschenberg and Jasper *Johns found in his ironic detached stance an antidote to the increasingly manufactured frenzy of *Abstract Expressionism. Duchamp's idea of *appropriation and his irreverence toward fine-art traditions was significant for *Pop artists such as *Warhol and Hamilton. Histories of *Conceptual art sometimes cite Duchamp as a kind of founding father and *Kosuth saw him as the first artist who had made the condition of art itself the centre of interest. Duchamp's idea of the *ready-made has certainly been important for more recent artists such as Jeff *Koons, Cornelia *Parker, and Tracey *Emin, although they often emphasize the preciousness and uniqueness of the object rather than its commonplace quality. The philosophical issues raised by Duchamp's work have continued to engage scholars and in recent years the issues of sexuality and gender have also been addressed in critical studies of the artist.

In spite of Duchamp's enormous historical importance he has not always been seen as a positive force, even by those who have, in some way, continued his challenge to traditional art. The cool, detached attitude to the world has seemed inappropriate to artists who seek to extend their work into political activism or more overt personal expression. In 1965 three young painters, Eduardo *Arroyo, Gilles *Aillaud, and Antonio Recaltati exhibited a set of paintings entitled *Live and Let Die or the Tragic End of Marcel Duchamp*. It showed the three artists strangling the old man and kicking him downstairs. The final panel made a cruel political point by showing his coffin draped in the American flag and borne by the United States military. Breton protested but Duchamp remained 'indifferent'. Joseph *Beuys once gave a demonstration entitled 'The Silence of Duchamp is overrated'. The Performance artist Alastair Mackintosh, writing on Beuys, provided a succinct critique of Duchamp: 'He belonged to the old European tradition of artists—elegant, sensitive, aristocratic. If the language of art were tainted, then the only thing a gentleman could do was lapse into enigmatic silence. Duchamp's art is one of defeat' (S. and T. Pendergast, *Contemporary Artists*, 2002). *See also* POPULAR PRINTS.

Further Reading: D. Ades, N. Cox, and D. Hopkins, *Marcel Duchamp* (1999)

J. Mundy (ed.), *Duchamp, Man Ray, Picabia* (2008)

F. Nauman, 'The Bachelor's Quest', *Art in America* (September 1993)

Duchamp, Suzanne (1889–1963) French painter, the sister of Marcel *Duchamp, Raymond *Duchamp-Villon, and Jacques *Villon. She exhibited with the *Section d'Or group in 1912, and after the First World War became involved with the *Dada movement in Paris. In 1920 she married the Dada painter Jean Crotti (1878–1958), and as a wedding present her brother Marcel sent instructions for an 'unhappy *ready-made', consisting of a geometry text book suspended by strings from her balcony; 'the wind had to go through the book', he said, 'choose its own problems, turn and tear the pages'. Suzanne made a painting of it—*Marcel's Unhappy Ready-Made* (1920, private collection). Her paintings were typically in a delicately mechanistic abstract vein.

Duchamp-Villon, Raymond (1876–1918) French sculptor, born in Damville, near Rouen, the brother of Marcel and Suzanne *Duchamp and of Jacques *Villon (he adopted the name Duchamp-Villon in about 1900). After illness forced him to give up his medical studies at the University of Paris in 1898, he took up sculpture, at which he was essentially

self-taught. For the next dozen years or so he experimented with various styles, being especially interested in the representation of the body in motion, until about 1910 he became involved with *Cubism. Several other Cubists used to meet in the studios of Duchamp-Villon and Villon (*see* PUTEAUX GROUP) and from these meetings the *Section d'Or group emerged. Duchamp-Villon was especially concerned with the decorative functions of sculpture. In 1912 he exhibited a *Cubist House* at the Salon d'Automne, an attempt to integrate sculpture and architecture. In 1914 he enlisted in the army as an auxiliary doctor, and he contracted typhoid fever in 1916; he spent his last two years as an invalid before he died in a military hospital in Cannes. His death cut short a career of great promise, for his major work, *The Horse* (1914), has been described by George Heard *Hamilton as 'the most powerful piece of sculpture produced by any strictly Cubist artist' (original plaster in Philadelphia Museum of Art, casts of a posthumous enlarged version in Tate, MoMA, New York, and elsewhere). This 'abstract diagram of the muscular tensions developed by a leaping horse' (Hamilton) has been compared with the work of the *Futurists, particularly that of *Boccioni, who met Duchamp-Villon in 1913. In the success with which it suggests taut energy it certainly achieves at least one of the things the Futurists were aiming at in their attempts to represent 'the dynamics of movement'.

Further Reading: J. Zilczer, 'Raymond Duchamp-Villon', *Bulletin of Philadelphia Museum of Art* (1980–81)

Dufresne, Charles (1876–1938) French painter, designer, and engraver, born at Millemont, Seine-et-Oise. He trained as a commercial engraver, then studied medal engraving at the École des *Beaux-Arts, Paris, but he turned increasingly to painting, exhibiting his pictures regularly from 1899. In 1910 he was awarded the Prix de l'Afrique du Nord and spent the next two years in Algeria. This contact with an exotic civilization stimulated his sense of colour and stirred his interest in the kind of romantic African subjects painted by Delacroix in the 19th century. During the First World War he served in the French army, and after being gassed he worked in *Dunoyer de Segonzac's camouflage unit. Like Segonzac, Dufresne became recognized in the interwar period as an upholder of traditional skills and values (*see* NÉO-RÉALISME), but he also

adopted a mild degree of *Cubist stylization. His output included religious paintings and portraits, but his most characteristic works are imaginative scenes recalling his exotic travels (*Spahi Attacked by a Lion*, 1919, Tate).

Dufy, Raoul (1877–1953) French painter, graphic artist, and designer. He was born in Le Havre and from 1892 studied there at evening classes at the École Municipale des Beaux-Arts whilst working for a firm of coffee importers. In 1900 he won a scholarship that took him to the École des *Beaux-Arts in Paris for four years. His early work was *Impressionist in style, but he became a *convert to *Fauvism in 1905 after seeing *Matisse's *Luxe, calme et volupté* ('this miracle of creative imagination in colour and line') at the *Salon des Indépendants. He exhibited with the Fauves in 1906 and 1907, but in 1908 he worked with *Braque at L'Estaque and abandoned Fauvism for a more sober style influenced by *Cézanne. However, he soon returned to a lighter style and in the next few years developed the highly distinctive personal manner for which he has become famous. It is characterized, in both oils and watercolours, by rapid calligraphic drawing on backgrounds of bright, thinly washed colour and was well suited to the scenes of luxury and pleasure Dufy favoured. He had achieved considerable success by the mid-1920s and the accessibility and *joie de vivre* of his work helped to popularize modern art. George Heard *Hamilton writes that 'Like many minor masters he found a formula which, once established, he never fundamentally changed, but it is so amusing, and its variations so clever, that it rarely grows tiresome'.

In 1910 Dufy made friends with the fashion designer Paul Poiret (1879–1944), and he did design work for both Poiret and Bianchini-Férier, a silk manufacturer of Lyons. His other work included stage designs, numerous book illustrations, notably for *Apollinaire's *Bestiare* (1910), and several murals, the largest of which was *The Spirit of Electricity*, commissioned for the Pavilion of Light at the 1937 Paris World Fair and now in the Musée d'Art Moderne de la Ville de Paris. With Othon *Friesz (a friend since boyhood) he did another large mural (1937–40) on the subject of the River Seine for the bar of the Théâtre du Palais de Chaillot, Paris (now in the Pompidou Centre, Paris); Friesz painted the section covering the river from its source to Paris, and Dufy the section from Paris to the sea at Le Havre. In 1952 he was awarded the main painting prize

at the Venice *Biennale. His popularity has continued undiminished since his death, not least in Japan, where he is a favourite with collectors.

Dujardin, Édouard *See* CLOISONNISM.

Dulac, Edmund (1882–1953) French-born illustrator, designer, painter, and sculptor who settled in England in 1905 and became a British citizen in 1912. Dulac is best known as a book illustrator, particularly for fairy-tale and legendary subjects, in which his sense of fantasy and gifts as a colourist were put to brilliant effect (he was much influenced by Middle and Far Eastern art). In the period before the First World War, when there was a vogue for lavish and expensive children's books, he was Arthur *Rackham's only serious rival in the field. He was also a portrait painter and caricaturist, and a highly versatile designer; his output included much work for the stage (notably for plays by his friend W. B. Yeats), and one of his last commissions was a stamp commemorating the coronation of Queen Elizabeth II in 1953.

Dumas, Marlene (1953–) South African artist, born in Cape Town. She studied fine art at the University of Cape Town, graduating in 1975. In 1979 she went to the Netherlands to study psychology and has since lived and worked in Amsterdam. She is known for freely painted images, especially of children, which have an uncanny and unsettling quality, as in her series of paintings of babies entitled *The First People* (1991). Her imagery is usually taken from photographs, sometimes the artist's own, sometimes culled from newspapers and magazines. She has recalled that while at art school she was drawn to photography 'because it was closer to "real life" . . . When I started to embrace the ambiguity of the image, and accepted the realisation that the image can only come to life through the viewer looking at it, and that it takes on meaning through the process of looking, I began to accept painting for what it was.' She points out that if photography, as *Picasso told *Brassaï, had 'liberated painting from the subject', it had also freed the painter from responsibility for it. Anything could be painted without permission from or negotiation with the subject. The disquieting sense of exposure which is sensed in her paintings of the nude, such as the series of *Magdalena* (1996, Tate), can be related to this. This kind of distance from the subject paradoxically lends force to her paintings of blindfolded Palestinian prisoners or a painting such as *Frisked* (2006), based on a detail of a news photograph of an aged Afghan tribesman being searched.

Further Reading: Arts Council of England, *The Painting of Modern Life* (2007)

D. Boegard, *Marlene Dumas* (1999)

Dunn, Anne *See* MOYNIHAN, RODRIGO.

Dunoyer de Segonzac, André (1884–1974) French painter, printmaker, and designer. He studied at various academies in Paris, 1900–07 (interrupted by military service in 1902–3). Early in his career he went through a period of *Cubist influence, but after the First World War he became recognized as one of the leading upholders of the naturalistic tradition (*see* NÉO-RÉALISME). Like *Vlaminck, he was a pugnacious opponent of the influence of *Cubism and all kinds of intellectualism in art. 'An art critic should judge a work of art as a horse-dealer judges a horse,' he declared in 1923, 'and above all should not find it a simple excuse for having fun with words.' Segonzac's oil paintings (mainly landscapes, still-lifes, and figure compositions) are often sombre in tone and usually executed in thick paint, emphasizing the weight and earthiness of the forms. His watercolours and etchings, however, are more elegant and spontaneous, with a wider range of subject-matter, including dancers and boxers. He also did designs for the theatre and ballet.

Segonzac's reputation was at its height in the 1930s: he won first prize at the *Carnegie International in 1933 and the main painting prize at the Venice *Biennale in 1934. There is a museum of his work at his birthplace, Boussy-St-Antoine, near Paris, and he is also well represented in the Musée de l'Île de France at Sceaux.

Dunstan, Bernard (1920–) British painter, born in Teddington, Middlesex. He studied at the Byam *Shaw School of Art, 1939, and the *Slade School, 1939–41. His work is 'mostly to do with figures in interiors: nudes particularly, but also musical subjects, scenes in galleries and so on; a few portraits; also townscapes, mostly Italian, and the odd landscape. I have always liked the French-English tradition of the 19th/20th century (pre-Cubist) . . . and have never felt a need to do anything different. The combination of everyday charm and solid painting—finding the colour and the pattern

by observation—seems to me inexhaustible.' He has had numerous one-man shows, notably a series at Roland, Browse & Delbanco (*see* BROWSE) between 1952 and 1972, and he has exhibited regularly at the *Royal Academy since 1945. He has also written instructional manuals, such as *Learning to Paint* (1970). In Jeffrey Archer's novel *Not a Penny More, Not a Penny Less* (1976), the villain, Harvey Metcalfe, is an admirer of Dunstan's work: 'Harvey made a special point of looking at the Bernard Dunstans in the [Royal Academy Summer] Exhibition. Of course, they were all sold. Dunstan was one of the artists whose pictures always sold in the first minutes of the opening day.'

Durand-Ruel, Paul (1831–1922) The best-known member of a family of French picture-dealers. He took over the family firm in Paris in 1865 and is celebrated chiefly as the first dealer to give consistent support to the *Impressionists—his belief in them often brought him close to bankruptcy. The firm was one of the main channels through which the American collector *Barnes and the Russian collectors *Morozov and *Shchukin built up their superb representations of modern French painting. In 1911 Durand-Ruel handed over the business to his sons, **Joseph** (1862–1928) and **Georges** (1866–1933). The New York branch (established in 1886) closed in 1950 and the Paris gallery continued until 1974, run by Joseph's son, **Charles** (1905–85).

Durham, Jimmie (1940–) American artist, political activist, and poet of Cherokee descent, born in Connecticut. He studied at the École des Beaux-Arts, Geneva, and lived for a time in Mexico. He now lives and works in Berlin. Before achieving his international reputation as an artist he was the director of the International Indian Treaty Council, which campaigned and negotiated for land rights. He has made works out of material stereotypically associated with Native Americans such as animal skulls but does so in a somewhat ironic manner which challenges assumptions about identity. For instance in his work of 1985 *On Loan from the Museum of the American Indian* he included items such a toothbrush and feathered underpants as well as an exhibit entitled 'Types of Arrows' with pedantically obvious labels such as 'tiny' and 'wavy'. As well as this rather *Conceptual kind of work, Durham has often achieved sculpture of great visual power sometimes with strikingly economical means. In the 1992 *documenta a bent length of piping arising from a stream evoked the evolution of life from water to land. *The Flower of the Death of Loneliness* (2000, Saatchi Gallery, London) is a stone crashed into a broken mirror which reflects painted eyes. Lucy *Lippard writes that 'Durham sees the world through the eyes of Coyote—the trickster, the Native American embodiment of all that is base and godlike in humans.'

Further Reading: L. Lippard, 'Jimmie Durham: postmodernist "savage"—Native American Artist', *Art in America* (February 1993)

Düsseldorf, Nordrhein-Westfalen Collection *See* NORDRHEIN-WESTFALEN COLLECTION.

Duveen, Joseph *See* TATE.

Dyn and **Dynaton movement** *See* PAALEN, WOLFGANG.

Eakins, Thomas (1844–1916) American painter, mainly of portraits, active for most of his life in his native Philadelphia. He began teaching there at the Pennsylvania Academy of Fine Arts in 1876 and was attacked for his radical ideas, particularly his insistence on working from nude models. In 1886 he was forced to resign after allowing a mixed class to draw from a completely nude male model, but his ideals were carried on by his successor Thomas Pollock Anschutz (1851–1912). Eakins also caused controversy more than once because of the unsparing realism of his work. Financial support from his father enabled him to continue on his chosen course despite public abuse, but much of his later career was spent working in bitter isolation. In 1894 he wrote: 'My honours are misunderstanding, persecution, and neglect, enhanced because unsought.' It was only near the end of his life that he achieved recognition as a great master, and in the first two decades of the 20th century his desire to 'peer deeper into the heart of American life' was reflected in the work of the *Ashcan School and other realist painters. Many critics today consider him one of the greatest of all American painters. Eakins also made a few sculptures. Little of his work can be seen outside the USA; the best collection is in the Philadelphia Museum.

Further Reading: E. Johns, *Thomas Eakins: The Heroism of Modern Life* (1992)

Eames, Charles See BERTOIA, HARRY.

Eardley, Joan (1921–63) British painter, born in Sussex but considered Scottish (her mother was Scottish and she lived in Scotland from 1940). She studied at *Goldsmiths College, London, 1938–9 (leaving because of the outbreak of war), *Glasgow School of Art, 1940–43, and after working for three years as a joiner's labourer, at the summer school at Hospitalfield House, Arbroath, 1947. Her teacher there was James *Cowie; he perhaps helped to shape her preference for subjects drawn from everyday experience, but her approach was more earthy and sensuous than his. In 1948–9 she travelled abroad, mainly in Italy, on a scholarship awarded by the Royal Scottish Academy. After her return she divided her time between Glasgow (where she painted *Kitchen Sink type subjects) and the fishing village of Catterline, about 20 miles south of Aberdeen on the north-east coast. She discovered this fairly remote spot in 1950 and became increasingly devoted to it, acquiring a house and studio there. Her favourite subjects in her later years were the village and the sea, especially in stormy weather (she is said to have set off from her Glasgow home as soon as she heard reports of gales). The freely painted, often bleak and desolate works that resulted are among the most powerful and individual landscapes in 20th-century British art. After her early death from breast cancer her ashes were scattered on the beach at Catterline. Her work is well represented in the Scottish National Gallery of Modern Art, Edinburgh.

Further Reading: C. Oliver, *Joan Eardley, RSA* (1988)

earthwork See LAND ART.

East Anglian School of Painting and Drawing See MORRIS, SIR CEDRIC.

École de Paris (School of Paris) A term that was originally applied to a number of artists of non-French origin, predominantly Jewish in background, who in the years immediately after the First World War lived in Paris and painted in figurative styles that might loosely be called poetic *Expressionism, forming the most distinctive strand in French painting between *Cubism and *Surrealism. *Chagall (a Russian), *Foujita (a Japanese), *Kisling (a Pole), *Modigliani (an Italian), *Pascin (a Bulgarian), and *Soutine (a Russian) are among the most famous artists embraced by the term. However, the meaning of the term was soon broadened (particularly

outside France) to include all foreign artists who had settled in Paris since the beginning of the century (the Dutchman van *Dongen and the Spaniard *Picasso, for example), and then it expanded still further to cover virtually all progressive art in the 20th century that had its focus in Paris. In this broadest sense, the term reflects the intense concentration of artistic activity, supported by critics and dealers, which made the city the world centre of innovative art up to the Second World War. The centre of creativity before the First World War was Montmartre in the north of the city. After the war, Montmartre was left largely to the tourists and Montparnasse became a more significant area.

In 1951 an exhibition devoted to the École de Paris, covering the period 1900 to 1950, was held at the New Burlington Galleries, London. In his introduction to the catalogue Frank McEwen wrote that Paris then had 130 galleries (as opposed to a maximum of 30 in any other capital city), in which were shown the work of some 60,000 artists, one-third of them foreigners; there were 20 large Salons exhibiting annually an average of 1,000 painters each, mostly semi-professionals. The city remained a lure for painters throughout the 1950s, in spite of the increasing significance of New York. As late as 1961 Bernard Dorival reported that 70,000 artists were at work between Montmartre and Montparnasse, of whom around a third were born outside France. 'Many of them', he commented, 'live in direst poverty, but their ardour cannot be damped.' Nonetheless following a crisis in the art market in 1962 after several years of boom, and the success of Robert *Rauschenberg at the Venice *Biennale in 1964, Paris lost its central role in contemporary art and, in spite of considerable endeavours and expenditure by the French state, most notably the establishment of the *Pompidou Centre, it has never quite recovered.

Further Reading: Dorival (1962)

Musée d'Art Moderne de la Ville de Paris, *L'École de Paris: 1904–1929* (2000)

École des Beaux-Arts, Paris. *See* BEAUX-ARTS.

Ede, H. S. (1895–1990) British collector, curator, lecturer, and writer, born in Penarth, Glamorgan, the son of a solicitor; the 'H. S.' stands for Harold Stanley, but from about 1920 he adopted the name 'Jim'. After leaving school he began training as a painter at *Newlyn and then Edinburgh College of Art, but the First World War interrupted his studies. From 1919 to 1921 he studied at the *Slade School, then became the photographer's assistant at the National Gallery. In 1922 he moved to the *Tate Gallery, where he worked until 1936, during which time he established contacts with leading modernist artists including *Brancusi, *Miró, and *Picasso. The British artists with whom he was friendly included Ben and Winifred *Nicholson (whom he met in 1923 and who played an important part in stimulating his interest in contemporary art), Barbara *Hepworth, David *Jones, Henry *Moore, and Christopher *Wood, all of whose work he collected. In 1926 he discovered the work of *Gaudier-Brzeska when his estate was offered to—and declined by—the Tate. Ede acquired much of it and from that point championed the artist's work, by making gifts to museums in Britain and France, arranging for bronze casts to be made, and by writing *A Life of Gaudier-Brzeska* (1930), which was reprinted in 1931 with the title *Savage Messiah*. He also became a major supporter and collector of Alfred *Wallis. He was regarded as a leading contender to be next director of the Tate, but he resigned in 1936, being unable to work any longer with the director at the time, J. B. *Manson, who did not share Ede's enthusiasm for modernist art and signally failed to exploit his knowledge and contacts.

After leaving the Tate, Ede moved to Tangier and supported himself partly with lecture tours in America. In 1952 he moved to France, then in 1956 returned to England. The following year he bought four derelict 17th-century cottages in Cambridge and converted them into a single house that he called Kettle's Yard. In this house he presented his art collection in a setting 'which harmonized the modernist spirit of the 1930s with the experience of living in north Africa' (*DNB*). The house was open to the public every afternoon, and in 1966 Ede presented it and its contents to the University of Cambridge. An extension and exhibition gallery, designed by Sir Leslie Martin (*see* CIRCLE), were added in 1970, but Kettle's Yard still retains the character of a private home, although it is now as noted for its temporary exhibitions as its permanent collection. Ede moved to Edinburgh in 1973 and lived there for the rest of his life, but he kept close links with Kettle's Yard and published a book on it in 1984: *A Way of Life: Kettle's Yard*.

Edelson, Mary Beth See FEMINIST ART.

Edinburgh, Scottish National Gallery of Modern Art See SCOTTISH NATIONAL GALLERY OF MODERN ART.

Eggeling, Viking (1880–1925) Swedish painter, draughtsman, and film-maker, born at Lund. After studying painting in Milan and teaching drawing in Switzerland, he moved to Paris in 1911. He met *Arp in 1915 and soon afterwards moved to Switzerland, where he became a member of the *Dada group in Zurich in 1916. In 1918 he met Hans *Richter, who later said that they found themselves in 'complete agreement on aesthetic as well as philosophical matters', and they began collaborating on 'scroll' paintings consisting of sequences of images on long rolls of paper investigating transformations of a given geometrical form. By multiplying, transforming, and shifting the geometrical elements and combining them with curving lines, it was intended that the passage from one image to another would produce in the spectator the impression of continuous movement. After quarrelling in 1921, Eggeling and Richter went on to work separately on film animation. Eggeling moved to Berlin in 1922 and his *Diagonalsymphonie*, first shown there publicly in 1925, was one of the first purely abstract films. It was in essence an animated version of the drawings in the scroll paintings.

Eggleston, William (1939–) American photographer and film-maker, born in Memphis, Tennessee. His subjects are taken from the life and landscape of the area and are generally in an informal 'snapshot' manner, although Eggleston's preoccupations are not with any specific sense of place. 'People always want to know when something was taken, where it was taken, and, God knows, why it was taken. It gets really ridiculous. I mean, they're right there, whatever they are,' he told an interviewer. Ian Jeffrey has made an illuminating comparison with the great 17th-century Dutch genre painters Vermeer and de Hooch, in that content frequently seems of little consequence or is actually 'baffling': one of Eggleston's most celebrated images is *Greenwood: Mississippi* (1973, MoMA, New York), an angled shot of a single light bulb with three white flexes like spiders' legs linking to it. What gives his work its special character is use of colour. The bulb photograph is dominated by the brilliant dark red of the ceilings and walls. In 1973 he began using a new dye-transfer process which provided an unprecedented saturation of colour, to make prints from his transparencies. His 1976 exhibition at MoMA, New York, and the accompanying book, *William Eggleston's Guide*, were crucial in establishing the acceptance of colour photography as a serious artistic medium. Eggleston's film *Stranded in Canton*, constructed from video footage he had shot in the early 1970s, was released in 2006.

Further Reading: S. O'Hagan, 'Out of the ordinary', *The Guardian* (25 July 2004)

Eight, The A name of three groups of artists, respectively (1) American, (2) Czech, and (3) Hungarian; they were not connected in any way, but they all originally consisted of eight members, and they were all active in the first decade of the 20th century.

1. A group of eight American painters who exhibited together in 1908, united by opposition to the conservative National Academy of Design and a determination to bring painting into direct touch with life. The eight members were: Arthur B *Davies, William J. *Glackens, Robert *Henri, Ernest Lawson (1873–1939), George *Luks, Maurice *Prendergast, Everett *Shinn, and John *Sloan. They banded together when the National Academy of Design rejected work by Glackens, Luks, and Sloan for its 1907 exhibition. Henri, who was the dominant personality of the group and a member of the Academy's jury, withdrew his own work in protest, and Davies was then asked to organize an independent exhibition at the Macbeth Gallery, New York. This took place in February 1908; it was the only exhibition in which The Eight showed together as a group, but it was subsequently circulated to nine other venues over a period of a year and gained a good deal of publicity. The members of the group were not unified stylistically (one hostile reviewer referred to the 'clashing dissonances of eight differently tuned orchestras'), but their predominant theme was contemporary urban life (several of them were part of the broader trend known as the *Ashcan School). Their exhibition is regarded as an important landmark in American art: its principle of nonjuried selection was taken up in the Exhibition of Independent Artists in 1910 (*see* HENRI), which in turn led the way to the *Armory Show of 1913.

2. A group of progressive Czech artists formed in Prague in 1906 (the name in Czech is Osma). The members, who were

essentially *Expressionist in outlook, held two exhibitions, in 1907 and 1908. These were poorly received and the group ceased to function, although it never officially disbanded. *Filla and *Kubišta were the best-known members.

3. A group of Hungarian painters founded in Budapest in 1909, the first avant-garde group in Hungarian art (the name in Hungarian is Nyolcak). The members were opposed to *Impressionism, desiring an art that had a greater sense of order and structure, *Cézanne being a major influence. Originally the group was called 'The Seekers'; the name 'The Eight' was adopted in 1911. Károly Kernstok (1873–1940) was the leading figure of the group. It held three exhibitions (1909, 1911, 1912), the first of which prompted an essay by the philosopher Georg Lukács (1885–1971) entitled 'The Ways Have Parted', in which he wrote that The Eight had made 'a declaration of war on Impressionism'. John Willett writes that 'His views are important ... first and foremost as showing how the Hungarian middle-class radicals interpreted the new art ... To Lukács, who was philosophically and temperamentally against anything so vague as the essences, atmospheres and impressions which he felt had invaded painting, Kernstok and his group were striking a gratifyingly sharp blow on behalf of Order' (catalogue of the exhibition 'The Hungarian Avant Garde: The Eight and the Activists', Hayward Gallery, London, 1980). The Eight disintegrated after its third exhibition, but it made an important impact on Hungarian art and prepared the way for other groups, particularly the *Activists.

Eilshemius, Louis Michel (1864–1941) American painter, one of the great eccentrics of 20th-century art. Born in New Jersey, the son of a Dutch merchant, he studied at the *Art Students League, New York, 1884–6, and the *Académie Julian, Paris, 1886–7, then travelled widely—in Europe, Africa, and the South Seas—before settling in New York in 1903. His early work, influenced by the *Impressionists, was fairly conventional, but by the turn of the century he had adopted a visionary manner, depicting scenes from a private dream world in which figures often float in the air (*Afternoon Wind*, 1899, MoMA, New York). There is a kinship of feeling with the poetic, introverted work of another eccentric, Albert Pinkham *Ryder, but Eilshemius's style was rougher and sometimes had a *naive

quality. He adopted the pseudonym 'Mahatma' and grew embittered at the lack of recognition he thought was due to him as 'the world's mightiest mind'. Although he was championed by Marcel *Duchamp and Duncan *Phillips (Duchamp arranged for him to have a one-man show at the *Société Anonyme in 1920), Eilshemius abandoned painting in 1921 and failed to profit when his work gained belated recognition in the 1930s.

Further Reading: P. A. Kahlstrom, *Louis Michel Eilshemius* (1978)

Élan, L' *See* OZENFANT, AMÉDÉE.

Elementarism A modified form of *Neo-Plasticism propounded by van *Doesburg in a manifesto published in *De *Stijl* in 1926. Whilst maintaining *Mondrian's restriction to the right angle, Elementarism abandoned his insistence on the use of strict horizontals and verticals. By introducing inclined lines and forms van Doesburg sought to achieve a quality of dynamic tension in place of the classical repose of Mondrian: 'Through his diagonal *Counter-Compositions* Van Doesburg believed he could construct a non-reductivist abstract painting capable of a convincing representation of the variety and vitality of life. This embodied a schematic rendering of the dynamics of human experience of movement and changing relationships instead of the static balancing of "universals" found in earlier De Stijl theory and practice' (Paul Overy, *De Stijl*, 1991). Mondrian was so offended by this rejection of his principles that he left De Stijl.

Eliasson, Olafur (1967–) Danish/Icelandic installation artist, born in Copenhagen. He now lives and works in Berlin. He is noted for spectacular crowd-pleasing displays which invoke something of a sense of the sublime in nature. The most famous is *The Weather Project* (2004), in which the vast turbine hall of *Tate Modern was dominated by an artificial sun (made out of two hundred single filament light bulbs) while the ceiling was covered with mirrored panels to increase its apparent height and double the illuminated half circle of the artificial sun. A light fog was introduced which enhanced the sense that the walls were insubstantial. The installation attracted over a million visitors, many of whom lay on the floor to experience the work. After it was removed, Eliasson said that, as visiting it had become a ritual, the removal 'preserved its integrity as

an artistic project'. The element of the unexpected is important to the artist. In a number of cities he has surprised residents who discover that the river has suddenly turned green for the day. In 2008 he constructed four artificial waterfalls for New York.

Further Reading: C. Diehl, 'Northern Lights', *Art in America* (October 2004)

Elliott, David *See* MODERN ART OXFORD.

El Paso An association of Spanish artists formed in Madrid in 1957. The name, meaning 'crossing' or 'passage', was meant to suggest movement or renewal. Its founding members were the painters *Canogar, Luis Feito (1929–), *Millares, and *Saura, together with the writers José Ayllón and Manuel Condé. They were soon joined by the painters Manuel Rivera (1927–1995) and Manuel Viola (1919–87) and the sculptor Martín Chirino (1925–). The group, inspired by *Dau al Set, was important in establishing expressive abstraction or *Art Informel as a major idiom in Spanish art. In spite of official hostility, it held exhibitions until 1960.

Éluard, Paul (pseudonym of Eugène Grindel) (1895–1952) French writer, patron, collector, entrepreneur, draughtsman, and collagist, a leading figure of *Surrealism from the beginning of the movement. Éluard is best known as one of the outstanding French poets of the 20th century, but he was deeply interested in the visual arts and was a friend of many distinguished painters, several of whom he commissioned to illustrate his books (notably Max *Ernst, Man *Ray, and *Picasso). He helped to organize various events, including the International Surrealist Exhibition in London in 1936, and he was on the editorial committee of *Minotaure*. His first wife, Gala, later married another leading Surrealist, Salvador *Dalí. Éluard made a varied and constantly changing art collection, including work by many of his contemporaries as well as examples of African and other non-Western art. In the late 1930s he abandoned Surrealism. He joined the Communist Party in 1942 and remained a committed member for the rest of his life. During the Second World War he was the best known of the Resistance writers, his works circulating clandestinely in occupied France.

Emin, Tracey (1963–) British multimedia artist and writer whose controversial work and personality have brought her celebrity, if not always admiration, far beyond the professional art world. Born in Croydon, Surrey, she moved to the seaside resort of Margate in Kent when she was three. Her father was a Turkish Cypriot who had made and lost a considerable amount of money in the London property market. She is drawn upon early experiences in her life in autobiographical art works and writings, including frank reminiscences of her first sexual experiences or being 'broken into as we say in Margate'. She graduated from Maidstone College of Art in 1986 and studied painting at the *Royal College of Art, which she hated. Subsequently, she destroyed all of her early paintings, which she recalled as something between Edvard *Munch and Byzantine church frescoes. The element of self-exposure in *Expressionism was to remain an important element of her art. The religious aspects have been less obvious, but an exhibition of 1997 was called 'I Need Art Like I Need God', suggesting some kind of link between the aesthetic and the spiritual.

In 1993 Emin held her first solo exhibition, entitled 'My Major Retrospective 1963–1993', at the *White Cube Gallery in London. The name implied that her whole life was being exhibited. The exhibition featured framed relics of the car crash that had killed her Uncle Colin, including the cigarette packet he was holding at the moment of his death. Earlier that year, she had opened a shop in Bethnal Green Road with her friend and fellow artist Sarah *Lucas to sell small artworks. The most famous was an ashtray decorated with the face of Damien *Hirst, by then the most celebrated British artist of his generation. The autobiographical and confessional aspects of her work were, together with a drunken outburst on live television in 1997, to bring her public notoriety. *Everyone I Have Ever Slept With 1963–1995* (1995, formerly Saatchi collection) was a tent with about ninety appliquéd names. It played on the ambiguous erotic connotations of the phrase 'slept with', which is only rarely used in its most literal sense. Matthew Collings described it as 'very intimate and rather moving', but it also needs to be contextualized by the revelations of casual and violent sex in the video *Why I Never Became a Dancer* (1995) and the text *Explorations of the Soul* (1994).

My Bed (1998, Saatchi collection) commemorates an emotional crisis in the artist's life by preserving her untidy bed surrounded by detritus including soiled knickers and a used

tampon. It became the most renowned of her works. In 2004 she made a film entitled *Top Spot*, about the lives of young girls in Margate. The British censor refused to permit it to be shown to viewers under eighteen on the grounds that it might encourage suicide. She moved out of the virtual public space of media notoriety into the traditional physical space of public art in 2005 with a sculpture outside Liverpool Anglican Cathedral. It consists of a small bird on the top of a pole, designed so as to disappear when seen from the front.

In 2005 she published *Strangeland*, a volume of reminiscences. In 2007 she exhibited in the British Pavilion at the Venice *Biennale and became a Royal Academician. She has become a familiar figure on British television, appearing in popular programmes such as *Have I Got News For You?*

Emin's objects are completely different in concept to the Duchampian *ready-made. Rather than being chosen, at least in theory, through indifference, they are charged with the actual experience of life, love and death, sometimes arduous, always unrepeatable. It is this uniqueness of the object which made the incident in 1999 when two men jumped on *My Bed* while it was on exhibition at the Tate Gallery so shocking. In 2004 the corrugated iron beach hut *The Last Thing I Said to You is Don't Leave me Here* (1999) was destroyed in a fire alongside the tent, an event greeted with glee by much of the popular press. Emin, who had shared the hut with her lover Carl Freedman, spoke of its loss: 'It had stood in Whitstable for 25 years before I had it . . . It had a life.' The statement links the sense of loss of the artwork with something of wider import in British culture. It is no accident that an autobiography based around the seaside should have had such an impact in Great Britain. Although Emin herself has spoken of the economic decline of Margate, where her father once ran an hotel, as early as 1957 John Osborne's play *The Entertainer* used a failed show in a seaside resort to stand for the decline of a traditional working-class culture. While playing the contemporary popular culture game of celebrity, she also comments on collective experience in danger of being lost as irrevocably as virginity. There will be no more corrugated iron beach huts in Whitstable. The problem for the wider public is not that her work is difficult and obscure but that is so accessible and direct. Those who claim to despise her art may well also have experienced something of it, even through the dark mirror of the mass media, with disturbing clarity.

Further Reading: N. Brown, *Tracey Emin* (2006)

G. Burn, 'Burned into the Memory', *The Guardian* (27 May 2004)

empaquetage (packaging) *See* CHRISTO.

Energism *See* NEO-EXPRESSIONISM.

English, Michael *See* SUPERREALISM.

Ensor, James (1860–1949) Belgian painter and etcher (his father was English and he had British nationality until 1929). One of the most original artists of his time, Ensor had links with *Symbolism, was a major influence on *Expressionism, and was claimed by the *Surrealists as a forerunner, but his work defies classification within any school or group. He was born in Ostend, where his parents kept a souvenir shop, and apart from a period studying at the Academy in Brussels, 1877–80, and a few brief trips abroad, he rarely left his home town. His early works were mainly bourgeois interiors painted in a thick and vigorous technique. When several were rejected by the Salon in Brussels in 1883, Ensor joined the progressive group Les Vingt (*see* LIBRE ESTHÉTIQUE). From about this time his subject-matter changed and he began to introduce the fantastic and macabre elements that are chiefly associated with him: 'Reason is the enemy of art', he said. 'Artists dominated by reason lose all feeling, powerful instinct is enfeebled, inspiration becomes impoverished and the heart lacks its rapture.' He made much use of carnival masks, grotesque figures, and skeletons, his bizarre and monstrous imaginings recalling the work of his Netherlandish forebears Bosch and Bruegel. The interest in masks probably originated in his parents' shop, but he was also one of the first European artists who appreciated African art, in which they play such a great part. Through his 'suffering, scandalized, insolent, cruel, and malicious masks', as he called them, he portrayed life as a kind of hideous carnival. Often his work had a didactic or satirical flavour involving social and religious criticism: his most famous work, the huge *Entry of Christ into Brussels* (1888, Getty Museum, Malibu), shows how he imagined Christ might be greeted on a new Palm Sunday. It provoked such an outburst of criticism among his associates in Les Vingt (who refused it for

exhibition) that he was almost expelled from the group.

Although Ensor continued to exhibit with the Les Vingt and later with La Libre Esthétique, from this time he became something of a recluse and his work became even more misanthropic. Nevertheless, from about the turn of the century his reputation grew rapidly. In 1899, for example, the Paris journal *La Plume* devoted a special issue to him and organized an exhibition of his work; in 1903 he was made a Knight of the Order of Leopold; in 1905 he was given a large one-man exhibition at L'Art Contemporain in Antwerp; and in 1908 there appeared the first major monograph on him (by the poet Émile Verhaeren). The culmination of his career came in 1929, when the inaugural exhibition of the Palais des Beaux-Arts in Brussels was devoted to his work (*The Entry of Christ into Brussels* was shown in public for the first time) and he was created a baron by King Albert. His work changed little after about 1900, however, and he was content to repeat his favourite themes. From 1904 he also gave up printmaking (he was one of the greatest etchers of his time and also made lithographs). His home in Ostend is now a museum and the nearby Museum of Fine Arts has a fine collection of his work.

entartete Kunst *See* DEGENERATE ART.

Environment (Environmental) art An art

form in which the artist creates a three-dimensional space in which the spectator can be completely enclosed and involved in a multiplicity of sensory stimulations—visual, auditory, kinetic, tactile, and sometimes olfactory. This type of art was prefigured by work which came out of *Dada and *Constructivist challenges to the traditional art object, such as *Lissitzky's Proun Rooms and the Merzbau of Kurt *Schwitters, as well as the elaborate decor of the International *Surrealist Exhibition in Paris in 1938. As a movement it originated in the late 1950s and flourished chiefly in the 1960s, when it was closely connected with *Happenings. Allan *Kaprow, who wrote a book called *Assemblage, Environments & Happenings* (1966), gave the following definitions: 'The term "environment" refers to an art form that fills an entire room (or outdoor space) surrounding the visitor and consisting of any materials whatsoever, including lights, sounds and colour . . . The term "happening" refers to

an art form related to theatre, in that it is performed in a given time and space. Its structure and content are a logical extension of environments.' Apart from Kaprow, the other leading figures who have worked in Environment art include *Kienholz and *Oldenburg, and one of the most celebrated works in the genre was created by Niki de *Saint Phalle in Stockholm in 1966.

One particular form involves the making of spaces that can, at least hypothetically, actually be inhabited, as in the work of Andrea *Zittel or of Absalon (1964–93), an Israeli artist who lived in Paris and devised basic structures which bear a close resemblance to *Minimal art and are designed for a mobile lifestyle.

'Environment' has been loosely used, and confusingly it has sometimes been applied to *Land art or its analogues—that is, to a category of art that consists in manipulating the natural environment, rather than to an art that *creates* an environment to enfold and absorb the spectator. *Christo and Jeanne-Claude's work, for example, is sometimes described as Environmental art. It should not necessarily be assumed that an 'environmental' artist has any special concern with environmental causes in the political sense of the word and it is perhaps to avoid this confusion that the term *installation is more common today. A concern for environmental issues certainly exists in recent art. It is found, for instance, in the work of Joseph *Beuys and Agnes *Denes.

Enwonwu, Ben (Benedict Chuka Enwonwu) (1921–94) Nigerian sculptor and painter, an Ibo born at Onitsha in Eastern Nigeria. His father was a carver of masks and traditional images for ceremonies and shrines. In 1944 he was awarded a scholarship to study in Britain and in 1947 he took a degree at the *Slade School. Subsequently his work was widely exhibited in Britain, Africa, and the USA, and he won numerous distinctions, including the MBE in 1955. In 1947 he was appointed Art Supervisor by the Nigerian Government and in 1959 Art Adviser to the Federal Government. His public commissions include the bronze statue of Elizabeth II in front of the Federal Parliament, Lagos. Enwonwu's work unites the magical quality of traditional African art with an awareness of contemporary developments in Western art. In his more expressive work there are frequent reminiscences of traditional African tribal styles and in particular his own Ibo art.

Epstein, Elizabeth See BLAUE REITER.

Epstein, Sir Jacob (1880–1959) American-born sculptor (and occasional painter and illustrator) who settled in England in 1905 and became a British citizen in 1911. He was born in New York into a family of Polish-Russian Orthodox Jews. From 1894 to 1902 he studied sporadically at the *Art Students League. At the same time he attended evening classes in sculpture at which he was taught by George Grey *Barnard. In 1902, on the proceeds of his illustrations for *The Spirit of the Ghetto* by the journalist Hutchins Hapgood, Epstein moved to Paris. There he studied at the École des *Beaux-Arts and the *Académie Julian, but at least as significant was his discovery of 'a mass of primitive sculpture' at the Musée de l'Homme. Not only was he to be profoundly influenced by this as an artist but he was also to acquire a remarkable collection of African art. In 1905 he moved to London, where he executed his first important commission in 1907–8: eighteen Portland stone figures, over life size, for the façade of the British Medical Association's headquarters in the Strand. They aroused a furore of abuse on the grounds of alleged obscenity and were mutilated in 1937 after the building was bought by the government of Southern Rhodesia. Such verbal attacks and acts of vandalism were to become a feature of Epstein's career.

The next outcry came with his tomb of Oscar Wilde (1912, Père Lachaise Cemetery, Paris), a magnificently bold and original piece featuring a hovering angel inspired by Assyrian sculpture; it was banned as indecent until a bronze plaque had been placed over the angel's sexual organs. Epstein spent a good deal of time in Paris during the initial period of controversy; he met *Brancusi, *Modigliani, and *Picasso there and was influenced by their formal simplifications. Back in England, he associated with the *Vorticists, and at this time he created his most radical work—*The Rock Drill* (1913–15), a robot-like figure that was originally shown mounted on an enormous drill; later he said it symbolized 'the terrible Frankenstein's monster we have made ourselves into' (casts of the torso are in Tate, and elsewhere).

Epstein's later work was generally much less audacious than this, but his public sculptures were still attacked with monotonous regularity, their expressive use of distortion being offensive to conservative eyes even when they were immune to charges of indecency. An element of anti-Semitism also played a part. Often Epstein was mocked as well as censured, and in 1938 *Adam* (Harewood House) was displayed in Blackpool in a kind of seaside freakshow. *Rima*, a stone relief memorial to the naturalist W. H. Hudson in Hyde Park, London (1925), roused perhaps the greatest storm of any of Epstein's works. It was daubed with green paint and a number of well-known figures petitioned for its removal: they included *Dicksee and *Munnings (present and future presidents of the *Royal Academy) and Sir Arthur Conan Doyle. Muirhead *Bone came to its defence with a letter in *The Times*, signed by an equally impressive line-up, including *Dobson, *Kennington, and George Bernard Shaw. In the face of such controversy Epstein continued to make monumental stone carvings, even when he had no commission to do so, although he found a more appreciative audience for his portrait busts. Many notable men and women sat for him and he portrayed them with psychological intensity and great mastery of expressive surfaces, carrying on the tradition of *Rodin (Frank *Rutter, indeed, called him 'the greatest modeller since Rodin').

It was only after the Second World War that Epstein's work began to achieve public acceptance, and in the 1950s he belatedly received a stream of honours (including a knighthood in 1954) and major commissions including the *Lazarus* (New College Chapel, Oxford, 1947–8) and a huge *St Michael and the Devil* (1956–8) at Coventry Cathedral.

Epstein published an autobiography, *Let There Be Sculpture*, in 1940 (a revised edition, entitled *An Autobiography*, came out in 1955). *The Sculptor Speaks* (a series of his conversations on art) appeared in 1931. A few days after Epstein's death, Henry *Moore paid tribute to his central role in the development of modern sculpture in Britain: he 'took the brickbats...the insults...the howls of derision with which artists since Rembrandt have learned to become familiar. And as far as sculpture in this century is concerned, he took them first' (*Writings and Conversations*, 2002).

Further Reading: E. Silber, *The Sculpture of Epstein* (1986)

Eragny Press See PISSARRO, LUCIEN.

Erbslöh, Adolf See NEUE KÜNSTLER-VEREINIGUNG MÜNCHEN.

Ernest, John *See* CONSTRUCTIVISM.

Ernst, Jimmy (1920–84) German-born American painter, originally called Ulrich Ernst. He was born at Brühl, the son of Max *Ernst and his first wife, the art critic Louise Straus. After leaving school he studied typography and became a printer's apprentice, but he had no formal training in painting. In 1939 he emigrated to the USA and in 1941 he had his first one-man exhibition at the Norlyst Gallery, New York. He was a friend of *Matta and his painting was in a vein of *Surrealist abstraction influenced by him.

Ernst, Max (1891–1976) German-born painter, printmaker, collagist, and sculptor who became an American citizen in 1948 and a French citizen in 1958, one of the major figures of *Dada and even more so of *Surrealism. He was born at Brühl, near Cologne; his father, who taught at a school for deaf and dumb children, was a keen amateur painter. From his early life, he constructed a persona for himself in the line of the cursed figures of German Romanticism like E. T. A. Hoffman or Robert Schumann, describing himself as a nervous and imaginative child, strangely affected at the age of fourteen by the death of a favourite cockatoo on the same day as the birth of a sister. Later he wrote that 'In his imagination Max coupled these two events and charged the baby with the extinction of the bird's life. There followed a series of mystical crises, fits of hysteria, exaltations and depressions. A dangerous confusion between birds and humans became fixed in his mind and asserted itself in his drawings and paintings' (he came to identify himself with Loplop, a birdlike creature that features in many of his works). In 1909 Ernst began to study philosophy and psychology at Bonn University, but he became fascinated by the art of psychotics (he visited the insane as part of his studies) and in 1911 he abandoned academic study for painting. He had no professional training as an artist, but he was influenced by August *Macke, whom he met in 1911. Throughout the First World War he served as an artillery engineer, but thanks to an art-loving commanding officer he was sometimes able to paint, and he exhibited at the *Sturm Gallery in 1916. After the war he settled in Cologne, where with his lifelong friend *Arp (whom he had met in 1914) he became the leader of the city's Dada group. In 1920 he organized one of

Dada's most famous exhibitions in the conservatory of a restaurant: 'In order to enter the gallery one had to pass through a public lavatory. Inside, the public was provided with hatchets with which, if they wanted to, they could attack the objects and paintings exhibited. At the end of the gallery a young girl, dressed in white for her first communion, stood reciting obscene poems' (David Gascoyne, *A Short Survey of Surrealism*, 1935). His Dada period was marked by ingenious use of *photomontage, not so much for political satire as the Berlin Dadaists had employed it, but as a vehicle of fantasy. *Breton may well have been speaking on his behalf in 1921 when he introduced an exhibition of his work by declaring that 'The invention of photography has delivered a mortal blow to the old modes of expression, in painting as well as in poetry.'

In 1922 Ernst settled in Paris, where he joined the Surrealist movement on its formation in 1924. Even before then, however, he had painted works that are regarded as Surrealist masterpieces, such as *Celebes* (1921, Tate), inspired by a photograph of an African corn bin, in which an elephant is transformed into a strange mechanistic monster. The irrational imagery seen here, in part inspired by childhood memories, occurs also in his highly original *collages. In them he rearranged parts of banal engravings from sources such as trade catalogues and technical journals to create strange and startling scenes, showing, for example, a child with a severed head in her lap where a doll might be expected. He also arranged series of such illustrations with accompanying captions to form 'collage novels'; the best-known and most ambitious is *Une Semaine de bonté* ('A Week of Kindness'), published in Paris in 1934. In 1925, the year when a dealer's contract gave him some financial stability, he invented the technique of frottage, the rubbing by pencil of a rough surface, usually wood, to produce random patterns. As he later recalled, 'I was surprised by the sudden intensification of my visionary powers and by the hallucinatory succession of contradictory images superimposed, one upon the other, with the persistence and rapidity peculiar to amorous memories.' (When applied to painting the process was called 'grattage'.) The function of these techniques was to use chance to provoke the hallucinations to which he had been subject from childhood. The images emerge from the patterns created by wood grains or the fall of a piece of string.

These may be threatening and violent, as with *The Horde* (1927, Stedelijk Museum, Amsterdam), or erotic like *The Chaste Joseph* (1928). It was at this time that the obsession with birds and Loplop became a major feature of his work. In 1930 he appeared in the Surrealist film *L'Age d'or*, created by Luis Buñuel and Salvador *Dalí, and in 1935 he made his first sculpture (he worked seriously but intermittently in this field, characteristically creating totemic-like figures in bronze). In the 1930s he also produced a remarkable series of paintings of overgrown cities and jungles. These works make it especially clear that Ernst can be regarded as a successor to a Germanic tradition of Romantic art that includes Caspar David Friedrich, Hans von Marées, and Arnold Böcklin as much as a Surrealist. In an essay of 1934 ('What is Surrealism?', reprinted in Harrison and Wood) he proposed that 'one of the most revolutionary acts of Surrealism' was to have attacked the 'fairy-tale of artistic creativity' and to have insisted emphatically upon 'the purely passive role of the "author" as far as the mechanism of poetic inspiration is concerned'. Ernst was restating the *automatist roots of Surrealism at a time when the more consciously constructed 'hand-painted dream pictures' of Dalí were beginning to dominate public perception of the movement.

Ernst left the Surrealist group in 1938, as he refused to comply with André *Breton's demand that members should 'sabotage in every possible way the poetry of Paul *Éluard' (a close friend of Ernst), but the break did not affect his work stylistically. At this time he was living with the British Surrealist painter Leonora *Carrington, whom he had met in 1936. They set up home at St-Martin-d'Ardèche, near Avignon, but in 1939, after the outbreak of the Second World War, he was interned as an enemy alien. Éluard helped to secure his release, but he was twice more interned, escaping each time. In 1941 he managed to flee to the USA, where he stayed until 1953 (apart from a visit to France in 1948), living first in or near New York and then in Arizona. While in the USA he collaborated with Breton and *Duchamp in the periodical *VVV. *'Decalcomania', a technique invented by Óscar *Domínguez, was to give rise to a series of paintings which refelected upon a devastated Europe. He was briefly married (his third of four wives) to the American art dealer and collector Peggy *Guggenheim, then in 1946 married the American Surrealist painter Dorothea *Tanning. In 1953 they settled in France,

living first in Paris and then from 1955 in Huismes, Loire. Ernst had often struggled financially early in his career, but in 1954 he won the main painting prize at the Venice *Biennale and this marked the beginning of a much honoured old age, when he received many awards and was the subject of several major retrospective exhibitions. His later work became more lyrical and abstract but continued to make use of the chance effects of rippling paint, as in *Old Man River* (1953, Kunstmuseum Basel).

Further Reading: M. Ernst, *Beyond Painting* (1948)
W. Spies, *Max Ernst* (1991)

Erró (Gudmundur Gudmundsson) (1932–) Icelandic painter, active mainly in Paris, which has been the principal centre of his activity since 1958. He is a leading exponent of *Pop art, his most characteristic works being large canvases of densely packed arrays of consumer goods or foodstuffs painted impersonally and mechanistically. Frequently these bear an unsubtle political message. Mao Zedong's Chinese invade havens of Western consumerist comfort or, as in *Venus* (1975, Neue Galerie-Sammlung Ludwig, Aachen), the most treasured images of high art. He has also made films and taken part in *Happenings.

'Erster Deutscher Herbstsalon' *See* STURM, DER.

Erté (Romain de Tertoff) (1892–1990) Russian-born French designer, painter, and sculptor. He derived his pseudonym from the French pronunciation of his initials ('r' and 't'). He was born in St Petersburg into an aristocratic family and in 1912 moved to Paris, where he studied at the *Académie Julian. Erté was best known for his fashion illustrations (particularly for the American magazine *Harper's Bazaar*) and for his costume and set designs for theatre, cabaret, opera, ballet, and cinema (he designed costumes for Mata Hari among other celebrities). However, he also painted, and in the 1960s he made lithographs and sculptures of sheet metal.

Escher, M. C. (Maurits Cornelis) (1898–1972) Dutch printmaker. He was born in Leeuwarden and studied at the School of Ornamental Design in Haarlem, 1919–22, becoming a virtuoso craftsman in woodcut; later he took up lithography and wood engraving. He lived in Italy from 1922 to 1934, then successively in Switzerland and

Belgium, before returning to the Netherlands and settling in Baarn in 1941. His early prints were mainly landscapes and townscapes in a bold but fairly naturalistic style; however, after he left Italy he turned increasingly to what he described as 'inner visions'. His work can be related closely to the *Magic Realist tendency popular in the interwar years, particularly when seen alongside Dutch contemporaries such as Pyke *Koch and Carel *Willink. Many of his inner visions were expressed as sophisticated designs in which repeated figures of stylized animals, birds, or fish are arranged in dense, interlocking patterns. From about 1940 the bizarre element in his work became more overt, particularly in the kind of print for which he is now most famous—views of strange imaginary buildings in which he made brilliant play with optical illusion to represent, for example, staircases that seem to go both up and down in the same direction (*Ascending and Descending*, 1960). He said of his work: 'By keenly confronting the enigmas that surround us, and by considering and analyzing the observations that I had made, I ended up in the domain of mathematics. Although I am absolutely innocent of training or knowledge in the exact sciences, I often seem to have more in common with mathematicians than with my fellow artists.' Indeed his prints have been of considerable interest to mathematicians as well as psychologists involved with visual perception; an exhibition of them was given at the International Mathematical Congress in Amsterdam in 1964. Nor is it surprising that E. H. *Gombrich, preoccupied as he was with the mechanics of representation and illusion, should have admired his work, writing that 'to the explorer of the prose of representation, his nightmarish conundrums are invaluable' (*Meditations on a Hobby Horse*, 1963). Escher's work has found a large popular audience, especially among young people, some of whom in the psychedelic sixties may well have felt that his images complemented the 'mind-expanding' experiences gained through hallucinogenic drugs.

Espace *See* GROUPE ESPACE.

Esprit nouveau, L' *See* OZENFANT, AMÉDÉE.

Estes, Richard (1932–) American painter and printmaker, one of the best-known exponents of *Superrealism. Born in Kewanee,

Illinois, he studied at the Art Institute of Chicago, 1952–6, and settled in New York in 1959. He worked as a graphic artist for several years and did not devote himself full-time to painting until 1966. His first one-man show was at the Allen Stone Gallery, New York, in 1968, and by the end of the decade he was a leading figure in his field. Estes's work is devoted to the urban landscape; early paintings focused on people, but since about 1967 buildings have been the main point of interest. He usually depicts fairly anonymous or typical pieces of streetscape, however, his only 'portrait' of a well-known building being his commissioned painting of the Solomon R. *Guggenheim Museum (1979, Guggenheim Museum, New York). His method of work is to take several photographs of a scene and then combine parts of them until the 'feel' is right. Unlike many Superrealists, he works with traditional brushes rather than airbrushes, often using acrylic paint and then switching to oils for the finishing touches to obtain extra clarity of focus. He presents the city as a visual spectacle, usually in bright light, so that even the garbage looks glossy. Estes has also made very elaborate *screenprints.

Estève, Maurice (1904–2001) French painter, printmaker, and designer, one of the leading abstract painters of the École de Paris of the 1950s. He was born in Culan, Cher. He worked at a variety of jobs, notably as a designer for a textile factory in Barcelona, before studying at the Académie Colarossi in Paris in 1924. In 1930 he had his first one-man exhibition (at the Galerie Yvangot) and in 1937 he assisted Robert *Delaunay on his mural decorations for the Paris World Fair. He was to share the older painter's taste for spectral colour. His main subjects at this time were figure compositions, interiors, and still-lifes, and these formed the basis for the abstract style that he gradually developed in the 1940s, featuring tightly-knit interlocking shapes. He employed a distinctive colour range biased towards acidic lemony yellows, greens, and oranges. As with other French abstractionists of his generation, the paintings have a glow which recalls stained glass. His process was to paint directly on to canvas, not using any preliminary drawings, so colour and form would evolve simultaneously. A painting could be reworked over a period of several months. He also made collages and designed stained glass. There is a museum of his work in Bourges.

Estorick, Eric and **Salome** *See* FUTURISM.

Etchells, Frederick *see* REBEL ART CENTRE

Eurich, Richard (1903–92) British painter.
Born in Bradford, he studied at the *Slade
School London, where one of his reports
said: 'This student is being influenced by pain-
ters who have not been long enough dead to
be respectable.' In spite of this, for most of
Eurich's career, he was identified as a some-
what conservative figure, specializing in atmo-
spheric landscapes and beach scenes, often
with a touch of menacing fantasy, as with
Men of Straw (1957, Castle Museum, Notting-
ham). His skill in extensive panoramas was
well exploited in his distinguished contribu-
tions to the War Artists Advisory Committee
scheme (*see* OFFICIAL WAR ART), including an
impressive overhead view of the *Withdrawal
from Dunkirk* (1940, National Maritime Muse-
um, London). *Survivors from a Torpedoed
Ship* (1942, Tate) was originally censored by
the War Artists Advisory Committee, although
Winston Churchill admired the painting and
used it as a book illustration. It shows two
sailors clinging to an upturned boat. Eurich
poignantly contrasts their plight to the situa-
tion of a seagull which has landed on the boat
and is completely free to fly away at any time.

Further Reading: N. Usherwood, *Richard Eurich: From
 Dunkirk to D-Day* (1991)

Euston Road School A name coined in
1938 by Clive *Bell for a group of British pain-
ters centred round the 'School of Drawing and
Painting' that opened in a studio at 12 Fitzroy
Street, London, in 1937, and soon transferred
to nearby 316 Euston Road. Its founding
teachers were William *Coldstream, Victor
*Pasmore, and Claude *Rogers, and the orga-
nizing secretary was Thelma Hulbert (1913–
95), whose work included landscapes and pic-
tures of birds and flowers; Lawrence *Gowing
was also an important member of the circle.
These artists advocated a move away from
modernist styles to a more straightforward
naturalism. The School's prospectus said that
'In teaching, particular emphasis will be laid
on training the observation, since this is the
faculty most open to training'. By encouraging
sound skills in representational painting, the
teachers hoped to end the isolation of artist
from public that avant-garde movements
had created. In practice the kind of painting
it inspired has had a somewhat esoteric

appeal, mainly to those well acquainted with
the challenges of the life class. Herbert *Read
accused the painters of pretending to be
'tough guys', but actually being 'the effete
products of the *Bloomsbury school of needle-
work'. The outbreak of the Second World War
in 1939 caused the School to close, but al-
though it was so short-lived, it was influential:
the term 'Euston Road' was used for a decade
or so afterwards as a generic description for
painting done in a style similar to
that practised by the founders. Coldstream,
through his position as professor at the
*Slade School, was the chief upholder of the
tradition, which can be seen in younger British
figurative painters such as Patrick *George and
Euan *Uglow. The most immediately obvious
characteristics of their works are the tiny
marks left on the picture surface recording
the meticulous measurements made by the
painter of the subject.

Further Reading: B. Laughton, *The Euston Road School*
 (1986)

Evans, Merlyn (1910–73) British painter,
printmaker, and sculptor. He was born in Car-
diff and grew up in Glasgow, where he studied
at the School of Art from 1927 to 1930. During
this period he was already working as an ab-
stract artist. A travelling scholarship then took
him to France, Germany, Denmark, and Swe-
den, after which he continued his studies at
the *Royal College of Art in London and from
1934 to 1936 in Paris, where he worked in
*Hayter's printmaking studio and met many
leading artists, including *Kandinsky and
*Mondrian. His work at this time was influ-
enced by both *Cubism and *Surrealism, al-
though the most important models were
Wyndham *Lewis and the now almost forgot-
ten *Vorticist sculptor Lawrence Atkinson
(1873–1931). He took part in the International
Surrealist Exhibition in London in 1936,
showing *The Conquest of Time* (1934, Tate),
not in fact an especially Surreal work, inspired
by the image of a kingfisher 'still beside the
moving river'. From 1938 to 1942 he lived in
South Africa, teaching at the Natal Technical
College in Durban. The influence of the gro-
tesquerie of Lewis was clearest in a series of
paintings from these years which address the
themes of war and economic deprivation. The
best-known is *The Chess Players* (1940), a
comment on the Hitler–Stalin non-aggression
pact. Evans did not hold the right-wing
political views of Lewis, but they did share

something of a common outlook in their pessimistic view of human nature. In 1944 Evans noted that 'Now we have no trouble in agreeing that humanity is very wicked *indeed*' and agreed with Lewis's friend T. E. *Hulme that we should 'attack the great *unconscious* . . . assumptions such as the desirabilty of progress *per se*; the Hedonist-Humanist concept (in a time of unparalleled misery) that the end of human life is happiness for the many.' From 1942 to 1945 he served with the army in North Africa and Italy. After the war he settled in London, where he had his first substantial one-man exhibition at the *Leicester Galleries in 1949. From the 1950s his paintings tended to grow larger and more abstract. He occasionally made sculpture and was regarded as one of the leading British printmakers of his day; some of his prints were in mezzotint, a technique he helped to revive. He also worked frequently in egg tempera. This was probably inspired by the painters of the Italian Renaissance; he once made a copy of a Madonna and Child by Crivelli, and it suited his hard-edged style. From 1965 until his death, Evans taught painting at the Royal College of Art.

Further Reading: Tate Gallery, *The Political Paintings of Merlyn Evans* (1985)

Victoria and Albert Museum, *The Prints of Merlyn Evans* (1972)

Evans, Myfanwy See AXIS; PIPER, JOHN.

Evans, Walker (1903–75) American photographer. He began his career as an architectural photographer but he is best known for the work he did in the late 1930s commissioned by the Farm Security Administration, documenting the lives of sharecroppers under the harsh conditions of the Great Depression. In 1936 he spent three weeks with three sharecropper families in Alabama alongside the writer James Agee. The original purpose was to produce a magazine feature; this never materialized but the work finally resulted in the book *Let us Now Praise Famous Men* (1941). His most famous single image is the gravely dignified portrait of Allie Mae Burroughs, a member of one of the families with which he stayed. However, historians of photography have pointed out that his great strength as a photographer is not adequately represented by this work, as it does not manifest his use of settings and objects. Moreover, for Evans, the single photographs took their meaning

from being presented in sequence in book form. The dust-jacket of *American Photographs* (1938) instructed the reader of this explicitly, so making the images almost analogous to the series of shots within a film. Ian Jeffrey has described his photographs as 'encyclopedic, rich with details of daily life' and has compared them to the work of Eugène *Atget, whom Evans much admired.

Eve, Jean See NAIVE ART.

Evergood, Philip (1901–73) American painter, born in New York, the son of Myer Blashki, a landscape painter of Australian-Polish descent (Blashki changed his surname in 1914, anglicizing it to a version of his mother's maiden name, Immergut). Philip's mother came from a cultured British family and in 1909 he was sent to England to receive the best possible education. After schooling at Eton, he went to Trinity Hall, Cambridge, where he studied English literature, but he left without taking a degree to go to the *Slade School, 1921–3. Subsequently he studied at the *Art Students League in New York, 1923–4, and the *Académie Julian in Paris, 1924–6. He returned to Paris in 1929–31 and during this time briefly studied engraving under *Hayter. His early works were mainly of biblical and imaginative subjects, but after settling in New York in 1931 he became a leading figure among the *Social Realists who used their art as an instrument of protest and propaganda during the Depression years. By his own account, this came about through his contact with groups of outcasts in New York. He became involved in several organizations concerned with the civil rights of artists, and under the banner of the *Federal Art Project he produced militant paintings of social criticism, his best-known work in this vein being *American Tragedy* (1937, Whitney Museum, New York), which commemorates a police attack on striking steel workers in Chicago.

After the 1930s Evergood was less concerned with topical or political themes and returned to allegorical and religious paintings, but these too sometimes had sociological overtones, as in *The New Lazarus* (1954, Whitney Museum), with its figures of starving children. He experimented technically (sometimes, for example, mixing marble dust with his paint to obtain a textured surface) and his work was varied stylistically; at times he had an inclination for the bizarre and the grotesque which allies him to *Magic

Realism, as is seen particularly in his most famous work, *Lily and the Sparrows* (1939, Whitney Museum).

existentialism *See* SARTRE, JEAN-PAUL.

experimental art An imprecise term which has sometimes been applied to art that is concerned with exploring new ideas and/or technology. It is sometimes used virtually synonymously with *'avant-garde', but 'experimental' usually suggests a more explicit desire to extend the boundaries of the art in terms of materials or techniques, whereas 'avant-garde' can include novel and provocative ideas expressed through traditional techniques. Most writers today would prefer more precise terms such as *Kinetic or *installation art for such activities.

The term implies a link with science. In 1923 Picasso said 'I can hardly understand the importance given to the word research in connection with modern painting. In my opinion to search means nothing in painting. To find, is the thing' (A. H. Barr *Picasso: Fifty Years of his Art*, 1946). These magisterial words are hardly an end to the matter. In practice the scientific notion of experiment or research has, legitimately or not, frequently been invoked by avant-garde artists. Picasso himself spoke of a period in 1912 when 'the studio became a laboratory' (J. Richardson, *Braque*, 1959). In its early days the Surrealist movement conducted what it called a 'Bureau of Surrealist Research' and its first journal, *La Révolution surréaliste*, was modelled on a scientific journal.

Stephen Bann's 1970 book *Experimental Painting* uses the idea to cover a very wide range of art. It begins with Constable and Monet (because of their 'scientific' approach to nature) and goes through to *Constructivists and *abstract artists with a methodical or technological bent such as *Vasarely. Then he takes in some figurative artists such as *Giacometti and *Auerbach, whom he sees as having an approach in common with the 'auto-destructive' art of Gustav *Metzger.

John A. Walker (*Glossary of Art, Architecture and Design Since 1945*, 1973, 3rd edn, 1992) writes of 'experimental': 'It is a word with both positive and negative connotations: it is used to praise and condemn. Those writers for whom it is a term of praise often mean by it an empirical practice in which the artist plays with his materials and adopts chance proce-

dures in the expectation that something of value will result...Those writers for whom "experimental" is a pejorative description mean by it "a trial run", "not the finished work", "something transitional".' Walker points out that in E. H. *Gombrich's celebrated book *The Story of Art*, first published in 1950, the whole of 20th-century art was originally embraced in a chapter called 'Experimental Art'. Paradoxically it was Gombrich, in *Art and Illusion* (1960), who made one of the most thoroughly worked-out attempts to relate the artistic process to that of scientific experiment. He was concerned here, not with strictly technical experimentation, but to argue for an analogy between the processes of representation as a series of experiments and that of the scientific 'testing' of a theory. Artists, in this model, test their theories (representations) against experience. As in science, therefore, there can be a kind of 'progress' as mistakes in the 'theory' are gradually corrected. There is no contradiction whatsoever between this notion of 'experiment' and Gombrich's generally conservative view of 20th-century developments (*see* ABSTRACT ART).

Writing on Nicolas de *Stäel, the philosopher Richard Wollheim (1923–2003) contrasted the 'experimental' with the 'innovatory' artist and proposed that the former type was most common in the first part of the 20th century and the other in the later years. According to Wollheim, the difference is 'that the innovatory artist innovates in order to give his work a distinctive look, whereas the experimental artist innovates in the hope, later to be confirmed or disconfirmed, that this new look will help him do better justice to his subject matter' (*London Review of Books*, 24 July 2003). Such views contrast a quasi-scientific view of experiment which involves a kind of 'testing' against observation with the more open-ended notion of 'experiment' which has frequently been applied to modern art.

experimental film *See* VIDEO ART.

EXPORT, VALIE (1940–) Austrian Performance and installation artist, photographer and film-maker. Born in Linz as Walltraud Höllinger, she adopted the name VALIE EXPORT, derived from a brand of cigarette, in 1967. Her demand that it always be capitalized is not universally respected in publications. In the same year in Vienna she developed in collaboration with Peter Weibel (1944–) the

conception of 'expanded cinema'. One notorious instance was the *Tapp und Tastkino* (Touch Cinema) of 1968 when she walked the streets in a box like a tiny cinema with curtains through which passers-by, regardless of age or gender, could touch her breasts. Roswitha Mueller has argued that this reverses the normal functions of cinema in which the female body can be enjoyed voyeuristically through sight while the spectator can take refuge in the cinema's darkness. Here physical contact is possible but the price is that the toucher can be seen publicly. At this time the naked female breast had ceased to be a taboo in the context of European commercial cinema. Sexual liberation was seen by many of the young as the vital counterpart to political liberation. In another piece to be performed inside the cinema, *Genital Panic* (1969), she walked through spectators with the crotch cut from her tight fitting trousers. 'Expanded Cinema' also comprised combinations of film, performance, and installation. Later she made a number of feature films for normal cinema presentation such as *Invisible Adversaries* (1976).

EXPORT states that her work represents a 'Feminist Actionism' (*see* VIENNA ACTIONISM) in contrast to that of her male Viennese contemporaries such as Gunter *Brus. It seeks to 'transform the object of male natural history, the "material woman", into an independent actor and creator'. In a lecture of 2003, 'Expanded Cinema as Expanded Reality', she placed her practice within a tradition going back to the *Futurists and *Constructivists of the early 20th century, in its rejection of illusionism.

Further Reading: R. Mueller, *VALIE EXPORT: Fragments of Imagination* (1994)

Expressionism A term employed in the history and criticism of the arts to denote the use of distortion and exaggeration for emotional effect or—to use the more Expressionist language of the critic Waldemar George—'an exorcism and a liberation'. The term is used in several different ways and can be applied to various art forms. In the pictorial arts, it can be used in its broadest sense to describe art of any period or place that raises acute subjective feeling above objective observation, reflecting the state of mind of the artist rather than images that conform to what we see in the external world. The paintings of the 16th-century artists Grünewald and El Greco, which convey intense religious emotion through distorted forms, are outstanding examples of expressionism in this sense (when used in this way the word is usually spelled with a small 'e'). More commonly, the term is applied to a trend in modern European art in which strong, non-naturalistic colours and distorted or abbreviated forms were used to project inner feelings. More specifically, the term is used for one aspect of that trend—a movement that was the dominant force in German art from about 1905 until about the mid-1920s. (In the German-speaking countries Expressionism also had a powerful effect on other arts in this period, notably drama, poetry, and the cinema, which often show a common concern with the eruption of irrational forces from beneath the surface of the modern world. Some music, too, is described as Expressionist because of its emotional turbulence and lack of conventional logic, and there are also a few remarkable Expressionist buildings, although the most startling architectural designs remained on paper.)

In the second (broad European) sense described above, Expressionism traces its beginnings to the 1880s, but it did not crystallize into a distinct programme until about 1905, and as a description of a movement the term itself is thought to have been first used in print in 1911—in an article in *Der *Sturm* (it was used more loosely long before this, in English and in German). The most important forerunner of Expressionism was the Dutch painter Vincent van Gogh (1853–90), who consciously exaggerated natural appearances 'to express . . . man's terrible passions'. He was virtually unknown at the time of his death, but his reputation grew rapidly after that and his work made a major impact at a number of exhibitions in the early years of the 20th century. His first retrospective after the turn of the century was at the Galerie *Bernheim-Jeune in Paris in 1901; this and his exhibition at the *Salon des Indépendants in 1905 were important in the development of *Fauvism (for an example of the overwhelming effect the Bernheim-Jeune show had on one of the future Fauves, *see* VLAMINCK). In 1905 a huge exhibition of van Gogh's work was held at the Stedelijk Museum, Amsterdam, and his influence reached England with Roger *Fry's first *Post-Impressionist exhibition of 1910. He was the dominant artist at the great *Sonderbund exhibition in Cologne in 1912 and was well represented at the *Armory Show in New York in 1913.

Van Gogh's friend *Gauguin was also important for the development of Expressionism. His own work cannot be described as Expressionist, but he was the first to accept explicitly the principles of *Symbolism, which in turn influenced Expressionism. He simplified and flattened forms, and sometimes used colour in a way that abandoned all semblance of realism. As a counterpart to his stylistic innovations, Gauguin sought for simplicity of subject-matter and found it first in the peasant communities of Brittany and later in the islands of the South Pacific. In turning away from European urban civilization, he looked outside Western high art towards folk art and *'primitivism', both of which later became of absorbing interest to the Expressionists.

A third fundamental influence on Expressionism (especially in Germany, where he spent much of his career) was the Norwegian Edvard *Munch, who knew the work of van Gogh and Gauguin well. From the mid-1880s he began to use violent colour and linear distortions to express the most elemental emotions of fear, love, and hatred. In his search to give pictorial form to the innermost thoughts that haunted him he came to appreciate the abrasive expressive potential of the woodcut— its revival as an independent art form (in which Gauguin also played a prominent role) was a distinctive feature of Expressionism. Many of the leading German artists of the movement did outstanding work in the medium. Another artist whose formative influence on Expressionism was spread partly through the medium of prints (in this case etchings) was the Belgian James *Ensor, who depicted the baseness of human nature by the use of grotesque and horrifying carnival masks.

The first Expressionist groups appeared almost simultaneously in 1905 in France (the *Fauves) and Germany (Die *Brücke). *Matisse, the leader of the Fauves, summed up their aims when he wrote in 1908: 'What I am after above all is expression...The chief aim of colour should be to serve expression as well as possible...The expressive aspect of colours imposes itself on me in a purely instinctive way. To paint an autumn landscape I will not try to remember what colours suit this season; I will be inspired only by the sensation that the season arouses in me.' Even at their most violent, however, the Fauves always retained harmony of design and a certain decorativeness of colour, but in Germany restraint was thrown to

the winds. Forms and colours were tortured to give vent to a sense of revolt against the established order. *Kirchner, the dominant figure of Die Brücke, wrote in 1913: 'We accept all the colours that, directly or indirectly, reproduce the pure creative impulse.'

The high point of German Expressionism came with the *Blaue Reiter group, formed in Munich in 1911 with *Kandinsky and *Marc as leaders. These two and other members tried to express spiritual feelings in art and their work was generally more mystical in outlook than that of the Brücke painters. The Blaue Reiter was dispersed by the First World War (during which Marc and another key member, August *Macke, were killed), but after the war Expressionism became widespread in Germany. Even artists such as Otto *Dix and George *Grosz, who sought a new and hard realism (*see* NEUE SACHLICHKEIT), kept a good deal of Expressionist distortion and exaggeration in their work. However, Expressionism was suppressed by the Nazis when they came to power in 1933, along with all other art they considered *degenerate. It revived in the 1970s, and Germany has been one of the main homes of its descendant *Neo-Expressionism.

In its broadest sense, the influence of Expressionism can be seen in the work of artists of many different persuasions and schools. There was a significant Expressionist movement in Belgium in the 1920s, in which Constant *Permeke and Gustave de *Smet were among the leading figures. Some French and *École de Paris painters such as *Rouault, *Chagall, *Soutine, and *Gromaire can also be regarded as Expressionists. The 'Expressionism' in *Abstract Expressionism should not be taken too literally, but it does signal the break of abstract art with a tradition of ideal form and geometry.

Further Reading: W. George, *Expressionism* (1960)

E. Langui, *Expressionism in Belgium* (1971)

J. Lloyd, *German Expressionism: Primitivism and Modernity* (1991)

R.-C. Washton Long (ed.), *German Expressionism* (1993)

Exter, Alexandra (née Grigorovich) (1882–1949) Russian painter and theatrical designer. She was born at Belestok, in the Kiev region of Ukraine, and studied at the Kiev School of Art, graduating in 1906. In 1908 she visited Paris for the first time and from then until the outbreak of the First World War she made regular visits there, forming a link between the Western avant-garde and that in

Russia (she knew *Apollinaire, *Braque, and *Picasso, among other luminaries). Her work was shown at numerous avant-garde exhibitions in Russia in this period, in Moscow, St Petersburg, and elsewhere: she was a member of the *Knave of Diamonds and the *Union of Youth, for example, and M. N. Yablonskaya writes that 'Because of her Western contacts Exter was always treated with respect by the Russian avant-garde and was often consulted as an authority on Western developments' (*Women Artists of Russia's New Age*, 1990).

Exter's early paintings were influenced by various modernist styles, including *Futurism and *Cubism, and by 1917 she had arrived at complete abstraction, using interpenetrating, semi-geometrical slabs of colour in a manner that is something like a cross between *Delaunay's *Orphism and *Malevich's *Suprematism. From 1917 to 1921 she taught at her own studios, first in Odessa (1917–18) and then in Kiev (1918–21). Her pupils, who included Pavel *Tchelitchew, helped her to create huge abstract designs for agit-steamers (propaganda boats) and agittrains, which the new Soviet government used to celebrate the Russian Revolution and spread knowledge of it (*see* AGITPROP ART). Her most impressive and original work, however, was as a stage designer, particularly for Alexander Tairov's Kamerny (Chamber) Theatre in Moscow between 1916 and 1921. In powerful *Constructivist sets she explored the architectural potential of the stage through what she called 'the dynamic use of immobile form', avoiding traditional decorative illusionism on the one hand and flat stylization on the other. Perhaps her most famous set design is for *Romeo and Juliet* (1921), in which she pioneered multi-level staging; the set was 'conceived as a dynamic three-dimensional construction comprising ladders, platforms, rails, and inclined planes which were brought to life by their bold intersection and the bright colours of the beams of light which played on them. The various vertical levels of the set were transformed into different locations by the rapid furling and unfurling of curtains' (Yablonskaya). Exter also designed Constructivist costumes (made from 'industrial materials') for the science fiction film *Aelita* (1923). Her friend the poet Benedikt Livshits called her an 'Amazon of the avant-garde'.

In 1924 Exter settled in Paris, and she lived in France for the rest of her life. She earned part of her living from teaching (at her friend *Léger's school and in her own studio), but in her later career she was mainly active as a theatre, ballet, and fashion designer. She also made witty marionettes (for an unrealized film), using a variety of materials and motifs drawn from Cubism and Suprematism. A good collection of her drawings for stage designs is in the Victoria and Albert Museum, London.

Fabre, Jan (1958–) Belgian multimedia artist and theatre director, born in Antwerp. From early in his career he made provocative gestures. For one performance he burnt money provided by the audience and made drawings from the ashes. Fabre made his reputation with drawings in blue ballpoint, in 1990 entirely covering Tivoli castle in Mechelen with sheets drawn in this medium. He shares a name with a famous French entomologist, Jean Henri Fabre (1823–1915), and this has been the cue for work involving insects, which are seen as heralds of death: *Vlaamse krijger* (1996) is a bust with a winged head and breastplate covered with scarabs. The theme of death has been explored by Fabre in artworks that incorporate real meat, which rots during the course of the installation. For the exhibition 'Over the Edges' in Ghent in 2000, Fabre adorned the city's columns, including those of the recently closed Jesuit college, with hunks of ham. In 2008 Fabre was invited to make an installation in the Louvre, being given *carte blanche* to reorganize the Northern paintings. A sculpture of himself as a dwarf with a bleeding nose, the result of banging against a medieval sculpture, suggests a certain ironic modesty in the face of the privilege.

fabricated photography *See* PHOTO-WORK.

Fabro, Luciano (1936–2007) Italian sculptor, born in Turin. He lived and worked in Milan, where he had his first solo exhibition in 1965. Influenced by the work of Lucio *Fontana, Piero *Manzoni, and Yves *Klein, he became associated with *Arte Povera, although he described himself in an interview as a 'heretic of the Arte Povera church'. This might be a reference to the love of expensive materials and impeccable craftsmanship which characterizes his art. The *Feet* (1968–71) are great sheaves of silk hung from the ceiling. From these emerge feet in bronze, Murano glass, or marble. 'Phidias and Praxiteles, Donatello and

Michelangelo, Bernini and Canova, are my witnesses', he told *Flash Art* in 1971, clearly signalling his identification with a sculptural tradition. In 1978 he installed *Io* (Me), a bronze sculpture of exactly his own weight, in the water of Bernini's Fontana delle Api in Rome. Fabro made a series of sculptures in the distinctive outline of Italy hung upside-down. One is gilded and shows the mountain ranges in relief. Another uses copper ribbon. The sinister *Italy of War* (1981) is made entirely from wire mesh. It is as though Fabro was telling the recent history of his country, one of post-war prosperity, but also of corruption, inequality, and social conflict, through the transformation of materials.

Further Reading: R. Fuchs, *Fabro* (2008)

R. Kennedy, 'Luciano Fabro, Italian Artist Dies at 70', *New York Times* (3 July 2007)

Fairhurst, Angus (1966–2008) British artist, born in Pembury, Kent. He studied at Canterbury College of Art, 1985–6, and *Goldsmiths College, 1986–9, where he became friends with Damien *Hirst and Sarah *Lucas and took part in Hirst's 'Freeze' exhibition. His work tended to be less brash and rather more cerebral than that of his colleagues and as a result was sometimes overlooked. (He was not included in the *'Sensation' exhibition of 1997.) *Gallery Connections* (1991–6, Tate) is a series of audio tapes produced by the simple expedient of phoning various galleries, putting the hand sets together and withdrawing and recording the resulting confused conversations. On one level this can be interpreted as a satire on the inward-looking nature of the art world. The fascination of the work goes further as people who all know each other find their customary relationships made strange and unsettling. Fairhurst made a number of sculptures of gorillas which were included in 'In-da-Gadda-da-Vida', an exhibition held at Tate Britain in 2004 with Hirst and Lucas. *A Couple of Differences Between Thinking and Feeling*

(2002) had the gorilla contemplating his severed arm. Richard Dorment has interpreted this piece as saying that 'we become conscious of who we are only when we realise we are not complete, when our brain can imagine its own limitations.' Fairhurst committed suicide. He was found hanged in Argyll the day his final solo exhibition closed.

Further Reading: R. Dorment, 'In the Garden of Horrors', *The Daily Telegraph* (3 March 2004)

G. Muir, 'Angus Fairhurst', *The Guardian* (2 April 2008)

Fairweather, Ian (1891–1974) Scottish-born Australian painter. After serving in the British army in the First World War, he studied intermittently at the *Slade School, 1919–24, then travelled the world. In 1934 he visited Melbourne, where he obtained a commission to paint a mural for the Menzies Hotel. Because it was compared unfavourably with the work of *Brangwyn, he destroyed it and boarded a ship bound for the Philippines the following morning. From 1940 to 1943 he served as a captain in the British army in India. On being invalided out he lived in Melbourne and then near Cairns before moving to Darwin. In April 1952 he attempted to sail from Darwin to Dili in Timor on a raft made of softwood and petrol drums. He was presumed lost at sea and an obituary appeared in *The Melbourne Herald* on 13 May 1952, but thirteen days later he landed on a Timor beach. The Indonesian authorities refused him permission to stay and eventually deported him to Singapore, where he was placed in a home for the destitute. He was eventually returned to England as a result of the intervention of British government authorities, but after some disagreeable experiences, such as digging ditches in the winter to repay his fare, he returned to Sydney in 1953. He constructed a hut for himself on Bribie Island, off the Queensland Coast near Brisbane, and lived and worked there until his death.

Fairweather painted mainly in earth colours used by the artists of South-East Asia and the Pacific and he was one of the first artists to assimilate aboriginal art into his own work. He also had a great admiration for Chinese art and civilization, which was expressed in his fluent, calligraphic style. He began as a painter of figure subjects, but his work 'moved gradually towards an abstraction that allowed him to transcend personal anxieties and construct a cosmological or religious vision in which, most perfectly in *Monastery* (1961, NG, Can-

berra), the movement of becoming and the stillness of being could be held in a tenuous equilibrium' (Christopher Allen, *Art in Australia*, 1997).

Falk, Robert (1886–1958) Russian painter (mainly of landscapes, portraits, and still-life), graphic artist, and stage designer, born in Moscow. His early work was influenced by *Cézanne and he was a founder member of the avant-garde *Knave of Diamonds group in 1909. He was also a member of the *World of Art group and of *AKhRR. From 1918 to 1928 he taught at *Vkhutemas, and from 1928 to 1938 he lived in France. After his return to Russia he taught at the Samarkand Regional Art Institute, then in 1944 settled again in Moscow, where he lived for the rest of his life and taught at the Moscow Institute of Applied and Decorative Art. His later works tended towards mild *Expressionism. In 1962, four years after his death, they were attacked by Khrushchev, and the press branded him a 'cultural deviationist'. In 1966, however (two years after Khrushchev's downfall), a comprehensive retrospective exhibition of Falk's work in Moscow rehabilitated him from official censure.

Fantastic Realism (Phantastischer Realismus) A kind of painting, developed in Vienna in the late 1940s, in which a fairy-tale world of fantasy and imagination is depicted in minute detail. Its exponents were mainly pupils of *Gütersloh. They shared an interest in the art of the past, notably Bruegel (supremely well represented in the Kunst-historisches Museum in Vienna) and their paintings were often literary and anecdotal in character. Ernst *Fuchs is the best-known representative of Fantastic Realism; others include Erich Brauer (1929–), Rudolf Hausner (1914–1995), Gütersloh's son Wolfgang Hutter (1928–), and Anton Lehmden (1929–).

Fascist art *See* TOTALITARIAN ART.

Fattah al Turk, Ismail (1938–2004) Iraqi sculptor and painter, born in Basra. He graduated from the Institute of Fine Arts in Baghdad in 1958, then continued his studies in Rome. In the 1970s he produced various murals and sculptures for public buildings in Baghdad and in 1981–3 carried out his most famous work, the enormous Martyrs' Monument commemorating the dead in the Iran-Iraq War, probably the only one of Saddam Hussein's

projects to have any artistic merit. Situated in the middle of an artificial lake in Baghdad, it consists of an onion dome about 40 metres high, split in half to reveal the Iraqi flag rendered in twisted metal. It is said to have cost the Iraqi treasury $250 million. The artist's brilliantly coloured figurative paintings have been largely overshadowed by the notorious reputation of the monument.

Fauteux, Roger *See* AUTOMATISTES.

Fautrier, Jean (1898–1964) French painter, sculptor, and printmaker, born in Paris. He was born out of wedlock and was brought up by his grandmother. In 1908 both she and his father died and Fautrier moved to London to live with his mother. He began studying at the *Royal Academy in 1912, when he was fourteen, and also studied briefly at the *Slade School. In 1917 he was called up into the French army and was gassed. After the war he returned to Paris, where he exhibited regularly at the *Salon d'Automne and in commercial galleries; his work included still-lifes, portraits, and nudes in a style similar to that of *Derain. He achieved considerable success in the 1920s (André *Malraux was one of his admirers), but the economic decline of the 1930s damaged his market and from 1935 to 1939 he worked as a ski instructor in the Alps. He returned to Paris in 1939, but after being briefly imprisoned by the Germans in 1943 he fled to Châtenay-Malabry on the outskirts of the city, living there for the rest of his life. His new home was within earshot of woods where the Nazis carried out massacres, and it was here that Fautrier began the series for which he is particularly famous—*Hostages*, inspired by his horror at brutality and suffering in wartime. These strange paintings feature layer upon layer of heavy paint creating a central image that is abstract but suggests a decaying human head. The pale powdery colours evoke death, but the delicacy of the handling gives the paintings a mysterious ambivalence. They were exhibited at the Galerie René Drouin in Paris in 1945 and were much acclaimed. Fautrier also created sculptural versions of the *Hostages* (examples of both types are in the Musée de l'Île de France, Sceaux).

The painted *Hostages* have been seen as forerunners of *Art Informel, and with the post-war vogue for this kind of expressive abstraction Fautrier gained a reputation as one of the leading painters of the *École de Paris.

Many exhibitions of his work were held in the 1950s, including one at the *Institute of Contemporary Arts in London in 1958 that led Herbert *Read to comment that 'Fautrier, no less than *Kandinsky, or *Klee, or *Pollock, is a pioneer of a movement which has transformed the whole basis and intention of the plastic arts'. Although it might seem now excessive to link Fautrier with such illustrious names, he was with *Dubuffet one of the first to develop a kind of painting largely dependent on texture and matter. Fautrier's other works included prints (notably lithographs illustrating Dante's *Inferno*, 1928), and he developed a novel type of work called 'multiple originals', printing a basic drawing on anything up to 300 canvases and then completing each work by hand. He first exhibited such works in 1950. In 1960 he was awarded the Grand Prix at the Venice *Biennale. *See also* MULTIPLES.

Fauvism Movement in painting based on the use of intensely vivid, non-naturalistic colours; centred on a group of French artists who worked together from about 1905 to 1907, it was the first of the major avant-garde movements in European art in the period of unprecedented experimentation between the turn of the century and the First World War. The dominant figure of the Fauvist group was Henri *Matisse, who used vividly contrasting colours as early as 1899, but first realized the potential of colour freed from its traditional descriptive role when he painted with *Cross and *Signac in the bright light of St-Tropez in the summer of 1904 and with *Derain at Collioure in the summer of 1905. The Fauves first exhibited together at the *Salon d'Automne of 1905 and their name was given to them by the critic Louis *Vauxcelles, who pointed to a Renaissance-like sculpture in the middle of the same gallery and exclaimed: 'Donatello au milieu des fauves!' (Donatello among the wild beasts). The remark was printed in the 17 October issue of *Gil Blas* and the name immediately caught on. Predictably, the Fauvist pictures came in for a good deal of mockery and abuse: Camille *Mauclair, for example, wrote that 'A pot of paint has been flung in the face of the public'. However, there were also some sympathetic reviews, and Gertrude and Leo *Stein bought Matisse's *Woman with a Hat* (San Francisco Museum of Modern Art), the picture that was attracting the worst abuse. This greatly helped to restore Matisse's

battered morale and marked the beginning of a dramatic rise in his fortunes.

Among the artists who exhibited with Matisse at the 1905 Salon d'Automne were Derain, *Friesz, *Marquet, *Rouault, *Vlaminck, and the Dutch-born van *Dongen. Later they were joined by *Dufy (1906) and *Braque (1907). All of these were a few years younger than Matisse (mainly in their 20s, whereas he was 35 at the time of exhibition in 1905). Lesser figures associated with the group included Jean *Puy and Louis *Valtat. These artists were influenced in varying degrees by *Cézanne, van Gogh, *Gauguin, and the *Neo-Impressionists. Their most characteristic subject was landscape and the outstanding feature of their work was extreme intensity of colour—colour used arbitrarily for emotional and decorative effect, but sometimes also (as it had been by Cézanne) to mould space and volume. Apart from this, they had no programme in common. As a concerted movement Fauvism reached its peak in the Salon d'Automne of 1905 and the *Salon des Indépendants of 1906, and by 1907 the members of the group were drifting apart. For most of them Fauvism was a temporary phase through which they passed in the development of widely different styles (Valtat was an exception), and their work never again displayed such similarity. Although short-lived, however, Fauvism was highly influential, for example on German *Expressionism.

Further Reading: J. Elderfield, *The 'Wild Beasts': Fauvism and its Affinities* (1976)

J. Freeman, *The Fauve Landscape* (1990)

J. D. Herbert, *Fauve Painting: The Making of Cultural Politics* (1992)

Favory, André (1889–1937) French painter, born and active in Paris. Although virtually forgotten today, Favory was in his day much admired by critics, including Louis *Vauxcelles, as a painter who had found a way out of *Cubism while being strengthened by it. In practice this meant a compromise between Cubist angularity and a certain sensuality in the treatment of the nude. The latter element subsequently dominated, as Favory absorbed the influence of *Renoir and of Rubens (whose paintings he saw on a trip to Belgium in 1922). *Self-Portrait with Blond Woman* (1924, Pompidou Centre, Paris) leaves little doubt as to the painter's own preferences, the two figures being seen from behind to emphasize the artist's caressing of the female form. His final

years were blighted by a crippling illness which prevented him from painting.

Federal Art Project (FAP) A project run by the US Government from 1935 to 1943 with the dual purpose of helping artists through the Depression years and of deploying the artistic potential of the country in the decoration of public buildings and places. There were also a Federal Writers' Project, a Federal Theater Project, and a Federal Music Project, and collectively they were known as the Federal Arts Projects. They were part of the Works Progress Administration (later called Work Projects Administration, both abbreviated to WPA), a work programme for the unemployed executed as part of President F. D. Roosevelt's New Deal. The Federal Art Project grew out of a previous scheme of a similar nature—the Public Works of Art Project; this was set up to assist artists over the winter of 1933–4 by employing them on public works for a weekly wage. As a sequel, in October 1934 the Section of Painting and Sculpture in the Treasury Department was established to commission murals and sculpture for new public buildings. This was not a relief project, artists being paid only if their designs were accepted, but the following year the Federal Art Project was set up with the primary aim of helping the unemployed. There was also a smaller Treasury Relief Art Project (TRAP), set up in in 1935 to commission art for existing public buildings; this was essentially a relief project, although it also employed some established artists. These schemes are sometimes known collectively as the Federal Art Projects. Thus it is possible to distinguish between the Federal Art Project (the main scheme), the Federal Art Projects (the main scheme plus the various other ones), and the Federal Arts Projects (the WPA schemes for the visual arts, music, theatre, and writing collectively). Not surprisingly, the terms are very often confused.

The Federal Art Project was directed by Holger Cahill (1887–1960), a museum administrator and expert on American folk art. It employed people on a monthly salary and at its peak there were more than 5,000 on the payroll. They not only decorated public buildings, but also produced prints, posters, and various works of craft, and they set up community art centres and galleries in parts of the country where art was virtually unknown. The Project also involved an Index of American Design, a gigantic documentation of the

decorative arts in America. Virtually all the major American artists of the period were involved in the Project, either as teachers or practitioners (Barnett *Newman is one of the rare exceptions). A huge amount of work was produced, the *Encyclopaedia Britannica* giving the following figures: '2,566 murals [few of these survive], more than 100,000 easel paintings, about 17,700 sculptures, nearly 300,000 fine prints, and about 22,000 Index of American Design plates, along with innumerable posters and objects of craft'. Most of the work was unremarkable in quality, but this was in line with Cahill's philosophy: 'The organization of the Project has proceeded on the principle that it is not the solitary genius but a sound general movement which maintains art as a vital, functioning part of any cultural scheme. Art is not a matter of rare, occasional masterpieces.'

Further Reading: F. V. O'Connor, *Art for the Millions* (1973)

Feeley, Paul (1910–66) American painter, designer, and teacher, born at Des Moines, Iowa. He moved to New York in 1931 and studied at the *Art Students League under *Benton. In 1935 he opened a commercial art studio, designing such things as stage sets and window displays, and in the same year he began teaching at the Cooper Union Art School. From 1939 until his death (with the exception of the years 1943–6, when he served with the US Marines), Feeley taught at Bennington College, Vermont. Helen *Frankenthaler was among his pupils there, and he organized exhibitions of the work of Hans *Hofmann, Jackson *Pollock, and David *Smith.

Feeley's early works moved through various *Expressionist modes, but in the 1950s he began to reject what he called the 'jungles of movement and action' in search of an art of 'sanity, joy, peace, and pleasure'. His most characteristic works employ fairly simple geometrical shapes—such as the quatrefoil or 'jack' shape—arranged in formal patterns. However, the effect is not stark or *Minimalist: there is a rhythmic interplay of convex and concave contours and a striking feeling for colour. They can be classified as *Post-Painterly Abstraction and as *Systemic art. Feeley often worked in series to test the effect of different colours on a particular motif or arrangement. He also worked with *shaped canvases, and in 1965 he began to make painted

wooden sculptures, projecting his paintings into three dimensions.

Feibusch, Hans (1898–1998) German-born painter, sculptor, and lithographer who settled in England in 1933 to escape the Nazi regime. He was Britain's most prolific specialist in mural painting in churches, typically working in a rather mannered swirling figure style. Examples are in Chichester Cathedral and many parish churches in the south of England, and some are illustrated in his book *Mural Painting*, published in 1946. Feibusch also painted secular murals, including a series (1961–4) in Newport Civic Centre, of which John Newman writes: 'As a scheme of municipal decoration, it is perhaps unsurpassed in twentieth century Britain' (*The Buildings of Wales: Gwent/Monmouthshire*, 2000). In the 1970s Feibusch concentrated on landscapes and in 1975 he took up sculpture; he did many portraits and also figures such as the fibreglass statue of John the Baptist (1979) outside St John's Wood Church, London. He died a month before his 100th birthday.

Feininger, Lyonel (1871–1956) American painter, printmaker, and caricaturist who spent most of his career in Europe. He was born in New York into a German-American musical family, and in 1887 he went to Germany with the intention of studying music (he played the violin and also composed); although he later maintained that 'Music has always been the first influence in my life', he turned instead to art, studying in Hamburg, Berlin, and Paris between 1887 and 1893. After returning from Berlin to Paris, he became a full-time caricaturist and by the turn of the century he was Germany's leading exponent of political cartoons. In 1906 he received a lucrative contract for comic strips from *The Chicago Sunday Tribune* and this allowed him to live in Paris for the next two years. During this time he turned to painting, and on a subsequent visit to Paris in 1911 he first saw *Cubist pictures. Under their influence he quickly evolved a highly distinctive style in which natural forms were treated in terms of a rhythmic pattern of prismatically coloured interpenetrating planes bounded by straight lines—a manner that he applied particularly to architectural and marine subjects. Although—as an American citizen—he was an alien, he remained in Germany throughout the First World War and afterwards taught at

the *Bauhaus from its foundation in 1919 (one of his woodcuts appeared on the cover of its manifesto) until its closure by the Nazis in 1933; he was the only person to be on the staff from start to finish (although he did little teaching in its later years). From 1919 to 1925 he was in charge of the school's printing workshop, where he was influential in introducing colleagues and students to the technique of woodcut. In 1935 he visited the USA, and in 1937 the Nazi exhibition of *degenerate art (in which his own work was included) made him decide to return there permanently. He settled in New York and adopted the architecture of Manhattan as one of his favourite subjects. At first he found it hard to adjust to his new life, after half a century in Europe, but he became an honoured and respected figure and worked with vigour into his 80s, his later work becoming more colourful and spontaneous. His son **Andreas Feininger** (1906–1999) was a distinguished photographer and writer on photography. Another son, **T. Lux Feininger** (1910–), is a photographer and painter.

Feitelson, Lorser *See* HARD-EDGE PAINTING

Feito, Luis *See* EL PASO.

Felixmüller, Conrad (1897–1977) German painter and graphic artist, born in Dresden, where he studied at various schools. Felixmüller's early work was in a politically orientated vein combining elements of *Expressionism and *Neue Sachlichkeit—it was eclectic (he toyed with *Cubist and *Futurist mannerisms), wild, and uneven. In 1923 the poet Carl Sternheim wrote, rather exaggeratedly, that 'He tore the aesthetic mask . . . from the face of his contemporaries: in his pictures the proletarian who, until now, had been overlooked by the bourgeoisie, appeared for the first time'. From about 1930 Felixmüller's work began to lose its bite and he settled into a much more conventional naturalistic style. He spent most of his career in Berlin (where he exhibited at the *Sturm Gallery and with the *Novembergruppe), but in 1949–61 he taught at the University of Halle.

Fell, Sheila (1931–79) British painter. She was born in Aspatria, Cumberland, and studied at Carlisle School of Art, 1947–9, and *St Martin's School of Art, London, 1949–51. Although she lived in London for most of her later life (she taught at Chelsea School of Art

from 1958), she often visited her family in Cumberland, and in 1977 she wrote: 'My main concern is landscape (although I have painted several portraits) and I have mostly drawn and painted in Cumbria, Yorkshire and Wales. The chief influence has therefore been that of the country and the different activities which take place on the land, the presence of the mountains, moors, sea, and the effect of the changing light in relation to the earth.' Her early death was caused by an accident when she fell down a steep staircase.

Further Reading: I. Herbert, 'L. S. Lowry's brilliant but tragic protégée gets her day in the sun', *The Independent* (29 March 2005)

feminist art A term applied to art that deals with issues specifically relating to women's identity and experience and made from a female point of view. Feminism itself has been defined by Peggy Phelan as 'the conviction that gender has been, and continues to be, a fundamental category for the organization of culture'. She adds that the pattern of that organization usually favours men over women'. Feminist art is not a style but rather is concerned with a range of endeavour aimed at giving women a just place in the world and specifically in the art world.

The history of feminist art, it can be argued, stretches back long before the point when it was identified as a specific 'movement'. In America, Mary *Cassatt made a mural on the theme of *Modern Woman* (1893, now lost) for the Women's Building at the World's Columbian Exposition in Chicago. There was concerted feminist activity in the arts in the vigorous support given by numerous British women artists to the campaign for voting rights for women at the beginning of the 20th century. For some years after this, gender ceased to be such a visible issue in art, although some women artists (for example Grace *Hartigan) exhibited under male names, presumably to avoid prejudice. Others insisted on being judged in the same way as men. (Léonor *Fini said 'I am a painter, not a woman painter'.) Many women artists, even when they are feminist in outlook in other ways, continue to think this way, and some critics have suggested that the attempt to define an 'art of women' runs the risk of placing female creativity in a ghetto. It has also been argued that the category 'woman artist' implies that 'man artist' represents the norm. Nonetheless, responses to art and judgement

of artists were frequently influenced by considerations of gender. Studies of *Surrealism and *Abstract Expressionism have shown how women artists were marginalized within these movements. Even positive assessments of the work of women artists did not treat gender as invisible. For instance *Vieira da Silva is praised for her 'delicate, feminine quality' (*Studio*, May 1961). Furthermore work by female artists such as Hannah *Höch, Frida *Kahlo and Käthe *Kollwitz continued to raise issues about power and representation in gender.

As a movement, feminist art originated in the late 1960s, in parallel with Women's Liberation. In those days much of the activity of feminist art was collective—for example in the organization of exhibitions, in the setting up of courses dealing with women's art (such as the Feminist Art Program at the California Institute of Arts, established in 1971), and in the publishing of periodicals, several of which have appeared since the early 1970s, the best-known including the *Feminist Art Journal* (founded in New York in 1972), *Women's Art Journal* (Knoxville, Tennessee, 1980), and *Women's Art Magazine* (London, 1986). Two publications which were especially influential were Linda Nochlin's essay 'Why have there been no great women artists?' (*Art News*, January 1971) and Germaine *Greer's book *The Obstacle Race* (1979). These focused not only on the achievements of women artists but on the difficulties in their way.

Because the central definition of feminist art is ideological rather than aesthetic, there is a wide range of style and medium. Some is innovative in terms of content rather than form. For instance in the paintings of Sylvia *Sleigh, long-standing stereotypes of the nude are reversed by presenting males as a subject for female erotic delectation. However, there has been a particular tendency to make use of film, performance, video, and installation, often focusing on sexuality and the body, as in the work of VALIE *EXPORT or Carolee *Schneeman. Another common theme is matriarchy, as in the work of the American *installation and Performance artist Mary Beth Edelson (1933–) or the paintings of the Swedish-born, British-domiciled Monica Sjöö (1938–2005). Edelson draws on ancient traditions of goddess worship and aims at 'exorcising the patriarchal creation myth through a repossession of the female visionary faculties'. Sjöö is best known for her painting *God Giving Birth* (1969), similarly inspired by goddess-worship, which aroused great controversy when it was shown at the 'Womanpower' exhibition at the Swiss Cottage Library, London, in 1973, leading to threats of legal action on the grounds of blasphemy and obscenity. Some feminist art, however, is more concerned with technique than imagery. Indeed, an important aspect of the movement has been the desire to revive interest in art forms such as quiltmaking that employ skills traditionally regarded as female and which have generally been given a low status compared with 'fine art'. This helped to create the interest in *Fibre art and in the kind of rich decorative effects that characterize Miriam *Schapiro's 'femmages' and the *Pattern and Decoration movement in painting. This kind of art has been identified as 'post-feminist'. Judy *Chicago's huge sculpture *The Dinner Party*, probably the most famous work of feminist art, similarly emphasized a return to craft skills: more than a hundred women (and also some men) worked on the elaborate china-painting and needlework it involved.

Other artists have taken a more analytical view of the construction of gender in society. More theoretically inclined artists, like Mary *Kelly, have drawn on Marxism and *psycho-analysis, especially the writings of Freud and Lacan, to explore how gender identities have been constructed socially. The work of Barbara *Kruger involves an analysis of advertising imagery and Victor *Burgin has made photographic work intended to encourage a critical look at gender representation. (Whether or not a male artist can be said to make feminist art has been a subject for debate.) Although she does not explicitly identify her work as 'feminist', the Czech/German artist Katharina Sieverding (1944–) has been associated with feminism because of work involving the transformation of her own face by make-up to explore the fluidity of gender identity. It has also been argued that some abstract art might be considered feminist in so far as it presents an alternative to male forms, often associated either with rigidity and geometry or with the blatant exposure of masculine action through violent brushwork. This idea has been applied to Eva *Hesse and Iza *Genzken as well as the poured paintings and sculptures of Lynda *Benglis. The works in which Helen Chadwick (1953–96) photocopied her body alongside dead animals or made a chocolate fountain were explorations of

female desire. Her work was initially criticized by some feminists as providing the same kind of objectification of the body as pornography.

Since the 1990s it has been harder to make a clear distinction between 'feminist' art and any other art produced by women, although the issue of women's representation in museums and galleries still occasionally surfaces. The issues of other kinds of discrimination and prejudice, for example those based on race, have also come to the fore in the work of artists such as Sonia *Boyce and Kara *Walker. The autobiographical work of Sophie *Calle, Sarah *Lucas, or Tracey *Emin has certainly been made more acceptable as a result of the permission gained to deal with female experience by feminist art, although the approach is recognizably less high-minded than that of their predecessors. The tone was set by the exhibition organized by Marcia Tucker at the *New Museum of Contemporary Art, New York in 1994 entitled 'Bad Girls'. The title was an implicit reference to Tucker's earlier notorious show *'Bad Painting'; the catalogue's bookmark was a tampon string. Tucker included the work of a few male artists, but as was pointed out, the problem was that 'most men who are making art about gender issues are trying to be good boys rather than bad girls'.

Further Reading: Butler (2007)
D. Cameron, 'Post-Feminism', *Flash Art* (February–March 1987)
Lippard (1976)
L. Nochlin, *Women, Art and Power* (1989)

Feng Mengbo *See* VIDEO ART.

Fénéon, Félix (1861–1944) French art and literary critic, dealer, and collector. He was most active as an art critic in the 1880s and 1890s, when he wrote for various magazines and became especially known as a champion of Georges Seurat (in 1886 Fénéon coined the term *Neo-Impressionism to characterize his work). From 1896 to 1903 he was editor of the literary journal *La Revue blanche*, and from 1906 to 1925 he was a director of the Galerie *Bernheim-Jeune, where he promoted the work of various avant-garde artists. His own collection included work by leading contemporaries such as *Braque and *Derain and also African art. He devoted much of his retirement to assisting César de Hauke with a catalogue raisonné of Seurat's work, eventually published in two volumes in 1961. *Oeuvres*, a col-

lection of Fénéon's articles and other works, was published in 1948.

Ferber, Herbert (1906–91) American sculptor (and, in his later career, painter), born in New York. He attended evening classes at the Beaux-Arts Institute of Design, New York, 1927–30, while studying dentistry at Columbia University, and subsequently continued both professions. After a gradual development towards abstraction, in 1945 he abandoned representation altogether and developed an openwork abstract style using welded rods and strips of lead, copper, or brass. By the end of the decade he was prominent among the group of sculptors, including *Lassaw, *Lipton, and *Roszak, whose metal sculpture paralleled the work of the *Abstract Expressionist painters. His constructions were cage-like but suggestive of organic forms and he was one of the first to obtain an expressively textured surface by the manipulation of molten metal. In the 1950s he received several commissions for sculptures on or in religious buildings, and it was partly through these that he began to eliminate the base, experimenting, for example, with forms suspended from the ceiling. These in turn led to room-sized *environmental sculptures, the first of which he created for the Whitney Museum, New York, in 1961. In the 1970s Ferber began to devote much of his time to painting.

Further Reading: R. Berlind, 'Herbert Ferber', *Art Journal*, vol. 53 no. 1 (1994)

Fergusson, J. D. (John Duncan) (1874–1961) Scottish painter (mainly of landscapes and figure subjects) and occasional sculptor, one of the *Scottish Colourists. He was born at Leith and began to study medicine in Edinburgh, but he gave this up for art. Apart from a brief period of study in Paris he had no formal training. From about 1895 he made regular visits to Paris and he lived there 1907–14. His early work was *Whistlerian and he then came under the influence of Manet, but by 1907 he had adopted the bold palette of *Fauvism and became the most uncompromising adherent to the style among British artists (*Blue Beads*, 1910, Tate). From 1911 to 1913 he was art editor of *Rhythm*, a short-lived avant-garde journal. The cover design featured a boldly stylized nude adapted by Fergusson from his painting *Rhythm* (1911, University of Stirling), and the Anglo-American artists in Fergusson's circle in Paris are sometimes called the

*Rhythm Group. In 1914 the war brought him back to Britain; he lived in London, 1914–29, in Paris, 1929–40, and finally in Glasgow, 1940–61. Soon after his arrival in Glasgow he founded the New Art Club to provide better exhibiting facilities for the city's progressive artists, and out of it grew the New Scottish Group (1942), of which Fergusson was first president. At this time he was also editor of the periodical *Scottish Art and Letters*, and he wrote a book entitled *Modern Scottish Painting* (1943). There is a museum of his work in Perth—the Fergusson Gallery, opened in 1992. He was married to the dancer Margaret Morris (1891–1980), who wrote *The Art of J. D. Fergusson: A Biased Biography* (1974).

Festival of Britain A large-scale celebration of British culture mounted in 1951; ostensibly it was meant to commemorate the centenary of the Great Exhibition (held in the Crystal Palace in Hyde Park, London), but in fact it was intended as 'a tonic to the nation' (the words of Sir Gerald Barry, director general of the Festival) following a period of post-war austerity. The heart of the Festival was a huge exhibition, the South Bank Exhibition, held from 3 May to 30 September on a large area of formerly derelict land in central London, on the south bank of the River Thames between Westminster Bridge and Waterloo Bridge. There were also major exhibitions in Belfast and Glasgow, and a large travelling exhibition was seen in Birmingham, Leeds, Manchester, and Nottingham; a Festival ship, the *Campania*, visited various ports, and many places staged local events—indeed, virtually every town and village joined in the celebrations in some way. Hugh Casson (later president of the *Royal Academy) was director of architecture for the South Bank Exhibition, which featured an impressive array of specially designed buildings; all of these were intended to be temporary apart from the Royal Festival Hall, which remains as one of London's leading concert halls, forming part of the South Bank arts complex that has grown around it, including the Hayward Gallery (*see* ARTS COUNCIL) and the National Theatre. The exhibition attracted more than eight million visitors and acted as a massive showcase for British design; it displayed an enormous range of manufactured goods and helped create a fashion for zany patterning and bright colours.

The industrial designer Misha Black (1910–77), who was a leading figure in organizing the Festival, wrote that he and his colleagues had two main objectives: 'The first was to demonstrate the quality of modern architecture and town planning; the second to show that painters and sculptors could work with architects, landscape architects and exhibition designers to produce an aesthetic unity. On these two counts our success was complete.' He thought that 'there was little real innovation, almost nothing on the South Bank which had not previously been illustrated in the architectural magazines . . . but what had previously been the private pleasure of the cognoscenti suddenly, virtually overnight, achieved enthusiastic public acclaim'. The roster of painters and sculptors involved was highly impressive: they included established names such as Jacob *Epstein, Barbara *Hepworth, Henry *Moore, Victor *Pasmore, John *Piper, and Graham *Sutherland, but also relative newcomers such as Reg *Butler and Lynn *Chadwick, who contributed a *mobile. There was a notable absence of the more traditional artists associated with the *Royal Academy. In spite of the array of talent, Black thought that painting and sculpture made relatively little impact on public or press, probably because they had to compete with the sheer size of the Festival and the diversity of other attractions. There was, however, a mild rumpus when an abstract painting by William *Gear was one of five pictures awarded a purchase prize (£500) by the Arts Council at an exhibition it organized. The other four prizes went to figurative works by Lucian *Freud, Patrick *Heron, Rodrigo *Moynihan, and Claude *Rogers.

Further Reading: M. Garlake, *New Art/New World: British Art in Postwar Society* (1998)

Festival Style *See* CONTEMPORARY STYLE.

Fetting, Rainer (1949–) German painter, born in Wilhelmshaven, the son of an art teacher. To avoid military service he moved to Berlin in 1972 to study art. In 1977 he co-founded the Galerie am Moritzplatz in the factory building where he lived with *Salomé, which provided an exhibition space for many of the *Neo-Expressionists. In 1980 he took part in an exhibition in Berlin entitled 'Heftiger Maler' ('Violent Painters'). Afterwards he, Salomé, Bernd Zimmer (1948–), and Helmut Middendorf (1953–) became known as the 'Neue Wilden'. Fetting identified strongly with van Gogh as the tragic outsider figure and he made a series of paintings in which

the Dutch painter is confronted with the Berlin Wall and sprays it with graffiti. Some of Fetting's paintings depict the gay club scene in Berlin; others attempt unsubtle political comment, as in *Die Bombe* (1972), in which dancing figures are threatened with annihilation. Fetting's vigorous and vividly coloured paintings were widely seen in the 1980s, but his reputation has not really outlived the fashion for Neo-Expressionism.

Few, Elsie *See* ROGERS, CLAUDE.

Fibre art A broad term that covers various types of modern work that are made with fibre but which are distinct from traditional categories such as tapestry. Experimental work with fibre goes back at least as far as the 1920s, when Gunta Stölzl (*see* BAUHAUS) created abstract tapestries in which variations of texture are an important part of the design; slightly later, Anni *Albers, too, created textiles that do not merely reproduce a design made in another medium, but depend for their effect on the distinct physical properties of the fibre. However, it was not until the 1960s that there was anything like a movement in fibre art (Magdalena *Abakanowicz was the best-known pioneer). The term itself was coined in the 1970s, when the breaking down of distinctions between 'fine art' and 'craft' was a significant strand in *feminist art because it was considered to challenge the way in which conventional art history valued certain processes and materials over others allegedly in the interests of devaluing female creativity. Most of the leading exponents of Fibre art are women, including the Americans Sheila Hicks (1934–), whose work includes floor pieces, Faith *Ringgold, well known for her 'story-quilts', and Claire Zeisler (1903–91), whose work included cascading pieces.

Fièvre, Yolande (1907–83) French artist, born in either Paris or Nantes. The uncertainty may derive from her father having been a roving circus performer. According to Iris *Clert, her dealer, it was as a consequence of a vow to him on his deathbed that she never wore a skirt, which led to a widespread misconception that she was a lesbian. She studied painting at the École des *Beaux-Arts and the Académie de la Grande Chaumière in Paris. In the 1930s she discovered *Surrealism and met André *Breton and consequently gave up landscape for *automatism. Her best-known work was made between the late 1950s and

1960s. These 'box reliefs' were constructed from fragments of wood, clay, and pebbles, sometimes inhabited by tiny figures, giving the impression of mysterious cities. The sense of worlds in miniature was something she shared with Bernard *Réquichot, whose suicide made a profound impression upon her. After the death of her husband in 1968 she moved into a tiny apartment and had to assign the monkey which was her special companion to the zoo in Vincennes. (The zoo keeper became a closer friend than any of her art world contacts.) Her artistic activity diminished, but an exhibition at the Halles St Pierre in Paris in 2007 has contributed to a posthumous interest in her work.

Further Reading: J Planche, 'Yolande Fièvre', *L'œuf sauvage*, no. 1 (1991)

Figari, Pedro (1861–1938) Uruguayan painter, born and mainly active in Montevideo. He had a versatile and distinguished career as a lawyer, politician, writer, and editor (he founded the Montevideo newspaper *El Diario*) and although he had studied painting in his youth he did not devote himself full-time to art until 1921, when he moved to Buenos Aires. Although he was already 60, he rapidly made a name for himself as an artist and his work was widely exhibited in Uruguay, the USA, and Europe. From 1925 to 1933 he lived in Paris, then returned to Montevideo. He applied a style derived from *Bonnard and *Vuillard to specifically Latin American themes. His work is well represented in the National Museum at Montevideo.

Figuration Libre *See* NEO-EXPRESSIONISM.

Figuration narrative *See* POP ART.

Filla, Emil (1882–1953) Czech painter, sculptor, graphic artist, and writer on art, born at Chropyně in Moravia. He studied at the Prague Academy, 1903–6, and in 1906 was one of the founders of The *Eight (2). Between 1907 and 1914 he spent much of his time in France, Germany, and Italy, and during this period he turned from his early *Expressionist manner to *Cubism, becoming the pioneer and one of the most distinguished exponents of the style in Czechoslovakia in both painting and sculpture. He spent the First World War in the Netherlands and returned to Prague in 1920. His most characteristic paintings of this time were still-lifes, but in the late 1930s he turned to themes of violence, presaging the

horrors of the Second World War (during which he was imprisoned in the concentration camp at Buchenwald). After the war he taught at the School of Industrial Art in Prague. His post-war work was more naturalistic in style and included some large landscapes. He wrote numerous articles on art and several books, of which the best known is *Kunst und Wirklichkeit: Erwägungen eines Malers* (Art and Reality: Considerations of a Painter), published in Prague in 1936.

Filliou, Robert See FLUXUS.

Filonov, Pavel (1883–1941) Russian painter, illustrator, designer, teacher, and poet, born in Moscow and active mainly in St Petersburg/Leningrad. He was one of the most individual Russian artists of his time, developing a style that has been described as proto-*Surrealist and remaining untouched by the general trend towards *Constructivism. In 1925 he founded a school named 'The Collective of Masters of Analytical Art' in Leningrad and ran it until 1932, when the state—intent on imposing *Socialist Realism—disbanded all existing art groups. His paintings (often in watercolour or gouache) are elaborately finished and highly eclectic stylistically: Alan Bird writes that they owe 'a little to child art, a little to icon painting, mosaic, primitivism and analytical *Cubism, and much more to his own researches into Oriental and African art as well as that of the Middle Ages ... they are deeply pessimistic about the human condition'. Filonov died in the siege of Leningrad during the Second World War.

Fini, Léonor (1908–96) Italian painter, stage designer, and illustrator, active mainly in Paris. She was born in Buenos Aires to an Argentinian father and an Italian mother and was brought up in Trieste, her mother's home town. She painted from an early age but had no formal training; her artistic education was instead gained from visiting galleries and from her uncle's extensive library. In 1935 she had her first one-woman exhibition in Paris and at this time she became friendly with some of the leading *Surrealists, including Victor *Brauner and Max *Ernst. She showed her work in several Surrealist exhibitions but never formally joined the movement, as she disliked its authoritarian attitudes. After the Second World War she had numerous one-woman shows in Europe and the USA, and in 1972 a retrospective exhibition toured Japan. Fini also made a

reputation as a stage designer, particularly for the ballet; she created one ballet herself, *Le Rêve de Léonor* (1949), with choreography by Frederick Ashton and music by Benjamin Britten (his *Variations on a Theme of Frank Bridge*). Her work also included book illustrations. In her obituary in *The Times* she was described as 'perhaps the last link with the Surrealist era' and 'a woman of such arresting beauty that many beholders found her presence even more disconcerting than the nightmarish visions of her canvases [her paintings are characteristically concerned with themes of morbid eroticism]...her entrance to private views and parties was such that critics were left with their pencils poised inertly over their notebooks'. She never married but 'her lovers were legion. Their names read like a roll of the literary and artistic talents of that brilliant age'.

Finlay, Ian Hamilton See HAMILTON FINLAY, IAN.

Fischer, Harry See MARLBOROUGH FINE ART.

Fischer, Lothar See SPUR.

Fischl, Eric (1948–) American painter, sculptor, and printmaker, born in New York. He studied at the California Institute of Arts, Valencia, and taught at the Nova Scotia College of Art and Design, Halifax, before returning to New York in 1978. Characteristically he paints large figure compositions showing scenes of middle-class American life. These are reminiscent of Edward *Hopper but often with a strong sexual element dealing with contentious themes like masturbation and voyeurism. His notorious *Bad Boy* (1981) shows a boy staring at the open crotch of a naked woman on a bed while he steals a purse from her bag. By the artist's own testimony the process of constructing the picture began with a bowl of fruit on the table and then the streaked light of the sun coming through bamboo blinds. Only after other combinations of figures did he arrive at the final narrative and that 'transition...from a state of grace to something where the decisions are more complex, people's exchange is more loaded'. Fischl has further admitted that 'I always thought I would be letter-bombed by feminists.' He went on: 'I think that women can recognize the kind of sympathy with which I've portrayed the roles they have been put

in, and I think men can identify the conflicts they deal with.' Robert *Hughes described him as the 'painter laureate of American anxiety in the 1980s'.

Further Reading: R Hughes, *Nothing if not Critical* (1990)

Fischli, Peter (1952–) and **Weiss, David** (1946–) Swiss artists, both born in Zurich. Fischli's father was an architect and artist who had trained at the *Bauhaus and had austere notions about interior design, refusing to allow 'bourgeois' upholstered furniture in the house, but he also admired the more playful aspects of modernism exemplified by *Duchamp, *Picabia, and *Schwitters. Fischli and Weiss began their collaboration in 1979 and since then have made work in a wide variety of media; a constant theme has been the attempt to make the commonplace appear extraordinary. *Suddenly this Overview* (1981) is a series of over 200 tiny sculptures in unfired terracotta. On examination, and with a prompt from the titles, these apparently inconsequential objects are revealed to depict important events. *Mick Jagger and Brian Jones going home satisfied after composing 'I Can't get no Satisfaction'* and *The last dinosaur standing lonely on a deserted landscape* are examples. They have also made sculptures of everyday objects in polyurethane. Their best-known work is in film. In *The Least Resistance* (1981) and *The Right Way* (1983) the artists were disguised as animals exploring first the art world, then a wilderness. *The Way Things Go* (1987) is an elaborately set-up sequence of events in which for half an hour objects fall on one another and interact in a kind of crazy domino-toppling mechanism. This last has become something of a popular favourite and has been much plagiarized by the advertising industry.

Further Reading: J. Heiser, 'The Odd Couple', *Frieze* (October 2006)

G. Moure, 'Peter Fischli and David Weiss', *Artforum International* (February 2001)

Fisher, Sandra *See* KITAJ, R. B.

Fitton, James *See* ARTISTS INTERNATIONAL ASSOCIATION.

FitzGerald, LeMoine *See* GROUP OF SEVEN.

Fitzroy Street Group *See* CAMDEN TOWN GROUP.

Flack, Audrey *See* SUPERREALISM.

Flanagan, Barry (1941–) British sculptor, draughtsman, and printmaker, born in Prestatyn, Wales. He studied at various art schools, principally *St Martin's School of Art, London, 1964–6, his main teacher there being Phillip *King. His early practice was very much part of the questioning of the nature of sculpture taking place at St Martin's. In 1963 he had written to Anthony *Caro: 'I might claim to be a sculptor and do everything but sculpture.' He was one of those who had assisted John *Latham in the chewing-up of Clement *Greenberg's *Art and Culture*. In 1965 he began making sculptures in unusual non-rigid materials which tended to generate their own forms. *Aaing j gni aa* (1965, Tate) is made from sewn-up shapes filled with plaster. The final form is determined by factors outside the artist's control. In 1966 he exhibited a sculpture made from a cone of sand from which four handfuls had been scooped out. This work has to be remade every time it is shown. Other pieces involved rope and hessian sacks filled with sand. These paralleled the development in mainland Europe of *Arte Povera and the use of soft materials by Robert *Morris and Eva *Hesse. He was included in the 1969 exhibition 'When Attitudes Become Form', an early manifestation of *Conceptual art. Since 1973, Flanagan has concentrated on more traditional materials, notably stone and bronze. However, as Graham Beal suggests, 'he brought to carving the sense of paradox, verging on ambivalence, that characterizes his earlier work'. In *The Road to Altissimo* (1973) Beal points out that one side of the marble block is left flat as it was cut by the masons. The other sides demonstrate different ways of attacking the material with punches and chisels and invoke fossil traces. In other works in stone Flanagan left the actual carving to Italian craftsmen, providing them with clay models, so turning his back on the modernist practice of *direct carving. Since the early 1980s he has made bronze figures of animals, especially hares, which are typically shown leaping, prancing, or boxing. Frances Spalding (*British Art Since 1900*, 1986) writes: 'These works had a joyous élan and instant appeal, the hares perhaps symbolizing the imaginative agility of the artist's mind.' These have become his best-known works with a wider public and their popularity has rather obscured his innovatory work of the 1960s and 1970s. In 1982

he represented Britain at the Venice *Biennale.

Further Reading: G. Beal, 'Barry Flanagan: "Twice as Hard in a Negative Way"' in T Neff (ed.), *A Quiet Revolution: British Sculpture Since 1965* (1985)

Flannagan, John B. (1895–1942) American sculptor, an isolated figure whose career was blighted by illness and poverty and ended in suicide. He was born at Fargo, North Dakota, and studied painting at the Minneapolis Institute of Arts, 1914–17. In 1922 he was rescued from near destitution by Arthur B. *Davies, at whose suggestion he took up woodcarving. About five years later he was attracted to the natural beauty of stone and he became a highly original exponent of *direct carving in this medium. He preferred natural to quarried material, and for him part of the creative process lay in 'seeing' the image within the raw stone (in 1930–31 and 1932 he visited Ireland and drew special inspiration from some of the stones he found in remote areas there). He made a few portraits, but most of his subjects were taken from the animal world. His early work was rather tortured in style, fusing elements from Germanic *Expressionism and medieval art. During the 1930s, however, his style broadened and became increasingly abstract, as he pared his work down to an intense, primordial simplicity (*Triumph of the Egg, 1*, MoMA, New York, 1937).

Flash Art Italy's leading periodical in the field of contemporary art. It was founded in Milan as a monthly journal in 1967, since when there have been various changes of identity. In Italy it is now published as *Flash Art Italia* (eight issues a year) and elsewhere as *Flash Art International* (six issues a year). A Chinese edition has also appeared. Germano Celant was among the early contributors to the journal; an article by him in the fifth issue (November–December 1967) launched the term *Arte Povera.

Flavin, Dan (1933–96) American artist, chiefly known for his work in fluorescent light, born in New York. Apart from some lessons at the Hans *Hofmann School in 1956 he had no formal training in art and he did not take it up seriously until 1959. In 1961 he had his first one-man exhibition (of watercolours and constructions) at the Judson Gallery, New York, and in the same year he began to make 'icons', in which plainly painted, square-fronted constructions were combined with electric lights. In 1963 he began using coloured fluorescent tubes. The particular quality of this material is its capacity to glow from the surface rather than from the inside like neon or filament lighting. He eschewed complicated effects of pulsating or flashing lights, preferring a bare and simple presentation that brought him within the orbit of *Minimal art. As with much art of this type the effect on the space in which the work is placed can be as important as the object itself. As Briony Fer puts it, 'The phenomenological experience of a room of fluorescent light is not to look *at* it but to be *in* it.' The lights were arranged in corridors down which the spectator might pass, or in a corner arranged so that some of the light was visible only by its reflection. He had been impressed by the way in which *Tatlin, to whom he dedicated a series of 'monuments', had arranged some of his reliefs in this way, just as Russian icons had traditionally been displayed across the corners of rooms. Flavin insisted on leaving the labels of the suppliers on the lights, so emphasizing the distance between the mundane origins and the complex effects. At the same time he sometimes gave his works poetic titles. A piece entirely in red neon is called *monument 4 those killed in ambush/ to PK who reminded me of death* (1966, DIA Art Foundation). This is mounted at a level just above the heads of most spectators and it is likely that Flavin was making a reference to the Vietnam War. His character was sometimes described as 'spleenish' by his contemporaries. The editor of *Artforum, Phillip Leider, once accused him of 'bit[ing] the hands that pay the light bills' and Flavin referred to artists and writers with whom he disagreed as 'dilettante dada homosexuals'. He had many commissions, including an outdoor work at the Kunstmuseum Basel in 1975 and the lighting of several tracks at New York's Grand Central Station in 1976. There is a foundation devoted to his work in Bridgehampton, New York, in a renovated fire station.

Further Reading: J Weiss (ed.), *Dan Flavin* (2007)

Fleury, Sylvie *See* APPROPRIATION.

Flight, Claude *See* LINOCUT.

Flint, Sir William Russell (1880–1969) British painter, printmaker, and illustrator, born in Edinburgh, the son of a commercial artist. After a six-year apprenticeship with a firm of lithographic printers he moved to

London in 1900. In 1903–7 he was a staff artist on *The Illustrated London News*, and then he went freelance. He was a prolific and highly successful book illustrator, but is now best remembered for his watercolours (particularly his mildly erotic nudes and Spanish gypsy scenes), painted in a distinctive, rather flashy style. His work has been widely disseminated in the form of prints, and limited editions are still being issued. He commented that 'Of the many hundreds of people who look at the reproductions, perhaps only one has seen the original', and he saw nothing to complain of in this state of affairs. From 1936 to 1956 he was president of the Royal Society of Painters in Water-Colour. 'He was a modest and unassuming man, a fine and versatile craftsman, entirely detached from everything that was controversial or experimental in the art of his time' (*DNB*). This avoidance of controversy, however, applied only to his attitude to art. His book *Models of Propriety: Occasional Caprices for the Edification of Ladies and the Delight of Gentlemen* (1951) contains a lurid anecdote about the chastisement of one of his models after her strict parents had discovered that she had posed for him naked. The artist was 'distracted and helpless between his love of classic perfection and burning with indignation at the thought of his lovely model being ignominiously and painfully whipped and her English curves temporarily marred by Scottish thongs'. He concludes his story thus:

So here's an end, tho' no amend,
The lassie still is bare-O.

Flouquet, Pierre-Louis *See* SERVRANCKX, VICTOR.

Fluxus A loosely organized international group of avant-garde artists set up in Germany in 1962 and flourishing until the early 1970s. There was no common stylistic identity among the members; one of their manifestos stated that its aim was to 'purge the world of bourgeois sickness . . . of dead art . . . to promote a revolutionary flood and tide in art, to promote living art, anti-art'. Reviving the spirit of *Dada, Fluxus was fervently opposed to artistic tradition and to everything that savoured of professionalism in the arts. In theory all the members avoided artistic professionalism by working at something else. For instance the American George Brecht (1926?–) worked as

a chemist. The activities of Fluxus were mainly concerned with *Happenings (usually called 'Aktions' in Germany), street art, and so on. Fluxus festivals were held in various European cities (including Amsterdam, Copenhagen, Düsseldorf, London, and Paris), and also in New York, which became the centre of the movement's activities. The most famous artist involved with Fluxus was Joseph *Beuys, although the high seriousness he brought to the idea of being an artist was uncharacteristic of the group's ethos. Other participants included leading avant-garde artists from various countries, among them the Frenchman Robert Filliou (1926–87), the American Dick Higgins (1938–), the Japanese-born American-based Yoko *Ono, and the German Wolf *Vostell. The movement's chief coordinator and editor of its many publications was the Lithuanian-born American George Maciunas (1931–78), who coined its name—Latin for 'flowing', suggesting a state of continuous change. His own goal for the movement, not necessarily shared by all participants, was the gradual elimination of the fine arts on the grounds of the alleged waste 'of material and human resources'.

C. Phillpot and J. Hendricks, *Fluxus* (1988)

Flynt, Henry *See* CONCEPTUAL ART.

Folkwang Museum, Hagen *See* SONDERBUND.

Fondation Maeght *See* MAEGHT, AIMÉ.

Fontana, Lucio (1899–1968) Italian painter, sculptor, and ceramicist, born in Argentina, the son of an Italian sculptor, Luigi Fontana, and an Argentinian mother. In 1905 his family moved to Milan, where he studied sculpture, first with his father and then (after spending several years in Argentina) at the Brera Academy, 1928–30. He had his first solo show at the Galleria del Milione, Milan, in 1930; this was the first exhibition in which abstract sculpture was seen in Italy and Fontana became a leading figure in promoting abstract art in his country. In 1935 he moved to Paris, where he became a member of the *Abstraction-Création association, then in 1940 returned to Argentina, where in 1946 he issued his *White Manifesto*. This introduced a new concept of art called *Spatialism (Spazialismo), which aimed for co-operation with scientists in synthesizing new ideas and materials. In 1947 he returned to Milan, and in the same year officially launched the Spatialist movement and issued

the *Technical Manifesto of Spatialism* (four more manifestos followed, the last in 1952). He lived in Milan for most of the rest of his life, but usually spent the summers at Albisola Marina, where he made ceramics. His most characteristic works, which he began producing in 1958, are paintings in which completely plain surfaces are penetrated by gashes in the canvas, but he also made *environments (for example using neon lights in blackened rooms) and carried out various decorative projects. In 1966 he was awarded the International Grand Prize for Painting at the Venice *Biennale.

Further Reading: S. Whitfield, *Lucio Fontana* (1999)

Forain, Jean-Louis (1852–1931) French painter, lithographer, and caricaturist, born in Reims, the son of a house-painter. In the first half of his career he worked mainly on satirical illustrations for various Paris journals, but he exhibited at four of the *Impressionist exhibitions and after the turn of the century he concentrated more on painting. His most distinctive work included some court scenes, two examples of which are in Tate: *The Court of Justice* (*c.*1902) and *Counsel and Accused* (1908). Forain was a friend of *Degas and was much influenced by him: Degas said of him, 'he paints with his hand in my pocket'.

Forbes, Stanhope (1857–1947) British painter, born in Dublin. His mother was French, and after studying at the *Royal Academy Schools (1874–8) he completed his training in Paris (1880–82). He was impressed by contemporary French plein-air painting, and in the summer of 1881 he painted out of doors in Brittany with H. H. *La Thangue, who had been a fellow student at the RA. In 1889 Forbes married the Canadian-born painter Elizabeth Armstrong (1859–1912) and later that year they settled in Newlyn, a Cornish fishing village that he 'discovered' in 1884. Forbes was not the first painter to work there, but he encouraged others to do so and was 'the centre and rallying point' (*Art Journal*, 1896) of the colony of artists that became known as the *Newlyn School. In 1899 he and his wife founded the Newlyn School of Art, which continued until 1938, and Forbes lived in the village until the end of his long life. His devotion to outdoor painting introduced, in his own words, 'a breath of fresh air in the tired atmosphere of the studios', and he often exhibited with like-minded artists at the *New

English Art Club (of which he had been a founder member in 1886). He painted landscapes, genre scenes, and historical subjects. From about 1910 his palette lightened somewhat, and figures gradually became of lesser importance in his work, but otherwise his style altered little, and his later paintings often have a nostalgic air, reflecting the realization that the world he depicted was fast disappearing.

Forbes, Vivian See PHILPOT, GLYN.

Forces Nouvelles An association of painters formed in Paris in 1934 with the aim of bringing new life to French art by reviving strict principles of draughtsmanship and craftsmanship and combining them with an expressive vigour relevant to the values of contemporary life, which in their work almost invariably meant rural scenes. The leading figures included Jacques Despierre (1912–95), Robert Humblot (1907–62), and Georges *Rohner, who were united in condemning current avant-garde movements as too precious. A manifesto of 1938 declared *Impressionism to be public enemy no. 1 of art and excepted only Picasso, with reservations, from its disapproval. In practice the stylistic range of the group ranged from the painterly manner of Pierre *Tal-Coat, who was to be an exponent of *Lyrical Abstraction after the war, to the expressive figuration of Humblot. The most prevailing influence was probably the late work of Roger de *La Fresnaye. Politically the sympathy of the painters was on the left. One member, André *Fougeron, was to become a leading figure in Communist artistic circles, while some of Humblot's paintings directly referred to the sufferings of the Spanish peasant during the civil war. Furthermore they held their exhibitions at the Galerie Billiet-Worms, which openly supported the left-wing Popular Front. The Forces Nouvelles group held exhibitions from 1935 to 1943, but its impetus had been lost by the beginning of the Second World War.

Further Reading: Musée d'Art Moderne de la Ville de Paris, *Forces Nouvelles 1935–1939* (1980)

Ford, Edward Onslow See NEW SCULPTURE.

formalism A term used in the discussion of the arts to describe an approach in which the means of representation are regarded as of greater significance than what is represented. In the visual arts it is especially applied to the

belief that the formal qualities of a work—such as line, shape, and colour—are self-sufficient for its appreciation, and all other considerations—such as representational, ethical, or social aspects—are treated as secondary or redundant. The idea that formal qualities can have value independent of representational function was essential to the development of *abstract art, and many notable writers on art in the 20th century have been essentially formalist in outlook. Among them were Clive *Bell and Roger *Fry, who were among the leading British critics in the first half of the century, and Clement *Greenberg, the most influential American critic of the 1950s and 1960s. By directing attention away from *what* was represented in a work to *how* it was represented, such writers played an important role in increasing appreciation of various types of non-naturalistic art such as African sculpture. Bell coined the vague term 'significant form' to try to isolate what he considered was the factor that stirred our aesthetic emotions— the common demoninator in all visual art. He did not deny that there were other qualities to be enjoyed in art, but these were subsidiary. Fry was less explicitly theoretical in approach, but his outlook was broadly similar, as is indicated by the following passage, in which he discusses Indian sculpture with a sweeping lack of concern for its cultural context: 'A great deal of their art, even their religious art, is definitely pornographic, and although I have no moral prejudices against that form of expression, it generally interferes with aesthetic considerations by interposing a strong irrelevant interest which tends to distract both the artist and spectator from the essential purpose of a work of art.'

Whereas Fry and Bell thought of formal value as being a constant throughout art, *Greenberg tied his thinking to the historical development of *modernism and a model of artistic progress. He argued that this would lead in the direction of each art form being more concerned with what was distinctive to it, eliminating any effect 'that might conceivably be borrowed from . . . any other art'; in painting, this involved 'stressing the ineluctable flatness of the support (i.e. the stretched canvas or panel) . . . Flatness alone was unique and exclusive to that art . . . and so, Modernist painting oriented itself to flatness as it did to nothing else.' Abstraction was not, therefore, an end in itself but was a logical outcome of modernism. Nonetheless, this attitude led him

to critical judgements which tended to denigrate not just pictorial illusionism but the display of any kind of human interest in art. For instance *Picasso is taken to task for the 'will to illustrative expressiveness' that he shows in *The Three Dancers* (1925, Tate): it 'goes wrong, not just because it is literary . . . but because the theatrical placing and rendering of the head and arms of the center figure cause the upper third of the picture to wobble'.

It can be argued that formalism represents too limited a view of the functions of art. It does need to be made clear that formalist critics do not deny that in the real world works of art are made for many different reasons: they only maintain that these reasons are irrelevant to artistic value. In the discussion of pre-modernist art there is a similar debate. Heinrich Wölfflin (1864–1945), the author of *Classic Art* (1898), held that it was possible to extract the essential 'artistic' element in any work, namely its formal organization, and that the development of art should be understood in terms of a succession of styles. The 'iconographic' school of art history, as represented by Erwin Panofsky (1892–1968), saw art as primarily a form of communication and looked to understand any work as the representation of an idea. Neither historian had much interest in or sympathy with modernist art.

Much art of the 1960s and 1970s can be understood as an opposition to formalism. *Process art as practised by Robert *Morris emphasized the work as the result of a particular kind of making rather than the attempt to achieve formal coherence. The use of soft, pliant materials by artists such as Barry *Flanagan and Eva *Hesse challenged the notion that the value of a work of art lay in a specific formal configuration.

Formalism has had different and almost purely negative associations in Communist countries, especially Stalinist Russia, where art was supposed to serve a moral purpose in the education and inspiration of the masses and anything that suggested cultural elitism was condemned. The Soviet authorities regarded formalism as a sign of Western decadence—so much so that the word was used virtually as an all-purpose term of abuse for Western art or its influence. In 1933, Osip Beskin (1892–1969), head of the critics' section of MOSSKh (Moscow Section of the Union of Soviet Artists) published a book entitled *Formalism in Painting*. It begins by remarking that 'Formalism in any area of art, in particular

in painting, is now the chief form of bourgeois influence' and goes on to censure painters who have not adhered closely enough to the ideals of *Socialist Realism. Artists guilty or suspected of formalism were persecuted (in at least two cases shot) and encouraged to make public recantations for their offences. This applied to writers and composers as well as painters and sculptors. In 1936, for example, Dmitri Shostakovich was attacked in *Pravda* for producing 'leftist confusion instead of music for the people' in his opera *Lady Macbeth of the Mtsensk District*, which 'tickles the perverted tastes of bourgeois audiences abroad'. In literature, 'The charge of formalism will commonly mean that a novelist has devoted too much attention to plot, characterization and description, and that his work lacks the requisite inspirational quality' (R. N. Carew Hunt, *Guide to Communist Jargon*, 1957).

In this context it was almost certainly with a sense of paradox that Victor *Burgin published an essay entitled 'Socialist Formalism' (*Studio International*, March/April 1976). Burgin argued that a distinction should be drawn between the way in which *Cubism provided a critique of the concept of the transparency of the sign and the aesthetics of Fry, Bell, and Greenberg, which simply maintained the freedom of art from concerns not specific to it. He drew on the semiology (*see* BARTHES) of Ferdinand de Saussure, who argued that all representation was an arbitrary code, like verbal language, and proposed a kind of formal analysis which would reveal these codes. In so far as these were complicit in the power structure of society, this was conceived as a politically subversive project.

Although formalism is normally used to denote a theory or critical approach which might be applied to any art, the term 'formalist' has been, even in the West, applied, often with hostile intent, to art works, usually abstract, to which such an analysis might be especially appropriate. Examples would include the sculpture of Anthony *Caro or the paintings of Kenneth *Noland. It is, of course, no contradiction to admire the work of such artists and, at the same time, reject formalism as a critical method.

A further potential source of confusion is that *Art Informel does not necessarily reject the aesthetic theory of formalism. It is simply 'informal' in the colloquial sense of the term, wild and rough, as opposed to the neatness and order of the geometric art of a *Mondrian. In older art criticism, 'formalist' is occasionally used in the sense of social formality. For instance, in 1913 John *Lavery's *The Royal Family at Buckingham Palace* (NPG, London) was praised as 'a veritable triumph over the formalism to which in such pictures we are accustomed'.

Further Reading: Harrison and Wood contains important texts by Fry, Bell, Greenberg, and Burgin

Forma Uno Group of Italian artists, founded in Rome in 1947, who declared themselves both 'formalists and Marxists' in opposition to the members of the *Fronte Nuovo delle Arti, who advocated an art with a more human content. Forma represented an early foray into abstraction for Italian artists: two of the members, Pietro *Consagra and Giulio *Turcato, founded a monthly journal entitled *Forma 1*, which in April 1947 published a manifesto of abstract art. Consagra, Turcato, and several other members of the group went on to join *Continuità.

Formes *See* JEUNE PEINTURE BELGE.

Fortescue-Brickdale, Eleanor *See* SHAW, JOHN BYAM.

Forum exhibition *See* WRIGHT, WILLARD HUNTINGTON.

Fosso, Samuel (1962?–) African photographer, born in Cameroon. Originally an Ibo from eastern Nigeria, he left for the Central African Republic to escape the Biafran War. He set up a photographic studio in Bangui making passport and wedding photographs and, by night, worked on increasingly extravagant self-portraits. In 1994 these were noticed by the French photographer Bernard Descamps. The interest in his work led to a trip to Paris and worldwide exhibition. In a series of colour photographs he presented himself as a transvestite, a pimp, and most famously as *The Chief, the One who Sold Africa to the Colonialists* showing him with his eyes concealed by fashionable slit sunglasses and holding a bouquet of sunflowers. This image became celebrated when used to publicize the international touring exhibition 'Africa Remix' in 2005. He continues to work in Bangui at his photography business.

Further Reading: J. Taylor, 'Here's looking at me', *The Guardian* (27 June 2002)

Fougeron, André (1913–98) French painter, born in Paris. He came from a working-class family and in the 1930s was drawn to left-wing politics. In 1937 he painted *Martyred Spain* (Tate), a work which mixes the distortions of *Masson with dramatic Baroque dark and light, as a comment on the Spanish Civil War. During the German occupation he was involved in the printing of clandestine journals as well as *Vaincre*, an anti-Nazi collection of lithographs. After the war Fougeron became the official painter of the French Communist Party. An album of his drawings issued in 1947 had a preface by Louis *Aragon in which abstraction was attacked. Fougeron's most powerful work during this period was a series of paintings of miners, which denounced the harsh conditions in which they lived. *The Pensioner* (1950) depicts a retired miner who has lost his legs. He has a photograph of the Communist Party leader Maurice Thorez on his mantelpiece. These paintings were toured around the mining centres of France before being shown in Paris at the Galerie *Bernheim-Jeune. Fougeron's style at this point drew on the example of the Neoclassicist Jacques-Louis David (1748–1825). In 1953 Fougeron exhibited *Civilization Atlantique* (Tate), a vast polemical painting denouncing the influence of America on French life. It is dominated by the image of an automobile from which emerges a soldier with a gun. Sarah Wilson points out that there is an explicit elision between 'American capitalism and the Nazi occupation of France'. This painting was attacked by Fougeron's old ally Aragon on the grounds that its montage techniques ran counter to realism, but the real reasons for sidelining Fougeron may have been political. The strident anti-Americanism of the painting was no longer popular and the party wanted to capitalize on the membership of *Picasso, whose portrait of Stalin Fougeron had publicly denounced. In retrospect this much-criticized painting seems to anticipate the way in which European artists of the 1960s such as *Erro and *Arroyo used disjointed popular imagery for political commentary.

Further Reading: S. Wilson, 'Obituary: André Fougeron', *The Independent* (18 September 1998)

Foujita, Tsugouharu (Tsuguharu Fujita, Léonard Foujita) (1886–1968) Japanese-French painter and graphic artist, born in Tokyo, the son of an army doctor. From 1906 to 1910 he studied at the Tokyo Academy, which had made Western-style oil painting part of the curriculum in 1896, then with Kuroda Seiki (1866–1924), who was an important figure in introducing French influence to Japanese art; he had trained in Paris with Raphaël Collin (1850–1916) and had adopted something of his mentor's light palette and penchant for female nudes. In 1913 Foujita himself moved to Paris. He soon became a member of bohemian circles in Montparnasse, and by 1918 he was regularly selling his work, helped greatly by his first wife, the art dealer Fernande Vallé. In the 1920s he developed a distinctive style of delicately mannered *Expressionism, combining Western and Japanese traits, and he became recognized as a leading figure of the group of emigrés who made up the *École de Paris—the only Japanese artist of his time to earn a considerable reputation in Europe. Characteristic works in his extensive output include landscapes, nudes, pictures of cats (which were once very popular in reproduction), and compositions in which still-life and figures are combined. He also painted portraits, a good example being his self-portrait (1928) in the Pompidou Centre. Typically his work is elegantly drawn, with a melancholic air. It owed some of its distinctive quality to a liberal use of white. Some of his fame derived from flamboyant behaviour. He once attended a party dressed only in a loincloth carrying a cage on his back with a naked woman inside. His best-known works today are the two paintings entitled *Mon Interieur* (1921, 1922, Pompidou Centre, deposited with Musée des Beaux-Arts, Nancy): formalized images of traditional 'Frenchness', a checkered tablecloth, earthenware, *une image d'Epinal* as Romy Golan put it, they 'read almost as religious *ex voto* dedicated to his new homeland' (*Modernity and Nostalgia*, 1995).

In 1933, after his savings were threatened by a financial scandal, Foujita returned to Japan, where he remained (apart from a visit to France in 1939–40) until 1950. In this period he raged against the Western art world in which he had once been successful and became an outspoken Japanese nationalist, attacking 'strange international perverts' and 'Jewish gallery owners'. During the war he painted propaganda pictures on behalf of the Emperor of Japan. In 1947 the Japan Artists Association held him officially responsible for war crimes. He then settled once again in Paris and became a French citizen in 1955. In 1959

he converted to Roman Catholicism and adopted the first name Léonard in recognition of his admiration for Leonardo da Vinci. From this time he began painting religious subjects and tended to lapse into sentimentality.

SEE WEB LINKS

• C. Benfey, 'A Japanese Painter and his art de vivre', on the International Herald Tribune website.

found object See OBJET TROUVÉ.

Four, The See GLASGOW FOUR.

Fourteenth Street School See MILLER, KENNETH HAYES.

Frampton, Sir George (1860–1928) British sculptor, born in London. Early in his career he was one of the leading exponents of the *New Sculpture, experimenting with unusual materials and polychrome and working in a style imbued with elements of *Art Nouveau and *Symbolism (*Mysteriarch*, 1892, Sudley Art Gallery and Museum, Liverpool). Later he had a successful career as an accomplished, if traditional, monumental sculptor. His work in this field includes two well-known sights of London—the bronze Peter Pan statue (1911) in Kensington Gardens and the Edith Cavell memorial (1920) in St Martin's Place; the figure of the First World War heroine is in marble and the rest of the structure in granite. Above the statue the monument terminates in a cross surmounted by a sorrowing woman protecting a child—symbolizing humanity protecting the smaller nations of the world, including Belgium, where Nurse Cavell was executed by the occupying Germans for helping British and French soldiers escape to the Netherlands. While the Peter Pan statue is Frampton's most popular work, the Cavell memorial has been much criticized from its unveiling onwards. At the time, some of the details in the symbolic group were considered too modernistic and it is now generally dismissed as heavy-handed: in the *London Encyclopaedia* (ed. Ben Weinreb and Christopher Hibbert, 1983) it is described as 'a very ugly monument'. Frampton's wife, née Christabel Annie Cockerell (1863–1951), was a painter of landscapes and children.

Their son, **Meredith Frampton** (1894–1984), was a painter, primarily of portraits. Like his father, he studied at the *Royal Acad-emy, and he exhibited there from 1920, his work winning increasing critical recognition. However, he gave up painting in 1945 because his sight was failing, and he was almost entirely forgotten until an exhibition of his work was held at the Tate Gallery, London, in 1982, revealing him as an artist of great distinction. His work is beautifully finished, with a sense of hypnotic clarity (the images seem almost palpable yet at the same time strangely remote), and he excelled at conveying the intellectual qualities of his sitters. He was a slow worker and his output was small. He wrote of his own work: 'I think my principal aim has always been to paint the sort of picture that I would like to own and live with had it been painted by someone else.'

The painter **Edward Reginald Frampton** (1870–1923) was not related, but he was a friend of Sir George and Lady Frampton. He specialized in murals (including several in churches as war memorials) in a flat stately style influenced by French Symbolism and by stained glass (his father was a stained-glass artist). His work also included symbolic subjects and landscapes, and early in his career he made sculpture.

Francis, Sam (1923–94) American painter, one of the leading second-generation *Abstract Expressionists. He was born in San Mateo, California, and studied psychology and medicine at the University of California, Berkeley, 1941–3. While serving in the US Army Air Corps he injured his spine in a plane crash and he took up painting in 1944 while he was recovering in hospital. He studied with David Park in San Francisco, then returned to the University of California and took an MA in fine arts in 1950. In the same year he settled in Paris, where he studied under *Léger and was friendly with *Riopelle and other *Art Informel painters; his style was influenced by these artists as well as by Americans such as Jackson *Pollock. In 1957–8 Francis twice travelled round the world, making a long stay in Japan. He often returned there, and the thin texture of his paint, his drip and splash technique, and his asymmetrical balance of colour against powerful voids (he often left areas of canvas blank) led critics to speak of influences from Japanese traditions of contemplative art. In 1961 Francis returned to California, settling first at Santa Barbara and then in Santa Monica. From the mid-1960s the feeling of oriental simplicity in his painting

increased: frequently they were dominated by unpainted surfaces with the colour only at the edges. Francis carried out several mural commissions, but he often worked on a small scale in watercolour. He also made lithographs (from 1960) and sculpture (from 1965).

Frank, Robert (1924–) Swiss/American photographer, born in Zurich of a German father. He left for the United States at the end of the Second World War. He worked for a short time as a fashion photographer but after a year gave it up to become a freelance photographer travelling around the world. Frank became convinced that the truth of life could only be presented in a sequence of photographs, not a single 'masterpiece', and with this in mind he produced his book *The Americans* (1958), which dealt with a wide range of facets of contemporary life. It had an introduction by the 'beat' writer Jack Kerouac, identified as a subversive figure, and there is a case for seeing the book as something of a parody of Edward *Steichen's enormously popular *Family of Man*. Images include a racially segregated bus. When the American flag appears it frequently obscures faces and figures in an interesting parallel to Jasper *Johns' deadpan presentation of the same sign in his paintings of the period. Certainly, in spite of the acclaim the book received, what Minor White, a critic much preoccupied with the spiritual role of photography, disparagingly called 'the jukebox eye on American life' was a provocation in the context of the patriotic fervour of the Cold War period. Frank has also worked as a film-maker. The most famous of his films, *Cocksucker Blues* (1972), is, paradoxically, also the least seen. Dealing with an American tour by the British rock band the Rolling Stones, it depicted drug taking and group sex with such honesty that the musicians tried to get the film suppressed. A court decided that it could be screened five times a year in the presence of the director.

Further Reading: J. Eisinger, *Trace and Transformation: American Criticism of Photography in the Modernist Period* (1995)

Frankenthaler, Helen (1928–) American painter, printmaker, and sculptor, born in New York, where she has spent most of her life. She studied at various art schools, her teachers including *Hofmann and *Tamayo, and by 1950 she had met many of the leading *Abstract Expressionists. The work of Jackson *Pollock particularly impressed her, and she developed his drip technique by pouring and running very thin paint—like washes of watercolour—on to canvases laid on the floor. She first used this method in *Mountains and Sea* (1952, artist's collection, on loan to NG, Washington), which is regarded as the seminal work of Colour Stain Painting (*see* COLOUR FIELD PAINTING): it particularly impressed Morris *Louis and Kenneth *Noland when they saw it in her studio in 1953. In 1962 Frankenthaler changed from oil to *acrylic paint, which allowed her to achieve more richly saturated colour. The limpid veils of colour float on the surface of the canvas, but they often evoke suggestions of landscape: she believes that 'Pictures *are* flat and part of the nuance and often the beauty or the drama that makes a work, or gives it life . . . is that it presents such an ambiguous situation of an undeniably flat surface, but on it and within it an intense play and drama of space, movements, light, illusion, different perspectives, elements in space'.

Frankenthaler has continued to exploit her stain techniques in her later paintings, often working on a large scale. She had her first major success in 1959, when she won first prize at the Paris *Biennale, and since then has received numerous awards and distinctions, including representing the USA at the Venice Biennale in 1966 and at Expo 67 in Montreal the following year. In the 1980s her paintings generally became calmer in mood and more sombre in colour. Since 1960 she has also made aquatints, lithographs, and woodcuts; in 1964 she began to work in ceramics, and in 1972 she made her first sculpture. From 1958 to 1971 she was married to Robert *Motherwell.

Further Reading: H. Rowley, *Helen Frankenthaler: Painting History, Writing Painting* (2007)

Fraser, Robert *See* DINE, JIM.

Frayling, Sir Christopher *See* ROYAL COLLEGE OF ART.

Freddie, Wilhelm (1909–95) Danish *Surrealist painter, sculptor, collagist, printmaker, draughtsman, designer, and film-maker, well known for the explicit erotic quality of his work, which often caused controversy. He was born in Copenhagen and studied briefly at the Academy there, but he was essentially self-taught. In 1929 he was introduced to

Surrealism by the magazine *La Révolution surréaliste*, and he became a pioneer of the movement in Denmark. His early work was influenced by the highly detailed style of *Dalí, but it later moved towards abstraction. He first made a major public impact in 1937, when, as Sarane Alexandrian writes (*Surrealist Art*, 1970), 'there were angry scenes at his Copenhagen exhibition "Sex-Surreal", which included "sado-masochistic interiors" and "sensual objects". One protestor was so infuriated that he hurled himself on Freddie on the day of the opening and tried to strangle him. The gallery was closed by the police, who confiscated the works on show, some of which . . . went to their "black museum", from which Freddie was not able to retrieve them until much later.' (In 1961, he provoked a reopening of the case and succeeded in having the country's obscenity laws revised.) During the Second World War, Denmark was occupied by the Germans and his work was declared *degenerate, prompting him to flee to Sweden, where he lived from 1944 to 1950. After his return to Denmark, his work was gradually found more acceptable by the public. He received several decorative commissions and from 1973 to 1979 he was a professor at the Copenhagen Academy.

Freedman, Barnett (1901–58) British painter, lithographer, book illustrator, and designer, born in the East End of London into a poor Russian-Jewish immigrant family. For much of his life he suffered ill-health and from the age of nine to fourteen he was in hospital, where he taught himself to draw and paint. His artistic talents enabled him to find employment in a monumental mason's workshop and then in an architect's office, and after studying for five years at evening classes at *St Martin's School of Art he won a scholarship to the *Royal College of Art in 1922. After leaving the RCA in 1925, he suffered poverty for several years before his career began to flourish. He regarded himself as a painter and hoped to make his living as such, but in fact he was chiefly successful in various types of commercial work, in which he made use of his expert skills as a lithographer. His output included many book jackets and posters, and—less typically but indicative of his all-round professionalism—the George V Jubilee postage stamp in 1935. From 1941 to 1946 he was an *Official War Artist, first with the army in France, then with the navy—on

Arctic convoys and on submarines. Examples of his war paintings—in which he said he 'tried hard to depict men doing their jobs'—are in the Imperial War Museum and Tate.

Freeze *See* HIRST, DAMIEN

French, Daniel Chester (1850–1931) The most famous American sculptor of public monuments during his day. His best-known work is the seated marble figure of Abraham Lincoln (dedicated 1922) on the Lincoln Memorial in Washington. He also made a standing figure of Lincoln for the town of Lincoln, Nebraska (1912). More typical of his work, however, are allegorical figures of women (*Alma Mater*, 1903, Columbia University, New York). 'Chesterwood', French's home and studio near Stockbridge, Massachusetts, has been preserved as a memorial to him.

French, Leonard (1928–) Australian painter, active mainly in his native Melbourne. He was apprenticed to a sign-writer, which encouraged him to think as a muralist, and studied at night at the Melbourne Technical College, 1944–7. In 1949 he worked his passage to England and met Alan *Davie in London. He visited Ireland and studied the heavy, intertwined shapes of Celtic art, but the work of *Gromaire and *Permeke, and later that of *Delaunay and *Léger, exercised a more direct influence on the paintings he produced after his return to Melbourne in 1952. Although his pictures often involved literary or religious imagery, his style became semi-abstract and intuitively evolved: 'I don't really know what I am going to paint; it has to grow up in the process of one colour on top of another.' His mature style emerged in the early 1960s in a series of paintings inspired by reading Evelyn Waugh's biography of the 16th-century Jesuit martyr Edmund Campion. These paintings best express French's ideal of the heroic, in which the spiritual will battles with and yet is in a sense contained by the mechanical, the seasonal, and the cyclical. In 1962–3 French lived for a time in Greece. On returning to Melbourne he was commissioned to design a stained-glass ceiling for the Great Hall of the new National Art Gallery of Victoria.

Freud, Lucian (1922–) German-born British painter and graphic artist. He was born in Berlin, son of an architect, Ernst Freud, and grandson of Sigmund Freud (*see* PSYCHOANALYSIS). In 1932 he settled in England with his

parents, and he acquired British nationality in 1939. His earliest love was drawing and he began to work full-time as an artist after being invalided out of the Merchant Navy in 1942 (his formal training was brief but included an important period in 1939 studying with Cedric *Morris, who encouraged his pupils to let feelings prevail over objective observation). From 1948 to 1958 he taught at the *Slade School. He first exhibited his work in 1944 and first made a major public impression in 1951 when his *Interior at Paddington* (Walker Art Gallery, Liverpool) won a prize at the *Festival of Britain; it shows the sharply focused detail, pallid colouring, and obsessive, slightly bizarre atmosphere characteristic of his work at this time. Because of the meticulous finish of such paintings, Freud has sometimes been described as a 'Realist' (or rather absurdly as a *Superrealist), but the subjectivity and intensity of his work have always set him apart from the sober tradition characteristic of most British figurative art since the Second World War. From the late 1950s he painted with much broader handling and richer colouring, without losing any of his intensity of vision. His work includes still-lifes, interiors, and urban scenes, but his specialities are portraits and nudes, often observed in arresting closeup, with the flesh painting given an extraordinary quality of palpability (*The Painter's Mother*, 1982, Tate). He prefers to paint people he knows well, one of his favourite recent subjects being the Australian Performance artist Leigh *Bowery, who was a friend from the mid-1980s: 'If you don't know them, it can only be like a travel book.'

Freud's work has been shown in numerous one-man and group shows and he has steadily built up a formidable reputation as one of the most powerful contemporary figure painters. In 1993 Peter *Blake wrote that since the death of Francis *Bacon the previous year, Freud was 'certainly the best living British painter', and by this time he was also well-known abroad (a major retrospective exhibition of his work in 1987–8 was seen in Paris and Washington as well as London). His fame has been won in spite of an aversion to self-publicity. Sir John *Rothenstein wrote of him: 'Freud holds himself aloof not only from official life but also from conventional social life as well. This is due largely to his determination to preserve the utmost possible independence, but even more because he needs an exceptional measure of freedom from distraction in order to

work... Freud is, in fact, an anomalous figure, a socially sought-after solitary with a seemingly facile mind to whom the pursuit of his vocation is a sombre ordeal daily renewed, a seemingly material temperament, who, like Francis Bacon [a close friend], beyond needing ready cash in his pocket, is without the acquisitive urge, and whose successive studios would be rejected as unfit to live in by the student of today' (*Modern British Painters*, vol. 3, 1984).

Further Reading: W. Feaver, *Lucian Freud* (2007)

Freundlich, Otto (1878–1943) German painter, sculptor, and designer (of mosaics, tapestries, and stained glass), active mainly in France. He was born at Stolp in Pomerania, studied history of art in Munich (under Heinrich Wölfflin; *see* FORMALISM) and Florence, and began painting in 1905. From 1909 to 1914 he spent much of his time in Paris, where he was a member of *Picasso's circle (he had a studio in the *Bateau-Lavoir) and flirted briefly with *Cubism. In 1918 he was a member of the *Novembergruppe in Berlin and soon afterwards he began producing purely abstract paintings, composing with interlocking swathes of colour. From 1924 to 1939 he lived in Paris, where he was a member of *Cercle et Carré and *Abstraction-Création. In his own country his work was condemned as *degenerate (his sculpture *The New Man* was reproduced on the cover of the catalogue of the infamous exhibition of 'Degenerate Art' held in Munich in 1937 and was later destroyed by the Nazis). He did not take up large-scale sculpture until 1928, but his few surviving works in this field are generally considered his finest achievements, notable for their feeling of sombre mystery. Much of Freundlich's work perished during the Second World War. His studio in Paris was confiscated by the occupying Germans and he died at Maidanek concentration camp, near Lublin, in Poland.

Freytag-Loringhoven, Elsa, Baroness von *See* DADA.

Friday Club *See* BELL, VANESSA.

Fried, Michael (1939–) American art critic and art historian, born in New York. An early supporter of Frank *Stella and Anthony *Caro, he is unusual among the most important critics of his generation in that he developed the ideas of Clement *Greenberg rather than

reacted against them. He originally studied English at Princeton University, where he met Stella. He also discovered the writing of Greenberg which, before the 1961 publication of *Art and Culture*, could only be accessed in the back numbers of periodicals. Later he recalled how Greenberg's 'austere and intellectually rigorous criticism' contrasted with the 'low-grade rhetorical and poetic writing' current in *Art News*. In 1958 he met Greenberg, who advised him against the study of art history because the historical approach led to the suspension of value judgements, advice which Fried rejected. 'In some ways I was virtually apprenticed to him', commented Fried in a 1998 interview. Nonetheless they were not always in agreement: Greenberg did not share Fried's admiration for Stella. While studying in London in 1961 Fried met Anthony Caro and wrote the introduction to the catalogue of his Whitechapel Gallery exhibition of 1963. In 1965 he organized an exhibition of the work of Kenneth *Noland, Jules *Olitski, and Stella at the Harvard Art Museum. His catalogue introduction is frequently cited as a defence of *formalist (Fried prefers 'formal') criticism. Fried's most influential essay is probably 'Art and Objecthood' (*Artforum*, June 1967). Here Fried engaged with the issue as to why in his view the logical end of *modernist art was not *Minimal art but the abstract art of Caro or Noland. He accused Minimal artists of 'literalism' and 'theatre', that is to say drawing attention to the context in which the work was displayed. This is a quality which became identified as a positive value for supporters of Minimal art. The problem of this for Fried was that they were in doing so providing the viewer with no more than day-to-day experience. 'We are all literalists most or all of our lives.' In the place of this he promotes the experience of 'presentness', perhaps the equivalent to what many call 'taking us out of ourselves'. A striking feature of Fried's writing on Morris *Louis, another Greenberg favourite, is how far Fried emphasizes the ethical aspect of Louis's activity. He begins by stressing above all the artist's integrity and the sacrifices he made for his art. It is as if the resistance to 'literalism' and 'theatre' is a heroic struggle which has moral and even political connotations. Fried's later activities have been principally as an art historian. He has been concerned with the origins of modernism in the 18th and 19th centuries. *Absorption and Theatricality: Painting and Beholder in the Age of Diderot* (1980) is regarded as a classic and he has also published important studies of Manet, Courbet, and Thomas *Eakins. More recently he has written on photography and his book *Why Photography Matters* was published in 2008. This interest has coincided with the rise of large-scale photographs such as those of Jeff *Wall, designed to be seen in gallery spaces on equal terms to paintings.

Further Reading: Fried (1998)

(((●))) **SEE WEB LINKS**

• Interview with Michael Fried in *John Hopkins Magazine*, June 1998.

Friedlander, Lee (1934–) American photographer. He moved to New York in 1967 and showed alongside Diane *Arbus at the Museum of Modern Art, New York, in the 'New Documents' exhibition of 1967. Friedlander's major subject is the street. The special characteristic of his photography is the way in which he incorporates what would, in standard photographic practice, be regarded as the obstacles to vision. One famous example is *New York City* (1966), in which the view of the street is blocked by the head and shoulders of a blonde woman seen from the back. The photographer's own shadow is then cast on the woman's body. In *Cincinnati* (1963) the picture is composed both of the reflections on a shop window and its interior.

Friesz, Othon (1879–1949) French painter (of landscapes, portraits, figure compositions, and still-lifes), graphic artist, and designer, born in Le Havre. He studied there at the École des Beaux-Arts, 1896–9, then in 1899–1904 at the École des *Beaux-Arts in Paris, where he met *Matisse. His early work was *Impressionist in style, then from 1905 to 1907 he was one of the *Fauves—his best work dates from this brief period. In 1907 he abandoned Fauvism and adopted a more traditional and solidly constructed style, under the influence of *Cézanne. *Spring* (1908, Musée d'Art Moderne de la Ville de Paris) is an exercise in the kind of large-scale figure composition, redolent of a golden age, in which Matisse had triumphed and which *Picasso had already viciously parodied in *Les Demoiselles d'Avignon*. From 1911, following a visit to Portugal, he adopted looser, freer handling. After serving in the army during the First World War, he returned to Paris, but up to 1930 he worked a good deal in Toulon

and Provence. From 1929 he taught at the Académie Scandinave in Paris (and later at the Académie de la Grande Chaumière, 1941–4), and in his final years he often painted on the Normandy coast. In 1937–40, with *Dufy (his friend since student days in Le Havre), he painted a large mural in the Palais de Chaillot, Paris, on the theme of the River Seine. As well as paintings, he made book illustrations and tapestry designs. By the end of his life he was a much honoured figure, but his later career is generally seen as marking a steep decline from his Fauve days: 'The son of a sea captain had cast anchor in the pool of stale ideas' (Carlton Lake and Robert Maillard, eds., *A Dictionary of Modern Painting*, 1956).

Frink, Dame Elisabeth (1930–93) British sculptor and graphic artist, born at Thurlow, Suffolk. She studied at Guildford School of Art, 1947–9, and Chelsea School of Art, 1949–53, then taught at Chelsea, 1953–61, and *St Martin's School of Art, 1954–62. In 1964 she became a visiting instructor at the *Royal College of Art. Her main teacher at Chelsea was Bernard *Meadows, through whom she underwent some influence from Henry *Moore; she was also influenced for a while by *Giacometti, some of her early work being angular and menacing. During the 1960s her figures—typically bronze horses and riders or male nudes—became smoother, but she retained a feeling of the bizarre in the polished goggles that feature particularly in her over-life-size heads: 'I think my sculptures are about what a human being or an animal feels like, not necessarily what they look like. I use anatomy to create the essence of human and animal forms.' Frink achieved success early (whilst still a student she won a prize in the competition for the Monument to the Unknown Political Prisoner (*see* BUTLER, REG) against competition from a huge international field) and she became one of the best-known British sculptors of her generation. Her work included numerous public commissions, beginning with the concrete *Wild Boar* (1957) for Harlow New Town; a characteristic work is the bronze *Horse and Rider* (1975) in Piccadilly, London (at the corner of Dover Street), commissioned by Trafalgar House Investments Ltd. Female figures are almost unknown in her sculpture, the only one being the striking and iconographically highly unusual *Walking Madonna* (1981) in the Cathedral Close at Salisbury. Later in her career she also did numerous portrait busts of distinguished sitters. In addition to sculpture she also made prints and drawings. These included a series of illustrations to Chaucer's *Canterbury Tales*. She was created a Dame in 1982.

Further Reading: S. Gardiner, *Frink: The Official Biography of Elisabeth Frink* (1999)

Fritsch, Katharina (1956–) German sculptor, born in Essen. She studied at the Düsseldorf Kunstakademie and during the 1980s rapidly gained a reputation as one of the most original sculptors in Europe. Many of her sculptures are life-size figures in brilliant monochrome presented on the ground without a plinth to engage directly with the spectator. In 1987 she placed a bright yellow Madonna, based on a tourist souvenir from Lourdes, on the streets in Münster, a strongly Catholic city. Although the figure itself was unexceptionable, its placing and its colour aroused strong reactions, presumably because it was impossible for the public to assess whether satire or reverence was the intention. Some laid flowers at its feet, but the piece was also attacked and eventually destroyed. Fritsch was actually taking up the challenge set down by *de Chirico, who wanted statues sharing the same space as human beings. Fritsch is a strong *feminist. Apart from the Madonna her figures have generally been male. She has commented: 'Men have women as their models, so obviously I have men as my models. They are my muses.' The sculptures of 'three bad men' are the monk (all black), the doctor (all white, a skeleton under the coat), and the dealer (brilliant puce with one foot cloven like the devil). The last plays on the double meaning of dealer, both a dealer in drugs and in art. They are in her words 'the physician who doctors his patients to death, the monk who is holier than thou and the dealer who cold-bloodedly rips you off and sells you rubbish'. Fritsch has also drawn on the German tradition of folk tales. *Heart with Money and Heart with Wheat* (1979) is a heart shape on the floor of the gallery made of glittering silver coins and another made of sheaths of golden wheat. It was inspired by a cautionary tale of a charcoal burner who trades his heart for money.

Further Reading: I. Blazwick, *Katharina Fritsch* (2002)

Frize, Bernard (1949/54?–) French painter, born in St Mandé. His date of birth is given differently in various sources, but he began

painting at the end of the 1970s. His work is always abstract and is concerned not with personal expression but with the actual process of making the work. He is fond of saying 'the brush paints'. Indeed his paintings often inspire curiosity about the process of their making, with paint which appears at once totally controlled and spontaneously flowing. Techniques include the use of several brushes tied together. In certain works in which multicoloured brushstrokes interweave like woven threads, he and a number of assistants produce the work in collaboration so that the brushes never have to leave the canvas.

Further Reading: Ikon Gallery, Birmingham, *Bernard Frize: Hands on* (2003)

Fronte Nuovo delle Arti (New Art Front)

An association of Italian artists founded in 1946 (it was originally called the Nuova Secessione Artistica Italiana but was renamed in 1947). It aimed to combat the pessimism of the postwar world and revitalize Italian art, which had not been a leading force in Europe since the heyday of *Futurism. Birolli (*see* CORRENTE) and *Guttuso were the best-known figures in the group, which embraced artists of very different styles and ideologies. Among the others were the painters Bruno Cassinari (1912–92) and Ennio Morlotti (1910–92) and the sculptors Leonardo Leoncillo (1915–68) and Alberto Viani (1906–89). The split between abstractionists and realists led to the disintegration of the association by 1952, when several of the members joined the Gruppo degli Otto Pittori Italiani.

Frost, Sir Terry

(1915–2003) British painter, born in Leamington Spa, Warwickshire, one of the leading artists of the *St Ives School. He attended evening classes in art when he was sixteen, but then worked at various jobs, mainly concerned with electricity and radio, and did not take up painting until 1943, when he was a prisoner of war in Germany. His fellow prisoner Adrian *Heath encouraged him. After the war Frost studied at St Ives School of Art (1946) under its founder Leonard Fuller (1891–1973), then at Camberwell School of Art (1947–50) under *Coldstream and *Pasmore (whom he described as 'my god'). In 1951 he worked as assistant to Barbara *Hepworth. His early work was in the sober realistic tradition of the *Euston Road School, but he soon turned to abstraction. His work remained based on observations of

nature, however, often the harbour at St Ives where he spent a great deal of time up until 1963. *Blue Movement* (1953, Vancouver Art Gallery) is an attempt to render in abstract terms the effect of the rise and fall of boats in a harbour on a twilit evening. Characteristically he used patterns of interlinked shapes—strongly outlined but avoiding geometrical regularity. Frost taught at Bath Academy of Art, 1952–4, Leeds College of Art, 1956–9, and Reading University, 1965–81. He was appointed professor at Reading in 1977 and became emeritus professor on his retirement. He was knighted in 1998. His son **Anthony Frost** (1951–) is also an abstract painter of the St Ives School.

Further Reading: C. Stephens, *Terry Frost* (2000)
'Sir Terry Frost', obituary, *The Times* (3 September 2003)

frottage

(French: 'rubbing') *See* ERNST, MAX.

Fry, Roger

(1866–1934) British critic, painter, and designer, born in London into a distinguished Quaker family. Although he gave up Christian beliefs in adulthood, his Quaker upbringing influenced his character in many ways, notably in his respect for truth, his industriousness, and his sense of social responsibility. In 1885–8 he studied natural sciences at King's College, Cambridge, graduating with a first-class degree. By this time, however, art was already replacing science as his main interest (to his parents' dismay), and over the next few years he travelled to France and Italy to study art (briefly at the *Académie Julian in 1892) and began to build up a reputation as a writer and lecturer (and a more modest one as a painter). Kenneth *Clark writes that he was 'by common consent, the most enthralling lecturer of his time'. From 1901 to 1906 Fry was the regular art critic of the *Athenaeum*, a prestigious literary review. This helped to make his name known in the USA and in 1906 he was appointed curator of paintings at the Metropolitan Museum, New York, where he worked until 1910. He had won his scholarly reputation writing on Italian Old Masters, but in the year he took up his New York appointment he began to be strongly drawn to *Cézanne and he developed into his period's most eloquent champion of modern French painting. In this role he waged 'a long and often thankless crusade . . . to lift English art out of its besetting provincialism' (Dennis Farr, *English Art 1870–1940*, 1978).

After his return to London in 1910 Fry organized two exhibitions of *Post-Impressionist painting (the term, contentious even today, originated with these events) at the Grafton Galleries (1910 and 1912) that are regarded as milestones in the history of British taste. They attracted an enormous amount of publicity and comment, much of it unfavourable: the establishment view was expressed by the eminent painter Sir William Blake Richmond (1842–1921), who wrote that 'Mr Fry must not be surprised if he is boycotted by decent society'. Many people thought that Fry was a charlatan or possibly even insane (his wife unfortunately was insane—she had been committed to an asylum in 1910—which prompted the unkind idea that her condition had somehow infected him). Certain young artists were immensely impressed by the exhibitions, however, and Fry became an influential figure among them. They included Vanessa *Bell and Duncan *Grant, both of whom worked for the *Omega Workshops, which Fry founded in 1913.

Fry kept up a steady output of writing and lecturing for the rest of his life and also continued to work seriously as a painter (he always regarded this activity as a central part of his career); at the time of his death he was Slade professor of fine art at Cambridge University. His books include monographs on Cézanne (1927) and *Matisse (1932) as well as several collections of lectures and essays, including *Vision and Design* (1920) and *Transformations* (1926). The Cézanne book is described by John Rewald in his *History of Impressionism* as 'the first good study of Cézanne's artistic evolution'. In his writing Fry—like his friend Clive *Bell—stressed the formal qualities of works of art (*see* FORMALISM), and this outlook made him responsive to African and other non-European art. However, his range of sympathy towards the new developments in Europe was limited. He did not care for *Expressionism or for German art in general (it was too emotional for his intellectual temperament) and he said of the *Futurists: 'All they do is to paint the confusion of the brain in a railway journey.' In spite of these limitations and the initial opposition to his ideas, he probably did more than anyone else to awaken public interest in modern art in England. Kenneth Clark called him 'incomparably the greatest influence on taste since Ruskin' and said: 'In so far as taste can be changed by one man, it was changed by

Roger Fry.' His painting was sometimes experimental (his work included a few abstracts), but he also made straightforward naturalistic portraits; his sitters included several of his *Bloomsbury Group friends.

Further Reading: C. Green, *Art Made Modern: Roger Fry's Vision of Art* (1999)

Fuchs, Ernst (1930–) Austrian painter and graphic artist, born in Vienna. He studied at the Vienna Academy under *Gütersloh, 1946–50, and is the best-known member of the school of *Fantastic Realism made up mainly of Gütersloh's pupils. His subjects are drawn from religion and magic, treated in a outlandish and vividly detailed manner—often his imagery is close to that of horror comics. He is a prolific etcher as well as a painter. There is a museum of his work in Vienna in a villa designed in 1889 by Otto Wagner. In 1993 he had a major exhibition at the Russian Museum, St Petersburg.

Fuchs, Rudi *See* NEO-EXPRESSIONISM.

Fujita, Tsuguharu *See* FOUJITA, TSUGOUHARU.

Fullard, George (1923–73) British sculptor, born in Sheffield. He came from a radical working-class background: his father was a miner, Communist, and strike leader. Fullard's own political stance has been described as 'lapsed Communist'. During the Second World War he fought in the Battle of Cassino, in which he was seriously wounded. As a young artist he was strongly associated with the *Kitchen Sink painters, especially Derrick *Greaves and Jack *Smith, and his realist sculpture was much admired by John *Berger. In the late 1950s he embarked on a series of wooden assemblages which draw upon the example of *Picasso's constructions. The finest of these, *The Patriot* (1959–60, Southampton City Art Gallery), which depicts a baby in arms waving a Union Flag, announces the theme that would dominate his best-known work, the relationship between war and children's games. *Death or Glory* (1963–4, Tate) is a characteristic example, a wood construction in which an upturned table becomes a barricade. Such works were contemporary both with Peter *Blake's Pop nostalgia for childhood and with widespread protests against nuclear arms. After the exhibition of the 'war series' in 1964, Fullard embarked on a group of sculptures dealing with the sea and ships. For him

there was a continuity between the artist's world and the child's. In 1959 he wrote 'Just as the child, without effort, slips through imagination out of life to make a man out of a pepper pot, or the heaving deck of a shipwreck out of a placid pavement, so the artist works towards the miracle of making visible that which apparently could not exist' ('Sculpture and Survival', *The Painter and Sculptor*, vol. 2, no. 2, summer 1959).

Fuller, Leonard *See* FROST, SIR TERRY.

Fuller, Meta Vaux Warrick (1877–1968) American sculptor, noted for her pioneering representations of African-American culture. Born in Philadelphia, she moved to Paris in 1899. During her stay there she met *Rodin, who was more impressed by her sculpture than her drawing. The work she exhibited in Paris, such as *Carrying the Dead Body*, earned her the reputation of a 'delicate sculptor of horrors'. She also made contact with the philosopher W. E. B. DuBois, who encouraged her interest in her African heritage, urging that she depict 'negro types'.

Following her return to Philadelphia in 1902 she concentrated on this theme. She moved to Boston in 1909 after her marriage to the neurologist Samuel Fuller. In 1922 she exhibited her best-known sculpture, *Ethiopia Awakening* (c.1914 Schomburg Center for Research in Black Culture, New York Public Library). This figure in Egyptian-style costume has been plausibly interpreted as relating to the pan-Africanist ideas which were gaining popularity among the African-American middle class. These ideas had been boosted by recent archaeological findings that had provided evidence of Ethiopian ascendancy in the Nile Valley, so placing an African heritage at the origins of civilization. It is also likely that a riposte was intended to the negative depiction of Africa in the allegorical depiction of the continent in Daniel Chester *French's 1904 sculptures for the Custom House in New York, unofficially christened 'Ethiopia Asleep'. Alain Locke, the leading theorist of the *Harlem Renaissance, described it as 'a female mummy released from a millennial sleep'.

She continued working on African themes. *The Talking Skull* (1937, Museum of Afro-American History, Boston) refers to a folk tale about a boy who finds a skull. After a period of illness in the 1950s she returned to sculpture in old age to support the Civil Rights Movement. She died in Framingham, Massachusetts.

Further Reading: T. Leninger-Miller, *New Negro Artists in Paris* (2001)

J. T. Robinson (ed.), *Bearing Witness: Contemporary works by African American Women Artists* (1996). See the contributions from Tritobia Hayes Benjamin and Judith Wilson

Fuller, Peter (1947–90) British art critic, born in Damascus, the son of a doctor. After graduating in English from Cambridge University in 1968, he began working for *City Press*, *New Society*, and other journals in London, and for the rest of his life he earned his living as a writer. At Cambridge he had been influenced by Marxist ideas, and in art criticism he was initially a follower of John *Berger. He created a particular stir with his polemical two-part essay 'The Crisis in British Art' (*Art Monthly* June/July 1977). Far beyond the actual merits of its arguments, it created a focus for a mood of widespread dissatisfaction among younger artists and critics with a British modern art establishment which appeared to have become complacent and servile to commercial values. However, Fuller gradually abandoned Marxism, and in 1980 he published *Seeing Berger* (reissued in 1988 with the title *Seeing Through Berger*), a riposte to his former mentor's highly influential book and television series *Ways of Seeing*, which he viewed as over-reductive in its equation of aesthetic value with the commercial and the ideological. An interest in psychoanalysis led him to locate the aesthetic value of art in its relationship to the body. This went very much against the prevalent reading of psychoanalysis in British art circles in which, under the influence of Jacques Lacan (*see* PSYCHOANALYSIS), the structure of language was seen as dominant. At this time 'anaesthetic structuralist' became his term of abuse of choice for those with whom he disagreed. His views became increasingly conservative, and in 1988 he founded the journal *Modern Painters* to champion what he perceived as traditional values. The following year he was appointed art critic of *The Sunday Telegraph*, one of the most right-wing of British newspapers. Although his outlook had changed greatly over the years, his bellicose personality had not, and he became the most controversial British critic of his time: to his admirers he was a bold, plain-speaking champion of time-honoured values and common sense, and to his detractors he was a short-sighted philistine. He died

in a car crash. 'Modern Painters: A Memorial Exhibition for Peter Fuller' was shown at the City Art Gallery, Manchester, in 1991. Apart from works on art, Fuller wrote an autobiography, *Marches Past* (1986), and he was co-author with John Halliday of *The Psychology of Gambling* (1974) (early in his life he had been a compulsive gambler).

Fulton, Hamish (1945–) British walking artist (his preferred designation), born in London. He studied at St Martin's School of Art, 1966–8, a contemporary of *Gilbert & George and Richard *Long, and his work came out of the same questioning of the nature of sculpture. While there he undertook with two other students, Rodney Milne and Alastair McDonald, a project to hitchhike to Andorra and record the distances travelled. In 1968 Fulton began using photography as a record. Since then, although his works take the form of books, photographs, and texts, the point is that they recall an actual passage through the landscape. Sometimes the work has a similar look to that of Long and the two artists are often bracketed together, but Fulton only rarely intervenes in the landscape and when he does so only in the most discreet and temporary way. *Shadow Stick Line: Utah 1969* simply records the movement of the sun. An exhibition of his work at *Tate Britain in 2002 consisted mainly of wall-size texts disposed to evoke the experience of walking. On one wall the letters in black and silver suggest the sudden illumination of a mountain by the sun on a cloudy day.

Further Reading: Kettle's Yard, Cambridge, *1965–1972 – when attitudes became form* (1984)

fumage *See* PAALEN, WOLFGANG.

Funk art Term applied to a type of art that originated in California (specifically the San Francisco area) around 1960 in which tatty or sick subjects—often pornographic or scatological—are treated in a deliberately distasteful way (the word 'funky' has various meanings, including 'smelly'; when applied to music it can mean 'earthy' or 'authentic'). By the mid-1960s there was something approaching a Funk movement, and an exhibition called 'Funk' was held at the University Art Museum, Berkeley, California, in 1967. Although the first works of Funk art were paintings, its characteristic products are three-dimensional—either sculpture or *assemblage. Influenced by *Dada and *Pop art, Funk art was 'dedicated to rude subversion of everything the New York scene stood for, especially its purist formalism, temple-like galleries, and priestly caste of critics... Funk artists... cultivated ephemeral as well as cheap materials, sloppy execution, weird eccentricity, and outrageously vulgar fun poked at everything sacred, from religion, patriotism, and pets, to art, sex, and politics' (Daniel Wheeler, *Art Since Mid-Century*, 1991). Edward *Kienholz was the best-known practitioner of the genre and one of its most distinctive exponents was Robert Arneson (1930–92), who worked mainly in ceramics, creating, for example, painted sculptures of toilets (*John with Art*, 1964, Seattle Art Museum). Other exponents include Bruce Conner (*see* JUNK ART) and Paul *Thek.

Futurism Italian avant-garde art movement, launched in 1909, that exalted the dynamism of the modern world; it was literary in origin, but most of its major exponents were painters, and it also embraced sculpture, architecture, music, the cinema, and photography. It lingered in Italy until the 1930s, and it had a strong influence in other countries, particularly Russia.

The founder of Futurism was Filippo Tommaso *Marinetti, who launched the movement with a manifesto published in French in the Parisian newspaper *Le Figaro* on 20 February 1909. In bombastic, inflammatory language, he attacked established values ('set fire to the library shelves... flood the museums') and called for the cultural rejuvenation of Italy by means of a new art that would celebrate technology, speed, and all things modern. Many Italians shared his dismay that—following the stirring days of unification in the mid-19th century—their country had failed to become a truly modern nation. The current political regime under the premiership of Giovanni Giolitti (1842–1928) was notorious for its emphasis on compromise and mediation between opposing interests, which 'angered true believers of all description' (A. Lyttleton in Braun). Few, if any, of the ideas expressed in the manifesto are original: they emerge from 'a tangled web of turn-of-the-century political, cultural and philosophical currents' (Tisdall and Bozzolla). The manifesto was notable for the exaggerated violence of the language and the skill with which the document was publicized. Marinetti was a brilliant manipulator of the media, and it is typical of his panache that he had his

manifesto published not in some obscure journal, but on the front page of one of the most prestigious newspapers in the world (he was very wealthy and simply hired the space). Futurism was also novel as a movement in that it chose its own name and that it started with an idea and only gradually found a way of expressing it in artistic form.

In spite of Marinetti's repeated use of 'we' in the manifesto, there was no Futurist group when it was published. However, he soon attracted adherents among other Italians, notably a group of painters based in Milan, whom he helped to produce the *Manifesto of Futurist Painters*, published as a leaflet by his magazine *Poesia* in February 1910. It was drawn up by *Boccioni, *Carrà, and *Russolo, and also signed by *Balla (who lived in Rome) and *Severini (who was in Paris at this time). The same five signed the *Technical Manifesto of Futurist Painting*, published in April 1910. Whereas the first painters' manifesto is little more than a repetition of Marinetti's bombast, the *Technical Manifesto* does suggest—although in vague terms—the course that Futurist painting would take, with the emphasis on conveying movement (or the experience of movement): 'The gesture which we would reproduce on canvas shall no longer be a fixed *moment* in universal dynamism. It shall simply be the *dynamic sensation* itself.'

In trying to work out a visual idiom to express such concerns, the Futurist painters at first were strongly influenced by *divisionism, in which forms are broken down into small patches of colour—suitable for suggesting sparkling effects of light or the blurring caused by high-speed movement, as in Boccioni's *The City Rises* (1910–11, MoMA, New York). In 1911, however, Boccioni and Carrà visited Marinetti and Severini in Paris, where they were influenced by *Cubism. Thereafter they began using fragmented forms and multiple viewpoints, with the sense of movement often accentuated by vigorous diagonals. Balla developed a different approach to suggesting motion, imitating the effects of multiple-exposure photography in which successive images taken a fraction of a second apart overlap and blur (such photographs had first been taken by Étienne-Jules Marey in the 1880s). The subjects of the Futurist painters were typically drawn from urban life, and they were often political in intent.

Futurist paintings were first publicly shown at a mixed exhibition in Milan in 1911, but the first proper group exhibition was held in February 1912 at the Galerie *Bernheim-Jeune in Paris. Subsequently it travelled to London (the Sackville Gallery), Berlin (the *Sturm Gallery, where many of the exhibits were bought by a private collector), Amsterdam, Zurich, Vienna, and Budapest. Marinetti's skilful promotion techniques (backed by his personal fortune) ensured that the exhibition gained a great deal of publicity; reactions to it were very mixed, but the Futurists were never ignored. The preface to the catalogue, signed by Balla (who did not exhibit), Boccioni, Carrà, Russolo, and Severini, was in effect an updated manifesto, in which they discussed a vague principle of 'force-lines', through which objects fuse with their surroundings. Their ideas are summarized by George Heard *Hamilton as follows: 'According to this document they wanted to portray the sum of visual and psychological sensations as a "synthesis of *what one remembers* and of *what one sees*". In addition to the visible surface of objects, there are the dynamic sensations conveyed by the invisible extensions of their "force-lines", which reveal how the object "would resolve itself were it to follow the tendencies of its forces". Since the work of art, through this process of "physical transcendentalism", can be considered the representation of a state of mind, and the force-lines, as perspective elements, tend towards infinity, the spectator is placed "in the centre of the picture".'

Boccioni (the only major sculptor in the group) expressed similar ideas about the relationship of form, motion, and environment in his *Manifesto of Futurist Sculpture*, published in April 1912. There was also a *Manifesto of Futurist Architecture*—by Antonio Sant'Elia (1888–1916), whose powerful and audacious designs remained on paper—as well as musical manifestos (*see* RUSSOLO), and several on other topics, including a *Manifesto of Futurist Lust* (1913) by the French writer, dancer, and painter Valentine de Saint-Point (1875–1953). She thought that lust was an essential part of life's dynamism: 'It is the sensory and sensual synthesis that leads to the greatest liberation of the spirit. It is a communion of a particle of humanity with all the sensuality of the earth.' The Futurists spread their ideas also through meetings—in various public venues—that were sometimes like a cross between political rally and variety theatre, anticipating *Performance art.

In keeping with this talent for self-promotion, the Futurists had widespread influence in

the period immediately before and during the First World War. Stylistically and even more in its rhetoric, the influence is clear in the work of the *Vorticists in England, for example, and that of Joseph *Stella in the USA, while the use of provocative manifestos and other shock tactics was most eagerly adopted by the *Dadaists. Outside Italy, however, it was in Russia that Futurism made the greatest impact, although there were significant differences between the movements in the two countries: Russian Futurism was expressed as much in literature and the theatre as in the visual arts, and it combined modern ideas with an interest in *primitivism. The *Union of Youth, founded in 1910, was an important nurturing ground for Futurism, but its starting-point as a movement in Russia is often reckoned to be the manifesto *A Slap in the Face for Public Taste* (1912), the signatories of which included David *Burliuk and Vladimir *Mayakovsky. The Russian Futurists rejected *Symbolism, which had been such a powerful force in the country's art, demanding a new and experimental attitude, and they welcomed the Revolution. In terms of Russian painting, Futurism was particularly influential on *Rayonism (*see also* CUBO-FUTURISM).

Marinetti had welcomed the war as a means of cleansing the world. However, it exacted a high price from Futurism: both Boccioni and Sant' Elia died. Severini and Carrà turned to *Neoclassicism. A 'second wave' of Futurism was spearheaded by Balla and its centre of activity moved from Milan to Rome, where he lived. He was joined by Fortunato *Depero and Enrico *Prampolini. In the hands of these three artists Futurism tended to turn towards abstraction.

After the war, Marinetti continued with his literary and political activities, supporting Fascism (he was an early supporter and friend of Mussolini). Fascism and Futurism shared an aggressive nationalism and the movements are often linked. Futurism has even been described as 'the official art of Fascism'. This, however, is only partially true. Some of the impact of the Futurist visual style, especially the projects of Sant'Elia, can be seen in the bombastic design for the 1932 exhibition in Rome commemorating ten years of Fascism. Generally, however, the pompous style of some *Novecento artists like *Sironi was favoured in official commissions and Marinetti's attempt to revive the movement as *Aeropitturra failed to attract artists of any stature.

However, the similarities between the political and artistic groups go further and can be traced back to Futurism's early years. The philosopher Benedetto Croce pointed to Futurism's 'desire to go down in the streets, to impose its own opinions . . . not to fear riots or fights, in its eagerness to break with all traditions, [and] in its exaltation of youth' (cited by Jensen). Unpalatable as this may be to lovers of a quiet life, this feature of youth movements is hardly unique to Fascism or the extreme right. It can be argued that Futurism and Fascism shared a cult of violence for its own sake as a kind of purifying force. Carrà's *Funeral of the Anarchist Galli* (1911, MoMA, New York) or Boccioni's *Riot in the Galleria* (1910, Brera Milan) give the strong sense that political violence is the mark of a dynamic modern society to be celebrated no matter what the cause. Emilio Gentile, who has explored the ideological links between Futurism and Fascism, concludes that 'Fascist regeneration . . . sacrificed the freedom of the Italians on the altar of politics', whereas the revolution envisioned by the modernist avant-garde 'was to produce a generation of free men, masters of their destiny'.

One of the best collections of Futurist art outside Italy is the Eric and Salome Estorick Foundation, London, which opened to the public in 1998. The collection was made by the American-born art dealer Eric Estorick (1913–93) and his wife, Salome (1920–89).

Further Reading: Braun (1989)

E. Gentile, 'The Myth of National Regeneration' in Affron and Antliff (1997)

R. Jensen, 'Futurism and Fascism', *History Today* (November 1995)

C. Tisdall and A. Bozzola, *Futurism* (1977)

G The title of a magazine founded by Hans *Richter in Berlin in 1923 with the intention of making it 'the organ of the *Constructivists in Europe'. There were six issues before it folded in 1926. *Lissitsky, who had himself published a short-lived Constructivist journal called *Vesch*, suggested the single-letter title: 'G' stands for 'Gestaltung' (Formation). Contributors to the magazine included *Arp, van *Doesburg, *Hausmann, *Man Ray, and *Schwitters.

Gabo, Naum (Naum Neemia Pevsner) (1890?–1977) Russian-born sculptor, painter, printmaker, and designer who became an American citizen in 1952, the most important link between the Russian *Constructivist avant-garde and the West. He was probably born in Klimovichi, Belarus, and was brought up in Briansk, where his father ran a prosperous metallurgy business. His surname was originally Pevsner, but he adopted another family name, Gabo, in 1915 to avoid confusion with his younger brother, Antoine *Pevsner. He never trained as an artist. In 1910 he began studying medicine at Munich University, but he soon switched to natural sciences, then engineering. He also took art history courses with Heinrich Wölfflin, whose *formalist approach, exemplified in his *Principles of Art History* (1915), saw the history of art as an autonomous development of style. Gabo was introduced to avant-garde art when he visited his brother in Paris in 1913–14, and in 1915 he began to make geometrical constructions in Oslo, where they had taken refuge during the First World War. In 1917 the brothers returned to Russia and in 1920 they published their *Realistic Manifesto*, originally issued as a poster to accompany an open-air exhibition of their work in Moscow. The commissar of the State printers, Trotsky's sister, permitted the publication because she mistakenly thought it was in favour of traditional realism. There is a conception of 'realism' behind the Manifesto, but it derives from the necessity for the artist to engage with the present rather than any kind of illusionist representation. Its style of rhetoric owes much to *Futurism—'Above the tempests of our weekdays. Across the ashes and cindered homes of the past. Before the gates of the vacant future'—but combines this with specific reference to the revolution and the dismissal of *Cubism and Futurism as having led to an impasse. The key points for artistic practice were the denial of weight and mass in sculpture. Opposing the 'static rhythms' of traditional art, it demanded '*kinetic rhythms'. Among Gabo's work of this period only the *Kinetic Construction (Standing Wave)* (1919–20, Tate), a thin strip of wire rapidly waving from side to side to produce the illusion of a volume, used real movement, but the replacement of volume by space was to be the key feature of all his later work.

Official policy in the new Soviet Russia increasingly insisted on art being channelled into industrial design and other socially useful work (as exemplified by *Tatlin). Gabo therefore left Russia in 1922 and spent the next ten years in Berlin, where he knew many of the leading artists of the day, particularly those connected with the *Bauhaus. In the aftermath of the civil war, the demands of leading critics for an 'uncompromising war on art' could threaten more than fervent debates and professional back-stabbing. In 1932 Gabo moved to Paris, where he was a leading member of the *Abstraction-Création group, and in 1935 he settled in England, living first in London, where in 1937 he was co-editor of the Constructivist review *Circle*, and then from 1939 in Cornwall (*see* ST IVES SCHOOL). In 1943–4 he worked with the Design Research Unit, formed by Herbert *Read and others to apply advanced art to industrial design, but none of his designs reached fruition.

In 1946 Gabo moved to the USA, settling at Middlebury, Connecticut, in 1953. He had a joint exhibition with Pevsner at the Museum of Modern Art, New York, in 1948, and in the

remaining three decades of his life he became a much-honoured figure, receiving various awards and carrying out numerous public commissions in America and Europe. He often worked on themes over a long period: his *Torsion Fountain* outside St Thomas's Hospital in London, for example, was erected in 1975, but it is a development from models he was making in the 1920s. In his later work he made full use of new materials, especially plastics, to achieve qualities of transparency and openness impossible in metal. A late piece like *Linear Construction no 2* (1970–71, Tate) demonstrates the same basic principles outlined in the *Realistic Manifesto* but with the aid of nylon filament, which had been unavailable when he wrote it. This notion of sculpture brought him into a friendly disagreement with Herbert Read, who was a critical supporter of Gabo as an artist but who conceived sculpture as an art of mass. Painting, sometimes rotated by a motor, and printmaking also became important activities.

Throughout his career Gabo was an advocate of Constructivism not merely as an artistic movement but as the ideology of a way of life. As Teresa Newman writes, 'Constructivism was and is "real" in the sense that it consists of three-dimensional, palpable images set in space . . . But constructive reality also has a philosophical dimension in so far as these sensuous images express a modern, life-affirming consciousness with materials and methods appropriate to our time.' His ideas were expounded at length in his 1959 lectures *On Divers Arts* (1962). Here he takes issue with the scientist's claim to absolute knowledge of the world, maintaining that 'whatever secrets there are in nature, I can unravel and understand them only through the images which my consciousness forms of my experiences'. In the first lecture he quotes the German monk Theophilus who wrote a treatise on the techniques of art in about 1100. 'Man was made in God's likeness; the Devil deceived him and deprived him of paradise, yet not of this inborn capacity to learn divers arts.' The reader is tempted to relate this to Gabo's own experiences of being 'cast out' of the failed paradise of the post-revolutionary Soviet Union.

Tate holds an outstanding collection of Gabo material, including many small models donated by the artist shortly before his death.

Further Reading: M. Hammer and C. Lodder, *Constructing Modernity: The Art and Career of Naum Gabo* (2000)
T. Newman, *Naum Gabo: The Constructive Process* (1976)

Galerie de l'Effort Moderne, Paris *See* ROSENBERG, LÉONCE.

Galerie l'Actuelle, Montreal *See* MOLINARI, GUIDO.

Galí, Francisco *See* MIRÓ, JOAN.

Gallatin, A. E. (Albert Eugene) (1881–1952) American collector, writer on art, and painter, born into a wealthy family. His earliest collecting interests were in Aubrey Beardsley and *Whistler, but in the 1920s he began buying more recent works, stimulated by his frequent visits to Europe, especially Paris. He was dismayed by the dispersal of John *Quinn's collection in 1926, and in 1927 he installed his own collection as a small, informal museum at New York University, where it remained until 1943 (when it was closed because of the war). It was entitled the Gallery of Living Art (renamed the Museum of Living Art in 1936) and was America's first museum devoted exclusively to contemporary art. Artists represented included *Arp, *Delaunay, *Hélion (who acted as Gallatin's adviser), *Léger, *Miró, *Mondrian, and *Picasso. Gallatin himself was an abstract painter, and his museum was an important stimulus for his fellow members of *American Abstract Artists. After its closure in New York, he presented most of his collection to the Philadelphia Museum of Art, and he encouraged the *Arensbergs to do likewise. Gallatin wrote a good deal on art, including books, articles, and exhibition catalogues on *Braque, *Demuth, *Ricketts, and Whistler.

Gallen-Kallela, Akseli (1865–1931) Finnish painter, graphic artist, designer, and architect, his country's most famous artist and a major figure in the *Art Nouveau and *Symbolist movements. He was born in Pori and studied in Helsinki and then in Paris (1884–9, notably at the *Académie Julian). In 1894 he settled at Ruovesi in central Finland, where he designed his own home and studio (1894–5) in a romantic vernacular style, together with its furnishings. He travelled widely, however, and was well-known outside his own country, particularly in Germany (he had a joint exhibition with *Munch in Berlin in 1895 and exhibited with Die *Brücke in Dresden in 1910). In 1911–13 he built a new home and studio for himself at Tarvaspää near Helsinki (now a museum dedicated to him). Gallen-Kallela was deeply patriotic (he volunteered to fight in the War of

Independence against Russia in 1918, even though he was in his fifties) and he was inspired mainly by the landscape and folklore of his country, above all by the Finnish national epic *Kalevala* ('Land of Heroes'). His early work was in the 19th-century naturalistic tradition, but in the 1890s he developed a flatter, more stylized manner, well suited to the depiction of heroic myth, with bold simplifications of form, strong outlines, and vivid—sometimes rather garish—colours. Apart from easel paintings, Gallen-Kallela did a number of murals for public buildings, including the Finnish National Museum, Helsinki, in 1928. His work also included book illustrations (notably for an edition of *Kalevala*, 1922) and designs for stained glass, fabrics, and jewellery. He is regarded not only as his country's greatest painter, but also as the chief figure in the creation of a distinctive Finnish art, and he was given a funeral befitting a national hero. His son **Jorma Gallen-Kallela** (1898–1939) was also a painter.

Galleria Nazionale d'Arte Moderna, Rome. Italy's major collection of art from the late 19th century onwards. It was founded in 1883 as one of the expressions of national pride that followed the unification of the country, and its original purpose was the documentation and promotion of living Italian artists. In 1911 the collection moved into a new building, the Palazzo delle Belle Arti, in the grounds of the Villa Borghese near the British School in Rome. In 1933 the building was enlarged and in 1988 a new wing was added to house the large collection of international contemporary art acquired since the Second World War. The Galleria Nazionale is not to be confused with Rome's municipal museum of 'modern art', the Galleria Comunale d'Arte Moderna, which is much smaller and devoted mainly to 19th-century art.

Gallery of Living Art, New York. *See* GALLATIN, A. E.

Gallery of Modern Art, Glasgow. Museum of modern art (initially devoted to the work of living artists), opened in 1996 following a decision by Glasgow District Council in 1991 to provide a fund of £3 million for buying contemporary works. It is housed in the former Royal Exchange, a handsome 18th-century building in Queen Street in the centre of the city. The collection is particularly strong in works by Scottish artists, but it is international in scope, including work by Niki de *Saint Phalle, for example. It covers graphic art and photography as well as painting and sculpture.

Games, Abram (1914–96) British graphic designer, born in London. His father was of Latvian origin. His mother came from the border area between Russia and Poland. He started as a freelance designer in 1936 after winning a competition for a poster to encourage enrolment in evening classes. He went on to work for Shell, which at that time had an especially innovative policy in the commissioning of posters. His best-remembered works are the posters he made during the Second World War for propaganda purposes. In these, he applied with great invention ideas from *abstract art and *Surrealism but never to an extent that the message would be confused for the ordinary viewer. One, designed for the Army Bureau of Current Affairs, was especially controversial and consequently withdrawn. Part of the series 'Your Britain: Fight for it Now', it showed a modernist building (Lubetkin's Finsbury Health Centre) gleaming white against the background of a derelict house. The official objection was to the depiction of a child with rickets. Games's own favourite was *Your Talk May Kill Your Comrades*, in which a spiral coming from the mouth of a soldier turns into a bayonet on which three soldiers are impaled. In Games's practice as a designer there are certain affinities with *Neo-Romanticism in the way in which some of the conventions of advanced art have been tamed and made more accessible for popular consumption. His most famous postwar work was the logo for the *Festival of Britain. *See also* AIRBRUSH.

Further Reading: N. Games et al., *Abram Games, Graphic Designer: Maximum Meaning, Minimum Means* (2003)

GAN *See* ADRIAN-NILSSON, GÖSTA.

Gargallo, Pablo (1881–1934) Spanish sculptor. He was born at Maella, near Catalonia, and trained at the Barcelona Academy. In 1903 he won a scholarship to Paris, but because of the death of his father he soon had to return home to support his family. However, he went back to Paris in 1911, remaining there until 1914, and during this period he started experimenting with *Cubism. Building on the Spanish tradition of fine metalcraft, he began to compose masks from thin sheets of iron and copper, hammered, twisted, cut, and fitted

together. He was one of the first sculptors to transpose convex and concave surfaces, and also, in his later work (which included full-length figures), one of the first to give positive significance to enclosed space. In 1914–24 he lived in Barcelona, then returned to Paris, and during the last decade of his life achieved recognition as one of the most inventive of modern sculptors in metal. His style in this period became freer and more expressive but more conventionally figurative than the technically similar metal sculpture of *Picasso and *González. *Prophet* (1931, Pompidou Centre), life-size, imposing, and somewhat rhetorical, is his best-known work. He also made more conventional classicizing works for public spaces, including statues for the stadium in Barcelona constructed for the 1929 World's Fair, now known as the Olympic Stadium. *See also* IRON AND STEEL.

Garouste, Gérard *See* PITTURA COLTA.

Garstin, Norman *See* NEWLYN SCHOOL.

Garwood, Tirzah (Tirzah Ravilious) *See* RAVILIOUS, ERIC.

Gatch, Lee (1902–68) American painter. He was born in Baltimore, where he studied at the Maryland Institute of Fine Arts, 1920–24 (John *Sloan was one of his teachers). After this he spent a year in Paris, studying under *Lhote and *Kisling, then moved to New York in 1925. From 1935 he lived a secluded life at Lambertville, New Jersey, although he exhibited in several individual and collective shows over the next 30 years. His main subject was landscape, which he painted in a semi-abstract style—lyrical and contemplative. He was a perfectionist who worked slowly, so his output was fairly small. In 1957 he began to experiment with collage and in the 1960s he started making 'stone pictures', in which the collage elements include thin pieces of flagstone.

Gaudí, Antoni *See* ART NOUVEAU.

Gaudier-Brzeska, Henri (Henri Gaudier) (1891–1915) French sculptor and draughtsman, active in England for most of his very short career and usually considered part of the history of British rather than French art. He was born at St Jean-de-Braye, near Orléans, the son of a carpenter, and was destined for a career in commerce. In 1910 he took up sculpture in Paris without formal training, and in the same year he met Sophie Brzeska, a Polish woman 20 years his senior, with whom he lived from that time, both of them adopting the hyphenated name. In 1911 they moved to London, which Gaudier had visited briefly in 1906 and 1908, and lived for a while in extreme poverty. He became a friend of Wyndham *Lewis, Ezra *Pound, and other leading literary and artistic figures, and his work was shown in avant-garde exhibitions, such as the *Vorticist exhibition of 1915. In 1914 he enlisted in the French army and he was killed in action the following year, aged 23.

Gaudier developed with astonishing rapidity from a modelling style based on *Rodin to a highly personal manner of carving in which shapes are radically simplified in a way recalling the work of *Brancusi (*Red Stone Dancer*, c.1913, Tate). In Britain, only *Epstein was producing sculpture as stylistically advanced at this time. Gaudier's work was appreciated by only a small circle during his lifetime, but since his death he has become recognized as one of the outstanding sculptors of his generation and has acquired something of a legendary status as an unfulfilled genius. Sophie Breszka's devotion to his memory bore fruit in a memorial exhibition of his work at the *Leicester Galleries, London, in 1918, and biographies of him were written by H. S. *Ede (1930) and Horace Brodzky (1933). Ede's biography was originally entitled *A Life of Gaudier-Breszka*, but when it was reprinted in 1931 it was retitled *Savage Messiah* in allusion to the demonic intensity and energy of his life; this was also the title of Ken Russell's film on the artist (1972). *See also* DIRECT CARVING.

Further Reading: E. Silber, *Henri Gaudier-Brzeska* (1996)

Gauguin, Paul (1848–1903) French painter, sculptor, and printmaker, born in Paris, the son of a journalist from Orleans and a Peruvian Creole mother. In 1883 he gave up a successful career as a stockbroker to devote himself to painting (previously a spare-time occupation for him) and in 1886 he abandoned his family, spending much of the next five years at Pont-Aven in Brittany, where he became the pivot of a group of artists who were attracted by his powerful personality and stimulating ideas about art. In 1887–8 he visited Panama and Martinique, and in 1891 he left France for Tahiti. Apart from two years in 1893–5 when ill-health and poverty forced him back to France, he spent the rest of his life in the South Seas, where he said 'I have

escaped everything that is artificial and conventional. Here I enter into Truth, become one with nature. After the disease of civilization, life in this new world is a return to health.' In taking inspiration from the art and culture he found there he was reacting vigorously against the naturalism of the *Impressionists and the scientific preoccupations of the *Neo-Impressionists. As well as using colour unnaturalistically for its decorative or emotional effect, he employed emphatic outlines forming rhythmic patterns suggestive of Japanese colour prints or stained glass. Gauguin also did woodcuts in which the black and white areas formed almost abstract patterns and the tool marks were incorporated as parts of the design. Along with those of Edvard *Munch, these prints played an important part in stimulating the major revival of the art of woodcut in the 20th century. Gauguin's other work included woodcarving and pottery.

In spite of ill-health (he had syphilis) and lack of money, Gauguin painted his finest pictures in Tahiti. His colours became more resonant, his drawing more grandly simplified, and his expression of the mysteries of life more profound. He was often unable to obtain proper materials and was forced to spread his paint thinly on coarse sacking, but from these limitations he forged a style of rough vigour wholly appropriate to the boldness of his vision. In 1897 he painted his largest and most famous picture, an allegory of life entitled *Where Do We Come From? What Are We? Where Are We Going To?* (Museum of Fine Arts, Boston), before attempting suicide (although he had deserted his family he had been devastated that year by the news of the death of his favourite daughter). In September 1901 he settled at Dominica in the Marquesas Islands, where he died two years later. As a result of a dispute with the local bishop he was denied a Christian burial.

Gauguin was not forgotten in France during his years in the South Seas, and in his last years he was supported by *Vollard, but at the time of his death few would have agreed with his self-assessment: 'I am a great artist and I know it. It is because I am that I have endured such suffering.' His reputation was firmly established, however, when 227 of his works were shown at the *Salon d'Automne in Paris in 1906, when his bold use of unnaturalistic colour made a deep impression on the *Fauves. More than any of his contemporaries, he was responsible for introducing the cult of

*primitivism into modernist art. Because of the romantic appeal of his personality, particularly his willingness to sacrifice everything for his art, Gauguin (like his friend van Gogh) has also been an inspiration for popular and fictional biography, including the novel *The Moon and Sixpence* (1919) by Somerset Maugham.

Further Reading: G. T. M. Shackleford, *Gauguin Tahiti: The Studio of the South Seas* (2004)
B. Thomson, *Gauguin* (1987)

Gauvreau, Pierre *See* AUTOMATISTES.

Gear, William (1915–97) British painter, teacher, and administrator, born at Methil, Fife. He spent several years of his career on the Continent and was one of the most international in spirit among British artists of his generation and one of the relatively few to make a reputation outside Britain. After studying painting at Edinburgh College of Art, 1932–36, and history of art at Edinburgh University, 1936–7, he spent a year in Europe on a travelling scholarship, working under *Léger in Paris for several months. During the Second World War he served in the Royal Signal Corps in Europe and the Middle East, but he found time to paint and in 1944 he had one-man shows in Florence and Siena. In 1946–7 he worked in Germany for the commission dealing with the country's monuments and art in the wake of the war, and from 1947 to 1950 he lived in Paris, where he became a member of the *Cobra group in 1948. His work at this time was in the mainstream of the *École de Paris—abstract but based on nature (he once described his paintings as 'statements of kinship with the natural world'): typically he used rich colours within a framework of strong black lines, in a manner suggesting stained glass. Like his friend and fellow Scot Alan *Davie, he was also aware of the work of the American *Abstract Expressionists: he exhibited alongside Jackson *Pollock at the Betty *Parsons Gallery in 1949. The degree of the American influence was, however, a sore point with Gear, who preferred to point to innovations in Europe as a source for his work. In 1950 he settled in England and the following year he was one of five painters who was awarded an Arts Council Purchase Prize at the *Festival of Britain; the decision caused protest from the press and public, for Gear's picture (*Autumn Landscape*, 1950, Laing Art Gallery, Newcastle upon Tyne) was the only abstract

work among the five chosen and abstract art was at this time still generally regarded with deep suspicion in Britain. From 1958 to 1964 Gear was curator of the Towner Art Gallery, Eastbourne, where his policy of purchasing contemporary art was highly controversial, and from 1964 to 1975 he was head of the department of fine art at Birmingham College of Art (later Polytechnic). In England, Gear's style became more delicate, as his characteristic grid dissolved and colours flowed into one another.

Further Reading: T. Sidey, obituary, *The Independent* (10 March 1997)

Geddes, Wilhelmina *See* AN TÚR GLOINE.

Gehenna Press *See* BASKIN, LEONARD.

Gehry, Frank *See* GUGGENHEIM, SOLOMON R.

Geldzahler, Henry (1935–94) American administrator and writer, born in Antwerp, the son of a diamond broker. His mother held American citizenship and the family settled in New York in 1940 after fleeing Belgium because of the Second World War. Geldzahler studied art history at Yale, graduating in 1957, then moved to Harvard to do a PhD on *Matisse's sculpture. In 1960 he left Harvard, leaving his thesis unfinished, to become curatorial assistant in contemporary art in the department of American painting and sculpture at the Metropolitan Museum, New York. To the dismay of some of the museum's trustees, he was more of an active participant in the contemporary art scene than a scholarly observer. He took part in *Happenings, was portrayed by David *Hockney, Alice *Neel, Larry *Rivers, and other artists, and was the subject of an Andy *Warhol film, *Henry Geldzahler* (1964), showing him smoking a cigar for 90 minutes. In 1967 he was appointed curator of the Metropolitan's new department of contemporary art (later department of 20th-century art), and in 1969 he organized a huge exhibition 'New York Painting and Sculpture 1940–70' as part of the museum's centenary celebrations. The exhibition attracted a great deal of hostile criticism, on account of Geldzahler's characteristically personal choice of artists. Other controversies followed, and in 1977 Geldzahler resigned to become commissioner of cultural affairs for New York City, a post he compared to being 'commissioner for wheat in Kansas' and held until 1983. His writings

include a book on Warhol's portraits (1993, co-author with Robert Rosenblum) and *Making it New: Essays, Interviews and Talks*, posthumously published in 1994.

Gemeentemuseum (Municipal Museum), The Hague. Museum consisting primarily of an outstanding collection of modern art. It had its origins in a collection founded in 1862 to illustrate the history of The Hague, but it was enriched to the extent that the artistic aspect of the collection took over from the historical. In 1935 it moved into a new building designed by the Dutch architect H. P. Berlage in a style in which the severe geometry of De *Stijl is modified with vernacular touches. The art department has a fine representation of 19th- and 20th-century art from the Netherlands and elsewhere, including the largest *Mondrian collection in the world. There are also departments devoted to decorative arts and music.

Gemini Graphics Editions Ltd *See* PRINT RENAISSANCE.

Generalić, Ivan (1914–92) Yugoslav (Croatian) *naive painter, the most famous figure of the school of peasant painters associated with his native village of Hlebine (*see* HLEBINE SCHOOL). He began drawing when working as a shepherd boy, and at the age of sixteen he was taught to paint by Krsto *Hegedušić. The following year—1931—he exhibited with Hegedušić's group Zemlja. After the Second World War he became internationally recognized as one of the finest of all naive artists, his work featuring in numerous group and solo exhibitions. In spite of his success, he continued to live the life of a peasant and to paint only in his spare time. Unlike most naive painters, Generalić had a wide repertory. Most of his pictures depict scenes from village life— weddings, funerals, farm work, fairs, and so on—but he also painted landscapes, portraits, still-lifes, and imaginative subjects. Some of his pictures are idyllic in mood, but in others there is an element of grotesque fantasy or strangeness. Usually he painted on glass and his pictures often have a kind of inner glow.

Genovés, Juan (1930–) Spanish painter and graphic artist, born in Valencia. He studied at the School of Fine Arts there, and in 1958 settled in Madrid. His most characteristic paintings feature crowds or groups of anonymous figures, seen from a very high

viewpoint, threatened by some unseen but alarming force. They suggest the brutal use of power and the terror of the oppressed fleeing before it, but their character is quasi-metaphysical rather than crudely political. The main influence on Genovés is the Russian film-maker Sergei Eisenstein, whose work features some memorable crowd scenes. In 1976 Genovés was imprisoned for seven days for making a poster demanding the release of political prisoners.

Gentils, Vic (1919–97) Belgian sculptor, born in Ilfracombe, Devon. His father returned with his family to Belgium in 1925, settling in Antwerp. Gentils trained as a painter and decorator, his father's profession, and his skills in woodworking and gilding were a crucial part of his later practice as a sculptor. He studied painting and engraving but in the mid-1950s began working in three dimensions. In 1960 he began making the constructions in wood for which he is best known, using old furniture, picture frames, and pianos. This last became so associated with him that it formed the basis of a self-portrait of 1965. The first examples were non-figurative, although they sometimes recalled the format of the altarpiece. By the mid-1960s figures started appearing, as in his haunting depiction of a boxed prostitute *Rua de Amor* (1969, Musées Royaux des Beaux-Arts, Brussels). They owe something to the towering constructed figures painted by *de Chirico and Max *Ernst. His work was often preoccupied with Belgian history and identity: homage is paid to artists such as Bruegel, *Ensor, and *Delvaux. The *Homage to Camille Huysmans* (1970–71) shows the Belgian socialist leader surrounded by workers, visiting Lenin. These specifically local concerns might be one reason why an artist so highly regarded in his own country has never made a comparable impact outside it.

Further Reading: K. Geirlandt, *Vic Gentils* (1985)

Genzken, Iza (1948–) German sculptor, painter, and multimedia artist. She was born in Bad Oldesloe and lives and works in Berlin. As a student she was confronted by the need to engage with American *Minimal art. German artists at that time were struggling to achieve international recognition in the face of American dominance. Her *Ellipsoid* sculptures were designed with the help of computers and have polychromatic surfaces. They lie on the floor, are hollow and can be anything up to 40 feet long. Genzken has also related her works to the products of the consumer society. The *Hi-Fi* (1979) series was derived from magazine photographs, copied in high contrast and presented behind glass. Placing an *Ellipsoid* on the floor, she thought that 'it must be at least as good as this advert. That's how good a sculpture needs to be.' More recently she has further applied an irreverent elaboration to Minimal forms and made sculpture incorporating household artefacts. *Urlaub* (2004, Saatchi collection) is a seven and a half foot tower of metal and wood, surmounted by plastic leaves, a giant glass, and toy figures. Genzken has also worked in film.

Further Reading: B. Buccloch, 'All Things Being Equal', *Artforum International* (November 2005)

Geometry of Fear A term coined by Herbert *Read to characterize the angst-ridden look of the work of a group of eight British sculptors who exhibited together at the 1952 Venice *Biennale: Robert *Adams, Kenneth *Armitage, Reg *Butler, Lynn *Chadwick, Geoffrey *Clarke, Bernard *Meadows, Eduardo *Paolozzi, and William *Turnbull. Several were strongly influenced by the 'existentialist' sculptures of *Giacometti and *Richier, whose work had been seen in London at the Anglo-French Art Centre in 1947. The Geometry of Fear sculptors, with their spindly forms and tortured surfaces, seemed to encapsulate the anguish and bewilderment of the post-war generation, although Adams was more closely connected to geometric abstraction. This was the first major international showing for these British sculptors, but their work made a strong impact: Alfred H. *Barr wrote that 'it seemed to many foreigners the most distinguished national showing of the Biennale'. A number of other sculptors were influenced by this tendency, including Anthony *Caro (before he took up more abstract work), Hubert *Dalwood, Elisabeth *Frink, George *Fullard, and Leslie *Thornton.

George, Patrick (1923–) British painter and teacher, born in Manchester. He studied at Edinburgh College of Art, 1941–2, and Camberwell School of Art, London, 1946–9. From 1974 he taught at the *Slade School, and he was Slade professor from 1985 to 1987. His paintings are mainly landscapes, interiors, and portraits. He writes of his work: 'I try to paint a likeness of what I see . . . In London I

paint pictures of people, of things lying around my room and the view out of the window. In the country I go outside and paint the landscape... The pictures take a long time to paint, sometimes several years.'

Gerasimov, Alexander (1881–1963) Russian painter, stage designer, architect, and administrator, a dominant figure in Soviet art. He was born in Kozlov (later renamed Michurinsk), the son of a cattle dealer, and studied at the Moscow School of Painting, Sculpture, and Architecture, 1903–15. After army service he returned to Kozlov and worked as a stage designer at the town theatre, which had been erected to his design in 1913 (this was his only executed architectural design, apart from a house he built for himself in the 1930s). In 1925 he settled in Moscow, where his friendship with Kliment Voroshilov, the Red Army chief, helped his career to prosper. However, even with friends in such high places, he sometimes had to tread warily: one of his large military pictures, shown at the Soviet Pavilion at the 1937 Paris International Exhibition, included portraits of army personnel who were imprisoned or executed in one of Stalin's purges soon after it was completed, so when the picture came back from Paris, he removed it from its stretcher and kept it under a carpet on his studio floor for twenty years.

Gerasimov painted various types of picture, and his most admired works are now perhaps those in which he recalled his peasant upbringing, notably *The Slaughter* (1929, Gerasimov Museum, Michurinsk), a powerful scene of a bull being killed. However, he has become best known for his hagiographical pictures of Stalin (*Stalin and Voroshilov in the Kremlin Grounds*, 1938, Tretyakov Gallery, Moscow), indeed as the archetypal artist of the repressive Stalinist era (*see* SOCIALIST REALISM): 'Gerasimov was president of the Academy of Arts of the USSR from 1947 to 1957; and also dominated the USSR Union of Artists, showing an implacable hostility towards the slightest signs of advanced art and meriting the epithets of "sinister" and "evil" which were showered upon him by Western critics and the more courageous of his countrymen' (Bird). After Stalin had been denounced by his successor Khruschev in 1956, Gerasimov was out of official favour. He had a heart attack the same year and never recovered his health. *See also* AKHRR.

Gerasimov, Sergei *See* MAKOVETS.

Gérome, Jean-Léon *See* IMPRESSIONISM.

Gerstl, Richard (1883–1908) Austrian painter, born in Vienna, where he studied at the Academy. His early painting was in the style of the Vienna *Sezession, but by 1905 he had developed a highly personal type of *Expressionism. His finest works are portraits, including two groups of the family of the composer Arnold Schoenberg (Österreichische Galerie, Vienna), remarkable for their psychological intensity. Gerstl was a tormented character, and after running off with Schoenberg's wife he committed suicide. His work, 'savage in character, with a tinge of mania and an amazing impasto technique... [was] largely independent of any influence of his teachers, and, apart from a certain colouristic connection with the work of *Klimt and, more especially, Edvard *Munch, appears wholly original in conception and development, characterized by even more violent abbreviations of form than *Kokoschka... ever permitted himself' (Vergo). Gerstl came from a wealthy family and had no need to try to earn a living from painting. It was not until the 1930s that his work became widely known and he was hailed as an 'Austrian van Gogh'.

Gerstner, Karl *See* COLD ART.

Gertler, Mark (1891–1939) British painter. He was born in the East End of London to poor Polish-Jewish immigrant parents and he spoke only Yiddish up to the age of eight. In 1907 he started work in a stained-glass factory, but in 1908 he was enabled by the Jewish Educational Aid Society to go to the *Slade School. He was a student there until 1912 and during that time won several prizes and scholarships. His fellow students included Dora *Carrington, with whom he later had an affair; she left him for the writer Lytton Strachey in 1917. Gertler's style, although influenced by advanced French painting, was highly individual, with strong elements of Eastern European folk art. His favourite subjects included female portraits, still-lifes, and nudes, such as the earthy and voluptuous *The Queen of Sheba* (1922, Tate), painted in his characteristic feverishly hot colours. His best-known work is *Merry-Go-Round* (1916, Tate); in this powerful and original image—a satire on militarism—figures spin on fairground horses in a mad, futile whirl.

Gertler had many admirers: one of them, D. H. Lawrence, made him the model for the sculptor Loerke in *Women in Love* (1920). The word 'genius' was frequently applied to him, and he was seen by many as the acceptable face of modernism. However, he began to lose popularity in the early 1930s when he adopted a more stylized manner characterized by a flatter sense of space and a greater emphasis on surface pattern. He had always been subject to fits of depression, and after the failure of an exhibition at the Lefevre Gallery, London, in 1939 he committed suicide.

Further Reading: Mark Gertler, ed. Noel Carrington, *Selected Letters* (1965)

Gertsch, Franz (1930–) Swiss painter and printmaker, best known for large-scale *photorealist paintings of young people, such as the transvestite performance artist Luciano Castelli, living 'alternative' lifestyles. He used unposed slides as source material. In the late 1970s he made a series of paintings about the poet and singer Patti Smith (1946–), a character who was something of an idol among the disaffected young. Recent work by the painter tends to a conservative Renaissance-style manner. There is a museum devoted to his work in Burgdorf, Switzerland, near his home. The critic M.-T. Perret was surprised by its mausoleum-like ambience, which seemed so much at odds with the ethos of the work that made the artist famous (*Frieze Magazine* January–February 2004).

Gerz, Jochen (1940–) German artist, born in Berlin. He has lived in Paris since 1965. Originally associated with *Conceptual art, he has tried to apply the valuing of process and idea over object, which marked vanguard practice in the late 1960s, to the problem of the memorial: he has been specifically concerned with the public commemoration of the Holocaust. For the *Monument Against Fascism, War and Violence—and for Peace and Civil Rights* (1986, Harburg, Hanover) he and his wife, Esther Shalev-Gerz, spurned the site offered in a park for an ordinary street near the civic centre. They erected a column in lead. The public were invited to make their own inscriptions on it (the artists accepted that there would be occasional racist comments) and it was engineered so that as it was covered with writing it would gradually sink into the ground, becoming invisible; this finally happened in 1993. Afterwards there

was visible only a small plaque inscribed 'Nothing in the long run can replace our own protest against injustice'. Gerz said that 'What we did not want was an enormous pedestal with something on it telling people what they ought to think.' The concept of the invisible monument was taken further in the project in the forecourt of Saarbrucken castle, which Gerz and his students carried out in 1990–93. Gerz researched the names of 2,146 Jewish cemeteries that had been destroyed by the Nazis. The names were inscribed on cobblestones, which were then reinserted into the paved path so that the visitor would not know which they were. The artist has described the invisibility of the stones as an 'intellectual challenge' and as a protective measure against defacement. However, some Jewish groups objected to the work as a literal attempt to bury the past.

Further Reading: S Michalski, *Public Monuments* (1997)

gestural painting The application of paint with expansive gestures so that the sweep of the artist's arm or movement of the hand is deliberately emphasized. The term carries an implication not only that a picture is the record of the artist's action in the process of painting it, but that the recorded actions express the artist's emotions and personality, just as in other walks of life gestures express a person's feelings. It has been applied particularly to *Abstract Expressionism and is sometimes used more or less as a synonym for *Action Painting. However, the term can also apply to figurative painting, notably *Neo-Expressionism.

Ghika, Nicolas (1906–94) Greek painter and graphic artist, born in Athens. In 1922 he enrolled at the Sorbonne in Paris to study French and Greek literature, but he devoted himself mainly to painting and engraving at the *Académie Ranson under *Bissière. He had his first one-man show at the Galerie Percier in 1927 and lived in Paris until 1934. At this time his work was strongly influenced by *Braque and *Picasso, but after his return to Athens he became interested also in Mediterranean landscape and Greek popular art. From the late 1930s he was recognized at home and abroad as Greece's leading painter, admired for his success in achieving a synthesis between his country's ancient traditions and contemporary artistic movements. In 1942 he was appointed a professor at the University of Athens and he continued to

teach there until his retirement in 1960. Besides painting, Ghika made numerous book illustrations, notably for a collected edition of the work of Constantine Cavafy, Greece's most famous modern poet (1966).

Giacometti, Alberto (1901–66) Swiss sculptor, painter, and draughtsman, active mainly in Paris. He was born in the village of Borgonovo, near the Italian border, the son of the painter **Giovanni Giacometti** (1868–1933), who was influenced by Impressionism and German Expressionism, styles which also marked the early paintings of Alberto. Cuno *Amiet, the artist's godfather, and Ferdinand *Hodler were both family friends. His father's cousin **Augusto Giacometti** (1877–1947) was also a painter, influenced by *Neo-Impressionism and *Dada. Although Alberto was to spend almost all his career in France, he retained great affection for Switzerland and returned regularly to visit his family. After short periods at the École des Arts et Métiers, Geneva (1919–20), and in Italy (1920–21), he moved to Paris, where he studied under *Bourdelle at the Académie de la Grande Chaumière from 1922 to 1925. At this time he tried to get 'as close as I could to my vision of reality'. From 1926 onwards he was influenced by *Cubism and by African art. He became associated with the *Surrealists, initially with the *Documents* group of Georges *Bataille and Michel *Leiris (who published the first article on his work). *Suspended Ball* (1930) brought him to the attention of André *Breton. This work, a cage in which a suspended ball with a groove can be slid along the edge of a form shaped like a wedge of fruit, caused something of a sensation among the Surrealists. Maurice Nadeau recalled that 'Everyone who saw this object functioning experienced a strong but indefinable sexual emotion . . . in no sense one of satisfaction but one of disturbance' (Krauss). Many of Giacometti's Surrealist works have an explicit violence that is more associated with Bataille than Breton. *Hour of the Traces* (1930, Tate) could well be related to Bataille's fascination with human sacrifice. *Woman with her Throat Cut* (1932, cast in Scottish National Gallery of Modern Art, Edinburgh) may have been inspired by an article about Jack the Ripper, but Patrick Elliott points out that a similar violence is to be found in Giacometti's political drawings of the early 1930s. Giacometti's sculptures of the period were partly responsible for inaugurating the movement

within *Surrealism towards the production and exhibition of mysterious objects—an idea taken up by Joan *Miró and Salvador *Dalí among others.

By 1935 Giacometti had broken with the Surrealists and begun to concentrate on working direct from the model, a process that was anathema to them. At first he found he could only make his figures and heads very tiny. From 1942 to 1945 he was in Geneva. On his return to Paris he began making the gaunt, attenuated figures for which he is best known, such as *Man Pointing* (1947, Tate). Male figures are always gesturing or in movement, the females are always still and upright. His sculptures were seen as encapsulating the fragile, essentially lonely nature of human existence. As the poet Francis Ponge (1899–1988) put it in 1951, 'Man—and man alone—reduced to a thread—in the ruinous condition, the misery of the world—who looks for himself—starting from nothing' (reprinted in Harrison and Wood). Giacometti was a friend of the existentialist philosopher Jean-Paul *Sartre, who wrote on his work, notably the introduction to the catalogue of his exhibition at the Pierre *Matisse Gallery, New York, in 1948. Sartre's sense of the existentialist significance of Giacometti went beyond the image of man he presented. The artist perpetually made and remade the work anew, refusing assumptions about what he saw. It was a radical alternative to the lies of traditional sculpture which trapped man in a single identity ('The Search for the Absolute', reprinted in Harrison and Wood). Giacometti saw the problem in terms of the representation of perception. He told an interviewer 'When I look at you across a table, I don't see you at all.' Distance was necessary to perceive the 'space-atmosphere' which surrounded the person (*Studio*, August 1961).

The New York exhibition became the basis for Giacometti's international reputation: his first post-war Paris exhibition did not take place until 1951. His work soon had widespread influence, seen, for example, in the *'Geometry of Fear' sculptors who exhibited at the Venice *Biennale in 1952 and in several of the entries for the competition for a Monument to the Unknown Political Prisoner in 1953 (*see* BUTLER, REG).

From the late 1950s Giacometti's reputation as a painter also began to increase. Characteristically the paintings are grey in tonality. This quality, together with their dusty-looking

surfaces and the skeletal proportions of the figures, often conveys a ghostly feeling. Some of them are obsessively overpainted with an accumulation of stabbed brushstrokes, an expression of the doubts and anxieties Giacometti felt about his creations. He returned to the same few sitters continually. These included not only his brother Diego (1902–85), a skilled technician and his life-long assistant, but also his wife, Annette, the photographer Eli Lotar (1905–69), a Surrealist who had fallen on hard times, and, during his last years, Caroline, a prostitute with underworld connections, with whom Giacometti had an affair. He was admired not only for the quality of his work, but also for the force of his personality, his integrity, and his devotion to his art. Throughout his career in Paris he worked in the same tiny, shabby studio, and Simone de Beauvoir, Sartre's companion, wrote of him: 'Success, fame, money—Giacometti was indifferent to them all.' Giacometti himself said: 'Establishing yourself, furnishing a house, building up a comfortable existence, and having that menace hanging over your head all the time—no, I prefer to live in hotels, cafés, just passing through.' There is a major collection of his work in the Giacometti Foundation at the Zurich Kunsthaus.

Further Reading: R. Krauss, 'No More Play', *The Originality of the Avant-Garde and Other Modernist Myths* (1985). A classic study of the Surrealist phase

J. Lord, *Giacometti: A Biography* (1986)

T. Stoos and P. Elliott, *Alberto Giacometti* (1996)

Giersing, Harald (1881–1927) Danish painter and critic, the most energetic advocate of modern art in Denmark at the beginning of the 20th century. He was born in Copenhagen, where he trained at the Academy, 1900–04, and then under Kristian Zahrtmann (1843–1917), 1904–6. In 1906–7 he visited Paris, where he was influenced by *Bonnard, *Cézanne, *Matisse, and *Vuillard. From these artists he took a feeling for vigorous simplified shapes, which he combined with deep, saturated colours. From about 1917 he was influenced by *Cubism. His work included landscapes, still-lifes, and figure compositions. He exercised an important influence on young Danish artists, not only through his work, but also through his teaching (he ran his own art school for ten years) and writing (he was one of his country's leading art critics).

Gies, Ludwig (1887–1966) German sculptor, born in Munich. He is best remembered

for an *Expressionist wood carving of the crucified Christ, now lost, which, after some controversy, was placed in the Marienkirche, Lübeck. Carl Georg Heisse (1890–1979), the director of the local Museum für Kunst und Kulturgeschichte and an embattled supporter of Expressionism, described it as 'equal to the architectural power of the Middle Ages'. The poet Julius Havermann, however, said that 'When I look at this Crucifixion I am wounded at the deepest level of my religious experience'. It became one of the most conspicuous exhibits in the *'Degenerate Art' exhibition of 1937. Shortly afterwards, Gies was dismissed from his teaching post. In the post-war era he designed an eagle for the West German parliament in aluminium with lights, supposedly representative of the new democratic spirit of the Federal Republic, but which came to be known as the 'fat hen', signifying a wealthy complacency. He died in Cologne.

Gilardi, Piero (1942–) Italian artist and critic, born in Turin. He is chiefly known for sculptures of rocks and vegetable matter modelled illusionistically in polyurethane. Gilardi associated with the *Arte Povera tendency, although his own word to describe the developments of the late 1960s was 'microemotive'. He sought parallels between the work of *Merz, *Nauman, and others and recent developments in molecular science. The argument is obscure but is built around the possibilities of individual freedom within a mechanistic universe. After 1968 he abandoned art in favour of political activism, but from the 1980s onwards he worked with interactive computerized environments.

Gilbert, Sir Alfred (1854–1934) British sculptor and metalworker, born in London. He originally intended becoming a surgeon, but after failing the entrance examination at the Middlesex Hospital in 1872 he turned to art, training in London at Heatherley's School and the *Royal Academy, and then from 1875 to 1878 at the École des *Beaux-Arts in Paris. After spending six years in Italy, he returned to England in 1884 and was soon given major commissions, the best known of which is his Shaftesbury Memorial Fountain in Piccadilly Circus, London (1887–93). The celebrated figure of *Eros* that surmounts the fountain is cast in aluminium, one of the earliest examples of the use of this metal in sculpture. Its light weight allowed Gilbert to achieve a more

delicately poised pose than if he had been restricted to the traditional material of bronze. Although Gilbert was hard-working, respected, and sought-after, he was unworldly and a hopeless businessman: his refusal to delegate or to compromise his high standards in any way meant that he took on more work than he could handle and he sometimes lost money on commissions. In 1901 he became bankrupt and moved into self-imposed exile in Bruges, where he lived for the next quarter of a century. Initially he kept up contact with the Royal Academy, but after 1907 he did not exhibit there again until 1932. His failure to complete new commissions led to unpleasant publicity (including an exposé in the sensationalist newspaper *Truth*) and he resigned from the Academy in 1908.

For many years thereafter Gilbert did little work, but he was not forgotten in England and in 1926 he returned to London, helped by Lady Helena Gleichen (1873–1947), a painter best known for her paintings of horses, who provided him with a studio, and by the journalist Isabel McAllister (1870–1945), who acted as his secretary (she also published a book on him in 1929). In 1926–8 he completed his masterpiece, the tomb of the Duke of Clarence in St George's Chapel, Windsor Castle, which he had begun in 1892. The sinuous and labyrinthine detailing, crafted with consummate skill, reveals Gilbert as one of the major practitioners of *Art Nouveau, although he was disparaging about the style. His final major work was the memorial to Queen Alexandra at Marlborough Gate, London (1926–32). On its completion he was knighted and restored to membership of the Royal Academy. His reputation sank after his death because he was so clearly outside the mainstream of 20th-century art (stylistically the Alexandra memorial looks more like a work of the 1890s than the 1930s), but he is now regarded as the greatest British sculptor of his generation. *See also* NEW SCULPTURE.

Further Reading: R Dorment, *Alfred Gilbert* (1985)

Gilbert, Stephen (1910–2007) British

sculptor and painter. He was born near Perth, Scotland, the grandson of Sir Alfred *Gilbert. He studied at the *Slade School of Art in 1929–32. In 1938–9 he was in Paris, where in 1939 he held his first solo exhibition. He spent the war in Ireland after being turned down for military service. There he painted pictures of insects inspired by both the paint-

ings of André *Masson and his readings of the psychoanalyst Jung and the philosopher Nietzsche. After the war he returned to Paris and in 1948 was invited to join the *Cobra group. Apart from William *Gear, he was the only British member. Among the Cobra artists, he became closest to *Constant and, like him, moved away from the wildness of the other members of the group towards a more structured approach and interest in the architectural context. This linked him with the British *Constructivist group, with whom he exhibited in 1954, although his projects for flats made of coloured metal and glass panels were not realized. The work for which he became best known are his shiny aluminium sculptures in curving planes around a central core. A good example is *Structure 14c* (1961, Tate). In these works he achieved a kind of balanced point between the exuberance of his Cobra work and the mental discipline of Constructivism. He was awarded first prize for sculpture at the Tokyo *Biennale in 1965. In the 1980s he returned to painting.

Further Reading: A. Grieve, obituary, *The Guardian* (14 February 2007)

Gilbert & George (Gilbert Proesch)

(1943–) **(George Passmore)** (1942–) British artists (Gilbert was born in the Dolomites in Italy, George was born in Devon) who met while studying at the vocational sculpture course at *St Martin's School of Art in London in 1967. Since then their work has been entirely collaborative and they are invariably identified by their first names alone. While at St Martin's, they reacted strongly against the *formalist stance of the teaching. They were not alone among students at the school in wishing to extend the questioning of the nature of sculpture beyond traditional object-making: a similar stance was taken by Richard *Long and Barry *Flanagan. Gilbert & George's response was perhaps the most radical of all, to turn themselves into 'living sculptures'. This went much further than a simple *Duchampian gesture of naming themselves as artworks. It was a process whereby the two individuals became a single work of art.

The most notable early manifestation was the *Singing Sculpture*, a work of *Performance presented on a number of occasions from 1969. This consisted of the two artists standing on a table-top, in the smart suits they always wear, with bronze-painted faces, miming for up to eight hours at a stretch to the old

Flanagan and Allen song 'Underneath the Arches'. The song itself has strongly nostalgic connotations. Popular in the 1930s and 1940s, it comes from the very end of the era of music hall, before the dominance of the American-influenced mass culture which had been the principal inspiration for *Pop art. There was also the disparity, played on in Flanagan and Allen's original presentation, between the smart appearance of the artists and the subject of the song, vagrants who boldly declare that they are happier sleeping rough 'underneath the arches' than in a luxury hotel. In this way, the work emphasizes the question which inevitably confronts all those who consider Gilbert & George's art: how far is the 'performance' real?

The image of the artists, almost exaggeratedly conventional, produced an effect of strangeness on a number of levels. Most obviously, it opposed the 'bohemian' artistic persona. But at the same time, the sense of an almost religious devotion to art undercut the cult of a certain matter-of-fact professionalism which marked the British art scene of the 1960s. A series of large paintings and charcoal drawings of the early 1970s enhanced the sense of incongruity by placing their besuited figures as romantic wanderers in rural settings. (In a 2007 event at Tate Modern they claimed to hate the countryside.) They even undermined the *'Conceptual' reading of their work by employing a decidedly artisanal language to describe it. 'The Lord chissels [sic] too so don't leave your bench too long' (*The Laws of Sculpture*, 1969), perhaps a memory of Gilbert's training by his father as a woodcarver.

Their subsequent reputation has been built on large-scale photo-works, often employing elaborate *photomontage techniques including, in later years, computer manipulation of the image. Increasingly criticism has been less concerned to mull over the conceptual implications of 'living sculpture' than to view Gilbert & George as chroniclers of contemporary life as seen from the area of East London where they live. The themes of these works are frequently controversial, including scatology, homoeroticism, and racial conflict. Most pieces include the artists' own familiar images, inspiring debates about their own attitudes. (At one point in the mid-1970s this led to open accusations of racism.) Gilbert & George have encouraged autobiographical readings of their work, for instance in the series on drunkenness, an example of which is *Dark Shadow no. 8* (1974, Van Abbe Museum, Eindhoven). Their view of the world acquires its distinctive character as much from what it excludes as from what it includes. Notoriously, women are almost entirely absent from their work, apart from occasional glimpses in crowds and, significantly, the appearance of the Queen in a 'postcard sculpture'. The old appear only infrequently and usually as vagrants, but young men abound. The vision of British culture, for all its populism, is also highly selective. The ethnic mix of the inner city is a constant theme, giving rise to images of both conflict and conciliation. Yet at the same time it is a Britain still defined by its native history and traditions, virtually untouched by the impact of American culture.

There has been some speculation as to the exact nature of the working and personal relationship of the two. It is a subject on which they are fairly reticent. Germaine *Greer (*The Guardian*, 26 February 2007), on the basis of evidence which would generously be described as circumstantial, painted a nightmarish picture of a Gilbert entirely sucked up into the world of George, dominated by the Englishman's obsessions to a point of loss of personal identity. A commentator less frightened by the idea of such close artistic collaboration might nonetheless point out the difference in background as a clue to the partnership. The cultural references point to the experience of George, while Gilbert's upbringing in the Tyrol, with a craftsman father, was more about, making things, suggesting a certain division of labour between conception and execution.

Further Reading: Tate Modern, *Gilbert & George: Major Exhibition* (2007).

Gili, Katherine *See* ST MARTIN'S SCHOOL OF ART.

Gilioli, Émile (1911–77) French sculptor. Born in Paris, he spent his childhood in Italy in the care of his grandmother. He worked as a blacksmith and then trained at the École des Beaux-Arts in Nice. After the war he became associated with the abstract artists who exhibited at the Denise *René Gallery in Paris. He worked in both highly polished bronze and different coloured stones. According to Jerome Mellquist, in an exhibition of 1958 these 'varied from turquoise blue to the gleaming white of Carrara and the yellow of Siena'.

Although Gilioli used flat planes and geometric forms, Mellquist maintains that his work 'contained an element of the unexpected'. He combined his practice of small-scale sculpture with monumental work. One was the monument to the Maquis in Glières, Haute-Savoie, a dramatic Alpine setting which was the site of a battle between the Resistance and the Nazi occupying forces. Although the treatment is abstract, the artist intended a symbolic element combining movement towards victory and liberty against a wound-like counterthrust.

Further Reading: J. Mellquist, entry on the artist in R Maillard (ed.), *A Dictionary of Modern Sculpture* (1962)

Gill, Eric (1882–1940) British sculptor, engraver, typographer, and writer, born in Brighton, the son of a clergyman. After studying at Chichester Art School, he was apprenticed to an architect in London from 1900 to 1903. During this period he also took evening classes in masonry at the Westminster Technical Institute and in lettering at the Central School of Art and Design, where he was taught by the celebrated calligrapher Edward Johnston (*see* ROYAL COLLEGE OF ART), who 'profoundly altered the whole course of my life and all my ways of thinking'. Gill began to earn his living as a letter cutter in 1903 and carved his first figure piece in 1910. In 1913 he became a convert to Roman Catholicism and was commissioned to make fourteen relief carvings of the *Stations of the Cross* for Westminster Cathedral (1914–18). These and the *Prospero and Ariel* group (1929–31) on Broadcasting House, London, are his best-known sculptures. Early in his career as a sculptor, Gill sometimes collaborated with Jacob *Epstein (Gill carved the lettering for Epstein's Oscar Wilde tomb), but they later quarrelled. Like Epstein, Gill was one of the leading figures in the revival of *direct carving, and his work usually has an impressive simplicity of conception: he wrote that his 'inability to draw naturalistically was, instead of a drawback, no less than my salvation. It compelled me . . . to concentrate upon something other than the superficial delights of fleshly appearance . . . to consider the significance of things.' In life, as in his work and writing, he was an advocate of a romanticized medievalism, and he tried to revive a religious attitude towards art and craftsmanship. His unconventionality was well known in his own time (he disliked trousers, for example, preferring to wear smocks),

but the most bizarre and unpleasant aspects of his personality were not revealed until Fiona MacCarthy's biography was published in 1989: he had incestuous relationships with two of his sisters and two of his daughters and sexual congress with a dog. Apart from religion, sex is the main subject of his work.

Gill was an important figure in book design and typography as well as sculpture. He illustrated many books and his 'Gill Sans-Serif' (1928) and 'Perpetua' (1930) typefaces are among the classics of 20th-century typography; they were commissioned for the Monotype Corporation by its consultant Stanley Morison (1889–1967). Gill's main literary works are *Christianity and Art* (1927), *Art* (1934), and *Autobiography* (1940), and he also wrote numerous pamphlets on art, religion, and sociology. From 1907 to 1924 he lived at Ditchling, Sussex, running the St Dominic's Press amongst other activities, and also setting up an artistic community (David *Jones was one of the members). In 1924 he moved to Capel y Ffin, Wales, and in 1928 settled at Pigotts, near High Wycombe, in Buckinghamshire.

His brother **Macdonald Gill** (1884–1947) was an architect, mural painter, and designer (mainly of posters and maps). Their cousin **Colin Gill** (1892–1940) was a painter, mainly of murals, although he also did portraits and genre subjects and was an *Official War Artist in the First World War.

Further Reading: J. Collins, *Eric Gill: Sculpture* (1992)

Gill, Madge *See* AUTOMATISM.

Gilliam, Sam (1933–) American painter. He was born in Tupelo, Missouri, studied at the University of Louisville, Kentucky, 1952–6 and 1958–61, and in 1962 settled in Washington, DC, where he turned to abstraction and worked in the vein of *Louis and *Noland. In 1968 he began producing stretcherless pictures, which were sometimes suspended from the ceiling to create pleated forms referred to as 'drape paintings', and he has subsequently experimented with other techniques, including the use of poles and thongs as supports to produce works that are part painting and part sculpture. Some of his works are huge, creating a kind of *environmental experience (*Autumn Surf*, 1973, MoMA, San Francisco). Gilliam has become the best-known black American abstract painter and as such has attracted some controversy, fuelled by his very success within the main-

stream art world, for his supposed lack of engagement with black culture. Nonetheless, some critics have detected an 'aesthetic of blackness' in Gilliam's work. Keith Morrison was reminded of his own childhood memories of the masquerade in the West Indies and the 'bright colours of African and African-American clothes and design'.

Gillick, Liam (1964–) British artist, designer, curator, and art theorist, born in Aylesbury. He studied under Michael *Craig-Martin at *Goldsmiths College, from which he graduated in 1987. His work is influenced by *Minimalism and is on an environmental scale which encourages spectator interaction. A notable example was *The Wood Way*, an installation at the *Whitechapel Art Gallery in 2002. This was a kind of maze in pine planks and brightly coloured Plexiglass—the title of the piece was taken from a German expression for getting lost—to which were added quotations with sources ranging from science fiction to the sentence of hanging, drawing and quartering passed on the Catholic martyr Sir Thomas More. Gillick's outlook could be seen as characteristic of *Postmodernism in that the austere forms of abstract art are no longer seen as neutral but as a manipulative force. He described his work redesigning the Whitechapel café for the exhibition as 'a bit like a regular neo-liberal, relativist refurbishment job where you can half the size of the sandwiches and double the price'.

Further Reading: S. O'Hagan, 'This is not an art gallery', *The Observer* (5 May 2002)

Gillies, Sir William (1898–1973) Scottish painter and art teacher. For most of his life he was associated with Edinburgh College of Art. He graduated there in 1924, and after two years studying with *Lhote in Paris, he returned as a teacher; he stayed until his retirement in 1966, serving as head of painting, 1946–60, and principal, 1960–6. His favourite subject was landscape, especially views in and around his home at Temple, a village about ten miles south of Edinburgh, where he settled in 1939: 'On coming to Temple I began to cope with my new material by relying on simple planning and tonal relationships as subtle and evocative as I could make them.' His work, which also includes still-lifes influenced by *Matisse, is indeed intimate, poetic, and completely unpretentious, and it has won him a position of affection as one of the most

popular Scottish painters of recent times. Gillies was knighted in 1970 and in that year the Scottish Arts Council mounted a large retrospective of his work.

Gilman, Harold (1876–1919) British painter of interiors, portraits, and landscapes, born at Rode, Somerset, the son of a country parson. He became interested in art during a long convalescence after an accident and he had his main training at the *Slade School, 1897–1901; his fellow student Spencer *Gore became a close friend. In 1907 Gilman met *Sickert and became one of the leading figures in his circle; he was a founder member of the *Camden Town Group in 1911 and of the *London Group (of which he was first president) in 1913. However, with his friend *Ginner he fell out with Sickert in 1914 (*see* NEO-REALISM). Gilman travelled fairly extensively (Odessa, 1895; Spain, 1902–3; America, 1905; Paris, 1911; Sweden, 1912; Norway, 1913), but he spent most of his career in or near London. After Gore's death in 1914 he took over his teaching at Westminster Art School, and in 1915–17 he ran his own art school with Ginner. His early work was rather sombre, but under the influence of Sickert he adopted a higher colour register and a technique of using a mosaic of opaque touches. From Sickert also he derived his taste for working-class subjects. After Roger *Fry's first *Post-Impressionist exhibition (1910) and the visit to Paris (1911) he used very thick paint and bright (sometimes garish) colour. He was one of the most gifted British painters of his generation and one of the most distinctive in his reaction to Post-Impressionism, but his career was cut short by the influenza epidemic of 1919.

Gilmour, Maeve *See* PEAKE, MERVYN.

Gimpel, René (1881–1944) French art dealer. He inherited successful galleries in Paris and New York from his father and became one of the best-known international dealers of his day (his wife, Florence, was the sister of the British dealer Joseph Duveen—*see* TATE). Gimpel was mainly interested in French art of the 18th century, but he also bought and sold modern pictures and he was friendly with numerous artists, notably Marie *Laurencin, who painted several portraits of members of his family. During the Second World War he worked for the Resistance and after being arrested by the Germans he died in a concentration camp. One of his fellow prisoners

described his remarkable fortitude: 'Knowing that he was soon to die, he continued, as if nothing was happening, to speak of life and to give to his companions, overwhelmed by exhaustion, despair and disgust, the example of the serenity of a man who, having nothing more to lose and having done what he can, is left with one duty, which is not to flinch and help others.' Between the wars he kept a diary that gives a lively account of the art world in Europe and the USA. It was published as *Journal d'un collectionneur* in 1963 (English translation, *Diary of an Art Dealer*, with an introduction by Herbert *Read, 1966). After the Second World War his sons Charles and Peter continued the family tradition with the firm of Gimpel Fils in London and New York. This firm has been especially notable for its international outlook and for promoting the careers of British sculptors including *Armitage, *Chadwick, and *Dalwood.

Ginner, Charles (1878–1952) British painter, born in Cannes, the son of an English doctor who was practising there. He grew up in France and because of parental opposition to his ambition to be a painter he initially trained in architecture. However, from 1904 to 1908 he studied painting in Paris, at the École des *Beaux-Arts and elsewhere. After a visit to Buenos Aires (where he had his first one-man exhibition) in 1909, he settled in London in 1910. He was already a friend of *Gilman and *Gore (having met them at the *Allied Artists' Association exhibition in 1908) and through them he was drawn into *Sickert's circle, becoming a founder member of the *Camden Town Group in 1911 and the *London Group in 1913. His Continental background made him a respected figure among his associates, who were united by an admiration for French painting. Ginner was primarily a townscape and landscape painter and he is known above all for his views of London (often drab areas, although he also depicted the hustle and bustle of places such as Leicester Square and Victoria Station). He painted with thick, regular brushstrokes and firm outlines, creating a heavily textured surface and a feeling of great solidity. Once he had established his distinctive style (by about 1911) it changed little and he became the main upholder of the Camden Town tradition after the First World War (although, unlike other members of the group, he never actually lived in Camden Town). He worked for the Canadian War Records Commission in the First World War and was an *Official War Artist in the Second. *See also* NEO-REALISM.

Glackens, William James (1870–1938) American painter and draughtsman, born in Philadelphia, where he studied at the Pennsylvania Academy of the Fine Arts. His early career was spent mainly as a newspaper illustrator, but he was encouraged to take up painting by Robert *Henri, whom he met in 1891. In 1895 he visited Paris and in 1896 he settled in New York. There he initially continued to work for newspapers and magazines, but he devoted more time to painting and did little illustration after about 1905. In 1908 he was one of the group of painters who exhibited together as The *Eight (1). His work as a newspaperman led him to depict scenes of contemporary life, and he is considered one of the central figures of the *Ashcan School. However, he was less concerned with *Social Realism than with representing the life of the people as a colourful spectacle, and he was heavily influenced by the *Impressionists. *Chez Mouquin* (1905, Art Institute of Chicago), a high-keyed depiction of a restaurant that was a favourite resort of artists in his circle, was inspired by Manet's famous *A Bar at the Folies-Bergère*. By the time of the *Armory Show (1913), which he helped to organize, Glackens was painting in a style reminiscent of the early *Renoir. From 1912 he was employed as art consultant by Dr Albert C. *Barnes and toured Europe buying paintings that formed the nucleus of the celebrated Barnes Foundation at Merion, Pennsylvania. In 1917 he was elected first president of the *Society of Independent Artists.

Glarner, Fritz (1899–1972) Swiss-born abstract painter who became an American citizen in 1944. He was born in Zurich and studied at the Academy in Naples, 1916–21. From 1923 to 1935 he lived in Paris, where his work developed from *Impressionism to *Constructivism; in 1933 he became a member of the *Abstraction-Création association. After a year in Zurich, Glarner emigrated to the USA in 1936, settling in New York, where he was an early member of *American Abstract Artists. He was a friend of *Mondrian and painted in a style similar to his but less severe, with the forms often departing from strict horizontal and vertical alignment, creating a shifting, dynamic feeling (he gave the name 'Relational

Painting' to this modification of Mondrian's *Neo-Plasticism). Unlike Mondrian, Glarner often worked on a large scale, as with his murals for the lobby of the Time-Life Building, New York (1959–60).

Glasgow Boys A loose association of Scottish artists active from about 1880 to the turn of the century; there was no formal membership or programme, but the artists involved were linked by a desire to move away from the conservative and parochial values they thought were represented by the Royal Scottish Academy in Edinburgh. Several of them had worked in France and were proponents of open-air painting. There is little obvious association with Glasgow in their work. The *Scottish Arts Review*, founded in 1888, acted as their mouthpiece. William York Macgregor (1855–1923) is sometimes referred to as the 'father' of the group; he was a few years older than most of the others and ran a life class in his Glasgow studio in which many of them used to meet. The heyday of the group was over by 1900 and it did not survive the First World War, but it rejuvenated Scottish art, breaking ground where the *Scottish Colourists were soon to follow.

The best-known members were Sir David Young *Cameron, Sir James *Guthrie, Edward Atkinson *Hornel, and Sir John *Lavery. *See also* GLASGOW SCHOOL.

Glasgow Four (The Four) A name sometimes given to four artists, interrelated by blood and marriage, who often worked together in Glasgow in the period from about 1890 to 1910, developing a common *Art Nouveau style in such fields as posters, metalwork, and interior decoration. The four were Charles Rennie *Mackintosh, Herbert MacNair (1868–1955), and the English-born sisters Frances Macdonald (1873–1921) and Margaret Macdonald (1864–1933), who were married to MacNair and Mackintosh respectively. Their work, which was influenced by Celtic art and *Symbolism, was more appreciated on the Continent than in Britain; an issue of the Viennese periodical *Ver Sacrum* was devoted to them in 1901. All four worked as painters as well as designers.

Glasgow Gallery of Modern Art *See* GALLERY OF MODERN ART, GLASGOW.

Glasgow School A term that has been applied to several groups of artists whose activities have centred on Glasgow. The largest of these groups, which was at its peak in the last years of the 19th century, consisted mainly of painters who challenged the conservatism of the Royal Scottish Academy; they preferred to be known as the *Glasgow Boys. A slightly later group, of which Charles Rennie *Mackintosh was the leading member, created a distinctive Scottish version of *Art Nouveau; the four principal members of this group are also known as the *Glasgow Four.

More recently, the term 'Glasgow School' (or facetiously 'Glasgow pups') has been applied to a group of figurative painters working in the city from the 1980s. They include Steven *Campbell, Ken *Currie, Peter Howson (1958–), and Adrian Wiszniewski (1958–), all of whom were students at *Glasgow School of Art at much the same time. (Among their teachers there was Sandy Moffat (1943–), who encouraged a return to figurative art after the *Conceptualist 1970s.) Duncan Macmillan (*Scottish Art in the 20th Century*, 1994) writes: 'In this group, Campbell, who was considerably older than the others, was the undoubted driving force . . . The success of this group as a whole was an important factor in Glasgow's cultural renaissance.'

Glasgow School of Art Art school founded in 1840 as the School of Design in Ingram Street, Glasgow. In 1869 it moved to Sauchiehall Street, and in 1885 Francis Newbery (1855–1946) was appointed director, ushering in the school's golden period. In 1896 Charles Rennie *Mackintosh won a competition to design a new building for the school in Renfrew Street, and this was erected in 1897–99, with a library block and other extensions added in 1907–9. Together they form one of the most original and dramatic works of architecture of the period anywhere in Europe. Mackintosh himself had attended evening classes at the school, and Newbery had introduced him to another student, Frances Macdonald, who became his wife. Newbery's own wife, Jessie Newbery, née Rowat (1864–1948), joined the staff of the school in 1894 and taught embroidery. Newbery treated design and craft as equal to the fine arts and had an unusually enlightened policy for his day in the employment of women as tutors. The First World War, followed by Newbery's retirement in 1918, brought the school's most distinguished period to an end, but it retained a high reputation and produced another

outstanding crop of graduates in the 1980s, including Steven *Campbell, Stephen *Conroy, and Alison *Watt.

Glazunov, Ilya (1930–) Russian painter whose work and career have aroused political as well as artistic controversy. Aleksandr Sidorov has commented that 'Judgements on Glazunov, the man and the artist, are completely polarised, ranging from the rapturous to the defamatory.' Glazunov was born in Leningrad and his close relatives all died during the German blockade of 1941–4. During the Soviet era he established a career by simultaneously appealing over the heads of the official art world to public taste and painting politically approved subjects, including a portrait of Leonid Brezhnev. From the 1960s onwards he also established an international practice as a portrait painter, his subjects including Federico Fellini and Kurt Waldheim. In 1978, he painted *20th Century Mystery*, an allegory in which the sheets on which the dead Stalin lies become a sea of blood, in the centre of a cast who include Hitler, Lenin, and John F. Kennedy, but also Louis Armstrong and Charlie Chaplin. His most celebrated painting, *Eternal Russia* (1988), polemically establishes Russia as essentially Christian, with Byzantine saints leading a procession of Russian celebrities under a giant crucifix. Glazunov has been accused of anti-Semitism. Certainly he has become an outspoken supporter of Russian nationalism, as was demonstrated by a speech of 2003 alleging genocide against the Russian people and demanding the teaching of Old Slavonic ('God's Law') in schools. In the 1999 painting *The Market of Our Democracy*, 'uncultured life is told in images of nudes, Beatles and rock musicians', according to the painter's official leaflet. The frame is lined with photocopied dollar bills.

After the fall of Communism Glazunov became the favourite of state patronage. In 2004 a new gallery was devoted entirely to his work opposite the Pushkin Museum of Fine Arts in Moscow. The gold and marble halls with classical statues and gold embossed labels were to the painter's own design. 'His hands would make Rembrandt jealous' was the comment of a journalist from the state news agency. This is certainly far from the tone of the first critical text devoted to him in 1964. Aleksandr Kamenski accused him of 'a range of hackneyed visual devices, accompanied by unprincipled borrowing from other artists of the past'.

Further Reading: A. Sidorov, 'Ilya Glazunov: A career in art', in M. C. Bown and B. Taylor, *Art of the Soviets* (1993)

Gleeson, James (1915–2008) Australian painter and writer. He was born in Sydney and studied at East Sydney Technical College, 1934–6. Gleeson was Australia's most committed exponent of *Surrealism, both as a painter and a propagandist. An example of his work is *We Inhabit the Corrosive Littoral of Habit* (1940, NG of Victoria, Melbourne), which shows a human face disintegrating and is close to *Dalí in style. Gleeson's writings include a standard monograph on William *Dobell (1964).

Gleichen, Lady Helena *See* GILBERT, SIR ALFRED.

Gleizes, Albert (1881–1953) French painter, graphic artist, and writer, born in Paris. After leaving school he worked in his father's design studio and he began to paint seriously whilst serving in the army, 1901–5. In 1906, with several friends, he founded the Abbaye de Créteil, near Paris, a Utopian community of artists and writers, but in 1908 it closed because of financial difficulties. Gleizes's early work had been *Impressionist in style, but in 1909 he took up *Cubism, and in 1912 he wrote with *Metzinger the book *Du Cubisme* (an English translation, *Cubism*, appeared in 1913 and in 1947 the authors produced a revised deluxe edition of the French text, illustrated with original prints). This was the first book on the movement and it remains Gleizes's main claim to fame. In 1912 he was among the founders of the *Section d'Or group and in 1913 he exhibited at the *Armory Show, New York. After serving again in the French army, 1914–15, Gleizes lived from 1915 to 1917 in New York, where he underwent a religious conversion. Much of his later career was devoted to trying to achieve a synthesis of medieval and modern art, expressing Christian ideas through pseudo-Cubist forms. In this he is generally reckoned to have been conspicuously unsuccessful and his modest reputation as a painter rests on his pre-war work. In 1927 he founded another Utopian community—Moly-Sabata at Sablons—and in the 1930s he painted several murals, taking as his ideal the close relationship between architecture, sculpture, and painting in the Middle Ages. He expounded his views in several books and pamphlets, including *La Peinture et ses lois* (1924).

Glickman, Maurice *See* BASKIN, LEONARD.

Gluck (Hannah Gluckstein) (1895–1976) British painter, a rebellious figure who dressed like a man (enjoying the embarrassment this caused)—'and adopted her monosyllabic name—'no prefix, suffix, or quotes'—because she thought the sex of the painter was irrelevant. She was born into the family that founded the J. Lyon & Co. catering empire and had the wealth to indulge her eccentricities. She studied at St John's Wood School of Art, 1913–16, and was encouraged by *Munnings. In the 1920s and 1930s she became well known for portraits and formal flowerpieces (she was a friend of the flower arranger Constance Spry), exhibiting with great success at the Fine Art Society, London. Her pictures were painted with fashionable panache in an *Art Deco style and in 1932 she designed and patented a frame in keeping with them: it consisted of three white bands stepped back from the picture so that, in her own words, 'the usual essence of all frames was reversed and instead of the outer edge dominating, it was made to die away into the wall and cease to be a separate feature'. After the Second World War she faded from prominence and in the 1950s and 1960s she devoted much of her time to an obsessive campaign to improve the quality of artists' materials. Near the end of her life she returned to the limelight with a retrospective exhibition at the Fine Art Society in 1973.

Gober, Robert (1954–) American sculptor and installation artist. He was born in Wallingford, Connecticut, and studied at Middlebury College, Vermont, from 1972 to 1976, also spending a year during this period at the Tyler School of Art in Rome, 1974–5. In 1976 he settled in New York, where he had his first one-man exhibition at the Paula Cooper Gallery in 1984. His best-known works simulate body parts in beeswax and are distributed around the gallery unexpectedly, for instance sticking out of walls. Sometimes they have plastic 'drains' inserted. Gober is gay and has written on the way that the AIDS epidemic has affected his perception of the world. This has tended to lead critics to see in his work a specific comment on the issue. His sculptures, with their disturbingly realistic surfaces, embellished with real hair, certainly give a sense of the body's vulnerability, but there are works which are more specific. In the installation work *Wedding Gown* (1989) he doctored a page from the *New York Times* so that the larger part was taken up by an advertisement showing the artist in a wedding dress under a headline reading 'Vatican condones discrimination against homosexuals'. Alongside this, there was a wedding dress, handmade by Gober and exhibited unworn, as well as bags of cat litter. The overall sense was of loss.

Gočár, Josef *See* CUBISM.

Goeritz, Mathias (1915–90) German painter, sculptor, architect, designer, teacher, writer, and controversialist, active in Mexico for most of his career. He was born in Danzig and studied philosophy and history of art in Berlin. From 1936 to 1938 he lived in Paris, where he studied painting, then returned to Berlin and gained a PhD in history of art in 1939. The following year he fled Germany and settled in Spanish Morocco. At the end of the Second World War he moved to Spain, living successively in Granada, Madrid, and finally Santillana, where in 1948 he helped to found an avant-garde group called the School of Altamira, which was devoted to creative freedom. In 1949 he moved to Mexico, where he had been invited to become professor of visual education and design in the School of Architecture at the University of Guadalajara. He remained in this post until 1954, when he settled permanently in Mexico City to teach at the National School of Architecture.

Goeritz played an important role in introducing modern ideas to Mexican art and he was attacked by some nationalists for infecting the country with 'European decadence': in response to his foundation of a short-lived museum of experimental art ('El Eco') in Mexico City (1951–3), *Rivera and *Siqueiros wrote an open letter in which they described him as 'a faker without the slightest talent or preparation for being an artist, which he professes to be'. His work was varied in range and style, but he is probably best known for his collaboration with architects in large-scale projects, particularly for his *Five Towers* (1957–8) at Satellite City, near Mexico City, carried out in partnership with the architect Luis Barragan. This group of five immense painted concrete towers, rising to heights of between 120 and 190 feet (35 and 58 metres), has been hailed as an early example of *Minimal art, but Goeritz was very different in his intentions from the

Minimalists. He championed human values in art and denounced what he considered the frivolity or vacuity of much contemporary painting and sculpture. For example, when *Tinguely demonstrated his self-destroying *Homage to New York* at the Museum of Modern Art, New York, in 1960, Goeritz distributed pamphlets outside the museum calling for a stop to 'aesthetic so-called "profound" jokes' and a return to timeless 'static' values.

Goetz, KARL *See* SMITH, DAVID.

Gogh, Vincent van *See* EXPRESSIONISM; POST-IMPRESSIONISM.

Goguen, Jean *See* NOUVEAUX PLASTICIENS.

Goings, Ralph (1928–) American *Superrealist painter, active in his native California, where he studied at the California College of Arts and Crafts, Oakland, 1950–53, and has taught at various schools and universities. His main subject is the automobile, often shown at a garage or service station. He works by projecting a slide or transparency on to the canvas and although he uses traditional brushes rather than airbrushes, his finish is seamlessly impersonal: 'Emphasis should be placed not on essences, generalizations or formal structures but specific, objective things and places. Looking supersedes formal contrivance, depiction becomes an extension of seeing.'

Golden Fleece (*Zolotoye Runo*) *See* BLUE ROSE.

Goldin, Nan (1953–) American photographer, film-maker, and installation artist. Born in Washington DC, she has worked in New York, Berlin, and Paris. She is best known for her series of colour photographs, *The Ballad of Sexual Dependency* (the title is taken from Bertolt Brecht's *The Three penny Opera*). These were exhibited as a series of slides, usually with a musical soundtrack; they were published in book form in 1986. The photographs depict frankly the 'alternative' club scene, looking at the lives of drug addicts, homosexuals, prostitutes, and drag queens, whom she regarded as her 'extended family'. The honesty extended to her own life. The series included self-portraits after she had been battered by her partner so seriously that she almost lost the sight in one eye. In the 1990s she continued to chronicle the subjects of her early photographs as their lives were

ravaged by AIDS. *Heart Beat* (2001) was a slide installation which showed the intimate lives of lovers against intense music by the composer John Tavener (1944–). *Sisters, Saints, and Sinners* (2004) was installed in the chapel of the Salpêtrière in Paris, a hospital which had a long tradition of treating prostitutes. Visitors to the exhibition had to pass along a high walkway to look down on the display, projected on three large screens, of photographs which documented Goldin's life as well as that of her sister Barbara, who committed suicide. It also included the wax figure of a girl on a bed.

Goldin has said: 'What I'm interested in is capturing life as it's being lived, and the flavour and smell of it, and maintaining that in the pictures.' She refuses to use digital techniques, maintaining a now somewhat unfashionable belief in the connection between photography and reality. Quite apart from the interest her work has aroused through its subject-matter, she is also one of the great colourists of contemporary photography, as is demonstrated by her landscape work.

Further Reading: N. Goldin, *The Devil's Playground* (2007)

Golding, John (1929–) British painter and art historian. He is probably best known as an eminent scholar of 20th-century art, particularly of *Cubism, but he has also made a reputation as an abstract painter. His early education was in Mexico and Canada, and in 1951–7 he did postgraduate work at the *Courtauld Institute of Art, London, his PhD thesis forming the basis of his book *Cubism: A History and an Analysis, 1907–1914*, published in 1959. This appeared in revised editions in 1968 and 1988 and remains a standard work on the subject, although some historians would now consider it too *formalist in its approach and criticize its concentration on a few major figures at the expense of a wider picture. A collection of his essays, *Visions of the Modern*, which includes a classic study of Marcel *Duchamp, appeared in 1994. *Paths to the Absolute* (2000) is a history of the development of abstract art. Golding taught history of art at the Courtauld Institute from 1962 to 1981, and in 1976–7 he was Slade professor of fine art at Cambridge University. He painted seriously throughout his academic career (his first one-man exhibition was in 1962) and eventually devoted himself full-time to it. In 1971 he started to teach at the *Royal College of Art and in 1981–6 (having given up his post at

the Courtauld Institute) was senior tutor there. His abstracts are typically large in scale, with broad expanses of glowing colour; he sees them as 'basically reflective or contemplative'.

Goldsmiths College Educational institute in the New Cross district of south-east London set up in 1891 as the Technical and Recreative Institute of the Worshipful Company of Goldsmiths. It was acquired by the University of London and renamed Goldsmiths' College in 1904. The apostrophe was dropped in 1993 and since 2006 it has branded itself as Goldsmiths University of London. Its fine art department became enormously influential in the 1980s, especially through the teaching of Michael *Craig-Martin, whose students included several of the *Young British Artists.

Goldstein, Jack (1945–2003) American video artist and painter. Born in Montreal, Canada, he moved to Los Angeles when a child. He studied at the California Institute of the Arts under John *Baldessari and like other students there became concerned with images from the mass media. He took part in the 'Pictures' exhibition in New York in 1977 (*see* APPROPRIATION). His work of this period was in the form of short video works. *Metro Goldwyn Mayer* (1975) took the famous MGM lion, isolated it on a red background and allowed it to repeat its roar silently on a continuous loop. In other videos the actions of a diver or dancing feet were isolated and then printed in a brilliant colour against black and again projected in constant repetition. In a performance piece of 1979 two boxers fight under stroboscopic lighting, producing a flickering effect reminiscent of early cinema. Such video work, although much admired, was hard to sell, and in the 1980s Goldstein began to produce paintings of light effects such as fireworks and lightning. In 1991 he moved away from the New York art scene to live a solitary life in the Californian desert. He was forgotten for many years and when his work was revived with a retrospective at the Whitney Museum of American Art in 2002 it seems to have brought him no pleasure. 'There's too many people here' was his response to the renewed interest. He died by suicide two years later.

(⊕) SEE WEB LINKS

- J. Lewis, 'Why you should know the name Jack Goldstein', *Slate* website.

Goldsworthy, Andy (1956–) British Land artist, born in Sale Moor, Cheshire. Goldsworthy uses natural materials found in the location where he works. He makes a point of not using manufactured adhesives or bindings such as glue or rope because, as he puts it, 'If I used glue I would forfeit the joy of discovering how materials join together by their own nature.' A typical example of his processes is *Scaur Water. Penpont. Dunfriesshire. 7.1.1987.* Fragmented sheets of ice are arranged to form a shape like the tail of a comet and float on the water. As in the work of Richard *Long, the photographic record of ephemeral structures is crucial, but Goldsworthy is far more concerned with the production of attractive images. He usually photographs in colour and the photographs have been published in a number of picture books; these have been one of the principal ways in which his works have been disseminated. They include *Passage* (2004) and *Enclosure* (2007). He has also made more permanent sculptures, but still using natural materials from the landscape, and site-specific works for the museum. One was in 2005 for the De Young Museum in San Francisco, which had just been rebuilt following its destruction by an earthquake thirty years before. It took the form of a crack running out in the courtyard, accompanied by slabs of limestone that also functioned as seats. Rather unusually for a Land artist, his work has been at least as popular with the wider public as in the museum world. His books sell in substantial numbers, but at the time of writing he is unrepresented in the Tate collection. A film about his work, *Rivers and Tides*, was released in 2001.

Goldwater, Robert (1907–73) American art historian. He was born in New York and studied at Columbia College (BA 1929), Harvard University (MA 1931), and New York University (PhD 1937). From 1934 he held various teaching positions, and in 1957 he became professor of art history at New York University. He wrote mainly on late 19th- and 20th-century art, his books including *Primitivism in Modern Painting* (1938; revised edn, as *Primitivism in Modern Art*, 1967), which was a pioneering work on the subject, *Gauguin* (1957), *What is Modern Sculpture?* (1969), and the posthumously published *Symbolism* (1979). Goldwater was married to Louise *Bourgeois.

Golub, Leon (1922–2004) American painter, described by Amei Wallach as a 'righteous monster who reconciled painting with the unpalatable realities of his time'. He was born in Chicago, where he studied art history at the University, graduating in 1942. After serving in the army during the Second World War, he studied painting at the Art Institute of Chicago, 1946–50, and he had his first one-man exhibition at the Contemporary Gallery, Chicago, in 1950. Subsequently he taught at various colleges in the USA (in Chicago, New York, and elsewhere) and spent two periods in Europe, living in Italy, 1956–7, and Paris, 1959–64.

At the beginning of his career Golub worked as an abstract painter, but he soon turned to figurative painting and became an outspoken opponent of the *Abstract Expressionism that dominated American art in the 1950s. Nonetheless he always worked on the imposing scale of the Abstract Expressionists. One of the earliest and strongest influences on him was *Picasso's *Guernica*, which was exhibited in Chicago in 1939. His work was mainly concerned with themes of stress and violence; often it is very large in scale, and his handling of paint is expressively raw, increasing the emotional impact of his images. In the 1950s many of his paintings depicted monster-like creatures, but thereafter his work became more naturalistic and more politically orientated, dealing with themes such as the Vietnam War, El Salvador, the activities of mercenary soldiers, and interrogation and torture by brutal guards (*Interrogation II*, 1981, Art Institute of Chicago). He employed a technique in which layers of acrylic were scraped back with a meat cleaver so as to leave a thin layer of paint in the weave of the canvas.

At one point in the 1970s Golub considered giving up painting altogether, but critical and commercial success in the early 1980s, including purchases by Charles *Saatchi, encouraged him to continue. Discussing the contradiction between his radical conscience and the position of wealthy collectors implicated in the system he was attacking, he argued that 'You can say that Saatchi or anyone else who buys a work owns me, takes possession of my mind, so to speak, my art. But then I enter his home, his situation, his environment. I put my mercenaries there.'

In 1951 Golub married the painter Nancy *Spero. who had been a fellow student at the Art Institute of Chicago. Amei Wallach commented that their art, although united by a social commitment, was in many ways antithetical, 'his a larger than life diatribe against masculinity run amuck; hers an intimate investigation of the valor and anguish of women'.

Further Reading: A. Wallach, 'Artist who Painted Indignation', *Art News* (October 2004)

Golubkina, Anna (1864–1927) Russian sculptor, one of her country's outstanding artists in the early 20th century. She was born in Zaraysk, the daughter of a market gardener, and studied in Moscow and St Petersburg before making two visits to Paris (1895–6 and 1897). During the first of these she studied at the Académie Colarossi and during the second she met *Rodin, whose vigorous surfaces and *Symbolist leanings strongly influenced her work (she later wrote to him: 'While I live I shall always venerate you as a great artist and the person who gave me the possibility of life'). After her return to Russia she settled in Moscow. Golubkina was principally renowned as a portraitist, and one of her most famous works is the first sculptural portrait of Karl Marx (1905, Tretyakov Gallery, Moscow). It was typical of her character that she donated her fee for this to a fund for homeless workers, for she had passionate humanistic convictions and took an active part in the Russian Revolution of 1905; two years later she was imprisoned for distributing literature that urged peasants to 'overthrow the Tsar and the government', but she was soon released because of ill-health. In 1914–15 she organized an exhibition of her work at the Museum of Fine Arts in Moscow 'in aid of the war-wounded'. From 1918 to 1921 she taught at *Svomas and then *Vkhutemas. She worked mainly in bronze, but also in marble and wood. Following serious illness in 1924, she concentrated on smaller works, including cameos.

Gombrich, Sir Ernst (E. H. Gombrich) (1909–2001) Austrian/British art historian. Born in Vienna, he moved to Britain in 1936. From 1959 to 1976 he was director of the Warburg Institute in the University of London. One of the most influential and controversial art historians of the 20th century, he is best known to a wide public for *The Story of Art* (1950). Despite the criticisms which might be made of it, for instance the bias towards the European tradition and the neglect of women artists, it has proved, in practice, impossible to beat as a guide to read rather than just refer to.

Gombrich's contribution to debates on modern art has often been characterized as negative. Certainly he looked sceptically at the claims of *abstract art and, among those influenced by advanced tendencies, he tended to treat most sympathetically figures such as Abram *Games or Saul *Steinberg, who used modernist devices in the context of the 'minor' genres of poster design and illustration. This was, however, not simply the result of knee-jerk conservatism but of a strongly argued position about the relationship between image making and perception, most completely set out in *Art and Illusion* (1960). Gombrich saw in modern art a manifestation of the idea that all representation was fundamentally a matter of convention, which is indeed a position taken by many contemporary art theorists, especially those whose approach has been informed by semiology (*see* BARTHES). Philosophically Gombrich's position may have considerable merit, and as he himself pointed out, 'where would the art historian be, if he felt obliged to endorse every ideology that has ever blossomed into art?' *See also* EXPERIMENTAL ART.

Further Reading: E. H. Gombrich, *Topics of our Time* (1991)

Gomringer, Eugen *See* CONCRETE POETRY.

Goncharova, Natalia (1881–1962) Russian-French painter, graphic artist, and designer, born in Tula province, near Moscow, into a distinguished family (she was related to Russia's greatest poet, Alexander Pushkin). From 1898 to 1902 she studied at the Moscow School of Painting, Sculpture, and Architecture. Initially she trained as a sculptor, but in 1900 she met her fellow student Mikhail *Larionov, who encouraged her to turn to painting. They became lifelong companions and in the years leading up to the First World War they were among the most prominent figures in Russian avant-garde art, taking part in and often helping to organize a series of major exhibitions in Moscow. Goncharova's early paintings were *Impressionist, but after the first 'Golden Fleece' (*see* BLUE ROSE) exhibition in 1908 she was strongly influenced by modern French painting (including the work of *Cézanne, *Gauguin, and *Matisse), combining this with her interest in peasant art and icon painting to create a *Neo-primitive style. To the influences of *Fauvism, she later added *Cubism and *Futurism, and by the time of the

*'Target' exhibition of 1913 she was painting in a near-abstract *Rayonist style (*Cats*, 1913, Guggenheim Museum, New York). This was Goncharova's most prolific period as a painter: in 1913 she held a one-woman exhibition in Moscow in which she showed more than 700 works. The preface to the catalogue takes the form of a manifesto in which she says that Western art has 'dried up' and that consequently she was looking to the East for inspiration. She was interested not only in ancient Russian art, but also in Chinese and Indian painting.

In 1915 Goncharova left Russia with Larionov and after settling in Paris in 1919 she devoted herself mainly to designing settings and costumes for the theatre, particularly *Diaghilev's Ballets Russes; this aspect of her work is well represented in the Victoria and Albert Museum, London. She also did a good deal of book illustration and continued to paint intermittently to the end of her life, but after the death of Diaghilev in 1929, her main period of achievement was over. Goncharova and Larionov became French citizens in 1938 and were married in 1955. By this time they had been virtually forgotten, but there was a great revival of interest in them in the early 1960s.

González, Julio (1876–1942) Spanish sculptor, metalworker, painter, and draughtsman, the leading pioneer in the use of welded iron (*see* IRON AND STEEL) as a sculptural medium. He learnt to work metal under his father, a goldsmith and sculptor, but his early career was spent mainly as a painter. In about 1900 he moved to Paris and formed a lifelong friendship with *Picasso, whom he had earlier met in his native Barcelona. In his early years in Paris he supported himself mainly by making metalwork and jewellery, but he also exhibited paintings and made sculpture including metal masks. In 1918 he learnt oxy-acetylene welding techniques at the Renault factory and it was the combination of industry and craft that was to be vital for his sculpture. Although he had exhibitions of sculpture in 1922 and 1923 it was not until the late 1920s, when he was already in his 50s, that he devoted himself wholeheartedly to sculpture and turned to welded metal as a material. Picasso sought his technical advice about metal sculpture and González worked with him between 1928 and 1931. Although Picasso was certainly an influence, Penelope Curtis

has argued against the assumption that 'the relationship was one of Picasso transforming an otherwise mediocre artist'. What survives of his earlier sculpture suggests that González was already an artist of some originality. The development of his sculpture was from cut and hammered reliefs to welded and forged pieces which were a kind of linear 'drawing in space'. He wrote: 'It is time this metal (iron) ceased to be a murderer and the simple instrument of a super-mechanical science. Today the door is wide open for this material to be forged and hammered by the peaceful hands of an artist.' His inventive visual punning has some affinities with *Surrealism and, although never formally linked to the group, he did exhibit at 'La Centaure' in Brussels and the Galerie Pierre in Paris, both of which had Surrealist affinities. This punning can at times be humorous, as in the whiskers/spikes of *Cactus Man II* (1939/40, Pompidou Centre), but can also have a strong emotional pull. *Gothic Man* (1935) is both bowing figure and cathedral. Occasionally, as in his masterpiece, *The Dream* (1931, Pompidou Centre), in which the figure can be read as both aggressor and victim, it takes us into a world of nightmare. His best-known work, *Montserrat* (1937, Stedelijk Museum, Amsterdam), is rather uncharacteristic, a fairly naturalistic piece, showing a woman with a child in her arms, and commemorates the suffering of the Spanish people in the civil war (Montserrat is a holy mountain in Spain). It was displayed alongside Picasso's *Guernica* in the Spanish Republic's Pavilion in the 1937 Paris International Exhibition. Gonzalez wanted to show his more abstract *Woman with a Mirror*, but the organizers demanded a more accessible and political work. His sculpture had great influence, notably on a generation of British and American sculptors exemplified by Reg *Butler and David *Smith, who wrote an appreciation entitled 'First Master of the Touch' (*Arts*, February 1956).

After his death bronze casts were made of the iron sculpture at the authorization of his daughter Roberta González, on the encouragement of her husband, the painter Hans *Hartung. She maintained that her father had always wished to work in bronze and would have been delighted to see his sculpture more widely disseminated. Certainly the casts are of very high quality and can sometimes be hard to tell from the iron originals with the naked eye. At the same time, as William *Tucker has pointed out, much of the character of the sculpture lies in the process and material. 'The action of the sculptor's tools *becomes* the form of the end material: the tensile potential of steel "as it comes"—i.e. in varieties of bar or sheet—is turned, in the sculptor's hands, to sheer invention.' A footnote describes the bronze versions as 'regrettable'.

His brother **Joan González** (1868–1908) was a draughtsman and painter, active in Barcelona and Paris. He died young of tuberculosis and his work was virtually unknown until the late 1950s, when Roberta González discovered a collection of his drawings (and a few paintings) in the attic of the family home. She presented numerous works by both Julio and Joan to the Tate Gallery, London, in 1972. There is also an outstanding collection of works by Julio at the Pompidou Centre, again from Roberta's donation and bequest.

Further Reading: South Bank Centre, *Julio González: Sculpture and Drawings* (1990). The catalogue contains a fine essay by Penelope Curtis, 'Julio González: Fact and Fiction'.

W. Tucker, *The Language of Sculpture* (1974)

J. Withers, *Julio González: Sculpture in Iron* (1978)

Goodrich, Lloyd (1897–1987) American art historian and museum administrator, born in Nutley, New Jersey. He studied in New York at the *Art Students League and the National Academy of Design, then worked in publishing for several years before joining the staff of the *Whitney Museum of American Art as a writer and researcher in 1935. This was the start of a lifelong association with the museum: he was director from 1958 until his retirement in 1968, then held the title of director emeritus until his death. Goodrich played a leading role in helping to build the Whitney Museum from a moderately sized private collection to a large public institution.

Gordine, Dora (1898–1991) British sculptor, born in Liepaja (also known as Libau) in Latvia. In her lifetime she made a mystery of her origins: it was long believed that she was born in 1906 in St Petersburg. The family moved to Tallinn in Estonia in 1912 and in 1920, as White Russians, they were encouraged to leave. After living in Berlin (1920–4) she moved to Paris, where she studied as a sculptor. In 1930 she moved to Singapore and in 1931 travelled through Malaya, Cambodia, and Thailand. She settled in London in 1935. In the following year, with her second husband, Richard Hare, whom she had first met

in 1926 but refused to marry until she had established herself professionally, she moved into a specially designed house called 'Dorich House' on Kingston Hill. It is now a museum dedicated to her work, and attached to Kingston University.

Her work as a sculptor and her wide travels reflected her interests in different ethnic types. As early as 1926 her *Head of a Chinaman* was used as an illustration in the magazine *Le Crapouillot* as a refutation of European anxieties about 'the yellow peril'. In 1928 she showed an exhibition of heads of racial types at the *Leicester Galleries. In 1933 a subsequent exhibition was dominated by Asiatic heads and the sculpture was especially influenced by her experience of Angkor Wat. The art historian Jonathan Black points out that these were 'non-threatening types' who were defined by the labels devised by Western anthropologists. Gordine also made full-length figures, telling a journalist in 1930 that she was fascinated by 'the naturally graceful movements of the Eastern peoples'. In 2005 Anthony *Caro paid tribute to her work, describing it as 'withheld, slowed down, as is the art of *Maillol' and that 'when we place her work against that of the much more successful academic sculptors of the time it is a million miles better'.

Further Reading: Ben Uri Art Gallery, *Embracing the Exotic: Jacob Epstein & Dora Gordine* (2006)

Gordon, Douglas (1966–) Scottish installation and *video artist, born in Glasgow. In 1984–5 he studied at Glasgow School of Art, where he was part of a department in which students were encouraged to make work outside the gallery and to consider 'context as 50 per cent of the work'. He studied at the *Slade School in 1988–90. He has made works involving language which emphasize the process of reading. In 1991 he adorned the domed ceiling of the Serpentine Gallery, London, with the phrase 'WE ARE EVIL', entitling the work *Above all Else*. Katrina Brown points out that the title has religious connotations: if original sin is an issue, then the name of the gallery itself is surely of significance. The origin of the phrase comes from a chant by Millwall football supporters. *30 Seconds Text* (1996, Goertz Collection, Munich) is a chilling work recounting an experiment by a French doctor on the residual consciousness of a head severed by the guillotine. He concluded that it lasted between twenty-five and thirty seconds (the time

it would take to read the text). Just as Gordon's language works focus on the process of reading, so do the video works focus on that of viewing. He engages with what has often been cited as a critical problem in *video art, that the conditions of viewing in the gallery are fundamentally different from those which obtain in the cinema or on television. The video works have frequently used actual narrative films but have re-presented them so that they appear quite different experiences. Two of the best known are based on very familiar films by Alfred Hitchcock. *24 Hour Psycho* (1993, Kunstmuseum, Wolfsburg) slows down the film to two frames a second. Familiar scenes become extracted from the story and perceived in microscopic detail as though a kind of 'unconscious' of the film is being revealed. *Feature Film* (1998) is based on *Vertigo*. It has often been acknowledged that this film, regarded as Hitchcock's masterpiece by many critics, owes an important part of its impact to the musical score by Bernard Hermann. Gordon's installation isolates the music and on the large screen is seen the conductor James Conlon as he guides the musicians. The film is relegated to a small monitor in the corner. Douglas comments on his work, 'I provide the board, the pieces and the dice, but you are the ones who have to play'. He was awarded the *Turner Prize in 1996.

Further Reading: K. M. Brown, *Douglas Gordon* (2004)

Gore, Spencer (1878–1914) British painter of landscapes, music-hall scenes, interiors, and occasional still-lifes. He was born in Epsom, Surrey, into a distinguished family: his father, Spencer William Gore, a surveyor by profession, was a famous sportsman (he won the first Wimbledon tennis championship in 1877); and his uncle, Charles Gore, was Bishop of Oxford. In 1896–9 he studied at the *Slade School, where he was a particular friend of Harold *Gilman. Another Slade contemporary was Wyndham *Lewis, with whom he visited Spain in 1902. In 1904, together with Albert *Rothenstein (who later changed his name to Rutherston) Gore visited *Sickert in Dieppe; this marked the beginning of his close acquaintance with recent French painting (he returned to France in 1905 and 1906), and the enthusiasm of the two young painters helped to decide Sickert to return to London in 1905. For the rest of his short career Gore was part of Sickert's circle, becoming a founder member successively of the *Allied Artists' Association

in 1908, the *Camden Town Group (of which he was first president) in 1911, and the *London Group in 1913. He and Sickert often visited music halls together, and both of them painted memorable scenes of this world. His early paintings were *Impressionist in style, but he was strongly influenced by Roger *Fry's *Post-Impressionist exhibitions (Gore's own work was included in the second in 1912) and his later pictures show vivid use of flat, bright colour and boldly simplified forms. He died of pneumonia aged 35 and was much lamented by his many friends in the art world. Sickert said Gore was 'probably the man I love and admire most of any I have known', and Frank *Rutter described him as 'the most lovable man I ever knew'; his obituary in *The Morning Post* remarked that 'his personal character was so exceptional as to give him a unique influence in the artistic affairs of London in the last dozen years'. His son **Frederick Gore** (1913–) is a painter, and Roger de Grey (*see* ROYAL ACADEMY OF ARTS) was his nephew.

Gorin, Jean (1899–1981) French *Constructivist artist, born in Saint-Émilion-de-Blein. He studied at the Académie de la Grande Chaumière in Paris and at the École des Beaux-Arts in Nantes. After discovering *Cubism and *Purism, he wrote to *Mondrian to gain a sense of direction, meeting him in 1927. Like Charles *Biederman later, he saw the logical development of Mondrian's art was outward into space, and in 1929 he began making relief constructions using horizontals and verticals. Some later work sets these patterns against curves or uses diagonals—as Michel *Seuphor points out, 'heresy in the eyes of the pure plasticity of Mondrian'. Gorin sought for a fusion of his art with architecture, saying in 1949 that 'The ordinary man in the 20th century should be able to live completely in pure air, light, and joy, through architecture.'

Further Reading: Centre National d'Art Contemporain, *Jean Gorin* (1969)

Gorky, Arshile (Vosdanig Manoog Adoian) (1904?–48) Armenian-born American painter, one of the leading figures of *Abstract Expressionism. During the First World War his father emigrated to the USA to avoid conscription into the Turkish army and his mother died a victim of Turkish persecution of the Armenians. Gorky managed to escape with his sister, and they found their way to America, settling first at Providence, Rhode Island. In his new country he adopted the pseudonym Arshile Gorky, the first name being derived from the Greek hero Achilles, the second (Russian for 'the bitter one') from the Russian writer Maxim Gorky, to whom he sometimes liked to claim he was related. In 1925 he moved to New York, where he first studied and then taught (1926–31) at the Grand Central School of Art. Gorky took a romantic view of his vocation and is said to have hired a Hungarian violinist to play during his classes to encourage his students to put emotion in their work. His early paintings were strongly influenced by *Cézanne (whom he considered 'the greatest artist that has lived') and he also fell under the spell of *Picasso, as can be seen both in the haunting *The Artist and his Mother* (c.1926–9, Whitney Museum, New York), based on a photograph taken when he was a child, and in his experimentation with *Cubism at this period. Much of his work of the 1930s represents an attempt to synthesize the flatness of Cubist structure (in which he was influenced also by Stuart *Davis) with the improvisatory fluidity and energy of *Surrealist *automatism.

From 1935 to 1939 Gorky worked for the *Federal Art Project, his paintings under its auspices including an abstract mural for Newark Airport, New Jersey. In the early 1940s he came into contact with the circle of European Surrealists who had emigrated to New York to escape the Second World War, and under their influence (particularly that of *Matta and *Miró) he created the distinctive style of his last phase, featuring 'a mass of delicately drawn, visceral shapes floating in a tangible world of brilliant transparent color. The shapes are suggestive of internal organs, brutally mutilated, or microscopic views of plants and flowers transformed into strange menacing beasts or embracing in an ecstasy of sexual fulfilment. They are at the same time living organisms, still-lifes, or landscapes, all filled with an ecstatic and disturbing sense of physical vitality and psychological conflict' (H. H. *Arnason in *Britannica Encyclopedia of American Art*, 1981). However, just as Gorky began to emerge as a powerful original voice in American art, he suffered a tragic series of misfortunes. In 1946 a fire in his Connecticut studio destroyed a large proportion of his recent work, and in the same year he was operated on for cancer. In 1948 he broke his neck in an automobile accident, and when his wife

left him soon afterwards he hanged himself, leaving a message chalked nearby reading 'Goodbye My Loveds'.

Gorky has been called both the last of the great Surrealists and the first of the Abstract Expressionists, and his work in the 1940s was a potent factor in the emergence of a specifically American school of abstract art: Adolph *Gottlieb wrote that he recognized 'the vital task was a wedding of abstraction and surrealism. Out of these opposites something new could emerge, and Gorky's work is part of the evidence that this is true.' Willem *de Kooning in particular was a close friend and was greatly influenced by him.

Gormley, Antony (1950–) British sculptor, born in London. He read history of art at Trinity College, Cambridge. His thesis on Stanley *Spencer was considered to be of sufficient quality to form the basis of an essay in an Arts Council catalogue in 1976. He studied sculpture in London at the Central School of Art and Design, *Goldsmiths College, and the *Slade School. In the early 1980s he tended to be exhibited alongside sculptors such as Tony *Cragg and Bill *Woodrow, whose main interest was in the object, although his focus by then was on the figure: he did, however, share his contemporaries' concerns with making sculpture from unexpected materials. *Bed* (1980–81) is made out of slices of bread, in which the reclining figures of man and woman have been eaten by Gormley in a kind of reverse carving by teeth. He had been enormously impressed by *Epstein's *Elemental Figure* (1932), which had been exhibited in the Whitechapel Gallery in 1981, a carving of a figure, clutching itself almost into a ball. He embarked on a series of sculptures based on life casts of his own body which were then cast in lead pieces, the welded seams being left visible. It is an uncomfortable process which involves the artist being covered in plastic sheeting with tubes inserted in his nose to enable him to breathe while the plaster hardens. Gormley has described it as a process of 'going to a place of darkness and of voluntary immobility. It's death in a way' (Collins, 2007). He won the *Turner Prize in 1995 and gained wider fame in 1998 when his huge *Angel of the North* was erected near Gateshead, overlooking the A1 trunk road. A steel figure 20 metres high with a wingspan of 54 metres, it was, for a time, Britain's biggest sculpture. In spite of some initial scepticism it has become a popu-

lar landmark and was even used as a symbol for the coming millennium by a newspaper not usually known for its support for contemporary art. A poll in 2008 found it a more widely recognized landmark than St Paul's Cathedral. In 2007 there was a major exhibition of Gormley's work at the Hayward. His figures were dotted at various points in the vicinity of the South Bank site including roof tops and on Waterloo Bridge.

Further Reading: Tate Gallery, Liverpool, *Antony Gormley* (1994)

Gosse, Sir Edmund (1849–1928) British writer. A major figure in the cultural life of his time, Gosse is now best known for his literary criticism and for the autobiographical *Father and Son* (1907). However, early in his career he wrote a good deal of art criticism and played a significant role in promoting interest in contemporary British sculpture. He was a friend of Hamo *Thornycroft and coined the term *New Sculpture in a series of articles in the *Art Journal* in 1894. Although these are invaluable sources today, his view of the subject differs from that of later historians in that he emphasizes naturalism as the distinctive feature of the tendency, rather than the imaginative and decorative aspects. His daughter **Sylvia Gosse** (1881–1968), a painter and etcher of landscapes, still-lifes, street scenes, portraits, and interiors with figures, was one of *Sickert's most devoted followers; she ran his art school for several years.

Gotch, Thomas Cooper *See* NEWLYN SCHOOL.

Goto, Joseph *See* JUNK ART.

Gottlieb, Adolph (1903–74) American painter, one of the leading *Abstract Expressionists. He was born in New York, where he studied at various art schools in the early 1920s, on either side of a visit to Europe in 1921–3. His early work was *Expressionist and from 1935 to 1940 he exhibited with the Expressionist group The *Ten. In 1936 he worked for the *Federal Art Project, then in 1937–9 lived in the Arizona desert. Some of his landscapes of this time have a *Surrealist air, and after his return to New York in 1939 this tendency was enhanced by contact with expatriate European Surrealists, who helped him to develop an interest in Freudian psychology and the idea of the subconscious as a source of artistic inspiration. His work began to take

on a distinctive identity in the early 1940s, and from then until the end of his life he worked in three main series: *Pictographs* (1941–51), *Imaginary Landscapes* (1951–7, and again in the mid-1960s), and *Bursts* (1957–74). The *Pictographs* use a loose grid- or compartment-like arrangement with schematic shapes or symbols suggesting some mythic force. The use of mythology was a way of escaping from the forms of figurative painting dominant in American painting (*Social Realism and *American scene) as well as *Cubism. The *Imaginary Landscapes* feature a zone of astral shapes against a foreground of heavy *gestural strokes; and the *Bursts*, becoming still freer, suggest solar orbs hovering above violently coloured terrestrial explosions (*Orb*, 1964, Dallas Museum of Fine Arts). Gottlieb also designed stained glass and other works for churches and synagogues, suggesting a religious mood without specific representation.

Gowing, Sir Lawrence (1918–91) British painter, teacher, administrator, and writer on art, born in London. From 1936 to 1938 he studied under *Coldstream, first privately and then at the *Euston Road School, and much of his subsequent work (mainly landscapes, portraits, and still-lifes) was in the sombre Euston Road vein. However, he also painted abstracts, and in 1976 he began producing large pictures in which he traced the outline of his own naked body stretched out on the canvas, the paint being applied by an assistant. He had a prominent career as a teacher, notably as professor of fine art at King's College, Newcastle upon Tyne (later Newcastle University), 1948–58, at Leeds University, 1967–75, and at the *Slade School, 1975–85. From 1965 to 1967 he was deputy director of the Tate Gallery, and he had a long association with the *Arts Council, for which he helped to organize and catalogue several exhibitions, notably the major *Matisse exhibition that inaugurated the Hayward Gallery, London, in 1968 (he also published a book on Matisse in 1979).

Other major 20th-century artists on whom Gowing wrote in book or catalogue form include *Cézanne (Arts Council exhibition, Edinburgh and London, 1954; 'Cézanne: The Late Works', MoMA, New York, 1977) and Lucian *Freud (monograph, 1982). He was knighted in 1982 and in 1983 an Arts Council retrospective of his work was shown in London, and elsewhere. The accompanying catalogue described Gowing as 'singularly

distinguished as a writer, a professor of painting and an adviser to the nation on the arts'.

Graevenitz, Gerhard von (1934–83) German sculptor and experimental artist, born at Schilde, Mark Brandenburg. After reading economics at Frankfurt University he studied art at the Munich Academy from 1957 to 1961. In the early 1960s he began to make *Kinetic pictures in which geometrical shapes were given random movement by electric motors. Later in the decade he developed 'light objects' in which movable aluminium parts were made to reflect light in constantly changing patterns. He conceived such work as an attempt to go beyond *Constructivism in the creation of a new art form and wrote in the catalogue of the exhibition 'Kinetics' at the Hayward Gallery, London, in 1970: 'My kinetic objects are visual objects. The elements are simple and geometric. Kinetic objects are not traditional sculptures set in motion. Motion means the changing of the network of relationships which defines the structure in space and time. Kinetic art is not a new style but a new art in the sense that it establishes a new object-spectator relationship.' Graevenitz died in an aeroplane crash in Switzerland, while taking aerial photographs of a work by Daniel *Buren.

Graffiti art (Spraycan art, Subway art) A type of painting based on the kind of spraycan vandalism familiar in cities all over the world and specifically in the New York subway system; the term can apply to any work in this vein, but refers particularly to a vogue in New York in the 1980s (several commercial galleries specialized in it at this time and a Museum of American Graffiti opened there in 1989). The best-known figures of Graffiti art are Jean-Michel *Basquiat and Keith *Haring, both of whom enjoyed huge reputations (and prices) during their brief careers.

Graffiti art initially had less of a vogue in Britain. In 1996 a young man called Simon Sunderland was given a five-year jail sentence for a campaign of graffiti vandalism in the Sheffield area. However, he was released later that year to take up a place at art college, having found 'a sense of purpose and direction in his art'. Following the enormous media and commercial success of *Banksy, Graffiti was rebranded as 'Street art' and as such

became the subject of a Tate Modern event in 2008.

Further Reading: C. Castelman, *Getting Up: Subway Graffiti in New York* (1982)

Graham, Dan (1942–) American installation and video artist and art theorist, born in Illinois. He began his career in art in 1964 organizing the John Daniels Gallery in New York. It lasted only a season, and showed the work of *Minimal artists; it was also the centre for discussion of contemporary cultural issues such as serial music and New Wave cinema. After the gallery closed, Graham began writing on art. Some of his publications went beyond art journalism, becoming art works which used the magazine as a context in the way that the Minimalists used the gallery as a kind of frame. In this way Graham can be regarded as one of the first *Conceptual artists. Through his meeting and correspondence with Terry *Atkinson he became a contributor to the first issue of *Art-Language* (*see* ART & LANGUAGE). The most significant of his early publications was 'Homes for America', which first appeared in *Arts* magazine in 1966, although by removing most of the visual material which Graham had wanted, the intention to produce a kind of artwork was undermined. On the surface this was an account of the architecture of post-war American suburban housing. What Graham showed implicitly was that, in spite of the apparent stylistic conservatism and appeal to tradition, the design of these buildings was subject to a kind of systematic approach close to the logic of much geometric *abstraction and Minimal art, and that such designs were imposed regardless of the site in which they were placed.

Much of Graham's subsequent work as an artist has reflected this interest in architecture and the relationship of the receptor of the work, both as body and viewer, within it. He has made installations which employ delayed action video to unsettling effect, as one observes one's movements of a few moments previously. He has also made installations involving two-way mirrors that depend on the active engagement of the viewer. There is one on the roof of the DIA Foundation in New York. Graham also has a strong interest in popular culture, especially music and television. His video piece *Rock my Religion* (1982–84) is an hour-long survey that shows how the

roots of contemporary popular music can be traced back to the radically egalitarian culture of the Shaker religion.

Further Reading: D. Graham (ed. B. Wallis), *Rock my Religion* (1993)

(((◉))) **SEE WEB LINKS**

• Dan Graham interview with Peter Doroshenko, *Journal of Contemporary Art* website.

Graham, John (1881–1961) Russian-American painter and writer on art, born Ivan Dambrowsky in Kiev. His early life is obscure and it is not certain where or even whether he received formal training in art. However, it is evident from his writings that he knew certain members of the Russian avant-garde—David *Burliuk, *Gabo, *Lissitzky, and *Mayakovsky—and his early paintings show the influence of *Rayonism. Like *Kandinsky and *Malevich, he later became interested in theosophy. He emigrated to the USA in the early 1920s and studied under John *Sloan at the *Art Students League. His paintings are eclectic, drawing variously on *Cubism, *Fauvism, and *Surrealism; they sometimes have an engaging eccentricity, but he is more important for his other activities. He introduced Jackson *Pollock to his future wife Lee *Krasner in 1941, knew many other young artists who later became celebrated figures (Stuart *Davis, Willem *de Kooning, Arshile *Gorky, David *Smith), and gained a reputation as the mouthpiece of modernism and a link with the European avant-garde. His emphasis on the importance of the unconscious as a spring of artistic inspiration has been cited as a source for the young *Abstract Expressionists, and David Anfam writes: 'On the evidence of his book *System and Dialectics of Art*, read by the cognoscenti at its appearance in 1937, Graham embodied a fascinating storehouse of ideas and pursuits for anyone eager to escape provincialism' (*Abstract Expressionism*, 1990). He collected African sculpture and received European magazines such as *Cahiers d'art* that were a stimulus to the artists in his circle. In the 1940s, however, Graham repudiated modernism and became immersed in the study of the occult. He spent his final years in London and Paris.

Graham, Martha *See* NOGUCHI, ISAMU.

Graham, Rodney (1949–) Canadian photographer and video artist, born in British Columbia. At the University of Vancouver he was

a fellow student of Jeff *Wall, with whom he formed a rock band. His work frequently has a disconcerting effect, as in his extensive series of large-scale photographs of upside-down trees. The tree is chosen as a motif partly because it is such a standard diagram in scientific textbooks. It is also a totally familiar image which links earth and sky and so relates especially powerfully to the viewer's sense of verticality. Graham shows us the actual retinal image before it has been corrected by the brain. In his video work *Vexation Island* (1997) he explores the distinctions between video art, perpetually open-ended and condemned to perpetual repetition, and conventional film with its demands for narrative closure. A Robinson Crusoe-like figure lies asleep on an island and is awoken by a parrot. He shakes a tree to obtain a coconut, which falls on his head; he is knocked unconscious, so the cycle begins again.

(⊕) SEE WEB LINKS

• Rodney Graham interview with Anthony Spira, Whitechapel Art Gallery website.

Grant, Duncan (1885–1978) British painter, decorator, and designer. He was born into an ancient Scottish family at Rothiemurchus, Inverness (although both his grandmothers were English). His father was an army officer stationed in Burma, and Grant spent most of his early childhood there. He studied at Westminster School of Art, 1902–5, at the Académie de la Palette, Paris, under *Blanche, 1906–7, and for six months at the *Slade School, 1907. Through the writer Lytton Strachey (his cousin) he became a member of the *Bloomsbury Group, and he was also familiar with avant-garde circles in Paris (he met *Matisse in 1909 and *Picasso soon afterwards). Up to about 1910 his work—which included landscapes, portraits, and still-lifes—was fairly sober in form and restrained in colour, but he then underwent a rapid development to become one of the most advanced of British artists in his response to modern French painting (he exhibited at Roger *Fry's second *Post-Impressionist exhibition in 1912). From about 1913 he was also influenced by African sculpture, and he was one of the first British artists to produce completely abstract art: in 1914 he made an *Abstract Kinetic Collage Painting*, which was meant to be unrolled to the accompaniment of music by J. S. Bach (Tate). However, he did not work for long as an abstract painter and soon reverted to a figurative style. In 1913 he had begun working for the *Omega Workshops, and having discovered a taste and talent for interior decoration, he sought similar commissions when the Workshops closed in 1919. In this field he worked much in collaboration with Vanessa *Bell, with whom he lived from 1916 (although Grant was basically homosexual, he enjoyed a long and happy relationship with Bell, who bore him a daughter in 1918). Sir John *Rothenstein thought that his work showed 'a tasteful intelligence' but 'an insufficiency of passion'.

Further Reading: S. Watney, *The Art of Duncan Grant* (1999)

grattage *See* ERNST, MAX.

Graves, Morris (1910–2001) American painter, born at Fox Valley, Oregon. Between 1928 and 1930 he worked as a seaman on mail ships to the Far East, bringing him into touch with Oriental art, which had a deep and lasting effect on his work and outlook. As a painter he was mainly self-taught, although he had some instruction from Mark *Tobey (another artist inspired by Eastern culture), whom he met in about 1935. From 1932 to 1964 Graves lived in or near Seattle, then moved to Loleta in northwest California. His work has affinities with *Surrealism as well as Oriental traditions, but it speaks a highly individual symbolic and formal language that has little in common with the work of his contemporaries. He mainly painted birds and small animals, with a keen eye for characteristic attitudes and poses, and a highly personal sense of fantasy reflecting an inner mystical world. In his *American Art of the 20th Century* (1973) Sam Hunter wrote of him: 'A deeply religious man...Graves has made a tender, lyrical poetry from such images as a pine tree tremulously holding a full moon in its branches, or tiny birds and snakes, images which seem to be secreted rather than painted on canvas or paper. His art is rapt, visionary, hypnotic.' He worked for preference on Chinese or Japanese paper, finding 'a delight in the fragility, the transiency of the material'. In the 1960s he turned also to abstraction in the form of three-dimensional constructions. Graves travelled widely, had numerous one-man exhibitions, and won several awards. His work is in many public collections, notably the Morris Graves Archival Collection at the Museum of Art of the University of Oregon in Eugene.

Graves, Nancy (1940–95) American sculptor and painter, born at Pittsfield, Massachusetts. She studied at Vassar College and Yale University and won a scholarship for painting that took her to Paris, 1964–5. Later in 1965 she visited North Africa and the Middle East, and in 1965–6 she lived in Florence, then settled in New York. In Florence she began making the life-size, realistically painted sculptures of Bactrian camels for which she is best known; *Camels VI, VII,* and *VIII* (1968–9) are in the National Gallery of Canada, Ottawa. Graves also produced abstract sculpture in painted bronze, abstract paintings, and films. She was married to Richard *Serra.

Greaves, Derrick (1927–) British painter and graphic artist, born in Sheffield. After an apprenticeship with a sign-writer, he studied at the *Royal College of Art, 1948–52. While living and working in Italy from 1952 to 1953 he was strongly influenced by the Italian *Social Realist Renato *Guttuso. In the 1950s he was a leading figure of the *Kitchen Sink School, depicting dour subjects including views of his home town (*Sheffield*, 1953, City Art Gallery, Sheffield). The member of the group he was closest to was Edward *Middleditch, in collaboration with whom he painted a mural, *The Four Seasons* (1957), for Nuffield College, Oxford. He was the most openly political of the group, visiting Russia in 1957 with John *Berger's 'Looking at People' exhibition, and was an early supporter of the Campaign for Nuclear disarmament. However, he became disillusioned with figurative painting because of its failure to reach a large audience. In 1959 he wrote 'I made attempts to form a pictorial language from nature which would be easily accessible to all who cared to look. To do this in England at the present time . . . is, I have realised, aesthetic suicide.' His realist paintings had used heavy impasto. Now his paint became thinner, recalling his early training as a sign-painter. His subsequent more abstract work tends to emphasize colour rather than texture and reflects his admiration for the late collages of *Matisse and Ellsworth *Kelly. He has taught at several art schools and from 1983 to 1991 was head of printmaking at Norwich College of Art.

Further Reading: J. Hyman, *The Struggle for Realism* (2002)

Greaves, Walter (1846–1930) British painter and etcher, mainly of river scenes, landscapes, and portraits. He was the son of a London boatbuilder and waterman who used to ferry J. M. W. Turner across the Thames. In the early 1860s Walter and his brother Henry met *Whistler (a neighbour in Chelsea) and began to row him about the river, which was one of his favourite subjects. In about 1863 they became his unpaid pupils and studio assistants; they hero-worshipped him, and their unsophisticated attempts to imitate his stylish dress and manner caused much amusement. Walter continued to be associated with Whistler until the 1890s. He had painted even before he met Whistler, and his early work is in a detailed, almost *naive style; he soon came completely under the master's influence, however, and in his *Self-portrait* (*c.*1890, Tate) he is clearly trying to paint just like Whistler as well as to look just like him (on occasion he was in fact mistaken for him). However, he recognized a difference in outlook when it came to river scenes: 'To Mr Whistler a boat is always a tone, to us it was always a boat.' Greaves was poor and unrecognized for most of his life, but he became well known after a group of paintings (discovered in bad condition in a London bookshop in 1910) were exhibited as his work at the Goupil Gallery, London, in 1911 and the Cottier Gallery, New York, in 1912. Many critics hailed him as an unsung genius, but Joseph and Elizabeth Pennell (*see* WHISTLER) thought that at least some of the pictures were Whistlers that Greaves had retouched and signed. A great controversy followed (*Sickert was one of those who defended Greaves) and the matter was never entirely resolved, the authorship of some of the pictures still being disputed. In 1922 Greaves was admitted to the Charterhouse, a hostel for poor men, where he lived for the rest of his life.

Greco, Emilio (1913–95) Italian sculptor, born at Catania, Sicily. After an apprenticeship with a funerary stonemason he studied briefly at the Palermo Academy of Art, 1934. In 1943 he settled in Rome, where he was professor of sculpture at the Liceo Artistico, 1948–52. He then taught at the Carrara Academy, 1952–5, and the Naples Academy, 1955–67, before returning to Rome as professor at the Academy. His most characteristic works are in bronze, chiefly portrait busts and life-size (or slightly over-life-size) female nudes. The latter are tall and posturing, with a Mannerist elegance embodying witty parody of classical statues, as in

Large Bather I (1956, Tate). He did many other kinds of work, however, including the Pinocchio monument at Collodi (1956), three bronze doors for Orvieto Cathedral (1959–64), and the monument to Pope John XXIII in St Peter's, Rome (1965–6). There is a museum devoted to his work in Orvieto.

Green, Anthony (1939–) British painter, born in London, where he studied at the *Slade School, 1956–60. He specializes in scenes from his own middle-class domestic life portrayed on a large scale with loving attention to detail and an engaging sense of whimsy. Often he uses irregular *shaped canvases that accentuate his strange perspective effects, and his subjects are frequently erotic as well as humorous (*Our Tent, 14th Wedding Anniversary*, 1975, Rochdale Art Gallery). His work is instantly recognizable and is generally highly popular with visitors to the *Royal Academy summer exhibition, for he communicates with rare intensity the loving feeling that he puts into his painting: 'I do not remember people, rooms, tents, incidents from a fixed view-point—I just remember. I remember joy, sadness, colours, patterns, scale. I remember the personality of objects; radiators are hard and shiny, my wife's lips are red and soft and lip-like, my mother's hair is up and French and never down . . . all this I want in one image. It is who I am *now*.' In 1984 he published a book about his life and work, *A Green Part of the World*.

Green, William See ACTION PAINTING.

Greenberg, Clement (1909–94) American art critic, born in New York. He was his country's most influential writer on contemporary art in the period after the Second World War, when American painting and sculpture first achieved a dominant position in world art, his only serious rival being Harold *Rosenberg; in particular he was a major champion of *Abstract Expressionism. Greenberg studied at the *Art Students League and Syracuse University; before he became a full-time writer he worked as a clerk for the US Customs. He was regular art critic for the *Nation* from 1942 to 1949 and wrote for several other journals, including *Arts Digest* and *New Leader*. Some of his early writing in the left-wing *Partisan Review*, notably the article 'Avant-Garde and *Kitsch' (1939), was concerned with the social and political role of art and with reconciling this with an approach to criticism which ele-

vated the purely visual. He argued that in each of the arts there was an urge towards 'purity'—dissociation from other arts—and that in painting this resulted in a progressive emphasis on the flatness of the picture surface and the rejection of any form of illusionism: 'The history of avant-garde painting is that of a progressive surrender to the resistance of its medium; which resistance consists chiefly in the flat picture plane's denial of efforts to "hole through it" for realistic perspective space' ('Towards a Newer Laocoon', *Partisan Review*, July–August 1940). Although he claimed he made 'disinterested aesthetic' appraisals of art, Greenberg's early contacts with Marxism gave him a strong sense of history having an order and purpose, and this enabled him to endow his verdicts with a claim for historical certainty: 'in a period in which illusions of every kind are being destroyed the illusionist methods of art must also be renounced . . . Let painting confine itself to the disposition pure and simple of color and line, and not intrigue us by associations with things we can experience more authentically elsewhere' ('Abstract Art', *The Nation*, 15 April 1944). These ideas were developed in his most influential essay, 'Modernist Painting' (1960), in which he argued that a historical logic lay behind this development, traceable to the work of Manet (*see* MODERNISM), which proceeded through a form of 'self-criticism' carried out through practice rather than theory. It is an approach to art generally described as *'formalist', a term which Greenberg loathed, regarding it as 'one of the "isms" in the Bolshevik lexicon of abuse'.

Greenberg wrote on many of the leading Abstract Expressionists, but he is particularly associated with Jackson *Pollock. He praised his first one-man show in 1943, and in 1945 he wrote: 'Jackson Pollock's second one-man show . . . establishes him, in my opinion, as the strongest painter of his generation.' The artists he later championed included the sculptors David *Smith and Anthony *Caro and *Post-Painterly Abstractionist painters such as Morris *Louis and Kenneth *Noland, whose emphasis on pure flat colour was perfectly in line with his theoretical outlook. In contrast, he rejected the work of artists such as *Rauschenberg as mere 'novelty', and even Abstract Expressionist painters such as *de Kooning, whose strength lay in expressive gesture, were relegated to a lower category. He generally maintained that he was ultimately

following his taste rather than applying a theoretical model. Greenberg's influence was at its peak in the 1950s and 1960s, and he was unusual among critics in that artists valued his advice (in such matters as the cropping or hanging of paintings). A collection of his essays, *Art and Culture* (1961), was one of the best-known aesthetic texts of the time, as is shown by John *Latham's ceremonial destruction of a copy in 1966 as a protest against the dominance of its ideas. In the 1970s, however, Greenberg's influence waned in the face of developments such as *Conceptual art. The supposed freedoms offered by *Postmodernism made his critical concepts appear far too restrictive. The way in which he divorced art from social and ethical considerations was suspect to many younger writers, but his essays are still frequently reprinted as exemplifying a certain type of modernist criticism. The two most important younger critics influenced by him were Rosalind *Krauss and Michael *Fried. The first of these came to reject his ideas, the latter adapted them to take account of new developments. He fell out with both. In his later years he devoted himself to lecturing rather than writing. His *Collected Essays and Criticism* were published in four volumes in 1986–93. Greenberg also wrote monographs on *Miró (1948), *Matisse (1953), and *Hofmann (1961). *See also* AVANT-GARDE; MODERNISM.

Further Reading: F. Rubenfield, *Clement Greenberg: A Life* (1997)

Greene, Balcomb (1904–90) American painter, born at Niagara Falls. He began to paint seriously in 1931 without formal training, having previously studied psychology (he did postgraduate work under Freud in Vienna) and taught English literature. In 1931–3 he lived in Paris, and on his return to the USA settled in New York. By 1935 his style had become completely abstract and in 1936 he was the first chairman of the *American Abstract Artists association. From 1936 to 1939 he worked for the *Federal Art Project, painting several abstract murals in a severe geometrical style. In the 1940s representational elements entered his work (he sometimes showed figures fragmented against an abstract background), and from the late 1950s a new note of humanism, almost of existentialism, became apparent in many of his pictures. His wife **Gertrude Greene** (1904–56) was an abstract painter and sculptor.

Greer, Germaine (1939–) Australian feminist critic, principally active in Britain. While most of her professional activity has been as a literary critic and political commentator, she made one highly influential foray into art writing with her 1979 book *The Obstacle Race: The Fortunes of Women Painters and their Work*. By examining the work of women artists through history and the disadvantages which they suffered, it popularized what had been up until then an academic debate about the relevance of *feminism to the study of art, although it has been criticized as naive in its methodology by some art historians. Greer has since frequently written on art in the newspapers and commented on the subject on television. Unsurprisingly, a particularly significant subject has been the work of women artists, including Paula *Rego, who painted Greer for the National Portrait Gallery, London, and Stella *Vine.

Greffe, Léon *See* NAIVE ART.

Gregory, Eric *See* INSTITUTE OF CONTEMPORARY ARTS.

Gris, Juan (1887–1927) Spanish painter, sculptor, graphic artist, and designer, active mainly in Paris, where he was one of the major representatives of *Cubism. He was born in Madrid, the son of a wealthy merchant, and his real name was José Victoriano González. From 1902 to 1904 he studied in Madrid, probably in mathematics, physics, and engineering, then took up painting, training with a local academic artist. He had adopted his pseudonym by 1905, when he used it to sign published drawings. In 1906 he moved to Paris and soon moved into the *Bateau-Lavoir, where *Picasso was already living. He never returned to Spain, where he would have faced prison for evading military service. For the next few years he earned his living mainly with humorous drawings for various periodicals. He made the decision to become a serious painter in 1910. However, he made such rapid strides that by 1912 he was becoming recognized as the leading Cubist painter apart from the founders of the movement, Picasso and *Braque. His work stood out at the *Section d'Or exhibition in that year, attracting the attention of collectors and dealers (Gertrude *Stein was among those who bought his paintings and *Kahnweiler gave him a contract). As early as 1912, *Apollinaire recorded a (perhaps imaginary) spec-

tator describing Gris as 'the demon of logic' and this reputation has remained with him. He introduced into Cubism a more brilliant colour range and made considerable use of *collage technique. According to Kahnweiler his motives were eminently logical and rational. 'Why give the illusion of things that can be displayed in their actuality?', Gris asks, hence the newspaper cuttings and actual fragments of patterned paper. He said that he conceived of his paintings as 'flat, coloured architecture' and his methods of visual analysis were more systematic than those of Picasso and Braque. It is likely that he was influenced by the ideas of the mathematician Henri Poincaré (1854–1912), who argued that certain senses should be considered in detachment from the others in order to clarify understanding. In Gris's paintings, different aspects of objects are isolated and presented simultaneously within a grid format. His subjects were almost all taken from his immediate surroundings (mainly still-lifes, with occasional landscapes and portraits), but he began with the image he had in mind rather than with an object in the external world: 'I try to make concrete that which is abstract...*Cézanne turns a bottle into a cylinder, but I make a bottle—a particular bottle—out of a cylinder.'

Gris was able to continue working in Paris throughout the First World War, and in 1919 he had his first major one-man exhibition there, at Léonce *Rosenberg's Galerie de l'Effort Moderne. His work and ideas embodied, more than those of any other artist, the link between Cubism and the *Neoclassicism promoted by Rosenberg. In 1925 he stated that Cubism had been a reaction against the 'fugitive elements employed by the *Impressionists'. Instead 'painters felt the need to discover less unstable elements in the objects to be represented'. These elements were local colour instead of the momentary effects of light or 'actual quality' instead of 'visual appearance'. This accorded well with the Neoclassical insistence on 'permanent values'. Like other artists of his generation, Picasso, *Derain, and *Severini, he was fascinated by subjects from the *Commedia dell' Arte*. Christopher Green has argued that, far from being neutral vehicles for pure painting, Harlequin and Pierrot stand for two aspects of Cubism, respectively its inventiveness and its purity. In 1920 Gris became seriously ill, diagnosed with pneumonia, and from then on his health was often poor; for this reason he spent much of his time in the South

of France. He was only 40 when he died of cardiac asthma. His later rather looser paintings are generally regarded as inferior. This has usually been put down to the artist's health, but there is a case to be made that it was symptomatic of a wider malaise in the artists of his generation, which affected *de Chirico, Derain, and even Braque, as avant-garde impulses were set aside for the 'return to order'. Apart from paintings, his work included book illustrations, and set and costume designs for *Diaghilev. His only sculpture, a painted plaster figure (1917, Philadelphia Museum of Art), has been identified both as Harlequin and as bullfighter. He wrote a few essays on his aesthetic ideas and a collection of his letters, edited and translated by Douglas *Cooper, was published in 1956.

Further Reading: C. Green, *Juan Gris* (1993)

Grohmann, Will (1887–1968) German art historian, born at Bautzen, Saxony. He studied literature at university, but he became interested in art through exhibitions of Die *Brücke in Dresden, then formed friendships with several leading painters of the day. In the 1920s he published books on *Kandinsky (1924), *Kirchner (1925 and 1926), and *Klee (1929), but when the Nazis came to power in 1933 he was prevented from working (*see* DEGENERATE ART). He resumed his career after the Second World War and became professor of art history at the Hochschule für Bildende Künste in Berlin in 1948. From then until his death he published a succession of monographs on German art, including further studies of Kandinsky, Kirchner, and Klee. Several of his books were translated into English, and he also helped to introduce German art to a British audience through collaborating on catalogues of exhibitions held by *Marlborough Fine Art in London, for example 'Painters of the Bauhaus' in 1962.

Gromaire, Marcel (1892–1971) French painter, graphic artist, and designer, born at Noyelles-sur-Sambre of a French father and Belgian mother. He had no formal training, but from 1910 he frequented artists' studios in Paris, meeting pupils of *Matisse and getting advice from *Le Fauconnier. Before the outbreak of the First World War he visited the Netherlands, Belgium, Germany, and England; he was impressed by contemporary *Expressionism and also by the naturalism of the Old Masters of the Low Countries. He fought

in the war and was wounded in 1916. His early work was influenced by *Cézanne and the *Fauves, but after the war he looked more to *Léger, reducing his figures to bulky, simplified, rounded shapes. Later his style became looser and more expressionistic. He depicted a variety of subjects (although his main interest was in portraying the life of the people) and he did some of his best work as a decorative artist: with Jean *Lurçat he was primarily responsible for the renaissance of French tapestry design in the 1930s. He also did a good deal of graphic work.

Grooms, Red (Charles Rogers Grooms) (1937–) American sculptor, painter, filmmaker, and creator of *Happenings, born in Nashville, Tennessee. He studied in Nashville at the Peabody College, then at the Art Institute of Chicago, the New School for Social Research in New York, and Hans *Hofmann's summer school at Provincetown. In the late 1950s he was one of the pioneers of Happenings in New York, and in the 1960s he developed the type of work for which he is best known—mixed-media constructions or *environments 'in which he peoples entire rooms with cut-out figures and objects painted in brilliant and clashing colors . . . characterized by wild fantasy and broad slap-stick humor . . . rather like three-dimensional comic strips that are rooted in a precise observation of contemporary popular culture' (H. H. *Arnason in *Britannica Encyclopedia of American Art*, 1981). These are often on a very large scale, built with the aid of collaborators he calls the Ruckus Construction Co. Grooms has also often collaborated with his wife, the painter Mimi Gross (1940–), and with the film-maker Rudolph Burckhardt.

Gropius, Walter (1883–1969) German-born architect, designer, and teacher who became an American citizen in 1944. In 1919 he founded the *Bauhaus, of which he was director until 1928, when he resigned to resume his architectural practice in Berlin. In 1934, after the Nazis had come to power, he moved to England, and in 1937 he settled in the USA, where he had been offered the Chair of Architecture at the Graduate School of Design at Harvard University. He occupied this post until 1951 and remained active until the end of his life, with a long list of notable buildings to his credit. His architecture is characterized by an uncompromising use of modern materials (he was one of the pioneers in the use of a glass screen to form the entire outer wall of a building), but also by lucidity and gracefulness. Although Gropius's practical work was mainly in the fields of architecture and interior design, his influence on modernist trends in all the visual arts was enormous. At the Bauhaus he brought together an unprecedented collection of outstanding artists, and through their teaching his ideas gained international currency; left-wing in his political views, he believed that design should be a response to the needs and problems of society, utilizing to the full the resources of modern technology and expressing the ideal of a humane, integrated community.

Gropper, William (1897–1977) American graphic artist and painter. He was born in New York into a poor family (his father was a sweatshop garment worker), but he saved enough money from various menial jobs to study under George *Bellows and Robert *Henri at the Ferrer School, New York, 1912–13, and then at the National Academy of Design, 1913–14, and the New York School of Fine and Applied Art, 1915–18. In 1920 he joined the staff of *The New York Herald-Tribune* as a cartoonist, but he was soon dismissed because of his left-wing political sympathies and then worked as a freelance cartoonist, contributing to fashionable periodicals such as *Vanity Fair* as well as radical publications such as *The New Masses*. His Communist sympathies led him to make a lengthy visit to the USSR in 1927, during which he worked for the Party newspaper *Pravda* in Moscow; the following year he published a book entitled *Fifty-Six Drawings of the USSR*. He had begun painting in 1921 and in 1936 had his first one-man show at the ACA Gallery in New York. In the late 1930s he also painted several murals under the auspices of the *Federal Art Project. His paintings were closely related to his caricatures in subject and style; he was concerned with exposing social injustice, sympathizing with the downtrodden and attacking businessmen and politicians in a formally simplified, satirical manner bordering on *Expressionism (he has been called 'the Expressionist Daumier'). His best-known painting is probably *The Senate* (MoMA, New York, 1935). In his later years he moved from satire to themes of broader social concern, his work taking on a more spiritual feeling.

Grosman, Tatyana See PRINT RENAIS-SANCE.

Gross, Mimi See GROOMS, RED.

Grosz, George (1893–1959) German-born painter and draughtsman who became an American citizen in 1938. He was born in Berlin and studied drawing at the Dresden Academy, 1909–11, and the School of Arts and Crafts, Berlin, 1912–14. In 1914 he enlisted in the army, but he was discharged on medical grounds the following year (he was called up again in 1917, but again discharged as unfit). The war instilled in him a hatred of the Prussian military caste, which he attacked mercilessly in his work—the most famous of the satirical anti-war illustrations he made at this time is the drawing *Fit for Active Service* (1918, MoMA, New York), in which a fat, complacent doctor pronounces a skeleton fit for duty. In 1917, with *Heartfield, he anglicized his name (adding an 'e' to Georg) as a protest against the hatred being whipped up against the enemy, and he became overwhelmed with loathing for his countrymen: 'To be German means invariably to be crude, stupid, ugly, fat and inflexible—it means being unable to climb a ladder at forty, to be badly dressed—to be a German means to be a reactionary of the worst kind; it means only one amongst a hundred will, occasionally, wash all over.'

From 1917 to 1920 Grosz was a prominent figure in the *Dada movement in Berlin, and in the 1920s, with *Dix, he became the leading exponent of the *Neue Sachlichkeit. In 1917 he published the first of several collections of drawings, through which he established an international reputation. The most famous are *Das Gesicht der herrschenden Klasse* ('The Face of the Ruling Class', 1921) and *Ecce Homo* (1927). In these and in his paintings he ruthlessly denounced a decaying society in which gluttony and depraved sensuality are placed beside poverty and disease; prostitutes and profiteers were frequently among his cast of characters. Grosz often used watercolour, and in spite of the nastiness of the subject-matter and the bluntness of his satire, his works in this medium are remarkable for the sheer beauty and delicacy of their technique. His more conventional works of this time include a number of portraits, of which the best known is probably that of the poet Max Hermann-Neisse (1925, Kunsthalle, Mannheim), which rivals Dix's portraits in incisiveness.

Grosz was prosecuted several times for obscenity and blasphemy, and in 1933, despairing of the political situation in Germany, he moved to the USA to take up the offer of a teaching post at the *Art Students League of New York. (He had joined the Communist Party in 1918 and after he left Germany he was described as 'Cultural Bolshevist Number One'.) In America Grosz largely abandoned his satirical manner for more romantic landscapes and still-lifes, with from time to time apocalyptic visions of a nightmare future. Although he won several honours in the last decade of his life, he regarded himself as a failure because he was unable to win recognition as a serious painter rather than a brilliant satirist, and he painted several self-portraits showing how isolated and depressed he was in his adopted country (*The Wanderer*, 1943, Memorial Art Gallery, University of Rochester, New York). His autobiography, *A Little Yes and a Big No*, was published in New York in 1946. He returned to Berlin in 1959, saying 'my American dream turned out to be a soap bubble', and died there shortly after his arrival following a fall down a flight of stairs.

Further Reading: Royal Academy of Arts, *The Berlin of George Grosz* (1997)

Groupe de Recherche d'Art Visuel (GRAV) A group of *Kinetic artists formed in Paris in 1960. The members, who included *Le Parc, *Morellet, and *Yvaral, adopted a scientific approach and investigated the use of modern industrial materials for artistic purposes. As well as creating individual pieces, they often worked together on anonymous collective projects, and it was one of their aims to produce art that called for involvement from the spectator (they were much concerned with the idea of 'ludic' art, or the art of the game). The group had its base at the Galerie Denise *René, but on various occasions it attempted to bring art into the life of the streets. One event was called *A Day in the Street* when in April 1966 they took a van around Paris confronting the public with objects such as a giant kaleidoscope and a sculpture which could be climbed on and off. The group disbanded in 1968.

Groupe Espace An association founded in Paris in 1951 by André *Bloc and artists

associated with his journal *Art d'aujourd'hui*. The members of the group included Jean *Gorin, Edgard Pillet (1912–96), and Nicolas *Schöffer. Their object was to promote the part of *Constructivist doctrine that formed the subject of the last paragraph of *Mondrian's essay 'Plastic Art and Pure Plastic Art', namely that Constructivist art, united with architecture, should create a new environment appropriate to the new society that was to emerge in the modern age. They envisaged a 'public art', art as a social and collective—not an individual—phenomenon.

Group of Plastic Artists (Skupina Výtvarných Umělcu) A splinter group of progressive Czech artists that broke away from the *Mánes Union in Prague in 1911 and flourished up to the First World War. The leading members of the group were Vincenc Beneš (1893–1979), Josef *Čapek, Emil *Filla, Otto *Gutfreund, and Antonín Procházka (1882–1945). Stylistically they combined *Cubism with *Expressionism, along with some *Futurist influence after 1913. The group published a journal *Umělecký měsíčník* (Art Monthly) from 1911 to 1914 and held six exhibitions in Prague between 1912 and 1914; at two of these, works by leading contemporary painters from other countries were shown (among them *Braque, *Gris, *Munch, *Pechstein, and *Picasso). The members were in touch with the artists of Die *Brücke in Germany and in 1913 they showed as a group in the *Sturm Gallery in Berlin. Closely associated with the group was the art historian Vincenc Kramář (1877–1960), who formed a superb collection of Cubist art. He became director of the National Gallery in Prague and bequeathed his collection to the nation.

Group of Seven Group of Canadian painters, based in Toronto, who found their main inspiration in the landscape of northern Ontario and created the first major national movement in Canadian art. The group was officially established in 1920, when it held its first exhibition, in the Art Gallery of Toronto, the seven painters involved being Frank Carmichael (1890–1945), Lawren *Harris, A. Y. *Jackson, Frank Johnston (1888–1949), Arthur Lismer (1885–1969), J. E. H. *MacDonald, and Fred Varley (1881–1969). Some members of the group had, however, been working together since 1913, and Tom *Thomson, who was one of the early leaders, had died in 1917.

Johnston resigned in 1926 and was replaced by A. J. Casson (1898–1992), and two other artists later joined, bringing the numbers up to nine: in 1930 Edwin Holgate (1892–1977), best known for his female nudes in landscape settings, and in 1932 LeMoine FitzGerald (1890–1956). The members made group sketching exhibitions and worked in a forceful *Expressionist style characterized by brilliant colour and bold brushwork. After initial critical abuse, they won public favour, and Emily *Carr was inspired by their example. The group held its last exhibition in 1931 and two years later it was disbanded and superseded by the *Canadian Group of Painters.

Group X A short-lived association of British artists, including some former members of the *Vorticist movement, formed in 1919 with the aim of providing a focus for London's avant-garde and an alternative exhibiting venue to that of the *London Group. The association, whose name seems to have had no particular significance, held only one exhibition, in 1920, at the Mansard Gallery. Wyndham *Lewis, who wrote the introduction to the catalogue, was the leading figure of the group. The other members were Jessica *Dismorr, Frank *Dobson, Frederick Etchells (*see* REBEL ART CENTRE), Charles *Ginner, Cuthbert Hamilton (1884–1959), E. McKnight *Kauffer, William *Roberts, John Turnbull (active 1919), whose paintings of aircraft were highly praised by Ezra *Pound, and Edward *Wadsworth.

Gruber, Francis (1912–48) French painter, born in Nancy, the son of a stained-glass designer. In 1916 the family moved to Paris. Gruber suffered from asthma as a child and was unable to have a normal education, but the artistic talent he showed from an early age was encouraged by his father and by his neighbours *Bissière and *Braque, who gave him private instruction. In 1929–32 he studied at the Académie Scandinave under *Dufresne and *Friesz, and in 1930 he had his first public success at the *Salon d'Automne; after this he rapidly made a name for himself, in spite of his youth. His early work was often of visionary subjects, but from about 1933 he began to paint mainly from the model in the studio; he also did still-lifes, views through windows, and from 1937 landscapes painted out of doors. Gruber's characteristic style was grave and melancholy, featuring long, drooping figures, and he is regarded as the founder of the

'Misérabiliste' strain in French painting, later associated chiefly with Bernard *Buffet. As one critic put it, 'His sky is never warm enough to take away the goose flesh'. A typical work is *Job* (1944, Tate) painted for the 1944 Salon d'Automne, which was known as the Salon of the Liberation because it was held soon after Paris was freed from the German occupation; the picture symbolizes oppressed peoples, who like Job in the Bible had endured a great deal of suffering. In spite of the tuberculosis that caused his early death, Gruber worked with great energy and had a substantial output. His friends remembered him as 'an overpowering gay blade who talked, drank, and painted at a furious clip'.

Guerrilla Art Action See ART WORKERS' COALITION.

Guerrilla Girls A group of women artists founded in New York in 1984 to combat what they considered sexism and racism in the art world. Jonathan Fineberg writes that 'After the Museum of Modern Art held its vast "International Survey of Contemporary Art" in 1984, in which almost no women or minorities were included, a number of professional women in the New York art world founded this collective organization. The Guerrilla Girls appeared on television (wearing gorilla masks to maintain their anonymity), they advertised, and distributed leaflets and posters to bring attention to the widespread race and gender discrimination that exists in the art world' (*Art Since 1940*, 1995). One of their posters shows a reclining female nude by Ingres, with the woman's head replaced by a gorilla's and accompanied by the words: 'Do women have to be naked to get into the Met. Museum? Less than 5% of the artists in the Modern Art Sections are women, but 85% of the nudes are female.' The group's activities were documented in a book published in 1995, *Confessions of the Guerrilla Girls (Whoever They Really Are)*. It includes an essay by the American art historian Whitney Chadwick (1943–), who has written widely on *feminist issues in art, notably in her book *Women, Art, and Society* (1990).

Guevara, Alvaro See SITWELL.

Guggenheim, Solomon R. (1861–1949) American industrialist, collector, and philanthropist, a member of a famous family of financiers whose fortunes were based on the mining and smelting of metals. Like other members of

the family, he devoted much of his vast wealth to philanthropy and in 1937 he founded the Solomon R. Guggenheim Foundation 'for the promotion and encouragement of art and education in art'. He started to collect art seriously soon after the turn of the century. In the later 1920s, he began to focus his attention on abstract painting, influenced by his friend Baroness Hilla Rebay von Ehrenweisen (1890–1967), herself an avant-garde artist. In 1939 the collection was first opened to the public in a gallery at 24 East 54th Street, New York, with the Baroness as director. It was called the Museum of Non-Objective Art. In 1943 Guggenheim commissioned Frank Lloyd Wright to design a museum to house the collection and it was opened in 1959, a decade after the founder's death. The name had been changed to the Solomon R. Guggenheim Museum in 1952, this more neutral title reflecting the broadening scope of the collection, which had grown to include sculpture as well as painting and many types of avant-garde art other than abstraction. It ranges from late 19th-century to contemporary art and includes examples by virtually all the major avant-garde artists of the time. Its chief glories include the world's largest collection of *Kandinsky's work. The museum is famous for its architecture as well as for its contents. The building—the last great work of America's most illustrious architect—marks a complete departure from traditional museum design, the exhibition space being a continuous spiral ramp, six 'storeys' high, encircling an open central space. It is architecturally exhilarating, but its suitability for displaying paintings and sculpture has been much questioned: some people think that the building upstages the exhibits. In 1992 an annexe and another branch in SoHo were opened, making available more conventional spaces for the display of art.

Guggenheim's niece, **Peggy Guggenheim** (1898–1979), was a patron, collector, and dealer who played an important role in promoting avant-garde art, in particular by helping to introduce *Surrealism to the USA and by furthering the careers of many leading *Abstract Expressionists. Her father, Benjamin Guggenheim, died when the *Titanic* sank in 1912, leaving her a substantial inheritance (although she was not as rich as some people assumed). She moved to Europe in her early 20s, living mainly in Paris, and in 1938 opened a gallery in London, Guggenheim Jeune, at which she organized exhibitions of *abstract and Surrealist art. In 1941 she left war-torn Europe for the

USA and in 1942 opened a gallery entitled Art of This Century in New York. She attended the opening 'wearing a tiny pink landscape by Yves *Tanguy on one ear-lobe and a metal and wire mobile by Alexander *Calder on the other in an attempt to demonstrate equal respect for Surrealist and abstract art. The gallery was both an exhibition space for young artists and a place to display Guggenheim's growing private collection...Guggenheim's frenzied whirl of parties and openings set the New York art world spinning, offering young American artists the chance to associate with the European avant-garde. Her support of *Pollock and encouragement of Robert *Motherwell, Hans *Hofmann, Clyfford *Still, Mark *Rothko and Adolph *Gottlieb made her the chief patron of the *New York School in its infancy' (catalogue of the exhibition 'American Art in the 20th Century', Royal Academy, London, 1993). Guggenheim had affairs with several artists and was briefly married to Max *Ernst. In 1947 she closed Art of This Century and returned to Europe, settling in Venice, where she founded another gallery. Her own superb collection is open to the public in Venice under the administration of the Solomon R. Guggenheim Foundation.

In 1997 a new Guggenheim Museum opened in Bilbao, Spain, financed by the Basque regional government. Designed by the American architect Frank Gehry (1929–), it is one of the most spectacular museum buildings in the world—huge, eccentric in shape, and clad largely in titanium; writing in *The Observer*, Robert McCrum described it as 'half Martian space-craft, half Californian Bacofoil fantasy'. It is intended particularly for the display of contemporary works that are too large to be shown in the Guggenheim Museum in New York, and one of its rooms is more than 100 metres long. Several artists were commissioned to produce work for this space, including Richard *Serra (a friend of the architect), who created *The Snake*, a massive piece in rolled steel, with sinuous curves echoing the forms of the building. There are now also branches in Berlin and Las Vegas (in alliance with the State Hermitage Museum, St Petersburg), giving rise to the idea that 'Guggenheim' has become a global art brand.

Guiette, René See MATTERISM.

Guillaume, Paul (1891–1934) French art dealer, collector, and publisher. He opened his first gallery in 1914 with an exhibition of Mikhail *Larionov and Natalia *Goncharova. He later showed *Derain, *Matisse, and *Picasso. He was far more flamboyant in the marketing of modern art than were *Vollard and *Kahnweiler. *Apollinaire helped publicize his activities in his articles and Guillaume published a review, *Les Arts à Paris* (1918–35), which promoted his gallery's artists. (The final issue was edited posthumously by his wife.) Albert *Barnes was both an important client and a contributor to the publication. The two men shared an admiration for African and Oceanic art and articles on these were a regular feature of the review. Guillaume's collection is now on view at the Musée de l'Orangerie in Paris.

Guino, Richard See RENOIR, PIERRE-AUGUSTE.

Gupta, Shilpa See COMPUTER ART.

Gupta, Subodh (1964–) Indian sculptor and installation artist, born in Khagaul, Bihar, and now based in New Delhi. Before becoming an artist, he worked for a theatre company and a certain sense of theatrical flair marks his art work, which makes use of materials traditionally associated with Indian identity, especially the cooking pot. For instance, *Sister* (2005, Pompidou Centre) has a pile of these pots underneath a table on which is projected a film of traditional Indian ceremonies. *Very Hungry God* (2006, Pinault collection, Palazzo Grassi, Venice) is a skull made entirely from such pots. Another material with special cultural associations used by Gupta is cow dung. In the video *Pure* (2000), he is seen covered with manure and slowly hosed down, a reference to the use of the substance for spiritual cleaning in Indian villages.

Further Reading: R. Ramesh, 'The Damien Hirst of Delhi', *The Guardian* (20 February 2007)

Gursky, Andreas (1955–) German photographer, born in Leipzig. He grew up in Düsseldorf, the son of a commercial photographer. A student of photography under Bernd and Hilla *Becher, he has become one of the most successful exponents of the large-scale photograph. He works in colour and, since the 1990s, has sometimes applied digital manipulation to the image. His subjects are taken from the commercial and financial worlds, a theme which allows Gursky, by working from a distance, to reveal an almost choreographed order of

movements within the apparent variety. *Singapore Stock Exchange* (1997, Guggenheim Museum, New York) is typical in the way it exploits the colour-coded jackets of the exchange members. Landscape has also been a theme of Gursky's work, but his best-known piece is probably *99 cent* (1999). This is a view of a vast and empty discount store, its goods united by the same low price. Tate curator Emma Dexter describes this as an example of 'terrifying toxic sublime' and perhaps Gursky's most significant achievement is to invoke that sense of awe, traditionally associated with the natural world, in the most banal manifestations of contemporary life. Alix Ohlin who has described Gursky's work as a 'map of the postmodern civilized world', has argued that this is because the 'sprawling network of technology, government, business and communications' has left us with a similar sense of powerlessness that we once felt in relation to God.

Further Reading: A. Ohlin, 'Andreas Gursky and the Contemporary Sublime', *Art Journal*, vol. 61, no. 4 (2002)

Guston, Philip (1913–80) American painter. He was born in Montreal and grew up in Los Angeles, where he was a schoolfriend of Jackson *Pollock. In 1930 he spent a few months at the Otis Art Institute, Los Angeles, but otherwise he was self-taught as an artist. After travelling in Mexico in 1934, studying the work of *Orozco and *Rivera in particular, he settled in New York and from 1934 to 1941 worked as a muralist on the *Federal Art Project. In 1941 he moved to Iowa City to teach at the State University there, and in 1945–7 he was the artist-in-residence at Washington University, St Louis. After leaving New York he switched from mural to easel painting, and during the 1940s his work changed in another fundamental way, moving from social and political subjects to abstraction; by 1950 (when, after travels in Europe, he settled in New York again) he had eliminated all figurative elements from his work. His most characteristic paintings of this period feature luminous patches of overlapping colours delicately brushed in the central area of a canvas of light background (*Dial*, 1956, Whitney Museum, New York). This manner of his has been described as *'Abstract Impressionism' and he was associated with the more lyrical wing of *Abstract Expressionism—he was the only member of the group who had already had a successful career as a figurative painter.

During the 1960s shades of grey encroached on the earlier brilliance of colour and vague naturalistic associations crept in. By the late 1960s he had returned to figurative painting in a satirical, garishly coloured, cartoon-like style, drawing on *Herriman's *Krazy Kat* and especially the counter-culture's favourite illustrator, Robert Crumb (1943–). Hooded figures, either Ku Klux Klan or penitents (perhaps both), were a motif seen driving, drinking, smoking, even painting. These are now among his most admired works, recognized as an important source for *Neo-Expressionism, although when first exhibited at the *Marlborough Gallery, New York, in 1970 they had a mixed reception: the influential Hilton *Kramer gave his review the headline 'A Mandarin Pretending to be a Stumblebum'. Harold *Rosenberg, however, wrote that 'Guston has demonstrated that the apparent opposition between quality in painting and political statement is primarily a matter of doctrinaire aesthetics.' At this time Guston had written in a note-book that 'American abstract art is a lie, a sham, a cover-up for a poverty of spirit' and that it was 'a mask to mask the fear of revealing oneself'. Indeed a strong element of self-revelation is as much a feature of the late work as social criticism. Guston and Rosenberg alike seemed to be seeking in figuration not so much an attack on Abstract Expressionism but an attempt to revitalize its deadly seriousness.

Further Reading: D. Ashton, *A Critical Study of Philip Guston* (1992)

M Auping (ed.), *Philip Guston* (2003)

Gutai Group (Gutai Art Association) A group of Japanese avant-garde artists founded at Osaka in 1954; the name means 'embodiment'. Jiro *Yoshihara was the group's leader; he was appreciably older than the other members of the group, and his personal wealth was largely responsible for financing their activities. These were varied, but the group was best known for *Performance art. In 1960, for example, it produced a Sky Festival: 'Large balloons bearing banners by the artists, and some invited foreigners like Lucio *Fontana and Alfred *Leslie, were released from the roof of a department store in Osaka, recalling a similar piece by Yves *Klein done in 1957' (Adrian Henri, *Environments and Happenings*, 1974). The Gutai artists also produced *Action Paintings using extremely unconventional techniques. The group held numerous exhibitions and published fourteen numbers of its magazine before breaking up following Yoshihara's death in 1972.

Gütersloh, Albert Paris von (1887–1973) Austrian painter, graphic artist, and writer, remembered mainly as a teacher. He was originally called Albert Conrad Kiehtreiber, but he adopted a pseudonym for his writings (he published several novels) and took Gütersloh as his official name in 1921. Early in his career he was an actor and stage designer (using the name Albert Matthäus) and later he worked as a journalist. He was self-taught as a painter. From 1919 to 1938 he taught at the Vienna School of Arts and Crafts, bringing new life to the department of tapestry design, and from 1945 until his retirement in 1962 he was a professor at the Vienna Academy, where his teaching was influential on the group of artists who created the *Fantastic Realism movement. His other pupils included *Kitaj.

Gutfreund, Otto (1889–1927) Czech sculptor. After training in Prague, he spent several months in Paris, 1909–10. He worked under *Bourdelle at the Académie de la Grande Chaumière, but he was inspired more by paintings he saw by *Braque and *Picasso and he became one of the first artists to try to apply the principles of *Cubism to sculpture. On his return to Prague in 1911 he became a member of the *Group of Plastic Artists who attempted to fuse Cubism with *Expressionism. An example of his work from this time is *Cubist Bust* (1912–13, Tate). In the First World War he fought with the French Foreign Legion and was taken prisoner. He returned to Prague in 1920 and in his later work developed a more naturalistic style based on folk art. He committed suicide by drowning.

Guthrie, Sir James (1859–1930) Scottish painter. In the 1880s and 1890s he was one of the *Glasgow Boys and made *Impressionist-influenced paintings of rural life, close to the style of *Clausen (*Little Villagers*, 1884, Museum voor Schone Kunsten, Ghent). For a few years he also kept a studio in London, but in 1902 he was elected president of the Royal Scottish Academy (the youngest person ever to hold this office) and moved to Edinburgh. He retired from the post in 1919 and intended devoting himself quietly to his own work, but later that year he received a commission from the National Portrait Gallery in London that occupied him for most of the rest of his life. This was for the huge group portrait *Statesmen of World War I*, completed in 1930, shortly before his death.

Guttuso, Renato (1912–87) Italian painter, born at Bagheria, near Palermo, in Sicily. He was a forceful personality and Italy's leading exponent of *Social Realism in the 20th century; although he never subordinated artistic quality to political propaganda, his art was often the direct expression of his hatred of injustice and the abuse of power. In 1931 he abandoned legal studies for painting, in which he was mainly self-taught. He settled in Rome in 1937 and in the following year became a founder member of the anti-Fascist association *Corrente. Fascism was not his only target, however, for he also pilloried the Mafia and in 1943 published a series of drawings protesting against the massacres that took place under the German occupation of Italy. His most famous painting of this time is probably the *Crucifixion* (1941, Galleria Nazionale d'Arte Moderna, Rome), which caused a public outcry when it won an award at a competition in Bergamo in 1942. It was attacked by the Catholic Church because of its modernity and use of female nudity. After the war (in which he worked with the Resistance) Guttuso became a member of the *Fronte Nuovo delle Arti in 1946. His post-war works were often inspired by the struggles of the Sicilian peasantry, and his other subjects included the 1968 student riots in Paris, a city he often visited (he was widely travelled and his work was admired and influential in Eastern Europe). Many of his paintings were large, with allegorical overtones, typically painted in a vigorous *Expressionist style. His interest in the history of art provided him with a major theme in his work, separate from his political and social concerns, and he introduced visual 'quotations' from *Picasso and other artists into his own paintings. However, there was a completely different side to his work, for he also painted simple and direct still-lifes. Bernard Berenson, the famous connoisseur of Renaissance art, called Guttuso 'the last painter in the great tradition of Italian art'.

Gwathmey, Robert (1903–88) American painter and printmaker, born in Richmond, Virginia. He studied at North Carolina State College, 1924–5, the Maryland Institute of Design, Baltimore, 1925–6, and the Pennsylvania Academy of the Fine Arts, Philadelphia, 1926–30. Up to his retirement in 1968 he taught at

various colleges, notably the Cooper Union School, New York, 1942–68. In 1939 he was a prizewinner in the government-sponsored Forty-Eight States Mural Competition, but he is better known for his easel paintings. His favourite subject was rural black workers in the Southern states, and his paintings often had strong social implications, castigating poverty and oppression, with occasional use of satire. However, he did not paint naturalistically, simplifying his subjects into strongly patterned designs featuring flat colours and bold outlines. He worked slowly and exhibited rarely.

H

Haacke, Hans (1936–) German artist, active mainly in the USA, who has been especially associated with the idea of 'institutional critique', a kind of political art that examines the very institutions in which it operates. He was born in Cologne, studied in Kassel, and first went to the USA on a Fulbright travelling scholarship in 1961, since when he has taught and exhibited widely there, living mainly in New York. His early work, a form of *Kinetic art, was much concerned with movement, light, and the reaction of objects with their environment. His interest in ecological systems led him to social systems through his reading of Ludwig von Bertallanfy's (1901–72) *General Systems Theory* (1968). From this he concluded that 'there is no break between the social world, the physical and biological world'. This, combined with the radicalization of his generation as a result of protests against the Vietnam War, drew him towards the political work for which he is best known. This has led to frequent controversy, not just because of the political dimension as such, but also because of the way in which the politics of the institutions with which he works are exposed and open to criticism. As the art historian Rosalyn Deutsche put it, his work is not just '*site-specific but politically site-specific'. An early indication of things to come was the cancellation of his 1971 exhibition at the Guggenheim Museum, 'Real Time Social System'. Here he exposed the activities of slum landlords in New York. The director of the museum, Thomas Messer, accused Haacke of making the work from 'ulterior motives' which were in conflict with aesthetic aims. In an interview many years after the event, he claimed that he might have taken a different approach had not Haacke named specific individuals. Nonetheless, in the immediate aftermath it appeared that the battle lines had been drawn between a younger generation of radicals and a museum establishment committed to a depoliticized conception of *formalism. In 1974 Haacke exhibited a work which presented information

about the members of the Guggenheim Museum's board, showing their family and business interests. The effect was to question the extent to which the museum might be guided by financial and social interests which could be very much at odds with those of artists or indeed of much of the museum's public. His examination of the way in which aesthetic and political concerns interact was demonstrated both elegantly and provocatively in *Manet-PROJEKT 74*, made for the exhibition 'Kunst Bleibt Kunst' ('Art is still art') held at at the Wallraf-Richartz Museum, Cologne, in 1974. He showed the ownership history of an apparently politically neutral work, Manet's *Bunch of Asparagus* (1880). This picture had been presented to the museum as a permanent loan by Herman J. Abs, the chairman of the Friends of the Museum. The panels charted how the work had passed from early supporters of the artist, who were frequently Jewish. Abs had in his early life been active as a businessman during the Third Reich. Like the Guggenheim piece, the work was removed by the museum, although as a gesture of support another participant, Daniel *Buren, pasted photocopies of Haacke's work over his own contribution.

In his series *The Chocolate Master* (1981), which exists both as a series of panels for exhibition and in book form, Haacke explores the activities of the collector and chocolate manufacturer Peter *Ludwig, presenting evidence that for him art was a tool for political influence. Here and elsewhere he apes the slickness of the advertising used by the corporations he attacks. This can sometimes open him to the charge that his work is stronger on rhetoric than analysis. For instance, his exhibition 'Sanitation', held at the Whitney Museum, New York, in 2000, was accused of trivializing the Holocaust by presenting statements about culture by the mayor of New York, Rudolph Giuliani, and other conservative politicians in the Gothic script favoured by the Nazis. Haacke's gift for visual rhetoric and sense of history were

exercised most powerfully in the German Pavilion at the 1993 Venice *Biennale, when he showed an installation entitled GERMANIA. The Pavilion itself dates from the Nazi period, having been built for the 1938 exhibition. On entering, the visitor passed by a false wall on which was a photograph of Hitler at the 1934 Biennale and then under a large plastic Deutschmark dated 1990 to refer to German reunification. When the main space was reached it was discovered that the floor has been shattered with a hammer. Marcia Vertrocq described this as 'a terse, desolate image of the spiritual fragmentation at the heart of today's Germany' (*Art in America*, September 1993). *See also* SAATCHI.

Further Reading: B. Wallis (ed.), *Hans Haacke: Unfinished Business* (1986)

(⊕) SEE WEB LINKS

- Hans Haacke interview with Thomas Messer, giving his side of story of cancellation of Guggenheim exhibition., on the website of the Smithsonian Institute Archives of American Art.
- Hans Haacke lecture at Tate (23 June 2007).

Hacker, Arthur *See* NEW ENGLISH ART CLUB.

Hadengue, Sébastien *See* KAHNWEILER, DANIEL-HENRI.

Haftmann, Werner (1912–99) German art historian and administrator. He was born in Glowno (now in Poland) and studied at the universities of Berlin and Göttingen. From 1935 he worked at the Kunsthistorisches Institut in Florence. After the Second World War he settled in Hamburg, where he taught history of art and worked as a freelance writer. From 1967 to 1974 he was director of the Nationalgalerie, Berlin. His major work is *Malerie im 20 Jahrhundert* (2 vols, 1954; 2nd edn, 1957), translated as *Painting in the Twentieth Century* (2 vols, 1961; 2nd edn, 1965). This is the most detailed survey of its type, and the second English edition contains more than a thousand illustrations. The book still has valuable insights to offer, although its language and theory, heavily influenced by idealist philosophy, can be problematic for the contemporary reader. For Haftmann, modern art is identified with the world of the spirit. The great modern artists who look intensely from the cover, *Picasso, *Kokoschka, *Marc, and *Chagall, are the visionaries who grasp that spirit. His other writings are mainly monographs on 20th-century artists, including *Nolde (1958), *Nay (1960), *Wols (1963), Chagall (1972 and 1975), and *Uhlmann (1975). He was also one of the organizers of the exhibition 'German Art of the Twentieth Century' at the Museum of Modern Art, New York, in 1957. With Arnold Bode, he was responsible for the first three *documenta exhibitions in Kassel.

Hague, Gemeente Museum *See* GEMEENTE MUSEUM.

Haines, Lett (Arthur Lett-Haines) *See* MORRIS, SIR CEDRIC.

Hains, Raymond *See* AFFICHISTE.

Hairy Who *See* NUTT, JIM.

Halicka, Alicia *See* MARCOUSSIS, LOUIS.

Hall, Fred *See* NEWLYN SCHOOL.

Halley, Peter (1953–) American painter, born in New York. While studying at Phillips Academy, Andover, Massachusetts, he read *The Interaction of Colour* by Josef *Albers. He graduated in art history from Yale University in 1976. Halley has been one of the leading figures of the *Neo-Geo movement, the term itself being more applicable to him than most of the other artists to which it has been applied. His paintings took the devices of geometric abstraction of the early 20th century but stripped them of their idealist philosophy and Utopian aspirations. Their designs tend to recall electrical circuits or conduits of information. The implicit architectural metaphors of early abstractionists have become signs for the apparatus of social control. Halley is an intellectually sophisticated theorist who has drawn on thinkers such as Jean *Baudrillard. Nonetheless, the considerable appeal which his paintings have had for collectors probably owes more to his skill in the manipulation of colour than to the intellectual weight they bear.

Further Reading: D. Birnbaum, 'Peter Halley', *Artforum International* (September 1999)

Hambling, Maggi (1945–) British painter and sculptor. She was born in Hadleigh, Suffolk, and studied at the East Anglian School of Art (with Cedric *Morris and Arthur Lett-Haines), 1960, Ipswich School of Art, 1962–4, Camberwell School of Art, 1964–7, and the *Slade School, 1967–9. Her style is

colourful and energetic and she is perhaps best known for her vigorous portraits, such as that of the eminent chemist Dorothy Hodgkin (1985, NPG, London). She has also painted series on the comedian Max Wall, on the mythological figure of the Minotaur, and on the sun. In 1980–81 she was the first artist-in-residence at the National Gallery, London, and in the mid-1980s she became well known for her trenchant views on art as a panellist on the television show *Gallery*, in which George *Melly and Frank *Whitford also appeared. She has also made prints and recently sculpture, notably a memorial to Oscar Wilde (1998, Adelaide Street, Trafalgar Square, London) and *Scallop* (2003), on the beach at Aldeburgh, Suffolk, to commemorate Benjamin Britten.

Hamilton, Cuthbert *See* GROUP X.

Hamilton, George Heard (1910–2004) American art historian. For most of his career he was associated with Yale University, where he studied (BA, 1932; MA, 1934; PhD, 1942) and then taught from 1936 to 1966 (he was appointed a professor in 1956). During this time he was also a curator of modern art at Yale University Art Gallery. From 1966 to 1977 he was director of the Sterling and Francine Art Institute in Williamstown, Massachusetts, and from 1966 to 1975 professor of art at its sister institution, Williams College, Williamstown. His best-known book is *Painting and Sculpture in Europe 1880–1940* (1967) in the Pelican History of Art series. This is an authoritative and readable introduction to its subject and has been revised and reprinted several times, although it is now dated in its approach and the serious student needs to complement it with more recent literature. He was a friend of Marcel *Duchamp and translated works by and about him.

Hamilton, Richard (1922–) British painter, printmaker, teacher, exhibition organizer, and writer, one of the leading pioneers of *Pop art. He was born in London and after leaving school at fourteen worked in advertising and commercial art whilst attending evening classes in painting. He then studied at the *Royal Academy in 1938–40 and 1946 (interrupted by war service as an engineering draughtsman) and at the *Slade School, 1948–51. In 1952 he became a member of the *Independent Group and in 1956, with other members, he helped to organize the exhibition 'This is Tomorrow' at the Whitechapel

Art Gallery. Hamilton's photomontage *Just What Is It that Makes Today's Homes So Different, So Appealing*? (1956, Kunsthalle, Tübingen) was used as a poster for the exhibition; a comment on consumerism and suburbia, it is made up of advertising images (including a lollipop bearing the word 'Pop') and is sometimes considered to be the first Pop art work. The general tenor of his work has been more analytical and cerebral than that of other British painters identified with Pop art. In 1960, he provoked heated debate with his article 'Persuading Image', which argued for the highly commercial American approach to industrial design that had as its overt aim the manipulation of the consumer. His admiration for such design was expressed in *Hommage à Chrysler Corp* (1957, Tate). Here he exalts the fusion of motor car with the science fiction imagery of the 'Bug-Eyed Monster' and emphasizes the sexualization of design by drawing analogies with the female body. *$he* (1958–61, Tate) depicts a woman in the kitchen with refrigerator and toaster. Commenting on the picture Hamilton wrote that 'sex is everywhere, symbolized in the glamour of mass produced luxury—the interplay of fleshy plastic and smooth, fleshier metal'.

In his early years he was a slow-working artist. His Pop works were not exhibited together until 1964 (Hanover Gallery, London) at a time when younger British Pop artists like *Blake and Allen *Jones were already well-known figures. In that year he made one of his most overtly political works, the *Portrait of Hugh Gaitskell as a Famous Monster of Filmland* (Arts Council Collection). This superimposed over a blown-up photograph of the recently dead leader of the Labour party the make-up worn by Claude Rains in the 1943 film *Phantom of the Opera*. Hamilton, a fervent supporter of nuclear disarmament, was protesting against Gaitskell's policies on this issue. Later in the decade, Hamilton became more prolific. The relationship between photography and celebrity was treated in the *Swingeing London* series of 1968-9, based on newspaper images of his dealer Robert Fraser (*see* DINE) and the rock star Mick Jagger handcuffed in a car after being arrested for drugs offences.

Hamilton has made a number of works reflecting on the conflict in Northern Ireland. The first of these, *The Citizen* (1981-3, Tate), shows a Republican prisoner involved in what

was known as the 'dirty protest', in which the prisoners refused prison clothing and smeared the walls with excrement. He has also played a significant role as an organizer of exhibitions (notably 'The Almost Complete Works of Marcel *Duchamp' at the Tate Gallery, London, in 1966, for which he made a reconstruction of Duchamp's *The Bride Stripped Bare by her Bachelors, Even*, now in Tate's collection). He has also had a distinguished career as a teacher, notably at King's College, Newcastle upon Tyne (later Newcastle University), 1953–66. An anthology of his writings, *Collected Words*, appeared in 1982. His second wife (whom he married in 1991) is the painter Rita Donagh (1939–), who has also made works dealing with the politics of Northern Ireland.

Further Reading: R. Morphet, *Richard Hamilton* (1992)

Hamilton Finlay, Ian (1925–2006) Scottish artist and poet, born in Nassau, Bahamas, of Scottish parents. His father had gained and lost a fortune by smuggling. He studied briefly at *Glasgow School of Art, but originally attracted attention as a poet. In 1963 he began making *Concrete poetry, in which the physical appearance of the poem—its shape and typography—is regarded as part of its meaning. From this he developed the idea of using artists and craftspeople—stone carvers, potters, calligraphers, even specialists in neon lighting—to translate his poems into other media. Athough such work has been included in sculpture exhibitions, notably the open-air exhibition at Battersea Park, London, in 1977, it is probably better regarded as a three-dimensional extension of his poetic activity. In 1967, with his wife, Sue, he moved to Stonypath, a remote farmhouse in the Pentland Hills of 'Strathclyde, the Infernal Region' (Hamilton Finlay's words), and they created a garden, 'Little Sparta', in which many of his poem objects are displayed: 'it is a garden full of surprises and contrasts, and manages to entertain as well as to stimulate thought. Visual puns and other jokes abound: for instance, a headstone next to a birch tree has the slogan "Bring back the birch"; a real clump of grass resembling an Albrecht Dürer watercolour has Dürer's monogram placed next to it; a tortoise carries the words "Panzer Division" engraved in gothic lettering on its shell; and birds land on a bird tray in the form of an aircraft carrier' (Michael Jacobs and Paul Stirton, *The Mitchell Beazley Traveller's Guides to Art: Britain & Ireland*, 1984). The garden has

attracted considerable publicity, not only because of its artistic interest, but also because of Hamilton Finlay's long-term fight against Strathclyde Council, which attempted to tax a garden 'temple' as a commercial art gallery. He also aroused controversy with his political imagery drawn not just from the most extreme wing of the French Revolution (one of his heroes was Saint-Just) but even from the Third Reich. He was described by the critic John MacEwen as a 'libertarian revolutionary', but an obituarist also noted that he 'had no discernible enthusiasm for civil rights at the expense of art'. Hamilton Finlay was indeed even harder to classify politically than artistically. He deplored the loss of 'harmony' and 'piety' in contemporary society and maintained that it was this view which drew him towards classicism.

Further Reading: obituary, *The Daily Telegraph* (28 March 2006)

Hammershøi, Vilhelm (1864–1916) Danish painter, born in Copenhagen, where he lived throughout his life. The son of a merchant, he was trained in drawing from the age of eight and studied at the Royal Danish Academy of Fine Arts. As a young artist, he was influenced by *Whistler. His early work aroused some controversy, initially over its limited colour range and somewhat sketchy handling. The rejection of *Bedroom* by the Academy jury in 1890 was the catalyst for the creation of a new Independent Exhibition the following year. Hammershøi is best known for his paintings of interiors, generally in a restricted greyish colour range. Where there is a figure, usually female, it is either seen from behind, absorbed in some task, or wrapped in contemplation of something beyond the space of the painting. The artist drew inspiration from the paintings of 17th-century Holland, especially a group of works then attributed to Peter de Hooch but now believed to be by Peter Janssens Elinga. Like the Dutch painter, he was preoccupied with near empty spaces and the effects of light from a window. The setting was Hammershøi's own apartment. He made particular play with open and closed doors to suggest a space beyond what the spectator can see directly. It is the elusiveness and sense of the mysterious which links Hammershøi to the international *Symbolist aesthetic. He also painted landscapes and the exteriors of buildings. These are bereft of any human presence, even in his depiction of what

was in reality the busy thoroughfare running by Gentoffte Lake. The painter was as reserved in his life as in his art. When he died he was internationally famous, but after his death his work was largely forgotten until a revival of interest began in the 1980s. His brother **Svend Hammershøi** (1873–1948) was a painter and also a ceramicist.

Further Reading: F. Krämer et al., *Hammershøi* (2008)

Hammersley, Frederick *See* HARD-HEDGE PAINTING.

Hammons, David (1943–) American sculptor and *installation artist, born in Springfield, Ohio. In 1974 he moved to New York, where he has subsequently lived and worked. His work addresses issues of Afro-American identity, not just through subject-matter, but even in apparently abstract work through the use of materials such as hair as signifier of racial identity. His practice implies a rebuke to the supposed 'universality' of abstract art. *Untitled (Night Train)* (1989) is an installation made from bottles of a cheap wine marketed to black communities; he found the bottles on the streets of Harlem. Hammons has been influenced by the art historian Robert Farris Thomson, who has written about the evidence of continuities between African cultural practices and the Americas. An example of this idea is the sculpture *Spade with Chains* (1973), an assisted *ready-made, which is reminiscent of African masks but also refers to a derogatory term for black people and to the history of slavery. Although he exhibits in galleries and museums, Hammons prefers working outdoors, so that his work becomes more accessible. He has said 'It's hard dealing with a white cube . . . It's not the way my culture perceives the world. It's for mad people, you put in the hospital.'

Hamnett, Nina (1890–1956) British painter, designer, and illustrator, famous more for her flamboyant bohemian life than for her work. She was born in Tenby, Wales, the daughter of an army officer, and studied at various art schools in Dublin, London, and finally Paris, where she met several leading avant-garde artists, including *Brancusi, *Modigliani, and *Zadkine. Another artist she met there was the Norwegian Roald Kristian (also known as Edgar de Bergen), whom she married in 1914. She seems to have been relieved when he was deported as an unregistered alien

during the First World War; they never saw one another again. From 1913 to 1919 Hamnett worked for Roger *Fry's *Omega Workshops; Fry (with whom she had a love affair) painted several portraits of her. In the 1920s, she spent much of her time in Paris, where once again she knew many leading figures of the avant-garde, including Jean *Cocteau and the composers Satie and Stravinsky. However, she often returned to London for exhibitions of her work, which included portraits, landscapes, interiors, and figure compositions (notably café scenes) in a robust style drawing on various modern influences. In addition to paintings, she made book illustrations (spontaneous pen-and-ink drawings), notably for Osbert *Sitwell's *The People's Album of London Statues* (1928). From the 1930s the quality of her work declined, partly because of the influence of alcohol; she died following a fall from the window of her flat in London. Her colourful, uninhibited life is recounted in two volumes of autobiography—*Laughing Torso* (1932) and *Is She a Lady?* (1955).

Hanak, Anton *See* WOTRUBA, FRITZ.

Hanly, Patrick (1932–2004) New Zealand painter and printmaker, born at Palmerston North. After studying at the University of Canterbury School of Art, he spent five years in Europe, 1957–62. He was one of New Zealand's best-known contemporary artists and his work included several murals in major public buildings, among them Christchurch Town Hall (1972) and Auckland International Airport (1977). Hanly had a reputation as a political activist, especially involved in waterborne anti-nuclear protests. He was a keen yachtsman, although he could not swim. At his memorial service his open coffin contained his life-jacket, while a 'No nuclear ships' banner hung above it. For Hanly, social and political criticism were inherent in his paintings. His 'Pop' style works attacked 'The nation sitting around on its bum, doing nothing'. Highly self-critical, he bought back a number of paintings for destruction or, as he put it, 'revitalisation'. Of his *Pacific Icons* series he told an interviewer, 'Nearly got 'em all. Extinct.'

Further Reading: 'Patrick Hanly: a conversation with Hamish Keith', *Art New Zealand* (summer 1979–80)

Hanson, Duane (1925–96) American sculptor, the best-known exponent of *Superrealism

in sculpture. He was born in Alexandria, Minnesota, and had his main training at Cranbrook Academy of Art, Michigan, where he graduated in 1951. From 1953 to 1960 he lived in Germany. In 1965, after teaching at various art schools, he moved to Miami, and in the late 1960s he began to attract attention with large tableaux of figures cast from the life in fibreglass, minutely detailed, dressed in real clothes, and accompanied by real props. The subjects were usually emotive or violent, dealing with issues such as the Vietnam War or race riots. However, in 1970 Hanson abandoned these 'expressionist' groups, as he called them, to concentrate on figures representing mundane types. In these he commented pungently on depressing or tasteless aspects of everyday American life—down-and-outs, exhausted shoppers, or in one of his most famous works, a pair of fat, ageing, and garishly dressed sightseers (*Tourists*, 1970, NG of Modern Art, Edinburgh). 'The subject matter that I like best', he wrote, 'deals with the familiar lower and middle class American types of today. To me, the resignation, emptiness and loneliness of their existence captures the true reality of life for these people. Consequently, as a realist I'm not interested in the human form . . . but rather a face or body which has suffered like some weather-worn landscape the erosion of time. In portraying this aspect of life I want to achieve a certain tough realism which speaks of the fascinating idiosyncracies of our time.'

Happening A form of artistic event, especially associated with the New York art scene about 1960, often carefully planned but usually including some degree of spontaneity, in which an artist performed or directed an event combining elements of theatre and the visual arts. The term was coined in 1959 by Allan *Kaprow, to whom the concept of the Happening was closely bound up with his rejection of traditional principles of craftsmanship and permanence in the arts. He thought of the Happening as a development mainly from the *assemblage and the *environment. While both the assemblage and the environment were relatively fixed and static—the assemblage something constructed to be contemplated from outside, to be 'handled or walked around'; the environment something to be 'walked into', something by which the observer was enveloped and manipulated—the Happening was conceived of as a genuine

'event'. It had close affinities with *Performance art (the two terms have sometimes been used more or less synonymously, although Performance is almost universal today) and it was not restricted like the environment to the confines of a gallery or some other specific site. In line with the theories of the composer John *Cage about the importance of chance in artistic creation, Happenings were described as 'spontaneous, plotless theatrical events'.

Cage (one of Kaprow's teachers) organized a performance at *Black Mountain College in 1952 that has sometimes been described as the first Happening. Kaprow's own first Happening is said to have taken place in 1958 at George *Segal's chicken farm in New Brunswick, New Jersey; the first to be titled with the term was *18 Happenings in 6 Parts* performed at the Reuben Gallery, New York, in October 1959. This was a kind of mixture of *Performance and *installation. Visitors (designated as members of the cast) sat in chairs facing in different directions as the performers walked backwards and forwards, playing musical instruments, holding placards, or painting unprimed canvases. The entire event lasted 90 minutes, was carefully rehearsed, and ran for a week.

Apart from Cage and Kaprow, the artists chiefly responsible for the development of the form in the USA include Jim *Dine, Red *Grooms, Claes *Oldenburg, and Robert *Rauschenberg. They all took the Happening to something closer to theatre, with a more conventional relationship between performer and audience. Outside America, the Happening was widely exploited in the 1960s—by the *Gutai Group in Japan, for example, and by many artists in Europe. The term has often been used to cover staged demonstrations for political or social propaganda, as for example in the work of *Fluxus group (whose Happenings in Germany were usually called *'Aktions').

Further Reading: A. Henri, *Environments and Happenings* (1974)

Hard-Edge Painting A type of abstract painting in which forms, although not necessarily geometrical, have sharp contours and are executed in flat colours. It was one of the types of painting that developed as a reaction against the spontaneity and painterly handling of *Abstract Expressionism (*see* POST-PAINTERLY ABSTRACTION). The term was coined by the

American critic Jules Langsner in 1958 and was popularized by Lawrence *Alloway, who in 1966 wrote that it was meant 'to refer to the new development that combined economy of form and neatness of surface with fullness of colour, without continually raising memories of earlier geometric art'. Major exponents of Hard-Edge Painting have included Ellsworth *Kelly and Kenneth *Noland. The four West Coast painters to whom Langsner originally applied the term were Karl Benjamin (1925–), Lorser Feitelson (1898–1978), Frederick Hammersley (1919–), and John McLaughlin (1898–1976); they preferred the term 'Abstract Classicism'.

Hare, David (1917–92) American sculptor, painter, and photographer, born in New York. He initially studied chemistry and had no formal training in art, which he approached as a form of experimentation. In the late 1930s he worked as a commercial photographer and in about 1940 he began to experiment with the technique of 'heatage' (gently heating the emulsion of a photographic plate so that it melted and the image flowed). His interest in this technique (pioneered by Raoul *Ubac) brought him into contact with the European *Surrealists who had moved to New York to escape the Second World War, and Hare founded and edited the Surrealist magazine *VVV*, which ran from June 1942 to February 1944. In 1942 he began to make sculpture, using a variety of materials and showing a typically Surrealist interest in visual puns. From 1944 he had many one-man shows, the first at Peggy *Guggenheim's Art of This Century gallery. In 1948 he was one of the founders of the *Subjects of the Artist School; the other four founders were leading *Abstract Expressionist painters and Hare's sculptures have been seen as three-dimensional analogues of their work. From 1948 to 1953 he lived in France. By the time he returned to New York he was working mainly in metal—welded or cast. In the 1960s he took up painting, but he returned to sculpture as his main medium in the 1970s.

Haring, Keith (1958–90) American painter, sculptor, and designer, born in Kutztown, Pennsylvania. He studied at the New York School of Visual Arts and in 1980 began drawings with marker pen over advertisements and adjacent wall areas on the New York subway. He developed a distinctive, instantly recogniz-

able style for this impromptu public art, using thick black lines and an equally distinctive range of imagery. There was a trademark 'radiant baby', almost a self-portrait, and also flying saucers, and a lot of sex. The hectic pattern of lines tends to cover the surface in an *all-over fashion.

Haring was given his first gallery exhibition in 1982 with the dealer Tony Shafrazi, previously known for having defaced *Picasso's *Guernica* as it hung in the New York *Museum of Modern Art, as an anti-war protest. By 1985 Haring was showing with New York's most powerful dealer, Leo *Castelli, and had extended his range to large-scale steel sculpture. More successfully than his friend and contemporary Jean-Michel *Basquiat, Haring bridged the gap between high art and the mass market. In 1986 he opened the Pop Shop. This sold Haring products and made his images even more celebrated. As Katherine Dieckmann commented, 'Haring himself became a kind of souvenir factory'. One surface adorned by Haring designs was the body of the popular singer Grace Jones. Haring also donated his work for campaigning purposes, against apartheid in South Africa and warning against crack cocaine and AIDS. He himself died from the latter. All this has perhaps made Haring's style somewhat over-familiar and caused something of a backlash. The inventiveness of his best work still startles and the darker aspects of his vision as an artist are too easily forgotten in the wake of the image of the relentlessly cheerful man with the round glasses. He has become one of those artists whose enormous public following is not quite matched by specialist acceptance. For instance, David Joselit's *American Art Since 1945* (2003) has no mention of him.

Further Reading: K. Dieckmann, 'Keith Haring', *Artforum International* (September 1997)

Harlem Renaissance A term describing a flowering of activity among black American artists in the 1920s, centred on the Harlem district of New York. It was primarily a literary movement, one of the leading figures being Alain Locke (1886–1954), an editor, literary critic, art historian, and philosopher (from 1907 to 1910 he had been the first black Rhodes Scholar at Oxford University, and in 1918 he became professor of philosophy at Howard University, Washington DC). In 1925 he edited a special issue of the *Survey Graphic* magazine entitled 'Harlem, Mecca of the New

Negro', and he expanded this into *The New Negro*, an anthology of fiction, poetry, and essays, published in the same year. His introduction to the volume expressed the idea that there was a new spirit of opportunity among black writers. Locke encouraged black American artists to explore their ancestral heritage, and he wrote several books dealing with black American culture and the influence of African art on modern painting and sculpture, among them *Negro Art: Past and Present* (1936) and *The Negro in Art* (1941). Among the visual artists who were involved in the Harlem Renaissance, the outstanding figure was the painter and illustrator Aaron *Douglas, who is regarded as the first black American painter consciously to incorporate African imagery in his pictures. Palmer Hayden (1890–1964) and Malvin Gray Johnson (1896–1934) were among the other artists associated with the movement, which was ended by the Great Depression of the 1930s.

Further Reading: R. J. Powell and D. Bailey, *Rhapsodies in Black: The Art of the Harlem Renaissance* (1997)

Harris, Lawren Stewart (1885–1970) Canadian painter, born at Brantford, Ontario, into a wealthy family. From 1904 to 1908 he studied in Berlin, where his work was influenced by *Expressionism. After a period of travel in the Middle East and a stint as a magazine illustrator in Minnesota, he returned to Canada in 1909 and settled in Toronto. Early in his career his favourite subjects were cityscapes and views of houses, but after meeting J. E. H. *MacDonald in 1911 he also took up landscape and from 1920 (when he was one of the founder members of the *Group of Seven) this became his main interest. In 1918 he had discovered Algoma in northern Ontario, and the dramatic and colourful style he had developed was well suited to depicting the lushness of its countryside (*Autumn, Algoma*, 1920, Victoria University, Toronto). Harris was a follower of theosophy (*see* ABSTRACT ART) and he used spectacular scenery as a way of expressing spiritual values. To this end he sought out the most overpowering landscapes he could find—in the Rockies and even the Arctic. The transcendental quality in his work was maintained when he turned to abstraction in the 1930s.

In 1934 Harris moved to Dartmouth College, Hanover, New Hampshire, as artist-in-residence, then in 1938 to Santa Fé, New Mexico, where he was one of the founders of the Transcendental Group of Painters; its members—influenced by the writings of *Kandinsky—sought 'to carry painting beyond the appearance of the physical world, through new concepts of space, colour, light, and design, to imaginative realms that are idealistic and spiritual'. He returned to Canada in 1940 and settled in Vancouver, where his presence did much to stimulate the artistic scene—a number of younger artists, including Jock *Macdonald, were encouraged by him. Harris, indeed, became a kind of patriarch of Canadian painting, and in 1948 he was given a large retrospective at the Art Gallery of Toronto.

Harris, Max *See* ANGRY PENGUINS.

Harrison, Charles *See* ART & LANGUAGE.

Hart, George Overbury 'Pop' *See* ROCKEFELLER, ABBY ALDRICH.

Hartigan, Grace (1922–2008) American painter, born at Newark, New Jersey. During the Second World War she worked as an industrial draughtsman while studying art at night. Later in the 1940s she travelled in Europe and lived for a while in Mexico before settling in New York. In the 1950s she became recognized as one of the leading figures among the second wave of *Abstract Expressionists, and in 1960 she was described as the most famous woman artist in America (earlier she had exhibited her work under the name 'George Hartigan' to try to combat bias against women artists). Her work—strongly influenced by that of *de Kooning—often retains figurative elements and is characterized by brilliant colour, with thick black outlines surrounding the forms. She wrote: 'I want an art that is not "abstract" and not "realistic" . . . my "subject" concerns that which is vulgar and vital in modern American life, and the possibilities of its transcendence into the beautiful. I do not wish to describe my subject . . . I want to distill it until I have its essence. Then the rawness must be resolved into form and unity.'

Hartley, Marsden (1877–1943) American painter. He was born in Lewiston, Maine, and studied in Cleveland, at the School (now Institute) of Art, and then from 1898 in New York, first at the *Art Students League and then at the National Academy of Design. In 1900 he returned to Maine and for the next decade his pattern was to spend the summer there and the winter in New York. His chief works of this time were views of the Maine mountains, painted with nervous strokes and broken

colours. They show the influence of *Cézanne and also of Albert Pinkham *Ryder, who was his favourite American artist. In 1909 Hartley was given a one-man exhibition by *Stieglitz, and in 1912 help from Stieglitz and Arthur B. *Davies enabled him to travel to Europe. He went first to Paris, where he frequented the *Stein household, and then Germany, where he met *Kandinsky and *Marc in Berlin. In 1913 he returned to New York and exhibited at the *Armory Show. From 1914 to 1916 he was again in Europe, visiting London, Paris, Berlin, and Munich. During these years he created a distinctive semi-abstract manner that combines 'a fascination with Germany's prewar military pageantry with American Indian motifs' (catalogue of the exhibition 'American Art in the 20th Century', Royal Academy, London, 1993). The most famous instance is *Painting No. 5* (1914–15, Whitney Museum, New York); it represents a remarkably personal synthesis of modernist trends, being more closely structured and objective than German *Expressionism and more freely patterned and highly coloured than French *Cubism. *A German Officer* (1914, Whitney Museum) is in a similar vein. These 'portraits' of German soldiers were inspired by Hartley's friendship with Karl von Freyburg, a young officer killed early in the First World War (they were condemned as pro-German when they were exhibited at Stieglitz's 291 Gallery).

In 1916 Hartley returned to America, and in 1918 said that he had grown weary of 'emotional excitement in art'. He turned once again to landscape as his principal subject, working in a more representational but still highly formalized style. In 1921 he returned to Europe, stayed there for a decade, then continued his wandering life in the early 1930s. In 1934 he returned to Maine, where he lived for the rest of his life apart from a visit to Nova Scotia in 1936. The work of his final years (usually rugged mountain and coastal scenes) was characterized by blunt, block-like forms, showing a powerful feeling for the beauty and grandeur of nature. A volume of his criticism, *Adventures in the Arts*, appeared in 1921. He was also a poet: *Selected Poems* appeared posthumously assembled in 1945.

Hartung, Hans (1904–89) German-born abstract painter and printmaker who became a French citizen in 1946. He was born in Leipzig, where he studied philosophy at the University and art at the Academy, continuing his studies at the Academies of Dresden and Munich. In Munich he met *Kandinsky and became interested in the work of *Marc. From 1926 to 1931 he lived mainly in Paris, then from 1932 to 1934 on the island of Minorca, where he is said to have angered peasants who thought his abstracts were blue-prints for a fortress. In 1934 he returned briefly to Germany, but left because of the Nazis and settled in Paris in 1935. During the Second World War he fought in the French Foreign Legion; he was badly wounded in 1944 and had a leg amputated without anaesthetic. After the war he returned to Paris, where he remained based for the rest of his life.

Hartung was an individualist who pursued his own path, unconcerned with fashion and sustained by what he called 'stubborn staying power'. He had begun painting abstracts in 1922, when he was only seventeen, and developed a sensuous, freely improvised style that anticipated postwar developments. It was only after the war that he made a reputation and was hailed as one of the pioneers of *Art Informel. His fame was at its peak around 1960, in which year he was joint winner of the main painting prize at the Venice *Biennale. In some of his paintings the vibrant thick black lines and blotches have a kinship with the work of Franz *Kline, but Kline is more brusquely energetic. Hartung's paintings of the 1960s employed a rather different technique, with parallel lines engraved into a painted surface with a steel comb. Despite his close links to Paris, he is still considered by many commentators to be more German than French in that his 'unease and urgency' make his art 'intensely expressive' (Frank *Whitford). Bernard Dorival, a strong partisan for the École de Paris, considered that 'In his work we find a blend of the exacting discipline that governs French art with what is best and most distinguished in German poetry.'

Hartung gave his paintings 'T' numbers (for *toile*—French for canvas) instead of titles, such as *T1963—R6* (1963, Tate). He was a prolific draughtsman, often basing his paintings on his drawings, and he also made etchings, lithographs, and (through friendship with Julio *González) a few sculptures. In 1929 Hartung married the Norwegian painter Anna-Eva Bergman (1909–87). He divorced her in 1939 and married Roberta González (daughter of Julio), but subsequently he divorced her also and remarried Bergman in 1957.

Further Reading: J. Mundy, *Hans Hartung* (1996)

Harvey, Marcus (1963–) British painter, born in Leeds. He is best known for what proved to be the most controversial exhibit in the 1997 *'Sensation' exhibition. This was a portrait, made in 1995, of the notorious child murderer Myra Hindley, based on a widely reproduced police photograph but made up of children's handprints. The issues went beyond the usual 'modern art' controversies about alleged incompetence or affronts to 'public morality'. There was the problem about the hurt to those most involved, the families of the victims of the events of thirty years earlier. In this respect, there was a considerable difference between the exhibition of the work in a small gallery, to a handful of people, and widespread public exposure at the *Royal Academy. This being said, the mass media showed cynicism quite beyond that of the artist in their management of the event, deliberately drawing the attention of those who would be most personally affected by the image. The issue was not simply the right of the artist to use the image of Myra Hindley but the right of newspapers and television to be able to monopolize discussion around it. In an interview given at the time the artist said, 'I just thought that the handprint was one of the most dignified images that I could find. The most simple image of innocence absorbed in all that pain.' Harvey's other work has not made the same impact. He has made paintings which combine *Abstract Expressionist brushwork with the outlines of pornographic photographs. In 2004 he exhibited in New York three still-lifes of the detritus of an 'Ann Summer's Party'. This, it had to be explained to the American public, was like a Tupperware party but with sex toys.

Hassam, Childe (1859–1935) American painter and printmaker, one of his country's foremost exponents of *Impressionism. Hassam trained as a wood engraver in Boston and early in his career he was a successful illustrator, particularly of children's stories. He discovered Impressionism on his second visit to Europe in 1886–9, when he studied briefly at the *Académie Julian, and he was one of the first artists to import the style to the USA. On his return to America he settled in New York, and the life of the city became one of his main sources of subject-matter; scenes of rainy streets were something of a speciality. Another favourite theme was a woman in an interior.

His early paintings are fresh and clear but sometimes rather slick and saccharine. After the turn of the century, his style tended towards greater simplification and flatness in composition and his colour became lusher—somewhat in the manner of *Bonnard. Hassam was immensely prolific in oils, watercolour, pastel, and a variety of drawing media; in his fifties he also took up printmaking seriously, producing a large number of etchings and lithographs (notably harbour scenes in a style reminiscent of *Whistler). His work was much exhibited and won a great deal of critical acclaim (although, not surprisingly, he was sometimes accused of overproduction). In addition to being a prominent figure at the annual shows of The *Ten, he had numerous one-man exhibitions, including one at the Paris galleries of *Durand-Ruel in 1901—a remarkable distinction for a non-Frenchman. He received many honours and died a wealthy man, although by this time he was seen in artistic circles as a very conservative figure. He left all his own paintings still in his possession to the American Academy of Arts and Letters, which profited greatly from their sale. His work is represented in many American public collections.

Hatoum, Mona (1952–) Palestinian installation artist, active in Britain. She was born in Beirut and after civil war broke out in 1975, she moved to London, where she studied at the Byam *Shaw School of Art and the *Slade School of Fine Art. She has said: 'My work is about my experience of living in the West as a person from the Third World, about being an outsider, about occupying a marginal position, being excluded, being defined as "Other" or as one of "Them".' Some critics have related this very specifically to Hatoum's experience as a Palestinian, but she has preferred to think of it as being concerned with a more general sense of being displaced. *Light Sentence* (1992, Pompidou Centre) consists of two rows of tiny cages stacked high, lit so as to throw fantastic shadows on the wall. The sense of the body itself being made strange is realized most powerfully in *Corps Etranger* (1994, Pompidou Centre). This is a cylindrical enclosure which can be entered by the viewer. Projected on the floor is a film of the interior of Hatoum's own body, investigated by an endoscopic medical scan. In her installation *Homebound* (2000) she used domestic objects from the 1950s, the period of her childhood. These were

placed behind thick cable and wired to make them gyrate and light up.

(⊕) SEE WEB LINKS

• Mona Hatoum interview with John Tusa, BBC website.

Hausmann, Raoul (1886–1971) Austrian painter, photographer, and writer, born in Vienna, the son of an academic painter who gave him his first instruction in art. In 1901 he moved to Berlin and in 1918 became one of the founders of the *Dada movement there, together with *Grosz, *Heartfield, and others. Hausmann and Heartfield are particularly well known for the *photomontages they produced in their Dada period—they were among the earliest and most brilliant exponents of the technique. Hannah *Höch, with whom Hausmann lived for several years, was another pioneer of this art form. An example of Hausmann's work of this time is *The Art Critic* (1919–20, Tate), an 'ironic photomontage depicting the critic as exclusively preoccupied with fashion and women and whose analyses are no more than successions of words without meaning…His portrait is stuck onto the background of a poem-poster whose huge letters speak the new language, which is beyond the understanding of the blinded critic' (Michel Giroud, *Raoul Hausmann*, 1975). In 1923 Hausmann abandoned painting and in 1927 he invented an apparatus called the optophone, which turned kaleidoscopic forms into music. Around this time he also experimented with various photographic techniques. In 1933 he left Germany and after much travelling settled in France in 1938. A few years later he took up painting again. From 1944 until his death he lived in Limoges.

Hausner, Rudolf *See* FANTASTIC REALISM.

Haworth, Jann *See* BROTHERHOOD OF RURALISTS.

Hayden, Palmer *See* HARLEM RENAISSANCE.

Hayter, S. W. (Stanley William) (1901–88) British printmaker, draughtsman, and painter, born in London, a member of a dynasty of artists that included Queen Victoria's official portraitist Sir George Hayter. He studied chemistry and geology at London University, 1917–21, then worked in the oil industry in the Persian Gulf for several years. In 1926 he settled in Paris, where he studied briefly at the *Académie Julian, and in 1927 he founded an

experimental workshop for the graphic arts—Atelier 17—that played a central role in the 20th-century revival of the print as an independent art form. (The name was adopted in 1933 when Hayter moved his establishment from its original home to no. 17 rue Campagne-Première.) In 1940–50 Hayter lived in New York—his second wife was the American sculptor Helen Phillips (1913–95) —taking Atelier 17 with him. After returning to Paris in 1950 he re-established Atelier 17 there and closed the American branch in 1955. The list of artists who worked with him includes some of the most famous names in 20th-century art, among them *Chagall, *Ernst, *Giacometti, and *Lipchitz. Hayter's training as a chemist gave him an unrivalled knowledge of the technicalities of printmaking, on which he wrote two major books, *New Ways of Gravure* (1949) and *About Prints* (1962). His prints are varied in technique and style, but most characteristically are influenced by *Surrealism and are notable for their experiments with texture and colour.

Hayward Gallery, London *See* ARTS COUNCIL.

Hazoumé, Romuald (1962–) Beninese multimedia artist, born in Porto Novo. Before deciding on a career in art, he had considered both medicine and sport. He has transformed used and discarded plastic canisters into masks in the Dogon tradition of the kind that had inspired *Picasso. Inka Gressel says of them: 'They say a great deal but they aren't talkative; they speak their own language' (*documenta 12, 2007). The best-known example is his gigantic installation *La Bouche du Roi* (1997–2000, British Museum, London), which was exhibited around Britain in 2007 to mark the bicentenary of the abolition of the slave trade. The title derives from the name of the port from which the transportations took place. The canisters are arranged in the pattern of a famous engraving of a slave ship; by showing the appalling conditions in which slaves were transported, the print helped fuel the anti-slavery movement. Broken canisters stand for those who died during the voyage and as part of the installation there are gin bottles and cowrie shells as examples of the goods traded for slaves. Quite apart from the quasi-human appearance of the canisters, they have powerful contemporary associations. Such canisters are often heated to

increase their capacity when transported, so creating extra dangers for those involved in the illegal traffic of fuel between Nigeria and Benin. Hazoumé points out how, even when slavery has been abolished, economic expedience takes precedence over human welfare.

(⊕) SEE WEB LINKS

• Article by Niamh Coghlan on Romuald Hazoumé, Aesthetica magazine website.

Head, Tim (1946–) British painter and installation artist, born in London. He studied at the University of Newcastle upon Tyne and in 1968 went to New York, where he worked as assistant to Claes *Oldenburg and met many leading *Minimalists. In 1969 he returned to London and studied under Barry *Flanagan at *St Martin's School of Art. He came to attention in the 1970s with *installations in which mirrors and projections create an eerie disruption of the sense of space. Typical of his inventive use of the setting was the one he made in 1974 in the unprepossessing white brick stairwell of the *Whitechapel Gallery. *Present* (1978) used still projection to make the illusion that the gallery wall was extended. Within this space was the image of a horse sharing the viewer's space but locked in the stasis of photography. Head has also made large-scale photographic works in collaboration with professional photographers. These continue the play with illusion but also often make a political point, as in *Erasers* (1985, Leeds City Art Gallery), which shows a mound of multi-coloured erasers shaped like skulls and others in the form of missiles. *State of the Art* (1984, Arts Council Collection) is a sinister array of consumer objects, including vibrators, arranged to resemble the towers of a modern city.

(⊕) SEE WEB LINKS

• The artist's website, with many excellent pictures of his work.

Healy, Michael *See* AN TÚR GLOINE.

Heartfield, John (Helmut Herzfelde) (1891–1968) German designer, painter, and journalist, born in Berlin, the son of a political radical who had been imprisoned for writing and publishing a revolutionary socialist poem. He studied at the School of Arts and Crafts in Berlin, 1912–14, then did military service. In 1918 he was one of the founders of the Berlin *Dada group. His brother Wieland Herzfelde owned a publishing firm and printed most of the group's literature. Heartfield is best known as one of the pioneers and perhaps the greatest of all exponents of *photomontage (rivalled in his time only by *Hausmann, also a leading light of Dada in Berlin). With *Grosz he anglicized his name during the First World War as a protest against German nationalistic fervour and his finest works are brilliantly satirical attacks—often in the form of book covers and posters—against militarism and Nazism. One of the most famous is *Hurrah, die Butter ist alle!* (Hurrah, the butter is finished!, 1935), showing a Nazi family, including the baby and dog, eating bicycle chains, hatchets, and other metal implements—a literal interpretation of Hermann Goering's dictum that 'Iron makes a country strong; butter and lard only make people fat'. Harassed by the Nazis, Heartfield left Germany in 1938 and moved to London, where he lived until 1950. There he worked as a designer for Penguin Books and other publishers. In 1950 he returned to Germany and settled in Leipzig, where his work included stage design. He died in Berlin.

Heath, Adrian (1920–92) British abstract painter, born in Burma. He studied at Newlyn School of Art under Stanhope *Forbes in 1938 and in the following year went to the *Slade School. In 1940 he joined the RAF and he was a prisoner of war in Germany, 1942–5; one of his fellow prisoners was Terry *Frost, whom he encouraged to paint. After the war Heath returned to the Slade School, 1945–7. In 1949 and 1951 he visited St Ives, where he met Ben *Nicholson, and he formed a link between the *St Ives School and the London-based *Constructivists—Anthony *Hill, Kenneth and Mary *Martin, and Victor *Pasmore—with whom he was also associated. During the early 1950s Heath was a significant figure in promoting *abstract art—by organizing collective exhibitions at his London studio (at 22 Fitzroy Street) in 1951, 1952, and 1953, and by writing a short popular book on the subject, *Abstract Painting: Its Origin and Meaning* (1953). The exhibitions helped to inspire Lawrence *Alloway's book *Nine Abstract Artists* (1954). Heath's paintings of this time featured large, block-like slabs of colour, heavily brushed. He also made a few constructions. Later his paintings became freer and more dynamic. From 1955 to 1976 he taught at the *Bath Academy of Art,

and from 1980 to 1985 at the University of Reading.

Heath Robinson, William *See* ROBINSON, WILLIAM HEATH.

Heckel, Erich (1883–1970) German painter and printmaker, born in Döbeln, Saxony. In 1904 he began studying architecture in Dresden, and in 1905, with three of his fellow students, he founded Die *Brücke. He gave up his architectural course soon afterwards, but supported himself by working in an architect's office until 1907, when he became a full-time artist. His work was somewhat more lyrical than that of other members of Die Brücke and he showed a special concern for depicting sickness and inner anguish (*Convalescent Woman*, 1913, Busch-Reisinger Museum, Harvard). His landscapes, too, sometimes have a decorative quality foreign to most German *Expressionism. In 1911 he moved to Berlin, where he had his first one-man exhibition in 1913 (Die Brücke now having broken up), at Fritz Gurlitt's gallery. Heckel was classified unfit for active service in the First World War, but he volunteered to work as a medical orderly in Flanders. His unit was commanded by an art historian, Walter Kaesbach (1879–1961), and through him Heckel met *Beckmann and *Ensor, who influenced his work; it became more melancholy and tragic, his landscapes expressing the agony of war through conflict of the elements. After the war his painting lost much of its intensity, with pastel tones replacing the bold, sometimes harsh colours he had earlier used. In 1937 his work was declared *degenerate by the Nazis and in 1944 his Berlin studio was destroyed in an air raid. Heckel then moved to Hemmenhofen on Lake Constance. From 1949 until his retirement in 1955 he taught at the Karlsruhe Academy.

Apart from *Kirchner, Heckel was the most prolific printmaker among the Brücke artists, producing more than 400 woodcuts, about 400 lithographs, and nearly 200 etchings, mainly in the period 1903–23.

Hegedušić, Krsto (1901–75) Yugoslav painter, theatrical designer, and graphic artist, born in Petrinja in Croatia. He studied at the Académy in Zagreb, 1920–26, and then in Paris, 1926–8. On his return to Yugoslavia he became the artistic and ideological leader of the group Zemlja (Earth), founded in 1929 and banned in 1935, which promoted an art of revolutionary social protest. He believed that the worn-out academicism of the day could be revitalized by direct contact with peasant life and with the genuine folk art of the people. In pursuit of this aim he was chiefly responsible for founding a school for peasant painters in the village of *Hlebine (where he had grown up) and for fostering the talent of Ivan *Generalić, the greatest of the Yugoslav *naive painters. His own painting had affinities with the *Neue Sachlichkeit of *Dix and *Grosz, with *Surrealism, and with the famous peasant scenes of the 16th-century Netherlandish painter Pieter Bruegel, but essentially his work is an expression of his deeply committed social conscience. A typical example is *A Fair at Koprivnica* (1930, Tate). Between 1931 and 1941 Hegedušić was arrested a number of times for left-wing political activities and he was interned during the German occupation in the Second World War. From 1936 he taught at the Zagreb Academy and was appointed a professor there in 1945.

Heidelberg School Group of Australian painters who worked together at Heidelberg, Victoria (at the time a village, now a suburb of Melbourne), from 1886 to about 1900. At first they met in painting camps, and in 1888 three of the best-known artists of the group—Charles *Conder, Tom *Roberts (the dominant figure), and Arthur *Streeton—moved into a disused farmhouse at nearby Eaglemont. This became a rendezvous for many young artists. The work of the group, based on the *Impressionist ideal of painting in the open air, featured local subject-matter and was associated with the emergence of a distinctive Australian literature. By 1900 the group had broken up, many of the leading members having gone to Europe, but its vision of Australian life and landscape came to dominate the country's painting in the early 20th century and inspired many other artists in later decades.

Heisig, Bernhard (1925–) German painter, one of the leading figures in the art of East Germany, born in Wrocław (Breslau). He studied at the Leipzig Academy but abandoned the course in 1951, disillusioned by the rigid political line imposed by the Communist Party. Nonetheless he continued painting and in 1961, after concurring with the official demand for 'partisan' art, he was appointed professor at the Leipzig Academy, subsequently becoming rector. In 1964 he

made a speech in favour of an art that 'makes waves, provokes, attacks', for which he was dismissed from his post as rector. Subsequently, to the disappointment of some, he retracted his statement. By the early 1970s the idea of a more critical kind of art had gained official favour and Heisig became one of the leading and most exportable East German painters, being seen, for example, in *documenta 6. His painting is in a somewhat *Expressionist manner, which Heisig said was a device to distance the viewer from the subject to allow for a more open interpretation of meaning. The same consideration applies to the accumulation of images and historical references in a way that can be confusing to the uninitiated. He was highly influential as the teacher of artists such as Neo *Rauch, who have become stars of the post-Communist art world.

(⊕) SEE WEB LINKS
• H. Rauterberg, 'The only thing I can really paint well is anger', *Sign and Sight* (8 April 2005).

Heizer, Michael *See* LAND ART.

Held, Al (1928–2005) American painter, born in New York, where he studied at the *Art Students League, 1948–9. He then spent two years in Paris, and on his return to New York worked in the prevailing *Abstract Expressionist idiom, being particularly influenced by Jackson *Pollock. From about 1960, however, he began to develop a more individual style characterized by clean-edged, bold, brightly coloured geometrical forms. It had affinities with *Hard-Edge Painting, but Held's work was distinguished by his use of very heavily textured paint. He often worked on a huge scale, giving his paintings an extremely forceful physical impact. In 1967 he began making black and white paintings, using white linear structures on a black ground or black lines on a white ground to create overlapping and interlocking box-like forms that demonstrate his interest in Renaissance perspective. In the 1980s he re-introduced colour with a vengeance, as in his 17-metre-long mural *Mantegna's Edge* (1983, Southland Center, Dallas), a work of tremendous high-keyed vigour.

Heldt, Werner (1904–54) German painter, born in Berlin, where he studied at the School of Arts and Crafts, 1923–4, and the Academy, 1924–30. In 1933–6 he lived on the island of Majorca, but had to leave because of the outbreak of the Spanish Civil War. After serving in the German army in the Second World War, he settled in West Berlin but made frequent visits to Ischia, an island in the Gulf of Naples. Heldt is best known as a painter of street scenes and for this reason has been called 'the *Utrillo of Berlin'. He visited Utrillo in Paris in 1930 and like him was a heavy drinker, but the resemblance between their work was slight. Heldt's streets are often depicted at night and are usually empty, sometimes with suggestions of mysterious or *'Metaphysical' perspectives. In some of his pictures he embodied his war experiences in views of dream cities that border on the *Surrealistic. Towards the end of his career his work became increasingly abstract.

Hélion, Jean (1904–87) French painter, born at Couterne, Orne. In 1921 he moved to Paris, where he was apprenticed to an architectural firm. He began painting full-time—self-taught—in 1925. His early work—landscapes, portraits, still-lifes—was naturalistic, but he was soon influenced by avant-garde art. An enterprising and energetic man, he quickly gained many friends in the art world, including *Torres García, who introduced him to *Cubism. Hélion was also influenced by *Mondrian and by 1929 he was painting in an uncompromisingly abstract style. In 1930 he signed van *Doesburg's manifesto *Art Concret* (*see* CONCRETE ART), and in 1931 he was a founder member of the *Abstraction-Création group. Hélion's most characteristic works were done during the next few years—broadly patterned geometrical abstractions with strangely curving tube-like forms recalling the mechanistic paintings of *Léger (*Île de France*, 1935, Tate). Following visits to New York in 1932 and 1934, Hélion moved to the USA in 1936 (dividing his time between New York and Virginia), becoming an important link between the European and American avant-gardes. In 1940 he returned to Europe to join the French army. He was taken prisoner but escaped and made his way back to America, where he published an account of his experiences, *They Shall Not Have Me*, in 1943. While there he also made contact with *Surrealist exiles including *Ernst, *Duchamp, and *Breton. After the war he returned to France and, disillusioned by the Utopian ambitions of geometric abstraction, radically changed his style, turning again to figurative painting and producing bold, colourful, almost caricature-like everyday life scenes. The

store-front was a frequent subject, a potent image in a time of post-war shortages. He contrasted his approach to Surrealists such as Magritte, who 'shows baguettes proceeding across the sky like a fleet of dirigibles...When I paint bread, I paint baguettes lying on the table. There's mystery there. Mystery that lasts forever.'

Further Reading: D. Ottinger, *Jean Hélion* (2004)

Helms, Jesse *see* SERRANO, ANDRES.

Henri, Robert (1865–1929) American painter, teacher, and writer, a major figure in combating conservative attitudes in American art in the early 20th century. He was born Robert Henry Cozad in Cincinnati but changed his name after his father killed a man in self-defence in 1882 and spent several years as a fugitive before being cleared of murder. From 1886 to 1888 he trained at the Pennsylvania Academy of the Fine Arts, Philadelphia, under Thomas Anshutz (1851–1912), who passed on the tradition of Thomas *Eakins, an artist Henri came to admire deeply. In 1888–91 he lived in Paris, studying mainly at the *Académie Julian. After returning to Philadelphia he became the leader of a circle of young artists— *Glackens, *Luks, *Shinn, *Sloan—that later became the nucleus of The *Eight (1) and of the *Ashcan School. In 1895–7 and 1898–1900 he again lived in Paris, then in 1900 settled in New York. There he became an outstanding teacher: among his students were George *Bellows, Stuart *Davis, and Edward *Hopper.

The essence of Henri's teaching was that art should grow from life, not from theories. He said that he wanted his own paintings to be 'as clear and as simple and sincere as is humanly possible', and he was a powerful force in turning young American painters away from academism to look at the rich subject-matter provided by modern urban life. In 1910 he was the prime mover behind the Exhibition of Independent Artists, the first large, unrestricted, no-jury exhibition in American art. Henri was open-minded about the new developments seen at the Armory Show (he often commented on *Braque, *Matisse, and *Picasso in his classes), but his own work was little affected by it. His early work had been *Impressionist, but in the 1890s he adopted a darker palette, with rapid slashing brushwork geared to creating a sense of vitality and immediacy. From 1909 his work became more colourful again. Apart from scenes of urban life, he painted many portraits, and also landscapes and seascapes (which have been rather neglected).

He wrote numerous articles on art and in 1923 published *The Art Spirit*, a collection of his letters, lectures, and aphorisms, in which art is seen as an expression of love for life. William Innes Homer comments that 'It has had universal appeal because it addresses an audience on so many levels: as a painter's manual, a guide to aesthetic appreciation, a philosophy of art and life, and a spur to creative activity' (*Robert Henri and his Circle*, 1969).

Hepher, David *See* SUPERREALISM.

Hepworth, Dame Barbara (1903–75) British sculptor, one of the most important figures in the development of abstract art in Britain. She was born in Wakefield, Yorkshire, the daughter of a civil engineer, and won scholarships to Leeds School of Art, 1919–21, and the *Royal College of Art, 1921–24. Henry *Moore was among her fellow students at both places and became a lifelong friend. In 1924 she came second to John *Skeaping in the competition for the Prix de Rome, but she obtained a travelling scholarship and spent the years 1924–5 in Italy, marrying Skeaping in Rome in 1925 (they were divorced in 1933). Her early sculptures were quasi-naturalistic and had much in common with Moore's work (*Doves*, 1927, Manchester Art Gallery), but she already showed a tendency to submerge detail in simple forms, and by the mid-1930s her work had become entirely abstract. At this time she worked in both stone and wood, and she described an important aspect of her early career as being 'the excitement of discovering the nature of carving' (she had learnt stone cutting in Italy). In this preference for *direct carving she was united with Moore, but whereas his abstractions always remained based on natural forms, hers were often entirely non-representational. Yet Hepworth consistently professed a Romantic attitude of emotional affinity with nature, speaking of carving both as a 'biological necessity' and as an 'extension of the telluric forces which mould the landscape'.

In 1931 Hepworth met Ben *Nicholson and began living with him soon afterwards (they were married in 1938 and divorced in 1951).

Through him she became more aware of contemporary European developments and more committed to abstraction. They joined *Abstraction-Création in 1933 and *Unit One in the same year. During the 1930s Hepworth, Nicholson, and Moore (who lived near them in Hampstead) worked in close harmony and became recognized as the nucleus of the abstract movement in Britain. Hepworth's outlook was already clearly formed in the short introduction she wrote for the book *Unit One* published in 1934: 'I do not want to make a stone horse that is trying to and cannot smell the air. How lovely is the horse's sensitive nose, the dog's moving ears and deep eyes; but to me these are not stone forms and the love of them and the emotion can only be expressed in more abstract terms. I do not want to make a machine which cannot fulfil its essential purpose; but to make exactly the right relation of masses, a living thing in stone, to express my awareness and thought of these things . . . In the contemplation of Nature we are perpetually renewed, our sense of mystery and our imagination is kept alive, and rightly understood, it gives us the power to project into a plastic medium some universal or abstract vision of beauty.'

In 1939 Hepworth moved to St Ives in Cornwall with Nicholson (*see* ST IVES SCHOOL) and she lived there for the rest of her life. The Cornish landscape helped to reintroduce a suggestion of natural forms to her sculpture and the ancient standing stones of the region encouraged her to use upright forms, sometimes pierced, although ovoid shapes also remained characteristic of her work. She had introduced the use of the 'hole' to British sculpture in 1931 with *Pierced Form* (destroyed during the Second World War) and she now developed this with great subtlety, making play with the relationship between the outside and inside of a figure, the two surfaces sometimes being linked with threaded string, as in *Pelagos* (1946, Tate). The strings open up space without volume—in this she was influenced by Naum *Gabo, who had joined her and Nicholson in Cornwall. *Pelagos* also shows her sensitive use of painted surface to contrast with the natural grain of the wood.

By the 1950s Hepworth had an international reputation and in her later career she received many honours, including the main prize at the 1959 São Paulo *Bienal, and numerous prestigious public commissions,

among them the memorial to Dag Hammerskjöld—*Single Form*—at the United Nations in New York (1963). From 1956 she worked more in bronze, especially for large pieces, but she always retained a special feeling for direct carving. However, like Moore, she made considerable use of assistants in her later years. She hated modelling and her bronze casts were all made from plaster, which she could carve: 'I only learned to love bronze when I found that it was gentle and that I could file it and carve it and chisel it.' Occasionally she diversified into other areas, notably with her sets and costumes for the first production of Michael Tippett's opera *The Midsummer Marriage* in 1955. Hepworth died tragically in a fire at her studio in St Ives, which is now a museum dedicated to her work. An art centre named after her is scheduled to open in her native city of Wakefield in 2010. At the time of her death she was generally regarded as the world's greatest woman sculptor, and her obituary in the *Guardian* described her as 'probably the most significant woman artist in the history of art to this day'. She believed that the woman artist could add something distinctive to sculpture because of 'a whole range of formal perception belonging to feminine experience . . . if I see a woman carrying a child in her arms it is not so much what I see that affects me, but what I feel within my own body' (Whitechapel Art Gallery, 'Barbara Hepworth Retrospective Exhibition', 1954). In all her work she showed a deep understanding of the quality of her materials and superb standards of craftsmanship.

Further Reading: P. Curtis and A. G. Wilkinson, *Barbara Hepworth: A Retrospective* (1994)
A. M. Hammacher, *Barbara Hepworth* (1987)

Hepworth, Dorothy *See* SPENCER, SIR STANLEY.

Herbin, Auguste (1882–1960) French painter, born at Quiévy, near Cambrai. He studied at the École des Beaux-Arts, Lille, 1900–02, then in 1903 moved to Paris, where he initially painted in a style influenced by the *Impressionists and *Post-Impressionists. However, after taking a studio in the *Bateau-Lavoir in 1909, his work was influenced by *Cubism and by about 1917 he was painting purely abstract compositions. Particularly notable are the decorative painted wood reliefs made in 1919–20. In the early 1920s he

reverted to a more figurative (though still Cubist-influenced) style, in which he did landscapes and portraits, but from about 1926 he turned to pure abstraction again and in 1931 he was a founder member of the *Abstraction-Création association. After the Second World War he painted completely flat compositions featuring simple geometrical shapes (circles, triangles, crescents, and so on) in pure, vivid, unmodulated colours. They were painted according to a highly personal theory of abstract art that he set out in his book *L'Art non-figuratif, non-objectif* (1949); it was based on correspondences between colours, shapes, forms, and letters of the alphabet. Herbin had an international reputation. He was one of the few French painters who consistently devoted himself to geometrical abstraction over a lengthy period and he had considerable influence on younger abstract artists. He also designed carpets and tapestries.

'Herbstsalon' *See* STURM.

Herman, Josef (1911–2000) Polish-born painter who became a British citizen in 1948. He was born in Warsaw, the son of a Jewish cobbler, and studied at the Warsaw School of Art, 1930–31. In 1938 he moved to Brussels, then in 1940 to Glasgow, where he became a friend of another Polish refugee, Jankel *Adler. He moved to London in 1943, then from 1944 to 1953 lived in the Welsh mining village of Ystradgynlais. Ill health forced him to seek a drier climate and subsequently he lived in London and Suffolk. Herman is best known for his sombre pictures of Welsh miners, with whom he felt a strong affinity. He often showed their black figures silhouetted against the sun: 'This image of the miners on the bridge against a glowing sky mystified me for years with its mixture of sadness and grandeur.' Michael Jacobs and Malcolm Warner write that 'The harsh realities of life here provided a subject perfectly attuned to his expressionist style of painting. He feels that he has achieved a special empathy with the local inhabitants, and knew that he was accepted by them as soon as they referred to him by the affectionate nickname "Joe bach" (little Joe). Much of his time at Ystradgynlais was spent underground observing the life of the miners' (*The Phaidon Companion to Art and Artists in the British Isles*, 1980). Herman made a considerable reputation with his mining scenes and was commissioned to paint a mural for the Festival of Britain in 1951 (*Miners*, Glynn Vivian Art Gallery and Museum, Swansea). In subsequent paintings he depicted the life of other working people he had seen on his extensive travels, which are documented in his book *Related Twilights: Notes from an Artist's Diary* (1975). He made an impressive collection of African sculpture and his figure style was to some extent based on it.

Hermitage, St Petersburg *See* MOROZOV, IVAN; SHCHUKIN, SERGEI.

Heroic Realism *See* SOCIALIST REALISM.

Heron, Patrick (1920–99) British painter, writer, and designer, born in Leeds. He studied at the *Slade School, 1937–9, and during the Second World War, when he was a conscientious objector, he worked on a farm, then as an assistant to the potter Bernard Leach in St Ives (Heron had lived there as a child). After the war he worked as art critic for *The New English Weekly*, 1945–7, and *The New Statesman and Nation*, 1947–50 and he was London correspondent of the New York journal *Arts* from 1955 to 1958. In the 1930s and 1940s he also made designs for Cresta Silks, a firm founded by his father T. M. Heron, who also commissioned work from *Kauffer, Cedric *Morris, and Paul *Nash. Heron's early paintings were influenced by *Braque and *Matisse, but in 1956 he turned to abstraction; in the same year he settled at Zennor (*see* ST IVES SCHOOL). His abstracts were varied, including stripe paintings—vertical and horizontal—as well as looser formats with soft-edged shapes, but all his work was notable for its vibrancy of colour. The paintings frequently refer to light and atmosphere in a manner close to Parisian *Lyrical Abstraction. For Heron colour was the 'only direction for painting'. The critic Adrian Searle recalled how, as an art student, he had been the only audience as Heron had stood on a chair, 'dressed in clashing shades of acrylic knitwear, a lurid purple scarf slung rakishly about his neck', and berated him about colour. His writings include a collection of essays entitled *The Changing Forms of Art* (1955), and books on *Vlaminck (1947), *Hitchens (1955), and Braque (1958). As a critic he emphasized the 'autonomy of art' in opposition to John *Berger's concentration on the political function. In 1974 he published a series of articles in *The Guardian*, claiming that the St Ives painters had exercised a decisive influence on

American *Post-Painterly Abstraction and
that, due to the machinations of Clement
*Greenberg, a one-time friend and ally with
whom he had fallen out, this had been ig-
nored. Heron's arguments have not generally
been accepted by art historians.

Further Reading: M. McNay and A. Searle, 'The Colour of
Genius', *The Guardian* (22 March 1999)
D. Sylvester (ed.), *Patrick Heron* (1998)

Herriman, George (1880–1944) American
cartoonist, born in New Orleans. He first
contributed cartoons to newspapers in about
1903. In 1913 he began drawing the *Krazy Kat*
cartoon strip. Taking place in the imaginary
Coconino County, the basic situation always
concerned a perpetually unrequited love trian-
gle. Offissa Pup, the symbol of law and order,
loves Krazy Kat, who loves Ignatz Mouse, who
loves throwing bricks at Krazy Kat, who desires
this deeply, not realizing that it is a sign of
contempt, not love. Offissa Pup constantly
attempts, usually in vain, to frustrate the con-
summation of brick on cat's head. Variations of
the theme kept Herriman at work for thirty
years, the finest examples being considered to
be the colour pages of 1935 onwards. The
events take place in a mysterious desert land-
scape, like *Dalí but less pedantically drawn,
which changes unpredictably from frame to
frame like a film with deliriously faulty conti-
nuity. Herriman has been admired by many
artists, including Philip *Guston, Claes *Old-
enburg, and Eduardo *Paolozzi.

Hesse, Eva (1936–70) German-born Ameri-
can sculptor and painter. Her family fled the
Nazis, settling in New York in 1939, and she
became a US citizen in 1945. She studied at
various art schools in New York, then at Yale
University under Josef *Albers, graduating in
1959. Her early work was entirely in the field of
painting: semi-abstract works but with strong-
ly visceral associations. She did not take up
sculpture until 1964, so her career in this field
lasted only six years, before her early death
from a brain tumour. However, in that time
she gained a high reputation as an exponent of
'Eccentric Abstraction' (the title of an exhibi-
tion in which her work was included,
organized by her friend Lucy *Lippard, at the
Fischbach Gallery, New York, in 1966). Just
before her death one of her sculptures was
illustrated on the cover of *Artforum*, a recog-
nition of success in the New York art world.
Hesse is sometimes described as a *Minimalist

and her work shared with Minimal art the use
of repeated units and severely limited colour.
She made inventive use of materials (includ-
ing fibreglass, wood, wire, various fabrics, and
rubber tubing); her forms are often organic
and sexually suggestive. An example is her
'break-through' piece, *Hang-up* (1966, Art In-
stitute of Chicago). A rectangle like a picture
frame is hung on a wall and bound in cloth. A
steel tube protrudes from points in the top and
bottom forming an irregular curve which rests
on the floor. Although other artists of the peri-
od such as Richard *Serra and Robert *Morris
were looking beyond the austere geometry of
Minimalism to more fluid forms and materi-
als, there seemed a particular emotional po-
tency about Hesse's work. There may well be a
degree to which the artist's premature death
has coloured subsequent interpretations. The
art historian Anne Middleton Wagner has
pointed out that in the artist's lifetime the
work was interpreted as quirky rather than
tragic. Her use of soft materials was regarded
as exemplary by younger *feminist artists.

Further Reading: M. Nixon (ed.), *Eva Hesse* (2002)

Heymans, Adrien *See* LUMINISM.

Heysen, Sir Hans (1877–1968) German-
born Australian landscape painter, mainly in
watercolour. He was born in Hamburg and
emigrated to Australia with his parents when
he was six. For most of his career he lived in or
near Adelaide, but he returned to Europe to
study, notably at the *Académie Julian, Paris.
Robert *Hughes (*The Art of Australia*, 1970)
writes: 'Heysen's large body of work was im-
mensely popular; it has most of the textbook
virtues and, for many years, no Australian
business firm was considered quite solid un-
less it had a Heysen in its boardroom . . . The
only deficiency of his art is that it has no
imagination . . . He was, in fact, the Alfred
*Munnings of the gum-tree.' The best collec-
tion of his work is in the Art Gallery of South
Australia, Adelaide.

Hicks, Edward *See* NAIVE ART.

Hicks, Sheila *See* FIBRE ART.

Hide, Peter (1944–) British sculptor, born in
Carshalton, Surrey. He was a student of An-
thony *Caro at *St Martin's School of Art and
became for a time his assistant. From 1967 he
was one of the leading figures in the Stockwell
Depot group of sculptors in south London;

they were based in a former warehouse which became a place of work and exhibition for a number of Caro's ex-pupils. Unsurprisingly he was much influenced by the welded metal sculpture practised by Caro, but Hide has also spoken of the significance of Michael Steiner (1945–), an American sculptor strongly admired by Clement *Greenberg, in helping him to find a way of humanizing the 'high abstract language' he had learnt as a student. Hide's sculpture *Zenith* (1975), which substitutes verticality for the horizontality that was characteristic of *Caro, is typical of this endeavour. Although the piece is basically abstract, he used the classic device of twisting the figure (*contrapposto*) to animate it. He has been professor of sculpture at the University of Alberta, Canada, since 1984.

(⊕) SEE WEB LINKS

• The artist's own website.

Higgins, Dick *See* FLUXUS.

Hildebrand, Adolf von (1847–1921) German sculptor and writer on art. He spent much of his career in Italy and is regarded as one of his period's main upholders of the classical tradition in sculpture. His most characteristic works were nude figures—timeless and rather austere, in the high-minded spirit of Greek art—although he also made several large monuments, including a statue of Johannes Brahms in Meiningen (1898) and an equestrian statue of Bismarck in Bremen (1907–10). These are both in bronze, but he also worked a good deal in stone. He is now, however, better known for his treatise *Das Problem der Form in der bildenden Kunst* (1893) than for his highly accomplished but rather bland sculpture. The book went through many editions (an English translation, *The Problem of Form in Painting and Sculpture*, was published in 1907) and it was influential in promoting a move against surface naturalism in sculpture in favour of clarity of form. Later his work was adopted as one of the models for the pseudo-classical sculpture typical of *National Socialist art.

Hilder, Rowland (1905–93) British painter, printmaker, illustrator, and designer. He was born in Long Island, New York, to British parents, and in 1915 moved to London, where he studied etching and drawing at *Goldsmiths College. Hilder taught at Goldsmiths from 1929 to 1941 and he is said to have produced the first *screenprint ever made in Britain (1924). His most characteristic works are pleasant views of the English countryside (often winter scenes), which have been much reproduced on greetings cards, calendars, and so on. A collection of his work was published in 1986 as *Rowland Hilder's England*.

Hill, Anthony (1930–) British abstract painter and maker of reliefs, born in London. He studied at *St Martin's School of Art, 1947–9, and at the Central School of Art and Design, 1949–51. After a period of experimentation with various styles and modes of expression in the early 1950s, he adopted a highly disciplined form of abstract painting. Writing in 1954 (Lawrence *Alloway, *Nine Abstract Artists*) he claimed a distinction between genuine abstract art and those works which 'have no coherent thematic or aesthetic and must be judged as representing obscure personal styles of artists in various degrees of conflict with figuration or mimeticism'. Genuine 'abstract' art had two main trends, 'architectonic', as represented by *Mondrian, and 'mathematical', as represented by *Gabo. Such art was 'distinctly rational and determinist in contrast to the subjectivist limbo in which the greater part of art is today submerged'. In 1954 he made his first relief and he abandoned painting two years later. With Kenneth and Mary *Martin he became recognized as one of the leaders of the *Constructivist movement in Britain. In 1956 he contributed reconstructions of historic abstract works such as those of *Rodchenko to 'This is Tomorrow' at the Whitechapel Gallery. His reliefs often use industrial materials such as plastic and mass-produced aluminium sections arranged in accordance with mathematical formulae (he was honorary research fellow in the mathematics department at University College London in 1971–3). He has published several articles on art and mathematics, and in 1968 he edited an anthology *DATA: Directions in Art, Theory and Aesthetics*, which was described by the critic Stephen Bann as 'by far the most illuminating and comprehensive recent survey of attitudes towards the constructive tradition'. He has also made *Dada-influenced reliefs under the pseudonym Achill Redo.

Hill, Gary *See* VIDEO ART.

Hiller, Susan (1942–) American/British artist. Born in Florida, she settled in London in the early 1970s after travelling through

Europe. Her work uses a great variety of media, including video and installation, and she cites both *Minimal Art and *Surrealism as sources. In spite of its stylistic and technical variety there is a consistency in the interests behind the work which is informed by *psychoanalysis and anthropology. She had studied the latter before becoming an artist but had become disillusioned by its claims to objectivity and by the manipulative use to which the United States government put it.

Dedicated to the Unknown Artist (1972-6) is a series of old postcards, collected by the artist, which all depict rough seas. These anonymous and forgotten images represent a popular reflection of the idea of the sublime (see ABSTRACT SUBLIME) which, in the period of the Romantic movement, was so important an ingredient of high culture. She later told an interviewer: 'I'm interested in things that are outside or beneath recognition, whether that means cultural invisibility or has to do with the notion of what a person is. I see this as an archaeological investigation, uncovering something to make a different kind of sense of it.' This concern with what is barely visible or perceptible is a constant theme of her work. Early in her career she became fascinated by the Latvian scientist Konstantin Raudive (1906-74), who claimed to be able to record the sounds of the dead. She has made use of the Surrealist practice of automatic writing (see AUTOMATISM), for instance in a series of works, the Midnight Self-Portraits (1980-89), in which her own face is obscured by automatic mark-making. Belshazzar's Feast, the Writing on Your Wall (1983-4, Tate) is an installation, made like an ordinary sitting room centred around a television, on which is shown the image of a burning fire. It comments on the widely reported tendency to 'see things' in the apparently random patterns of a fire or flickering screen. Hiller had been interested in a number of newspaper reports of people having apparently received extra-terrestrial messages on the television after close down.

In other works she deals with poignant and easily forgotten residues of history. Monument (1980, Tate) is a series of photographs of plaques in a London park, put up before the First World War, commemorating tragic but heroic acts of self-sacrifice. Hiller incorporates two distinct ways of receiving the work. The viewer can look at it frontally or sit on a bench, back to the wall and the photographs, listening to a commentary by the artist. If this second

option is adopted, the viewer necessarily becomes part of the work and potentially observable. In an installation of 2005, J-Street Project, the wall was covered by a map of Germany marking out all the streets with 'Juden' in their names, relics of a destroyed community. An accompanying video documents the artist's search for them

Further Reading: P. Kenrick, 'Susan Hiller, Automatic Writing and Images of the Self', in G. Griffin (ed.), Difference in View: Women and Modernism (1994)

Hilliard, John See PHOTO-WORK.

Hillier, Tristram (1905-83) British painter of landscape, still-life, and occasional religious subjects, born in Beijing, where his father was manager of the Hong Kong and Shanghai Bank. After two years studying at Cambridge University (which he described as 'a waste of time'), he was apprenticed to a London firm of chartered accountants, but he quickly abandoned this career to study at the *Slade School under *Tonks, 1926-7, while also attending evening classes at the Westminster School of Art. He then went to Paris, where he studied at the Académie Colarossi under *Lhote, and until 1940 he lived mainly in the south of France, with visits to Spain, which he 'came to love above all other countries'. Early in his career Hillier was influenced by a variety of modern idioms (he was a member of *Unit One), and his work included abstracts. In the mid-1930s, however, he evolved the style to which he remained faithful for most of his life: In a manner influenced by *Dalí and French *Neo-Romanticism, he painted with great sharpness of definition and smoothness of finish, creating scenes of stillness and calm that evoke an air of other-worldliness through the juxtaposition of incongruous objects and the use of unreal perspectives. One of the earliest examples in which he showed this personal voice is La Route des Alpes (1937, Tate) which, like many of his paintings, is executed in tempera. He came to regard himself as 'the slave of my own style', but in some of his later work he used freer brushwork or applied paint with a palette knife. In 1954 he published an autobiography, Leda and the Goose.

Hills, Joan See BOYLE, MARK.

Hilton, Roger (1911-75) British painter of German extraction, born in Northwood, Middlesex. His father was a doctor who changed his surname (Hildesheim) because

of anti-German feeling during the First World War. His mother, Louisa Holdsworth Sampson, had trained as a painter at the *Slade School. Hilton also studied at the Slade, 1929–31 and 1935–6, and during the 1930s he lived in Paris for a total of about two and a half years, spending part of this time at the *Académie Ranson, where he was taught by *Bissière. In 1939 he joined the army, and he was prisoner of war from 1942 to 1945 after being captured in a commando raid on Dieppe. After the war he taught for several years, at Bryanston School and then from 1954 to 1956 at the Central School of Arts and Crafts. In 1950 he began working as an abstract painter. Initially he was influenced by developments in Paris, which he revisited regularly, especially the work of *Poliakoff and de *Staël. After meeting the Dutch painter *Constant in 1953 and visiting Amsterdam with him, he was influenced more by *Mondrian, whose work inspired in him the sense that the space of a painting was not an aperture in which the spectator can move but something which builds out into real space. However, he never cultivated an impersonal geometric style, although he had been in contact with *Constructivists such as Victor *Pasmore and Stephen *Gilbert. During this period he was one of the most unequivocally abstract of British painters. From 1955 he reintroduced a sense of a shallow pictorial space, and from 1956, when he began making visits to St Ives (*see* ST IVES SCHOOL), there are suggestions of beaches, boats, rocks, and water in his work. Writing to his friend Terry *Frost in 1957 he said: 'It is disconcerting not knowing whether my next show will be of chaste abstracts or violent figuration, but in any case it will be one or the other'. In 1961 he returned to more overt figuration with a series of female nudes, exuberant and jokey, but also with more than a touch of the violence implied in the letter to Frost (*Oi yoi yoi*, 1963, Tate). This movement between abstraction and figuration was something he shared with many contemporaries, such as *Dubuffet. He generally felt closer to Parisian artists than the New York School, which he considered overrated. In 1965 he moved from London to St Just in Cornwall and lived there for the rest of his life. In his later years his painting activities were severely affected by his heavy drinking. Tate curator David Brown commented, in the context of a generally affectionate account of his character, that 'he was often discomfiting

company, particularly when inflamed by alcohol, when he often became verbally abusive'(*DNB*). For the last few years of his life he was bedridden with a muscular disease, but his ill-health was belied in the series of colourful, good-humoured gouaches he did in this period, described by Charles Harrison (*see* ART & LANGUAGE) as the 'strategic products of a kind of enforced incompetence'.

Hilton won numerous awards, including first prize at the 1963 *John Moores Liverpool Exhibition and the UNESCO prize at the 1964 Venice *Biennale. His view of art was highly individualistic. Although, more than those of most of his British contemporaries, his paintings have an air of spontaneity, he was preoccupied with the idea of the sheer difficulties of art. His attitude to painting derived much from existentialism (*see* SARTRE). He saw the artist as a man in a life-or-death struggle with existence like the saint in his cell, or the alchemist in his workshop. In 1961 Alan *Bowness wrote: 'I do not think he finds painting easy, only necessary.'

Further Reading: Arts Council of Great Britain, *Roger Hilton: Paintings and Drawings 1931–73* (1974)

A. Lewis, *Roger Hilton* (2003)

Hiltunen, Eila (1922–2003) Finnish sculptor. She was born at Sortavala, Karelia, and studied at the Academy in Helsinki, 1942–6. She began her career working in a naturalistic style and made her name as a sculptor of war memorials, of which the one at Simpele is considered the best. She worked in bronze, marble, and granite, but in the late 1950s she discovered the technique of welding and concentrated on this after meeting *Archipenko during a visit to the USA in 1958. Initially her welded pieces were figurative, but she then turned to abstraction, as in her most famous work, the Sibelius Monument (1967) in Sibelius Park, Helsinki. This consists of a nest of polished steel tubes that have been likened both to organ pipes and to the pine trunks of the Finnish forests.

Himid, Lubaina *See* BOYCE, SONIA.

Hine, Lewis Wickes (1874–1940) American photographer, born in Oshkosh, Wisconsin. After several years of factory work, he studied sociology and pedagogy for a short period at the University of Chicago. From there he went to New York, where he taught at the Ethical Culture School (1901–8). His interest in photography arose from his teaching practice. The

superintendent of the school, Frank Manny, who took a liberal view in the contentious debate on immigration, encouraged Hine to take his pupils with a camera to Ellis Island to photograph the new arrivals from Europe. The strongly individualized portrayals challenged the negative stereotyping which frequently dominated discussion of the issue. In 1907, Hine became official photographer for the National Child Labor Committee, documenting working conditions. He often used clandestine means to gain access to factories, sometimes pretending to be a fire inspector or a Bible salesman or claiming to be an industrial photographer who was only interested in the machinery. These photographs were published in journals such as the leftist *Survey* to provide visual evidence to reinforce the campaigns against child labour. After the First World War Hine's photographs tended to emphasize more the heroism of work, as in his best-known image, *Steamfitter* (1921). He also made a series of dramatic images (commissioned in 1930) recording the dangerous construction work on the Empire State Building. In spite of the great interest in social documentary photography during the 1930s, Hine died largely forgotten.

Further Reading: J. Guimond, *American Photography and the American Dream* (1991)

Hippolite, Hector *See* HYPPOLITE, HECTOR.

Hi-Red Center A group of Japanese *installation and *Performance artists active in 1963–64. The main figures were Genpei Akasegawa (1937–), Natsuyuki Nakanishi (1935–) and Jiro Takamatsu (1936–1998), and the group's title is a translation of parts of their names. They worked in the spirit of *Dada (Akasegawa had previously been a member of *Neo-Dada Organizers).

Hirschfeld-Mack, Ludwig (1893–1965) German-Australian abstract painter, experimental artist, and teacher, born in Frankfurt. While a student at the *Bauhaus (1919–25) he created 'Colour Light Plays' (1922 onwards) that give him a place as one of the pioneers of *Kinetic art and *Light art. He taught at various art schools from 1925 to 1936, when he left Germany because of pressure from the Nazis and moved to Britain. When war broke out he was interned and in 1940 he was sent to Australia. On being released from internment in 1942 he became art master at Geelong

Grammar School in Victoria, where he remained until his retirement in 1957. During these years he introduced Bauhaus teaching methods and he wrote *The Bauhaus: An Introductory Survey* (1963). The paintings he produced in Australia continued the colour researches of his Bauhaus days; an example is *Composition* (1946) in the Art Gallery of New South Wales, Sydney. A retrospective exhibition of Hirschfeld-Mack's work was held in this gallery in 1974.

Hirschhorn, Thomas (1957–) Swiss *installation artist. Born in Bern, he lives and works in Paris. He builds ephemeral structures out of disposable materials such as cardboard, tin foil, and tape. These are intended to provoke ideas about democracy and participation. He has made installations dedicated to important thinkers such as the philosopher Spinoza and most famously *Bataille, to whom he dedicated a 'monument' in the 2002 *documenta. This was a kind of pavilion which Hirschhorn constructed in a housing estate outside the main exhibition centre, using only the paid assistance of the residents. In the pavilion there was a display which documented Bataille's life and ideas. Visitors to the documenta saw the work by means of a 'shuttle service', cars driven to and from the monument by residents of the estate. Hirschhorn, who believes strongly in the participation of a 'non-art world' audience, regarded this as an important part of the experience of the work. A more overtly political statement was made by his work for the 1999 Venice *Biennale. The installation included a world map in the form of a rank of model aircraft in the colours of the national airlines, an array of branded goods, and images of socialist martyrs such as Rosa Luxemburg. Hirschhorn has stated: 'Freedom is what I am fighting for, and you only get freedom when you are fighting for it.'

Further Reading: M. Rappolt, 'Studio: Thomas Hirschhorn', *Tate*, no. 7

Hirshfield, Morris (1872–1946) Polish-born American *naive painter. He emigrated to the USA in 1890 and settled in New York, where he worked in the garment industry and then as a manufacturer of slippers. When illness forced him to retire in 1937, he at last had time to satisfy the artistic impulse he had felt since childhood (he had done some carving as a boy, but nothing since). He worked slowly and his output was consequently

small (seventy-seven pictures in his nine-year career). Most of his pictures fall into two main groups: animal subjects, taken from illustrations in children's books, but transformed from the banal originals into fabulous creatures from a fairy-tale world; and erotic female nudes with vacant faces (they have been compared to the work of Tom *Wesselmann, though Hirshfield's nudes were done without irony or conscious exhibitionism). He painted with meticulous attention to detail and with a strong sense of pattern, characteristics that perhaps stem from his experience with linear design and needlework in his business days. In 1939, only two years after he started painting, Hirshfield was 'discovered' by the art dealer Sidney *Janis, and in 1943 he was given an exhibition at the Museum of Modern Art, New York—a rare honour for a naive painter and an indication of the esteem in which he was held.

Hirshhorn Museum and Sculpture Garden, Washington DC. Collection of modern painting and sculpture founded by Joseph H. Hirshhorn (1899–1981), a Latvian immigrant to the USA, and presented to his adopted country in 1966. It is administered by the Smithsonian Institution. Hirshhorn left Latvia at the age of six and fulfilled the rags-to-riches American dream, his enormous fortune being made mainly from uranium mining. He began collecting in the early 1930s, relying entirely on his own instincts—if he liked an artist's work he tried to buy as much of it as possible. The collection extends from about 1880 to contemporary art and is particularly strong in sculpture, in American painting, and in European painting since the Second World War. Highlights include about 40 *de Koonings and about 50 Henry *Moores. The museum building was designed by one of the USA's leading architects, Gordon Bunshaft (of the firm of Skidmore, Owings & Merrill), and was opened to the public in 1974. It consists of a huge concrete drum raised above a plaza on four massive piers. The museum is linked by an underground passage to the sculpture garden on the opposite side of Jefferson Drive. Hirshhorn gave the trustees of the museum the freedom to add or dispose of works as they saw fit, and the collection continues to expand.

Hirst, Damien (1965–) British sculptor, painter, collector, and designer, a flamboyant personality whose inventive artworks, flair for self-publicity, and entrepreneurial skills helped him become the most famous British artist of his generation. He was born in Bristol and after an undistinguished school career (he often played truant and merely scraped an A Level in art) he worked on building sites in London while trying to get into art school. He failed to win a place at *St Martin's School of Art (his mother said this was 'Because you stick rubbish to bits of board'), but he was accepted by *Goldsmiths College, where he studied 1986–9. Whilst still at Goldsmiths he made a name for himself by organizing an exhibition of student work ('Freeze', 1988) in a large disused building in the Docklands area of London and persuading leading dealers and critics to come and see it. The exhibition was made possible by an economic recession which made such spaces available. From his youth Hirst had a fascination with death (he bought and stole pathology books 'for morbid curiosity about burns'). As a student he had himself photographed in a mortuary, his grinning face next to a corpse which also appeared to be grinning. He first attracted attention with works involving dead animals or fish as the raw materials (he became such a good customer at Billingsgate market in London that his regular fishmonger there was invited to his private views). *A Thousand Years* (1990, formerly *Saatchi collection) consists of two large glass cabinets in which flies are hatched from maggots, feed on a rotting calf's head and die by insect-o-cutor. As Sarah Kent points out, 'Can one feel sympathy with a fly? Most people kill them without compunction; they even hang insect-o-cutors in vegetarian restaurants.' His best-known work is *The Physical Impossibility of Death in the Mind of Someone Living* (1991, on loan to Metropolitan Museum of Art, New York), consisting of a dead tiger-shark 'floating' in preserving fluid in a large tank made of glass and steel. The shark came from Australia rather than Billingsgate (he had also tried Harrods in vain), and Hirst has had to put a good deal of planning into creating such large and potentially dangerous works (there have been scares over noxious fluid leaking from the tanks of his 'pickled animal' sculptures). The shark has had to be replaced because of the deterioration of the original. *Mother and Child Divided* (1993, Astrup Fearnley Museum, Oslo) consists of four tanks containing the severed halves of a cow and calf. According to the catalogue of the

1995 *Turner Prize exhibition, 'Hirst strips the closest of bonds between living creatures to its starkest reality'. Hirst himself said 'It's amazing what you can do with an E in A Level art, a twisted imagination and a chainsaw.' His other works include paintings consisting of rows of coloured spots and the interior design of the Quo Vadis restaurant in London (1997). In 2000 he made *Hymn*, a twenty foot enlargement of an anatomy model. This resulted in a legal claim against Hirst for plagiarism which was settled out of court, so raising issues about the wider consequences of the art world's general acceptance of *appropriation. In 2007 Hirst, perhaps seeking to trump Gabriel *Orozco's celebrated work, exhibited a diamond-encrusted skull entitled *For the Love of God*. It supposedly cost between £8 million and £10 million to produce, and the price tag was reputedly over £50 million.

Hirst has been a controversial figure. When he was awarded the Turner Prize in 1995 for, among other things, *Mother and Child Divided*, a letter to *The Times* suggested that the Tate authorities must be suffering from mad cow disease. It has not only been the usual opponents of 'modern art' who have questioned whether Hirst's success is not primarily a triumph of publicity. The art historian Julian Stallabrass argued that 'both art work and self disappear into pure image, pure celebrity'.

Hirst has also produced music, his best-known effort being *Vindaloo*, a football song. It is one of the less musically distinguished examples of the genre, but it is no doubt unique in its celebration of a goalless draw. Having been, more than any other artist, identified with the 'Saatchi effect', he broke with the famous collector, buying back many of his works. In September 2008 he took the unprecedented step of consigning a large amount of recent work, including a new shark piece, to an auction at Sotheby's. (The normal procedure for new work would have been to sell through a dealer.) In spite of difficult economic conditions, the event was a commercial success for the artist. Hirst has devoted some of his fortune to building up his own collection of art, including work by Francis *Bacon. *See also* YOUNG BRITISH ARTISTS.

Further Reading: T. Morton, 'Damien Hirst', *Frieze* (September 2007)

Hitchens, Ivon (1893–1979) British painter, mainly of landscapes. He was born in London,

son of the painter Alfred Hitchens, and studied at St John's Wood School of Art, 1911–12, and the *Royal Academy Schools (several years on and off between 1912 and 1919). In 1920 he became a founder member of the progressive *Seven & Five Society and was the only artist to belong to it throughout its entire lifetime until its demise in 1935. During this time he experimented with pure abstraction (he exhibited as one of the *Objective Abstractionists in 1934), but by the late 1930s he had created a highly distinctive style, on the borderline between abstraction and figuration, in which broad, fluid areas of lush colour, typically on a canvas of wide format, evoke but do not represent the forms of the English countryside that were his inspiration. In 1940, following the bombing of his London studio, he settled permanently at Lavington Common, near Petworth, in Sussex. His work altered little from then, apart from the fact that his palette changed from naturalistic browns and greens to much more vivid colours such as bright yellows and purples. In addition to landscapes, Hitchens painted flowers and figure subjects (usually nudes) and he did several large murals, for example at Nuffield College, Oxford (1959), and the University of Sussex (1963). His work is represented in Tate and many public collections. His son **John Hitchens** (1940–) is also a painter, mainly of landscapes and flower pieces.

Further Reading: P. Khoroche, *Ivon Hitchens* (2007)

Hlebine School A term applied to Yugoslav (Croatian) *naive painters working in or around the village of Hlebine, near the Hungarian border, from about 1930. At this time, according to the *World Encyclopedia of Naive Art* (1984), the village amounted to little more than 'a few muddy winding streets and one-storey houses', but it produced such a remarkable crop of artists that it became virtually synonymous with Yugoslav naive painting. The school developed from the encouragement given by Krsto *Hegedušić to the young Ivan *Generalić, whom he met in 1930. Generalić in turn encouraged his friends Franjo Mraz (1910–81; likewise a native of Hlebine) and Mirko Virius (1889–1943), who came from the nearby village of Djelekovac), and these three, sometimes known as the 'Hlebine Trio', formed the nucleus of the group. Hegedušić encouraged them to paint scenes of social protest in line with his own left-wing political views, but after the Second World War, Hlebine painters concentrated more on

idyllic depictions of country life (the post-war phase is sometimes characterized as 'second Hlebine School'). Generalić continued to be the dominant figure, and the younger artists included his son Josip.

Höch, Hannah (1889–1978) German artist, now best remembered as one of the pioneers of *photomontage. She was born in Gotha and studied in Berlin, where she worked as a designer for a firm publishing dress patterns, (which she sometimes used as material for her work) from 1916 to 1926. For much of this time she lived with Raoul *Hausmann, and like him belonged to the Berlin *Dada scene. In 1916 she began making *collages and soon afterwards photomontages. The technique is said to have been discovered in 1918 when Höch and Haussman were on holiday on the Baltic sea and observed a process of vernacular art whereby photographs were placed on the heads of engravings of heroic military figures. Her photomontages deal satirically with themes of female identity and contemporary politics. The most elaborate is *Cut with the Kitchen Knife Dada through the last Weimar Beer-Belly Cultural Epoch of Germany* (1919–20, National Gallery, Berlin). Maud Lavin argues that this work represents the revolutionary role of female liberation. In one of its most striking sections a female dancer juggles with the head of Käthe *Kollwitz. From 1926 to 1929 Höch lived in The Hague, then returned to Berlin. A one-woman exhibition of her work was planned to be shown at the *Bauhaus in 1932, but it never took place because the school was closed by the Dessau parliament that year. After the Nazis came to power, she lived in seclusion. Unlike John *Heartfield, she had never been interested in using the channels of mass media to disseminate her images. She also worked as an abstract painter, although this aspect of her activity has received less attention than her collages.

Further Reading: M. Lavin, *Cut with the Kitchen Knife: The Weimar Photomontages of Hannah Höch* (1993)

Hockney, David (1937–) British painter, draughtsman, printmaker, photographer, and designer, active mainly in the USA. After a brilliant career as a student, Hockney had achieved international success by the time he was in his mid-20s, and he has since consolidated his position as the best-known British artist of his generation. His phenomenal success has been based not only on the flair and versatility of his work, but also on his colourful personality, which has made him a recognizable figure even to people not particularly interested in art—so much so that a film about him, *A Bigger Splash* (1974), enjoyed some popularity in the commercial cinema.

Hockney was born in Bradford, Yorkshire, into a working-class family, and studied at Bradford School of Art, 1953–7. His early work—including portraits and views of his surroundings—was in the tradition of the *Euston Road School. After two years working in hospitals in lieu of National Service (he was a conscientious objector), he went to the *Royal College of Art in 1959 and graduated with the gold medal for his year in 1962. His fellow students included Derek *Boshier, Allen *Jones, R. B. *Kitaj, and Peter *Phillips, and with them Hockney was regarded as one of the leaders of British *Pop art after the *'Young Contemporaries' exhibition in 1961. Hockney himself disliked the label 'Pop', but his work of this time makes many references to popular culture (notably in the use of graffiti-like lettering, and one picture depicts a Ty-Phoo tea package) and is often jokey in mood. Most 'Pop' of all was his visible obsession with the well-known singer Cliff Richard, but this image was filtered through homosexual sub-culture rather than the mass media.

In 1963 he had his first solo show, at the gallery of the London dealer John *Kasmin, and his first retrospective came as early as 1970, at the *Whitechapel Art Gallery, London (it subsequently toured to Hanover, Rotterdam, and Belgrade). By this time he was painting in a weightier and more traditionally representational manner, in which he did a series of large double-portraits of friends, including the well-known *Mr and Mrs Clark and Percy* (1970–71, Tate). These portraits are notable for their airy feeling of space and light and the subtle flattening and simplification of forms, as well as for the sense of stylish living they capture. Hockney often paints the people and places he knows best (his art is frequently autobiographical) and he has memorably celebrated his romance with Los Angeles (he first visited the city in 1963 and settled there in 1976), particularly in his many paintings featuring swimming pools (*A Bigger Splash*, 1967, Tate). R. B. Kitaj wrote of these works: 'It is a rare event in our modern art when a sense of place is achieved at the level of very fine painting. *Sickert's Camden Town comes to mind, and above all *Hopper's America, in which I

grew up. Hockney's California is one of the only recent exemplars.'

Hockney has been outstanding in graphic art as well as in painting. His work in this field includes etched illustrations to Cavafy's *Poems* (1967) and *Six Fairy Tales of the Brothers Grimm* (1969), as well as many individual prints, often on homoerotic themes. The Cavafy illustrations were banned by the Foreign Office from a British Council exhibition in Mexico because of what was considered to be an over-explicit treatment of such themes. It was feared they would attract a crowd of 'young queens and beatniks'. In the 1970s Hockney came to the fore also as a stage designer, notably with his set and costume designs for Stravinsky's *The Rake's Progress* and Mozart's *The Magic Flute*, produced at Glyndebourne in 1975 and 1978 respectively. In the 1980s he worked a good deal with photography, making photographic collages in which a multiplicity of tiny images build up a scene in a manner he associates with *Cubism. Painting has continued to be his central activity, however. His works of the 1990s include a series entitled *Very New Paintings*, begun in 1992, in which he depicted Californian scenery in almost abstract terms. The loose handling of such works has disappointed some critics who admired the clarity of his earlier paintings. Hockney is a perceptive commentator on art and has published substantial books on his own work, including *David Hockney by David Hockney* (1976) and *That's the Way I See It* (1993), as well as a highly contentious foray into art history, *Secret Knowledge: Rediscovering the Techniques of the Old Masters* (2006). *See also* ACRYLIC; PHOTO-WORK.

Further Reading: P. Melia (ed.), *David Hockney* (1995)
National Portrait Gallery, *David Hockney Portraits: Life, Love, Art* (2006)

Hodgkin, Sir Howard (1932–) British painter and printmaker. He was born in London and studied at Camberwell School of Art, 1949–50, and *Bath Academy of Art, 1950–54; he later taught at Bath, 1956–66. His paintings sometimes look completely abstract, but he bases his work on specific events, usually an encounter between people—'one moment of time involving particular people in relation to each other and also to me'. He has travelled widely, making several visits to India, and his preference for flat colours and decorative borders reflects his admiration for Indian

miniatures, of which he has made a collection. His work has won him a reputation as one of the outstanding colourists in contemporary art, although Brian *Sewell has referred to him disparagingly as 'a painter of pretty post-*Omega tea trays' (Hodgkin is in fact distantly related to Roger *Fry and was familiar with Omega products from childhood). Sewell's comment reflects the small scale characteristic of Hodgkin's work, although in the 1980s he began producing much bigger pictures. A well-known figure in the art world, he has been a trustee of the National Gallery and the Tate Gallery, and in 1985 he was awarded the *Turner Prize. He was knighted in 1992, and there have been major exhibitions of his work at the Hayward Gallery in 1997 and Tate Britain in 2006.

Further Reading: N. Serota (ed.), *Howard Hodgkin* (2006)

Hodgkins, Frances (1869–1947) New Zealand painter, active mainly in England, where she settled in 1913 after some time spent alternating between the two hemispheres (her first visit to Europe had been in 1901). She was taught watercolour painting by her father—a barrister and amateur artist who had emigrated from England in 1859—and she studied at Dunedin Art School, 1895–8, but she did not begin to paint in oils until 1915. Until that time her work had been conventional, but she gradually developed a more modern style, echoing *Matisse and *Dufy in its use of vibrant colour (she spent a good deal of time in France). In 1929–34 she was a member of the progressive *Seven & Five Society and her late paintings, based on fluid colour, approach abstraction in a manner akin to the work of her fellow member Ivon *Hitchens. From the early 1930s she lived mainly at Corfe Castle in Dorset and she died at Herrison House psychiatric hospital, near Dorchester. Her chief subjects were landscape and still-life.

Further Reading: M. Evans, *Frances Hodgkins* (1948)

Hodler, Ferdinand (1853–1918) Swiss painter, born in Berne and active mainly in Geneva. He ranks alongside Arnold Böcklin (1827–1901) as the outstanding Swiss artist of his time. His early landscapes can be rather unimaginative, deriving from Corot and the Barbizon School. The figure paintings are another matter, combining realist observation of labouring figures with an attempt to communicate a sense of the infinite. In 1890, with his brooding *Night* (Kunstmuseum, Berne),

Hodler began a sudden change of style. This picture, which depicts a black-shrouded, phantom-like presence amid a number of semi-naked sleeping figures, set the pattern for his most characteristic works—allegories featuring stately groups of flat, stylized figures composed into a rhythmic and repetitive pattern of lines, forms, and colours. Often the same basic figure is repeated throughout the picture with only slight variations. Hodler called his method 'Parallelism'; he used the same principles in landscapes and scenes from Swiss history, including large mural compositions such as *Departure of the Volunteers in 1813* (1908, University of Jena). In this he was strongly influenced by late medieval painting. By the turn of the century he had become immensely popular throughout the German-speaking world and in 1904 a group of thirty-one of his paintings was the main attraction at the Vienna *Sezession's international exhibition, an event which marked the climax of international *Symbolism. In the last decade of his life Hodler returned more to landscape painting: 'In spare lines and a few vivid colours, comparable to the best Fauve work, he set forth his mystique of the Alpine landscape' (George Heard *Hamilton). There were also a number of paintings and drawings in which he documented the terminal illnesses of his two lovers Augustine Dupin (died 1909) and Valentine Godé-Dorel (died 1915). Following the death of the latter Hodler became a recluse, although he continued working as a landscape painter. As well as being a major figure of Symbolism and *Art Nouveau, Hodler has been seen as one of the harbingers of *Expressionism.

Further Reading: W. Hauptman, *Hodler* (2007)

Hofer, Karl (1878–1955) German painter, born in Karlsruhe, where he studied at the Academy under *Thoma, 1896–1901. Early in his career he found support from a rich Swiss patron, Dr Theodor Reinhardt, and this enabled him to live from 1903 to 1908 in Rome, where he painted in an idealized classical style. From 1908 to 1913 he lived in Paris, where he was influenced by the structural solidity of *Cézanne, and in 1909 and 1911 he visited India (at Reinhardt's expense), which for a time introduced an iconography of swooning, lyrical figures into his work. In 1913 he settled in Berlin, but he was trapped in Paris at the outbreak of the First World and spent three years in an internment camp;

George Heard *Hamilton writes that 'His memories of that time must have been ineradicable, because even years later the constraint of his figures and their hesitant gestures seem affected by physical or psychical confinement'. On his return to Berlin in 1918 he became a teacher at the Hochschule für Bildende Künste. He achieved considerable success, highlighted by a large exhibition in Berlin in 1928 to mark his 50th birthday, and his reputation spread outside Germany. However, in 1933 his work was declared *degenerate by the Nazis and he was removed from his teaching post. His studio and much of his work were destroyed by bombing in 1943. At the end of the Second World War he was reinstated at the Hochschule and was appointed its director. He wrote several critical and autobiographical books, including *Aus Leben und Kunst* (Life and Art), published in 1952.

In *Aus Leben und Kunst* Hofer said 'One must have the courage to be unmodern', and although his subjects in his work after the First World War were taken from modern life, he rejected the *Expressionism that was the dominant force in German art of his time. Except for a brief experiment with abstract painting in 1930–31, he concentrated on a small range of obsessively recurrent images, through which he expressed a dark and disillusioned vision of the world. His most typical works portray brooding figures, singly or in couples, but he also did portraits, landscapes, and large figure compositions. The simplicity and strength of design of his compositions reflect his lasting admiration for Cézanne, but their cool, chalky colours are distinctive.

Hoffmann, Josef *See* KLIMT, GUSTAV.

Hofmann, Hans (1880–1966) German-born painter and teacher who became an American citizen in 1941. He was born in Weissenburg, Bavaria, and brought up in Munich, where he studied at various art schools. From 1904 to 1914 he lived in Paris, where he knew many of the leading figures of *Fauvism, *Cubism, and *Orphism. In 1915 he founded his own art school in Munich and taught there successfully until 1932, when he emigrated to the USA (following visits in 1930 and 1931 during which he taught at the University of California, Berkeley). He founded the Hans Hofmann School of Fine Arts in New York in 1934 (followed the next year by a summer school at Provincetown, Massachusetts) and became a

teacher of great influence on the relatively small number of American artists who practised abstract painting during the 1930s. Hofmann continued teaching until 1958, when he closed his schools so that he could concentrate on his own painting. This was to counter opinions that he was merely an academic figure and a symbol of the avant-garde rather than a significant creative artist himself. In the course of his career he experimented with many styles, and was a pioneer of the technique of dribbling and pouring paint that was later particularly associated with Jackson *Pollock. His later works, in contrast, feature rectangular blocks of fairly solid colour against a more broken background. He gave a large collection of his pictures to the University of California, Berkeley.

As a painter and teacher Hofmann was an important influence on the development of *Abstract Expressionism. The essence of his approach was that the picture surface had an intense life of its own: 'Depth in a pictorial plastic sense is not created by the arrangement of objects one after another toward a vanishing point, in the sense of Renaissance perspective, but on the contrary by the creation of forces in the sense of push and pull.' In 1945 Clement *Greenberg described him as 'in all probability the most important art teacher of our time . . . He has, at least in my opinion, grasped the issues at stake better than did Roger *Fry and better than *Mondrian, *Kandinsky, *Lhote, *Ozenfant, and all the others who have tried to "explicate" the recent revolution in painting . . . this writer . . . owes more to the initial illumination received from Hofmann's lectures than to any other source . . . I find the same quality in Hofmann's painting that I find in his words—both are completely relevant. His painting is all painting . . . asserting that painting exists first of all in its medium and must there resolve itself before going on to do anything else.'

Further Reading: K. Wilkin, *Hans Hofmann: A Retrospective* (2004)

Hogarth Press *See* BELL, VANESSA.

Holgate, Edwin *See* GROUP OF SEVEN.

Höller, Carsten (1961–) German artist, born in Brussels, who has lived in Stockholm since 2000. He was trained as a scientist and this is reflected in work that tends to encourage mental states which lead to the confusion of ordinary expectations. Sometimes this is achieved in a physical sense, as with his best-known work, the series of slides such as *Test Site* installed at Tate Modern in 2006. The installation invited visitors to lose control and submit to what the French writer Roger Caillois (1913–78) called 'a voluptuous panic upon an otherwise lucid mind'. Höller has also made a *Frisbee House* (2000), which again invites participation. Yet the artist insists that physical engagement is only one way to understand the work and it is perfectly valid simply to watch without physical participation. Sometimes the effects are more purely perceptual. He has produced spectacles which induce an upside-down vision of the world. The *Upside-Down Mushroom Room* (2000) is an installation in which revolving models of mushrooms grow from the ceiling. For an exhibition in Stockholm in 2003 entitled 'One Day One Day' two separate openings were announced for two alternating exhibitions in the same space. Höller's idea was that the experience would depend upon the day on which the visitor arrived.

(⊕) SEE WEB LINKS

• Interview with Höller, Tate website.

holography *See* LIGHT ART.

Holroyd, Sir Charles *See* TATE.

Holt, Nancy (1938–) American *Land artist, photographer and film-maker. Her best known work is *Sun Tunnels* (1973–6). This consists of four cylinders placed in the Utah desert so that the open ends will capture the rising and setting of the sun during the winter and summer solstices. The walls of the tunnels are pierced with small holes in the pattern of the constellations. Diana Shafer identifies three distinct themes in Holt's work. The first is the *site-specific: Holt claims that *Sun Tunnels* can only exist in that particular place and were inspired by her experience of the desert. The second theme is the influence of the camera: the openings in the work frame natural phenomena like a telescope or camera lens. The third theme is that of time: Holt's work alludes to early methods of time measurement through the movements of the stars. While this suggests an interest in time as something cyclical and constant, Shafer further argues that the 'architectural identity of the arches, corridors, tunnels, and windows suggests themes of passage or transience'. Holt was also the

wife and collaborator of Robert *Smithson until his death in 1973, recording his works in film and photography.

Further Reading: D. Shafer, 'Nancy Holt: Spaces for Reflections or Projections', in A. Sonfist (ed.), *Art in the Land* (1983)

Holty, Carl (1900–73) American painter, born in Freiburg, Germany, to American parents who returned to Wisconsin the same year. In 1926 a legacy brought him financial independence and he went to Munich to study at Hans *Hofmann's school. After a period in Paris, where he knew *Mondrian and *Miró, he returned to the USA in 1935. He taught at the *Art Students League in the late 1930s; one of his students was Ad *Reinhard. Despite his German background he was not drawn at all to *Expressionism. He considered that on the contrary his heritage had encouraged an interest in structure. His abstract and semi-abstract paintings of the 1930s and 1940s are hard-edged, rather in the manner of his friend Stuart *Davis, but considerably more sober in colour and also without the reference to popular imagery. Miró considered that his work was 'interesting and serious, but also over-problematic and over-conscientious'. Later paintings are looser and more atmospheric.

Hölzel, Adolf (1853–1934) German painter, designer, writer, and teacher, born in Olmütz, Moravia. After working in lithography and typography, Hölzel studied at the Vienna and Munich Academies. In 1888 he settled in Dachau, where he opened a private school of painting in 1891; *Nolde was among his pupils. In 1906 he became head of the department of composition at the Stuttgart Academy, where his students included *Baumeister, *Itten, and *Schlemmer. From 1916 until his retirement he was director of the Academy.

Hölzel made an intensive study of colour theory and from about 1895 developed his own ideas about colour harmonies that eventually led him to produce paintings that come close to complete abstraction. In 1916 he wrote 'there exist certain qualities that are justified in their own right and do not require representational supplementation, in fact atrophy under it'. His theoretical views were widely read, for they were published mainly in the popular journal *Die Kunst für Alle* ('Art for All'), which had been founded in 1899 and to which he contributed from 1904. After his retirement from the Stuttgart Academy, Hölzel worked mainly in pastel and as a stained-glass designer (notably for windows in Stuttgart Town Hall). Shortly before his death his work was declared *degenerate by the Nazis.

Holzer, Jenny (1950–) American artist, whose work consists of verbal statements (typically aphorisms or exhortations) expressed in such forms as posters, electronic signs, or *installations. She was born in Gallipolis, Ohio, and studied successively at Duke University, Durham, North Carolina, the University of Chicago, Ohio University, Athens, and the Rhode Island School of Design. In 1977 she settled in New York and in the same year she began producing *Truisms*—broadsheets, printed with statements such as 'There is a fine line between information and propaganda', which were pasted on buildings and walls. Her work was influenced by *Conceptual art in its dependence on verbal language, but there was a strong element of rhetoric quite foreign to the more analytical approach of the early exponents of the movement. She made further series in various media—T-shirts, stickers, metal plaques, and especially electronic signs (displayed in public places such as Times Square), the form for which she has become best known: 'The topics range from the scientific to the personal and include "thoughts on aging, pain, death, anger, fear, violence, gender, religion, and politics"' (Whitney Chadwick, *Women, Art, and Society*, 1990). In 1989–90 she had an exhibition at the Guggenheim Museum, New York, that featured a vast installation of signs running around the spiral space of the interior, and in 1990 she was the first woman to represent the USA at the Venice *Biennale. Daniel Wheeler describes her as 'an installation artist of great power and invention' and writes that 'With her child-like diction, activist alarm, and sense of spectacle, Holzer, perhaps more than any other Conceptual artist, has succeeded in releasing the surreal in language, as well as in making words take command of space with something like the emotional, physical drama of a *Serra sculpture.' A contrasting opinion was that of Peter *Fuller, who described her as 'an unspeakably awful artist' whose work illustrates 'the infantile involvement with the trivia of the mass media which preoccupies the American art world'. The divergence of views demonstrates one of the great fault lines in contemporary art, between those who argue for the critical engagement with mass culture and

those who consider that the only proper response is to ignore it.

Homme-Témoin, L' (Man as Witness) A group of predominantly young French painters formed in Paris in 1948 to promote a style of expressive *Social Realism in opposition to the prevailing taste for abstraction. A manifesto drawn up for them by the critic Jean Bouret affirmed that 'Painting exists to bear witness, and nothing human can remain foreign to it.' The original group had five members, including Bernard Lorjou (1908–86) and Paul *Rebeyrolle, and first exhibited at the Galerie du Bac, Paris, in 1948. In 1949 they exhibited at the Galerie Claude, augmented by other artists including Bernard *Buffet and André Minaux (1923–86). Their paintings depicted everyday life in a gloomy, pessimistic manner. Werner Haftmann (*Painting in the Twentieth Century*, 1965) describes their work as 'the pictorial equivalent of existentialism' and says 'what these painters bore witness to was the emptiness of the world, the desolation of things deserted in the ghost-like barrenness of space, man's vulnerability'. This despairing outlook was for a time very fashionable, and the work of the group—particularly that of Buffet—proved highly popular with collectors. The success of the group led to imitators and the creation of the Salon des Peintres Témoins de leur Temps in 1951.

Hone, Evie (1894–1955) Irish painter and stained-glass designer, one of the most innovative of early 20th-century Irish artists, born at Roebuck Grove, County Dublin. She was partly crippled by polio at the age of eleven and was often ill thereafter, but she worked indomitably, sustained by a strong religious faith. After studying at various art schools in London (her teachers included *Sickert), she spent much of the period 1920–31 in Paris, where she studied with *Lhote and *Gleizes. Her painting at this time became abstract, like that of her friend Mainie *Jellett. However, after being overwhelmed by the deep spirituality of *Rouault's work, Hone began designing stained glass in 1933; this was to be her main preoccupation for the rest of her life and she is ranked among the 20th century's greatest artists in the field. Her most famous work is the huge east window of Eton College Chapel, commissioned in 1949 to replace glass destroyed by bombing in the Second World War and completed in 1952.

Hopper, Edward (1882–1967) American painter and etcher. He was born in Nyack in New York State and spent almost all his career in New York City, but he travelled extensively in the USA, making long journeys by car. After a year at a commercial art school he studied from 1900 to 1906 at the New York School of Art; his teachers included *Chase and *Henri and his fellow students included George *Bellows and Rockwell *Kent. Between 1906 and 1910 he made three trips to Europe (mainly Paris), but these had little influence on his style (he admired the *Impressionists but took no interest in avant-garde art). In 1913 he exhibited (and sold) a picture at the *Armory Show, but from then until 1923 he earned his living entirely by commercial illustration. After a successful solo show in 1924, however, he was able to devote himself full-time to painting and thereafter he enjoyed a fairly rapid rise to recognition as the outstanding exponent of *American Scene Painting (he was given a retrospective exhibition by the *Museum of Modern Art in 1933 and this set the seal on his reputation).

Hopper's distinctive style was formed by the mid-1920s and thereafter changed little. The central theme of his work is the loneliness of city life, generally expressed through one or two figures in a spare setting—his best-known work, *Nighthawks* (1942, Art Institute of Chicago), showing an all-night diner, has an unusually large 'cast' with four. Typical settings are motel rooms, filling stations, cafeterias, and almost deserted offices at night. He was the first artist to seize on this specifically American visual world and make it definitively his own. However, although his work is rooted in a particular period and place, it also has a peculiarly timeless feel and deals in unchanging realities about the human condition. He never makes feelings explicit or tries to tell a story; rather he suggests weariness, frustration, and troubled isolation with a poignancy that rises above the specific. Hopper himself enjoyed solitude and he disliked talking about his work. When he did, he discussed it mainly in terms of technical problems: one of his best-known pronouncements is that he wanted only to 'paint sunlight on the side of a house'. Of *Nighthawks* he said: 'I didn't see it as particularly lonely . . . Unconsciously, probably, I was painting the loneliness of a big city.' Deliberately so or not, in his still, reserved, and blandly handled paintings he exerts a powerful psychological impact that makes him one of the great painters of modern life.

Hopper worked in watercolour as well as oil and also made etchings, beginning in 1915. In fact his individual vision emerged in print-making before it did in painting—he later commented that 'After I took up etching, my painting seemed to crystalise'. His best-known print is *Evening Wind* (1921), establishing a theme that would later often recur in his paintings—the female nude in a city interior. He virtually abandoned printmaking in 1923, but in spite of his short career in the medium he has been described as 'undoubtedly the greatest American etcher of this century' (Frances Carey and Antony Griffiths, *American Prints 1879–1979*, 1980).

Hopper was dismayed by the rise of *Abstract Expressionism and in 1953 was one of a group of representational painters who launched the journal *Reality* as a mouthpiece for their views; in 1963 they protested to the Museum of Modern Art and the *Whitney Museum of American Art about the 'gobble-degook influences' of abstract art in their collections. Nevertheless, Hopper's widow, who survived him by only a year, left his entire artistic estate—numbering over 2,000 works—to the Whitney.

Further Reading: C. Troyen et al., *Edward Hopper* (2007)

Hopton Wood stone A very hard limestone from the Hopton Wood Quarries, near Middleton, Derbyshire, varying in colour from light grey to light tan, flecked with dark-grey glistening crystalline speckles. It can be cut to a smooth face and sharp ridge and takes a good polish. Jacob *Epstein used a twenty-ton block of it for his tomb of Oscar Wilde (1912) in Père Lachaise Cemetery, Paris, and other modern British sculptors who have used it include Barbara *Hepworth and Henry *Moore.

Horn, Rebecca (1944–) German sculptor, *Performance artist, and film-maker. She was born in Michelstadt and studied at the Hochschule für Bildende Künste, Hamburg, and at *St Martin's School of Art. In 1972–81 she lived in New York. In 1964 she became seriously ill as a result of working with fibre-glass without the proper protective mask. She was confined to bed and could make sculpture only through sewing. From this sprang much of her early work, which featured costumes or artificial extensions of the body. In *Unicorn* (1970) an otherwise naked young woman (not Horn herself) walked out into a field wearing only a tall horn-shaped headdress. Other works use feathers, sometimes to almost entirely cover the body. As Andrew Causey points out, 'Horn's prosthetic pieces demonstrate both power and vulnerability'. Horn has also worked as an *installation artist. Her works in this field frequently include some mechanical contrivance. *The Chinese Fiancée* (1976) was a large box with several doors which snapped shut on entrance, leaving the visitor in the dark for a minute. For some consolation there are whispers of endearment from a Chinese woman. Horn has said 'you have to have a jolting attitude and then afterwards caress'. In *Ballet of the Woodpeckers* (1986, Tate), small hammers peck against their own reflections in mirrors. Sometimes she makes use of musical instruments. *Concert for Anarchy* (1990, Tate) is a suspended grand piano which, every few minutes, ejects its keys and opens its lid with a great crash. The wait for something to happen, what Sarah Kent called 'the strange state of suspended animation', is crucial to the experience.

((◉)) SEE WEB LINKS

• S. Kent et al., 'Drawing the Line: A Round Table on Rebecca Horn' (2007).

Hornel, Edward Atkinson (1864–1933) Scottish painter, born in Bacchus Marsh, Victoria, Australia. Shortly after he was born his parents left for Kirkcudbright in Scotland, where he remained for most of his life. He was associated with the *Glasgow Boys and was strongly influenced by Japanese art, spending eighteen months in the country in 1894–5. He is noted for his flat tapestry-like paintings in jewelled colours, depicting girls in gardens and woodlands.

Hornton stone A limestone named after quarries at Hornton in north-west Oxfordshire. It is typically a rich rusty brown in colour, but green and greyish-blue tints also occur. It was a favourite stone of Henry *Moore, the celebrated *Madonna and Child* (1943–4) in St Matthew's, Northampton, being one of his best-known works in this material. The quarries at Hornton are now closed, but similar stone is obtained at nearby Edge Hill in Warwickshire.

Howson, Peter *See* GLASGOW SCHOOL; OFFICIAL WAR ART.

Hoyland, John (1934–) British abstract painter, born in Sheffield. He studied at Sheffield College of Art, 1951-6, and the *Royal Academy Schools, 1956-60. Early influences were the painting of Nicolas de *Stäel and the teaching of Victor *Pasmore. He took part in the *'Situation' exhibition of abstract painting in 1960. His paintings at this point used bands of colour which suggested a kind of buckling of the picture plane, but by the time of his appearance in the *'New Generation' exhibition in 1964 he was painting unequivocally flat works with the paint soaked into the canvas in a manner reminiscent of the *Colour Field painters: simple intensely coloured forms floated against a colour field (*14.6.64*, 1964, Manchester Art Gallery). Following the exhibition, he was awarded a bursary which enabled him to travel to New York, where he met Helen *Frankenthaler, Kenneth *Noland, and Clement *Greenberg. He also discovered the paintings of Hans *Hofmann; under his influence he employed thick layers of brilliantly coloured pigment. What has been consistant in Hoyland's painting has been its scale and its preoccupation with colour. 'The shapes and colours I paint and the significance I attach to them I cannot explain in any coherent way. The exploration of colour, mass, shape is, I believe, a self-exploration constantly varied and changing in nature: a reality made tangible on the painted surface.' He also makes screenprints and etchings.

Further Reading: M. Gooding, *John Hoyland* (2006)

Hsü Pei-hung *See* XU DEIHONG.

Hudson, Anna Hope ('Nan') *See* SANDS, ETHEL.

Huebler, Douglas *See* CONCEPTUAL ART.

Hughes, Robert (1938–) Australian art critic, resident in the USA since 1970. He was born in Sydney, where he studied architecture at the University, and he became art critic to the fortnightly magazine *Observer* when he was still an undergraduate. In 1964 he moved to Europe, living first in Italy and then from 1966 in London, where he wrote for *The Sunday Times* and other publications. Since 1970 he has been art critic of *Time* magazine in New York. His books include *The Art of Australia* (1966, revised 1970), *Heaven and Hell in Western Art* (1969), *Lucian *Freud: Paintings* (1988), and *Nothing if Not Critical: Selected Essays on Art and Artists* (1990). He writes mainly on 20th-century art and has a richly deserved reputation as a witty and penetrating observer of the contemporary art scene. His populist approach can easily lead to the originality of his thinking being overlooked. For instance, he discussed with considerable insight the homoerotic element in the work of *Rauschenberg long before it became a fashionable academic preoccupation. Although certainly not conservative in his aesthetic views, Hughes has been especially concerned with attacking the negative impact of commercialism on contemporary art. He has made films for television, notably two impressive series, *The Shock of the New* (1980) and *American Visions* (1996), both with accompanying books of the same title. In his work for television he has received the kind of praise previously enjoyed by Kenneth *Clark, but Hughes's approach is very different—forceful rather than suave.

Hulbert, Thelma *See* EUSTON ROAD SCHOOL.

Hulme, T. E. (Thomas Ernest) (1883-1917) British writer (a poet, critic, essayist, and—in his own phrase—'philosophic amateur'). He studied at Cambridge University but was sent down in 1904 for brawling. Thereafter he travelled widely, but he lived mainly in London, where he became friendly with many avant-garde artists. Hulme advocated the creation of a 'new geometrical and monumental art making use of mechanical forms', and he was a supporter of several artists in the *Vorticist circle, notably his friend *Epstein, who described him as 'a large man in bulk, and also large and somewhat abrupt in manner. He had the reputation of being a bully and arrogant . . . [but] only his intolerance of sham made him feared.' Hulme published his art criticism mainly in *The New Age*, a journal that lived up to its name in this period by being a forum for modernist ideas. Ardently militaristic, he enlisted at the beginning of the First World War and was killed in action. He had been writing a book on Epstein, but the manuscript was never found. However, he left numerous notebooks, and the material in these was edited by Herbert *Read into two books: *Speculations: Essays on Humanism and the Philosophy of Art* (1924) and *Notes on Language and Style* (1929).

Hulten, Pontus (1924-2006) Swedish art historian and curator, whose international

career was largely concerned with the founding of major collections of modern art. He was born in Stockholm and studied at the universities of Copenhagen and Stockholm. In 1958 he was appointed director of the *Moderna Museet, Stockholm, and in 1973 he became director of the Musée National d'Art Moderne, Paris, in which role he supervised the inauguration of the *Pompidou Centre; in 1981 he was described in the *International Herald Tribune* as 'a big man fond of jokes . . . a playful porpoise among the stuffed whales of the French cultural establishment'. From 1981 to 1982 Hulten was first director of the *Museum of Contemporary Art, Los Angeles, and from 1984 to 1990 he was first director of the Palazzo Grassi, Venice, a centre for temporary exhibitions, largely sponsored by the car firm Fiat. In 1990 he became chief administrative officer of the newly established Kunst- und Ausstellungshalle der Bundesrepublik Deutschland (Art and Exhibition Hall of the German Federal Republic) in Bonn, and he was also director of the Jean *Tinguely museum in Basel. Hulten organized numerous major exhibitions in his varied roles, including 'Paris-New York' (1977), the first of a series of blockbusters at the Pompidou Centre in which Paris was linked with other great art centres, and 'Futurism and Futurisms' (1986), the inaugural show of the Palazzo Grassi and the largest *Futurist exhibition ever held. In an article entitled 'Europe's Hottest Curators' in the March 1988 issue of *Art News*, Brigid Grauman described Hulten as 'perhaps the most brilliant of the curators who, over the years, have channelled a new enthusiasm for contemporary art'. Niki de *Saint Phalle said of him that he had 'the soul of an artist, not of a museum director'. Shortly before his death he donated his personal collection of about 700 works to the Moderna Museet, Stockholm, on condition that any not on display in the main building be available to the public in a specially constructed shed.

Further Reading: H. M. Obrist, 'The hang of it', *Artforum International* (April 1997)

Humblot, Robert *See* FORCES NOUVELLES.

Hume, Gary (1962–) British painter and sculptor, born in Tenterden, Kent. He graduated from *Goldsmiths College in 1988 and participated in Damien *Hirst's 'Freeze' exhibition in that year. His work up until 1993 was in the form of large rectangular

paintings reminiscent of hospital swing doors. He was playing on the architectural associations of big abstracts. Afterwards he embarked on the paintings for which he is best known. These are in highly reflective gloss paint, representing recognizable forms in simple outlines. As source material, he sometimes uses celebrity figures such as Sid Vicious or the radio disc jockey Tony Blackburn, popular with the older generation but rather a joke for the young, familiar enough to be identifiable but not yet a cliché. He was represented in the *'Sensation' exhibition of 1997, but any controversy over his work has come about not so much because of challenging subject-matter but because the paintings are remarkably easy to enjoy yet very difficult to intellectualize about. In 2007 in an exhibition on the theme of American cheer leaders, he also exhibited sculpture.

Humlebaek, Louisiana Museum *See* LOUISIANA MUSEUM.

Hundertwasser, Fritz (Friedrich Stowasser) (1928–2000) Austrian painter, graphic artist, and designer, born in Vienna, where he studied briefly at the Academy in 1948. He adopted the name Hundertwasser in 1949, translating the syllable 'sto' (which means 'hundred' in Czech) by the German 'hundert'. From about 1969 he signed his work 'Friedensreich Hundertwasser', symbolizing by 'Friedensreich' (Kingdom of Peace) his boast that through his painting he would introduce the viewer into a new life of peace and happiness, a 'parallel world', access to which had been lost because the instinct for it had been corrupted by the sickness of civilization. He often added 'Regenstag' (Rainy Day) to the name—making it in full 'Friedensreich Hundertwasser Regenstag'—on the ground that he felt happy on rainy days because colours then had an extra sparkle. This exaggerated concern with the name is a symptom of the braggadocio and conceit that characterized his life and work. He had a talent for self-advertisement and built himself up into a picturesque figure given to gnomic utterances about his own significance in the world. Standing outside most contemporary artistic movements, though borrowing from many, he worked mainly on a small scale, often in watercolour. His work has sometimes been compared with that of Paul *Klee, but although it is in the same tradition of figurative fantasy, it lacks

Klee's elegance and wit. In his concern with the dehumanizing aspects of 20th-century society, Hundertwasser was an outspoken critic of modern architecture, and he is now perhaps best known for the design of an idiosyncratic, multi-coloured, fairy-tale-like housing unit in Vienna—the Hundertwasser House (completed 1986).

Hunter, Leslie (1877–1931) Scottish painter of landscapes, still-lifes, and occasional portraits, one of the *Scottish Colourists who introduced a knowledge of modern French painting to their country. He was born in Rothesay, Isle of Bute, and in 1892 emigrated with his family to California, where between 1899 and 1906 he studied in San Francisco and then worked there as a painter and illustrator. In 1904 he visited New York and Paris. Much of his early work was destroyed in the San Francisco earthquake of 1906, ruining an exhibition he was planning, and in that year he returned to Scotland, settling in Glasgow. There he was supported by the dealer Alexander Reid (1854–1928), who played an important role in promoting a taste for French painting. His first one-man show was in 1913. Hunter's best-known works are perhaps his views of Loch Lomond, which through his eyes looks so French that it could almost be the River Seine at Argenteuil (*Reflections, Balloch*, 1929–30, NG of Modern Art, Edinburgh).

Hurd, Peter *See* REGIONALISM.

Hurrell, Harold *See* ART & LANGUAGE.

Husain, M. F. (Maqbool Fida) (1915–) Indian painter and film-maker, one of the best known and almost certainly the most controversial figure in the contemporary art of his country. Born in Pandha-pur, Maharashtra, he studied at the School of Art in Indore in 1937, then worked as a painter of cinema hoardings and as a toy designer. In 1947 he joined *Souza's Progressive Artists' Group in Bombay, which he saw as part of the independence movement, attacking both the British-dominated *Royal Academy and conservative revivalist art. Husain's own view of Western modernist art is that India had already passed the stages of *Impressionism and *Cubism and therefore had no need of them, saying that 'they [the West] took it [modernist art] from Japan and from Africa' (*Frontline*, August 9–22, 1997). Nonetheless, critics have seen the influence of European

painters such as *Matisse, *Picasso, and *Klee. It is not the style of his art but the subject which has made the strongest impact in India. He has been the frequent target of threats and legal attacks, especially from right-wing Hindu groups (Husain is a Muslim), on the grounds of 'obscene' treatment of sacred themes. The most contentious of all has been *Mother India* (2006), which visualizes the country as a naked female. The artist has been forced to move to Dubai. He won the Golden Bear award at the Berlin Film Festival in 1968 for *Through the Eyes of a Painter*.

Huszár, Vilmos (1884–1960) Hungarian-born painter, designer, and graphic artist, who settled in the Netherlands in 1906. He was one of the founders of De *Stijl in 1917 and he continued his association with the group until 1923. His speciality at this time was designing abstract stained glass and interior decoration. Later he returned to figure painting in a geometrical style.

Hutter, Wolfgang *See* FANTASTIC REALISM.

Huyghe, Pierre (1962–) French multimedia artist, born in Paris. He studied at the École Nationale Supérieure des Arts Décoratifs in Paris from 1982 to 1985. His art has consistently challenged ideas of authorship and exhibition in a way that is entertaining as well as thought-provoking. His work was brought together in Tate Modern in 2006 in an exhibition entitled 'Celebration Park'. It opened with a series of disclaimers in white neon consisting of statements of things which Huyghe did not own, including *Snow White* and *4.33* (John *Cage's silent composition). This theme is taken up by work which engages with the issue of the way in which the individual and collective imagination can be commercially appropriated. There was a video interview with the woman who voiced Snow White for the French version of the Disney animation. She still identified personally with the character, although her work was now in corporate ownership. Huyghe has said 'In a capitalist system which needs stories, the narrative still circulates but it cannot expand; it is locked, it can be listened to but cannot be told because the narrative belongs to someone as an immaterial moving property—there's a copyright attached to it.' Together with the artist Philippe Pareno (1964–) he bought the rights to a manga (Japanese cartoon) character called Annlee, offered her services to a number of other artists, then set her free with a firework

display. In 2005 he mounted an expedition to Antarctica to find a mythical albino penguin. The journey was real, the penguin was the product of computer-generated imagery. Huyghe says: 'There is nothing between reality and fiction. What we call fiction is what we identify as narrative constructions, but reality is something shaped by scripts.' Huyghe's most popular work is his film *This is not a time for dreaming* (2004). Enacted by puppets, it tells the tale of the architect *Le Corbusier and his difficult relations with Harvard University (represented by a science fiction villain) which had commissioned a building from him.

Further Reading: T. Morton, 'Space Explorer', *Frieze* (June–August 2006)

Hyperrealism *See* SUPERREALISM.

Hyppolite (Hippolite), Hector (1894–1948) Haitian painter. He is the most famous of his country's remarkable crop of *naive painters, but he did not achieve recognition until the final years of his life, after André *Breton en-countered his work on a visit to the island in 1945 and arranged exhibitions of his paintings in Europe. Before this, Hyppolite spent most of his life in poverty and obscurity, and there is little solid information about his early career. He was born in St Marc and followed his father and grandfather in becoming a Voodoo priest. He also worked as a cobbler and house-painter, and his artistic work began with the decoration of doors and walls. It was only towards the end of his life that he began painting easel pictures, and he is said to have regretted that they distracted him from his duties as a Voodoo priest. Many of his paintings were inspired by his religious beliefs, featuring Voodoo scenes and symbols. He used bold, flat forms and vivid colours, and had no interest in technical refinement, his paint sometimes being applied with chicken feathers or his fingers. His success helped to inspire other Haitian naive painters, notably Rigaud Benoit (1911–86), who married Hyppolite's daughter, and Wilson *Bigaud, who as a boy was a neighbour of Hyppolite in Port-au-Prince.

Ibbotson, Diane *See* SUPERREALISM.

ICA *See* INSTITUTE OF CONTEMPORARY ARTS.

Idea art *See* CONCEPTUAL ART.

Immaculates *See* PRECISIONISM.

Immendorff, Jörg (1945–2007) German painter, sculptor, and *Performance artist. Born in Bleckede in Lower Saxony, he became celebrated for his complex and provocative allegories of contemporary politics. He held his first exhibition of painting in Bonn at the age of fifteen. In 1963, he embarked on a course in theatre design at the Düsseldorf Academy but was thrown off after he refused to permit one of his paintings to be used as a set. In 1964 he joined the class of Joseph *Beuys, who appears in many early paintings. Immendorff also assisted on Beuys's famous performance *How to Explain Pictures to a Dead Hare* (1965). Beuys had rearranged the stage in response to his dealer's request on the grounds that 'We need to sell the stuff'. Immendorff applied a red sticker, the universally adopted sign for 'work sold', to Beuys himself. The pupil's attitude to his teacher was ambivalent. He approved strongly of the ambition to extend art to social activism but had no sympathy with the mystical aspects of the older artist's outlook.

'Hort auf zu malen!' ('Stop painting!') exhorts a canvas of 1966 (Stedelijk van Abbe Museum, Eindhoven). The statement is inscribed over a cross which cancels the now barely legible images beneath. For the next few years Immendorff was to concentrate on Performance art and political activity, usually under the umbrella label of LIDL. Like *Dada, this was a nonsense word. It was evocative of the sound of a baby's rattle. Immendorff used a baby mask in some of his performances and painted obese and ugly babies. His activities included the sabotage of the *documenta press conference in 1968 by pouring honey over the microphones in protest against the selection, which concentrated strongly on American *Pop. These activities were part of the widespread student protests against the Vietnam War. In 1969 the police acted to close down the 'LIDL Academy' group at the Düsseldorf Academy. By the early 1970s Immendorff had become committed to a Maoist political stance and practised a didactic strain of painting complete with 'self-criticism'. A painting of 1972 includes the caption 'I dreamed of becoming an artist', concluding that 'My guiding star was egoism'.

His presence at the 1976 Venice *Biennale included a statement which urged artists to resist 'the imperialist strategies of the Soviet Union and the USA'. At that exhibition he saw the work of Renato *Guttuso. The Italian painter was a bastion of the official Communist party and his painting *Caffè Greco* (1976, Museum Ludwig, Cologne) was a kind of static memorial to great figures in modern European culture. The *Café Deutschland* series, which Immendorff began in 1978 as a response, presented Europe not as a place where noted artists and intellectuals could discourse in civilized ease but as a divided culture framed by violence. They are set not in a sunlit café but in a dark and seedy nightclub in which the artist is sometimes to be seen jiving frenetically. The first of the series (1978, Museum Ludwig, Cologne) commemorates his friendship with the painter A. R. *Penck, who at that time was unable to leave East Germany. He is seen reflected in a column while Immendorff thrusts his hand through the Berlin Wall. The attitude behind the series is summed up by the pessimistic statement from an interview in *Artscribe* in 1983: 'There is a history now of Europe being the world's battlefield and Germany sitting right here on the frontier. What Hitler did is nothing compared to the evil we are ready to unleash upon ourselves.'

These paintings represent one of the boldest attempts by a late 20th-century painter to engage with contemporary history. Roberta

Smith described them as 'part political cartoon, part history painting, part memoir'. With the collapse of the DDR in 1989 and subsequent reunification of Germany, Immendorff's work came to be seen as less relevant. At the same time he became absorbed into the establishment he had once challenged so vehemently. In 2000 he was even commissioned to paint the German Chancellor Gerhard Schröder, whom he personally admired as a politician and who actually respected the place of the artist in society. However, scandal and notoriety attended his final years. In August 2003 he was arrested in a Düsseldorf hotel with a large quantity of cocaine and in the company of nine prostitutes. It has been noted by cynics that his sentence of eleven months' probation was just short of what would have entailed mandatory disciplinary action by the Düsseldorf Academy, where he held a professorship, so endangering his young wife's pension. In 1997 he was diagnosed with amyotrophic lateral sclerosis, which gradually left him paralysed and was eventually to cause his death. His final works were made by assistants under his direction.

Further Reading: Museum of Modern Art, Oxford, *Jörg Immendorff* (1984)

R. Smith, obituary, *The New York Times* (31 May 2007)

obituary, *The Times* (30 May 2007)

Imperial War Museum, London *See* OFFICIAL WAR ART.

Impossible art *See* ARTE POVERA.

Impressionism A movement in painting that originated in France in the 1860s and had an enormous impact on Western art over the following half century. As an organized movement, Impressionism was purely a French phenomenon, but many of its ideas and practices were adopted in other countries, and by the turn of the century it was a dominant influence on advanced art in Europe (and also in the USA and Australia). In essence, its effect was to undermine the authority of large, formal, highly finished paintings with historical, mythological, or religious subject-matter, in favour of works that more immediately expressed the artist's response to the world.

The nucleus of the Impressionist group was formed in the 1860s, and the name was coined facetiously by a reviewer of the first joint exhibition, held in Paris in 1874. Seven more Impressionist exhibitions followed, the last in 1886, by which time the group was beginning to lose its cohesion (it was in any case never formally structured). The central figures (in alphabetical order) were Paul *Cézanne; Edgar *Degas; Édouard Manet (1832–83), although he never exhibited in the group shows; Claude *Monet; Camille *Pissarro; Pierre-Auguste *Renoir; and Alfred Sisley (1839–99). These painters differed from each other in many ways, but they were united in rebelling against academic conventions, to try to depict their surroundings with spontaneity and freshness, capturing an 'impression' of what the eye sees at a particular moment. As the art historian César Graña put it, Impressionism 'assumes a world in which *moments* can exist as total units of experience...where the ephemeral and the unguarded can be memorable and must be followed and scanned by the painter with a flashing perceptivity of his own' (cited in Herbert, 2002). The subjects of the painter were drawn from the life of the city as well as landscape. With the significant exception of the anarchist Camille Pissarro, the Impressionists showed the countryside as a place of urban leisure rather than rural toil.

The Impressionists were at first generally received with suspicion, bewilderment, or abuse (although the critical response was not as one-sided as is sometimes suggested). To most observers, their vigorous brushwork looked sloppy and unfinished, and their colours seemed garish and unnatural. Among conservative artists and critics, this continued to be the prevailing view for many years. For example, when the painter Gustave Caillebotte (1848–94) left his superb Impressionist collection to the French nation, the academic painter and sculptor Jean-Léon Gérome (1824–1904) wrote that 'For the Government to accept such filth, there would have to be a great moral slackening'. In more sympathetic circles, however, the Impressionists began achieving substantial success in the 1880s (helped by the dedicated promotion of *Durand-Ruel), and during the 1890s their influence began to be widely felt. Few artists outside France adopted Impressionism wholesale, but many lightened their palettes and loosened their brushwork as they synthesized its ideas with their local traditions. The support of critics such as Julius *Meier-Graefe in Germany and George *Moore and Frank *Rutter in Britain was important in increasing awareness and understanding of the movement (the first

book on Impressionism in English, published in 1903, was a translation of a work by the French critic Camille *Mauclair).

Outside France, it was perhaps in the USA that Impressionism was most eagerly adopted, both by painters such as Childe *Hassam and the other members of The *Ten and by collectors (Mary *Cassatt helped to develop the taste among her wealthy picture-buying friends). It also made a significant impact in Australia, with Tom *Roberts playing the leading role in its introduction. In Britain, *Sickert and *Steer are generally regarded as the main channels through which Impressionism influenced the country's art, but the differences between their work shows how broadly and imprecisely the term has been used (at the time, D. S. *Mac-Coll commented that it was applied to 'any new painting that surprised or annoyed the critics or public'). For a few years around 1890, Steer painted in a sparklingly fresh Impressionist manner, but his style later became more sober; Sickert adopted the broken brushwork of Impressionism (as did his followers in the *Camden Town Group), but he used much more subdued colour, and he had a taste for quirky, distinctively English subject-matter. In contrast, the painters of the *Newlyn School often painted out of doors in conscious imitation of the French and used comparatively high-keyed colour, but they generally did not adopt Impressionist brushwork. Accordingly, many authorities think that among British artists, only Steer—and he only briefly—can be considered a 'pure' Impressionist. In Germany Max *Slevogt, Max *Liebermann, and Lovis *Corinth can all be described as Impressionists, but there the spontaneous approach to light and atmosphere had already been established in the early work of Adolph Menzel (1815–1905).

In addition to prompting imitation and adaptation, Impressionism also inspired various counter-reactions—indeed its influence was so great that much of the history of late 19th-century and early 20th-century painting is the story of its aftermath. The *Neo-Impressionists, for example, tried to give the optical principles of Impressionism a scientific basis, and artists such as *Gauguin and *Cézanne (in his later work) inspired a series of movements that tended to free colour and line from representational functions. Similarly, the *Symbolists wanted to restore the emotional values that they thought the Impressionists had sacrificed through concentrating so strongly on

the fleeting and the casual. The various reactions against Impressionism are sometimes bundled together under the term *Post-Impressionism. Quite beyond style, technique, and subject, the success of Impressionism established a set of priorities in modernist art, especially in France and wherever else, as in Britain, the French model of modernism held sway. As the sense of the immediate took over from history, as the relationship with dealer and private collector became more significant than that with the state and the academy, so too the relationship between artist and individual spectator became the central preoccupation. The public, political statement tended to work against the grain of *modernism, to be a 'special case'.

Further Reading: R. L. Herbert, *Impressionism* (1988)

R. L. Herbert, 'Impressionism, Originality, and Laissez-Faire', in *From Millet to Léger* (2002)

K. McConkey, *Impressionism in Britain* (1995)

J. Rewald, *The History of Impressionism* (1973)

Indépendants, Salon des *See* SALON DES INDÉPENDANTS.

Independent Group A small and informal discussion group that met intermittently between 1952 and 1955 at the *Institute of Contemporary Arts, London. The members, who represented a wide cross-section of the visual arts, included Lawrence *Alloway, Richard *Hamilton, Eduardo *Paolozzi, Reyner Banham (1922–88), an architectural and design historian, and several architects. The issues they discussed included advertising and mass culture, and the first phase of British *Pop art grew out of the group. After it had ceased to exist, some of the members were involved in mounting the 'This is Tomorrow' exhibition at the *Whitechapel Art Gallery, London.

Further Reading: A Massey, *The Independent Group: Modernism and Mass Culture in Britain 1949-59* (1995)

Index of American Design *See* FEDERAL ART PROJECT.

Indiana, Robert (1928–) American painter, sculptor, and graphic artist, born in New Castle, Indiana. His original name was Robert Clark, but he adopted the name of his native state as his own. He studied successively in Indianapolis, Ithaca, Chicago, Edinburgh, and London before settling in New York in 1956. He is regarded as one of the leading American *Pop artists, and although he has done some figurative paintings he is best known for pictures

involving geometric shapes emblazoned with lettering and signs. Formally these are closer to hard-edge abstractionists such as Ellsworth *Kelly, an early influence, or *Op art than to *Lichtenstein, *Rosenquist, or *Warhol. Lucy *Lippard commented that 'Despite his superficially 'purist' style, Indiana is an out-and-out romantic' (*Pop Art*, 1966). He is preoccupied with the notion of the 'American dream' (the title of a number of his paintings), albeit looked at from a critical perspective. *The American Dream 1* (1961, MoMA, New York) recalls the design of a pin-ball machine, but the letters 'tilt' and 'take all' suggest, as Marco Livingstone points out, the inequalities of American society. Elsewhere, in *The Demuth American Dream no.5* (1963, Art Gallery of Ontario, Toronto), he pays tribute to Charles *Demuth, an American modernist of an earlier generation who took the emblems of city life as source and inspiration. In 1964 Indiana collaborated with Warhol in a film, *Eat*, and in the same year executed a commission for the exterior decoration of the New York State Pavilion at the New York World's Fair, consisting of a 6-metre sign reading EAT. He has also done many sculptures of letters forming the word LOVE, the O being on a diagonal. The example in JFK Plaza, Philadelphia, has led to it being known unofficially as 'LOVE Park'. In 1978 he settled on the island of Vinalhaven, off the Maine coast.

Informalism *See* ART INFORMEL.

Informe *see* BATAILLE, GEORGES.

Inkhuk (Institut Khudozhestvennoi Kulturi) (Institute of Artistic Culture) An organization set up in Moscow in May 1920 for the purpose of working out and implementing a programme of artistic experiment for post-Revolutionary Russia. It was a section of the Department of Fine Arts, which had been formed in 1918 under the Commissariat for People's Enlightenment (IZO *Narkompros). *Kandinsky was Inkhuk's first chief. At the end of 1921 sections were formed in Petrograd under *Tatlin and in Vitebsk under *Malevich. Many of the leading Russian artists of the day were involved in one way or another.

Originally Inkhuk was going to be run according to a programme devised by Kandinsky, but his rarefied ideas were uncongenial to most of the members, who desired an art that would contribute directly to the creation of a Communist Utopia. When his programme was voted out, Kandinsky left Inkhuk, and the organiza-

tion divided into two schools of thought about the form that the new art should take, named 'laboratory art' and 'production art' respectively. The pronouncements of neither side were particularly clear. Laboratory art involved a rationalizing, analytical approach to artistic creation, with a social end in view, but not necessarily the abandoning of traditional materials (such as paint and canvas). In production art the distinction between artist and engineer was to be eliminated and the artist was to become a designer or craftsman for machine production. The production group was the more influential and contributed to the rise of *Constructivism. In the late 1920s Inkhuk also supported *Socialist Realism.

Innes, J. D. (James Dickson) (1887–1914) British painter, mainly of landscapes (particularly mountain scenes) but also occasionally of figure subjects. He was born in Llanelli and studied at Carmarthen Art School, 1904–5, and the *Slade School, 1906–8. In 1908 he met Augustus *John and formed a close friendship with him; they often painted together, particularly in their native Wales in 1911 and 1912. Another friend with whom he enjoyed working was Derwent *Lees. Between 1908 and 1913 Innes travelled widely in France, Spain, North Africa, and the Canary Islands, hoping to recuperate from tuberculosis, but he died from it aged 27. He was a self-destructively romantic figure who, in spite of his illness, insisted on sleeping out of doors, and buried a silver casket containing love letters from Euphemia Lamb (wife of Henry *Lamb) on the summit of Arenig in North Wales. Innes's early work was in an *Impressionist manner influenced by *Steer, but after leaving the Slade he developed a more expressive style, combining a strong sense of pattern with a range of hot colour similar to that used by *Derain and *Matisse. He usually painted on a fairly small scale, often on wooden panels; he also worked a good deal in watercolour.

Further Reading: E. Rowan, *Some Miraculous Promised Land: JD Innes, Augustus John and Derwent Lees in North Wales 1910–13* (1982)

Inness, George *See* TONALISM.

Inshaw, David *See* BROTHERHOOD OF RURALISTS.

installation A term that can be applied very generally to the disposition of objects in an

exhibition (the hanging of paintings, the arrangement of sculptures, and so on), but which also has the more specific meaning of a one-off work (often a large-scale *assemblage) conceived for and usually more or less filling an interior (generally but not always that of a gallery). This type of work has various precedents. The tradition of *'site-specific' works has indeed been traced back to prehistoric cave paintings by way of Greek temples and Renaissance frescos. However, what distinguishes installation art is a status which is neither that of permanent architectural decoration nor of portable object. The real origins lie in the avant-garde of the early 20th century, in the Proun rooms and agitational exhibitions of El *Lissitzky, the elaborate *Surrealist exhibitions with their funfair-like atmospheres, such as the New York 'First Papers of Surrealism' (1942), devised by Marcel *Duchamp, in which visitors had to negotiate webs of string to see the artworks, and in the room-filling *Merz* construction of Kurt *Schwitters. 'This is Tomorrow', mounted at the *Whitechapel Art Gallery in 1956, consisted of a series of environments, all the product of collaboration between fine artists and architects. Yves *Klein's exhibition of an empty room, *The Void*, in 1958 is sometimes considered the earliest example of an installation in the sense in which the term is now understood. The Happenings of Alan *Kaprow and Claes *Oldenburg could also have an element of installation. The interest of *Pop artists in trying to bridge the gap between the art work and the viewer's normal experience of consumer society led to such events as Martial *Raysse's beach scene (1962). *Kinetic artists, too, especially when, like *Oiticica, they encouraged spectator participation, moved into installation. *Minimal art tended to draw the attention of the viewer from the object in isolation towards its relationship to its context. This can make the line between 'sculpture' and 'installation' hard to draw, as in the *site-specific works of Richard *Serra. It was not until the 1970s that the term came into common use and not until the 1980s that certain artists started to specialize in this kind of work, creating a genre of 'Installation art'. In 1990 a Museum of Installation was opened in Deptford, London.

In the 1970s installations were often impermanent and could be seen as part of the movement against the collectable art 'object' that was current at the time. Some works are site-specific and therefore cannot adequately be recreated. However, many installations are now intended for permanent display, and even some of the most unlikely works have proved collectable and conservable in a museum context. One example is *20:50* (1987) by the British sculptor Richard Wilson (1953–), which consists of a room filled with used sump oil; this was created for the Matt's Gallery, London, but it was subsequently resited at the Royal Scottish Academy, Edinburgh, and it is now in the Saatchi Collection, London. Installation art frequently appropriates the art of the past, as in the work of Marcel *Broodthaers or *The Reign of Narcissism* (Museum of Contemporary Art, Los Angeles, 1989) by the American artist Barbara Bloom (1951–). This is a circular room, designed like a Victorian parlour. Every item, including portrait busts, stationery, and books, is either a likeness of the artist or contains her name. The work followed a wave of fashionable *Neoclassicism in the art of the 1980s and suggests, perhaps, that a supposedly impersonal style can be as much a vehicle for personal vanity as any other.

One radical form of installation deliberately frustrates the visitor by making the gallery itself impregnable. This was done at the Iris Clert Gallery, Paris, by Yves Klein's friend *Arman. As a reply to *The Void* he provided *Le Plein* (*Full Up*) by stocking the place with junk. Daniel *Buren in 1968 sealed off a gallery in Milan. In 2002 at London's Lisson Gallery the Spanish artist Santiago Sierra (1966–) denied the gallery's opening crowd their expected hospitality be sealing it with an iron shutter. For those with some knowledge of postwar art history, the joke must have worn a little thin.

Installation art has become a major weapon in the armoury of museums of modern art in their efforts to provide crowd-pulling spectacles. Peter Schjeldahl (*New Yorker*, 25 February 2008) has pointed out that there is a group of 'international art stars', including *Cai Guo-Qiang and Olafur *Eliasson, who travel the world specializing in such events. It has been especially attractive to institutions with large open spaces, such as the *Guggenheim Museum, New York, and *Tate Modern. The processes of museology themselves can become the material for installation. The American artist Mark Dion (1961–) produced a work entitled *History Trash Dig* (1995) which involved the removal of two cubic metres of earth from a waste dump in the Swiss city of

Friburg, then meticulously sifting through the results in the manner of an archaeologist and exhibiting them in the local museum.

The German installation artist Gregor Schneider (1969–), having turned his own house into a disquieting piece of installation art, produced *Weisse Folter* (*White Torture*) (2007, K21, Düsseldorf). The visitor goes through a series of rooms, in which the doors lock behind, and then through a series of cells, some of which provide distinctly uncomfortable experiences such as cold, heat and, darkness. Eventually a door leads to a park with a lake. Schneider was inspired by images of the prison camp at Guantánamo Bay, but Dominic Eichler (*Frieze*, June–August 2007) suggests that 'The world we live in isn't so very different to *Weisse Folter*, it's just that here the signs and consumption-driven comfort zones have been removed'. *See also* ENVIRONMENT ART; VIDEO ART.

Further Reading: C. Bishop, 'But is it Installation Art?', *Tate Etc.*, issue 3 (spring 2005)

N. de Oliveira, N. Oxley, and M. Petrie, *Installation Art in The New Millennium* (2004)

Institute of Contemporary Arts (ICA), London. Cultural centre founded by Roland *Penrose and Herbert *Read in 1947 to encourage new developments in the arts and to cater for some of the functions fulfilled by the *Museum of Modern Art in New York, organizing exhibitions, lectures, films, concerts, poetry readings, and so on. Also instrumental in its foundation was the publisher, collector and art patron Eric Gregory (1887–1959), who was the first treasurer. Its original home was in Dover Street, but it moved to more extensive premises at Nash House, the Mall, in 1968. Many leading artists have been members of the ICA and it has played an important role in certain developments: for example, in the 1950s it was the cradle of British *Pop art (*see* INDEPENDENT GROUP), and in 1969 it was the venue for the first exhibition of *Conceptual art in Britain, 'When Attitudes Become Form'.

Institutional critique *See* HAACKE.

intermedia *See* MIXED MEDIA.

International Artists' Association *See* ARTISTS INTERNATIONAL ASSOCIATION.

International Coalition for the Abolition of Art *See* ART WORKERS' COALITION.

International Studio *See* STUDIO, THE.

International Style (International Modern Style) *See* MODERN MOVEMENT.

Internet art *See* COMPUTER ART.

Intimisme A type of painting featuring intimate domestic scenes, more or less *Impressionist in technique, particularly associated with *Bonnard and *Vuillard, who practised it from the 1890s (this is when the term was first used). Whereas the Impressionists in their landscapes usually aimed at accurately reflecting the colours of the natural world, the Intimistes often exaggerated and distorted colour to express mood, conveying the warmth and comfort of an untroubled domestic life. Vuillard's style remained essentially Intimiste for the rest of his career, but Bonnard's work sometimes has a grandeur and richness to which the term does not seem altogether appropriate.

Ioganson, Boris *See* AKHRR.

Ipoustéguy, Jean (1920–2006) French sculptor, born at Dun-sur-Meuse. In 1938 he moved to Paris, where he studied art at evening classes. He initially worked mainly as a painter, and in 1947 he created frescos and stained-glass windows for the church of St Jacques at Montrouge. However, after he settled in the Parisian suburb of Choisy-le-Roi in 1948 he turned exclusively to sculpture. In that year he adopted the name Ipoustéguy: Jean Robert was too common. His working place and home was a disused ceramics factory, described by James Kirkup as 'an immense studio on a sort of treasure island, which he and his family had allowed to grow wild until it resembled one of the jungles of the Douanier *Rousseau'. He worked in various materials, including marble, but his most characteristic works are in bronze, usually carefully finished in a dark patina but with the surface riven and ravaged. H. H. *Arnason compared the effect to being as though 'the impregnable material has been torn apart by some cosmic explosion' (*A History of Modern Art*, 1969). In his early years as a sculptor he was much influenced by *Brancusi and, as with the Romanian's sculpture, even the most simplified geometric forms bear signs of life. As the poet John Ashbery put it, introducing a 1964 London exhibition, 'Ipoustéguy's work is not abstract because it is breathing'. A visit to

Greece in 1962 inspired the creation of large-scale figures such as *La Terre* (1962, Tate). This is a distinguished addition to that tradition of French sculpture which includes work by *Maillol, *Richier, and *César, in which the living body and the earth become imaginatively fused. Ipoustéguy made numerous public monuments, for example that to the poet Rimbaud in the Place de l'Arsenal, Paris (1984). From the mid-1970s he also worked as a printmaker.

Further Reading: J Kirkup, 'Ipoustéguy, Sculptor of Total Originality', *The Independent* (11 February 2006)

Irascible Eighteen (Irascibles) A group of American artists who in 1950 protested against the exhibition policy of the Metropolitan Museum, New York, demanding the formation of a department to show modern American art. A photograph (now much reproduced) of fifteen of the Irascibles appeared in *Life* magazine on 15 January 1951. Among them were many of the leading *Abstract Expressionists, including *de Kooning, *Newman, *Pollock, *Rothko, and *Still.

Irish Exhibition of Living Art *See* JELLETT, MAINIE.

Irish Museum of Modern Art, Dublin. Museum opened in 1991 in the Royal Hospital, Kilmainham (a district at the west end of the city). The Hospital, built in 1680–87 to house disabled and veteran soldiers, is the largest and most impressive secular building of its period in Ireland and stands on a commanding site, looking over the River Liffey opposite Phoenix Park. It consists of four ranges around a central courtyard. In 1949 the building was vacated as unsafe (at this time it was serving as the headquarters of the Civic Guard) and it was many years in restoration and conversion to a museum. When it opened it had no permanent collection, but one has quickly been built up by purchase and gift. It also holds loan exhibitions.

iron and steel Metals that have been among the main additions to the materials used in sculpture in the 20th century. Steel is a purified form of iron, but the two metals are not always precisely distinguished: up to about the Second World War, the material used in sculpture was generally referred to as iron, but much of it could probably more accurately be described as steel. Iron is one of the most widely distributed of metals and has been

used in ornamental work since prehistoric times. Its malleability varies with the impurities present, especially the amount of carbon. The type that has been most used in decorative work is wrought iron, which has a very low carbon content and can be hammered into elaborate shapes. In the 19th century it was superseded for many purposes by cast iron; this contains more carbon and is consequently more brittle, but it had the advantages of being cheaper to produce and less subject to corrosion. Steel combines something of the strength of wrought iron with the malleability of cast iron. 'Cor-Ten' steel is a proprietary name for a type of 'self-weathering' steel popular with some contemporary sculptors. It contains a small amount of copper and acquires a patina that resists corrosion.

The first modern sculptor to use iron was perhaps Pablo *Gargallo, who made hammered masks in the material from about 1907. His work helped to inspire *Picasso to create what has been described as the first steel sculpture, *Guitar* (1912, MoMA, New York,), made of sheet metal and wire. Picasso's sculptural experimentation was an inspiration to *Tatlin, the founder of *Constructivism, in which steel (along with other modern materials) played a large part, its association with engineering making it appropriate to the creation of forms expressing the machine age. Picasso also played an important role in the development of welded sculpture, collaborating from 1928 to 1931 with Julio *González, the main pioneer of the technique. González (who came from a family of metalworkers) taught Picasso welding, in which pieces of metal are joined by melting them together with a blowtorch. This made possible such free-flowing openwork constructions as Picasso's *Woman in a Garden* (1929–30, Musée Picasso, Paris), which Timothy Hilton describes as 'one of the great sculptures of the twentieth century' and as 'much more "modern" than anything he painted at this time' (*Picasso*, 1975). Among the many sculptors influenced by such 'drawing in space' was David *Smith, who said after seeing reproductions of González's work: 'I learned that art was being made with steel— the material and machines that had previously meant only labor and earning power.' Like González, Smith was highly influential on sculpture after the Second World War, and more than anyone else he established steel as a material with its own expressive qualities,

notably by grinding and polishing the surfaces of his work. Smith also helped encourage the use of scrap metal and prefabricated industrial parts in sculpture. Scrap has been much used in *Junk art, for example, and sheet steel in the work of Anthony *Caro, who inspired a generation of British abstract sculptors. *Minimal artists, too, have made much use of steel, valuing its impersonal qualities.

Ironside, Robin (1912–65) British painter, theatrical designer, and writer on art, born in London. He studied art history at the *Courtauld Institute and was assistant keeper at the Tate Gallery, London, from 1937 to 1946 (for most of this period he was also assistant secretary of the *Contemporary Art Society). In 1946 he resigned from the Tate to devote himself to painting (in which he was self-taught) and writing about art, supporting himself partly through designing for the stage. His most characteristic paintings were imaginative—often esoteric—figure subjects, usually in gouache. *The Somnambulist* (*c.*1943, Tate), a highly linear depiction of fantastic overgrown architecture, suggests a sensibility well tuned to the *Neo-Romanticism current in wartime Britain. Among the theatrical works for which he designed were *Der Rosenkavalier* (Royal Opera House, Covent Garden, 1948) and *A Midsummer Night's Dream* (Edinburgh Festival, 1954). His best-known book is *Pre-Raphaelite Painters* (1948), a pioneering modern work on this group. The art historian Denys Sutton described him as 'a strange man, something of an eccentric, secretive and gifted with an elegance, style and perception—an aristocrat' (*Apollo*, June 2004).

Irwin, Robert (1928–) American installation artist, painter, and sculptor. He grew up in Los Angeles. In the 1950s he worked in both *Abstract Expressionist and figurative modes, but became dissatisfied with painting. Like the *Minimalists he wanted an art which referred to nothing but itself. His solution to this was a kind of practice which emphasized light and perception. The actual art object appears disembodied in a work such as *Untitled* (1968, MoMA, New York). In this an aluminium disc is attached to the wall a short distance away so that it appears to float in space. Four spotlights are trained on it at precise angles so that the object is hard to distinguish from the shadows around it. Irwin has

subsequently made *site-specific art. *Violet V Forms* (1983, University of California) is placed in a eucalyptus grove and consists of fence-like structures suspended on 25-foot poles which reflect the constant changes in light. His work, like that of James *Turrell, can be regarded as an attempt to develop the idea of the *Abstract Sublime.

Further Reading: D. Frankel, 'Robert Irwin', *Artforum International* (December 1998)

Isham, Samuel *See* TONALISM.

Iskusstvo kommuny *See* NARKOMPROS.

Iskusstvo y massy *See* AKHRR.

Island, The *See* UNDERWOOD, LEON.

Itten, Johannes (1888–1967) Swiss painter, designer, writer on art, and teacher, born at Südern-Linden. He trained as a primary school teacher but decided to become a painter and studied under *Hölzel in Stuttgart, 1913–16. In 1916 he opened his own school of art in Vienna, then from 1919 to 1923 he taught at the *Bauhaus, where he was in charge of the 'preliminary course', obligatory for all students. In 1923 he left the Bauhaus and opened another school of his own in Berlin, then from 1932 to 1938 he taught at the Krefeld School of Textile Design. In 1938 he settled in Zurich, where he held four posts concurrently—as director of the School of Arts and Crafts, the Museum of Arts and Crafts, the Rietberg Museum, and the School of Textile Design. He retired in 1961.

Itten's work as a painter consisted mainly of geometrical abstractions, exemplifying his researches into colour. However, he is best remembered as a teacher, especially for his preliminary course at the Bauhaus, which had a great influence on instruction in other art schools. He emphasized the importance of knowledge of materials, but also encouraged his pupils to develop their imaginations through, for example, automatic writing (*see* AUTOMATISM). His mystical ideas were opposed to the technological outlook of *Gropius (their quarrels caused Itten's departure from the Bauaus) and he had a reputation as a crank (he followed an obscure faith called Mazdaznan, shaved his head, and wore a long robe), but he influenced many of his students. Frank *Whitford (*Bauhaus*, 1984) describes him as 'a man of strange beliefs, a

teacher of unconventional brilliance and a perplexing mixture of saint and charlatan'. Itten wrote several books on the theory of art, the best known of which is probably *Kunst der Farbe*, published in 1961 and in the same year translated into English as *The Art of Color: The Subjective Experience and Objective Rationale of Color*.

IZO Narkompros *See* NARKOMPROS.

Izquierdo, María *See* TAMAYO, RUFINO.

Jaar, Alfredo (1956–) Chilean artist. Born in Santiago, he left his native country as an exile from the Pinochet regime in 1981. He now lives and works in New York. Jaar's work is highly political and examines the way in which traumatic events are represented through the media. One project, which lasted from 1994 to 1998, dealt with the civil war and genocide in Rwanda. Jaar had been in the country when the war began. One of the works he produced was a protest against the indifference of the media in the developed world. We hear an account of the deepening crisis and the horrifically rising death toll while, on a screen, are projected the front covers of *Newsweek*, the leading American news magazine during the same period. The cover stories deal with the problems of the stock market or the suicide of the rock star Kurt Cobain. Only when the deaths reach a million does the African crisis register. Jaar's preoccupation is with how these events are received and the ethics of presenting them. *The Sound of Silence* (2006) is an installation which takes as its subject the story of the photographer Kevin Carter, who won a Pulitzer Prize for his photograph of a girl in Sudan shadowed by a vulture and who committed suicide after public condemnation for not intervening to save the girl.

SEE WEB LINKS

• A talk given by the artist in 2008, Tate website.

Jack of Diamonds *See* KNAVE OF DIAMONDS.

Jackson, A. Y. (Alexander Young) (1882–1974) Canadian landscape painter, born in Montreal and active mainly in Toronto, where he settled in 1913 after extensive travels in Europe (1905, 1907–9, and 1911–13). Jackson was one of the leading artists of the *Group of Seven and in the latter part of his long career he became a venerated senior figure in Canadian painting. He visited almost every region of Canada, including the Arctic, and responded particularly to the hilly region of rural Quebec along the St Lawrence River. From 1921 he visited the area almost every spring, and the canvases he produced from sketches made there are regarded as his finest works. Their easy, rolling rhythms and rich colouring influenced many other Canadian landscape painters. Jackson moved to Ottawa in 1955 and in 1958 published his memoirs, *A Painter's Country*. He died at Kleinburg, Ontario.

Jacob, Max (1876–1944) French writer, painter, and draughtsman, a colourful figure in the Parisian art world in the early years of the 20th century. He was born in Quimper, the son of a tailor, and moved to Paris in 1894 to study law. After dropping out of his course, he took up journalism (including art criticism), then studied at the *Académie Julian. He was initially unsuccessful at both writing and painting, and he took various lowly jobs to stave off his dire poverty. In 1901 he became friends with *Picasso after seeing his first exhibition in Paris and leaving an admiring note at the gallery (*Vollard's). John *Richardson writes that 'The pale, thin gnome with strange, piercing eyes almost immediately assumed the role of mentor in Picasso's life ... even if at first they had no language in common except mime and were in so many respects unalike. Jacob was Jewish and homosexual (*"sodomite sans joie ... mais avec ardeur"*) and deeply insecure ... However, he was infinitely perceptive about art as well as literature and an encyclopedia of erudition ... He was also very, very funny' (*A Life of Picasso*, vol. 1, 1991). During his third visit to Paris, in the winter of 1902–3, Picasso was going through a rare period of abject poverty himself and Jacob helped him out by letting him share his room, Picasso having the bed by day and Jacob by night; a few years later, after Picasso settled in Paris, he and Jacob were neighbours in the *Bateau-Lavoir. Jacob's other close friends in the art world included *Apollinaire and *Gris. His writings, which include poetry,

novels, and children's stories, are marked by fantasy and verbal clowning, but also by sharp and ironic observation and intense self-examination. In 1909 he became a convert to Catholicism, although he continued to delve into the occult, and in 1921 he went into semi-monastic retreat at St Benoît-sur-Loire, where he supported himself by painting, his work including pious religious scenes. However, he made visits to Paris, where his old dissolute ways overcame his new piety. In 1943, because he was Jewish, he was arrested by the Germans and sent to a concentration camp at Drancy. Picasso did nothing to save his old friend (their relationship had cooled in the 1930s). Instead, *Cocteau, whose relationship with the Occupiers was far more cordial, pulled strings to get him freed, but he died of pneumonia the day before he was to be released.

Jacobsen, Georg *See* ROLFSEN, ALF.

Jacquet, Alain *See* MEC ART.

Jagger, Charles Sargeant (1885–1934) British sculptor, best known for his war memorials. Jagger was born at Kilnhurst, Yorkshire, the son of a colliery manager, and at the age of fourteen he was apprenticed as a metal engraver with the Sheffield firm of Mappin & Webb. In 1907 he won a scholarship to the *Royal College of Art, where he studied from 1908 to 1911. In 1913 he was placed second to Gilbert *Ledward in competition for the Rome Scholarship and the following year he won the award. However, the First World War intervened before he could take it up. He enlisted in the army, fought at Gallipoli and in France, was wounded three times, and won the Military Cross. His experience of trench warfare is reflected in his huge bronze relief *No Man's Land* (1919–20, Tate). He began making sketches for this in 1918 when he was recovering from a severe wound, and the finished work was commissioned by the British School of Rome in lieu of the scholarship he had relinquished. It is one of the grimmest images inspired by the war, showing a solitary look-out taking cover behind corpses strewn across barbed wire.

Some of this realism survived in his memorials. In his most famous work, the Royal Artillery Memorial (1921–5, Hyde Park Corner, London), the most prominent feature is a huge stone howitzer (fulfilling the wishes of the regiment that the monument should be clearly identifiable as its own). Below this,

life-size bronze statues of an officer, a driver, a shell-carrier, and—a bold decision—a dead soldier are combined with stone reliefs depicting war as painful labour in a style reflecting Jagger's admiration for Assyrian art. This was a vision far removed from the symbolic or idealized approach of most contemporary war memorials and the work caused considerable controversy, partly because the howitzer was in stone rather than the more natural-seeming bronze (Jagger said that he did not want a dark object against the skyline).

Jagger remained a leading sculptor after the demand for war memorials was over, his major commissions including stone figures at Imperial Chemical House, London (1928). In 1933 he published an instructional book, *Modelling and Sculpture in the Making*; this was still in print in the 1950s and remains a valuable account of studio practice in the early part of the 20th century.

Further Reading: A. Compton, *The Sculpture of Charles Sargeant Jagger* (2004)

James, Edward (1907–84) British collector and patron. He inherited a fortune and spent lavishly on the arts, including financing ballet (he married the Austrian dancer Tilly Losch). As a collector he concentrated on *Surrealist art, particularly works by his close friend and fellow eccentric Salvador *Dalí. In the 1970s he converted West Dean Park, Sussex (his family home), into a crafts college.

Jameson, Frederic *See* POSTMODERNISM.

Janco, Marcel (1895–1984) Romanian-Israeli painter, born in Bucharest. In 1915–16 he studied architecture in Zurich, where he became one of the most energetic members of the original *Dada group. At this time he was producing constructions and coloured reliefs as well as oils and collages. He was something of an idealist, seeking a synthesis between abstract painting and architecture, and he was a member of a group of mainly Swiss artists called Das Neue Leben (The New Life), which aimed to remove barriers between 'fine' and 'applied' art and redefine the role of the artist in society. The group ran from 1918 to 1920 and organized exhibitions in Basle, Berne, and Zurich. In 1921 Janco visited Paris and in 1922 returned to Romania, where he was a member of the group Contimporanul, which published a journal of the same name. He left Romania in 1941 and

became a Jewish refugee in Israel, settling in Tel Aviv. In the 1940s he abandoned abstraction for an *Expressionist style in which he depicted his new surroundings.

Janis, Sidney (1896–1989) American art dealer and writer on art. Between the departure of Peggy *Guggenheim from the USA in 1947 and the rise of Leo *Castelli in the 1960s he was the most important figure in promoting the work of avant-garde American artists. He opened a gallery on 57th Street, New York, in 1948. He exhibited many of the leading *Abstract Expressionists, although the economic survival of the gallery was dependent on dealing in modern European art. Janis was also interested in *naive art and 'discovered' Morris *Hirshfield in 1939. He wrote *They Taught Themselves: American Primitive Painters of the 20th Century* (1942), *Abstract and Surrealist Art in America* (1944), and (with his wife, Harriet) *Picasso: The Recent Years, 1939–1946* (1946).

Jaray, Tess (1937–) British painter, graphic artist, and designer. She studied at *St Martin's School of Art, 1954–7, and the *Slade School, 1957–60. From 1964 to 1968 she taught at Hornsey College of Art, London, and subsequently at the Slade School. Her work is abstract, using geometrical shapes subtly arranged and typically painted in soft colours. Sometimes they form a kind of irregular grid evoking the decorative patterns of Islamic architecture (*Minaret*, 1967, Graves Gallery, Sheffield). Her own decorative work includes commissions on an architectural scale, notably a floor for Victoria Station, London (1980). She says that what she is trying to suggest in her work is 'the sense of all experience of life being part of a whole, perceptible only in flashes and fragments'.

Jaudon, Valerie *See* PATTERN AND DECORATION MOVEMENT.

'Jauran' *See* PLASTICIENS.

Jawlensky, Alexei von (1864–1941) Russian *Expressionist painter and printmaker, active mainly in Germany. He came from an aristocratic family and was originally destined for a military career. In 1889 he began studying painting at the St Petersburg Academy under *Repin and in 1896 he resigned his commission in the Imperial Guard and moved to Munich with his fellow student Marianne von *Werefkin to devote himself completely to art. Jawlensky and Werefkin were companions for 30 years, but in 1902 he had a child by another woman—Helene Nesnakomoff—and he married her in 1922 after finally parting from Werefkin.

Munich was to be Jawlensky's home until the outbreak of the First World War, but he travelled a good deal in this period, making several visits to France, for example (he was the first of his Munich associates to have direct contact with advanced French art). In 1905 he met *Matisse in Paris and was influenced by the strong colours and bold outlines of the *Fauves. He combined them with influences from the Russian traditions of icon painting and peasant art to form a highly personal style that expressed his passionate temperament and mystical conception of art. A mood of melancholy introspection—far removed from the ebullience of Fauvism—is characteristic of much of his work and it has been said that he 'saw Matisse through Russian eyes'. In 1909 he was one of the founders of the *Neue Künstlervereinigung, and apart from *Kandinsky he was the outstanding artist of the group. Although he did not become a formal member of its offshoot the *Blaue Reiter, founded in 1911, he was sympathetic to its spiritual outlook. His most characteristic works of this period are a series of powerful portrait heads, begun in 1910 (*Portrait of Alexander Sacharoff*, 1913, Städtisches Museum, Wiesbaden).

On the outbreak of war in 1914 Jawlensky took refuge in Switzerland, where he remained until 1921. His work there included a series of 'variations' on the view from a window—small, semi-abstract landscapes with a meditative, religious aura. Like Kandinsky and others, Jawlensky believed in a correspondence between colours and musical sounds and he named these pictures *Songs without Words*. In 1918 he began a series of nearly abstract heads, in which he reduced the features to a few curves and lines. Unlike Kandinsky, however, he always based his forms on nature. From 1921 he lived in Wiesbaden, and in 1924 he joined with Kandinsky, *Klee, and *Feininger to form the *Blaue Vier. From 1929 he suffered from arthritis and by 1938 this had forced him to abandon painting completely.

Jeanne-Claude *See* CHRISTO AND JEANNE-CLAUDE.

Jeanneret, Charles-Édouard *See* LE CORBUSIER.

Jellett, Mainie (1897–1944) Irish painter, stage designer, writer, lecturer, and administrator, one of the most important pioneers of modern art in her country. She was born in Dublin, where she studied at the Metropolitan School of Art before spending two years (1917–19) at the Westminster School of Art in London, where *Sickert was among her teachers. In 1920 she went to Paris, where she studied with *Lhote and then with *Gleizes (along with her friend Evie *Hone) and she returned to visit Gleizes regularly until 1932. By 1923 she was painting in a completely abstract, *Cubist-inspired style (*Decoration*, 1923, NG, Dublin,). Her work in this vein prompted derision when exhibited at the Dublin Painters' Society, and she devoted much of her energy—throughs essays and lectures—to trying to overcome conservative attitudes in Ireland, which was then culturally isolated. In the 1930s figurative elements reappeared in her painting, and her later work included landscapes and religious subjects. She also made designs for the theatre and ballet.

Jellett died young of cancer, but the year before her death, her campaigning on behalf of modern art bore fruit in the founding of the Irish Exhibition of Living Art, of which she was first chairman. This was an exhibiting society that became the main venue for avant-garde art in Ireland for many years.

Jencks, Charles *See* POSTMODERNISM.

Jenkins, Paul (1923–) American painter and sculptor, born in Kansas City. He settled in Paris in 1953 and has since worked both there and in New York. His paintings, which are built up from veils of prismatic colour poured on to the canvas, can seem half-way between Parisian and New York abstraction and are usually given a title beginning 'phenomena'. John *Berger has described the effect of his work thus: 'One watches them as one watches flames flickering at night in a fire, which abruptly stops for an instant (an aeon) and then imperturbably continues.' Jenkins has also made sculpture, including works at the Murano glass factory in Venice and designs for the theatre.

Further Reading: J. Berger, 'The Colour Code', *The Guardian* (19 October 2005)

Jenney, Neil (1945–) American painter, born in Torrington, Connecticut. He is associated with *New Image Painting. From the late 1960s onwards he made broadly executed figurative paintings that isolated objects against a monochrome background. The black frame he gave them had the important function of helping to produce a level of illusionism. It also provided the painter with a space for the title. Sometimes the paintings relate to themes of American rural life, as with *Beasts and Burdens* (1970, MoMA, New York). A panoramic image of a swimming man with a shark entitled *Friend or Foe* (1969, Los Angeles Museum of Contemporary Art) can be read as an allegory of the Cold War.

Jensen, Knud W. *See* LOUISIANA MUSEUM.

Jérôme, Jean-Paul *See* PLASTICIENS.

Jerwood Prize *See* CLOUGH, PRUNELLA.

Jeune Peinture Belge An avant-garde artists' association founded in Brussels in 1945 with the aim of holding exhibitions of contemporary Belgian art throughout Europe. The members of the group (who included *Alechinsky and *Bury) were strongly individualistic and had no common programme, but they were basically abstract in their outlook and were influenced particularly by the expressive abstraction of the post-war *École de Paris. Jeune Peinture Belge dissolved in 1948, but it inspired a successor called Art Abstrait (1952–54), which in turn was followed by another group, Formes (1956–7).

Jeunes Peintres de Tradition Française *See* PEINTRES DE TRADITION FRANÇAISE.

John, Augustus (1878–1961) British painter and draughtsman, born in Tenby, Wales, the son of a solicitor. He studied at the *Slade School, London, 1894–8. In his early days there 'he appeared a neat, timid, unremarkable personality' (*DNB*), but after injuring his head diving into the sea while on holiday in Pembrokeshire in 1897 he became a dramatically changed figure, described by Wyndham *Lewis as 'a great man of action into whose hands the fairies had placed a paintbrush instead of a sword'. He grew a beard and became the very image of the unpredictable bohemian artist; he had a notorious reputation as a ladykiller. John himself later commented that the idea that the accident 'had released hidden and unsuspected springs' was 'all nonsense', but his work did change at this time as well as his appearance: previously it

had been described by *Tonks as 'methodical', but it became vigorous and spontaneous, especially in his brilliant drawings—his draughtsmanship was already legendary by the time he left the Slade.

In the first quarter of the 20th century John was identified with all that was most independent and rebellious in British art and he became one of the most talked-about figures of the day. He was extremely energetic, travelling a good deal, teaching at Liverpool University (1900–02) and at Chelsea Art School, which he ran (1903–7) with his friend *Orpen, and pursuing a complex domestic life. In 1901 he had married Ida Nettleship, a fellow student at the Slade, but even before her death in 1907 he had fathered a child by another woman, Dorothy ('Dorelia') McNeill, who became his favourite model and his wife in everything but name. In 1911–14 he led a nomadic life, sometimes living in a caravan and camping with gypsies. As well as romanticized pictures of gypsy life he painted deliciously colourful small-scale landscapes, sometimes working alongside his friends J. D. *Innes and Derwent *Lees. During the same period he also painted ambitious figure compositions, with stylized forms that bring him close to French *Symbolism (1909–11, *The Way Down to the Sea*, Lamont Art Gallery, Exeter, New Hampshire). In the First World War he was an *Official War Artist. It is as a portraitist, however, that John was most highly regarded in his lifetime. He was taken up by society and painted a host of aristocratic beauties as well as many of the leading literary figures of the day, including Thomas Hardy (1923, Fitzwilliam Museum, Cambridge), T. E. Lawrence (several paintings and drawings, including a painting in Arab dress, 1919, Tate) and W. B. Yeats (several portraits, notably one in Kelvingrove Art Gallery, Glasgow, 1930). Increasingly, however, the painterly brilliance of his early work degenerated into flashiness and bombast, and the second half of his long career added little to his achievement, although he remained a colourful, newsworthy figure until the end of his life. He is one of the few British artists who have become familiar to the general public, and his image changed from that of rebel to Grand Old Man (he was awarded the Order of Merit in 1942). He wrote two volumes of autobiography, *Chiaroscuro*, 1952, and *Finishing Touches*, posthumously published in 1964. A new edition entitled *The Autobiography of Augustus John* appeared in 1975. His reputation declined after his death. It is now his early paintings that are most highly regarded.

Further Reading: L. Tickner, *Modern Life and Modern Subjects* (2000)

John, Gwen (1876–1939) British painter, born in Haverfordwest, Wales. She was the sister of Augustus *John, but his complete opposite artistically, as she was in personality, living a reclusive life and favouring introspective subjects. After studying at the *Slade School, 1895–8, she took lessons in Paris from *Whistler, and adopted from him the delicate greyish tonality that characterizes her work (once when Augustus John mentioned to Whistler that Gwen had a fine sense of character, he replied: 'Character? What's that? It's the tone that matters. Your sister has a fine sense of tone'). In 1899 she returned to London, but in 1904 she settled permanently in France; she had started out to walk to Rome with her friend Dorelia McNeill (later Augustus John's common-law wife), but they got no further than Toulouse. At first she lived in Paris (earning her living modelling for other artists—including *Rodin, who became her lover), then from 1911 in Meudon, on the outskirts of the city. In 1913 she became a Catholic, and she said 'My religion and my art, these are my life'. Most of her paintings depict single figures (typically girls or nuns) in interiors, painted with great sensitivity and an unobtrusive dignity. Good examples are her self-portraits in Tate and the National Portrait Gallery, London. She had only one exhibition devoted to her work during her lifetime (at the New Chenil Galleries, London, in 1926) and at the time of her death was little known. However, her brother's prophecy that one day she would be considered a better artist than him has been fulfilled, for as his star has fallen hers has risen, and since the 1960s she has been the subject of numerous books and exhibitions. 'Few on meeting this retiring person in black', wrote Augustus, 'with her tiny hands and feet, soft, almost inaudible voice, and delicate Pembrokeshire accent, would have guessed that here was the greatest woman artist of her age, or, as I think, of any other . . . Fifty years from now [he was writing in 1946] I shall be known as the brother of Gwen John.' In 2004 Tate Britain held an exhibition that brought together brother and sister. This may have been a good marketing ploy, but the confrontation did no service to either artist, who would have been far better seen in

separate spaces to allow the visitor to adjust to such different sensibilities.

Further Reading: A. Foster, *Gwen John* (1999)

John, Sir William Goscombe (1860– 1952) British sculptor, medallist, and lithographer, born in Cardiff, the son of a woodcarver, Thomas John; he assumed the name of Goscombe from a village in Gloucestershire. After studying at Cardiff School of Art, he moved to London in 1882 and continued his training at the *Royal Academy. Between 1888 and 1891 he spent a good deal of his time abroad (with the aid of a Royal Academy travelling scholarship): he visited Italy, Spain, Greece, and the Near East, and spent a year in Paris, where he met *Rodin. On his return he settled permanently in London, but he kept up close connections with Wales throughout his life. Goscombe John spent his formative years in London at a time when the *New Sculpture was coming to the fore, and his work was strongly influenced by its ideas, as for example in the strain of fantasy evident in *The Elf* (plaster model, 1898, Royal Academy, London; marble version, 1899, Kelvingrove Art Gallery, Glasgow; bronze versions National Museum of Wales, Cardiff, and elsewhere). He is now best known for his war memorials. Two are particularly highly regarded for their lively sense of dramatic action: the memorial at Port Sunlight (1921), a spectacular ensemble in which soldiers defend women and children around a village cross; and *The Response 1914* (1923, Newcastle upon Tyne), showing a procession of patriotic volunteers, led by drummer boys, with a winged figure of Victory above. He left a large collection of his work to the National Museum of Wales, Cardiff, where an exhibition was devoted to him in 1979.

Further Reading: F. Pearson, *Goscombe John at the National Museum of Wales* (1979)

John Moores Liverpool Exhibition A biennial exhibition, first held in 1957, named after its sponsor, John (later Sir John) Moores (1896–1993), founder of the Littlewoods Organisation (known originally for football pools and subsequently also for mail-order business and department stores). It is held in the Walker Art Gallery, Liverpool. Foreign works have sometimes been included, but it is primarily an exhibition of British painting, aimed at encouraging British artists and at bringing good contemporary work to Merseyside. Several prizes are awarded at each exhibition and they carry great prestige as well as a substantial cash award (currently the winner is awarded £25,000). The selection of the exhibition and prize winners is made in ignorance of the artist's name to prevent favouritism or prejudice, although it is hard to believe that the jury do not usually recognize works of well-known painters by their style. Until 2004 the first prize was always a purchase prize but this practice was abandoned to increase the value to the winning artist, whose work is still normally acquired for the collection. Among prize winners have been David *Hockney, Mary *Martin, Jack *Smith, Euan *Uglow, John *Hoyland, Peter *Doig, and most memorably Roger *Hilton, who in 1963 celebrated his winning by aiming a kick at his painting in front of a press photographer, saying that he was not surprised that his picture had won because the others were so bad.

(⊕) SEE WEB LINKS

• Part of the exhibition's official website, providing the history of the event.

Johns, Jasper (1930–) American painter, sculptor, and printmaker. His career has been closely associated with that of Robert *Rauschenberg, and they are considered to have been largely responsible for the move away from *Abstract Expressionism to *Pop art that characterized American art in the late 1950s. Johns was born in Augusta, Georgia, and studied at the University of Southern Carolina before dropping out and moving to New York in 1949. After two terms at a commercial art college, he worked at various jobs and did military service before meeting Rauschenberg in 1954. They were close friends until 1962, when they broke up with some bitterness. It is generally assumed that for a time they were lovers. Soon after meeting they formed a partnership to design window displays for upmarket stores, the money they earned allowing them to pursue their art. The implicitly homophobic accusation that Johns is basically a window-dresser has appeared from time to time in the writings of critics. It surfaced, for instance, in an interview with Peter *Fuller.

In 1955 Johns painted a picture of an American flag—a faithful flat copy of the real thing, except that the surface was heavily textured. He used the almost defunct technique of encaustic (melted wax) with newspaper cuttings embedded in the paint. His explanation is banal in the extreme: 'One night I dreamt I

painted a large American flag, and the next morning I went out and bought the materials to begin it.' However, the significance of these works has been far-reaching. Johns found a way of overcoming the residual spatial illusion in Abstract Expressionism while returning to the object. Another Johns theme was the target. His paintings of that subject were sometimes topped with fragments of body casts in small containers which could be opened and closed. Maps and figures and letters were also part of the repertoire. All were familiar, inherently flat, and man-made. Sometimes he used the original colours of the subject. Sometimes he used shades of greeny-grey to incorporate a sense of spatial illusion into the flat object. Leo *Steinberg pointed out to those who claimed that Johns had chosen familiar objects so that the spectator would stop thinking of them and concentrate on 'the poetic qualities of the picture itself' that 'not one of his subjects ever succeeded in getting itself overlooked'. The choice of the American flag is certainly an interesting one in the context of the period. It was a time of intense popular patriotism in the atmosphere of the Cold War. Alfred *Barr, an early supporter who bought his works for the New York *Museum of Modern Art, had strong reservations about acquiring a flag painting, worrying that it would be too politically contentious. Johns also began making three-dimensional objects. *Painted Bronze (Beer Cans)* (1960, Museum Ludwig, Cologne) is the illusionistically painted cast of two beer cans, which themselves simulate a bottle's pasted labels.

In 1958 Johns had his first one-man show—at Leo *Castelli's gallery in New York—and it was a huge success. After this he became one of the most famous (and highly priced) of living artists. As early as 1961 he bought a house on Edisto Island, off the coast of South Carolina, to escape some of the pressures of celebrity (it was destroyed by fire in 1968). From the early 1960s his paintings became more complex; handprints became a motif so that process and body image were fused. *Periscope (Hart Crane)* (1963) is one of the most beautiful and poignant. Entirely in shades of grey, it bears stencilled lettering spelling out the names of the primary colours both in order and jumbled. An arm print reaches out of a scraped circle, recalling the suicide by drowning of the poet named in the title. Later works often introduced autobiographical elements, as for example in *Racing Thoughts*

(1983, Whitney Museum, New York), a collage that depicts various elements from Johns's bathroom and other personal references. There are also repeated art-historical references. The cross-hatchings in many of his later works can be traced back to *Munch's last self-portrait, *Between the Clock and the Bed* (1940–42, Munch Museum, Oslo). A fragment from the Isenheim altarpiece by Grünewald constantly reappears, sometimes almost unidentifiable, except to the initiate. More clear is a well-known optical illusion in which the same image is legible as both an attractive young woman and an old crone. Much of his later work has been in the form of prints (he took up lithography in 1960 with Universal Limited Art Editions—*see* PRINT RENAISSANCE). His other work has included designs for the Merce Cunningham Dance Company, of which he was appointed artistic adviser in 1967.

Further Reading: J. Johnston, *Jasper Johns: Privileged Information* (1996). The artist disliked the approach of this book because of the writer's preoccupation with his biography and felt sufficiently strongly to refuse reproduction rights. It is nonetheless well worth reading

F. Orton, *Figuring Jasper Johns* (1994)

Johnson, Malvin Gray *See* HARLEM RENAISSANCE.

Johnson, Philip *See* MUSEUM OF MODERN ART, NEW YORK.

Johnston, Edward *See* ROYAL COLLEGE OF ART.

Johnston, Frank *See* GROUP OF SEVEN.

Jonchery, Charles *See* DIRECT CARVING.

Jonas, Joan (1936–) American *Performance and *Video artist, born in New York. She studied art history, sculpture, and drawing. While working as a gallery secretary she saw *Happenings by Claes *Oldenburg and Performance work by Robert *Morris. Her own first performance was in 1968. Her work has made considerable use of mirrors. In *Mirror Piece 1* (1969) fifteen women moved around carrying full-length mirrors which reflected the audience rather than themselves. This was a way of bringing the audience into the piece but it can also be interpreted as a work of *feminist art, in that the woman is no longer seen, as in classic representations, gazing into the mirror, but is controlling the reflection. Another feature of Jonas' work has

been elaborate costume. In *Organic Honey* she dressed up in pink chiffon, a feathered and jewelled headdress, and a mask. Some of her work refers to the rituals of the Hopi and Zuni tribes of the Pacific Coast where she grew up.

Further Reading: J. Simon, 'Themes and Variations', *Art in America* (July 1995)

Jones, Adrian (1845–1938) British sculptor. From 1867 to 1890 he was an army veterinary surgeon, painting and sculpting in his spare time. When he retired from military service (with the rank of captain) he became a full-time sculptor, specializing in subjects involving horses, of whose anatomy he had an intimate knowledge. His major work is the huge Quadriga (four-horsed chariot) surmounting Constitution Arch at Hyde Park Corner in London; a winged figure of Peace descends on the war chariot, causing the horses to rear to a standstill. The group, which was erected in 1912, was paid for by the financier Lord Michelman; he presented it to the nation in memory of his friend Edward VII, who had encouraged the project. Among Jones's other works is the Cavalry Memorial in Hyde Park (erected 1924). His autobiography, *Memoirs of a Soldier Artist*, was published in 1933.

Jones, Allen (1937–) British painter, printmaker, sculptor, and designer, born in Southampton. He studied at Hornsey College of Art, 1955–9 and 1960–61; in between these two periods he spent a year at the *Royal College of Art, from which he was expelled. In 1961 he was one of the artists who stood out at the *'Young Contemporaries' exhibition at which *Pop art first made a major impact in Britain and he has remained one of the most committed exponents of Pop. His early paintings were flatly painted in intense colours, which owed more to *Post-Painterly abstractionists, especially Morris *Louis, than to commercial sources. Although he has worked primarily as a painter, printmaker, and designer, he is best known to the public for a distinctive type of sculpture in which figures of women—more or less life-size, dressed in fetishistic clothing, and with what Jones calls 'high definition female parts'—double as pieces of furniture: for example, a woman on all fours supporting a sheet of glass on her back becomes a coffee table, and a standing figure with outstretched hands becomes a hatstand. He began making such sculptures in the late 1960s and has continued to produce sculpture based on the

female form, although in a manner that he calls 'less aggressive' and 'easier to take' (they have come in for a good deal of criticism for allegedly demeaning women as sex objects: an article in the feminist journal *Spare Rib* in 1973 suggested that they expressed a castration complex). Jones says that 'eroticism is an absolutely universal subject which relates you to every other human being', and his other work uses similar imagery—legs, stockings, high-heeled shoes, etc., often suggested by women's fashion magazines. His work as a designer has included sets and costumes for the erotic review *Oh! Calcutta!* (1969).

Jones, David (1895–1974) British painter, engraver, and writer, born at Brockley, Kent; his father, a printer, was Welsh, and his mother was English. He studied in London at Camberwell School of Art, 1909–15, and then after serving in France with the Royal Welch Fusiliers, at Westminster School of Art, 1919–22. His studies left him 'completely muddle-headed as to the function of art in general', but after converting to Roman Catholicism in 1921 he met Eric *Gill and under his influence achieved a sense of purpose. Gill not only introduced him to wood engraving but also guided him to reject the current concern with formal properties in favour of an art that aspired to reveal universal and symbolic truths behind the appearance of things. He collaborated with Gill for several years and was engaged to one of his daughters from 1924 to 1927. Jones worked mainly in pencil and watercolour, his subjects including landscape, portraits, still-life, animals, and imaginative themes (Arthurian legend was one of his main inspirations). As a writer he is best known for *In Parenthesis* (1937), a long work of mixed poetry and prose about the First World War. T. S. Eliot described it as a work of genius and it won the Hawthornden Prize. After the Second World War Jones retired to Harrow and devoted himself mainly to calligraphic inscriptions in the Welsh language.

Further Reading: Tate Gallery, *David Jones* (1981)

Jónsson, Ásgrímur See THORLÁKSSON, THÓRARINN B.

Jopling, Jay See WHITE CUBE.

Jorn, Asger (Asger Jørgensen) (1914–73) Danish painter, sculptor, printmaker, ceramicist, designer, collector, and writer, active in Paris for much of his career. He was born at Vejrum, Jutland, and grew up in Silkeborg.

Initially he trained to be a teacher, but in 1936 he went to Paris to study art. He attended *Léger's academy for ten months and then worked for *Le Corbusier on a mural for the 1937 International Exhibition. Throughout the Second World War he lived in Denmark and during the German occupation (1940–45) he printed a banned periodical entitled *Hellhesten*. After the war he returned to Paris, where in 1948 he was one of the founders of the *Cobra group. The group's central doctrine was freedom of expression, and Jorn's most characteristic works are painted with violent brushwork. In 1951 he became ill with tuberculosis and returned to Silkeborg, where he spent ten months in a sanatorium. After his recovery he travelled widely, but he divided his time mainly between Paris and Albisola Marina in northern Italy. In 1957–61 he participated in the International *Situationist movement. The influence of this came out most fully in the paintings he made 'modifying' old paintings discovered in junk shops in which demonic creatures stalk placid landscapes. His other works include numerous book illustrations and he also wrote several books himself, beginning with *Held og hasard* ('Risk and Chance') in 1952; this attacked conventional views of beauty and art. The others include *Magi og skønne kunster* (Magic and the Fine Arts), published in 1971. After 1962 his books were published by his own 'Scandinavian Institute for Comparative Vandalism'. Underlying his writings was an attempt to reconcile his commitment to Communism with his belief in the role of a creative elite. Although he lived mainly elsewhere, he retained a great affection for his homeland. He wrote 'In the North, we are not only at the cold frontier of civilisation but of existence, truth and life themselves.' He related the contradictory illogical elements in his art, summed up by the title and mood of one of his most celebrated paintings, *The Timid Proud One* (1957, Tate), to a Northern inheritance, writing that 'the essence of art in Scandinavia lies in an interaction of moods from laughter to tears and from tears to lethal rage'. He carried out several major works for sites in Denmark, notably a ceramic wall (installed 1959) and a tapestry (1960) for Århus State High School. In his last years he concentrated on sculpture. He presented many works by himself and by his contemporaries to the Silkeborg Museum, including a vast painting entitled *Stalingrad*, worked on between 1957 and 1972, inspired by the experiences of a friend who had fought in the decisive battle of the Second World War which gave its name to the painting.

Further Reading: J. Allison and C. Brown, *Border Crossings: Fourteen Scandinavian Artists* (1992)

Josephson, Ernst (1851–1906) Swedish painter and draughtsman. He travelled widely in Europe early in his career and in 1882–8 he lived in Paris, where he was the leader of a group of anti-academic Swedish artists. At this time he moved from a naturalistic style to a much more fantastic idiom, often inspired by Nordic myth, and his work is particularly distinguished for its intensity and vitality of colouring. In 1887 he began suffering from mental instability and never fully recovered. Nonetheless, he continued to work intensively, and the bizarre paintings he produced—although little known in his lifetime—were influential on *Expressionism in Sweden. Josephson's work is particularly well represented in the Konstmuseum at Göteborg and in the Nationalmuseum in Stockholm.

Jourdain, Frantz See SALON D'AUTOMNE.

Journiac, Michel (1935–95) French artist whose work dealt with issues of the body, sexuality, mortality and religion. He was born in Paris and originally studied theology and philosophy. In 1969 he held a *Mass for a Body*, a religious ceremony in which he offered his own blood, in the form of a sausage (*boudin*), to the public. He also provided the recipe. *Body Contract* (1972) allowed the art lover to become a work of art. The two conditions were, first, to bequeath your body to Journiac and, second, to die. There were three choices available: A) painting—the skeleton was to be lacquered white; B) object—the skeleton was to be dressed in the subject's clothes; C) sociological—the skeleton was to be coated in gold. In contrast to the chaotic mess of the *Vienna Actionists, whose preoccupation with blood, pain and death he shared, Journiac's rituals were as highly ordered as a Catholic service.

Further Reading: E. Filipovic, 'Michel Journiac', *Frieze*, issue 85 (September 2004)

Jowett, Percy See ROYAL COLLEGE OF ART.

Judd, Donald (1928–94) American sculptor, designer, and writer on art, one of the leading exponents and theorists of *Minimal art, although he personally spurned the term. He

was born in Excelsior Springs, Missouri, and after serving with the US Army in Korea, 1946-7, he studied in New York at both the *Art Students League and Columbia University. In 1953 he graduated in philosophy at Columbia and he gained an MA in art history there in 1962 (Meyer *Schapiro was one of his teachers). From 1959 to 1965 he earned his living as an art critic, working mainly for *Arts Magazine*. He began his career as a practising artist as a painter, producing what he later called 'half-baked abstractions', but in the early 1960s he took up sculpture with heavily textured monochrome reliefs. In 1963-4 he began making the industrially fabricated metal boxes for which he is best known. His essay 'Specific Objects' (*Arts Yearbook*, 1965) sought to justify such work as representing an art which was 'a thing as a whole'. What Judd was trying to do with the phrase was to define a kind of object that was not dependent, as a painting or most sculpture was, on internal relationships. So for Judd, even a painter like Kenneth *Noland, 'obviously one of the best painters anywhere', was deficient, because the work 'lacks the specificity and power of actual materials, actual colour, and actual space'. The sculpture of *Arp, on the other hand, was admired because 'a good piece is a whole which has no parts'(*Arts Magazine*, September 1963). J. Leering has argued for the importance of the exhibition space in Judd's work. He writes that 'The concreteness of the situation as a whole is Judd's primary concern.' An example might be in those works in which a series of identical boxes are mounted on a wall in a vertical ladder-like series. On a conceptual level the piece is about repetition and order. However, on the level of how they are perceived in an actual space by a spectator with an actual body with eyes at a specific height, there is an extraordinary difference between the separate levels. Judd's choice of materials included steel, aluminium and perspex. These materials and their colours were for Judd an aspect of the 'new possibilities open to the artist in three dimensions'. (He pointedly avoided using the word 'sculptor'.) In 1970 he began making works for the specific space in which they were to be exhibited, and in 1972 he began producing outdoor works. In spite of great financial and critical success, Judd disliked the New York 'art crowd' (he was notoriously touchy and had a low view of the work of certain artists such as Robert *Morris and Tony *Smith, who might be assumed to be natural allies). In 1973 he moved to Marfa, Texas, where he converted the buildings of an old army base into studios and installation spaces. In the 1980s he began designing furniture in a similar style to his sculptures. *Donald Judd: Complete Writings 1959-75* was published in 1976. A further volume, *Complete Writings 1975-1986*, appeared in 1986.

Further Reading: B. Fer, *On Abstract Art* (1997)
Van Abbe Museum, Eindhoven, *Don Judd* (1970); essay by J. Leering

Jugendstil *See* ART NOUVEAU.

Julian, Rodolphe *See* ACADÉMIE.

Juneau, Denis *See* NOUVEAUX PLASTICIENS.

Junk art Art constructed from the waste products of urban life. In so far as Junk art represented a revolt against traditional materials and a desire to show that works of art can be constructed from the humblest and most worthless things, it may be plausibly traced back to *Cubist collages, *Duchamp's *readymades, and the work of Kurt *Schwitters. However, it is not until the 1950s that it is possible to speak of a Junk movement, particularly with the work of Robert *Rauschenberg, who used rags and tatters of cloth, torn reproductions, and other waste materials in his combine paintings. Lawrence *Alloway, in 1961, was the first to apply the name 'Junk art' to such works, and the term was then extended to sculpture made from scrap metal, broken machine parts, used timber, and so on. Leading exponents included Joseph Goto (1916-94) and Richard Stankiewicz (1923-83). Their sculpture has sometimes been regarded as a kind of equivalent of *Abstract Expressionism in painting, but Stankiewicz often manifested a quirky humour, as in *Middle Aged Couple* (1954, Museum of Contemporary Art, Chicago). Californian *Funk art sometimes made use of similar materials. The sculptor and film-maker Bruce Conner (1933-2008) was a key figure, with his sinister constructions making use of old stockings and broken dolls. The Junk art of the USA had analogies in the work of *Tàpies and others in Spain, *Burri and *Arte Povera in Italy, and similar movements in most European countries and in Japan, where the refuse left over from the Second World War was sometimes converted to artistic use.

Kabakov, Ilya (1933–) Russian *installation artist, born in Djnepropetrovsk, Ukraine. In 1939 his family moved to Moscow. He worked as an illustrator for children's books to gain himself some independence while building up his reputation as an *unofficial artist and was one of a group of artists who were involved in what was known as 'Romantic Conceptualism'. These artists produced a kind of parallel to Western *Pop, but worked from the drab paraphernalia of Soviet life in the post-Khrushchev years. He said subsequently: 'In the 1970s we lived like Robinsons, discovering the world through our art.' In the 1980s Kabakov became known in the West through the New York dealer Ronald Feldman, who had developed contacts with the Russian underground. It was at Feldman's gallery in 1988 that Kabakov mounted the installation that was to be pivotal to his career. Entitled *Ten Characters*, it consisted of a series of rooms supposedly in a communal apartment block, each occupied by an idiosyncratic and obsessive character. For instance, 'The Man who collects the Opinions of Others' believes all opinions are arranged in circles. His collection technique is to place an object in the corridor, wait unnoticed for someone to come, and record the response. Kabakov writes, 'If it were possible to see him from the side, then he usually reminded me of a fisherman, tense and alert, waiting with his rod in his hand.'

After 1987 Kabakov worked in the West, but he continued for some years, even after the breakup of the Soviet Union, to describe himself as a 'Soviet artist', not out of any loyalty to that political system, but as an acknowledgement of the culture from which his work sprang. The distance between his practice and that of Western modernism was underlined by his contribution to *documenta 9 in 1992. This consisted of a reconstruction of a row of Russian-style public toilets, some of which had been given interior decoration as though they were living spaces. On one level

this was a reference to *Duchamp's famous gesture of exhibiting a urinal as *Fountain*, but, unlike Duchamp's *ready-made, Kabakov's installation derives its power not from being distanced from its context but by its inclusion of the details of everyday life. Kabakov was asked by an attendant how many Russians actually lived in toilets. The playing with tantalizing fictions is very much part of his art, but this led to an outcry in the Russian press, which accused the artist of showing the Western public things that should not be aired outside the country. Following this controversy, Kabakov decided to move to the West permanently. He now works in collaboration with his wife, Emilia Kabakov.

Further Reading: P. Suchin, 'Ilya Kabakov and Contemporary Russian Art', *Art & Design*, profile no. 35, Special issue, 'New Art from Eastern Europe' (1994)

(()) SEE WEB LINKS
- S. Boym, 'Ilya Kabakov: The Soviet Toilet and the Palace of Utopias', on the Art Margins website.

Kaesbach, Walter *See* HECKEL, ERICH.

Kahler, Eugen *See* BLAUE REITER.

Kahlo, Frida (1907–54) Mexican painter, the daughter of a German-born photographer and a Mexican mother. In 1925, while travelling home from school, she suffered appalling injuries in a traffic accident, leaving her a permanent semi-invalid, often in severe pain. During her convalescence she began painting portraits of herself and others. She remained her own favourite model and her art was usually directly autobiographical: 'I paint myself because I am so often alone.' In 1928 she married Mexico's most famous artist, Diego *Rivera, who was twice her age and twice her size. Their relationship was often strained, but it lasted to her death, through various separations, divorce and remarriage, and infidelities on both sides. One of her lovers was Leon Trotsky, who was

assassinated in Mexico City in 1940. Both Rivera and Kahlo were investigated for complicity and, although legally exonerated, both returned to a firm allegiance to Stalinist Communism in their later years. Kahlo was mainly self-taught as a painter. She was influenced by Rivera, but more by Mexican folk art (its impact was also apparent in her colourful clothes). This had a decided political significance. She became a strong adherent of 'Mexicanidad', a movement rejecting Western European and aristocratic culture in favour of a national folk culture, which was also strongly supported by Rivera. Oriana Baddeley and Valerie Fraser have argued that it was Kahlo rather than Rivera and the other muralists whose work 'effectively united the concerns of popular art with those of the modernist avant-garde'. Her work at its best combines a colourful, almost *naive vigour with a considerable delicacy, as well as a sense of fantasy that attracted André *Breton. He arranged an exhibition of her work in Paris in 1939, but Kahlo did not regard herself as a *Surrealist—'I never painted my dreams, I painted my own reality'. This, in fact, demonstrates that she was in spirit Surrealist in that she did not make the distinction between the two.

Kahlo's paintings of her own physical and psychic pain are narcissistic and nightmarish, but also—like her personality—fiery and flamboyant. She presents herself as a wounded deer in a painting of 1946 or with her spine as a broken column (1944, Museo Dolores Olmedo Patino, Mexico). Rivera described her work as 'acid and tender, hard as steel, and delicate and fine as a butterfly's wing, loveable as a beautiful smile, and profound and cruel as the bitterness of life'. Some paintings allude to a wider political context. One of the most striking, *Self-portrait on the Borderline* (1932), shows her between the technological world of the modern USA and symbols of ancient Mexico. Her paintings were widely shown in Mexico and in the year of her Paris exhibition (1939) she also had a successful show in New York, but during her lifetime she was overshadowed by her husband. Since her death, however, her fame has grown and she has become something of a feminist heroine, admired for her refusal to let great physical suffering crush her spirit or interfere with her art and her left-wing political activities. (She was carried on her deathbed to an anti-American rally and one of her last paintings was optimistically entitled

Marxism Will Heal the Sick.) As Sarah Lowe put it, 'Kahlo has been venerated for her proto-feminist resistance to patriarchal restraints and mythologised for her steadfast introspection in the face of the predominant "public art" of her time.' This aspect was capitalized on in the film *Frida*, starring Salma Hayek, that was released in 2002. When her work has been exhibited there has frequently been debate as to how far the paintings match up to the myths around the artist. Brian *Sewell (*Evening Standard*, 10 June 2005) wrote of 'clumsy ineptitude and premeditated primitivism' and said that Kahlo's work has 'become a major weapon in the cultural war waged by blind, ignorant, silly, and yet menacing feminists'. Even those repelled by Sewell's political polemic might have to concede that in bulk the work is very uneven. As a far less hostile commentator, Stephanie Mencimer, put it, 'her fans are largely drawn to the story of her life, for which her paintings are often presented as simple illustration'. Nonetheless, in the same article she concludes that 'when you sweep away the sideshow, ignore the overwrought analysis, and take a hard look at what she painted, much of it is extraordinary'. Indeed a selection of well-chosen paintings, generally the best-known pieces, make a powerful impact, which can be dissipated by repetitive or low-quality work. Kahlo's house in the suburb of Coyoacán in Mexico City was opened as a museum dedicated to her in 1958.

Further Reading: O. Baddeley and V. Fraser, *Drawing the Line: Art and Cultural Identity in Contemporary Latin America* (1989)

E. Dexter, *Frida Kahlo* (2005)

S. Lowe, *Frida Kahlo* (1991)

S. Mencimer, 'The trouble with Frida Kahlo: Uncomfortable truths about this season's hottest female artist', *Washington Monthly* (June 2002)

Kahnweiler, Daniel-Henri (1884–1979)

German-born art dealer, publisher, and writer, who became a French citizen in 1937. He was a banker by training but not by temperament, and he persuaded rich banker uncles to support him in opening a gallery in Paris— in the rue Vignon—in 1907. Initially he knew nothing about the art trade and simply bought what he liked, his first purchases being *Fauve paintings by *Braque, *Derain, and *Vlaminck. He was soon buying *Cubist works by Braque and *Picasso, and in 1912 both these artists signed contracts giving Kahnweiler an exclusive right to purchase

their entire outputs. He was also a friend and supporter of *Gris, of whom he wrote a standard biography (1946). During the First World War he lived in neutral Switzerland, where in 1916 he published the first four chapters of *Das Weg zum Kubismus* (*The Rise of Cubism*), an account which has remained highly influential on subsequent interpreters. (A full version was published in Munich in 1920.) He returned to Paris in 1920. As well as marketing paintings, Kahnweiler acted as a publisher, bringing out numerous books illustrated by the artists in whose work he dealt (*see* LIVRE D'ARTISTE). Because he was German, his stock had been confiscated during the war and it was sold in 1921-3. Another blow was that several of his artists, including Picasso, had gone over to Paul *Rosenberg. Nevertheless he set up another gallery, and in the inter-war years the artists in whom he dealt included *Klee and *Masson. He went into hiding during the Second World War, but resumed his activities afterwards. During the war the gallery was sold to his sister-in-law Louise Leiris, whose name the gallery subsequently bore. Kahnweiler was generally disenchanted with later developments in art. When in 1969 the art historian Pierre Cabanne pointed out to him that he had discovered only one artist in the last 25 years, he replied, 'That is because there has been only one.' (The artist in question was presumably Sébastien Hadengue (1932-), a painter whose work reflected the political demonstrations in Paris in May 1968.) In 1961 he published an autobiography, *Mes Galeries et mes peintres*; in the introduction to the English translation, *My Galleries and Painters* (1971), John *Russell wrote: 'Where the old-style dealers did their artists a favour by inviting them to luncheon, Kahnweiler lived with Picasso, Braque, Gris, Derain, and Vlaminck on a day-to-day, hour-to-hour basis. The important thing was not so much that they should sell as that they should be free to get on with their work; and Kahnweiler, by making this possible, helped to bring into being what now seems to us that last great flowering of French art.'

Kandinsky, Wassily (1866-1944) Russian-born painter, printmaker, designer, teacher, and art theorist, who became a German citizen in 1927 and a French citizen in 1939. He was one of the most important figures in the development of the theory and practice of *abstract art. He was born in Moscow, the son of a pros-

perous tea merchant, and grew up in Odessa. From 1886 to 1892 he studied law and economics at Moscow University and immediately after graduation began lecturing in law there. In 1895 he worked briefly as art director for a printing firm in Moscow and in 1896 he turned down the offer of a professorship in law at the University of Tartu (also called Dorpat) in Estonia because he had decided to become a painter. He had been interested in art for some time, and by his own account was greatly stimulated by an exhibition of French paintings that he saw in Moscow in 1895 (or 1891?), particularly one of *Monet's *Haystack* pictures, which he thought communicated something about colour and light rather than about haystacks: 'I had the feeling that here the subject of the picture was in a sense the painting itself', he later recalled, 'and I wondered if one couldn't go much further along the same route.' In 1896 he moved to Munich, one of the major artistic centres of Europe; this was to be the focus of his activities until 1914, but he travelled widely in this period and spent a year in Paris, 1906-7. Initially he studied at the art school run by Anton Azbe (1861-1905), meeting *Jawlensky and *Werefkin there, then at the Munich Academy under Franz von *Stuck in 1900. He was older and better educated than his contemporaries and tended to assume a position of leadership among them. One of his fellow students at the Academy was Paul *Klee, who later became a close friend. Klee said that Kandinsky's 'exceptionally handsome, open face inspired a certain deep confidence' in those around him, and he recalled that the student Kandinsky 'used to mix his colours on the palette with the greatest diligence and a kind of scholarliness'. He was indeed so methodical and fastidious in his working methods (contrary to the standard image of artists) that he joked he could paint in evening dress. His father provided him with a generous allowance, and he lived well with his wife (who was also his cousin) in Schwabing, the bohemian quarter of Munich. In 1901 he was one of the founders of the exhibiting society *Phalanx, which also ran an art school, at which he taught; one of his students was Gabriele *Münter, who—following the breakdown of his marriage—became his lover until the First World War separated them (from 1908 they divided their time mainly between Munich and Murnau, a picturesque market town nearby, where they bought a house that became a meeting-place for avant-garde artists).

Kandinsky's work at the turn of the century was much influenced by *Art Nouveau (Munich was one of its major centres) and had strong reminiscences of Russian folk art (his subjects included fanciful fairy-tale scenes). In the first decade of the century he exhibited in Berlin (at the *Sezession), Dresden (with Die *Brücke), Moscow, Paris (at the *Salon d'Automne), Vienna, Warsaw, and elsewhere. Landscape was his chief subject at this time, and he constantly reworked and simplified his favourite motifs. His colouring became very intense, under the influence of *Fauvism, and his forms became flatter and more attenuated until they began to lose their representational identity. Like the *Symbolists he was interested in analogies between colours and sounds (a great lover of music, he could play the cello and piano and was a friend of Arnold Schoenberg, whose revolutionary atonality he equated with his own experiments). Kandinsky himself described how he came to recognize that colour and line in themselves could be sufficient vehicles for the expression of emotions: he returned to his studio one evening and failed to recognize one of his own paintings that was lying on its side, seeing in it a picture 'of extraordinary beauty glowing with an inner radiance . . . Now I knew for certain that the subject-matter was detrimental for my paintings'. His views about the nature of art were influenced by mysticism and theosophy: he did not completely repudiate representation at this time either in theory or practice, but held that the 'pure' artist seeks to express only 'inner and essential' feelings and ignores the superficial and fortuitous. Kandinsky's attempt to visualize the spiritual had precedents in the colour illustrations accompanying accounts of higher worlds in certain theosophical texts. One of these was *Thought Forms* (1905) by Annie Besant and C. W. Leadbetter, illustrated with cloud-like configurations. A German translation appeared in 1908 and Kandinsky owned a copy. In his famous book *Concerning the Spiritual in Art* (written in the summer of 1910 and published late in 1911), he argued that if the artist could go beyond the outer shell of appearances he could 'touch the beholder's soul'; colour was a prime means of achieving this goal, for he believed that colours have 'a spiritual vibration' that could be linked with 'a corresponding vibration in the human soul'. At the same time he insisted that 'Today the artist cannot manage exclusively with pure abstract forms. These forms are too

imprecise for him'. Indeed in nearly all of Kandinsky's pre-1914 paintings some kind of figurative subject can be identified. For instance mountains, soldiers with lances, and battling horsemen are all visible in *Cossacks* (1910/11, Tate)

When, in 1911, one of his paintings was rejected by the *Neue Künstlervereinigung (he had been the first president of this society) he resigned and founded a rival organization, the *Blaue Reiter. The brief lifetime of this group (broken up by the First World War) marked a period of intense achievement and growing fame for Kandinsky, during which his work was shown at the *Knave of Diamonds exhibition in Moscow (1912), the *Sonderbund exhibition in Cologne (1912), the *Armory Show in New York (1913), the 'Erster Deutscher Herbstsalon' at the *Sturm Gallery in Berlin (1913), and the third exhibition of the *Moderne Kunstkring in Amsterdam (1913). The major work he showed at the 'Herbstsalon' was *Composition VI* (1913, Hermitage, St Petersburg), a huge, gloriously coloured apocalyptic vision. Other important paintings of the time include *Light Picture* and *Black Lines* (both Guggenheim Museum, New York, 1913), which he later singled out as *Non-Objective works—totally abstract in concept rather than abstracted from nature. However, writing in 1913, although he envisaged totally abstract art as a future eventuality, he seemed still puzzled as to how it might be achieved and how the 'danger of ornament' might be avoided. He wrote of being confronted by 'A terrifying abyss of all kinds of questions'. The contemporary evidence as to how these paintings were originally seen is somewhat contradictory. In a special issue of *Der Stürm* published in 1913, one writer, Rudolf Leonhard, insisted that there were images in Kandinsky's paintings, while Wilhelm Hausenstein said that they were without 'physical motifs'. It could well be that the long familiarity spectators today have with these paintings has made them more legible than they were on their first appearance. At this stage, his process, even in the most abstract works, was to seek to obliterate the figurative themes such as the Resurrection and the Deluge rather than dispense with them entirely. Nonetheless he wanted to make them as imperceptible to the spectator as possible, so as not to interfere with the emotional response. Hence the efforts of some art historians to point out

the residual subjects in such paintings have been controversial.

As a Russian citizen, Kandinsky had to leave Munich at the outbreak of war in August 1914 and by the end of the year he was back in Moscow (via Switzerland, Italy, and the Balkans). He had obtained a divorce in 1910 (following a legal separation in 1904) and in 1917 he made a very happy second marriage to a much younger Russian woman. This encouraged him to re-integrate into Russian life, and after the October Revolution in 1917 he became highly active as a teacher and administrator in various cultural organizations instituted by the new Soviet regime (*see* INKHUK, NARKOMPROS; VKHUTEMAS). However, he was out of sympathy with the growing tide of ideas that subordinated fine art to industrial design in the service of the proletariat (even though he made designs for cups and saucers himself), and in 1922 he accepted an offer to take up a teaching post at the *Bauhaus, where he remained until it was closed by the Nazis in 1933. He directed the mural painting workshop and also taught elements of form and colour on the preliminary course followed by all students. His own painting of this period became more geometrical, but in addition to circles and triangles he used arrow-like forms and wavy lines, as in *Swinging* (1925, Tate). The Bauhaus printing workshop produced his portfolio entitled *Kleine Welten* (Small Worlds, 1922–3), containing drypoints, lithographs and woodcuts and marking perhaps the height of his achievement as a graphic artist, and he also branched out into various types of design work (including stage sets and costumes and ceramic tiles). In 1926, to mark his 60th birthday, an exhibition of his work toured Germany, and by this time he was an internationally renowned figure (his reputation was spread in the USA by the Blaue *Vier). In that year the Bauhaus published his theoretical text *Point and Line to Plane*, in which he established a highly methodical basis for the construction of abstract art. Although 'pure painting' was not an aim of the Bauhaus, a systematic approach was. In 1929 he wrote 'I love the circle as I formerly loved the horse, for instance—perhaps even more, since I find more inner potentialities in the circle, which is why it has taken the horse's place.'

In 1934 Kandinsky moved to Paris and spent the remaining decade of his life in the suburb of Neuilly-sur-Seine, a much admired and respected figure. He continued to paint and write up to his death, although he had difficulty obtaining materials during the Second World War and often used board rather than canvas. The paintings of this last period represent something of a synthesis between the organic style of his Munich period and the more geometrical manner of his Bauhaus period, but there was also a new element of fantasy in the use of amoeba-like forms that show the influence of *Arp and *Miró, as in *Sky Blue* (1940, Pompidou Centre). His influence was immense through both his paintings and his writings, which are notably more accessible and attractive documents than those of *Malevich or *Mondrian. However, his claims for primacy in the development of abstraction, sustained by writers such as Will *Grohmann, the author of the first substantial monograph (1958), and Marcel Brion (*Kandinsky*, 1961), have been treated more sceptically by later historians. Examples of his paintings are in many of the world's leading collections, with particularly rich representations in, for example, the Lenbachhaus, Munich, the Guggenheim Museum, New York, and the Pompidou Centre, Paris (many presented by the artist's widow).

Further Reading: H. Fischer and S. Rainbird (eds.), *Kandinsky: The Path to Abstraction* (2006)

K. Lindsay and P. Vergo (eds.), *Kandinsky: Complete Writings on Art* (1994)

F. Whitford, *Kandinsky: Watercolours and other Works on Paper* (1999)

Kane, John (1860–1934) American *naive painter, born in Scotland, the son of a miner. He emigrated to the USA in 1879 and moved around a good deal, working at various labouring jobs. However, he considered Pittsburgh his home: 'I have worked in all parts of it, building the blast furnaces . . . the mills . . . The filtration plant, the bridges that span the river, all these are my own . . . I see it both the way God made it and as man changed it.' In 1891 he lost a leg when he was struck by a train, but he became so agile with his artificial limb that few realized he was disabled. After his marriage in 1897 he worked as a painter of railway coaches, as a tinter of photographs, and as a housepainter. He took to drink after his son died soon after birth in 1904 and his wife consequently left him, taking their two daughters with her. Kane then led a wandering life, scraping a living by housepainting and carpentry. His first oil paintings were done *c*.1910; he did portraits—an intense *Self-Portrait* (1929,

MoMA, New York) is his best-known work—landscapes, interiors, and cityscapes of industrial Pittsburgh, combining meticulous observation with naive stylization and imaginative reconstruction. He achieved sudden fame at the age of 67 when one of his paintings was accepted for the *Carnegie International Exhibition in Pittsburgh in 1927. Kane was the first American naive painter to achieve such recognition; some people thought his picture was a hoax, but in the remaining seven years of his life he achieved considerable acclaim and became something of a celebrity (in consequence of which he was re-united with his wife). His autobiography *Sky Hooks* (named after the supports of a housepainter's scaffold) was posthumously published in 1938.

Kanoldt, Alexander *See* NEUE KÜNSTLER-VEREINIGUNG MÜNCHEN; NEUE SACH-LICHKEIT.

Kanovitz, Howard *See* SUPERREALISM.

Kantor, Morris (1896–1974) American painter, born in Minsk, Russia. He emigrated to New York in 1911 and studied briefly at the Independent School of Art with the aim of being a cartoonist. However, he turned to painting and from 1919 to 1924 he experimented with abstraction, juggling a variety of 'isms'—*Cubism, *Futurism, *Orphism, *Synchromism—in what are generally considered his best works. In 1924 he adopted a naturalistic style and from 1928 concentrated on the human scene in New York, observed through the windows of his apartment on Union Square. Sometimes these works have a note of fantasy or eeriness. The most popular is probably *Baseball at Night* (1934, Smithsonian American Art Museum, Washington).

Kantor, Tadeusz (1915–90). Polish artist and theatre director. He was born at Wielopole near Cracow and trained at the Cracow Academy under the outstanding stage designer Karol Frysz. During the German Occupation in the Second World War he created an underground theatre group. From the end of the war to the late 1960s, he worked as a stage designer. He visited Paris, where he encountered abstraction, in 1947 and 1955. Because of the imposition of *Socialist Realism by the Communist regime he was unable to exhibit his *Tachist-influenced work until 1955. In 1957 he published an essay entitled 'Abstraction is Dead—Long Live Abstraction'.

Here he argued that the rationality represented by geometric abstractionists such as *Mondrian was no longer a sufficient tool for understanding the world. Instead he proposed *Dada and *Surrealism as models for the use of chance, instinct, and imagination as ways of confronting irrational forces. In 1955 he formed a theatre group entitled Cricot 2, which also applied these conceptions of chance. For instance, in one production, *Circus*, the actors were encased in bags which stripped them of their expected forms. In the 1960s he staged the first *Happenings in Poland, but his best-known work for the theatre was *The Dead Class* (1975), which was seen and acclaimed internationally. In this, Kantor played a teacher confronted by rows of dummies. The sense of the absurd is found in his later paintings, which incorporated discarded, damaged objects such as old umbrellas.

((⊕)) SEE WEB LINKS

• M. Kitowska-Lysiak, 'Tadeusz Kantor', on the culture.pl website.

Kapoor, Anish (1954–) British abstract sculptor, born in India, the son of a Hindu father and Jewish-Iraqi mother. In 1973 he settled in London, where he studied at Hornsey School of Art and Chelsea School of Art. Although his sculpture is not obviously indebted to his Asian background, he feels an affinity with the spirituality of Indian art: 'I don't want to make sculpture about form . . . I wish to make sculpture about belief, or about passion, about experience that is outside of material concern.' His early work was predominantly in fairly lightweight materials, including wood and mixed media, and was often brightly coloured with powdered pigment, but in the late 1980s he changed direction. Having acquired a large ground-floor studio where he could handle heavy materials, he turned to working in stone. Typically his sculptures from this time have consisted of large, rough-hewn blocks. However, he has also made smooth, organic pieces in cast metal (*Turning the World Inside Out*, 1995, Rijksmuseum Kröller-Müller, Otterlo). The most spectacular is the 66 by 33 foot *Cloud Gate* (2004, Millennium Park, Chicago) in stainless steel, inspired by the form of a drop of mercury. Kapoor was Britain's representative at the Venice *Biennale in 1990 and in 1991 he was awarded the *Turner Prize. In

2002 he created *Marsyas* for the Turbine Hall at *Tate Modern. The title referred to the 'rather fleshy quality' of the PVC skin: in Greek mythology Marsyas was flayed alive.

Kaprow, Allan (1927–2006) American artist and art theorist, best known as the main creator of *Happenings. He was born in Atlantic City, New Jersey, and graduated from New York University in 1949. He then studied painting at Hans *Hofmann's school, 1947–8, history of art under Meyer *Schapiro at Columbia University, 1950–52 (his MA thesis was on *Mondrian), and with the musician John *Cage at the New School for Social Research, New York, 1956–8. From Cage (who is sometimes credited with creating the first Happening at *Black Mountain College in 1952) Kaprow took over the idea of chance and indeterminacy in aesthetic organization. In the mid-1950s he gave up painting for *assemblages and then *environments, and in October 1958 published an article in *Art News entitled 'The Legacy of *Pollock'. For Kaprow, Pollock was an artist who had an 'amazingly childlike capability of becoming involved in the stuff of his art as a group of *concrete facts seen for the first time' and who 'left us at the point where we must become preoccupied with and even dazzled by the space and objects of our everyday life'. The conclusion was that 'art' could no longer be defined by specific media and that for the young artist, 'All of life will be open to him'. Happenings entered the public arena at the Reuben Gallery, New York, in 1959, although Kaprow evidently staged a comparable event the previous year in George *Segal's chicken farm. The essential feature of the Happening as theorized by Kaprow is the breakdown of the barrier between performance and spectator. Indeed in a true Happening there is no audience, only participants. Kaprow's Happenings took place in discontinuous places and times to avoid the closed structures of theatre and traditional art forms which 'contain highly sophisticated habits' (*Untitled Guidelines for Happenings*, *c.*1965). For instance, *Calling* (1965) was in two sections, a 'city section' on Saturday followed by a 'country section' on Sunday, according to an already socially inscribed pattern of 'shopping' and 'rural leisure'. In the city section 'Wrapped figures left in public places call each other'; the country section took place in the woods where 'people are found hanging, undressed and left to call

each other' (Henri). Kaprow was an evangelic promoter of his ideas through his teaching at various universities and his voluminous output of writings, as well as through his own performances. His books include *Assemblage, Environments & Happenings* (1966). Claes *Oldenburg and Lucas *Samaras are among the artists who cite him as an important influence on their work.

Further Reading: A. Henri, *Environments and Happenings* (1974)

A. Kaprow, *Essays on the Blurring of Art and Life* (1996)

Karlowska, Stanislawa de See BEVAN, ROBERT.

Kasatkin, Nikolai See AKHRR.

Kasmin, John (1934–) British art dealer who from 1963 to 1972 ran a gallery in New Bond Street, London. He primarily exhibited abstract art, especially the *Post-Painterly Abstraction supported by Clement *Greenberg. His first exhibition was work by Kenneth *Noland, but he also showed some of the most important British artists of the period, including Richard *Smith, Anthony *Caro, Bernard *Cohen, and David *Hockney, the only figurative painter associated with the gallery. Kasmin appears flattened behind a glass plate in Hockney's 1963 painting *Play Within a Play*. The historical significance of the gallery was partly in its design, described by Kasmin as 'a machine for looking at pictures in'. A single spacious room with white walls and—a defiantly anti-domestic touch—a curious ridged rubber floor, it was a highly appropriate setting for large-scale abstract art, the ultimate destiny of which was anticipated to be the museum. After the closure of the New Bond Street gallery, Kasmin continued to work as a dealer in partnership with others.

Kassák, Lajos See ACTIVISTS.

Kassel documenta See DOCUMENTA.

Katz, Alex (1927–) American painter, born in Brooklyn, New York. He was initially influenced by *Abstract Expressionism but wanted to reintroduce the figure into painting. In the late 1950s, he turned against the emphasized mark or gesture and developed a kind of figurative painting with large flat areas of colour which has sometimes been related to *Pop art. However he rejected Pop's use of commercial imagery and he is much closer to Philip *Pearlstein. Both artists were aiming at a

reintroduction of realism and the figure in a way that would compete with the scale and formal strength of contemporary American abstract art. Katz's paintings characteristically depict heads in close-up, sometimes cropped unexpectedly. He also makes paintings of figures in groups which are remarkable for their sense of human interaction and power play.

Kauffer, E. McKnight (1890–1954) American designer and painter, active mainly in England. After studying in San Francisco, Chicago, and Paris, he settled in London in 1914. He was a member of *Group X, but he virtually abandoned easel painting in 1921 and is best known for brilliant and witty poster designs, notably for the London Transport Board and the Great Western Railway; he created posters for London Underground from 1915 to 1940, under the patronage of its commercial manager Frank Pick (1878–1941), who was the mastermind behind the modern image that the company created in the interwar years through employing some of the best artistic talent of the day. Writing in *The Evening Standard* in 1928, Arnold Bennett said that Kauffer had 'changed the face of London streets' and that his success 'proves that popular taste is on the up-grade'. Kauffer was also a successful textile designer and book illustrator, and in 1935 Paul *Nash wrote that he considered him 'responsible, above anyone else, for the change in attitude towards commercial design in this country...his influence as an applied draughtsman has been immensely important'. In 1940 Kauffer returned to the USA and settled in New York. His work in America included posters (for government agencies during the Second World War and afterwards for American Airlines) and also book jackets and illustrations.

Kawara, On (1932/3–) Japanese artist, born at Kariya. The ambiguity in the birthdate is the result of a discrepancy between the date given in most sources and a calculation made from the 'life-date', which can be deduced from paintings in which he gives his age at the time of making them in days. He was self-taught as an artist. In the early 1950s he came to prominence with violently satirical paintings and drawings of disjointed human figures and corpses in which he portrayed the predicament of Japan after the Second World War. Later he devised a method by which he duplicated an original painting in a number of variations that he called 'Original Printed Paintings'. In 1959 he left Japan and after extensive travels settled in New York in 1965. From this time he devoted himself to *Conceptual art, notably with a series of *I am Still Alive* postcards and telegrams sent to friends and other correspondents. He has made a series of over 2,000 paintings showing only the date of execution and made within a set of strict rules. If the painting is not completed by midnight it is destroyed. The date form and language is always that of the country in which the work is executed. If the language does not employ the Roman alphabet, he uses Esperanto. All the paintings are square and identically sized. The paintings are packaged with newspaper cuttings from the same day. Like Stanley *Brouwn, another artist whose work makes elliptical reference to his own life, he abjures any interviews or interpretations of his art.

Further Reading: A. Searle, 'It's a Date', *The Guardian* (3 December 2002)

⊕ SEE WEB LINKS
• 'On Kawara': essay by Lynne Cooke on the Dia art foundation website.

Keane, John *See* OFFICIAL WAR ART.

Keating, Sean (1889–1977) Irish painter, born in Limerick. He studied at Limerick Technical College and in 1911 won a scholarship to the Metropolitan School of Art in Dublin, where he was taught by *Orpen, whom he idolized. Later he taught at the School himself and he was president of the Royal Hibernian Academy from 1948 to 1962. Keating is best known for his vigorous, picturesque portrayals of Irish peasants, above all for *Men of the West* (1915, Dublin City Gallery, The Hugh Lane). 'It is Keating who sums up the "discovery" of the West of Ireland as a source for patriotic, heroic, almost propagandist subject-matter which seems to have been adopted by the independence movement to straightjacket Irish art into nationalist terms' (Anne Crookshank and the Knight of Glin, *The Painters of Ireland*, 1978).

Kelley, Mike (1954–) American multimedia artist, born in Detroit. He played for some years in a rock band with Paul *McCarthy, with whom he worked in collaboration on the installation work *Heidi* (1991). Both artists explore the idea of 'abjection' (*see* KRISTEVA).

Kelley has made drawings of steaming excrement and snot. *Manipulating Mass-Produced Idealised Objects* (1990) is a two part *photowork in which a man and a woman sexually stimulate themselves with soft toys. He was among the generation of artists among whom there was a reaction against the hand-made, which was associated with 'clichéd ideas of self-expression'. However, many of his own objects are hand-made. He uses discarded toys and he has said that 'the hand-made now is pitiful and doesn't necessarily have anything to do with emotion or personal psychology' (interview with Ralph Rugoff, 1991, reprinted in Harrison and Wood).

Kelly, Ellsworth (1923–) American painter, sculptor, and printmaker, born in Newburgh, New York. He studied at the Pratt Institute, Brooklyn, 1941–2, and then after service in the US Army at the Boston Museum School, 1946–48. From 1948 to 1954 he lived in Paris, then settled in New York. In 1949 he switched from figurative to abstract art. By his own account this came about as a result of noticing that he found the large glass windows in the Paris Musée National d'Art Moderne (formerly housed in the Palais de Tokyo, *see* POMPIDOU CENTRE) more interesting than the paintings. In the mid-1950s he became recognized as one of the leading exponents of the *Hard-Edge style that was one of the successors to *Abstract Expressionism. His paintings are characteristically very clear and simple in construction, sometimes consisting of a number of individual panels placed together, identical in size but each painted a different uniform colour (he started using this formula in 1952). He was also one of the first artists to develop the idea of the *shaped canvas. His work has been widely exhibited and he has had numerous public commissions, including a mural for UNESCO in Paris (1969). Kelly has also made prints in various techniques and has worked as a sculptor (using painted cut-out metal forms related to those in his paintings).

Kelly, Felix (1914–94) British painter, designer, and illustrator, born in Auckland, New Zealand, the son of a wealthy businessman. He settled in London in 1938 and served in the RAF during the Second World War. Initially he worked as a graphic designer and then branched out into painting. He had no formal artistic training. Kelly's most characteristic pictures are views of country houses that often have an enigmatic, slightly *Surrealistic air. His obituary in *The Times* comments that 'His good looks, charm and easy manner made him a welcome dinner table guest as well as a recorder of the architectural nuances of the houses to which he was invited'. In 1982 he painted murals at Castle Howard, Yorkshire, funded by the success of the television series *Brideshead Revisited*, largely filmed there. Apart from paintings his work included stage design and book illustrations, notably for Herbert *Read's only novel *The Green Child* (1945; the book was originally published in 1935). Read returned the compliment by writing the introduction to *Paintings by Felix Kelly* (1946).

Kelly, Sir Gerald (1879–1972) British painter, mainly of portraits, born in London of Irish descent. He was educated at Eton and Cambridge (where he read English), and in 1901 went to Paris, where he studied painting without formal tuition. His first important patron was Sir Hugh *Lane, and by 1914 he was well established as a society portraitist in London, a position he richly consolidated for the rest of his long career. He was very well connected, his diverse circle of friends including Clive *Bell, the occultist Aleister Crowley (who was married to Kelly's sister for a few years), and the writer Somerset Maugham. He painted Maugham several times, notably in a picture called *The Jester* (1911, Tate); Maugham, in turn, based several of the characters in his novels on Kelly. In 1945 he completed state portraits of King George VI and Queen Elizabeth (Windsor Castle) and his career culminated when he was president of the *Royal Academy, 1949–54. Although he was 70 when elected, he still had great drive, and he was a resounding success as president, revitalizing the Academy's image after the damage done by his predecessor, the arch-conservative *Munnings. Kelly became something of a television personality in programmes relating to the Academy's exhibitions and his popularity helped to boost attendances. Apart from portraits, he painted landscapes and also pictures of Asian dancing girls (he visited Burma in 1909) that were once much reproduced in the form of *popular prints. His favourite model, however, was his wife, Lilian, known as Jane. He was modest about his abilities, considering himself a craftsman rather than an artist (he was extremely fastidious about his materials). However, Kenneth *Clark

wrote of him: 'He had a great gift for summing up the character of his sitters and painted with scrupulous honesty…he was the most reliable portrait painter of his time.'

Kelly, Mary (1941–) American artist who has been highly influential in the theory and practice of *feminist art. Born in Fort Dodge, she first studied painting in Florence, learning traditional techniques from followers of Giorgio *Morandi. However, being more interested in contemporary practice, she moved to London in 1968 to study at *St Martin's School of Art. While a student she became interested in film and radical feminist politics (for instance, she was involved in the protests aginst the 1971 Miss World contest at the Royal Albert Hall). In this context she worked on the collective film project *Nightcleaners*, about the struggle to unionize women workers. In 1976 she exhibited *Post-Partum Document* at the *Institute of Contemporary Arts. This work drew on a combination of *psychoanalytic theory and Kelly's experience as mother. Diary notes were combined with memorabilia, including hand prints and nappies, together with diagrams derived from the work of Jacques Lacan (*see* PSYCHOANALYSIS). The purpose was to explore the role of the acquisition of language in the formation of gender identity. She continued this project until 1979. *Interim*, on which she worked throughout the 1980s, explored issues of female fetishism and the ageing process. The first part, *Corpus*, combined images of articles of clothing with handwritten texts. A special role is played by a leather jacket, the zip forming a kind of serpentine 'line of beauty'. Kelly moved to New York in the early 1980s and to Los Angeles in 1996. Much of her later work has examined the trauma produced by political atrocities, as in *Mea Culpa* (1999), an archive of stories from Sarajevo, South Africa, and elsewhere. Although the theoretical underpinning is less obvious than in earlier works, the artist has spoken of Lacan's notion of trauma—'a missed confrontation with the Real'—as significant. Kelly has also been active as writer, theorist, and teacher. *Love Songs* (2007), shown at *documenta 12, was partly the result of her work as professor at UCLA and the fascination of her students with the revolutionary events of 1968. It consists of a kind of glass house with texts from the feminist politics of that time.

Further Reading: J. Carson, 'Mea Culpa: a Conversation with Mary Kelly', *Art Journal*, vol. 58, no. 4 (1999)
I. White, 'The Body Politic', *Frieze* no. 107 (May 2007)

Kelly, Oisín (1915–81) Irish sculptor and designer. He was born in Dublin, where he studied modern languages at Trinity College, 1933–7. In 1937 a scholarship took him to Frankfurt, where he became interested in German *Expressionism, particularly the sculpture of *Barlach. After returning to Ireland he studied at evening classes at the National College of Art, Dublin, and Waterford School of Art, and also worked briefly with Henry *Moore in England. From 1946 to 1964 he taught at St Columba's, Rathfarnham, near Dublin. Kelly was probably the best-known and most prolific Irish sculptor of his time. He worked in a variety of materials, including bronze, copper, and wood, and he produced a wide range of work, including portrait busts, statues, and figures of animals and birds. Above all, he was a leading exponent of church art; good examples of his work in this field are the façade carving of *The Last Supper* (completed 1966) and the font at St Theresa's Church, Sion Mills, County Tyrone. His style, combining traditional Irish elements with mild Expressionist distortion, was influential on several younger Irish artists, notably the painter and stained-glass designer Patrick Pye (1929–), who studied under Kelly at Rathfarnham, and the sculptor John Behan (1938–).

Kemeny, Zoltan (1907–65) Hungarian-born sculptor and designer who became a Swiss citizen in 1957. He was born in Banica (now Bănița, Romania). He studied in Budapest, 1924–30 (at the School of Decorative Arts until 1927, then at the School of Fine Arts), lived in Paris 1930–40, and then in Marseilles until 1942, when he settled in Zurich. Early in his career he worked mainly as a fashion designer, but in 1946 he began making reliefs on the borderline between painting and sculpture, incorporating many different materials and creating swirling surface rhythms. In 1951 he began making translucent reliefs intended to be set up in front of electric lights, and from the mid-1950s he produced the 'Relief Images' for which he became chiefly known. These were metal reliefs into which he incorporated curious agglomerations of industrial metal products and mass-produced articles. He devoted himself entirely to sculpture from 1960 (giving up his fashion jobs) and in his last years

k

received several large commissions. In 1964 he won the main sculpture prize at the Venice *Biennale.

Kemp-Welch, Lucy *See* OFFICIAL WAR ART.

Kennard, Peter *See* PHOTOMONTAGE.

Kennington, Eric (1888–1960) British painter, sculptor, and draughtsman, born in Liverpool, son of the London-based painter **Thomas Benjamin Kennington** (1856–1916), known for his pictures of poverty and hardship. He studied at various art schools in London and exhibited at the *Royal Academy from 1908, first attracting attention with scenes of Cockney life, notably *Costermongers* (1914, Musée d'Art et d'Industrie, Roubaix), which was bought by William *Nicholson and presented to the Musée de Luxembourg, Paris. In 1914–15 Kennington served in France with the 13th London Regiment, the Kensingtons, and after being invalided out he painted *The Kensingtons at Laventie* (1915, Imperial War Museum, London), which was a great success when shown at his first one-man exhibition, at the Goupil Gallery, London, in 1916: one reviewer described it as 'decidedly the finest picture inspired by this war as yet by an English artist'. It shows a group of exhausted men from his regiment, and in his paintings and drawings as an *Official War Artist (1916–19) Kennington similarly concentrated on depicting the everyday life of the ordinary soldier. It is for this work that he remains best known. Between the wars he was mainly a portraitist, but he also did book illustrations, including those for T. E. Lawrence's *Seven Pillars of Wisdom* (1926), and he turned seriously to sculpture, in which he was an advocate of *direct carving. As a sculptor, his practice concentrated on public, monumental work. Examples include the Monument to the 24th Division in Battersea Park, London (1926) (the writer Robert Graves was the model for one of the three soldiers); the Memorial to the Missing in Soissons (1928); figures (in carved brick) for the Shakespeare Memorial Theatre in Stratford-upon-Avon (1930); and the recumbent effigy of T. E. Lawrence on his tomb in St Martin's Church, Wareham, Dorset (1940). His most powerful carving is the *War God* (1935, on long-term loan to Leeds City Museums and Galleries). First exhibited in an exhibition organized by the *Artists International Association entitled 'Artists Against Fascism and War' (1935), it is a grotesque squat figure, caricaturing Musso-

lini. During the Second World War Kennington was again an Official War Artist; three collections of his work (mainly pastel portraits) were issued in book form: *Drawing the RAF* (1942), *Tanks and Tank-Folk* (1943), and *Britain's Home Guard* (1945).

Further Reading: J. Black, *The Sculpture of Eric Kennington* (2002)

S. Malvern, *Things to Come: Eric Kennington's War God* (2001)

Kent, Rockwell (1882–1971) American painter, graphic artist, and writer, born at Tarrytown Heights, New York. He began to train as an architect at Columbia University but dropped out of the course to study painting, his teachers including *Chase and *Henri. His preference was for scenes of the great outdoors, painted in a vivid, dramatic style with strong contrasts of light and shade. They reflected his own lifestyle, for he loved exploring remote areas (including Alaska, Greenland, and Tierra del Fuego) and early in his career he supported himself by working at such jobs as lobsterman and ship's carpenter. His pictures appealed to the American pioneer spirit and by the 1920s he was one of the country's most popular artists. However, he had outspoken left-wing political sympathies and at the time of the anti-Communist witch-hunts in the 1940s and 1950s he was dogged by various investigating committees. He was chairman of the National Council for American-Soviet Friendship and in 1967 was presented with the International Lenin Peace Prize by the Soviet government; he gave the award money to the people of North Vietnam. Kent illustrated numerous books, including his own accounts of his travels, such as *Wilderness* (1920). His other writings include an autobiography, *It's Me, O Lord* (1955).

Kentridge, William (1955–) South African draughtsman, animator, and theatre director, born in Johannesburg. He came from a Jewish family of political activists opposed to the apartheid system. He studied politics but while a student developed a passion for art and theatre. The drawings and prints made in the 1980s reflected his response to the political system but through inference rather than direct statement. *State of Grace, State of Hope*, and *State of Siege* (1988, South African National Gallery, Cape Town; Johannesburg Art Gallery) are three massive screenprints which depict different responses to the

situation. A woman with a fish on her head represents naive denial. Another figure with a fan for a head refers back to the revolutionary aspirations of early 20th-century art (*Tatlin, *Boccioni). The final image in the series is a corrupt business man. Kentridge acknowledges the influence of political artists such as *Grosz in the construction of such images. It was only after the end of apartheid that he began to be noticed on the international scene, with his appearance at *documenta X in 1997 being especially significant. He has been acclaimed for a series of six animated films based around the same characters. Soho Eckstein is a business man who has profited enormously from the system. Felix Teitelbaum is a poet who is also having an affair with Soho's wife. Kentridge has stated that over the course of making the films he has grown to see them as two sides of the same character. As well as its specific relationship to the South African situation, the artist has stated that the work can also be read 'as about space between the political world and the personal, and the extent to which politics does or does not find its way into the private realm'. The internal conflicts of the characters are as significant as the external struggle. The films are remarkable technically as well as politically. Kentridge works from charcoal drawings which are constantly rubbed and redrawn so that when animated they evolve before the eyes of the viewer. His work in the theatre includes a production of *The Magic Flute* in 2007 that dramatized the hopes of the Enlightenment but also the dark side which led to colonial exploitation.

Further Reading: C. Alemani, *William Kentridge* (2006) M. Stevens, 'Moral Majority', *New York Magazine* (12 February 2006)

Kernstok, Károly See EIGHT, THE (3).

Kertész, André (Andor) (1894–1985) Hungarian-born photographer who worked in France and America. He began making photographs in 1912, initially producing images of Hungarian rural life. He settled in Paris in 1925 and established friendships with many leading artists of the period, including *Chagall, *Léger, and *Mondrian. One of his most memorable photographs of the period is the frequently reproduced picture of Mondrian's home, reflecting the painter's austere outlook, with the table adorned by a single white flower. During his years in Paris, Kertész worked successfully for picture magazines, recording images of everyday life. In 1928 he became one of the first professional photographers to adopt the lightweight Leica camera, which had been introduced three years previously. Jonathan Szarkowski has commented that 'Perhaps more than any other photographer, André Kertész has discovered and demonstrated the special aesthetic of the small camera.' By this he meant that it suited Kertész's preoccupation, not with analytical description, but with the 'elliptical view'. An example of this might be in his depiction of street demonstrations in 1934. The foray into an overtly political subject was rare for him and he photographed, not from a distance to emphasize the mass movement, but close-up from below to give a subjective sense of the enveloping crowd. From his Paris period come some of his most experimental work, reflecting his links to the artistic vanguard. The most extreme instances are the *Distortions* (1933), in which nudes are seen reflected in fairground 'crazy mirrors'. In 1936, Kertész moved to New York, where he continued his career working for magazines such as *Vogue* and *Life*, becoming an American citizen in 1944. Because of the war he was unable to return to Europe and he felt somewhat marginalized in America, where the emphasis was more on technical perfection than the human interest at which he aimed. His work was regarded as 'sentimental', an epithet he did not abjure. His international reputation rose considerably after he gave up working for *House and Garden* in 1962 and, after years of neglect (he was not included in *Steichen's 1955 'Family of Man' exhibition), he was honoured by retrospectives at MoMA, New York (1964), and the Metropolitan Museum of Art (1985). He also published many anthologies of photographs including *On Reading* (1971), *Washington Square* (1975), and *From My Window* (1981).

Further Reading: Greenhough, S., Gurbo, R., and Kennel, S., *André Kertész* (2005)

Kessler, Count Harry See MAILLOL, ARISTIDE.

Kettle's Yard, Cambridge See EDE, H. S.

Keynes, John Maynard See ARTS COUNCIL.

Kiefer, Anselm (1945–) German painter and sculptor, born in Donaueschingen. He

originally studied law and his intermittent training as a painter included periods of study with Horst *Antes (1968) and Joseph *Beuys (1970–72). Early in his career, in 1969, he made provocative photographs, entitled *Occupations*, of himself giving a Nazi salute in various settings all over Europe. The solitude of the figure, which makes the gesture absurd, also recalls the lonely wanderings of German Romantic painters such as Caspar David Friedrich. From the early 1970s Kiefer turned to painting, with work sometimes classed as *Neo-Expressionist, but it would be more accurate to see him, like *Immendorff, as preoccupied with politics rather than self-expression. According to the curator Rudi Fuchs, Kiefer wanted to 'reinstate painting as an art of High Seriousness (which does not exclude irony) and to bring it back into the realm of Grand Rhetoric'. Fuchs, who featured Kiefer's works strongly in the *documenta 7 exhibition (1982), also stated hyperbolically, 'The painter is the guardian-angel carrying the palette in blessing all over the world.' For the cultural theorist Andreas Huyssen, however, the palette, a frequent image in Kiefer's paintings, does not soar but crashes to earth over a war-ravaged landscape. Kiefer certainly deals with big themes of history and mythology and ones which are, in the context of postwar Germany, painful and controversial. His work alludes to Wagner, the Siegfried myth, and the whole Germanic intellectual and cultural tradition that was appropriated by the Nazis. Some paintings have included explicit depictions of Third Reich architecture, for instance *Shulamite* (1983), based on a Nazi memorial hall intended to commemorate the heroes of the regime, but painted by Kiefer as darkened by smoke in memory of the Holocaust. When his paintings were shown at the Venice *Biennale in 1980, alongside *Baselitz's *Model for a Sculpture*, both artists were attacked by German critics for their obsession with nationalistic themes. Conversely, commentators in America and Britain have tended to praise Kiefer for addressing dark aspects of German history, even suggesting that he was engaged in a kind of exorcism.

From the later 1980s, when Kiefer became internationally celebrated, he tended to look outside Germany for his themes. One of the most discussed of his later works has been *The High Priestess* (1985–9). This massive sculpture consists of about two hundred books in lead, displayed in a bookcase. Each is too heavy for a

single person to lift. About half of them have material added by the artist, including photographs and collaged elements such as hair. The alternative title is *Zweistromland* (Land of Two Rivers), a reference to the birth of civilization in Mesopotamia. The whole work alludes to half-hidden mysteries. The pages of the books cannot be seen directly by most viewers; partial knowledge is imparted through publication as authorized by the artist.

Further Reading: A. Huyssen, 'Anselm Kiefer: The Terror of History, the Temptation of Myth', *October*, no. 48 (spring 1989)

A. Zweite, *The High Priestess* (1989)

Kienholz, Edward (1927–94) American sculptor, specializing in life-size three-dimensional tableaux. He was born in Fairfield, Washington, to a farming family and was trained in carpentry and plumbing; as an artist he was self-taught. In 1953 he moved to Los Angeles, where he ran one of the city's first avant-garde galleries, the Now Gallery. This was short-lived (1956–7), but after its closure he opened the Ferus Gallery, which he ran with the critic Walter Hopps. Meanwhile, in his own work he had begun to make painted wooden abstract reliefs in 1954. They grew increasingly three-dimensional and figurative until by 1961 he was producing complete *environments involving life-size figures and various found objects, including furniture. Typically he used the shoddy detritus of contemporary life to create situations of a bizarre and shockingly lurid character in which death and decay are common themes (his work is sometimes categorized as *Funk art), and which often involve elements of satire or political protest. A much-reproduced example is *The State Hospital* (1964–6, Moderna Museet, Stockholm) showing a mentally ill patient strapped to his bed with his own self-image (in a thought bubble) strapped to the bed above. Both figures are modelled with revolting realism but have glass bowls for heads. Even more gruesome is *The Illegal Operation* (1962, Los Angeles County Museum of Art). Even though the body itself is suggested only by a cut-open sack, it is surrounded by real surgical instruments. Other works refer to sexual encounters, such as the notorious *Back Seat Dodge 38* (1964, Los Angeles County Museum of Art), in which the sense of claustrophobia is reinforced by the compression of the car body. All of these works have a strong element of voyeurism. As the art historian Cécile Whiting

points out, the experience includes 'peering on scenes you would otherwise not have access to.' A more specific political statement is found in the *Portable War Memorial* (1968, Museum Ludwig, Cologne). Made at the time when protests against the Vietnam War were at their height, it juxtaposes life-size figures of soldiers from a celebrated Second World War photograph of Marines raising the Stars and Stripes at Iwo Jima, a blackboard on which is inscribed the names of states which no longer exist, and a table at which the visitor can drink a Coca-Cola (business as usual). There is a non-stop soundtrack of the Irving Berlin song 'God Bless America'. From 1972 Kienholz worked in collaboration with his wife, **Nancy Reddin Kienholz** (1943–), and from 1973 they divided their time between Berlin and Hope, Indiana. Some of his later work commented on Nazism. In 1977, for example, he staged exhibitions consisting of imitation radio-receiving apparatus in decrepit state, which when activated played raucous music by Wagner. His funeral became one final artwork. His embalmed body was placed in the back of a vintage 1940 car with a dollar and a deck of cards in his pocket, a bottle of Chianti and the ashes of his dog. 'To the whine of bagpipes, the Packard, steered by his widow, Nancy Reddin Kienholz, rolled like a funeral barge into the big hole' (Robert Hughes).

Further Reading: R. Hughes, 'All-American Barbaric Yawp', *Time* (6 May 1996)

Kiki of Montparnasse (Marie Prin)

(1901–53) The most famous artists' model of the 20th century, a celebrated figure in Paris in the period between the two world wars. She came from a farming family in Burgundy and settled in Paris at the end of the First World War; her intention was to get a job in a shoe factory, but she was almost immediately discovered by *Kisling. Among the other artists for whom she posed were *Foujita, Per *Krogh, and most notably *Man Ray, with whom she lived for several years before their separation in 1929. His most famous picture of her is the photograph entitled *Le Violin d'Ingres* (1924), in which he has painted a violin's f-holes on her naked back. She also appeared in his experimental film *L'Étoile de mer* (1928) and in his notorious series of clandestine photographs published privately in 1929 in which her unmistakable lips are seen fellating the photographer. From 1926 she exhibited her own paintings (she

had a one-woman show in 1930) and she made a name for herself as a night-club singer. In 1929 she published her memoirs. However, her career declined as she lost her looks and she ended her days in drunken poverty.

Kikkert, Conrad *See* MODERNE KUNST-KRING.

Kikoïne, Michel *See* SOUTINE, CHAÏM.

Kilbourn, Oliver *See* ASHINGTON GROUP.

Kinetic art Term describing art incorporating real or apparent movement (from the Greek *kinesis*, 'movement'). In its broadest sense the term can encompass a great deal of phenomena, including cinematic motion pictures, *Happenings, and the animated clockwork figures found on clocktowers in many cities of Europe. More usually, however, it is applied to sculptures such as *Calder's *mobiles that are moved either by air currents or by some artificial means—usually electronic or magnetic. In addition to works employing actual movement, there is another type of Kinetic art that produces illusory movement when the spectator moves relative to it (and *Op art paintings are sometimes included within the field of Kinetic art because they appear to flicker).

The idea of moving sculpture had been proposed by the *Futurists as early as 1909, and the term 'kinetic' was first used in connection with the visual arts by *Gabo and *Pevsner in their *Realistic Manifesto* in 1920. Gabo completed an electrically driven oscillating wire construction in this year (*Kinetic Sculpture (Standing Wave)*, 1919–20, Tate) and at the same time Marcel *Duchamp was experimenting with *Rotative Plaques* that incorporated movement. Various other works over the next three decades made experiments in the same vein, for example *Moholy-Nagy's *Light-Space-Modulator* (1922–30, Busch-Reisinger Museum, Harvard University), one of a series of constructions he made using reflecting metals, transparent plastics, and sometimes mechanical devices to produce real movement. However, for many years Calder was the only leading figure who was associated specifically with moving sculpture (and many people regarded him as eccentric), and it was not until the 1950s that the phrase 'Kinetic art' became a recognized part of critical vocabulary; the

k

exhibition 'Le Mouvement' at the Denise *René Gallery, Paris, in 1955 was a key event in establishing it as a distinct genre. The artists represented in the exhibition included *Agam, *Bury, Calder, Duchamp, *Soto, *Tinguely, and *Vasarely. Kinetic art continued to flourish in the 1960s and early 1970s, when it was often combined with other means of expression such as *Light art. It varied in practice, with some artists such as Nicholas *Schöffer or Frank *Malina employing a 'high tech' approach, and others, such as David *Medalla, using natural materials. Some, like Mira *Schendel or Hélio *Oiticica, depended on the spectator to manipulate the work. During the 1960s, Kinetic art had a politically radical tinge. The London gallery 'Signals', which opened in 1964 and specialized in Kinetic art, published a journal which, alongside articles on art and science, included condemnations of American policy in Vietnam. This was short-lived. The film *Sunday, Bloody Sunday* (director John Schlesinger), released in 1971, featured a character who was a Kinetic artist. The film's point was that this was an indication of his general lack of commitment: his works were no more than executive toys. The aspirations of Kinetic art were realized in ways rather different from that of most of its original exponents: they frequently looked to a kind of transformation of the function of art within the *Constructivist tradition by fusing their practice with architecture. Instead, in the work of such figures as Hans *Haacke, who was concerned in his early work with natural systems, it tended to lead towards *Conceptualist ideas of the 'dematerialization of the art object'.

Further Reading: G. Brett, *Kinetic Art* (1968)
South Bank Centre, *Force Fields: Phases of the Kinetic* (2000)

King, Phillip (1934–) British sculptor, born in Tunisia. After reading modern languages at Cambridge University, 1954–7, he studied at *St Martin's School of Art, 1957–8, and began teaching there in 1959; in 1958–60 he was assistant to Henry *Moore. King is probably the most renowned of the generation of British abstract sculptors (mainly, like himself, pupils of *Caro) who came to prominence at the *'New Generation' exhibition in 1965. His work at this time was characteristically in smooth man-made materials such as plastic or fibreglass, often brightly coloured, with the cone shape being a favourite motif (*And the Birds Began to Sing*, 1964, Tate). At the end of the decade he began using more rugged materials, including steel, slate, and wood. In 1973 he wrote: 'I have tried to see raw materials, when beginning a new sculpture, as something free of associations, having a high physical resistance, but a low mental one, being essentially pliable, stackable, cuttable, etc.' He said that for him any associations were taken on through the act of shaping that material. With Bridget *Riley he represented Britain at the 1968 Venice *Biennale, and his work has been included in many other international exhibitions. A major retrospective show of his work was held at the Hayward Gallery, London, in 1981. King was professor of sculpture at the *Royal College of Art from 1980 to 1990. From 1999 to 2004 he was President of the *Royal Academy.

Further Reading: Arts Council of Great Britain, *Phillip King* (1981)

King, William Dickey *See* MARISOL.

Kippenberger, Martin (1953–97) German painter, sculptor, and installation artist, one of the most notorious and controversial artistic figures of his generation and one of the hardest to sum up. Born in Dortmund, after a troubled youth which included therapy for drug abuse while still in his teens, he studied at Hamburg Art Academy, which he left for Florence in 1976 with the intention of becoming an actor. While there, he made a series of black and white paintings in the same 60 x 50 cm format, all derived from photographs. Kippenberger stated that Gerhard *Richter was a role model, but his paintings had nothing of the older artist's meticulous finish. In 1978 he moved to Berlin, where he founded the 'Kippenberger Office', which organized exhibitions and also managed a punk club, S.O. 36. Kippenberger combined this support for the more anarchic side of youth culture with a well-dressed respectable image. In 1981 he was hospitalized as a result of a violent beating from some of his customers, an event he commemorated in a painting entitled *Dialogue with the Young*. Kippenberger had a scepticism towards the political earnestness of *Conceptual art and also towards the expressive claims for painting being made by the new wave of *Neo-Expressionists. In 1981 he had a series of twelve large paintings made to his instructions from photographs by a sign painter. These were exhibited under the

general title *Dear Painter, Paint for me*
The most striking shows the artist from be-
hind walking through the street with a friend,
a casual snapshot blown up to the propor-
tions of history painting. Elsewhere Kippen-
berger took a provocative approach to
political imagery. The *Sympathetic Commu-
nist Girl* or *A Lady Farmer of the Cultural
Revolution Repairing her Tractor* (both 1983)
are neither satirical nor celebratory, yet the
political implications of the subject-matter
were still too charged to be taken purely as
an exercise in painting. Certainly he took
some delight in challenging earnest attitudes
to current affairs. In 1985, a year when famine
in Africa inspired worldwide concern and re-
sponse, he exhibited a group of sculptures
with holes for stomachs entitled *Hunger Fam-
ily*. When an art magazine published an essay
attacking him entitled 'The Artist as Exemp-
lary Alcoholic', Kippenberger produced a
sculpture entitled *Martin, Go in the Corner
and Shame on You*. Happy to offend conser-
vatives and the left alike, he also made a
sculpture of a crucified frog with egg and
beer mug entitled *Zuerst die Füße* (*Feet First*)
(1990, Museion, Bolzano). For the work's de-
fenders it was an attack on hypocrisy and in
2008 a public campaign, which included a
hunger strike by a local politician and con-
demnation by the Pope, failed to persuade
the museum which owned it to withdraw
the allegedly blasphemous sculpture from
display.

Kippenberger was enormously prolific in
his brief career, sufficiently so as to be able
to make one work entitled *Heavy Guy* from a
skip containing the remains of 51 discarded
paintings. When a major retrospective was
seen at Tate Modern in 2006, what made the
strongest impression on many critics was not
the paintings but the room-size installation
The Happy End of Kafka's Amerika. The asso-
ciation of the notoriously angst-ridden writer,
who failed to finish any of his major works,
with happiness and completion was itself a
paradox. The work is an ensemble of chairs
and tables including classics of modern de-
sign. The implication is of a series of invita-
tions to interview, but, as Richard *Cork
points out, there are 'far more unsettling
presences, like watchtowers reminiscent of a
concentration camp' (*New Statesman*, 20
February 2006). The spectators cannot them-
selves rest in the chairs, although at Tate
stadium-style seating was provided to enable

viewers to contemplate the piece as a whole.
Kippenberger's own end was early death
from liver cancer in Vienna, probably preci-
pitated by his extreme indulgence in smoking
and drinking. Among his last paintings are a
series based on Géricault's *Raft of the Medusa*,
showing his own diseased body. Kippenberger
can be seen as a figure in the succession of
Andy *Warhol, turning his own life into a high-
ly marketable art commodity, but, unlike
Warhol or Kippenberger's friend Jeff *Koons,
he exemplifies, as Alison Gingeras points out,
a 'paradigm shift in artistic persona—from . . .
staged perfection to . . . bold embrace of im-
perfection' (*Artforum International*, October
2004). It was almost as though Warhol had
taken on the attributes of some of his self-
destructive entourage. Kippenberger's star
status belongs firmly to the age of reality tele-
vision, not that of classic Hollywood.

Further Reading: A. Taschen (ed.), *Martin Kippenberger*
(2003)

Kirchner, Ernst Ludwig (1880–1938)
German *Expressionist painter, printmaker,
and sculptor, the dominant figure in the
*Brücke group. He was born in Aschaffen-
burg, the son of a distinguished chemist in
the paper industry, and moved around a
good deal in his early years because of his
father's career before settling at Chemnitz in
1890. From childhood he was nervous and
highly imaginative, often disturbed by night-
mares. His father opposed his wish to be a
painter, so from 1901 to 1905 he studied ar-
chitecture in Dresden (though with an inter-
lude in Munich in the winter of 1903–4 when
he combined his architectural studies with
classes in painting—the only tuition he
received in the subject). A few weeks before
he graduated in July 1905 he founded Die
Brücke with a number of other students in
Dresden. Like the other members of the
group, he was influenced by *Gauguin and
van Gogh, by *Fauvism, and by *Munch. He
also claimed that he was the first of the group
to appreciate Polynesian and other *'primi-
tive' art (which he saw in the Zwinger Muse-
um in Dresden), but this had little obvious
effect on his work. His paintings consisted
mainly of figure compositions, including por-
traits and nudes (he often spent the summer
months in seclusion in the country or on the
coast, where he could draw and paint nude
models in natural movement). There is often
an explicit erotic quality in his work and

sometimes a feeling of malevolence. His forms are typically harsh and jagged, and his colours dissonant. From 1910 he began to spend much of his time in Berlin and he settled there in 1911. During the next few years his work developed more independently of the other members of Die Brücke, and his criticisms of his associates were an important factor in the the break-up of the group in 1913. His most celebrated paintings of this period are a series of street scenes of Berlin that are regarded as marking one of the high-points of Expressionism. In a style that had become more spiky and aggressive he depicted the pace, the glare, and the tension of big city life (*Street, Berlin*, 1913, MoMA, New York).

Kirchner was drafted into the German army in 1915, but he was soon discharged after a mental and physical collapse. He was treated at a sanatorium in Königstein, near Frankfurt, and painted several murals for the hospital. In 1916 he was hit by a car in Berlin and during his long period of recuperation he settled in Frauenkirch, near Davos, in Switzerland, which became his home for the rest of his life. By 1921 he had recovered from heavy dependence on drugs, but he never fully regained mental equilibrium. When he started painting again he concentrated on mountain landscapes and peasant scenes, his work gaining in serenity what it lost in vigour. He planned to found a progressive artists' community in Switzerland, and although his idea came to nothing, many young artists sought him out for guidance, for his work had become very well known and he was regarded with awe by some admirers (Kirchner himself—for all his problems—remained unshaken in his belief that he was the greatest German artist of his age). From the late 1920s his style began to move towards abstraction, as he painted less directly from nature. Many exhibitions of his work were held in the 1930s, in Germany and elsewhere, but in the middle of the decade he was overcome again by mental anxiety and physical deterioration. The inclusion of his work in the Nazi exhibition of *degenerate art in 1937 caused him acute distress and the following year he shot himself.

Throughout Kirchner's career, printmaking was as important to him as painting and he ranks as one of the 20th century's greatest masters in this field. He produced a huge body of work in woodcut, etching, and lithography, but each print usually exists in only a few impressions, as he liked to print his work himself. His early prints reflect the mannered linearism of Jugendstil, the German version of *Art Nouveau, but this was soon displaced by a harsh contrast of planes and abrupt angularity influenced by his admiration for medieval German woodcuts. In addition to paintings and prints, he also made wooden sculpture, rough-hewn and harshly coloured (*Dancing Woman*, 1911, Stedelijk Museum, Amsterdam).

Kirkeby, Per (1938–) Danish painter, sculptor, and writer, born in Copenhagen. He studied as an Arctic geologist as well as an artist; the one activity has sometimes informed the other. He was a member of *Fluxus and early work was influenced by *Pop art. In 1969 he designed a clock which appeared a normal object until it was noticed that the face was numbered from one to seventeen. Instead of measuring time, it measured its own circumference. He is best known for semi-abstract paintings in a distinctive colour range, making great use of greys, dirty greens, velvety reds, and ochres, which can be related to the sublime tradition of landscape (Kirkeby is an admirer of Turner). There is also a rich surface treatment with scratched and dripped paint suggesting weathered rock surfaces suddenly and dramatically illuminated. Kirkeby has talked of 'the light from the cave opening, the light that is often reflected upon into the cave's inn'ards, the inner light, this light seems to promise visions'. But he has also said: 'I am not a landscape painter. I am from the city.' This city background is more apparent in his brick sculptures, which reference traditional Danish housing and more particularly the Grundtvig Church, Copenhagen, a building of the 1920s which Kirkeby values because of its 'radical roughness and "lack of serenity"'. His sculptures have expanded to an architectural scale, as in *Wanås* (1994, Wanås Sculpture Park, Knislinge, Sweden).

Further Reading: J. Alison and C. Brown, *Border Crossings: Fourteen Scandinavian Artists* (1992)

Whitechapel Art Gallery, *Per Kirkeby: Recent Painting and Sculpture* (1985)

Kirstein, Lincoln *See* LACHAISE, GASTON.

Kisling, Moïse (1891–1953) Polish-born painter who became a French citizen in 1915. After studying at the Academy in his native Cracow, he moved to Paris in 1910 and became friendly with numerous members of the avant-garde, particularly his fellow expatriates *Chagall, *Modigliani, and *Soutine (his work

has a similar melancholy character to theirs); he also knew *Derain, *Gris, and *Picasso, and *Cubism was one of the influences on his eclectic early work. After the outbreak of the First World War, Kisling volunteered for the Foreign Legion, was wounded, and invalided out in 1915. Between 1917 and 1920 he lived in the South of France, then returned to Paris, where he had a successful exhibition at the Galerie Druet in 1919. By this time he was consolidating the various influences on his work into a personal style marked by elegant draughtsmanship and delicately modulated colours. He had considerable success as a portraitist and also painted nudes and landscapes. From 1941 to 1946 he lived in the USA, mainly in New York, although he also spent a year in Hollywood (1942–3) at the invitation of his friend Artur Rubinstein, the celebrated Polish-born pianist. After returning to France he settled at Sanary-sur-Mer, near Toulon.

Kitaj, R. B. (Ronald Brooks) (1932–2007) American painter and graphic artist, active mainly in England. He was born in Cleveland, Ohio, and studied at the Cooper Union, New York, 1950–51, and the Academy in Vienna, 1951–2. After working as a merchant seaman and serving in the US Army in Germany he came to England on a GI scholarship, studying at the Ruskin School, Oxford, 1958–9, and the *Royal College of Art, 1959–61. His wide cultural horizons gave him an influential position among his contemporaries at the RCA (they included David *Hockney and Allen *Jones), particularly in holding up his own preference for figuration in opposition to the prevailing abstraction. His relation to the *Pop phenomenon is a complex one. Like his contemporaries, he composed most of his work of the 1960s out of second-hand imagery. The sources were, however, not usually from mass culture, but from the history of ideas, especially a blend of radical politics and iconology derived from the studies of the Warburg Institute, the London-based institution which specializes in recondite research into the classical tradition. *The Murder of Rosa Luxemburg* (1960, Tate) associated the death of the German Jewish revolutionary with Kitaj's own ancestors who had been forced to leave Russia and Austria as a result of anti-Semitic persecution. His first solo exhibition in 1963, held at the *Marlborough New London Gallery, cited the philosopher Karl Popper in its dedication 'To the Open Society, with Reservations'. Like *Paolozzi, he made considerable use of screenprinting to bring together images from multiple sources, as in his 1964–7 series *Mahler Becomes Politics*. Another group of screenprints of 1969 reproduced unchanged a series of book covers, generally of a fairly intellectual nature, as a riposte to *Pop. His processes fell foul of the definitions of the original print which operated in France and four of his screenprints were banned and then segregated in the Paris *Biennale des Jeunes Artistes in 1965. Kitaj's early activities, with their strong element of *appropriation, tended to be overshadowed later by his role as a champion of figurative art, stressing the importance of drawing and painting from the life. In 1976 he organized an *Arts Council exhibition of figurative art entitled 'The Human Clay', including work by Francis *Bacon and David *Hockney. In the catalogue, he coined the phrase *School of London'. His paintings continued to abound in recondite references; his preferred choices for portrait subjects were intellectuals and academics.

After a visit to Paris in 1975 Kitaj was inspired by the example of *Degas to take up pastel, which he has used for much of his subsequent work. Late 19th-century French art was a major source of inspiration, as was a preoccupation with his Jewish identity, and he said: 'I took it into my cosmopolitan head that I should attempt to do *Cézanne and Degas and Kafka over again, after Auschwitz.' He identified strongly with the composer Mahler, 'thrice homeless—as a Bohemian among Austrians, as an Austrian among Germans and as a Jew throughout the world'. Kitaj's sense of Jewishness was given verbal expression in his two 'diasporist manifestoes', published in 1989 and 2007, in which he made a link between the situation of the Jew and all other outsiders. *If not, not* (1975–6, Scottish National Gallery of Modern Art, Edinburgh) recalls in its composition Giorgione's *Tempest*, art's most powerful image of a threatened Arcadia. At the crown of a hill there is the gate of a concentration camp. There are references to T. S. Eliot's *Waste Land*; the poet himself, notorious for his anti-Semitism, is seen with a hearing aid in the embrace of a woman. In 1994 a retrospective exhibition of Kitaj's work at the Tate Gallery, London, received strongly negative reviews, which especially attacked him for

allegedly putting the literary above the pictorial. This hostile response, which was not repeated when the exhibition was subsequently seen in Los Angeles and New York, has been accounted for by the sociologist Janet Woolf as deriving from a combination of 'a certain anti-literary prejudice in art criticism, a lingering anti-Americanism, and a persistent (though by no means pervasive) anti-semitism'. His wife, the American artist Sandra Fisher (1947–94), died of a brain haemorrhage shortly after the exhibition ended, and Kitaj caused controversy by blaming this on his critics: 'They tried to kill me and they got her instead.' In 1996 he showed a painting at the *Royal Academy entitled *The Critic Kills* and was widely accused of 'emotional blackmail'. One commentator suggested that he should live in Italy, where critics could be 'paid to write nice things'. However, he remained a highly respected figure in the art world and the affair seemed to have little long-term impact on the success and honours he achieved. In 1997 he settled in Los Angeles. His death was by suicide.

Further Reading: J. Aulich and J. Lynch (eds.), *Critical Kitaj* (2000)

M. Livingstone, *Kitaj* (1992)

Kitchen Sink School A group of British *Social Realist painters active in the 1950s who specialized in drab working-class subjects, notably interior scenes and still-lifes of domestic clutter and debris; the term, not intended as a compliment, was coined by the critic David *Sylvester in an article in the December 1954 issue of the journal *Encounter*. The main artists covered by the term were John *Bratby, Derrick *Greaves, Edward *Middleditch, and Jack *Smith, who were supported by Helen *Lessore's Beaux Arts Gallery in London. In 1956 they exhibited together at the Venice *Biennale. By their choice of dour and sordid themes and their harsh aggressive style they were seen to express the same kind of dissatisfaction with the values of post-war British society as the 'Angry Young Men' in literature (writers such as John Osborne, whose *Look Back in Anger* was first produced in 1956, were sometimes referred to as 'kitchen sink dramatists'). Their principal critical supporter was the Marxist John *Berger, although not all the painters had a strong political motivation. In the context of the Cold War, opponents of the school's brand of Social Realism were inclined to associate it with the *Socialist Realism imposed as an artistic dogma in the Eastern bloc. From the late 1950s the painters of the Kitchen Sink School developed in different ways, Bratby, for example, emphasizing his *Expressionist handling, and Smith eventually turning to abstraction, for which he was dismissed by the Beaux Arts Gallery. Berger denounced his former protégés.

The bad feelings aroused by the controversy over the painters' work, and especially its politicized interpretation, ran high for many years afterwards. In the catalogue of an exhibition held at the Graves Art Gallery, Sheffield, in 1984 entitled 'The Forgotten Fifties', which included the Kitchen Sink painters, the curator, Julian Spalding, commented that the research for the exhibition had meant 'opening wounds'. Jack Smith was initially particularly critical of the proposed exhibition, although he eventually contributed a statement of his own point of view on the subject to the catalogue, in which he denied that there had been any political agenda behind his work.

Peter Coker (1926–2004), a painter noted for thickly painted images of a butcher's shop, has also been associated with the tendency.

Further Reading: F. Spalding, *The Kitchen Sink Painters* (1990)

kitsch A term applied to art or artefacts characterized by vulgarity, sentimentality, and pretentious bad taste. In German the word means 'vulgar trash' (from the verb 'verkitschen'—to cheapen or sentimentalize) and was 'originally applied to ephemeral and trashy works, especially sentimental novels and novelettes, and their graphic equivalents, and to poetry of like character' (*Oxford Companion to German Literature*, 1976). Its meaning was extended to cover other forms of expression, and in 1925 the art historian Fritz Karpfen published a book entitled *Der Kitsch: Eine Studie über die Entartung der Kunst* ('Kitsch: A Study of the Degeneration of Art'). The first recorded occurrence of the word in the *Oxford English Dictionary* is of 1926 (quoting a remark about 'listening to "Kitsch" on the wireless') and the first serious critical discussion of the word in English was Clement *Greenberg's essay 'Avant-Garde and Kitsch' published in *Partisan Review* in 1939. Greenberg thought that kitsch was the outcome of a world in which money and desire had become much more widely spread than taste and knowledge—'a product of the industrial revolution which urbanized the masses of Western Europe and America and established what is called

universal literacy'. He argued that before literacy became widespread, formal culture was the preserve of educated people with money and leisure; however, the 'peasants who settled in the cities as proletariat and petty bourgeois' lost the taste for their traditional folk culture and 'set up a pressure on society to provide them with a kind of culture fit for their own consumption. To fill the demand of the new market, a new commodity was devised: ersatz culture, kitsch, destined for those who, insensible to the values of genuine culture, are hungry nevertheless for the diversion that only culture of some sort can provide. Kitsch, using for raw material the debased and academicized simulacra of genuine culture, welcomes and cultivates this insensibility. It is the source of its profits...The precondition for kitsch...is the availability close at hand of a fully matured cultural tradition, whose discoveries, acquisitions and perfected self-consciousness kitsch can take advantage of for its own ends.'

Greenberg's analysis of how kitsch operates can still be considered broadly valid, but he took an extremely expansive view of what constituted kitsch, including jazz and Hollywood movies—forms that are now treated just as seriously as museum art. Among the artists he mentioned as exemplifying kitsch were Maxfield *Parrish and Norman *Rockwell, who likewise are now treated with respect (at least by some critics). The reappraisal of artists such as these, formerly dismissed as shamelessly vulgar, came in the wake of *Pop art, which blurred the distinctions between 'high' and 'low' art and therefore complicated attitudes towards kitsch. *Postmodernism has further complicated the issue, for now kitsch imagery is used in an 'ironic' way by 'serious' artists such as Jeff *Koons (although Koons himself says he does not perceive any ironic quality in his work: 'What it does have for me is a sense of the tragic'). Artists whose work is still sometimes labelled kitsch in a straightforward, uncomplimentary, unironic sense include Salvador *Dalí (in his late religious paintings) and Vladimir *Tretchikoff—the 'King of Kitsch'.

In the USA the term 'Schlock art' is sometimes used as an alternative to 'kitsch'; 'schlock', derived from Yiddish, means 'cheap, shoddy, or defective goods' (it is also used in the combination form 'schlockmeister' or 'schlockmaster'—'a purveyor of cheap merchandise').

Kitson, Linda *See* OFFICIAL WAR ART.

Kjarval, Jóhannes *See* THORLÁKSSON, THÓRARINN B.

Klapheck, Konrad (1935–) German painter, born in Düsseldorf, where he studied at the Academy, 1954–8. He made his reputation with simplified, smoothly painted representations of utility objects such as typewriters, telephones, and so on. These are sometimes seen from a low angle to give them a degree of architectural portentousness recalling the drawings of Sant'Elia (*see* FUTURISM). In the catalogue of the exhibition 'German Art in the 20th Century' (Royal Academy, London, 1985), it is said that 'Far from simply reproducing his motifs he introduces idiosyncratic and technically absurd modifications whose interpretative significance is often clinched by the title he gives his pictures'; an example is *The Logic of Women* (1965, Louisiana Museum, Humlebaek), which depicts a mysterious-looking sewing machine. Klapheck's work has been seen as both a late flowering of *Surrealism (André *Breton agreed with this) and as a forerunner of *Superrealism. In 1979 he became a professor at the Düsseldorf Academy.

Klee, Paul (1879–1940) German-Swiss painter, graphic artist, writer, and teacher, one of the most individual and best-loved figures in 20th-century art. He was born at Münchenbuchsee, near Berne, to a German father and a Swiss mother (he is often referred to as Swiss, but he was a German citizen throughout his life, and although he eventually sought Swiss citizenship this was not granted until the day after his death). From 1898 to 1901 he studied in Munich, principally at the Academy under Franz von *Stuck. After travelling in Italy, 1901–2, he lived in Berne for the next four years, then in 1906 moved to Munich after marrying the German pianist Lily Stumpf (both Klee's parents were musicians and he was himself a violinist of professional standard—as a boy he had played in the Berne Symphony Orchestra). Lily was the main breadwinner with teaching work until Klee's career took off after the First World War. In 1911 he became friendly with *Jawlensky, *Kandinsky (whom he had first met as a student ten years earlier), *Macke, and *Marc, and in the following year he took part in the second *Blaue Reiter exhibition. Also in 1912 he

visited Paris for the second time (he had earlier been there with Louis *Moilliet in 1905); he met *Delaunay on this occasion and saw *Cubist pictures. At this point he was principally an etcher, his most notable prints including a series of eleven *Inventions* (1903–5)—bizarre and satirical works with freakishly distorted figures. However, in 1914 he visited Tunisia with Macke and Moilliet and was dramatically awakened to the beauty of colour. Two weeks after arriving he wrote: 'Colour possesses me. I no longer need to pursue it: it possesses me forever, I know. Colour and I are one—I am a painter.'

In 1916 Klee was drafted into the German army, but unlike his friends Macke and Marc (both of whom died in action) he was not involved in combat; his work included painting aeroplanes. After the war he returned to Munich, and in 1919 he applied to succeed Adolf *Hölzel at the Stuttgart Academy. He was rejected on the grounds that his work (in *Schlemmer's words) was 'playful in character and lacking firm commitment to structure and composition'. The following year, however, he had a huge success when the Munich dealer Hans Goltz staged a large retrospective exhibition of his work. This secured his reputation and led *Gropius to invite him to teach at the *Bauhaus; he moved to Weimar to take up the post in January 1921 and remained with the school for the next ten years. He proved an inspired, undogmatic teacher, both in his specialist work in the stained-glass, bookbinding, and weaving workshops and in the more general classes of the preliminary course devoted to the understanding of basic principles of design. (His popularity with his students was so great that to mark his 50th birthday in 1929, one of them, Anni *Albers, hired an aeroplane to drop bouquets of flowers on his house.)

In 1925 the Bauhaus published Klee's *Pedagogisches Skizzenbuch*, the best-known of his writings (it was translated into English as *Pedagogical Sketchbook* in 1953). There is no complete and reliable edition of his theoretical texts (few of which were published during his lifetime), and it is difficult to summarize his views on art, especially as his statements tend to be couched in poetically compressed language. Frank *Whitford writes (*TLS*, 8 April 1994): 'Apparently objective but in reality highly personal, Klee's theories deploy vivid metaphor and terminology borrowed from natural science in an attempt to identify and comprehend the well-spring of all creation,

natural and artistic, and to examine the work of art as a microcosm of the universe.' During his Bauhaus days Klee was particularly close to another theoretician of poetic cast of mind—his colleague Kandinsky (they even lived in adjoining parts of the same building). He kept aloof from the internal disputes of the school (his detachment earned him the nicknames 'Bauhaus Buddha' and 'the heavenly father'), but the quarrels became increasingly tiresome to him and he resigned in 1931 and took up a post at the Academy in Düsseldorf. Two years later he was dismissed by the Nazis and returned to Switzerland, settling permanently in Berne. His work was included in the notorious exhibition of *degenerate art in 1937.

Although Klee was not politically inclined, his mood during his last years was one of profound disappointment; he was cut off from the German public that had greatly admired his work, and although he received visits from distinguished admirers (including *Picasso in 1937), the Swiss artistic milieu was generally less sympathetic. In 1935 he suffered the first symptoms of the illness that killed him—a rare debilitating disease called scleroderma, which restricts joint motion by tightening the skin—and although he remained active to the end, his earlier playfulness gave way to a preoccupation with malign and malevolent forces. His exquisitely sensitive line grew deliberately rough and crude and his sense of humour became macabre; his imagery was haunted by premonitions of death, as in *Death and Fire* (1940, Paul Klee Foundation, Kunstmuseum, Berne), one of his starkest and most powerful works. It depicts a ghastly, ashen face, the features of which are made up of letters forming the word 'Tod'—German for 'death'. In the catalogue of the exhibition 'Paul Klee: The Last Years (Hayward Gallery, London, 1974), Douglas Hall writes: 'The late work of Paul Klee, besides its enormous psychic interest, was of high importance for the future development of modern art. His disjunctive method of composition, his abnegation of the necessity to focus on a point or an episode of a painting, represent one of the very few new inventions in painting since cubism.'

Klee was one of the most inventive and prolific of modern masters, his complete output being estimated at some 9,000 works. He usually worked on a small scale; initially he painted only in watercolour, but he took up

oils in 1919 and sometimes used both media in one painting. It is impossible to categorize his work stylistically, for he moved freely between figuration and abstraction, absorbing countless influences and transforming them through his unrivalled imaginative gifts as he explored human fantasies and fears. In spite of this variety, his work—in whatever style or medium—is usually instantly recognizable as his, revealing a joyous spirit that is hard to parallel in 20th-century art. The finest collection of his work is in the Paul Klee Foundation in the Kunstmuseum, Berne.

Further Reading: R. Kudielka and B. Riley, *Paul Klee: The Nature of Creation* (2002)

Klein, César See NOVEMBERGRUPPE.

Klein, William (1928–) American photographer, painter, sculptor, and film-maker. Born in New York, he moved to Paris after the Second World War. He studied painting under *Lhote and for a few weeks with *Léger, whom Klein recalled as 'a great artist who told us that galleries were dead, easel painting was finished'. As a young artist, he began painting abstract murals under the influence of *Mondrian and Max *Bill, then began mixing abstract painting with photography. He returned to New York in 1954 on the invitation of Alexander Liberman, director of American *Vogue*, for a photographic assignment. His street photographs of New York deliberately violated 'good photography': the subjects looked at the camera, images were unexpectedly cropped or even blurred and out of focus. Sometimes the subjects even gesticulate grotesquely at the camera, as in *Little Italy* (1954), in which a woman, head just out of frame, playfully points a gun at a grinning child, while two other children gawp at the photographer. As Miles Orvell points out 'Klein emphasizes the chaos of twentieth century urban life, the chance conjunction of people and circumstances in a moment of time'. He also depicted the impact of the commercial sign on the environment in a way that anticipates *Pop art, as in *7up and Tree* (1954). Klein's view of himself was that 'For me photography was good old-fashioned muckraking'.

In 1956 Klein went back to Paris and worked on both street and fashion photography, often combining the two genres. His experience of the fashion world was used in his first feature film, *Who Are You, Polly Magoo?* (1966). His second film, *Mister Freedom* (1968), was a far more violent satire, this time on the impact of American power in Europe. (Unsurprisingly Klein has continued to prefer to be based in Paris.) Klein resumed photography in the 1980s and made mixed-media works incorporating painting.

Further Reading: J. Guimond, *American Photography and the American Dream* (1991)

Klein, Yves (1928–62) French artist, born in Nice, one of the most influential figures in European avant-garde art in the post-war period. Both his parents were painters: his father, Fred Klein (1898–1990), specialized in fantastic landscapes with horses, while his mother, Marie Raymond (1908–88), had some success in the 1950s as an exponent of *Lyrical Abstraction. As a young man he became interested in the philosophy of Rosicrucianism through the occultist Max Heindel's book *La cosmogonie des Roses-Croix* (*The Rosicrucian Cosmo-Conception*, 1909). This proposed a new age of space and pure spirit and an end to the ego and materialism. Sidra Stich's excellent study of Klein argues that his mystical interests went rather against the grain of post-war French culture, marked on the one hand by the highly politicized existentialist (*see* SARTRE) demand for engagement and, on the other, by a more pragmatic mood of concern with economic reconstruction. This is questionable. Klein's fascination with the spiritual can be seen as a highly idiosyncratic manifestation of a tendency which is also found in the period in the religious nature cult of the paintings of *Manessier, the music of Messiaen, the films of Robert Bresson, and the wave of modernist church building. Klein had no formal artistic training and for much of his short life he earned his living as a judo instructor; in 1952–53 he lived in Japan, where he obtained the high rank of black belt, fourth dan, and in 1954 he published a textbook on the subject, in spite of his Japanese qualification having no official recognition in France. In his early 20s he also travelled a good deal elsewhere (including England and Spain to learn the languages), but in 1955 he settled permanently in Paris. He had started to paint in the mid-1940s and he began to feel a serious vocation as an artist in about 1950. He claimed to have made his first monochrome paintings in 1947 and in 1954 a series of monochromes were published in book form. Here the paintings are not reproduced photographically in the usual way;

rather they are represented by slabs of colour in the manner of paint samples. The dimensions are stated only in numerical terms without units of measurement, so it is ambiguous how far these might stand for actual paintings. His monochromes at first were exhibited in various colours in 1956. The effect was of a decorative ensemble, a kind of wall pattern, which was precisely the effect Klein was trying to avoid. In 1957 he did this by confining himself to an especially pungent blue he christened International Klein Blue (IKB). The paintings have an intense powdery surface giving the impression of a colour filtered and refined. Klein had claimed that the sky at Nice had been his first monochrome. This blue became a kind of trademark which Klein applied to casts of statues and reliefs, suggesting the surface of the earth as though it had been impregnated by this sense of space. In a lecture given at the Sorbonne in 1959, Klein explained his theory of monochrome painting as an attempt to depersonalize colour by ridding it of subjective emotion and so give it a metaphysical quality. To IKB Klein added two further colours for monochromes, rose and gold. These three colours took on the role of alchemically transformed versions of the three primary colours.

In 1958 he created a sensation (and almost a riot) at the Galerie Iris *Clert in Paris by an 'exhibition of emptiness'—an empty gallery painted white. It was called *Le Vide* (the Void). The experience was carefully prepared. The outside windows were painted with the now familiar IKB, the invitations had special IKB stamps and guests were served a special cocktail which caused them to urinate IKB for several days afterwards. However, the most effective preparation was invisible. Klein was present in the empty gallery in the hours before the opening attempting to mentally produce the spirit of 'the void'. Later he dramatized the idea of introducing the void into the commercial art market by selling certificates for 'Zones of Immaterial Pictorial Sensitivity' in exchange for gold. The collector could only experience the void by destroying the certificate, therefore having no physical object. Klein disposed of half of the gold in the River Seine. The rest he kept back and it was eventually included in an *ex-voto* for St Rita, noted for her intervention on behalf of lost and impossible causes and also one associated with a miraculous flight. In 1960 he gave his first public demonstration of his *Anthropométries*: naked women smeared with blue pigment dragged each other over canvas

laid on the floor to the accompaniment of his *Symphonie monotone*—a single note sustained for ten minutes alternating with ten minutes' silence. This was held in an exclusive ambience before an audience in evening dress. The sensational reputation of the event led to its being recreated for the cameras in the exploitation film *Mondo Cane*. Klein hated the result (jazz was used for accompaniment instead of his own music), and his anger over the outcome may have been one of the causes of the heart attack which led to his early death. The *Anthropométries*, most of which were actually made privately in his studio, are probably his most powerful achievements as a painter: haunting, shadowy, sometimes sinister images of the body which fuse the corporeal and the disembodied. Also in 1960 he became the central figure of *Nouveau Réalisme, a group that included his long-time friend *Arman and his most prominent critical supporter, Pierre *Restany. In October of that year he made his leap into 'Le Vide'. He was photographed, as if in flight, soaring from a roof in Fontenay-aux-Roses, a suburb in the south of Paris. The ecstatic and dangerous gesture is at odds with the mundane setting: a little suburban railway station is visible and, when first published, a cyclist is seen riding by, as nonchalant and indifferent as the ploughman in Bruegel's *Fall of Icarus*. A later publication of the photograph, without the cyclist, reveals it to be an ingenious *photomontage. Klein had friends from the local judo club holding a blanket. (Long after the artist's death the blanket was exhibited at the Louvre as a Klein artwork.) It is not clear whether Klein was implicitly inviting spectators to see through the deception. If he was, it suggests a level of tragic irony behind his aspirations. Part of the context for the gesture was the accelerating space race between the Soviet Union and the USA. The Russians were to launch Yuri Gagarin into space just a few months later. The artist, the representative of creative power, but also of a Europe being sidelined by the Cold War between the superpowers, becomes the first man in space. Klein produced a large body of work and had wide influence, particularly on the development of *Minimal art, although most Minimal artists took a rigorously materialist view quite at odds with Klein's religious outlook. In fact, in spite of the historical importance of his practice, the spiritual element of his work has proved problematic for some later critics, as have been the repeated allegations of extreme right-wing views. It remains a matter of debate

as to whether he should be accounted as a great exponent of the mystical like *Malevich or merely a great showman like Salvador *Dalí. For Thierry de Duve, Klein was an artist who 'testified to the failure of avant-gardist utopias'. *See also* POMPIER.

Further Reading: T. de Duve, 'Yves Klein, or The Dead Dealer', *October*, no. 49 (summer 1989)

T. Génevrier-Tausti, *L'Envol d' Yves Klein: L'origine d'une légende* (2006)

S. Stitch, *Yves Klein* (1995)

Klimt, Gustav (1862–1918) Austrian painter, draughtsman and designer, one of the leading figures in one of the most exciting epochs of Vienna's cultural history. He was born just outside Vienna, the son of an engraver, and rarely left the city (except to visit a spa in the Austrian lake district every summer—he was something of a hypochondriac). From 1876 to 1883 he studied at the School of Applied Arts, Vienna, then quickly achieved success as a painter of sumptuous decorative schemes in the tradition of Hans Mackart, whose staircase decoration in the Kunsthistorisches Museum in Vienna Klimt completed after Mackart's death in 1884. In this and other schemes he worked in collaboration with his brother Ernst Klimt (1864–92) and Franz Matsch (1861–1942). In spite of his acclaim in official circles, Klimt was drawn to avant-garde art, and his work was influenced by *Impressionism, *Symbolism, and *Art Nouveau. Discontent with the conservative attitudes of the Viennese Artists' Association led him and a group of friends to resign in 1897 and set up their own organization, the *Sezession, of which he was elected first president. In a short time Klimt thus went from being a pillar of the establishment to a hero of the avant-garde, and this new role was confirmed when his enormous allegorical mural paintings for Vienna University aroused great hostility, being called nonsensical and pornographic. (Klimt was given the commission in 1894 and abandoned it in 1905; the paintings—on the themes of *Jurisprudence, Medicine*, and *Philosophy*—were destroyed by fire in 1945.)

Although official commissions dried up after this, Klimt continued to be much in demand with private patrons, as a portraitist as well as a painter of mythological and allegorical themes. He was highly responsive to female beauty (he was a great womanizer) and in both his portraits and his subject pictures he stresses the mystery and allure of womanhood. Notable examples are the magnificent full-length portrait of Emilie Flöge (his sister-in-law and close friend) in the Historisches Museum der Stadt, Vienna (1902) and *Judith I* (1901, Österreichische Galerie, Vienna), one of the archetypal images of the *femme fatale*. Characteristically, the figures in Klimt's paintings are treated more or less naturalistically but embellished—in the background or their clothing—with richly decorative patterns recalling butterfly or peacock wings, creating a highly distinct style of extraordinarily lush sensuality. The erotic aspect of his work is even more pronounced in his drawings, most of which were done as independent works rather than as preparatory studies for paintings: characteristically they show naked or semi-naked women in a state of sexual arousal.

In addition to paintings and drawings, Klimt made designs for the *Wiener Werkstätte (he was a member of the board of management). Most of his designs were fairly modest, but the great exception was the major commission of his later years—the mosaics for the dining room of the Palais Stoclet in Brussels, a luxury home built at huge expense for the young Belgian industrialist Adolphe Stoclet, who had just inherited the family fortune. The architect was the Austrian Josef Hoffmann (1870–1956) and some of the finest talents of the Werkstätte collaborated with him in the interior decoration. It was begun in 1905 and Klimt's mosaics were executed in 1909–11; the two long walls of the room are decorated with curling branches of the Tree of Life, with a figure of a young woman symbolizing Expectation on one wall and an embracing couple opposite representing Fulfilment.

Klimt was regarded by many of his contemporaries as the outstanding Austrian artist of his period, and his work superbly evokes an age of luxury and optimism before the First World War. Although he is so closely associated with Vienna, his reputation spread outside his own country, and in 1910 he was given an exhibition at the Venice *Biennale. It was very popular with the public, although some critics attacked Klimt's work as decadent and the *Futurists regarded it as self-indulgent and irrelevant to modern life. He was influential on some of his Viennese contemporaries, notably *Kokoschka and *Schiele, although he had no real successors

as a painter in the German-speaking world, as it turned more to *Expressionism than decorative Symbolism.

Further Reading: F. Whitford, *Gustav Klimt* (1990)

Kline, Franz (1910–62) American painter, generally considered one of the most individual of the *Abstract Expressionists. He was born in Wilkes-Barre, Pennsylvania, of immigrant parents—a German father and an English mother. After studying art at Boston University, 1931–5, he set off for Paris in 1937 but got no further than London, where he continued his studies at Heatherley's School of Art, 1937–8. On his return to the USA he settled permanently in New York in 1939. His early work was representational, including urban landscapes and commissioned portraits, but he turned to abstraction at the end of the 1940s. This change of direction reflected the influence of Willem *de Kooning (whom he met in 1943), but the most important factor in his 'conversion' was seeing some of his own quick sketches enlarged by a projector, an experience that made him realize their potential as abstract compositions. Elaine de Kooning commented that Kline was amazed at what he saw: 'A four by five inch brush drawing of the rocking chair . . . loomed in gigantic black strokes which eradicated any image, the strokes expanding as entities in themselves, unrelated to any reality but that of their own existence . . . From that day, Franz Kline's style of painting changed completely.'

Once he had embarked on his new path, Kline very quickly developed a highly personal style of expressive abstraction, converting the brushstrokes of his drawings into large-scale abstract paintings, using bold black patterns on a white ground in a manner reminiscent of oriental calligraphy but with a distinctive rough vigour (he used commercial paints and house-painters' brushes, sometimes up to eight inches wide). He had his first one-man show at the Charles Egan Gallery, New York, in 1950 and made a strong impression, particularly with *Chief* (1950, MoMA, New York). After this his reputation grew rapidly. Kline referred to his works as 'painting experiences. I don't decide in advance that I'm going to paint a definite experience, but in the act of painting, it becomes a genuine experience for me . . . I'm not painting bridge constructions, sky scrapers or laundry tickets.' However, some of his paintings do allude to memories of the industrial part of Pennsylvania where he grew up: the titles of several of them (including *Chief*) are taken from the names of railway engines, and his dense blacks evoke a feeling of coal country. Towards the end of his life he sometimes used vivid colours, but for the most part he remained loyal to his characteristic black-and-white style. He died of heart disease.

Further Reading: C. Christov-Bakargiev and D. Anfam, *Franz Kline (1910–1962)* (2004)

Klingender, Francis *See* ARTISTS' INTERNATIONAL ASSOCIATION.

Klinger, Max (1857–1920) German painter, sculptor, and graphic artist, born in Leipzig. He studied at the Academies of Karlsruhe and Berlin, then after brief periods in Brussels, Berlin, and Munich he spent the years 1883–86 in Paris, 1886–8 in Berlin, and 1888–93 in Rome. After his return to Germany in 1893 he settled in Leipzig, where his home was one of the centres of the city's cultural life. His work reveals a powerful imagination and an often morbid interest in themes of love and death. As a painter he is best known for the enormous *Judgement of Paris* (1885–7, Kunsthistorisches Museum, Vienna), in which the frame is part of the decorative scheme. As a sculptor he experimented with polychromy, culminating in his statue of Beethoven (1899–1902, Museum der Bildenden Künste, Leipzig), in white and coloured marbles, bronze, alabaster, and ivory. It is as a graphic artist, however, that Klinger is now best known and that he most clearly showed his originality, especially in his series *Adventures of a Glove*, a grotesque exploration of fetishism that antedated the publication of Freud's theories. His drawings for this were exhibited in Berlin in 1887 when he was only 21 and made a great impact; the etchings that he made from them (three series, beginning in 1881) were widely influential. The series concerns a hapless young man and his involvement with an elusive lost glove that has clearly sexual connotations. This and other works of Klinger have been seen as forerunners of *Surrealism, and his influence is seen in the work of *de Chirico (one of his greatest admirers), *Dalí, and *Ernst, amongst others.

Klutsis, Gustav Gustavson (1895–1938/44) Russian/Latvian painter, photographer, and graphic designer. Born in Ruiena, Latvia, he is sometimes referred to as Klucis, the Latvian form of his name. He is said to have

participated in the abortive 1905 Russian revolution in spite of his young age. He certainly took part in the 1917 Revolution as a member of the Latvian Rifles Regiment, a notoriously ruthless outfit. In 1919 he resumed his art studies with both Kasimir *Malevich and Antoine *Pevsner. *The Dynamic City* (1919–20, State Museum of Contemporary Art, Thessaloniki) shows the influence of *Suprematism. However, Klutsis was one of those members of the Russian avant-garde who sought a utilitarian and propagandist role for art. In 1922 his abstract constructions evolved into designs for kiosks which could be used for the display of posters or photographs. He was one of the pioneers of the technique of *photomontage, his earliest examples dating from 1919. In an essay of 1931 he distinguished between the 'photomontage of form', deriving from American publicity, which he associated with the Dadaists and Expressionists, and 'militant and political photomontage . . . created on the soil of the Soviet Union'. The full force of the 'cult of personality' is visible in the work of the 1930s, as the manipulative power of the medium allows Stalin literally to fuse into Lenin or to tower over factories, soldiers or a party congress.

'Committed communist, he put his creative art in the service of the new socialist society', said Jean-Claude Marcadé (*L'avant-garde Russe*, 1995). This did not save Klutsis from arrest in 1938 alongside many other veterans of the Latvian Rifles. It used to be thought that he died in a labour camp some years later, but most recent publications state that he was shot at Butovo prison near Moscow shortly after his arrest. In 1964 his widow, Valentina *Kulagina, made a substantial donation of about 400 works to the State Museum of Art in Riga.

Further Reading: M Tupitsyn, *Gustav Klutsis and Valentina Kulagina: Photography and Montage after Constructivism* (2004)

Knave of Diamonds (Jack of Diamonds)

(Bubnovyi Valet) An artists' association, formed in Moscow in 1910, that was for a time the most important of the avant-garde associations in Russia. There are various explanations of how the name came about, one being that it refers to the diamond markings on the uniforms of civil prisoners; the artists involved thus wanted to indicate that they were revolutionaries. The group's first exhibition, in December 1910, featured work by

*Goncharova, *Larionov, and *Malevich, the expatriate Russians *Jawlensky and *Kandinsky, and the French Cubists *Gleizes and Le *Fauconnier. In 1911 Goncharova, Larionov, and Malevich broke away from the group, accusing it of being too dominated by the 'cheap orientalism of the Paris School' and the 'Munich decadence', and founded their own association, the *Donkey's Tail, to promote an art based on native inspiration. The Knave of Diamonds held regular exhibitions up to 1917, then broke up; it reappeared after the Revolution and continued for some time under various different names.

Knight, Dame Laura (née Johnson)

(1877–1970) British painter, born at Long Eaton, Derbyshire; her mother was an art teacher. From 1889 to 1894 she studied at Nottingham School of Art, where she met **Harold Knight** (1874–1961), who married her in 1903 and who became a successful portraitist. They lived in Yorkshire, the Netherlands (at an artists' colony at Laren), and Newlyn (1907–18) before settling in London. In the interwar years Laura Knight was one of the most highly regarded of British artists and in 1936 she became the first woman to be elected a full *Royal Academician since 1768. At the height of her considerable fame (she was regarded as a 'character'—the nearest equivalent to a female Augustus *John) she won great popularity for her colourful scenes of gypsies, the ballet, and circus life (Alfred *Munnings introduced her to the circus owner Bertram Mills). She was so strongly identified with such subjects that she called her autobiography *Oil Paint and Grease Paint* (1936) and began it with the words: 'I was not, as most people assume, born in a circus, suckled by an elephant.' The pictures that made her famous were at one time regarded as rather corny, but *Charivari* (1928, Newport Museum), a complex assembly of circus themes, made a strong impact at 'La Grande Parade', an exhibition held at the Grand Palais, Paris, in 2004. Her early *Newlyn School landscapes, which at their best have a sparkling sense of *joie de vivre*, have similarly come back into favour. Some of the work she did as an *Official War Artist during the Second World War is also now highly regarded; it depicted, for example, women working in armaments factories (*Ruby Loftus Screwing a Breech Ring in the Bofors Gun*, 1942, Imperial War Museum,

London). In 1946 she went to Nuremberg to make a pictorial record of the War Criminals' Trial; she made scores of sketches from which she produced a large painting (Imperial War Museum). In 1965 she published a second volume of autobiography, *The Magic of a Line*.

Knoebel, Imi (1940–) German painter, born in Dessau. He studied alongside Blinky *Palermo at the Düsseldorf Academy under Joseph *Beuys. From the late 1960s he made installations of painted wooden panels, sometimes placed face down. *Ghent Room* (1980) was originally shown in Ghent but when reconstructed has always been modified to suit the dimensions of the space in which it is shown. The geometric austerity and flat colour of the work recalls early *Mondrian. Reviewing an exhibition of his work in 2007, Michael Archer identified Knoebel's 'spiritual father' as *Malevich (*Artforum International*, February 2007), but the idealism of the geometric tradition is brought down to earth with a sense of contingency and informality. The apparent contradiction is acknowledged by Knoebel, who has cited the 19th-century French poet Baudelaire's (*see* MODERNISM) distinction between beauty as eternal and beauty which is a product of circumstance. The first is invisible without the second.

Koberling, Bernd See NEO-EXPRESSIONISM.

Kobro, Katarzyna See STRZEMIŃSKI, VLADISLAV.

Koch, Pyke (1901–91) Dutch painter, born in Beek. He was self-taught as an artist and throughout his life remained committed to sharp-focus *Magic Realism, which he defined in the following terms in order to demonstrate his distance from *Surrealism: 'Magic Realism confronts us with situations that are possible, even commonplace but which contain an element of improbability . . . Magic Realism exists by the grace of ambiguity, which is the source of fascination on an entirely different level to that of beauty (or morality)'. He took some of his subject-matter from fair grounds: *The Shooting Gallery* (1931, Boymans–van Beuningen Museum, Rotterdam) is probably his best-known painting and is characteristic of his perverse eroticism. The contrast between beauty of execution and lowly subject is most apparent in *Nocturne* (1930, Museum voor Moderne Kunst, Arnhem): an illuminated

pissoir, a thinly veiled reference to prostitution, is treated like a lantern in a 17th-century religious painting. Koch was working in Utrecht, which had been a major centre for the Dutch followers of Caravaggio (1571–1610), so he could have been directly influenced by the dramatic interplay of light and shadow in painters such as Gerrit van Honthorst (1592–1656). Koch's work could be frankly autobiographical. *Rhapsody of the Suburbs* (1929, Stedelijk Museum, Amsterdam) has in the foreground discarded doll parts in a cart, still smiling and waving invitingly. The numbers 28 and 48 on the picture refer to the difference in age between the young painter and his lover. Although not a great traveller, he spent time in Italy during the 1930s, an admirer not just of its art, but of Mussolini's Fascist regime. Claims that his *Self-Portrait with a Black Headband* (1937, Centraal Museum, Utrecht) is without any political connotation seem disingenuous. He was a slow and meticulous worker. By 1982, after 55 years of painting, he had completed only about 80 pictures.

Further Reading: C. Blotkamp, *Pyke Koch* (1982)

Koehler, Bernhard See MACKE, AUGUST.

Kokoschka, Oskar (1886–1980) Austrian *Expressionist painter, graphic artist, and writer. He became a Czech citizen in 1937 and a British citizen in 1947 but reverted to Austrian citizenship in 1975. He was born in Pöchlarn of Austrian and Czech parents and grew up mainly in Vienna, where he studied at the School of Arts and Crafts from 1905 to 1909 (in this period he also worked for the *Wiener Werkstätte, painting fans and designing postcards among other things). In 1909–10 he began to make an impact as a painter with his 'psychological portraits', in which the soul of the sitter was thought to be laid bare. Ernst *Gombrich described them as 'the most poignant gallery of individuals painted in this century' (catalogue of the Arts Council exhibition 'Kokoschka', Tate Gallery, London, 1962). A good example of this type of portrait is that of the architect Adolf Loos (1909, Staatliche Museen, Berlin), showing the sensitive, quivering line through which Kokoschka captured what he called the 'closed personalities, so full of tension' of his sitters. Later his brushwork became much broader and more broken, with high-keyed flickering colours.

Kokoschka had his first one-man exhibition in 1910, at Paul *Cassirer's gallery in Berlin, and

in the same year he began to contribute illustrations to the avant-garde Berlin periodical *Der *Sturm* (he did a good deal of graphic work at this time). The early years were marked by a tumultuous relationship with Alma Mahler, widow of the composer, which was commemorated in one of his most celebrated works, *The Bride of the Wind* (1913, Kunstmuseum, Basel). In 1915 he was badly wounded whilst serving in the Austrian army, and in 1917—still recuperating—he settled in Dresden, where he taught at the Academy from 1919 to 1924. His most noted painting of these years, *Woman in Blue* (1919, Staatsgalerie, Stuttgart), depicts a stuffed doll he had made for company, even taking it to the theatre, before ceremonially burning it. In the later 1920s, he embarked on a period of wide travel that lasted for seven years, and during this time his attention turned more from portraits to landscapes, including a distinctive type of townscape seen from a high viewpoint (*Jerusalem*, 1929–30, Detroit Institute of Arts). In 1931 he returned to Vienna, but he was outspokenly opposed to the Nazis (who later declared his work *degenerate) and he moved to Prague in 1934 and then to London in 1938. From these years date a number of curious allegorical paintings on political themes. These sometimes demonstrate a certain bitterness towards Britain, which he blamed for the Nazi occupation of Austria. By this time he had an international reputation, but his work was as yet little known in England and he was poor throughout the war years. After the war his fortunes soon improved and he came to be generally regarded as one of the giants of modern art. From 1953 he lived mainly at Villeneuve in Switzerland, and from 1953 to 1963 he ran a summer school at Salzburg, the Schule des Sehens (School of Seeing).

In his later years Kokoschka continued to paint landscapes and portraits, but his most important works of this time are allegorical and mythological pictures, including the *Prometheus* ceiling (1950, Courtauld Gallery, London) for the house of Count Seilern (an Anglo-Austrian art historian and collector) at Princes Gate in London, and the *Thermopylae* triptych (1954) for Hamburg University. Kokoschka remained steadfastly unaffected by the developments of art around him and throughout his long life he pursued his highly personal and imaginative version of pre-1914 Expressionism. Unlike many other Expressionists, however, he was essentially optimistic in outlook. His writings include an autobiography, *Mein Leben* (1971, English translation, *My Life*, 1974), and several plays, the most important of which is *Mörder Hoffnung der Frauen* ('Murder Hope of Women'), an early example of Expressionist theatre that caused outrage when it was first perfomed in 1908 because of its violence. He also worked for the stage, including designs for a production of *The Magic Flute* in Salzburg in 1955.

Further Reading: F. Whitford, *Oskar Kokoschka: A Life* (1986)

Kolbe, Georg (1877–1947) German sculptor, born at Waldheim, Saxony. He trained as a painter in Dresden, Munich, and Paris (at the *Académie Julian, 1898), then took up sculpture during a stay in Rome, 1898–1901. From 1903 he lived in Berlin, but in 1909 he revisited Paris, where he met *Rodin, who together with *Maillol influenced him in turning exclusively to sculpture and in his choice of favourite subject—the nude. Kolbe's early work had vigour and freshness and his lithe figures were often expressive of the dance. In 1929 one such female figure was displayed in the German Pavilion, designed by Ludwig Mies van der Rohe, at the Barcelona World Exhibition and it looked completely at home in this exquisite modern setting (by common consent one of the loveliest buildings of the 20th century). However, after the rise of the Nazis (*see* NATIONAL SOCIALIST ART) Kolbe's work lost its individuality as he turned to evoking the popular image of the 'master race'. His studio in Berlin is now a museum.

Kollwitz, Käthe (née **Schmidt)** (1867–1945) German graphic artist and sculptor. She was born in Königsberg in East Prussia (now Kaliningrad in Russia) and had her main artistic training in Berlin and Munich. Originally she intended becoming a painter, but she soon realized that her strength lay in drawing and printmaking. She was also influenced by the ideas of Max *Klinger, who, in his pamphlet *Painting and Drawing* (1891), argued that graphics were better at describing 'resignation . . . misery . . . the pitiful creature in his eternal struggle'. She came from a family of strong moral and social convictions, and married Karl Kollwitz, a doctor of similar outlook, in 1891. With him, she moved to one of the poorer quarters of Berlin, where she gained first-hand knowledge of the wretched conditions in which the urban poor lived. The

k

two series of etchings that established her reputation were inspired by a spirit of protest against working conditions of the day, although their subjects are set in the past— *Weavers' Revolt* (1893-7) and *Peasants' War* (1902-8). After about 1910 lithography replaced etching as her preferred medium (she also made woodcuts). Her work is uncompromisingly serious and often deeply pessimistic in spirit: as Frank *Whitford put it, her clearest message is that 'man is born to tragedy'. Many of her later drawings and prints are pacifist in intention (her son was killed in the First World War and her grandson in the Second World War). Appropriately, her best-known sculpture is a war memorial—that at Dixmuiden, Flanders, near where her son was killed, completed in 1932.

One of Kollwitz's finest images is the woodcut she made in the aftermath of the repression of the Spartakist revolt, the *Memorial to Karl Liebknecht* (1919-20). The Communist leader had been a family friend, although Kollwitz's diaries of the period reveal an ambivalent attitude to revolution. She described herself as 'by no means revolutionary, but evolutionary'. At the same time she strongly suspected that 'if I declare no party allegiance, that the real reason for it is cowardice' (October 1920). In line with her left-wing views Kollwitz visited the Soviet Union in 1927, and in 1932 made a lithograph entitled *The Propeller Song*, a poster inscribed 'We protect the Soviet Union'. However, she never became a party member and her work was criticized by Communists on account of its pessimism. As well as works with a specific political polemic, she depicted themes of universal appeal such as the Mother and Child. In 1919 she had been made the first-ever woman member of the Berlin Academy, but when Hitler came to power in 1933 she was forced to resign. She suffered harassment, but she was never declared a *degenerate artist (in fact the Nazis sometimes used her images—without her name or authorization—in their propaganda), and she continued to produce outstanding work. Her masterpiece is arguably the series of eight lithographs on *Death* (1934-5), memorably showing the powerful breadth of her style, in which all accidentals and inessentials are eliminated. In 1943 her studio in Berlin was destroyed by bombing and she spent the last year of her life as a guest of Prince Ernst Heinrich of Saxony in the castle of Moritzburg near Dresden. She died only a few days before the end of the Second World War. In its

poignant concern for suffering humanity, her work represents one of the highpoints of 20th-century graphic art. She is often classified as an *Expressionist, but she is better understood in the context of the mixture of *Symbolism and politically committed *Social Realism which flourished in the late 19th and early 20th centuries. Of her contemporaries, she felt the most affinity with *Barlach, whose funeral she attended, in the face of Nazi disapproval. 'I should like', she wrote in 1922, 'to exert influences in these times when human beings are so perplexed and in need of help.'

Further Reading: R.-C. W. Long, *German Expressionism: Documents from the End of the Wilhemine Era to the Rise of National Socialism* (1993)

F. Whitford, *Käthe Kollwitz: The Graphic Work* (1981)

Komar & Melamid (Vitaly Komar) **(1943-) (Aleksander Melamid)** (1945-) Russian painters, both born in Moscow. The two artists met as students at the Stroganov Institute of Art and Design in Moscow, while studying anatomy at a morgue. In 1972 they launched the *'Sots Art' movement. In 1974, they took part in the unofficial open-air art display in Belijaevo, Moscow, which became known as the 'Bulldozer Exhibition' because of the response of the authorities. Their double self-portrait was one of the works destroyed. In 1978 they moved to New York, having already gained an audience in the West for their work through exhibitions with the dealer Ronald Feldman, so managing to avoid the disappointingly indifferent reception encountered by many émigré Soviet artists. One of their first activities in America was to engage in the business of the buying and selling of souls under the name of 'Komar & Melamid Inc'. Generally they found clients more willing to sell their own souls than buy someone else's. Andy *Warhol's was among those which passed through their hands and was knocked down to a Russian buyer for 34 roubles.

In the early 1980s they made a series of monumental paintings which drew on the imagery and style of *Socialist Realism. Part of the appeal of such works might have been that few painters in the West had undergone the rigorous training necessary to create them. The effect, however, was not to celebrate, but to undermine that tradition. Boris Groys argues that these paintings 'would have struck the Soviet consciousness as blasphemous' because of the way in which they reinscribed

the rhetoric of official painting into a history of mythological imagery, so challenging the claims of the USSR to historical uniqueness. However, Komar & Melamid depart from the sunlit brilliance and optimism of most Socialist Realism for a dramatic interplay of dark and light. This refers art-historically to the *chiaroscuro* of Baroque masters such as Caravaggio and Georges de La Tour, and also to the perpetual darkness brought about by power shortages, which the artists recalled from their youth. There is parodic, carnival-esque humour, but also the invocation of a world of nightmare.

Subsequently their work looked more to-wards the analysis of Western society. The Bayonne series (1988–90) applied the heroic treatment of the proletariat, the standby of Soviet Socialist Realism, to workers at a New Jersey brass foundry. The 'most wanted' paintings, a series on which they embarked in 1995, treated critically the notion of the autonomy and freedom of the artist. They painted according to the results of a poll to determine the most desirable characteristic for a painting in various countries. As Groys puts it, the results were 'shabby, kitschy, and clumsy', but also 'pleasantly poetic'.

The partnership was dissolved in 2003. Since then Komar has continued working in New York on a more theoretical and concep-tual path, while Melamid has moved to Rome, where in 2007 he embarked on a series of portraits of cardinals.

Further Reading: Fruitmarket Gallery, Edinburgh, *Komar & Melamid: History Painting* (1985)

B. Groys, 'The Other Gaze: Russian Unofficial Art's View of the Soviet World', in A. Erjavec (ed.), *Postmodernism and the Post Socialist Condition* (2003)

V. L. Hillings, 'Komar and Melamid's Dialogue with (Art) History', *Art Journal*, vol. 58, no. 4 (1999)

Kooning, Willem de See DE KOONING, WILLEM.

Koons, Jeff (1955–) American artist, one of the most controversial and financially successful figures in art since Andy *Warhol. He was born in York, Pennsylvania, and studied at the Maryland Institute of Art, Bal-timore, and the Art Institute of Chicago. Be-fore achieving recognition as an artist, he had a prosperous career as a Wall Street commodities broker. He also worked for a time at the New York Museum of Modern Art, significantly and successfully in the fundraising department. During the 1980s he rose to fame with work which addressed issues of commodity culture and *kitsch in ways that aroused both critical interest (if not always acclaim) and support from collectors. In early works, branded objects like balls and vacuum cleaners were put in glass cases, emphasizing their cult status by placing them beyond use. Other works not only skirt the kitsch effect but exult in it to an extent that even *Pop art would often find embarrassing. *French Coach Couple* (1986) is made in stainless steel but shines like Rococo silver. As Koons has pointed out, its reflective quality has associations with luxu-ry: 'Polished objects have often been dis-played by the church and by wealthy people to set a stage of both material secu-rity and enlightenment of a spiritual nature.' Other works play specifically with religious symbols. *Ushering in Banality* (1988) has two little angels leading forward a pig with a red-clad urchin behind. Such works are lovingly crafted. Koons employs German woodcarvers and frequently appropriates existing images. Robert *Rosenblum has compared the shock he first received from the work of Koons to that he had from his first sight of the cartoon images of *Lichten-stein, but the difference is surely that the comics of the older artist are material which few would mind admitting to have enjoyed at least when young. Koons has stated that his aim is to capture a large audience and 'also have the art stay on the highest orders' (*Flash Art*, summer 1986). He continues: 'I tell a story that is easy for anyone to enter into and in some way enjoy'. His fame (or notoriety) has been enhanced by his relationship with the Hungarian-born Italian porn star and politi-cian Ilona Staller (La Cicciolina). She figures in much of his work, which includes glass sculptures and enlarged colour photographs of the couple in sexually explicit poses. They married in 1991 but soon separated. Although some critics, like Rosalind *Krauss, have found his engagement with kitsch and the marketplace abhorrent, he has gained considerable acceptance within the museum world. For instance his floral sculpture *Puppy* is permanently installed at the *Gug-genheim Bilbao. An exhibition of his sculp-ture in 2008 at the Château de Versailles was picketed by a right-wing nationalist group who claimed that it was 'an insult to Marie-Antoinette'.

k

Further Reading: G. Politi, 'Jeff Koons', *Flash Art* (February/March 1987)

R. Rosenblum, *On Modern American Art* (1999)

P. Schedahl, 'From Criticism to Complicity', *Flash Art* (summer 1986)

Košice, Gyula (1924–) Argentinian sculptor and Kinetic artist. He was born in Košice, Czechoslovakia (now Slovakia), as Fernando Fallik and moved to Argentina with his parents when he was four. He studied at the Academia Bellas Artes in Buenos Aires but considers himself largely self-taught. In 1946 he was one of the founders of Madí (the origin of the name is uncertain), an avant-garde group that has been seen as the forerunner of international *Fluxus. Its manifesto, written by Košice, calls for a kind of universal art incorporating music, dance, poetry, and architecture. The argument was that bourgeois realism was in decline but that abstraction was too tied to the old academic techniques. Madí artists drew on *Dada and Russian *Constructivism, using shaped, uneven surfaces or moveable parts. He is regarded as one of the founders of *Constructivism in Argentina and his work often uses modern industrial materials; he was one of the first artists anywhere to incorporate neon tubing (*see* LIGHT ART) in a work (*MADI Neon No. 3*, Musée de Grenoble, 1946). His best-known works are his *Hydrosculptures*, which use jets or sheets of water. In 1965 he made a proposal for 'hydro-kinetic cities', a form of 'town-planning for space' which would take advantage of the lack of gravity to build cities supported by water vapour. In 1988 he was commissioned to make a sculpture for the Seoul Olympic Games and in 2000 he created a *Monument to Democracy* in Buenos Aires.

⊕ SEE WEB LINKS

• The artist's website.

Kossoff, Leon (1926–) British painter, born of Russian-Jewish immigrant parents in the East End of London, an area that has provided the subject-matter of many of his paintings. He studied at *St Martin's School of Art, 1949–53, and the *Royal College of Art, 1953–6, and also attended David *Bomberg's evening classes at Borough Polytechnic, 1950–52. His work has close affinities with that of another Bomberg student, Frank *Auerbach—in choice of subject, emotional treatment of it, and use of extremely heavy impasto, 'the paint dripped, dragged, flicked or coagulated, leaving the impression that the surface of the canvas is still moving, heaving and re-forming like boiling tar' (Frances Spalding, *British Art Since 1900*, 1986). Kossoff generally retains a firmer sense of structure than Auerbach, however, often using thick black outlines, and unlike him does not approach abstraction. He says that 'I simply use the paint to get closer to what I'm experiencing visually—the accumulation of memories and the unique quality of the subject on one particular, unrepeatable day'. His reputation was slow to grow, but there was a major retrospective exhibition of his work at the Tate Gallery, London, in 1996. *See also* SCHOOL OF LONDON.

Kosuth, Joseph (1945–) American artist, known for his important role in the development of *Conceptual art. He was born in Toledo, Ohio, and studied at the Toledo Museum School of Design, 1955–62, and the Cleveland Art Institute, 1963–4, before settling in New York, where he studied at the School of Visual Arts, 1965–7, and at the New School for Social Research (his subjects were anthropology and philosophy), 1971–2. In 1969 he became American editor of the journal *Art-Language*, but he soon fell out with the British *Art & Language group and launched his own journal, *The Fox*, in opposition to them. Kosuth has been much concerned with linguistic analysis of concepts of art, his best-known work being *One and Three Chairs* (1965, MoMA, New York), which consists of an actual chair alongside a full-scale photograph of a chair and an enlarged photograph of a dictionary definition of a chair. His three-part essay 'Art after Philosophy', first published in *Studio International* in 1969, was perhaps the most influential and uncompromising of all the early statements on Conceptual art. Kosuth drew on linguistic philosophy to demonstrate that art could only be understood as the definition of art. Most of what was commonly called art was, in fact, not art, because it was concerned with something else, for instance decoration, self-expression, or propaganda. The essay was especially critical of Clement *Greenberg's theories. *Formalist art was simply a form of decoration, therefore not art at all. Greenberg's values were, according to Kosuth, dependent on mere judgements of taste. *Duchamp was the crucial originator because he, according to Kosuth, was the first artist who, in his *ready-mades, had addressed the status of art itself. A van Gogh painting was no more significant than his palette: they were both purely mementoes of an earlier definition of

art. There are parallels with the contemporary 'Cultural Revolution' which was taking place in China, in the way that the past was dismissed as a mere collection of relics. Paradoxically, Kosuth seems, in retrospect, close to Greenberg in his attempt to erect a single narrow historical pathway for 'authentic' modern art. In more recent years Kosuth has been preoccupied with making art out of the 'relics'. In 1990 he mounted an exhibition, 'The Play of the Unmentionable', at the Brooklyn Museum, New York, in response to debates about censorship, using works from the collection which had at some time or another been accounted objectionable. Needless to say, most were innocuous to a contemporary audience. Kosuth remained in this work preoccupied with the use of language, complementing the objects with quotations from Oscar Wilde, Adolf Hitler, and Jean-Jacques Rousseau.

Kounellis, Jannis (1936–) Greek/Italian painter, sculptor, draughtsman, and installation artist, born in Piraeus. In 1956 he settled in Rome, where he studied at the Academy, and he has rarely returned to Greece. His early work included canvases embellished with stencilled letters, numbers, and signs, but in the mid-1960s he abandoned painting and in 1967 became associated with the *Arte Povera movement. Materials including gas flames, coal, burlap sacks, and white cotton are employed by Kounellis for their associations as well as their visual qualities. As Rudi Fuchs put it, 'there is a history in Kounellis's work of freely flowing shape and of allowing pliant material to find its own shape: smoke leaving traces of soot, loosely hanging wool or coal poured out of the sack.' Fire, for Kounellis, was not just a physical force: it also had associations with punishment and purification. The choice of materials also suggests a past industrial revolution and a human intervention into the natural world which now, through the passage of time and nostalgia, becomes itself a form of nature. In 1979, as a temporary installation, he put a track with a toy train running around a column in the cloister of the Renaissance chuch of Santa Maria Novella in Florence. Some of his most striking work has involved the presence of live humans or animals. *Cavalli* (1969) brought horses into the gallery space. This emphasis on the physicality of material has, Kounellis recognizes, a special significance in the context of the contemporary world of vir-

tual experience. In 2004 he argued that 'If construction is what counts today, if the virtual world is over, political life could perhaps benefit from the subtle and penetrating skills offered by artists as image builders *par excellence* and people capable of transforming matter, presenting the past on a silver platter, reshaped and, in the most successful cases, resplendent and dialectic'.

Further Reading: Modern Art Oxford, *Jannis Kounellis* (2004)

Kozloff, Joyce (née Blumberg) (1942–) American painter, one of the leading figures of the *Pattern and Decoration movement. She was born in Somerville, New Jersey, and studied at Carnegie Mellon University, Pittsburgh, and Columbia University, New York, where she took an MFA degree in 1967. In the same year she married the critic **Max Kozloff** (1933–), whose publications include *Renderings: Critical Essays on a Century of Modern Art* (1970); also in 1967 she visited Spain, where she became fascinated with the elaborate patterns of Islamic art. This was one of the sources that led her to a work in a style that she calls 'deliberately and even ostentatiously decorative. It comes out of a love of objects which are visually rich and sensuous. I found that in the art of other cultures there is that careful and pleasurable attention to detail which have become taboo in recent American art, and so I went to these other sources for inspiration. The paintings have a bold, geometrical structure, but they simultaneously have an intricate texture of lines and strokes on the surface, which draw the viewer up close to the work. I hope, with these paintings, to begin breaking down the hierarchies between the *high* and the *decorative* arts—and between *primitive* and *sophisticated* cultures.' Kozloff's work has included not only paintings, but also a number of large tile decorations, made between 1979 and 1984, for subway and train stations in Buffalo, Cambridge (Massachusetts), Philadelphia, and Wilmington, and for the international terminal of San Francisco airport.

Kramář, Vincenc *See* GROUP OF PLASTIC ARTISTS.

Kramer, Hilton (1928–) American critic, born in Gloucester, Massachusetts. After taking his BA at Syracuse University, he did postgraduate work at Columbia University,

the New School of Social Research, New York, Harvard University, and Indiana University. In 1954 he became associate editor and feature editor of *Arts Digest* and subsequently has worked for numerous journals, notably *The New York Times*, of which he became chief art critic in 1974. Like his colleague on *The Times*, John *Canaday, he has sometimes caused controversy because of his forceful views. He has been engaged in a long-standing war of words with politicized artists such as Hans *Haacke. The curator and critic Robert Storr has listed his condescension towards *de Kooning, *Johns, *Nauman, and *Tuttle and 'just about anyone of significant accomplishment that one can cite' and said that 'signal wrongheadedness is his only claim to art historical immortality' (*Artforum*, November 1997). In addition to journalism, he has written several books, notably *The Age of the Avant-Garde: An Art Chronicle of 1956–1972* (1973), *The Revenge of the Philistines: Art and Culture, 1972–1984* (1985), and monographs on Gaston *Lachaise (1967) and Richard *Lindner (1975). He is also the co-founder of a conservative political and cultural journal, *The New Criterion*.

Krasner, Lee (1908–84) American painter, born in Brooklyn, New York, as Lenore Krassner. Between 1926 and 1932 she studied at the Cooper Union School and the National Academy of Design, and in 1937 she was a pupil of Hans *Hofmann. She recalled that what was most important was not his lessons on painting but the seriousness of his attitude towards art. Her early work was naturalistic, but by 1940 she had turned to abstraction and was exhibiting with *American Abstract Artists. In 1941 she met Jackson *Pollock, and she married him in 1945 (they separated shortly before Pollock's death because of his affair with another woman). They sometimes exhibited together in group shows, and Krasner was an important source of encouragement and support to Pollock, whose attitude to his work fluctuated from supreme confidence to dismal uncertainty. She was herself an *Abstract Expressionist painter of some distinction, but it was only after her husband's death in 1956 that she began to receive serious critical recognition. David Anfam writes that 'Prejudice alone kept Lee Krasner outside standard histories ... her fellow artists held the same assumptions about gender that most Americans had then. At one of their

hangouts, the Cedar Tavern, Krasner recalled women being "treated like cattle".' When her work was exhibited alongside Pollock's in 1949 in an exhibition entitled 'Artists: Man and Wife' at the Sydney *Janis Gallery, *Art News* singled out her work as an example of the 'tendency among some of these wives to "tidy up" their husband's style'. The *feminist art historian Anne Middleton Wagner sees the work in a more positive light, as a product of her different roles as artist, wife, and widow. Krasner's most substantial and ambitious paintings such as *Gothic Landscape* (1961, Tate) postdate Pollock's death. She frequently made use of collage, employing her own cut-up drawings. Her handling of the Pollock estate gave rise to allegations that paintings were being released slowly for financial reasons.

Further Reading: A. M. Wagner, *Three Artists (Three Women)* (1996)

Krauss, Rosalind (1941–) American art historian and critic. She is one of the founders of *October magazine*. Trained as an art historian, she did her doctoral research on David *Smith and her book on the artist, *Terminal Iron Works* (1971), remains an outstanding study. Although originally a disciple of Clement *Greenberg, she broke radically with his thinking. In 1974 she published an article in *Art in America* which effectively accused Greenberg of vandalizing Smith's sculptures by removing the paint surface. (In fact these were not finished pieces and the paint was primer.) *Passages in Modern Sculpture* (1977) argued for a view of modernist sculpture which, by incorporating manifestations such as *Land art into a history going back to *Rodin, radically opposed the kind of *formalist purity espoused by Greenberg. *Minimal art was no longer associated with an image of reductive austerity. Instead its perceptual ambiguities and the uncertainties it offered to the spectator were emphasized. Krauss has also made noted contributions to the study of *Surrealism, arguing for the centrality of photography in the project and revaluing the role of Georges *Bataille as a theorist. His affirmation of the *informe* has been linked by Krauss to ideas in more recent art, such as the *antiform proposed by Robert *Morris as the basis of history of modernist art, which emphasizes the impure, the unclean, and the indeterminate, a radical alternative to the *formalism of Greenberg. She has now taken on something of the authority which used to be wielded by

her one-time mentor and, with it, some of the resentment. Despite her formidable reputation, there is a humorous element to her activities. In a 1995 film on Robert Morris, entitled *The Mind/Body Problem*, she appears as a pedantic lecturer, a Krazy Kat to be undermined by the artist's Ignatz Mouse (*see* HERRIMAN). Her other books include *The Originality of the Avant-Garde and Other Modernist Myths* (1985), *The Optical Unconscious* (1993), and *Bachelors* (1999). The last is a series of essays on women artists, including Louise *Bourgeois and Agnes *Martin.

Krebs, Rockne *See* LIGHT ART.

Krémègne, Pinchus *See* SOUTINE, CHAÏM.

Kren, Kurt *See* MUEHL, OTTO.

Kricke, Norbert (1922–84) German sculptor, born in Düsseldorf. He served in the air force during the war and afterwards studied at the Berlin Academy of Fine Arts. He returned to Düsseldorf because he admired the dynamism of the city with 'factories going up every day'. He worked with welded steel rods. An important influence was the wire sculpture of Hans *Uhlmann, but he was also inspired by the sight of birds in flight. 'Never', he told an interviewer in 1960, 'will I use lines as a limiting element!' In practice this meant that the steel rods were never used like the outline in drawing to delineate shape. He was also passionate about the sculptural use of water. Among many public commissions were fountains for the University of Baghdad in collaboration with Walter *Gropius. Kricke's sculpture, a technocratic art of industrial technique and material, might in fact be said to be the closest artistic embodiment of Germany's post-war 'economic miracle'. In 1972 he was appointed director of the Art Academy in Düsseldorf. It was in this capacity that he came into conflict with Joseph *Beuys, an artist with a very different conception of the role of art in post-war Germany.

Kristeva, Juliea (1941–) Bulgarian-born theorist and psychoanalyst who has lived in Paris since 1966. Although she was concerned with semiology (*see* BARTHES), the importance of her ideas for contemporary art lies in her argument that semiology is not enough. The linguistic sign must enter the realm of the symbolic, that is to say that of the body. In this Kristeva is actually restating

and providing a theoretical justification for the disquiet that many feel when art is 'reduced' to a system of conventional coded signs, as semiology so often does. Her most influential essay for the theory and practice of art is *Powers of Horror* (1980, English translation 1982). This text discusses the apocalypse which results in the loss of faith in religion and rationality, exposing the individual's sense of abjection. The idea of the 'abject' tends to be invoked by critics whenever a piece of art involves anything rather nauseating, such as the sculpture of Kiki *Smith, certain photographs by Cindy *Sherman, or the work of Mike *Kelley.

Further Reading: Harrison and Wood (2002)

Kristian, Roald *See* HAMNETT, NINA.

Krohg, Christian (1852–1925) Norwegian painter. After taking a degree in law in 1873, he trained as a painter in Germany, then in 1881–2 worked in Paris. Thereafter he lived mainly in Christiania (now Oslo), although he had a lengthy stay in Paris from 1902 to 1909, when he taught at the Académie Colarossi. In 1909 he was appointed director of the newly founded Academy of Fine Arts in Christiania and he held this post until his death. Krohg took his subjects mainly from ordinary life—often from its sombre or unsavoury aspects. In particular, he is well-known for his paintings of prostitutes, and he wrote a controversial novel on the same subject (*Albertine*, 1886). His work was often attacked by conservative critics, but his vigorous and forthright tackling of modern issues made him a hero to many Norwegian artists of a younger generation, most notably Edvard *Munch.

His son **Per Krohg** (1889–1965) was also a painter. He taught at the Academy in Oslo from 1946 to 1958 and followed in his father's footsteps by becoming director in 1955.

Kröller-Müller, Helene (1869–1939) Dutch collector and patron. She was born Helene Müller, the daughter of a shipper, and married the businessman Anton Kröller in 1888. Originally she collected delftware, but after meeting the critic H. P. Bremmer (1871–1956) in 1906, she turned her attention to modern art dating from about 1870 onwards. Bremmer remained her adviser for the rest of her life. The heart of her collection is a superb representation of paintings and drawings by van Gogh. The Dutch

government built a museum at Otterlo to house the collection in return for its bequest to the nation; designed by Henry van de *Velde, the museum—officially known as the Rijksmuseum Kröller-Müller—opened to the public in 1938, although it was not finished until 1954. The building is regarded as one of the finest pieces of museum architecture of the 20th century and is attractively set in wooded country. Helene Kröller acted as director until her death. Apart from van Gogh, the Dutch artists in whose work it is strong include Bart van der *Leck (who received regular financial support from the founder), *Mondrian (up to about 1920—Kröller did not care for pure abstract art), and the *Symbolists *Thorn Prikker and Jan *Toorop. Otherwise, French art is best represented, especially *Cubism. There are also examples of non-Western art. Acquisitions have been made since the founder's death; in particular, a sculpture garden was created in the 1960s, featuring work by *Hepworth, *Maillol, *Moore, *Rodin, *Serra, and other eminent artists.

Kropivnitsky, Lev See RABIN, OSKAR.

Kruchenykh, Alexei See ROZANOVA, OLGA.

Kruger, Barbara (1945–) American artist and designer. She had a successful career as a magazine and book designer in New York, working for magazines such as *Mademoiselle* and *House and Garden*, before turning to art in the mid-1970s, initially with fibre hangings influenced by Magdalena *Abakanowicz and then with paintings. In 1977 she began using the form for which she is best known—black and white photographs or *photomontages carrying texts challenging social stereotyping, particularly of women; in these she turned the graphic skills she had acquired as a magazine designer against the consumerist culture those publications celebrated. A famous example of 1985 showed a little girl feeling a little boy's muscles with the caption 'We don't need another hero'. More sinister is the image of three blades, the kind found in a designer's studio, in raking light, arranged like *film noir* gangsters, captioned 'I am your slice of life'. These pieces are generally untitled to emphasize that the words are part of the work rather than an explanation of the image. Her work has been seen in a museum context but also on T-shirts, billboards, matchbooks, and postcards. It has a characteristic look, one might almost say 'corporate identity', based on a limiting

of colour to black, white, and red and a consistent typeface (Futura bold italic). Kruger commented that 'If those images on the street are read as pictures with words on them, that is what they are. Whether they are read as art or not is really not of much meaning to me.'

Further Reading: S. Nairne, *State of the Art: Ideas and Images of the 1980s* (1987)

Kubin, Alfred (1877–1959) Austrian graphic artist, painter, and writer, born at Leitmeritz (Litoměřice) in Bohemia. After working as a photographer's assistant, he went to Munich to study art in 1898. From 1906 he lived mainly at Zwickledt in Upper Austria, although he travelled a good deal. He was a friend of *Kandinsky and showed his work in the second *Blaue Reiter exhibition in 1912, but his preoccupations were very different to those usually associated with the group. His work shows a taste for the morbid and fantastic, which he combined with pessimistic social satire and allegory. Often he depicted weird creatures in the kind of murky nightmare world associated with Odilon *Redon, whom he met in 1905. Kubin's imagery reflects his disturbed and traumatic life (he had an unhappy childhood, attempted suicide on his mother's grave in 1896, and in 1903 underwent a mental breakdown after the death of his fiancée). He was obsessed with the theme of death (he is said to have liked to watch corpses being recovered from the river) and with the idea of female sexuality as a symbol of death. In 1909 he published a fantastical novel, *Die andere Seite* (The Other Side), which he illustrated himself. He also illustrated many other books, often ones whose subject-matter matched his own macabre interests, such as the stories of Edgar Allan Poe. From the 1920s his reputation was widespread and he was influential on the *Surrealists. His spidery style changed little throughout his career. A translation of a collection of autobiographical essays was published in 1983 as *Alfred Kubin's Autobiography*.

Kubišta, Bohumil (1884–1918) Czech painter and graphic artist. He was born at Vlčkovice in Bohemia (as Hradec Králové) and studied in Prague and Florence. In 1907 he was one of the founders of the avant-garde Prague group The *Eight (2), and in 1909 he visited Paris; this turned his art decisively towards *Cubism, of which he became one of the leading Czech exponents. In 1911

*Kirchner and *Müller met Kubišta when they visited Prague and invited him to become a 'corresponding member' of Die *Brücke. Poverty forced him to join the army in 1913, and just as he was beginning to achieve some material security and had decided to go back to art full-time, he died in the influenza epidemic of 1918.

Kubota, Shikego See ACTION PAINTING.

Kuhn, Walt (1877–1949) American painter, cartoonist, designer, and art adviser, born in New York. His first name was originally William, but he adopted 'Walt' at about 1900. In his late teens he earned his living partly by running a bicycle shop, then in 1899 began working as a cartoonist in San Francisco. From 1901 to 1903 he studied in Europe, before settling in New York, where he worked as a cartoonist and illustrator for various journals over the next decade. His painting of this time was influenced by *Fauvism, but Kuhn was more important as a promoter of modern art than for his own work. His most significant role was in helping to organize the *Armory Show in 1913: he and Arthur B. *Davies were its chief architects. Kuhn was also an adviser to several pioneer collectors of modern art in the USA, notably Lillie P. *Bliss and John *Quinn.

In the wake of the Armory Show, Kuhn experimented with *Cubism, but he reverted to a much more naturalistic style, and in the 1920s he began producing the pictures of circus performers that are his best-known works. Typically they depict a single figure, seated or half-length, boldly and frontally presented against a stark background (*The Blue Clown*, 1931, Whitney Museum, New York). The colours are often strong, even garish, but otherwise these paintings are fairly conservative. Kuhn also painted still-lifes and landscapes and he worked as a designer for musical reviews and of industrial products. He died in a mental hospital after suffering a nervous breakdown.

Kulagina, Valentina (1902–87) Russian graphic designer, born and active in Moscow. Like her husband, Gustav *Klutsis, she employed the technique of *photomontage but sometimes combined it with stylized figures close to *Art Deco. It is likely that she collaborated without credit on some of his work. She was responsible for the photomontage design dedicated to Siberia in the Soviet

pavilion at the 1937 Paris International Exhibition. The 'deforming perspective and scales' were criticized by *Soviet Photo*, a signal of a hardening line against experimentalism in photography comparable to that taken in painting earlier with the establishment of *Socialist Realism.

Further Reading: M. Tupitsyn, *Gustav Klutsis and Valentina Kulagina: Photography and Montage after Constructivism* (2004)

Kuniyoshi, Yasuo (1893–1953) Japanese-American painter, born at Okayama. He emigrated to the USA in 1906 and studied first in Los Angeles and then, after moving to New York in 1910, at several art schools, notably the *Art Students League, 1916–20. His work shows evidence of his Oriental origins only in a very vague way. In the 1920s and early 1930s he painted in a slightly whimsical manner, often with pastoral imagery, but in the 1930s (at which time he began to achieve serious recognition) his style became more sensuous; his pictures of moody women are indebted to those of his friend *Pascin. His later work showed a deepening social and political conscience, expressed in harsher colouring and sometimes disquieting imagery. During the Second World War he designed posters against Japan, but since the 1960s there has been a growing interest in his work there. From 1933 until his death Kuniyoshi taught at the Art Students League.

Kunst für Alle See HÖLZEL, ADOLF.

Kunst- und Ausstellungshalle der Bundesrepublik Deutschland, Bonn See HULTEN, PONTUS.

Kupka, František (Frank, François) (1871–1957) Czech painter and graphic artist, active mainly in France, a pioneer of abstract art. He was born in Opočno in eastern Bohemia and studied at the Academies of Prague (1889–92) and Vienna (1892–3). At this time he was painting historical scenes in a traditional style. In 1895 or 1896 he moved to Paris, which was to be his home for the rest of his life (from 1906 he lived in the suburb of Puteaux). In his early days in Paris he worked mainly as a book illustrator and satirical draughtsman; his paintings were influenced by *Symbolism and then *Fauvism. From an early age he had been interested in the supernatural (later in theosophy), and from this grew a concern with the spiritual symbolism

of colour. It became his ambition to create paintings whose colours and rhythms would produce effects similar to those of music, and in his letters he sometimes signed himself 'colour symphonist'. From 1909 (inspired by high-speed photography) he experimented—in a manner similar to that of the *Futurists—with ways of showing motion, and by 1912 this had led him to one of the earliest examples of complete abstraction in *Amorpha: Fugue in Two Colours* (NG, Prague). This was exhibited at the *Salon d'Automne that year. As with *Delaunay and the *Orphists, to whom his work was closely related, Kupka excelled at this stage in his career in the creation of lyrical colour effects.

At the outbreak of the First World War Kupka volunteered for military service and fought on the Somme; he also did a good deal of propaganda work such as designing posters and was discharged with the rank of captain in 1919. In 1922 he lectured at the Prague Academy, which appointed him a professor in Paris with the brief of introducing Czech students there to French culture. Before the war Kupka had written a theoretical text in French, *La Création dans les arts plastiques*, and in 1923 this was published in Prague as *Tvoření v Umění výtvarém* (Creativity in the Visual Arts). In 1931 he was one of the founder members of the *Abstraction-Création group, but he resigned in 1934. His later work was in a more geometrical abstract style. Although Kupka gradually established a considerable reputation, his pioneering role in abstract art was not generally realized in his lifetime. The re-evaluation of his career began with an exhibition of his work at the Musée National d'Art Moderne, Paris, in 1958, a year after his death.

Kuroda Seiki See FOUJITA, TSUGOUHARU.

Kusama, Yayoi (1929–) Japanese painter, sculptor, installation and Performance artist, and writer. Born in Matsumoto, as a child she suffered from hallucinations in the form of fields of dots. These became the principal motif of her work. In 1958 she settled in New York, where she established a close relationship with Joseph *Cornell. Initially she worked as a painter but, by her own account, developed towards installation as a result of one of her hallucinations during which, while painting, she discovered her hands covered with red polka dots. Her environments engulf the viewer in the artist's dot obsession, most spectacularly in the works using mirrors to produce an infinite space. The dots recurred in *Happenings, as in the *Grand Orgy to Awaken the Dead* (1969), held at MoMA, New York, during which naked figures, painted with dots, posed in the sculpture garden. The dots represent for the artist 'self-obliteration', by which she means 'By obliterating one's individual self, one returns to the infinite universe'. Another Kusama motif was the phallus. Everyday objects were covered with soft phallic protrusions or, in her 1965 installation *Infinity Mirror Room (Phalli's Field)*, strewn all over the floor. She has stated 'The armchair thickly covered with phalluses was my psychosomatic work done when I had fear of sexual vision'. Her work was closely allied to the anti-war, free love, spirit of the late 1960s, but although she achieved some celebrity, she had little commercial success and returned to Japan in 1973. Since 1975 she has lived voluntarily in an asylum near Tokyo. She was almost forgotten outside her home country until the late 1980s, but she represented Japan at the Venice *Biennale in 1993 and a major exhibition of her work which toured Los Angeles, New York, and Tokyo in 1998–9 set the seal on her international reputation. Her striking appearance, frequently enhanced in later years by brilliantly coloured wigs, has played such an important role in the reception of her work that it is now almost irrelevant to make a distinction between art and persona.

Further Reading: G. Turner, 'Yayoi Kusama', *Bomb*, issue 66 (winter 1999)

Kushner, Robert See NEO-EXPRESSIONISM; PATTERN AND DECORATION MOVEMENT.

Kuznetsov, Pavel See BLUE ROSE.

LAA *See* COURTAULD, SAMUEL.

Labisse, Félix (1905–82) French painter, theatre designer, and illustrator. He was born in Douai in northern France and died in Paris. In 1927 he moved to Ostend, where he met James *Ensor, who was to be a lasting influence. He returned to France in 1937 but his style of *Surrealist painting always had a closer affinity with the Belgians René *Magritte and Paul *Delvaux than with the Paris-based artists of the movement. Certain of his paintings carry an obvious political import. In *La Terreur blanche* (1945) the King and Queen from a pack of cards are holed up in a derelict building, doggedly defending themselves to the last against revolution, while *Le Délassement de l'odalisque* (1968) confronts a nude reminiscent of Ingres with a scene of colonial warfare in North Africa. More frequently he aimed at a perverse eroticism. As in a fetishist's obsession, the female head is veiled, obscured, or even replaced by that of an animal. The blue nude became something of a trademark. The poet Jacques Prévert praised him because 'he shows beautiful images, delicately bloodied'. This was especially true of the object shown at the 1964 exhibition of Surrealism at the Galerie Charpentier in Paris. An exquisitely manicured hand in plaster, severed by an axe, was accompanied by the message 'My love, you asked me for my hand, I give it to you'.

Further Reading: Casino Kursaal, Ostend, *Labisse 50 Jaar Schilderkunst* (1979)

Laboratory art *See* INKHUK.

Labyrinthe *See* SKIRA, ALBERT.

Lacan, Jacques *See* PSYCHOANALYSIS.

Lacey, Bruce (1927–) British artist, born at Catford, London. After leaving school aged thirteen, he worked at a variety of jobs. He took up painting while in hospital suffering from tuberculosis, 1947–8, then studied at Hornsey College of Art, 1948–51, and the *Royal College of Art, 1951–4. 'Within a year of leaving it had all gone . . . All I could do was sit in my little attic studio and play with the sunlight'; he stopped painting, and turned to the world of entertainment, working as a knife-thrower among other things. Then in 1962 he began making *environments and the works for which he is best known—witty animated robots, ingeniously constructed of all manner of debris (*Boy Oh Boy, Am I Living*, 1964, Tate). These were brought together in an exhibition at the Marlborough New London Gallery in 1965. After this he abandoned sculpture, moving to Avebury and becoming involved with 'earth magic'. As a Performance artist he worked for a time in partnership with his second wife Jill Bruce, whom he married in 1967.

Lachaise, Gaston (1882–1935) French-born sculptor who became an American citizen in 1916. He was born in Paris and his training included a period at the École des *Beaux-Arts. In 1906 he emigrated to the USA, where he became one of the pioneers of modern sculpture. He settled first in Boston, then in 1912 moved to New York, where he became assistant to Paul *Manship. In 1913 he exhibited in the *Armory Show, and he had his first one-man exhibition in 1918, at the Bourgeois Galleries. This established his reputation, and in the 1920s he became admired by the poets and intellectuals who were associated with *The Dial*, the leading literary review of the period. His most important patron was Lincoln Kirstein (1907–96), a writer and founder of the New York City Ballet.

Lachaise was a consummate craftsman in stone, metal, and wood (his father a cabinetmaker); he helped to introduce the method of *direct carving in America, but his most characteristic works are in bronze. He is best known for his female nudes—monumental and anatomically simplified figures, with voluptuous forms and a sense of fluid rhythmical movement (*Standing Woman*, 1912–27,

Whitney Museum, New York). Their smooth modelling links them with the work of *Nadelman, who was also at this time helping to lead American sculpture away from the 19th-century academic tradition, but Lachaise's figures are bulkier than those of Nadelman and have an overt sexuality that has caused them to be compared with the nudes of *Renoir. In 1935 he was given a retrospective exhibition at the Museum of Modern Art, New York—the first American sculptor to be so honoured. Later that year he died of leukemia.

Further Reading: H. Kramer, *The Sculpture of Gaston Lachaise* (1987)

Laethem-Saint-Martin (Sint-Martens-Latem)

A Belgian village, near Ghent, that became popular with artists in the late 19th century and which in the early 20th century was the centre of two distinct groups, known as the First and Second Laetham Schools. The artists who made up the First School settled there c.1900 under the aegis of the poet Karel van de Woestijne to enjoy the simple life in communion with nature. The principal figures were the sculptor Georg *Minne and the painters Valerius de Saedeleer (1867–1941), Albert *Servaes, and Gustave van de Woestijne (1881–1947), brother of the poet. Their work consisted mainly of simple peasant scenes and landscapes in a meditative and somewhat melancholy *Symbolist vein. A few years later the members of the Second School came together; they included Frits van den *Berghe and the brothers Gustave and Léon de *Smet. In 1909 they were joined by *Permeke. This Second Laetham School was broken up by the First World War, but it was the chief cradle of Belgian *Expressionism.

Lafontaine, Mari-Jo See VIDEO ART.

La Fresnaye, Roger de (1885–1925)

French painter. He was born in Le Mans, the son of an aristocratic army officer, and between 1903 and 1909 studied in Paris successively at the *Académie Julian, the École des *Beaux-Arts, and the Académie Ranson. In 1912–14 he was a member of the *Section d'Or group, and his work shows an individual response to *Cubism: his paintings were more naturalistic than those of *Braque and *Picasso, but he adopted something of their method of analysing forms into planes. As Clement *Greenberg put it, 'Cubism is used as a decorative façade rather than as a means

of transforming space integrally'. La Fresnaye's prismatic colours reflect the influence of *Delaunay, as in his most famous and personal work, *The Conquest of the Air* (1913, MoMA, New York), in which he portrays himself and his brother in an exhilaratingly airy setting with a balloon ascending in the background. La Fresnaye's health was ruined during his service in the army in the First World War (he was discharged with tuberculosis) and he never again had the physical energy for sustained work. In his later paintings he abandoned Cubist spatial analysis for a more linear style. His final works include a number of self-portraits and also, in *Le Bouvier* (1921), an early and distinguished contribution to those monumental images of rural labour which were a feature of French painting between the wars. His reputation was at its height in the years after his death when he was regarded in France as a major painter, but today he tends to be sidelined as another 'Salon Cubist'.

Laing, Gerald See POP ART.

Lam, Wifredo (1902–82)

Cuban painter, born in Sagua la Grande. His father was Chinese, his mother of mixed African, Indian, and European origin, and Lam's career was appropriately cosmopolitan. After studying at the Academy in Havana, 1930–33, he settled in Madrid in 1924. In 1938 he moved to Paris, where he became a friend of *Picasso. He also met *Breton (whose book *Fata Morgana* he illustrated in 1940) and in 1939 he joined the *Surrealists. In the same year he had his first one-man exhibition, at the Galerie Pierre Loeb. In 1941 he sailed from Marseilles to Martinique on the same ship as Breton, *Masson, and many other intellectuals who were fleeing the Germans. He made his way back to Cuba in 1942 and over the next few years his work was influenced both by jungle scenery and by savage local ceremonies. Following visits to Haiti in 1945 and 1946 he also began incorporating images of Voodoo gods and rituals in his work. From 1947 to 1952 he travelled extensively, spending time in Cuba, New York, and Paris. In 1952 he settled in Paris again, but from 1960 he also spent much of his time in Albisola Mare, near Genoa. In the 1970s he began making bronze sculpture.

Lam's work reconciled the European avant-garde with the artistic traditions of Latin America and the powerful mystique of African

and Oceanic art, fusing human, animal, and vegetable elements in menacing semi-abstract images (*Rumblings of the Earth*, 1950, Guggenheim Museum, New York). He won several prestigious prizes and his work is included in numerous leading collections of modern art, among them Tate, and the Museum of Modern Art, New York.

Further Reading: C. L. Carter, *Wifredo Lam in North America* (2008)

Lamb, Henry (1883–1960) British painter, mainly of portraits. He was born in Adelaide, Australia, where his father, Sir Horace Lamb, was professor of mathematics at the university, and was brought up in Manchester, where his father became professor in 1885. Under parental pressure he studied medicine, but he abandoned it in 1904 to become an artist, training first at Chelsea Art School (*see* JOHN, AUGUSTUS) and then in 1907–8 in Paris under *J.-E. Blanche. (On the outbreak of the First World War, however, Lamb returned to his medical studies, qualifying at Guy's Hospital, London, in 1916 and then serving as a medical officer in France, Macedonia, and Palestine; he was gassed and won the Military Cross. He also worked as an *Official War Artist, as he did again in the Second World War.) Lamb was associated with the *Bloomsbury Group and is best known for his sensitive portraits of fellow members, done in the restrained style that characterized his work throughout his career. Above all he is remembered for his portrait of the writer Lytton Strachey (1914, Tate), in which he 'has relished emphasizing Strachey's gaunt, ungainly figure, and the air of resigned intellectual superiority with which he surveys the world from that incredible slab-like head' (*DNB*). Apart from portraits, Lamb also painted landscapes and (especially in later life when his health was failing) still-lifes.

Further Reading: K. Clements, *Henry Lamb: The Artist and his Friends* (1985)

Lambert, Maurice (1901–64) British sculptor, born in Paris, son of the Australian portrait painter **George W. Lambert** (1873–1930) and brother of the composer Constant Lambert. He trained as a sculptor by serving as apprentice to Derwent *Wood, 1918–23. Lambert was a versatile artist, equally adept at carving and modelling; he used a wide variety of materials, including various stones, metals, and woods, and he experimented with glass and concrete. His work included portraits, statues, fountains,

and architectural sculpture. Stylistically he was eclectic, achieving a compromise between traditionalism and modernism: 'If he had one eye on the example set by *Brancusi, his other rested on the potential buyer: his *Birds in Flight* [1926, Manchester Art Gallery], for example, has an ingratiating elegance, a vitiating desire to do no more than please' (Frances Spalding, *British Art Since 1900*, 1986). From 1950 to 1958 he taught at the *Royal Academy.

Lamourdedieu, Raoul *See* DIRECT CARVING.

Lanceley, Colin (1938–) Australian painter and sculptor. He was born in Dunedin, New Zealand, and moved to Australia as a child in 1940. After studying at East Sydney Technical College and the National Art School, Sydney, he went to Italy on a travelling scholarship in 1965, then settled in London until 1981, when he returned to Sydney. In the early 1960s he became the leading Australian exponent of *Pop art; later his style became more abstract. His work has often included three-dimensional elements, including found objects: 'I work in an area between painting and sculpture, combining both painted and sculpted images, in order to create an ambiguous space in front of the picture surface.'

Land art (Earth art, Earthworks) A type of art that uses as its raw materials earth, rocks, soil, and so on. The three terms above are not usually clearly differentiated, although 'Earthworks' generally refers to very large works. This type of art emerged as a movement in the late 1960s and has links with several other movements that flourished at that time: *Minimal art in that the shapes created are often extremely simple; *Arte Povera in the use of 'worthless' materials; *Happenings and *Performance art because the work created was often impermanent; and *Conceptual art because the more ambitious earthwork schemes frequently exist only as projects. The art historian Robert Rosenblum located Land artists within a long Romantic tradition. He wrote: 'As pilgrims to the sublime, breaking free from the confines of museums and galleries, these new voyagers have gone, often literally, to the ends of this earth in order to make a human mark so that we, and perhaps some future extraterrestrials, will know that the impulses that produced Stonehenge and the great pyramids are still, against all odds, alive.' There are affinities with the

passion at this time for the study of prehistoric mounds and ley lines—part of the hippie back-to-nature ethos that expressed a disenchantment with the sophisticated technology of urban culture. The desire to get away from the traditional elitist and money-orientated gallery world was also very much typical of the time, although large earthworks have in fact necessitated very hefty expenditure, and far from being populist and accessible, such works are often in remote areas. Moreover, in spite of the desire to sidestep the gallery system, dealers have proved capable of exploiting this kind of art, just like any other. The concept of Land art was established by an exhibition at the Dwan Gallery, New York, in 1968 and an exhibition 'Earth Art' at Cornell University in 1969. The Dwan exhibition included the photographic records of Sol *Lewitt's *Box in a Hole* (the burial of a steel cube) and Walter *De Maria's *Mile Long Drawing* (two parallel white lines traced in the Nevada desert). These belong equally (if not more) to the category of Conceptual art, but De Maria has also filled rooms with earth, and other artists have brought materials such as rocks and twigs into the gallery.

The artist associated more than any other with large-scale earthworks *in situ* was Robert *Smithson, whose *Spiral Jetty* (1970) in the Great Salt Lake, Utah, is easily the most reproduced work of this kind. Other leading exponents include Alice Aycock (1946–), whose work has included underground mazes, Mary Miss (1944–), and Michael Heizer (1944–), whose best-known work is *Double Negative* (1969–70) in the Nevada desert—two cuts 30 feet wide and 50 feet deep, with a total length of 1,500 feet, in an area where he said he found 'that kind of unraped, peaceful religious space artists have always tried to put in their work'. Some critics, however, consider that earthworks on such a scale can themselves constitute a type of rape or violation.

Further Reading: Rosenblum (1999)
A. Sonfist (ed.), *Art in the Land* (1983)

Lane, Sir Hugh (1875–1915) Irish dealer, patron, collector, and administrator, born at Ballybrack House, County Cork, the son of a clergyman. He spent much of his boyhood travelling on the Continent and in 1893 began working for Colnaghi's, the famous London firm of picture-dealers. In 1898 he set up in business on his own, and his sure eye, energy, and flair soon earned him a for-

tune. He had no particular interest in Ireland until about 1900, when through the influence of Sarah Purser (*see* AN TÚR GLOINE) and the playwright Lady Gregory (his aunt) he became caught up in the rising tide of nationalism in the arts. In the remaining years of his short life he became 'the most important patron of the arts Ireland has ever had' (Anne Crookshank and the Knight of Glin, *The Painters of Ireland*, 1978). He commissioned John *Butler Yeats to paint a series of eminent contemporary Irishmen (it was completed by *Orpen, a distant cousin and close friend of Lane's) and he helped to found Dublin's Municipal Gallery of Modern Art, opened in temporary premises in 1906. In addition to giving and lending numerous works to the gallery (and persuading others to do the same) he offered to bequeath his finest late 19th- and early 20th-century French paintings to Dublin, on condition that a suitable gallery be built to house them. This caused arguments with the Dublin city authorities, however, and he moved the 39 pictures (among them *Renoir's celebrated *Umbrellas*) to the National Gallery in London. In 1914 Lane was appointed director of the National Gallery of Ireland, and the following year he was killed when the *Lusitania* (on which he was returning from business in the USA) was torpedoed by a German submarine. A codicil to his will expressed his intention of returning the French pictures to Dublin, but it was not witnessed and was, in any case, dependent upon a suitable building, creating a long-term legal dispute about their ownership. In 1959 an agreement was eventually reached whereby the paintings were divided into groups to be shown alternately in Dublin and London. This agreement was renewed in 1980 and modified in 1993 so that the bulk of the collection remains in Dublin. The Municipal Gallery of Modern Art was given a permanent home in Dublin in 1933, and in 1979 it was renamed the Hugh Lane Municipal Gallery of Modern Art. It is now known as Dublin City Gallery, The Hugh Lane.

Lange, Dorothea (1895–1965) American photographer, born in Hoboken, New Jersey, as Dorothea Magaretta Nutzhorn. She adopted her mother's maiden name after her father abandoned the family in 1907. As a child she had polio that left her crippled in one leg, a circumstance which she maintained gave her a special sympathy with the downtrodden. She is best known for the documentary images of

migrant workers she made in 1935–7 for the Farm Security Administration. This scheme to record rural poverty was specifically intended to arouse support for Government reform programmes and Lange worked in close association with her husband, the economist Paul Taylor. *Migrant Mother, Nipopomo, California*, perhaps the most potent single picture of the Great Depression, became a timeless icon of endurance and suffering. Analysis of the entire sequence of photographs which led up to this image shows that in spite of the speed with which Lange worked—she was only with the family for ten minutes—the picture was carefully composed and framed to establish an almost religious association with the traditional iconography of Madonna and Child. In 1942 Lange had a further government commission, this time to record the internment of Japanese Americans following the attack on Pearl Harbor. On this occasion, the photographs were implicitly so critical of the policy and revealing of its consequences that the results were impounded by the army and virtually unseen until 1972, when they were exhibited at the Whitney Museum, New York.

Further Reading: J. Curtis, *Mind's Eye, Mind's Truth: FSA Photography Reconsidered* (1989)

Langlands and **Bell** *See* VIDEO ART.

Langley, Walter *See* NEWLYN SCHOOL.

Lantéri, Edward *See* ROYAL COLLEGE OF ART.

Lanyon, Peter (1918–64) British painter, born at St Ives, Cornwall. He studied at Penzance School of Art in 1937, at the *Euston Road Art School in 1938, and then under Ben *Nicholson and Naum *Gabo at St Ives. From 1940 to 1946 he served in the RAF and from 1950 to 1957 taught at the *Bath Academy of Art, Corsham. He also travelled and taught in the USA, but St Ives remained his home and his principal inspiration. Early in his career he made *assemblages influenced by Gabo; they were built up from found objects such as driftwood, pieces of glass, rope, etc, sometimes free-standing and sometimes boxed, and often brightly painted. His paintings developed from a lyrical naturalism to complete abstraction, but they remained based on his observation of the Cornish landscape that he loved. In the 1950s his handling became free and *gestural, and in 1959 he took up gliding, which led him to paint pictures evoking the invisible forces of the air rather than specific places (*Thermal*, 1960, Tate). He wrote that 'The air is a very definite world of activity, as complex and demanding as the sea'. Lanyon died in a gliding accident. Among the notable abstract painters of the *St Ives School, he was the only one who was a native of the town. As well as paintings, he made prints in various techniques.

Further Reading: M. Garlake, *Peter Lanyon* (2002)

Lapicque, Charles (1898–1988) French painter, printmaker, and sculptor, born at Taizé, Rhône. He obtained a degree in civil engineering at Lisieux in 1924 and in 1938 became a Doctor of Science with a dissertation on 'Optics and the Perception of Contours'. He took up painting as a hobby in 1925 and during the 1930s exhibited in the main Paris Salons. In 1937 he painted decorations for the Palais de la Découverte at the Paris Exposition Universelle, and in 1941 he began exhibiting with the *Peintres de Tradition Française. After the Second World War his work took on some of the characteristics of the abstraction typical of the *École de Paris at this time, but it remained based on natural appearances. From the scene before him, he evolved a network of heavy crisscross lines, the intervals between which were filled with colour as if seen behind a lattice. His colourful style was influenced by *Dufy, with whom he shared a liking for cheerful subjects such as horse races and regattas. In addition to paintings, he made prints in various techniques and occasionally worked as a sculptor, producing carved stone heads.

Lapoujade, Robert *See* SARTRE, JEAN-PAUL.

Lapper, Alison *See* QUINN, MARK.

Larionov, Mikhail (1881–1964) Russian-French painter and designer, one of the leading figures in the development of modernism in Russia in the period before the First World War. He was born at Tiraspol, near Odessa, the son of a doctor, and studied at the Moscow School of Painting, Sculpture, and Architecture, 1898–1908; he was suspended three times during his course because of disagreements with the staff. His fellow student Natalia *Goncharova became his lifelong companion and artistic associate (they eventually married in 1955). Larionov's early work was influenced by *Impressionism, but from 1908, together

with Goncharova, he developed a style known as *Neo-primitivism, in which he blended *Fauvist colour with elements drawn from Russian folk art. Together they were involved in a series of avant-garde groups and exhibitions, notably the *Knave of Diamonds group, founded in 1910, the *'Donkey's Tail' exhibition in 1912, and the *'Target' exhibition in 1913, at which Larionov launched *Rayonism, a near-abstract movement that was a counterpart to Italian *Futurism.

In May 1914 Larionov and Goncharova accompanied *Diaghilev's Ballets Russes to Paris. They returned to Russia in July on the outbreak of the First World War, and Larionov served in the army and was wounded. After being invalided out, he and Goncharova left Russia permanently in 1915, moving first to Switzerland and then settling in Paris in 1919 (they became French citizens in 1938). In Paris he practically abandoned easel painting and concentrated on theatrical designing for the Ballets Russes. The ballets he worked on included *Les Contes russes* (1922), a sequence of episodes from Russian fairy-tales and folklore, with choreography by Léonide Massine and music by Liadov. After Diaghilev's death in 1929 Larionov took up painting again, but he gradually sank into obscurity and his final years were marred by illness and poverty. His reputation was revived shortly before his death with retrospective exhibitions (jointly with Goncharova) in London (Arts Council, 1961) and Paris (Musée d'Art Moderne de la Ville de Paris, 1963).

Further Reading: A. Parton, *Mikhail Larionov and the Russian Avant-Garde* (1996)

Larsson, Carl (1853–1919) Swedish painter, illustrator, printmaker, and writer. He was born in Stockholm, where he studied at the Academy. His work included numerous portraits and book illustrations, as well as several large-scale murals (the best known are those on Sweden's artistic history in the Nationalmuseum, Stockholm, 1896), but he is now remembered mainly for the house he created in the village of Sundborn in Dalarna (Dalecarlia) and for his watercolours of the idyllic life he enjoyed there. Larsson and his wife, **Karin** (1859–1928), a textile designer, were given the property by her father in 1889; at this time it was a simple log cabin, used as a holiday home, but they greatly extended and embellished it over the next decade and settled there permanently in 1901. They created a

totally new approach to interior decoration, replacing the sombre and cluttered look typical of the late 19th century with simple furniture, bright colours, and a sense of light and air. Larsson delighted so much in the house—called Lilla Hyttnäs—that he recorded every nook and cranny in his watercolours. He said that 'They are a genuine expression of my personality and of my deepest feelings, and of all my limitless love for my wife and children'. From 1895 he published several collections of these watercolours in book form accompanied by his own texts. The books were enormously popular and made Larsson into a national institution. Lilla Hyttnäs soon became a tourist attraction and it was opened as a museum in 1942. To Swedes it epitomizes a healthy, happy society, and it has exercised a lasting influence on Scandinavian interior design. Fittingly, the Swedish furniture firm Ikea was the sponsor of a major exhibition on the Larssons at the Victoria and Albert Museum, London, in 1997: 'Carl and Karin Larsson: Creators of the Swedish Style'.

Lartigue, Jacques Henri (1894–1986) French photographer and painter, born in Courbevoie on the outskirts of Paris as Jacques Lartigue; he only added his father's name to his at the age of 69. He came from one of France's wealthiest families. For most of his career, he regarded himself primarily as a painter, but his work in that medium, although pleasant and accomplished, is unremarkable. What brought him worldwide fame was his photography. He took his first photograph at the age of six and began pasting the results into scrapbooks when he was eight. The photographs he made before the First World War are an extraordinary record of high society in the *Belle Époque* but also document the technical innovations of the period, notably the early motor car and, especially, the aeroplane. He began visiting airfields in 1907 and photographed the flights of the most celebrated aviators, including Blériot. Quite apart from their historical value, what impresses in these images is their extraordinary dynamism. The combination of spontaneity and exact composition had scarcely been achieved by earlier photographers but was to be one of the markers of supreme achievement in the medium in the century to follow. During the First World War, Lartigue was excused military service for health reasons and in 1915 began studying painting at the *Académie Julian. In the

1920s, although his major professional activity was painting, he made colour photographs using the autochrome process. Ian Jeffrey has written that these 'embody luxury and ease as few other images do'. It was not until 1963 that his photographs became widely known through an exhibition at the New York Museum of Modern Art. In 1979 he donated his entire photographic work to the French state. He died in Nice.

SEE WEB LINKS

• The website of the Donation Jacques Henri Lartigue.

Lasers *See* LIGHT ART.

Lassaw, Ibram (1913–2003) American sculptor, born in Egypt of Russian parents. His family emigrated to the USA in 1921 and he became an American citizen in 1928. He studied at various art colleges in New York. By 1933 he was experimenting with abstract sculpture (one of the first Americans to do so) and in 1936 he was a founder of *American Abstract Artists (he was president 1946–9). Most of his early work was in plaster, but during his army service in the Second World War he learnt the welding techniques that led to the creation of his distinctive mature style in about 1950. From this time he began making three-dimensional latticework constructions in welded bronze and steel, looking rather like some kind of bizarre scaffolding. In the 1960s his work became more expressive and sometimes took on a suggestion of natural forms. He was a serious student of Zen and his later work has sometimes been held to be expressive of the serenity and sense of cosmic oneness associated with that philosophy. It includes several large indoor and outdoor commissions for religious buildings and private residences.

Lassnig, Maria (1919–) Austrian painter and film-maker, born in Carinthia. After studying at the School of Fine Arts in Vienna, she went to Paris on a scholarship in 1951, when she met leading *Surrealists including André Breton. From 1968 to 1978 she lived in New York. In 1980 she was appointed Chair of the Academy of Fine Arts in Vienna, the first woman ever to have such a post in a German-speaking country. Lassnig's paintings are based on what she calls 'body-awareness', which she puts in opposition to the external view of 'retinal awareness'. In her late works, which she calls 'drastic paintings', she claims

to have conjoined the two forms of perception. Unlike many figurative painters today, she never works from photographs. For this reason, in spite of her admiration for Francis *Bacon, she describes him as 'not a kindred spirit'. Yet the viewer is likely to perceive some similarity in the two painters' chilling vision of the human condition and fascination with the capacity of paint to simulate flesh. This is a theme of one of her most powerful paintings, *Iron Virgin and Fleshly Virgin* (2004). It is a double self-portrait, Lassnig as both artist and model: the austere grey iron virgin in her old woman's cap brings to life the fleshly puling infant virgin in a startling metaphor for the combination of detachment and engagement involved in the making of art. Lassnig has also made animated and live action films. The best known of these, *Cantata* (1992), has the artist singing an account of her life and work in a faux-naif folksy style, playing the 'feisty old woman'. An exhibition at the Serpentine Gallery, London, in 2008 provoked widespread astonishment that her work was so little known.

Further Reading: J. Heizer, 'Inside Out', *Frieze Magazine* (November 2006)

Serpentine Gallery, *Maria Lassnig* (2008)

Latham, John (1921–2006) British artist and theorist, born in Livingstone, Northern Rhodesia (now Maramba, Zambia). After serving in the Royal Navy in the Second World War, he studied at Chelsea School of Art, 1946–50. Latham was best known for work in which he used books as raw material. In 1958 he began making 'skoob' ('books' spelt backwards) reliefs, and in the 1960s he was involved in *Happenings that he called Skoob Tower Ceremonies, in which sculptures made of piles of books were ritually burned—'to put the proposition into mind that perhaps the cultural base has been burned out'. His most famous gesture came in 1966, when—as a part-time lecturer at *St Martin's School of Art—he borrowed a copy of Clement *Greenberg's *Art and Culture* from the library and with the sculptor Barry *Flanagan, alongside invited guests, chewed up pages and immersed them in acid to produce a 'culture'. Some months later he was requested to return the book by the librarian. He was told it was urgently needed by a student. Shortly after attempting to return the remnants, his contract was terminated. The work created by the chewed pages—entitled *Art and Culture*—was

bought by the Museum of Modern Art, New York, in 1970.

In 1966 Latham took part in the Destruction in Art Symposium alongside *Metzger at the *Institute of Contemporary Arts, London. Out of this he founded the Artist Placement Group (later called O + I) with his wife, Barbara Steveni. The intention was to make links between artists and industry. An exhibition at the Hayward Gallery, London, in 1971 publicized his ideas more widely. Although the *Arts Council withdrew funding in 1972 on the grounds that the APG was more concerned with social engineering than with art, the organization continued to make links with business and government organizations. Latham's ultimate concern was not just to find work for artists but to use their input to achieve social change according to a complex theory of the 'event structure'. His ideas were widely mocked within the art world during the 1970s, partly because, in a climate strongly affected by Marxism, the whole idea of collaboration with business seemed hopelessly conformist. His conception of 'time-based events' was greeted by one correspondent to *Art Monthly with the riposte that all events have to be time-based because 'they get awfully short otherwise'. However, shorn of a philosophy which perhaps only Latham and a few associates entirely understood, the basic practical notion has survived in a changed social and political climate.

(⊕) SEE WEB LINKS

• Resource on the Artist Placement Group on the Tate website.

La Thangue, H. H. (Henry Herbert) (1859–1929) British painter. He had his main training at the *Royal Academy in London and the École des *Beaux-Arts in Paris. In 1887 he described the Academy as 'the diseased root from which other evils grow', and he was one of the leading figures in founding the *New English Art Club in opposition to it and in introducing the ideals of French *plein-air* painting to Britain. He lived in the countryside (first in Norfolk, then in Sussex), and *Clausen wrote of him: 'Sunlight was the thing that attracted him: this and some simple motive of rural occupation, enhanced by a picturesque surround.' From about 1898 he turned to peasant scenes set in Provence or Italy, places where he often stayed. As the countryside changed, his work became increasingly nostalgic, as he hankered after what *Munnings called a 'quiet old world village where he could live and find real country models'.

Laurencin, Marie (1883–1956) French painter, illustrator, and stage designer, born in Paris. Apart from evening classes in drawing, she was self-taught as an artist. In 1907 she was introduced by the picture dealer Clovis Sagot to *Apollinaire, *Picasso and their circle (she painted a group portrait of several of her famous friends in 1908: *The Guests*, Baltimore Museum of Art). For several years she lived with Apollinaire, and she exhibited with the *Cubists. Her work, however, was entirely peripheral to the Cubist movement. She specialized in portraits of oval-faced, almond-eyed young girls painted in pastel colours, and although she borrowed a few tricks of stylization from her Cubist friends, her style remained essentially unaffected by them. Her work was lyrically charming and rather repetitive. From 1914 to 1920 she lived in Spain and Germany, then returned to Paris. Apart from paintings, her work included book illustrations and set and costume designs for the ballet and theatre. There is a museum dedicated to her work in Nagano Prefecture, Japan.

Laurens, Henri (1885–1954) French sculptor, printmaker, designer, and illustrator, born in Paris, where he trained as an ornamental stonemason. He suffered throughout his life from osteo-tuberculosis and early in life he lost a leg. A tomb in cement made for his mother in 1912 suggests that he was one of the many sculptors of his generation who were reacting against the example of *Rodin to make more simplified, monumental forms. In 1911 he became a friend of *Braque (he later met *Gris, *Léger, and *Picasso) and he became one of the first artists to adapt *Cubism to sculpture. He made collages, reliefs, and constructions of wood and metal, including still-lifes using the familiar Cubist repertory of bottles, glasses, and fruit, but also one of the most dynamic of Cubist figure sculptures, *The Clown* (1915, Lehmbruck Museum, Duisburg). Much of his work was coloured, but there was nothing of the sense of impermanence and ephemerality of *Picasso's constructions. In 1917 he began to exhibit with Léonce *Rosenberg's Galerie de l'Effort Moderne and produced a number of attractive small-scale Cubist nudes in bronze and terracotta. In the mid-1920s he moved away from his geometrical style to one that featured

curved lines and voluptuous forms, notably in female nudes. He also made a considerable amount of decorative and monumental sculpture including the tomb for an aviator (1924, Montparnasse Cemetery) and a bas-relief for the Sèvres manufacture pavilion at the 1937 Paris International Exhibition. The combination of monumentality and sensuality brought him close at times to *Maillol. At the same time, he had a sense of the metaphorical use of the body which could be reminiscent of *Surrealism. Some of his finest work came from the later years of his life, including the haunting crouched figure *L'adieu* (1941, Pompidou Centre, Paris), probably a lament for the fall of France. *Autumn* (1948, Tate) has the freedom in the handling of the figure of the Cubist period but realized entirely in delicately curved forms. Many of his fellow artists regarded him as one of the greatest sculptors of his time, but financial success and official recognition were slow in coming. When he failed to win the first prize for sculpture at the 1950 Venice *Biennale, *Matisse was so disgusted that he shared the money from his own painting prize with him. In 1953, however, Laurens won the Grand Prix at the São Paulo Bienal. Apart from sculpture, his work included stage design for *Diaghilev and numerous book illustrations.

Further Reading: Musée d'Art Moderne Villeneuve d'Ascq, *Henri Laurens* (1992)

Lavery, Sir John (1856–1941) British painter, mainly of portraits. He was born in Belfast and studied in Glasgow, in London, and then in the early 1880s in Paris (at the *Académie Julian and elsewhere). Between 1885 and 1896 he lived mainly in Glasgow (*see* GLASGOW BOYS), then settled in London, although he travelled a good deal and often wintered in Morocco, where he bought a house in about 1903. Lavery enjoyed immense success as a fashionable portraitist (particularly of women), painting in a dashing and fluid, if rather facile, style. His wife, Hazel, was an American society beauty, and he said that her social accomplishments helped his career to flourish. In 1940 he published his autobiography, *The Life of a Painter*, in which he wrote, 'I have felt ashamed of having spent my life trying to please sitters and make friends instead of telling the truth and making enemies.'

Law, Bob (1934–2004) British painter, sculptor, draughtsman, and film-maker, one of the founders of British *Minimalism. He was born in Brentford in Middlesex, leaving school at fifteen to take up an apprenticeship as an architectural designer. When he finished his National Service in 1954 he earned his living as a carpenter, taking up in 1957 the watercolour painting he had learnt as a child from his grandmother. He moved to St Ives where in 1959 he made his first 'field' drawings and paintings. These works, which are reminiscent of the naive style of Alfred *Wallis, were made while lying in fields. At the same time he travelled to London to see the exhibition of American painting at the *Tate Gallery. There, he encountered for the first time paintings by *Newman and *Rothko. In 1960 he had his first exhibition, at the *Institute of Contemporary Arts, and also took part in the *'Situation' exhibition. Afterwards, he embarked on a series of all 'black' paintings. These were made from successive coats of different coloured paint. This was an exacting process. Law reckoned his success rate was around one in eight or ten to achieve the effect he was seeking without distracting surface marks. The results were also dependent on the making of perfect stretchers, for which his carpentry skills were vital. When the paintings were exhibited at the Museum of Modern Art, Oxford (*see* MODERN ART OXFORD) in 1974 they were found to be impossible to reproduce photographically, so instead the catalogue used ten black cards to stand in for them. It was important for Law, like *Reinhardt, that his paintings had a gradual impact and would be discovered over the course of time: 'If you go openly to them, and you are a receptive kind of person for this sort of work they swallow you up and take you inside.' Law also worked as a sculptor. *Is a Mind a Prison* (1970, Tate) is a lead slab like an open envelope or a tombstone on which is impressed a text entirely in capitals, so it is unclear as to whether or not it should be read continuously. *The Last Supper* (1984) is a bronze table with chairs. They are identical except for those of Christ (with a pointed top) and Judas (broken backed with nails beneath it).

Further Reading: Michael McNay, obituary, *The Guardian* (26 May 2004)

Lawrence, Jacob (1917–2000) American painter, one of the first black Americans to win recognition in the white art world. He was born in Atlantic City and studied at the Harlem Art Workshop and other schools in

New York in the 1930s. His work was concerned with black culture, both in the past and the present. In 1936, for example, he began a series on the life of Toussaint L'Ouverture, the former slave who founded the republic of Haiti, and in 1940–41 he did a series of 60 paintings on 'The Migration of the Negro' (examples are in MoMA, New York), considered to be his greatest achievement. These paintings addressed the theme of the 'Black Exodus' from South to North after the First World War. In 1995 he told an interviewer that he would like the spectator to 'experience the beauty of life, the struggle, how people can overcome things that could be very frustrating or very demeaning'. Contemporary subjects included life in Harlem and desegregation in the South during the 1960s. His later work tended to be more decorative and less concerned with social comment, but all his work is characterized by the stylization of his figures into strong, angular, flattened forms and brilliant colour. Lawrence taught at various colleges, including the University of Washington in Seattle, where he settled in 1972.

(((∰))) SEE WEB LINKS

• Online News Hour, *Remembering Jacob Lawrence* (13 June 2000)

Lawson, Ernest *See* EIGHT, THE (1).

Leach, Bernard *See* ST IVES SCHOOL.

Lebrun, Rico (1900–64) American painter, sculptor, and graphic artist, born in Naples. He moved to the USA in 1924 when the stained-glass studio for which he was working as a designer opened a factory in Springfield, Illinois. In the following year he moved to New York and in 1938 settled in California. His initial success came as an advertising artist and he also taught animation at the Walt Disney film studios (he was involved in the production of *Bambi*, 1943). From the late 1930s, however, he turned to painting deeply serious subjects concerned with man's inhumanity to man. They include a series on the Crucifixion and one on Buchenwald concentration camp (1954–8), which Matthew Baigell calls 'one of the few major sustained artistic attempts to respond to the mass murders of World War II . . . His large forms and theatrically abrupt lighting schemes as well as his high sense of spiritual drama give his art a Baroque gloss rarely seen in modern times' (*Dictionary of American Art*, 1979). Two years before his death Lebrun took up sculpture.

Lechmere, Kate *See* REBEL ART CENTRE.

Leck, Bart van der (1876–1958) Dutch painter and designer, born in Utrecht. After working for eight years in stained-glass studios, he studied painting in Amsterdam, 1900–04. His early work was influenced by *Art Nouveau and *Impressionism, but from about 1910 he developed a more personal style characterized by simplified and stylized forms: his work remained representational, but he eliminated perspective and reduced his figures (which included labourers, soldiers, and women going to market) to sharply delineated geometrical forms in primary colours. In 1916 he met *Mondrian and in 1917 was one of the founders of De *Stijl. At this time his work was purely abstract, featuring geometrically disposed bars and rectangles in a style close to Mondrian and van *Doesburg. However, he found the dogmatism of the movement uncongenial and left it in 1918, reverting to geometrically simplified figural subjects. In the 1920s he became interested in textile design and during the 1930s and 1940s he extended his range to ceramics and interior decoration, experimenting with the effects of colour on the sense of space. His work can best be seen at the Rijksmuseum Kröller-Müller, Otterlo.

Leckey, Mark *See* TURNER PRIZE.

Le Corbusier (Charles-Édouard Jeanneret) (1887–1965) Swiss-born architect, painter, designer, and writer who settled in Paris in 1917 and became a French citizen in 1930. Although chiefly celebrated as one of the greatest and most influential architects of the 20th century, Le Corbusier also has a small niche in the history of modern painting as co-founder (with *Ozenfant) of *Purism in 1918. Up to 1929 he painted only still-life, but from that time he occasionally introduced the human figure into his compositions. He retained the Purist dislike of ornament for its own sake, but his work became more dynamic, imaginative, and lyrical, though still restrained by his horror of any form of excess. He adopted the pseudonym Le Corbusier in 1920, but continued to sign his paintings 'Jeanneret'; the pseudonym derives from the name of one of his grandparents and is also a pun on his facial resemblance to a raven

(French: *corbeau*). Apart from architecture and paintings, his enormous output included drawings, book illustrations, lithographs, tapestry designs, furniture, and numerous books, pamphlets, and articles.

Leduc, Fernand See AUTOMATISTES; PLASTICIENS.

Leduc, Ozias (1864–1955) Canadian painter, active mainly in his native St Hilaire, Quebec. His career was devoted principally to church decoration, but he also painted portraits, genre scenes, and still-life—mostly for his own pleasure or for friends. In 1897 he visited Paris, and his later work was affected by *Symbolist ideas. He lived modestly and unambitiously, away from the main centres of art, but he was an inspiration to many of those who knew him, notably Paul *Borduas, who said Leduc showed him 'the way from the spiritual and pictorial atmosphere of the Renaissance to the power of illusion which leads into the future. Leduc's whole life shines with this magic illusion.'

Ledward, Gilbert (1888–1960) British sculptor, son of the sculptor Richard Arthur Ledward (1857–90). He studied at various art schools in London, including the *Royal Academy and the *Royal College of Art. In 1913 he was the winner of the first Rome scholarship offered to a sculptor (*Jagger was runner-up), but his studies in Italy were interrupted by the First World War, during which he served in the army. After the war (and again after the Second World War) he had several commissions for memorials, including the five bronze figures on the Guards Memorial in St James's Park, London (unveiled 1926). From 1926 to 1929 he was professor of sculpture at the Royal College of Art. At about this time he became interested in *direct carving, and in 1934 he founded the organization Sculptured Memorials and Headstones to improve the design and carving of memorials in English churchyards and encourage the use of local stone. Among his later works the best known is the Venus Fountain (unveiled 1953) in Sloane Square, London.

Lees, Derwent (1885–1931) Australian painter, active mainly in Britain. As a boy he lost a foot in a riding accident. He studied at Melbourne University and in Paris before settling in London, where he trained at the *Slade School, 1905–8. From 1908 to 1918 he taught drawing at the Slade. He was a close friend of J. D. *Innes and Augustus *John and often travelled and worked with them. His main subject was landscape and he shared with them a lyrical response to the countryside; usually he worked on a small scale, with fluid brushwork in oil on panel or watercolour. He travelled widely, visiting Belgium, France, Germany, Italy, and Russia. In his biography of Augustus John (1976), Michael Holroyd describes Lees as 'a copycat of genius . . . He could paint *McEvoys, Inneses or Johns at will and with a fluency that sometimes makes them almost indistinguishable from their originals—though his figures with their great dense areas of cheek and chin do have originality.' In about 1918 Lees began to suffer from mental illness and spent the rest of his life confined in an institution.

LEF (Left Front of the Arts) See MAYAKOVSKY, VLADIMIR.

Le Fauconnier, Henri (1881–1945/6) French painter, mainly of figure subjects, including nudes and allegories. He was born at Hesdin, Pas-de-Calais, the son of a doctor, and in 1900 he began studying law at the University of Paris. However, he soon gave this up for art and had his main training at the *Académie Julian. From about 1910 he was influenced by *Cubism and he took part in the first organized group show of Cubist artists, at the *Salon des Indépendants in 1911. In about 1914 his style began to become more *Expressionist, but he still retained structural features derived from Cubism. He spent the First World War in the Netherlands, where he laid the basis of a European reputation and exercised considerable influence on the development of Expressionism in that country (his work is better represented in Dutch collections than it is in French). After returning to Paris in 1920 he gradually abandoned Expressionism for a more restrained style. He never again enjoyed his former level of fame and in his final years he became a recluse. The exact date of his death is not known, as it was some days before his body was found. He is not now generally highly regarded as a painter, but he played an important role in spreading the mannerisms of Cubism. An example of the wide exposure his work had is that his painting *Abundance* (1911, Gemeentemuseum, The Hague) was reproduced in the *Blaue Reiter *Almanac* in 1912 and in the same year was shown in the

*Knave of Diamonds exhibition in Moscow (in 1911 it had been shown at the Salon des Indépendants in Paris).

Lefranc, Jules *See* NAIVE ART.

Léger, Fernand (1881–1955) French painter and designer, born at Argentan in Normandy of peasant farming ancestry. In 1897–99 he was apprenticed to an architect in Caen, then in 1900 settled in Paris, where he supported himself as an architectural draughtsman (and for a while as a photographic retoucher) whilst studying art at the *Académie Julian and elsewhere. His early paintings were *Impressionist in style, but in 1907 he was overwhelmed by the exhibition of *Cézanne's work at the *Salon d'Automne, and in the following year he came into contact with several leading avant-garde artists when he rented a studio in La *Ruche. Robert *Delaunay was among his friends and he met and admired Henri *Rousseau. He was briefly influenced by *Fauvism, but in 1909 he turned to *Cubism. Although he is regarded as one of the major figures of the movement, he was in his early works closer to the 'Salon Cubists': he disjointed forms but did not fragment them in the manner of *Braque and *Picasso, preferring bold tubular shapes (he was for a time known as a 'tubist'), as in his first major work, *Nudes in a Forest* (1909–10, Rijksmuseum Kröller-Müller, Otterlo). He also used much brighter colour than Braque and Picasso. In 1912 he had his first one-man exhibition, at *Kahnweiler's gallery, and he was beginning to prosper when the First World War interrupted his career. By this time his work had come close to complete abstraction.

Léger enlisted in the army and served as a sapper in the front line, then as a stretcher-bearer. The war was 'a complete revelation to me as a man and a painter'. It enlarged his outlook by bringing him into contact with people from different social classes and walks of life and also by underlining his feeling for the beauty of machinery: 'During those four war years I was abruptly thrust into a reality which was both blinding and new. When I left Paris my style was thoroughly abstract . . . Suddenly, and without any break, I found myself on a level with the whole of the French people; my new companions in the Engineer Corps were miners, navvies, workers in wood. Among them I discovered the French people. At the same time I was dazzled by the breech of a 74-millimetre gun which was standing uncovered

in the sunshine: the magic of light on white metal. This was enough to make me forget the abstract art of 1912–13 . . . Once I had got my teeth into that sort of reality I never let go of objects again.' After being gassed, he spent more than a year in hospital and was discharged in 1917. In that year he painted *Soldiers Playing at Cards* (Rijksmuseum Kröller-Müller), which he regarded as 'the first picture in which I deliberately took my subject from our own epoch'.

During the next few years, Léger's work showed a fascination with machine-like forms, and even his human figures were depicted as almost robot-like beings (*The City*, 1919, Philadelphia Museum of Art). In 1920 he met the *Purists *Le Corbusier and *Ozenfant, who shared his interest in a machine aesthetic. Unlike them, however, he did not confine himself to the ideal forms of manufactured objects. There were also monumental figure paintings such as *Le Grand Déjeuner* (1923, MoMA, New York), which allied this preoccupation with machinery with the *Neoclassical aesthetic. The concentration on the object sometimes brought him close to the orbit of *Surrealism in drawings and paintings in which isolated objects such as bits of wood or crumpled trousers have a hallucinatory quality recalling Max *Ernst. In the interwar years he expanded his range beyond easel painting with murals (sometimes completely abstract) and designs for the theatre and cinema (in 1923–4 he conceived, produced, and directed the film *Le Ballet mécanique*, with photography by *Man Ray; it has no plot and shows everyday objects in rhythmic motion). He was also busy teaching at his own school founded with Ozenfant in 1924 as the Académie de l'Art Moderne (Ozenfant left in 1929 but it continued as the Académie de l'Art Contemporain until 1939). He also travelled extensively, making three visits to the USA in the 1930s. The contacts that he made during these visits stood him in good stead when he lived in America during the Second World War, teaching at Yale University and at Mills College, California.

Léger's work of the war years included pictures of acrobats, cyclists, and musicians, and after his return to France in 1945 he concentrated on the human figure rather than the machine. He joined the French Communist Party soon after his return (he had been sympathetic to it long before this) and favoured proletarian subjects that he hoped would be

accessible to the working class. *Les Constructeurs* (1950, Musée Fernand Léger, Biot) is actually based on an illustration in a Soviet propaganda publication. Some of the late pictures are very big (notably *The Great Parade*, 1954, Guggenheim Museum, New York), and in his later career he also worked a good deal on large decorative commissions, notably stained-glass windows and tapestries for the church at Audincourt (1951) and a glass mosaic for the University of Caracas (1954). In 1949 he began making ceramic sculptures. Many honours came to him late in life, including the Grand Prix at the 1955 São Paulo *Bienal. Shortly before his death he bought a large house at Biot, a village between Cannes and Nice, and his widow built a museum of his work there, inaugurated in 1960 and acquiring the status of a national museum in 1969.

John Golding has written of Léger: 'Fauvism, Cubism, *Futurism, Purism, *Neo-Plasticism, Surrealism, Neoclassicism, *Social Realism, his art experienced them all.' Golding argues that he was not on this account a derivative artist, rather one who was able to turn these different tendencies to his own ends. Nonetheless he has tended to be an artist who has been highly regarded by other artists and an object of fascination for art historians but never really taken to heart by a wider public, who perhaps find him too austere and impersonal or are sceptical of his optimistic vision of mechanized modern life.

Further Reading: J. Golding and C. Green, *Léger and Purist Paris* (1970)

Whitechapel Art Gallery, *Fernand Léger: The Later Years* (1987)

Legros, Alphonse (1837–1911) French-born etcher, painter, sculptor, and teacher who settled in England in 1863 (encouraged by *Whistler) and became a British citizen in 1881, although he never acquired fluency in English. His chief importance was as an influential teacher (particularly of etching) at the *Slade School, where he was professor 1876–92 in succession to *Poynter. He encouraged a respect for the tradition of the Old Masters.

Legueult, Raymond See NÉO-RÉALISME.

Lehmbruck, Wilhelm (1881–1919) German sculptor. He was born in Meiderich, near Duisburg, the son of a miner, and studied in nearby Düsseldorf, first at the School of Arts and Crafts, 1895–9, then at the Academy, 1901–7. His early work was in a fairly conservative academic manner, but when he was living in Paris from 1910 to 1914 he developed a more modern style, influenced by the formal simplifications of *Archipenko, *Brancusi, and *Modigliani, although still essentially in the tradition of *Rodin and *Maillol. One of his most impressive works in this vein is *Kneeling Woman* (1911, MoMA, New York), notable for its attenuated forms, angular pose, and melancholic expression; it was greatly praised when it was exhibited at the Cologne *Sonderbund exhibition in 1912. His reputation grew substantially after this, and the first book on him was published in Berlin in 1913. In 1914 he had a one-man exhibition at the Galerie Levesque, Paris, but soon afterwards the outbreak of the First World War forced him to return to Germany. He managed to avoid conscription into the army and instead worked in a hospital, the suffering he witnessed being reflected in the poignancy of the sculpture from his final years. In 1916 he moved to Switzerland, where he planned major works, including war memorials, but made only smaller pieces and fragments. The war had brought him to a state of acute depression and he committed suicide in 1919.

Lehmbruck often worked in marble, but he was by temperament a modeller rather than a carver; he liked to work in clay over a spindly armature, and several of his figures were cast in artificial stone to preserve the texture of the clay. With *Barlach he ranks as the outstanding German *Expressionist sculptor. He also made etchings and lithographs, painted, and wrote poetry. There is a museum named after him in Duisburg, with a notable collection of modern sculpture.

Lehmden, Anton See FANTASTIC REALISM.

Leicester Galleries (Ernest Brown & Phillips) London Commercial gallery founded in premises off Leicester Square in 1902 by the brothers Wilfred and Cecil Phillips. They were joined in 1903 by Ernest Brown, a dealer of long experience, but the dominant figure in the firm was his son **Oliver Brown** (1885–1966), who became a partner in 1914 and dedicated his life to the gallery. In the first half of the century it was one of the country's leading venues for promoting modernist art, exhibiting the work of *Matisse and *Picasso. Brown's experience was valuable to the *Arts Council in its early days (he served on its arts panel from 1949 to 1954) and his

expertise was valued by Christie's auction house (he was a close friend of its chairman Sir Alec Martin). *Exhibition: The Memoirs of Oliver Brown* was posthumously published in 1968. The original gallery in Leicester Square subsequently moved to Great Audley Street, where the site provided more spacious premises, and then to Cork Street, a location especially associated with the art trade. The gallery closed in 1977.

Leiris, Michel (1901–90) French critic and ethnologist. He was a founder member of the *Surrealist group and an early friend of André *Masson. However, after breaking with André *Breton he became associated with the rival group around Georges *Bataille and contributed to *Documents*. He, Masson, and Bataille shared a fascination with the themes of violence and sacrifice. His writings include books on Masson (1947), Francis *Bacon (1974), and *Giacometti (1978). Like Masson and Bacon, Leiris was an enthusiast for the bullfight and contributed the commentary for the 1951 documentary film *La Course des taureaux*. He also published important works of anthropology including *L'Afrique fantôme* (1934).

His wife, **Louise Leiris** (1902–88), was the sister-in-law and associate of Daniel-Henri *Kahnweiler. In later years his gallery took her name.

Le Moal, Jean (1909–2007) French painter and designer, born at Authon-de-Perche of Breton ancestry. He studied at the École des Beaux-Arts, Lyons, and then from 1935 to 1938 at the *Académie Ranson, where—like many other students—he was influenced by Roger *Bissière. At this time he was associated with the *Forces Nouvelles group. Le Moal was an exponent of *Lyrical Abstraction, the type of painting that dominated the *École de Paris in the late 1940s and 1950s. Like his contemporaries *Bazaine, *Estève, *Manessier, and *Singier, he evolved his abstractions from impressions made by natural appearances. His style was characterized by linear arabesques interspersed with spots and flecks of colour. Le Moal also designed stage decor, tapestry, and stained glass.

Lempicka, Tamara de (c.1895–1980) Painter of Polish/Russian birth, active mainly in Paris and the USA. She was born Tamara Gorska to wealthy parents. By her own account she was born in Warsaw in 1898, but there is evidence she was in fact born in Moscow

a few years earlier. In 1916 she married Tadeusz de Lempicki, a Russian lawyer and socialite. In 1918 they fled the Russian Revolution to Paris, where she studied with Maurice *Denis and André *Lhote. She quickly established a reputation as a painter of portraits, mainly of people in the smart social circles in which she moved—writers, entertainers, the dispossessed nobility of Eastern Europe (an example is her portrait of her husband, 1928, in the Pompidou Centre, Paris). Her style owes something to the 'tubism' of *Léger, but is very distinctive in its hard, streamlined elegance and sense of chic decadence—better than anyone else she represents the *Art Deco style in painting. Apart from portraits, her main subjects were hefty erotic nudes and still-lifes of calla lilies. She received considerable critical acclaim and also became a social celebrity, famed for her aloof Garboesque beauty, her parties, and her voracious sexual appetite (with women as well as men). In 1939 she moved to the USA with her second husband Baron Raoul Huffner, repeating her artistic and social success in Hollywood and New York. By the 1950s, however, her work was going out of fashion. She tried working in a different, much looser style and even painted abstracts, but her paintings in this new vein were coolly received and after 1962 she did not exhibit her work. In 1963–78 she lived in Houston, Texas, then spent the last two years of her life in Cuernavaca, Mexico. She continued to paint into her old age, often in Paris, to which she regularly returned. Interest in her began to revive in the 1970s (notably with the exhibition 'Tamara de Lempicka de 1925 à 1935' at the Palais du Luxembourg, Paris, in 1972) and by the 1990s she had again become something of a style icon, with her work fetching enormous prices in the saleroom and featuring in television advertisements as a symbol of the high life.

Further Reading: A. Blondel et al., *Tamara de Lempicka, Art Deco Icon* (2004)

Lennon, John *See* ONO, YOKO.

Lentulov, Aristarkh (1882–1943) Russian painter (of landscapes, portraits, still-life, and genre scenes) and stage designer. He was born in Penza Province and studied in Penza, Kiev, and St Petersburg before settling in Moscow. From 1908 he took part in avant-garde exhibitions and in 1910 he was one of the founders of the *Knave of Diamonds group (his wife was the daughter of a wealthy merchant and

Lentulov was able to give the group financial support). In 1911 he travelled to Italy and France, where he was influenced by *Gleizes, Le *Fauconnier, and *Metzinger, and in 1912 he exhibited *Cubist-inspired works. Around 1916 he painted a few abstract pictures, but in the 1920s he changed from experimental work to a more naturalistic and conventional manner, joining *AKhRR in 1926. He taught stage design at *Vkhutemas, 1919–26, and painting at the Moscow Art Institute, 1919–43.

Leonard, Michael *See* SUPERREALISM.

Leoncillo, Leonardo *See* FRONTE NUOVO DELLE ARTI.

Le Parc, Julio (1928–) Argentinian painter, sculptor, and *Kinetic artist. He was born at Mendoza and studied at the School of Fine Arts in Buenos Aires. In 1958 he settled in Paris and in 1959 became a founder member of the *Groupe de Recherche d'Art Visuel (GRAV). Le Parc professes to adopt a rational and objective attitude to his work, working according to scientific principles. He often uses the idea of spectator participation, but tries to eliminate subjective response on the part of the spectator, looking for an objective and predictable perceptual response to a planned stimulus. Much of his work consists of devices for disorientating the spectator (distorting glasses and so on), but he has also made some outstanding *mobiles, using perspex or metallic elements to scatter or reflect the light (*Continual Mobile, Continual Light*, 1963, Tate, London).

Leslie, Alfred (1927–) American painter and film-maker. He was born in New York and studied at New York University. In the 1950s he was an *Abstract Expressionist, working with an explosive *Action Painting technique, but in the 1960s he changed course completely and became a *Superrealist. Like Jack *Beal, he paints ambitious figure subjects, often in compositions derived from the Old Masters. He is perhaps best known for *The Killing Cycle*, a series of paintings, on which he worked for over a decade, commemorating the death of the poet and art critic Frank O'Hara (1926–66), who was run over by a taxi. Leslie's film *The Cedar Bar* (2002) was based on memories of the New York art world in the heyday of Abstract Expressionism.

Lessore, Helen (née Brook) (1907–94) British painter (of portraits, figure subjects, and interiors) and art dealer. She was born in London and studied at the *Slade School, 1924–8. In 1934 she married the portrait sculptor Major **Frederick Lessore** (1879–1951), brother of **Thérèse Lessore** (1884–1945), *Sickert's third wife and herself a painter of figure subjects and urban scenes (*see* CAMDEN TOWN GROUP). Frederick Lessore had opened the Beaux Arts Gallery in London in 1923, and after his death Helen Lessore ran it until it closed in 1965. In its early years, the gallery was prominent in supporting avant-garde art: Christopher *Wood had his first solo exhibition there in 1927, for example, and Barbara *Hepworth had one of her first shows there (with her husband, John *Skeaping) in 1928. After the war, the gallery was identified with a commitment to figurative painting and helped to launch the careers of Frank *Auerbach and Leon *Kossoff amongst others (their first solo shows were held there in 1956 and 1957 respectively), and it became particularly associated with the *Kitchen Sink School: its four leading members—John *Bratby, Derrick *Greaves, Edward *Middleditch, and Jack *Smith—were known as the 'Beaux Arts Quartet'. The general ambience of the gallery, with its hessian wall coverings, was closer to that of a painter's studio than to the luxurious atmosphere generally associated with West End art dealers.

John Lessore (1939–), son of Helen and Frederick, is a painter of portraits, landscapes, figure subjects, and interiors. He studied at the Slade School, 1957–61, and had his first exhibition at the Beaux Arts Gallery in 1965. In 1978 he began teaching at Norwich School of Art.

Lethaby, W. R. *See* ROYAL COLLEGE OF ART.

Lett-Haines, Arthur *See* MORRIS, SIR CEDRIC.

Lettrism *See* SITUATIONIST INTERNATIONAL.

Levine, Jack (1915–) American painter and draughtsman, born in Boston. As a child he had lessons at the Museum of Fine Arts School in Boston and from 1929 to 1933 he attended painting classes at Harvard University. From 1935 to 1940 he worked intermittently for the *Federal Art Project. Levine is an independent figure, standing apart from groups and movements, and his work is highly distinctive. His

style is based upon *Expressionists of the *École de Paris such as *Rouault and *Soutine, but the theme of his art is social satire, through which he mercilessly attacks avarice, corruption, and hypocrisy. His best-known work is *Gangster Funeral* (1953, Whitney Museum, New York), which shows policemen and political leaders gathered in mourning around a mobster's coffin. For all the savagery of his imagery, there is much subtlety of handling in his work, and he is deeply aware of the work of the Old Masters as well as of contemporary painting; he thinks it is the artist's function to bring 'the great tradition and whatever is great about it up to date'. Levine has also done gentler satires, poking fun at middle-class pretensions, as well as straightforward portraits, and in the 1980s he turned to serious depictions of biblical subjects.

Levine, Sherrie (1947–) American artist, born in Hazleton, Pennsylvania. Her work is based on the practice of *appropriation. The most celebrated examples are her photographs *After Walker *Evans* (1981), photographic replicas of the work of one of America's most important photographers, copied from exhibition catalogues. This project has been seen as an attack on the idea of originality and authorship in art. Some of the photographs Levine uses are those Evans made to document rural poverty in the South during the 1930s. When Levine's versions were shown at the International Center of Photography in 2008 their website pointed out that 'Evans may be the photographer of these works but not the singular author of the social and cultural phenomenon that engendered them.' As nobody has yet suggested that Walker Evans was single-handedly responsible for engineering the Great Depression, this is not a very startling statement. After the photographic work, Levine made painted copies of work by early abstractionists such as *Mondrian (*White on White*, 1984) and *Lissitsky. She theorized this work from a *feminist angle. 'What I was doing was making explicit how this Oedipal Relationship artists have with artists of the past (i.e. wanting to kill them) gets repressed: and how I, as a woman, was only allowed to represent male desire.' She has also made paintings consisting of wood panels with the knot holes picked out in gold paint (*Large Gold Knot* 2, 1987). She has said: 'They are about death in a way; the uneasy death of Modernism.'

Lewis, Norman (1909–79) American painter of Caribbean descent, born in Harlem, New York. He began painting at Augusta *Savage's studio and studied at Columbia University and the John Reed Club Art School, a Communist Party organization. He painted murals for the Works Progress Administration (*see* FEDERAL ARTS PROJECT) but he generally worked on easel paintings. Lewis dismissed the demand that his work reflect "Africanness'. However, in *Untitled* (1944), a self-portrait as a gambler, the face of the artist does bear the striations characteristic of masks from Zaire. It is likely that he was actually making fun of the cult of 'ancestralism' as well as the *'primitivism' of the avant-garde. Although Lewis considered himself a Marxist, he rejected the Communist Party's demand for *Socialist Realism on the grounds that it was based on 'no universal consideration'. Instead, he attempted in his painting a kind of synthesis between Western and non-Western traditions. In practice this entailed a kind of painting close to *Abstract Expressionism in a calligraphic manner reminiscent of *Tobey.

Further Reading: D. Craven, *Myth Making: Abstract Expressionist Painting from the United States* (1993)
A. E. Gibson, *Abstract Expressionism: Other Politics* (1997)

Lewis, Wyndham (1882–1957) British painter, novelist, and critic, born of a British mother and a wealthy American father on their yacht off Nova Scotia. He came to England as a child, studied at the *Slade School, 1898–1901, then lived on the Continent for seven years, mostly in Paris (although he travelled widely). During this period he became one of the first British artists to become familiar with *Cubism and *Expressionism, but little of his work of this time survives. In 1908 he returned to England and in the years leading up to the First World War emerged as one of the leading figures in British avant-garde art. From 1911 he developed an angular, machine-like, semi-abstract style that had affinities with *Futurism as well as Cubism. He worked for a short time at Roger *Fry's *Omega Workshops, but after quarrelling with Fry in 1913 he formed the *Rebel Art Centre, from which grew *Vorticism, a movement of which he was the chief spokesman and whose journal *Blast* he edited. He served with the Royal Artillery, 1915–17, and as an *Official War Artist, 1917–18, carrying his Vorticist style into paintings such as *A Battery Shelled* (1918, Imperial War Museum, London), which is regarded as one of his finest works. In 1919 he

founded *Group X as an attempt to revive Vorticism, but this failed, and from the late 1920s he devoted himself mainly to writing, in which he often made savage attacks on his contemporaries (particularly the *Bloomsbury Group).

Lewis's association with the British Fascist Party and his praise of Hitler alienated him from the literary world: W. H. Auden called him 'that lonely old volcano of the right'. The best-known paintings of his later years are his incisive portraits, more naturalistic than his earlier works but still with a bold, hard simplification of form; the rejection of that of T. S. Eliot (Durban Art Gallery) by the hanging committee of the *Royal Academy summer exhibition in 1938 caused Augustus *John (a longstanding friend of Lewis) to resign from the Academy in disgust. During the Second World War Lewis lived in the USA and Canada. After his return to London he was art critic of *The Listener* from 1946 until 1951 (the artists he supported included *Bacon and *Colquhoun). By the time he stopped working for *The Listener* he was almost blind, but he wrote the introduction for the catalogue of the exhibition 'Wyndham Lewis and the Vorticists' held at the Tate Gallery, London, in 1956.

Lewis was the most original and idiosyncratic of the major British artists working in the first decades of the 20th century. He built his style on features taken from Cubism and Futurism but did not accept either. He accused Cubism of failure to 'synthesize the quality of LIFE with the significance or spiritual weight that is the mark of all the greatest art' and of being mere visual acrobatics. The Futurists, he wrote, had the vivacity that the Cubists lacked, but they themselves lacked the grandness and the 'great plastic qualities' that Cubism achieved. His own work, he declared, was 'electric with a mastered and vivid vitality'. His writings include novels, poetry, collections of essays and criticism, and the autobiographical *Blasting and Bombadiering* (1937).

Further Reading: P. Edwards, *Wyndham Lewis: Painter and Writer* (2000)

LeWitt, Sol (1928–2007) American sculptor, graphic artist, and writer. He was born in Hartford, Connecticut, and studied at Syracuse University, New York, where he graduated in fine art in 1949. After serving in the US Army in Japan and Korea, 1951–2, he settled in New York, where he worked as a graphic designer and also painted. His career did not take off until the early 1960s, when he turned to sculpture and became one of the leading exponents of *Minimal art. His 'structures', as he preferred to call them, depended on the permutation of simple elements. An example was the piece of 1974 in which he worked through every possible variation of the incomplete open cube from three-sided pieces (three potential variations) to eleven-sided pieces (only one variation). Although he was not always regarded as, in the fullest sense of the word, a *Conceptual artist, because his work was too physical, he was one of the earliest artists to try to define the phenomenon. His two major statements on the subject 'Paragraphs on Conceptual Art' and 'Sentences on Conceptual Art' were published in 1967 and 1969 (Stiles and Selz). The latter text, in particular, has achieved something of a canonical status as a definition. Underlying LeWitt's notion of Conceptual art is the dogged carrying out of an idea. Once the project is embarked on, judgements of taste must not deflect the artist's purpose. At the same time this is not a rational process: Conceptual artists 'leap to conclusions that logic cannot reach'. This was, in fact, rather a different notion to the philosophical and political preoccupations of early Conceptual artists such as Joseph *Kosuth and the *Art & Language group. There was, however, some interest on LeWitt's part in the idea of escaping the commodification of the art market by creating an invisible object. In 1968 he fabricated a metal cube containing 'an Object of Importance but Little Value' and buried it in the ground at Visser House at Bergeyk in the Netherlands, documenting photographically the object's disappearance. LeWitt's most original contribution probably lies in his wall drawings. These are executed according to an existing plan and do not depend on the artist's hand, provided that the executants are competent. The drawings exist firstly as an idea and can be remade in different contexts and may change slightly, according to architecture or wall surface. In 1982, for instance, the Museum of Modern Art, New York, 'lent' an example to the British Museum, but nothing physical except the plan crossed the Atlantic.

Further Reading: A. Legg, *Sol LeWitt* (1978)

Lhote, André (1885–1962) French painter, sculptor, teacher, and writer on art. He was born in Bordeaux, where he was apprenticed to an ornamental sculptor in 1897. He also studied sculpture at the city's École des Beaux-Arts, 1898–1904, and painted in his

spare time. In 1905 he gave up sculpture to devote himself to painting and in 1906 he settled in Paris. His early paintings were *Fauvist in spirit, but from 1911 he adopted *Cubist mannerisms in his varied range of subjects, including landscapes, still-lifes, interiors, mythological scenes, and portraits. These pictures were deliberately composed, with complicated systems of interacting planes and semi-geometrical forms, precisely articulated and defined by clear, unmodulated colours. His later work included some large decorative pieces, notably a set of three panels, *Gloire de Bordeaux* (1955), for the Faculty of Medicine at Bordeaux. Lhote, however, was more important as a teacher and critic of modern art than as a practising artist. In 1922 he opened his own school, the Académie Montparnasse, and through this had an extensive influence on younger artists, French and foreign; he founded a South American branch on a visit to Rio de Janeiro in 1952. His writings included treatises on landscape painting (1939) and figure painting (1950); the two were issued together in a revised edition in 1958 as *Traités du paysage et de la figure.*

Libre Esthétique, La An association of artists formed in Brussels in 1894 to carry on the work of the Groupe des Vingt (XX), which had dissolved in 1893. Les Vingt (so called because there had originally been twenty members) was made up mainly of *Symbolist painters, including *Ensor and *Toorop; the group showed work not only by its own members, but also by non-Belgian artists such as *Cézanne and *Gauguin, and it was influential in spreading the ideas of *Neo-Impressionism and *Post-Impressionism. La Libre Esthétique maintained these ideals, continuing until 1914, with most of the leading avant-garde Belgian artists of the period as members. It was administered by the lawyer and critic Octave Maus (1856–1919), who also founded and ran the weekly periodical *L'Art moderne* (1881–1914), the leading Belgian avant-garde journal of the period. (*L'Art moderne* was also the title of a short-lived periodical published in Paris, 1875–6.)

Lichtenstein, Roy (1923–97) American painter, sculptor, and printmaker, born in New York. He studied at the *Art Students League, 1939, and then at Ohio State University, Columbus, 1940–43 and (after service in the US Army) 1946–9. For the next two years he

taught there, then lived in Cleveland, Ohio, 1951–7, working at various odd jobs to support his painting. For the next few years he returned to teaching—at New York State University, Oswego, 1957–60, and Rutgers University, New Brunswick, 1960–63. In the late 1950s his style was *Abstract Expressionist, but in the early 1960s he changed to *Pop art and his first one-man exhibition in this style, at the Leo *Castelli gallery, New York, in 1962 was a sensational success, enabling him to give up teaching the following year and devote himself entirely to painting. In common with other Pop artists, Lichtenstein adopted the images of commercial art, but he did so in a highly distinctive manner. He took his inspiration from comic strips but blew up the images to a large scale, reproducing the primary colours and dots of the cheap printing processes (*Whaam!*, 1963, Tate). Whenever comparisons with the original sources are made, they tend to show Lichtenstein removing narrative information for the sake of visual impact. Therefore, unlike the contemporary work of *Warhol, they cannot be considered as pure *appropriation. In the mid-1960s he began making Pop versions of paintings by modern masters such as *Cézanne and *Mondrian, and also started making screenprints. In the 1970s he expanded his range to include sculpture, mostly in polished brass and imitating the *Art Deco forms of the 1930s. His later work included several large commissions for public places, for example the sculpture *Mermaid* (1979) for the Theatre of the Performing Arts, Miami, and *Mural with Blue Brushstrokes* (1986) for the Equitable Building, New York.

Further Reading: J. Hendrickson, *Lichtenstein* (2000)

Licini, Osvaldo (1894–1958) Italian painter, born at Monte Vidon Corrado in the Marches, the son of a commercial artist. In 1908–13 he studied at the Academy in Bologna, where he was friendly with *Morandi, and he spent most of the period 1917–26 in Paris. Up to 1931 he painted in a naturalistic style (portraits, landscapes, still-lifes), but then abandoned it for abstraction. His paintings of the 1930s, which put him in the forefront of modernism in Italy, are usually called *Constructivist, but although they use geometric forms, they also have an individual poetic quality that sometimes brings them close to *Klee or *Miró in spirit: 'Painting is the art of colours and signs', Licini said; 'signs express force, will and the idea, while colour expresses magic.' After the

Second World War Licini became the first Communist mayor of his home town and worked there in semi-seclusion. He turned from abstraction to a *Surrealist-influenced style in which he expressed a personal mythology. A few months before his death he won the International Grand Prize for Painting at the 1958 Venice *Biennale.

Liebermann, Max (1847–1935) German painter (of portraits, figure subjects, and landscapes), etcher, and lithographer, born in Berlin. From 1873 to 1878 he lived mainly in Paris, and together with *Corinth and *Slevogt he came to be considered one of the leading German representatives of *Impressionism. In 1878 he moved to Munich and in 1884 to Berlin, where he became first president of the *Sezession in 1899. However, he did not keep abreast of developments and a decade later he was regarded as a pillar of the traditionalism against which the German *Expressionists were in revolt. He was one of the dominant figures in the German art world and in the later part of his career he accumulated many honours. When the Nazis came to power, however, he was required—as a Jew—to resign as president of the Prussian Academy and from his other prestigious positions. His widow committed suicide in 1943 rather than suffer at the hands of the Gestapo. There are some good examples of Liebermann's work in Tate, including his last self-portrait (1934).

Ligare, David See PITTURA COLTA.

Light art A general term for works that use artificial light (generally electric) as an artistic medium of its own or as an important constituent of a piece. The major pioneer of light art was the Danish-American artist Thomas *Wilfred, who made his first small works in this vein in 1905, but the idea can be traced back to the 18th century, when the French scientist Louis-Bertrand Castel became interested in the relationship between sound and colour (both of which, he argued, were products of vibration) and constructed various 'ocular harpsichords', some of which incorporated coloured glass. His theories do not seem to have been followed up until the early 20th century, when the Russian composer Alexander Scriabin envisaged a similar type of 'colour organ' to perform in his orchestral work *Prometheus*; it was premiered in 1911,

but the light-show accompaniment proved impracticable. (It was finally realized in performance at the Barbican Centre, London, in November 1999.) Twelve years later, in 1923, Vladimir *Baranoff-Rossiné constructed a piano that produced light as well as sound effects, and various other experiments with light art were made in the interwar years—by *Moholy-Nagy, for example. Hitler's architect Albert Speer (see NATIONAL SOCIALIST ART) used dramatic arrays of searchlights at Nazi rallies in a way that anticipated the son et lumière spectacles now popular as tourist entertainments, and soon after the Second World War Gyula *Košice, in 1946, is credited with being the first artist to make a sculpture consisting essentially of neon tubing (a decade earlier the Czech sculptor Zdeněk Pešánek (1896–1965) had used neon, but not as the main constituent of a work). In the 1950s Nicolas *Schöffer made some highly ambitious sculptures incorporating light effects, but it was not until the 1960s that it is possible to think of Light art constituting a movement. During this decade there were several large exhibitions of Light art in Europe and the USA (for example 'Light, Motion, Space' at the Walker Art Center, Minneapolis in 1968) and Light art often overlapped with other genres, particularly *Kinetic art, but also for example *Minimal art (notably in the work of Dan *Flavin, who typically used fluorescent tubes rather than neon) and *Pop art (notably in the work of *Chryssa). In the 1960s, also, lasers and holography (which was made possible by lasers) became available to the artist. Lasers have been used most characteristically to create spectacular nocturnal displays, the pioneer in this field being the American artist Rockne Krebs (1938–), who created his first such show in Buffalo, New York, in 1971. Many artists, including Salvador *Dalí, have experimented with holograms, and they have been sold by leading dealers such as Leo *Castelli, but in the art world holography is generally regarded as a curiosity rather than a serious means of expression.

Thomas Wilfred used the word 'Lumia' to refer to his works, and the term *Luminism is now sometimes used as an alternative to 'Light art'. However, this usage is potentially confusing, as the term 'Luminism' already has other meanings in art-historical writing.

Lightfoot, Maxwell Gordon See CAMDEN TOWN GROUP.

Lim, Kim *See* TURNBULL, WILLIAM.

Lin, Maya (1959–) American sculptor and architect, born in Athens, Ohio. Her parents, both immigrants from China, were professors at the University of Ohio. In 1981, while still an architecture student at Yale University, she won the competition for the design of the Vietnam Veterans' Memorial in Washington, which was completed in 1983. Lin's approach to the memorial had something in common with *Minimal art in its simplicity of form, its *site-specific character, and its direct physical engagement with the spectator. It consists of two long, tapering black granite walls, meeting in a V shape and sunk into the ground, with earth behind them. On the surface are inscribed the names of all those Americans who died in the conflict, in order of their death. The visitor can pass in front of the memorial on a sloping path, touching the names and being reflected in the shiny surface. It was initially controversial because of its rejection of the traditional bombast of war memorials (a compromise was reached by the addition of a conventionally heroic group in the vicinity), but it remains her best-known work.

In 1989 Lin made the Civil Rights Memorial in Montgomery, Alabama. It consists of a table of black Canadian granite, inscribed with the names of 40 men, women and children who died in the struggle for racial equality. Again the work encourages physical engagement by visitors, who can run their hands through the water which flows from the centre. Subsequently Lin has been especially concerned with themes of environmentalism. 'Systematic Landscapes' (2008) was a travelling exhibition in the form of an installation which invoked the forms of mountains and lakes.

Lindner, Richard (1901–78) German-born painter who became an American citizen in 1948. He was born in Hamburg, into a bourgeois Jewish family, and grew up in Nuremberg, where he studied piano at the Conservatory. He then moved to Munich, where he studied at the Academy and became art director of a publishing firm. In 1933 he fled Germany because of the rise of Nazism (he left the day after Hitler became Chancellor) and settled in Paris, then moved to New York in 1941. At first he worked very successfully as an illustrator for magazines such as *Harper's Bazaar* and *Vogue* and he did not begin to paint seriously until the early 1950s. He had his first one-man exhibition at the Betty *Parsons Gallery in 1954. His most characteristic works take their imagery from New York life, often with overtly erotic symbolism, and are painted with harsh colours and hard outlines (*Rock-Rock*, 1966–67, Dallas Museum of Fine Arts). His work forms a unique historic link between the world of *Grosz and *Dix and that of American *Pop art.

Further Reading: H. Kramer, *Richard Lindner* (1975)

Lindsay Family of Australian artists. The members included five of the ten children of Dr R. C. Lindsay (an Irish-born surgeon) of Creswick, Victoria: **Percy Lindsay** (1870–1952), painter and graphic artist; **Sir Lionel Lindsay** (1874–1961), art critic, watercolour painter, and graphic artist in pen, etching, and woodcut, who helped to create an interest in the collection of original prints in Australia; **Norman Lindsay** (1879–1969), painter, graphic artist, sculptor, critic, and novelist; **Ruby Lindsay** (1885–1919), graphic artist; and **Sir Daryl Lindsay** (1889–1976), painter and director of the National Gallery of Victoria from 1942 to 1956. Norman's son **Raymond** (1904–60) and Daryl's wife, **Joan** (1896–1984), were also painters. For over half a century this family, through one or other of its members, played a leading role in Australian art. The most interesting character among them was Norman Lindsay, who according to Robert *Hughes (*The Art of Australia*, 1970) 'has some claim to be the most forceful personality the arts in Australia have ever seen'. He believed that the main impulse of art and life was sex, and his work was often denounced as pornographic. However, when he saw some of Lindsay's works at an exhibition of Australian art in London in 1923, Sir William *Orpen commented that they were 'certainly vulgar, but not in the least indecent. They are extremely badly drawn, and show no sense of design and a total lack of imagination'. Lindsay's output as an artist in various media was enormous and he was also a prolific writer of fiction and non-fiction. His novels include *Age of Consent* (1935), in which the central character is an artist based loosely on himself. A film adaptation appeared in 1969, and a fictionalized version of Lindsay appears in another film, *Sirens* (1994), which was shot largely at his home, Springwood, in New South Wales, now a museum dedicated to him. His son **Jack Lindsay** (1900–90) was a writer who settled in

England in 1926. His books include several biographies of major artists.

Linien *See* MORTENSEN, RICHARD.

linocut A term applied to the technique of making a print from a thick piece of linoleum and to the print so made. Linoleum was invented in the 1860s, but it was not used for printing (in the manufacture of wallpaper) until the 1890s. The technique is essentially a development of the woodcut, the earliest of printmaking methods, but linocuts are much simpler to make because the material is soft and grainless and therefore easier to work. For this reason linocuts have been much used in the art education of children, the pioneer in this field being the Austrian painter and teacher Franz *Cižek, who toured Europe and North America with examples of his pupils' work and had a great influence on art teaching. Because of the close association with children's art, the medium has been somewhat lightly regarded, but it has also been used by eminent artists. The members of Die *Brücke were among the earliest to adopt it (*Heckel, who was making linocuts by 1903, before the group was founded, was probably the first major figure to take up the technique). *Kandinsky was making colour linocuts by about 1907.

In Britain, the most important popularizer of the medium was Claude Flight (1881–1955). He was probably the first artist to specialize in the technique and he wrote two books on the subject: *Lino-Cuts: A Handbook of Linoleum-Cut Colour Printing* (1927, revised edition 1948) and *The Art and Craft of Lino Cutting and Printing* (1934). Flight's pupils included the Australian painter and printmaker Dorrit Black (1891–1951). After returning to Australia in 1929 she tried to promote the linocut as a form of original art that was cheap enough to be bought by the ordinary person.

The two most famous artists to use linocut are *Matisse and *Picasso. Matisse took up the medium in 1938 and made about 70 linocuts between then and 1952. Picasso made his first black and white linocut in 1939 and began making linocut posters in the early 1950s. In 1958–9 he made a series of 45 colour linocuts and in 1962–3 a series of 55 more. The medium is particularly suitable for colour prints, since a number of large blocks may be used without undue expense (Picasso, however, employed a method of printing in several colours from one block). Because the surface can be cut rapidly and spontaneously, linocut is also highly suitable for big prints boldly conceived.

Lipchitz, Jacques (1891–1973) Lithuanian-born sculptor who became a French citizen in 1925 and an American citizen in 1958. His father, a Jewish building contractor, did not wish him to become an artist, but he was supported by his mother. After studying engineering in Lithuania he moved to Paris in 1909 and studied at the École des *Beaux-Arts and the *Académie Julian. He also frequented museums and became deeply interested in ancient and non-Western art (in particular, he collected African art). By about 1912 he was part of a circle of avant-garde artists including *Matisse, *Modigliani, and *Picasso, and from 1914 he became one of the first sculptors to apply the principles of *Cubism in three dimensions (*Man with Guitar*, 1916, MoMA, New York). Such works are almost three-dimensional equivalents of the paintings of Juan *Gris and generally less imaginative than those of his contemporary Henri *Laurens. For Lipchitz Cubism was 'a means of stating the nature of sculptural form in a simple essence and asserting the work of the sculpture as an identity in itself rather than an imitation of anything else', but he also recorded that 'In my Cubist sculpture I *always* wanted to retain the sense of organic life, of humanity.' A contract with Léonce *Rosenberg in 1916 enabled Lipchitz to employ a stone cutter and many of his Cubist works exist in stone and bronze versions. After the First World War he became affected by the general move towards *Neoclassicism and made a series of simple austere busts. In the late 1920s, finding Cubism overrestrictive, he came under the influence of the *Surrealist idea of metamorphosis. In this period he made his 'Transparents'. These were first made in cardboard, then transferred to wax and cast in bronze, producing a kind of open-work sculpture close to what *González was shortly after to achieve in iron. Albert Elsen interprets *Pierrot Escapes* (1926, Kunsthaus Zurich) as an autobiographical work, a metaphor for the artist's escape from the prison of the Cubist grid. Even when he was not employing the novel technique of the 'Transparents', he still made some of his most inventive work in this period, including the sculpture known both as *The Couple* and *The Cry* (1928–9, Kröller-Müller Museum, Otterlo), a double image of howling animal and copulating pair

of humans. From about 1930 he began to use allegorical subject-matter drawn from the Bible or classical mythology. After the German invasion of France in 1940 he fled to Toulouse and the following year he moved to the USA, settling at Hastings-on-Hudson, New York, in 1947. His work was already well known in his adopted country: Albert C. *Barnes had commissioned work from him in the 1920s and he had had a large one-man exhibition at the Brummer Gallery, New York, in 1935. In America he returned to greater solidity of form, but with a desire for greater spirituality. At times the tortured, bloated forms of his late work look rather like inflated shrubbery, as in *Prometheus Strangling the Vulture* (1944–53, Walker Art Center, Minneapolis). Towards the end of his career he carried out several large public commissions, for example *Peace on Earth* (1967–9, Los Angeles Music Centre). In 1972 he published an autobiography, *My Life in Sculpture*, coinciding with a major exhibition of his work at the Metropolitan Museum, New York, entitled 'Jacques Lipchitz: His Life in Sculpture'. He died on holiday in Capri (he usually spent several months each year in Italy) and was buried in Jerusalem (he first visited Israel in 1963 and regarded it as his spiritual home).

Further Reading: C. Putz, *Jacques Lipchitz: The First Cubist Sculptor* (2002)

Lippard, Lucy (1937–) American art critic who is particular known for her writings on *Conceptual art and *feminist art. She was born in New York and studied at Smith College and the New York Institute of Fine Arts. In 1969 she was one of the founders of the *Art Workers' Coalition, which combined demands for artists' rights with protests against the Vietnam War. She was closely involved with the early history of Conceptual art, and in 1973 published the first attempt in book form to document its growth, *—Six Years: The Dematerialization of the Art Object*. This used a collage of chronologically ordered references and quotations and deliberately suspended aesthetic judgement. Part of the reason Lippard was interested in this kind of art was that its abandoning of a physical 'product' appeared to undermine the commercial values of the art market, although she admitted in her 'post-face' to the book that by 1972 Conceptual artists were selling works for substantial sums and that 'art and artists in a capitalist society remain luxuries'. Lippard's

other books include *Pop Art* (1966), *Changing: Essays in Art Criticism* (1971), *From the Center: Feminist Essays on Women's Art* (1976), *A Different War: Vietnam in Art* (1990), *Mixed Blessings: New Art in a Multicultural America* (1992), and monographs on Eva *Hesse (1976) and Ad *Reinhardt (1981).

Lippold, Richard (1915–2002) American abstract sculptor, born in Milwaukee. The son of an engineer, he graduated in industrial design from the school of the Art Institute of Chicago in 1937. For several years after this he worked in industry and taught design. In 1942 he made his first sculptures—constructions of wire and scrap metal. From these he developed the 'space cages' for which he has become famous—elegant hanging constructions that give the effect of a gossamer-like network of wires suspended in space. He sometimes increased the impression of weightlessness by exhibiting them in semi-darkness against a black background. Lippold settled in New York in 1944 and had his first one-man exhibition at the Willard Gallery there in 1947. Subsequently he won much acclaim and had many public commissions, often on a large scale. Indeed, his *Orpheus and Apollo* (1962) in the Philharmonic Hall in the Lincoln Center for the Performing Arts, New York, was said at the time of its installation to be the largest piece of sculpture created in the 20th century.

Lipton, Seymour (1903–86) American sculptor, born in New York. He studied dental surgery at Columbia University, 1923–7, and was entirely self-taught as a sculptor; by 1932 he was seriously committed to art, but for many years after that he pursued a dual career (like *Ferber, another dentist-sculptor). Until the mid-1940s he carved in wood and stone, using violent distortions to reflect the social struggle and anguish of the years of the Depression and the Second World War. In about 1942, however, he took up metal casting and abandoned the human figure as a subject, instead using 'skeletal forms, horns, pelvis . . . to convey the basic struggles in nature on a broader biological level'. By 1945 his work was completely abstract and he became part of a group (Ferber, *Lassaw, *Roszak) whose work paralleled that of the *Abstract Expressionist painters. His first one-man exhibition of metal sculpture was at the Betty *Parsons Gallery in 1948. In the 1950s, as he searched for 'a controlled organic dynamism', his

violently expressive abstractions began to give way to more lyrical forms fashioned from curving shells of Monel (a nickel-copper alloy) welded together at the edges and covered with nickel-silver or bronze. Towards the end of the 1950s he once again introduced forms suggestive of the human figure, as in *Sentinel* (1959, Yale University Art Gallery). He had many major public commissions, including *Archangel* (1964) for Philharmonic Hall, Lincoln Center, New York.

Lismer, Arthur *See* GROUP OF SEVEN.

Lissitzky, El (Lazar Lissitzky) (1890–1941) Russian painter, designer, graphic artist, and architect. He was born at Pochinok near Smolensk and from 1909 to 1914 studied engineering at Darmstadt, returning to Russia on the outbreak of the First World War. Exempt from military service because of poor health, he worked in an architect's office in Moscow and collaborated with *Chagall on the illustration of Jewish books (he was an expert lithographer). In 1918 Chagall became head of the art school at Vitebsk and in the following year he appointed Lissitzky professor of architecture and graphic art. One of his colleagues at Vitebsk was *Malevich, whose advocacy of the use of pure geometric form influenced Lissitzky, notably in the series of abstract paintings to which he gave the collective name 'Proun', an acronym for Russian words meaning 'Project for the affirmation of the new' and which he referred to as 'the interchange station between painting and architecture'. They do indeed look like plans for three-dimensional constructions and in 1923 he designed a Proun Room for the 'Great Berlin Art Exhibition' (reconstruction in Stedelijk van Abbe Museum, Eindhoven), an early instance of *installation art. In 1921, after a brief period as professor at *Vkhutemas in Moscow, he was sent to Berlin, where he arranged and designed the major exhibition of abstract art at the Van Diemen Gallery that first comprehensively presented the modern movement in Russia to the West (it was later shown in Amsterdam). While in Berlin he worked on *Constructivist magazines; he also made contact with van *Doesburg and members of De *Stijl and with *Moholy-Nagy, who spread Lissitzky's ideas through his teaching at the *Bauhaus. In 1923 he went with *Gabo to a Bauhaus exhibition at Weimar and there met *Gropius. From 1923 to 1925 he lived in Swit-

zerland, then (after a short visit to Russia) from 1925 to 1928 in Hanover. He returned to Russia permanently in 1928 and settled in Moscow. By this time he had abandoned painting and devoted himself mainly to typography and industrial design. His work included several propaganda and trade exhibitions (he was a far more orthodox Communist than Malevich), notably the Soviet Pavilion of the 1939 World's Fair in New York, and his dynamic techniques of *photomontage, printing, and lighting had wide influence.

During his lifetime Lissitzky was the best known of the Russian abstract artists in the West. In his mature work he achieved a fusion of the *Suprematism of Malevich, the Constructivism of *Tatlin and *Rodchenko, and features of the *Neo-Plasticism of *Mondrian.

Further Reading: M Tupitsyn, *El Lissitzky: Beyond the Abstract Cabinet* (1999)

Lisson Gallery, London *See* NEW BRITISH SCULPTURE.

literalists Term used by Michael *Fried as a virtual synonym for exponents of *Minimal art. It is not intended as complimentary, implying that their work emphasizes actual space and conditions of viewing, so denying the kind of transcendental experience which, in his opinion, should be provided by art.

Liu Xiaodong (1963–) Chinese painter, born in Jincheng. He studied at the Central Institute of Fine Arts, Beijing, graduating in 1988. In 1992 he spent time in New York. He took part in the 'Chinese Avant-garde Art Exhibition' in Beijing in 1989. This exhibition was something of a breakthrough for independent artists in China. The critic Li Xianting detected 'tragic overtones' in Liu's paintings exhibited there. He described 'people lost in their own thoughts' and 'bored expressions and ennui'. The paintings neither followed the party directive to 'praise the masses of workers, farmers and soldiers' nor engaged ironically with official propaganda imagery as did the work of his contemporaries. To a Western spectator they seem closer to painters such as *Balthus or Edward *Hopper in their naturalistic rendering of confining social alienation or to Eric *Fischl, with whom he has frequently corresponded, for the painterly violence in his treatment of naked flesh.

Liu Xiaodong frequently works from photographs. This gives some of his paintings the air

of film stills, but he does not copy them slavishly, treating them very freely as source material. He has commented that in his paintings he has 'tried to show more humanity' as a reaction against the extent to which the human has been neglected in the recent history of China. In 1993 he witnessed the death of a worker who fell from a construction site. This incident became the basis of a series of paintings in which the dead man is seen in the distance from above, the focus being on the watchers, who confront mortality. In *Watching* (2000), psychologically the most powerful of the cycle, we do not see the body at all but only the pensive response of the spectators; as the artist put it, 'How people are curious about things, about the Unknown, about the Other World.' When it was shown in Paris at the Pompidou Centre in 2003, the curators considered it a more general reflection of puzzlement at the drastic changes taking place in China.

In 2001, following a trip to Singapore, he exhibited a group of paintings under the title of *Prostitutes, Transvestites and Men who have nothing to do*. Liu has also made a series of paintings about China's controversial Three Gorges project. The government maintained that this hydroelectric scheme to dam the Yangtze River was essential to the economic modernization of the nation, but it has been much criticized abroad on environmental and conservation grounds. The paintings concentrate on the effects on those displaced from their lands and livelihoods when thousands of villages are submerged. They were shown in San Francisco and at the Sydney *Biennale in 2006.

Further Reading: J. M. Decrop (ed.), *Liu Xiaodong* (2006)

Liverpool, John Moores Exhibition
See JOHN MOORES LIVERPOOL EXHIBITION.

Liverpool, Tate Gallery *See* TATE.

livre d'artiste (artist's book) A type of luxury illustrated book in which each illustration is printed directly from the surface on which the artist has worked (etching plate, lithographic stone, etc.). The genre was originated by the dealer Ambroise *Vollard, a great promoter of printmaking, and the first example is regarded as *Parallelement* (1900), a book of poetry by Paul Verlaine illustrated with lithographs by Pierre *Bonnard. Vollard commissioned about 50 such books, the artists involved including *Braque, *Maillol, *Picasso,

*Rodin, and *Rouault, and he was soon followed by other publishers, among them *Kahnweiler, who in 1909 issued *Apollinaire's *L'Enchanteur pourrissant* with wood engravings by *Derain. The livre d'artiste has continued to flourish particularly in France, but notable examples have also been produced elsewhere, for example *Six Fairy Tales of the Brothers Grimm* (1969), with etchings by David *Hockney.

Usually livres d'artiste are published in unsewn sheets, rather than bound (this means that they can be specially bound to the owner's requirement or dismantled for individual display of particular illustrations). The number of copies in an edition typically ranges from about 20 to 300. Printing is done by specialist establishments, using carefully selected paper, inks, and typefaces, and the artists and publishers often go to great lengths to secure the exact results they require (for an example, *see* SKIRA).

Llewellyn, Sir William *See* ROYAL ACADEMY OF ARTS.

Lloyd, Frank *See* MARLBOROUGH FINE ART.

Locke, Alain *See* HARLEM RENAISSANCE.

Lohse, Richard (1902–88) Swiss painter and graphic artist, born in Zurich, where he studied at the School of Arts and Crafts. In his early works he experimented with various subjects and styles, but in the 1940s he became one of the leading representatives of *Concrete art. His paintings are mathematically based, often featuring chequer-board or grid-like patterns, but they are not cold or analytical in effect; indeed his work is particularly noted for its beauty and refinement of colour, and it has a certain resemblance to *Op art of the kind associated with Bridget *Riley. Lohse began to gain an international reputation from about 1950 and in 1958 he was awarded the Guggenheim International Prize.

London, Courtauld Institute of Art *See* COURTAULD, SAMUEL.

London, Goldsmiths College *See* GOLDSMITHS COLLEGE.

London, Hayward Gallery *See* ARTS COUNCIL.

London, Imperial War Museum *See* OFFICIAL WAR ART.

London, Institute of Contemporary Arts *See* INSTITUTE OF CONTEMPORARY ARTS.

London, Royal Academy *See* ROYAL ACADEMY OF ARTS.

London, Royal College of Art *See* ROYAL COLLEGE OF ART.

London, Saatchi Collection *See* SAATCHI, CHARLES.

London, St Martin's School of Art *See* ST MARTIN'S SCHOOL OF ART.

London, School of *See* SCHOOL OF LONDON.

London, Serpentine Gallery *See* ARTS COUNCIL.

London, Slade School *See* SLADE SCHOOL OF FINE ART.

London, Tate Gallery *See* TATE.

London, Whitechapel Art Gallery *See* WHITECHAPEL ART GALLERY.

London Artists' Association *See* COURTAULD, SAMUEL.

London Bulletin See MESENS, E. L. T.

London College of Fashion *See* ST MARTIN'S SCHOOL OF ART.

London College of Printing and Distributive Trades *See* ST MARTIN'S SCHOOL OF ART.

London Gallery *See* MESENS, E. L. T.

London Group An exhibiting society of British artists formed in 1913 after the *Camden Town Group petered out and its members joined forces with a number of other progressive artists. The first president was Harold *Gilman; apart from other ex-Camden Town Group artists, the strongest representation among the early members consisted of *Futurists and those who would soon become known as *Vorticists, among them *Bomberg, *Epstein (who suggested the name), *Nevinson, and *Wadsworth. The first exhibition of the group was held at the Goupil Gallery, London, in March 1914, with the Vorticists seeming to the press and public to swamp the show. Bomberg's enormous and dazzling *In the Hold* (1913-14, Tate) was the most spectacular work on view; Lucien *Pissarro said that the

'drunkards' had triumphed over the 'teetotallers'. Once the initial Vorticist domination was over, the group became less aggressively avantgarde: it became increasingly associated with the *Bloomsbury Group. The London Group was revived after the Second World War, and came to be looked on as something of an institution, not associated with any particular aesthetic philosophy. An exhibition marking the group's golden jubilee was held at the Tate Gallery, London, in 1964. The group still exists.

London Studio See STUDIO, THE.

Long, Richard (1945–) British artist whose work brings together sculpture, *Conceptual art, and *Land art. Born in Bristol, he studied there at the West of England College of Art, 1962-5, during which time he made sculptures out of doors from snow and other natural materials, and then at *St Martin's School of Art, London, 1966-8, when he encountered a radical questioning of the nature of sculpture. A response to this was *A Line Made by Walking* (1967), a photographic record of the trace in the grass of a walk carried out several times across the same path, so the work becomes a compound of action, trace, and documentation. Since then, his artistic activity has been based on long solitary walks that he makes through landscapes, initially in Britain, and from 1969 also abroad, often in remote or inhospitable terrain. Sometimes he collects objects such as stones and twigs on these walks and brings them into a gallery, where he arranges them on the floor, usually in circles or other fairly simple geometrical shapes (*Circle of Sticks*, 1973, *Slate Circle*, 1979, both Tate). Stones are never cut specially but always used as they are found. Mud and clay have been used by Long for wall drawings. He also creates such works in their original settings, and documents his walks with photographs, texts (which refer to the things he passes and more recently to his state of mind), and maps. The relationship of the walks to the exhibited works is not simple. What is seen in the gallery records, we presume, a real act. In the map pieces the walks frequently follow a line already established conceptually on the map itself. The text pieces represent the journey filtered through memory as a series of fragments; for the spectator, especially when the work is seen on a gallery wall, the process of reading evokes the real space with which the artist has engaged

physically. Long is the leading British exponent of Land art, with an international reputation (as early as 1976 he represented Britain at the Venice *Biennale). Richard Cork wrote that 'Long achieves the remarkable feat of drawing inspiration from the most ancient sculptural forms and at the same time contributing to adventurous notions about sculpture in his own period' (catalogue of the exhibition 'British Art in the 20th Century', Royal Academy, London, 1987). More sceptically, Paul Overy commented that his 'long marches across apparently empty continents could be construed as an impotent shadow of nineteenth century imperialism' (*Art Monthly*, no. 4, 1977). Long has, however, maintained that 'if the politics of the world changed and for some reason or other I was limited to work in England, I hope and I am sure I could be an artist working within fifteen miles of Bristol'. In 1989 he was awarded the *Turner Prize and in 1991 a major *Arts Council exhibition of his work entitled 'Walking in Circles' was held at the Hayward Gallery, London.

Further Reading: A Seymour, *Walking in Circles* (1991)

Longo, Robert (1953–) American painter, sculptor, and film-maker, born in Brooklyn, New York. His work was first noted when it was selected for the 1977 'Pictures' exhibition in New York (*see* APPROPRIATION). Like other artists in the exhibition, he used recognizable images but taken from the mass media rather than from life. In the 1980s his images of men in business suits, photographically rendered in charcoal against a white background, the *Men in Cities* series, tumbling like fallen shooting victims in a gangster film, made him among the most successful artists in New York. Some political comment was detected in his work, as in *Sword of the Pig* (1983), in which a muscled male torso, headless but with conspicuous penis, is juxtaposed with a missile silo. He recalled later 'I wanted to take an aggressive position in a culture that I thought was sick.' Later work has been criticized for a lack of development. Daniel Kunitz (*New Criterion*, December 1999) found in his recent pieces 'a distinctly eighties idea of corporate heroism'. Since 2000 he has made work addressing the expulsion of Freud from Vienna by the Nazis and returned to the theme of nuclear war. Longo has also made sculpture reminiscent of science fiction monsters and directed a commercial feature film, *Johnny Mnemonic* (1995).

Further Reading: 'Robert Longo talks to Mary Haas', *Artforum International* (March 2003)

López, Francisco *See* SPANISH REALISTS.

López García, Antonio *See* SPANISH REALISTS.

López Torres, Antonio *See* SPANISH REALISTS.

Lorimer, Hew (1907–93) Scottish sculptor, born in Edinburgh, son of the distinguished architect (and occasional painter) **Sir Robert Lorimer** (1864–1929) and nephew of the portrait painter **John Henry Lorimer** (1856–1936). Hew Lorimer intended to follow his father into architecture and began studying the subject at Edinburgh College of Art, but he switched to sculpture, and was taught by Alexander Carrick (1882–1966), head of the department there from 1928 to 1942, who encouraged his students to practise *direct carving. Between 1933 and 1935 scholarships enabled Lorimer to travel in France and Italy and to spend a period working with Eric *Gill, who passed on his belief that the artist is a humble collaborator in God's creative acts. This idea remained central to Lorimer's work throughout the rest of his career, as did his love of stone carving. He carried out numerous religious commissions, but his best-known works are probably the seven allegorical figures of the *Liberal Arts* (1952–5) on the façade of the National Library of Scotland, Edinburgh.

Los Angeles, Museum of Contemporary Art *See* MUSEUM OF CONTEMPORARY ART, LOS ANGELES.

Lorjou, Bernard *See* HOMME-TÉMOIN.

Lotar, Eli *See* BATAILLE, GEORGES.

Louis, Morris (Morris Louis Bernstein) (1912–62) American painter, considered the main pioneer of the movement from *Abstract Expressionism to Colour Stain Painting (*see* COLOUR FIELD PAINTING). The son of Russian-Jewish immigrants, he was born in Baltimore, where he studied at the Maryland Institute of Fine and Applied Arts, 1929–33. In 1934–40 he lived in New York, working on the *Federal Art Project (it was during this period that he dropped his last name), but otherwise his whole career was spent first in Baltimore and then from 1947 in nearby

Washington (initially he lived in the suburb of Silver Spring, then from 1952 in the city itself). He isolated himself from the New York art world, concentrating on his own experiments and supporting himself by teaching. However, it was a visit to New York in 1953 with Kenneth *Noland that led to the breakthrough in his art. He and Noland went to Helen *Frankenthaler's studio, where they were immensely impressed by her painting *Mountains and Sea*, and Louis immediately began experimenting with her technique of applying liquid paint on to unprimed canvas, allowing it to flow over and soak into the canvas so that it acted as a stain and not as an overlaid surface of pigment. He was secretive about his technical methods and it is uncertain how he achieved his control over the flow of colour, but towards the end of his life he suffered from severe back problems caused by his constant bending and stooping over the canvas. Whatever his technique, the effect was to create suave and radiant flushes of colour, with no sense of brush gesture or hint of figuration. His method was exacting, allowing no possibility of alteration or modification. For this reason, perhaps, Louis destroyed much of his work of this period.

Louis painted various series of pictures in his new technique, the first of which was *Veils* (1954; he did another series in 1957–60). The other major series were *Florals* (1959–60), *Unfurleds* (1960–61), and *Stripes* (1961–2). The *Veils* consist of subtly billowing and overlapping shapes filling almost the entire canvas, but his development after that was towards rivulets of colour arranged in rainbow-like bands, often on a predominantly bare canvas.

It was not until 1959 that Louis's reputation began to take off (he had his first foreign exhibition in 1960 at the Institute of Contemporary Arts in London), and he had little time to enjoy his success before dying of lung cancer. However, his reputation now stands high and he has had enormous influence on the development of Colour Stain Painting. In the introduction to the catalogue of the 1974 Arts Council exhibition of his work, John Elderfield wrote: 'Morris Louis is one of the very few artists whose work has really changed the course of painting . . . With Louis, fully autonomous abstract painting came into its own for really the first time, and did so in paintings of a quality that matches the level of their innovation.'

Further Reading: J. Elderfield, *Morris Louis* (1991)

Louisiana Museum, Humlebaek, near Copenhagen. Collection of modern art founded by the Danish merchant Knud W. Jensen (1921–2000) in 1958. It is housed in a series of buildings erected in stages between 1958 and 1982 and linked to a 19th-century house called Louisiana (this had belonged to a nobleman—an ancestor of Jensen's—who married three times, each wife being called Louise). The museum buildings are modern in style, but they make extensive use of rustic materials and are sympathetically related to the beautiful setting, near the sea and a lake (many of the walls are predominantly glass, allowing views of the surrounding landscape, and much of the sculpture in the collection is shown in the open air). The museum is particularly rich in Danish works, but it also has the best collection of international modern art in the country.

Lowe, Peter *See* CONSTRUCTIVISM.

Lowry, L. S. (Laurence Stephen) (1887–1976) British painter. He lived all his life in or near Manchester and worked as a rent collector and clerk for a property company until he retired (as chief cashier) in 1952. His painting was done mainly at night after his day's work, but he was not a *naive painter, having studied intermittently at art schools from 1905 to 1925. The most important of his teachers—at Manchester School of Art—was Adolphe Valette (1876–1942), a French painter who settled in Manchester in 1905 and whose work includes some memorably atmospheric views of the city. Lowry, too, concentrated on urban subjects, but his style was very different to Valette's and much more in the tradition of certain painters of the *Camden Town Group. His most characteristic pictures feature firmly drawn backgrounds of industrial buildings, often bathed in a white haze, against which groups or crowds of figures, painted in his distinctive stick-like manner, move about their affairs. There is sometimes an element of humour in Lowry's work, but the prevailing feeling is generally what Sir John *Rothenstein calls 'a kind of gloomy lyricism' (Lowry was a solitary character and said 'Had I not been lonely I should not have seen what I did'). Many of his paintings record his immediate surroundings, but others are semi-imaginary views, such as *The Pond* (1950, Tate), one of his largest and most ambitious

works. Mervyn Levy, a leading scholar of Lowry's work, writes of this picture: 'This is perhaps the Elysium of the artist's dream; the pure poetry of the industrial landscape—miraculous and shining. People and animals, buildings and smoking stacks, the boats bobbing on the pond, and high up, the most haunting of all the artist's grass-root images—the Stockport Viaduct—combine in a glorious harmony.'

Lowry's first one-man exhibition, at the Reid & Lefevre Gallery, London, in 1939, established his name outside his home area for the first time, and his reputation steadily increased (particularly after a television documentary on him in 1957), leading to a large retrospective exhibition arranged by the *Arts Council in 1966 (it was shown at the Tate Gallery, London, and elsewhere). By this time he was turning from industrial subjects to landscapes and seascapes. He also occasionally painted portraits (there is a self-portrait, 1938, in the Lowry, Salford, which holds the largest collection of his work). In spite of his growing fame, he continued to lead a frugal life and he turned down a knighthood and other honours (although he did accept some awards, including honorary doctorates from three universities).

In 1976, a few months after Lowry's death, a comprehensive retrospective exhibition of his work at the *Royal Academy brought considerable divergence of opinion among critics. Some thought of him as a great artist with an important original vision. Others represented him as a very minor talent, although interesting as a social commentator. What is certain is that his work has struck a chord with the general public: the 1976 exhibition broke attendance records, and two years later Lowry had the distinction of becoming the only 20th-century painter to be the subject of a number-one hit record, the memorable 'Matchstalk Men and Matchstalk Cats and Dogs', an apt and poignant tribute to the artist by the one-hit wonders Brian and Michael. The author Howard Jacobsen has argued that Lowry's vision should be regarded as 'a brutal consideration of the modern world' and compared him to the playwrights Samuel Beckett and Harold Pinter. After the artist's death a considerable number of private drawings of women in bondage came to light.

Further Reading: S. Rohde, *L.S. Lowry: A Life* (2007)

V. Thorpe, 'Lowry's Dark Imagination Comes to Light', *The Observer* (25 March 2007)

Lozano, Lee (1930–99) American artist born as Leonore Knaster in Newark, New Jersey. She studied at the Art Institute of Chicago from 1957 to 1959. She took the name of her husband, an architect and designer, although they were divorced in 1960 at the time that she embarked on her career as an artist in New York. In the early 1960s she made explicit and violent drawings of mechanical sex, sometimes using visual puns (a spanner in jeans as a penis), sometimes using crude language. Other drawings and paintings deal with subjects like the plucking of eyebrows or the squeezing of zits. All the work, while hardly illusionistic, is vigorously modelled in three dimensions: at one point she said 'I hate flatness'. The body and the machine come together again in what are probably Lozano's most attractive works, a series of paintings of the mid-1960s such as *Clash* (1965, University of North Carolina). With a facture described by Todd Alden as 'industrial but never impersonal' (*documenta 12 catalogue) and using the colours of ferrous oxide, although apparently abstract, they relate to the earlier machine imagery and suggest gleaming curved surfaces interacting. At the time she was close to the *Minimalist artists such as Robert *Morris and Richard *Serra and shared their preoccupation with the relation between material process and the body. In a notebook comment of 1968 she identified two concepts of paint. One was a 'liquid state', which she associated with '*Pollock and Lewis' (presumably Morris *Louis: Lozano's spelling was as idiosyncratic as her art); the other was 'being matter in solid state. A painter who thinks of it this way is Lee Lozano whose bowels function magnificently'. She became disenchanted with the highly competitive world of the New York art scene and resolved to disengage with it. In 1971 she announced that, as an art work, she would refuse to talk to any woman for a month. Paradoxically this has been claimed as a *feminist gesture, an exposure of where the real power lay. However, she took this further and not only gave up art, but completely disappeared for ten years. Today little is known of her later life. One of the last of her extensive written notes, which form her final art works, includes the sentence 'I will be human first, artist second'. She died in Dallas in 1999, a forgotten figure, although her posthumous reputation is growing.

Further Reading: Kunsthalle, Vienna, *Seek the Extremes: Lee Lozano* (2006)

Lucas, Colin See UNIT ONE.

Lucas, Sarah (1962–) British artist. Born in London, she studied alongside Angus *Fairhurst and Damien *Hirst at *Goldsmiths' College, 1984–7. She took part in Hirst's 'Freeze' exhibition of 1988. Her first solo exhibition in London in 1992 was entitled 'Penis Nailed to a Board', from a tabloid news story about sadomasochism. In 1993 she and Tracey *Emin opened a shop in Bethnal Green Road in the East End of London where they sold their works. By this time, Lucas was already represented in the collection of Charles *Saatchi and was included in the *'Sensation' exhibition of 1997. Lucas has worked in many media but her art is consistently marked by a confrontational treatment of taboo subjects. When she deals with sexuality it is in a notably raunchy manner, quite distinct from the emphasis on the maternal body or the mythical treatment of female empowerment found in an earlier generation of *feminist artists. *Sod you gits* (1991, Tate) is a photocopied page from the *Sunday Sport*, featuring a story about the exploits of a midget woman ('Men go wild for my body'). *Two Fried Eggs and a Kebab* (1992) presents the female body in terms of the verbal derision of the nervous adolescent male. She poses for photographs in a masculine garb with fried eggs on her breasts or a fish on her shoulder. The *Bunny* series uses stuffed tights to evoke a headless sexually compliant woman. This interest in sexual metaphor made her an appropriate exhibitor at the Freud Museum, London, in 2000. Julian Stallabrass has related her work to an idea of the 'urban pastoral'. He argues that the art audience today seeks refuge, not in an Arcadia of shepherds, but in working-class culture. *Concrete Void and Islington Diamonds* (1997) is an example. The title refers to a colloquial term for a smashed windscreen; Lucas exhibited her own wrecked car. In the present climate Lucas's treatment of the theme of smoking may be a greater cause for controversy than sex. Cigarettes have been used as sculptural material. An interview with her was entitled 'Drag Queen'. Lucas has also designed for the ballet. A retrospective of her work was held at Tate Liverpool in 2005.

Further Reading: M. Collings, *Sarah Lucas* (2005)

A. C. Grayling, 'An Uncooked Perspective on the Nature of Sex', *Tate* (autumn 2005)

Luce, Maximilien (1858–1941) French painter and graphic artist. He was a friend of *Signac and like him an exponent of *Neo-Impressionism, although he was less rigid in his interpretation of its doctrines. His main subjects were landscape and townscape (especially of industrial areas). He was a fairly minor painter, but he is noteworthy for helping to popularize Neo-Impressionism outside France, particularly in Belgium (he exhibited with Les Vingt and La *Libre Esthétique). There is a museum of his work at Mantes-la-Jolie.

Luchism See RAYONISM.

Lucie-Smith, Edward (1933–) British poet and writer on art. He was born in Kingston, Jamaica, settled in England in 1946, and read history at Merton College, Oxford. He has worked mainly as a freelance journalist, radio broadcaster, and author, and has written or edited more than 100 books, mainly poetry anthologies or popular works on 20th-century art. He has also written introductions to collections of homoerotic photographs and has been art critic for *The Listener* (his references to Wittgenstein and Ezra Pound while writing for this publication were in strong contrast to his populist approach elsewhere) and for *The Evening Standard*, on which he replaced the controversial Richard *Cork.

Ludwig, Peter (1925–96) German businessman and art collector, born in Koblenz. He studied art history at Mainz University (writing a doctoral thesis on *Picasso in 1950), then went into business and ran various firms, including his wife's family's chocolate factory, which he took over in 1952. His collecting interests were initially very broad, but he came to concentrate on contemporary art, in which he built up one of the world's largest collections, particularly rich in American *Pop art (which he bought en bloc at *documenta 4 in 1968). He made many donations to public collections, and several cultural bodies in Germany and Austria now bear his name, notably the Museum Ludwig in Cologne (founded 1986), which is one of the world's leading galleries of modern art. According to his obituary in *The Times*, Ludwig 'displayed a quasi-scientific approach to collecting and a monastic aversion to the limelight'; his 'aloofness, and a certain irritability with interviewers, saw to it that his name was not well known outside Germany'. His activities did not receive universal acclaim. He was a particular target of Hans *Haacke's investigations of the

political manipulations behind apparently disinterested patronage. *See also* BREKER.

Lu Haisu *See* XU BEIHONG.

Lukács, Georg *See* EIGHT, THE (3).

Luks, George (1867–1933) American painter and graphic artist. He was born in Williamsport, Pennsylvania, and began his studies at the Pennsylvania Academy of the Fine Arts, Philadelphia, in 1884. Over the next decade he travelled in Europe, studying at various academies en route. In 1894 he became an illustrator on *The Philadelphia Press* and made friends with other newspaper artists—*Glackens, *Shinn, and *Sloan—who introduced him to Robert *Henri. In 1896 Luks moved to New York, where he turned more to painting and became a member of The *Eight (1) and the *Ashcan School. A flamboyant character who identified himself with the poorer classes and made a pose of bohemianism, he was much given to tall tales and sometimes posed as 'Lusty Luks', an ex-boxer. His work was uneven and unpredictable. It had vigour and spontaneity but often lapsed into superficial vitality. One of his best-known works is *The Wrestlers* (1905, Museum of Fine Arts, Boston), which shows his preference for earthy themes and admiration for the bravura painterly technique of artists such as Manet. Luks taught for several years at the *Art Students League and also ran his own school. His death was slightly mysterious, his body being found in a doorway; newspapers reported that he had died sketching in the street, but some of his friends assumed he had picked one fight too many.

Luminism A term used in several different ways in art-historical writing, some fairly distinct, others more vague. The three most distinct ones are: to describe an aspect of mid-19th-century American landscape painting in which the rendering of light and atmosphere was paramount; as an alternative term for *Light art; and as a name for *Neo-Impressionism in Belgium. In this last sense, the name derives from the group Vie et Lumière founded in 1904. Its members, several of whom had exhibited with La *Libre Esthétique, included Anna Boch (1848–1936), Emile Claus (1849–1924), the French-born William Degouve de Nuncques (1867–1935), Adrien Heymans (1839–1921), and George Morren (1868–1941). By loose extension, the term 'Luminism' was also used from about 1910 to refer to the late phase of *Impressionism in the Netherlands. In his book *Modern Masterpieces* (1940), Frank *Rutter used the term more vaguely, to characterize the 'attempt to express in paint the colour of light' that he thought typical of Impressionism.

Lunacharsky, Anatoly *See* NARKOMPROS.

Lüpertz, Markus (1941–) German painter and sculptor, born in Reichenberg (now Liberec, Czech Republic). His family moved to West Germany in 1948. In 1964 he began his so-called 'dithyrambic' paintings in reference to the Dionysian cult, of special significance in German philosophy because of Nietzsche's invocation of it in his book *The Birth of Tragedy* (1892), as in opposition to the calm ordered cult of Apollo. The idea, formalized by a manifesto of 1966, was to fill an abstract form with expressive pathos. His best-known work is the triptych *Black-Red-Gold-dithyrambic* (1974, Galerie der Staat, Stuttgart). This consists of three near-identical images of ancient war emblems including a helmet, apparently abandoned in a field but still potentially menacing. Another motif has been the actual attributes of painting—the brush and the palette. He began making sculpture in painted bronze in 1981.

Lurçat, Jean (1892–1966) French painter and designer, born at Bruyères, Vosges. He studied in Nancy before moving to Paris in 1912. For a time he was influenced by *Cubism, but more important and lasting influences on his painting came from his extensive travels during the 1920s in the Mediterranean countries, North Africa, and the Middle East. His pictures were dominated by impressions of desert landscapes, reminiscences of Spanish and Greek architecture, and a love of fantasy that led him to join the *Surrealist movement for a short period in the 1930s. Lurçat is chiefly remembered, however, for his work in the revival of the art of tapestry in both design and technique. His designs combined exalted themes from human history with fantastic representations of the vegetable and insect worlds, and he succeeded in reconciling the stylizations of medieval religious tapestry with modern modes of abstraction. In 1939 he was appointed designer to the tapestry factory at Aubusson and together with Marcel *Gromaire he brought about a renaissance in its work. He made more than a thousand designs, the most

famous probably being the huge *Apocalypse* (1948) for the parish church of Assy (Haute-Savoie). From 1930 onwards he did a number of coloured lithographs, stage designs, and book illustrations, and in the 1960s he renewed his painting activities. He also wrote poetry and books on tapestry.

Lutyens, Sir Edwin *See* ROYAL ACADEMY OF ARTS.

Lyon, Robert *See* ASHINGTON GROUP.

Lyotard, Jean-François *See* POST-MODERNISM.

Lyrical Abstraction A term applied to a type of expressive but non-violent abstract painting flourishing particularly in the 1950s, chiefly in France; the term seems to have been coined by the French painter Georges *Mathieu, who spoke of 'abstraction lyrique' in 1947. In that year, the exhibition which is usually considered to have launched the ten-dency was held, 'L'Imaginaire' at the Galerie du Luxembourg in Paris. The critic and co-organizer of that exhibition, José-Jean March-and, wrote of 'a lyricism disengaged from all servitude and pseudo-problems', presumably implying freedom from the political demands for realism as well as from the need to theorize. European critics often use the term more or less as a synonym for *Art Informel or *Tachisme; Americans sometimes see it as an emasculated version of *Abstract Expressionism. To some writers the term implies particularly a lush and sumptuous use of colour. An exhibition of 'abstraction lyrique' held at the Musée du Luxembourg, Paris, in 2006 included, among others, Vieira *da Silva, Nicolas de *Staël, Pierre *Soulages, and *Zao Wou Ki. The critic Pierre Descargues has argued that the term can also be applied to certain sculptors, including François *Stahly, whose work had a similar improvisational quality.

Further Reading: *L'abstraction lyrique: Paris 1945–56*, special edition of *L'objet d'art*, no. 24 (2006)

MA See ACTIVISTS.

Maar, Dora (1907–97) French photographer and painter, born in Paris as Henriette Theodora Markovitch; her father was a Croatian architect. For many years she was best remembered as the mistress of *Picasso and the model for some of his most powerful portraits, including *Weeping Woman* (1937, Tate). Today her photographs and collages are recognized as important contributions to *Surrealism. She made photomontages placing figures in disquieting architectural settings. *29 Rue d'Astorg* (c.1936, Pompidou Centre) has a statuette of a seated woman with a bizarrely phallic head within a distorted cloister. *Portrait of Ubu* (1936) became a kind of mascot for the exhibition of Surrealist objects which was staged in Paris that year. Maar kept the secret of exactly what it represented until her death. The most plausible identification has been an armadillo foetus, but perhaps it should be seen as a representation of Georges *Bataille's (another of Maar's lovers) concept of the 'formless'. In her last years she became a recluse and took to religion saying, 'After Picasso, only God'.

Further Reading: M. A. Caws, *Dora Maar: With and Without Picasso* (2000)

McAllister, Isabel See GILBERT, SIR ALFRED.

McAlpine, Alistair See NEW GENERATION.

McBride, Henry (1867–1962) American art critic, born at West Chester, Pennsylvania. He worked as a writer and illustrator of seed catalogues before he saved enough money to move to New York in 1889. After studying at the *Art Students League and elsewhere, he taught at various schools and gained a wide experience of art through travels in Europe. In 1913 he began working for *The Sun* in New York, in writing art criticism. Some of his first articles (unsigned) were on the *Armory Show (1913) and they were among the most moderate and informative devoted to the exhibition. McBride continued writing for *The Sun* until 1950 and also contributed criticism to *The Dial*, which during the 1920s (it ceased publication in 1929) was 'the most distinguished literary monthly in the US to champion modern artistic movements' (*Oxford Companion to American Literature*). From 1930 to 1932 he was editor of *Creative Art*, which was initially published as a supplement to the American edition of the London-based *Studio*. When *The Sun* merged with the *World Telegram* in 1950, it dispensed with the services of McBride (now in his 80s), but he was taken on by *Art News*, for which he wrote a regular column, 1950–5. McBride was a much-liked man who had many friends in the art world; he even got on tolerably well with the quarrelsome Dr *Barnes. His sympathies were wide (in his later years he wrote perceptively about such rising stars as *Pollock and *Rothko) and his literary style was relaxed and unpretentious. A collection of his articles was published in 1975 as *The Flow of Art: Essays and Criticisms of Henry McBride*.

MacBryde, Robert (1913–66) British painter and theatre designer, born at Maybole, Ayrshire. After working for five years as an engineer in a factory, he studied at *Glasgow School of Art, 1932–7. He formed an inseparable relationship with his fellow student Robert *Colquhoun and they lived and worked together until the latter's death in 1962. MacBryde himself consistently maintained that Colquhoun was the dominant figure artistically, and his own work (mainly still-lifes and figure subjects) has been overshadowed by that of his partner. Colquhoun was certainly the more imaginative, but some critics maintain that MacBryde had a better sense of colour.

McCahon, Colin (1919–87) New Zealand painter. With Rita *Angus and Toss *Woollaston, McCahon formed 'the trinity of native-born painters who pioneered the modern movement

in New Zealand art' (Gil Docking, *Two Hundred Years of New Zealand Painting*, 1971) and he is generally considered his country's foremost 20th-century artist. He was born in Timaru, studied at Dunedin School of Fine Arts, and 'roamed the length of New Zealand' (Docking). His paintings—intense and visionary in style—are mainly landscapes and religious subjects, and he often combined the two, as in his *Fourteen Stations of the Cross* (1966, Auckland AG), in which Christ's Passion is placed in the North Otago hills. In 1953 McCahon was appointed keeper of the Auckland City Art Gallery and in 1964 he became lecturer in painting at the University of Auckland.

McCall, Anthony (1946–) British installation artist and designer. He was born in St Paul's Cray, Kent, and studied graphic design at Ravensbourne College of Art. In the early 1970s he staged events including the *Landscape for Fire* (petrol burning in a field) which were the basis for films. This emphasized for him the extent to which conventional cinema was always the record of a past event. He found an alternative to this after he moved to New York in 1973 and made his best-known film, *Line Describing a Cone*. On the screen there is seen the gradual tracing of the circumference of a circle in light against dark, but the spectator attends not just to the image but to the beam of projected light, a kind of dematerialized sculpture. This and other *Solid Light* films were initially shown in downtown lofts. As he put it, 'when you had a few people in them the dust would get kicked up to create a kind of medium through which you could see my films'. The works were invisible when moved to the spotless environment of the uptown galleries but can now be seen again thanks to the invention of the fog machine. He has said that his installations need to be viewed as both sculpture and painting to be fully appreciated. From 1979 to 1998 he worked as a graphic designer, especially on exhibition catalogues, but afterwards returned to projection, this time working digitally rather than with film.

Further Reading: M Falconer, 'Seeing the Light: Anthony McCall at Serpentine Gallery', *The Times* (24 November 2007)

J Kastner, 'Anthony McCall talks about his "solid light" films', *Artforum International* (summer 2004)

(⊕) SEE WEB LINKS

• Interview by Julia Peyton-Jones and Hans Ulrich Obrist, on the Serpentine Gallery website.

McCarthy, Paul (1945–) American sculptor, video and performance artist, born in Salt Lake City, Utah. His work engages with extremes of scatology, sexuality, and violence, and he has sometimes been compared to the *Vienna Actionists, although he has insisted that unlike them he is concerned with ketchup rather than blood. He has worked in collaboration with Mike *Kelley and one of his best-known works is the video *Heidi*, which they made together. This shows the much-loved heroine of the Swiss children's story engaging in sexual rituals with her grandfather. The target is not just the sentimentality of the story: the video has a soundtrack on which is read Adolf Loos's 1908 essay 'Ornament and Crime'. This text became a rallying cry for *Modern Movement austerity, denouncing superfluous decoration on architecture as being as barbaric and infantile as the tattooing of the body. At one point in the video we see that Heidi's buttocks are tattooed, while the preoccupation with excrement opposes the 'cleanliness' associated with modern architecture. An added irony is that Loos was eventually disgraced as the result of a paedophile scandal. *Painter* (1995) is sometimes considered to be a satire on Willem *de Kooning, who, by the time the film was made, was known to be mentally incapacitated. McCarthy, grotesquely masked, kisses the buttocks of a collector, futilely attempts to paint, and finally attacks outsize fingers with a knife until they spurt blood. McCarthy has also made inflatable sculpture. In 2008 a gigantic blow-up dog turd was blown from its moorings in an exhibition in Berne and created havoc.

Further Reading: M. Duncan, 'Daddy's Little Helper', *Frieze* issue 10 (May 1993)

MacColl, D. S. (Dugald Sutherland) (1859–1948) British painter, critic, lecturer, and administrator. He was born in Glasgow and studied at University College London and Lincoln College, Oxford, where he graduated in classics in 1884. In the next few years he travelled extensively on the Continent and also studied at Westminster School of Art under Frederick *Brown and at the *Slade School under *Legros. From 1890 to 1895 he was art critic of *The Spectator* and from 1896 to 1906 of *The Saturday Review* (and again from 1921 until 1930, when he moved to the newly founded *Week-end Review*). In these positions he helped to influence public taste in favour of *Impressionism, and his book *Nineteenth*

Century Art (1902) contains one of the earliest balanced assessments of the movement. He did not care for the *Post-Impressionists, however, and thought that *Cézanne must have suffered from an eye defect. MacColl was keeper of the *Tate Gallery, 1906–11, and of the Wallace Collection, 1911–24, one of the founders of the *Contemporary Art Society in 1910, and a vigorous controversialist. He was one of Roger *Fry's most earnest critics, believing that the artist can only paint what can be seen. As a painter he concentrated on landscape watercolours, although he also did portraits in oils, including one of Augustus *John (1907, Manchester Art Gallery). His books include *Confessions of a Keeper* (1931) and a monograph on *Steer (1945).

Macdonald, Frances See GLASGOW FOUR.

MacDonald, J. E. H. (James Edward Hervey) (1873–1932) Canadian landscape painter. He was born in Durham, England, the son of a Canadian father, and moved to Hamilton, Ontario, when he was fourteen. In 1889 the family moved to Toronto, where he studied at the Central Ontario School of Art and Design. After spending several years in England working as a commercial artist, he returned to Toronto in 1907. In 1911 he met Lawren *Harris, who persuaded him to devote all his time to painting; they began working together and their shared dream of creating a uniquely Canadian type of landscape painting culminated in 1920 in the formation of the *Group of Seven. MacDonald's best-known works include *The Solemn Land* and *Autumn in Algoma* (1921 and 1922 respectively, NG, Ottawa)—large, spectacular canvases that are regarded as being among the very finest produced by the group. He was important in its affairs not only as a painter, but also as a spokesman against reactionary criticism. From 1921 he taught at the Ontario College of Art, where he became principal in 1929. His last works included some sketches of beach and surf in Barbados, where he had gone to recuperate following a stroke in 1931.

Macdonald, Jock (1897–1960) Canadian painter, born in Thurso, Scotland, the son of an architect. Initially he worked as an architectural draughtsman, and after serving in the First World War he studied commercial design at Edinburgh College of Art, 1919–22. For the next few years he worked as a designer for a textile firm and taught at Lincoln School of Art,

before emigrating to Canada in 1926 to take up a post as head of design at the newly founded Vancouver School of Decorative and Applied Arts. It was only at this point that he began painting, encouraged by Fred Varley, who was head of drawing, painting, and composition at the school. Macdonald's early paintings were in the tradition of the *Group of Seven (of which Varley was a member), but in 1934 he produced his first abstract work, *Formative Colour Activity* (NG, Ottawa). In the late 1930s he became a friend of Emily *Carr, whom he considered 'undoubtedly the first artist in the country and a genius without question', and in 1940 of Lawren *Harris, who encouraged him in his abstract experiments. These included *automatic paintings in a *Surrealist vein in the late 1940s and early 1950s. In 1947 Macdonald settled in Toronto and in 1953 he was one of the founders there of the abstract group *Painters Eleven. From this time his output was prodigious, as he threw himself into experimenting with various media and techniques. His final works are radiant in colour and suggestive of organic growth (*Nature Evolving*, 1960, Art Gallery of Ontario, Toronto).

Macdonald, Margaret See GLASGOW FOUR; MACKINTOSH.

Macdonald-Wright, Stanton (1890–1973) American painter, designer, teacher, administrator, and writer, remembered chiefly as a pioneer of abstract art. He was born in Charlottesville, Virginia, moved to California as a child, and entered the Art Students League of Los Angeles in 1905. In 1907 he moved to Paris, where he studied briefly at the Académie Colarossi, the *Académie Julian, and the École des *Beaux-Arts. He met Morgan *Russell in 1911 and together they evolved *Synchromism—a style of painting based on the abstract use of colour. They first exhibited their works in this style in 1913 and claimed that they, rather than *Delaunay and *Kupka (whose work of the time was very similar), were the originators of a new type of abstract art. In 1914–16 Macdonald-Wright lived in London, where he helped his brother, the critic Willard Huntington *Wright, with his book *Modern Painting: Its Tendency and Meaning* (1916). He returned to the USA in 1916, living first in New York, and then from 1919 in California. By this time he had abandoned Synchromism for a more traditional

representational style, although he returned to abstraction after retiring from teaching in the 1950s.

Mach, David (1956–) Scottish sculptor, born in Fife. He studied at Duncan of Jordanstone College of Art and the *Royal College of Art. He has been identified with the *New British Sculpture because of his use of ordinary objects. He accumulates these into representations of other objects, most spectacularly and controversially with *Polaris*, a full-size submarine made out of tyres which was exhibited outside the Hayward Gallery, London, in 1983. Mach has said that the work had a political element, being a comment on Britain's defence budget. He has also made use of objects usually identified as *kitsch, in works such as *101 Dalmatians* (1988), in which painted plaster dogs are interspersed with furniture. More abstract are the sculptures made from magazines piled up in wave-like forms, such as *Fully Furnished* (1994). This work also incorporates a model horse and a mildly erotic nude painting. The obvious ingenuity of much of his work makes it more accessible to a wide public than that of many of his contemporaries.

Maciunas, George See FLUXUS.

MacIver, Loren (1909–98) American painter, born in New York, where she lived for most of her life. Apart from lessons in a children's class at the *Art Students League in 1919–20 she was self-taught as an artist. During the 1930s she worked for the *Federal Art Project and in 1936 her work was included in the *Museum of Modern Art's 'Fantastic Art, Dada and Surrealism' exhibition. Her paintings do indeed have something of a *Surrealist sense of fantasy, but they are highly individual and distinctive. They hover between figuration and abstraction and concentrate on capturing fleeting impressions of beautiful or magical images seen in the commonplace—a bunch of flowers on a garbage tip, the rainbow colours in an oil slick, the patterns left by children's chalk marks on a pavement (*Hopscotch*, 1940, MoMA, New York). 'Quite simple things can lead to discovery. This is what I would like to do with painting: starting with simple things, to lead the eye by various manipulations of colors, objects and tensions toward a transformation and a reward . . . My wish is to make something permanent out of the transitory.' The word 'poetic' is often applied to her subtle, mysterious work, and she felt an artis-

tic kinship with poets (she was married to one Lloyd Frankenberg (1907–1975)).

Mack, Heinz (1931–) sculptor and *Kinetic artist, born at Lollar, Hesse. After an injury to his hand forced him to abandon plans to become a pianist, he studied at the Academy in Düsseldorf from 1950 to 1953, and then took a degree in philosophy at Cologne University (1956). Early in his career he worked as a painter, but in 1957 he founded the Kinetic group *Zero with Otto *Piene and since 1958 he has concentrated on working with light. Typically his works use polished aluminium and glass or plastic; irregular movement is imparted to them by an electric motor so as to cause constantly changing light reflections. Mack has used many other kinds of material, however, and his work has included water sculptures and wind sculptures. He is interested in environmental work and has made several visits to the Sahara in connection with his project for a 'vibrating column of light in the desert'. Since 1968 he has also done stage design. Mack has had numerous public commissions, including a spectacular fountain on the Platz der Deutschen Einheit in Düsseldorf (1988) and has also made book illustrations, including to the poems of Goethe (1999).

Macke, August (1887–1914) German painter and designer, one of the founders of the *Blaue Reiter. He was born at Meschede, Westphalia, and grew up in Bonn and Cologne. His main training was at the Düsseldorf Academy, 1904–6, and he also studied with Lovis *Corinth in Berlin, 1907–8. Between 1907 and 1912 he visited Paris several times and he came closer in spirit to French art than any other German painter of his time, evolving a personal synthesis of *Impressionism, *Fauvism, and *Orphism (he met Robert *Delaunay in 1912). His subjects were generally light-hearted, without any of the angst associated with other *Expressionists, and although his colour was bright it was never strident; often he showed people enjoying themselves (*Zoological Garden, I*, 1912, Lenbachhaus, Munich). In 1910 he joined the *Neue Künstlervereinigung in Munich and in 1911 was part of the breakaway group that formed the Blaue Reiter. Apart from a few experiments, his work moved less towards abstraction than that of the other members of the group. In 1914 he visited Tunisia with Paul *Klee and Louis *Moilliet, and the vivid watercolours he did on this trip are often

m

considered to be his finest achievements. Apart from painting, Macke made pottery, woodcarvings, and a few prints, and he also did a good deal of design work, notably for carpets, embroideries, tapestries, and wall-hangings, many of which were executed by his wife, Elizabeth; she was the niece of Bernhard Koehler (1849–1927), a Berlin industrialist and art collector who was an important patron for the Blaue Reiter group.

Macke volunteered for the army soon after the outbreak of the First World War, seeing the conflict as a chance to cleanse and renew Western society. He changed his mind very quickly when he saw action, writing to his wife: 'It is all so ghastly that I don't want to tell you about it. Our only thought is for peace.' A few weeks after enlisting, he was killed in action, aged 27. Franz *Marc, who was to suffer the same fate himself two years later, wrote of his friend: 'Those of us who worked with him...knew what secret future this man of genius bore within him. With his death one of the most beautiful and most daring trends in the history of modern German art is abruptly broken off; none of us is in a position to continue where he left off...the loss of his harmonies means that colour in German art must pale by several tones and assume a duller, dryer ring. More than any of us he gave colour the clearest and purest sound—as clear and lucid as his whole being.' Another artist who admired Macke greatly (even though he was very different stylistically) was Max *Ernst, who described him as 'a subtle poet, the very image of just and intelligent enthusiasm, generosity, judgement and exuberance'.

McKenna, Stephen (1939–) British painter, born in London. He studied at the *Slade School of Art between 1959 and 1964 under Harold *Cohen, who encouraged a *modernist view of the importance of discovery through process. McKenna's subsequent development as an artist was very much based on a critique of this way of thinking, looking instead towards a kind of figurative painting. This was not the figurative tradition of the British art school as exemplified by *Tonks and *Coldstream, based principally on the life room, but instead an approach that could incorporate ideas, symbols, and historical reference. Therefore his dominant models lay in the French classical tradition of Poussin and of Jacques-Louis David, as well as later painters whose work looked back to

classical antiquity, such as Böcklin and *de Chirico. The strong element of revivalism in McKenna's art was, during the 1980s, linked to *Postmodernism's rejection of the idea of progress. Nonetheless it was McKenna's aim not just to resuscitate the images and painting skills of the past but to comment on the present. For instance, *The City of Derry* (1982) revisits Giorgione's *Tempest* to reflect on the tragedy of the situation in Northern Ireland.

Further Reading: Institute of Contemporary Arts, London, *Stephen McKenna* (1985)

Mackennal, Sir Bertram *See* NEW SCULPTURE.

Mackintosh, Charles Rennie (1868–1928) Scottish architect, designer (chiefly of furniture), and watercolourist, born and principally active in Glasgow. He was one of the most original and influential artists of his time and a major figure of *Art Nouveau. His most famous building is *Glasgow School of Art (1897–9), to which he later added a library block and other extensions (1907–9). They are strikingly original in style—clear, bold, and rational, yet with an element of fantasy. In his interior decoration and furniture design, often done in association with his wife, Margaret Macdonald (1864–1933), he worked in a sophisticated calligraphic style but avoided the exaggerated floral ornament often associated with Art Nouveau. His finest achievements in this field were four tea-rooms in Glasgow, designed with all their furniture and equipment for his patron Catherine Cranston (1897–c.1911, now mainly destroyed). Mackintosh had an enormous reputation among the avant-garde on the Continent, especially in Germany and Austria, where the advanced style of the early 20th century was sometimes known as 'Mackintoshismus'; his work was widely exhibited and he was particularly esteemed among members of the Vienna *Sezession, who urged him to come and live in the city. However, admiration was more restrained in his own country, where he antagonized fellow architects by criticizing traditional values: 'How absurd it is to see modern churches, theatres, banks etc....made in imitation of Greek temples', he said in 1896. The First World War brought a decline in his career, for there was little call for work as sophisticated as his. In 1914 he moved to London and thereafter virtually gave up

architecture. He did, however, do some fine work as a designer, particularly of fabrics. From 1923 to 1927 he lived at Port Vendres in the south of France, where he devoted himself to watercolour painting, mainly landscapes. He died in London of cancer. After the death of his wife five years later, the contents of their studios were officially appraised as 'practically of no value', but Mackintosh's reputation now stands very high in all the fields of his activity. *See also* GLASGOW FOUR.

McLaughlin, John *See* HARD-EDGE PAINTING.

McLean, Bruce (1944–) Scottish *Performance artist and painter, born in Glasgow. He studied at *Glasgow School of Art, then at *St Martin's School of Art from 1963 to 1966, the time when the influence of Anthony *Caro's abstract sculpture was dominant. He said of the experience: 'The St Martin's sculpture forum would avoid every broader issue, discussing the position of one piece of metal in relation to another for hours. Twelve adult men with pipes would walk around for hours and mumble.' McClean's response to this was to make work that emphasized the style and behaviour around art as much as the art object. This sometimes took the form of making a kind of abstract sculpture but doing it from materials or in a context which were remote and unexpected. Sculpture might be made in the outdoors of ice or mud. 'I liked the idea of a puddle as a sculpture, because it is not eternal, it exists only when it rains.' As *Land art became a recognized artistic genre, McClean moved into Performance and *Body art. A photograph of 1969 is entitled *People who Live in Glass Houses* and shows the artist in a tiny conservatory without a roof attempting to make an abstract sculpture several sizes too big for its space. In another piece he posed as Henry *Moore's *Fallen Warrior*. In spite of its iconoclasm, McClean's work achieved official recognition quickly. His one-day installation *King for a Day* was held at the Tate Gallery in 1972. In the same year he formed the performance group 'Nice Style', claimed to be 'the world's first pose band', based on McClean's idea that an artist is judged not just by the work but by the behaviour or 'pose'. This broke up in 1975, but McClean continued with performance for some years, working with ensemble pieces which had some satirical intent, such as *Academic Board* (1976), in

which sheets of corrugated plastic are handed around a table. It is an accurate representation of the working lives of many artists who derive their living from education. From the late 1970s McClean has been increasingly occupied with painting, although his work retains the irreverent tone of his performance pieces.

Further Reading: N. Dimitrijević, *Bruce McClean* (1981)

McLean, John (1939–) British abstract painter, born in Liverpool to Scottish parents. His father, **Talbert McLean** (1906–92), was a painter, whose later work was influenced by *Abstract Expressionism; after the Second World War, during which he served in the armed forces, he returned to Scotland and taught at Arbroath High School until 1972. John studied at St Andrews University, 1957–62, then did postgraduate work in art history at the *Courtauld Institute of Art, London, 1963–6. He was mainly self-taught as a painter. For most of his career he has lived in London, where he has taught at various art colleges, but he was artist-in-residence at Edinburgh University, 1984–5, and he lived in New York, 1987–9. His paintings typically feature broadly brushed shapes and rich colours (*Strathspey*, 1993, Gallery of Modern Art, Glasgow). He writes that 'My works have no hidden meanings. To understand, all you have to do is look. Everything only works in relation to everything else in the painting . . . Looking triggers imagination and association . . . I only work with the feelings I can elicit with drawing, colour and surface . . . Instinct and spontaneity are crucial Thought goes into it too, in the same way it does in singing and dancing.' He has had numerous one-man exhibitions in Britain and abroad and is regarded as one of the outstanding British abstract painters of his generation.

MacNair, Herbert *See* GLASGOW FOUR.

McQueen, Steve (1969–) British video artist, sculptor, and film-maker, born in London. He studied at Chelsea School of Art and *Goldsmiths College, London. Subsequently he took a course in film at Tisich School of the Arts, New York University, but found it too oriented towards commercial production: 'They wouldn't let you throw the camera up in the air,' he complained. He made his reputation with black-and-white video works designed to be projected so that they occupied an entire wall of an enclosed room. Especially effective in its use of this format is *Deadpan* (1969)

which repeats a famous (and dangerous) gag in Buster Keaton's silent comedy *Steamboat Bill Jr.* (1928), in which the actor stands unmoved as a wall falls on top of him and he emerges unscathed because of the exact placement of a window frame. McQueen shows the scene from a number of angles. *Drumroll* (1967) was shot in New York and uses three screens which project the images shot by three cameras attached to an oil drum which the artist trundled through the streets. The visual impact is striking: Andrew Gellatly refers to 'magical instances when interiors of mirrored electrical goods are transformed into kaleidoscopes by the rolling cam'.

In 2003 McQueen was commissioned by the Imperial War Museum (*see* OFFICIAL WAR ART) to make a work on the Iraq war. On his first visit he saw little, as his movements were so closely controlled. 'It was like a magical mystery tour,' he told an interviewer. Instead of documenting events of which he had no firsthand experience, he decided to make a work which commemorated the British service men and women who died in the conflict. With the collaboration of the families of those involved, he designed sheets of postage stamps. In spite of a considerable campaign, these have not been used by Royal Mail, but they have been put on display under the title *Queen and Country*. They are presented in oak cases with sliding doors of the kind usually employed to display rare stamp collections, so that the viewer becomes engaged physically with the process of seeing them. McQueen was awarded the *Turner Prize in 1999. In 2008 his feature film *Hunger* was shown at the Cannes Film Festival.

Further Reading: A. Gallatly, 'Steve McQueen', *Frieze* (May 1999)

M. Herbert, 'Post War: Steve McQueens's Queen and Country' *Artforum International* (May 2007)

McShine, Kynaston *See* PRIMARY STRUCTURES.

MacTaggart, Sir William (1903–81) Scottish painter, grandson of **William McTaggart** (1835–1910), who had been the leading Scottish landscape painter of his period. He studied at Edinburgh College of Art, 1918–21, and in the 1920s regularly visited the south of France for the sake of his health. His work—mainly landscapes and still-lifes—was much influenced by his grandfather's free and fervent brushwork and also by French painters,

particularly *Rouault, an exhibition of whose work MacTaggart saw in Paris in 1952. From Rouault he took in particular the use of soft black outlines around richly glowing colours. MacTaggart taught at the Edinburgh College of Art, 1933–58, and was president of the Royal Scottish Academy, 1959–64. He was knighted in 1962 and made a chevalier of the Legion of Honour in 1968.

McWilliam, F. E. (Frederick Edward) (1909–92) British sculptor, born at Banbridge, County Down. He studied drawing at the *Slade School, 1928–31, and in 1931–2 lived in Paris, where a visit to *Brancusi's studio fired his imagination and led to his taking up sculpture in 1933. His early work was influenced by the playful *biomorphic forms of *Arp and in 1938 he joined the English *Surrealist group. The special characteristic of his early sculpture was the combination of smooth modelling with fragmented incomplete figures, as with his wood carving *Profile* (1940, Tate). After the Second World War (during which he served in the RAF) McWilliam's work moved away from Surrealism to a more rugged style, sometimes in the 'existentialist' vein associated with Kenneth *Armitage and Lynn *Chadwick (*see* GEOMETRY OF FEAR), although he also did fairly straightforwardly naturalistic figures, as in his statue of the sculptor Elisabeth *Frink (1956, Harlow New Town), one of the many public commissions he received. He always retained links with his native Ireland, although he seldom returned. His early life there gave him 'a lasting awareness and hatred of intolerance and religious bigotry', and in 1972–3 he made a series of bronze figures entitled *Women of Belfast* inspired by the city's political troubles: 'The sculptures are concerned with violence, with one particular aspect—bomb blast—the woman as victim of man's stupidity. I did not choose the subject consciously; it happened, I suppose, because the situation in Ulster is inescapable, even at this safe remove, something that is always nagging at the back of one's mind.' As well as bronze, McWilliam worked in stone, concrete, and terracotta. From 1947 to 1968 he taught at the Slade School.

Further Reading: M. Gooding, *F. E. McWilliam: Sculpture 1932–89* (1989)

Maddox, Conroy (1912–2005) British painter, born at Ledbury, Hertfordshire. He

was the most committed, energetic, and enduring British exponent of *Surrealism, remaining true to its ideals throughout a very long career. He moved to Birmingham in the 1930s and in 1935, inspired by an encounter with a book by R. H. *Wilenski, became a convert to modern art. In 1937 he worked with the Paris Surrealists and the following year he joined the short-lived English Surrealist group; he thought that 'the collapse of the English Surrealist movement can be attributed to its failure to establish a coherent political position' (Charles Harrison, *English Art and Modernism: 1900–1939*, 1981). He had not taken part in the London International Surrealist Exhibition of 1936 because he considered it insufficiently Surrealist. One of Maddox's paintings from this period, *Passage de l'Opéra* (1940, Tate), shows a clear debt to *Magritte in its enigmatic bowler-hatted figures, but he also worked in different veins and made collages and objects as well as paintings. Much of his work was inspired by his intense antagonism to religion ('It is not that I am just against religion: I want to destroy it,' he said in 1994) and he made something of a speciality of deriding nuns. His conception of Surrealism was always a highly political one: he wrote in 1996 that 'it opposes those myths upon which capitalist culture depends, it breaks down all those Christian values which have been erected around a wooden cross'. He was among the artists who most unwaveringly kept the spirit of Surrealism alive. In 1978 he said, 'No other movement has had more to say about the human condition, or has so determinedly put liberty, both poetic and political, above all else.' In 1974 he published a book on *Dalí.

Further Reading: T. Hilton, obituary, *The Guardian* (19 January 2005)

Madí *See* KOŠICE, GYULA.

Maeght, Aimé (1906–81) and **Marguerite** (1905–77) French dealers, collectors, patrons, and publishers, husband and wife. They married in 1928 and in 1937 opened the Galerie Arte in Cannes. At the end of the Second World War they moved to Paris, where they opened the Galerie Maeght in 1945 with an exhibition of *Matisse's work. The gallery promoted the work of a wide range of artists, including *Braque, *Giacometti, *Kandinsky, *Léger, and *Miró; it moved with the times, showing Francis *Bacon in 1966, for example.

Branches of the gallery opened in Zurich in 1970 and Barcelona in 1974. From the time they settled in Paris, the Maeghts also became active as publishers, producing illustrated books by the artists they represented (Aimé Maeght had trained as a lithographer) and monographs devoted to them. The death of their son Bernard in 1953 prompted them to create a lasting memorial, and they did this by turning their home at St-Paul-de-Vence, near Nice, into the Fondation Maeght—in addition to exhibition halls and a sculpture park, it includes ceramic and print studios, a cinema, a concert hall, a bookshop and a reference library. The buildings (1962–3) were designed by the Spanish-born American architect José Luis Sert (1902–83), who worked in close collaboration with artists, particularly his friend Miró, who executed ceramics and mosaics. Other artists involved in this way included Braque, who designed a fountain and stained glass, and *Chagall, who designed mosaics. The Fondation Maeght has major works by most of the leading artists for whom the Maeghts acted as dealers, and with its beautiful setting is regarded as one of the world's most attractive museums of modern art.

Mafai, Mario (1902–65) Italian painter, born in Rome. Early in his career he painted abstracts, but in 1928 he became, with *Scipione, the founder of the *Roman School, which cultivated poetic expressiveness in opposition to the stereotyped classicism of the *Novecento. Though less imaginative, less visionary than those of Scipione, Mafai's pictures, especially his still-lifes and town scenes, were touched with poetic sensibility. During the Second World War he painted a series of *Fantasies* depicting horrors of the Fascist regime, and after the war his style moved to a delicate lyricism expressed particularly in landscapes and street scenes. Late in his career he also returned to abstract painting.

Magic(al) Realism Term coined by the German critic Franz Roh in 1925 to describe the aspect of *Neue Sachlichkeit characterized by sharp-focus detail. In the book in which he originated the term—*Nach-Expressionismus, Magischer Realismus, Probleme der neuesten europäischen Malerie* (1925)—Roh also included a rather mixed bag of non-German painters as 'Magic Realists', among them *Miró, *Picasso, and *Severini. Subsequently

critics have used the term to cover various types of painting in which objects are depicted with sharp-focus naturalism but which because of paradoxical elements or strange juxtapositions convey a feeling of unreality, infusing the ordinary with a sense of mystery. There was a strong school in the Netherlands during the 1930s, including such artists as Pyke *Koch and Carel *Willink. In the English-speaking world the term gained currency with an exhibition entitled 'American Realists and Magic Realists' at the Museum of Modern Art, New York, in 1943. The organizer of the exhibition, Alfred H. *Barr, wrote that the term was 'sometimes applied to the work of painters who by means of an exact realistic technique try to make plausible and convincing their improbable, dreamlike or fantastic visions'. There are affinities with aspects of *Surrealism, especially the works of René *Magritte and Salvador *Dalí. Surrealists and Magic Realists share a common ancestry in the painting of Giorgio *de Chirico. There would be a gain in precision if certain artists referred to journalistically and colloquially as Surrealist, such as M. C. *Escher, were to be defined as 'Magic Realist'.

Magnelli, Alberto (1888-1971) Italian painter, active mainly in France. He was born in Florence into a wealthy family and was self-taught as an artist. In his early work he moved from a naturalistic style to one influenced by *Futurism and then *Cubism (he visited Paris in 1914 and met *Picasso). After the First World War his style became more representational under the influence of *Metaphysical Painting. Until 1931 he lived in Florence, then moved to Paris; he lived in or near the city for the rest of his life (apart from the years of the Second World War when he lived in Provence and became friendly with *Arp, *Taeuber-Arp, and Sonia *Delaunay). In the late 1930s he turned to pure abstraction, his work characteristically making use of a dynamic interplay of hard-edged shapes. An exhibition at the Galerie René Drouin, Paris, in 1947 established his reputation and from the 1950s he was much honoured and recognized as one of Italy's leading abstract artists.

Magritte, René (1898-1967) Belgian painter, sculptor, printmaker, and film-maker, one of the outstanding figures of *Surrealism. He was born in Lessines, the son of a businessman and commercial traveller and a seamstress. His ad-

olescence was clouded by the suicide of his mother, who drowned herself in the river Sambre in 1912. Some commentators have seen traces of this event in later paintings: in a number of works a head is seen covered by a sheet, and in *Les Eaux profondes* (1941, Shirley C. Wozencraft collection), a female figure in black coat and gloves with a head of white marble is juxtaposed with an ominous bird and a stretch of water. Magritte studied at the École des Beaux-Arts, Brussels, 1916-18. After initially working in a *Cubo-Futurist style, he turned to Surrealism in 1925 under the influence of *de Chirico and by the following year had already emerged as a highly individual artist with *The Menaced Assassin* (MoMA, New York), a picture that displays the startling and disturbing juxtapositions of the ordinary, the strange, and the erotic that were to characterize his work for the rest of his life. The painting is based on the scene from the famous series of pulp novels about a master criminal, Fantomas, created by Marcel Alain and Pierre Souvestre. Magritte was to share with Louis Feuillade (1873-1925), the director who brought Fantomas to the screen, a taste for shrouded figures.

In 1927-30 Magritte lived in Paris, participating in Surrealist affairs, but like many others in the movement he fell out with André *Breton, and he spent almost all of the rest of his life working in Brussels, where he lived a life of bourgeois regularity (the bowler-hatted figure who often features in his work is to some extent a self-portrait). Here he was at the centre of the Belgian Surrealist movement, which was more concerned with undermining the norms of conventional society, by attacking its representations, than with exploring the unconscious. The bourgeois image did not preclude adherence to the Communist Party and scatological attacks on the Catholic Church. Part of his venom against his contemporary and rival Paul *Delvaux was based on his view that he was 'naive, basically pretentious, respectful of and a believer in the most bourgeois order'. What J. T. *Soby said about Magritte's art could be applied also to his life. 'In viewing Magritte's paintings . . . everything seems proper. And then abruptly the rape of commonsense occurs, usually in broad daylight.' This 'rape of commonsense' applied especially to assumptions about the role of language and images which, for the Belgian Surrealists, had a politically subversive dimension. Magritte was highly self-conscious in his theorization of the relationship between verbal language and the image.

In the early 1940s Magritte adopted a kind of *Renoiresque manner which he called 'Surrealism in full Sunlight', perhaps as a counterblast to the bleak years of the Nazi occupation. In 1947, for his first solo exhibition in Paris, he showed a series of violent, strident 'vache' paintings, deliberately playing on the image of the Belgian provincial. His friend the writer Louis Scutenaire contributed a catalogue introduction in thick Walloon dialect. This was an unusual interlude in his career. For most of his life he worked in a precise, scrupulously banal manner (a reminder of the early days of his career when he made his living designing wallpaper and drawing fashion advertisements). He had a repertory of obsessive images that appeared again and again in ordinary but incongruous surroundings. Enormous rocks that float in the air and fishes with human legs are typical leitmotifs. He loved visual puns and paradoxes and repeatedly exploited ambiguities concerning real objects and images of them (many of his works feature paintings within paintings), inside and out-of-doors, day and night. In a number of paintings, for example, he depicted a night scene, or a city street lit only by artificial light, below a clear sunlit sky. He also made Surrealist analogues of famous paintings—for example David's *Madame Récamier* and Manet's *The Balcony*—in which he replaced the figures with coffins. Late in life he also made wax sculptures based on such paintings, and some of them were cast in bronze after his death (*Madame Récamier*, Pompidou Centre). He also made prints and a few short comic films, using his friends as actors.

Magritte's work was included in many Surrealist exhibitions, but it was not until he was in his 50s that he began to achieve international success and honours: in the 1950s and 1960s he painted several large mural commissions (notably for the Casino at Knocke-le-Zoute, 1951–3) and he was given major retrospective exhibitions in Brussels (1954), New York (1965), and Rotterdam (1967). By the time of his death his work had had a powerful influence on *Pop art, and it has subsequently been more widely imitated in advertising. His explorations of the arbitrary nature of language were also important for the younger Belgian artist Marcel *Broodthaers.

Further Reading: Musée Royaux des Beaux-Arts de Belgique, *Magritte* (1998)

H. Torczyner, *Magritte: The True Art of Painting* (1979)

Maillol, Aristide (1861–1944) French sculptor, painter, graphic artist, and tapestry designer. He was born in Banyuls-sur-Mer, in the south-east of France, near the Spanish border, and moved to Paris in 1881 to study painting (he entered the École des *Beaux-Arts in 1885). He met *Gauguin in 1889 and later became associated with the *Nabis. His paintings of this period have an emphasis on strong outlines and arabesque (*Les lavandières*, 1896, Musée Maillol, Paris). His early career, however, was spent mainly as a tapestry designer, and he opened a tapestry studio in Banyuls in 1893. He first made sculpture in 1895, but it was only in 1900 that he decided to devote himself to it. He gave up tapestry entirely in 1903 after suffering severe eyestrain. In 1902 he had his first one-man exhibition (at the Galerie *Vollard in Paris), which drew praise from *Rodin; in 1905 came his first conspicuous success as the *Salon d'Automne with *Mediterranean*. After about 1910 he was internationally famous and received a constant stream of commissions. His most important patron was Count Harry Kessler (1868–1937), with whom he visited Greece in 1908, and who was later to be a patron of Berlin *Dada. With only a few exceptions, he restricted himself to the female nude, expressing his whole philosophy of form through this medium. Commissioned in 1905 to make a monument to the 19th-century revolutionary Louis-August Blanqui, he was asked by the committee what form he proposed to give it and replied 'Eh! une femme nue.' More than any other artist before him he brought to conscious realization the concept of sculpture in the round as an independent art form stripped of literary associations and architectural context, and in this sense he forms a transition between Rodin and the following generation of modernist sculptors. This was acknowledged in his lifetime. In 1929 Christian Zervos wrote in *Cahiers d'art*: 'With other premises and a very different effect, Maillol was a precursor of today's *Constructivism. All his figures create an impression of massive structure, of a search for beautiful volume.' Maillol himself said: 'My point of departure is always a geometrical figure', and that although 'there is something to be learned from Rodin . . . I feel I must return to more stable and self-contained forms. Stripped of all psychological details, forms yield themselves up more readily to the sculptor's intentions.' He rejected Rodin's emotionalism and animated surfaces; instead,

Maillol's weighty figures, often shown in repose, are solemn and broadly modelled, with simple poses and gestures. As André Gide put it in his response to *Mediterranean*, contrasting the piece with the 'restlessness' of Rodin, 'She is beautiful and she does not mean anything. She is full of silence.' Although it was forward-looking in many ways, Maillol's work also consciously continued the classical tradition of Greece and Rome; at the same time it has a quality of healthy sensuousness (his peasant wife sometimes modelled for him). Maillol's fame can make him appear a more isolated figure than he was. His simplified classicism was shared by many contemporary French sculptors such as Charles *Despiau, but they are less frequently seen in modern art museums and did not have the same support from modernist critics such as Zervos.

Maillol settled at Marly-le-Roi on the outskirts of Paris in 1903 but usually spent his winters in the south. In 1939 he returned to his birthplace. He took up painting again at this time, but apart from his sculpture the most important works of his maturity are his book illustrations, which helped to revive the art of the book in the 1920s and 1930s. His finest achievements in this field are the woodcut illustrations (which he cut himself) for an edition of Virgil's *Eclogues* (begun 1912 but not published until 1926), which show superb economy of line. He also made lithographic illustrations. A museum dedicated to Maillol opened in Paris in 1995, organized by the art dealer and one-time model of the artist, Dina Vierny (1919–2009). It also shows outstanding temporary exhibitions, not necessarily related to Maillol, such as those devoted to Francis *Bacon (2004), to René *Magritte's work on paper (2006), and to contemporary Chinese painting (2008). The visitor to Paris can also see many of Maillol's most important works, presented by Vierny, in the open air at the Tuileries Gardens, including his moving memorial to the pacifist writer Henri Barbusse, *La Rivière* (1938–9).

Further Reading: B. Lorquin and D. Vierny, *Aristide Maillol* (2002)

Maistre, Roy de (1894–1968). Australian painter, active mainly in England. He was born at Bowral, New South Wales, and studied at the Royal Art Society of New South Wales and Sydney Art School. De Maistre also studied music at the Sydney Conservatorium and throughout his career he was interested in the analogy between colour combinations and musical harmony. This led him to early experiments with abstraction with Roland *Wakelin; they produced the earliest abstracts painted in Australia, but only one survives—de Maistre's *Rhythmic Composition in Yellow Green Minor* (1919, Art Gallery of New South Wales, Sydney). Between 1923 and 1928 he lived in Europe, mainly France, and returned to Europe permanently in 1930, settling in London after a brief period of residence in France. He became a friend of Francis *Bacon and in the 1930s he ran an art school in London with Martin Bloch (1883–1954). After the Second World War (in which he worked for the Red Cross) he exhibited widely. He painted portraits, interiors, still-life, and religious subjects (he became a convert to Roman Catholicism in 1949) in a style that Sir John *Rothenstein characterized as 'reticent but extremely complex'. *Cubism was one of the major influences on his eclectic style. There are several examples of his work in Tate.

Majerus, Michel (1967–2002) Luxembourgeois artist, born in Esch. He lived and worked in Berlin. In ten years of work he completed more than 1,500 paintings. These combine *Abstract Expressionism with *Pop imagery in a way that can strike the spectator as manic and frenetic. *If we are dead so it is* (2000) was installed at the Kunstverein Cologne. Majerus covered the half-pipe used as a surface by skate-boarders with a computer-aided design. Another installation in New York in 2002, entitled *Leuchtland* ('Shining Country'), was based on the classic and by then thoroughly antiquated video game *Space Invaders*. The object of the game was to shoot down skull-like aliens that were attacking the earth. Majerus magnified the screens into silkscreens that occupied the entire wall. Cary Levine (*Art in America*, December 2002) found the experience 'truly menacing' and suggested that the artist's conception of culture was that 'there's no way to stop its assault so you may as well dive in'. Majerus was killed in an air crash.

Makovets A society of artists and writers founded in Moscow in 1921. The name derived from the hill on which the famous monastery at Zagorsk (one of Russia's holiest places) was built in the 14th century—a gesture indicating the emphasis its members placed on spiritual and religious values in art

(the society was originally known as the 'Art is Life' Union of Artists and Poets). The painters involved in the organization included Vasily Chekrygin (1897–1922), whose highly promising career was cut short by his death in a railway accident, Sergei Gerasimov (1885–1964), and Alexander *Shevchenko. Their works included landscapes and portraits in a lyrical, sometimes *Expressionist style. Alan Bird (*A History of Russian Painting*, 1987) writes that the society had no 'chance of public success in the artistic world of revolutionary Russia controlled by the followers of *Tatlin and *Malevich'; to such people 'easel painting was ostensibly anathema, and all figurative art, even when, as in some pictures and drawings by Chekrygin, it was used to show in graphic terms the hunger that stalked the country, was considered an affront to the new spirit of the nation'. The society organized one exhibition (Moscow, 1922) and published a journal, also called *Makovets* (two issues, Moscow, 1922; a third issue was censored), before breaking up in 1926. After this Gerasimov changed course completely, abandoning his exquisite watercolours for vast *Socialist Realist propaganda canvases. In spite of this he fell foul of authority in 1948 when he was removed from his teaching post in Moscow after being accused of encouraging *Impressionism. The following year he repainted one of his best-known pictures, *The Mother of a Partisan* (1943, Russian Museum, St Petersburg), to make the title figure conform more closely to the Soviet heroic ideal of womanhood.

Malevich, Kasimir (1878/9–1935) Russian painter, designer, and writer, with *Mondrian the most important pioneer of geometric *abstract art. He was born in Kiev, where he studied at the School of Art, 1895–6. For a few years he worked for a railway company to raise money, and then moved to Moscow, where he continued his studies at the School of Painting, Sculpture, and Architecture (1904–5) and elsewhere. His early aspirations were to be a realist painter in the manner of *Repin, but he began to absorb the influence of contemporary French art (partly through the superb collections of *Morozov and *Shchukin) and of Russian avant-garde artists, particularly *Goncharova and *Larionov (with whom he was a member of the *Knave of Diamonds group). By the time of the *'Donkey's Tail' exhibition in 1912 he was painting peasant

subjects in a massive 'tubular' style similar to that of *Léger and had also produced some exhilarating *Cubo-Futurist pictures, combining the fragmentation of form of *Cubism with the multiplication of the image of *Futurism (*The Knife Grinder*, 1912, Yale University Art Gallery). Certain paintings of 1914, notably *An Englishman in Moscow* (Stedelijk Museum, Amsterdam), juxtapose images in a collage-like manner. He shared with the writer Matuishin the philosophy of 'alogism', which demanded the destruction of 'the antiquated movement of thought based on laws of causality'. Malevich was dissatisfied with representational art or—as he put it—fired with the desire 'to free art from the burden of the object'. He had strong mystical leanings and like other artists of his generation he was preoccupied with the fourth dimension (see L. D. Henderson, *The Fourth Dimension and Non-Euclidean Geometry in Modern Art*, 1983). He thought that by abandoning the need to depict the external world he could break through to a deeper level of meaning and 'swim in the white free abyss'. By his own account he had a lifelong fascination with flight and he once recalled how as a child he would tether chickens to the roof just to enjoy the swoop of the hawks as they attacked their prey. His first abstract work was a backdrop for the Futurist opera *Victory over the Sun*, produced in the Luna Park Theatre, St Petersburg, in December 1913; his original drawing (now in the Theatrical Museum, St Petersburg) shows a rectangle divided almost diagonally into a black upper segment and a white lower one. From this he developed *Suprematism, which brought painting to a geometric simplicity more radical than anything previously seen. He claimed that he made a picture 'consisting of nothing more than a black square on a white field' as early as 1913, but Suprematist paintings were first publicly exhibited in Petrograd (now St Petersburg) in 1915. In the 'Tramway V' exhibition of February that year only Cubo-Futurist and alogic paintings were shown, so it is quite likely that all the first Suprematist paintings were produced in a single burst in that year. (There is often difficulty in dating his work, and also in knowing which way up his paintings should be hung; photographs of early exhibitions sometimes show alternative possibilities). The black square has been described by Jean-Claude Marcadé as the 'total eclipse of the world of objects'. It was first exhibited straddled across the

corners of a room, like *Tatlin's contemporary corner-reliefs but also in the position near the ceiling traditionally reserved for the religious icon. For Malevich the square was not the end of abstraction but a starting point for a new age of art. Looking back in 1920 he distinguished between three phases of Suprematism: a black period, a coloured period, and a white period. From the middle period date the most complex of the paintings, in which geometric elements appear to float in space. The forms in white paintings, such as *White on White* (1918, MoMA, New York), only become visible through subtle changes in tone and handling.

In 1919, at the invitation of *Chagall, Malevich started teaching at the art school in Vitebsk. There he exerted a profound influence on *Lissitzky, who nonetheless was to be a far less problematic servant of the Soviet regime. In 1920 he declared the death of easel painting, a common stance for the Russian avant-garde at the time, and he led his students into the streets, black squares stitched on to their sleeves, in order to effect a Suprematist transformation. In 1922 he moved to Petrograd, where he taught at the Institute for Artistic Culture from 1922 to 1927 and lived for the rest of his life. Together with his students, in 1924 he made a series of small plaster models which translate Suprematist forms into architectural terms. He went to Warsaw and Berlin in 1927, accompanying an exhibition of his work, and during this trip he visited the *Bauhaus. When he returned he left many paintings with the architect Hugo Häring, no doubt fearing for their future in the changing political climate of the Soviet Union. These were eventually sold by Häring to the Stedelijk Museum in Amsterdam. In the late 1920s he returned to figurative painting, sometimes dating new works as being from the years before his Suprematist period. The stylized work he produced, which has been interpreted by Jean-Claude Marcadé as a pictorial denunciation of 'the totalitarian hydra of the twentieth century', was out of favour with a political system that now demanded *Socialist Realism from its artists and he ran into trouble with the authorities (he was actually arrested in 1930 and the director of the Tretyakov Gallery, which had given him an exhibition, was sentenced to a spell in prison). In many ways Malevich appears to have been a fervent, if hardly orthodox, Communist. He had joined striking workers during the Battle of the Barri-

cades in Moscow during the 1905 revolution. In 1917 in the period between the fall of the Tsar and the October Revolution he was clearly on the side of the Soviets. On the death of Lenin he wrote a long essay in his praise. One of his late paintings is *Red Cavalry* (c.1928–32, Russian Museum, St Petersburg). Certainly one factor in any conflict with officialdom would have been his attitude to religion. In an avowedly atheist state, he saw the Black Square 'as an image of God as a perfect being'. (For a detailed disentangling of Malevich's ideas on art and politics and their relevance to his work see Y. Petrova, 'Personal Religiousness and Religious Consciousness among Russian Artists at the turn of the 20th century', in Royal Academy London, *'From Russia'*, 2008.) He remained a revered figure among artists and after his death he lay in state at the Leningrad Artists' Union in a coffin—designed by himself—bearing Suprematist designs.

Malevich was a prolific producer of theoretical writings and his influence was spread through these as well as his paintings, although his ideas are notoriously difficult to come to grips with. The most widely known text is *The Non-Objective World*, first published in German as a *Bauhaus book in 1927. The book includes a radical polemic against utilitarian and propagandist views of the function of art and expresses a pessimistic vision of the public's ability to understand artistic value. 'If it were possible to extract from the works of the great masters the feeling expressed within them—the actual artistic value that is—and to hide this away, the public, along with the critics and the art scholars, would never even miss it.' Nonetheless he also argued that his Suprematism was not entirely detached from the world but was stimulated by the new environment created by the aeroplane. John *Golding has argued that his thinking was strongly influenced by the philosophy of Hegel. His abstract art represented a final phase of evolution in which 'spirit detaches itself from nature and achieves total freedom, thus becoming pure universal form'. The presence of his paintings in the West from an early date helped make him one of the most familiar figures of the Russian avant-garde. Although he remains less known to a wide public than either *Kandinsky or *Mondrian, it is likely that through *Minimal art and beyond he has, in the long term, been the most influential of all early abstract artists.

Further Reading: J. Golding, 'Malevich, Supreme Suprematist' in *Visions of the Modern* (1994)

J.-C. Marcadé, 'Malévitch aujourd'hui', in *Musée d'Art Moderne de la Ville de Paris, Malévitch. Un choix dans les collections du Stedelijk Museum d'Amsterdam* (2003)

National Gallery of Art, Washington, *Kazimir Malevich* (1990)

Malfatti, Annita *See* SEMANA DE ARTE MODERNA.

Malraux, André (1901–76) French writer and statesman, born in Paris into a well-to-do family. He worked in the book trade before becoming a political activist (and archaeologist) in China in the 1920s and fighting in the Spanish Civil War in the 1930s. Out of his experiences he wrote a number of novels on revolutionary themes. In the Second World War he served in the tank corps, was taken prisoner by the Germans, escaped, and worked for the Resistance. He was a friend of Charles de Gaulle and after the war he became increasingly involved in politics, serving as France's Minister of Culture from 1959 until his retirement in 1969 (in this role he initiated a programme of cleaning the great buildings and monuments of Paris and commissioned ceiling decorations for the Paris Opéra from Marc *Chagall, 1963–4). His postwar writings were devoted mainly to art, in a philosophical—at times metaphysical—vein. The major work is *La Psychologie de l'art*, originally published in three volumes as follows: *Le Musée imaginaire*, 1946, translated as *Museum without Walls*, 1949; *La Création artistique*, 1948, translated as *The Creative Act*, 1949; *La Monnaie de l'absolu*, 1949, translated as *The Twilight of the Absolute*, 1951. A revised version of the work was published in four volumes in 1951 entitled *Les Voix de silence*, translated as *The Voices of Silence*, 1953 (the individual volumes are entitled *Museum without Walls, The Metamorphoses of Apollo, The Creative Process*, and *The Aftermath of the Absolute*; a one-volume edition appeared in 1954). His other major work on art was *La Métamorphose des dieux*, 1957, translated as *The Metamorphosis of the Gods*, 1960. Malraux's writings reflect the broadening of aesthetic outlooks in the 20th century, when for the first time it had been possible to have some familiarity with the art of the whole world throughout the entire course of human history. He thought that art should be appraised entirely by aesthetic standards, expressing this notion in his now famous concept of the 'museum without walls', in which all works of art—whatever their origin—are available to be appreciated for their formal qualities, independently of whatever they originally signified.

Mamontov, Savva *See* VRUBEL, MIKHAIL.

Mancini, Antonio *See* BOLDINI, GIOVANNI.

Mané-Katz (Mané Katz) (1894–1962) Russian-born painter (and occasional sculptor) who became a French citizen in 1927. Born at Kremenchug in Ukraine, he studied in Vilna and Kiev, then went to Paris in 1913 and entered the École des *Beaux-Arts. He returned to Russia in 1914 on the outbreak of war, but settled in Paris in 1921. Between 1928 and 1937 he travelled widely in Egypt, Palestine, and Syria. In 1939 he volunteered for the French army and was taken prisoner; on his release he went to the USA in 1940, returning to Paris in 1945. Mané-Katz painted still-lifes and landscapes, but he was chiefly known for his ghetto scenes and pictures of Jewish life and folklore. They are somewhat reminiscent of *Chagall's treatments of similar themes, but more brilliantly coloured. Mané-Katz visited Israel annually from 1948 and died in Tel Aviv. He bequeathed the works in his studio to the city of Haifa.

Manessier, Alfred (1911–93) French painter, lithographer, and designer of tapestries and stained glass, born at Saint-Ouen, the son of a merchant. In 1929 he moved to Paris to study architecture at the École des *Beaux-Arts but turned to painting, studying informally at several academies. He was encouraged particularly by Roger *Bissière, whom he met at the *Académie Ranson in 1935. During the 1930s he was influenced by *Cubism and *Surrealism, but after staying at a Trappist monastery in 1943 he became deeply committed to religion and turned to expressing spiritual meaning through abstract art. Characteristically his paintings feature rich colours within a loose linear grid, creating an effect reminiscent of stained glass (a medium in which he was very prolific, designing some 200 windows, and in which he did some of his best work). After the Second World War he came to be regarded as one of the leading exponents of expressive abstraction (*see* ART INFORMEL) in the *École de Paris, and he won numerous awards, including the main painting prize at the 1962 Venice *Biennale. In retrospect, this was the last manifestation of Parisian hegemony in the modern art world. Two years later the same prize was

controversially awarded to *Rauschenberg. In later life Manessier lived in seclusion near Chartres and, as with many other French painters of his generation, his reputation underwent something of an eclipse, but a major retrospective was devoted to him at the Grand Palais, Paris, in 1992. The following year he died from injuries received in a car crash.

Mánes Union of Artists An association of artists in Prague, analogous to the *Salon d'Automne in Paris, largely responsible for introducing progressive trends to Czech art in the early years of the 20th century. It was founded in 1887 in opposition to the conservative Prague Academy of Arts and named after Josef Mánes (1820–71), who is regarded as the founder of Czech national painting. Among the exhibitions staged by the Union were: 1905, works by *Munch; 1907, French *Impressionist and *Post-Impressionist paintings; 1910, French artists from the *Salon des Indépendants, including examples of the *Fauves; 1914, *Cubist works, but without *Picasso, *Braque, or *Gris. The Mánes Union continued until 1949.

Manet, Édouard *See* IMPRESSIONISM; MODERNISM.

Mangold, Robert (1937–) American painter, born in North Tonawanda, New York. He is known for *Minimalist paintings, sometimes with *shaped canvas. *Red Wall* (1965, Tate) was inspired by the loft architecture of New York and was made from standardized sheets of masonite painted with a spray gun. The brick-like colour is intended to remind the spectator of ordinary objects. Mangold sometimes divides his canvases with simple geometric shapes such as squares and circles but the results are rarely perfectly symmetrical. For Roberta Smith (*New York Times*, 29 September 1989) his paintings brought to mind the qualities of a Renaissance altarpiece.

Manguin, Henri-Charles (1874–1949) French painter, born in Paris. In 1894 he became a student at the École des *Beaux-Arts, where he made friends with *Camoin, *Marquet, and *Matisse. Like them, he became one of the *Fauves, exhibiting at the famous 1905 *Salon d'Automne show that gave them their name. In the same year he visited St-Tropez and loved the light and the landscape so much that he was based there for the rest of his life. Throughout his career he retained the Fauvist

love of bright colour, but he toned down Fauvist aggressiveness to create a stylish and exuberant art that to many people represented the acceptable face of modernism. He generally worked on a fairly small scale and was very popular with private collectors. His subjects included Riviera scenes, nudes, and still-lifes.

Manley, Edna (1900–87) Jamaican sculptor, born Edna Swithenbank in Bournemouth, the daughter of an English clergyman and a Jamaican mother. She studied sculpture in London, at the *Royal Academy and elsewhere. In 1921 she married her cousin Norman Manley and settled with him in Jamaica, where he had a distinguished career as a barrister and later as a politician, doing more than anyone else to lead the island to self-government. Edna Manley's sculpture to some extent formed an artistic counterpart to her husband's political activities, for she is regarded as the fountainhead of the nationalistic 'Jamaican Art Movement'; several of her works have become icons of a period when black Jamaicans were seeking self-determination, notably *Negro Aroused* (1935, NG, Kingston), a powerfully stylized piece in carved mahogany. In the 1940s Manley's work became more intimate, but from the 1950s she did numerous large-scale public commissions, including *He Cometh Forth* (1962), an allegory of Jamaican independence in the Sheraton Hotel, Kingston. After the death of her husband in 1969, her work tended to grow more introspective (*Angel*, 1970, Kingston parish church). In the last two years of her life she gave up sculpture for painting.

Mann, Sally (1951–) American photographer, born in Lexington, where she still lives and works. In 1984 she embarked on a series of photographs entitled *Immediate Family*. These dealt intimately with the lives of her three children in ways that have aroused considerable controversy about the sexualization of childhood. For instance *Popsicle Drips* shows her son's naked torso with splashes which could easily be bodily fluids. Only the title confirms the innocuous truth. *Jessie at Five* in pose and accessories can be regarded as having an inappropriate level of sexual provocation. Anne Higonnet has argued that these works confound the romantic notions of childhood innocence.

Further Reading: A. Higonnet, *Pictures of Innocence* (1998)

Manolo (Manuel Hugué) (1872–1945) Spanish sculptor, born in Barcelona into an impoverished family. He attended evening classes in drawing but had no formal training in sculpture. From 1901 to 1910 he lived in Paris, where he was a member of *Picasso's circle and was noted for his high spirits. In 1910 (with a contract from *Kahnweiler) he moved to the Pyrenean village of Céret, near the border with Spain, then in 1927, following a severe attack of multiple arthritis, he settled in Caldas de Mombuy in Catalonia, a village renowned for its thermal waters. After the arthritis attack he had to give up stone carving, and his work consisted mainly of small bronzes, including nudes in a style similar to that of *Maillol and reliefs on traditional Spanish themes—bullfighting, flamenco dancing, and so on. He had a considerable reputation in the 1920s and 1930s, now somewhat faded.

Man Ray (1890–1976) American painter, photographer, draughtsman, sculptor, and film-maker, born in Philadelphia, the son of a Russian-Jewish immigrant tailor. He was originally called Emmanuel Radinski, but he was known only as Man Ray from the age of about fifteen because other youngsters jeered at his foreign-sounding name. In 1897 his family moved to New York, where he worked as a designer whilst attending evening classes in art. After seeing the *Armory Show in 1913 he began painting in a *Cubist style. In 1915 he began a lifelong friendship with Marcel *Duchamp, and these two together with *Picabia were the mainstays of the New York *Dada movement. Man Ray also collaborated with Duchamp and Katherine *Dreier in forming the *Société Anonyme in 1920. His activities at this time were very varied, including painting aerographs (*see* AIRBRUSH) and making the first packaged objects—a field that *Christo later made his own. In 1921 he settled in Paris, where he continued his Dada activities and then became a member of the *Surrealist movement. For several years he earned his living mainly as a fashion and portrait photographer (he had a high reputation in these fields), while he pursued his more creative work as well as a sideline in fetishistic pornography, but he painted regularly again from the mid-1930s. In 1940 he moved back to America to escape the German occupation of Paris and settled in Hollywood, then in 1951 returned to Paris, where he died. His autobiography, *Self Portrait*, was published in 1963.

From the 1940s, photography took a secondary place in Man Ray's activities, but it is as a photographer that his reputation is now most secure. In the 1920s and 1930s he was one of the most inventive artists in this field, particularly for his development of the technique of 'solarization' (the complete or partial reversal of the tones of a photographic image) and for his exploitation of 'Rayographs'—photographs produced without a camera by placing objects directly on sensitized paper and exposing them to light (Christian *Schad had earlier used the same method). The models who appear in his photographs include Meret *Oppenheim, his mistress *Kiki of Montparnasse, his assistant Lee *Miller, and his wife, Juliet Browner (Juliet Man Ray), a dancer, whom he married in 1946. In addition to his celebrity as a photographer, Man Ray gained an international reputation as one of the most prominent figures of Dada and Surrealism; his *objects were a particularly important contribution. The most famous is probably *Gift* (1921), consisting of a flatiron with a row of nails sticking out of its smooth face (the original is no longer extant; a reconstruction is in MoMA, New York). His paintings are generally less highly regarded. The best-known is probably *Observatory Time* (1934, private collection), showing an enormous pair of floating lips which suggest a naked body. He made several experimental (including abstract) films and collaborated with Duchamp on one entitled *Anemic Cinema* (1926); 'anemic' is an anagram of 'cinema'.

Further Reading: J. Mundy, *Duchamp, Man Ray, and Picabia* (2008)

Manship, Paul (1885–1966) American sculptor. He was born in St Paul, Minnesota. His intensive academic training included a scholarship to the American Academy in Rome, where he worked from 1909 to 1912. After his return to the USA he lived mainly in New York, although from 1922 to 1926 he was based in Paris. Manship worked in an elegant, streamlined style, his beautifully crafted figures (in bronze and stone) characterized by clarity of outline and suave generalized forms. A dedicated student of the history of art, he was influenced by archaic Greek and Indian sculpture, but his work also has a kinship with fashionable *Art Deco. He achieved great success as a sculptor of public monuments, one of the best known being the gilded bronze *Prometheus* (1933) in Rockefeller Center Plaza,

New York, and he was also an accomplished portraitist. Because of the sleek stylization of his work, for a time he had a reputation as a pioneer of modern sculpture in America, but his modernism was fairly superficial and by about 1940 he was being labelled an academic artist.

Manson, J. B. (James Bolivar) (1879–1945) British painter and art administrator, born in London. His father—a writer and editor—did not want him to follow the risky career of an artist and compelled him to work in a bank, which he hated. He took lessons part-time at Heatherley's School and eventually saved enough money to leave the bank and study at the *Académie Julian in Paris, 1903–4. After his return to London he achieved modest success with portraits, landscapes, and still-lifes painted in an unexceptional *Impressionist manner. He met Lucien *Pissarro in 1910 and through him was drawn into *Sickert's circle, becoming secretary of the *Camden Town Group and of its successor the *London Group. In 1912 he became a curator at the Tate Gallery, and although he continued to paint and exhibit, he was mainly occupied with administration, especially after he was appointed director of the gallery in 1930. His directorship was notable mainly in a negative sense, for he was hostile to avant-garde art and tried to prevent works by artists of the calibre of *Matisse and *Rouault entering the collection. The modern painters in whom he was interested included *Degas and *Sargent, on both of whom he wrote books. A genial character, Manson was fond of the bottle and in 1938 he was compelled to resign from the Tate on the grounds of 'ill-health' after uttering 'remarkably life-like and penetrating cock-a-doodle-dos' at an official banquet in Paris (the episode is recounted with gusto by Kenneth *Clark in his autobiography, *Another Part of the Wood*; he says it was 'the only public banquet that I have ever really enjoyed'). *See also* EDE.

Manzoni, Piero (1933–63) Italian artist whose questioning of convention was an important source for *Arte Povera and *Conceptual art. He was born into an aristocratic family at Soncino and studied briefly at the Brera Academy in nearby Milan, the city in which he spent most of his short career. Until 1956 he painted in a traditional style (mainly landscapes), but he then turned to avant-garde work, making pictures featuring impressions

left by objects such as keys and scissors that had been dipped in paint or tar. In 1957 he began to produce *Achromes*, textured white paintings influenced by *Burri and by *Klein (whom he met at an exhibition of the Frenchman's work in Milan in 1957). Manzoni's first one-man exhibition was held in the foyer of the Teatro delle Maschere, Milan, in the same year. The most important characteristic of the achromes was that their form was a product of their material existence. For instance the canvases were sometimes creased and stiffened by soaking in kaolin or made up of patches sewn together. White no longer had the connotations of purity and cleanliness associated with the tradition of idealist geometric modernism, the stuccoed walls of International Style architecture or the pure white of a Ben *Nicholson relief. White was also the colour of bird excrement. From 1959 Manzoni devised a series of provocative works and gestures. Art could be the product of the artist's body, as in his cans of 'artist's shit' in limited editions or his balloons filled with the artist's breath. Rumours abound about the actual filling of the 'shit cans', which have been said to contain plaster or pineapple chunks. Tate's example is cautiously catalogued as 'unknown contents'. Manzoni's wealthy father had a meat canning factory and had described his son's work as 'shit'. The balloons have long since deflated and survive as mementoes. One has been photographed kept by a collector under a bell jar to preserve the last precious molecules of the breath. Hand-drawn lines of precise length were placed in sealed capsules mocking abstraction's quest for the infinite and spiritual. The bodies of naked women were signed by the artist and he gave (a special privilege accorded to Marcel *Broodthaers and a few others) or sold certificates declaring individuals as works of art. Sometimes there would be conditions applied. One subject was a work of art only when he slept. Manzoni's early death was caused by cirrhosis.

Further Reading: G. Celant, *Piero Manzoni* (1998)
J. Miller, 'Excremental Value', *Tate Etc.* (summer 2007)

Manzù, Giacomo (1908–91) Italian sculptor, painter, graphic artist, and designer, born in Bergamo. He came from a poor family (his father was a cobbler) and from the age of eleven he worked successively for a woodcarver, a gilder, and a stucco-worker. In this way he learnt the elements of several crafts, but he was mainly self-taught as an artist. He

left Bergamo for the first time in 1927 to do his military service in Verona, where he occasionally attended classes at the Accademia Cignaroli and was impressed by the Romanesque bronze doors of the church of San Zeno Maggiore. When he finished his military service, Manzù went to Paris in 1928 with the aim of studying sculpture (he hoped to meet *Maillol, whose work he knew through illustrations in books), but he had no means of support and after collapsing from hunger he was deported as an undesirable alien. On his return to Italy he settled in Milan, where a commission for decorative work at the Catholic University in 1929 enabled him to devote himself seriously to sculpture. Milan was the main centre of his activities until 1964, when he moved to Ardea, near Rome.

Manzù's early work was influenced by Egyptian and Etruscan art, but he soon turned to a more Impressionistic style owing much to the example of *Rodin and *Rosso. In the 1940s he simplified his style, so that although the surface of the work is often animated, the feeling it produces is one of classic calm. His sculpture included nudes, portraits, and scenes from everyday life, but he was best known for religious subjects. In 1938 he produced his first figure of a cardinal, a type of work that became particularly associated with him. His *Cardinals* have been variously interpreted as expressions of an anti-clerical attitude or as glorifications of ecclesiastical dignity. The divergence of intepretation is hardly surprising in that the sculptor was both a firm Communist (he was awarded the Lenin Prize in 1966) and a good friend of Pope John XXIII, whose death mask he made. Manzù himself always said that he regarded the cardinals as still-lifes with no deeper significance than a plate of apples, representing 'not the majesty of the church but the majesty of form'. Only one is a portrait, the over-life-size statue of Cardinal Giacomo Lercaro in San Petronio, Bologna, commissioned in 1953.

In 1947 Manzù entered a competition for a set of bronze doors for St Peter's, Rome; he was awarded the commission in 1952, but the work was not completed until 1967. The competition theme had been 'The Triumph of the Saints and Martyrs', but Manzù received papal permission to create instead a 'Door of Death', featuring a series of visual meditations suggesting death as the threshold of another world. Meanwhile he had carried out another bronze door for Salzburg Cathedral (1957–8) on the theme of Love,

and a third followed for the church of St Laurenz in Rotterdam (1965–8) on the theme of War and Peace. These works have been much praised and show the possibility of producing sculpture that fits within a traditional religious context and yet is in a modern and personal idiom.

Apart from sculpture, Manzù also produced paintings and prints (including a series of twenty etchings illustrating an edition of Virgil's *Georgics*, 1947) and worked as a stage designer (for example for Wagner's *Tristan und Isolde* at the Teatro della Fenice, Venice, in 1971). There is an outstanding collection of his work in the Raccolta Amici di Manzù in Ardea (a branch of the Galleria Nazionale d'Arte Moderna, Rome).

Mapplethorpe, Robert (1946–89) American photographer. Born in Floral Park, New York, in a strict Catholic family, he left home in 1962. He studied painting and sculpture and met the poet and musician Patti Smith. They both became part of the New York underground. In 1971 Smith provided the soundtrack while Mapplethorpe appeared in the short film *Robert Having His Nipple Pierced*. In the early 1970s Mapplethorpe was not particularly concerned with photography for its own sake. He was making constructions which frequently contained photographs of friends. Many of the spontaneous Polaroid images made in these years were only exhibited for the first time nearly twenty years after his death. His move into photography as the main focus of his activity came about through his contact with the curator and collector Sam Wagstaff (1921–89), who also became Mapplethorpe's lover. Unlike Mapplethorpe, Wagstaff had come from a very wealthy background and also, as a considerably older man, had experienced the repressive atmosphere towards homosexuality in the 1950s against which, by then, he was reacting strongly. Wagstaff gave Mapplethorpe a Hasselblad camera, a type which produces a larger negative than the normal 35mm, and is popular with professional fashion photographers, and with this were produced the highly formalized images for which he is best known. The most notorious of these deal explicitly with the gay subculture. *The Perfect Moment* shows one man urinating into another's mouth. A self-portrait depicts Mapplethorpe pushing a bull whip up his anus. Mapplethorpe's eroticized male nudes often contrast black and white

bodies and he has been accused of racism in his objectification of the black male nude. In addition to this work he also made remarkably beautiful black-and-white images of flowers. These have probably been his most popular works and play on the erotic potential of the close-up plant, which was already a well established trope through the paintings of Georgia *O'Keefe. Some critics consider Mapplethorpe's finest works to be his portraits. The image of Louise *Bourgeois smilingly carrying her sculptured penis has been frequently reproduced. Both Mapplethorpe and Wagstaff died of AIDS. The Mapplethorpe Foundation which now controls his work has, as part of its objective, the raising of money for AIDS research as well as the promotion of the art of photography.

Given the nature of Mapplethorpe's subject matter, it is unsurprising that his work has provoked controversy, in spite of its obvious high artistic quality. He was bracketed with Andres *Serrano for attack in the so-called 'Culture Wars' during which the National Endowment for the Arts was attacked by political conservatives for its alleged support for obscenity. When an exhibition at the Corcoran Gallery of Art in Washington was cancelled, some artists protested by projecting the 'offending' images on to the exterior walls.

Further Reading: A. C. Danto, 'Robert Mapplethorpe', *The Nation* (26 September 1988)

S. Wolf, 'Mapplethorpe's Secret Diary', *The Guardian* (23 October 2007)

Mara, Pol (1920–98) Belgian painter, born in Antwerp as Leopold Leysen. His paintings of the 1940s were in the tradition of Flemish *Expressionism. In the 1950s he practised an informal abstraction. Following a trip to Greece in 1961 the work became more austere. He visited the USA in 1964 and subsequently became the best-known Belgian *Pop artist. He used images from the mass media, predominantly of women, often with a strongly erotic, voyeuristic flavour, and frequently introduced lesbian themes. In 1975 he made a series of murals entitled *Thema* for the Montgomery Metro station in Brussels. There is a museum dedicated to his work in the château at Gordes near Avignon.

Marc, Franz (1880–1916) German painter (and occasional printmaker and sculptor), born in Munich, where he spent most of his life. He was the son of a landscape painter and after studying philosophy and theology at Munich University he switched to painting and trained at the Academy, 1900–02. His early work was in an academic style, but visits to Paris in 1903 and 1907 introduced him to *Impressionism and *Post-Impressionism. He was particularly impressed by the work of van Gogh, under whose influence his style moved towards *Expressionism. In 1910 he met August *Macke, who became his closest friend, and in the same year he was greatly impressed with an exhibition of *Matisse's work in Munich. At the beginning of 1911 he joined the *Neue Künstlervereinigung and at the end of the year he joined *Kandinsky and others in founding a splinter group, the *Blaue Reiter. On the outbreak of the First World War in August 1914 he volunteered almost immediately for the army, but his initial mood of elation changed after Macke was killed in action the following month. Marc himself died in combat at Verdun in March 1916. He was unable to paint while he was in the army, but his drawings and letters show how appalled he was by the carnage he saw.

Marc had a deeply religious disposition (he visited Mount Athos in Greece, with its famous monasteries, in 1906), and the death of his father in 1907 brought on him a sense of profound spiritual malaise. Through painting he sought to uncover mystical inner forces that animate nature. His ideas were expressed most forcibly in paintings of animals (eventually they became his exclusive subject), for he believed they were both more beautiful and more spiritual than man: 'The ungodly human beings who surrounded me did not arouse my true emotions, whereas the inherent feel for life in animals made all that was good in me come out.' He visited the zoo in Berlin several times and from 1907 to 1910 earned a good part of his living by teaching animal anatomy to artists. There was a vogue for animal painting in Munich at this time, but Marc's approach was radically different to that of any of his contemporaries. Using non-naturalistic, symbolic colour and simplified rhythmic shapes, he said he tried to paint animals not as we see them, but as they feel their own existence. In a letter to Macke in December 1910 he explained the emotional value he assigned to colours: 'Blue is the main principle, astringent and spiritual. Yellow is the female principle, gentle, gay and spiritual. Red is matter, brutal and heavy and always the colour to be opposed and overcome by the other two.'

In 1912 Marc saw an exhibition of *Futurist paintings in Berlin and also met *Delaunay in Paris. These events helped to move his work towards abstraction, as in *Animal Destinies* (1913, Kunstmuseum, Basle), one of his most famous paintings, which uses panic-stricken animals to symbolize a world on the edge of destruction. On the back of the picture he wrote: 'Und alles Sein ist flammend Leid' (And all being is flaming suffering), and later, whilst serving at the front, he remarked of this work: 'It is like a premonition of this war, terrible and gripping, I can hardly believe I painted it.' His final paintings became still more abstract, losing almost entirely any representational content, as in *Fighting Forms* (1914, Neue Pinakothek, Munich), an image of convulsive fury in which there are the merest suggestions of beak- and claw-like forms. These late works are considered to be among the most powerful representatives of German Expressionism.

Marca-Relli, Conrad (1913–2000) American painter, born in Boston of Italian parents. In 1926 he settled in New York; he studied there briefly at various art schools, but was mainly self-taught as an artist. After serving in the US Army, 1941–5, and then travelling in Europe and Mexico, he came to prominence in the 1950s as one of the second wave of *Abstract Expressionists, and he was particularly acclaimed for his large (sometimes mural scale) *collages, which he developed from 1953. In these he attached cut-out shapes of painted canvas to a canvas ground, using a black glue that served to outline the forms. During the 1960s he experimented with relief paintings and constructions and briefly with free-standing sculpture before returning to collage paintings.

Marchand, Jean (1882–1941) French painter (of landscapes, figure compositions, still-life, and occasional decorative schemes), engraver, illustrator, and designer. He was born in Paris and studied there at the École des *Beaux-Arts, 1902–9, whilst supporting himself by designing jewellery, textiles, and other types of applied art. His earliest paintings included landscapes and scenes of tramps sleeping out of doors. In about 1912 he also experimented with *Cubism and occasionally with *Futurist multiple images, but soon after this he settled into a style of vigorous naturalism akin to that of *Derain. When some of his work was shown at a mixed exhi-

bition at the Carfax Gallery, London, in 1915, Clive *Bell wrote: 'No living painter is more purely concerned with the creation of form and the emotional significance of shapes and colours than Marchand.' His first one-man show was at the Carfax Gallery in 1919 and after this he exhibited frequently in Paris and internationally. In the late 1920s he made a lengthy visit to the Middle East, in the course of which he painted a mural for the Residence at Beirut. Apart from paintings he produced a good deal of graphic work, including numerous book illustrations in lithograph and woodcut.

Marcks, Gerhard (1889–1981) German sculptor and printmaker, born in Berlin. He had a varied but patchy artistic training, beginning as a painter. In 1919 he was one of the first teachers to be appointed at the *Bauhaus, and was put in charge of the ceramic workshop. Encouraged by his fellow teacher *Feininger, he also took up woodcut and this led to a greater use of wood as a material in his sculpture. He became disillusioned with the increasingly technological outlook of the Bauhaus, so he left when it moved to Dessau in 1925 and took up a teaching position at the Kunstgewerbeschule at Burg Giebichenstein near Halle, becoming director in 1928. In 1933 his work was declared *degenerate by the Nazis and he retired to the Baltic coast. After the Second World War he was professor at the State School of Art in Hamburg, 1946–50, then moved to Cologne, where he spent the rest of his life. His major work was the completion of a series of statues on the façade of the church of St Catherine in Lübeck (1947) that had been left unfinished by *Barlach, but his refined and somewhat sentimental style is generally closer to that of *Lehmbruck.

Marcoussis, Louis (1878–1941) Polish-French painter and etcher. Originally he was called Louis Markus; his adopted name, suggested by *Apollinaire, came from the village of Marcoussis near Paris. He was born in Warsaw into a cultured Jewish family that had converted to Catholicism, studied at the Academy in Cracow from 1901 to 1903, then moved to Paris. During the First World War he served with distinction in the French army and he was granted French nationality on the basis of this. His early paintings were *Impressionist in style and in 1907–10 he earned his living as a cartoonist, but in 1910 he met Apollinaire,

*Braque, and *Picasso and joined the *Cubist group. He remained faithful to Cubism for the rest of his career and is regarded as one of the most appealing minor masters of the movement, combining clarity and simplicity of structure with delicacy of handling. He illustrated a number of books, including two by the Romanian-French poet Tristan Tzara, one of the founders of *Dada. Marcoussis's wife, whom he married in 1913, was the Czech painter Alicia Halicka (1895-1975).

Marden, Brice (1938-) American painter, born in Bronxville, New York. He came to attention in the 1960s with large monochrome paintings using a technique of oil mixed with wax that gave his paintings an almost fleshly quality in spite of their lack of surface incident. Peter Schjedahl has argued that for all the *Minimalist appearance of his paintings, Marden should really be thought of as the last of the *Abstract Expressionists, a 'maker of lyrical paint fields that hint at elevated subjective states'. His paintings from the mid-1980s onwards are more gestural. In a painting like *Couplet III* (1989, Tate) tangles of loose curves cover a vertical painted surface, the result of Marden's observation of nature and also of his interest in Eastern calligraphy.

Further Reading: P. Schjedahl, *Art of Our Time: The Saatchi Collection* (1984)

Mare, André *See* CUBISM.

Mariani, Carlo Maria (1931-) Italian painter associated with *Pittura Colta. His paintings refer to the history of his native city of Rome and look back at the classical tradition, although with an eye to the contemporary situation. This stemmed from Mariani's activities in the 1970s as a *Conceptual artist. As such, he 'completed' some works for Angelica Kauffmann (1741-1807), a painter who worked in the *Neoclassical style which Mariani subsequently adopted. The issue is how far such work could be produced in the late 20th century without irony. Certainly some of Mariani's paintings suggest that the past they represent is irretrievably lost. *It is Forbidden to Awaken the Gods* (1984) shows two artists with the physiques of Greek gods lying asleep among fragments of giant antique statues. Mariani's paintings attracted critical attention at a time of intense debates about *Postmodernism and especially about the role of revivalism. Charles Jencks (*see* POST-

MODERNISM), although primarily concerned with architecture and design, illustrated Mariani's paintings as exemplary of the way in which a sense of history could restore the meaning which had been drained from culture by *modernist purity.

Marin, John (1870-1953) American painter and printmaker, born in Rutherford, New Jersey. He began painting when he was eighteen, but worked for several years as an architectural draughtsman before he took up art seriously. From 1899 to 1901 he studied in Philadelphia at the Pennsylvania Academy of the Fine Arts (where Anshutz (*see* HENRI) was one of his teachers), then from 1901 to 1903 in New York at the *Art Students League. In 1905 he went to Europe and remained there (apart from a brief return visit in 1909) until 1910, living mainly in Paris where he was discovered by Edward *Steichen in 1909. He was influenced by *Whistler's watercolours and etchings but was also exposed to avant-garde trends. He settled finally in New York in 1911, when he became a member of *Stieglitz's circle, and the *Armory Show in 1913 made an impact on him. Responding especially to German *Expressionism and the planimetric structure of the late work of *Cézanne, he developed a distinctive semi-abstract style that he used most characteristically in powerful watercolours of city life and the Maine coast (where he often painted in the summer). Ideologically he was certainly closer to Expressionism than *Cubism, saying 'the true artist must perforce go from time to time to the elemental big forms—sky, sea, mountain, plain—to sort of re-true himself up, to recharge the battery. But to express these, you have to love these, to be a part of these in sympathy.' One of the last notes he made before his death recorded that 'The Hurricane has just hit. The Seas are Glorious—Magnificent—Tremendous. God be praised that I have yet the vision to see these things.' His oil paintings (which became more important in his work from the 1930s) are often similar in effect to watercolours, leaving part of the canvas bare. Marin also made etchings, mainly early in his career. From the 1920s he enjoyed a high reputation and was considered one of the outstanding watercolourists of his time. However, Marin felt some frustration that his oils did not achieve the same success, referring to his unsold canvases as 'the Dark Room Collection'. *See also* DEMUTH.

Marinetti, Filippo Tommaso (1876–1944) Italian writer and artistic entrepreneur, the founder of *Futurism and the movement's chief theorist and promoter. He was born in Alexandria, the son of a wealthy lawyer, and family money later allowed him the freedom to pursue his artistic interests. In 1893 he moved to Paris, then studied law in Genoa, graduating in 1899. At this point he settled in Milan, but he kept close links with Paris (his early poetry—up to 1912—was written in French) and it was in Paris that he launched Futurism in 1909 with his famous manifesto published on the front page of *Le Figaro*. Over the next few years, up to the beginning of the First World War, he was extremely vigorous in promoting Futurist ideas, travelling widely around Europe, organizing exhibitions, giving lectures, holding press conferences, and so on. Wherever he went, he attracted attention because of his outspoken and provocative behaviour. In London in 1911, for example, he challenged a journalist to a duel for making slighting remarks about the Italian army, and in Italy 'Marinetti gained enormous publicity from the three trials for obscenity that followed the publication in 1910 of his novel *Mafarka futurista*, the offending item being Mafarka's eleven-metre-long penis which he wrapped round himself when he slept. Marinetti was acquitted at the first trial, given a two-and-a-half-month suspended sentence at the second, and had the same suspended sentence confirmed at the third' (Caroline Tisdall and Angelo Bozzolla, *Futurism*, 1977).

Marinetti agitated for Italy to enter the First World War, and when the country did so in 1915, he volunteered for the army; during his service he was wounded and decorated for bravery. The war had a disastrous effect on the Futurist movement, but Marinetti continued promoting it afterwards. In 1918 he founded the Futurist Political Party, which supported Mussolini (a friend of Marinetti's) in his rise to power. He moved to Rome in 1925, and in 1929 launched *Aeropittura as an offshoot of Futurism. In 1935—as aggressive as ever in his nationalism—he served as a volunteer in the army when Italy invaded Abyssinia, and in 1942 (in spite of his advanced age) he once again enrolled in the army and fought in Russia. He was soon repatriated because of illness, and he spent the last months of his life at Bellagio di Como, where he was archivist of the Accademia d'Italia (of which he had been made a member in 1929).

Throughout his life Marinetti kept up a stream of writing, often in an experimental vein; in his poetry, for example, he sometimes used typography that had expressive qualities of its own, anticipating *Concrete poetry. He also occasionally tried his hand in the visual arts, making collages, for example, and also producing a *Self-Portrait (Dynamic Collection of Objects)* (1914, private collection), made up of odds and ends including matchboxes, brushes, and a handkerchief—an anticipation of the *Surrealist *object. Although he is not regarded as a major writer or artist himself, he had an enormous influence as a provocateur—so much so that he is described by Robert *Hughes as 'one of the key figures of twentieth-century culture' and as 'the prototype of avant-garde promoters'.

Further Reading: *See under* FUTURISM.

Marini, Marino (1901–80) One of the leading Italian sculptors of the 20th century, also a painter, etcher, and lithographer. He was born in Pistoia, studied at the Academy in Florence, and worked mainly as a graphic artist until he was invited by Arturo *Martini to succeed him as professor of sculpture at the Villa Reale School of Art at Monza, near Milan, in 1929. During the 1930s he made frequent visits to Paris and travelled widely in Europe. He had his first one-man exhibition at the Galleria Milano in 1932. In 1940 he became professor of sculpture at the Brera Academy in Milan, which was his home for most of the rest of his life (although he lived in Switzerland, 1943–6). His travels (particularly his visits to Paris) brought him into contact with many distinguished modern artists (*Braque, *Giacometti, *Gonzáles, *Maillol, *Picasso—to name but a few), but he did not ally himself with any avant-garde movements. Although he experimented with various materials, he worked mainly in bronze and concentrated on a few favourite themes, most notably the Horse and Rider, a subject in which he seemed to express an obscure but poignant tragic symbolism. He reverses the traditional triumphalism of the theme, putting him close in mood to contemporaries such as Germaine *Richier and the *'Geometry of Fear' sculptors (*Horseman*, 1947, Tate). His other subjects include female nudes and he also made numerous portrait busts, remarkable for their psychological penetration and sensuous exploitation of the surface qualities of the material (a cast of his bust of Henry *Moore (1962) is in the National

Portrait Gallery, London). Often he poly-chromed his bronzes, sometimes working with corrosive dyes. In 1948 he took up painting seriously, producing some colourful near-abstracts. During the 1950s his reputation became international (he had a highly successful exhibition at Curt Valentin's gallery in New York in 1950 and won the main sculpture prize at the Venice *Biennale in 1952). There are Marini museums in Florence, Milan, and Pistoia and his work is represented in many major collections of modern art.

Marisol (Marisol Escobar) (1930–) American sculptor, born in Paris of Venezuelan parents. She spent much of her childhood in Los Angeles but in 1949 studied in Paris at the École des *Beaux-Arts and the *Académie Julian. In 1950 she moved to New York, where she studied at the *Art Students League under *Kuniyoshi, the *Hofmann School, and the New School for Social Research. In about 1953, after seeing an exhibition of Pre-Colum-bian art, she turned her attention primarily to sculpture, at first making small, playfully erotic terracottas. From about 1955, perhaps influenced by the gently satirical sculptures of William King (1925–), she began to carve life-size figures from wood. Her subjects include family groups and parodies of middle-class social life, such as *Women and Dog* (1964, Whitney Museum, New York). Her figures combine block-like wooden torsos with plaster faces, hands, and legs, often cast from her own face or limbs. She embellishes her figures with a variety of accessories such as necklaces, umbrellas, television sets, mirrors, pots of flowers, and so on, so that they sometimes verge on being *assemblages. Her works have been widely exhibited and by the mid-1960s she had an international reputation. This was the heyday of *Pop art and her work has some affinity with it, but in her combination of caricature, humour, and social satire she has remained uniquely herself. In her life-size portrait figures—which include President Lyndon B. Johnson, Queen Elizabeth II, and the comedian Bob Hope—she demonstrates a gift for conveying the commonplace character of famous people.

Marlborough Fine Art, London. Firm of art dealers founded in London in 1946 by two Austrian-born dealers who had emigrated to England because of the rise of Nazism: Frank Lloyd (1911–98) and Harry Fischer (1903–77) (who had no connection with the Fischer Galerie that organized the auction of confiscated *degenerate art in Lucerne, Switzerland, in 1939). They served together in the British army during the Second World War and decided to open a gallery when peace returned. The name was chosen because of its aristocratic associations. By the 1960s it was recognized, not without resentment from rivals, as the most important modern art dealer in London. Part of its prestige came from its spectacular shows of early modern art. Its annual summer exhibitions entitled 'Aspects of Twentieth Century Art' gained a legendary reputation for their museum-quality contents. The firm became agent for the estate of Jackson *Pollock and vigorously promoted the work of Kurt *Schwitters with a major exhibition in 1963 at a time when he was known only to *Dada specialists. At one time it had a near monopoly of the best-known names in contemporary British art. A particular coup was the holding of simultaneous exhibitions of the new work of Henry *Moore and Francis *Bacon in 1963. Other artists contracted to it included Ben *Nicholson, Barbara *Hepworth, Oskar *Kokoschka, Graham *Sutherland, John *Piper, and Victor *Pasmore. It was also significant in developing the market in contemporary limited edition prints. Generally, it was most successful with artists who had already achieved some reputation with other dealers, although it gave R. B. *Kitaj his first solo exhibition in 1963 and he remained with the firm for the rest of his career. In the 1960s there were branches on each side of Old Bond Street, the New London, on the east side, usually being devoted to more contemporary work.

In 1963 the firm expanded to New York. At its height, Marlborough also had branches in Rome, Zurich, Toronto, and Montreal. The handling of the estate of Mark *Rothko led to public scandal and a well-publicized law suit which eventually resulted in a criminal conviction for Frank Lloyd. Harry Fischer left the firm and started his own business near St James's Square, exhibiting some of Marlborough's leading artists, most notably Henry Moore. He also continued the Marlborough tradition of spectacular mixed summer exhibitions. Many leading American artists also left the firm in the wake of the affair. During the 1970s and 1980s other London dealers, especially Leslie Waddington and Anthony d'Offay, became more significant as forces in the

contemporary scene. Nonetheless Marlborough Fine Art continues to operate from spacious premises in Albermarle Street, adjacent to the original Old Bond Street site.

Further Reading: R Smith, 'Frank Lloyd, Prominent Art Dealer Convicted in the '70s Rothko Scandal, dies at 86', *New York Times* (8 April 1998)

Marquet, Albert (1875–1947) French painter and draughtsman, born in Bordeaux. In 1890 he settled in Paris, where he studied at the École des Arts Décoratifs (he became a lifelong friend of his fellow student *Matisse) and later at the École des *Beaux-Arts. With Matisse he became one of the *Fauves, taking part in the notorious display at the *Salon d'Automne in 1905, although his boldness of colour rarely equalled that of his friend. However, Marquet showed great compositional originality in his Fauve period. As Bernard Dorival put it, Fauvism for Marquet 'is not so much a partiality for intense colour as for synthesis and summarizing' (*School of Paris*, 1962). His subsequent work was marked by a restrained style of such consistency that Tate's example of his work, *Bay of Naples*, has had to be dated '1908, 1930s?' He painted some fine portraits and did a series of powerful female nudes (1910–14), but he was primarily a landscapist. His favourite themes were ports, bridges, and quays, subjects he depicted with unaffected simplicity and great sensitivity of tone. He was also an outstanding draughtsman: his rapid brush drawings have an economy and vigour recalling the work of Oriental masters (Matisse called him 'our Hokusai'). Marquet travelled extensively in Europe and North Africa on painting expeditions, including a trip to the USSR in 1934. It is likely that, although not generally vocal politically, he had Communist sympathies and an exhibition of his work was held at the Pushkin Museum, Moscow, in 1959 at a time when even work such as his would have appeared aesthetically radical to the Soviet authorities. He built up an international reputation, but he refused all awards, including the Legion of Honour, and lived very quietly (he was timid in personality, perhaps partly because he was short-sighted and had a limp). His work is particularly well represented in the Musée des Beaux-Arts in Bordeaux.

Further Reading: Centre Pompidou, *Albert Marquet: From Fauvism to Impressionism* (2001)

Marsh, Reginald (1898–1954) American painter and illustrator. He was born in Paris to wealthy American parents, both of whom were painters (Fred Dana Marsh and Alice Marsh), and he was brought to the USA when he was two. After graduating from Yale University in 1920 he studied at the *Art Students League, New York, in the early 1920s. Until 1930 he worked mainly as a newspaper illustrator, but he took up painting seriously after a study trip to Paris in 1925–6, and in the 1930s he became well known for his paintings depicting shabby and tawdry aspects of life in New York. His favourite subjects included Coney Island, the amusement arcades of Times Square, and the cheap and grubby street life of the Bowery district (1932, *Tattoo and Haircut*, Art Institute of Chicago). He was also capable of bitter satire against the smug complacency of the wealthy, but in general his work shows a love of depicting teeming life through ugly yet colourful subjects rather than a desire for social protest. His aim was to depict contemporary life in the manner of the Old Masters and he worked mainly in tempera (he also experimented with reviving other venerable techniques). To some extent his work expressed a rejection of the affluent and genteel circumstances in which he grew up. He said he would 'rather paint an old suit of clothes than a new one because an old one has character; reality is exposed not disguised. People of wealth spend money to disguise themselves.' Marsh's first wife, Betty Burroughs, was a sculptor.

Marshall, Kerry James (1955–) American painter and installation artist. Born in Birmingham, Alabama, he moved to the Watts Community in Los Angeles when he was eight. He has said 'You can't be born in Birmingham, Alabama, in 1955 and not feel like you've got some kind of social responsibility. You can't move to Watts in 1963 and grow up in South Central near the Black Panthers' headquarters and see the kinds of things I saw in my development years and not speak about it.' His work has continually reflected a preoccupation with civil rights and black identity, both in large-scale paintings which evoke the tradition of the European Grand Manner, such as the *Garden Project* series of the 1990s, and in strip-cartoon style drawings, the *Rhythm Master* series, to challenge the 'scant representation of the black body in the historical record'. In his exhibition 'One True Thing', held at the Museum of Contemporary Art, Chicago, in 2003, he included a video

installation and a large painting, both entitled *Garden Party*, in which African Americans, Hispanics, and Asians took the place of whites in an Impressionist-style garden picnic.

Further Reading: R. C. Baker, 'Kerry James Marshall's Black Whole', *Village Voice* (4 March 2008)

Martin, Agnes (1912–2004) Canadian-born painter, printmaker, and writer on art who settled in the USA in 1932 and became an American citizen in 1950. She lived mainly in New Mexico, but part of her intermittent studies in art were at Columbia University, New York (1941–2 and 1951–2), and she again lived in New York from 1957 to 1967. During this time she was a neighbour of several other painters (among them Robert *Indiana, Ellsworth *Kelly, and James *Rosenquist) in a block of artists' lofts, but essentially she lived a fairly solitary life. She never owned a television and for the last fifty years of her life never even read a newspaper. Up to the mid-1950s her paintings were representational, but she then turned to abstraction, and by 1964 had arrived at her characteristic type of work—a square monochromatic canvas covered with a fine grid of horizontal and vertical lines: 'My forms are square, but the grids are never absolutely square...when I cover the square grid surface with rectangles, it lightens the weight of the square, destroys its power.' Her technique was always to cover the canvas with two layers of gesso, adding hand-drawn pencil lines and thin layers of oil or acrylic paint. Although she was a major influence on *Minimal art, her own allegiances were to the earlier generation of *Abstract Expressionists. From 1967 to 1974 she concentrated on writing, but after her return to painting she achieved a high reputation, winning several honours. Joan Simon described her life at the age of 83 in these terms: 'She rises early, paints mornings in her studio, often lunches with friends or other visitors in favorite Taos restaurants, reads at home in the afternoon, favoring mysteries, especially recommending Agatha Christie'. Lucy Lippard described her work as 'legendary examples of the unrepetitive use of a repetitive medium'.

Further Reading: J. Simon, 'Perfection is in the Mind: an interview with Agnes Martin', *Art in America* (May 1996)

Martin, Kenneth (1905–84) British painter, sculptor, and printmaker. He was born in Sheffield and studied part-time at Sheffield School of Art, 1927–9, whilst working as a designer, and then at the *Royal College of Art, 1929–32. In 1930 he married his fellow student Mary Balmford, whose artistic development as Mary *Martin had close affinities with his own. At this time he painted in a naturalistic style, but during the 1940s his work became less representational until in 1948–9 he produced his first abstract pictures. His wife soon followed suit and in the early 1950s they began making abstract constructions. With Victor *Pasmore and others they became recognized as leaders of the *Constructivist movement that burgeoned in England in the 1950s. Kenneth Martin's contribution came not only through his work, but also by writing and organizing exhibitions. His most distinctive and best-known works are the 'screw mobiles' made from 1953 onwards, spiral forms in highly polished brass which produce constantly changing outlines and reflections as they rotate. This theme of rotation is implied in the intellectual processes behind other works, such as the *Oscillation* series of sculptures. Generally the elements of the works are simple in themselves and depend on their changing relationships to give them significance. In the 1960s he became interested in the role of chance in art, making drawings in which the random selection of numbers determined the placement of lines on a grid. Of his conversion to abstraction he said: 'The moment I became a purely abstract artist I began to realize what I'd been missing...That I'd really missed the whole of the modern movement.' From 1946 to 1967 Martin was a visiting teacher at *Goldsmiths College, London. He won various awards and had several public commissions, including a stainless steel fountain for Brixton Day College (1961) and the *Construction in Aluminium* (1967) outside the Engineering Laboratory in Cambridge. His work is well represented in Tate, where a major retrospective was held in 1975.

Further Reading: Tate Gallery, *Kenneth Martin* (1975)

Martin, Sir Leslie *See* CIRCLE.

Martin, Mary (née **Balmford**) (1907–69) British painter and maker of constructions, the wife of Kenneth *Martin. She was born in Folkestone, Kent, and studied in London at *Goldsmiths College, 1925–9, and the *Royal College of Art, 1929–32. Early in her career she painted landscapes and still-lifes in a style close to the *Camden Town Group, but during

the 1940s her work, like that of her husband, moved towards abstraction. She made her first purely abstract painting in 1950, her first geometric abstract relief in 1951, and her first free-standing construction in 1956. With her husband she was regarded as one of the leaders of *Constructivism in England. Together they took part in 'This is Tomorrow' at the *Whitechapel Gallery in 1956. The geometric environment they produced for the occasion has, like many other contributions to that event, been overshadowed by the enormous impact of Richard *Hamilton's *Pop intervention. Martin had numerous major commissions: among them were a screen for Musgrave Park Hospital, Belfast (1957), reliefs for the liner SS *Oriana* (1960), and a wall construction for the University of Stirling (1969). She had decided views on the architectural use of abstract art, writing in 1957 that 'the work becomes a comprehensible symbol of the building itself, a part of the architecture but not architecture'. She tended to base her work on mathematical sequences and systems of proportion. In 1969 she was joint winner of the first prize at the *John Moores Liverpool Exhibition. An *Arts Council exhibition was devoted to her and her husband in 1970–71.

Further Reading: Tate Gallery, *Mary Martin* (1984)

Martini, Arturo (1889–1947) Italian sculptor and painter, born at Treviso, where he served apprenticeships as a goldsmith and in a ceramics factory before turning to sculpture in 1906. He moved to Venice in 1908 and in 1909 went to Munich to study under *Hildebrand. In 1912 and 1914 he visited Paris and after the First World War (during which he worked in an armaments factory and gained a knowledge of casting) he worked mainly in Rome, Venice, and Milan (he taught at the Villa Reale Art School at Monza, near Milan, in the 1920s). Some of his early work was extremely adventurous, notably the bizarrely *Expressionist *Prostitute* (1909–13, Ca' Pesaro, Venice) in coloured terracotta, but in 1921 he became associated with the journal *Valori plastici* and, in line with its views calling for a return to the Renaissance tradition, his work took on a classical simplicity. It is also possible to detect the influence of Hildebrand in his generalized forms. However, his work was far from being mere revivalism or pastiche. There is often an air of *Surrealist strangeness in his sculptures, especially his rather ghostly terracotta figures, and he reflected the troubles

through which he lived: 'Condemned to work in an increasingly provincial, dictatorially brutal cultural environment, Martini gave expression to the hopes and anguish of his times in a series of powerful yet infinitely fragile figures' (Fred Licht, *Sculpture: 19th and 20th Centuries*, 1967). Martini began to paint in the late 1930s, and in 1945, suffering an artistic crisis, he published a pamphlet announcing the death of sculpture, *La Scultura: lingua morta*. Pietro *Consagra replied to this in his book *Necessità della scultura* (1952).

Martins, Maria *See* DUCHAMP, MARCEL.

Martyn, Edward *See* AN TÚR GLOINE.

Masereel, Frans (1889–1972) Belgian graphic artist and painter, active mainly in France. He was born in Blankenberge and studied at the Academy in Ghent, 1907–8. Before the First World War he travelled extensively and during the war he settled in Switzerland. He moved to Paris in 1920 and in 1940 fled the German invasion and settled in the South of France, thereafter living mainly in Avignon and Nice. Masereel was a prolific illustrator of books and periodicals. Much of his work was motivated by social concern, one of his chief themes being the suffering caused by war. He often used the formula of *romans in beelden* (novels in pictures), which are series of woodcuts telling a story without a text. His style was mildly *Expressionist.

Mass-Observation *See* ASHINGTON GROUP.

Masson, André (1896–1987) French painter, printmaker, sculptor, stage designer, and writer, one of the major figures of *Surrealism. He was born at Balagne and at the age of eight he moved with his family to Brussels, where he studied art part-time whilst working as a pattern-drawer in an embroidery studio. In 1912 he moved to Paris, where he studied at the École des *Beaux-Arts until the outbreak of the First World War, when he joined the army. During the war he was seriously wounded and deeply scarred emotionally. His pessimism was accompanied by a profound and troubled curiosity about the nature and destiny of man and an obscure belief in the mysterious unity of the universe; he devoted the whole of his artistic activity to penetrating and expressing this belief.

After the war Masson lived in the South of France until 1922, when he returned to Paris.

He moved into a studio next door to *Miró, who became a lifelong friend. Initially he was influenced by *Cubism. His first exhibition was at the Cubist dealer *Kahnweiler, but in 1924 he joined the Surrealist movement after his work was admired and purchased by André *Breton. Early issues of *La révolution surréaliste* contained reproductions of his *automatist drawings, a parallel to the automatic writings which the journal was publishing at the time. In some of his paintings of the late 1920s he practised a kind of automatism by dripping glue on to the canvas and sprinkling sand on the surface, as in *Battle of Fishes* (1926, MoMA, New York). He remained a member of the Surrealist group until 1929, when he left, feeling more affinity with the rival grouping around Georges *Bataille. Themes of metamorphosis, violence, psychic pain, and eroticism dominated his work. In particular he shared with Bataille the preoccupation with sacrifice and remained close to his circle, providing illustrations for his writings. It was Michel *Leiris, a close ally of Bataille, who wrote, with Masson's old friend Georges Limbour, the first substantial book on his work, *André Masson and his Universe* (1947). In 1936 he lived in Spain until the Civil War drove him back to France and in 1941–5 he took refuge from the Second World War in the USA. There his work formed a link between Surrealism and *Abstract Expressionism, especially through his influence on Arshile *Gorky. It included a series of large canvases reflecting the carnage he had lived through, among them *There is No Finished World* (1942, Baltimore Museum of Art), which features disintegrating monsters symbolizing (in his own words) 'the preciousness of human life and the fate of its enterprises, always threatened, destroyed, and recommenced'. In 1945 Masson returned to France and two years later settled at Aix-en-Provence, where he concentrated on landscape painting, achieving something of the spiritual rapport with nature associated with Chinese painting. Apart from paintings his work included designs for the theatre, book illustrations, and several sculptures. He also wrote a good deal on art, including the two-volume book *Métamorphose de l'artiste* (1956).

Further Reading: D. Ades, *André Masson* (1994)

MAT *See* SPOERRI, DANIEL.

Mataré, Ewald (1887–1965) German sculptor, printmaker, painter, designer, and teacher. He was born in Aachen and had his main training at the Academy in Berlin (he also spent a few months there with *Corinth). During the First World War he served briefly in the army, and in 1918 he joined the *Novembergruppe in Berlin. In 1920 he began making woodcuts (mainly portraits and animal studies in a style influenced by *Expressionism) and in 1922 he took up sculpture, which soon became his main concern. His first sculptures were woodcarvings; originally he used driftwood, but he moved on to fine pieces of timber and made great play of exploiting beautiful grain. Characteristically he used broadly contoured forms and polished his surfaces to immaculate smoothness, unbroken by projections or incisions. He worked in a similar vein when using other materials, but in his metal sculpture he sometimes enhanced the surface by inserting gems. His favourite theme was the human figure (*Standing Figure*, 1926–7, Lehmbruck Museum, Duisburg) and his other subjects included animals and portraits. In 1932 he became professor of sculpture at the Academy in Düsseldorf, but he was dismissed by the Nazis the following year and his work was declared *degenerate. After the Second World War he was re-instated at Düsseldorf, and his post-war work included a number of public commissions, especially for churches. Among these were doors for Cologne Cathedral (1947–54), the Alte Kirche in Krefeld (1942), and the Church of World Peace in Hiroshima (1953–4). He also designed the complete interior decoration of the St Rochuskirche in Düsseldorf. In addition to such large-scale ecclesiastical works, Mataré designed liturgical objects such as chalices. In these, and in his later sculpture, his style was more decorative than in his austere pre-war work.

Mathieu, Georges (1921–) French painter, born in Boulogne. After studying philosophy and law, he began to paint in 1942. In 1947 he settled in Paris and in the 1950s gained an international reputation as one of the leading exponents of expressive abstraction. His fame has depended partly on a flair for publicity that has led to him being described as 'the Salvador *Dalí of *Art Informel'. He works rapidly, often on a large scale, with sweeping impulsive gestures, sometimes squeezing paint straight from the tube on to the canvas. 'To him, speed of execution is essential for intuitive spontaneity ... Typically Mathieu turned to elaborate titles taken from battles or other events of French history,

reflecting his insistence that he is a traditional history painter working in an abstract means. In love with spectacle and performance, he has at times painted, dressed in armor, before an audience, attacking the canvas as though it were the Saracen and he Roland. His critics have frequently raised the question as to who won the battle' (H. H. *Arnason, *A History of Modern Art*, 3rd edn, 1988). Mathieu has written several books expounding the theories behind his work.

Matisse, Henri (1869–1954) French painter, sculptor, draughtsman, printmaker, and designer, one of the most illustrious artists of the 20th century. From the 1920s he enjoyed an international reputation alongside *Picasso as the foremost painter of his time. Unlike Picasso, he was a late starter in art, and he was not quite so prolific or versatile, but for sensitivity of line and beauty of colouring he stands unrivalled among his contemporaries.

Matisse was born in Le Cateau, Picardy, the son of a shopkeeper (originally a draper, he became a grain merchant). To alleviate the boredom of life as a solicitor's clerk, Matisse attended drawing classes and he took up painting in 1890 when he was convalescing from an appendicitis operation. He later recalled that 'When I started to paint I felt transported into a kind of paradise', and in 1891 he abandoned his legal career to study art in Paris. He attended various schools, including the *Académie Julian, the École des Arts Décoratifs, the École des *Beaux-Arts, and (briefly in 1899), the *Académie Carrière. His early pictures—mainly still-lifes and landscapes—were sober in colour, but in the summer of 1896, painting in Brittany, he began to adopt the lighter palette of the *Impressionists. In 1899 he began to experiment with the *Neo-Impressionist technique, which he still used five years later in one of his first major works—the celebrated *Luxe, calme et volupté* (1904–5, Musée d'Orsay, Paris), exhibited at the *Salon des Indépendants in 1905 and bought by *Signac. During the same years he had been painting with *Marquet, had met *Derain and through him *Vlaminck, and in 1905, together with these and other friends from student days, he took part in the sensational exhibition at the *Salon d'Automne that give birth to the name '*Fauves'. In the same year (Matisse's *annus mirabilis*) he acquired his first important patrons—the expatriate Americans Gertrude, Leo, and Michael *Stein—and they

were soon followed by the great Russian collectors Ivan *Morozov and Sergei *Shchukin. Previously he had struggled to earn a living, but their patronage freed him from financial worries and meant he could afford to travel (before the First World War he visited Germany, where his work was becoming influential among the *Expressionists, Morocco, Russia, and Spain). His growing reputation also attracted many pupils to the art school he ran in Paris from 1907 to 1911. At the outbreak of the First World War he volunteered for military service, but he was rejected as too old at 44. For the next two years he often found it difficult to paint because of the anxieties of the war, but he was able to work at etching. He also took comfort in music (he was a good amateur violinist).

Matisse had met Picasso as early as 1906, and like him was excited by African sculpture at this time. During the second decade of the century he was influenced by *Cubism (or rather responded to its challenge) and painted some of his most austere and formal pictures (*Bathers by a River*, 1916–17, Art Institute of Chicago,). In the 1920s, however, he returned to the luminous serenity that characterized his work for the rest of his long career. From 1916 he spent most of his winters on the Riviera, mainly at Nice. The luxuriously sensual works he painted there—odalisques, still-lifes of tropical fruits and flowers, and glowing interiors—are irradiated with the strong sun and rich colours of the south. His extraordinary ability to orchestrate rich colour has been well described by John *Berger: 'It is comparatively easy to achieve a certain unity in a picture by allowing one colour to dominate, or by muting all the colours. Matisse did neither. He clashed his colours together like cymbals and the effect was like a lullaby.'

During the 1930s Matisse began to travel widely again. In 1930, for example, he visited Pittsburgh to serve on the jury of the *Carnegie International Competition, and while he was in the USA he met Dr Albert C. *Barnes, who commissioned murals from him for the Barnes Foundation. By this time he was an international celebrity, with a stream of articles, books, and exhibitions devoted to him: in 1930–31 large exhibitions of his work were held in Basle, Berlin, New York, and Paris. In 1940 he settled permanently in the South of France to escape the German occupation of Paris. He lived mainly in the Hôtel Régina in Nice. Following two major operations for

duodenal cancer in 1941, he was confined to bed or a wheelchair, but he worked until the end of his life and one of his greatest and most original works was created in 1948–51, when he was in his 80s. This is the Chapel of the Rosary at Vence, a gift of thanksgiving for a woman who had nursed him after his operations and then become a nun at the Dominican convent in Vence (Matisse lived there from 1943 to 1949). He designed every detail of the chapel and its furnishings, including the priests' vestments. The stained-glass windows show his familiar love of colour, but the walls feature murals of pure white ceramic tiles decorated with black line drawings of inspired simplicity. Matisse was not a believer, but he created here one of the most moving religious buildings of the 20th century and expressed what he called 'the nearly religious feeling I have for life'. Henri *Cartier-Bresson, a lifelong admirer, had a different view. 'Monsieur Matisse,' he asked him, 'you have never shown any serious interest in religion, and you are all the time painting these odalisques, these beautiful girls. Why didn't you decorate, instead of this Christian church, a Temple of Voluptuous Delight? Wouldn't that have suited your temperament better?'

In his bedridden final years Matisse also embarked on another kind of highly original work, using brightly coloured cut-out paper shapes (*gouaches découpées*) arranged into purely abstract patterns (*L'Escargot*, 1953, Tate) 'The paper cut-out', he said, 'allows me to draw in the colour. It is a simplification for me. Instead of drawing the outline and putting the colour inside it—the one modifying the other—I draw straight into the colour.' The colours he used in his cutouts were often so strong that his doctor advised him to wear dark glasses. They must rank among the most joyous works ever created by an artist in old age. Unlike many of his great contemporaries, he did not generally attempt to express in his work the troubled times through which he lived. His concerns were aesthetic, not moral—'to study separately each element of construction; drawing, colour, values, composition; to explore how these elements could be combined into a synthesis without diminishing the eloquence of any one of them by the presence of the others'. In 1908 he wrote: 'What I dream of is an art of balance, of purity and serenity devoid of troubling or disturbing subject-matter . . . like a comforting influence, a mental balm—something like a good arm-

chair in which one rests from physical fatigue.' Jack Flam has argued that Matisse's words should not be taken to imply that his art was simply concerned with decoration or entertainment, but that he was seeking a kind of elevation of the spirit. It should also be remembered that in the context of 1908 Matisse would have been seeking to distance himself from both the quasi-scientific approach of previous generation of Neo-Impressionists and the threat presented to his dominance by the more immediately challenging work of Picasso.

Matisse made sculptures at intervals throughout his career, the best known probably being the four bronzes called *The Back I–IV* (1909–*c.*1929, casts in the Tate and elsewhere), in which he progressively removed all detail, paring the figure down to massively simple forms. However, his most original work as a sculptor lies elsewhere. In the great series of five *Heads of Jeanette* made between 1910 and 1916 he explores, more intensely than any full-time sculptor of the period, the contradictions between an atmospheric modelling, which takes account of the transformation of the subject in memory and perception, and the sense of sculpture as a solid object. He also designed sets and costumes for *Diaghilev and was a brilliant book illustrator. His work is represented in most important collections of modern art, the finest holdings being at the Barnes Foundation in Merion, Pennsylvania, the Hermitage, St Petersburg, and the Pushkin Museum, Moscow. There are also Matisse museums in his birthplace, Le Cateau, and in Nice.

His son **Pierre Matisse** (1900–89) was an art dealer. He settled in the USA in 1925 and became an American citizen in 1942. The art historian William Rubin described him as 'the great American dealer of the European *Surrealist generation that came of age in the late 1920s and 1930s'. Among the many exhibitions he held in the Pierre Matisse Gallery, New York (opened 1932), the best known is probably 'Artists in Exile' (1942), which featured the work of many Surrealists who had moved from Europe to America to take refuge from the Second World War. He was particularly associated with *Miró (he held 37 exhibitions of his work), and the other artists whose work he sold included *Tanguy, a friend since schooldays. Matisse did not deal only in the work of the Surrealists, however: the artists he represented in his lengthy career

included figures as varied as *Balthus, *Chagall, *Giacometti, and *Riopelle. He also sold his father's work, although he never actually devoted an exhibition to it. He was married three times; his first wife, Alexina Sattler, later married Marcel *Duchamp.

Further Reading: J. D. Flam (ed.), *Matisse on Art* (1990) L. Gowing, *Henri Matisse* (1989)

Matta (Roberto Matta Echaurren) (1911–2002) Chilean painter and sculptor who worked mainly in Paris, but also in Italy and the USA. He trained as an architect in his native Santiago and in Paris under *Le Corbusier in 1934–5, but he turned to painting in 1937 and in the same year joined the *Surrealist movement. He particularly admired the work and character of Yves *Tanguy, while Marcel *Duchamp had suggested to him ways in which art could depict time and change. Matta's contribution to Surrealist thought was his theory of 'psychological morphology', according to which 'The optical image is only a theoretical cut to the sequential morphology of the object.' Martica Sawin has argued that the theories had less to do with the original preoccupations of Surrealism than with the ideas of the Russian mystic P. D. Ouspensky (1878–1947). In 1939 Matta fled from Europe to New York, where with other emigrés including *Breton, *Ernst, *Masson, and Tanguy he formed a strong and influential Surrealist presence. He played a particularly significant role in encouraging *Gorky, *Pollock, and others to experiment with *automatism: he, 'more than any other of the Surrealists, made himself available to young New Yorkers. A keen intellectual and scintillating conversationalist, he was able to focus attention on issues, to crystallize and dramatize them verbally' (Irving *Sandler, *Abstract Expressionism*, 1970). From about 1944 Matta began to create his most characteristic works—large canvases bordering on abstraction that evoke fantastic subjective landscapes and take as their theme the precariousness of human existence in a world dominated by machines and hidden forces. In 1948 he broke with the Surrealists and returned to Europe, but his work continued in a similar vein. He lived in Rome in the early 1950s, then mainly in Paris, although he travelled widely. In 1957 he began making sculpture. Matta had strong political views which were frequently expressed in his paintings. For instance *The Djamila Question* (1962) was made in honour of the Algerian nationalist Djamila Bouhired who was condemned to death by the French. (She was released after a public campaign by her lawyer.) He also made a painting protesting against the 1973 coup in his home country of Chile.

Further Reading: M. Sawin, *Surrealism in Exile and the Beginning of the New York School* (1995)

Matta-Clark, Gordon (1943–78) American environmental artist, born in New York, the son of Roberto *Matta. He studied architecture at Cornell University. In 1969 he met Robert *Smithson, whom he assisted, and Matta-Clark's work can be regarded as developing the older artist's concepts of entropy and the *site-specific by applying them to architecture. Comparisons have also been made with the *Situationist attempt to undo the authoritarian power of urban space. His work usually took the form of making cuts into buildings which had been scheduled for demolition, so linking inside and outside. An example is *Splitting in Engleswood* (1974), in which he used a house from which the tenants had been evicted to make room for a housing estate that was never built. The house was cut in half, with a split which tapered to a point at the bottom. Matta-Clark had a critical relationship to architecture, especially to that of the *Modern Movement, which he saw as a device for social control. He was invited to participate in the exhibition 'Idea as Model' at the Institute of Architectural and Urban Studies in New York in 1976, alongside projects by architects. His contribution was to borrow a gun from Dennis *Oppenheim, enter the building at 8.00 am and blow out the windows of the exhibition space. These were replaced by photographs of a new housing estate whose windows had been broken by the tenants.

His interventions are only known now as photographs and documentation, although this has not prevented him from being recognized as an important figure in the development of *installation art.

Further Reading: C. Diserens, 'Gordon Matta-Clark', in A. Benjamin (ed.) *Installation Art* (1993)

Matterism (Matter Painting) A type of painting which emphasizes paint as a physical substance. It became identifiable as a tendency in Paris in the 1940s in the work of *Fautrier and *Dubuffet, and became widespread in the 1950s. An entire school of such painting (the dominant figure being *Tàpies) emerged in

Spain. Other exponents included Bram *Bogart, René Guiette (1893–1976) and Marc Mendelson (1915–) in Belgium, and Jaap Wagemaker (1906–72) in the Netherlands.

Mattheuer, Wolfgang (1927–2004) German painter and sculptor, born in Reichenbach. He studied at the Leipzig Hochschule für Grafik und Buchkunst, an institution which was strongly committed to *Socialist Realism. His highly dramatic figure compositions were a conspicuous example of the *Problembild*, the critical, ambiguous kind of painting which was characteristic of East German painting from the mid-1960s. An example is *Kain* (1965, Staatliche Galerie, Moritzburg), supposedly referring to the war in Vietnam but which could equally be about the post-war division of Germany. After reunification, his work was sometimes read as an expression of political dissidence. For instance his sculpture *The Century Step* (1984, Haus der Geschichte der Bundesrepublik Deutschland, Bonn) has changed meaning in the intervening years from being about the struggle between Socialism and Fascism to being about their continuity. The visual evidence could perfectly well support either, and in the circumstances to invoke any statement by the artist as to 'intention' at face value seems naive.

Matulka, Jan See SMITH, DAVID.

Mauclair, Camille (Séverin Faust) (1872–1945) French writer. His large and varied output included fiction, poetry, and literary and musical criticism, but he is best known for his writings on art, in which he supported *Symbolism but was a fervent opponent of various forms of avant-garde art, seeing himself as an upholder of French tradition. Mauclair's *The French Impressionists* (1903) was the first book on the movement to appear in English (this translation preceded the French edition—*L'Impressionnisme, son histoire, son esthétique, ses maîtres*, 1904). His other books include *La Farce de l'art vivant* (2 vols, 1929–30) and monographs on *Besnard (1914), *Monet (1924, English translation 1925), and *Rodin (1918, preceded by an English translation in 1905). See also FAUVISM.

Maurer, Alfred H. (1868–1932) American painter, a pioneer of modernism in his country. He was born in New York, son of **Louis Maurer** (1832–1932), a lithographer who worked for the famous Currier & Ives firm of popular printmakers. After studying at the National Academy of Design and working as a lithographer, Alfred went to Paris in 1897 and briefly attended the *Académie Julian; apart from a short visit to America in 1901, he remained in Paris until 1914. His early style was influenced by *Whistler, and he won first prize at the *Carnegie International Exhibition in 1901 with a picture that was virtually an act of homage to him—*An Arrangement* (1901, Whitney Museum, New York), showing a woman in front of a Japanese screen. About 1907 Gertrude *Stein introduced Maurer to the work of the *Fauves, and he rapidly became a convert to a modernist idiom. His paintings in the Fauvist style were introduced to America by *Stieglitz in a joint exhibition with John *Marin at the 291 Gallery in 1909, and when Arthur B. *Davies and Walt *Kuhn visited Paris in 1912 to prepare for the *Armory Show they were helped by Maurer with introductions to the dealer Ambroise *Vollard. Maurer himself exhibited in the Armory Show (1913), in the Forum exhibition (*see* WRIGHT) that followed it in 1916, and in the first exhibition of the *Society of Independent Artists in 1917.

During the 1920s he reverted to a more naturalistic style, and an air of melancholy in his work has been interpreted as sorrow for promise unfulfilled. In the early 1930s he painted some pictures featuring *Cubist mannerisms (*Still-life with Doily*, 1930–31, Brandeis University Art Collection), but by this time he no longer took part in avant-garde activities. The final loss of confidence in his work seems to have been caused by the acclaim that his father started to receive in his extreme old age; with the flowering of *Regionalism, Louis's scenes of the American West suddenly took on a new lease of life. A month after his father died, at the age of 100, Maurer hanged himself.

Maus, Octave See LIBRE ESTHÉTIQUE.

Maximalism See POST-MINIMALISM.

Mayakovsky, Vladimir (1893–1930) Russian poet, playwright, critic, editor, designer, and painter, a leading figure in avant-garde art in the years of tumultuous activity before and after the 1917 Revolution. He was born in Bagdadi, Georgia, and moved to Moscow with his family in 1906, following the death of his father. In 1908 he joined the Bolshevik

Party, and he was arrested several times for his involvement in left-wing political activities; he began writing poetry while he was in prison. From 1911 to 1914 he was a student at the Moscow School of Painting, Sculpture, and Architecture, where one of his fellow pupils was David *Burliuk. He and Mayakovsky became leading figures of the Russian *Futurist movement, in spite of their youth; their activities included poetry readings and public clowning that anticipated *Performance art. In 1914 Burliuk and Mayakovsky were expelled from art school. Over the next couple of years Mayakovsky painted some *Cubo-Futurist pictures, but his main work in the visual arts was as a poster designer. In 1915 he met the critic Osip Brik (1888–1945), who was later head of *Inkhuk in Moscow. Brik helped to promote Futurism, and Mayakovsky fell in love with his wife, Lili Brik, to whom he dedicated numerous literary works.

Like other Futurists, Mayakovsky supported the 1917 Revolution, and in its aftermath he was involved in various kinds of *agitprop art, including performing in propaganda films and designing posters for the Russian Telegraph Agency—bold, cartoon-like images intended to be understood by the barely literate. He had the support of *Narkompros, but the leaders of the Communist Party generally regarded Futurism as elitist, Lenin describing one of Mayakovsky's works as 'incomprehensible rubbish' (entitled *150,000,000*, it is a description of a boxing match between the entire population of Russia and the American President, Woodrow Wilson). In 1923 Mayakovsky was one of the founders of the group LEF (Left Front of the Arts), which published a journal of the same name. This was a response to the conservative trends in art and literature that had re-emerged following the country's civil war (1918–21). The journal became the principal mouthpiece for 'Production art' (*see* INKHUK), in which art was essentially a form of industrial design, but it folded in 1925. Mayakovsky refounded the journal in 1927 as *Novy Lef* (New Lef), which placed an emphasis on documentary photography. Like its predecessor, *Novy Lef* had a short life, closing in 1928. By this time, *Socialist Realism was emerging as the official style of Soviet art and Mayakovsky was accused of being 'unintelligible to the masses'. In 1930 he organized a retrospective exhibition of his work, shown in Moscow and Leningrad, with the intention of demonstrating his relevance to the present day. Its poor reception, coupled with an unhappy love life, led him to shoot himself that year.

The huge crowds that attended Mayakovsky's funeral in Moscow showed that he did indeed command popular support, but over the next few years his reputation dwindled. In 1935, however, Lili Brik wrote to Stalin commending Mayakovsky's 'enormous revolutionary heritage', and Stalin responded by declaring him 'the best and most talented poet of our Soviet epoch'. From this point he became regarded as an official laureate, with the details of his life and beliefs rewritten to suit Stalinist propaganda. As the writer Boris Pasternak put it, he was 'propagated compulsorily like potatoes in the reign of Catherine the Great. This was his second death. He had no hand in it.'

Mayor, Fred *See* UNIT ONE.

Mazzacurati, Marino *See* ROMAN SCHOOL.

Meadows, Bernard (1915–2005) British sculptor, mainly in bronze, born in Norwich. After studying at Norwich School of Art, 1934–36, he was studio assistant to Henry *Moore in London, 1936–9. He had two periods of study at the *Royal College of Art, 1938–40 and 1946–48, interrupted by war service in the RAF, 1941–46. During his period in the RAF he spent some time on the Cocos Islands in the Indian Ocean, from which he derived the crab motif that he used in many of his works (*Black Crab*, 1952, Tate). Characteristically his sculpture is abstract but suggests animal and plant forms— during the 1960s he sometimes used real fruits in his casting. Meadows taught at Chelsea School of Art, 1940–60, and was professor of sculpture at the Royal College of Art, 1960–80.

Mécano A review founded by van *Doesburg in Leiden in 1922 and edited by him under the pseudonym I. K. Bonset; it ran to four numbers, 1922–3. Van Doesburg was at this time interested in *Dada, and the contributors included leaders of the movement such as *Arp, *Hausmann, *Picabia, and *Schwitters, who made fun of the *Bauhaus for its solemn sense of dedication. In this review van Doesburg also attempted to extend the principles of *Constructivism to poetry.

Mec art A term (abbreviation for 'mechanical art') applied to works produced by transferring photographic images to canvas treated with photosensitive emulsion. Andy *Warhol

used photographic transfers unadapted in many of his screenprints, but the European artists associated with Mec art have usually modified or restructured the original image to create a new, synthetic one. The term was perhaps first used by the French painter Alain Jacquet (1939–2008) in 1964 (with a pun on the word 'mec', French slang meaning 'bloke'), and it was adapted soon afterwards by several other artists, among them the Belgian Pol *Bury, the Greek Nikos (Nikos Kessanlis, 1930–2004), and the Italians Gianni Bertini (1922–) and Mimmo *Rotella.

Medalla, David (1942–) Filipino *Kinetic and *Performance artist who has lived and worked in London since the early 1960s. His work does not depend on elaborate technology but on the inventive use of simple materials. His most famous works are the *Cloud Canyons* sculptures (1961 example in Tate) which employ soap bubbles that are pushed from round apertures to produce snake-like forms. He has also worked with mud and sand. Such works anticipate the ideas of *anti-form and *process art arrived at by American artists some years later. He was one of the founders of Signals, a London gallery specializing in Kinetic art. Later work has often been based on spectator participation, as in *A Stitch in Time* at the 1972 *documenta, in which visitors were invited to add their own embroidery to a cloth, or performances held outside the gallery space in public places, such as Brighton Beach or the Eurostar terminal at the Gare du Nord, Paris.

Medley, Robert (1905–94) British painter and theatre designer, born in London. He studied at the Byam *Shaw School, London, 1921–3, the *Royal Academy Schools briefly in 1924, the *Slade School, 1924–6, and in Paris under Jean *Marchand, 1926–7. In the 1930s he worked with the left-wing Group Theatre, designing sets and costumes for plays by W. H. Auden (who was Medley's lover for a time), T. S. Eliot, Christopher Isherwood, and Louis MacNeice. During this period he became interested in *Surrealism and his work was included in the London International Surrealist Exhibition in 1936. In the Second World War he worked mainly on camouflage in the Middle East. Before and after the war he taught at Chelsea School of Art, then in 1951–8 taught stage design at the Slade School. From 1958 to 1965 he was head of the Department of Fine

Art at Camberwell School of Arts and Crafts. His main subjects as a painter were landscape, still-life, and figure compositions, and his approach was highly varied. In 1979 he summed up his stylistic development as follows: 'Early influences until 1939 were the *Bloomsbury Group and the *École de Paris, though from 1932 Surrealist and political pressures also exerted their influence. After the war my work was concerned with the movement of human figures in space . . . and with industrial landscape . . . By the 1960s the freedom of line and direct brushwork disintegrated the "representational", but the pictures remained metaphors for actual visual experiences. This was followed by an entirely non-figurative and geometric period . . . I now work in both conventions—non-figurative and figurative—as I feel inclined.' In 1976 he played the role of Diocletian in Derek Jarman's film *Sebastiane* and in 1983 he published an autobiography, *Drawn from Life*. He continued working and exhibiting until the end of his long life and in the year of his death he won a prize for the most distinguished work in the Royal Academy summer exhibition.

Medunetsky, K. *See* OBMOKHU.

Mehoffer, Józef (1869–1946) Polish painter and stained-glass artist, a leading representative of his country's *Symbolist movement. He was born in Ropczyce, his family moving to Cracow in 1870. While still a student of art in Cracow he worked as assistant on the frescos in St Mary's Basilica. Between 1891 and 1896, he spent most of his time in Paris. Despite this his style owes much more to the Vienna *Sezession, which he joined in 1896, than to advanced styles in France. In 1899 he married Jadwiga Janakowska, whose striking presence frequently graces his paintings. As an easel painter his masterpiece is *The Strange Garden* (1902–3, National Museum, Warsaw). This was the product of a stay in the village of Seilac, just outside Cracow. His wife and naked son walk down a country path, delicately shaded by overhanging branches, accompanied by their nursemaid. A note of fantasy is introduced by the enormous gilded dragonfly at the top of the painting. The intensity of the colour attracted early admiration. The critic Samlicki in 1912 described it as 'a symphony of greens, yellows, gold, and sapphire'. Mehoffer's decorative gifts found an outlet in the

considerable amount of work he made for churches, including stained glass and frescos.

Further Reading: A. Senczak and X. Deryng, *Józef Mehoffer* (2004)

Mehretu, Julie (1970–) Ethiopian/American painter. Born in Addis Ababa, she lives and works in New York. She creates large-scale paintings and wall-size installations which have been described as 'explosive', with dense layers of contours reminiscent of the apocalyptic visions of Leonardo da Vinci interlaced with geometric forms out of *Malevich. The artist also cites 'renaissance painting and drawing, tattoos, comic books, graffiti, graphic design, kung fu flicks, hip hop and video games' as sources for her painting. Her paintings, it has been argued, are not simply abstract but 'a question about the ways in which we construct and live in the world' (Lawrence Chua). She begins with an architectural plan then overlays this with more gestural markings. The conjunction of different spaces can be taken as a kind of metaphor for globalization.

(((⊕))) SEE WEB LINKS

• L. Chua, 'Julie Mehretu', in *BOMB* magazine (spring 2005).

Meidner, Ludwig (1884–1966) German painter, graphic artist, and writer, born at Bernstadt, Silesia. In 1903–5 he studied at the Breslau Academy, in 1905–6 he eked out a living as a fashion artist in Berlin, and in 1906–7 he studied at the *Académie Julian in Paris. He was unaffected by avant-garde developments there, although he became a friend of *Modigliani, who did several portraits of him (throughout his life Meidner remained an independent figure who stood apart from the main groups). In 1908 he returned to Berlin, and in about 1912 he began to paint visionary and apocalyptic scenes that gave him a reputation as 'the most *Expressionist of the Expressionists' (*Apocalyptic Landscape*, 1913, Los Angeles County Museum of Art). At the same time he began a period of prolific and equally ecstatic literary work. Whilst serving in the German Army, 1916–18, he wrote two books, *Septemberschrei* (September Cry) and *Im Nacken das Sternenmeer* (Behind My Head the Sea of Stars). However, his intense Expressionist period ended abruptly and in 1923 he wrote: 'It is only with the deepest blushes that I can read my youthful work.' In painting and drawing he now turned mainly to Jewish themes, but for a while he gave up art and

became a successful writer of humorous stories for a Berlin newspaper. Growing persecution of Jews led him to leave Berlin in 1935 and settle in Cologne, where he became drawing master at the Jewish Hochschule. In 1939 he fled to England, where he was interned in 1940–41. He returned to Germany in 1953, settled in Frankfurt, and in 1963 moved to Darmstadt. By this time he was almost forgotten, but in 1964 there were celebrations in Germany to mark his 80th birthday. Werner *Haftmann (*Painting in the Twentieth Century*, 1965) describes Meidner as 'a visionary and prophet of high stature endowed with keen feeling for the soul of his time, yet utterly unable to draw'.

Meier-Graefe, Julius (1867–1935) German art historian. He spent most of his career in Berlin, where he was co-founder of the luxuriously produced literary and artistic journal *Pan* (1895–1900). Its prestige helped to make Berlin the most important German art centre apart from Munich. From 1895 to 1904 Meier-Graefe lived in Paris, where he ran a gallery called La Maison Moderne, which championed *Art Nouveau (the great Art Nouveau architect Henri van de *Velde designed furniture for his apartment). In this period he also founded the periodical *Dekorative Kunst* (published in Munich, 1897–1929) and a companion title in French, *L'Art décoratif* (1898–1914). Meier-Graefe's own publications were devoted mainly to French painting, and John Rewald comments that his 'numerous and enthusiastic writings on *impressionism did much to spread its fame in Germany and abroad' (*The History of Impressionism*, 1946, 4th edn, 1973). His most important work was *Die Entwicklungsgeschichte der modernen Kunst* (3 vols, 1904; translated as *Modern Art*, 1908), which Rewald describes as 'the first broadly conceived general history of modern art' (*Post-Impressionism*, 1956, 3rd edn, 1978). In 1930 Meier-Graefe moved to France and he died in Switzerland. By this time he was reviled by the Nazis for his support of *degenerate art (quotations from his writings were displayed on the walls of the 'Degenerate Art' exhibition in Munich in 1937 along with those of other like-minded critics, who were pilloried along with the pictures).

Meireles, Cildo (1948–) Brazilian Performance and installation artist, born in Rio de Janeiro. Meireles came from a politically radical family who were especially concerned with

m

the rights of indigenous peoples. He was initially influenced by artists such as Lygia *Clark and Hélio *Oiticica, who were concerned with environment and audience participation. He became known for works which were a tactic of resistance against the military regime in power in the late 1960s and 1970s. These he called *Insercoes em Circuitos Ideologicos* ('insertions into ideological circuits'). Banknotes were stamped with political slogans, as were Coca-Cola bottles. The latter were both symbols of the political power of the United States and also objects which could be put back into circulation after use. Meireles printed on them in white, just like the normal lettering on the bottle, so that when empty his intervention would easily escape notice but be clearly visible when the bottle was filled with the dark liquid. One such intervention took the form of instructions for converting the bottle into a Molotov cocktail. The most dramatic of his gestures against the military regime was his 1971 performance named *Tiradentes: Totem-Monument to the Political Prisoner*. In this, ten live chickens were tied to a spike and set on fire. He spent the years between 1971 and 1973 in political exile in New York. He has subsequently worked as an installation artist, often inviting dramatic physical participation and providing an experience which was tactile and auditory as well as visual. In *Volatile* (1980–94), the visitor takes off shoes and socks to walk through ash. In *Through* (1983–89) it is necessary to tread on shards of broken glass while confronting various forms of barrier, both physical and visual. *Cinza* (ash grey) (1984/6) was in two rooms. In one the floor was covered with chalk sticks, in the other with charcoal. The movement of visitors tended to mingle the two substances, a likely reference to the idea that miscegenation was a source of strength for Brazil.

Further Reading: E. Leffingwell, 'Unspoken Stories–Cildo Meireles Exhibition', *Art in America* (July 2000)

C. Meireles and F. Morais, 'Material Language', *Tate Etc.* (autumn 2008)

Melamid, Alexander *See* KOMAR AND MELAMID.

Meldrum, Max (1875–1955) Australian painter. He was born in Edinburgh, emigrated to Melbourne in 1889, and studied there at the National Gallery of Victoria Art School. In 1899 he won the School's travelling scholarship and went to France, where he lived for the next twelve years. He returned to Melbourne in 1911 and in 1917 established a school there at which he disseminated his highly opinionated ideas on art. These theories were also expressed in a book published in 1917—*Max Meldrum: His Art and Views*, edited by Colin Colahan. Meldrum's ideas were based on study of the Old Masters, particularly Velázquez, whom he revered above all other painters. He regarded painting as a wholly objective exercise in defining and translating optical impressions by analysing tone in a rationally ordered way: 'The careful study of undisputed art strongly leads me to the conviction that the art of painting is a pure science.' He thought that modern art, with its emphasis on colour and individual expression, spelt social decadence. Meldrum's paintings faithfully reflect his doctrines, being competently handled but singularly lacking in inspiration. In spite of his obvious limitations as an artist, his views gained many adherents in Melbourne and Sydney in the inter-war period. He was a powerful personality (Lionel *Lindsay called him 'the mad Mullah') and 'inspired in his students the devotion appropriate to a Messiah. He mercilessly drilled every shred of personal vision out of them, and they loved him for it' (Robert *Hughes, *The Art of Australia*, 1970). None of his pupils gained any great distinction. Meldrum's outspokenness and dedication to his convictions often brought him into public conflict, particularly in his role as a trustee of the National Gallery of Victoria (1937–45).

Melly, George (1926–2007) British jazz and blues singer, writer, broadcaster, and collector. A flamboyant personality, he was described by Bamber Gascoigne (*Encyclopedia of Britain*, 1993) as 'something of a living art object in a wide repertoire of large and violently coloured suits'. However, he also published serious work in art history, his writings including a monograph on Scottie *Wilson (1986). He was a noted collector of modern paintings (particularly of *Surrealist works) and he helped to organize an exhibition of cartoons about modern art at the Tate Gallery, London, in 1973, entitled 'A Child of Six Could Do It'. His television appearances included chairing the Channel 4 art quiz show *Gallery*, which ran for several series in the 1980s; the opposing teams were led by Maggi *Hambling and Frank *Whitford. He wrote several volumes of autobiography.

Melotti, Fausto (1901–86) Italian sculptor, born in Rovereto, South Tyrol. He was a life-long friend of Lucio *Fontana and, like him, practised abstraction in the 1930s, making links with the international *Abstraction-Création group. His work at the time was far from the bombast of official Fascist art. The sculptures were in thinly cut sheet metal and wire. For Melotti art addressed 'the intellect, not the senses'. He made sculpture based on systems of geometric proportion analogous to musical composition. When first shown in 1935 such work was poorly received and for a time Melotti's practice was confined to commissions for figurative sculpture. In the post-war period he at last achieved success and acclaim for work such as his *Small Theatres*, terracotta boxes, sometimes with figures, rather distanced from the austere impersonal approach he had advocated earlier in his career. From the 1960s onwards he made figures in wire mesh and cloth.

Mendelson, Marc *See* MATTERISM.

Méndez, Leopoldo *See* TALLER DE GRÁFICA POPULAR.

Mendieta, Ana (1948–85) Cuban-born artist, working in the United States. She was born in Havana but was sent away with her sister as a political refugee in 1961 after her father fell out with the Castro regime. She graduated from the University of Iowa with a degree in painting in 1972. Her work was in an area between *Body, *Performance, and *Land art. She identified the female body with the earth; 'My art is grounded in the belief in one Universal Energy which runs through everything from insect to man, from man to spectre, from spectre to plant, from plant to galaxy.' Certain work addressed the issue of violence against women. In one performance of 1973, which followed the rape and murder of a student at the University of Iowa, she recreated the scene of the crime with herself taking the role of the victim. In other works she used the form of her own schematized figure, cutting it into the earth or setting it on fire. She made drawings on leaves, producing works of extreme fragility. She was married to Carl *Andre and died after plunging from the window of their New York apartment. Andre was charged with her murder but acquitted. However, suspicions have remained. When his work was shown at the Guggenheim Museum, New York, in 1993

a feminist demonstration carried banners inscribed 'Where is Ana Mendieta?'

Further Reading: J. Blocker, *Where is Ana Mendieta?* (1999)

Mérida, Carlos (1891–1985) Guatemalan painter, active mainly in Mexico. In 1910–14 he studied in Paris under van *Dongen, meeting *Modigliani, *Picasso, and other members of the avant-garde. He returned to Guatemala in 1914 and in 1919 moved to Mexico, where he worked as *Rivera's chief assistant for several years. In 1927–9 he was again in Europe, where he became friends with *Klee and *Miró, then returned to Mexico. His early work was in a politically conscious figurative style, but in the 1930s he was influenced by *Surrealism (he took part in the International Surrealist Exhibition in Mexico City in 1940, organized by *Breton and *Paalen), and he eventually developed a completely abstract manner. From the 1950s much of his work was done for architectural settings, and he often worked in mosaic (for example at the Municipal Palace, Guatemala City, 1956) as well as in fresco.

Merkurov, Sergei (1881–1952) Russian sculptor. He was born in Armenia, studied in Zurich and Munich, and lived in Paris for several years before settling in Moscow in 1909. His best-known works are his enormous statues of Lenin and Stalin in Moscow and elsewhere, many of them now destroyed. Most typically he worked in granite, but his largest statue (about 16 metres high) of Stalin in Yerevan (1950, destroyed) was in copper. From 1945 to 1950 Merkurov was director of the Pushkin Museum of Fine Arts in Moscow. *See also* SOCIALIST REALISM.

Merleau-Ponty, Maurice *See* PERFORMANCE.

Merz *See* SCHWITTERS, KURT.

Merz, Mario (1925–2003) Italian painter and sculptor, born in Milan. His father was an engineer and inventor. In 1945 he was imprisoned for political activities on behalf of the anti-Fascist group Giustizi e Libertà. In spite of his political leanings towards the Communist party, he did not follow the *Socialist Realist line and during the 1950s he worked as an abstract painter. In the 1960s he became associated with the *Arte Povera movement sponsored by the critic Germano *Celant. In an obituary of the artist Celant recalled his first

visit to his studio in 1966, seeing the triangular structures made of fabric and woven bamboo. At the same time, Merz began incorporating neon light into his work. This was bent into the form of handwritten lettering, creating an indeterminate effect quite unlike the *Pop art brashness usually associated with it. The tubes tend to destroy the solidity of the objects they pass through or alternatively pierce through an atmosphere, as in *Città Irreale* (1968, Stedelijk Museum, Amsterdam), which quotes T. S. Eliot in its invocation of a smog-bound metropolis. *Che Fare?* (1968, Musée Départmental d'Art Ancien et Contemporain, Épinal) echoes the revolutionary mood of its time by citing Lenin in blue neon in a metal bowl. Like other Arte Povera artists, Merz was concerned with the linking of natural and cultural processes as a critique of contemporary industrialism and capitalism. Some sculptures took the form of the igloo. These were constructed out of glass plates or packed with sand bags. The *Igloo di Giap* (1968, Pompidou Centre, Paris) refers to the guerrilla tactics of the Vietnamese general who had humiliated the French in 1954. Merz also made use of the Fibonacci sequence of numbers. This is both an open-ended series and one which suggests an underlying order behind natural forms, especially the spiral.

Further Reading: G. Celant, 'Spheres of Influence', *Artforum International* (January 2004)

R. Smith, obituary, *New York Times* (13 November 2003)

Mesens, E. L. T. (Édouard Léon Théodore) (1903–71) Belgian musician, poet, collagist, exhibition organizer, and dealer, born in Brussels. He was a talented composer in his youth, but he gave this up in 1923 to concentrate on poetry. His interest in the visual arts developed under the influence of *Duchamp and *Picabia, whom he met in Paris in 1921, and he was influenced towards *Surrealism by the paintings of *de Chirico. He became a friend and champion of *Magritte and a highly active figure in the Surrealist movement, although more as an organizer than an artist. In 1936 he was the Belgian representative on the committee of the International Surrealist Exhibition in London, and he settled there in 1938. He became director of the London Gallery in Cork Street, the headquarters of Surrealism in England, organizing exhibitions of the work of many European artists there (including *Ernst, *Schwitters, and *Tanguy); he also edited the gallery's pub-

lication, the *London Bulletin*, an important documentary source for the period (it ran for twenty issues, 1938–40; the first issue was called *London Gallery Bulletin*). The gallery closed during the Second World War (when Mesens worked on French broadcasts for the BBC), but it reopened in 1946 and survived into the early 1950s. Mesens then returned to Belgium. In his own work as an artist, he was best known for his collages, which he created from an assortment of materials—tickets, ribbons, pieces of paper and print, etc. He made extensive use of printed words to create disconcerting or amusing ambiguities and suggested meanings, some of which might almost be regarded as anticipations of *Conceptual art.

Messager, Annette (1943–) French artist and collector (her preferred description), born at Berck-sur-Mer. She studied at the École des Arts Décoratifs in Paris. Influenced by the turbulent political atmosphere of the time, she aimed to create an art which would challenge artistic hierarchies. This led Messager to make work that incorporated everyday objects but also to making *feminist art that examined the standards of beauty imposed by society on women. *Mes jalousies* (1972) looked at plastic surgery by means of photographs of the face inscribed with markings which prematurely aged them. *Les Pensionnares* (1972) is a collection of dead birds, each given a woollen knitted coat. This was Messager's comment on the constraints laid on women. In later years Messager has made some of the most spectacular and absorbing of installation works. She sometimes evokes childhood with assemblies of toys. *Casino* (2005), seen at the Venice *Biennale, was a large red sheet which was made to rise and fall like a wave by means of a wind machine.

Further Reading: A. Messager, *The Messengers* (2007)

A. Riding, 'Annette Messager: a bold messenger for feminist art', *International Herald Tribune* (26 June 2007)

Meštrović, Ivan (1883–1962) Yugoslavian (Croatian)-born sculptor and architect who became an American citizen in 1954. He was born at Vrpolje, into a peasant family, and studied at the Academy in Vienna, 1900–04. In 1908–9 he lived in Paris, where he met *Rodin. After returning to Yugoslavia he worked in a style that was basically classical

but furbished with a superficial air of modernity. He passed the First World War in Rome, Geneva, Paris, and London, where a large exhibition of his work was held at the Victoria and Albert Museum, contributing to the growth of his international reputation (he became easily his country's best-known artist). In 1919 he returned to Yugoslavia, where he was appointed a professor at the Zagreb Academy and received many public commissions, including an enormous mausoleum outside Belgrade in commemoration of the Unknown Soldier (1934), one of the many works in which he expressed his ardent patriotism. During the Second World War he had several commissions from the Vatican, and after living in Switzerland from 1943 to 1946 he settled in the USA. He was professor of sculpture at Syracuse University, New York, 1947–55, and at the University of Notre Dame, Indiana, from 1955 until his death. His work in the USA included a number of monuments. The great reputation he enjoyed in his lifetime has declined since his death, the rhetoric of his large-scale works now seeming rather ponderous; his smaller, more lyrical pieces have dated less. There are Meštrović museums at Split (his former house, which he designed himself), Vrpolje, and Zagreb; and the church of the Holy Redeemer at Otavice is in effect another specialized collection of his work—he designed the building and created the sculptural decoration. He was highly prolific and there are other examples of his work in many major collections of modern art, including Tate.

Metaphysical Painting A style of painting invented by *de Chirico in about 1913 and practised by him, *Carrà (from 1917), *Morandi (from 1918), and a few other Italian artists (notably de *Pisis, *Sironi, and *Soffici) until about 1920. The term was coined by de Chirico and Carrà in 1917, when both were patients at a military hospital in Ferrara. Metaphysical Painting started with no inaugural programme, although attempts were later made to define a 'metaphysical aesthetic' in the periodical *Valori plastici*, which ran from 1918 to 1921, and in Carrà's book *Pittura metafisica* (1919). The meaning attached to the term 'metaphysical', which occurs in the titles

of several pictures by de Chirico particularly, was never precisely formulated, but the style is characterized by images conveying a sense of mystery and hallucination. This was achieved partly by unreal perspectives and lighting, partly by the adoption of a strange iconography involving, for example, the use of tailor's dummies and statues in place of human figures, and partly by an incongruous juxtaposition of realistically depicted objects in a manner later taken over by some of the *Surrealists. But the dreamlike quality conveyed by Metaphysical painters differed from that of the Surrealists because of their concern with pictorial structure and a strongly architectural sense of repose deriving from Italian Renaissance art.

Metcalf, Willard L. *See* TEN, THE.

Metelli, Orneore (1872–1939) Italy's most famous *naive painter, born at Terni in Umbria, where he was a master-shoemaker (he designed as well as made shoes and won several awards at national and international competitions). Metelli took up painting when he was 50 and often worked far into the night after a day at the shoemaker's craft (he sometimes painted a small boot or pair of boots after his signature on his canvases). His main subjects were portraits and scenes in his home town; occasionally he did copies of Old Masters.

Meteyard, Sidney Harold *See* PRE-RAPHAELITISM.

Methuen, Lord (Paul Ayshford) *See* BATH ACADEMY OF ART.

Metzger, Gustav (1926–) German-born artist who settled in England in 1939 as a refugee from Nazism (his parents were Polish Jews) and now calls himself stateless. From 1941 to 1944 he worked at joinery and farming, then studied art in Cambridge, Oxford, Antwerp, and London (under *Bomberg at Borough Polytechnic, 1950–53). In 1959 he published his first manifesto of 'Auto-destructive art'. Metzger credited the invention of the term itself to the *Kinetic artist Brian Robins, who thought it more striking than 'self-destructive'. His first exhibition, in 1959, was of reliefs made from cardboard packaging placed against the wall. In 1960 he gave the first public demonstration of a process in which he 'painted' with acid, spraying it on nylon cloth, creating rapidly

changing patterns until the nylon was destroyed. Another form of auto-destructive art was liquid slide projection crystals. The heating and cooling of these crystals created ever-changing and ephemeral effects. There was process but no final object. For Metzger, an active supporter of the Campaign for Nuclear Disarmament, 'Auto-destructive art mirrors the compulsive perfectionism of arms manufacture—polishing to destruction point'. In 1966 he organized a Destruction in Art Symposium (DIAS) in London. By that time there was an identifiable international trend which could embrace among others Jean *Tingueley, Niki de *Saint Phalle, Yoko *Ono, and the *Vienna Actionists. Metzger was one of the 'Seven German Artists' represented at the 'Art into Society/Society into Art' exhibition staged at the *Institute of Contemporary Arts, London, in 1974. In the accompanying catalogue he advocated a three-year strike by artists, claiming that if they ceased all artistic activities from 1977 to 1980, this would cripple the mechanisms for the production, distribution, and consumption of art. From 1980 he has lived mainly in Germany, Switzerland, and the Netherlands. Among his admirers is the rock musician Pete Townshend, whose act with his group The Who used to include smashing guitars. He used Metzger's projections in the group's concerts and helped fund the artist's 1998 retrospective at the Museum of Modern Art, Oxford.

Further Reading: *Art and Artists* (August 1966; special 'auto-destructive' issue)

Museum of Modern Art, Oxford, *Gustav Metzger* (1998)

Metzinger, Jean (1883–1956) French painter (mainly of still-life, landscapes, and figure compositions) and writer on art. He was born in Nantes, where he studied at the Académie des Beaux-Arts, and moved to Paris after three of his paintings sold well at the *Salon des Indépendants in 1903. After passing through *Neo-Impressionist and *Fauvist phases, he became one of the earliest devotees of *Cubism and a central figure of the *Section d'Or group. He was typical of the so-called 'Salon Cubists' in that his paintings tended to be more legible and far less radical in their treatment of space than those of Picasso and Braque. Although not particularly distinguished as a painter, he has a considerable importance as an early theorist of Cubism. His 1911 article 'Cubism and Tradition' was the first to argue that Cubist painting combined different views of a subject in a single

picture to 'heighten the likeness': *Tea-time* (1911, Philadelphia Museum of Art) is almost a literal illustration of the process. The teacup is seen from different angles, full-face and profile are combined, and two slightly different moments in the raising of the spoon are presented simultaneously. The novelty of the representational process can distract the viewer from the fact that the model is taking tea in the nude. 'Near-pornographic' is the description of Christopher Green (*Art in Paris 1910–1940*, 2000). Metzinger's best known literary work, *Du Cubisme*, written in collaboration with Albert *Gleizes, was published in 1912. In the 1920s he turned from Cubism to a more naturalistic style, reminiscent of the monumental figure compositions of *Léger, but from about 1940 he made a partial return to his earlier manner.

Meunier, Constantin (1831–1905) Belgian sculptor and painter, well known for his glorification of the nobility of labour in his treatment of such subjects as miners, factory workers, and stevedores. As Fred Licht put it, 'he gave to proletarian society an archetype which was to be as commonly recognized as Van Dyck's characterization of the English gentleman was in the seventeenth century' (*Sculpture: 19th and 20th Centuries*, 1967). The invocation of Van Dyck is hardly accidental, considering the incongruous elegance of Meunier's most famous sculpture, *The Docker*, a cast of which stands outside Antwerp City Hall, and the nearest that *Social Realism has ever come to the swagger portrait (*see* SARGENT). From 1897 onwards he had plans to integrate his figures into a monument to labour. This was finally realized in Laeken, a suburb of Brussels, in 1930, from maquettes left in the artist's studio. Meunier never arrived at a definitive form and Marie Bouchard has commented that it 'appears more of a homage to the sculptor than a glorification of labour'. In the early 20th century he had considerable influence on younger sculptors interested in Social Realist subjects. There is a museum of his work in Brussels.

Further Reading: Marie Bouchard, '"Un Monument au Travail": Dalou, Meunier, Rodin and Bouchard', *Oxford Art Journal*, vol. 4 no. 2 (November 1981)

Meyer, Hannes *See* BAUHAUS.

Meyer, Ursula *See* CONCEPTUAL ART.

Michals, Duane *See* PHOTO-WORK.

Michaux, Henri (1899–1980) Belgian-born poet and painter who became a French citizen in 1955. Before settling in France in 1940 he led an adventurous life of travel. He began to write in 1922, did his first paintings in 1926, and took up art seriously in the late 1930s. Michaux was an independent figure and his work is richly imaginative and often mystical in feeling (he was deeply religious and the death of his wife in an accident in 1948 intensified his visionary bent). Like the *Surrealists, he experimented with *automatism and in the mid-1950s he began to make drawings whilst under the influence of the hallucinogenic drug mescalin to explore 'the landscapes of the mind'.

Microemotive art *See* GILARDI, PIERO.

Middendorf, Helmut *See* FETTING, RAINER.

Middleditch, Edward (1923–87) British painter, born in Chelmsford. After war service (during which he was awarded the MC) he studied in London at the Regent Street Polytechnic, 1948, and the *Royal College of Art, 1948–52. His contemporaries at the RCA included Derrick *Greaves and Jack *Smith, and with these two and John *Bratby he became one of the leading representatives of the *Kitchen Sink School in the 1950s. However, Middleditch was more interested in nature than in *Social Realism (landscapes and flowers are his favourite subjects) and in the 1960s his work became increasingly abstract without completely abandoning subject-matter. His dealer Helen *Lessore recalled that he never talked of his wartime experiences and deduced from this that the memory of them lay behind all he did. There is certainly a strong sense of mortality in his treatment of animals. *Pigeons in Trafalgar Square* (1954, Leicestershire Education Committee) is an almost entirely grey painting. The low viewpoint makes the square appear nearly deserted; the setting is dominated not by the buildings but a deep perspective of rain pools. Middleditch taught at various art schools, notably Norwich School of Art, where he was head of fine art, 1964–84. From 1984 to 1986 he was keeper of the *Royal Academy Schools.

Further Reading: J. Hyman, *The Struggle for Realism* (2001)

Mies van der Rohe, Ludwig *See* BAUHAUS.

Miki, Tomio *See* NEO-DADA ORGANIZERS.

Milioti, Nikolai and **Vasily** *See* BLUE ROSE.

Millares, Manolo (Manuel) (1926–72) Spanish painter, born at Las Palmas in the Canary Islands. He was self-taught as an artist. After beginning as a landscape painter he turned to *Surrealism (influenced by *Klee and *Miró) and by 1949 he was experimenting with abstraction. He first visited Spain in 1953 for the International Congress of Abstract Art at Santander, and in 1955 he settled in Madrid. In 1957 he was a founder-member of the avant-garde group *El Paso. His paintings are highly emotional and often incorporate unusual materials, such as torn sackcloth (*Painting 150*, 1961, Tate).

Miller, Godfrey (1893–1964) New Zealand-born painter who became a pioneer of abstract art in Australia. He was born in Wellington, where he trained as an architect. After serving in Egypt and Gallipoli in the First World War, he travelled widely. His intermittent training as a painter included periods of study at the *Slade School, London, between 1929 and 1938. In 1938 he returned to New Zealand, then settled in Sydney, Australia, soon afterwards. He lived a reclusive life and did not exhibit until 1952, when he was nearly 60 (he inherited a shipping fortune, and so had no need to make money from his work). His first one-man exhibition was at the Macquarie Galleries, Sydney, in 1957, and his eccentric, diffident personality helped to promote him quickly to the status of a cult figure. He painted in a semi-abstract style, with a fine grid of lines dissolving the subject into a kind of *Cubist mosaic (*Still-Life with Musical Instruments*, 1962, NG of Victoria, Melbourne).

Miller, Kenneth Hayes (1876–1952) American painter and teacher. He was born in Oneida, New York, and studied at the *Art Students League and then at the New York School of Art, where he joined the teaching staff in 1899 after returning from a trip to Europe. In 1911 he moved to the Art Students League, teaching there intermittently until 1951. During this career of more than half a century he became one of the most renowned teachers of the day: his pupils included George *Bellows, Isabel *Bishop, Edward *Hopper, Reginald *Marsh, and George *Tooker. Miller's early paintings had been in a romantic vein, influenced by his

friendship with Albert Pinkham *Ryder, but from about 1920 his work became more solid and intellectual, influenced by Renaissance figure compositions. His subjects, however, were contemporary, notably scenes of women shopping (*The Fitting Room*, 1931, Metropolitan Museum, New York), and his preference for depicting everyday New York life influenced several of his pupils. In 1923 Miller began working in a studio in 14th Street, in the heart of the city's shopping district, and some of the painters influenced by him in the interwar period are known as 'The Fourteenth Street School'. During his lifetime he was highly regarded as an artist as well as a teacher, but he was virtually forgotten after his death. Interest in him greatly revived in the 1970s.

Miller, Lee (1907–77) American photographer, writer, and model, born in Poughkeepsie. She went to Paris in 1929, after already working as a photographic model. There she decided to become a photographer, working as assistant to *Man Ray, whose lover she became. Together they developed the process of 'solarization'. She appeared in many of Man Ray's photographs, as well as in *Cocteau's film *Le Sang d'un poète* (1930). She returned to New York in 1932, complementing experimental photography with a successful career as a fashion photographer. Her work of the early 1930s was strongly influenced by *Surrealism. In 1934–8 she lived in Egypt, and some of her finest photographs were made there. The most famous is probably *Portrait of Space, near Siwa* (1937), showing the desert seen through a torn mesh, an image which is said to have inspired René *Magritte. In 1937 she met Roland *Penrose, whom she lived with and subsequently married. After 1940 she was based in London and worked for *Vogue* magazine, principally on photojournalism. In 1941 her photographs of the London Blitz were published under the title *Grim Glory: Britain under Fire*, and in 1944–6 she photographed the war and its aftermath in Europe, providing text as well as pictures. The subject matter of some of these pictures—the concentration camp at Dachau or the execution of the Fascist prime minister of Hungary, László Bárdossy—was inherently powerful, but Miller brought to her photography a Surrealist sense of the potent fragment. She also photographed many of the leading artistic figures of her day, including on numerous occasions

*Picasso, who in 1937 painted her portrait (Musée Picasso, Paris).

Further Reading: A. Penrose, *The Lives of Lee Miller* (1985)

Milles, Carl (1875–1955) Sweden's most famous sculptor. He was born at Lagga, near Uppsala, and from 1892 to 1897 was apprenticed to a cabinet-maker in Stockholm, whilst also attending classes in carving and modelling. From 1897 to 1904 he lived in Paris, where he worked for a time as assistant to *Rodin, then moved to Munich (1904–6), where he was influenced by *Hildebrand. In the following two years he lived in Rome, Stockholm, and Austria, then settled at Lidingö, near Stockholm, in 1908. His travels had given him a wide knowledge of ancient, medieval, and Renaissance art, as well as of recent developments, and he forged from these varied influences an eclectic but vigorous style. He is best known for his numerous large-scale fountains, distinguished by rhythmic vitality and inventive figure types (he would fuse classical and Nordic types such as tritons and goblins), and sometimes by a grotesque humour. In 1930 he was appointed professor of modelling at the Stockholm Academy, and by this time, his growing international reputation had been marked by a one-man exhibition at the Tate Gallery, London, in 1927. From 1931 to 1945 he was professor of sculpture at the Cranbrook Academy at Bloomfield Hills, Michigan; his work in the USA includes fountains in Chicago, Kansas City, New York, and St Louis. He became an American citizen in 1945 but returned to Sweden in 1951 and died at Lidingö, where his home is now an open-air museum of his work, known as Millesgården.

Milne, David Brown (1882–1953) Canadian painter, mainly of landscape, born near Paisley, Ontario. In 1904 he gave up his job as a schoolteacher to study at the *Art Students League, New York, remaining there until 1907 whilst he supported himself with commercial work such as lettering. He continued living in the USA until 1928, first in New York (where he exhibited at the *Armory Show in 1913) and then from 1915 at Boston Corners in the Berkshire Hills in New York State. In 1918–19 he served with the Canadian army and became an *Official War Artist in Britain, France, and Belgium. After returning to Canada in 1928 he lived in seclusion in various parts of Ontario, although he was a regular visitor to Toronto. His

love of solitude limited the impact he made in his lifetime, but he is now regarded as one of the finest and most individual Canadian painters of his time. He particularly admired the work of Tom *Thomson and lamented his early death by drowning: 'I rather think it would have been wiser to have taken your ten most prominent Canadians and sunk them in Canoe Lake—and saved Tom Thomson.' However, he was not interested in the aggressive nationalism of Thomson's followers in the *Group of Seven (another reason for his comparative lack of public acclaim). Rather, he was concerned with 'pure' painting. His style was vigorous and spontaneous, with a calligraphic quality in the handling. From 1937 he worked mainly in watercolour, a medium he used in an oriental-like way as a sensitive means of expressing his emotional response to nature (*Rites of Autumn*, 1943, NG, Ottawa). Late in life he also painted fantasy subjects, some of a whimsically religious nature.

Milroy, Lisa (1959–) Canadian–British painter, born in Vancouver. She settled in London in the late 1970s, studying at *St Martin's School of Art and *Goldsmiths College. She achieved fame in the 1980s for paintings in which everyday objects were arranged in a grid pattern against an off-white background. These paintings were marked by a remarkable balance between a painterly surface and a vivid, almost illusionistic representation of the textural qualities of objects. *Handles* (1988, Walker Art Gallery, Liverpool), for which she won the *John Moores Prize in 1989, is a fine example. The variety of ornate Rococo types is emphasized by the deadpan composition. The range of subjects became extended to include more exotic or precious objects such as rare stamps and Greek vases. She has recently painted more humorous pictures, including cartoon-like images of Japanese geishas in incongruous situations, first exhibited in 2003.

Further Reading: A. Searle, 'How the Zebra got its Stripes', *The Guardian* (20 January 2001)

Minaux, André *See* HOMME-TÉMOIN.

Minimal art A type of *abstract art, particularly sculpture, characterized by extreme simplicity of form, usually on a large scale and using industrial materials; it emerged in the 1960s and has been influential ever since. The term was probably first used in print by the British philosopher Richard Wollheim in an article entitled 'Minimal Art' in *Arts Magazine* in January 1965, although the American writer Barbara Rose is sometimes credited with coining it (it had been used by David *Burliuk in 1929 but with different connotations). Wollheim had been especially struck by the all-black paintings of Ad *Reinhardt, that had recently been seen at London's *Institute of Contemporary Arts, and related them to a wider tendency in modern art which also included *Duchamp's *ready-mades. For Wollheim, Minimal art avoided the kind of differentiation which was part of traditional artistic organization, and involved the minimal degree of artistic intervention. The term became applied to sculptors who used simplified geometric forms, usually fabricated industrially, such as Tony *Smith, Donald *Judd, Robert *Morris, and Carl *Andre, or painters such as Robert *Ryman, Marthe *Wéry, or Bob *Law, who presented monochrome or near-monochrome paintings. More contentious is the application of the term to artists such as Anthony *Caro or Kenneth *Noland. Even at their most simplified, their art is the result of the exercise of visual judgement rather than the application of a system, a feature often regarded as crucial to the definition.

This distinction was not always made in the late 1960s. Gregory Battcock's anthology *Minimal Art* (1968) reproduces a wide range of artists including Caro. The 1969 travelling exhibition organized by E. C. Goosen for the New York *Museum of Modern Art, *'Art of the Real', likewise drew together *Post-Painterly artists such as Morris *Louis with others who would now be regarded as 'hard-core' Minimalists. The clarification and restriction of the idea of Minimal art derives above all from two contrasting texts, one by a practitioner, the other by a critic and historian. 'Specific Objects' (*Arts Yearbook*, 1965) by Donald Judd identified a kind of work which 'has been neither painting nor sculpture'. The problem with these traditional forms for Judd was that they were always ultimately concerned with internal relationships. He looked for an art of 'real space' which 'gets rid of the problem of illusionism and of literal space in and around marks and colour...one of the salient and most objectionable relics of European art'. Judd was especially drawn to art like that of Dan *Flavin which used industrial materials, another indication that part of his agenda was

to define a specifically American kind of modern art in opposition to a conservative Europe. 'Art and Objecthood' by Michael *Fried (*Artforum*, June 1967) was written in opposition to Minimal art. He decried what he called the 'theatre' of Minimal art, by which he meant the way in which a work such as Tony Smith's *Die*, a six-foot steel cube, encouraged an awareness of the conditions in which the work was placed, usually the gallery setting. By denying the relationship of one part to another the Minimalists had simply succeeded in setting up a relationship to their immediate surroundings. What Fried was demanding from art was a kind of experience of transcendence from the here and now, an experience which could only be provided by a kind of absorption in the work as a discrete object. Paradoxically, Fried defined an aspect of the aesthetic of Minimalism which would be regarded as a positive feature by supporters such as Rosalind *Krauss and Lucy *Lippard, who wrote of the desire of artists to create projects which would 'create a new landscape made by sculpture rather than decorated by sculpture'.

The historical logic behind Minimal art is open to debate. On the one hand it can be viewed as the logical development of the *modernist drive towards purity. As *The Tate Gallery: An Illustrated Companion* (1979) puts it, 'without the diverting presence of "composition", and by the use of plain, often industrial materials arranged in geometrical or highly simplified configurations we may experience all the more strongly the pure qualities of colour, form, space and materials'. Another view, associated especially with Rosalind Krauss, is that Minimal art is unconcerned with purity. The simplified forms are nothing to do with the Platonic ideal world of early abstract art. The scale of Minimal art makes the spectators aware not of an abstract order but of the contingencies of experience, especially of their own bodies. If there is a historical precedent it lies with the 'culture of materials' of the Russian *Constructivists *Tatlin and *Rodchenko rather than with the idealism of *Malevich and *Mondrian. The world it relates to is that of the factory floor, not the design studio. In a further interpretative development, the feminist critic Anna Chave has argued that Minimal art's claims to radical abstraction are illusory and that its real subject is an oppressive domination over space and the spectator.

Certainly, artists of a later generation influenced by Minimalism have not seen it as 'pure' or 'socially neutral'. In the paintings and installations of the American artist Steven Parrino (1958–2005) the glossy black and silver surfaces are used for their cultural connotations, especially the world of biking. The misshapen canvases were compared by the critic Robert Nickas to 'the crumpled body of a car after an accident . . . a clear sign of violence being served cold'. The installations of Liam *Gillick use Minimalist forms to comment on social manipulation. *See also* POST-MINIMALISM.

Further Reading: K. Baker, *Minimalism: Art of Circumstance* (1988)

G. Battcock (ed.), *Minimal Art* (1968)

A. Chave, 'Minimalism and the Rhetoric of Power', in Frascina and Harris (1992)

R. Krauss, *Passages in Modern Sculpture* (1981)

Minne, Georg (1866–1941) Belgian sculptor, painter, and graphic artist, born at Ghent, the son of an architect. He initially studied architecture at the Ghent Academy, then transferred to painting and sculpture. In 1886 he met the *Symbolist poet Maurice Maeterlink and began to illustrate Symbolist books, including Maeterlink's *Serres chaudes* (1889), in a pseudo-medieval manner. Then, turning his attention increasingly to sculpture, he became one of the most successful artists in expressing Symbolist ideas in bronze and marble. His favourite theme was the kneeling adolescent. As Robert *Goldwater (*Symbolism*, 1979) points out, the posture 'inhibits movement and implies humility in a pose at once natural and symbolic . . . the figure remains in dolorous isolation, its body an encumbrance to thought'. Minne's work has links with *Expressionism, and it was influential on Expressionist sculptors such as *Lehmbruck, who admired Minne's *Fountain of the Kneeling Youths* (1898–1906), commissioned for the Hagen Museum and now in the Folkwang Museum, Essen. From 1898 Minne lived at *Laethem-Saint-Martin, with the exception of the years of the First World War, when he took refuge in Wales. About 1908 he began to turn away from his Symbolist outlook, which no longer seemed viable. Thinking that he had lost touch with nature, he studied anatomy and turned to a more realistic and socially oriented style in the manner of his countryman Constantin *Meunier.

Minotaure A journal of art and literature published in Paris between February 1933 and

May 1939 (13 numbers appearing irregularly); it was devoted mainly to *Surrealism and constituted the movement's most important journal in this period (which may be considered its zenith), following *La Révolution surréaliste* and *Le Surréalisme au service de la révolution* and preceding *VVV*. Albert *Skira was the administrative director and *Tériade was the artistic director; when Tériade left after the ninth issue (October 1936), Skira established an editorial committee that included *Breton, *Duchamp, and *Éluard. The title was suggested by André *Masson and the writer Georges *Bataille, who at this time were, in Masson's words, 'concerned with the most mysterious of the Greek and Iranian mythologies'. For the cover of the first issue *Picasso created a collage that had at its centre a drawing of a minotaur holding a sword (1933, MoMA, New York); among the other artists who designed covers for the journal were *Derain, *Ernst, *Magritte, and *Matisse. In keeping with such elevated company, *Minotaure* was notably more luxuriously produced than its predecessors, the illustrations including original prints. The journal was also notable for the photographs of *Man Ray and *Brassaï.

Minton, John (1917-57) British painter, graphic artist, and designer, born at Great Shelford, Cambridgeshire. After studying in London at St John's Wood School of Art, 1936-8, he spent a year in Paris, where he shared a studio with Michael *Ayrton (with whom he later collaborated on designs for John Gielgud's production of *Macbeth* at the Piccadilly Theatre, London, in 1942). Among the artists whose work he saw in Paris, he was particularly influenced by the brooding sadness of *Berman and *Tchelitchew. In 1941-3 he served in the Pioneer Corps, and after being released on medical grounds he had a studio in London at 77 Bedford Gardens (the house in which *Colquhoun, *MacBryde, and Jankel *Adler lived), 1943-6. From 1946 to 1952 he lived with Keith *Vaughan. Minton was a leading exponent of *Neo-Romanticism. Of all the major figures of that movement he came closest to pure pastiche of Samuel Palmer. Minton was also an influential figure through his teaching at Camberwell School of Art (1943-7), the Central School of Arts and Crafts (1947-8), and the *Royal College of Art (1948-56): the *Phaidon Companion to Twentieth-Century Art* (1973) comments that 'His graphic and topographical mannerisms were rife in postwar British art schools'. He was extremely energetic, travelling widely and producing a large body of work as a painter (of portraits, landscapes, and figure compositions), book illustrator, and designer. After about 1950, however, his work went increasingly out of fashion. He made an effort to keep up with the times with subjects such as *The Death of James Dean* (1957, Tate) but stylistically he changed little. Minton was renowned for his charm and generosity, but he was also melancholic and troubled by self-doubt. He committed suicide with an overdose of drugs.

Mir Iskusstva *See* WORLD OF ART.

Mirko (Mirko Basaldella) (1910-69) Italian sculptor, born at Udine, brother of the painter *Afro and of the sculptor Dino Basaldella (1909-77). He trained in Venice, Florence, and Monza, where he was a pupil of Arturo *Martini. In the late 1940s he began to experiment with abstraction and he worked with many different materials in his search for fresh and expressive forms. He had numerous public commissions, his best-known work being bronze gates and balustrades for the Mausoleo delle Fosse Ardeatine, Rome (1949-51), a memorial to the 320 Italians executed by the Germans in 1944 in reprisal for the killing of 32 German soldiers. Their spiny, tormented forms convey 'the horror of modern extermination, perpetuating the moment of anguish rather than dealing in the facile coinage of patriotic condolence' (Fred Licht, *Sculpture: 19th and 20th Centuries*, 1967). Mirko also worked as a painter and in 1951 he did murals and mosaics for the Food and Agriculture Organization Building, Rome. In 1953 he won a second prize in the international competition for the Monument to the Unknown Political Prisoner (*see* BUTLER, REG) and in 1955 he was awarded the grand prize for sculpture at the São Paulo *Bienal. He moved to the USA in 1958 to teach at Harvard University.

Miró, Joan (1893-1983) Spanish painter, sculptor, graphic artist, and designer. The son of a prosperous goldsmith, he was born in Barcelona and studied there at La Lonja Academy of Fine Arts, 1907-10, and after two years working as a clerk, at an art school run in a liberal spirit by the painter Francisco Galí (1880-1965). In 1917 he met *Picabia and in 1918 he had his first one-man show (a failure) at the gallery of the Barcelona dealer José

Dalmau. He first visited Paris in 1919 and from then until 1936 (when the Spanish Civil War began) his regular pattern was to spend the winter in Paris and the summer at his family's farm at Montroig, about 70 miles from Barcelona.

Miró's early work was eclectic, showing the influence of *Fauvism and *Cubism (he made friends with *Picasso), but he started to show an individual vision in a series of paintings which combined a highly detailed accounting of the individual facts of landscape, rocks, earth, and plants, with intense colour (few artists have ever made sunlight scorch so much) and a flattened Cubist space. The summit of his early period was *The Farm* (1921–2, National Gallery of Art, Washington), a painting which was executed in Montroig, Barcelona, and Paris and which was bought in 1925 by the writer Ernest Hemingway.

In Paris Miró became the friend of another struggling young painter, André *Masson. They had adjoining studios in the Rue Blomet. Both were engaged in trying to combine Cubism with a more personal element of the fantastic and, both were drawn to *Surrealism, then being established by André *Breton as the leading avant-garde movement in Paris. The 'First Surrealist Manifesto' of 1924 does not mention Miró—it has little to say about painting—but his work was reproduced in *La Révolution surréaliste* and Breton wrote that he 'could pass for the most "Surrealist" of us all'. Breton's oft-quoted statement has given rise to some misunderstanding. It is easy to assume that some of Miró's early, Surrealist-inclined paintings such as *The Birth of the World* (1925, MoMA, New York) are in a very literal sense automatic works (*see* AUTOMATISM). Actually they are carefully planned with preliminary drawings and are not necessarily any more spontaneous than the tightly painted works of the same period, such as *Harlequin's Carnival* (1924–5, Albright-Knox Art Gallery, Buffalo). This features a bizarre assembly of insect-like creatures dancing and making music—a scene inspired by 'my hallucinations brought on by hunger'. Much of Miró's work has the delightful quality of playfulness seen in this picture, although there is often a sinister side which brings him much closer to the Surrealism of Georges *Bataille. The three *Dutch Interiors* of 1928, which were inspired by 17th-century genre paintings, include disturbing references to the relationship between human and animals. In the final work

of the series, a woman, her foot nailed down, gives birth to a goat. By 1930 much of Miró's work was inspired by the same savage spirit which motivated Louis *Aragon's essay *La Peinture au défi*. Works such as *Head* (1930, Musée de Grenoble) had an almost Dada scorn for technical niceties and were admired by Bataille as evidence of the painter's desire to 'kill painting'. During the Spanish Civil War Miró was inspired to especially savage and sombre imagery, as in the *Still Life with an Old Shoe* (1937, MoMA, New York). Previously one of the less political Surrealists, he designed posters for the Republicans fighting against Franco and made a mural, *The Reaper*, for the Spanish pavilion at the Paris International Exhibition of 1937.

Miró settled in Paris in 1936 because of the Civil War, but in 1940 he returned to Spain to escape the German occupation of France and thereafter lived mainly on the island of Majorca. It was from about this time that he began to achieve international recognition, a milestone in this respect being a large retrospective exhibition devoted to him at the Museum of Modern Art, New York, in 1941. For the rest of his long life he worked with great energy in a wide variety of fields and with an unquenchable thirst for experiment. In 1944 he began making ceramics in collaboration with the potter Josep Llorens Artigas (1892–1980), and slightly later he took up sculpture, initially small-scale terracottas, but eventually large-scale pieces for casting in bronze. He visited the USA for the first time in 1947 and did a large mural for the Terrace Hilton Hotel in Cincinnati. This fulfilled his desire to communicate with a large public, and several of his major works of the 1950s were in a similar vein: a mural for Harvard University in 1950 (now replaced by a ceramic copy; the original is in MoMA, New York) and two vast ceramic wall decorations, *Wall of the Sun* and *Wall of the Moon* (installed 1958), for the UNESCO Building in Paris: 'I'd like to get beyond easel painting, which in my opinion pursues a petty aim, and find ways of getting closer, in terms of painting, to the broad mass of human beings who have always been in my thoughts.' Another aspect of his desire to make his art widely accessible is his productivity as a printmaker (etchings and lithographs). The most remarkable of his late works is the group of three near-monochrome blue paintings (1961, Pompidou Centre) in which he boldly confronted the challenge laid down by the

*Abstract Expressionists. He continued to explore new techniques into his old age, taking up stained-glass design when he was in his eighties.

The Foundation Joan Miró was opened in 1975 on the heights of Montjuic overlooking Barcelona. It is designed both as a memorial museum housing a collection of Miró's works and as a centre of artistic activity.

Further Reading: Centre Pompidou, *Joan Miró 1917– 1934: La naissance du monde* (2004)

Miss, Mary *See* LAND ART.

Mistry, Dhruva (1957–) Indian sculptor, born in Kanjari, Gujurat. He studied at the MS University of Baroda from 1974 to 1981, then from 1981 to 1983 at the *Royal College of Art on a British Council scholarship. Mistry first came to wide attention with sculptures in painted plaster, frequently of hybrid human/animal forms (*Reguarding Guardian 2*, Manchester Art Gallery, 1985). Although these can be related to a specifically Indian cultural heritage, Mistry has also been influenced by the art of ancient Egypt. He has had many public commissions, including sculpture for Victoria Square in Birmingham in 1992. More recently he has made figures in cut-out painted steel (*Reclining Figure*, 2003– 4, Delhi University). He lived and worked in Britain until 1997, when he returned to India to take up the post of head of sculpture and dean of the faculty of fine arts at the MS University of Baroda, resigning in 2002. He was elected to the *Royal Academy in 1991.

Mitchell, Joan (1926–92) American painter, born in Chicago, where she had her main training at the Art Institute of Chicago School, 1944–7. In 1950, after a year in Europe on a scholarship, she moved to New York. She began her career as a figurative painter, but in the early 1950s she met several leading *Abstract Expressionists and became a representative of the second generation of the movement, painting in a free, vigorous, rough-textured style that owes much to *de Kooning in particular. Mitchell said that 'Music, poems, landscapes and dogs make me want to paint' and her work often conveys a feeling of landscape (which was her main subject in her figurative days). From 1955 she lived mainly in France and she died in Paris.

mixed media A term used to describe works of art composed of a variety of different materials. Such works have been made since ancient times, but the term is applied particularly to modern pieces in which a range of unconventional materials is used, thereby making a succinct statement of medium (such as 'oil on canvas') impossible—in other words, exactly where the viewer would appreciate more precise information. Mixed media in this sense was popularized by the *Dadaists and *Surrealists, to whom the use of unconventional materials was an aspect of artistic anarchy and freedom. The terms 'composite media', 'intermedia', and 'multimedia' have sometimes been used more or less synonymously with 'mixed media', but they are more usually applied to works in which different forms of art (rather than different materials) are combined, for example *installations with *Performance art or *Video art. 'Multimedia' is now also used in another sense, referring to the publishing of various types of information—text, pictures, sound—on CD-ROM.

mobile Term coined by Marcel *Duchamp in 1932 to describe the motor- or hand-powered *Kinetic sculptures of Alexander *Calder and soon extended to those he produced where the movement is caused by a combination of air currents and their own structural tension. Typically they consisted of flat metal parts suspended on wires. Jean-Paul *Sartre wrote of Calder's invention: 'A mobile does not suggest anything: it captures genuine living movements and shapes them. Mobiles have no meaning, make you think of nothing but themselves. They are, that is all; they are absolutes. There is more of the unpredictable about them than in any other human creation...In short, although mobiles do not seek to imitate anything...they are nevertheless at once lyrical inventions, technical combinations of an almost mathematical quality and sensitive symbols of Nature.' Many other sculptors (notably Lynn *Chadwick and Kenneth *Martin) have made mobiles, and they have been adopted as articles of interior decoration and (on a miniature scale) as playthings for babies.

Moderna Museet (Modern Art Museum), Stockholm. The Swedish national collection of modern art. It is situated on Skeppsholmen (Ship Island), a former naval base in the centre of the city. In 1954 a large building on the island (an old drill hall, originally 18th century but much altered) was given to the Nationalmuseum to house its modern works,

and this opened as the Moderna Museet in 1958. The first director was the painter Otte Sköld (1894–1958), who was also head of the Nationalmuseum. He died soon after the opening and was succeeded by Pontus *Hulten, who was director until 1974. Hulten quickly established the Moderna Museet as one of the world's leading institutions in its field, with an outstanding permanent collection and a vigorous exhibition programme. In 1966, for example, the museum was the site for Niki de *Saint Phalle's creation of her huge sculpture *Hon*, considered a pioneering work of *Environment art and *installation art, and in 1968 a reconstruction of *Tatlin's model for the *Monument to the Third International* was made for an exhibition devoted to him (*Hon* no longer exists, but the Tatlin model remains in the museum's collection). In line with the politics of Sweden at this time, the Moderna Museet expressed social democratic ideals and aimed to appeal to a broad audience, including children, for whom education programmes and workshops were devised.

The museum has a particularly strong tradition in contemporary art, but its collections and exhibitions cover the whole field of modernism (it also covers photography; the Fotografiska Museet was amalgamated into the Moderna Museet in 1974). In 1994 it moved to temporary accommodation in an old tram depot on the Birger Jarlsgatan in the north of the city whilst a new museum (designed by the Spanish architect Rafael Moneo) was built adjacent to the original (now converted into an architecture museum). The new Moderna Museet building opened in 1998. It is more than four times the size of the original building, giving it space to sustain varied programmes for temporary exhibitions, film, and video, as well as show substantial parts of the permanent collection. The director at this time was the first non-Swede to run the Moderna Museet, David Elliott (formerly director of the Museum of Modern Art, Oxford; *see* MODERN ART OXFORD), who held the post from 1996 and 2001.

modern art An imprecise term that can be used purely chronologically to designate any art produced in present and recent times, but which is usually applied more specifically to art that is consciously in tune with the progressive attitudes and beliefs of those times—the 'spirit of the age'. The terms *avant-garde and *'modernist art' are also sometimes used

to distinguish art which has specifically 'modern' features from more traditional forms.

A number of features or issues might be held to distinguish 'modern art', not all of which could be deduced from visual examination of the art alone and which are in some cases mutually contradictory: (i) a relative devaluation of tradition and traditional skills; (ii) an attempt by artists to 'be of their own time' or 'of the future'; (iii) a departure from 'common sense' consensus about reality and appearance; (iv) an affirmation of the autonomy and independence of art and the art object; (v) an ambition to make common cause with advanced developments in design and architecture; (vi) a declaration of independence from the Academy and the State in favour of the open market; (vii) an extreme artistic individualism; (viii) a need to form groupings with like-minded artists in opposition to critical or public hostility.

There is no general agreement on when modern art can be regarded as starting. As with *contemporary art, the question is complicated by the fact that the point from which we view the issue is constantly moving forward in time, so that the term 'modern' can be considered relatively rather than absolutely (the first citation of the phrase 'modern art' in *The Oxford English Dictionary* is from *The Art Journal* in 1849). From today's standpoint, however, the beginnings of modern art are usually placed at some point within the period from the mid-19th century (Courbet and Manet) to the period from 1905 up to the outbreak of the First World War in 1914. This decade saw the birth of a number of radical 'isms', notably *Cubism, *Expressionism, and *Fauvism. Depending upon one's point of view, these either distorted natural appearances beyond anything that had been seen in the 19th century or signalled the collapse of a consensus as to what constituted the objective imitation of the world.

This is, in fact, the dividing point which museums have frequently found the most appropriate. *Tate Modern's displays begin about 1900 and both of the major Paris collections, the *Pompidou Centre and the *Musée d'Art Moderne de la Ville de Paris, begin with Fauvism. This choice of dividing line has been surprisingly robust. Tate has adopted it since handing over most of its *Impressionists to the National Gallery in the 1960s. The Musée National d'Art Moderne, which preceded the Pompidou Centre, closing its doors in the

mid-1970s, started its displays a little earlier, with *Signac and the *Neo-Impressionists. The *Museum of Modern Art, New York, starts its collection a little earlier still, in the late 1880s, reflecting the first ever exhibition there of Cézanne, van Gogh, Gauguin, and Seurat, but also a *formalist view that modern art is defined by its departures from visual experience. About 1915 there was born another radical movement, *Dada, that went beyond stylistic innovation and began questioning the nature and validity of art. This type of questioning has become one of the keynotes of *avant-garde art. Many critics therefore see the ten-year span from 1905 (the debut of Fauvism) to 1915 (the first stirrings of Dada) as the period in which the foundations of modern art—as the term is now understood—were laid.

It is now common to make a distinction between 'modern' and *'contemporary' art, the latter beginning at any time between 1945 and about 1970.

Modern Art Oxford Institution founded in Oxford in 1966 by a group of art lovers under the chairmanship of Trevor Green, an architect. Initially they hoped to create a museum with a permanent collection of post-1945 art, but this proved financially unfeasible, so they decided instead to establish a home for a programme of changing exhibitions. The original premises were in King Edward Street, and in 1970 the museum moved to its present home—part of a 19th-century storehouse in Pembroke Street that was formerly used as a brewery. A large extension was completed in 1981 and named as the John *Piper Gallery. The museum mounts a wide range of exhibitions (which often tour in Britain and abroad) and also hosts lectures and seminars. Many of the exhibitions have dealt with art that is generally little known in Britain, particularly from eastern European countries, and their catalogues have made significant contributions to scholarship. The museum has built up a research library and archive based on its activities, and has a particularly important *Rodchenko collection, assembled for an exhibition of his work in 1979 (much of the material was donated by the artist's family in Moscow). The impressive contributions to Russian studies reflect the fact that the director of the museum for much of its history, David Elliott (1949–), is a noted scholar of Russian art. He succeeded Nicholas *Serota as director in 1976 and left to become director of the

*Moderna Museet, Stockholm, in 1996. Subsequent directors have been Kerry Brougher, appointed in 1996, and Andrew Nairne, 2001–8. Until 2002 the institution was known as the Museum of Modern Art, an appellation which had given rise to some criticism on the grounds that there was no permanent collection. The core funding comes from Oxford City Council and *Arts Council England.

(⊕) SEE WEB LINKS
• The official history of the organization.

Moderne Kunstkring (Dutch: 'Modern Art Circle') A society of Dutch artists founded in 1910 by the painter and critic Conrad Kikkert (1882–1965) with the aim of bringing modern developments from Paris (where Kikkert had recently settled) to the Netherlands. It held its first exhibition in 1911 at the *Stedelijk Museum in Amsterdam, the artists represented including *Braque, *Cézanne (with no fewer than twenty-eight works), and *Picasso. *Mondrian, who also exhibited, was so impressed by what he saw (including the first *Cubist pictures publicly exhibited in the Netherlands) that he moved to Paris soon afterwards. The society held comparably impressive exhibitions in 1912 and 1913 (the latter including more than a dozen works each by *Kandinsky and *Marc), but its activities were ended by the First World War.

modernism The common ideology, in so far as one can be said to exist, which underwrites all the varying manifestations of *modern art. Its exact features have been the subject of intense debate and dispute. Charles Harrison and Paul Wood (*Art in Theory 1900–2000*, 2002) write that 'Modernism stands on the one hand for a cluster of notionally independent values associated with the practice of modern art and on the other for a particular form of critical *representation* of the modern in art—a representation in which the pursuit of art's moral independence is taken to be decisive.'

The 'cluster of values' to which Harrison and Wood refer are largely concerned with ideas of change and progress, and historians and critics have devoted a good deal of time to discussing where to locate the changes of attitude, style, and technique that brought about an outlook that can be called modernist. Arnold Hauser (1892–1978), a Hungarian-born British-naturalized art historian, placed the origins of the 'modern temper in art' as early

as the 16th century. In his book *Mannerism: The Crisis of the Renaissance and the Origin of Modern Art* (2 vols, 1965), Hauser defined 'modern' art in terms of self-consciousness and anxiety, and in accordance with his Marxist views he related this to a crisis resulting from the beginnings of modern capitalism. It is more usual, however, to locate the origins of modernism in the Paris of the mid-19th century, and the idea that art must change because the experience of life itself changes is often specifically traced to the poet and critic Charles Baudelaire (1821–67). Baudelaire believed that 'absolute and eternal beauty does not exist' and promoted the idea of an art that portrays modern life; he was a friend of Edouard Manet, whose pictures are often regarded as central works in the tradition of modernism because they marked the beginning of a trend for avant-garde painting to become increasingly preoccupied with the visual and material facts of the medium for their own sake. Mid-19th-century Paris also witnessed a decisive breaking of the monopoly of state-sponsored exhibitions, and such affirmation of the artist's liberty and individuality has been seen as an important strand in modernism. This 'freedom', however, is dependent on a shift from the patronage of state institutions to that of a private art market based on the promotion of a relatively small number of 'stars', so the much-prized individuality is as rooted in economic factors as was academic conformity.

The 'particular form of critical *representation*' mentioned by Harrison and Wood is associated above all with Clement *Greenberg; indeed they say his name is 'virtually synonymous with Modernist criticism'. Greenberg saw modernism as a continuous, self-critical tradition concerned with 'purely optical experience', beginning with Manet and virtually ignoring any art produced outside Paris and New York. He wrote that 'Modernism has never meant anything like a break with the past . . . Modernist art develops out of the past without gap or break.' The modern work that did not fit into his critical scheme—for example *Kinetic art and *Pop art—he dismissed as 'novelty art'. An alternative view is to emphasize the importance of modernist art that breaks with tradition, especially where this breach is associated with challenges to the political order, as in *Dada. For those who accept Greenberg's formulation, it is possible to regard modernism as having come to an

end with *Conceptual art and the shift of debate from abstraction versus figuration to the very validity of the art object itself. *Postmodernism has been both celebrated and attacked as representing a pluralist alternative to modernism's single line of development.

Modernismus A term adopted into English from German by the architect and writer Sir Reginald Blomfield (1856–1942) as a synonym for *modernism or more specifically to characterize what he regarded as the unacceptable face of modernism—'a revolt against the past . . . in blind ignorance of the accumulated experience of man'. Blomfield used the term as the title of a book, *Modernismus* (1934), in which he wrote that 'Since the war, Modernism, or "Modernismus", as it should be called on the German precedent, has invaded this country like an epidemic'.

Modernist Painting See GREENBERG, CLEMENT.

Modern Movement A term that in the 20th century was sometimes used more or less as a synonym for *modern art or for *modernism, but which is generally used to refer primarily to architecture and design rather than to painting and sculpture. R. H *Wilenski's book *The Modern Movement in Art* (1927) is about painting and sculpture; Nikolaus Pevsner's *Pioneers of the Modern Movement* (1936) is mainly about architecture and design (although it has a chapter on painting) and was retitled *Pioneers of Modern Design* for its third edition in 1960; Kurt Rowland's *A History of the Modern Movement* (1973) is, as the subtitle states, about 'Art, Architecture, Design'. In architecture the term is particularly equated with the style known as 'International Modern' (or 'International Style'). Characterized by rationality and clarity of design, clean lines, generally cubic shapes, and a conscious renunciation of all historical references, this style was dominant among progressive architects in the period between the two world wars. Leading exponents included *Gropius, *Le Corbusier, and Mies van der Rohe (see BAUHAUS), and the style also influenced certain aspects of the work of Frank Lloyd Wright (1867–1959), the most illustrious American architect of his time. These four are generally regarded as the greatest architects of the 20th century, which is an indication of the central importance of the International Modern Style. It continued to flourish after the Second World

War, but its dominance was challenged in the 1950s by a rougher and more expressive style called Brutalism and in the 1960s and 1970s by the eclecticism of *Postmodernism and the 'structural exhibitionism' of High Tech (*see* POMPIDOU CENTRE).

Modern Painters A quarterly art journal founded in London by the critic Peter *Fuller in 1988; the title is a reference to a work by the Victorian writer John Ruskin, and the journal aimed to stir appreciation of British artists who maintained traditional skills in drawing and painting—Lucian *Freud and Graham *Sutherland for example. At the same time, it launched an assault on various institutions and organizations (including 'most of the existing art magazines') for promoting 'a tacky preference for the novel and the fashionable'—*Gilbert & George and Julian *Schnabel were among the stars of the avant-garde who were attacked in the first issue. After Fuller's death in 1990 the journal became less doctrinaire and has become the closest contemporary equivalent to the now defunct *Studio International.* Among its well-known contributors are Brian *Sewell; Sister Wendy Beckett (1930–), a nun who presents television programmes on art and tends to be loved by the public and derided by the critics; and the rock singer David Bowie (1947–), who is also an actor (he appeared as Andy *Warhol in Julian Schnabel's film *Basquiat*), painter, sculptor, collector of contemporary art, and publisher of art books through his company 21 ('It's called 21 for the 21st century', he says). His first contribution to *Modern Painters* was a long interview with *Balthus, published in 1994; the first book published by his company was Matthew Collings's *Blimey! From Bohemia to Britpop: The London Artworld from Francis Bacon to Damien Hirst* (1997).

Modersohn-Becker, Paula (1876–1907) German painter, born Paula Becker into a cultured middle-class family in Dresden. From an early age it was her ambition to be an artist, but her family persuaded her to qualify as a teacher before they supported her artistic career. Her training in art included lessons in London (where she stayed with relatives in 1892), Bremen (where she did her teacher training, 1893–5), and Berlin (at the School of Art for Women, 1896–8). In 1898 she joined the artists' colony at Worpswede, and in 1901 she married Otto Modersohn

(1865–1943), another member of the group. Her early work—mainly landscapes and scenes of peasant life—was in the lyrical, rather sentimental manner associated with Worpswede at this time, but in a career that lasted less than a decade she developed a massively powerful style through which she expressed a highly personal vision of the world. This development was influenced by four visits she made to Paris between 1900 and her early death in 1907. The work of *Gauguin and van Gogh in particular helped her to find the 'great simplicity of form' for which she had been searching, and in her mature work she concentrated on single figures, including self-portraits and portraits of peasants. She also did some impressive still-lifes. In her self-portraits she typically shows herself with wide, staring eyes and often in the nude. Although she had a weak physical constitution, she worked with great discipline and perseverance, producing several hundred paintings in her short career, as well as many drawings and a few etchings. She died of a heart attack three weeks after giving birth to her first child. She was little known at the time of her death, but is now regarded as one of the outstanding German artists of her time. Her symbolic use of colour and pattern, her subjective outlook (she wrote that 'the principal thing is my personal feeling') and the almost primitive force of some of her work give her a place among the most important precursors of *Expressionism.

Further Reading: G. Perry, *Paula Modersohn-Becker: Her Life and Work* (1979)

Modigliani, Amedeo (1884–1920) Italian painter, sculptor, and draughtsman, active in France from 1906, one of the legendary figures of modern art. He was born in Leghorn (Livorno) into a Jewish merchant family. Serious childhood illness (pleurisy and typhus) prevented him from following a normal education, but in 1898 he began studying with a local landscape painter; after a brief stay in Florence in 1902, he moved to Venice, where he continued his studies at the Institute of Fine Arts. He stayed in Venice until 1906, when he settled in Paris; apart from visits to his family in Italy and a year spent in Nice and Cagnes, 1918–19, this was his home for the rest of his life, and he became a familiar figure in the café and night life of Montmartre.

Although virtually his whole career was spent in France, Modigliani laid the foundations

of his style in Italy with his studies of the Renaissance masters. In particular, he is often seen as a spiritual heir of Botticelli because of the linear grace of his work. His early paintings in Paris show numerous other influences, including *Gauguin, the *Fauves, and then *Cézanne (like many other artists, Modigliani was enormously impressed by his memorial exhibition at the *Salon d'Automne in 1907 and he learnt a great deal from him about simple dignity of composition and subtle handling of colour harmonies). In 1909, however, he met *Brancusi and under his influence devoted himself mainly to stone carving until 1915, when the war made it impossible for him to get materials (his delicate health in any case made sculpture increasingly difficult, especially as the stone dust aggravated his illness). He therefore returned to painting, and his finest and most characteristic works were produced in the last five years of his short life. Both as a sculptor and as a painter his range was limited. Almost all of his two dozen or so surviving sculptures are heads and the great majority of his paintings are portraits or female nudes. His portraits include many of his artist friends, such as *Juan Gris* (1915, Metropolitan Museum, New York) and *Jacques Lipchitz* (1916, Art Institute, Chicago). Common to virtually all his work are extremely elongated, simplified forms and a superb sense of rhythmic vitality, but there is a great difference in mood between, for example, his sculpted heads (*Head*, c.1911–12, Tate) which have the primitive power of the African masks that inspired them, and his gloriously sensual nudes (*Reclining Nude*, c.1919, MoMA, New York), which were censured for their open eroticism (the only solo show he held in his lifetime, at the Galerie Berthe Weill, Paris, in 1917 was closed by the police because of the 'filth' on display).

Modigliani's early death from tuberculosis was hastened by his notoriously dissolute lifestyle, and his mistress Jeanne Hébuterne, pregnant with their second child, committed suicide two days after he died. He had exhibited little during his lifetime, although from 1916 the Polish-born dealer Léopold Zborowski (1889–1932) supported him with regular payments. His posthumous fame was established by an exhibition at the Galerie *Bernheim-Jeune, Paris, in 1922 and a biography by André *Salmon in 1926—*Modigliani, sa vie et son oeuvre*. His position as one of the outstandingly original artists of his time is now se-

cure, but his fame rests even more on his reputation as a bohemian artist *par excellence*: in the popular imagination he is the archetypal romantic genius, starving in a garret, addicted to drugs and alcohol, an inveterate womanizer, but painting and carving obsessively.

Further Reading: E. Braun et al., *Modigliani and his Models* (2006)

C. Mann, *Modigliani* (1980)

Modotti, Tina (1896–1942) Italian–American photographer, actress, and secret agent. She was born Assunta Adelaide Luigia Modotti in Udine to a working-class family with strong socialist beliefs. She went to the United States in 1913 to join her father, who had already gone some years earlier, moving to San Francisco. While working as an actress in the silent cinema, she met the photographer Edward *Weston, with whom she had an affair. In 1923 she went with Weston to Mexico City. She modelled for Weston and looked after his house. In exchange, he taught her photographic skills. Weston moved back to California in 1926 while Modotti remained in Mexico and continued her independent career as a photographer. In 1927 she joined the Mexican Communist Party and much of her work was closely tied to her political activities. One famous image is a still-life in which a sickle and a bandolier are laid across a guitar, suggesting a link between Communism and Mexican national identity. She photographed the hardship of the lives of women, as well as men at political meetings. For all the visual rhetoric of her work, she held that the importance of photography was that it was 'the most satisfactory medium for registering objective life in all its aspects'. In 1930 she was forced to leave Mexico as a result of having been accused of complicity in the attempted murder of the president. After being refused entry into the United States, she moved to Berlin, but her photographic practice there was not a success. She was persuaded by her lover, Vittorio Vidali, to join him in the Soviet Union, from where she undertook clandestine missions in support of political prisoners. It was in this capacity that the couple were sent to Spain, where she worked under a pseudonym in a tuberculosis hospital for Republicans during the Civil War. After the victory of Franco she was allowed to return to Mexico. She died in Mexico City in the back of a taxi and the publication of the autopsy has not dispelled

rumours about suspicious circumstances. The puzzles around her did not cease with her death. The New York Museum of Modern Art acquired its Modotti prints when a mysterious unidentified young man deposited them on the desk in a brown paper parcel. The event took place in the early 1950s at the time when Modotti's fervent Communism would have been most problematic. Attempts have been made by optimistic historians to 'discover' photographs by Modotti from after 1931, when she supposedly renounced photography for political activity. These have turned out either to have been taken by Modotti herself earlier or to be by a completely different photographer.

Further Reading: L. Mulvey and P. Wollen, 'Frida Kahlo and Tina Modotti', in Frascina and Harris (1992)

A. Noble, *Tina Modotti: Image, Texture, Photography* (2000)

Moffat, Sandy See GLASGOW SCHOOL.

Moholy-Nagy, László (1895–1946) Hungarian-born painter, sculptor, designer, photographer, experimental artist, and writer who became an American citizen in 1944. He was born in Borsod (now Bácsborsod) and studied law at Budapest University before serving in the Austro-Hungarian army in the First World War. He took up art in 1917 whilst recovering from a wound and was completely self-taught in his wide range of skills. By temperament he was an engineer and his approach to art was methodical and rational; he even gave his works pseudo-scientific titles consisting of combinations of letters and numbers, such as *K VII* (1922, Tate), the 'K' standing for 'Konstruction'. In 1919 he moved to Vienna and then in 1920 to Berlin, where he painted abstract pictures influenced by *Lissitzky (himself recently arrived from Russia). He also experimented with *collage, photograms (*see* SCHAD), and *photomontage, and in 1922 had his first one-man exhibition at the *Sturm Gallery. From 1923 to 1928 he taught at the *Bauhaus, taking over from *Itten the running of the preliminary course. Frank *Whitford (*Bauhaus*, 1984) emphasizes the difference in approach between these two highly distinctive characters: 'Even Moholy's appearance proclaimed his artistic sympathies. Itten had worn something like a monk's habit and had kept his head immaculately shaved with the intention of creating an aura of spirituality and communion with the transcendental. Moholy

sported the kind of overall worn by workers in modern industry. His nickel-rimmed spectacles contributed further to an image of sobriety and calculation belonging to a man mistrustful of the emotions, more at ease among machines than human beings.'

As well as directing the preliminary course, Moholy was co-editor, with *Gropius, of the Bauhaus publications. The substance of his teaching was summed up in his book *Von Material zu Architektur* (1929), translated as *The New Vision, from Material to Architecture* (New York, 1932). Although he was regarded as a brilliant teacher, his assertiveness and rejection of a spiritual dimension in art made him unpopular with some of his colleagues. He resigned when Hannes Meyer replaced Gropius as director in 1928, then worked for some years in Berlin, chiefly on stage design and experimental film. In 1934 he left Germany because of the Nazis, moving to Amsterdam and then in 1935 to London, where he worked on designs, unused in the final film, for the science fiction movie *Things to Come* (1936), produced by his fellow-Hungarian Alexander Korda, and contributed to the *Constructivist review *Circle* (1937). In 1937 he emigrated to Chicago, where he became director of the short-lived New Bauhaus (1937–38), then founded his own School of Design (1939; it changed its name to the Institute of Design in 1944), directing it until his death.

Moholy was one of the most inventive and versatile of Constructivist artists, pioneering especially in his use of light, movement (*see* KINETIC ART), photography, and plastic materials, and he was one of the most influential teachers of the 20th century. He was an emphatic advocate of the Constructivist doctrine that so-called fine art must be integrated with society as a whole. His views were most fully expressed in his posthumously published book *Vision in Motion* (1947), but even at the outset of his career his utilitarian outlook had been clear: 'My conscience asks unceasingly: is it right to become a painter at a time of social upheaval?', he wrote in his diary in 1919. 'During the last hundred years art and life have had nothing in common. The personal indulgence of creating art has contributed nothing to the happiness of the masses.'

His wife, the Czech-born **Lucia Moholy**, née Schulz (1894–1989), was a photographer and writer on photography. The couple married in 1921 and divorced in 1934. In that year Lucia settled in England and she became a British

citizen in 1947. She is perhaps best-known for her book *A Hundred Years of Photography: 1839-1939* (1939), commissioned by the recently founded Penguin Books. This was the first general history of photography to be published in English and was an enormous success, selling 40,000 copies in two years.

Further Reading: K. Passuth, *Moholy-Nagy* (1985)

Moilliet, Louis (1880-1962) Swiss painter and designer of stained glass. He was born in Berne, where he was a schoolfriend of Paul *Klee, and studied in Worpswede (*see* MODER-SOHN-BECKER), Weimar, and Stuttgart. In 1911 he introduced Klee to the *Blaue Reiter circle, and in 1914 he visited Tunisia with Klee and *Macke. He spent the First World War in Switzerland, after which he travelled extensively, especially in the Mediterranean. As a painter, he worked mainly in watercolour in a style influenced by *Orphism. The same feeling for colour comes out in the stained-glass windows he designed for Swiss churches, notably the Lucaskirche at Lucerne (1934-6) and the Zwinglikirche at Winterthur (1943-4). His work is well represented in Swiss museums.

Moira, Gerald *See* ROYAL COLLEGE OF ART.

Molinari, Guido (1933-2004) Canadian painter, sculptor, and writer, one of his country's leading abstract artists. He was born in Montreal, where he studied at the École des Beaux-Arts, 1948-51, and the Musée des Beaux-Arts, 1951. From the beginning of his career Molinari was devoted to abstract art with rigorous seriousness and from 1955 to 1957, while still in his early 20s, he ran Galerie l'Actuelle, a small avant-garde showplace in Montreal for non-figurative art. In his very early work he experimented with *automatism, but by 1956 (when he held a one-man show at his own gallery) his paintings consisted of simple arrangements of black straight-edged forms on white (*Black Angle*, NG of Canada, Ottawa 1956). Such works were influenced by the formal purity of Les *Plasticiens, but Dennis Reid (*A Concise History of Canadian Painting*, 1973) writes that they are 'much more economical and finally more emotionally satisfying than anything the Plasticiens were ever able to achieve'. In the early 1960s Molinari began using vertical bands of colour and from 1963 he made the bands of equal width. This 'stripe' format brought his work within the orbit of *Op art and he was

represented at the exhibition that more than any other established the movement—'The Responsive Eye' at the Museum of Modern Art, New York, in 1965. After this Molinari began to make paintings based on geometric division of the canvas, for example into chequer-board patterns. He also made sculpture and wrote on art, including articles in the magazine *Situations*, which he helped to found in 1959. A collection of his writings, *Écrits sur l'art (1954-1975)*, was published in Ottawa in 1976. In the same year the National Gallery of Canada organized a major retrospective that was shown in Ottawa, Montreal, Toronto, and Vancouver. Some of his later paintings are virtually monochromatic.

Molvig, Jon (1923-70) Australian painter. He was born in Newcastle, New South Wales, the son of a Norwegian immigrant steel worker, and after army service in the Second World War he studied at East Sydney Technical College. From 1949 to 1953 he lived in Europe, then settled in Brisbane. In the 1950s his style was predominantly *Expressionist, marked by brilliant but often subtle colouring (he is widely regarded as one of the finest colourists in Australian art). His subjects included portraits, figure compositions, and landscapes. In 1961 his style changed abruptly, as he turned to semi-abstraction with totemic imagery; he abandoned oils for synthetic resins, burning them with a blowtorch to produce a heavy, pitted surface.

Mondrian, Piet (Pieter Mondriaan) (1872-1944) Dutch painter, one of the most important figures in the development of *abstract art. He was born in Amersfoort, near Utrecht; his father (a strict Calvinist schoolteacher, described by a friend of Mondrian as 'sententious, forbidding, and frankly disagreeable') was an amateur artist and his uncle was a professional painter. Between 1892 and 1897 he studied intermittently at the Amsterdam Academy and his initial progress was slow (he was unsure of his vocation and for a time considered becoming a minister of religion). His early paintings were naturalistic and direct, often delicate in colour, though greys and dark greens predominated (*Mill by the Water*, c.1905, MoMA, New York). Between 1907 and 1910 his work took on a *Symbolist character, partly under the influence of Jan *Toorop and partly perhaps because of his conversion to theosophy (he joined the Dutch Theosophical

Society in 1909), and he also experimented with a kind of loose *Neo-Impressionist technique, using large blobs (rather than small dots) of pure colour (*Church at Zoutelande*, 1910, Tate). At the beginning of 1912 he moved to Paris, where he initially lived in the studio of his countryman Conrad Kikkert (*see* MODERNE KUNSTKRING). He divided his time between Paris and the Netherlands until the outbreak of the First World War in 1914 made it impossible to continue working in France. In this period he was strongly influenced by *Cubism, painting a series of pictures on the theme of a tree in which the image became progressively more fragmented and abstract (*Flowering Apple Tree*, 1912, Gemeente Museum, The Hague). By 1914 he had virtually eliminated curved lines from his work, using a structure that was predominantly horizontal and vertical, with the merest suggestion of natural forms underlying the patterning.

During the First World War Mondrian worked mainly at Laren, near Amsterdam. This was a place much favoured by intellectuals and provided a sympathetic climate in which to develop his ideas about abstract art. In 1915 he met Theo van *Doesburg, and two years later he joined him in founding the association De *Stijl; it promoted a new kind of rigorously geometrical abstract painting of which Mondrian became the main exponent. In this style, which he named *Neo-Plasticism, he limited himself to straight lines and basic colours to create an art of great clarity and discipline that he thought reflected the laws of the universe, revealing immutable realities behind the ever-changing appearances of the world. Typically he used a bold grid of black lines (all completely straight and either strictly horizontal or strictly vertical) to form an asymmetrical network of rectangles of various sizes that were painted with a narrow range of colours (the three primaries—blue, red, and yellow—plus black, white, and initially grey, although this was later dropped). At first his work was very similar to van Doesburg's, but by about 1920 the two men had begun to develop separately (*see* ELEMENTARISM). Mondrian gradually refined his methods until by about 1925 he used his simple repertoire to achieve a sense of taut balance and poise that none of his imitators could match. A good example is *Composition in Yellow and Blue* (1929, Boymans–van Beuningen Museum, Rotterdam), of which George Heard *Hamilton writes: 'Five lines of slightly varying thickness intersect to create six rectangles, all of different sizes, four

white, one yellow, and one blue. The means could scarcely be "purer", nor the result more "complete". There is no conventional balance or symmetry, but the elements of line, shape, and colour are disposed on the flat surface so that each is held in subtle but inescapable relation to every other ... His compositions ... have no centre, no focus, and their tensions are so distributed across the entire surface that each square inch is essential to the whole.'

From 1919 to 1938 Mondrian lived in Paris, where in 1931 he joined the *Abstraction-Création group. For many years he had struggled to earn a living (sometimes producing watercolours of flowers to make ends meet), but in the 1920s he gradually became known to an international circle of admirers, his patrons including the American Katherine *Dreier (from 1926). A retrospective exhibition of his work was organized at the Stedelijk Museum, Amsterdam, in 1922 to mark his 50th birthday, an indication of the esteem he enjoyed among the avant-garde in his own country. In 1938 he left Paris because of the threat of war and for the next two years lived in London, near Naum *Gabo and Ben *Nicholson (who had encouraged him to move). After the house next door to his studio was hit by a bomb, he moved to New York in 1940 and spent his remaining years there, adapting well to his new home even though he was now almost 70. In America he developed a more colourful style (he dispensed with the black grid), using syncopated rhythms that reflect his interest in jazz and dancing (*Broadway Boogie-Woogie*, 1942–3, MoMA, New York,); he was noted for his immaculate tidiness and rather ascetic, priestly air (Ben Nicholson compared his studio to a hermit's cave), but he had a passion for social dancing and took lessons in fashionable steps. John Milner writes: 'Even in middle age, when he was already enjoying some celebrity, his studio was stark and denuded of all but the most necessary comforts. His only indulgence was a gramophone. Some of his furniture was constructed from wooden boxes ... He had no wife, no children, to enrich and complicate the simplicity of his daily life, to impose upon him or to upset the stillness of the studio where he lived and found the real measure of his world ... He rarely smiled for photographs, appearing reserved, austere, preoccupied and a little awkward in company ... [but] he was welcoming and helpful to visitors.'

Mondrian's influence was not limited to painting. The visual similarity of his work to much industrial, decorative, and advertising art, and especially architecture, from the 1930s onwards makes it easy to overestimate his significance in this respect. For instance, in 1967 Ian Dunlop wrote: 'It is no exaggeration to say that his effect on the look and style of contemporary life has been greater than that of any modern artist, even of such supreme masters as *Matisse and *Picasso.' A more accurate way of putting this might be that no other of the great early 20th-century painters, not even *Léger, had a style more attuned to the social and technological developments which were shaping material culture. Apart from numerous articles in the periodical *De Stijl*, Mondrian wrote the book *Néo-plasticisme* (Paris, 1920), which was published by the *Bauhaus in German translation as *Neue Gestaltung* (1924), and the essay 'Plastic Art and Pure Plastic Art', published in *Circle* (1937). *Piet Mondrian: Plastic Art and Pure Plastic Art, 1937, and Other Essays, 1941–43*, was published in New York in 1945; *The New Art—The New Life: The Collected Writings of Piet Mondrian* in London in 1987.

Further Reading: J. Milner, *Piet Mondrian* (1992)

Monet, Claude (1840–1926) French *Impressionist painter. He is regarded as the archetypal Impressionist in that his devotion to the ideals of the movement was unwavering throughout his long career, and it is fitting that one of his pictures—*Impression: Sunrise* (1872, Musée Marmottan, Paris)—gave the movement its name. Early in his career he often endured great poverty, but he began to prosper in the 1880s and by 1890 was successful enough to buy the house at Giverny (about 40 miles from Paris) where he had lived since 1883. From 1890 he concentrated on series of pictures in which he painted the same subject at different times of the day and in different lights—*Haystacks* or *Grainstacks* (1890–91) and *Rouen Cathedral* (1891–5) are the best known, but he also did many pictures of the Thames, for example, during three visits to London between 1899 and 1904 (he stayed at the Savoy Hotel, from which he had a good view of the river). In 1904 he exhibited thirty-seven views of the Thames at *Durand-Ruel's gallery in Paris, including eighteen of Waterloo Bridge. In addition to his trips to London, Monet visited Venice several times during his later years and in 1895 he painted in Norway,

with his beard 'covered in icicles'. However, his attention was focused increasingly on the celebrated water-garden that he created at Giverny, which served as the theme for his series of paintings on *Waterlilies* (*Nymphéas*) that began in 1899 and grew to dominate his work completely (in 1914–16 he had a special studio built in the grounds of his house so he could work on the huge canvases). In his final years he was troubled by failing eyesight (he had a cataract operation in 1923), but he painted until the end, completing a great decorative scheme of waterlily paintings that he donated to the nation in 1926, the year of his death. They were installed in the Orangerie, Paris, in 1927.

Apart from the relatively minor figure of Armand Guillaumin (1841–1927), who died the year after him, Monet was the last survivor of the group who had exhibited in the first Impressionist exhibition in 1874, and in his later years he was the Grand Old Man of French painting, the friend of the Prime Minister Georges Clemenceau and other notables. As a central figure of Impressionism, he exerted a huge influence on late 19th-century art, and it is sometimes claimed that the almost abstract forms of his final waterlily paintings influenced later art. Certainly there is a resemblance between Monet's late works and some forms of abstraction, which has long been noted: *Kandinsky seems to have been aware of the abstract suggestions of Monet's work as early as 1895, and in 1937 Meyer *Schapiro referred to 'the Water Lilies, with their remarkable spatial forms, related in some way to contemporary abstract art', but he was not specific about which contemporary art he had in mind. In the 1960s the revaluation of Monet's late work coincided with the emphasis on pure colour in the work of painters such as Morris *Louis and Kenneth *Noland. *See also* ABSTRACT IMPRESSIONISM.

Further Reading: P. H. Tucker (ed.), *Monet in the 20th Century* (1998)

Monnington, Sir Thomas *See* ROYAL ACADEMY OF ARTS.

Mono-ha *See* CONCEPTUAL ART.

Monory, Jacques *See* POP ART.

Monosiet, Pierre *See* NAIVE ART.

montage (French: 'mounting') A pictorial technique in which a number of cut-out illustrations, or fragments of them, are arranged

together and mounted on a suitable background; the term also refers to the picture so created. Ready-made images alone are used and they are generally chosen for their subject and message; in both these respects montage can be distinguished from *collage, in which materials of varied kinds can be used, often primarily with an interest in their decorative qualities. Montage is now associated particularly with advertising, but it has also been used by artists. *Photomontage is montage using photographic images only. In cinematic usage, the term 'montage' refers to the assembling of separate pieces of film into a sequence or superimposed image.

Moon, Jeremy (1934–73) British painter and sculptor, born in Altrincham, Cheshire. He read law at Christ's College, Cambridge, 1954–7, then briefly studied at the Central School of Art and Design, London, but he was mainly self-taught as an artist. Originally he worked as a sculptor (he was a friend of Phillip *King, a fellow student at Cambridge) and he won a prize for sculpture at the 1962 *'Young Contemporaries' exhibition. From 1963, however, he concentrated on painting and taught the subject part-time at Chelsea School of Art. In his short career he gained a reputation as one of the leading British exponents of *Hard-Edge abstraction; often he worked on *shaped canvases. He was killed in a motorcycle accident. Norbert Lynton said of his work: 'Clarity does not mean coldness: it means the pursuit of an idea with passion.'

Further Reading: Arts Council of Great Britain, *Jeremy Moon: Paintings & Drawings 1962–73* (1976)

Moore, George (1852–1933) Anglo-Irish writer and painter, born in County Mayo. In 1873 he went to Paris intending to become a painter (he studied at the *Académie Julian), but he realized that his talent lay in writing and eventually won fame as a novelist, notably with *Esther Waters* (1894). He remained in Paris for most of the 1870s and often returned afterwards. From 1880 to 1901 he divided his time mainly between London and Ireland, from 1901 to 1911 he lived in Dublin (where he was a leading figure of the Irish cultural renaissance), and then settled in London for the rest of his life. In Paris he was friendly with many of the leading French painters of the day (in 1911 he wrote 'I am the only one in Dublin who knew Manet, *Monet, Sisley, *Renoir and

*Pissarro'), and he was one of the first writers to introduce *Impressionism to the English-speaking world (for example, his essay '*Degas—The Painter of Modern Life', published in *The Magazine of Art* in September 1890, was the first article in English on this artist). He was art critic to *The Speaker* from 1891 to 1895 and also wrote for other journals; many of his articles were collected in his books *Impressions and Opinions* (1891) and *Modern Painting* (1893). His other books include *Reminiscences of the Impressionist Painters* (1906) and several volumes of autobiography. Such works are a lively commentary on a great age of French painting, but they are often inaccurate, and Julian Campbell writes that 'Much of Moore's writing about art is superficial and repetitive' (*The Irish Impressionists*, 1984). In his later years he turned increasingly against modern art. Moore owned a good collection of pictures and his portrait was painted by many of his artist friends, including *Blanche, Manet, *Orpen, *Sickert, *Tonks, and Jack *Yeats.

Moore, Henry (1898–1986) British sculptor, draughtsman, and printmaker. He is regarded as one of the greatest sculptors of the 20th century and from the late 1940s until his death he was unchallenged as the most celebrated British artist of his time. He was born in Castleford, Yorkshire, the son of a miner, and despite an early desire to become a sculptor, he began a career as an elementary school teacher at the insistence of his father. In 1917–19 he served in the army (he was gassed at the Battle of Cambrai), then after a brief return to teaching went to Leeds College of Art (1919–21) on an ex-serviceman's grant; Barbara *Hepworth, who became a close friend, was one of his fellow students. In 1921 he won a scholarship to the *Royal College of Art, and after completing his training in 1924 he taught there until 1931. His first solo exhibition was at the Warren Gallery, London, in 1928, and his first public commission was a stone relief of the *West Wind* (1928–9) for the exterior of the new headquarters of the London Underground Railway. Jacob *Epstein was among other sculptors who worked on the building, and there was a predictably hostile public response to the grandly simplified figures—'grotesque caricatures' according to one letter to *The Times*. In 1932 Moore became the first head of sculpture in a new department at Chelsea School of Art and he continued there

until the school was evacuated to Northampton on the outbreak of war in 1939. During the 1930s he lived in Hampstead in the same area as Hepworth, Ben *Nicholson, the critic Herbert *Read, and other leading members of the avant-garde. In 1940, after the bombing of his studio, he moved to Much Hadham in Hertfordshire, where he lived for the rest of his life.

Most of Moore's early work was carved, rejecting the academic tradition of modelling in favour of the doctrine of *truth to materials, according to which the nature of the stone or wood—its shape, texture, and so on—was part of the conception of the work (*see also* DIRECT CARVING). He also rejected classical notions of beauty in favour of an ideal of vital force and formal vigour that he found exemplified in much ancient sculpture (Mexican, Sumerian, etc.), which he studied in the British Museum (*see* PRIMITIVISM), and also in the frescos of Giotto and Masaccio, which he saw in Italy in 1925 in the course of a travelling scholarship. In 1934 (in *Unit One*) he wrote: 'For me a work must first have a vitality of its own. I do not mean a reflection of the vitality of life, of movement, physical action, frisking, dancing figures, and so on, but that a work can have in it a pent-up energy, an intense life of its own, independent of the object it may represent. When a work has this powerful vitality we do not connect the word Beauty with it. Beauty, in the later Greek or Renaissance sense, is not the aim in my sculpture.'

During the 1930s Moore's work was influenced by European avant-garde art as well as ancient sculpture, particularly the *Surrealism of *Arp. Although he produced some purely abstract pieces, his sculpture was almost always based on forms in the natural world—often the human figure, but also, for example, bones, pebbles, and shells. The reclining female figure and the mother and child were among his perennial themes. By the late 1930s he was well-known in informed circles as the leading avant-garde sculptor in Britain. His first critical supporters were R. H. *Wilenski and Herbert Read, the latter remaining a lifelong friend, although Kenneth *Clark was probably more important in establishing his reputation with a wider public. It was as a result of Clark's support that he found work as an *Official War Artist and made the series of poignant drawings of Londoners sheltering from the Blitz in the underground which are among his most famous works (1940–42). The later series of coal miners have never had

the same broad appeal. His only major sculpture achieved during the war was a relatively naturalistic carving of the Madonna and Child for St Matthew's Church, Northampton (1944). This set the pattern for works of rather more popular appeal, including a series of *Family Groups* which were probably the nearest that the post-war Welfare State got to establishing an official artistic iconology. After the war Moore's reputation grew rapidly (particularly after he won the International Sculpture Prize at the 1948 Venice *Biennale), and from the 1950s he carried out numerous public commissions in Britain and elsewhere. Many of these commissioned works stand in prominent places in the great cities of the world, for example outside the Lincoln Center in New York and the National Gallery in Washington.

In the postwar period there were major changes in Moore's way of working. Bronze took over from stone as his preferred material and he often worked on a very large scale, requiring the use of assistants (over the years they included Bernard *Meadows, Anthony *Caro, and Phillip *King). The influence of Surrealism became for a time more explicit, especially in his life-size *King and Queen* (1952–3, Tate and elsewhere). In the 1960s he began a series of two- and three-piece figures inspired by bone forms. Some critics discerned a falling away of powers in his later work, marked by a tendency towards inflated rhetoric, but to others he remained a commanding figure to the end. Anthony Caro, whose practice represented in many ways a rejection of Moore's example, regarded his late *Sheep Piece* (1971–2) as one of his finest works. His posthumous reputation has declined somewhat. At the time of his 80th birthday, the celebrations were so widespread that it was hard to find any modern art in the Tate Gallery not made by Henry Moore and a further exhibition not only filled the Serpentine Gallery (*see* ARTS COUNCIL) but spread over Kensington Gardens. His 100th anniversary was marked chiefly by an academic conference at the University of East Anglia.

Moore held broad socialist principles (although one witness records an admiration for Margaret Thatcher), was pleased to find that his work could be appreciated by a wide audience and not just an elite, and gave his time generously to serve on public bodies. 'In personal appearance . . . it was often said that he looked more like a successful farmer than

an artist. He had an attractive modesty that hid great self-confidence and ambition. He kept a light Yorkshire accent all his life, and expressed himself in simple straightforward terms, avoiding any philosophizing. Interpretations of his work he left to others; he was the maker, driven by some creative force that he could not and perhaps did not wish to understand' (*DNB*). This very elevation of 'common sense' over theory doubtless made him a less threatening figure to the British establishment than some of his contemporaries. It has also contributed to his seeming a less attractive exemplar to a younger generation.

Moore's output was immense. The complete catalogue of his sculptures lists almost a thousand works. The bronzes were usually cast in editions of between three and ten, and it has been reasonably claimed that 'By the time Henry Moore died in 1986, his work had been distributed more widely throughout the Western world than that of any other sculptor, living or dead' (Peter *Fuller). From the late 1960s he also worked a good deal as a printmaker, producing several series of etchings such as *Elephant Skull* (1969) and the *Sheep Portfolios* (1972 and 1974). In 1977 he set up the Henry Moore Foundation, a charitable foundation to advance public appreciation of art, especially his own work. As well as arranging exhibitions of his work worldwide, it funds fellowships and publications. Most major collections of modern art have examples of his work; those with particularly fine holdings include the Moore Sculpture Gallery (opened in 1982) at Leeds City Art Gallery, Tate, the Art Gallery of Ontario, Toronto, and the Hirshhorn Museum and Sculpture Garden, Washington.

Further Reading: Royal Academy of Arts, *Henry Moore* (1988)

A Wilkinson (ed.), *Henry Moore: Writings and Conversations* (2002)

Moore, Thomas Sturge *See* SHANNON, CHARLES.

Moores, John *See* JOHN MOORES LIVERPOOL EXHIBITION.

Moorman, Charlotte *See* SKY ART.

Morandi, Giorgio (1890–1964) Italian painter and printmaker, best known for his depictions of still-life but also a painter of landscape. He was born in Bologna, where he spent most of his life, a factor which has sometimes led to writers overestimating his isolation from wider trends in art. As Guido Ballo put it, 'there came into being a mythical Morandi isolated in his ivory tower and revelling in the dust on bottles and lamps, and the bric-à-brac of his studio'. Between 1907 and 1909 he studied at the Accademia di Belle Arti in Bologna, first discovering the work of *Cézanne, a decisive influence in his composition but not his colour, in 1909; he probably did not encounter originals until 1913, when they inspired a series of landscapes. In 1914 he exhibited alongside the *Futurists, although he did not follow their cult of speed. He enlisted in the army when Italy entered the war in 1915 but, following a mental breakdown, he was discharged and resumed painting. Between 1918 and 1919 he made a series of still-life paintings. Drawn and painted in a precise manner, in a limited palette of browns and ochres, they were influenced by the *Metaphysical Painting of *Carrà and *de Chirico, although he would maintain afterwards that the dummy head which linked his paintings most decisively to theirs had been in his possession since 1914. His work was published in *Valori plastici* and its editor, Mario Broglio, was Morandi's first significant collector. In 1922 de Chirico said of him: 'he partakes of the great lyricism that was sought by the last profound phase of European art: *the metaphysics of the commonest objects*'. This could be taken as a description of Morandi's subsequent work. Everyday kitchen and domestic objects, lamps, plates, vases, are arranged close together as if clinging for company. Many writers have been tempted to anthropomorphize them. Werner *Haftmann describes the artist's relationship to them in these terms: 'He had come across them who knows where, mostly junk dealers, he had fallen in love with each and brought them home, one by one, arranging these orphans in neat rows as his roommates, experimentally and with high hopes.' The basic subject and approach changes little, although over the years the colour tends to lighten: later paintings tend to a range of whites and light greys. Apart from Cézanne the artists he most admired were Italian Renaissance painters such as Uccello and Piero della Francesca. In his tastes he was very much in line with the general tenor of Italian art during the Fascist period, although he generally kept apart from art politics. (There are contradictory accounts of the artist's personal political views.) He was,

however, drawn to the *strapaese* group of Bolognese critics and writers who advocated a return to the 19th century and the countryside. Although not overtly anti-Fascist, this ideal did present an alternative to the official emphasis on Imperial Rome in the past and modernization in the present.

Morandi's landscapes have not achieved the fame of his still-life subjects. He tended to prefer unspectacular subjects that bore the mark of human intervention in the form of walls and roads. The brushwork tends to be more fluid and atmospheric than elsewhere in his work. He was also an accomplished etcher, achieving with no more than intersecting lines the sense of light present in his painting. After the Second World War his international reputation increased, especially after he was awarded the prize for painting at the 1948 Venice *Biennale. However, he remained a reclusive figure, not visiting Paris until 1956. There is a museum dedicated to his work in Bologna.

Further Reading: G. Ballo, *Modern Italian Painting from Futurism to the Present Day* (1958)

J. M. Lukach, 'Giorgio Morandi and Modernism in Italy between the Wars', in Braun (1989)

((⊕)) SEE WEB LINKS

• The website of the Morandi museum.
• W. Haftmann, 'The Studio', on the Morandi museum website.

Moreau, Gustave *See* ROUAULT, GEORGES.

Moreau, Luc-Albert *See* NÉO-RÉALISME.

Morellet, François (1926–) French painter, sculptor, and installation artist, born in Cholet. He was self-taught as an artist and his early paintings were realist still-life subjects. In his first solo exhibition in Paris in 1950 he showed *primitivist paintings and sculpture, reminiscent of, but far more restrained than, the contemporary work of the *Cobra group. In the same year he encountered for the first time the *Concrete art of Max *Bill. Subsequently his work has usually been based on mathematics. In 1960 he was a co-founder of the *Groupe de Recherche d'Art Visuel, but as well as optics and movement he was interested in using systems which combine logic and chance. *Sphère-Trame* (1962), made from intersecting steel rods and produced as a *multiple, is an object which can appear from different angles transparent and simple or opaque and complex. One theme has been a design which is carried across a series of disconnected paintings. For instance

a three-part work of 1974 (FRAC, Burgundy) is entitled *Horizontal Line Passing Through Three Squares*. Morellet has also made works in neon. *Homage to Lamour* (2002) is on the exterior of the Musée des Beaux-Arts in Nancy and in its elaborate curves is a tribute to the designer of the famous iron gates of that city. In spite of the logical system behind Morellet's work he has confessed that his abstract ideal has always been tempered by the 'charming nihilism' of *Duchamp.

Further Reading: Musée des Beaux-Arts de Nancy, *François Morellet* (2003)

Moreno, Maria *See* SPANISH REALISTS.

Morgner, Wilhelm (1891–1917) German painter, printmaker, and draughtsman, born in Soest, where he spent most of his short career. He was an *Expressionist artist of outstanding promise, but he died in the First World War when he was only 26. From 1908 to 1910 he trained in Worpswede (*see* MODERSOHN-BECKER) with the painter Georg Tappert (1880–1957), who moved to Berlin in 1910 and encouraged Morgner to exhibit there. His work was shown not only in Berlin, but also at the second *Blaue Reiter exhibition in Munich in 1912 and in the *Sonderbund exhibition in Cologne in 1913. By this time Morgner had moved from vigorous scenes of country life, with fiery, spiralling brushwork recalling van Gogh, to pure abstracts such as *Astral Composition* (1913, Westfälisches Landesmuseum, Münster). He was beginning to make a name for himself among his fellow artists when he was called up for military service in 1913, the year before the war started. From this point he produced only drawings and watercolours. He fought at the front from the beginning of the war and was reported missing at the Battle of Langemarck in France. Morgner said that 'Every picture should be a life symphony. I don't mean by this an allegorical symphony to life or something similar; but that the lust for life should ring through in the colours and lines.'

Mori, Mariko (1967–) Japanese multimedia artist. Born in Tokyo, she works there and in New York. She studied design and worked part time as a fashion model but decided that this was insufficiently creative and began staging tableaux in which she posed in costumes and settings of her own design. She draws on the mixing of Western and national sources which

form Japanese mass culture. *Birth of a Star* (1995, Museum of Contemporary Art, Chicago) is a life-size transparency of Mori in plasticized tartan micro-skirt with outsize headphones, spiky hair, and silver contact lenses. The critic Rachel Schreiber was reminded of the cyborg, defined by the cultural theorist Donna Haraway as 'a hybrid of machine and organism, a creature of social reality as well as a creature of fiction'. She also draws on and updates the traditional Japanese tea ceremony. In *Tea Ceremony II* (1995) she is dressed in an outfit with silver stockings and outsize ears, making her appear half alien. She stands on the outside of an office block offering the tea to business men who pass by indifferently. Is Japanese tradition now so strange in the contemporary world that it might have come from another planet? Kay Itoi who interviewed the artist in her studio describes her enactment of the tea ceremony as 'an impressive piece of performance art'. What is peculiar to her work is not simply the flavour of an exotic culture but the way that her interest in fashion and technology is combined with a Buddhist perspective. For an exhibition in 1998 she provided a statement which referred very specifically to 'The chain of reincarnation [which] harks back in time forever'. *Tea Ceremony* has been interpreted as a representation of the Buddhist *mappo*, which is a period of decline before the arrival of the future Buddha. Much more specific is the spectacular video installation *Nirvana* (1996–7), which moves on from the social criticism of her earlier work. Mori rises from a lotus flower and floats like a goddess above a tranquil beach (it takes 3D to a level of poetry quite beyond anything so far achieved by the commercial cinema), yet the plastic props are obviously the product of contemporary popular taste and mass production. She writes: 'Let our spirit be liberated. Let us be at one with the ultimate truth of our selves and the whole universe.' The implications of Mori's work are that contemporary technology need not necessarily be a hindrance to that process.

Further Reading: Art Institute of Chicago/Serpentine Gallery, London, *Mariko Mori* (1998)

R. Schreiber, 'Cybers, Avatars, Laa-Laa and Po: The work of Mariko Mori', *Afterimage*, vol. 26., issue 5 (1999)

(((⨁))) SEE WEB LINKS

- K. Itoi, 'Tea with Mariko', interview in the artnet online magazine.

Morison, Stanley *See* GILL, ERIC.

Morley, Malcolm (1931–) British painter, born in London. He became interested in painting whilst he was in prison (he served a three-year sentence for house-breaking) and then studied at Camberwell School of Art, 1952–3, and the *Royal College of Art, 1954–57. At this period he was deeply interested in American *Abstract Expressionism, and in 1958 he settled in New York. Whilst working as a waiter he met his hero Barnett *Newman, who gave him advice and encouragement. In the 1960s he turned from abstract to figurative work and became one of the pioneers of *Superrealism (a term he coined). He emphasized the photographic source by including the white borders of the image, most famously in his expansion of a reproduction of Vermeer's painting of the artist in his studio. He commented in 2007 that 'basically painting from a reproduction was painting a still life, because the image itself on paper still has three dimensions (including the edge)'. The paintings were constructed by dividing the original image into a series of cells and copying them. He has said that 'the less information there is in the cell, the more painting invention occurs in the corresponding place in the canvas'. Therefore his procedure is to avoid cells which are too large because then the painting becomes too literal, as the artist is distracted by too much information. From about 1970, however, his paintings became increasingly loose in handling, often depicting animals in lush landscapes. In his more recent work he has returned to his Superrealist manner. In spite of the apparent impersonality of his method there is sometimes a strong level of political motivation behind his subject matter. *Race Track* (1970, Ludwig Collection) was a protest against the apartheid system in South Africa. *Wall Jumpers* (2002, Musée d'Art Moderne et Contemporain de Strasbourg) reflects the Middle East conflict. In 1984 Morley was the first winner of the *Turner Prize, awarded for 'the greatest contribution to art in Britain in the previous twelve months'. The decision caused much controversy because he had for so long been resident in the USA.

Further Reading: South Bank Centre, *The Painting of Modern Life* (2007)

Morlotti, Ennio *See* FRONTE NUOVO DELLE ARTI.

Morozov, Ivan (1871–1921) Russian art collector. He was a wealthy Moscow business-

man, owner of a complex of textile mills, and —like his brother Mikhail (1870–1903)—a passionate lover of French *Impressionist and *Post-Impressionist painting, on which he spent huge sums. Many of the pictures in his collection were bought from *Durand-Ruel, but Morozov also employed a representative in Paris to buy from other sources. He also regularly visited Paris himself, and Félix *Fénéon wrote that 'No sooner had he got off the train than he found himself in an art shop'. In 1907 he acquired a group of pictures from Ambroise *Vollard and later bought from this dealer a *Cubist portrait by *Picasso (of Vollard himself, 1910, Pushkin Museum, Moscow), even though—unlike the other great Russian collector of the time, Sergei *Shchukin—he was not particularly sympathetic to Cubism. Morozov corresponded regularly not only with dealers, but also with many French artists, including *Bonnard, *Denis, *Matisse, and *Vuillard, from whom he also commissioned works (Denis visited Moscow in 1909 to install a series of five large paintings on *The Story of Psyche*, and Morozov ordered six additional pictures from him). The chief glory of the collection was a group of seventeen *Cézannes: at this time it was probably the finest representation of his paintings in the world, featuring superb examples of every genre in which he worked. Morozov's collection was less accessible than Shchukin's, but it was visited by many artists and connoisseurs. In 1918, following the Russian Revolution, it was nationalized and opened to the public. During the 1920s it was amalgamated with that of Shchukin, and they were later divided between the Hermitage in Leningrad (now St Petersburg) and the Pushkin Museum in Moscow, each of which consequently boasts one of the greatest collections of early 20th-century French painting in the world.

Morrell, Lady Ottoline *See* CONTEMPORARY ART SOCIETY.

Morrice, James Wilson (1865–1924) Canadian landscape and figure painter, active mainly in Paris. He was born in Montreal, the son of a merchant who collected art and encouraged his son's interest in painting. After studying art in Toronto, he moved to Paris in 1890 and enrolled at the *Académie Julian. Paris remained his home for the rest of his life, but he spent a great deal of time travelling, visiting North Africa, Venice, and the West Indies among other places, as well as making frequent trips to Canada, where he worked in Quebec, Montreal, and along the St Lawrence River (*The Ferry, Quebec*, c.1909, NG, Ottawa). Morrice was friendly with many leading artists in Paris. His early inspiration came from *Whistler and *Conder; later his style became gently *Fauvist under the influence of *Matisse and *Marquet. His work was important in introducing modern trends to Canada (although he did not exhibit in his own country after 1916): Dennis Reid (*A Concise History of Canadian Painting*, 1973) writes that 'countless young Canadians sought out his work. Along with Horatio *Walker, he was the Canadian who then had the strongest reputation abroad.' *See also* CANADIAN ART CLUB.

Morris, Sir Cedric (1889–1982) British painter and teacher, born at Sketty, Glamorgan, the son of Sir George Lockwood Morris, to whose baronetcy he succeeded in 1947. He took up art seriously shortly before the First World War; he attended various academies in Paris but was essentially self-taught. During the war, his delicate health prevented him from enlisting in the army, but he was a good horseman and helped *Munnings in training horses that were to be sent to the Front. Soon after the end of the war Morris met the painter Arthur Lett-Haines (1894–1978), and although each had other liaisons, they lived together until Lett's death sixty years later. After a short period in Newlyn (*see* NEWLYN SCHOOL), 1919–20, they lived in Paris from 1921 to 1926, then London from 1926 to 1929, before settling in East Anglia. In 1937 they founded the East Anglian School of Painting and Drawing, originally at Dedham, Essex, then from 1940 at Hadleigh, Suffolk, where they lived permanently from this date. The school was anti-academic in approach: 'what the pupil felt about appearances mattered more than what he or she saw: drawing, dictated by feeling, could employ emotive distortion' (Frances Spalding, *British Art Since 1900*, 1986). Well-known students of the school include Lucian *Freud and Maggi *Hambling, both of whom felt they profited greatly from the teaching. Morris's work included portraits, landscapes, and still-lifes, but he is best known for his paintings of flowers, done in startlingly vivid colours. Lett-Haines was a very different kind of artist—more experimental and concerned with symbolism. Morris became fairly well known and successful between the wars (he

exhibited with the *Seven & Five Society from 1926 to 1932). After about 1940, however, he sank from fashionable consciousness, although he remained an admired figure in East Anglia. He gave up painting in 1975 because of failing eyesight, but he lived long enough to see the beginnings of a revival of interest in his work.

Further Reading: R. Morphet, *Cedric Morris* (1984)

Morris, Desmond *See* OBJET TROUVÉ.

Morris, Edmund *See* CANADIAN ART CLUB.

Morris, George L. K. (1905–75) American art critic, painter, and occasional sculptor, born in New York. After taking a BA degree at Yale University in 1928, he studied at the *Art Students League, New York, in 1929, and at the Académie Moderne, Paris, under *Léger and *Ozenfant, in 1930. In Paris he was converted to abstract art and he became one of its most vigorous advocates in print. He was co-editor with *Taeuber-Arp of the abstract art magazine *Plastique* (published in Paris and New York, 1937–9), and from 1937 to 1943 he worked on the New York journal *Partisan Review*, a leftist publication which by that time had strong Trotskyist leanings. In 1936 he was a founder member of *American Abstract Artists and he was president of this association from 1948 to 1950. He exhibited frequently during the 1930s and 1940s and had a retrospective at the Institute of Contemporary Art, Washington, in 1958. His paintings were eclectic and decorative, characterized by bright, generally unmodulated colours and hard-edged (but not necessarily geometrical) shapes; in the 1950s he went through a slightly more 'painterly' phase, perhaps influenced by *Abstract Expressionism, but in the 1960s he reverted to his earlier style.

Morris, Margaret *See* FERGUSSON, J. D.

Morris, Robert (1931–) American sculptor, painter, Performance artist, and art theorist. He was born in Kansas City, Missouri, and studied engineering at the university there whilst also attending classes at the city's Art Institute. After service in the US Army, 1951–2, he began his artistic career in San Francisco, painting *Abstract Expressionist pictures. He has generally preferred not to exhibit these in later years because he considered that abstract painting 'had become highly questionable in terms of what was represented' but also that

'the style had been too filled in by "footsteps which were not my own". He was also involved with other activities including improvisatory theatre and dance. (At this time his partner was the dancer Simone Forti.) In 1961 he moved to New York, where he took an MA in art history at Hunter College in 1963 (his thesis was on *Brancusi). His writings continued to abound in erudite references to the art of the past. A video work of 2004, *Birthday Boy*, marked, not uncritically, the five hundredth anniversary of Michelangelo's *David*.

He turned from painting to sculpture and he emerged as one of the most prominent exponents and theorists of *Minimal art. His concerns included the disparities between what the mind tells us about the simplicity of objects and the experience of their perception. *Untitled* (1965–71, Tate) is a series of mirrored boxes which defy our expectations by failing to reflect us. *Untitled* (1967–78, Tate) is a fibreglass object hung at average eye level. Spectators can measure themselves by comparison to the work; a short and a tall visitor will in a literal sense see it differently. Another crucial idea is the importance of making process part of the experience of the artwork. A work of 1961 was entitled *Box with Sound of its Own Making*. This for him was the significance of abstract painters such as Jackson *Pollock and Morris *Louis: their work was a representation of its process of production, not, as *Greenberg would have it, a purely visual experience. Morris's concept of anti-form, using material such as felt, which would be shaped not by the artist's aesthetic judgement but by gravity, was part of this concern with the relationship between form and the physical properties of matter. The most extreme example of anti-form was a work in steam (1967). In 1969 in New York he mounted under the auspices of his dealer Leo *Castelli an exhibition entitled 'Nine in a Warehouse', in which he showed a number of younger artists including Eva *Hesse and Richard *Serra who had similar preoccupations. In 1971 he had an exhibition at the Tate Gallery. Rather than present the conventional retrospective of previous work, he produced a participatory environment which was closed down within a week because of problems over safety. The line of demarcation between art gallery and fairground had been breached.

During the 1960s and 1970s it was customary for critics to view Morris's work in abstract and formal terms. However, in October 1979

the critic Carter Ratcliff published an article entitled 'Robert Morris: Prisoner of Modernism' (*Art in America*) in which he argued that Morris's boxes should be seen as cages and that Morris was 'an Expressionist in bondage, a confessional artist condemned by his self-consciousness to wear a gag'. He may well have intuited something important about Morris. From the 1980s onwards the artist returned to painting with works invoking atomic war such as the *Firestorm* series and drawing upon artists of the past such as Leonardo and Turner who were fascinated by the theme of apocalypse. At the time Morris argued that what he described as an 'emotional weariness' with the forms of modernism had occurred, with the 'growing awareness of the more global threats to the existence of life itself'. Although this is sometimes interpreted as a *volte-face*, the critic Donald Kuspit has pointed out that throughout the artist's career there has been a fascination with themes of death. A notorious early work, the *I-Box* (1962), shows the artist displayed naked 'as one will appear before God . . . fitted in what might be called a conceptual coffin'.

Morris's writings have been anthologized as *Continuous Project Altered Daily* (MIT, 1993) and the title seems an appropriate description of his wide-ranging work and ideas.

Further Reading: Solomon R. Guggenheim Museum, *Robert Morris: The Mind Body Problem* (1994)

P. Karmel, 'Robert Morris: Formal Disclosures', *Art in America* (June 1995)

Krauss (1977)

D. Kuspit, *The New Subjectivism: Art in the 1980s* (1993)

Morris, William *See* BRANGWYN, SIR FRANK; CRANE, WALTER; WIENER WERKSTÄTTE.

Morrisseau, Norval (1932–2007) Canadian painter of native Canadian origin. Born in Northern Ontario as Jean-Baptiste Norman Henry Morrisseau and from the Anishaabe Ojibwa nation, he was also known by his spirit name of 'Copper Thunderbird'. He took up painting while recovering in a TB clinic. His first Toronto exhibition in 1962 was an instant sell-out and in 1967 he painted a mural for Expo 67 at Montreal. His paintings were brilliantly coloured and drew on the spiritual imagery which had been repressed by Catholic missionaries. His work was an inspiration to a group of painters known as the Woodland School. In 2006 he became the first native Canadian to have a solo exhibition at the National Gallery of Canada. In spite of the success and acclaim he achieved, much of his life was spent battling with alcohol and drug addiction. In the 1980s he was living on the streets of Vancouver selling his pictures for drink and, allegedly, cocaine. In the 1990s, however, he managed to conquer his addiction and painted prolifically until struck down by Parkinson's disease. He once told an interviewer why he lived and painted. It was 'To heal you guys who're more screwed up than I am. How can I heal you? With colour. These are the colours you dreamt about one night.'

Further Reading: G. A. Hill, 'Norval Morrisseau', *The Guardian* (10 April 2008)

R. Kennedy, 'Norval Morrisseau, Native Canadian Artist is Dead', *New York Times* (8 December 2007)

Mortensen, Richard (1910–93) Danish painter and designer, born in Copenhagen, where he studied at the Royal Academy, 1931–2. While still a student he discovered the work of *Kandinsky and during the 1930s he played an important role in introducing abstraction to Denmark, being one of the founders in 1934 of the group Linien (The Line), a small circle of abstract artists; it published a periodical of the same name. In 1947 Mortensen settled in Paris, but he returned to Copenhagen to become a professor at the Academy in 1964, holding this post until 1980. During the Second World War Mortensen painted some harsh, tormented canvases, but his most characteristic pictures are sophisticated in composition and refined in colour; they feature smooth, taut sheets of colour interlocking with sharp lines, creating a subtle interplay between surface tension and spatial allusion and combining clear articulation with a lively feeling of spontaneity. He also produced tapestry cartoons and designs for theatrical sets and costumes.

Mortimer, Raymond *See* NEO-ROMANTICISM.

Moscow, Pushkin Museum *See* MOROZOV, IVAN; SHCHUKIN, SERGEI.

Moser, Koloman (Kolo) (1868–1918) Austrian painter, graphic artist, and designer, born in Vienna. He was a founder member of the Vienna *Sezession and contributor to *Ver Sacrum*, and his practice embodied the ideal of fusing the fine and decorative arts on equal footing. He made a stained-glass window, a winged figure symbolic of art, for the vestibule

of the Sezession building. The critic Hermann Bahr (1863–1934) commented of him: 'He is Viennese through and through. His inventions seem to dance, to hover . . . Old Socrates would have been pleased: everything is but a game.' Moser designed some of the mosaics for Otto Wagner's church of St Leopold 'am Steinhof' and would probably have had even more work on the building had he not converted to Protestantism. He concentrated exclusively on painting after 1906, being strongly influenced by Ferdinand *Hodler. Moser shares the philosophical pretensions of the Swiss painter but has little of his emotional intensity. His limitations were cruelly exposed by a Grand Palais, Paris, exhibition of 2005–6, which presented him on equal terms with *Klimt, *Kokoschka, and *Schiele.

Further Reading: P. Vergo, *Art in Vienna 1898–1918* (1975)

Moses, Grandma (born Anna Mary Robertson) (1860–1961) The most famous of American *naive painters. She was born on a farm at Greenwich in Washington County, New York State, of Irish and Scottish ancestry. In 1887 she married a farmer, Thomas Moses; they lived in Virginia for twenty years, then returned to New York State, where Anna spent the rest of her life within a few miles of her birthplace. She regularly won prizes with embroidery at county fairs, and when arthritis made it impossible for her to continue with this in her 70s, she took up painting, initially copying postcards and popular prints. At first her work was crude, but she soon developed a lively, fresh, and colourful style, abounding in lovingly observed detail. Her first exhibition was held in a drugstore in Hoosick Falls, New York State, and her work was 'discovered' there by Louis J. Caldor, an engineer and art collector who happened to be passing through the town. In 1940, at the age of 80, she had a one-woman show at the Galerie St Etienne in New York, and thereafter she rapidly became famous and something of a national institution, her work being widely reproduced, notably on Christmas cards (her winter scenes were ideal for this; she sometimes dusted 'glitter' over the snow to make it look more realistic to her eye). In 1949 she was received at the White House by President Harry Truman, and in 1960 Governor Nelson Rockefeller proclaimed 7 September—her 100th birthday—'Grandma Moses Day' in New York State. She produced more than 1,000 pictures (working on a sort of production line

system, three or four at a time, painting first the skies and last the figures), her favourite subjects being scenes of what she called the 'old-timey' farm life she had known in her younger days. She described this life in her autobiography, *My Life's History* (1952); in the preface Otto Kallir writes that 'Her kind and good-natured approach to everything that surrounds her can be felt in her personal presence as well as in her work'. Her paintings are in many American collections, notably the Bennington Museum, Vermont.

(()) SEE WEB LINKS

• 'Grandma Moses is dead at 101', article on *New York Times* Learning Network.

Moskowitz, Robert See NEW IMAGE PAINTING.

Mosset, Olivier See TORONI, NIELE.

Motherwell, Robert (1915–91) American painter, collagist, printmaker, writer, editor, and teacher, one of the pioneers and principal exponents of *Abstract Expressionism. He was born in Aberdeen, Washington, and began to study painting at the Otis Art Institute, Los Angeles, in 1926, when he was only eleven. However, it was not until he settled in New York in 1940 that he took up painting seriously. Before then he had taken a degree in philosophy at Stanford University (1936), followed by postgraduate work at other universities interspersed with two trips to Europe. His scholarly background coloured his writings on art, and their erudite approach helped to set the serious intellectual tone of the Abstract Expressionist movement. He had moved to New York to study art history under Meyer *Schapiro at Columbia University, but after becoming friendly with *Matta and other expatriate *Surrealists he turned increasingly to painting and he decided to become a professional artist in 1941. His first one-man exhibition was at Peggy *Guggenheim's Art of This Century gallery in 1944. Motherwell was unusual among the Abstract Expressionists in that his work was essentially abstract from the beginning of his career, but there is often a suggestion of figuration in his paintings. Moreover, his intellectual sensibilities are reflected in the fact that there is frequently an underlying inspiration from literature, history, or his personal life in his work. He painted, for example, a long series of works (more than 100 pictures) entitled *Elegy to the Spanish*

Republic; it was inspired by the Spanish Civil War ('the most moving political event of the time'), but not begun until a decade later in 1949. Motherwell wrote of the series: 'The *Spanish Elegies* are not "political" but my private insistence that a terrible death happened that should not be forgot...The pictures are also general metaphors of the contrast between life and death, and their interrelation.'

During the 1940s Motherwell established friendships with the other leading exponents of Abstract Expressionism and in 1948 he joined several of them in founding the *Subjects of the Artist School. His earliest paintings had been amorphous and improvisatory, influenced by Surrealist ideas of *automatism (he admired *Miró above all the other Surrealists). By the late 1940s, however, he was using very bold slabs of paint, often ovals or upright rectangles, in a manner similar to that of Franz *Kline: his palette was subdued and like Kline he made highly dramatic use of black on white (*Elegy to the Spanish Republic XXXIV*, 1953-4, Albright-Knox Art Gallery, Buffalo). His style did not change greatly until 1967, when he began a series of *Colour Field paintings called *Open* featuring large areas of dense, sensuous colour broken only by a few spare lines (*Open No. 122 (in Scarlet and Blue)*, 1969, Tate). He chose the name 'Open' for its suggestions of expansiveness and simplicity. At about the same time he took an increased interest in printmaking, using etching and coloured aquatint to achieve similar effects to those in the paintings. Eventually he set up his own printing facilities at Greenwich, Connecticut, where he moved from New York in 1971 (in this year he was divorced from Helen *Frankenthaler, whom he had married in 1958).

Motherwell was highly prolific as an artist and also energetic as a teacher, writer, and editor. He taught at *Black Mountain College in 1950, Hunter College, New York, 1951-5, and Columbia University, 1964-5, and he lectured widely elsewhere. He wrote articles for numerous avant-garde periodicals, including *VVV* and *Dyn* (*see* PAALEN), and he edited a major series of books, *Documents of Modern Art* (1944-61), and launched another one, *Documents of 20th-Century Art*, in 1971. An anthology of his own writings, *The Writings of Robert Motherwell*, was published in the latter series in 1978.

Mousseau, Jean-Paul *See* AUTOMATISTES.

Moynihan, Rodrigo (1910-90) British painter, born on the island of Tenerife to an Irish father (a fruit-broker) and a Spanish mother. He moved to England at the age of eight and travelled widely before studying at the *Slade School, 1928-31. His work was varied and fluctuated between figuration and abstraction. In the early 1930s he was one of the most radical of British abstract painters (*see* OBJECTIVE ABSTRACTIONISTS), but he then turned to figurative art, and was associated with the *Euston Road School, founded in 1937, the fountainhead of a long-lived soberly realistic strain in British painting. However, his own style was more influenced by *Impressionism, especially Manet, than by the more methodical work of William *Coldstream and Graham *Bell. After being invalided out of the army, he became an *Official War Artist in 1943, concentrating on the everyday life of the troops. From 1948 to 1957 he was professor of painting at the *Royal College of Art, and one of his best-known works is the large *Portrait Group* (1951, Tate) showing the nine members of the teaching staff of the painting school there (himself included). In 1956 he turned again to abstract art, initially in a style influenced by *Abstract Expressionism, although by the mid-1960s he was closer to *Hard-Edge Painting. In the 1970s he took up figurative art again (mainly portraits and still-lifes), characteristically painting in pale, muted colours. In spite of all the apparent shifts in style in his art, it was consistent in its fascination with the stuff of paint itself. From 1957 he lived mainly in France. Moynihan's first wife was the painter Elinor Bellingham Smith (1906-88), his second wife the painter Anne Dunn (1929-).

Further Reading: Royal Academy of Arts, *Rodrigo Moynihan* (1978)

Mraz, Franjo *See* HLEBINE SCHOOL.

Mucha, Alphonse (1860-1939) Czech painter and designer. He was born at Ivančice in Moravia and worked as a theatrical scene painter before studying in Munich and then in Paris, where he settled in 1888; it was his main home until about 1905, when he began to spend an increasing amount of time in his homeland. Mucha had a highly varied career, but he is best known for his luxuriantly flowing poster designs, which rank among the most distinctive products of the *Art Nouveau style. They often feature beautiful women, but they

have nothing of the morbid sexuality typical of the period. Some of the best known were made in the 1890s for the celebrated actress Sarah Bernhardt, for whom Mucha also designed sets, costumes, and jewellery. He was successful in the USA as well as Europe, making four journeys there between 1903 and 1922. A Chicago industrialist and Slavophile, Charles Richard Crane, sponsored his series of twenty huge paintings entitled *Slav Epic* (1909–28, Moravský Krumlov Castle). Although he is so strongly associated with Paris, Mucha was an ardent patriot, and in 1922 he settled in Prague. Czechoslavakia had won its independence only in 1918 and Mucha did a good deal of work for the new nation (giving his services free), including designing its first banknotes and stamps. When the Germans occupied Prague in 1939 (a few months before his death) he was one of the first to be arrested and questioned by the Gestapo. After the war his work was long out of fashion, but a revival of interest began in the 1960s. Since then numerous books and exhibitions have been devoted to him (notably a major exhibition of his paintings, posters, drawings, furniture, and jewellery shown at the Grand Palais, Paris, in 1980, and afterwards in Darmstadt and Prague) and in the popular imagination he has become one of the symbols of the turn-of-the-century era.

Mucha, Reinhard (1950–) German installation artist, born in Düsseldorf, where he lives and works. He makes use of bits of furnishings and other objects, usually from around the site of the exhibition itself. These are both *site-specific and impermanent. What is disconcerting is that it is not always obvious that the work is an art exhibition at all. *Calor* (1986) was an assembly of ladders and scaffolding at the Pompidou Centre, Paris, which could almost have been the preparation for an exhibition. Only the fact that the ladders jutted out at an irrational angle gave it away as 'art'.

Muche, Georg *See* SCHWITTERS, KURT.

Mueck, Ron (1958–) Australian sculptor, born in Melbourne, who settled in London in 1986. After working as a puppet-maker and puppeteer Mueck embarked on a career as an independent sculptor. In 1995 he made a figure of Pinocchio for Paula *Rego (his mother-in-law), who was working on a series of paintings inspired by Walt Disney. This led to contact with Charles *Saatchi. What remains

Mueck's best-known sculpture, *Dead Dad* (1996–7), was shown in the *'Sensation' exhibition. This is a three-foot long figure of a corpse (based on Mueck's own father) lying on the floor. Mueck's sculpture generally depends for its impact on a disparity between unnatural scale and highly realistic modelling and colouring. Sometimes, as in his outsize self-portrait head, the effect is obvious. Elsewhere Mueck can be more subtle, as in *Ghost* (1998, Tate), in which a shy modest girl in a bathing suit turns away from the spectator's gaze, although she towers over most viewers at seven feet high.

Muehl, Otto (1925–) Austrian actionist and painter, born in Grodnau. He was one of the group of *Vienna Actionists and, arguably, the most extreme, although 'playful' is a term which has been used by some commentators. Originally a painter, he defined his 'material actions' in painterly terms. He viewed the destruction of the canvas in 1961 as his 'big bang'. In 1964 he wrote 'paint is not a means to colour but is mush, liquid, dust, the egg is not an egg but a gooey substance'. This thinking brings him close to the ideas of Georges *Bataille, who is quoted in the films of his actions. These films were made by the photographer Kurt Kren (1929–98), whose use of rapid intercutting and colour filters sometimes makes it hard to fathom exactly what is going on. *Scheisskerl* (1967) starts innocuously enough with a woman eating meringues but she subsequently excretes over Muehl's body and into his mouth. When Muehl is sick it is not clear whether this was planned as part of the action. Artistic actions were not enough for Muehl, who founded the AA Commune, in which money and women were held in common. The attempt to fuse Marxist ideas about the abolition of private property with sexual liberation was characteristic of the 1960s but few attempted to carry it out with such rigour and persistence. Part of the idea was to bring children up without sexual repression. When the commune fell apart Muehl was imprisoned for seven years for 'sexual offences'. He has also made *Pop style paintings of political leaders.

(∰) SEE WEB LINKS

- Interview with Otto Muehl ('An Actionist Begins to Sing'), *Bright Lights Film Journal*.

Mueller, Otto *See* MÜLLER, OTTO.

Mukhina, Vera (1889–1953) Russian sculptor and designer. She was born in Riga, Latvia, into an old merchant family, grew up in Kiev and Kursk, where she took lessons in drawing and painting, and in 1910 moved to Moscow, where she studied at various private art academies. From 1912 to 1914 she lived in Paris, where she studied under *Bourdelle at the Académie de la Grande Chaumière, met other leading sculptors including *Lipchitz and *Zadkine, and was a close friend of *Popova (they travelled together in Italy in 1914). She returned to Moscow after the outbreak of the First World War, and for the next few years she worked mainly on theatrical designs, sometimes in collaboration with *Exter (they worked together on the science fiction film *Aelita*, 1923). In the 1920s Mukhina emerged as one of the leading sculptors in Lenin's Plan for Monumental Propaganda, in which Communist ideals were to be expressed in public art. She became recognized as one of the outstanding sculptural exponents of *Socialist Realism, and her career was crowned with the gigantic *Worker and Collective Farm Girl*, made to surmount the Soviet pavilion at the International Exhibition in Paris in 1937. The stainless steel group (now at the entrance to the Park of the People's Economic Achievements, Moscow) stands almost 25 metres high and weighs about 35 tonnes. Showing a pair of heroic figures striding forward, with a hammer and sickle held proudly aloft, it became one of the greatest symbols of Stalin's USSR (it was, for example, adopted as a logo by one of the state film studios, appearing at the beginning and end of its films). Matthew Cullerne Bown (*Art under Stalin*, 1991) sums up the work's appeal as 'its combination of great formal brio—huge size, dynamic design, stainless steel skin—on the one hand, and unashamed corniness on the other'. In 1941, in recognition of her masterpiece, Mukhina was awarded one of the newly instituted Stalin Prizes for art. She subsequently won four other Stalin Prizes and many other honours. Her husband, the physician Alexei Zamkov, was less favoured: he was imprisoned and exiled by the regime. Her later work included the design of glass figurines and vases, some of which were mass-produced.

Mülhemer Freiheit See DAHN, WALTER.

Müller, Otto (1874–1930) German *Expressionist painter and graphic artist, born at Lie-bau in Silesia (now Libawka, Poland). After four years' apprenticeship in lithography at Breslau he studied painting in Dresden, 1896–8, and remained based there until 1908. He was a prolific worker but later destroyed most of his paintings from these years. Those that survive show he was strongly influenced by the curvilinear forms of *Art Nouveau. In 1908 he moved to Berlin and after being rejected by the Berlin *Sezession in 1910 he joined forces with other rejected artists to form the Neue Sezession; among them were members of Die *Brücke, which he also joined. Apart from *Kubišta—who became a member in theory rather than practice—he was the group's last significant recruit. Under the influence of other members, particularly *Kirchner, his style became more harsh and angular, with emphatic outlines. However, he remained distinct from them in certain ways. He painted in distemper, which produced a matt finish, and his gentle colour harmonies are very different from the brilliant or harsh hues often associated with German Expressionist painting. His whole outlook, in fact, was tranquil rather than violent, and his most typical paintings depict a kind of primitive Arcadia in which nude figures disport themselves in forests or on lake shores. After about 1920 he also did many gypsy subjects (his grandfather is said to have been a gypsy and he had great sympathy for their way of life, studying their culture at first hand in Bulgaria, Hungary, and Romania). From 1919 until his death he taught at the Academy in Breslau.

multimedia See MIXED MEDIA.

multiples A term designating works of art other than prints or cast sculpture that are designed to be produced in a large—potentially limitless—number of copies. Whereas prints and casts of sculptures are copies of an original work hand-made by the artist, multiples are different, for the artist often produces only a blueprint or set of specifications for an industrial process of manufacture in materials such as plastic. Similarly, they differ from the 'multiple original' paintings produced from 1950 by Jean *Fautrier, in which he hand finished a basic design printed on a large number of canvases. The idea of multiples in the sense defined above was devised by *Agam and *Tinguely; in 1955 they proposed the production of such works to the art dealer Denise *René, who later tried unsuccessfully to patent the word 'multiple'.

The first examples were produced in 1962 and many artists took up the idea, among them *Le Parc and *Oldenburg. Usually they are similar in style to the artist's 'normal' work. In theory, multiples represented a democratization of art—works were no longer to be regarded as rare items for collectors and connoisseurs but as consumer goods for the masses like any other industrial product. In practice, however, they are too expensive for a mass market and have been sold through galleries rather than high street shops or supermarkets (although Richard *Hamilton designed a plastic relief showing the exterior of the Guggenheim Museum, New York, that was sold in the museum shop). In 1971 substantial exhibitions of multiples were held at the Philadelphia Museum of Art ('Multiples: The First Decade') and the Whitechapel Art Gallery, London ('New Multiple Art'); by the end of the decade the idea seemed to be dying out, but it revived in the 1990s.

Munari, Bruno See AEROPITTURA.

Munch, Edvard (1863–1944) Norwegian painter and printmaker of figure compositions, portraits, and landscapes, his country's greatest artist. He was born in Løten, the son of a doctor, but his family moved to Christiania (now Oslo) when he was a baby. After leaving school he began training as an engineer, but he abandoned this for art, studying at the Royal School of Design, 1881–3. However, he learnt more through informal tuition from Christian *Krohg, who was a hero to many young artists because of his championing of new ideas. Through Krohg, Munch became part of Christiania's bohemian world of artists and writers, who outraged bourgeois society with their advocacy of sexual as well as artistic freedom. In 1885 he visited Paris for the first time, and soon after returning to Norway painted the first picture in which he showed a distinctly personal vision, *The Sick Child* (1885–6, NG, Oslo). Munch himself described this hauntingly sad scene (of which he painted five later versions) as 'the breakthrough in my art. Most of what I have done since had its birth in this picture.' The choice of subject was highly significant, for it reflected his own tragic childhood. His mother and favourite sister had died of tuberculosis in 1868 and 1877 respectively, and his father—driven close to insanity with grief—became almost dementedly pious. Munch wrote that 'Illness, madness, and death were the black

angels that kept watch over my cradle', and in his paintings he gave expression to the neuroses that haunted him. Certain themes—jealousy, sickness, the awakening of sexual desire—occur again and again, and he painted extreme psychological states with an unprecedented conviction and an intensity that sometimes bordered on the frenzied. Already in *The Sick Child* he showed some of the bold simplification of form, the expressive use of non-naturalistic colour, and the pungency of feeling that were to characterize his mature work.

In 1892 Munch was invited to exhibit at the Verein Berliner Künstler (Association of Berlin Artists), and the anguished intensity of his work caused such an uproar that the exhibition was closed. The scandal made him famous overnight in Germany, so he decided to base himself there and from 1892 to 1908 he lived mainly in Berlin (although he moved around restlessly, staying in boarding houses, and made frequent visits to Norway as well as journeys to France and Italy). During this period—the heart of his creative life—he devoted much of his time to an ambitious series of pictures that he called collectively *The Frieze of Life*—'a poem of life, love, and death'. The idea was to display the pictures together, as he thought that the force of his vision could be fully appreciated only when his work was seen en masse. The *Frieze* never had a definitive form, but it included some of Munch's finest work, including his most famous picture, *The Scream* (1893, NG, Oslo), a vision of panic that has become one of the great icons of the modern world. Many of the other pictures in the series deal with a different kind of dread—the fear engendered by female sexual power. Munch characteristically depicted this in three stages—awakening womanhood, voracious sexuality, and an image of death—and he sometimes combined two or even all three of these aspects in one picture. Although he was tall, strikingly handsome, and very attractive to women, Munch was wary of the opposite sex and reluctant to contemplate marriage for fear that any children he might have would inherit the family disposition to mental and physical illness.

Munch translated the images from many of his paintings into prints. He had begun etching in 1894 to earn extra money, but he soon came to love printmaking and also mastered lithography and woodcutting. His woodcuts (often in colour) are particularly impressive,

exploiting the grain of the wood to contribute to their effect of rough vigour. Together with the woodcuts of *Gauguin (who likewise took up the medium in the 1890s) they were the major stimulus for the great revival of the technique in the 20th century, especially among the German *Expressionists. By a process of artistic feedback, Munch's prints also influenced his own paintings, for after refining his ideas as he turned a composition from painting to print, he often translated the image back into a painting in a simpler and more powerful form.

In 1908 Munch suffered what he called 'a complete mental breakdown', the legacy of heavy drinking, overwork, a wretched love affair, and the general debilitating effects of his nomadic lifestyle. After recuperating in a clinic in Copenhagen for eight months he returned to settle in Norway in 1909, determined to change his life. He realized that his mental instability was part of his genius ('I would not cast off my illness, for there is much in my art that I owe to it'), but he made a conscious decision to devote himself to recovery and abandoned his familiar anguished imagery, looking to the world around him for subjects rather than inwards to the mind or soul. Almost immediately he began work on a project that emphasized his change of direction—a series of large canvases to decorate the Assembly Hall of Oslo University (1910–16). The subjects, which deal with universal forces, include *History* and *The Sun*. Munch depicted them with bright and vigorous colours and an energetic technique.

In 1916 Munch bought a large house called Ekely, at Skøyen on the outskirts of Oslo, and he spent most of the rest of his life there, leading an increasingly isolated existence. By now he was a much honoured figure in Norway; ironically, he had begun to receive official recognition (he was made a Knight of St Olav in 1908) at the very time when the most creative part of his career was ending. He remained extremely productive for the rest of his life, his favourite subjects in his later years including landscapes and scenes of workmen. Occasionally he rekindled some of the passion and profundity of his earlier days, as in the last of his numerous self-portraits, *Between the Clock and the Bed* (1940–42, Munch Museum, Oslo), in which he shows himself old and frail, hovering on the edge of eternity. His final years were marred by trouble with his eyesight and by the German invasion of Norway in

1940 (earlier his art had been declared *degenerate by the Nazis). At his death he left the huge body of his work still in his possession to the City of Oslo: about 1,000 oils, 4,500 watercolours, 15,000 prints, and six sculptures. The remarkable state in which he left his house is described in Sigurd Willoch's book on Munch's etchings (1950): 'The interior had a wondrous appearance and in no way resembled a house inhabited by an ordinary mortal. Munch lived in a few sparsely furnished rooms, as if he had not really moved in and was just a passing visitor . . . On the top floor of the main building, in rooms that had obviously not been lived in for many years, were massive piles of prints: thousands upon thousands of etchings, lithographs and woodcuts . . . covered in dust and neglected.' This astonishing legacy is now housed in the Munch Museum, Oslo, which opened in 1963.

Munch ranks as one of the most powerful and influential of modern artists. His impact was particularly strong in Scandinavia and Germany, where he and van Gogh are regarded as the two main sources of Expressionism. The intensity with which he communicated mental anguish opened up new paths for art. 'Just as Leonardo da Vinci studied anatomy and dissected corpses,' he said, 'so I try to dissect souls.'

Further Reading: I. Müller-Westermann, *Munch by Himself* (2005)

Munich New Artists' Association *See* NEUE KÜNSTLERVEREINIGUNG.

Munnings, Sir Alfred (1878–1959) English painter and occasional sculptor, a specialist in subjects involving horses, which he loved passionately. He was born at Mendham, Suffolk, the son of a miller and a farmer's daughter, and trained as a lithographer, 1893–8, while studying in the evenings at Norwich School of Art. In 1903–4 he studied at the *Académie Julian, Paris. Because he had lost the sight of an eye in an accident, he was refused for combat service in the First World War, but he helped to train horses for the army and in 1917 he became an *Official War Artist for the Canadian Government. Munnings was at the height of his popularity in the inter-war years, when he cut a figure in fashionable society and was often invited to the grandest country houses to paint the owners with their horses. From 1944 to 1949 he was president of the *Royal Academy. His presidency was remarkable mainly for the speech he

made at the RA annual dinner in 1949, a typically rabid attack on 'this so-called modern art', which he characterized splenetically as 'affected juggling...damned nonsense...violent blows of nothing...foolish drolleries'. The speech was broadcast live on radio and was a national talking-point the next day as much for its colourful language as its content.

Munnings was an artist of considerable natural ability, but he became rather slick and repetitive and his continued popularity is more with lovers of horses and the countryside than with lovers of painting. His work can best be seen at Castle House, Dedham, Essex, his home from 1919, which his widow converted into a Munnings Museum. He wrote a three-volume autobiography, *An Artist's Life* (1950), *The Second Burst* (1951), and *The Finish* (1952); a one-volume abridgement appeared in 1955.

Further Reading: N. Usherwood, *Alfred Munnings 1878–1959* (1987)

Muñoz, Juan (1953–2001) Spanish sculptor and installation artist, born in Madrid. In 1970 he moved to London, where he studied at the Central School of Art and Design. He is one of the sculptors credited, alongside Antony *Gormley and Katharina *Fritsch, with re-introducing the figure into sculpture in the 1980s. He did this with slightly under-life-size figures, distanced from the viewer by monochrome and scale in a somewhat theatrical setting. The effect is that they occupy the space of the spectator, yet their interactions remain fundamentally mysterious. It is clear that the figures exist as much to reveal the space, as for their own sake. Here there is a parallel with *Minimalist sculpture. In *The Wasteland* (1987), a dwarf sits on a ledge in an otherwise empty room with elaborate illusionistic patterned flooring. Muñoz admired the Baroque and here he acknowledges both Velázquez, the great painter of dwarfs, and such masters of architectural illusionism as Francesco Borromini. *Many Times* (1999) is equally disconcerting. This is a roomful of small figures, all with the same Chinese head, who gesticulate, converse, and greet each other. It can at first be taken as a kind of celebration of human interaction until it is noted that none of the figures has feet and each is imbedded in the ground. He once said 'The representation of movement and gesture within stillness is endlessly fascinating'. Muñoz also used the uncanny

effect of things seen from below. An early series of sculptures consisted of balcony railings displayed high on the wall. The idea was developed in his final and most spectacular installation, *Double Bind* (2001), in the Turbine Hall at Tate Modern, in which figures were suspended in space. Muñoz also made a sound piece with the composer Gavin Bryars and worked on written texts with John *Berger. He died suddenly while on holiday in Ibiza.

Further Reading: S. Wagstaff, *Juan Muñoz* (2008)

Münster Sculpture Project Event which has taken place every ten years since 1977 in Münster, a university town in north-west Germany, in which artists are invited to work in public spaces. The results tend to be site-specific installations rather than sculpture in the traditional sense. For instance, in the first event Michael *Asher arranged for a caravan to be parked in various places: it was a typical gesture by this artist to make a work which was barely perceptible as art. Other artists who took part in 1977 included Carl *Andre, Joseph *Beuys, Richard *Long, Claes *Oldenburg, and Richard *Serra. In 2007 the most impressive contribution was generally found to be Guillaume *Bijl's buried cathedral spire.

Münter, Gabriele (1877–1962) German painter, born in Berlin. She was a talented pianist before she took up painting. In 1902 she became a pupil of *Kandinsky at the *Phalanx School in Munich and she was his lover until the First World War parted them in 1914 (he returned to Russia; she went to Switzerland). With Kandinsky and *Jawlensky she helped to found the *Neue Künstlervereinigung München in 1909 and she contributed to many of the most significant avant-garde exhibitions in Germany up to the First World War, including both *Blaue Reiter exhibitions. After the war she travelled a good deal before settling in Murnau (where she had previously lived with Kandinsky) in 1931. Their relationship had often been a difficult one (Kandinsky felt guilty because he was married and could not obtain a divorce), but she revered him as a man and artist: 'He was a holy man...He loved, understood, treasured, and encouraged my talent.' Stylistically, however, her work is closer to Jawlensky. Landscape was her chief subject. She lived a secluded life after her return to Murnau, but in 1957, to mark her

80th birthday, she presented 120 paintings by Kandinsky (as well as sixty of her own and many by other leading contemporaries) to the city of Munich. This superb collection is now in the Lenbachhaus.

Murakami, Takashi (1962–) Japanese artist, born in Tokyo. He studied traditional Japanese painting and he now lives and works in New York and in Japan. He has developed a distinctively Japanese version of *Pop art which he calls 'Superflat', based on *otaku* culture. (This is the contemptuous Japanese equivalent for the 'geek' who stays at home obsessed with manga comic books.) This is a controversial strategy in Japan, where the phenomenon is associated with anti-social behaviour, but Murakami has achieved, as he intended, a high degree of success in the West. His art is based on the invention of a range of characters: the best known is Mr DOB. He makes large-scale sculptures and paintings for collectors but also markets his ideas through inexpensive products like mouse pads and key rings. Somewhere between is his work with the upmarket fashion brand Louis Vuitton. Like *Warhol, Murakami has his own factory, in the suburbs of Tokyo, which employs artists as well as dealing with production, but, very unlike Warhol's establishment, this is a genuinely industrialized affair.

Further Reading: M. Darling, 'Plumbing the Depths of Superflatness', *Art Journal*, vol. 60, issue 3 (2001)

Murphy, Gerald (1888–1964) American painter. Murphy was born in Boston, the son of a successful leather and luggage merchant. In 1921 he moved to Paris, discovered modern art when he saw an exhibition at the Paul *Rosenberg gallery, and decided to become a painter. He took lessons with Natalia *Goncharova, through whom he met *Diaghilev, who commissioned him to repaint scenery for his Ballets Russes that had been damaged in a fire. Among the other leading figures whom he knew in the art world were *Braque, *Léger (who became a close friend), and *Picasso. Murphy shared with Léger an enthusiasm for machine-made objects and strong, flat forms, and between 1924 and 1929 he painted a number of bold, schematized images of objects such as pens, matchboxes, and safety razors that have something in common with *Purism but seem closer in spirit to *Pop art, which they anticipate by a generation (*Razor*, 1924, Dallas Museum of Art). In 1929, however, Murphy stopped painting because of problems with his children's health, and in 1932 he returned to the USA to help the family firm through the difficulties of the Depression. Some of his paintings remained in storage in Europe until after the Second World War and his work was more or less unknown until an exhibition of it was held at the Dallas Museum of Fine Arts in 1960.

Further Reading: C. Tomkins, *Living Well is the Best Revenge* (1971)

Murray, Elizabeth (1940–) American painter and printmaker, born in Chicago. She studied at the Art Institute of Chicago, 1958–62, and Mills College, Oakland, California, where she took an MFA degree in 1964. After working as a teacher in Buffalo (where she also set up a print workshop), she settled in New York in 1967. In the early 1970s her work became abstract, and from 1976 she began to use *shaped canvases, a format that she has made her own. She has not only used unusual irregular shapes, but also taken the idea further into pictures made up of multiple canvases, sometimes in overlapping, interlocking layers and sometimes arranged in patterns like jigsaws in which the pieces do not quite fit: *Painter's Progress* (1981, MoMA, New York) is made up of nineteen parts. She says of such works 'I want the panels to look as if they had been thrown against the wall, and that's how they stuck there', but in spite of the energy and seeming spontaneity of her work, she plans it very carefully, making full-scale preparatory drawings. Typically her paintings are large and exuberant, often brilliantly coloured. At first glance they usually look purely abstract, but they often contain figurative elements. Murray has also produced coloured lithographs.

Musée d'Art Moderne de la Ville de Paris Paris's municipal collection of 20th-century art, opened in 1961 in a wing of the Palais de Tokyo on the right bank of the Seine. This building was erected for the 1937 World Exhibition and one of the highlights of the museum is *Dufy's decorative scheme *The Spirit of Electricity*, painted for the Pavilion of Light at this exhibition. The permanent collection is rich and varied, reflecting artistic developments in Paris from *Fauvism onwards. The museum has a high reputation for its temporary exhibitions both of contemporary art, usually shown on the top floor, and of earlier phases of

modernism. A showing of *Bonnard held in 2006 to mark the reopening of the museum after a period of closure for restoration work was especially successful. The dramatic curved spaces of the museum have been employed with notable effect to display the work of artists who work on a large scale, such as Dan *Flavin (2006) and Kara *Walker (2007). The museum is not to be confused with the Musée National d'Art Moderne, which was originally housed in another wing of the Palais de Tokyo and is now part of the *Pompidou Centre.

Musée National d'Art Moderne, Paris.
See POMPIDOU CENTRE.

Museum of Contemporary Art, Chicago.
Museum founded in 1967 by a group of art lovers in Chicago who thought that the city's major gallery, the Art Institute, gave insufficient representation to modern art. It opened that year in a turn-of-the-century building in East Ontario Street that was originally a bakery and had later been the home of Playboy Enterprises. The building was modernized and the exterior was embellished with a large copper frieze by Zoltan *Kemeny. In 1977 the museum expanded into an adjacent building, and in 1996 it moved to a large new building designed by the German architect Josef Paul Kleinhues in a park-like setting near Lake Michigan. The museum was established to cover 'the untried, the unproved, the problematical, and the controversial' in art, and from the first has mounted a broad-ranging exhibition programme covering diverse fields. It has also built up a large permanent collection.

Museum of Contemporary Art (MOCA), Los Angeles.
Museum devoted to art since 1940, opened in 1979. Pontus *Hulten was the first director. The founders and benefactors have included several prominent local collectors of modern art. In 1983 the museum moved into temporary accomodation in a large warehouse converted by the American architect Frank Gehry, and in 1986 into its present home—a striking *Postmodernist building by the Japanese architect Arata Isozaki. It has a large permanent collection, particularly rich in American art, and also holds temporary exhibitions. Other exhibitions are held in the warehouse building, which is now an adjunct of the main museum and was first known as Temporary Contemporary (in 1996 it was renamed Geffen Contemporary in

honour of the recording executive David Geffen, who gave $5 million to the museum). Its size and uncluttered spaces make it particularly suitable for displaying large works.

Further Reading: R. Hughes, 'Getting the Map', *Time* (24 June 2001)

Museum of Living Art, New York. See GALLATIN, A. E.

Museum of Modern Art (MoMA), New York.
The world's pre-eminent collection of visual arts from the late 19th century to the present day. It was founded in 1929 by a group of seven well-connected art lovers, among whom were Lillie P. *Bliss and Abby Aldrich *Rockefeller. In May 1929 they formed a committee, and in summer of the same year they appointed a director (Alfred H. *Barr—an inspired choice), rented premises in the loft of an office building on Fifth Avenue, and issued a brochure entitled *A New Art Museum*, which set out some of their aims. Their immediate purpose was to hold 'some twenty exhibitions during the next two years', but the ultimate objective was 'to acquire, from time to time, either by gift or purchase, the best modern works of art . . . It is not unreasonable to suppose that within ten years New York, with its vast wealth, its already magnificent private collections and its enthusiastic but not yet organized interest in modern art, could achieve perhaps the greatest museum of modern art in the world.' Barr was even more ambitious in his plans (and amazingly clear-sighted in the way he envisioned the future broad scope of the collection): he proposed that 'In time the Museum would probably expand beyond the narrow limits of painting and sculpture in order to include departments devoted to drawings, prints, and photography, typography, the arts of design in commerce and industry, architecture (a collection of *projets* and *maquettes*), stage designing, furniture and the decorative arts. Not the least important collection might be the *filmotek*, a library of films.' This vision of the functions of a museum of modern art was far-seeing. The idea that all of these activities might be part of the remit of such an institution is now found elsewhere, but it was unknown at the time and was very much a reflection of *Bauhaus ideals.

In October 1929 the seven founders held their first formal meeting as trustees; the industrialist A. Conger Goodyear (1877–1964)

was elected president, Miss Bliss was vice-president, and Mrs Rockefeller was treasurer. Later in the same month, seven more trustees were elected, including Duncan *Phillips. The museum's first exhibition, '*Cézanne, *Gauguin, Seurat, Van Gogh', opened on 8 November, accompanied by a catalogue illustrating almost all of the 101 works on show. The exhibition was a great success, attended by 47,000 people in its four-week run, with 5,400 packing the galleries on the last day (the landlord of the building threatened to cancel the lease because the crowds were clogging the elevators). By the end of the year the museum had also bought its first acquisitions—eight prints and a drawing—and Goodyear had presented the first sculpture to enter the collection, a nude torso by *Maillol. The first painting acquired by the museum was *Hopper's *House by the Railroad* (1925), given by Stephen C. Clark, one of the trustees, early in 1930. A trickle of other gifts followed, but the core of the permanent collection was established by Lillie Bliss's bequest at her death in 1931. (The phrase 'permanent collection' was abandoned in 1941 in favour of 'museum collection', as it was the policy to sell works that were regarded as surplus in order to raise funds.)

In 1932 the museum moved to larger premises at 11 West 53rd Street. The collection was at this time growing slowly during the Depression years, but in 1935 it was given its first purchase fund by Abby Aldrich Rockefeller, one of her many benefactions to the museum. In 1937 it moved temporarily to the Rockefeller Center to allow the construction of a new building at the site in West 53rd Street (this remains the museum's home, but it has since expanded enormously in size in various stages). In 1939 the new premises opened and the museum celebrated its 10th anniversary with an exhibition entitled 'Art in Our Time', in which all its departments were represented: Painting and Sculpture, Drawings and Prints, Architecture, Industrial Design, Posters, Film, and Photography. Among the exhibits was *Picasso's recently acquired *Les Demoiselles d'Avignon*, now the most famous work in the collection. The catalogue of the exhibition recorded that in its first decade the museum had held 112 exhibitions attended by about one-and-a-half million people. By this time the balance of its collections and activities had moved strongly from 19th-century to 20th-century art: in the words of the 'Art in our Time' catalogue, 'our aim has been to present to the public the living art of our own time and its sources'.

In 1943 the museum announced that Barr had resigned as director 'to devote his full time to writing the works on modern art which he has had in preparation and which heavy directorial duties have made it impossible for him to undertake'; however, he continued to work at the museum until his retirement in 1967, first as director of research and then from 1947 as director of museum collections (the varied titles are somewhat confusing; there was no overall director again until 1949, the Museum being run in the intervening period by a committee, and Barr remained MoMA's dominant presence). Another distinguished scholar of modern art, James Thrall *Soby, was briefly director of the department of painting and sculpture, 1943–5.

In 1947 MoMA came to an arrangement with the Metropolitan Museum, New York, whereby it was to sell to the Metropolitan 'paintings and sculptures which the two museums agree have passed from the category of modern to that of "classic"', with the proceeds being used to buy new works for MoMA. In 1953, however, the board of trustees announced a change of policy, described by Barr as follows: 'A permanent nucleus of "masterworks" was to be selected under the supervision of the Board. In accordance with this new policy, the 1947 agreement with the Metropolitan Museum was terminated; the Museum of Modern Art would no longer sell . . . its "classical" paintings in order to purchase more "modern" works. Instead it would permanently place on view masterpieces of the modern movement beginning with the latter half of the nineteenth century.'

In 1953 MoMA added the Abby Aldrich Rockefeller Sculpture Garden, designed by the celebrated architect Philip Johnson (1906–2005), who had two periods in charge of the museum's Department of Architecture and was also a generous benefactor of works of art from his own collection. Johnson remodelled the sculpture garden in 1964 when he added a new east wing to the museum. In 1966 MoMA was again greatly enlarged when it took over the adjacent premises formerly occupied by the *Whitney Museum. When Alfred Barr retired the following year, MoMA had become such a huge institution that it employed more than 500 people. In 1976 it announced plans for a new west wing. To help finance this it sold the air rights over the

museum to a property developer, who built an apartment block—Museum Tower—over the new wing, which was opened in 1984. In 1996 MoMA bought adjacent land for further expansion. The new Rockefeller building was opened in November 2006, doubling the former capacity of the museum.

The history of the museum has been marked by debate as to how far it has sought (or should seek) to influence the development of art. In 1944 Soby wrote an article for *Museum News* explaining MoMA's acquisitions policy, defending the museum against the charge of being insufficiently supportive of American artists: 'it should be remembered that the Museum does not exist for the direct benefit and patronage of artists. We do not consider it our job to force contemporary art in one direction or another through propaganda or patronage, much as enthusiasts for a particular dogma would like to have us do. For in the final analysis it is not our job to lead artists, but to follow them—at a close yet respectful distance.' In spite of such robust words of defence, as MoMA grew in size and prestige, its power to make reputations was generally acknowledged. Alexander *Calder, for example, wrote in 1966 that 'I have long felt that whatever my success has been' was 'greatly as a result of the show I had at MoMA in 1943'.

For some later critics of MoMA the issue was not simply one of the influence of the institution but the influence on it of private finance. It can be argued that the view of modern art presented by the museum, depoliticized, *formalist, and the handmaid of developments in industry, is closely related to the interests of its wealthy sponsors like Goodyear and the Rockefellers, anxious to appear progressive and internationalist in outlook but fearful of any fundamental social and political change which would threaten their status. A notable example was the 'Fantastic Art, Dada, and Surrealism' exhibition of 1936, which represented two of the most revolutionary and subversive tendencies in early 20th-century culture as instances of artistic fantasy.

An influential and controversial aspect of the museum's activities has been its international programme. It was responsible for an exhibition of American art shown in Paris in 1938 which was generally considered derivative by the French critics. The programme became overtly politicized during the Second World War when the museum organized cultural exhibitions in Latin American countries which sought to controvert 'elements in Central and South America who are doing their best to minimize the achievements and the potentialities of the United States'. In 1952, with funds provided by the Rockefeller Foundation (Nelson Rockefeller was also the President of the Board of Trustees), a programme was initiated to exhibit works by contemporary American artists abroad. The context of this was that in the post-war era, modern art had become increasingly a means of achieving national prestige. For instance there had been the success of Henry *Moore at the Venice *Biennale in 1948. In most countries there was government support for showing contemporary art overseas as an instrument of foreign policy, but this was not the case in the USA. In part this was the result of the State Department's mistrust of 'experimental art' and especially its suspicion as to the political allegiances of some modernist artists. The MoMA programme was designed to counteract this and it did so successfully. By the 1950s a degree of state support was underwriting the programme and there was the full co-operation of embassies. It was under the auspices of MoMA that the major exhibition 'The New American Painting', which showed the work of the *Abstract Expressionists, toured Europe in 1958–9. The implicit political agenda of this exhibition, to demonstrate American freedom at the height of the Cold War, has been the subject of much comment since, although the decision to concentrate on these painters was principally the result of negative responses to earlier American art, which, for many years had been considered to be provincial and inferior to Europe. In terms of sheer public impact, however, 'The New American Painting' was outdone by the photography exhibition 'The Family of Man', organized by Edward *Steichen. First shown in 1955, by 1960 it had been seen by over seven million people in twenty-eight countries. Like the exhibition of painting, this event has been viewed subsequently as highly political, the 'sense of kinship with all mankind' suggested as the message of the show in Nelson Rockefeller's preview address in fact promoting 'a benign view of an American world order stabilized by the rule of international law' (Sekula).

Further Reading: J. Elderfield (ed.), *The Museum of Modern Art at Mid-Century* (1994)

A. Sekula, 'The Traffic in Photographs', in B. Buccloch et al., *Modernism and Modernity* (1983)

A. Wallach, 'The Museum of Modern Art: The Past's Future' in Frascina and Harris (1992)

Museum of Modern Art, Oxford. *See* MODERN ART OXFORD.

Museum of Modern Art, San Francisco. *See* SAN FRANCISCO MUSEUM OF MODERN ART.

Museum of Modern Art, Stockholm. *See* MODERNA MUSEET.

Museum of Modern Art and Design of Australia, Melbourne. *See* ANGRY PENGUINS.

Museum of Modern Art at Heide, Bulleen, Victoria. *See* ANGRY PENGUINS.

Museum of Modern Western Art, Moscow. *See* SHCHUKIN, SERGEI.

Museum of Non-Objective Art, New York. *See* GUGGENHEIM, SOLOMON R.

'Museum without Walls' *See* MALRAUX, ANDRÉ.

Music, Zoran (1909–2005) Slovenian/Italian painter and printmaker, born in Gorizia on the border between Slovenia and Italy. He described himself as being 'of no fixed abode'. In travels over Europe he encountered the works of El Greco, *Klimt, and *Schiele. As a consequence of the Civil War, he left Spain and settled in Dalmatia, where the dusty landscapes profoundly affected his later work, and moved to Venice in 1943. He was arrested and tortured by the Gestapo for political reasons (he was not Jewish), and sent to Dachau concentration camp, where he made a number of drawings. After being liberated, he repeated these with expressive emphasis. As Ziva Amishai-Maisels points out, the most shocking feature of these drawings is that the corpses 'sometimes seem to be still alive, they establish eye contact with the spectator'. After the war Music divided his time between Paris and Venice, achieving considerable international success with semi-abstract landscapes, usually in a fairly restricted range of browns and greys, sometimes with a strong folk art quality. In the 1970s he embarked on a series entitled *We Are Not the Last*, which drew on his experience of the Holocaust. These are not purely documentary works.

The corpses no longer lie on the ground but rise up to confront the spectator, as if it is no longer enough for the artist to represent what has happened. Instead the artist must call on humanity to change its ways.

Further Reading: Z. Amishai-Maisels, 'The Complexity of Witnessing', in M. Bohm-Duchen, *After Auschwitz: Responses to the Holocaust in Contemporary Art* (1995)
M. Estorik, obituary, *The Independent* (28 June 2005)

Myers, Jerome (1867–1940) American painter and etcher, born in Petersburg, Virginia, into a poor family. He spent his youth in Philadelphia and Baltimore, working at various odd jobs, then in 1886 settled in New York, where he worked as a theatrical scene painter for the next three years whilst studying in the evenings at the Cooper Union and the *Art Students League. During the 1890s he worked for an engraving company and in the art department of *The New York Tribune*, and he visited France in 1896. He began to paint in 1900, encouraged by the art dealer William Macbeth, at whose gallery he had his first one-man show in 1908. Myers's most characteristic works depict city slums, and he was one of the first American artists to paint such scenes. His own deprived background had given him sympathy for slum dwellers (his friend and fellow painter Harry Wickey (1892–1968) wrote that he 'enjoyed nothing so much as being in their midst'), but he portrayed them in a picturesque, romanticized way rather than in a spirit of *Social Realism. He was one of the founder members of the Association of American Painters and Sculptors, which organized the *Armory Show in 1913, but he was uninfluenced by the modern art that was shown there, continuing to work in the same style throughout his life. By the end of his life his work looked distinctly nostalgic, and in 1940, shortly before his death, he commented 'Something is gone. Something is missing. I say to myself, "It is the warmth of human contact; that's what it is. It is gone. Men and women and children hide behind the walls of their homes." New Yorkers no longer live in the open.' His autobiography, *Artist in Manhattan*, was published in 1940.

Nabis A group of painters, mainly French, active in Paris in the 1890s; their outlook was essentially *Symbolist and they were particularly influenced by *Gauguin's expressive use of colour and rhythmic pattern. Sources disagree as to whether the poet Henri Cazalis or the critic Auguste Cazalis coined the name; it derives from *neebin*, the Hebrew for 'prophets', so indicating the members' missionary zeal and their interest in the occult and mystic. *Sérusier, who met Gauguin at Pont-Aven in 1888, was the driving force behind the group and with *Denis was its main theorist. Other members included *Bonnard, *Maillol (before he turned to sculpture), Ranson (*see* ACADÉMIE), *Roussel, *Vuillard, the Hungarian József Rippl-Rónai (1861–1927), the Swiss *Vallotton, and the Dutchman Jan Verkade (1868–1946). They were active in design (of posters, stained glass, and theatrical decor) and book illustration as well as painting. Group exhibitions were held between 1892 and 1899, after which the members gradually drifted apart. Several of them, however, continued Nabis ideas into the 20th century, notably Denis and Sérusier, whose work remained esoteric in spirit and bound up with their religious beliefs. (Verkade was even more devout, entering a Benedictine monastery in Germany in 1894 and being ordained in 1902, after which he was known as Dom Willibrod Verkade; he continued to paint fairly regularly up to the First World War.) Bonnard and Vuillard departed radically from Nabis ideas in the quiet *Intimiste scenes for which they became chiefly famous, but their later decorative work sometimes retained a feeling for flat pattern that recalls their Nabis days.

Further Reading: C. Fréches-Tory and A. Terrasse, *The Nabis* (2002)

Nadelman, Elie (1882–1946) Polish-born sculptor and draughtsman who became an American citizen in 1927. After brief studies in his native Warsaw and in Munich he settled in Paris in 1903 or 1904 and lived there until 1914. Initially he was influenced by *Rodin, but he soon became interested in more avant-garde trends and he later claimed that in some of his work (particularly drawings) of around 1906–7 he had anticipated *Picasso in the diffraction of forms typical of *Cubism. He knew many leading members of the Parisian avant-garde (including *Apollinaire, *Brancusi, Picasso, and the *Steins), and his early patrons included Helena Rubinstein (1870–1965), the Polish-born cosmetics manufacturer and art collector. His first one-man exhibition was at the Galerie Druet, Paris, in 1909. With the outbreak of the First World War he moved to London and then New York, helped by Madame Rubinstein, who commissioned him to make sleek marble heads for her beauty salons.

Nadelman already had a considerable reputation when he arrived in America and his first one-man show there (at *Stieglitz's gallery in 1915) was a great success. Within a short time he was well established in the New York art world, his friends including Paul *Manship and Gertrude Vanderbilt *Whitney. He married a wealthy widow in 1919 and they lived in some style, with a town house in Manhattan and an estate at Riverdale, New York State. They also spent lavishly collecting American folk art. Nadelman's work has a witty sophistication appropriate to the high society world in which he moved, as with *Man in the Open Air* (1915, MoMA, New York), a delightful bowler-hatted bronze figure in a pose mimicking ancient Greek sculpture. With his humour went a bold simplification and distortion of forms (akin to those of *Lachaise) that place him among the pioneers of modern sculpture in America. The Depression had a disastrous effect on his market (he had to sell the house in Manhattan) and his career virtually ended when a good deal of his work was accidentally destroyed in 1935. He was already leading a reclusive life by this time, but during the Second World War he taught

ceramics and modelling at the Bronx Veterans' Hospital. Two years after his death there was a major exhibition of his work at the Museum of Modern Art, New York.

Further Reading: L. Kirstein, *Elie Nadelman* (1973)

Nagare, Masayuki (1923–) Japanese abstract sculptor. He was born in Nagasaki, the son of a distinguished statesman, and had a samurai upbringing; his interest in martial arts led him to study with a swordsmith, laying the foundations of the understanding of materials and superb craftsmanship that he later displayed in his sculpture. He served as a fighter pilot, 1943–5, and in the aftermath of the Second World War he led a wandering life for about a decade, associating with artists, including writers and potters. During this time he produced pottery himself and developed a passion for stone by visiting war-scarred graveyards and re-erecting fallen tombstones. In 1955 he had his first one-man exhibition at the Mimatsu Gallery, Tokyo, dedicating it to the memory of American and Japanese pilots killed in the war. The sculptures he showed here were in metal and wood, but he took up stone carving the following year. From 1958 his work began to attract American collectors visiting Japan (*see* ROCKEFELLER), and he had his first great success with a 600–ton stone wall entitled *Stone Crazy* for the Japanese Pavilion at the 1964 New York World's Fair. Its popularity with critics and public alike encouraged him to spend most of the next decade in the USA, where his work included the well-known *Cloud Fortress* (1969–75) in the plaza outside the World Trade Center, New York, consisting of two gigantic triangular clusters in black granite. It was destroyed as a result of the terrorist attack on 11 September 2001.

Disillusioned with American involvement in Vietnam, Nagare has reaffirmed his identity as an Asian and from 1975 he has worked mainly in Japan, where he has carried out numerous major commissions and is recognized as one of the country's outstanding artists. His sculpture is abstract but often evokes the human figure or other forms, such as the sharp edges and subtle curves of samurai sword blades. Most characteristically he works in granite, polished to mirror smoothness; often he contrasts sleek shapes with raw, rough surfaces, and he has also used other materials, including bronze and steel, with a similar feeling for their own special qualities.

naive art Term applied to painting (and to a much lesser degree sculpture) lacking conventional expertise in illusionistic skills but produced in the context of cultures in which such skills constitute the professional norm. Colours are characteristically bright and non-naturalistic, perspective non-scientific, and the vision childlike or literal-minded. The term *'primitive' is sometimes used synonymously with naive, but this can be confusing, as 'primitive' is also applied loosely to paintings of the pre-Renaissance era as well as to, highly contentiously, the art of certain cultures (*see* PRIMITIVISM). Other terms that are sometimes used in a similar way are 'folk', 'popular', or 'Sunday painters', but these too have their pitfalls, not least 'Sunday painter', for many amateurs do not paint in a naive style, and naive artists (at least the successful ones) often paint as a full-time job. Sophisticated artists may also deliberately affect a naive style, but this 'false naivety' (*faux naïf*) is no more to be confused with the spontaneous quality of the true naive than the deliberately childlike work of say *Klee or *Picasso is to be confused with genuine children's drawing.

Naive art, as the term is now generally understood, developed in the 19th century (before then, pictures that have a naive quality might more reasonably be classified as folk art or simply as amateurish works) and the first notable exponent was perhaps the American Edward Hicks (1780–1849), famous for his religious scenes (he was a Quaker preacher). It was not until the early years of the 20th century, however, that a vogue for naive art was established. Henri *Rousseau was the first naive painter to win serious critical recognition and many others have won an honourable place in modern art. The first significant collector of naive art was the French humorous writer Georges Courteline (1858–1929), whose collection in his Paris home was illustrated in the satirical magazine *Cocorico* in August 1900. However, it was the critic Wilhelm *Uhde—in the years after the First World War—who was mainly responsible for putting naive painters on the map. At first their freshness and directness of vision appealed mainly to fellow artists, but a number of major group exhibitions in the 1920s and 1930s helped to develop public taste for them: they included the exhibition of Courteline's collection at the Galerie *Bernheim-Jeune, Paris, in 1927; 'Maîtres Populaires de la Réalité', shown at the Salle Royal, Paris, in 1937 and then at the

Kunsthaus, Zurich; and 'Masters of Popular Painting: Modern Primitives of Europe and America' at the Museum of Modern Art, New York, in 1938.

Most of the early naive painters to make reputations were French (mainly because Uhde was active in discovering and promoting them in France): they included *Bauchant, *Bombois, Jean Eve (1900–68), Jules Lefranc (1887–1972), Dominique Peyronnet (1872–1943), René Rimbert (1896–1991), *Séraphine, and *Vivin. By the middle of the century, however, most countries had their share of such painters. They included the Belgian Léon Greffe (1881–1949), the German *Paps, the Greek *Theophilos, the Italian Orneore *Metelli, the Pole *Nikifor, the Spaniard Miguel *Vivancos, and the Swiss Adolf Dietrich (1877–1957). In Britain Alfred *Wallis was an inspiration for the modernist painters Ben *Nicholson and Christopher *Wood and more recently Beryl *Cook achieved enormous popular and commercial success. L. S. *Lowry is often claimed as a naive painter, but he had many years of professional training and even in 'naive' works he can betray the signs of a highly sophisticated draughtsman. In the USA the leading figures include Morris *Hirschfield, John *Kane, Grandma *Moses, and Horace *Pippin. Haiti is noteworthy in that naive painting has been the country's central tradition in 20th-century art, the leading figures including Wilson *Bigaud, Hector *Hyppolite, and Pierre Monosiet (1922–83), who was first director of the Musée d'Art Haitien in Port-au-Prince from 1972 until his death. The richest crop of naive painters, however, has been in the former Yugoslavia (mainly Croatia), Ivan *Generalić being the most famous figure (*see also* HLEBINE SCHOOL). A Gallery of Primitive Art was founded in Zagreb, the capital of Croatia, in 1952, and there are other museums in the country specializing in naive art.

The Yugoslavian painters are unusual in that they have concentrated around four main centres: Hlebine, Kovačica, Oparić, and Uzdin. In many other countries, naive painters have worked in isolation from each other and from the orthodox art production around them. They are extremely diverse in both their habits and their work. Some have shown an interest in painting since childhood, others have taken it up in middle age or late in life. From necessity or choice many of them have been spare-time artists, painting for their own pleasure while earning a living by other means. Many have been interested primarily in depicting scenes and incidents from the daily life around them. These have often given great attention to realistic detail, rendering each feature with painstaking precision, whether or not it could in actuality be so seen within the image as a whole. Others have given free rein to imagination and fantasy, sometimes with an almost surreal effect. The traditional principles of perspective usually go by the board, although many naive artists are capable of rendering distance and depth by their own means. So-called 'psychological' perspective is a prominent feature of much naive painting, the relative size of figures and objects being determined by psychological interest without regard to natural proportions. As in the case of Rousseau, naive painters have often been admired for qualities in their work of which they themselves were unaware. If it is possible to point to any quality which the best naive work has in common with that of sophisticated artists, it is a power of pictorial construction and a power to invest the depiction of the commonplace and familiar with poetic freshness. The cult of naive painting, however, has perhaps led to the overrating of much work, for the truly outstanding naive painter is probably as rare as the truly outstanding artist in any other field. When their work acquires financial value, there is the danger—as happened to some extent in Yugoslavia during the late 1960s—that naive painters begin to repeat themselves, with a consequent loss of spontaneity in their work. There is no very clear dividing line between naive art and *Art Brut or outsider art, but the latter two terms tend to be identified with work which is more subversive of the existing order and made by artists who are personally nonconformists.

Further Reading: O. Bihalji-Merin, *World Encyclopedia of Naive Art* (1984)

Nakanishi, Natsuyuki *See* HI-RED CENTER.

Nakian, Reuben (1897–1986) American sculptor, born at College Point, New York, the son of Armenian immigrant parents. He studied at several art colleges before being apprenticed to Paul *Manship, 1917–20. In Manship's workshop he became friendly with Gaston *Lachaise and they shared a studio in the early 1920s. At this time Nakian worked in a polished traditional style and in the 1930s he

was particularly known as a portraitist. During the Second World War he confined himself mainly to drawing, and when he returned to sculpture in earnest in about 1947 it was with a radically changed style. Influenced by his friend Arshile *Gorky, he became one of the sculptors (others were *Lassaw, *Lipton, and *Roszak) who created a kind of three-dimensional version of *Abstract Expressionism. Typically he used cloth stretched on chicken wire and dipped in plaster or glue, creating rough, sensuous textures. Later he had his works cast in bronze and sometimes added elements in welded steel. Often he based his work on mythological themes, but retained only vague suggestions of figurative elements (*Goddess of the Golden Thighs*, 1964–5, Detroit Institute of Arts). Much of his work is on a large scale, intended for outdoor display.

Namuth, Hans *See* ACTION PAINTING.

Narkompros (NKP) A cultural organization founded in Soviet Russia in 1917 shortly after the October Revolution; the word is an abbreviation of *Narodny Komissariat Prosveshcheniya* (People's Commissariat for Enlightenment). Narkompros was directed by the writer and politician Anatoly Lunacharsky (1875–1933) and was in charge of general cultural and educational policy. It contained several sections, including a Visual Arts Section called IZO Narkompros; this was headed by the painter David Shterenberg (1881–1948), who was based in Petrograd (St Petersburg), assisted by *Tatlin in Moscow. IZO organized a series of state exhibitions (twenty-one between 1918 and 1921), administered the new art schools (*Svomas/*Vkhutemas) and research institutes (*Inkhuk), and was involved in public commissions. Many avant-garde artists and critics were involved with IZO Narkompros in one way or another. In 1918–19 it published its own journal, *Iskusstvo kommuny* (Art of the Commune), the contributors including *Altman, *Malevich, *Pougny, and *Punin. Narkompros also contained sections devoted to the cinema (FOTO-KINO), literature (LITO), music (MUSO) and the theatre (TEO). In the early years, partly because of Lunacharsky's tolerance and liberalism, Narkompros maintained a fairly independent stance, but by the late 1920s (especially after Lunacharsky's departure in 1929) it had become part of the Communist apparatus.

Narrative Figuration *See* POP ART.

Nash, David (1945–) British sculptor, born in Esher, Surrey. He has lived and worked in Blaenau Ffestiniog, north Wales, since 1967; initially he moved because of the cost of living in London. In 1969 he bought a disused chapel as a studio and began working with fallen wood from the nearby forest. He works on this before it has been seasoned so that cracks can appear after the sculptor has completed his work. The material is not only carved but chopped and twisted into shape; he has described the cracks as 'rather like smiles, revealing more about themselves'. In 1977 he planted his *Ash Dome*, a work which has grown into shape in the years since. In a 1978 interview he said, 'I'll have to work on the dome four or five times over a period of 40–50 years, but then let it go...My own demise will take care of that.' Another long-term work is the *Wooden Boulder*. Originally carved from an oak tree which had to be felled for safety reasons, it was rolled by the sculptor into a river. Nash then charted its transformations; it became more like an actual boulder in appearance, as it moved down the river. It was finally sited on a sandbank in 2003. He now assumes that it has found its way to the sea.

Further Reading: J. Andrews, *The Sculpture of David Nash* (1999)

Nash, Paul (1889–1946) English painter, book illustrator, writer, photographer, and designer, born in London, the son of a barrister. Nash was one of the most individual British artists of his period, taking a distinguished place in the English tradition of deep attachment to the countryside (he saw himself as a successor to Blake and Turner) whilst at the same time responding imaginatively to European modernism. The most important part of his training was at the *Slade School, 1910–11, after which he worked briefly for Roger *Fry's *Omega Workshops. At the outbreak of the First World War he enlisted with the Artists' Rifles and in 1917 was posted to the front at Ypres. He was invalided out after a few months, but he returned to France the same year as an *Official War Artist (a result of the success of his exhibition 'Ypres Salient' at the Goupil Gallery, London, 1917). The paintings he produced include some powerful views of the pitted and shattered landscape of No Man's Land that rank among the most famous images of the conflict (*We Are Making a New World*, 1918, Imperial War Museum, London). He held a second successful exhibition, 'The

Void of War', at the *Leicester Galleries, London, in 1918, and although his later career was varied and distinguished, many critics think that his First World War paintings mark the summit of his achievement.

During the 1920s and particularly the 1930s Nash was influenced by *Surrealism (above all by *de Chirico, an exhibition of whose work he saw in London in 1928), and he often concentrated on mysterious aspects of landscape. For much of this time he lived in rural areas (Kent, 1921–5; Sussex, 1925–33; Dorset, 1934–5), basing his work on scenes he knew well but formalizing and imaginatively transforming them, sometimes almost to the point of abstraction (*Landscape from a Dream*, 1937–8, Tate). However, he continued to be involved in the London art world. As well as teaching at the *Royal College of Art, 1924–5 and 1938–40, he was the prime mover behind the formation of the avant-garde group *Unit One in 1933 and he helped to organize and exhibited in the International Surrealist Exhibition in 1936. During the Second World War he was again an Official War Artist, even though at the outbreak of war he was already very ill with the asthmatic condition that killed him. His Second World War paintings are not generally as highly regarded as those of the First, but they include one acknowledged masterpiece, *Totes Meer (Dead Sea)* (1940–41, Tate), which shows shot-down aircraft with their wings looking like undulating waves. Nash based it on a dump of wrecked planes he saw near Oxford, where he was living at this time, and he wrote that 'a pervasive force, baffled yet malign, hung in the heavy air'. His final paintings, produced when he was very weak, were of flowers.

Nash also designed scenery, fabrics, and posters, and he was considered to be one of the finest book illustrators of his day: he regarded his illustrations to an edition of Sir Thomas Browne's *Urn Burial* (1932) as his most successful work in this field. In 1936 he published a guidebook to Dorset in the Shell Guide series, and two collections of his writings appeared posthumously: *Outline* (a fragment of autobiography with some letters and essays) in 1949, and *Poet and Painter* (his correspondence with the poet Gordon Bottomley) in 1955. A collection of his photographs taken for use in his paintings was published as *Fertile Image* in 1951.

His brother **John Nash** (1893–1977) was also a landscape painter and an illustrator,

excelling in meticulous flower drawings for botanical publications. Like Paul he was an Official War Artist in both world wars. His work is well represented in Tate.

Further Reading: R. Cardinal, *The Landscape Vision of Paul Nash* (1989)
A. Causey, *Paul Nash* (1980)
J. Rothenstein, *John Nash* (1983)

National Art Collections Fund *See* CONTEMPORARY ART SOCIETY.

National Socialist art

The art endorsed and encouraged by the Nazis from 1933 to 1945—that is from the time when Hitler became Chancellor of Germany as head of the National Socialist Workers' Party of Germany (Nationalsozialistische Deutsche Arbeiterpartei) until the end of the Second World War. Hitler, who had been an unsuccessful painter in his youth, realized that art could have immense propaganda value and used it to promote the cult of his own personality as well as the Nazi ideas of Nordic racial superiority and 'Strength through Joy' (Kraft durch Freude). Hand-in-hand with this policy went the repression, ridicule, and eventually destruction of art that conflicted with Nazi ideology (*see* DEGENERATE ART).

On 15 October 1933 Hitler laid the foundation stone of a new museum, the House of German Art, in Munich, and the city celebrated with a Day of German Art. The architect of the museum was Paul Ludwig Troost (1878–1934), who was Hitler's most trusted adviser on art; after his death, Albert Speer (1905–81) became Hitler's chief architect, adapting Troost's stark, bludgeoning classicism to works on a megalomaniac scale. In April 1935 Joseph Goebbels, Hitler's propaganda minister, issued a decree bringing all artists under the jurisdiction of the Reich Chamber of Culture (Reichskulturkammer), founded in 1933, and artists were ordered to produce a 'racially conscious' popular art. Two years later Goebbels declared: 'The freedom of artistic creation must keep within the limits prescribed, not by any artistic idea, but by the political idea.'

In 1937 the House of German Art opened with an exhibition of such approved art—the Great German Art Exhibition, the first of an annual series that went on until 1944. These eight exhibitions were huge: all but one of them showed over a thousand works (the average number was about 1,200) and well over 500 artists were represented at each

one. Hitler intervened personally at the pre-view of the first exhibition, rejecting eighty pictures with the remark 'I won't tolerate un-finished paintings' and accepting works by certain artists who had previously been re-jected. He entrusted the organization of the seven exhibitions that followed to his personal photographer, Heinrich Hoffmann. Within the next few years some 20,000 officially approved paintings were disseminated to museums throughout the country, where they took the place of the degenerate works that had been purged. They were removed from public view at the end of the war, and only began to emerge again many years later.

The fact that these works were so long kept in storage indicates the strong feelings that they still arouse. Peter Adam goes so far as to describe National Socialist art 'as the artistic expression of a barbaric ideology'. Many of the militaristic pictures are certainly hard to stom-ach, but among the other genres there is much that could be closely paralleled in the academ-ic art of any other Western country (not least the discreetly salacious nudes that were seen in abundance at the Great German Art Exhibi-tions). Reviewing Adam's book, David Watkin attacked the 'astonishing crudity' of the author's view and wrote: 'what surely strikes the unbiased observer is the mild and tradi-tional character of most of the images repro-duced in his book. This is the kind of art and architecture which would have been produced in Germany in the 1930s whoever was in power.' To this one might counter that to 'normalize' the art of the Third Reich in this way is to ignore the repression of all that had been most creative in German art in the 40 years or so previous to the rise of Hitler. None-theless the uncomfortable fact remains that the policy was carried out not just by politicians but with the willing collaboration of artists. As Hans-Ernst Mittig puts it, 'Thus to the words "Never was art so oppressed" must be added "Never before were artists such oppressors"'.

Among Third Reich painters a representa-tive figure is Adolf Ziegler (1892–1959), who in 1936 was appointed president of the Reich Chamber of Visual Arts (Reichskammer der Bildenden Künste) and as such was responsi-ble for choosing the works shown in the infa-mous 'Degenerate Art' exhibition in 1937. He specialized in paintings of nudes and was nicknamed 'the master of German pubic hair'. Among sculptors, the best-known fig-ures were Arno *Breker, Georg *Kolbe, and

Josef Thorak (1889–1952), who was 'popularly nicknamed "Professor Thorax" because of his preoccupation with Herculean masculinity . . . his gigantomania inspired the story of a visitor who had asked the studio assistant about the sculptor's whereabouts, only to be told "The Herr Professor is up in the left ear of the horse"' (Richard Grunberger, *A Social History of the Third Reich*, 1971). *See also* TOTALITARIAN ART.

Further Reading: P. Adam, *The Arts of the Third Reich* (1992)

H.-E. Mittig, 'Art and Oppression in Fascist Germany', in I. Rogoff, *The Divided Heritage: Themes and Problems in German Modernism* (1991)

Nauman, Bruce (1941–) American sculp-tor, installation and *Video artist, born at Fort Wayne, Indiana. He studied mathematics, physics, and art at the University of Wisconsin, then two years' postgraduate study at the University of California, Davis, 1964–6. He has worked in an extraordinary variety of media, but there is a consistency of theme, namely, the idea of the body as object, and of tone, often highly aggressive to a point at which the spectator can feel threatened. The critic Carter Ratcliff devised the phrase 'adversary spaces' to describe the experience offered by Nauman and certain other artists like Richard *Serra. Such spaces sometimes take the form of corri-dors, for instance *Green Light Corridor* (1970, Guggenheim Museum, New York), which in-vites the viewer to pass through a twelve-inch space. Elsewhere Nauman uses closed circuit video so the viewers see their own presence. Nauman's practice was crucial to the argu-ments of Rosalind *Krauss in *Passages in Mod-ern Sculpture* (1977), against what she saw as Michael *Fried's 'idealist' opposition to 'theat-ricality' in sculpture. This kind of art was de-pendent on interaction with the viewer, unlike a *'formalist' art which purported to be based entirely on the relationships *within* the work.

As Andrew Causey points out, Nauman's work has a strong affinity with Piero *Manzoni in the preoccupation with the idea of art as a bodily trace. *Bouncing Balls* (1969) is a video of the artist bouncing his own testicles. Like Jasper *Johns and Marcel *Duchamp before him, he used casts of body parts, as in the punning *From Hand to Mouth* (1967, Hirshhorn Museum and Sculpture Garden, Washington DC). Nauman has also worked in neon light in ways that con-tradict the normal glamorously commercial as-sociations of that medium. A spiral neon reads

The true artist helps the world by revealing mystic truths (1967, Philadelphia Museum of Art). Another neon work is the crudely animated *Marching Man* (1985, Kunsthalle, Hamburg). As he raises his leg his penis rises. Elsewhere Nauman has been quite explicit in using his art as a protest against political repression. *South American Triangle* (1991, Hirshhorn Museum and Sculpture Garden) has a chair suspended upside down within a metal triangle in reference to torture and interrogation techniques. In *Anthrosocio* (1992, Kunsthalle, Hamburg), it is the spectator who suffers the indignity of being yelled at from multiple video screens by an aggressive bald-headed man. Annette *Messager said in an interview that she regarded Nauman as the most important artist in the world today: 'His images of self-torture reflect human torture in general.' His work has been seen in many major exhibitions and in 1991 he won the city of Frankfurt's Max Beckmann Prize. At the 2009 Venice *Biennale he represented the USA, which won the Golden Lion award for best national participation. Since 1979 he has lived in New Mexico.

Further Reading: A. C. Danto, 'Bruce Nauman', *The Nation* (8 May 1995)

Nay, Ernst Wilhelm (1902–68) German painter, born in Berlin, where he trained at the Academy under *Hofer, 1925–8. He visited Paris in 1928 and Rome in 1930, but more significant for his work was a trip to Norway (as a guest of *Munch) in 1937, during which he visited the Lofoten Islands, within the Arctic Circle. They inspired a series of powerful *Expressionist landscapes, with heavy brushstrokes and vivid colours, in which he first developed a personal style. His work was declared *degenerate by the Nazis and he was called up for military service in 1940, but he managed to continue to paint whilst serving in France. After the war Nay lived in Hofheim until 1951, when he settled in Cologne. By this time he was working in a completely abstract style, characteristically featuring large, freely arranged spots of sumptuous colour. By the mid-1950s Nay was regarded as one of his country's leading painters: he was prominently represented in the first three *documenta exhibitions in 1955, 1959, and 1964, and he was West Germany's representative at the Venice *Biennale in 1964.

Naylor, Martin (1944–) British sculptor whose work sometimes comes close to *installation art. He was born in Morley near Leeds and he studied at the *Royal College of Art. His solo exhibition at the Rowan Gallery, London, in 1974, which included the *Discarded Sweater* (1973, Tate) and the series entitled *Young Girl Seated by her Window*, was significant because it represented a reintroduction of a sense of the figure in sculpture through allusive references created by the mixing of sculptural form and found objects. These sculptures and other works represented a break with the abstract sculpture of *Caro and his successors, who had dominated British sculpture in the previous decade, and looked forward to the *New British Sculpture of a few years later. Naylor also made powerful use of film and photographic imagery in his work. *Important Mischief* (1976, City Art Gallery, Leeds) has a threatening blown-up photograph of a man wielding a baseball bat, with two glazed frames on each side and a collection of machine parts on the floor. Naylor now lives in Argentina, claiming disenchantment with the official British art scene. In an exhibition held in Buenos Aires in 1996, he pinned a text by the existentialist writer Albert Camus at the entrance: 'It is by a continual effort that I can create... It is how I despair and how I cure myself of despair.' Certainly the existentialist view of art (*see* SARTRE) has been consistently unfashionable in Britain both in the highly politicized 1970s and in the equally highly commercialized art world of the late eighties and after.

Further Reading: D. Cohen, 'Exile in a land of Mischief', *The Independent* (20 August 1996)

Neel, Alice (1900–84) American painter, born at Merion Square, Pennsylvania. She studied at Philadelphia School of Design for Women (now Moore College of Art), 1921–5, and after living briefly in Cuba, settled in New York in 1927. In the 1930s she worked for the *Federal Art Project and painted scenes of urban poverty, but she was principally a portraitist. She was an independent figure, unconcerned with passing fashions, and fame came to her late in life, when her stark, frontal, penetrating images suddenly attracted widespread attention. The most famous example is probably *Andy Warhol* (1970, Whitney Museum, New York), in which Warhol is seen as a frail rather than a glamorous figure, stripped to the waist exposing the scars left by the assassination attempt on him in 1968.

Further Reading: M. Walters, *The Nude Male: A New Perspective* (1979)

Negret, Edgar (1920–) Colombian sculptor. He was born in Popayán and studied at the School of Fine Arts, California, 1938–43. His career has been spent mainly in Bogotá, but he has had two periods in New York, 1948–50 and 1953–63, and in between them travelled in Europe, 1951–3. Early in his career he produced semi-abstract stone carvings in the tradition of *Arp, but in the 1950s he turned to *Constructivism, using industrial metal parts bolted together (*Coupling*, 1966, Public Gardens, Bogotá).

Neiman, LeRoi *See* WARHOL, ANDY.

Neizvestny, Ernst (1925–) Russian sculptor and graphic artist. During the years of Soviet oppression in the arts, when *Socialist Realism was the officially sanctioned style, Neizvestny was one of the leading figures in *Unofficial art. In the Second World War he joined the army at the age of sixteen and was badly wounded, an event that helped to shape his predilection for themes of life and death, as seen through the sufferings of the Russian people. Writhing forms and clenched fists are typical of his work. Following Stalin's death in 1953 there was a slight thaw in the political climate and in 1962 Neizvestny had a public confrontation with Stalin's successor Khruschev, who had denounced modern art (after Khruschev's fall from power, however, he began a friendly correspondence with Neizvestny, who designed a memorial for the former premier's grave). In 1976 Neizvestny was given permission to leave Russia; he moved to Switzerland and later settled in the USA.

Further Reading: J. Berger, *Art and Revolution: Ernst Neizvestny and the Role of the Artist in the USSR* (1969)

Nemour, Aurélie (1910–2005) French painter, born in Paris. She studied graphic design, then painting under André *Lhote and Fernand *Léger. In 1947 she began painting geometric abstracts. Her works were generally based on the square, in her view 'the noblest form'. She had her first exhibition in Paris in 1953. It was to be nearly thirty years before her paintings were seen again in the city, in the exhibition 'Paris-Paris' (1981) at the Pompidou Centre. Subsequently her reputation grew in France and she was honoured with a retrospective at the Pompidou Centre in 2004. Nonetheless she remained little known outside her own country. She gave up painting

in 1991, but still designed a public project for Rennes entitled *Alignment for the 21st Century* (completed 2004) consisting of eighty-two columns. She also designed stained glass.

Neo-avant-garde *See* AVANT-GARDE.

Neoclassicism A term that usually refers to a major revival of the ideals and forms of ancient Greek and Roman art in the late 18th and early 19th centuries, but which in the context of modern art is applied to a more limited revival of the spirit of classicism among avant-garde artists, most notably in the second and third decades of the 20th century, marking a reaction against the experimention of the early years of the century. Other terms for this phenomenon include 'the New Classicism', 'the classical revival', 'the return to order', and 'the call to order' (this last being the title of a book by Jean *Cocteau, published in 1926—*Le Rappel à l'ordre*). The first stirrings of Neoclassicism were evident even before the First World War in the sculpture of *Maillol, the late paintings of *Renoir, certain works by *Matisse, and even *Picasso in *The Painter and his Model* (1914, Musée Picasso, Paris). It was Picasso who was responsible for some of the most impressive expressions of the movement. In a number of his paintings of the early 1920s, he depicted massively grand figures, nude or in 'timeless' draperies, consciously recalling the world of antiquity (*The Pipes of Pan*, 1923, Musée Picasso, Paris). Such works have been seen partly as a response to his trip to Italy in 1917 (in the course of which he visited the Archaeological Museum in Naples), and during his 'classical period' he spent a good deal of time on the Mediterranean coast, where he felt more open to antique influence: 'It is strange, in Paris I never draw fauns, centaurs, or mythical heroes ... they always seem to live in these parts.'

Most of the other artists who were prominent in the classical revival also came from Mediterranean countries (chiefly France, Italy, and Spain), and—like Picasso—many of them spent part of their working lives on the Riviera or in other areas fairly remote from the modern industrial world, where the surroundings helped evoke the idea of an Arcadian existence free from strife. However, the 'return to order' also found expression in ways that were very different to Arcadian reverie. The *Purists, for example, attempted to combine

the classical ideals of clarity and order with a functionalist outlook appropriate to the machine age. In Italy the Fascist Party used classical imagery to foster nationalist sentiment (see NOVECENTO ITALIANO) and the ideals were promoted in the journal *Valori plastici*. Indeed some historians such as Benjamin Buccloch have seen Neoclassicism as representative of a wider political conservatism in this period. Elizabeth Cowling and Jennifer Mundy view the tendency as the product of a wider craving for stability and tranquillity after the First World War. It certainly stood for an alternative to the challenges to the traditional functions of art represented by *Dada, *Constructivism, and *Surrealism.

A further wave of Neoclassical style and imagery was a feature of the 1980s and as in the 1920s it followed a wave of experimentation when the very existence of the art object in the traditional sense seemed under attack. The painters Carlo Maria *Mariani and Stephen *McKenna were leading figures; the *Concrete poet Ian *Hamilton Finlay and the sculptures of Edward *Allington referred to classical architecture. At the time this tendency was commonly interpreted as one aspect of *Postmodernism in its rejection of the necessity of progress and willingness to quote from the past. It coincided with similar tendencies in architecture.

Further Reading: Art & Design, *The Classical Sensibility in Contemporary Painting and Sculpture* (1988)
B. H. D. Buccloch, 'Figures of Authority, Ciphers of Regression', in Frascina and Harris (1992)
Cowling and Mundy (1990)

Neo-Conceptual art See CONCEPTUAL ART.

Neo-Concrete art See CLARK, LYGIA.

Neo-Dada A term that has been applied to various styles, trends, or works that are perceived as reviving the methods or spirit of *Dada. It has been used as a synonym for *Nouveau Réalisme and *Pop art, for example, and has been applied to the work of Jasper *Johns.

Neo-Dada Organizers A group of Japanese artists based in Tokyo, active from 1960 to 1963. Those associated with it included Genpei Akasegawa (1937–), Shusaku Arakawa (1936–), and Tomio Miki (1937–78). They were essentially *anti-art in spirit, their work including violent demonstrations.

Neo-Expressionism Movement in painting (and to a lesser extent sculpture) emerging internationally at the end of the 1970s, characterized by intense subjectivity of feeling and aggressively raw handling of materials. Various other names have been applied to the movement: Energism, New Fauvism, Wild Painting; in France, Figuration Libre; in Italy, *Transavantgarde. Neo-Expressionist paintings are typically large and rapidly executed. They are usually figurative, often with violent or doom-laden subjects, but the image is sometimes almost lost in the welter of surface activity. Neo-Expressionism was put firmly on the map by a number of large exhibitions at the beginning of the 1980s, including 'A New Spirit in Painting' at the *Royal Academy, London, in 1981 and 'Zeitgeist' at Martin Gropius Bau, Berlin, in 1982, with the final seal being put on the phenomenon by its domination at *documenta 7 (1982). The last-named exhibition was directed by the Dutch curator Rudi Fuchs (1942–), who had previously been a supporter of *Conceptual art. Justifying this new direction he stated, 'Painting is salvation: it preserves freedom of choice of which it is the triumphant expression.' Critical response to Neo-Expressionism was initially mixed, although the development was welcomed by many collectors, including Charles *Saatchi. The 'case against' was stated forcefully by Hal Foster's essay 'The Expressive Fallacy' (*Art in America*, January 1983), in which he accused the new tendency of returning uncritically to discredited notions of personal expression, supposedly definitively refuted by *Minimal and *Conceptual art. It is a moot point as to how much such arguments were motivated by the fact that for the first time in over twenty-five years contemporary art was dominated by a movement in which European artists had taken precedence over North Americans. A less sophisticated response was simply to accuse the artists of incompetence.

Neo-Expressionism flourished especially in Germany (where a number of artists had been working in this manner since the 1960s without much exposure outside their own country), Italy, and the USA. Leading exponents include: in Germany, Georg *Baselitz, Rainer *Fetting, Bernd Koberling (1938–), Markus *Lüpertz, and A. R. *Penck; in Italy, Sandro *Chia, Francesco *Clemente, Enzo *Cucci, and Mimmo *Paladino; in the USA, Robert Kushner (1949–), David *Salle, and Julian *Schnabel. The term has sometimes been applied to the German painters Jörg *Immendorff and Anselm *Kiefer, but they are artists

more concerned with the representation of history than with personal expression. *See also* NEW IMAGE PAINTING.

Further Reading: J. Cowart (ed.), *Expressions: New Art from Germany* (1983)

P. Groot, 'The Spirit of Documenta 7', *Flash Art* (summer 1982)

Neo-Geo Term (short for Neo-Geometric Conceptualism) applied to the work of a group of American artists active in New York in the mid-1980s who employed a variety of styles and media but were linked by the fact that their paintings, sculpture, or other products were predominantly cool and impersonal, in reaction to the emotionalism of *Neo-Expressionism. Jeff *Koons, who exhibited consumer products such as vacuum cleaners in a reworking of *Dada *ready-mades, is the best-known figure of the group. Others include Peter *Halley, Haim *Steinbach, and Philip Taaffe (1955–), who paints geometrically patterned pictures parodying earlier styles such as *Op art.

Further Reading: S. Levine et al., 'From Criticism to Complicity', *Flash Art*, no. 129 (summer 1986)

Neo-Impressionism A movement in French painting—both a development from *Impressionism and a reaction against it—in which the Impressionist approach to depicting light and colour was made more rational and scientific. The term was coined in 1886 by the critic Félix *Fénéon. Georges Seurat (1859–91) was the founder of the movement and far and away its outstanding artist. His friend Paul *Signac was its main theoretician. The theoretical basis of Neo-Impressionism was *divisionism, with its associated technique of 'pointillism'—the use of dots of pure colour applied in such a way that when seen from an appropriate distance they achieve a maximum of luminosity. In each painting the dots were of a uniform size, chosen to harmonize with the scale of the work. In Seurat's paintings, this approach combined solidity and clarity of form with a vibrating intensity of light; in the hands of lesser artists, it often produced works that look rigid and contrived. As an organized movement Neo-Impressionism was short-lived, but it had a significant influence on several major artists of the late 19th and early 20th centuries, notably *Matisse, who worked with Signac and another Neo-Impressionist, Henri-Edmond *Cross, at St Tropez in 1906.

Further Reading: B. Thomson, *Post-Impressionism* (1998)

Neo-Plasticism Term coined by Piet *Mondrian for his style of austerely geometrical abstract painting and more broadly for the philosophical ideas about art that his work embodied. He claimed that art should be 'de-naturized', by which he meant that it must be purely abstract, with no relation to the appearance of the natural world. To this end he limited the elements of pictorial design to the straight line and the rectangle (the right angles in a strictly horizontal-vertical relation to the frame) and to the primary colours—blue, red, and yellow—together with black, white, and grey. In this way he thought that one might escape the particular and achieve expression of an ideal of universal harmony. These ideas were greatly influenced by the writings of Dr Matthieu Schoenmaekers, a Dutch author of popular books on philosophy and religion, whom Mondrian admired for a time but later considered to be a charlatan. In his book *Het Nieuwe Wereldbeeld* (The New Image of the World), published in 1915, Schoenmaekers wrote of the pre-eminence of horizontals and verticals as follows: 'the two fundamental complete contraries which shape our earth are: the horizontal line of power, that is the course of the earth around the sun, and the vertical, profoundly spatial movement of rays that originate in the centre of the sun'; and he similarly stressed the importance of the primary colours: 'The three principal colours are essentially yellow, blue and red . . . Yellow is the colour of the ray . . . Blue is the contrasting colour to yellow . . . it is the firmament, it is line horizontality. Red is the mating of yellow and blue . . . Yellow radiates, blue "recedes", and red floats.'

Mondrian took from Schoenmaekers the term 'nieuwe beelding', which he used in his first published work, the long essay 'De Nieuwe Beelding in de Schilderkunst' (Neo-Plasticism in Pictorial Art), which appeared in twelve instalments in the periodical *De *Stijl in 1917–18. Paul Overy writes that 'The terms *beeldend* and *nieuwe beelding* have caused more problems of interpretation than any others in the writing of Mondrian and other De Stijl contributors who adopted them. These Dutch terms are really untranslatable, containing more nuances than can be satisfactorily conveyed by a single English word. *Beeldend* means something like "image forming" or "image creating", *nieuwe beelding* "new image creation", or perhaps "new structure". In German, *nieuwe beelding* is

translated as *neue Gestaltung*, which is close in its complexity of meanings to the Dutch. In French, it was rendered as "néo-plasticisme", later translated literally into English as "Neo-Plasticism", which is virtually meaningless.' The first usage of the French word was by Mondrian himself in his book *Le Néo-Plasticisme* (1919); the first occurrences of the words 'neo-plastician', 'Neoplastic', and 'Neo-plasticism' cited in the *Oxford English Dictionary* are of 1933, 1934, and 1935 respectively. Later, some English writers adopted the phrase 'the New Plastic', which Overy describes as an 'absurd term'.

Further Reading: P. Overy, *De Stijl* (1991)

Neo-primitivism A movement or trend in Russian painting in the early 20th century in which influences from the Western avant-garde were combined in a deliberately crude way with features derived from peasant art, lubki (brightly coloured popular prints), and other aspects of Russia's artistic heritage. Neo-primitivism in Russia was distinguished by being a movement in its own right rather than one aspect of something else, as in Expressionism, Fauvism, and *Cubism. The main exponents of Neo-primitivism were *Goncharova and *Larionov, and it was given its name by Alexander *Shevchenko in a book published in 1913—*Neo-Primitivism: Its Theory, its Possibilities, its Achievements*. Shevchenko's view was strongly nationalist, based on a vision of Russia which was unequivocally anti-European. He wrote: 'Russia and the Orient have been indissolubly linked since the Tartar invasions, and the spirit of the Tartars, the spirit of the Orient is embedded in our lives' (Harrison and Wood). This bias towards the national was reiterated in the *Donkey's Tail and *Target manifestos and led Larionov and Goncharova to break from the Knave of Diamonds on the grounds that it was too slavishly devoted to French painting. Among the other painters influenced by Neo-primitivism were David *Burliuk, *Chagall, *Filonov, and *Malevich. It also affected Russian poets, for example *Mayakovsky, in their choice of peasant themes or use of deliberate archaisms, incorrect spellings, and other deviations from standard usage.

Further Reading: D. V. Sarabianov, *Russian Art from Neo-Classicism to the Avant-garde* (1990)

Neo-Realism An aesthetic philosophy developed by Harold *Gilman and Charles

*Ginner in 1913. They exhibited together under the name 'Neo-Realists' on two occasions: at the *Allied Artists' Association in 1913, and in a joint exhibition at the Goupil Gallery, London, in 1914. The catalogue of the Goupil exhibition was prefaced by an article by Ginner entitled 'Neo-Realism'; it had originally been published in the periodical *The New Age* on 1 January that year. In this article he put forward the idea that good art is the result of constantly renewed contact with nature: 'the aim of Neo-Realism is the plastic interpretation of life through the intimate research into Nature.' He thought that the *Impressionists and the three foremost *Post-Impressionists—*Cézanne, *Gauguin, and van Gogh—had exemplified this contact with nature, but that the *Neo-Impressionists had neglected it in favour of scientific interests and that the *Cubists and *Matisse had debased art because they had lost direct contact with reality. Ginner thought that the lack of such contact led to Academicism, which he defined as 'the adoption by weaker commercial painters of the creative artist's personal methods of interpreting "Nature" and the consequent creation of a formula'. In the catalogue of the 1981–2 *Arts Council Harold Gilman exhibition, Andrew Causey writes that 'Neo-Realism drew an aggressive riposte from *Sickert [in *The New Age*, 30 April 1914], not because he deeply disagreed with it, as he admitted, but probably because he resented the pontifical tone of what was certainly a statement of modest substance.'

The term 'Neo-Realism' has also been used in other ways, notably as a synonym for *New Realism or *Nouveau Réalisme. In Werner *Haftmann's *Painting in the Twentieth Century* (1961) it is used more or less as a synonym for *Neue Sachlichkeit. Haftmann uses the term 'Neo-Verism' in a similar way.

Néo-Réalisme A term applied to the work of a number of French painters of the 1930s who repudiated avant-garde art and practised a style of 'poetic naturalism'. The painters embraced by the term include Jean Aujame (1905–65), Jean-Louis *Boussingault, Maurice Brianchon (1899–1979), Charles *Dufresne, André *Dunoyer de Segonzac, Raymond Legueult (1898–1978), and Luc-Albert Moreau (1882–1948). There were ties of friendship among several of them, but they did not form a group or movement.

Neo-Romanticism A movement in British painting and other arts, *c.*1935–*c.*1955, in which artists looked back to certain aspects of 19th-century Romanticism, particularly the 'visionary' landscape tradition of William Blake and Samuel Palmer, and reinterpreted them in a more modern idiom. More immediate sources for the style were Graham *Sutherland's Palmer-influenced etchings of the 1920s and those paintings of Paul *Nash in which he married *Surrealism to a vision of the English countryside. The term was first applied to contemporary British art by the critic Raymond Mortimer (1895–1980) in 1942. However, the ideology of the movement was best defined by John *Piper's 1942 book *British Romantic Artists*. Here he identified romanticism with an idea of the 'particular', a pointed riposte both to abstraction's affirmation of the universal and to the supposedly 'objective' realism of the *Euston Road School. This is seen at its clearest in some of the work of Graham Sutherland, whose paintings frequently describe not a view but a specific patch of ground or a tree stump, usually dramatically gnarled. Piper himself was a one-time abstract painter whose landscapes invoked the 18th-century conception of the 'sublime'. Both painters continued to be influenced by abstraction and Surrealism but found an appropriate subject in the desolation created by war-time bombardment. Neo-Romanticism received the influential support of Kenneth *Clark, who had a strong distaste for abstraction. Other painters and graphic artists whose work is embraced by the term include Michael *Ayrton, John *Craxton, John *Minton, and Keith *Vaughan, who all worked in a landscape tradition that was regarded as distinctly national and projected a romantic image of the countryside at a time when it was under threat from Nazi Germany. Although not concerned with landscape, the wartime drawings of Henry *Moore are also sometimes related to the movement. Its highly linear manner made it appropriate for book illustration and also meant that it reproduced successfully on the small pages of publications such as *Horizon* and *Penguin New Writing*, so disseminating it widely.

Neo-Romanticism was part of a wider cultural movement which attempted some kind of reconciliation between modernism and a specifically British tradition. The most striking affinities are to be found in cinema, especially Powell and Pressburger's *A Canterbury Tale* (1944), a film of extraordinary emotional force about wartime rediscovery of landscape and history. The photography of Bill *Brandt and Edwin Smith (1912–71) and the graphic design of Abram *Games might also be considered as part of the same phenomenon. There are also parallels in literature. Dylan Thomas (1914–53) and the apocalyptic poets such as Henry Treece (1911–66) were seen very much as a romantic reaction against the poets of the 1930s, such as W. H. Auden (1907–73), with their more sociological and scientific outlook.

For many years, the strong nationalist element, the very reason for the movement's popularity in the 1940s, resulted in it being condemned in the 1950s for insularity, especially by younger American-leaning critics such as Lawrence *Alloway. However, traces of the Neo-Romantic spirit are seen in the more nostalgic aspects of British *Pop, especially the fairground and circus subjects of Peter *Blake, in the landscape-based abstraction of Terry *Frost, and even the fascination with dereliction and decay in the early sculpture of Eduardo *Paolozzi. The style's last gasp is usually regarded as Coventry Cathedral (consecrated 1962), to which Piper contributed stained glass and Sutherland a tapestry. Retrospectives of Sutherland (1982) and Piper (1983) at the Tate Gallery and especially the Barbican Art Gallery exhibition 'A Paradise Lost' (1987) marked a revival of interest in the movement. However, its nostalgic ethos did not accord well with the 'rebranding' of Britain as 'Cool Britannia', in the late 1990s.

The term Neo-Romanticism has also been applied to certain painters working in France in the 1930s, notably *Berard, *Berman, and *Tchelitchew, who typically painted dream-like imaginary Mediterranean landscapes in deep perspective, influenced by *de Chirico and Dalí, with rather mournful figures. Their work made a strong impression on certain British Neo-Romantics, especially Ayrton and Minton. In the 1980s the term was one of the many that was used as a synonym for *Neo-Expressionism, but it did not catch on in this sense.

Further Reading: Barbican Art Gallery, *A Paradise Lost* (1987)

J. T. Soby, *After Picasso* (1935). This covers the French Neo-Romantics

Yorke (2001)

Neo-Verism *See* NEO-REALISM.

Neshat, Shirin (1957–) Iranian photographer and video artist. Born in Qazvin, she

moved to the United States, where she studied art at the University of California. She graduated in 1983 but she has said that her 'real education' as an artist was working at the Storefront in New York, an alternative space for art and architecture run by her husband. Because of the Islamic revolution she did not return home until 1991. Although she has taken the Islamic world as her principal theme, for political reasons she has chiefly worked in America, Morocco, and Tunisia. Nonetheless it was her contact with Iran that provided her with the inspiration for the series of photographs which were her first important work. Entitled *Women of Allah*, they depicted a woman wearing the traditional loose black robes compulsory in Iran since the revolution. In certain of the images a weapon is present. There are inscriptions in Farsi, either on the surface of the photograph or on the woman's skin. Spectators unfamiliar with the language tend to assume that they are taken from the Qur'an. In fact they are militant feminist texts. These works have been acclaimed for their challenging of stereotypes. As Igor Zabel puts it, 'Neshat's aim is not to dispose of media clichés, but to recompose and reorganize them in ways that produce more flexible and complex readings.' Neshat has, in fact, been criticized by some for not making a more unambiguous statement against the repression of women in Islamic societies. However, quite apart from their political resonance, her photographs are also strikingly beautiful images, a consideration of some significance to the artist who has said 'in Islam beauty is critical, as it directly ties to ideas of spirituality and love of God'. Neshat has also made a number of spectacular video installations, sometimes collaborating with the composer Philip Glass.

Further Reading: A. C. Danto, 'Shirin Neshat', *Bomb* (fall 2000)

I. Zabel, 'Women in Black', *Art Journal*, vol. 60 no. 4 (2001)

Neue Künstlervereinigung München (NKV) (New Artists' Association of Munich)

An association of artists founded in Munich in 1909 as a more liberal alternative to existing exhibiting venues, particularly the *Sezession. *Kandinsky was elected president, Alexander Kanoldt (1881–1939) was secretary, and Adolf Erbslöh (1881–1947) was chairman of the exhibition committee. Other members included *Jawlensky, *Kubin, *Münter, and *Werefkin. They were strongly influenced by *Fauvism

and the three exhibitions that they held (1909, 1910, and 1911) were far too advanced for the critics and public and were met with torrents of abuse (they were held in the gallery of the Munich dealer Heinrich Thannhauser, who said he had to clean spit off the paintings each evening). The second exhibition was European in character, including works by the Russians David and Vladimir *Burliuk, by *Le Fauconnier, *Picasso, and *Rouault, and by members of the Fauves (*Braque, *Derain, van *Dongen, *Vlaminck), some of whom had already moved on to *Cubism. Franz *Marc came to the NKV's defence after this exhibition and it was in this way that he met *Kandinsky. When Erbslöh rejected a painting submitted by Kandinsky for the third exhibition, Kandinsky resigned and with Marc founded the *Blaue Reiter. They moved so quickly that the Blaue Reiter's first exhibition opened on the same day as the NKV's last and stole its thunder.

Neue Leben *See* JANCO, MARCEL.

Neue Sachlichkeit (New Objectivity)

Movement in German painting in the 1920s and early 1930s reflecting the resignation and cynicism of the post-war period. The name was coined in 1923 by Gustav Hartlaub, director of the Kunsthalle, Mannheim, and used as the title of an exhibition he staged there in 1925, featuring 'artists who have retained or regained their fidelity to positive tangible reality'. The movement was not characterized by a unified style or by any kind of group affiliation, but its major trend involved the use of meticulous detail and violent satire to portray the face of evil. This marked a continuation of the interest in social criticism that had characterized much of *Expressionism and Berlin *Dada, but Neue Sachlichkeit rejected the abstract tendencies of the *Blaue Reiter, in which Expressionism had reached its high point just before the First World War. *Dix and *Grosz were the greatest figures of the movement, which was dissipated in the 1930s with the rise of the Nazis (*see* NATIONAL SOCIALIST ART). Other artists associated with Neue Sachlichkeit include Conrad *Felixmüller, Christian *Schad, and Rudolf *Schlichter, and among lesser figures Heinrich Davringhausen (1894–1970), who turned to abstraction after he settled in France in 1936, Alexander Kanoldt (1881–1939), Anton Räderscheidt (1892–1970), who also turned to abstract painting after the Second World War, and

Georg Scholz (1890–1945). Georg *Schrimpf is also sometimes embraced by the term, although his connection was one of technique rather than subject. *See also* MAGIC REALISM.

Neue Wilden *See* FETTING, RAINER.

Nevelson, Louise (1899–1988) Russian-born American sculptor, painter, and printmaker. She was born Louise Berliawsky in Kiev and in 1905 emigrated to the USA with her family, who settled in Rockland, Maine. Her father became prosperous working in lumber and property and both parents encouraged her to develop her artistic gifts. In 1920 she married a businessman, Charles Nevelson, and settled in New York. She had a son in 1922 and did not take up art seriously until she was 30, studying at the *Art Students League, 1929–30, then under Hans *Hofmann (first for six months in Munich, then in New York). She had left her son behind to go to Munich and after her return to the USA she separated from her husband; during the 1930s she often endured great poverty as she tried to support herself and her child. In 1932 she worked with Ben *Shahn as assistant to Diego *Rivera on his murals at the Rockefeller Center in New York. She started to make sculpture in 1932 and had her first one-woman show in 1941, at the Nierendorf Gallery, New York. In 1944 she started experimenting with abstract wood assemblages and in 1958 began the 'sculptured walls' for which she became internationally famous. These are wall-like reliefs made up of many boxes and compartments into which abstract shapes are placed together with commonplace objects such as chair legs, sections of balustrade, and other 'found objects' (*An American Tribute to the British People*, 1960–64, Tate). These constructions, which she painted a uniform black or (from 1959) white or gold, won her a reputation as a leader in both *assemblage and *environments. They have great formal elegance but also a strange ritualistic power. Writing in 1959, Robert Rosenblum compared them to the great spaces of *Rothko, *Still, and *Newman, and said that they 'recall the iconoclastic innovations of the new American painting rather than the more tradition-bound character of the new American sculpture'. In the late 1960s Nevelson began to work in a greater variety of materials, including aluminium and transparent perspex, and she sometimes produced small constructions for reproduction as *multiples. From the same time, with her belated fame, she began to receive commissions for large open-air sculptures, which she executed in aluminium or steel.

Nevinson, C. R. W. (Christopher Richard Wynne) (1889–1946) British painter and printmaker, born in London, son of the writer and philanthropist Henry Woodd Nevinson (1856–1941). He studied at St John's Wood School of Art, 1907–8, the *Slade School, 1908–12, and in Paris at the *Académie Julian, 1912–13. In Paris he shared a studio with *Modigliani and met *Marinetti and other *Futurists. With Marinetti, Nevinson wrote the Futurist manifesto *Vital English Art*, published in *The Observer* on 7 June 1914, and he became the outstanding British exponent of Futurism in painting, finding his ideal subjects during the First World War. He served in France with the Red Cross and the Royal Army Medical Corps, 1914–16, before being invalided out, and his harsh, steely images of life and death in the trenches met with great acclaim when he held a one-man exhibition at the *Leicester Galleries, London, in 1916. Stylistically they drew on certain *Cubist as well as Futurist ideas, but they are closer to the work of the *Vorticists (with whom he had exhibited in 1915). *Returning to the Trenches* (1914–15, NG, Ottawa), depicting a column of weary marching men, is one of his best-known works of this time, its jagged forms creating a feeling of relentless mechanism.

In 1917 Nevinson returned to France as an *Official War Artist, and he was the first to make drawings from the air (he also produced lithographs). Some of his work was considered too unpleasant and was censored (he had probably experienced more horror at first hand than any other Official War Artist), but a second one-man exhibition at the Leicester Galleries in 1918 was another triumph. At the end of the war Nevinson renounced Futurism and the more conventional paintings he produced thereafter are generally regarded as an anticlimax. He published an autobiography, *Paint and Prejudice*, in 1937.

Further Reading: M. J. R. Walsh, *C.R.W. Nevinson: This Cult of Violence* (2002)

New Age *See* HULME, T. E.

New American Painting A term used more or less synonymously with *Abstract

Expressionism. It was the title of an international touring exhibition launched by the *Museum of Modern Art, New York in 1958.

new art A term sometimes (but now rarely) used as a translation of *Art Nouveau (in *Brighton Rock*, 1938, Graham Greene writes, 'He touched a little buzzer, the New Art doors opened') and sometimes used very vaguely to describe the latest trends in art. John A. Walker (*Glossary of Art, Architecture and Design Since 1945*, 1973, 3rd edn, 1992) writes that this 'feeble expression' is 'generally employed when critics and exhibition organisers are at a total loss for a name'. He cites as examples of its use an anthology of essays entitled *The New Art* (1966), edited by Gregory Battcock, and an exhibition of the same title at the Hayward Gallery, London, in 1972. The accuracy of Walker's well-aimed barb was confirmed when the expression was again used as the title of an eclectic anthology of contemporary art at the Tate Gallery in 1983. The director, Sir Alan *Bowness, wrote that with the turn of the decade 'new artists and new art movements suddenly appeared on the scene'. Then, neatly negotiating the point that some of the artists in the exhibition had been prominent in the art world for many years, he added that 'The work of some older artists took on a new relevance'.

New Art Club *See* FERGUSSON, J. D.

New Artists' Association of Munich *See* NEUE KÜNSTLERVEREINIGUNG MÜNCHEN.

Newbery, Francis *See* GLASGOW SCHOOL OF ART.

New British Sculpture A term sometimes applied to the work of a loosely connected group of British sculptors who emerged in a series of exhibitions at the beginning of the 1980s, notably 'Objects and Sculpture' shown at the *Institute of Contemporary Arts, London, and the Arnolfini Gallery, Bristol, in 1981. There is no single stylistic factor linking these sculptors, but predominantly their work is abstract (although sometimes with human associations), using industrial or junk material, and several of them were represented by the same dealer—the Lisson Gallery, London. When taken together their work seemed to represent a way out of an impasse reached by British sculpture in the 1970s. It had appeared then that the alternatives were either abandoning the object altogether, as with

*Conceptual art, or continuing the tradition started by Anthony *Caro of large-scale abstract sculpture. These sculptors all explored ways of using objects to allude to human experience without returning to a conservative tradition of figure sculpture. Among the leading figures are: Tony *Cragg, Grenville *Davey, Richard *Deacon, Anish *Kapoor, David *Mach, Julian *Opie, Richard *Wentworth, Alison *Wilding, and Bill *Woodrow. This tendency was anticipated a few years before by the work of Martin *Naylor and Carl *Plackman.

Further Reading: M. Newman, 'Discourse and Desire: Recent British Sculpture', *Flash Art*, no. 115 (January 1984)

New Classicism *See* NEOCLASSICISM.

New Contemporaries *See* YOUNG CONTEMPORARIES.

New Decorativeness *See* PATTERN AND DECORATION MOVEMENT.

New English Art Club (NEAC) An artists' society founded in London in 1886 in reaction against the conservative and complacent attitudes of the *Royal Academy. The founders—largely artists who had worked in France and had been influenced by *plein-air* painting—included Frederick *Brown (who drafted the constitution), *Clausen, Stanhope *Forbes, Arthur Hacker (1858–1919), *La Thangue, *Sargent, *Steer, Edward Stott (1859–1918), and *Tuke. There were about fifty members when the inaugural exhibition was held in April 1886 at the Marlborough Gallery in London. Several of them were members of the *Newlyn School and various *Glasgow Boys joined the following year. In 1889, however, the Club came under the control of a minority group led by *Sickert, and in that year he and his associates held an independent exhibition under the name 'The London *Impressionists'. Sickert resigned in 1897 (he returned in 1906) and from then up to about the First World War the NEAC was effectively controlled by Brown, Steer, and *Tonks (all of whom taught at the *Slade School). In this period its members included most of the best painters in England. From about 1908, however, it began to lose initiative to progressive groups such as the *Allied Artists' Association and the *Camden Town Group. After the war the Club occupied a position midway between the Academy and the avant-garde groups. With

the gradual liberalization of the Academy exhibitions, its importance diminished, but the Club still exists.

New English Style See CONTEMPORARY STYLE.

New Fauvism See NEO-EXPRESSIONISM.

New Figuration A very broad term for a general revival of figurative painting in the 1960s following a period when abstraction (particularly *Abstract Expressionism) had been the dominant mode of avant-garde art in Europe and the USA. The term is said to have been first used by the French critic Michel Ragon, who in 1961 called the trend 'Nouvelle Figuration'.

New Generation The title of four exhibitions, sponsored by the Peter Stuyvesant [tobacco company] Foundation, held at the *Whitechapel Art Gallery, London, in 1964, 1965, 1966, and 1968, with the aim of introducing young British painters and sculptors to the public. The first exhibition showed twelve painters, including figures who subsequently became household names, such as Bridget *Riley and David *Hockney. The series is best remembered, for the 1965 exhibition, which included a group of sculptors who were seen as creating a new school of British abstract sculpture, largely under the influence of Anthony *Caro (they had all been his pupils at *St Martin's School of Art). Subsequently their work has been referred to as 'New Generation Sculpture'. The leading figures were Phillip *King, Tim *Scott, and William *Tucker; others were David *Annesley, Michael *Bolus, and Isaac *Witkin. Their work had in common a liking for simple shapes and strong colours, often using non-traditional materials such as fibreglass or plastic. William *Turnbull is sometimes grouped with them, even though he was appreciably older and did not train at St Martin's or show at the New Generation exhibition and, even more significantly, had a very different approach to sculpture. Alistair McAlpine (1942–), later Lord McAlpine of West Green, made a collection of the work of these seven sculptors and presented it to the Tate Gallery, London, in 1970.

New Image Painting (New Image Art) A term applied since the late 1970s to the work of certain artists who work in a strident figurative style, often with cartoon-like imag-

ery and abrasive handling, with some affinity to *Neo-Expressionism, although the most significant influence was probably Philip *Guston's late figurative painting. The term was given currency by an exhibition entitled 'New Image Painting' at the Whitney Museum, New York, in 1978. Its curator, Richard Marshall, noted that the paintings were marked by 'the use of recognizable images'. The exhibition included, among others, Jennifer *Bartlett, Neil *Jenney, Robert Moskowitz (1935–), Susan *Rothenberg, and Joe *Zucker. Although the exhibition was part of the wider painting revival of the period, alongside *'Bad Painting', Marshall's catalogue introduction claimed affinities with *Minimal and *Conceptual art in the general visual spareness. He also argued that although the choice of vernacular imagery was common to *Pop art, the approach was very different. Whereas Pop was concerned with how such images were collectively understood, the New Image painters looked for what was 'strange and jarring'. Indeed, the 'recognizable' images could come close to abstraction. Subsequently the term 'New Image' has been used in the title of other exhibitions and in a book by Tony Godfrey, *The New Image: Painting in the 1980s* (1986).

Other American artists who have been labelled New Image painters include Jonathan Borofsky (1941–) who is a sculptor as well as a painter and who once applied his trademark 'running man' image to the Berlin Wall, Pat Steir (1940–), and Donald Sultan (1951–). In Britain the term 'New Image' has been applied particularly to painters of the 1980s *Glasgow School.

Further Reading: R. Smith, 'A Painting Landmark in Focus', *New York Times* (2 August 1987)

Whitney Museum of American Art, *New Image Painting* (1978)

New Lef See MAYAKOVSKY, VLADIMIR.

Newlyn School A name applied to the painters who worked in the Cornish fishing port of Newlyn, now a suburb of Penzance, from the 1880s, particularly those directly linked with Stanhope *Forbes, who was the founder and leader of the school. One of the attractions of Newlyn was the mild climate, which made it particularly suitable for outdoor work, and Forbes and his associates were among the pioneers of *plein-air* painting in Britain. The village also made a strong appeal

to artists because of its picturesque charm, which was strongly reminiscent of Brittany—at that time a favourite haunt of painters. Many of them shared Forbes's first impression of Newlyn: 'Here every corner was a picture, and, more important from the point of view of the figure-painter, the people seemed to fall naturally into their places, and to harmonize with their surroundings.' Apart from Forbes and his wife, Elizabeth, the artists most closely associated with Newlyn in its heyday include: Frank Bramley (1857–1915); Norman Garstin (1847–1926); Thomas Cooper Gotch (1854–1931), better known for his later work, particularly his allegorical pictures of children; Fred Hall (1860–1948); Walter Langley (1852–1922); and Henry Scott *Tuke. Many of the Newlyn artists were members of the *New English Art Club, but they also showed their work at the *Royal Academy. The golden period of Newlyn was over by the turn of the century; thereafter it was vulgarized by an influx of inferior talent, and *St Ives came to have a greater attraction for 20th-century artists. However, distinguished painters continued to be associated with Newlyn: Harold and Laura *Knight lived there, 1908–18, for example, and Dod and Ernest *Procter studied with Forbes and settled in the village after their marriage in 1912.

Newman, Barnett (1905–70) American painter, one of the leading figures of *Abstract Expressionism and one of the initiators of *Colour Field Painting. He was born in New York, the son of Polish immigrant parents and studied at the *Art Students League, 1922, and the City College of New York, 1923–7, before working for his father's clothing company, 1927–37 (he again attended the Art Students League in 1929–30). During the 1930s he had a hard time financially: the Depression almost ruined his father's business, and unlike most American painters of the time Newman did not work for the *Federal Art Project, being unwilling to accept State handouts. Part of his living came from teaching art in high schools. He destroyed most of his early work and stopped painting in the early 1940s, but he began again in 1944, and in the second half of the 1940s evolved a distinctive style of mystical abstraction—he considered 'the sublime' to be his ultimate subject-matter (*see* ABSTRACT SUBLIME). The work with which he announced this style was *Onement I* (1948, MoMA, New York), a monochromatic canvas of dark red with a single stripe of lighter red

running down the middle. Such stripes (or 'zips' as Newman preferred to call them) became a characteristic feature of his work. By the time he painted *Onement I* Newman already had a reputation as a controversialist and a spokesman for avant-garde art (in catalogue essays and in articles in journals such as *Tiger's Eye*, of which he was associate editor), and in 1948 he collaborated with *Baziotes, *Hare, *Motherwell, and *Rothko in founding the *Subjects of the Artist School.

In 1949 Newman painted his first wall-size pictures (he was one of the pioneers of the very large format) and in 1950 he had his first one-man exhibition, at the Betty *Parsons Gallery. In a typed notice he specifically asked that viewers stand close to the paintings so that the impact of the scale would register. The exhibition was coolly received by critics and fellow artists, and by the mid-1950s his very spare style had separated him from the predominantly *'gestural' idiom of his colleagues. For a time he became a somewhat marginalized figure and he stopped painting in 1956. He had a heart attack in 1957, but the following year a resurgence began with a series of paintings in black and white, and in the last decade of his life his reputation soared, although his output remained small. In the 1960s he began producing large steel sculptures featuring slender shafts recalling the vertical stripes of his paintings (*Broken Obelisk*, 1963–9, MoMA, New York) and in his late years he also used *shaped canvases, painting several triangular pictures.

Unlike his contemporaries he made a point of not being photographed at work or even in his studio. His appeared in photographs in sober suit and bow tie, belying his lifelong commitment to anarchism. He once said that if his work 'were properly understood, it would be the end of state capitalism and totalitarianism'. In 1968 he wrote an introduction to the writings of the anarchist Kropotkin. Like Rothko he strongly emphasized the spiritual dimension of art. In 1967 he asserted 'What matters to the true artist is that he distinguish between a place and no place at all: and the greater the work of art the greater will be this feeling. And this feeling is the fundamental spiritual dimension.' Thomas Hess has specifically interpreted Newman's art in terms of Jewish mysticism. Unlike many of his contemporaries he did not abjure poetically suggestive titles. *Vir Heroicus Sublimis* (1950–51, MoMA, New York) led to a pedantic correction

of Newman's Latin by the art historian Erwin Panofsky. John *Canaday, a critic who was no friend to the Abstract Expressionists, accused his work of being 'literary painting' and of being 'an extreme case of dependence on verbal exercises'. Nonetheless, a generation of artists with a far more pragmatic anti-mystical approach, such as Frank *Stella and Donald *Judd, held him in high regard. (Unlike the suspicious Rothko, he took an active interest in the work of younger artists.) Bob *Law described the impact of his work in these terms: 'They knocked me out by their sheer size. I found Newman's spacing took me a long time to work out. It often seemed excessive but necessary to get the message through.'

Further Reading: T. Hess, *Barnett Newman* (1972)

J. P. O'Neill (ed.), *Barnett Newman: Selected Writings and Interviews* (1990)

A. Temin, *Barnett Newman* (2002)

New Museum of Contemporary Art, New York. Museum devoted to contemporary art (meaning in this instance work done within the last ten years), founded in 1977 by Marcia Tucker (1940–), formerly a curator at the *Whitney Museum of American Art, who had lost her post partly as a result of vicious attacks by the influential Hilton *Kramer. It was originally called the New Museum and was located in the New School of Social Research on Fifth Avenue. In 1983 it moved to 583 Broadway, a handsome late 19th-century building. A new building opened in 2007 in the Bowery district. The museum is devoted mainly to temporary exhibitions, but it also has a small 'semi-permanent' collection, works being periodically sold to buy others (as in the early days of the *Museum of Modern Art, New York).

New Realism A term that has been used in at least three distinct senses in connection with art of the 1960s and later. First, it has been used in a way similar to the term *New Figuration to describe a revival of figurative art after a dominant period of abstraction; whereas 'New Figuration' has been used very broadly, however, 'New Realism' has often been applied more specifically to works that are objective in spirit, particularly *Superrealist pictures or those of Philip *Pearlstein. In a second sense, 'New Realism' has been used as a straight translation of *Nouveau Réalisme and applied to works that incorporate three-dimensional objects, usually mass-produced consumer goods, in *assemblages or attached

to the surface of a painting. Thirdly, it has been used as a synonym for *Pop art. An exhibition of English Pop that circulated to The Hague, Vienna, and Berlin in 1964–5 was entitled 'Nieuwe Realisten'.

New Scottish Group *See* FERGUSSON, J. D.

New Sculpture A trend in British sculpture between about 1880 and 1910 characterized chiefly by an emphasis on naturalistic surface detail and a taste for the spiritual or *Symbolist in subject-matter, in reaction against the blandness of much mid-Victorian sculpture. The name was coined by the critic Edmund *Gosse in a series of four articles, 'The New Sculpture, 1879–1894', published in *The Art Journal* in 1894. He singled out the concentration on surface realism as the major characteristic. However, another significant early commentator, M. H. Spielmann (1859–1949), the editor of *The Magazine of Art*, concentrated more on the imaginative aspects (*British Sculpture and Sculptors of Today*, 1901). Leading representatives of the trend include Gilbert *Bayes, Alfred *Drury, Edward Onslow Ford (1852–1901), Sir George *Frampton, Sir Alfred *Gilbert, the Australian-born Sir Bertram Mackennal (1863–1931), Frederick William Pomeroy (1857–1924), Sir William Reynolds-Stephens (1862–1943), Sir Hamo *Thornycroft, Albert Toft (1862–1949), and Derwent *Wood. Although many of the sculptors made distinguished contributions to monumental and decorative work, their most characteristic work was in the field of 'ideal sculpture', that is to say, sculpture which was not dependent on commission but was the product of the artist's imagination. These pieces were customarily exhibited in plaster and only cast in bronze or carved in stone when purchased by a collector. Bronze was the favoured medium, although polychromy—using such materials as ivory and coloured stones—was also a feature of the New Sculpture. Mythology and poetry were the main sources of imagery. Although the New Sculpture did not survive the First World War as a major force, some of the practitioners went on working in the idiom long after this.

Further Reading: Beattie (1983)

Newton, Algernon (1880–1968) British painter, born in London, grandson of one of the founders of Winsor & Newton, the firm of artists' colourmen. He left Clare College,

Cambridge, after two years without taking a degree and then studied at various art colleges in London, including the School of Animal Painting in Kensington run by Frank Calderon (1865–1943). Newton specialized in urban views painted in a sombre, naturalistic style; his penchant for scenes involving waterways earned him the nickname 'the Canaletto of the canals' (*The Surrey Canal, Camberwell*, 1935, Tate). He also painted landscapes in Cornwall and Yorkshire and was in demand for 'portraits' of country houses. Generally he worked from sketches done on the spot and occasional photographs. In his obituary in *The Times* he is described as 'a painter of quiet distinction…He could take the most forbidding canal or group of factory buildings, and, without romanticizing or shrinking any detail, create a poetic and restful composition out of it.' He was the father of the actor Robert Newton (1905–56).

Further Reading: Graves Art Gallery, Sheffield, *Algernon Newton R.A.* (1980)

Newton, Helmut *See* BEECROFT, VANESSA.

New York, Art Students League *See* ART STUDENTS LEAGUE OF NEW YORK.

New York, Museum of Modern Art *See* MUSEUM OF MODERN ART, NEW YORK.

New York, New Museum of Contemporary Art *See* NEW MUSEUM OF CONTEMPORARY ART.

New York, Solomon R. Guggenheim Museum *See* GUGGENHEIM, SOLOMON R.

New York, Whitney Museum of American Art *See* WHITNEY, GERTRUDE VANDERBILT.

New York Realists An informal name applied in the early years of the 20th century to Robert *Henri and his disciples, whose work included scenes of unidealized contemporary urban life.

New York School Term applied to the innovatory painters, especially the *Abstract Expressionists, who worked in New York in the 1940s and 1950s and whose critical and financial success helped the city to replace Paris as the world's leading centre of avant-garde art.

Nicholson, Ben (1894–1982) British painter and maker of painted reliefs, one of the most distinguished pioneers of abstract art in Britain. He was born at Denham, Buckinghamshire, son of Sir William *Nicholson and Mabel Nicholson, who was the sister of James *Pryde and herself a painter. After studying briefly at the *Slade School, 1910–11, he spent most of the next few years abroad for the sake of his health (he had asthma) and did not devote himself seriously to art until 1920, when he married the painter Winifred Dacre, the first of his three wives. Nicholson's early work consisted mainly of simple and fastidious still-lifes, very much in the tradition of his father, and of landscapes (although he destroyed many experimental paintings). He first saw *Cubist paintings on a visit to Paris in 1921 and in the following years his still-lifes showed a personal response to the standard Cubist repertoire of jugs and glasses, which he arranged as flat shapes on the picture plane. His most sophisticated work in this vein is *Au Chat Botté* (1932, Manchester Art Gallery), a picture of a shop window that incorporates reflections in the glass of objects behind the artist. Nicholson was also influenced by the *naive painter Alfred *Wallis, whose work he discovered in 1928 and whose roughly textured surfaces he emulated.

From the early 1930s Nicholson turned to abstraction, partly because of the influence of Barbara *Hepworth (they shared a studio from 1932 and married in 1938) and partly because of the impact of several visits he made to Paris at this time. He joined the *Abstraction-Création association in 1933 and became friendly with several leading avant-garde artists there, *Mondrian's work in particular coming as a revelation to him. Nicholson visited his studio in 1933, and later commented: 'The paintings were entirely new to me and I did not understand them on this first visit (and indeed only partially understood them on my second visit a year later). They were merely, for me, part of the very lovely feeling generated by his thought in the room. I remember after this first visit sitting at a café table on the edge of a pavement almost touching all the traffic going in and out of the Gare Montparnasse, and sitting there for a very long time with an astonishing feeling of quiet and repose!' In 1933 Nicholson made his first abstract relief and in 1934 his first strictly geometrical 'white relief' in painted wood, using only straight lines and circles. Such works were the most uncompromising examples of abstract art made by a British artist up to that date

(*White Relief*, 1935, Tate). He also did paintings in a similar intellectual vein but marked by a poetic refinement of colour that offsets their severity of composition (*Painting*, 1937, Tate). By this time Nicholson was recognized as being at the forefront of the modern movement in England. He was a member of *Unit One (1933), and one of the editors of *Circle (1937), and under his chairmanship the *Seven & Five Society organized the first all-abstract exhibition to be held in England (1935). Simon Wilson describes him as 'the only English painter to develop a pure abstract art of international quality between the two World Wars' (*Tate Gallery: An Illustrated Companion*, 1990).

In 1939 Nicholson and Hepworth moved to Cornwall, where they became the nucleus of the *St Ives School. Nicholson remained in St Ives until 1958, when he settled in Switzerland with his third wife, the Swiss photographer Felicitas Vogler. After the Second World War he won an international reputation, accompanied by many awards, among them first prize at the *Carnegie International Exhibition in 1952 and the first Guggenheim International Painting Prize in 1957. In 1968 he was awarded the Order of Merit. He returned to England in 1971 and died in London. His late work moved undogmatically between abstraction and figuration and included large, freestanding reliefs, notably one in marble in the garden of Sutton Place, Surrey (1982).

Nicholson's first wife, **Winifred Nicholson** (1893–1981), also known by her maiden name of Roberts and her mother's surname Dacre, was a painter of distinction. She is best known for her flower paintings, but she also did other subjects and abstracts, all her work showing a joy in light and colour. Even after they separated in 1931 (they divorced in 1938) she and Ben Nicholson took a keen interest in each other's work: he said, 'I learnt a great deal about colour from Winifred Nicholson and a great deal about form from Barbara Hepworth'. **Kate Nicholson** (1929–), the daughter of Ben and Winifred Nicholson, and **Rachel Nicholson** (1934–), the daughter of Nicholson and Hepworth, are also painters. Another daughter of Nicholson and Hepworth married the art historian Alan *Bowness.

Further Reading: S. J. Checkland, *Ben Nicholson* (2001)
J. Collins, *Winifred Nicholson* (1987)

Nicholson, Sir William (1872–1949) British painter and graphic artist, the father of Ben *Nicholson. He was born in Newark-on-Trent and studied at Sir Hubert *Herkomer's school of art in Bushey, Hertfordshire, 1888–9, and the *Académie Julian, Paris, 1889–90. In 1893 he married James *Pryde's sister Mabel. He joined forces with his brother-in-law in 1894, designing posters under the name J. & W. Beggarstaff. (They came across the name on a sack of fodder in a stable.) Their work was noted for its bold simplicity and clarity, with powerful use of large areas of black against white. After the turn of the century Nicholson worked principally as a painter. He was successful mainly as a portraitist; his early work was strongly influenced by *Whistler (his friend and fellow-dandy), but his colouring became brighter in the 1920s. He also painted landscapes, still-lifes, and other subjects, made woodcuts, and designed for the stage, including the sets for the first production of *Peter Pan* in 1904. His still-lifes are now his most admired paintings—typically small, unpretentious, and sensitively handled. There are examples of his work in the National Portrait Gallery and Tate.

Further Reading: C. Campbell, *The Art of William Nicholson* (2005)

Niestlé, Jean Bloé See BLAUE REITER.

Nikifor (*c*.1895–1968) Polish *naive painter, born at Krynica. His mother was a deaf-mute beggar (he did not know his father) and Nikifor himself had a speech impediment. He lived the life of a tramp, wandering through the villages of Galicia, and made paintings on any scraps of paper available, including the backs of cigarette packets, selling them for a trifle. His main subjects were architectural scenes and cityscapes, in which he mixed reality with fantasy, and he was also fond of representing himself in various imagined situations (he was deeply and naively religious and often depicted himself as a bishop-judge condemning those who had done him some injustice). He was very prolific and some thousands of his small paintings are in existence. Usually they are inscribed with meaningless combinations of letters (he was virtually illiterate). Nikifor was 'discovered' in 1930, and late in life he achieved material comforts, but by then he was too old and ill to enjoy them. He has a high reputation in Poland and has been the subject of several books and documentary films.

Nikos *See* MEC ART.

Nitsch, Hermann (1938–) Austrian painter
and actionist, the founder of the Orgien Mys-
terien Theater. His work is a form of *Perfor-
mance art, although he makes a clear
distinction between the mere 'presentation',
that is to say simulation, of most performance
and his 'total work of art'. His characteristic
performances are violent rituals involving ani-
mal slaughter and fake crucifixion accompa-
nied by very loud music and lasting several
hours. A six-day event was held in 1998 at
Schloss Prinzendorf, the artist's mansion in
Austria, which he purchased in 1971. On the
one hand these came out of American *Action
Painting and *Happenings but they also had a
strongly Central European intellectual source
in the writings of Nietzsche. The artist drew on
the philosopher's idea of the Dyonisiac rite of
sacrifice, necessary to lead a fuller life but also
feared. Reference is also made to Catholic
ritual and priest's vestments were worn in
some events. His practice reflects a belief
that the aggressive instincts have been tamed
by the media. The killing of animals, which
ought to be a natural aspect of human beha-
viour, is generally carried out in abattoirs away
from the view of the public. Nitsch's paintings
also involve either the use of actual blood
or of red paint flung on the canvas as if it
is the site of a bloody act. *See also* VIENNA
ACTIONISTS.

NKV *See* NEUE KÜNSTLERVEREINIGUNG.

Noguchi, Isamu (1904–88) American
sculptor and designer, born in Los Angeles,
the son of a Japanese father and an American
mother, both of whom were writers. He was
brought up in Japan, 1906–18, and after re-
turning to the USA he was briefly apprenticed
in 1922 to Gutzon *Borglum, who told him he
would never make a sculptor. For the next two
years he studied medicine at Columbia Uni-
versity and also took sculpture classes at the
Leonardo da Vinci School in New York, until
in 1924 he decided definitively to be an artist.
In 1927 he won a Guggenheim Fellowship that
enabled him to spend two years in Paris,
where he worked as *Brancusi's assistant and
under his influence turned from figuration to
abstraction. He returned to New York in 1929
and in the same year had his first one-man
show there at the Eugene Schoen Gallery. Al-
though he used various materials, including
wood, bronze, and iron, Noguchi was essen-

tially a stone carver, and his work has a kin-
ship with Brancusi's in its craftsmanship and
respect for materials as well as its expressive
use of organic shapes (*see* DIRECT CARVING).
For several years he supported himself mainly
by making academic portrait busts, but in
1938 he scored his first major success, winning
a competition to make a huge stainless steel
piece for the façade of the Associated Press
Building in Rockefeller Center, New York. Be-
fore this he had already begun what was to be
a highly distinguished career as a stage de-
signer, working most notably for the choreog-
rapher Martha Graham (1894–1991). His first
design for her was for *Frontier* (1935, the first
time she had used a set) and he continued
collaborating with her until 1966. Noguchi
drew on the Japanese tradition of No drama
in his stage designs, creating spare, elegant
abstract environments. Apart from Martha
Graham, he worked for other famous choreo-
graphers, including George Balanchine and
Merce Cunningham, and also for the Royal
Shakespeare Company, designing Sir John
Gielgud's production of *Macbeth* in 1955.

After the Second World War Noguchi be-
came recognized internationally as one of the
leading sculptors of the day and from the
1960s he had many major commissions for
public spaces that allowed him to fulfil his
long-held ambition to combine Western mod-
ernism with Eastern traditions of contempla-
tive art (he had begun designing sculptural
gardens—as well as children's playgrounds—
in the 1930s, but he had not had the opportu-
nity to put them into practice). Examples of
this type of work are the Water Garden at
Chase Manhattan Bank Plaza, New York
(1963), and Hart Plaza, Detroit (1975), with
its huge Dodge Memorial Fountain in stainless
steel and granite. Throughout his career No-
guchi frequently returned to Japan and his
work is regarded as a successful marriage of
East and West. He published an autobiogra-
phy, *A Sculptor's World*, in 1968.

Nolan, Sir Sidney (1917–92) The most in-
ternationally famous of Australian painters.
He was born in Melbourne, and after leaving
school at the age of fifteen he had various
short-term jobs, including work in commer-
cial art. He became a full-time artist in 1938,
and he held his first one-man show (at his
Melbourne studio) in 1940. While he was
serving in the Australian army, 1942–5, sta-
tioned in the Wimmera district of Victoria,

he painted a series of landscapes that gave the first unmistakable signs of his originality of vision, vividly capturing the heat and emptiness of the bush. In 1946 he began a series of paintings on the notorious 19th-century bushranger Ned Kelly, who had become a legendary figure in Australian folk history, and it was with these works that he made his name. He returned to the Kelly theme throughout his career, and he also drew on other people and events in Australian history, for example the explorers Burke and Wills, who died in 1861 on the first expedition to cross the country from south to north, and the Eureka Stockade, a goldminers' uprising against colonial rule in 1854. In works on such themes he created a distinctive idiom to express this novel Australian iconography and memorably portrayed the hard, dry beauty of the desert landscape. Technically his work is remarkable for the lush fluidity of his brushwork, and he sometimes painted on glass or other smooth materials.

In 1950 Nolan won the Dunlop Prize, which enabled him to visit Europe for the first time. He soon made a name for himself in Britain (he had his first London exhibition at the Redfern Gallery in 1951) and from 1955 lived mainly in England. Apart from paintings and prints, Nolan occasionally made set and costume designs, for example for a production of Stravinsky's *The Rite of Spring* at the Royal Opera House, London, in 1962. He was knighted in 1981. *See also* ANGRY PENGUINS.

Noland, Kenneth (1924–) American abstract painter and sculptor, born in Asheville, North Carolina. After serving in the US Air Force during the Second World War he studied at *Black Mountain College, 1946–8, and then under *Zadkine in Paris, 1948–9. In 1949 he moved to Washington DC, where he became a close friend of Morris *Louis. On a visit to New York in 1953 they were greatly impressed by Helen *Frankenthaler's *Mountains and Sea* and they began experimenting with the kind of pouring and staining techniques she pioneered. They became the leading figures of the group of *Colour Field Painters, but from the late 1950s Noland began to use centralized circular images. At first these were fuzzy, but they became much more precisely articulated until by 1960 he was producing crisp, target-like images featuring concentric circles of strongly contrasting colours on a square canvas. During the 1960s he developed other sharply delineated formats that won him

a reputation as one of the leading exponents of *Hard-Edge Painting. The 'targets' lasted until 1962 (*Gift*, 1961–2, Tate), and were followed by a chevron motif (1962–4), which developed into diamond-shaped pictures (1964–7), sometimes of very large format. From 1967 he used horizontal stripes running across a long rectangular canvas. At about the same time he began making sculpture, influenced by his friend Anthony *Caro. Noland lived in New York from 1961 to 1963, then in South Shaftesbury, Vermont, until 1979, when he settled in South Salem, New York.

Nolde, Emil (1867–1956) German painter and printmaker, one of the most powerful representatives of *Expressionism. He was born Emil Hansen, the son of a farmer, at Nolde in Schleswig-Holstein and adopted the name of his village as his surname when he married in 1902. Originally he trained as a cabinetmaker and woodcarver, and he came late to artistic maturity. In the 1890s he spent several years teaching drawing at St Gall in Switzerland, and the financial success of some comic postcards he designed showing mountains with human faces enabled him to study painting seriously—in Munich, in Dachau (in *Hölzel's school), and finally at the *Académie Julian in Paris, 1899–1900. The following years were very difficult for him (his wife became a semi-invalid), and he was almost 40 when he first made an impact as a painter at the 1906 exhibition of the Berlin *Sezession. In the same year he became a member of Die *Brücke, but he was essentially an isolated figure, standing apart from his great German contemporaries. This was a reflection of his suspicious and touchy character (he resigned from Die Brücke after eighteen months and was expelled from the Sezession in 1910 after making a vicious personal attack on Max *Liebermann).

In the early part of his career Nolde lived mainly in Berlin, but he moved around a good deal in Germany and travelled extensively elsewhere (in 1913–14 he visited Russia, the Far East, and the South Sea islands as part of an ethnographic expedition); however, at times he lived almost like a hermit, painting on the lonely moorlands and seashore of north Germany. His travel broadened his knowledge of the kind of *primitive art that was then beginning to excite avant-garde artists, but Nolde had already established the essential features of his style before his contact

with such art, and when the term 'primitive' is applied to his work, it refers to its brutal force, not to any exotic trappings. He was a deeply religious man and is most famous for his paintings of Old and New Testament subjects, in which he expressed intense emotion through violent colour, radically simplified drawing, and grotesque distortion (*Pentecost*, 1909, Staatliche Museen, Berlin). The majority of his pictures, however, were landscapes, and he was also one of the outstanding 20th-century exponents of flower painting, working with gloriously vivid colour, often in water-colour; Frank *Whitford calls him 'perhaps the greatest modern watercolourist'. Nolde also made many prints (etchings, lithographs, and woodcuts), mainly early in his career (there are few after 1926). In spite of attempts to ingratiate himself with the Nazi Party, he was declared a *degenerate artist and in 1941 was forbidden to paint. However, he executed small watercolours in secret (these are called the *Ungemalte Bilder*, 'Unpainted Pictures') and from these made larger oils after the war. From 1926 he lived at Seebüll, where there is now a Nolde Foundation that has an outstanding collection of his work. An anthology of his letters was published in 1927 and his autobiography has been published in four volumes, two of them posthumous (1931, 1934, 1965, 1967); a one-volume edition, *Mein Leben*, appeared in 1976.

Further Reading: P. Vergo and F. Lunn, *Emil Nolde* (1995)

Non-Conformist art *See* UNOFFICIAL ART.

Non-Figurative Artists' Association, Montreal. *See* PLASTICIENS.

Non-Objective art A general term for *abstract art that is intended to be completely non-representational, rather than derived (however remotely or obliquely) from appearances in the world around us; most commonly it is applied to severely geometrical works. The term was coined by *Rodchenko, who used it in the title of some of his paintings (*Non-Objective Painting: Black on Black*, 1918, MoMA, New York). It is also particularly associated with *Malevich, who in 1919 wrote: 'In referring to non-objectivity, I merely wished to make it plain that *Suprematism is not concerned with things, objects, etc.' In 1927 the *Bauhaus published a book by Malevich entitled *Die gegenstandslose Welt*, which appeared in English translation in 1959 as *The*

Non-Objective World. The *Guggenheim Museum in New York was originally called the Museum of Non-Objective Art.

Nordrhein-Westfalen Collection (Kunstsammlung Nordrhein-Westfalen), Düsseldorf. Collection of 20th-century paintings founded in 1961 in Düsseldorf, capital of the Land (state) of Nordrhein-Westfalen (North Rhine-Westphalia) and opened to the public in 1965. It is unusual among collections in that it was founded by parliamentary decree and built up from scratch in a short space of time. The decision to found it was taken after the regional government of Nordrhein-Westfalen bought 88 works by Paul *Klee from an American private collection. The Klee collection established a principle that nothing prior to that artist should be included. The aim was to build up a collection based on quality rather than history. The result has been a rather predictable collection of 'big names', but there is a classic black-and-white *Pollock and one of the finest of *Picasso's late paintings. It is now divided into two collections: K20, which deals with art up to 1980; and K21, opened in 2002, which contains contemporary art. Paradoxically, it is this second collection which is housed in an old building, at one time occupied by the state parliament. The first director was Werner Schmalenbach, who initially built up the collection. In 1990 Armin Zweite took up the position.

Further Reading: W. Schmalenbach, *Picasso to Lichtenstein: Masterpieces of Twentieth-Century Art from the Nordrhein-Westfalen Collection in Düsseldorf* (1974)

Norwich, Sainsbury Centre for the Visual Arts *See* SAINSBURY CENTRE FOR THE VISUAL ARTS.

Nouveau Réalisme A term coined by the French critic Pierre *Restany in 1960 (in a manifesto of this name) to characterize the work of a group of artists whose concern was to respond to the changed role of art within a consumer society by challenging traditional forms and media. Restany's argument was that easel painting was dying and must be replaced by the 'passionate adventure of the real'. In October of that year a number of artists, some of whom had connections with the Iris *Clert gallery, formally signed up to Restany's tenets, including Yves *Klein, Jean *Tinguely, *Arman, *Martial Raysse and Daniel *Spoerri. There had been some heated discussion as to whether Raysse and Spoerri,

n

introduced respectively by Klein and Arman and by Tinguely, should be included. *César and Mimmo *Rotella were not at the initial meeting but became associated with the group's manifestations, as did later Niki de *Saint Phalle and *Christo. Restany recognized a debt to *Dada, especially *Duchamp—hence the title of an exhibition he held at Galerie J (run by his wife) in Paris in 1961, '40° au-dessus de Dada' ('40 Degrees above Dada'). The title also suggests that the artist's engage-ment with their material was more intense than Duchamp's cool detachment. In the fol-lowing year another representative exhibition, entitled 'New Realists', took place at the Sid-ney *Janis gallery in New York. Nouveau Réa-lisme was above all, like *Pop art in Britain and the USA, an engagement with the consumer society. The rapid rise of this in France was even more of a challenge to traditional artistic values than in other countries. François Plu-chart talked of 'a remodelled conception of the work of art, in which tradition ceases to exist, ceases to contaminate the mythologies of today, ceases to impede the onset of a new industrial civilization in which the *École de Paris, with all of its Impressionist and Cubist by-products, will be unfit to pursue its small trade' (*Art and Artists*, August 1966). This ide-ology was ultimately manifested on an official level in the displays of the *Pompidou Centre, which, when it opened in 1977, placed fine art alongside industrial design. There are parallels with the writings of Roland *Barthes, whose *Mythologies* (1956) also charted the uneasy transformations in French popular culture. See also AFFICHISTE.

Further Reading: C. Francklin, *Les Nouveaux Réalistes* (1997)

Nouveaux Plasticiens A group of four Ca-nadian abstract painters formed in Montreal in 1959; they succeeded Les *Plasticiens as leaders of the avant-garde and were the dominant force on the city's art scene during the 1960s. The members were Jean Goguen (1928–89), Denis Juneau (1925–), Guido *Molinari, and Claude *Tousignant. They painted large, completely abstract canvases, sometimes *Hard-Edge and verging on *Op art.

Novecento Italiano (Italian 20th Century) Association of Italian artists, founded in 1922 and officially launched in 1923 at an assembly at the Pesaro Gallery in Milan; it aimed to reject European avant-garde movements and revive a naturalistic type of art based on classical Italian tradition. The Novecento thus represented a tendency that had already found expression in *Carrà and *de Chirico's interest in Renaissance art. However, the as-sociation had no clear artistic programme (although it wished to revive large-scale figu-rative compositions) and numbered within its ranks artists of very different styles and temperaments, among them *Campigli, Carrà, and *Marini. Increasingly the Nove-cento came to be associated with Fascist propaganda (Mussolini had been one of the speakers at the launch) and during the 1930s it was the main bastion of reactionary atti-tudes. It disbanded in 1943. See also NEO-CLASSICISM; TOTALITARIAN ART.

Novelli, Gastone See CONTINUITÀ.

November Group See SALLINEN.

Novembergruppe A group of radical left-wing artists formed in Berlin in December 1918; it took its name from the revolution that had broken out in Germany the previous month, at the end of the First World War, and the professed aim of the Novembergruppe was to help national renewal by means of a closer relation between progressive artists and the public. The prime movers in the creation of the group were César Klein (1876–1954), a painter and theatrical designer, and Max *Pechstein. Others who quickly joined includ-ed Rudolf *Belling, Heinrich *Campendonk, Otto *Müller, and Hans *Purrmann. In 1919 the group created the Arbeitsrat für Kunst (Workers' Council for Art) in an attempt to bring about a dialogue between art and the masses, but this collapsed in 1921 and interest and support came mainly from the middle classes. Artistically the group covered a wide spectrum, from *Cubism and *Expressionism to geometrical abstraction and *Social Real-ism. Through its numerous exhibitions in the 1920s it did much to foster an artistic revival, although many of its aims were more fully realized at the *Bauhaus. The group dis-banded in 1929.

Further Reading: Harrison and Wood (2002)

Novy Lef See MAYAKOVSKY, VLADIMIR.

Nuclear Art Movement See BAJ, ENRICO.

Nussbaum, Felix (1904–44) German paint-er, born in Osnabrück. He began his studies in

the applied arts but decided to be a painter, holding his first exhibition in 1927. After a stay in Rome, he moved to Belgium in 1934. As a Jew, he was threatened by the rise to power of the Nazis. When the Germans occupied Belgium he was arrested as an enemy alien and sent to an internment camp in France, but he managed to escape and lived clandestinely in Brussels. It was during this period that he painted his most significant works, which recalled his period as a prisoner. Among them is his well known *Self-Portrait with a Jewish Identity Card* (1943, Felix Nussbaum House, Osnabrück). The last painting he made before his arrest in 1944 was a large allegorical work, *Death Triumphant* (1944, Felix Nussbaum House). He died at Auschwitz. The style of his work is dry and precise, close to Otto *Dix. A museum dedicated to his work opened in Osnabrück in 1998.

(⊕) SEE WEB LINKS

• A catalogue raisonné of Nussbaum's work, available online.

Nutt, Jim (1938–) American painter. He is based in Chicago where, during the 1960s and 1970s, painters had a reputation for spurning the cerebral concerns of the New York art world in favour of fantasy and caricature. Nutt was a member of an art group called the Hairy Who and he specialized in cartoon-like representations of distorted figures in garish flat colour. Outsize noses on both sexes were a trademark. The poet Geoffrey Young said of him: 'Nutt has never seen a nostril he couldn't invaginate'. Titles could be highly suggestive, as with his drawing *Rosie Comon* (1968, MoMA, New York). After a period of critical disfavour an exhibition in New York of Picasso-influenced heads of women, still with big noses, was acclaimed in 2003. *Village Voice* critic Jerry Saltz admitted that in the 1970s Nutt had stood for everything he hated but that now he admired Nutt's extraordinary ingenuity with hair and, of course, noses.

(⊕) SEE WEB LINKS

• Review of Jim Nutt exhibition in the artnet online magazine.

Nyolcak *See* EIGHT, THE (3).

0.10 ('Zero–Ten') See POUGNY, JEAN.

object A term applied to a type of three-dimensional work (usually fairly small) made up of any materials that take the artist's fancy and usually put together with some symbolic or ironic meaning. Works in this vein were produced by the *Dadaists, and the idea was anticipated to some extent by *Marinetti, who made a *Self-portrait (Dynamic Collection of Objects)* in 1914, but it was the *Surrealists who really cultivated the object. It is impossible to define the term with any great precision, and the Surrealists listed (or invented) various categories, many of which seem intended to mystify rather than clarify. They include the *objet trouvé and the *ready-made, both of which have a fairly clearly understood meaning, and also, for example, the 'poem-object' (invented by *Breton) and the 'symbolically functioning object' (invented by *Dalí). Sarane Alexandrian (*Surrealist Art*, 1970) describes the poem-object as 'a kind of relief which incorporates objects in the words of a poetic declaration so as to form a homogeneous whole', whilst the symbolically functioning object 'expresses a repressed desire or allows a compensatory satisfaction of the libido. Dalí made one consisting of a woman's shoe inside which was placed a glass of milk.' The most famous of all Surrealist objects is probably Meret *Oppenheim's *Cup, Saucer and Spoon in Fur* (1936, MoMA, New York), also known simply as *Object*, which Alexandrian classifies as a 'dreamt object': 'According to Breton, this corresponds to "the need, inherent in the dream, to magnify and dramatize". It is a humble, familiar object, which by some caprice of desire is given a sumptuous appearance.'

Breton, inspired by a dream in which he had seen a curious book with wool pages, had first suggested creating such dream-objects in 1924. In December 1928 an advertisement in issue 8 of *La Révolution surréaliste* announced a forthcoming exhibition of objects, but this never took place, and their heyday was the 1930s. The idea that they should form a distinctive category of art was promoted by Dalí in an article entitled 'Objects surréalistes' in the third issue of *Le Surréalisme au service de la révolution* (December 1931). He regarded the object as 'absolutely useless from the practical and rational point of view, created wholly for the purpose of materializing in a fetishistic way, with the maximum of tangible reality, ideas and fantasies having a delirious character'. The first group exhibition of Surrealist objects was held in 1936 at the Galerie Charles Ratton, Paris, followed in 1937 by 'Surrealist Objects and Poems' at the London Gallery (*see* MESENS).

In reference to more recent art, the term 'object' has tended to be used to describe three-dimensional art which is neither entirely abstract nor dependent on the figure as a source of reference. There is a rich variety of such work, especially among British sculptors such as Richard *Wentworth and Tony *Cragg. Much of this was brought together in a Hayward Gallery exhibition of 1997 entitled 'Material Culture: The Object in British Art of the 1980s and 1990s'.

object book See BOOK ART.

'objecthood' See FRIED, MICHAEL.

Objective Abstractionists A group of British painters associated with an exhibition entitled 'Objective Abstractions' held at the *Zwemmer Gallery, London, in 1934. Seven artists participated: Graham *Bell, Thomas Carr (1909–99), Ivon *Hitchens, Rodrigo *Moynihan, Victor *Pasmore, Ceri *Richards, and Geoffrey Tibble (1909–52). Only three of these artists were out-and-out abstract painters at this time: Bell, Moynihan, and Tibble. All seven, however, were united by the aim of taking nature as an initial 'objective' point of reference; thereafter the painting might develop according to its own logic. The abstracts they produced were freely painted, and Sir John *Rothenstein writes that 'several of the exhibits proclaimed

the autonomy of paint and brush in a way that anticipated the *abstract expressionism of twenty years later'.

objet trouvé (French: found object) An object found by an artist and displayed with no, or minimal, alteration as (or as an element in) a work of art. It may be a natural object, such as a pebble, a shell, or a curiously contorted branch, or a man-made object such as a piece of pottery or old piece of ironwork or machinery. The essence of the matter is that the finder-artist recognizes such a chance find as an 'aesthetic object' and displays it for appreciation by others as he would a work of art. The practice began with the *Dadaists (especially Marcel *Duchamp) and was particularly cultivated by the *Surrealists. George Heard *Hamilton writes that the devotees of the objet trouvé believed that such pieces 'by their unexpected isolation from their customary purpose and environment could open magic casements on interior psychic seas...But the technique was easily abused, especially by interior decorators, until no bit of driftwood or broken bone was free from Surrealist implications.' Subsequently, found material has been much used in *assemblage.

Although the objet trouvé is considered a 20th-century phenomenon, the zoologist (and Surrealist painter) Desmond Morris (1928–) thinks that the earliest known art object in the world comes into this class. It is the 3 million-year-old Makapansgat Pebble (University of Witwatersrand, Johannesburg), discovered in the Transvaal in 1925. 'Investigations revealed that it could not have come from the cave where it was found and must have been carried from a location about three miles away. What made it special was that it had the shape of a human skull, on one side of which were small cavities that looked like a pair of sunken eye-sockets above a simple mouth. There is no suggestion that this "face" had been artificially manufactured but its accidental resemblance is so striking that it seems certain the object was collected and brought back to a favoured dwelling place as a "treasured possession"...the cave where it was discovered was not occupied by prehistoric man but by the early man-apes known as Australopithecines' (*The Human Animal*, 1994).

Obmokhu (Society of Young Artists) A group of Russian artists, most of them pupils of *Rodchenko and *Tatlin in the Moscow

*Vkhutemas, who experimented with spatial constructions and the properties of industrial materials. In 1920 Obmokhu held an exhibition of work by thirteen students of Vkhutemas. These were not socially useful designs, but open spatial constructions making dynamic use of the spiral form. A year later, however, most of these artists aligned themselves with the *Constructivists, signed a manifesto condemning non-useful (i.e. 'fine') art as a 'speculative activity', and thereafter devoted themselves to theatrical or industrial design. Prominent among them were the *Stenberg brothers and Konstantin (or Kasimir) Medunetsky (1899–c.1935), one of whose constructions, from 1919, was illustrated in *Circle* 1937.

O'Connor, Victor *See* ANGRY PENGUINS.

O'Conor, Roderic (1860–1940) Irish painter and etcher, active for most of his life in France (mainly Paris), where he settled in 1883 after studying in London and Antwerp. He was strongly influenced by *Gauguin and van Gogh, and by the early 1890s was painting in a full-blooded style with bold colour, often used non-naturalistically, and thick brushwork. Gauguin (whom he met at Pont-Aven) asked him to return to the South Seas with him, but O'Conor declined. After the death of his father in 1893 he was financially secure and had no need to promote his work (he often sold direct to collectors, including Somerset Maugham, who used aspects of O'Conor's character in his novel *The Moon and Sixpence*, 1919, about a Gauguinesque artist). He lived a fairly reclusive life (although he was friendly with many British visitors to France, including Clive *Bell and Roger *Fry) and he was virtually unknown in the British and Irish art worlds. It was only after his death that he was recognized as the outstanding pioneer of *Post-Impressionism among English-speaking artists. He did, however, notably influence Matthew *Smith, whom he met in 1919. O'Conor was mainly a landscapist, but he also painted still-lifes, portraits, interiors, and figure subjects. After about 1910 his colouring became less intense and some of his late work comes within the orbit of *Intimisme. There are good examples of his work in the Ulster Museum, Belfast, the National Gallery, Dublin, and Tate.

October Journal founded in 1976 by a number of American critics including Rosalind

*Krauss, for whom the existing contemporary art journals were too tied to the art market. Its title was intended to convey political radicalism, referring especially to the legacy of the post-revolutionary Soviet avant-garde (*see* CONSTRUCTIVISM). It has covered photography and film as much as the traditional media and most of its articles are theoretically oriented towards Marxist and feminist perspectives (*see* FEMINIST ART). Over the years it has acquired a distinct policy in favour of a materialist approach to art, as opposed to a more spiritual one, so *Broodthaers, *Haacke, and *Serra tend to be persistently promoted at the expense of Yves *Klein and *Beuys.

Oehlen, Albert (1954–) German painter, born in Krefeld. He studied under Sigmar *Polke and was a close associate of Martin *Kippenberger. All three shared a somewhat ironic stance and a reaction against the emphasis on painterly passion of the *Neo-Expressionists. Unlike Kippenberger, Oehlen, after a period of multimedia work, has concentrated on painting and since 1988 has worked as an abstract painter. He has described his work as 'post-non-representational' but also has admitted that he is 'not big on theory'. The paintings tend to be characterized by a strong sense of controlled chaos, with different kinds of spatial systems working against each other. Brandon Taylor has commented that 'his works speak of irresolution on a grand scale' and this is clearly not intended negatively but rather relates to the dilemmas of anyone trying to paint after *Conceptual art.

Oelze, Richard (1900–80) German painter, born at Magdeburg. He was a taciturn, maverick figure who for his first 40 years led a wandering existence, often in poverty, then lived almost like a hermit for the rest of his days. Recognition did not come until he was almost 60, but he is now regarded as Germany's leading exponent of *Surrealism apart from Max *Ernst.

Oelze studied at the *Bauhaus in Weimar, 1921–5, then for the next few years lived mainly in Dresden and Berlin. From 1933 to 1936 he lived in Paris, where he was associated with the Surrealists (in 1936 his work was shown in the International Surrealist Exhibition in London and in the exhibition 'Fantastic Art, Dada, Surrealism' at the Museum of Modern Art, New York). After spending two years mainly in Italy and Switzerland he

returned to Germany in 1938 and served in the army in the Second World War, during which he was taken prisoner. After his release he settled at Worpswede (*see* MODERSOHN-BECKER) until 1962, when he moved finally to Posteholz near Hameln. His reputation began to grow after his work was shown in the 1959 *documenta exhibition and in the last years of his life he received various distinctions (including the Max Beckmann Prize of the City of Frankfurt in 1978), although he continued to live a life of solitude, fiercely defending his privacy. He had trained in the precise style of *Neue Sachlichkeit and his early work is sometimes classified as *Magic Realism. The best-known example is *Expectation* (1935, MoMA, New York), showing a crowd of apprehensive figures—viewed from the back—looking at or for some unseen presence in the sky. It has an eerie science-fiction feel that is also seen in some of Oelze's later works, notably his weird semi-abstract landscapes made up of vegetable-like as well as geological forms.

Official War Art Art sponsored by the British Government during the First and Second World Wars to make a visual record of all aspects of the war effort for information and propaganda purposes. By extension, the term is also applied to art produced under official auspices for other Allied countries: Australia commissioned work for the Australian War Memorial in Canberra (originally intended to commemorate the First World War, but extended to encompass all wars in which the country was involved); Canada had a Canadian War Records Office that commissioned paintings and drawings; and the USA had a War Portraits Commission.

In the First World War, official art was directed by the Ministry of Information, which was advised by a committee drawn from distinguished figures in the art world and public life, among them Campbell Dodgson, keeper of prints and drawings at the British Museum, and Eric Maclagan, later director of the Victoria and Albert Museum. In 1916 the Ministry launched the Official War Artists scheme, under which artists were recruited, with appropriate military ranks, to serve as chroniclers (the Germans already had a similar scheme in operation). The first artist to be commissioned was Honorary 2nd Lieutenant Muirhead *Bone, who set off for France on

16 August 1916 and toured the front in a chauffeur-driven car. Many others followed, among them some of the most illustrious British artists of the time. They included men who had already been serving in the armed forces, such as Paul *Nash, C. R. W. *Nevinson, and Stanley *Spencer, and others who were too old for active duty. The works produced varied enormously in style and quality (the committee was admirably broad in its choice of artists) and included imaginative evocations of the war as well as sober factual records. There were many portraits of participants, but two of the most notable portraitists who worked as Official War Artists—*Orpen and *Sargent—showed a different and unexpected side to their talents, powerfully depicting the horrors they saw. Charles Harrison (*English Art and Modernism*, 1981) writes that 'the War was the occasion of the first major exercise in this country of state patronage of modern art. Virtually every professional artist of any demonstrable competence who was prepared to put on uniform was offered employment as an official war artist sooner or later.'

In autumn 1939, soon after the outbreak of the Second World War, the Ministry of Information appointed Kenneth *Clark chairman of a small group that became known as the War Artists Advisory Committee (Muirhead Bone was one of the members). It met weekly at the National Gallery, of which Clark was director, and its functions were principally 'to draw up a list of artists qualified to record the War at home and abroad . . . [and] to advise on the selection of artists from this list for war purposes and on the arrangement for their employment'. Clark regarded his work on the committee as 'my only worthwhile activity' during the war: 'We employed every artist whom we thought had any merit, not because we supposed that we would get records of the war more truthful or striking than those supplied by photography, but because it seemed a good way of preventing artists being killed' (*Ravilious was one of the rare fatalities). Several painters who had been Official War Artists in the First World War were employed in the same capacity in the Second, among them Nash and Spencer, but the Committee mainly employed men of a younger generation. The terms on which they were employed varied: some were given salaried posts for a specific period, while others were given one-off commissions. The Committee also encouraged artists, whether serving or civilian, to submit pictures for consideration. Generally the commissions in the Second World War were on a smaller scale than those in the First, with many works being executed in watercolour (Spencer's huge canvases of shipbuilding on the Clyde are a conspicuous exception). Henry *Moore's drawings of Londoners sheltering from air raids in Underground stations are perhaps the best-known of all the works produced under the auspices of Clark's committee.

In both wars women were employed as Official War Artists on the home front, notably the animal painter Lucy Kemp-Welch (1869–1958) in the First and Laura *Knight in the Second. A huge number of works was produced. The largest collection (about 10,000 items) is in the Imperial War Museum, London, which was opened in 1920 and moved to its present home (the former Royal Bethlehem Hospital) in 1936. There is another major collection in Tate and many provincial museums have good examples.

The tradition of Official War Art has been continued by the Artistic Records Committee of the Imperial War Museum, established in 1972. Artists who have worked under its auspices include Linda Kitson (1945–), who went on its behalf to the Falkland Islands during the war there against Argentina in 1982; John Keane (1954–), who went to the Gulf War in 1991; and Peter Howson (1958–) (*see also* GLASGOW SCHOOL), who went to Bosnia in 1993. Howson's exhibition 'War in Bosnia' at the Imperial War Museum in 1994 attracted attention because of its unsparing depiction of atrocities: 'Now that I've actually seen dead bodies, and guts and brains, and starving children, it has made the work authentic.' In 2003 Steve *McQueen visited Iraq.

Further Reading: B. Foss, *War Paint: Art, War, State and Identity in Britain 1939–1945* (2007)

M. and S. Harries, *The War Artists* (1983)

S. Malvern, *Modern Art, Britain, and the Great War* (2004)

Ofili, Chris (1968–) British painter of Nigerian descent, born in Manchester. He studied at Chelsea College of Art and Design and the *Royal College of Art. While at the latter, Ofili won a travelling scholarship to Zimbabwe. There he discovered the material which was to be his trademark, elephant dung. This was a way of linking his art to his African heritage but it was also, at first, used as a clever marketing ploy. Stickers marked 'elephant shit' were placed on London street furniture and

two 'shit sales' were held (more performance pieces than actual functioning market stalls), one in Berlin and one in Brixton market. Ofili's brilliantly coloured paintings also employ glitter and map pins (the ones with bright plastic balls on the end) to produce patterns and spell out names. The dung, in ball form covered with resin, is both attached to the canvas and used to raise the paintings, which are not hung but rested against the wall, from the floor. The technical complexity of some of his paintings means that from a distance they can appear like a purely abstract pattern. For instance it is only on close inspection of *Afrodizzia* (1996) that one sees the collage of black faces with painted-on 'Afro' hairstyles. Ofili has commented on his work: 'It's what people really want from black artists. We're the voodoo king, the voodoo queen, the witch doctor, the drug dealer, the *magicien de la terre*.' Much of the debate around Ofili's work is about whether it has a critical element or simply panders to an appetite for the stereotype. For Richard Powell, his painting only underscores 'how ineffectual and even counterproductive are many racial conventions in today's world'. Ofili was awarded the *Turner Prize in 1998. *See also* SAATCHI; SENSATION.

O'Gorman, Juan (1905–82) Mexican architect and painter, born in Mexico City, the son of Irish parents. He graduated from the school of architecture of the National University of Mexico in 1927, and between then and the mid-1930s he designed a series of houses in Mexico City (notably ones for himself and Diego *Rivera) that were among the first in the Americas to show the functional ideas of *Le Corbusier. In the 1930s, however, he abandoned architecture for painting, and he is described by Edward *Lucie-Smith as 'the most interesting of the less acclaimed artists in the Mexican Muralist movement' (*Latin American Art of the 20th Century*, 1993). O'Gorman's work was strongly nationalistic and his anti-Fascist, anti-church frescos at Mexico City airport (1937–8) were destroyed in 1939 during a political swing to the right. In the 1950s he returned to architecture, now advocating a more 'organic' approach inspired in part by the great American architect Frank Lloyd Wright. His most celebrated work is the Library of the National University in Mexico City (1951–3), in which a modern structural design is completely covered exter-

nally in mosaics of his own design symbolically representing the history of Mexican culture. O'Gorman committed suicide.

O'Hara, Frank *See* LESLIE, ALFRED.

O'Higgins, Pablo *See* TALLER DE GRÁFICA POPULAR.

Oiticica, Hélio (1937–80) Brazilian painter, sculptor, and installation artist, born in Rio de Janeiro. His father was a photographer and painter, his grandfather was an anarchist leader. A combination of radical aesthetics and political revolt were to be the hallmarks of his career. In the 1950s he worked in the field of geometric abstraction, exploring visual dynamics and the effects of colour. Early influences were Piet *Mondrian, *Kasimir *Malevich, and above all Paul *Klee. His concern was not just with the internal structure of the works but their relationship to the environment and the spectator. The *Série Branca* (1958–9) paintings were in pure white to maximize the effect of light. Other works hung from the ceiling. The *Invenções* (1959–62) appear at first sight to be undifferentiated monochrome but eventually reveal divisions subtly created by changes in the direction of brush-stroke.

In 1960 Oiticica joined the Neo-concrete group, which had been established a year earlier and whose leading figures included Lygia *Clark. Influenced by phenomenology, they opposed the idealist tradition of geometric abstraction, accused of addressing the 'eye machine' rather than the 'eye as body', as based on a mechanistic concept of humanity. Oiticica proposed the theory of 'nuclear colour', the idea that colour could be organized in a series of transitions from a 'nuclear' centre. This received its most spectacular manifestation in the *Grand Nucleus* (1960–6), a collection of large fibreboard rectangles suspended at different levels at right angles from each other. There is a violet core surrounded by various shades of yellow. It is likely that he was influenced by the then popular Munsell system for the scientific classification of colour. Oiticica explored ways in which a more immediate sense of colour could be induced. The *PN 1 Penetrável* (1961) is a cabin which the viewer can enter. The critic Mario Pedrosa (1900–81) described it as a 'labyrinth of colour in which the spectator was invited to stand on colour, smell colour, live colour'. *Bólides* ('Fireballs') of 1963 onwards would include

pigment in the form of coloured powder in wooden boxes which could be manipulated by the spectator. Guy Brett (*Kinetic Art*, 1968) wrote of a 'kineticism of the body' as a specifically Brazilian contribution to the art of movement.

In 1964 there was a military coup in Brazil. Oiticica became drawn to the world of the Mangueira *favela* (shanty town) and the life of marginals. The *Parangolés*, colourful capes which sometimes bore political slogans, designed to be experienced as much by the wearer as the viewer, were 'part of the fruit of this change of situation. According to Vincent Katz, the title is a colloquial expression referring to the devious behaviour of the 'well dressed ne'er-do-well who lives off women'. After his friend the outlaw Cara de Carvalo was killed by the police, Oiticia made *Box Bólide 18* in his memory. Described by Edward Leffingwell as a 'kind of cenotaph or reliquary', it was filled with red earth in a sealed bag with an image of the dead man's body. Another image of Carvalo was used on a red banner with the words 'Be an outlaw. Be a hero.' The music group Os Mutantes went into exile after using this banner in a concert. Oiticica liked to cite the idea that Brazil was a country 'condemned to modernity'. His work clearly demonstrates a less celebratory view of technology than that of most European and North American exponents of *Kinetic art. His installation *Tropicália* (1967, Tate), employing live parrots, sand, and a flickering television, is a comment on the uneasy relationship between progress and traditional culture and an attempt to establish a specifically Brazilian aesthetic in a global movement.

Oiticica moved to London in 1969. Not only was he a political dissenter but his open homosexuality was highly problematic in Brazilian culture. In London he made what is still regarded as his finest achievement, the *Eden* environment at the Whitechapel Art Gallery, a multi-sensory experience based on the artist's theory of 'cre-leisure' or creative leisure which opposed the traditional distinction between work and play. It could be regarded as an attempt to put into practice Mario Pedrosa's Marxist view that art was 'the best experimental laboratory for creating a socially emancipated Utopia' (F. Alambert, '1001 words for Mario Pedrosa', *Art Journal*, winter 2005).

Oiticica subsequently moved to New York. Some controversy persists on the final years of his life. Certain critics have talked of a 'lost decade' as a result of the cocaine addiction which was certainly a partial cause of his early death from a stroke. He worked at the concept of 'quasi-cinema', which involved the environmental use of slide projection and amplified sound. *CC1 Trashscapes* (1973), made in collaboration with the Brazilian film-maker Neville D'Almeida, used photographs of the Surrealist film director Luis Buñuel and the record jacket of Frank Zappa's *Weasels Ripped my Flesh*. Pillows and nail files were provided for the viewer's sensory experience. The faces were embellished by lines of cocaine employed as pigment or make-up which then vanished, presumably ingested by Oiticica himself. He returned to Brazil in 1978.

Further Reading: E. Leffingwell, 'Hélio Oiticica: myth of the outlaw', *Art in America* (December 2002)

O'Keeffe, Georgia (1887–1986) American painter. One of the pioneers of modernism in the USA, she was a member of the circle of *Stieglitz, whom she met in 1916 and married in 1924. She was born near Sun Prairie, Wisconsin, and trained at the Art Institute of Chicago, 1905–6, and the *Art Students League, New York, 1907–8. For the next two years she worked as a commercial artist, then taught at schools in South Carolina, Texas, and Virginia. In 1915–16 she did a series of abstract drawings and watercolours that evoked the natural world in simple forms and vivid colours. They impressed Stieglitz (who when he first saw her work is said to have exclaimed 'Finally, a woman on paper!') and he gave O'Keeffe her first one-woman show in 1917. She settled in New York the following year with the promise of his financial support. In the 1920s her work became more representational, but she remained interested in the underlying abstract forms of objects rather than in depicting them naturalistically. Particularly characteristic and admired are her near-abstract paintings based on flower and plant forms, works of great elegance and rhythmic vitality, whose sensuous forms are often sexually suggestive (*Black Iris*, 1926, Metropolitan Museum, New York). In the 1920s she also painted townscapes of New York in a manner close to that of the *Precisionists and landscapes done in broad, simple forms. From the 1930s she spent each winter in New Mexico and she settled there after Stieglitz's death in 1946, the desert landscape appearing frequently in her paintings (bleached animal bones were a favourite subject). She began to travel widely in the 1950s and many of her later paintings were inspired

by views of the earth, sky, and clouds seen from an aeroplane. Her growing reputation was marked by a major retrospective exhibition at the *Whitney Museum, New York, in 1970. She became partially blind in the following year and did little work thereafter. A museum of her work opened in Santa Fe in 1997.

Oldenburg, Claes (1929–) Swedish-born sculptor and graphic artist who became an American citizen in 1953, a leading figure of *Pop art. He was born in Stockholm, the son of a consular official. His father's diplomatic duties took the family to New York in 1929–33 and Oslo in 1933–6 before they settled in Chicago in 1936. Oldenburg studied art and literature at Yale University, 1946–50, then returned to Chicago, where he took courses at the Art Institute whilst earning his living with part-time jobs as a reporter and illustrator. In 1956 he settled in New York, where he came into contact with a group of young artists including Jim *Dine, Allan *Kaprow, and George *Segal, who were attempting to extend the ideas of *Action Painting beyond the traditional art object, and from c.1958 he was involved in numerous *Happenings. Creating the props and costumes for these helped to turn his interest from painting to three-dimensional work—*environments as well as sculpture. His inspiration was drawn largely from New York's street life—shop windows, advertisements, graffiti, and so on—and in 1961 he opened 'The Store', at which he sold painted plaster replicas of domestic objects. This led to the work with which his name is most closely associated—giant sculptures of foodstuffs, typically made of canvas stuffed with foam rubber (*Dual Hamburger*, 1962, MoMA, New York), and 'soft sculptures' of normally hard objects such as typewriters and washbasins, typically made of shiny vinyl. With these he was hailed as one of the leaders of American Pop art. Subsequently Oldenburg has also become well known for projects for colossal monuments—for example, *Lipsticks in Piccadilly Circus* (1966, Tate), consisting of a magazine cutting of an array of lipsticks pasted on to a picture postcard. The first of these projects to be realized was a giant lipstick erected at Yale University in 1969. Since 1976, in collaboration with his second wife, the Dutch writer Coosje van Bruggen (1942–2009), Oldenburg has concentrated almost exclusively on such large-scale projects, for example the

gigantic 20-metre-high *Match Cover* erected in Barcelona in 1992.

Further Reading: B. Rose, *Claes Oldenburg* (1984)

Olitski, Jules (1922–2007) Russian-born American painter and sculptor, one of the leading figures of *Post-Painterly Abstraction, specifically of *Colour Field Painting. He was born in Snovsk in Ukraine shortly after his father was executed by the Bolsheviks for political offences and was brought to the USA by his mother and grandmother in 1923. His main training was at the *Art Students League, New York, 1939–42. In 1949–51 he travelled in Europe and studied sculpture under *Zadkine in Paris. His early paintings were influenced by *Fauvism and he then went on to heavily textured abstracts, but in 1960 the direction of his work changed radically when he began experimenting with stain techniques in the manner of *Frankenthaler and *Louis. In 1964 he began using a spray gun and in the second half of the 1960s he developed the type of painting for which he is best known—vast canvases covered with luscious mists of atmospheric colour: he said that ideally he would like 'nothing but some colours sprayed into the air and staying there'. Sometimes there are some heavier touches at the edges of the canvas and in the 1970s Olitski returned to a more textural handling of paint, often reducing his colours to delicate modulations of greys and browns. He took up sculpture seriously in 1968 and worked mainly with painted steel. His work divides critics along fairly predictable ideological lines, according to their general sympathy with *formalist abstraction. He was strongly supported by Clement *Greenberg, but the Swedish critic Ulf Linde (1929–) denounced his art as 'visual muzak'.

Further Reading: T. Hilton, obituary, *The Guardian* (13 February 2007)

Olsen, John (1928–) One of Australia's leading abstract painters, born in Newcastle, New South Wales. He grew up and studied in Sydney, where he had his first one-man exhibition at the Macquarie Galleries in 1955. A year later he was one of the artists who took part in the Direction 1 exhibition—a milestone in the development of abstract art in Australia. In 1957–60 Olsen travelled in Europe, and on his return to Australia helped to form the group Sydney 9, aimed at increasing appreciation of abstraction in his country. In Europe Olsen's work had been strongly influenced by

the *Expressionism of the *Cobra group and the totemic imagery of Alan *Davie, whom he met in London. Back in Australia, he applied the lessons he had learned to an imaginative exploration of the bush landscape, notably in his series *Journey into You Beaut Country* (1961), in which lively calligraphic brushwork evokes a feeling of vegetation and insect life. In 1972 Olsen painted a mural for the newly completed Sydney Opera House, and in 1978 he made an extensive painting tour of Africa.

Omega Workshops Decorative arts company founded by Roger *Fry in London in 1913 with the twin aims of improving the standard of design in Britain and providing work for the young avant-garde artists in his circle. The headquarters were at 33 Fitzroy Square in *Bloomsbury. In a prospectus, Fry wrote that the workshops would undertake 'almost all kinds of decorative design, more particularly those in which the artist can engage without specialized training in craftsmanship'. He disliked the smooth finish of machine products, and Omega works characteristically have the irregularities of hand craftsmanship, although the furniture it sold was originally bought ready-made and then painted on the premises, and its linens were expertly printed in France. The favourite Omega motifs included flowers, nudes, and abstract patterns, and colour was often very bright; *Cubism and *Fauvism were strong influences.

Apart from Fry himself, the designers most closely associated with Omega were Vanessa *Bell and Duncan *Grant, and several other distinguished artists worked for the enterprise, including Paul *Nash and William *Roberts. However, all the work was sold anonymously. Several commissions came from aristocratic patrons, including Lady Ottoline Morrell (*see* CON-TEMPORARY ART SOCIETY). Artists were paid a regular wage (the financing came from Fry himself and from subscribers including George Bernard Shaw), and this steady income could be of great importance. Not all the employees appreciated Fry's endeavours, however, and in October 1913 Wyndham *Lewis left in unpleasant circumstances, together with Frederick Etchells (*see* REBEL ART CENTRE), Cuthbert Hamilton (*see* GROUP X), and Edward *Wadsworth. Lewis claimed publicly that Fry had played 'a shabby trick' on him and Spencer *Gore (not a member of Omega) by cheating them of a commission from *The Daily Mail* to decorate a room for the forthcoming Ideal Home Exhibition. The affair

seems to have originated in a simple misplaced message, but it caused considerable bad publicity and gave Lewis a lasting hatred of the *Bloomsbury Group. The First World War had a disastrous effect on Omega's sales (Fry in any case had little business aptitude) and the company was officially liquidated in 1920. The best idea of Omega furnishings in a contemporary setting can be gained at Charleston, the country home of Bell and Grant at Firle in Sussex.

Further Reading: F. Spalding, *Roger Fry: Art and Life* (1999)

Ono, Yoko (1933–) Japanese artist, active mainly in the USA. She had her first solo exhibition in New York in 1961; it included a *Painting to be stepped on* and a *Smoke painting*, made by lighting a painting with a cigarette. These works anticipated *Conceptual art in that more important than the objects themselves were the instructions for making them. Her most famous early work was *Cut Piece*, performed in Kyoto in 1964 and at New York's Carnegie Hall in 1965, in which she sat motionless on the stage and invited members of the audience to cut off her clothing. Influenced by John *Cage's ideas of noise as music she had the cutting sounds amplified. The performances are said to have been very different in mood, the New York one being far more aggressive, with blatant racism and sexism being displayed by the audience. When the work was recreated in Paris in 2003 as a demonstration for peace, *The Guardian* reported that the audience was disappointingly timid and polite. In 1966 Ono met the Beatle John Lennon (1940–80) at an exhibition of her work. They subsequently married and worked in collaboration, for instance on an exhibition at the Robert Fraser Gallery (*see* DINE) in 1968, an installation of charity boxes. She also made films, the most famous of which is *Film no. 4* (1966), consisting of close-ups of bottoms. Refusing it a certificate, the British censor said that there was no problem with showing bottoms but that other parts of the anatomy had got in as well. Ono has remained active as an avant-garde artist. At the 2008 Liverpool *Biennial she presented an installation of stepladders in a bombed church.

Onslow Ford, Edward *See* NEW SCULPTURE.

Onslow Ford, Gordon *See* PAALEN, WOLFGANG.

Op art (abbreviation of Optical art, on the analogy of Pop art) A type of abstract art that exploits certain optical phenomena to cause a work to seem to vibrate, pulsate, or flicker. Op art flourished mainly in the 1960s; the term was first used in print in the American magazine *Time* in October 1964 and had become a household phrase by the following year, partly through the attention given to the exhibition 'The Responsive Eye' held at the Museum of Modern Art, New York, in 1965. This was the first international exhibition with a predominance of Op paintings. The development of Op art as a recognizable movement had begun a few years earlier than this, in about 1960, the works and theories of Josef *Albers and the *Roto-Reliefs* of Marcel *Duchamp being among the main sources. The devices employed by Op artists (after-images, effects of dazzle and vibration, and so on) are often elaborations on the well-known visual illusions to be found in standard textbooks of perceptual psychology, and maximum precision is sought in the control of surfaces and edges in order to evoke an exactly prescribed retinal response. Many Op paintings employ repeated small-scale patterns arranged so as to suggest underlying secondary shapes or warping or swelling surfaces. This kind of work can retain much of its effect in reproduction, but Op art also embraces constructions that depend for their effects on light and/or movement, so Op and *Kinetic art sometimes overlap.

The two most famous exponents of Op art are Bridget *Riley and Victor *Vasarely. Their work illustrates the considerable impact that Op made on fashion and design in the 1960s—its instant popular success is hard to parallel in modern art. Op art became something of a craze in women's fashion and in 1965 Riley unsuccessfully tried to sue an American clothing company that used one of her paintings as a fabric design. One of Vasarely's designs was used on the plastic carrier bags of France's chain of Coop stores. Other leading artists whose work falls mainly or partly within the category of Op include *Agam, *Anuszkiewicz, *Cruz-Diez, *Sedgeley, and *Soto. *See also* PERCEPTUAL ABSTRACTION.

Further Reading: J. Houston, *Optic Nerve* (2007)

Opie, Julian (1958–) British sculptor and painter, born in London, where he studied at *Goldsmiths College. He first became noted in the 1980s for sculpture in steel in which the surface and colours of the objects were represented semi-illusionistically in vigorously handled paint. This fitted in with the art world's fascination with the ideas of Jean *Baudrillard about 'simulation'. Opie represented both ordinary objects and 'Old Master' paintings. *Eat Dirt Art History* was the title of one work. He followed up such works with abstract structures in wood or Perspex suggesting modernist buildings that were impossible to enter. As a painter he has developed a readily recognizable style, with simple hard black outlines and dots for eyes. This gained wider public recognition when in 2000 he designed an album cover for the pop group Blur. Opie has animated drawings both with computer and with LED display. In 2008 he designed the ballet *Infra* for the Royal Opera House, Covent Garden.

Oppenheim, Dennis (1938–) American artist, born in Electric City, Washington. His work has spanned *Land art, *Performance, *Body art, *installation, and sculpture but is rooted in the questioning of the traditional art object signalled by *Conceptual art. Early in his career, in the late 1960s, he was close to Lawrence *Weiner and shared his idea that the work of art might be a process rather than an object. However, he did not follow Weiner's conclusion that this process need not be enacted by the artist. Instead Oppenheim's projects were played out, sometimes elaborately and expensively, occasionally even painfully. In spite of its diversity the work has a frequently recurring theme of the exchange and transference of materials. In *Cancelled Crop* (1969) a field was sown in lines which followed closely the topography of the path between the field and the grain silo. When the grain was ready for harvesting in September, it was done in the form of an X. The grain was never processed, so removing it both from its exchange value and from any function outside its role as art. In *Branded Mountain* (1969) the cattle and the land they graze upon share the same brand. As Oppenheim put it 'Cows gaze on abstractions of their own bodies'. In the cringe-inducing *Material Exchange* (1969), the end of one of the artist's fingernails is ripped off and inserted in a wooden floor, a splinter from which is lodged in his finger. These activities emphasize that this art is a process which takes place in real time rather than operating as a timeless object. Such actions are documented in photographs and text

which provide a permanent record of the event. Although these records end up in museum collections, the question arises as to how far they have a status of art works in their own right. Oppenheim's work also challenges the idea of art as necessarily a benevolent force. One sinister piece is entitled *Attempt to Raise Hell* (1974). A metal figure, in some versions a Buddhist priest, is seated opposite a metal bell. Drawn to the bell by magnetism every hundred seconds, the figure is struck between the eyes, creating a resounding clang. *Lecture #1* (1976) takes the form of an effigy of the artist with a recording of a lecture in which he recounts the imaginary deaths of many of his contemporaries as a result of conspiracy. What gives the work a particular sense of danger is that the fantasy was triggered by the actual tragic death of Robert *Smithson in an air crash. In later years Oppenheim has made conventionally object-based sculpture, although he remains an unusual and highly imaginative artist. *Rising and Setting Neighborhood* (2006, Riverdale Station, Bronx) is sited to greet New York commuters with an image of rows of houses rising and setting like the sun.

Further Reading: Musée d'art contemporain de Montréal, *Dennis Oppenheim: retrospective works 1967–1977* (1978)

Oppenheim, Meret (1913–85) German–Swiss painter, sculptor, designer, and maker of *objects. She was born in Berlin and studied at the Kunstgewerbeschule in Basle. In 1932 she moved to Paris, where she was introduced to the *Surrealist group by *Giacometti and became for a while the model and disciple of *Man Ray. He described her as 'one of the most uninhibited women I have ever known' and she became celebrated among the Surrealists as the 'fairy woman whom all men desire'. She had a long career, but she is remembered mainly for one early work: *Object* (1936, MoMA, New York), a fur-lined tea cup and saucer. This became famous after being shown at two major exhibitions in 1936—the International Surrealist Exhibition in London, and 'Fantastic Art, Dada, Surrealism' at the Museum of Modern Art, New York. In 1937 she returned to Switzerland, where her career was sporadic. Among her later works the best known is probably *Cannibal Feast*, made for a Surrealist exhibition in Paris in 1959; it involved a nude woman lying on a table and covered with food. In her final years Oppenheim received commissions for public

sculptures, notably a fountain in the Waisenhausplatz in Berne (1983).

Orlan (1947–) French artist, born in St Étienne. The name is a pseudonym which sounds like a brand of beauty product. By the artist's own account she adopted it when, under psychoanalysis, she became aware that her signature had come to resemble 'mort', (death). Taking out the two middle letters she added 'lan' to make it sound like 'or-lent' (slow gold). She studied painting and sculpture but she concluded that 'Painting is a refusal to fully assume one's own exhibitionism; it is to wear a mask.' She started to use the body in photographic works in 1964. Her performance of 1977 *Le Baiser de l'artiste*, in which she wore a kind of placard on which she offered kisses to the public for sale, incited controversy. She stood alongside a life-size photograph of herself as 'St Orlan', dressed like a Baroque saint. Such work was very much part of the French *feminist movement's demand for women's right to control their own bodies, especially in the areas of contraception and abortion. The choice of Baroque imagery was influenced by the general unpopularity of the style in France, where the great sculptor and architect Gianlorenzo Bernini (1598–1680), whose ecstatic image of St Theresa was a source for Orlan, had conspicuously failed to achieve the success which he had had in Rome. Orlan has said: 'My work is in the area of pleasure and sensuality. I do not believe in pain as a form of redemption and purification.' This separates her from some other female body artists including Gina *Pane and Marina *Abramović, even in her most extreme works in which she undergoes plastic surgery. *The Reincarnation of St Orlan* was a series of surgical procedures carried out between 1990 and 1993, during which her face was remodelled according to standards of beauty set by Old Master paintings. Implants were added to her forehead, which she subsequently emphasized with silver make-up. The operations were broadcast live and conducted under local anaesthetic so that the artist could participate, reading appropriate theoretical texts. When the critic Barbara Rose wished to publish an article on her in *Art in America*, the editor insisted on seeing videotapes of the surgery in order to verify the authenticity of the events. The project is hardly an attack on plastic surgery as such; indeed, Orlan has encouraged the view that what she calls

'Carnal Art' is, in some way, a celebration of the power to transform the body and negate pain. Nonetheless it is also a critique of imposed images of beauty, which has been taken further in the 'self-hybridization' series of 1997 onwards. Here Orlan's features are transformed, not by surgery, but by digital technology, to represent different standards of beauty.

Further Reading: L. Heygi et al., *Orlan: Le Recit* (2007)

'Orovida' (Orovida Pissarro) *See* PISSARRO, LUCIEN.

Orozco, Gabriel (1962–) Mexican artist, born in Jalaga. His work combines elements of performance, sculpture, drawing, and *installation, and is rooted in paradox, games play, and the unexpected. Sometimes he seems to be extending the *Duchampian idea of the *ready-made by thinking of the whole world as a collection of potential artworks. In *Until You Find Another Yellow Schwalbe* (1995), he rode around Berlin on a yellow scooter photographing similar ones. Whereas Duchamp claimed, somewhat disingenuously, an indifference to his choice of object, Orozco dramatizes the relationship between the choice and the artist's identity. In 1996 he made an oval billiard table without pockets, which he described as 'a speculation relating to space, topography, mathematics, and the logic of the object itself'. His most elaborate application of mathematics to the object is *Black Kites* (1997). This is a human skull on which is drawn an exactly plotted chequerboard design which took the artist six months to draw by hand. Again it is tempting to reference Duchamp, who famously at one stage renounced art for chess. Orozco has also made hand-crafted objects out of fired terracotta. Although critics have found it hard to classify his work, it is marked by a preoccupation with the precarious status of art-making in the contemporary world and the tussle between taste and theory.

Further Reading: A. Searle, 'The Player of Games', *The Guardian* (6 July 2004)

Orozco, José Clemente (1883–1949) Mexican painter, with his contemporaries *Rivera and *Siqueiros one of the trio of politically and socially committed fresco painters who were the dominant force in modern Mexican art. He was born in Zapotlán el Grande (now Ciudad Guzmán) and grew up in Guadalajara and Mexico City. Originally he trained to be an architect, but he abandoned this idea after losing his left hand in an accident in 1900 and turned instead to painting, studying under Dr *Atl at the Academy of San Carlos in Mexico City, 1906–14. Following the first outburst of revolutionary activity in Mexico in 1910 (which was to last on and off until 1920), Orozco began working as a political cartoonist. In 1912 he began a series of watercolours called 'House of Tears' dealing with prostitutes (a favourite symbol of human degradation for Orozco). The angry reaction of critics and moralists to these works was one of his reasons for leaving for the USA, where he spent three unhappy and unproductive years, 1917–20.

His career as a muralist began after he returned to Mexico in 1920. The country was now relatively stable under the government of Alvaro Obregón, who encouraged paintings on nationalistic subjects as a way of creating a positive identity for the country after years of turmoil. Orozco's first murals were in the Escuela Nacional Preparatoria (National Training School), 1923–4. They were controversial because of their caricatural style, and all except *Maternity* and *The Rich Banquet while the Workers Quarrel* were subsequently destroyed or altered. His style matured towards a greater monumentality in frescos in the Casa de los Azulejos (House of Tiles), Mexico City (1926), and in a second series at the National Training School (1926–7). The work brought him little recognition, however, so from 1927 to 1934 (broken by a brief trip to Europe in 1932) he again worked in the USA. This time he was much more successful than during his first stay, carrying out a number of important mural commissions, most notably a cycle for Dartmouth College, New Hampshire, on *The Coming* and *The Return of Quetzalcoatl* (1932–4). This huge scheme showed his outlook crystallizing into a contrast between a pagan paradise and a capitalist hell. Unlike Rivera and Siqueiros, Orozco did not align himself with a particular political viewpoint (the Mexican Communist Party called him a 'bourgeois sceptic'), but his work had an intense humanitarian mission.

Orozco returned to Mexico in 1934 with a big reputation after his success in the USA, and he spent most of the rest of his life engaged on mural projects in Mexico City and Guadalajara, the country's second city. His last work, *Hidalgo and the Liberation of Mexico*, for the Senate Chamber of the Palace of Government in

Guadalajara, was finished shortly before his death in 1949. In his last years his work became ever more violent in expression, moved by a passionate concern for the suffering and miseries of mankind. Four years before his death, Orozco's autobiography was published; it was translated into English in 1962. His studio in Guadalajara is now a museum dedicated to him; a commemorative statue of Orozco stands in the park opposite.

Orpen, Sir William (1878–1931) British painter, chiefly famous as one of the leading fashionable portraitists of his day. He was born at Blackrock, near Dublin. A child prodigy, he began studying at the Metropolitan School of Art, Dublin, in 1890, when he was only eleven. In 1897 he settled in London and spent two years at the *Slade School, winning the composition prize in 1899. His contemporaries at the Slade included Augustus *John. The circles in which he moved can be gauged from his *Homage to Manet* (1909, Manchester Art Gallery), which shows a group of some of the leading figures in the art world informally arranged around a tea-table beneath Manet's portrait of his pupil Eva Gonzales: the six figures represented are the patron and collector Sir Hugh *Lane, D. S. *MacColl, who at this time was keeper of the Tate Gallery, the novelist and critic George *Moore, and the painters *Sickert, *Steer, and *Tonks.

Orpen's style in portraiture had much in common with that of his friend John, being vigorous and painterly but sometimes rather flashy. He was at his best when he was away from his standard boardroom and drawing-room fare, and his numerous self-portraits are often particularly engaging, as he pokes fun at himself in character roles. Up to the First World War he had a steady rise in worldly success and after the war he earned an average of about £35,000 a year, rising to over £50,000 a year in 1929—a colossal sum then.

Apart from portraits, Orpen also painted genre subjects, landscapes, interiors, nudes, and allegories, and he did memorable work as an *Official War Artist in France (he also attended the 1919 Peace Conference in Paris and painted *The Signing of the Peace in the Hall of Mirrors, Versailles, 28 June 1919* (Imperial War Museum, London)). He wrote two books, *An Onlooker in France 1917–1919* (1921) and *Stories of Old Ireland and Myself* (1924) and edited *The Outline of Art* (1923), which was written, largely uncredited, by Frank *Rutter.

Further Reading: R. Upstone, *William Orpen: Politics, Sex, and Death* (2005)

Orphism (Orphic Cubism) Terms coined by *Apollinaire to describe a type of painting—a development from *Cubism—practised by Robert *Delaunay and some of his associates between 1911 and the outbreak of the First World War in 1914. The reference to Orpheus, the singer and poet of Greek mythology, reflected the desire of the artists involved to bring a new element of lyricism and colour into the austere intellectual Cubism of *Picasso, *Braque, and *Gris. Apollinaire first used the terms in print in his book *Les Peintres cubistes* (1913), but he is said to have used them earlier in a lecture at the exhibition of the *Section d'Or in October 1912. (Previously the word 'Orphic' had been used by the *Symbolists.) Apart from Delaunay, the artists whom Apollinaire mentioned as practitioners of Orphism were Marcel *Duchamp, Fernand *Léger, and Francis *Picabia (all members of the Section d'Or), but František *Kupka, another member of their circle, was in fact closer in style to Delaunay than these three. Apollinaire described Orphism as 'the art of painting new structures with elements that have not been borrowed from the visual sphere, but have been created entirely by the artist himself, and been endowed by him with fullness of reality. The works of the Orphic artist must simultaneously give a pure aesthetic pleasure, a structure which is self-evident, and a sublime meaning, that is, a subject. This is pure art.' This indicates a move towards abstraction, and by 1912 both Delaunay and Kupka were painting completely non-representational pictures characterized by intensely vibrant fragmented colours. Despite its short life, Orphism was highly influential, notably on the *Synchromists, who also worked in Paris, and on several major German painters, particularly *Klee (who visited Delaunay in 1912), *Macke, and *Marc. On 19 October 1913 *The New York Times* published an article entitled '"Orpheism" Latest of Painting Cults', emphasizing Kupka's role in the development of abstract art.

Oshogbo Workshop See SEVEN-SEVEN, TWINS.

Osma See EIGHT, THE (2).

Osthaus, Karl Ernst *See* SONDERBUND.

Oteiza, Jorge (1908–2003) Spanish sculptor and art theorist, with strong commitment to Basque culture, born in Orio, Guipúzcoa. In 1935 he moved to South America, where he made contact with Communists and Basque nationalists exiled by the Spanish Civil War. He returned to Spain in 1948. His iron sculptures, partial and distorted geometric shapes, achieved considerable international success, but in 1959, two years after winning the sculpture prize at the São Paulo *Bienal, he renounced sculpture altogether for polemics and theory. His ideas were based on the notion of art as a sacramental activity, that was the alternative to conventional religion as the answer to the problem of death. He found this in the ancient sculpture of the Andes, the characteristic funerary statues of Basque cemeteries, and the work of *Cézanne, *Malevich, and *Tatlin. He spent much of the rest of his life distanced from the art world, even refusing to sell his early sculptures, but campaigning for a modern art museum in San Sebastian. His own project was finally rejected just as the *Guggenheim Museum in Bilbao, which he opposed even to the point of threatening violence, was agreed.

Further Reading: J. Zulaika (ed.), *Oteiza's Selected Writings* (2003)

Otero, Alejandro (1921–90) Venezuelan painter, sculptor, administrator, and writer, regarded as one of his country's leading artists. He was born at El Manteco, Bolivar State, and studied painting, sculpture, and stained glass at the School of Fine and Applied Arts, Caracas, 1939–45. On graduation he was awarded a government grant that enabled him to visit Paris. His early work had been influenced by *Cézanne and *Cubism, and in Paris he moved to complete abstraction; the transition can be seen in his *Cafetera* (Coffeepot) series. Otero had a longer stay in Paris in 1949–52, and after his return to Venezuela he was one of the artists who worked on the design of University City Caracas. This was masterminded by Carlos Raúl Villanueva (1900–75), who was an art patron as well as an architect, and commissioned work from artists of the stature of *Arp, *Calder, and *Léger for his buildings; Otero contributed to the exterior design of the School of Architecture. In 1955 he began a long series of *Coloritmos* (Colour-rhythms), probably his best-

known works, which feature patterns of vertical or horizontal stripes in a manner anticipating *Op art. From 1960 to 1964 he again lived in Paris, and after his return to Venezuela he was vice-president of the National Institute of Culture and Fine Arts, 1964–6. He had a solo exhibition at the Venice *Biennale in 1966, and the following year he began producing large outdoor *Constructivist sculptures, a good example of which is *Delta Solar* (1977) outside the Air and Space Museum in Washington DC. Otero also wrote and lectured a good deal on art.

Otterlo, Kröller-Müller Museum *See* KRÖLLER-MÜLLER, HELENE.

Oulton, Therese (1953–) British painter and printmaker, born in Shrewsbury. She originally studied anthropology, but she was so impressed by a chance visit to an exhibition of Morris *Louis's *Veil* paintings that she took up art, first studying at evening classes and then full-time at *St Martin's School of Art, London, 1975–9, and the *Royal College of Art, 1980–83. In 1984 she had her first solo show, at *Gimpel Fils Gallery, London, and she very quickly established a considerable reputation with her sombre, richly worked abstract or semi-abstract paintings. They are often seen as evoking landscape or architectural forms, and Oulton has even been discussed in terms of the British tradition of landscape painting. The paintings, however, also relate to the invocations of sublime landscape in *Abstract Expressionists such as *Rothko or later artists such as Per *Kirkeby and Anselm *Kiefer. Oulton has also produced lithographs and monotypes.

Oursler, Tony *See* VIDEO ART.

Outsider art *See* ART BRUT.

Ovenden, Annie and **Graham** *See* BROTHERHOOD OF RURALISTS.

Oxford, Modern Art *See* MODERN ART, OXFORD.

Ozenfant, Amédée (1886–1966) French painter, writer, and teacher. He was born in St Quentin, where he studied at the municipal drawing school before moving to Paris in 1905 to study architecture and painting. From April 1915 to December 1916 he published a journal entitled *L'Élan*, intended to form a channel of communication between avant-garde artists

serving in the armed forces and those remaining in Paris. In 1918 he met *Le Corbusier, with whom he founded *Purism, a cool style characteristically featuring such objects as bottles and glasses in profile. Together they edited the journal *L'Esprit nouveau* (1920–25), which expounded their theories; these proposed a link between the 'rational' forms supposedly associated with industrial production and the *Neoclassicism which so characterized contemporary art in Paris. After 1926 his work became somewhat freer and included figure compositions. However, he is much better known as a teacher and writer than for his own artistic output. In 1924 he founded an art school in Paris with *Léger, the Académie de l'Art Moderne. From 1935 to 1939 he lived in London, then from 1939 to 1955 in New York, founding schools in both cities (he became an American citizen in 1944 but later reverted to French nationality). His views ran counter to the prevailing ethos of America at the height of the McCarthy period (he had made outspokenly pro-Communist statements in the 1930s) and he returned to France in 1955, settling in Cannes, where he directed a studio for foreign art students. His most important book was *Art* (1927), subtitled *Bilan des arts modernes: Structure d'un nouvel esprit* ('The Balance Sheet of Modern Arts: The Structure of a New Spirit'). The book was translated into English as *Foundations of Modern Art* (1931, enlarged edn, 1952). It is a study of the interrelationship of all forms of human creativity, including science and religion, and is one of the most widely read books by any modern artist.

Further Reading: Golding (1994)

Paalen, Wolfgang (1905/7–59) Austrian-born painter who became a Mexican citizen in 1945. He was born in Vienna, and after studying in France, Germany, and Italy, he lived in Paris from the late 1920s until 1939, when he emigrated to Mexico at the invitation of Frida *Kahlo. Paalen had a varied career in avant-garde circles (in the early 1930s, for example, he painted cool abstractions and was a member of *Abstraction-Création), but he is best remembered for his involvement with *Surrealism, which lasted from 1936 to 1941. His most characteristic pictures depict phantasmagoric clawed creatures that he called 'Saturnine Princes'. He also experimented with *automatism and is credited with inventing the technique of fumage, which exploited the effects produced by candle soot on paper. In 1940 he helped to organize an international Surrealist exhibition in Mexico City. However, the following year he abandoned Surrealism and concentrated on his 'Dynaton' movement, aimed at uniting aspects of pre-Columbian art (which he studied and collected) and modern science. He put forward his ideas in the review *Dyn* (six issues, 1942–4), his writings for which (in English) were collected in his book *Form and Sense*, published in New York in 1945. His collaborator in the Dynaton movement was another former Surrealist, the British-born (later American) painter Gordon Onslow Ford (1912–2003). Together they arranged a Dynaton exhibition at the San Francisco Museum of Art in 1951. Later in the 1950s Paalen developed a violent abstract style. He committed suicide, following a scandal about dealing in stolen artefacts.

Pacheco, Ana Maria (1943–) Brazilian-born sculptor, painter, and printmaker who has lived and worked in the UK since 1973. She is best known for her ensembles of sinister life-size figures in painted wood which comment especially on male cruelty and arrogance. (Her work first came to attention in an exhibition held at the *Institute of Contemporary Arts, London, in 1980, entitled 'Women's Images of Men'.) Her figures tend to be hunched and dwarf-like, given an additional nightmare quality by the use of real teeth in the mouths (*Man and his Sheep*, 1989, Birmingham Museum and Art Gallery). Mythical and religious themes, usually given a dark edge, also figure in much of her work.

Paik, Nam June (1932–2006) Korean *Video and *Performance artist and musician, born in Seoul. He trained as a classical musician. Because of the Korean War his family fled first to Hong Kong and then to Japan, where he studied music and art history. In 1956 he went to Germany to study new music at the University of Munich. In 1964 Paik moved to New York, where he subsequently lived and worked. In 1958 he met John *Cage and in 1961 became involved with *Fluxus. Paik's early performances came out of his background in experimental music. For instance, *One for Violin Solo* (1962) consists of the smashing of the instrument. The *Étude for Piano (Forte)* performed in Cologne in 1960 was even more provocative. Paik sat down and played Chopin, lay down on a second piano, then suddenly got up and went to Cage who was sitting in the front row, cut off his tie and part of his shirt, shampooed his head, and then pushed through the audience to the exit. A few minutes later he phoned from outside to announce the end of the performance. This may have been inspired by an experience when he had visited his revered teacher in a hotel and found him washing his shirts, but may also have been a test to destruction of the passivity and acceptance of things at the core of Cage's outlook.

In 1963 Paik began working with television sets and it is this that has given him the reputation of the founder of Video art. His use of the medium is, however, rather closer to sculpture and performance than the more

cinematic or pictorial concerns of later Video artists. This is exemplified in the 1963 Munich exhibition entitled 'Exposition of Music: Electronic Television', in which dozens of televisions were strewn around the gallery, all doctored to distort what was being broadcast. In later pieces television sets are arranged to form crazy robots. His most celebrated video sculpture is probably the *TV Buddha* (1974, Stedelijk Museum, Amsterdam), in which a Buddha statue sits contemplating its own image on closed-circuit television. In 1996 he suffered a stroke which curtailed his Performance activities, but he continued to work from his apartment in Miami.

Further Reading: Hayward Gallery, *Nam June Paik: Video Works 1963–88* (1988)

Obituary, *The Times* (29 January 2006)

Painters Eleven A group of Canadian abstract painters based in Toronto and active from 1953 to 1960. The most important member was William *Ronald. Apart from being abstract rather than figurative artists, the painters had little in common stylistically and for this reason the non-committal name of the group was deliberately chosen. They were united mainly by the desire to promote their work in an environment unfavourable to abstract art and in this achieved considerable success, especially after they were guest exhibitors with *American Abstract Artists in New York in 1956. A group of their works is in the Robert McLaughlin Gallery, Oshawa, Ontario.

Paladino, Mimmo (1948–) Italian painter and sculptor, a leading figure in the *Transavantgarde. Born in Paduli as Domenico Paladino he spent most of his youth in Naples. His paintings tend to vivid reds and yellow-golds, frequently using the image of the mask. As Norman Rosenthal puts it, they are 'full of the imagery of rituals', and he draws both on Catholic ritual and on the animism he discovered during trips to Brazil. This is, however, always a generalized suggestion, never a precise narrative. He has tended to be most admired by those who celebrated unreservedly the painting revival of the 1980s (*see* NEO-EXPRESSIONISM). His work has a notably wide range of art-historical reference: Rosenthal cites 'African cave painting, Gothic sculpture, the great fourteenth century frescoes of Florence, the Roman mysteries as described in Pompeian wall paintings'. Where he is condemned, the usual charge is

that he is part of a generally reactionary tendency. The 'archaic personages' reappear in his sculpture in wood and patinated bronze. His work has been widely seen, but critical commentary has tended to be thin. Rachel Withers writes: 'The art world evidently likes looking at Paladino's neoprimitivist paintings and sculptures, but not taking them apart' (*Artforum International*, November 1999).

Palazzo Grassi, Venice. *See* HULTEN, PONTUS.

Palermo, Blinky (1943–77) German artist. Born in Leipzig as Peter Schwarze, he was adopted and called Peter Heisterkamp. He took the name Blinky Palermo from an American boxing promoter and *mafioso* (once described as 'one of boxing's certifiable bad guys', whom he physically resembled. He was a student of Joseph *Beuys at the Düsseldorf Academy and became closely associated with Gerhard *Richter, Sigmar *Polke, and Imi *Knoebel. All these artists were involved with exploring the physical processes of painting and representation. Jan Verwoert has argued that his art represents a kind of transition between the Romantic concept of art maintained by Beuys and the materialist concept of art as a response to the mundane adopted by his fellow students. Indeed his work has been identified both with a German Romantic tradition and with a *Pop sensibility. He made use of simple forms and materials like sticks and T squares. Reductivist geometric abstractions were made from sown-together lengths of ready made fabric. Works were sometimes designed for a particular space and so could never be repeated. The distinctive quality of his art is in the way that these apparently inconsequential structures seem to represent a meeting point of so many strands of modern art, from the geometry of *Malevich to the socially aware sense of the poetry of materials of Beuys. Palermo died suddenly on holiday in the Maldives after some years of alcohol and substance abuse. As with so many artists who died young, a romantic myth has grown up around him. In 1981 Julian *Schnabel made a painting entitled *The Unexpected Death of Blinky Palermo in the Tropics.*

Further Reading: B. Adams, 'The Ballad of Blinky Palermo', *Art in America* (June–July 2005)

J. Verwoert, 'Blinky Palermo', *Frieze* (March 2003)

Panamarenko (1940–) Belgian artist, born in Antwerp. There has been some speculation

as to the origin of his pseudonym. It may derive from the name of a Soviet general responsible for the quelling of riots in East Germany or from Pan American Airways with a Russian-sounding ending. His original name was Henri van Herwegen, although many sources are conspicuously silent on this. He operates in a field somewhere between art and fantastic invention. A constant theme is the attempt to defy gravity. One example of his work is *The Aeromodeller* (1969–71), a balloon designed to impress the actor Brigitte Bardot and supposedly providing the artist a means to elope with her. *The Flying Cigar* (1980) was designed to use the magnetic force of the earth to power a spaceship, a concept which strikes the non-physicist as about as plausible as the perpetual motion machine. Indeed his work seems more in the tradition of *Duchamp's ultimately tragic 'bachelor machines' than the inventions of Leonardo da Vinci and is visually striking rather than functional.

(WEB) SEE WEB LINKS

- 'Panamarenko: Orbit': essay by Lynne Cooke on the Dia art foundation website.

Pandemonium See BASELITZ, GEORG.

P & D *See* PATTERN AND DECORATION MOVEMENT.

Pane, Gina (1939–90) French artist, associated with the more extreme forms of *Body art. Born in Biarritz of Austrian and Italian parents, she attended the École des Beaux-Arts in Paris during the early 1960s. Her performances, which involved self-mutilations and extremes of endurance, were associated with protests against the Vietnam War. For instance, in *Unanaesthetized Climb* (1970) she climbed up and down a ladder with spikes on the rungs until her feet bled, as a symbol of the escalation of the war. Her work has also carried *feminist implications. One of her best-known works was *Azione Sentimentale*, which occupied three separate spaces in a Milan gallery. In the first, the floor was covered with black velvet in the centre of which there was a white rose. On the walls there were photographs of roses, each dedicated to one woman from another. In the second, there was a projected image of the artist holding red roses. In the final space, Pane enacted a performance in front of an all-female audience. After adopting a foetal position she pricked her arms with thorns and cut the palms

of her hands which she then offered to the audience. In the background there were French and Italian texts read by women and a recording of Frank Sinatra singing 'Strangers in the Night'. As well as social protest against the confinement and control of the body and an appeal to political lesbianism, it is quite possible to read a religious element in the implications of sacrifice in Pane's work.

(WEB) SEE WEB LINKS

- J. V. Aliaga, 'The Folds of the Wound: On Violence, Gender, and Actionism in the Work of Gina Pane', on the Artecontexto website.

Paolini, Giulio (1940–) Italian artist, born in Genoa. He trained as a graphic artist and became associated with *Arte Povera. However, he was already a well-established figure by the time that the tendency was identified in the late 1960s and of all the artists connected with it, he was the most cerebral and his work has sometimes been considered closer to *Conceptual art. One preoccupation was an exploration of the basis of art and representation. His earliest documented work, *Geometric Design* (1960), was a small canvas divided by a horizontal, a vertical, and two diagonals, the grid used by artists to ensure the transfer of accurate proportions. A further feature is the frequent reference to classical antiquity and Renaissance art, something shared with Michelangelo *Pistoletto. This challenged both *modernist notions of progress and the materialist consumerist culture which was threatening to sweep away the past in postwar Italy. The viewer of Paolini's work is always bound in time and history. *Presumed Portrait of Pyrrhus* (1963) is a two-sided picture. On what would normally be the front (the supports are less visible), one sees only a grid drawn on white. On the other side on the rough hardboard there is pasted a photograph of the bust in question, together with the artist's signature, address, and the date. Questions are raised about what we are expected to look at—how we distinguish relevant and irrelevant information from a work of art. What does it imply for our ideas about likeness when we *presume* the identity of a bust? There is a major installation by Paolini in the Musée des Beaux-Arts in Lille.

Further Reading: F. Poli, *Giulio Paolini* (1992)

Paolozzi, Sir Eduardo (1924–2005) British sculptor, printmaker, and designer, born in

Edinburgh of Italian parentage. He studied at Edinburgh College of Art, 1943, and the *Slade School, 1944–7. While still a student he had his first one-man exhibition as a sculptor, at the Mayor Gallery, London, in 1947. Robert Melville wrote: 'His work is more barbaric and at the same time more classical in its casual poise than anything the English school can show, and a long European holiday is not likely to bring him to heel' (*Horizon*, September 1947). Indeed it did not. In the same year he began making witty collages using cuttings from American magazines, advertising prospectuses, technological journals, etc. (*I Was a Rich Man's Plaything*, 1947, Tate). Paolozzi regarded these collages as 'ready-made metaphors' representing the popular dreams of the masses, and they have been seen as forerunners of *Pop art (he eventually amassed a large collection of 20th-century pulp literature, art, and artefacts, which he presented to the University of St Andrews). In 1947–50 he lived in Paris, where he was influenced by the legacy of *Dada and *Surrealism, and in the early 1950s he was a member of the *Independent Group, for which he produced a now legendary event in which he projected 'Pop' imagery.

In 1952 Paolozzi was one of the young British sculptors who showed at the Venice *Biennale and were identified by Herbert *Read as representative of the *Geometry of Fear. His sculpture embodied this idea as well as anyone's. *Forms on a Bow* (1949, Tate) is a series of very sinister visceral items impaled on some infernal washing line. Later he evolved a technique for assembling wax casts of discarded bits of machinery, which were then cast in bronze to suggest heads, bodies or animals. They have a general air of dereliction far from the Utopian optimism of early modernist responses to the machine, or for that matter the cheerful acceptance of consumer culture of Pop art. In the 1960s, however, his work became more colourful, very much in accord with current developments in art such as Pop and *New Generation sculpture; it included large totem-like figures made up from casts of pieces of machinery and often brightly painted. Printmaking became an important activity in this period. He was drawn to the process of *screenprinting because of its capacity to emulate the image-combining possibilities of collage. One series, *As is When* (1965), was inspired by the life of the philosopher Ludwig *Wittgenstein. His links to Pop went beyond the art world. Paul McCartney

acquired one of his sculptures and a screenprint appears on the wall in the Beatles' film *Help!* (1965). In the 1970s he made solemn machine-like forms and also box-like low reliefs, both large and small, in wood or bronze, sometimes made to hang on the wall, compartmented and filled with small items. The compartmented reliefs were sharply and precisely cut and had some resemblance to the work of Louise *Nevelson. His later work included several large public commissions, for example mosaic decorations for Tottenham Court Road underground station in London (commissioned 1979, installed 1983–5). *The Wealth of Nations* (installed 1993), a huge bronze sculpture, was commissioned by the Royal Bank of Scotland for a new building at South Gyle on the edge of Edinburgh. Duncan Macmillan describes it as 'a great, fallen giant, struggling as the classical Laocoon struggled with the serpents who overpowered him, but Paolozzi's figure is struggling not with living serpents, but with the modern, abstract, mechanized shapes of the modern world of technology' (*Scottish Art in the 20th Century*, 1994). An alternative reading might be that the fragmented figure is a very literal representation of the economist Adam Smith's conception of individuals pursuing their own goals but, in so doing, increasing the total sum of wealth. *Newton* (1995), another large bronze, was made for the courtyard of the British Library and is based on William Blake's print. Paolozzi taught at various art schools and universities in Britain, Europe, and the USA, including the *Royal College of Art, where he tutored in ceramics, but according to his *Times* obituary, 'his gruff and combative manner worked to the detriment of his teaching career'. He was knighted in 1989. In 1995 he made a substantial donation of his work to the *Scottish National Gallery of Modern Art and a purpose-built gallery to house it opened in 1999. A stroke in 2001 resulted in at least one premature obituary.

Further Reading: F. Pearson, *Paolozzi* (1999)
Obituary, *The Times* (23 April 2005)

papier collé (French: 'pasted paper') A type of *collage in which pieces of decorative or printed paper are incorporated into a picture or—when stuck on a ground such as canvas—themselves constitute the picture. It was first employed in the *Cubist paintings of *Picasso and *Braque. One of the earliest examples was Picasso's *Still Life with Chair Caning* (1912, Musée Picasso, Paris), which introduced a

piece of mass-produced illusionist printing into a typically fragmented Cubist painting. Later in the same year Braque discovered wallpaper imitating wood in a shop window and began using this in his work. Generally Picasso's use of the medium was, as John *Golding put it, 'both visually and mentally more acrobatic than Braque's' (*Cubism*, 1959). He was bolder in the medium, utilizing a variety of patterned papers and newsprint. Braque's work tended to make greater use of conventional drawing contrasted with the flat areas of paper. The Cubist 'papier collé' arose from the practice of introducing into painting flat areas of patterning and stencilled letters. The pasted elements operate on a number of levels. In a *formalist sense, as Clement *Greenberg argued in a classic essay of 1958 ('The Pasted Paper Revolution' in *Collected Essays and Criticism*), they combine illusionism with an acknowledgement of the literal flatness of the picture plane. They also, as Golding points out, suggest actual objects in the painting as well as existing 'as solid tactile pieces of extraneous matter'. To this it should be added that the collage elements also spoke of a wider world of commerce, popular culture, and politics.

Paps (Dr Waldemar Rusche) (1882–1965) Germany's most famous *naive painter, born at Naumburg. An internationally distinguished ophthalmologist, he was head of the eye clinic in the hospital of St Josef Stift in Bremen and began to paint after retiring at the age of 70. His subjects included scenes remembered from his travels as a young ship's doctor (he was particularly fond of harbour scenes), flower pieces, and the life around his North German home. His style was colourful and lively. The nickname by which he is known is German for 'Dad'.

Pareno, Philippe *See* HUYGHE, PIERRE.

Paris, École des Beaux-Arts *See* BEAUX-ARTS.

Paris, Musée d'Art Moderne de la Ville de Paris *See* MUSÉE D'ART MODERNE DE LA VILLE DE PARIS.

Paris, Musée Nationale d'Art Moderne *See* POMPIDOU CENTRE.

Paris, School of *See* ÉCOLE DE PARIS.

Park, David *See* BAY AREA FIGURATION.

Parker, Cornelia (1956–) British multimedia artist, born in Cheshire. She studied at Gloucester College of Art, Wolverhampton College of Art, and Reading University. Much of her work is dependent on the *appropriation and sometimes transformation of existing objects. However, the objects are nothing like the *Duchampian *ready-mades. They are not mass-produced items which had no status or dignity before they were singled out as art. Instead they are often objects with strong powers of association, which carry what Walter *Benjamin would call an 'aura'. Some part of Parker's project seems to be searching for instances where this quality still resides. For instance, in 2006 as the result of a commission by the Brontë Parsonage Museum in Haworth, she produced works consisting of close-up photographs of items that were used by Charlotte Brontë, such as her needle or her pen nib, materials which have a history. To fully appreciate the work the viewer needs some knowledge of this history. The *Pornographic Drawings* (1996, Tate) are Rorschach-test-like images which suggest naked bodies in such an inexplicit and vague way that few would describe them as the title does. However, they have been painted with liquid solutions of video tapes which have been seized and condemned as obscene by Customs and Excise. In another piece a doll was cut in half by the same blade which beheaded Marie Antoinette. Her best-known works are probably her visually impressive installations. *Thirty Pieces of Silver* (1988–9, Tate) suspends silver and plate objects just above the floor. Once obviously prized by their owners but now discarded, they were crushed flat by Parker with a steamroller. *Cold Dark Matter: An Exploded View* (1992, Tate) fills the room with the suspended dark fragments of a shed which was exploded, at Parker's instructions, by the British army. The impact of the work is enhanced by the light shining in the middle. Parker's recent work has been increasingly informed by her environmental and political concerns. *Chomskian Abstract* (2007) is a 40-minute video work consisting only of discussion of current affairs, especially of the destructive power of American business and government interests, by the radical philosopher Noam Chomsky.

Further Reading: R. C. Johnston, 'Cornelia Parker is out to save the planet', *The Times* (12 February 2008)

C. Parker, *Never Endings* (2007)

Parkes, Kineton *See* DIRECT CARVING.

Parmentier, Michele *See* TORONI.

Parr, Martin (1952-) British photographer, born in Epsom, Surrey. He studied photography at Manchester Polytechnic. He has published many books of his work, including *Signs of the Times* (1992), which was made in conjunction with a television series that took a sociological view of taste in interior decoration. An abiding theme of his work is the British at leisure and the way in which this manifests the British class system. The observations he makes in his work open him to a certain charge of patronizing his subjects, whether these be the wealthy flaunting their possessions or the working class taking their pleasures at the faded seaside resort of New Brighton. In spite of these reservations, Parr's best pictures are irresistibly memorable. *Morris Dancers* (1988) plays on the incongruity of the traditional activity outside a branch of McDonald's. But beside this rather blatant *punctum* (*see* BARTHES) there is the erotic charge between the male and female dancers, only emphasized by the space between them and the observation of the unstable definitions of 'spectator' and 'passer-by'.

Parrino, Steven *See* MINIMAL ART.

Parrish, Maxfield (1870-1966) American painter and illustrator, born in Philadelphia, son of the landscape painter **Stephen Parrish** (1846-1938). He studied at the Pennsylvania Academy of the Fine Arts and also attended classes given by the author illustrator Howard Pyle (1853-1911), celebrated for his children's books. In 1895 Parrish designed a cover for *Harper's Weekly* and thereafter rapidly made a name for himself with illustrations, posters (he won a national poster competition in 1897), and advertisements. He also branched out into mural painting, notably with a series on Old King Cole (1906) for the Knickerbocker Hotel (now the St Regis-Sheraton Hotel) in New York. His greatest fame and popularity, however, came with colour prints designed for the mass market. Sentimental scenes such as *The Garden of Allah* (copyrighted 1919) and *Dawn* (1920) sold by the million and were found in homes all over the country. They are in a lush and romantic style, set in an escapist world combining elements of the Arabian Nights, Hollywood, and classical antiquity, with languorous maidens and idyllic landscape backgrounds. His draughtsmanship and detailing are immaculate and his colouring distinctively high-keyed and luminous. Many of his advertisements were in a similar vein. In the 1930s his style went out of fashion and he retired to paint landscapes, working up to his death at the age of 95. Shortly before this there was a revival of interest in his work, which had long been dismissed as *kitsch: in 1964, for example, the Metropolitan Museum, New York, bought his painting *Errant Pan* (*c*.1915). *See also* POPULAR PRINTS.

Parsons, Betty (1900-82) American art dealer, collector, painter, and sculptor, born in New York. She learned the art gallery trade working for various dealers, notably running the Wakefield Gallery, New York (within the Wakefield Bookshop), which specialized in contemporary art, and in 1946 she opened her own gallery. The following year Peggy *Guggenheim closed her New York gallery, and for a brief period after this Parsons was the leading dealer of the *Abstract Expressionists: *Newman, *Pollock, *Rothko, and *Still were among the artists she represented. Many of these, annoyed by the gallery's support for less successful artists, left her for the more commercial Sydney *Janis, but she continued to support younger talent, including Helen *Frankenthaler, Ellsworth *Kelly, Robert *Rauschenberg, and Richard *Tuttle. The art historian Ann Gibson has argued that it was Parsons's identity as a lesbian which encouraged her interest in diversity. She kept the gallery open until her death. Parsons always kept up her own work as an artist, and from the 1960s she had numerous one-woman shows. Her painting was predominantly abstract, and her sculpture often made use of found items such as pieces of driftwood, which she used in painted constructions.

Further Reading: C. Strickland, 'Betty Parsons's 2 Lives: She Was Artist, Too', *New York Times* (28 June 1992)

Pascali, Pino (1935-68) Italian sculptor, painter, and graphic designer, born at Bari and active in Rome, where he studied at the Academy, 1955-9. He was impressed by an exhibition of *Rauschenberg in Rome in 1959. Most of his work before 1964 was destroyed after his death by his father on the artist's request, but it has been described as being 'in diverse media such as plastic and polyester, treated with plaster and papier mâché'. More important for his later work was probably his experience as a graphic designer in the mass media. In his first exhibition

of 1965 he showed large poster-scale canvases stretched to make shapes like the lips of Billie Holiday or a woman's cleavage. The technique had some affinity with the work of the British painter Richard *Smith but with added eroticism. At this time he could have been identified unproblematically as a *Pop artist, although he maintained that Pop was specifically American and that the European or Italian artist 'could only be an isolated phenomenon of revolt', while admitting a common interest in sex and mass culture. The following year he exhibited the life-size models of weapons which announced him as a distinctive and hard to classify artist. These striking all-black pieces were comments on the tensions and hypocrisies of the Cold War. A missile was entitled *Paloma delle Pace* (Dove of Peace). In a lighter mood he made 'play pieces' such as his *Fictitious Sculptures* of 1966 (animals made of white canvas stretched over wooden ribs) and his *Water Pieces* of 1967 (aluminium basins filled with water dyed to imitate sea water). Such work was to be important to the development of *Arte Povera. In 1968 he achieved the recognition of a display at the Venice *Biennale, but later that year he died from injuries received in a motorcycle accident. The critic Giuliano Briganti identified Pascali's recurring theme as 'the search for the essential, for the *primal*, the urge to strip things of all superstructure, to remove them from the authority of history and arrive at what can be understood as the mythical core'.

Further Reading: Musée d'Art Moderne de la Ville de Paris, *Pino Pascali* (1990)

Paschke, Ed (1939–2004) American painter, born in Chicago. He trained at the Art Institute of Chicago, where Jim *Nutt also studied, and they had in common an approach which emphasized the aggressive aspects of popular imagery, what John *Russell called 'a relentlessly gabby, arm-twisting, eyeball-contacting quality' (*The New York Times*, 31 January 1982). He made his name with garishly coloured paintings of startling subjects such as circus freaks. The photographic quality of these works eventually came to dissatisfy Paschke, who was worried that their initial impact was not sufficiently lasting, and he developed a different style, featuring fragmented images appearing as though on poorly functioning video screens. Paschke was a celebrity in his native Chicago, even appearing

alongside another famous son of the city, the basketball player Michael Jordan, on a mural for a menswear store. In addition to his local fame, Paschke was enormously admired in Paris, where a retrospective exhibition of his work was held at the Pompidou Centre in 1990.

Further Reading: A. G. Artner, 'Ed Paschke; 1939–2004', *Chicago Tribune* (28 November 2004)

Pascin, Jules (Julius Pincas) (1885–1930) Bulgarian-born painter and draughtsman. He led a wandering life, and although he acquired American citizenship in 1920, after moving to New York during the First World War, he is chiefly associated with Paris, where he belonged to the circle of emigré artists who gravitated around *Chagall, *Modigliani, and *Soutine. He was born in Vidin, Bulgaria, the son of a Spanish father and an Italian mother. After travelling widely and studying painting in Berlin, Munich, and Vienna, he settled in Paris in 1905. In the same year he adopted the name Pascin to distance himself from his family, who disapproved of his bohemian life. He lived in the USA from 1914 to 1920, then returned to Paris. His work includes portraits of his friends, café scenes, and flower pieces, as well as a few large paintings with biblical themes, but the bulk of his output consists of erotically charged studies of nude (or very flimsily dressed) teenage girls. They have been compared with the work of *Degas and Toulouse-Lautrec, but Pascin's paintings are less penetrating and more obviously posed. He can be rather repetitive, but his best work has great delicacy of colour and handling and a poignant sense of lost innocence. Pascin achieved financial success, but he led a notoriously dissolute life and was emotionally unstable: just as a major exhibition of his work was about to open at the Galerie Georges Petit in Paris he committed suicide in his studio (slashing his wrists and then hanging himself). As a mark of respect, several galleries in Paris closed on the day of his funeral. There are examples of his work in many major collections, notably the *Barnes Foundation, Merion, Pennsylvania, which has about fifty Pascins.

Further Reading: G. Diehl, *Pascin* (1968)

Pasmore, Victor (1908–98) British painter and maker of constructions who is unusual in having achieved equal eminence as a figurative and an abstract artist. He was born at Chelsham, Surrey, the son of a distinguished

doctor, and from 1927 to 1937 worked as a clerk for the London County Council, while attending evening classes at the Central School of Arts and Crafts. From 1930 he exhibited with the *London Group (he became a member in 1934) and in 1934 he exhibited with the *Objective Abstractionists at the *Zwemmer Gallery. His work at this time was still figurative, in a freely handled, *Fauve-influenced style, but the work of his fellow exhibitors at the Zwemmer Gallery led him to experiment with abstraction. He soon reverted to naturalistic painting, however, and in 1937 he combined with William *Coldstream and Claude *Rogers in founding the *Euston Road School. Characteristic of his work at this time and in the early 1940s are some splendid female nudes and lyrically sensitive Thames-side landscapes that have been likened to those of *Whistler (*Chiswick Reach*, 1943, NG, Ottawa). In 1948 he underwent a dramatic conversion to pure abstraction, and by the early 1950s he had developed a personal style of geometrical abstraction. As well as paintings, he made abstract reliefs, partly under the influence of Ben *Nicholson and partly inspired by Charles *Biederman's book *Art as the Evolution of Visual Knowledge*, lent to him in 1951 by Ceri *Richards. His earlier reliefs had a hand-made quality, but later—through the introduction of transparent perspex—he gave them the impersonal precision and finish of machine products. Through work in this vein he came to be regarded as one of the leaders of *Constructivism in Britain. Later his paintings became less austere and more organic. However, the work of Pasmore was always underwritten by an attitude that there was an underlying order in art and nature and when looked at from a *formalist viewpoint there is a surprising unity as he moves from figuration to abstraction and through greater and lesser degrees of austerity. This was also apparent in 'The Artist's Eye' exhibition he selected for the National Gallery, London, in 1990. He chose work from the range of the collection, and the visitor could note the repetition of the same spiral compositional device in artists as varied as Degas and Veronese.

Pasmore was an influential teacher and was much concerned with bringing abstract art to the general public. He taught at Camberwell School of Art, 1943-9, the Central School of Art and Design, 1949-53, and King's College, Newcastle upon Tyne (now Newcastle University), as head of the painting department, 1954-61. The 'basic design' course that he taught at Newcastle (based on *Bauhaus ideas) spread to many British art schools. From 1955 to 1977 he was consulting director of urban design for the south-west area of Peterlee New Town, County Durham, where he attempted to 'achieve the sort of synthesis between architecture and painting envisaged by *Le Corbusier and van *Doesburg. The result has echoes of De *Stijl' (*Buildings of England*). His most personal work there, the *Apollo Pavilion* (1963-70), has been a repeated target for vandalism. In 1966 Pasmore bought a house in Malta and subsequently divided his time mainly between there and London. He won many honours, and Kenneth *Clark described him as 'one of the two or three most talented English painters of this century'.

Further Reading: Arts Council of Great Britain, *Victor Pasmore* (1980)
J. Reichardt, *Victor Pasmore* (1962)

Paso, El *See* EL PASO.

Pattern and Decoration (P & D) movement ('the New Decorativeness')

A movement in American art, originating in New York in the mid-1970s, in which painters and other artists produced works that consist essentially of complex and generally brightly coloured patterns (abstract, figurative, or a mixture of both). The movement was one aspect of the reaction against the stark impersonality of *Minimal art (*see* POST-MINIMALISM) and also represented a defence of the idea that decorative art is a humanizing influence and should not be regarded as inferior to 'fine' art. Many of the artists involved in the movement were women, influenced by the feminist concern with highly decorative crafts such as quiltmaking that have traditionally been the preserve of women. They included Valerie Jaudon (1945-), whose work is influenced by Celtic patterns, Joyce *Kozloff, and Miriam *Schapiro. However, several men also were involved in the movement, notably Robert Kushner (1949-) and the sculptor Ned Smyth (1948-). The New York Pattern and Decoration Group first met in 1975 and organized an exhibition the following year. Many of the members were taken up by the dealer Holly Solomon, who had recently established a gallery in New York, and their work enjoyed considerable success in the later 1970s.

Pau-Brasil *See* AMARAL, TARSILA DO.

Peake, Mervyn (1911–68) British writer and illustrator, born in China, the son of medical missionaries. He is now best known as a novelist, but he studied at the *Royal Academy Schools and spent much of his career teaching drawing, notably at Westminster School of Art, 1935–8, and the Central School of Arts and Crafts, 1950–60. His reputation rests mainly on his trilogy of novels *Titus Groan* (1946), *Gormenghast* (1950), and *Titus Alone* (1959), a work of grotesque Gothic fantasy to which his vividly imaginative drawing style was well matched (originally, however, the books were published without his accompanying illustrations). Peake also illustrated numerous other books, including Coleridge's *The Rime of the Ancient Mariner* (1943), Stevenson's *Treasure Island* (1949), and several by himself (among them an instructional manual, *The Craft of the Lead Pencil*, 1946). In 1946 he was commissioned by the Ministry of Information to make drawings of people liberated from Belsen concentration camp—an experience that left him emotionally scarred. In the last decade of his life he was gradually incapacitated by Parkinson's disease and his final works were completed with the aid of his wife, Maeve Gilmore.

Pearlstein, Philip (1924–) American painter and printmaker, a leading proponent of the return to naturalism and interest in the human figure that was one aspect of the move away from the dominance of *Abstract Expressionism in American art. He was born in Pittsburgh and studied there at the Carnegie Institute, graduating in 1949, before settling in New York. In 1955 he took an MA in art history at New York University. His early works (mainly landscapes) were painted with a vigorous *gestural handling, but in the 1960s he developed a cooler, more even type of brushwork. He specializes in starkly unidealized portrayals of the nude figure (singly or in pairs), usually set in domestic surroundings (*Male and Female Models Leaning on Chair*, 1970, Art Institute of Chicago). Because of the clarity of his compositions and the relentlessness of his scrutiny, he is sometimes described as a *Superrealist, but his work does not really fit this classification. He uses harsh lighting, oblique angles, and cropping of the image (heads are often excluded and the body is seen in voyeuristic close-up) in a way that suggests candid photography, but his pictures do not try to counterfeit the effect of photographs: the handling of paint is smooth—but vigorous rather than finicky. In addition to oils, he has also worked in watercolour and produced etchings and lithographs. Pearlstein calls himself a 'post-abstract realist' and describes the figures in his paintings as 'a constellation of still-life forms'. He feels that he has 'rescued the human figure from its tormented, agonized condition given it by the expressionist artists'.

Further Reading: R. Storr, *Philip Pearlstein since 1983* (2002)

Pechstein, Max (1881–1955) German painter and printmaker. He was born near Zwickau and began his training as an apprentice to a decorative painter. From 1900 to 1906 he studied in Dresden, where he was a star pupil first at the School of Arts and Crafts and then at the Academy, winning several prizes. In 1906 he joined Die *Brücke, which had been founded by four other Dresden students the previous year. After visiting Italy on a scholarship in 1907, he spent a few months in Paris before settling in Berlin (which was his home for the rest of his life) in 1908. His energy and charm as well as his talent quickly made him a leading figure in Berlin's artistic life and in 1910 he was elected president of the Neue *Sezession. In the same year the other members of the Brücke moved to Berlin. Pechstein had kept up his contact with them in the intervening years, but in 1912 *Kirchner expelled him because he had exhibited his work at the Sezession without the group's consent. In 1913–14, showing an interest in the exotic shared with other *Expressionists, Pechstein visited the Palau Islands in the Pacific, where he painted lively, almost-*Fauvist scenes depicting the paradisal life of the fishermen. His other subjects included nudes, landscapes, portraits, and opulent flower pieces. Among the German *Expressionists he was the most French in spirit (he was particularly influenced by *Matisse) and, probably because his work was essentially decorative rather than emotionally intense, he was the first member of the Brücke to achieve popular success and general recognition; the 1920s marked the height of the fashion for his work. Since then his reputation has faded whilst those of his former colleagues has grown.

Pechstein was in Palau when the First World War broke out. He was taken prisoner by the Japanese but escaped and made his way back to Germany via the USA and Holland in 1915.

Immediately drafted into the army, he fought on the Somme but was discharged in 1917 following a nervous collapse. At the end of the war he was one of the founders of the *Novembergruppe and in 1923 he began teaching at the Berlin Academy. He was dismissed by the Nazis in 1933 (his work was declared *degenerate) and reinstated in 1945. His later paintings became repetitive, and the high quality of his work in his pre-First World War period is sometimes forgotten. In addition to paintings, he produced a large number of prints—etchings, lithographs, and woodcuts. His posthumously published memoirs (*Max Pechstein: Erinnerungen*, 1960) are an important primary source for the history of the Brücke.

Pedersen, Carl-Henning (1913–2007) Danish painter, born in Copenhagen and self-taught as an artist. His early paintings were abstract, but in the 1940s he turned to *Expressionism and in 1948 became a founder member of the *Cobra group. Characteristically he portrayed a fantastic world of palaces and princesses, demons and dwarfs. Pedersen became well known internationally when his work was shown at the Venice *Biennale in 1962. There is a museum dedicated to him and his wife, the painter Else Alfelt (1910–74), at Herning in Denmark.

Pedrosa, Mario *See* OITICICA, HÉLIO.

Peintres de Tradition Française (Painters in the French Tradition) A name applied to a group of French painters who during and immediately after the Second World War aimed to work in a style that they regarded as both modern and quintessentially French. The name comes from an exhibition entitled 'Vingt Jeunes Peintres de Tradition Française' held at the Galerie Braun, Paris, in 1941. It has the reputation of being the first exhibition of modernist art mounted during the German occupation and it was held without German permission. The main members of the group were *Bazaine, *Estève, *Lapique, *Le Moal, *Manessier, and *Singier. The exhibition is poorly documented (it is not certain even now exactly which artists took part), but it acquired something of a mythical status after the Liberation. René Huyghe, for instance, described it as 'the reassembling of all the live revolutionary forces, those most relentlessly opposed to intellectual compromise'. However, many of the painters in the exhibition were later included in 'official' exhibitions mounted by the occupation regime. Most of the painters were represented by work completed before the war and what was shown was probably closer to the middle-of-the-road landscapes and still-lifes popular in French art of that period than to their more radical and abstract later work, which became identified as *Lyrical Abstraction. Moreover, the very notion of 'French tradition' was less subversive to the occupying forces than the wishful thinking of later years might suggest. The right-wing anti-Semitic collaborationist critic Lucien Rebatet (1903–72) supported, not academic *'pompier' art, but the idea of 'French moderation', as exemplified by artists such as *Derain and *Vlaminck and the tradition inspired by Corot. What does seem to have been common to many of the painters was a strong religious strain, which was later to be manifested in the influence of stained glass in the work of Manessier and others.

Further Reading: M. Cone, *Artists under Vichy* (1992)

Pellizza da Volpedo, Giuseppe (1868–1907) Italian painter, born in Volpedo. He adopted the *divisionist technique and his approach to art was marked by both his study of optics and his commitment to Socialism. His most ambitious work is *The Fourth Estate* (1901, Galleria d'Arte Moderna, Milan), depicting workers striding purposefully towards the viewer and their goal of progress. He adopted the laborious Renaissance method of working from full-scale cartoons, and the likeness of the gestures to those in Raphael's *Disputa* (1510–11, Vatican, Rome) has been noted by Sandra Beresford (A. *Bowness *Post-Impressionism*, 1979). The painting was exhibited only twice in the artist's lifetime, in Turin in 1902 and Rome in 1907, on each occasion attracting little attention. However, it was frequently reproduced in the Socialist press and many years later achieved worldwide exposure on the credit sequence of Bernardo Bertolucci's Marxist epic film *Novecento* (1976). Pellizza died by suicide.

Penalba, Alicia (1913/18–82) Argentine sculptor and printmaker, born in Buenos Aires. She moved to Paris in 1948 and trained in the studio of *Zadkine after destroying almost all her work as a painter. She made tall semi-abstract sculptures in bronze and stone, reminiscent of the growth of trees. Her favourite material was terracotta, and when

the sculptures were cast in bronze, she would ensure that the patina was similar to the source material. Some were intended for playgrounds, designed to invite children to climb them. She was awarded the prize for best foreign sculptor at the São Paulo *Bienal in 1961.

(⊕) SEE WEB LINKS

• The artist's website.

Penck, A. R. (1939–) German painter, born in Dresden. He was born Ralf Winckler and took on his pseudonym in 1968, deriving the name from the geographer and Ice Age researcher Albrecht Penck (1858–1945), referring to his conception of art 'as empirical science in the age of the Cold War' (Gillen). He first decided to become a painter in 1955 but was rejected by the academies in Dresden and East Berlin. On the day before the erection of the Berlin Wall he went to visit his friend George *Baselitz, who was by then living in West Berlin. His return to the East that evening marked his last opportunity to go to the West for many years. Apart from occasional inclusions in exhibitions he worked entirely as an unofficial artist, being excluded from the all-powerful Artists' Union. In spite of this, in the early 1960s he was still a supporter of the socialist system, but his approach to art was far removed from the officially sanctioned *Socialist Realism. From 1961 onwards he developed the 'stick figures' for which he is best known, abandoning Rembrandt and *Picasso as models. These figures were conceived as a way of examining values in society in a quasi-scientific manner. He was to continue working by virtue of a contract with a dealer in the West, Michael Werner, who organized his first exhibition in Cologne in 1968. In the mid-1970s he made contact with the West German painter Jörg *Immendorff. After 1979 a change in the law in East Germany meant that Penck's contacts with the West, for instance collaboration with publishers, would now be illegal. In 1980 the painter Willi Sitte (*see* SOCIALIST REALISM), one of the leading figures in official East German art, refused to allow his paintings to be shown alongside those of Penck in an exhibition in Paris. Later, after requesting the right to leave the country, Penck was stripped of his nationality and told to leave East Germany before midnight.

He already had some reputation in the West and his arrival came at the time when *Neo-Expressionist painting, spearheaded by his old friend Baselitz, was becoming highly successful in the Western art world. Penck's work tended to become associated with it in that he painted in a vigorous manner, although his preoccupations are as much with politics as individual expression. *Weltbild* (1961, Kunsthaus, Zurich) is a schematic representation of the aftermath of the building of the Berlin Wall, which Penck initially supported. Each side confronts the other with armaments, children are frustrated by the barrier as they can no longer meet, but an embracing couple and a figure joyously balancing a ball suggest that life is still friendlier in the East. *Der Übergang* (1963, Museum Ludwig, Cologne) announces a bleaker view as a man uses his outsize hands in a desperate attempt to balance himself as he crosses an abyss on a flaming bridge. Penck's own passage through the wall was commemorated in two giant paintings in black and white, *West* and *East* (1980, Tate), which contrast the artist feeling around in the dark in the East and opening the door to the West with its offers of both money and new uncertainties. In the 1980s he lived for a time in London and now works in Dublin and Düsseldorf. He has also worked as a sculptor, making totemistic figures from wood and bronze.

Further Reading: E. Gillen, 'Passages: Three East German artists before and after 1989', in H. F. Deshmukh, *Culture and Conflict: Visual Arts in Eastern Germany Since 1990* (1998)

B. Marcadé, *A. R. Penck* (1988)

Pène du Bois, Guy (1884–1958) American painter and writer on art. He was a pupil of Robert *Henri, and as art critic or reporter on several newspapers he was a leading spokesman for the painters in Henri's circle. His own paintings concentrated on themes set in New York, particularly the social life of the rich, often treated satirically, with the figures like mannequins. He wrote several short books on American artists, including *Hopper and *Sloan, and an autobiography, *Artists Say the Silliest Things* (1940).

Pennell, Joseph *See* WHISTLER, JAMES MCNEILL.

Penone, Giuseppe (1947–) Italian artist, born in Garessio Ponte in Piedmont. He studied at the Accademia di Belle Arti in Turin under *Anselmo and *Pistoletto. He had his first solo exhibition in Turin in 1968. Of all the artists associated with *Arte Povera, it is Penone who is most concerned with a dialogue with natural materials. His theme as

an artist is the integration of the human and natural worlds and he has a fascination with the process of casting. In 1968 he fixed a mould of his own hand to a young tree so that it would, in years to come, grow with it attached. In *Potatoes* (1977) casts of his ears, lips, and nose were placed over the vegetables, which then took on their form. The results were then cast in bronze and photographed among ordinary potatoes. The series of *Breath* sculptures (1978) in fired clay look like massive vases, but they imagine the shape of breath itself in terms of the volume of air between lungs and mouth. For Penone this has a mythological aspect: Prometheus modelled the human race from figures of clay, but it was Athena who brought life by breathing on them.

Penrose, Sir Roland (1900–84) British writer, collector, exhibition organizer, and artist, born in London, the son of a painter. As an artist he holds a distinguished place among British *Surrealists (he produced collages and *objects as well as paintings), but he is chiefly remembered for the missionary zeal with which he promoted Surrealism and contemporary art in general in England. After taking a degree in architecture at Queens' College, Cambridge, he went to Paris in 1922 to study painting—on the advice of Roger *Fry (who like Penrose came from a Quaker family). He stayed until 1935 and during that time came to know many leading artists, including *Ernst, *Man Ray, *Miró, and above all *Picasso, who became a lifelong friend. After his return to England he was one of the organizers of the International Surrealist Exhibition in London in 1936. During the Second World War he was a camouflage instructor. In 1947 he was co-founder (with Herbert *Read) and first chairman of the *Institute of Contemporary Arts in London, and he organized several major exhibitions at the Tate Gallery, London: Picasso paintings (1960), Max Ernst (1961), Miró (1964), Picasso sculpture and ceramics (1967). He was instrumental in the acquisition of Picasso's *Three Dancers* (1925) for the Tate in 1965, a crucial work with which the artist had previously refused to part. The best known of his writings is *Picasso: His Life and Work* (1958, 3rd edn, 1981). Penrose's other books included studies of Miró (1970), Man Ray (1975), and *Tàpies (1978), and he also wrote poetry. His second wife, whom he married in 1947, was the photographer Lee *Miller, who had formerly been a pupil and

favourite model of Man Ray. His library and archive were bought by the *Scottish National Gallery of Modern Art in 1994, and a year later the gallery bought twenty-five works from the outstanding collection (mainly of Surrealist art) he had assembled.

Penwith Society *See* ST IVES SCHOOL.

Peploe, S. J. (Samuel John) (1871–1935) Scottish painter, the oldest of the *Scottish Colourists. He lived almost all his life in Edinburgh, but he often visited France, studied briefly at the *Académie Julian, and made his home in Paris, 1910–13. During this time in Paris he moved from an *Impressionist style to one influenced by *Cézanne and the *Fauves, but later his work became less aggressively modern. In the 1920s he frequently visited the island of Iona, which—together with still-life—was his favourite subject. There is a large collection of Peploe's work in the Kirkcaldy Museum and Art Gallery.

Perceptual Abstraction A broad term sometimes used to embrace several types of abstract art that developed in the 1950s in reaction against *Abstract Expressionism, such as *Hard-Edge Painting, *Minimal art, and *Op art. The term indicates a change from expressive and painterly qualities to an emphasis on clarity and precision based on objective perception.

Perceval, John (1923–2000) Australian painter and ceramic artist, born at Bruce Rock, Western Australia. He showed artistic talent from an early age (and an enforced stay in bed because of poliomyelitis when he was fifteen enabled him to develop his skills), but he had almost no formal training. In 1944 he married Mary Boyd (1926–), the sister of Arthur *Boyd and herself a painter and potter (in 1978, after divorcing Perceval, she married Sidney *Nolan). Perceval's early works were in a vigorous and spontaneous *Expressionist vein, sometimes exploring the fantasies and fears of childhood. In the late 1940s and early 1950s he worked mainly as a potter, but in 1956 he returned seriously to painting, principally as a landscapist. Robert *Hughes writes: 'His work, owing to its unreflective spontaneity, is uneven; but at its best its voracious appetite for stimuli and its good humour are matched by few of his contemporaries' (*The Art of Australia*, 1970).

Pereira, Irene Rice (1901–71) American painter, born at Chelsea, a suburb of Boston. After studying at the *Art Students League, New York, 1927–30, she travelled widely in Europe, returning to New York c.1933. During her travels she had studied with *Ozenfant in Paris in 1931 and she shared his interest in mechanistic imagery and 'unadorned functionalism'. By the late 1930s she had developed a geometrical abstract style (one of the earliest American artists to do so) and continued to explore this mode for the rest of her life. Generally she used rectangular and trapezoid shapes in conjunction with linear grids and loosely brushed textures, and sometimes she added layers of transparent or translucent materials to the canvas, increasing the sense of mysterious spatial effects. She came to see her art in metaphysical terms and wrote several books concerning her interest in light, space, and mysticism, among them *The Nature of Space* (1957) and *The Transcendental Formal Logic of the Infinite* (1966). Pereira taught at several colleges and universities in New York and elsewhere.

Performance (Performance Art) An art form related to dance and theatre, in which the actions of the body, generally presented 'live' to an audience, are the most important element. Unlike the *Happening, a term principally associated with New York about 1960, it has become a worldwide phenomenon, practised by many leading contemporary artists. It was in the later 1960s and particularly in the 1970s that Performance art became recognized as a category of art in itself (the first quotation cited under the term in the *Oxford English Dictionary* dates from 1971).

It is common, as did RoseLee Goldberg in her pioneering study first published in 1979, to trace Performance art back to the *Futurists and *Dadaists, who often staged humorous or provocative events to promote their work or ideas. Soviet *agitprop and *Bauhaus theatre are later contributions to this history. The art historian Attanasi de Felice has looked back still further to the masquerades of Leonardo da Vinci (1452–1519) or the spectacles of Gianlorenzo Bernini (1598–1680). When this history is considered, Performance is less a specifically *modernist art practice than a reaction against the restricted specialist notion of the artist's role, which reached its apogee in the *formalist theories of Roger Fry and Clement *Greenberg. In practice, the exact boundaries between Performance and theatre, dance, or music can be hard to draw, especially when some Performances, such as those of Laurie *Anderson, have been presented in a conventional theatrical setting. The simple and tautological solution would be to say that Performance art is done by artists for an art audience, that is to say one which is already primed with certain knowledge and expectations. Certainly much Performance has been produced by artists active in other fields, such as Joseph *Beuys, Robert *Morris, and *Gilbert & George. The objection here might be that Performance is a form which has conspicuously moved outside the framework of gallery and museum, demanding that its audience, whether 'insiders' or not, draw upon experiences and responses which may include shock and laughter, going beyond normal responses to both art and theatre. One of the most important contemporary practitioners, Marina *Abramović, has stated that Performance is totally different from theatre, in which 'you are repeating the role you are acting'. Performance, by contrast, 'is about transformation' and is therefore unrepeatable (lecture at Tate Modern, 29 March 2003). This strongly personal element in Performance has made it attractive to artists such as VALIE *EXPORT and Carolee *Schneemann, who are especially concerned with gender issues (*see* FEMINIST ART).

Another approach would be to consider its art status in relation to more traditional forms of object-based art. The production of any art work, even a painting by Mondrian, is something which unfolds in real time and becomes a kind of performance. Fascination with this aspect of art has co-existed with the idea of the artwork as a timeless object, as when in 1937 Dora *Maar photographed the successive stages of Picasso's *Guernica* or, in a 1947 film, slow-motion photography showed the hand of Henri *Matisse wavering for a brief moment in what might have been assumed to have been a totally spontaneous artistic gesture. It is still open to debate as to how far the 'drip painting' of Jackson *Pollock should be considered as some kind of performance and how far the 'action' was simply a means to an end to accomplish a particular kind of painting. Georges *Mathieu painted in front of an audience. Yves *Klein staged his *anthropometries* involving human paint brushes as invitation-only events. It is only a step from this for the object to disappear entirely or at

least be reduced to the status of a 'relic'. For the elaborate installations of *Christo and Jeanne-Claude the process of mounting the work, which comprises not only the technical challenges but the political ones, is a kind of performance which is as significant as the final artwork. Artists especially concerned with *'process', such as Robert Morris, have also been active in Performance, as have artists such as Joseph Beuys or Jörg *Immendorff, for whom art has been a form of political activism.

Gregory Battcock wrote in 1979: 'Before man was aware of art he was aware of himself...In performance art the figure of the artist is the tool for the art.' He was drawing on the phenomenological theories of Maurice Merleau-Ponty (1908–61), who wrote of the distinction between the body and other objects. 'For us', he wrote, 'the body is much more than an instrument or a means; it is our expression in the world, the most visible form of our intentions.' This philosophical background suggests that what the Performance artist is doing is not creating a theatrical illusion but presenting a kind of being to a public whose task is not so much to be a spectator as to empathize with the artist's real actions. The face of the Performance artist tends to be marked with inner concentration on the task in hand. The work can be closer to dance or even sport than drama. Hence there is the frequent emphasis on pain and endurance, as in the work of Stuart *Brisley and Gina *Pane, or violence, as in the *Vienna Actionists. The Italian-British artist Franko B (1960–) has used bleeding in his performances. There are affinities here with *Body Art and Autodestructive art (*see* METZGER). Arthur Danto has argued that rather than being located between theatre and painting, it should be 'located between theatre and whatever dark ritual it was out of which theatre evolved and against which it was a defence' ('Cindy Sherman', *The Nation*, 15 August 1987).

Further Reading: G. Battcock and R. Nickas (eds.), *The Art of Performance* (1984)

R. Goldberg, *Performance Art: from Futurism to the Present* (2001)

Perjovschi, Dan (1961–) Romanian cartoonist, born in Sibiu. He began making his drawings for *22*, a satirical magazine launched after the fall of the dictator Nicolae Ceaușescu in 1989. The drawings have reached an international audience, especially after being seen at the Venice *Biennale in 1999. With his wife, Lia Perjovschi, as collaborator, he has developed a way of making his drawings into a kind of *Performance and *installation art, covering the walls of museums with sketches, as in *The Room Drawing* at Tate in 2006 and *Project 85* at the Museum of Modern Art, New York. He has said that he sees himself as the modern equivalent of a medieval troubadour commenting subversively on the news. His drawings are extremely simple, the ideas conveyed in a few strokes on tiny bits of paper, and deal with the topics of globalization, pollution, and social inequality.

Further Reading: A. Wege, 'Dan Perjovschi: Schnittraum', *Artforum International* (April 2005)

Peri, László (Peter) *See* BERGER, JOHN.

Perilli, Achille *See* CONTINUITÀ.

Permeke, Constant (1886–1952) Belgian painter, draughtsman, and sculptor, with Frits van den *Berghe and Gustave de *Smet one of the leading exponents of *Expressionism in Belgium in the period between the two world wars. He was born in Antwerp, the son of a painter, **Henri-Louis Permecke** (1849–1912), and studied at the academies of Bruges and Ghent before settling at *Laethem-Saint-Martin in 1909. From 1912 to 1914 he lived in Ostend. He was badly wounded in 1914 whilst serving in the Belgian army and was evacuated to England. In 1919 he returned to Belgium, where he lived in Antwerp and then Ostend before building his own house and studio at Jabbeke, near Bruges, now a Permeke museum (he called his home De Vier Windstreken, 'The Four Corners of the Earth'). His subjects were taken mainly from the life of the coastal towns of Belgium and he is best known for his strong and solemn portrayals of sailors and fishermen with their women (*The Fiancés*, 1923, Musées Royaux, Brussels). In addition to figure paintings, he did numerous seascapes. From 1935 he also made sculpture, carving in artificial stone. During the Second World War he was unable to obtain materials for painting or sculpture and so concentrated on drawing in various media. After the war he was appointed to two prestigious posts in Antwerp, as director of the Institut National Supérieur and the Académie Royale des Beaux-Arts, but he soon resigned in order to devote himself to painting.

Perry, Grayson (1960–) British potter, born in Chelmsford. He has achieved the unusual feat for an artist working in ceramics to move out of the world of 'craft' into that of modern art. His work generally consists of classically shaped vases. What makes them unusual is their surface decoration, which makes an immediate appeal on the grounds of its lustrous colour. On closer examination disturbing images about child abuse are sometimes revealed. He has also made fun of the pretensions of other artists. *Gimmick* (1996) lists trademark devices such as Pollock's drips or Calder's mobiles. A cynical view might be that Perry has a fairly good gimmick himself. He has made no secret of his female *alter ego*, Clare, and it was as Clare that he attended the *Turner Prize ceremony in 2003 when he won the award. A more generous view would be that Perry is a genuinely populist artist working in the tradition of the great visual satirists like James Gillray (1757–1815), to whom his drawing style has been compared. The print is no longer the place which commands attention, but the mass media, the attention of which Perry has successfully attracted, and his choice of ceramic are ways of providing an alternative to the culturally more intimidating form of painting.

Pešánek, Zdeněk *See* LIGHT ART.

Peters, DeWitt *See* BIGAUD, WILSON.

Pétridès, Paul *See* UTRILLO, MAURICE.

Petrov-Vodkin, Kuzma (1878–1939) Russian painter, graphic artist, designer, writer, and teacher. He was born in Khvalynsk, a Volga port in Saratov province, southern Russia, and studied in Samara (1893–5), St Petersburg (1895–7), Moscow (1897–1905), briefly in Munich (1901), and Paris (1905–8). During these years he also visited Italy, Greece, and Africa. After his return to Russia from Paris he settled in St Petersburg, where he taught at various art schools. He was one of the most original and independent Russian painters of his day, creating a highly distinctive style blending *Symbolism with the traditions of medieval Russian and Italian Renaissance art: he specialized in large-scale figure groups in which he displayed something of the stately, solemn grandeur of Quattrocento frescos. With this powerful design went strong—sometimes harsh—colouring and a curious sense of space based on a curved horizontal axis (the artist himself referred to 'spherical perspective'). This style accommodated well to the early years of the regime of *Socialist Realism. *Death of the Commissar* (1928, State Russian Museum, St Petersburg) has something of the quality of a Pietà and seems a natural development from the religious imagery of his pre-revolutionary painting. He also painted still-lifes, in which he showed the same quality of dignified severity that characterized his figure paintings: he thought that 'a simple apple lying on the table contained all the secrets of the universe'. His other work included stage design and he also wrote several books, mainly autobiographical.

Pettibon, Raymond (1957–) American draughtsman, born in Tucson, Arizona. He lives and works in California. His stark monochrome drawings reflect the style of commercial illustration and employ violent and satirical imagery. He originally published his drawings in small booklets but now his work is generally seen in a gallery setting, as in the room of drawings at *documenta 11 in 2002, which reflected on the violence of terrorism. Pettibon draws on a mélange of images from high and low culture. This sometimes makes him opaque to a non-American audience: for instance, the cartoon figure of Gumby is either a treasured childhood memory or totally obscure. There is, however, a consistent emphasis on the culture of the 1950s and 1960s, the age marked at one end by Elvis Presley and at the other by the murderous Charles Manson. Robert Storr has argued that his work should be read as an unsparing analysis of the self-deceptions of the counter-culture of the 1960s.

Further Reading: R. Storr, *Raymond Pettibon* (2002)

Pettoruti, Emilio (1892–1971) Argentine painter, born at La Plata. From 1913 to 1923 he studied and worked in Europe, taking part in the *Futurist movement in Italy, and experimenting with the *Cubism of Juan *Gris, whom he met in Paris. After his return to Argentina in 1924 he had a great influence on the younger generation of painters there through his advocacy of European modernism. An exhibition of his paintings at the Galeria Witcomb in Buenos Aires in 1924 provoked a scandal, even though the pictures were mild and decorative by European standards, and in 1930 he caused further controversy, when as director of the Museum of Fine Arts in La Plata he exhibited current European

art (he had two terms as director of the museum, both short-lived because of official disapproval of his activities). By the late 1940s his own work had become abstract. In 1952 he returned to Europe and settled in Paris, where he died. He published a book of memoirs, *Un Peintre devant son miroir*, in 1962.

Peverelli, Cesare *See* SPATIALISM.

Pevsner, Antoine (1884–1962) Russian-born sculptor and painter who became a French citizen in 1930. He was the elder brother of Naum *Gabo and like him one of the pioneers of *Constructivism. Born in Orel, he grew up in Briansk and studied at the School of Fine Arts in Kiev, 1902–9, then briefly at the Academy in St Petersburg. Between 1911 and 1914 he made lengthy visits to Paris, where *Archipenko and *Modigliani were among his friends. After two years in Norway with Gabo he returned to Russia in 1917, and taught at the Moscow School of Painting, Sculpture, and Architecture (and after the Revolution in the institutions descended from it—*Svomas and *Vkhutemas). After experimenting with various avant-garde styles, he had turned to abstraction by about 1918 (or perhaps a few years earlier—there is often difficulty in dating his work). In 1920 he was co-signatory of Gabo's *Realistic Manifesto*, which set forth the ideals of Constructivism, and in 1922 he helped to organize a major exhibition of Soviet art in Berlin. He left Russia in 1923 because the authorities were turning against the 'pure' art in which he was interested in favour of utilitarian work. After a few months in Berlin, he settled in Paris in October 1923 and lived there for the rest of his life.

Up to this time Pevsner had been a painter, but he now turned to sculpture, at first working mainly in plastic, then in welded metal. His early sculptures often retained vestiges of representation, as in his witty *Portrait of Marcel Duchamp* (1926, Yale University Art Gallery), but increasingly he worked in a pure abstract idiom. His later work was characterized by bold spiralling forms (*Dynamic Projection in the 30th Degree*, 1950–51, Baltimore Museum of Art). Pevsner was a founder member of *Abstraction-Création in 1931 and was influential in transmitting Constructivist ideas to other artists in the group. His style was similar to that of Gabo, but he had a more spiritual outlook: he thought that 'the power of the constructive work must be like that of

painting, which represents the divine song and music; it must have an active life of great power and eternal salvation.' By the end of his career he was a much honored figure.

Pevsner, Nikolaus *See* POSTMODERNISM.

Peyronnet, Dominique *See* NAIVE ART.

Peyton, Elizabeth (1965–) American painter born in Connecticut. She studied at the School of Visual Arts in New York between 1984 and 1987. Initially she made paintings of historical figures such as Ludwig of Bavaria or Napoleon. She adopted a style of painterly adaptation of photographs, sometimes news stories or celebrities, sometimes of friends. Her paintings of men are usually posed, rather like pin-ups on the wall of a teenage girl, and are generally small in size. The depictions of pop stars or mildly eroticized male figures appear to be without any irony. Giorgio Verzotti (*Artforum International*, February 2002) described her as 'a small woman who works for the most part on a small scale'; but, he continues, 'she is a majestic painter, perhaps the most important of her generation'. She prefers photographs which are 'incidental and accidental' because they give her greater freedom to pick and choose information. Her transcriptions are not literal: she will pick details from different photographs and combine them. The subjects she draws upon tend not to be 'hard news' stories. British royalty recurs. There are images of the Queen Mother's funeral or Prince Harry at a football match.

Further Reading: interview with Elizabeth Peyton, *Index* (July 2000)

Phalanx An association of artists organized in Munich in 1901 in opposition to the conservative views of the Academy and the *Sezession. *Kandinsky was one of the founders of the association and its leading figure, becoming president in 1902. He wrote that the society's 'set task is to further common interests through close association. Primarily, it means to help young artists overcome the difficulties that are frequently encountered when they wish to show their work.' For the first group exhibition in August 1901 Kandinsky designed a magnificent poster in *Art Nouveau style showing Greek warriors advancing across a battlefield in phalanx formation. The militaristic name of the association was chosen to suggest its aggressive, progressive spirit. Eleven more exhibitions followed before Kandinsky dissolved Phalanx in 1904 because

of lack of public support. The shows featured not only work by members, but also by 'guest' artists—*Monet for the seventh exhibition in 1903, and French *Neo-Impressionists at the tenth exhibition in 1904. This was the most important of the exhibitions, confirming Kandinsky's internationalism and having a marked effect on several young artists, notably *Kirchner. In 1902–3 Phalanx ran an art school. One of the first students was Gabriele *Münter, who became Kandinsky's mistress.

Phantastischer Realismus *See* FANTASTIC REALISM.

Phillips, Duncan (1886–1966) American collector and writer on art. His family had made a fortune in steel and glass and he devoted much of his substantial inheritance to collecting, following his own judgement and buying mainly the work of late 19th- and 20th-century artists. After his father and brother died in quick succession in 1917–18, Phillips conceived the idea of making his collection a memorial to them, and in 1921 he opened his Washington home to the public three afternoons a week. The collection was subtitled 'A Museum of Modern Art and its Sources' (it includes a few examples of the work of earlier artists, among them El Greco, Chardin, and Goya) and it represented the first permanent museum of modern art in the USA (the *Société Anonyme was founded a year earlier, but initially concentrated on temporary exhibitions). It proved so popular that Phillips moved with his family to another home in 1930 and made the house over completely as a gallery. Although there have been substantial extensions since then (the most recent opened in 2006), the Phillips Collection retains its intimate, domestic air, and is widely regarded as one of the world's finest small museums. Phillips's writings include a collection of essays entitled *The Enchantment of Art* (1914) and *A Collection in the Making* (1926). His wife, Marjorie (née Acker), whom he married in 1921, was a painter and took an active role in building and administering the collection. She became director after her husband's death and in 1970 published *Duncan Phillips and his Collection*. On her retirement in 1972, her son Loughlin became director of the Phillips Collection. In 1992 the directorship was handed over to Charles S. Moffett, who was succeeded in 1998 by Jay Gates.

(((•))) SEE WEB LINKS

• The website of the Phillips Collection.

Phillips, Helen *See* HAYTER, S. W.

Phillips, Peter (1939–) British painter, born in Birmingham. He studied at Birmingham College of Art, 1955–9, and at the *Royal College of Art, 1959–62, and with a number of fellow RCA students—Derek *Boshier, David *Hockney, Allen *Jones, R. B. *Kitaj—he emerged as one of the leading exponents of British *Pop art at the *Young Contemporaries exhibition of 1961. Early in his career a certain sinister edge was detected which distinguished him from the others. The painter Richard *Smith said that he 'adds darkness to brightness'. Typically his imagery is drawn from modern American culture—jukeboxes, pinball machines, automobiles, film star pinups and so on—painted in the tight, glossy manner of commercial art. However, the images are usually set into bold heraldic frameworks or fragmented into sections and reorganized, so that illusionism, reinforced by the use of spray-paint technique, and abstraction are combined. Phillips described his paintings as 'multi-assemblages of spatial, iconographical, and technical factors'. He went on to maintain that having grown up with advertising and mass communication he used such imagery 'without a second thought'. Reviewing a retrospective exhibition, Richard Shone (*Burlington Magazine*, October 1982) noted that he had never achieved in his own country the popularity of some of his contemporaries. He puts this down to Phillips being an 'unsympathetic' artist, whose paintings while undeniably intelligent are 'peculiarly repellent—harsh, ungenerous, lacking visual oxygen'. In 1964–6 Phillips lived in New York, then settled in Zurich and subsequently in Mallorca.

Further Reading: M. Livingstone, *Retrovision: Peter Phillips* (1982)

Phillips, Tom (1937–) British painter, graphic artist, musician, and writer, born in London. He studied English literature at St Catherine's College, Oxford, 1957–60, and painting at Camberwell School of Art, 1961–3, his teachers including *Auerbach and *Uglow. Phillips's work resists classification and has been much concerned with the fusion of words and images. Simon Wilson (*British Art from Holbein to the Present Day*, 1979) writes that his 'primary source material is the modern, photographically based, coloured picture postcard of which he is an obsessional

collector...Phillips typically develops some specific human or social theme and then submits the source image to an elaborate painting process so devised that the theme is embodied in a visual scheme of maximum richness and subtlety.' In 1966 he began using texts from a Victorian novel (*A Human Document* by W. H. Mallock, 1892) and has produced various suites of prints and other works based on it under the collective title *A Humument*. A by-product of this work is his opera *Irma* (first produced 1973, recorded 1980). Another ambitious project is his set of illustrations to Dante's *Inferno* (1979–83), consisting of etchings, lithographs, and screenprints accompanying his own translation. His writings include the book *Music in Art* (1997).

Philpot, Glyn (1884–1937) British painter and sculptor, born in London. He studied at Lambeth School of Art, 1900–03, and at the *Académie Julian, Paris, 1905. It was as a portraitist that Philpot had his main success, which was at its height in the 1920s. However, he also did a mural, *Richard I Leaving England for the Crusades* (1927), for St Stephen's Hall, Westminster, and had ambitions as a painter of allegories and religious subjects (he became a convert to Catholicism in 1905). Philpot grew tired of routine fashionable portraiture (however lucrative it was) and in 1931 he moved to Paris for a year and started working in a more modern idiom—flatter and more stylized than his earlier manner. The new style met with a mixed reception and some of Philpot's earlier admirers were dismayed: 'Glyn Philpot "Goes Picasso"', read a headline in the *Scotsman* on 30 April 1932. He died suddenly of heart failure in his London studio. The day after his funeral his friend and disciple Vivian Forbes (1891–1937) committed suicide; his behaviour had been unbalanced for several years. Philpot was out of fashion for many years, but his reputation began to revive in the 1970s (coinciding with a general renewal of interest in the *Art Deco style, of which he is sometimes said to be a representative) and there was a major exhibition of his work at the National Portrait Gallery, London, in 1984–5. He is now perhaps best known for his portraits of black people—his West Indian servant Henry Thomas was a favourite model.

Further Reading: R. Gibson, *Glyn Philpot 1884–1937: Edwardian Aesthete to Thirties Modernist* (1984)

photogram *See* SCHAD, CHRISTIAN.

photomontage Term applied to a technique of making a pictorial composition from parts of different photographs and also to the image so made. The technique has antecedents in the 19th century, particularly in the work of O. G. Rejlander (1813–75), a Swedish photographer and painter active in England. Known as 'the father of art photography', he tried to expand the expressive range of photography by experimenting with double exposures and printing from several negatives on to a single sheet of paper. His best-known work in this vein is the highly elaborate allegorical scene *The Two Ways of Life* (1857), printed from thirty negatives on to two sheets joined together. As the term is now generally understood, however, photomontage involves cutting out, arranging, and pasting pre-existing photographic images rather than the manipulation of negatives taken for a particular purpose. Photomontage in this sense was largely the creation of the *Dadaists (specifically the Berlin Dadaists), who used the technique for political propaganda, social criticism, and generally to assist the shock tactics in which they engaged. Often they incorporated type and graphic symbols in the image, the elements being chosen for the meaning they convey rather than (as is often the case in *collage) for their decorative qualities. Raoul *Hausmann claimed to have invented photomontage in 1918, but no one person can be given the credit. John *Heartfield and Hannah *Höch ranked with Hausmann among the most distinguished pioneers. Photomontage has also been memorably used by, for example, Max *Ernst and other *Surrealists and by *Pop artists such as Richard *Hamilton. Later artists who have used it for political purposes include Klaus Staeck (1938–) and Peter Kennard (1949–), although the latter has expressed his doubts as to the effectiveness of the technique today in view of the ubiquitous computer manipulation of images. *See also* MONTAGE.

Photorealism or **Photographic Realism** Terms more or less synonymous with *Superrealism, although some critics prefer to restrict them to works painted directly from a photograph or photographs rather than use them for all paintings in a photographically detailed style.

photo-work A term used since the 1970s to describe various types of works of art based on photographic images that have been manipulated by the artist in some way. It is a difficult

term to define with any precision, as artists have routinely made use of photographic imagery since the days of *Pop art. However, it generally carries with it the suggestion that a photograph is physically the essential component of the work, rather than merely a part of a *mixed media work or the starting-point for a work in some other medium. Photography was an important tool in *Conceptual art and those other forms of art in the late 1960s and 1970s which proposed alternatives to the traditional art object. Sometimes it might record something which would otherwise disappear altogether, such as some of the landscape pieces of Richard *Long. Sometimes, as with the work of John Hilliard (1945–), who dealt with the way that framing could change the meaning of an image, the preoccupation was with photography itself, not as an art form, but as a social phenomenon which produces meaning.

One form of photo-work which emerged around 1970 was the multiple image photographic narrative usually combined with language. A prominent exponent was Duane Michals (1932–). *A Young Girl's Dream* (1969) is in five frames. A girl lies naked on a sofa unmoving in sleep. By the use of trick photography a man emerges gradually over the sequence to touch her breast and disappears in the final frame. *Gilbert & George create spectacular wall-sized panels in which black and white photographs arranged into regular grids are overlaid with garish tints; the artists themselves call these images 'photo-pieces', rather than 'photo-works'. In practice they are making a form of *photomontage. David *Hockney, also, has created elaborate images using photographs—in his case 'photocollages' made up of as many as six hundred overlapping prints. At the other extreme are the pictures of the American Cindy *Sherman, in which the 'manipulation' occurs before the photograph is taken, rather than after it, and the photographic print itself is presented perfectly 'straight'. Sherman's use of her own image is deliberately protean. Other artists have been far more personal. The *feminist photographer Jo Spence (1934–92), working in collaboration with Terry Dennett, having made photographic works with her own image, exploring the construction of feminine identity, used phototherapy to document her struggle with breast cancer. Yinka Shonibare MBE (1962–), a British/Nigerian artist, links performance and staged photographs in his 'Victorian Dandy' series, in which he plays on the incongruity of a black presence within the upper-class world of early 19th-century Britain. The capacity of photography to make its subjects seem 'more real than reality' is exploited by the German artist Thomas Demand (1964–). What appear to be shots of actual rooms, often with an historical significance such as Hitler's bunker or Jackson Pollock's studio, turn out, on close inspection, to be taken from paper reconstructions.

Further Reading: P. Schimmel, *American Narrative/Story Art 1967–1977* (1977)

Picabia, Francis (1879–1953) French painter, designer, writer, and editor, born in Paris of a Spanish father and a French mother. His restless and energetic personality gave him a significant role successively in the *Cubist, *Dadaist, and *Surrealist movements, and through his publications he played an important role in disseminating avant-garde ideas. A private income enabled him to carry on his activities without having to worry about earning a living, as well as to indulge his love of fast cars, fast women, and wild living in general. He owned 120 cars in the course of his life.

Picabia studied at the École des Arts Décoratifs in Paris, 1895–7, and for the next ten years was a prolific and successful painter of *Impressionist landscapes. In 1908–9 he worked through *Neo-Impressionism, and then *Fauvism and Cubism. *Rubber* (c. 1909, Pompidou Centre, Paris) has sometimes been put forward as the first completely abstract painting, but it makes perfect sense as a depiction of a bowl of flowers on a table. In 1911 he met Marcel *Duchamp, who was to be the most important influence on his career, and became associated with that notoriously hard to define tendency, *Orphism. Paintings such as *La Source* (1912, MoMA, New York) fall within the genre of 'Salon *Cubism', in that they are large-scale multi-figure compositions. As with some near-contemporary work of Léger, their complexity creates a difficulty in reading them which brings them close to abstraction. In 1913 Picabia visited New York as spokesman for the Cubist pictures in the *Armory Show. On the voyage he met the dancer Mlle Napierskowa, whose performances were to lead to her arrest in New York. She inspired a number of paintings he made on his return, including the ten-foot-square *Udnie* (Pompidou Centre), which are surely the most erotically suggestive of all vanguard paintings of

that date. He returned to New York in 1915–16, when he, Duchamp, and *Man Ray were involved in the first stirrings of Dada. He contributed to *Stieglitz's review *291*, in which he published some of the images of anthropomorphized (and sexualized) machines which were to be a hallmark of his painting for the next few years. The *Young American Girl in a State of Nudity* (1915) is an 'Ever Ready' spark plug. After moving to Barcelona (where he lived 1916–17), he launched his own magazine based on 291—*391* (1917–24). In 1917 he returned to New York for six months (during which he produced three Americanized issues of *391*), then lived in Zurich (1918–19) before returning to Paris, where he helped to launch the Dada movement in 1919 and began publishing a review called *Cannibale*. However, in 1921 he denounced Dada for being no longer 'new', and became involved with André *Breton and the nascent Surrealist movement. In 1924 he attacked this, too, in the pages of *391*. From 1925 to 1945 he lived mainly on the Côte d'Azur, organizing extravagant *soirées* such as *La Nuit Tatouée*. Some of his later paintings take the form of 'transparents', layers of superimposed images. Others frankly embrace *kitsch and even soft-core pornography, as in the notorious *Women with Bulldog* (1941–2, Pompidou Centre). In 1945 he settled permanently in Paris and in his final years returned to abstract painting. Perhaps the only way that these late works can be interpreted is in the light of Picabia's statement that 'We need a lively, childlike, happy art if we are not to lose the freedom we value above everything.' He died in the same house where he was born.

Apart from his contributions to avant-garde magazines, Picabia published various pamphlets and wrote poetry. He also conceived the fantasy ballet *Relâche* (1924), with music by Erik Satie, together with the film *Entr'acte* (directed by René Clair), which was used to fill the intermission between the ballet's two acts. Unlike many of his contemporaries, he did not base his radicalism on sympathy with the left. Rather it was rooted in an extreme individualism inspired by the writings of the 19th-century philosopher Max Stirner, author of *The Ego and its Own*. In 1927 he wrote 'Can you imagine socialism or communism in Love or Art? One would burst into laughter—if one were not threatened by the consequences.' As Alain Jouffroy points out, he was hardly an apolitical artist, citing his 1937 painting *The*

Spanish Revolution in which a woman in Sevillian costume embraces a skeleton wrapped in a red flag. Jouffroy argues that Picabia's revolutionary quality was his jettisoning of all artistic systems. For art today his rejection of all notions of 'good taste' is as important as his contribution to early modernism.

Further Reading: A. Jouffroy, *Picabia* (2002)
J. Mundy (ed.), *Duchamp, Man Ray, Picabia* (2008)

Picasso, Pablo (1881–1973) Spanish painter, sculptor, draughtsman, printmaker, ceramicist, and designer, active mainly in France, the most famous, versatile, and prolific artist of the 20th century. He was the dominant personality in the visual arts during much of the first half of the 20th century and he provided the incentive for many of the revolutionary changes during this time. Although it is conventional to divide his work into certain phases, these divisions are to some extent arbitrary, as his energy and imagination were such that he often worked simultaneously on a wealth of themes and in a variety of styles. Picasso himself said: 'The several manners I have used in my art must not be considered as an evolution, or as steps toward an unknown ideal of painting. When I have found something to express, I have done it without thinking of the past or future. I do not believe I have used radically different elements in the different manners I have used in painting. If the subjects I have wanted to express have suggested different ways of expression, I haven't hesitated to adopt them.'

Picasso was born in Málaga, the son of an undistinguished painter and drawing-master, José Ruiz Blasco (1838–1913). He was immersed in art from childhood (his first word is said to have been '*piz*', baby talk for *lápiz*, pencil), and although he was not quite the child genius he later liked to suggest, he certainly showed exceptional talent by the time he was in his early teens. In 1895 his family moved to Barcelona, where he studied at the School of Fine Arts, 1896–7, before attending the Academy in Madrid for a few months in 1897. By this time he had his own studio in Barcelona, and he thrived on the city's intellectual and bohemian life, centring on the café Els Quatre Gats (The Four Cats). In 1900 he made his first visit to Paris and by this time had already absorbed a wide range of influences. Between 1900 and 1904 he alternated between Barcelona and Paris, and this time coincides with his Blue Period, when he took

his subjects from the poor and social outcasts, and the predominant mood of his paintings was one of slightly sentimentalized melancholy expressed through cold ethereal blue tones (*La Vie*, 1903, Cleveland Museum of Art). He also did a number of powerful etchings in a similar vein (*The Frugal Repast*, 1904).

In 1904 Picasso settled in Paris and quickly became a member of a circle of avant-garde artists and writers. A brief phase in 1904–5 is known as his Rose (or Circus) Period. The predominant blue tones of his earlier work gave way to pinks and greys and the mood became less austere. His favourite subjects were acrobats and dancers, particularly the figure of the harlequin. In 1906 he met *Matisse, but although he seems to have admired the work being done by the *Fauves, he did not share their interest in the decorative and expressive use of colour (indeed his work often shows little concern with colour, and it is significant that—unlike most painters—he preferred to work at night by artificial light). Until 1909 he lived with other artists and nonconformists in the ramshackle *Bateau-Lavoir, but he rarely suffered real poverty (*see* JACOB) but his work soon began to attract the attention of important collectors, even though he did not exhibit at any of the usual salons. In 1905–6 the Americans Gertrude and Leo *Stein, the German Wilhelm *Uhde, and the Russian Sergei *Shchukin began buying his paintings, and in 1907 he was taken up by the dealer *Kahnweiler.

The period around 1906–7 is sometimes referred to as Picasso's 'Negro period', because of the influence of African sculpture on his work at this time. *Cézanne was another major influence, as he concentrated on the analysis and simplification of form. This process culminated in *Les Demoiselles d'Avignon* (1906–7, MoMA, New York), which in its distortions of form was as violent a revolt against tradition as the paintings of the Fauves in the realm of colour. The painting shows five sinister-looking naked women, and its title was jokingly suggested by André *Salmon, who pretended to see a resemblance between them and prostitutes in the Carrer d'Avinyo (Avignon Street) in Barcelona. At the time the picture was startling even to other avant-garde artists, including Matisse and *Derain, and it was not shown publicly until 1916 and only once reproduced before 1925. It is now seen not only as a pivotal work in Picasso's personal

development but as the most important single landmark in the development of early 20th-century painting. It was the herald of *Cubism, which Picasso developed in close association with *Braque and then *Gris from 1907 up to the First World War. From 1912 onwards Picasso added *collage elements to his paintings and made an equally revolutionary contribution to sculpture by creating works from pieces of commonplace material, for example *Guitar* (1912, Musée Picasso, Paris), which is made of cardboard, paper, and string. His sculptures of this type were generally fairly small, but the idea was soon developed in a more ambitious way, for instance in the multi-coloured *Glass of Absinthe* (1914). Some have argued that the revolution in sculpture was even more far-reaching than that in painting. As the sculptor Peter *Hide (*Edmonton Review*, Summer 1999) put it, 'Picasso took a spare rib from cubist collage and invented abstract sculpture, in effect shattering the monolith that had dominated sculpture since the *Venus of Willendorf*'. *Tatlin visited Picasso in 1914 and the sculptures were a major inspiration for *Constructivism.

During the First World War Picasso continued working in Paris, but in 1917 he went to Rome with his friend Jean *Cocteau to design costumes and scenery for the ballet *Parade*, which was being produced by *Diaghilev. Picasso fell in love with one of the dancers, Olga Koklova, and they married in 1918, moving into a grand apartment in a fashionable part of Paris, as the bohemian days of his youth were left behind. The visit to Italy was also an important factor in introducing the strain of monumental *Neoclassicism that was one of the most prominent features of Picasso's work in the early 1920s (*Mother and Child*, 1921, Art Institute of Chicago), but at this time he also became involved with *Surrealism—indeed André *Breton hailed him as one of the initiators of the movement. It is a measure of the significance of his Cubist work that it could be taken by different groups both as a passage into the world of the irrational and the dream and as the analysis and synthesis of form. Both readings make sense in terms of different aspects of Picasso's achievement.

Following his serene *Neoclassical paintings, Picasso began to make violently expressive works, fraught with emotional tension, anguish, and despair. This phase begins with *The Three*

Dancers (1925, Tate), painted at a time when his marriage was becoming a source of increasing unhappiness and frustration (Picasso could not obtain a divorce, so he remained officially married to Olga until her death in 1955; he remarried in 1961). The life-size figures in *The Three Dancers* are aggressively distorted in a savage parody of classical ballet; Alfred H. *Barr calls the picture 'a turning point in Picasso's art almost as radical as the proto-cubist *Demoiselles d'Avignon'*. Following this, he became concerned with the mythological image of the Minotaur and images of the Dying Horse and the Weeping Woman. The period culminated in his most famous work, *Guernica* (1937, Centro de Arte Reina Sofía, Madrid), produced for the Spanish pavilion at the Paris Exposition Universelle of 1937 to express horror and revulsion at the bombing of the Basque capital, Guernica, by General Franco's German allies during the Spanish Civil War. It was followed by a number of other paintings attacking the cruelty and destructiveness of war, including *The Charnel House* (1945, MoMA, New York), specifically commemorating the Spanish victims of the Holocaust.

Picasso remained in Paris during the German occupation, but from 1946 he lived mainly in the South of France, where he added pottery to his other activities (from 1948 to 1955 he lived in Vallauris, a town renowned for its ceramics); he settled at his final home, the Villa Notre-Dame-de-Vie at Mougins, in 1961. In 1944 he had joined the Communist Party, and in the post-war years he attended several International Peace Congresses organized by the Party, including one in Sheffield in 1950. It was very much as a Communist that he made one of his few theoretical statements about his purpose as an artist. 'Painting is not done to decorate apartments. It is an instrument of war against brutality and darkness.' His later output as a painter does not compare in historical significance with his pre-war work, but it remained prodigious in terms of sheer quantity. It included a number of variations on paintings by other artists, including forty-four on Velázquez's *Las Meninas* (the theme of the artist and his almost magical powers is one that exercised him greatly throughout his career). Some critics think that Picasso remained a great master to the end of his long life, but others see a sad falling off in his post-war work. Douglas *Cooper, for example, described the paintings of his old age as 'incoherent doodles done by a frenetic

dotard in the anteroom of death', whereas to John *Richardson they constitute 'a phenomenal finale to a phenomenal œuvre'. These pictures, such as *Reclining Nude with Necklace* (1968, Tate), are often aggressively sexual in subject and almost frenzied in brushwork; they have been seen as sources for *Neo-Expressionism.

After the Cubist period, Picasso's interest in sculpture was fairly sporadic, much of his three-dimensional work being executed in short bursts of activity, but in this field too he ranks as one of the outstanding figures in 20th-century art. His best-known sculptures include some amusing works in which he demonstrated his remarkable sharpness of eye in transforming found objects (*see* OBJET TROUVÉ): the most celebrated example is *Head of A Bull, Metamorphosis* (1943, Musée Picasso, Paris), made of the saddle and handlebars of a bicycle. The most innovative sculptures were the iron constructions such as *Tête de Femme*, made in collaboration with Julio *González, which launched a kind of constructed metal sculpture to be developed by such artists as David *Smith and Anthony *Caro. However, he also made more figurative works, the largest being the over-life-size bronze *Man with a Sheep* (1943), one cast of which stands in the main square in Vallauris. There is a case for seeing Picasso's artistic imagination as being as much sculptural as painterly. Julio González, a major sculptor in his own right, recalled that in his first Cubist paintings, Picasso had considered that he just needed to cut them up to be in the presence of a 'sculpture' (*Cahiers d'art*, 1936, in Wood, Hulks, and Potts). Many later paintings can be visualized as models for unmade monuments.

As a graphic artist (draughtsman, etcher, lithographer, linocutter), Picasso ranks with the greatest of the century, one of his outstanding achievements being the set of etchings known as the *Vollard Suite* (*see* VOLLARD). He was a prolific book illustrator and, as few other artists, had the power to concentrate the impress of his genius in even the smallest and slightest of his works. His emotional range is as wide as his varied technical mastery. By turns playful and tragic, his work is suffused with a passionate love of life, and no artist has more devastatingly exposed the cruelty and folly of his fellow men or more rapturously celebrated the physical pleasures of love. There are several museums devoted to Picasso's work in France and Spain, the largest being in Paris and Barcelona; other examples

of his huge output (which has been estimated at over 20,000 works) are in collections throughout the world.

Just as Picasso's work has been more discussed than that of any other modern artist, so his personal life has inspired a flood of writing, particularly regarding his relationships with women. He once described women as either 'goddesses or doormats' and he has been criticized for allegedly demeaning them in his work (especially his later erotic paintings) as well as mistreating them in person. Several of the women in his life came out of their relationships with him badly. His first wife became almost deranged, screaming abuse at him in public, and his second wife committed suicide some years after his death, as did Marie-Thérèse Walter, who became his mistress in 1927, when she was 17 and he was 45. Even the strong-willed Dora *Maar, talented in her own right, spent much of her later life as a recluse. Picasso tried unsuccessfully to prevent two of his long-term lovers from publishing their memoirs of life with him: Fernande Olivier's *Picasso et ses amis* (1933, translated as *Picasso and His Friends*, 1965), and Françoise Gilot's *Life with Picasso* (1964). (Olivier, an artists' model whom he met in 1904, was his first great love; Gilot, a painter, was the mother of two of his children including Paloma Picasso (1949–), an actress and jewellery designer.) John Richardson describes Gilot's book as telling the story of a 'young girl seduced, manipulated and betrayed by a sadistic old Bluebeard' and writes that it outraged Picasso so much (he maintained he was the one who had been betrayed) that it 'cast a shadow over the rest of his life'. David *Sylvester, however, regards it as 'one of the most illuminating and entertaining books ever written about an artist'.

Further Reading: E. Cowling, *Picasso: Style and Meaning* (2002)

C. Green, *Picasso: Architecture and Vertigo* (2005)

T. Hilton, *Picasso* (1975)

Pick, Frank *See* KAUFFER, E. MCKNIGHT.

Pictorialism *See* TONALISM.

Piene, Otto (1928–) German painter, sculptor, and Kinetic artist, born in Laasphe, Westphalia. At the age of sixteen he was called up for war service as an anti-aircraft gunner and was taken prisoner. After the war he trained at the academies of Munich and Düsseldorf, 1948–53, and then studied philosophy at Cologne University, 1953–7. With Heinz *Mack

and Günther *Uecker he founded the *Zero group in 1957. His work has included paintings employing smoke and large out-of-doors light projects such as *Lichtlinie* at the Massachusetts Institute of Technology in 1968. In 1969 he coined the term *Sky art to refer to certain works of this type. He has had a great influence as a teacher and from 1974 to 1994 was director of the MIT Center for Advanced Visual Studies (CAVS) which specializes in links between art and technology.

Pignatari, Décio *See* CONCRETE POETRY.

Pignon, Édouard (1905–93) French painter, graphic artist, ceramicist, and designer, born at Bully-les-Mines, Pas-de-Calais. A miner's son, he worked in the mines himself until 1927, when he moved to Paris and kept himself by a variety of occupations while painting in his spare time and attending evening classes in sculpture. In 1936 he opted for painting on the advice of *Picasso, but it was not until 1943 that he was able to devote himself entirely to art. During the 1930s his work included large canvases depicting the life of working people in a style influenced by Picasso and *Léger. In the 1940s his style developed into a more painterly synthesis of the post-*Cubist structure of Picasso and Léger with the decorative colour of *Matisse, and from the 1950s his handling became freer and looser. Apart from the scenes of working life with which he is most closely associated, Pignon treated a wide range of subjects, including landscapes in the South of France (from the 1950s he spent much of his time in Provence), sea scenes, nudes in landscapes, cock fights, and a series of *Battles* in the 1960s. He was inspired by Picasso to take up ceramics and his other work included theatre designs and book illustrations.

Pillet, Edgard *See* GROUPE ESPACE.

Pincus-Witten, Robert *See* POST-MINIMALISM.

Piper, Adrian (1948–) American artist, theorist, and philosopher. She was born in New York and studied art at the School of Visual Arts, New York, and then philosophy at Harvard University under John Rawls (1921–2002), the author of *A Theory of Justice* (1971), whose ideas about the need to reconcile liberty and fairness were a powerful influence on her. She met Sol *LeWitt in 1967 and through him came

into contact with *Conceptual and *Minimalist artists. In a tribute to LeWitt she said that 'he proved that we could be artists and theorists at the same time'. She brought to Conceptual art her interests in philosophy and in race and gender issues. Piper is black but pale-skinned, so that her ethnicity sometimes passes unnoticed and she has made work which challenges attitudes to racial identity. In the *Mythic Being* series (1973–6) she constructed an alternative identity, providing cryptic diary entries which she placed as advertisements in the New York magazine *Village Voice*, chosen because it reached an audience outside the art world. *Cornered* (1988) is a video installation in which the television screen is set up behind a table on its side, suggesting an improvised barricade. The confrontational nature of the setting at first seems to be at odds with the calm nature of the video itself, in which Piper talks with a demeanour and appearance which reminds spectators of a schoolteacher or a librarian. What she says challenges the idea of pure 'whiteness' in race, pointing out the probability that in the United States even those who imagine themselves as 'white' are in fact of mixed ancestry. Piper has also had a distinguished career as a philosopher, in which capacity she was professor at Wellesley College. There are clear links between her philosophical and artistic interests in that her writings have explored the roots of racism and also how it might be combatted, by drawing on the writings of Immanuel Kant. However, she cheerfully admitted to an interviewer: 'When I am in an art context, for me to start spouting philosophy is going to guarantee that I will put everyone to sleep.' She now lives and works in Berlin.

(()) SEE WEB LINKS

• T. Sokolowski 'Adrian Piper: A Conversation', in *Carnegie Magazine* (2001).

Piper, John (1903–92) British painter, printmaker, draughtsman, designer, and writer, born at Epsom, Surrey, the son of a solicitor. He reluctantly became an articled clerk in his father's legal firm, but after his father's death in 1926 he studied at Richmond School of Art and then the *Royal College of Art, 1926–8. From 1928 to 1933 he wrote art criticism for *The Listener* and *The Nation*, and he was among the first to recognize such contemporaries as William *Coldstream, Ivon *Hitchens, Victor *Pasmore, and Ceri *Richards. He became a member of the *London Group in 1933

and of the *Seven & Five Society in 1934. Also in 1934 he met the writer Myfanwy Evans (1911–97) and soon afterwards began assisting her on the avant-garde quarterly *Axis*, which was launched in 1935. Evans became Piper's second wife in 1937. At this time he was one of the leading British abstract artists, but by the end of the decade he had abandoned non-representational art. He concentrated on landscape and architectural views in a subjective, emotionally charged style which exemplified the *Neo-Romanticism of the period. Some of his most memorable works in this vein were done during the Second World War when he made pictures (watercolours as well as oils) of bomb-damaged buildings for the War Artists Advisory Committee. A similar stormy atmosphere pervades his famous views of country houses of the same period, which were done either for himself or on private commission: for example, he made a series of paintings of Renishaw Hall, Derbyshire, for Sir Osbert *Sitwell.

Piper's work diversified in the 1950s and he became recognized as one of the most versatile British artists of his generation. He did much work as a designer of stained glass (notably at Coventry Cathedral) and also for the stage. His stage designs included sets for several Benjamin Britten operas, beginning with *The Rape of Lucretia* (1946); in addition, Piper made book illustrations and designed pottery and textiles, including a tapestry in Chichester Cathedral (1966). As a writer he is probably best known for his book *British Romantic Artists* (1942), which contributed to the definition of Neo-Romanticism. He also compiled several architectural guidebooks to English counties (Oxfordshire, 1938; Shropshire, 1939; Buckinghamshire, 1948; Berkshire, 1949), usually in collaboration with his friend the poet Sir John Betjeman. Betjeman wrote a book on Piper in the 'Penguin Modern Painters' series (1944). His son **Edward Piper** (1938–90) was a painter, photographer, and graphic designer.

Further Reading: Tate Gallery, *John Piper* (1983)

D. F. Jenkins and F. Spalding, *John Piper in the 1930s: Abstraction on the Beach* (2003)

Pippin, Horace (1888–1946) African-American *naive painter. He was born at West Chester, Pennsylvania, and brought up in Goshen, New York. After leaving school at the age of fifteen, he worked at various jobs (bellboy, foundryman, junk dealer) then enlisted in the US Army in 1917. Pippin had

drawn since childhood and he kept an illustrated diary of his experiences as a soldier in France. A severe wound paralysed his right arm and after returning to the USA he settled in West Chester and supplemented his disability pay by doing light work. Through exercise he strengthened his arm and he began to paint in oils in about 1930. His work included scenes from personal experience (including memories of the war) and from the imagination (he did numerous religious pictures). He was 'discovered' in 1937 and the following year his work was included in a major exhibition at the *Museum of Modern Art, New York—'Masters of Popular Painting: Modern Primitives of Europe and America'. In the 1940s he attained a considerable reputation. His work has a dramatic feeling and psychological intensity rare in naive painting, especially in his paintings on John Brown, the anti-slavery campaigner.

Pirandello, Fausto (1889–1975) Italian painter, born in Rome, the son of the playwright Luigi Pirandello. Advised by his father to express himself in other ways than literature, he initially studied sculpture but in 1920 turned to painting. In 1927 he moved to Paris, where he was for a time influenced by *Cézanne and *Cubism. He returned to Rome in 1931. In the following years he made the paintings for which he is best remembered, mysterious interiors in dominantly earthy colours. These are superficially naturalistic but on exploration reveal strange haunting discrepancies in viewpoint and sudden abridgement of figures and objects. Female figures in various states of undress appear pressed close to the picture plane. In *Interior in the Morning* (1931, Pompidou Centre, Paris) a woman is fragmented by her own reflection, another is inexplicably cut off at the waist, while a picture of a mother and child, torn from a newspaper, looms unnaturally large. Although Pirandello had a certain success during the years of the Fascist regime, his vision is far from the heroic classicism of its official art.

Pissarro, Lucien (1863–1944) Anglo-French painter and graphic artist, born in Paris, the eldest son of the celebrated *Impressionist painter **Camille Pissarro** (1830–1903). His four brothers all became painters. Lucien was taught and continuously coached by his father, and the letters they exchanged are valuable documents on late 19th-century art.

Lucien visited England in 1870 as a child, worked there briefly in 1883–4, and settled permanently in the country in 1890 (although he often made trips to France), becoming a British citizen in 1916.

Pissarro had a thorough knowledge of printing techniques, and in 1894 he founded the Eragny Press (named after a village in Normandy where his father lived). This was one of the most distinguished of the private presses that flourished at this time, creating books that existed primarily for the sake of their appearance—typography, illustration, binding—rather than their content. The illustrations were mainly from Pissarro's own drawings, engraved on wood by himself and his wife, Esther, and they are remarkable for their use of colour. The heavy dependence on foreign sales led to the firm's closure in 1914. In spite of his intense involvement in printing, Pissarro always regarded painting as his primary concern. From 1905 he was a member of *Sickert's circle. His main subject was landscape. He was a modest and unassuming character and has been overshadowed by his more famous father, but he was important as a link between French Impressionism and *Neo-Impressionism and English art.

Lucien's daughter, **Orovida Pissarro** (1893–1968), often known simply as 'Orovida', was a painter and etcher, mainly of animal subjects.

Pistoletto, Michelangelo (1933–) Italian artist, born in Biella in Piedmont. From 1947 to 1958 he worked with his father, a picture restorer, and also did advertising work. He had his first one-man show at the Galleria Galatea, Turin, in 1960, and in 1962 he began making the 'mirror paintings' for which he is best known. In these he used life-size cut-out photographs of people, usually shown in arrested action, which he pasted on to thin sheets of polished steel. The spectator sees his or her own moving image reflected in the steel alongside the photographic image. They were originally associated with *Pop art, but Pistoletto describes them as 'phenomenological works in which time shows itself'. This is clearer today than in the 1960s, when the modern viewer mingles with pictures from the past. Pistoletto deliberately rejected the option of continuing with a device which had achieved great success with collectors (*Rauschenberg and Jasper *Johns were both buyers), and subsequently worked in a wide variety of media and styles. He radically opposed the notion of the

'signature style' in the *oggetti in meno* (minus objects) he made in 1965. These were first only shown to a small group of friends, but alongside the contemporary works of Pino *Pascali now appear as important early examples of *Arte Povera. Some of the pieces openly invited spectator participation. Pistoletto saw Arte Povera as concerned not just with poor materials but with defining a model for Italy independent of the pressures from the axis represented by America, the Vatican, and the Mafia on one side and Soviet-inspired Communism on the other. The combination of these two ideas is present in his best-known work, *Venus of the Rags* (1967/remade 1974, Tate). A marble sculpture of Venus is placed against the wall and surrounded by a colourful array of fragments of fabric. This unforgettable image is open to different levels of interpretation. Germano *Celant saw the rags as representative of 'the confusion and multivalence of marginalized people . . . perverts, convicts, racial minorities, women and prisoners'. However, the turning to the wall could also be related to Pistoletto's preoccupation with reflection and its absence. There was also a strongly performative element to his work. In 1966 he rolled a large ball covered in newspaper through the streets of Turin; it picked up dirt on the way. The work was called *Mappomondo*. He has set up a Pistoletto Foundation in Biella. Established in an old textile factory, this is conceived not so much as a museum for the artist's work but as a centre for research into the relationship between art and society

- J. Stallabrass, 'Reflections on Art, Time and Poverty: An interview with Michelangelo Pistoletto', on the Courtauld website.

Pite, Beresford *See* ROYAL COLLEGE OF ART.

Pittsburgh International *See* CARNEGIE INTERNATIONAL.

Pittura Colta ('Cultured Painting') A movement in painting, flourishing from the 1980s, in which artists imitate certain features of the figure style of the Old Masters in an ironic way that is considered characteristic of *Postmodernism. The name was coined by the Italian critic Italo Mussa, who published a book entitled *La Pittura colta* in 1983, and the movement is associated mainly with Italy. Probably the best-known of the artists who work in this vein is Carlo Maria *Mariani.

Others are Alberto Abate (1946–), Bruno d'Arcevia (1946–), Antonella Cappuccio (1946–), and Vittorio Scialoja (1942–). They all paint mythological or pseudo-mythological scenes in a gaudy, sleek, and stagey reworking of Old Master conventions. Non-Italian artists who have worked in a similar style include the American David Ligare (1945–); in addition to figure compositions he paints classical landscapes, somewhat in the manner of 17th-century artists such as Nicolas Poussin, but with a glossy modern air (*Landscape for Baucis and Philemon*, 1984, Wadsworth Atheneum, Hartford, Connecticut). The French painter Gérard Garouste (1946–) has also drawn on mythological themes, although his style is rather more expressionistic.

Pittura Metafisica *See* METAPHYSICAL PAINTING.

Plackman, Carl (1943–2004) British sculptor, born in Huddersfield. Between 1962 and 1967 he studied at the West of England College of Art, Bristol, where Richard *Long was also a student. Plackman, in his own way, was involved in a questioning of sculptural norms, but in his case it took the form of extending sculpture into room-size environments. One of the most impressive was *For those who serve: The Raft of the Medusa* (1975). An arrangement of tables and an unusually high-backed chair, it referred in metaphorical terms to his father's life as a waiter. The tying up of objects stood for slavish service. The questioning of this, the 'cutting loose', associated with the floating raft in Géricault's painting, stood for the predicament of those who rejected established authority. Plackman said: 'I have always felt ill at ease: my body fitting as awkwardly as my clothes.'

Further Reading: R. Wentworth, obituary, *The Independent* (12 March 2004)

Plasticiens, Les A group of four Canadian abstract painters founded in Montreal in 1955: Louis Belzile (1929–); Jean-Paul Jérôme (1928–2004); Rodolphe de Repentigny (1926–59), who painted under the name 'Jauran' and who was also a mathematician, philosopher, and art critic; and Fernand Toupin (1930–). The group published a manifesto on 10 February 1955 proclaiming: 'The Plasticiens are drawn, above all else in their work, to the "plastic" facts: tone, texture, form, line, the ultimate unity of these in painting, and the relationship between these

elements ... The significance of the work of the Plasticiens lies with the purifying of the plastic elements and of their order; their destiny lies typically in the revelation of perfect forms in a perfect order ... The Plasticiens are totally indifferent, at least consciously so, to any possible meanings in their paintings.' Their style was austerely geometric, the name of the group being a reference to *Mondrian's *Neo-Plasticism. However, they acknowledged the importance of Les *Automatistes in promoting abstract art in Montreal, even though the spontaneous style associated with that group was very different to their own. In 1956 Les Plasticiens were partially absorbed in the larger Non-figurative Artists' Association of Montreal, which included abstract artists of various persuasions (Fernand Leduc of Les Automatistes was president, and de Repentigny was secretary). In 1959 the *Nouveau Plasticiens was formed. De Repentigny died in a climbing accident later that year.

Plastique See TAEUBER-ARP, SOPHIE.

Plastov, Arkady (1893–1972) Russian painter, one of the outstanding representatives of *Socialist Realism. He divided his time between Prislonikha (his native village) and Moscow, where he studied at the Stroganov School, 1912–14, and the Moscow School of Painting, Sculpture and Architecture, 1914–17. Until 1931, when he became a full-time artist, he worked also as a farmer, and he was above all a painter of agricultural life. Alan Bird (1987) says of his work that 'it displays a liveliness of invention, a sureness of technique, a flamboyant, baroque quality which matches the wedding cake splendours of Russian architecture of that period and which merits more than the jeers it has received in the West or the senseless attacks made on it by latter-day critics in the Soviet Union itself'. Plastov also painted portraits, designed posters (mainly early in his career), and made book illustrations. His work is well represented in the Tretyakov Gallery, Moscow, and the State Russian Museum, St Petersburg.

Plato/Platonic See ABSTRACT ART.

Poiret, Paul See DUFY, RAOUL.

Poliakoff, Serge (1906–69) Russian-born painter, printmaker, and designer who settled in Paris in 1923 and became a French citizen in 1962. He was born in Moscow into a musi-

cal family. In 1919, in the wake of the Revolution, he left Russia with his aunt Nadia Poliakoff, a singer, and travelled to Constantinople, Sofia, Belgrade, Vienna, and Berlin before arriving in Paris, where he earned his living as a guitarist for many years. In 1930 he began to study painting, attending various art schools, including the *Slade School during a two-year stay in London, 1935–7. His early work was figurative, but after his return to Paris in 1937 he met *Kandinsky and Robert and Sonia *Delaunay, and under their influence he turned to abstraction in 1938. He had his first one-man exhibition at the Galerie L'Esquisse, Paris, in 1945, and in 1952 he was able to give up his work as a musician and devote himself full-time to painting. By this time he had developed his characteristic style, featuring bold irregular slabs of mat, roughly textured colour (*Abstract Composition*, 1954, Tate). He adopted an almost religious attitude towards painting, saying 'You've got to have the feeling of God in the picture if you want to get the big music in'. In the 1950s he gained recognition as one of the leading abstract painters in the *École de Paris, but his reputation, alongside other Parisian abstractionists of his generation, had declined somewhat by the time of his death. As well as paintings, he made lithographs and stage designs.

Polke, Sigmar (1941–) German painter, born at Oels (now Olesnicka) in Lower Silesia (now Poland). His family moved to West Germany in 1953. He has a reputation as both man and artist for being difficult to pin down. From 1961 to 1966 he studied at the Düsseldorf Academy, where he was influenced by Joseph *Beuys. Alongside Gerhard *Richter, he was associated in the early 1960s with the tendency of 'capitalist realism'. He made paintings such as *Girlfriends* (1965) which mimic the dotted surface of cheap newspaper reproduction. These have a parallel with the second-hand imagery of American *Pop, but this led, not as with most of the American painters to constant repetition of a successful line, but to a richly varied practice of painting. Like some other European artists working with popular imagery, he looked for subject-matter which had a national resonance rather than speaking of an imposed American culture. An amusing example is *The Sausage Eater* (1965), a white canvas with a mouth, a hand and a long string of very Germanic sausages. Sometimes there is

a strong element of satire of other modern art. *Moderne Kunst* (1968) imitates the gestural qualities of informal abstraction but in an obviously mechanical way and with the title as a neatly written caption on the bottom of the painting. *Carl *Andre in Delft* (1968) uses the American *Minimalist's characteristic grid but instead of industrial materials there are depictions of hand-painted Dutch tiles. The scepticism of Polke and his generation about modern art's traditional claims to represent some kind of higher reality (*see* ABSTRACT ART) is demonstrated in a 1969 painting (Stedelijk van Abbe Museum, Eindhoven), a blank canvas in which one corner has been painted black, according to the caption on the instruction of 'higher beings'.

In the 1970s he turned to photography and video for several years but returned to painting in the early 1980s. This coincided with the wider revival of interest in painting after the dominance of *Conceptual art, especially in Germany, but Polke's practice had little in common with that of the *Neo-Expressionists. His paintings were technically inventive and cool and humorous in mood, quite in contrast to the frenzy of a *Baselitz. He continued to use second-hand imagery but he took it from, not just popular sources, but the entire history of European culture. The age of Enlightenment and Romanticism is one frequent huntingground and Polke shares something in common with those thinkers who believe that many of the ills of the past hundred years can be traced back to that age. In *Children's Games* (1988) two children in 18th-century costume, almost out of Mozart, are seen playing with a skull. In *Paganini* (1981–3) the celebrated violinist and composer, who allowed it to be rumoured that he had sold his soul to the devil for his musical skills, lies in bed, while the devil plays to him. To the left a juggler with a death's head mask juggles skulls and nuclear hazard signs. Taken at face value the political allegories might appear crude, but the imagery is only one element of Polke's art. The paintings are multi-layered in ways that prompt thought not just about the images but about the history which has brought them to us. They may start as paintings, then they are disseminated as engravings as part of the early industrialization of image production, then they have been photographed, then broken down for printing through dots and finally restored to painting by Polke.

He has been enormously influential on younger painters, who have generally found his ironic stance and omnivorous attitude to imagery a more fruitful example than the frenzy of his expressionistic contemporaries.

Further Reading: Tate Gallery, Liverpool, *Sigmar Polke: Join the Dots* (1995)

Pollock, Griselda (1949–) British art historian, born in South Africa, who studied at Oxford University and the *Courtauld Institute of Art, London. Most of her career has been spent at the University of Leeds, where she is currently Professor of Social and Critical Histories of Art. She has been a central figure in promoting the argument that *feminist approaches to the study of art are not merely an adjunct, adding a few women artists to the canon, but crucial to the project of rethinking the role of art in society, in so far as that society is predicated on gender inequalities. She has combined historical studies of 19th-century artists such as van Gogh and *Degas, who have a privileged role within traditional art history, the biases of which she has attacked, with that of female artists past and present, including Mary *Cassatt and Mary *Kelly. Her work employs an array of theoretical resources from psychoanalytic and Marxist theory. The most influential and widely read works in her substantial output are probably *Old Mistresses: Women Art and Ideology* (with Roszika Parker, 1981) and *Vision and Difference* (1988).

Further Reading: J. G. Istrabadi, 'Griselda Pollock', in C. Murray (ed.), *Key Writers on Art: The Twentieth Century* (2003)

Pollock, Jackson (1912–56) American painter, a leading figure in *Abstract Expressionism. He was born on a sheep ranch at Cody, Wyoming, and grew up in Arizona and California, moving homes several times in childhood because of his father's lack of success as a farmer. In 1929 he moved to New York and studied at the *Art Students League under the *Regionalist painter Thomas Hart *Benton. He was influenced not only by Benton's vigorous style, but also by his image as a virile, truculent, hard-drinking macho-man (Pollock began treatment for alcoholism in 1937 and in 1939 he started therapy with Jungian psychoanalysts, using his drawings in sessions with them). During the 1930s he painted in the manner of the Regionalists, and was influenced also by the Mexican muralists (he attended *Siqueiros's experimental workshop in New York in 1936) and by certain aspects of

*Surrealism, particularly the use of mythical or totemic figures as archetypes of the unconscious. From 1935 to 1942 he worked for the *Federal Art Project, and in 1943 he was given a contract by Peggy *Guggenheim; his first one-man show was held at her Art of This Century gallery in that year. A characteristic work of this time is *The She-Wolf* (1943, MoMA, New York), a semi-abstract picture with vehemently handled paint and ominous imagery recalling the monstrous creatures of *Picasso's *Guernica* period.

By the mid-1940s Pollock's work had become completely abstract, and the 'drip and splash' style of *Action Painting for which he is best known emerged with some suddenness in 1947. Instead of using the traditional easel, he laid his canvas on the floor (he worked in a large, barn-like studio on Long Island, where he settled in 1945 with his wife, Lee *Krasner) and poured and dripped his paint from a can (using commercial enamels and metallic paint because their texture was better suited to the technique); instead of using brushes, he manipulated the paint with 'sticks, trowels or knives' (to use his own words), sometimes obtaining textured effects by the admixture of 'sand, broken glass or other foreign matter'. As he worked, Pollock moved around (and sometimes through) his paintings, creating a novel *all-over style that avoided any points of emphasis and abandoned the traditional idea of composition in terms of relation among parts. Sometimes the canvas was presented as it was painted, but the smaller works are the result of docking and cropping of the painting. The immediate source for the drip technique was Surrealist *automatism, especially the work of Max *Ernst, who had produced paintings by dripping paint from a hole in a can. The sand painting of Native Americans was also a possible influence. The drip paintings were first publicly shown at Betty *Parsons's gallery in 1948. Pollock paintings in this rein occupied him for a relatively short period, from 1947 to 1951. Contrary to popular belief, for most of this time he was not drinking. Certainly attention to these works reveals a highly controlled response to chance elements as well as an extraordinary range of expression, from the highly lyrical *Lavender Mist* (1950, NG, Washington) to the bouncingly alive *Autumn Rhythm* (1950, Metropolitan Museum, New York), and to the almost Dada gesture of *Hobby Horse 10A* (1948, Moderna Museet, Stockholm). During these years Pollock

began to achieve celebrity. In 1949 *Life* magazine published a feature entitled 'Jackson Pollock: Is he the Greatest Living Painter in the United States?' The article pointed out that he was 'virtually unknown in 1944', but that 'Now his paintings hang in five US museums and 40 private collections'. The photographs of the artist at work and the film made in 1950 by Hans Namuth (1915–90) helped produce the public image of Action Painting.

The drip paintings were followed by a series of black paintings in oil and enamel paint on raw cotton duck. Although they are still strikingly gestural, they sometimes refer to the Surrealist-influenced figure imagery of the early work. Pollock commented that 'the non-objectivists will find them disturbing— and the kids who think anyone can splash a Pollock out'. The culmination of the series is *Portrait and a Dream* (1953, Dallas Museum of Art), a two-part picture in which a self-portrait in colour is confronted with a tangle of black lines suggestive of turbulent bodies. Pollock's personal life became increasingly difficult at this period and he again began drinking heavily. It has been suggested that the experience of 'performing' for the Namuth film, the shooting culminating in a ferocious row between the two men, was partially responsible. The final paintings of Pollock are generally less admired and he painted virtually nothing in the year before his death in an automobile accident at the age of 44. His death paralleled that of another doomed American hero of the period, the actor James Dean. Certainly he had some cause for despair. Lee Krasner had left for Europe and a forthcoming retrospective at the New York *Museum of Modern Art would have made public his creative impasse. Any attempt to romanticize the event should be cut short by consideration of the death of one of Pollock's passengers. Stephen Polcari points out that 'if he had lived he could have been convicted for manslaughter'.

Pollock's significance goes far beyond his public image as the 'bearded shock trooper of modern art', as *Time* magazine put it. As with other innovatory artists, his legacy could be understood by artists and critics in distinct, even contradictory ways. For Clement *Greenberg, his earliest important critical supporter, his material procedure was, above all, a means to achieve a certain kind of painting which took further the historical development whereby the flatness of the picture surface was acknowl-

edged. This quite logically led to the *Post-Painterly Abstraction of Morris *Louis and Kenneth *Noland. It is a view which has its attractions for anyone who considers the drip paintings of 1947–51 to be Pollock's greatest achievements or even has a certain squeamishness about the myth of the *artist maudit*. (Greenberg himself could be scathing about some of Pollock's later work.) Lost in the interlacing threads of paint which seem to create a completely new kind of pictorial space, it can be surprisingly easy for spectators to detach themselves from those famous photographs. The paintings do not need the 'invisible label' of 'self-destructive alcoholic artist'. Robert *Hughes, a critic with no automatic respect for mythical reputations, writes of 'an almost preternatural control over the total effect of those skeins and receding depths of paint... So one is obliged to speak of Pollock in terms of perfected visual taste, analogous to natural pitch in music—a far cry, indeed, from the familiar image of him as a violent expressionist'.

Nonetheless, alternative views are possible. There remains a residual figure imagery in some of the drip paintings and it is quite possible to see them as an extension of the forays into the unconscious of the earlier work or as a development of the muralist aspirations of the Siqueiros workshop. For many younger artists, Pollock's methods of working were not a secondary feature but the most significant aspect of his achievement. Robert *Morris viewed him essentially as a *process artist whose paintings revealed their means of construction. The art historian Rosalind *Krauss has argued for the significance of Pollock's having laid his canvases on the floor, so challenging painting's tradition of verticality.

Further Reading: R. Krauss, *The Optical Unconscious* (1993)

K. Varnedoe, *Jackson Pollock* (1991)

Pomeroy, Frederick William *See* NEW SCULPTURE.

Pomodoro, Arnaldo (1926–) Italian sculptor and designer, born at Morciano di Romagna. He studied architecture and stage design and served an apprenticeship in goldsmithery before taking up sculpture. In 1954 he settled in Milan and had his first exhibition there in 1955. His most characteristic works are large-scale bronzes, sometimes incorporating wheels, sprockets, and other machine

parts. Some of his works are constructed from parts that can be arranged at will by the spectator. In 1963 he was awarded the Sculpture Prize at the São Paulo Bienal and in 1964 he won the Prize for Italian Sculpture at the Venice *Biennale. There is a foundation dedicated to his work in Milan.

Pomodoro, Giò (1930–2002) Italian sculptor and designer, born at Orciano di Pesaro. He was self-taught as a sculptor and like his brother Arnaldo worked as a jeweller early in his career. He settled in Milan in 1953 and had his first exhibition in Florence in 1954. In 1959 he won the Sculpture Prize at the Paris *Biennale. His work was varied, but he was best known for abstract reliefs. In his *Surfaces in Tension* series (begun 1958) he used stretched fabric and tried to integrate the surface of the piece with the surrounding space. He was a member of *Continuità.

Pompidou Centre (Centre National d'Art et de Culture Georges Pompidou) Cultural centre in Paris named after Georges Pompidou (1911–74), who was President of France from 1967 to 1974. In 1969 he declared: 'I passionately wish that Paris could have a cultural centre that would be both a museum and a centre for creativity—a place where the plastic arts, music, cinema, literature, audiovisual research, etc. would find a common ground.' Pompidou believed that contemporary art could have a role in persuading French society to 'modernize'. Hence his personal preference for the technologically oriented *Kinetic artists (he covered over 18th-century woodcarving in the Élysée Palace with work by *Vasarely and *Agam) and the *Nouveaux Réalistes (who embraced consumerism) over the previous generation of *Lyrical Abstractionists, who might be seen as embodying more traditional French virtues of artisanship and good taste. The site chosen for this centre was the Plateau Beaubourg, a once lively area near the centre of Paris that had degenerated into a slum and become derelict between the two world wars (it has given the Pompidou Centre its colloquial name 'Beaubourg Centre', or simply 'Beaubourg'). The *Situationist Ralph Rumney described the destruction of the area as 'the grossest and most obscene mutilation... of Paris's secret private parts' (*Art Monthly*, February 1977). An international competition for the building produced 681 submissions, including bizarre

ideas such as a giant egg and an enormous hand extended towards the sky, each finger being intended to house a separate department. The winning design—chosen by an international jury—was submitted by an Italian and a British architect working in partnership: Renzo Piano and Richard Rogers (later Lord Rogers). Their huge building was constructed in 1971–7 (it was inaugurated in 1977 with a large exhibition of the work of Marcel *Duchamp) and it soon became one of the most famous sights of the city and one of the busiest art centres in the world. It is a leading example of High Tech architecture, with the building's service systems fully exposed on the exterior, brightly and systematically coloured—yellow for the electrical system, blue for the air-conditioning ducts, and so on. It has been described as looking like a 'crazy oil refinery', and as architecture it has attracted extremes of praise and censure. The large plaza in front of the building is conceived as part of the Centre and is the main forum for the city's street performers. Also outside the building is the ebullient Beaubourg Fountain (1983) by Jean *Tinguely and Niki de *Saint Phalle.

The Pompidou Centre, of which Pontus *Hulten was the first director, is divided into various departments, including a library, an industrial design centre, and an institute for the development and promotion of avant-garde music. The largest of the departments and the main reason for the Centre's popularity is the national collection of modern art—the Musée National d'Art Moderne—which was formerly housed in the Palais de Tokyo, adjacent to the *Musée d'Art Moderne de la Ville de Paris. It was opened there in 1947, but its origins are much older, for it is the heir to the Musée du Luxembourg, opened in 1818 as a showcase for the work of living artists. The Musée National d'Art Moderne has one of the world's greatest collections of modern art. The present collections and displays have overcome the extreme bias towards France and Paris which marked the Palais de Tokyo era, but there are now serious space problems in presenting the collection, which means that the holdings are far less publicly visible than those of *Tate. This is exacerbated by the policy, instituted from the time of the centre's opening, of including industrial design and architecture, which really demand a site of their own. A branch in Metz is due to open in 2009. Many items in the collection are currently on long-term deposit to other museums

in France. Among the permanent highlights is the studio of Constantin *Brancusi, which he left to the state and which has been reconstructed at the Centre.

pompier French term, invariably used with contempt, for highly conservative academic art. It derives from the resemblance of the helmets of the warriors in classical paintings to those of firemen ('pompiers'). It was doubtless this which inspired Yves *Klein, when working on his fire paintings, to have a 'pompier', complete with uniform and helmet, to douse the flames with his hose.

Pompon, François (1855–1933) French sculptor, born at Saulieu, near Dijon, the son of a carpenter. He studied briefly at the École des Beaux-Arts in Dijon, but his main training was as a stonemason, and after settling in Paris in 1894 he worked as an assistant for various sculptors (including *Rodin) for the next twenty years. Although he later had several commissions for public monuments, it was not until the last decade of his career that he achieved genuine recognition. This came with his *Polar Bear* (Pompidou Centre, Paris), which scored a great success at the 1922 *Salon d'Automne. It was so popular that it was reproduced in a variety of forms (small pottery versions sold in large numbers), and Pompon was belatedly hailed as the greatest animal sculptor since Antoine Barye (1796–1875). He was acclaimed not only for the excellence of his craftsmanship, but also for his skill in rendering the essential form of animals with great economy of means.

Ponç Joan (1927–84) Spanish painter and graphic artist, born in Barcelona, where he was a founding member of the *Dau al Set group in 1948. At this time his work was *Surrealist in flavour, featuring a world of fantastic landscapes inhabited by monsters. In the 1960s his style became more abstract, although still retaining vague Surrealist overtones. Apart from paintings, he produced a large body of graphic work, including etchings and lithographs. From 1955 to 1962 he lived in Brazil.

Poons, Larry (1937–) American abstract painter, born in Japan. Originally he studied music, but in 1958 he turned to painting and spent about six months at the Boston Museum School. In 1963, he had his first one-man exhibition, at the Green Gallery, New York, and

thereafter he exhibited frequently, both in solo shows and major collective exhibitions. One of these was 'The Responsive Eye' at the Museum of Modern Art, New York, in 1965, the exhibition that gave currency to the term '*Op art', and Poons's early works are usually classified under this heading. They were an attempt to transpose musical structures into abstract geometrical compositions. Typically they featured a background of pure, bright, flat colour, against which ovoid spots of strongly contrasting colour (green against an orange background, for example) were arranged in patterns that can seem random but are in fact controlled by underlying grids. The dots often seem to flicker or jump across the canvas. The lack of any points of emphasis in the compositions was reminiscent of the *all-over style initiated by Jackson *Pollock, and Poons shared with the *Abstract Expressionists a preference for very large canvases. By the end of the 1960s his work had become more painterly, the colour more austere and the dots extended to streaks. At the same time the paintings gained in depth and atmosphere, but Poons's interest remained primarily in the manipulation of colour. In the 1970s he broke completely with his earlier style, producing thickly textured, amorphous compositions with cracked and blistered surfaces (in some works he incorporated pieces of foam rubber soaked in paint).

Pop art Art which is based on images of mass consumer culture. It is principally associated with the USA and Britain in the 1960s. The term originated in the discussions of the *Independent Group c.1955. The originator of the phrase is disputed, but the British critic Lawrence Alloway later recalled 'sometime between the winter of 1954–5 and 1957 the phrase gained currency in conversation'; the first appearance in print recorded in the *Oxford English Dictionary* is of September 1957. Initially Alloway used the term (and also the expression 'Pop culture') to refer to 'the products of the mass media', rather than to 'works of art that draw upon popular culture', but by the early 1960s the phrase was being used as a label for such art. Comic books, advertisements, packaging, and images from television and the cinema were all part of the iconography of the movement.

In the USA Pop art was initially regarded as a reaction from *Abstract Expressionism because its exponents brought back figural im-

agery and made use of impersonal handling. It was seen as a descendant of *Dada (in fact Pop art is sometimes called *Neo-Dada) because it debunked the seriousness of the art world and embraced the use or reproduction of commonplace subjects (comic strips, soup tins, highway signs) in a manner that had affinities with *Duchamp's *ready-mades. The most immediate inspiration, however, was the work of Jasper *Johns and Robert *Rauschenberg, both of whom began to make an impact on the New York art scene in the mid-1950s. They opened a wide new range of subject-matter with John's paintings of flags, targets, and numbers, and his sculptures of objects such as beer cans, and Rauschenberg's *collages and combine paintings with Coca-Cola bottles, stuffed birds, and photographs from magazines and newspapers. While often using similar subject-matter, Pop artists generally favoured commercial techniques in preference to the painterly manner of Johns and Rauschenberg. Examples are Andy *Warhol's silkscreens of soup tins, heads of Marilyn Monroe, and so on, Roy *Lichtenstein's paintings in the manner of comic strips, Mel *Ramos's brash pin-ups, and James *Rosenquist's billboard-type pictures. Claes *Oldenburg, whose subjects include ice-cream cones and hamburgers, has been the major Pop art sculptor.

In Britain an interest in the 'popular', a folk art of barge painting, fair grounds, and tattooed ladies, was already present in high art circles, very much an aspect of the *Neo-Romantic love of 'British tradition' as celebrated in the *Festival of Britain. However, the Independent Group is commonly credited with nurturing the interest in American mass culture. The *Bunk* collages of Eduardo *Paolozzi and Richard *Hamilton's collage *Just What Is It that Makes Today's Homes so Different, so Appealing?* (1956, Kunsthalle, Tübingen) reflect its preoccupations. British Pop art first made a major impact at the *Young Contemporaries exhibition in 1961. The artists in this exhibition included Derek *Boshier, David *Hockney, Allen *Jones, R. B. *Kitaj, and Peter *Phillips, who had all been students at the *Royal College of Art. In 1962 the BBC screened Ken Russell's film *Pop Goes the Easel*, which featured Peter *Blake, Boshier, *Boty, and Peter Phillips. Other British exponents of Pop include the sculptor Clive Barker (1940–), whose works are sometimes chromium-plated, the painter Gerald Laing (1936–), best known for pictures of cars, and the painter, printmaker, and sculptor Colin

Self (1941–). Although Paolozzi and Hamilton had both been inspired primarily by American themes such as big automobiles and science fiction films, the younger British Pop artists also drew on more home-grown sources, sometimes as much nostalgic as contemporary. Blake looked to fairgrounds or the royal family; Hockney depicted the Ty-phoo tea packet and was drawn to Cliff Richard rather than Elvis Presley. David *Sylvester argued that that there was a further distinction in attitude because 'Coke culture' had not yet entirely taken over in Britain. He wrote of British Pop as 'a dream of far-off Californian glamour as sensitive and tender as the pre-Raphaelite dream of far-off medieval pageantry'.

Richard Hamilton defined Pop art as 'popular, transient, expendable, low-cost, mass-produced, young, witty, sexy, gimmicky, glamorous, and Big Business', and it was certainly a success on a material level, getting through to the public in a way that few modern movements have done and attracting big-money collectors such as the American taxi magnate Robert Scull (1917–86). However, it remained critically controversial throughout the 1960s. Lawrence Alloway and David Sylvester were both early supporters, but it was disparaged by many critics normally sympathetic to contemporary art, such as Herbert *Read or Harold *Rosenberg, who described Pop as being 'Like a joke without humour, told over and over again until it begins to sound like a threat . . . Advertising art which advertises itself as art that hates advertising.' The attack on it was two-pronged. On the one hand, its acceptance of consumerism seemed to challenge the *avant-garde ethos of the principled outsider. On the other, for a *formalist like Clement *Greenberg it ducked the serious challenges of *modernist art. More recently the art historian Thomas Crow has attacked the notion that it achieves a 'breakdown between popular and elite cultures' because it 'equates the commercial and the popular', that is to say it takes at face value the idea that mass culture achieves its popular status simply because 'it gives the public what it wants'. Whether Pop was a symptom or a critique of the culture it depicted remains a matter for debate.

Although mainly associated with Britain and the USA, Pop art has also had adherents elsewhere, including Valerio *Adami in Italy and *Erró, an Icelandic artist working in Paris. There are links with other movements, too, such as *Nouveau Réalisme in France. Also in France, the Narrative Figuration (Figuration narrative) painters such as Hervé *Télémaque, Gilles *Aillaud, and Jacques Monory (1934–) brought a Pop style to politically critical painting as an alternative both to abstraction and to *Socialist Realism. Some Pop artists have continued working with Pop imagery long after the movement's heyday, Allen *Jones in Britain being a leading example. In recent years critics have identified a Neo-Pop tendency in the work of artists such as Martin *Kippenberger, Jeff *Koons, and Takashi *Murakami. The distinguishing feature of such art is not just the imagery but also the acceptance of the notion of the artist as business person.

Further Reading: 'Pop after Pop: a Roundtable', *Artforum International* (October 2004)

M. Livingstone, *Pop Art: A Continuing History* (1990)

D. Sylvester, 'Art in a Coke Culture' in *About Modern Art* (1997)

Popova, Lyubov (1889–1924) Russian painter and designer, born near Moscow. She was one of the leading figures of Russian avant-garde art in its most exciting period, but she died tragically young of scarlet fever. After studying painting in Moscow, 1907–8, she travelled extensively (she came from a wealthy bourgeois family) and in 1912–13 worked in Paris, frequenting the studios of two *Cubist artists—*Le Fauconnier and *Metzinger. When the First World War broke out she returned from Italy to Moscow, where she worked with *Tatlin and contributed to major avant-garde exhibitions. From Cubism she developed to complete abstraction in a series of pictures she called *Painterly Architectonics* (1916–20). They owe something to both Tatlin and *Malevich, but have a distinctive voice, especially in her rich colouring. Camilla Gray (*The Great Experiment: Russian Art 1863–1922*, 1962) writes that 'after Tatlin and Malevich, Popova was the outstanding painter of the post-1914 abstract schools in Russia . . . [Her paintings] are often executed on a rough board, and the angular forms—in strong blues, greens and reds—are brushed in on this crude, raw surface, leaving the impression of lightning-swift movement, a darting, breathless meeting of forces, a kiss-imprint, as it were, of the driving energy around us.'

Popova also worked as a designer of costumes and sets for the stage and of textiles

('everyday clothes for women in which subtle geometric patterns were placed against a plain background', Anna Moszynska, *Abstract Art*, 1990). Her best-known stage designs are her *Constructivist sets for Vsevolod Meyerhold's production of Fernand Crommelynck's *The Magnanimous Cuckold* (1922) at the Actors' Theatre in Moscow.

popular prints A term used in the context of 20th-century culture to describe mass-produced and mass-marketed coloured reproductions that are generally bought as items of furnishing by people who otherwise demonstrate no interest in art. They generally reflect a conservative aesthetic and a view of the world in which, as Christine Lindey, one of the few art historians to have studied the subject seriously, puts it, 'fruits are unblemished, flowers never fade, and snow is never slushy...Landscapes are peaceful and unscarred, animals roam free, children never grow up and work is virtually non-existent'. This kind of print was pioneered by the American firm of Currier & Ives, which operated in New York from 1857 to 1907, and in the 20th century many specialist firms catered for the market: Frost & Reed and the Medici Society in Britain, for example, the New York Graphic Society in the USA, and Hanfstaengl in Germany. They were frequently marketed by mail order alongside household goods and would be more likely to be obtained from department stores than specialist art dealers. Nonetheless the 'anti-elitism' of the form should not be over-idealized. The popular erotica of Sir William Russell *Flint is made available in strictly controlled limited editions. Marcel *Duchamp in his assisted *ready-made *Pharmacy* (1914) pointed out that the fundamental feature of the phenomenon was the mass production of the appearance of spontaneity and individuality.

Many of the artists involved are not well known by name, although Maxfield *Parrish was famous in the USA for many years and Sir Gerald *Kelly was once prominent in the field, his picture of a Burmese girl entitled *Saw Ohn Nyun* achieving enormous sales. Another best seller was Rodrigues Clemente's *Red Skirt*, a depiction of a Flamenco dancer, which was a bestseller in the early 1960s, significantly just as holidays in Spain began to be popular and affordable. It hung on the living-room wall of the house of Jack and Vera Duckworth in the long-running British soap opera *Coronation Street*, perfectly defining both their taste and their generation. The other artists who have achieved large sales of popular prints include the British marine painter Montague Dawson (1890–1973), the so-called 'king of the clipper-ship school', and the Russian-born, South African-domiciled Vladimir *Tretchikoff, probably the most financially successful specialist in the market: *The Chinese Girl* (1952), the most famous of his exotic beauties, is said to have sold more than half a million copies in large format. More recently Jack *Vettriano has had enormous commercial success with works such as *The Singing Butler*, which project a world of retro glamour, although calendars and greetings cards are now as important a vehicle as the framed print. The name of Cassius Marcellus Coolidge (1844–1934) is less familiar, although there can be few who have never seen his images of dogs playing poker. Among 'serious' artists whose work has achieved success in popular print form are Salvador *Dalí (notably with *Christ of St John of the Cross*) and Andrew *Wyeth (notably with *Christina's World*). *Picasso (*Jacqueline with Flowers*, 1954) and *Buffet (although not his more critically acclaimed and gloomier early works) have also been popular with those who aspired to more 'contemporary' taste. In 1977 the exhibition 'Towards Another Picture', organized by Lynda Morris and Andrew Brighton for the Midland Group, Nottingham, attempted to present a picture of British art which brought together modernist artists such as *Hoyland and *Caro with artists popular in reproduction such as *Cuneo and *Shepherd. In spite of the interest this aroused at the time, a gulf usually remains between those contemporary artists most popular with the general public and those lionized by the modern museum, with only rare figures such as David *Hockney bridging the gap.

Further Reading: C. Lindey, *Art in the Cold War: From Vladivostok to Kalamazoo, 1945–1962* (1990)

P-Orridge, Genesis (1950–) British *Performance artist, rock musician, and editor, born Neil Andrew Megson in Manchester (he adopted his pseudonym in 1971). He gave his first performance in 1967 and in 1969 founded the group COUM Transmissions, which typically used sexual and violent imagery as a protest against industrial society. In 1975, as a means of reaching a wider audience, he founded the rock group Throbbing Gristle, which featured his

companion Cosey Fanni Tutti on guitar. Their recordings included 'Death Threats' (compiled from hostile messages left on their answering machine), 'Slug Bait', and 'Zyklon B Zombie', and they were denounced by *The Daily Mail* as 'wreckers of civilization'. In similar vein, COUM caused a scandal in 1976 with the exhibition 'Prostitution' at the *Institute of Contemporary Arts, London, 'consisting of documentation from Cosey's activities as a model for a pornographic magazine ... the press was outraged, accusing the *Arts Council (who partially sponsor the ICA) of wasting public money. Subsequently COUM were unofficially banned from exhibiting in galleries in England' (RoseLee Goldberg, *Performance Art*, 1988). Showing a different side to his talents, P-Orridge was co-editor of *Contemporary Artists* (1977), a vast compendium of information 'on 1350 artists of international reputation [P-Orridge included], selected by an international advisory board'.

Portinari, Candido (1903–62) Brazilian painter of Italian descent. He was born at Brodósqui and studied at the National School of Fine Arts, Rio de Janeiro, 1918–21. In 1928 he was awarded a scholarship that took him to Europe for three years, 1928–31. Portinari is best known for his portrayals of Brazilian workers and peasants, but he dissociated himself from the revolutionary fervour of his Mexican contemporaries, and painted in a style that shows affinities with *Picasso's '*Neoclassical' works of the 1920s (which he saw in Paris during his scholarship years). In the 1940s his work acquired greater pathos and he also turned to biblical subjects, notably with a ceramic tile design on the life of St Francis of Assisi (1944) for the façade of the church of San Francisco at Pampulha, a suburb of Belo Horizonte. He gained an international reputation and his major commissions included murals for the Hispanic section of the Library of Congress in Washington (1942) and for the United Nations Building in New York (two panels representing *War* and *Peace*, 1953–5).

Posada, José Guadalupe (1852–1913) Mexican graphic artist. His enormous output was largely devoted to political and social issues, attacking, for example, President Porfirio Díaz, and revealing the dreadful conditions in which the poor lived. From 1890 he made his studio in Mexico City an open shop fronting the street, and turned out sensational broadsheets and cheap cartoons that spread among the illiterate throughout the country. His work had the vigour and spontaneity of genuinely popular art, with the inborn Mexican taste for the more gruesome aspects of death—one of his recurring motifs is the *calavera* or animated skeleton. He made a lasting impression on both *Orozco and *Rivera during their student days.

Post-avant-garde *See* AVANT-GARDE.

Post-feminism *See* FEMINIST ART.

Post-Impressionism Term applied to various trends in painting, particularly in France, that developed from *Impressionism or in reaction against it in the period *c.*1880–*c.*1905. Roger *Fry coined the term in 1910 as the title of an exhibition, 'Manet and the Post-Impressionists', which he organized at the Grafton Galleries, London. The exhibition was dominated by the work of *Cézanne, *Gauguin, and van Gogh, who are considered the central figures of Post-Impressionism. These three artists varied greatly in their response to Impressionism: Cézanne, who wished 'to make of Impressionism something solid and enduring, like the art of the museums', was preoccupied with pictorial structure; Gauguin renounced 'the abominable error of naturalism' to explore the symbolic use of colour and line; and van Gogh's uninhibited emotional intensity was the fountainhead of *Expressionism. Georges Seurat, a figure of almost equal importance, concentrated on a more scientific analysis of colour (*see* NEO-IMPRESSIONISM). The general drift of Post-Impressionism was away from the naturalism of Impressionism towards the series of avant-garde movements (such as *Fauvism and *Cubism) that revolutionized European art in the decade leading up to the First World War.

Fry organized his first Post-Impressionist exhibition at short notice (to fill a gap in the gallery's programme) and in an almost casual atmosphere, but he brought together a highly impressive (if far from balanced) collection of pictures, mainly loaned by leading French dealers, including *Bernheim-Jeune and *Durand-Ruel. He was assisted by Clive *Bell and by the literary critic Desmond MacCarthy, who acted as secretary. There were more than 200 exhibits, Cézanne, Gauguin, and van Gogh being represented by more than twenty pictures each. It was the first time they had been seen in such

strength in Britain and the exhibition created what *The Daily Mail* called 'an altogether unprecedented artistic sensation' or what *Sickert more succinctly described as a 'rumpus'. The extensive press coverage included some vicious attacks: Robert Ross, critic of *The Morning Post*, wrote that 'If the movement is spreading, it should be treated like the rat plague in Suffolk'. Some visitors were angry (Duncan *Grant recalled people shaking their umbrellas at the pictures) and others mocked (Desmond MacCarthy wrote of 'a stout elderly man...who went into such convulsions of laughter on catching sight of Cézanne's portrait of his wife...that his companion had to take him out and walk him up and down in the fresh air'). The conservative opinion was that the pictures on show were childish, crude, and the product of moral degeneracy or mental derangement. However, there was also a positive response. Duncan Grant said that he and Vanessa *Bell were 'wildly enthusiastic' about the exhibition, and it powerfully affected the work of several of the painters in Sickert's circle (*see* CAMDEN TOWN GROUP), in general encouraging the use of strong, flat colours. Sickert himself was on the whole rather blasé about it (he admired Gauguin and admitted—or pretended—to embarrassment that he had once advised him to stick to stockbroking, but he thought Cézanne overrated, lacking 'a sense of aplomb', and he disliked van Gogh's way of applying paint, although he said this was 'a mere personal preference').

Fry organized a second Post-Impressionist exhibition in 1912, at the Grafton Galleries This was more wide-ranging, coherent, and up-to-date than the first (it included several *Cubist works), with a British section chosen by Clive Bell and a Russian section organized by Boris *Anrep. It too caused a great deal of controversy, but did not have quite the same impact as the first.

The term has remained in use, although many art historians prefer to avoid it, as it does not designate any consistent style or theory. In 1979 the *Royal Academy of Arts held an ambitious exhibition which extended the term to cover not only what came after Impressionism, including memorable representations of painting from Great Britain and Italy, but also aspects of Impressionism in the 1880s, such as work by *Monet and *Renoir. The event was very popular with the public but severely criticized by some art historians. It was argued that the use of such a blanket term to cover a wide range of different

practices presented a simplistic view of history. Fred Orton and Griselda *Pollock described it as 'a signifier in the camouflaging rhetoric of *Modernist art history'.

Further Reading: A. Bowness et al., *Post-Impressionism* (1979)

I. Dunlop, *The Shock of the New* (1972)

R. Fry, *Vision and Design* (1957)

F. Orton and G. Pollock, 'Les Données Bretonnantes: La Prairie de la Représentation', in F. Frascina and C. Harrison (eds.), *Modern Art and Modernism: A Critical Anthology* (1982)

Post-Minimalism A term coined in 1971 by the American critic Robert Pincus-Witten (1935–) to refer to developments in American art that succeeded *Minimal art (which had been the dominant avant-garde trend of the 1960s); Pincus-Witten first used it in print in an article entitled 'Eva *Hesse: Post-Minimalism into Sublime' in the November 1971 issue of *Artforum*. It generally implies a reaction against the values of Minimalism, but sometimes it is used more neutrally, with the term 'Anti-Minimalism' being used to suggest a more deliberate antipathy.

Pincus-Witten also coined the word 'Maximalism' as a 'shock value journalistic term' to characterize various forms of art that were fashionable in the early 1980s, notably *Neo-Expressionism. It has also been used loosely as a synonym for *Postmodernism. Pincus-Witten published *Post-Minimalism: Essays 1966–76* in 1977 and *Post-Minimalism into Maximalism: American Art 1966–86* in 1987.

Postmodernism A term that has been used in a broad and diffuse way, with reference to a wide range of cultural phenomena to characterize a move away—beginning about 1960—from the seriousness of *modernism in favour of a more electic and populist approach to creativity. The word came into common use towards the end of the 1970s and featured prominently in discussions of contemporary art, on both an academic and a journalistic level, during the 1980s and 1990s. It has been employed both as a stylistic term (one can speak of Postmodern paintings or films) and as a period designation (the Postmodern age), but there has been much disagreement about how it should be used and even about whether it is worth using at all (as modernism is in itself a difficult and multi-faceted concept, it is hard to be clear about the ways in which *Post*modernism can be regarded as a development from it, and some writers even choose to

refer to Postmodernism*s*). Chris Baldick in the *Concise Oxford Dictionary of Literary Terms* (1990) describes it as 'a cultural condition prevailing in the advanced capitalist societies since the 1960s, characterized by a superabundance of disconnected images and styles—most noticeably in television, advertising, commercial design, and pop video' and 'a culture of fragmentary sensations, eclectic nostalgia, disposable simulacra [*see* BAUDRILLARD], and promiscuous superficiality, in which the traditionally valued qualities of depth, coherence, meaning, originality, and authenticity are evacuated or dissolved amid the random swirl of empty signals'.

The term was evidently first used by the Spanish literary critic Federico de Onís in his *Antología de la poesía española e hispanoamericana, 1882–1932* (1934) and soon afterwards by the British historian Arnold Toynbee in his multi-volume work *A Study of History* (the part in which it appears was written in 1938 but not published until 1947). Toynbee used the word in a largely negative sense. He thought the Postmodern age began about 1875 and was characterized by the decline in Christianity, capitalism, individualism, and the influence of the West. After Toynbee, the word appeared sporadically for the next two decades, mainly in literary contexts, and it was introduced to serious discussion of the visual arts by Nikolaus Pevsner (1902–83) during the 1960s. Pevsner used it in connection with architecture, and the writer chiefly responsible for popularizing it in English is the Anglo-American architectural historian Charles Jencks (1939–), the author of *What is Post-Modernism?* (1986) and other books on the subject. Jencks used the term to describe a reaction against the austere, rational, clean-cut International Modern Style (*see* MODERN MOVEMENT) in favour of brash eclecticism, 'fundamentally the eclectic mixture of any tradition with that of its immediate past: it is both the continuation of Modernism and its transcendence', and it is in this sense that Postmodernism as a style has its clearest meaning. Postmodern architects returned to regional and traditional sources, introducing colour and ornament, often in a 'jokey' manner. One of the best known among them, the American Robert Venturi (1925–), wrote that he liked 'elements which are hybrid rather than pure' and preferred 'messy vitality' to 'obvious unity'.

Outside architecture it is usually less easy to categorize works as Postmodernist, but the word has often been applied to paintings and sculpture that similarly blend disparate styles and make knowing cultural references, often in an ironic way. *Pop art, for example, has been retrospectively labelled Postmodernist, and there is indeed a kinship in the way it emphasized style and surface and blurred the distinction between high art and popular culture. Other works described as Postmodernist include the classically inspired works of the British artist Stephen *McKenna and of the Italian Carlo Maria *Mariani, as well as Peter *Blake's *The Meeting or Have a Nice Day Mr Hockney* (1981–3, Tate), a playful reworking of a picture by the 19th-century French painter Gustave Courbet, showing Blake, David *Hockney, and Howard *Hodgkin as the main protagonists. In other fields, works that have been labelled Postmodernist range from pop songs by Madonna to novels by Salman Rushdie to films such as Jean-Jacques Beineix's *Diva* (1981), which uses elements of plot, setting, and character from several different cinematic genres.

The Marxist literary critic Frederic Jameson (1934–) makes the distinction between 'parody' and 'pastiche', the latter being characteristic of the Postmodern. In the parody there is an original which is referred to and which the audience is expected to recognize, as in the Blake painting already referred to. The 'pastiche' simply produces a general sense of nostalgia for some past style. The Rococo references in the paintings of David *Salle or Sigmar *Polke, or the photographs of Cindy *Sherman, which recall the films of Alfred Hitchcock or Antonioni in an unspecific manner, might be pastiche. The distinction is a useful one, but whether 'pastiche' in this sense is a particular characteristic of a Postmodern era is more problematic. It is arguably just the product of a certain self-consciousness of art history, also found in *Renoir's suggestions of 18th-century France recreated in the contemporary world or Poussin's recreation of the antique. More broadly, some critics such as Baudrillard believe that Postmodernism pervades the whole of contemporary Western society: they argue that in a world dominated by technology and the mass media, culture inevitably becomes superficial and self-referential. These definitions can all be related to the arguments of the French philosopher Jean-François Lyotard (1923–98), who, in works such as *The Postmodern Condition: A Report on Knowledge* (1979) contended

that the 'grand narratives' of history such as those provided by Marxism had become fragmented. It was an easy step to apply this idea to the grand one-dimensional narratives of modernist art provided by such critics as Clement *Greenberg and either celebrate or deplore the consequent pluralism. By the turn of the millennium the term had become less prevalent, but a distinction is frequently made between *modern and *contemporary art, the line of demarcation usually being around 1970, suggesting a similar time frame to the emergence of Postmodernism.

Post-Object art *See* CONCEPTUAL ART.

Post-Painterly Abstraction A term coined by the critic Clement *Greenberg to characterize a broad trend in American painting, beginning in the 1950s, in which abstract painters reacted in various ways against the *gestural 'painterly' qualities of *Abstract Expressionism. Greenberg used the term as the title of an exhibition he organized at the Los Angeles County Museum of Art in 1964. He took the word 'painterly' (in German 'malerisch') from the Swiss art historian Heinrich Wölfflin (1864–1945), who had discussed it in his book *Kunstgeschichtliche Grundbegriffe* (1915), translated as *Principles of Art History* (1932). By it Greenberg understood 'the blurred, broken, loose definition of color and contour': Post-Painterly Abstractionists, in contrast, moved 'towards' physical openness of design, or towards linear clarity, or towards both'. The characterization was never a very exact one, but essentially it described a rejection of expressive brushwork in favour of broad areas of unmodulated colour. The term thus embraces more precisely defined types of abstract art including *Colour Field Painting and *Hard-Edge Painting. Among the leading figures of the trend are Helen *Frankenthaler, Al *Held, Ellsworth *Kelly, Morris *Louis, Kenneth *Noland, Jules *Olitski, and Frank *Stella.

Pougny, Jean (Ivan Puni) (1892–1956) Russian–French painter of Italian descent. He was born in Kuokkala (later renamed Repino after Ilya *Repin), near St Petersburg, and studied in Paris (at the *Académie Julian and elsewhere), 1910–12. After returning to St Petersburg he became a member of avant-garde circles that included *Larionov, *Malevich, and *Tatlin. Pougny came from a well-off family, and his wife, the painter Kseniya Boguslavskaya (1892–1972), was an heiress; their

wealth enabled them to finance avant-garde activities, including two major *Futurist exhibitions in St Petersburg (at this time known as Petrograd): 'Tramway V: The First Futurist Exhibition of Paintings' (1915) and '0.10: The Last Futurist Exhibition of Paintings' (1915–16). The second exhibition was originally intended to be called '0–10' (Zero-to-Ten) rather than 0.10 (Zero-point-Ten), but the latter form came about through a printing error in the catalogues and posters. The exhibition showed for the first time the *Suprematist paintings of *Malevich and the corner-reliefs of *Tatlin, so marking a radical new development in Russian avant-garde art. 'The name of the exhibition referred to a new beginning…as Malevich wrote…in May 1915, "we intend to reduce everything to zero…[and] will then go beyond zero." It was to be the last Futurist exhibition, the end of Western European domination of the Russian avant-garde, and the beginning of a new age' (Altshuler, *The Avant-Garde in Exhibition*, 1994). At the time of these exhibitions Pougny himself was producing work in both *Cubist and Suprematist veins. After the Revolution, he was given a teaching position at the reorganized Academy of the Fine Arts in Petrograd, but in 1919 he left Russia. He went first to Finland and then Berlin, where he exhibited at the *Sturm Gallery and with the *Novembergruppe. In 1923 he settled in Paris, where he abandoned his abstract and Cubist styles and painted mainly still-lifes and interiors in a late *Impressionist manner, not unlike that of *Vuillard. He became a French citizen in 1946.

Pound, Ezra (1885–1972) American writer, active in Europe for most of his career. He is principally famous as a poet, but he also wrote criticism and was an aggressive and controversial promoter of modern ideas in the visual arts as well as in literature. Pound was born in Hailey, Idaho, and studied Romance languages at the University of Pennsylvania and Hamilton College, Ithaca, New York. After teaching briefly at Wabash Presbyterian College, he settled in Europe in 1908, living mainly in London until 1920. His British friends included Wyndham *Lewis, and it was Pound who coined the name *Vorticism for the movement that Lewis launched in 1914. Pound contributed to the Vorticist magazine *Blast*, and wrote elsewhere about the work of several of the artists connected with the movement (for example, he contributed the

'Prefatory Note' to *Gaudier-Brzeska's memorial exhibition at the *Leicester Galleries in 1918). He also persuaded the American collector John *Quinn to buy Vorticist works. From 1920 to 1924 Pound lived in Paris, where he was involved in the *Dada movement, then settled at Rapallo in Italy until 1945. He became a supporter of Fascism and developed bizarre economic theories that led him into anti-Semitic ideas about an international conspiracy of Jewish bankers. During the Second World War he made many broadcasts on Rome Radio attacking the US Government and the American war effort. He was arrested in 1945 and returned to America to face charges of treason, but he was pronounced 'insane and mentally unfit for trial' and was committed to a hospital for the criminally insane in Washington. There he regularly received visitors and kept up a voluminous output of writing. In 1958 he was released and allowed to return to Italy, where he spent the rest of his life. The events of his later years clouded Pound's reputation, but he is nevertheless regarded as holding a central position in modern literature.

Further Reading: Tate Gallery, *Pound's Artists: Ezra Pound and the Visual Arts in London, Paris and Italy* (1985)

Pousette-Dart, Richard (1916–92) American abstract painter, born at St Paul, Minnesota. He was mainly self-taught as an artist, although he learned much from his father, **Nathaniel Pousette-Dart** (1886–1965), a painter and writer. In 1936 he settled in New York. Initially he worked as a secretary and bookkeeper by day and painted by night, but by 1940 he had become a full-time artist. His work at this time was vaguely *Surrealist, with forms resembling primitive hieroglyphs painted in a heavy impasto. Over the next decade his rough textures gradually dissolved any suggestion of identifiable forms into an *all-over style of rich, jewel-like colours and he became recognized as part of the *Abstract Expressionist movement. However, his work retained a lyrical character of its own and David Anfam (*Abstract Expressionism*, 1990) describes him as 'a rather neglected figure, perhaps because of a religious mysticism which separated him from the mainstream'. Apart from painting, Pousette-Dart also experimented with various other media, including collage, photography, and sculpture (in metal and wire).

Poynter, Sir Edward (1836–1919) British painter and administrator, son of the architect Ambrose Poynter. He made his reputation with the huge *Israel in Egypt* (1867, Guildhall, London) and he became one of the most popular painters of the day with similar elaborate historical tableaux in which he displayed his great prowess as a draughtsman. In the latter part of his career, however, he confined himself to smaller works, devoting his time mainly to administration. He was first *Slade professor of fine art at University College London, 1871–5; director for art at the South Kensington Museum (now Victoria and Albert Museum) and principal of the National Art Training School (now the *Royal College of Art), 1875–81; director of the National Gallery, 1894–1904; and president of the *Royal Academy, 1896–1918. At the Slade he established an emphasis on draughtsmanship that was to become characteristic of the school and at South Kensington he revived a stagnant curriculum (by virtue of this office he was also supervisor of the chief provincial art schools, and in these too he raised standards). However, he was hostile towards recent developments in art, castigating the 'clique of self-styled "Impressionists" and their apologists in the Press' for 'their incompetency in drawing and slovenliness in execution' (preface to the fourth edition of his *Lectures on Art*, 1897). In his role as director of the National Gallery, Poynter was responsible for the arrangement and opening of the *Tate Gallery in 1897.

Praesens *See* BLOK.

Prampolini, Enrico (1894–1956) Italian painter, sculptor, and designer, born in Modena. He joined the *Futurist movement in 1912 and in 1914 began making *mixed media, 'polymaterial' compositions (*arte polimaterica*) built up from a variety of materials—cork, sponges, tin foil, and so on. During the First World War he went through a *Dadaist phase, but then returned to Futurism (in 1929 he was one of the signatories of *Marinetti's manifesto of the offshoot movement *Aeropittura). From 1925 to 1927 he lived in Paris. With *Magnelli he was one of the leading pioneers of *abstract art in Italy and he participated regularly in international exhibitions. Apart from painting and sculpture, his work included a good deal of theatrical design.

Prassinos, Mario (1916–85) Greek-French painter, designer, and graphic artist, born in Constantinople. He moved to Paris in 1922, studied languages at the Sorbonne, 1932–6, and acquired French nationality in 1940. In 1937 he began exhibiting *Surrealist paintings, but after the Second World War he turned to expressive abstraction in the *Tachiste manner. Much of his work was concerned with the image of his grandfather Pretextat; Prassinos explained the obsession in his book *Les Pretextats* (1973). His work also included illustrations for several books and designs for the theatre and ballet.

praticiens See DIRECT CARVING.

Precisionism A movement in American painting, originating *c.*1915 and flourishing in the interwar period, particularly the 1920s, in which urban and especially industrial subjects were depicted with a very smooth and precise technique, creating clear, sharply defined, sometimes quasi-*Cubist forms. The terms 'Cubist-Realists', 'Immaculates', and 'Sterilists' have also been applied to Precisionist painters. There was no formal group, but some of the artists involved in the movement exhibited together. *Demuth, *O'Keeffe, and *Sheeler were the best-known figures; others included George Ault (1891–1948), Ralston Crawford (1906–78), and Niles Spencer (1893–1952). In Precisionist painting the light is often brilliantly clear (although Ault is best known for his night scenes), and frequently forms are chosen for their geometric interest. There is no social comment—indeed there are usually no human figures in the paintings. Rather, the American industrial and technological scene is endowed with an air of epic grandeur. The degree of Cubist influence varied greatly. Some of Sheeler's paintings are in an almost photographically realistic style, whereas Dickinson's works are sometimes semi-abstract. Precisionism was influential in both imagery and technique on American *Magic Realism and later on *Pop art.

Preece, Patricia See SPENCER, SIR STANLEY.

Prem, Heimrad See SPUR.

Prendergast, Maurice (1858–1924) Canadian-born American painter and printmaker. He was a member of The *Eight (1), but stood somewhat apart from the rest of the group. Boston was his home for most of his life and he spent much of his career travelling and painting abroad (he studied at the *Académie Julian, Paris, in the early 1890s); it was only in 1914 that he moved to New York, the centre of The Eight's activities. The main thing he had in common with other members was a desire to revive American art from academic stagnation, and his work is remarkable for its brilliant decorative colour. His paintings were often of people enjoying themselves in innocent pleasures (*Central Park in 1903*, 1903, Metropolitan Museum, New York). He was one of the first American artists to be influenced by advanced French painting, notably in the way in which he emphasized flat pattern rather than illusionistic space. His love of colour and decorative effects was instinctive, however, rather than based on theoretical considerations. In 1913 he showed seven works in the *Armory Show and at this time he stood out as one of the most stylistically advanced American artists. Collectors of his work included Albert C. *Barnes, Lillie P. *Bliss, and John *Quinn. Most of his paintings were in watercolour, but in later years he turned increasingly to oils. He also made about 200 monotypes (mainly between 1891 and 1902), an unusually large œuvre in this medium. There is an outstanding collection of them in the Terra Foundation for American Art, Chicago.

Pre-Raphaelitism A term originally applied to the work of a group of young, idealistic British artists founded in 1848, and subsequently used to describe a dreamy, romantic, pseudo-medieval style of painting that was highly popular in Britain in the late 19th century and lingered well into the 20th. The link between the two types of Pre-Raphaelitism was the painter-poet Dante Gabriel Rossetti (1828–82): he was a member of the original group, which favoured morally uplifting themes treated in a devoutly detailed style, but he subsequently changed his approach and specialized in pictures of langourous *femmes fatales*. His smouldering temptresses, together with the more pallid and ethereal beauties of Sir Edward Burne-Jones (1833–98), were immensely influential at the turn of the century, when they were part of the taste for *Symbolism. The painters who continued the Pre-Raphaelite tradition in the 20th century include Maxwell *Armfield, Robert Anning *Bell, Evelyn *De Morgan, Sidney Harold

Meteyard (1868–1947), John Byam *Shaw, and John Melhuish Strudwick (1849–1937). After the First World War, work in this style was increasingly considered old-fashioned, and the reputations of the original Pre-Raphaelites slumped. The writings of William Gaunt and Robin *Ironside, whose book *Pre-Raphaelite Painters* was published in 1948 to mark the centenary of the founding of the Brotherhood, ensured that the subject was not entirely forgotten, but it was not until the late 1960s that there was a major revival of interest in Pre-Raphaelitism.

Preston, Margaret (1875–1963) Australian painter, printmaker, writer, and lecturer, born in Adelaide and active mainly in Sydney. She had a thorough training, beginning at the Adelaide School of Design and progressing via Melbourne to Munich and Paris. After briefly returning to Australia, she had a second, longer stay in Europe, from 1910 to 1920, during which she lived in Paris and London and moved from an academic style to a more modern idiom influenced by *Fauvism. In the 1920s her work was characterized by 'strong, simple and blocky shapes, first only in oils, later in woodcut, lino-cut, masonite-cut, silk-screen, and monotype—and indeed almost anything else that could be cut and printed' (Smith). A good example is *Implement Blue* (1927, Art Gallery of New South Wales, Sydney), a powerful still-life showing a collection of crockery and other tableware casting dense blue shadows. By the time she painted this picture she was recognized as one of the leading artists in the country; the journal *Art in Australia* devoted a special issue to her in 1927. Her characteristic subjects included bush landscapes and flower paintings of native flora, and she was passionately devoted to the idea of creating a distinctive national art, promoting this through writing and lecturing as well as painting. She was one of the first to appreciate Aboriginal art, her article 'The Indigenous Art of Australia', published in *Art in Australia* in March 1925, being a pioneering work in the field. Much of her own work from the 1940s onwards shows the influence of such art, particularly in her adoption of earthy colours.

Primary Structures Name given to a type of sculpture that came to prominence in the mid-1960s, characterized by a preference for extremely simple geometrical shapes and frequently a use of industrially fabricated elements. The term was popularized by an exhibition entitled 'Primary Structures' at the Jewish Museum, New York, in 1966, organized by the museum's curator of painting and sculpture, Kynaston McShine (1935–). Among the artists who worked in this vein were Carl *Andre, Dan *Flavin, Donald *Judd, Sol *LeWitt, Robert *Morris, and Tony *Smith. Primary Structures comes within the scope of *Minimal art and the two terms have sometimes been used synonymously.

primitivism A term employed in the context of 20th-century art to refer to the use by Western artists of forms or imagery derived from the art of cultures conventionally considered 'primitive' or 'under-developed', such as those of sub-Saharan Africa or Oceania.

The word 'primitive' suggests a lack of sophistication relative to some particular standard. It was once widely used, for example, of pre-Renaissance European painting, especially of the Italian and Netherlandish schools (as in the expression 'the Flemish primitives'); the Renaissance had established the idea of painting as illusionism that dominated Western art for centuries, so paintings from earlier periods were long found wanting in the illusionistic skills that had become accepted as the norm. The term 'primitive art' is now rarely used, as it is considered derogatory and patronizing. An art historian of an older generation, Robert *Goldwater, wrote in 1955: 'We all know by now that primitive art is not primitive in any esthetic sense, since we rank its finest achievements with those of the highest of high cultures; nor in any technical sense, since it includes powerful stone carvings and bronze and gold work of great delicacy; and it is often not primitive in any cultural sense, since the societies from which it emerges vary from the simple structures of the interior of New Guinea or the south-western Congo to the complicated feudal organizations of Benin and the civilizations of Central America.'

For centuries, such art was known in the West mainly as colonial booty, and it attracted interest either for its curiosity value or (if made of precious materials) for its monetary worth (in 1520 Albrecht Dürer enthused about Aztec treasures sent to the Emperor Charles V from 'the new land of gold'). Although the idea of the 'noble savage' untainted by European civilization had a vogue in the 18th century, it was not until the 1890s that primitivism made a

significant impact on Western art—in the work of *Gauguin, who tried to escape 'the disease of civilization' among the natives of Tahiti. From about 1905 many other avant-garde artists followed his example in cultivating 'primitive' art as a source of inspiration, finding in it a vitality and sincerity that they thought had been polished out of Western art. Usually they followed Gauguin in spirit rather than body, although *Nolde and *Pechstein, for example, visited Oceania. Many artists in Paris collected African masks (which could be bought very cheaply in curio shops), among them *Derain, *Matisse, *Picasso, and *Vlaminck, and their influence is particularly clear in Picasso's *Les Demoiselles d'Avignon* (1906–7, MoMA, New York), the painting that is often regarded as the originating work of *Cubism. More generally, the simplification and exaggeration of forms seen in much primitive art were influential on the anti-naturalistic trend of avant-garde art in the period of unprecedented experimentation in the decade before the First World War.

Western artists saw examples of 'primitive' art not only in their own and other artists' studios, but also in various public collections. Picasso, for example, visited the Musée d'Ethnographie in Paris, the members of Die *Brücke frequented the Museum für Völkerkunde in Dresden, and Henry *Moore was impressed by the powerful block-like forms of Maya sculpture he saw in the British Museum in London. Moore later said 'I began to find my own direction, and one thing that helped, I think, was the fact that Mexican sculpture had more excitement for me than negro sculpture. As most of the other sculptors had been moved by negro sculpture, this gave me a feeling that I was striking out on my own.' In spite of their enthusiasm for such art, few Western artists in the first half of the 20th century had much knowledge of the cultural background of the primitive objects they admired; in line with *formalist aesthetics, they believed that visual devices could be transposed from one culture to another without loss of power or meaning. Patrick *Heron expressed such an outlook in 1955 when he wrote: 'The palpable forms, the actual rhythms, the precise manipulations of space —these are the prime realities, the determining factors, the definite features which cause an art to be great or trivial. Even the horror of a stone bowl made for containing twitching human remains, fresh-torn from sacrificial victims, is in a curious way neutralized if the

thing is "beautiful": that is, if it transmits a vital rhythm.' (Heron was referring to a Maya 'Chacmool' figure, holding an offering bowl, that had inspired Henry Moore.) After 1945 the positive value in escaping from 'civilized' aesthetics was promoted by Jean *Dubuffet and the *Cobra group, but in their case the sources were more the 'primitive' in Western societies, the art of children, outsiders, and the mad, than the non-Western art which had inspired an earlier generation.

Australian aboriginal art has tended to be excluded from broad discussions of primitivism because it was not until after this key period that it became the subject of serious interest: 'Despite being one of the longest continuous traditions of art in the world, dating back at least fifty millennia, it remained relatively unknown until the second half of the twentieth century' (Wally Caruana, *Aboriginal Art*, 1993). Margaret *Preston, in the 1920s, was one of the first to consider Aboriginal art as *art*, rather than ethnographic material, and she was one of the first non-Aboriginals to be influenced by it in her own work.

Visual 'appropriation' of other cultures has sometimes been interpreted as a kind of exploitation, akin to the exploitation of native labour or resources by colonial powers and this has in its turn made it a contentious topic for art historians, as was exemplified by the wave of hostile criticism aimed at William Rubin's 'Primitivism in Modern Art' exhibition held at the New York *Museum of Modern Art in 1984. As Graham Birtwhistle put it, 'within a few years a new generation of academics and critics had loaded the term with colonialist and racist implications from a guilty past'. However, there is evidence that certain modern artists approached primitive art in a spirit that was far from cynical or opportunist. For example, the American art historian Patricia Leighten has argued that there was a close link between Picasso's use of African masks as source material and contemporary anarchist protests against imperialism ('The White Peril and *l'art nègre*: Picasso, Primitivism, and Anticolonialism', *Art Bulletin*, vol lxxii (1990), pp 609–30). Similarly, in 1931, the Paris *Surrealists used tribal art in their exhibition 'The Truth about the Colonies', which was a protest against a recently opened official exhibition celebrating the French colonies. An influential and controversial attempt at an alternative perspective from inside the museum was the

exhibition entitled 'Les Magiciens de la Terre' at the Pompidou Centre in 1989, which aimed to display the world's contemporary art on an equal footing regardless of origin. *See also* NEO-PRIMITIVISM.

Further Reading: G. Birtwhistle, 'Behind the Primitivism of Cobra', in P. Shields, *Cobra* (2003)

R. Goldwater, *Primitivism in Modern Art* (1986)

C. Green, *Art in Paris 1900–1940* (2000). See especially Chapter 11, 'Primitivising the Modern'.

Prince, Richard (1949–) American artist, born in Panama. His practice has been associated with *appropriation. He came to attention in the early 1980s with photographs blown up from sections of advertisements. They would isolate features such as the cowboy whose image advertised a well-known brand of cigarettes. They matched perfectly the *Postmodern view, current in art theory at that time, of the impossibility of originality. Prince's subsequent work has shown a preoccupation with the yearnings and dissatisfactions which underwrite contemporary culture. A series of paintings are based on vulgar cartoons which tend to express the bitterness of the modern American male. Captions and pictures can be interchangeable. A man is seen coming home to find his wife on the knee of another man. It is labelled 'I remember practicing [*sic*] the violin in front of a roaring fire. My old man walked in. He was furious. We didn't have a fireplace.' Another series of paintings is derived from the covers of popular novelettes about nurses. Prince has been highly influential on younger artists. He commented to an interviewer: 'It would be strange for me to think I'm being ripped off, because that's what I do!'

(⊕) SEE WEB LINKS

• Karen Rosenberg, 'Q & A with Appropriation Artist Richard Prince' (25 April 2005), on the New York Magazine website.

Print Renaissance (Print Revival) Term sometimes used to describe an upsurge of interest in printmaking among American artists from the late 1950s. It was characterized by the opening of several workshops specializing in the creation of high-quality artists' prints, the first of which (producing lithographs) was Universal Limited Art Editions (ULAE) at West Islip on Long Island, New York, set up in 1957 by the Russian-born Tatyana Grosman (1904–82). Her friends

Fritz *Glarner and Larry *Rivers were among the first to work there; they were followed by Jasper *Johns (1960), Robert *Rauschenberg (1962), and other well-known artists. In 1960 the most famous establishment of the Print Renaissance—the Tamarind Lithography Workshop—was established in Los Angeles (it is named after a street there) by June Wayne (1918–), a painter, printmaker, designer, and writer. She had received a grant from the Ford Foundation to set up a workshop that would be organized on an apprenticeship system, through which experienced lithographers would work with students who would in turn, it was hoped, become master lithographers. In addition, practising artists were given two-month fellowships to work there. The Workshop flourished in Los Angeles until 1970 and then was transferred to the University of New Mexico in Albuquerque as the Tamarind Institute. During its decade in Los Angeles, 104 artists held fellowships, including Sam *Francis and Louise *Nevelson. Among the successful Tamarind graduates was Kenneth Tyler (1931–), who in 1966 was one of the founders of Gemini GEL (Graphics Editions Ltd) in Los Angeles. In 1967 it produced Rauschenberg's six-feet-high *Booster*, the largest lithograph ever printed up to that date. It was not only lithography that figured in the Print Renaissance: *screenprinting became popular in the early 1960s, and the Crown Point Press in Oakland, California, established by Kathan Brown in 1962, encouraged the use of intaglio processes such as etching.

Further Reading: R. Castelman, *Prints of the 20th Century* (1988)

Problembild *See* SOCIALIST REALISM.

Process art A term applied to a trend in art in the late 1960s and early 1970s in which emphasis is put not on the formal aspects of a work but on the processes involved in creating it and on the processes of change and decay it is subject to thereafter. The principal theorist is Robert *Morris, who has interpreted the work of such artists as Jackson *Pollock, Morris *Louis, and even the Renaissance sculptor Donatello, in terms of process. Examples of Process art include Richard *Serra's *Splashing* (1968), in which he splashed molten lead against the bottom of a wall in the Leo *Castelli gallery, New York, and Robert Morris's own *Untitled* (1967–73), consisting of

clouds of steam. Some Process art has a more enduring life, however, including sculptures made of soft material, such as the work of Claes *Oldenburg or Eva *Hesse, in which there is a degree of permanency but no fixed form. There are also affinities with *Land art because of the interaction between the art object and the natural world, the sociological inquiries of Hans *Haacke, and some aspects of *Performance art.

Procházka, Antonin See GROUP OF PLASTIC ARTISTS.

Procktor, Patrick (1936–2003) British painter, printmaker, illustrator, and theatrical designer, born in Dublin. After serving in the Royal Navy, he studied at the *Slade School, 1958–62. His career was launched by an enormously successful exhibition at the Redfern Gallery, London in 1963: the paintings shown were marked by colourful and painterly treatment of the figure in space. His work was varied in subject—including landscapes, townscapes, figure compositions, portraits, and interiors—and was frequently based on his extensive travels. He often worked in watercolour and his style is distinguished by limpid colouring. As a printmaker he favoured aquatint. The books he illustrated include Coleridge's *Rime of the Ancient Mariner* (1976), and his own publications include *A Chinese Journey* (1980), illustrated with aquatint landscapes.

Procter, Dod (1890–1972) British painter of portraits, figure subjects, landscapes, and flowers, born Doris Shaw in London. She studied under Stanhope *Forbes in Newlyn, 1907–10, and then at the Académie Colarossi in Paris. In 1912 she married the painter **Ernest Procter** (1886–1935), who had been a fellow student in Newlyn and Paris. They lived mainly in Newlyn. Dod is now remembered mainly for one work—*Morning* (1926, Tate). The *Daily Mail* bought it for the nation when it was on show at Newlyn Art Gallery, and in 1927 it was voted 'picture of the year' at the *Royal Academy summer exhibition. Dod returned in triumph to Newlyn, where she was greeted by flags and a brass band, and the painting went on a tour of provincial galleries. It shows Cissie Barnes, the sixteen-year-old daughter of a local fish merchant, lying sleeping on her bed in the dawn light. Simon Wilson remarks that 'Its power as a painting certainly partly stems from its strong atmo-

sphere of burgeoning adolescent sexuality, although this does not seem to have been acknowledged at the time' (*Tate Gallery: An Illustrated Companion*, 1990). In the 1930s Dod's style became much softer and more painterly. She continued working into old age, and when she died in Newlyn in 1972 she was the last link with the village's great artistic flowering at the turn of the century.

Ernest Procter's range of subjects was similar to that of his wife, but his figure paintings leaned more towards allegorical and religious themes (he was a devout Christian) and he did a good deal of decorative work, including a remarkable composition for the altar wall of St Mary's Church, Penzance (now destroyed). Nikolaus Pevsner describes it as 'a spectacular affair of 1934, with a whole prospect including the heavenly host, a corrugated silvery backcloth, jagged rays; all smacking a little of the Wurlitzer' (*Buildings of England: Cornwall*, 1970). In 1934 Ernest was appointed director of studies in design and craft at *Glasgow School of Art, but he died the following year.

Proctor, Thea See CONTEMPORARY GROUP.

Production art See INKHUK.

Progressive Artists' Group See HUSAIN, M. F.; SOUZA, FRANCIS NEWTON.

Proun See LISSITZKY, EL.

Pryde, James (1866–1941) British painter and designer. He was born in Edinburgh and studied there at the Royal Scottish Academy, 1886–7, and then for three months at the *Académie Julian, Paris. In the 1890s he designed posters with his brother-in-law William Nicholson under the name J. & W. Beggarstaff. Pryde sometimes supplemented his income at this time by taking small parts on the stage. As a painter he is best known for dramatic and sinister architectural views, with figures dwarfed by their gloomy surroundings. They have something of the spirit of the prison etchings by the 18th-century Italian artist Giovanni Battista Piranesi, but they are broadly brushed, and in the entry on Pryde in the *Dictionary of National Biography*, Derek Hudson says that they were probably influenced by his 'early Edinburgh memories—the high-ceilinged, dimly-lit interior of the house [in which he lived] in Fettes Row, the four-poster in Mary Queen of Scots' bedroom at Holyrood, the strings of washing outside the upper

windows of the tall tenement buildings off the High Street'. Pryde—'tall and handsome', but 'dilatory, extravagant, and unproductive for long periods'—did little after 1925. However, in 1930 he designed the sets for Paul Robeson's memorable *Othello* at the Savoy Theatre, London.

Psychoanalysis Branch of psychology pioneered by Sigmund Freud (1856–1939). Although there are a number of schools and versions they are unified by the idea that human actions are influenced by the unconscious as well as the conscious mind. Freud held that unconscious motivations were the result of impulses, especially sexual ones, repressed by society. This obviously has great significance for the understanding of art. No longer does the interpreter need to be bound by the 'artist's intention', at least as consciously expressed by that artist. Taste in art, as well, might be determined by matters which the spectator might not be able to or wish to articulate. Psychoanalysis has had enormous influence on the practice of art, although not necessarily in ways in which Freud might have approved. He saw himself ultimately as a doctor concerned to improve the quality of life for an individual patient. Artists, on the other hand, have seen psychoanalysis as a source of imagery or even as a critique of a repressive society. Such was the interest of the *Surrealists, who used *automatism to reveal the unconscious or, like Dalí, illustrated psychoanalytic themes. More recent artists who have employed psychoanalytic themes for the purposes of political criticism include Mary *Kelly and Victor *Burgin. Both of these have also been influenced by the writings of Jacques Lacan (1901–81) who wrote of the role of the acquisition of language in the formation of the unconscious. His ideas gave some support for the elevation of verbal language over the visual in *Conceptual art.

Puni, Ivan *See* POUGNY, JEAN.

Punin, Nikolai (1888–1953) Russian art critic. From 1918 to 1921 he was active in the organization of *Narkompros and in 1921 he was one of the founders of the Petrograd (St Petersburg) section of *Inkhuk. During the 1920s he was one of the most widely read of Russian writers on art. He believed that modern art criticism should be scientific and even tried to reduce the creative process to a mathematical formula: $S(Pi + Pii + Piii ...)Y = T$,

where S is the sum of the principles (P), Y is intuition, and T is artistic creation. It is therefore not surprising that Punin preferred the 'engineer' *Tatlin to the artist *Malevich, concluding that Malevich was too subjective to examine material in a scientific and impartial manner. Even so, Punin was a keen supporter of many different members of the Russian avant-garde. He also did valuable research on earlier Russian art. His *formalist views were opposed to the ideals of *Socialist Realism demanded by Stalin, and after the Second World War he was one of a number of critics who were persecuted for their 'cosmopolitan' views (the campaign against them was led by Alexander *Gerasimov). In 1949 Punin was arrested and sent to a prison camp in Siberia, where he died.

Purism A movement in French painting advocating an art of clarity and objectivity in tune with the machine age; its founders and sole exponents were Amedée *Ozenfant and *Le Corbusier, who met in Paris in 1918, and it flourished from then until 1925. Feeling that *Cubism—'the troubled art of a troubled time'—was degenerating into an art of decoration, they regarded their association as a call for order, or, as they put it, 'a campaign for the reconstitution of a healthy art', their object being to 'inoculate artists with the spirit of the age'. They set great store by 'the lessons inherent in the precision of machinery' and held that emotion and expressiveness should be strictly excluded from art, apart from the beauty of functional efficiency—the 'mathematical lyricism' that is the proper response to a well-composed picture. Their characteristic paintings are still-lifes—cool, clear, almost diagrammatically flat, and impersonally finished.

Despite the anti-emotionalism of this functionalist outlook, Ozenfant and Le Corbusier advocated Purism with missionary fervour and dogmatic certainty. Ozenfant had begun the attack on Cubism with an article in his periodical *L'Élan* in 1916, but as a movement Purism was launched with a short book he wrote with Le Corbusier, *Après le Cubisme* (1918). They also expounded their ideas in another joint book, *La Peinture moderne* (1925), and in the journal *L'Esprit nouveau*, which they ran from 1920 to 1925. The journal attracted contributions from eminent artists and writers of various persuasions, but Purism was more important in theory than in practice

and did not succeed in establishing a school of painting. However, there were affinities with the wider trend towards Neoclassicism; *Léger especially links the two tendencies. Both Le Corbusier and Ozenfant seemed to realize that Purism represented something of a dead end pictorially and moved on to much looser styles. Its main sequel is to be found in the architectural theories and achievements of Le Corbusier and more generally in the field of design, where there is some kinship with the contemporary ideals of the *Bauhaus.

Purrmann, Hans (1880–1966) German painter. He was born in Speyer, son of the painter **Georg Heinrich Purrmann** (1844–1900), and trained with his father and then in Karlsruhe and Munich. From 1906 to 1914 he lived in Paris, where he became a friend of *Matisse and helped to run his art school. He was one of Matisse's most talented followers and he wrote of the master: 'In my personal contact with Matisse, I noticed how strictly he examined and judged the effect as a whole. He always seemed to ask himself how he should fill his canvases to create something expressive, clear and penetrating, without any superfluous ballast.' Until 1935 Purrmann worked mainly in Berlin, then moved to Italy, his work having been declared *degenerate by the Nazis. From 1944 he lived mainly in Switzerland. In his later work he moved from the bright *Fauvist colour inspired by Matisse to a mellower style akin to that of late *Renoir.

Purser, Sarah See AN TÚR GLOINE.

Puryear, Martin (1941–) American sculptor, born in Chicago into a middle-class black family. He studied painting at the Catholic University, Washington, graduating in 1963, then worked as a Peace Corps volunteer in Sierra Leone, where he learnt traditional carpentry, studied printmaking and sculpture at the Academy in Stockholm, and travelled in Japan. After returning to the USA he took a Master of Fine Arts degree at Yale University in 1971 and settled in New York in 1973. These varied experiences have been a formative influence and he has said that 'the time in Sierra Leone and Sweden has become the myth behind the work'. His work combines African craftsmanship with *Minimalist form, using wood with extraordinary virtuosity. *Self* (1978, Joslyn Art Museum, Omaha), with a form that alludes to male sexuality, is a shape curved everywhere except where it meets the floor and built out of thin layers of wood over a hidden core. Puryear has also worked as a *Land artist. *Bodark Arc* (1982, Nathan Manilow Sculpture Park, Illinois) is demarcated by a row of orange trees and a semi-circular path that at one point crosses over a bridge on an existing pond, so forming a bow shape. To this he added a wooden gateway and a bronze chair modelled on that of a Liberian chief. Although Puryear has rejected interpretations of his work based narrowly on race (*Duchamp, *Brancusi, and *Arp are all part of his artistic background), he has nonetheless made specific reference to black identity. *Ladder for Booker T. Washington* (1996, Modern Art Museum, Fort Worth) is a precariously curvy ladder, the title of which refers to the black leader who was born into slavery and who argued that education rather than confrontation was the way forward. Puryear may be alluding to the greater challenges faced by blacks who attempt to climb the ladder, but he is also fascinated by the technical challenges of making a sculpture that works with artificial perspective.

Further Reading: R. Smith, 'Humanity's Ascent in Three Dimensions', *The New York Times* (2 November 2007)

Pushkin Museum, Moscow. *See* MOROZOV, IVAN; SHCHUKIN, SERGEI.

Puteaux Group A group of *Cubist artists, who met informally between 1911 and 1913 in the studios of Jacques *Villon and Raymond *Duchamp-Villon in the Parisian suburb of Puteaux. Their brother Marcel *Duchamp was also a member of the group, and others included *Archipenko, *Gleizes, *Gris, *Kupka, *Léger, and *Metzinger. The group (under the direction of Duchamp-Villon) produced a 'Cubist House' at the *Salon d'Automne of 1912 and in the same year organized the *Section d'Or exhibition. They criticized the Cubism of Picasso and Braque on the ground that it lacked human interest, and introduced an interest in colour that led to *Orphism.

Puy, Jean (1876–1960) French painter and printmaker, born at Roanne. He trained at the École des Beaux-Arts, Lyon (1895–8) and in Paris at the *Académie Julian (1898) and the *Académie Carrière (1899), where he became a friend of *Matisse. His early work was *Impressionist, but he became one of the more moderate members of the *Fauves, exhibiting with them at the famous *Salon d'Automne

show of 1905. He painted traditional subjects such as landscapes, nudes, interiors, and flowers in a bright, clear, spontaneous style. After the heyday of Fauvism (1905–7) his work became more straightforwardly naturalistic. Apart from paintings he produced etchings, lithographs, and woodcuts as book illustrations. His brother **Michel Puy** (1878–1960) was an art critic; he was one of the first writers to champion the Fauves and was also sympathetic to *Cubism.

Pye, Patrick *See* KELLY, OISÍN.

Pyle, Howard *See* PARRISH, MAXFIELD.

Quietism *See* TONALISM.

Quinn, John (1870–1924) American lawyer, collector, and patron. Quinn was of Irish ancestry and came to collecting through purchasing manuscripts of Irish literary works. He did not start collecting paintings and sculpture until after the turn of the century, but he then rapidly became a major figure in the field of avant-garde art; indeed, he was described by Alfred H. *Barr as 'the greatest American collector of the art of his time'. He was legal representative to the *Armory Show (1913), and was a major lender to and purchaser at the exhibition. It introduced him to *Brancusi's work, and from then until his death eleven years later, Quinn was Brancusi's most important patron, buying most of his output. He also collected the work of *Matisse, *Picasso, and *Rousseau, as well as various Americans. Especially notable was his patronage of leading figures in British modernism, including Augustus *John, whom he met in London in 1909, *Epstein and *Gaudier-Brzeska. (His interest in the last two came through his friendship with Ezra Pound). Quinn also played an important role in creating a buoyant art market in New York by successfully campaigning for works of art less than twenty years old to be exempt from import duty. His collection was known only to his friends during his lifetime, but in 1926 part of it was shown in a memorial exhibition at the New York Art Center. The collection was sold at auction in Paris and New York in 1926–7. Its dispersal encouraged A. E. *Gallatin to open his own collection to the public as the Museum of Living Art in New York.

Quinn, Marc (1964–) British sculptor, born in London. His background was in history and history of art, which he studied at Cambridge University. He has been strongly identified with the *Young British Artists, gaining considerable support early in his career from Charles *Saatchi. His work is in many different media but is unified by a preoccupation, shared with *Hirst, with mortality and the body, although when an interviewer suggested to him that he might make a sculpture from a corpse he replied: 'I am more interested in life. Or evoking the fragility of life' (*The Times*, 26 February 2005). This was manifested in the work which made his name, *Self* (1991, formerly Saatchi collection). This consists of a cast of the artist's head in eight pints of his own frozen blood. It was once falsely rumoured that it had accidentally melted.

In 2005 Quinn's marble sculpture of Alison Lapper (1965–), a severely disabled artist, represented when she was eight and a half months pregnant, was displayed temporarily on the empty plinth in Trafalgar Square, London. Quinn pointed out that the square already contained a statue of a disabled person, Nelson, and described the Lapper statue as a 'new model of female heroism', a conquest over circumstances and prejudice.

Quintanilla, Isabel *See* SPANISH REALISTS.

RA *See* ROYAL ACADEMY OF ARTS.

Rabin, Oskar (1928–) Russian painter, one of the leading figures of *Unofficial art in the Soviet Union. He was born in Moscow and trained at the Riga Academy, 1944–7. For many years he worked as a railway porter and engine driver in Moscow, painting in his spare time, but from 1967 he was a full-time artist. His subjects were often taken from the railway and also included fantastic cityscapes juxtaposed with incongruous objects such as a samovar, a torn vodka label, or even a Titian nude. Characteristically he painted in thick impasto, mainly with a palette knife and generally in subdued ochre and umber tones. Although his work did not conform to the ideals of the officially approved *Socialist Realism, he was allowed to exhibit abroad, and he was the only Unofficial artist included in the exhibition of contemporary Soviet art held at the Grosvenor Gallery, London, in 1964. In the following year he had a one-man exhibition at the same gallery. Rabin left Russia in 1978 and settled in Paris. His wife, **Valentina** (1924–), is a painter, as was her brother, Lev Kropivnitsky (1922–79), who spent nine years in labour camps.

Rackham, Arthur (1867–1939) British illustrator, celebrated for his work in children's books. He was born in London, into a comfortable middle-class family. The book that established his reputation was *Fairy Tales of the Brothers Grimm*, published in 1900, and from then until the First World War he had his golden period, when Edmund *Dulac was his only serious rival as an illustrator of children's books. They were very different in style. Dulac was much more painterly, using strong expressive colour, whereas Rackham relied on wiry line and subtle, muted colour. He said he believed in 'the greatest stimulating and educative power of imaginative, fantastic and playful pictures and writings for children in their most impressionable years', and he

worked in a striking vein of Nordic fantasy, creating a bizarre world populated by goblins, fairies, and weird creatures (he looked rather like a gnome himself). After the First World War the market for expensive children's books declined, but he continued to prosper from gallery sales of his work.

Räderscheidt, Anton *See* NEUE SACHLICHKEIT.

Raedecker, John (1885–1956) Dutch sculptor, painter, and draughtsman, born in Amsterdam, the son of a decorative sculptor. He originally trained in his father's profession, then studied drawing at the Amsterdam Academy and took up painting. From the 1920s, supported by the critic H. P. Bremmer (*see* KRÖLLER-MÜLLER), he became the leading Dutch sculptor working in a traditional vein. His most famous work, designed in collaboration with the architect J. J. P. Oud, is the National Monument (1947–56) in Amsterdam, a memorial to the Second World War.

Rainer, Arnulf (1929–) Austrian painter, printmaker, photographer, and collector, born in the spa town of Baden, near Vienna. He had virtually no formal instruction in art (he stayed for a total of less than a week at the two art schools he attended in Vienna in 1949–50), and his technical procedures are often unconventional. His early works, mainly drawings and prints, were inspired by the fantastic vein of *Surrealism, and after a visit to Paris in 1951 he was influenced by *Abstract Expressionist and *Art Informel paintings that he saw there. Although he met André *Breton in Paris, he soon moved away from Surrealism, and in the mid-1950s he began producing *Overpaintings*, in which he took as a basis a painting, drawing, or photograph (either his own work or someone else's) and partially obliterated the image with monochromatic colour. A similar concern with reworking surfaces occurs in many of his prints, in which he sometimes uses the same plates

again and again over a period of many years, during which the plates become more and more scratched. Overpaintings dominated Rainer's work for about a decade, until the mid-1960s, but he also produced a series of cruciform pictures during this period (*Black Cross*, 1956, Lenbachhaus, Munich). In 1963 he began collecting *Art Brut and the following year he began experimenting with hallucinogenic drugs—indications of his interest in extreme emotional states. Rainer has collaborated with other artists, notably Dieter *Roth.

Ramos, Mel (1935–) American painter. He was born in Sacramento, California, and studied at the state colleges of San José, and Sacramento, 1954–8. His first exhibition was at the Bianchini Gallery, New York, in 1964, but he has lived and worked mainly in California. Ramos is usually described as a *Pop artist. In the early pictures his paint surfaces are often thick and creamy, unlike the impersonality of the work of *Lichtenstein or *Rosenquist but close to the food paintings of Wayne *Thiebaud, who taught him at Sacramento. Later he practised an impersonal handling in oil and watercolour close to *Superrealism. After a period in which he drew on comic strip imagery, he came to specialize in paintings of nude women of the calendar pin-up or 'playmate' type. By his own admission, he has been criticized by feminists for making figures that are 'very, brassy, shiny, and fláwless'. Sometimes they are posed with oversized products such as pieces of cheese and sometimes they allude to the work of leading painters of the past (more rarely the present). *Touché Boucher* (1974) derives from a notorious image of an adolescent girl displaying her behind by the 18th-century French painter François Boucher, and re-enacts it with a modern glamour model of a more mature age, appropriate to contemporary mores. 'One of the central issues of my work has been the notion that art grows from art. I've been fascinated by the myths, iconography, and clichés that have perpetuated themselves throughout the history of art in various forms and idioms'. The jokey quality of his work is reflected in his titles: two typical series are 'You Get More Spaghetti with Giacometti' and 'You Get More Salami with Modigliani'. Marco Livingstone comments that Ramos 'flaunted his art as kitsch devoid of intellectual pretension but with an earthy humour that remains its saving grace'.

(((●))) SEE WEB LINKS
• Interview with the artist on the website of the Smithsonian Institute Archives of American Art.

Ramsden, Elizabeth *See* COLLINS, CECIL.

Ramsden, Mel *See* ART & LANGUAGE.

Ranson, Paul *See* ACADÉMIE.

Ratcliffe, William *See* CAMDEN TOWN GROUP.

Rauch, Neo (1960–) German painter, born in Leipzig, where he still lives and works. He grew up in East Germany and was trained under Bernhard *Heisig. In the Communist East Germany during the 1980s, overtly propagandistic *Socialist Realism had given way to a more critical kind of painting, sufficiently ambiguous to avoid any open attack on the existing order, but acting as a safety valve for intellectuals and providing evidence of openness for well-wishers in the West. The system still provided artists with formidable skills in the production of figurative painting. Rauch's paintings, which have had enormous success with collectors, are very much a product of such a system. They are on a large scale. Individual figures and objects are startlingly illusionistic, but as the consequence of superb drawing rather than meticulous finish, and the actual space in the painting is incoherent. The paint is very thin, the colour reminiscent of old cheap colour printing common in the Communist block. Peter Schedahl describes Rauch as a 'bard of Eastern Europe, rooted in the obsolete future of revolutionary hopes'. Much of the appeal of his painting, apart from its considerable technical skill, certainly lies in the way in which the images of *Socialist Realism, once the bearers of threats and promises, are paraded as comfortingly emasculated. For Rauch, recognition has come more through the market than the museum, but a major exhibition was mounted at the Metropolitan Museum, New York, in 2007.

Further Reading: P. Schedahl, 'Paintings for Now', *The New Yorker* (4 June 2007)

Rauschenberg, Robert (1925–2008) American painter, printmaker, and designer. With Jasper *Johns, whom he met in 1954 and with whom he had a close friendship until an acrimonious split in 1964, he was a leading figure in the *Neo-Dada tendency which both built on and challenged *Abstract

Expressionism and pointed the way to *Pop art. Rauschenberg was born in Port Arthur, Texas, as Milton Rauschenberg, and became interested in art after a chance visit to a gallery while serving in the US Navy as a neuro-psychiatric technician, 1942–5. He said of his work in the navy: 'This is where I learned how little difference there is between sanity and insanity and realized that a combination is essential.' After leaving the navy he studied at Kansas City Art Institute, 1946–8, the *Académie Julian, Paris, 1948, *Black Mountain College, 1948–9, and the *Art Students League of New York, 1949–52. Black Mountain College made the greatest impact on him and he returned several times in the early 1950s. The people he met there included the composer John *Cage and the dancer Merce Cunningham (1919–), both of whom influenced him greatly (he was designer for Cunningham's dance company from 1955 to 1965).

Rauschenberg had his first one-man show (coolly received) at the Betty *Parsons Gallery, New York, in 1951. At this period his work included monochromatic paintings in black, white, and red. 'You have to feel sorry for yourself', he once commented, 'to be a good Abstract Expressionist', reflecting on the dominant tendency at the time he first exhibited. The most drastic manifestation of his attitude is the *Erased *de Kooning Drawing* (San Francisco Museum of Modern Art). Although this appears an iconoclastic, even patricidal act, given de Kooning's status among the artists of the older generation, Rauschenberg said that 'the whole idea just came from my wanting to know whether a drawing could be made out of erasing'. If he had used a drawing of his own, the making as well as the construction of the image would be part of the process. As Rauschenberg told the story, de Kooning, having excluded special favourites, deliberately chose a drawing which would be as hard to erase as possible. The task took Rauschenberg a month and around 40 erasers. In the mid-1950s he began to incorporate three-dimensional objects into what he called 'combine paintings'. This was a radical form of *collage in which paint applied with *Abstract Expressionist vigour was combined with real objects and pictures. Objects he used included Coca-Cola bottles, fragments of clothing, electric fans, and radios. It is this choice of material which led him to be regarded as one of the initiators of Pop. *Bed* (1955, MoMA, New York) features a real pillow, sheet, and quilt. *Monogram* (1955–9, Moderna Museet, Stock-

holm) features a stuffed angora goat with a rubber tyre around its middle, its face splashed with paint. Robert Hughes (*The Shock of the New*, 1991) describes it as 'one of the few great icons of homosexual love in modern culture, the satyr in the sphincter'. Indeed, some critics have seen in the work of Rauschenberg and Johns a critique from a homosexual perspective of the aggressive masculinity associated with *Abstract Expressionist art and behaviour.

In 1958 Rauschenberg was given a one-man show by Leo *Castelli and from that time his career began to take off. By the early 1960s he was building up an international reputation, and in 1964 he was awarded the Grand Prize at the Venice *Biennale. This success (the revered French painter Roger *Bissière was widely expected to win) gave rise to rumours of political interference and even military threats by part of the American government. The Vatican newspaper *L'Osservatore Romano* described the award as 'the total and general defeat of culture', while the French *Arts* magazine printed the headline 'In Venice, America Proclaims the End of the School of Paris and Launches Pop Art to Colonize Europe'.

By this time Rauschenberg had returned to working on a flat surface. He employed a combination of screenprint and paint to bring together images from fine art and the contemporary world, especially ones redolent of American political power, such as the eagle and the recently assassinated president John F. Kennedy. In his essay 'On the Museum's Ruins' (H. Foster (ed), *The Anti-Aesthetic*, 1983), Douglas Crimp argues for such works being *Postmodernist because they 'dispense with aura' (the reference is to Walter *Benjamin) and that the 'fiction of the creating subject gives way to the frank confiscation, quotation, excerptation, accumulation, and repetition of other images'.

Rauschenberg became interested in combining art with new technological developments and in 1966 with the scientist Bill Klüver he helped to form EAT (Experiments in Art and Technology), an organization to help artists and engineers work together. One outcome of this was *Mud Muse* (1968–71), in which bubbles of mud were programmed to respond to noises in the gallery. 'I am, I think, constantly involved in evoking other people's sensibilities. My work is about wanting to change your mind. Not for the art's sake, not for the sake of that individual piece, but for the

sake of the mutual coexistence of the entire environment.' In line with these beliefs, in 1985 he launched Rauschenberg Overseas Cultural Exchange (ROCI), an exhibition dedicated to world peace that toured the world and included works created specifically for each place visited. For all this high-mindedness Rauschenberg's work after around 1970 has generally been found by critics to lack the inventiveness of that of his early years.

Further Reading: L. J. Monahan, 'Cultural Cartography: American Designs at the 1964 Venice Biennale', in S. Guilbaut (ed.), *Reconstructing Modernism: Art in New York, Paris, and Montreal 1945–1964* (1990)

C. Tomkins, *Off the Wall: Robert Rauschenberg and the Art World of Our Time* (1981)

Raverat, Gwen (1885–1957) British graphic artist, theatre designer, painter, and writer, born in Cambridge, the daughter of Sir George Darwin, professor of astronomy, and granddaughter of Charles Darwin. She studied at the *Slade School, 1908–11, but was mainly self-taught in wood engraving, which was her primary activity. In 1911 she married Jacques Raverat, a French former student of mathematics at Cambridge who had taken up painting and studied with her at the Slade. They spent much of their time in France until his death in 1925; thereafter she lived in London and Cambridge. She was a founder of the Society of Wood Engravers in 1920 and was best known for her book illustrations, notably of collections of poems by her cousin Frances Cornford and for the *Cambridge Book of Poetry for Children*, selected by Kenneth Grahame (1932).

Ravilious, Eric (1903–42) British watercolour painter, printmaker, and designer, born in London. He had his main training at the *Royal College of Art (1922–5), where he was influenced by his teacher Paul *Nash and became a lifelong friend of his fellow student Edward *Bawden. In addition to paintings, his highly varied output included book illustrations and book jackets and designs for furniture, glass, textiles, and the Wedgwood pottery factory (including a commemorative coronation mug). Ravilious was one of the outstanding wood engravers of his time, his book illustrations in this medium making striking use of bold tonal contrasts and complex patterning. He also worked with colour lithography. In 1940 he was appointed an *Official War Artist, and he produced some memorable watercolours of naval scenes off Norway

(*Norway, 1940*, Laing Art Gallery, Newcastle upon Tyne). While on a flying patrol near Iceland in September 1942 his plane disappeared, and he was officially presumed dead the following year.

His wife, **Tirzah Ravilious**, née Garwood (1908–51), whom he married in 1930, was a painter and illustrator.

Further Reading: F. Constable, *The England of Eric Ravilious* (2003)

Raw Materialist art See ARTE POVERA.

Ray, Man See MAN RAY.

Raymond, Marie See KLEIN, YVES.

Raynal, Maurice See CUBISM; ROSENBERG, LÉONCE.

Rayonism (Rayonnism, Rayism, Luchism) A type of abstract or semi-abstract painting practised by the Russian artists *Goncharova and *Larionov and a few followers from about 1912 to 1914 and representing their own adaptation of *Futurism. Rayonism was launched at the *'Target' exhibition in Moscow in 1913. In the same year Larionov published a manifesto on the subject, although it bore the date June 1912 (he claimed to have been painting in a Rayonist manner as early as 1909, but Russian artists of this time were not averse to backdating their works in an effort to stake their claims as pioneers of modernism). The manifesto stated: 'Rayonism is a synthesis of *Cubism, Futurism and *Orphism', and Rayonist pictures do indeed combine something of the fragmentation or splintering of form of Cubism, the dynamic movement of Futurism, and the colour of Orphism. The style was bound up with a very unclear theory of invisible rays, in some ways analogous to the 'lines of force' that were postulated by the Futurists. These lines or rays were thought to be emitted by objects and intercepted by other objects in the vicinity, and it was the artist's task to manipulate them for his own aesthetic purposes: 'The rays which emanate from the objects and cross over one another give rise to rayonist forms. The artist transfigures these forms by bending them and submitting them to his desire for aesthetic expression.' In early Rayonist paintings an underlying subject is broken up into bundles of slanting lines, but in later ones the lines take over the picture completely so that there is no discernible naturalistic starting point and the

work becomes completely abstract, as in Larionov's *Rayonist Composition: Domination of Red* (dated on painting 1911, but thought to have been executed *c.*1913–14, MoMA, New York). Rayonism was short-lived, as both Goncharova and Larionov virtually abandoned easel painting after they left Russia in 1915 and they had no significant followers.

Raysse, Martial (1936–) French painter, installation artist, film-maker, and theatrical designer. He was born at Golfe-Juan, near Nice, and has worked mainly in Paris. One of the original signatories of the manifesto of *Nouveau Réalisme in October 1960, he is best known for his *assemblages of mass-produced commonplace objects. Often these works have a neat, display-rack character: 'I wanted my works to possess the serene self-evidence of mass-produced refrigerators.' *Raysse Beach* (1962) was an environment constructed for the Stedelijk Museum, Amsterdam, a scene of modern European leisure including a plastic pool with inflatable ducks, an artificial lawn, and a jukebox. The *Made in Japan* (1965) series applies a synthetic plastic colour to the nudes of Ingres. This kind of visual luridness was a positive value for Raysse. He told an interviewer 'Beauty is bad taste . . . Bad taste is the dream of a beauty too much longed for' (*Arts*, 16 June 1965). He also made striking use of neon. In *Bateau* (1967, Pompidou Centre, Paris) the light evokes the smoke of a steamer on a stormy sea. After the Paris riots of 1968 he temporarily abandoned painting for film-making in a rejection of the consumer culture he had so celebrated. Later paintings tend to landscape subjects, often with classical references.

Further Reading: M. Alocco, *L'École de Nice* (1995)

RCA *See* ROYAL COLLEGE OF ART.

Rea, Betty (1904–65) British sculptor and political activist, born in London. Her formation as an artist included studies under Henry *Moore at the *Royal College of Art. An early carving in mahogany, *Mother and Child* (1925), shows Moore's influence and her interest in *direct carving. In the early 1930s she moved in Communist circles and made several trips to Russia. In 1932 she was a founding member of the *Artists International Association. Her sculpture during this period was closely associated with her political work. As Gillian Whiteley points out, her 1938 sculpture *Holidays with Pay* 'echoes the optimistic and heroic view of work found in Soviet *Socialist Realist art'. After the war, her sculpture became less overtly political, and she tended to specialize in the representation of children and adolescent girls. Her political record and the relatively traditional nature of her work made her a British artist whose works were acceptable in the Communist world and she exhibited to some acclaim in the Pushkin Museum, Moscow, in 1955.

Further Reading: G. Whiteley, *A Context of Commitment: The Sculpture of Betty Rea* (n.d.)

Read, Sir Herbert (1893–1968) British poet and critic, who throughout the middle third of the 20th century was widely regarded as his country's foremost advocate and interpreter of modern art. He was born at Kirbymoorside (now Kirkbymoorside), Yorkshire, into a farming family, and studied at Leeds University before serving in France in the First World War; his distinguished record as a soldier lent an added authority to his later pacifism and anarchism. After the war he worked at the Treasury, then in the ceramics department of the Victoria and Albert Museum, 1922–31, before becoming Watson Gordon professor of fine arts at Edinburgh University, 1931–3. By this time he had published several collections of his verse as well as various art-historical studies (including *English Stained Glass*, 1926, long a standard work), critical works on English literature, and the first of his philosophical works on art, *The Meaning of Art* (1931). In 1933 he returned to London as editor of *The Burlington Magazine* (1933–9) and his attention turned increasingly to contemporary art: in 1933 he published *Art Now*, the first comprehensive defence in English of modern European art, and in 1934 he edited the modernist manifesto *Unit One*. What distinguished him from earlier British critical supporters of modernism, such as Roger *Fry or R. H. *Wilenski, was the range of his sympathies, which looked beyond *Fauvism and *Cubism to encompass *Expressionism, *Surrealism, and total *abstraction. Furthermore his theoretical approach went beyond the *formalist framework that had previously dominated advanced British thinking about modern art, drawing on psychology and sociology.

During the 1930s Read lived near Henry *Moore, Barbara *Hepworth, and Ben *Nicholson, and he acted as the public mouthpiece of

the group of artists of which they were the centre; Moore later wrote that 'In the 1930s he was available to in all the way that he could see both sides of any situation and act as a link between the different things that were going on.' His simultaneous support for Surrealism and geometric abstraction cut across ideological divides in the art world of the period. He saw the new developments as revolutionary in a political as well as an artistic sense, as he argued in his 1935 essay 'What is Revolutionary Art?' (reprinted in Harrison and Wood). In 1936 he was one of the organizers of the International Surrealist Exhibition in London. In the introduction to the catalogue, anxious to emphasize the political agenda, he described the movement as 'the desperate act of men too profoundly convinced of the rottenness of our civilization to want to save a shred of its respectability'. In the late 1930s Read planned a Museum of Modern Art in London, of which he would have been the first director. The Second World War ruined the plans, but some of the ideas bore fruit in the *Institute of Contemporary Arts, which he founded with Roland *Penrose in 1947 as 'an adult play-centre . . . a source of vitality and daring experiment'.

In 1950 Read returned to Yorkshire, but he spent a good deal of his time abroad as a speaker at international conferences. He also kept up a steady stream of books. His most influential work was probably *Education Through Art* (1943), which used the insights of psychoanalysis to promote the idea of teaching art as an aid to the development of the personality. *The Philosophy of Modern Art* (1952), an anthology of essays, is the best general introduction to his thinking. His other books include *A Concise History of Modern Painting* (1959) and *A Concise History of Modern Sculpture* (1964), both of which have been frequently reprinted. By the time he wrote these surveys he was becoming acutely aware of the conflict between his political views and the role which he necessarily played in a materialistic art world ('The Ambiguous Critic' in *Letter to a Young Painter*, 1962). This was part of the context for his disenchantment with many contemporary artistic developments: the last generation of new artists he could support wholeheartedly were the *Geometry of Fear sculptors. Lecturing at *documenta in 1964 he described *Pop art as 'the eternal funfair which is neither funny nor fair, but an inferno'. Behind this thinking was also his strong sense that modern art had a

political and moral purpose and must detach itself from the merely amusing distractions of mass culture.

Since his death his importance as an advocate and promoter of modern art has been widely recognized as almost comparable to that of Alfred H. *Barr in the USA, although, of course, he did not have the benefit of Barr's institutional position to achieve what he did. There is less agreement as to the critical value of his writings. John *Skeaping, perhaps a little influenced by Read's support for his ex-wife, Barbara Hepworth, wrote: 'I distrusted him—his style of writing struck me as a specious use of pseudo-intellectual jargon' (*Drawn from Life*, 1977). David Cohen's view that 'What makes Read a crucial figure . . . is his ability to reconcile a romantic conservatism in outlook with a career as an evangelist of the new' sums up well his attractiveness to a generation of British readers but also suggests his limitations for wholehearted supporters of modernity. His method was generally to link the art under discussion to some broader context, usually a psychological or political one. For this reason the critical works which stand up best today are usually the ones in which he addresses ideas about art in general and its relationship to society, rather than individual artists and artworks.

Further Reading: D. Cohen, 'Herbert Read', *Modern Painters* (winter 1993)

B. Read and D. Thistlewood, *Herbert Read: A British Vision of World Art* (1993)

ready-made A name given by Marcel *Duchamp to a type of work he invented consisting of a mass-produced article selected at random, isolated from its functional context, and displayed as a work of art. His first ready-made (1913) was a bicycle wheel, which he mounted on a kitchen stool. Strictly speaking, this was a 'ready-made assisted', but other 'pure' ready-mades soon followed, notably *Bottle Rack* (1914), *In Advance of the Broken Arm* (a snow shovel, 1915), and the celebrated *Fountain* (1917)—a urinal which he signed 'R. Mutt' (alluding to the name of a firm of manufacturers of sanitary ware); most of the originals have disappeared, but several replicas exist. The ready-made can be considered a type of *objet trouvé (found object), although Duchamp himself made a clear distinction between them, pointing out that whereas the objet trouvé is discovered and chosen because of its interesting aesthetic qualities, its beauty

and uniqueness, the ready-made is one—any one—of a large number of indistinguishable mass-produced objects. Therefore the objet trouvé implies the exercise of taste in its selection, but the ready-made does not. When *Fountain* was rejected by the hanging committee of the *Society of Independent Artists, Duchamp defended his creation by writing: 'Whether Mr Mutt with his own hands made the fountain or not has no importance. He CHOSE it. He took an ordinary article of life, placed it so that its useful significance disappeared under a new title and point of view . . . [he] created a new thought for that object.' The ready-made was one of *Dada's most enduring legacies to modern art, especially in its influence on the concept of *appropriation.

realism A term used with various meanings in the history and criticism of the arts, and—particularly in the study of modern art—in a confusing variety of combination forms. In its broadest sense, the word is used as vaguely as 'naturalism', implying a desire to depict things accurately and objectively. Often, however, the term carries with it the suggestion of the rejection of conventionally beautiful subjects or of idealization in favour of a down-to-earth approach, with a stress on low life or the activities of the common people.

It is also sometimes used confusingly as a synonym for illusionism. The second term implies a degree of deception, but a 'realistic' representation may well not lead the spectator to believe that it is anything other than that, a representation. There is a certain tradition that sees 'illusionism' as an active obstacle to the representation of reality. In 1943 Adolph *Gottlieb, Mark *Rothko, and Barnett *Newman, three painters later to be leading exponents of *Abstract Expressionism, wrote that 'We are for flat forms because they destroy illusion and reveal truth.'

In a more specific sense, the term (usually spelled with a capital R) is applied to a movement in 19th-century (particularly French) art characterized by a rebellion against the traditional historical, mythological, and religious subjects in favour of unidealized scenes of modern life.

The term *Social Realism has been applied to 19th- and 20th-century works that are realistic in this sense and make social or political comment. Practitioners and supporters are generally anxious that it be distinguished from *Socialist Realism, the name given to

the officially approved style in the Soviet Union and some other Communist countries; far from implying a critical approach to social questions, it involved toeing the Party line in a traditional style.

'Realism' has also been used in a totally different way, describing art that eschews conventional representation. An early example was the 'Realistic Manifesto', issued in Moscow in 1920 by Naum *Gabo and Antoine *Pevsner, which called for an abstract art that was 'realistic' in the sense of being appropriate to its time. In the early 1960s the terms *New Realism and *Nouveau Réalisme were applied to works made of materials or objects that are presented for exactly what they are and are known to be. A 1969 exhibition 'The *Art of the Real' held at the Tate Gallery was actually devoted to *Minimal art.

*Magic Realism and *Superrealism are names given to two styles characterized by extreme realism—in the sense of acute attention to detail. *Neo-Realism and *Néo-Réalisme refer to specific minor aspects of British and French art respectively, but both terms have also been used in vaguer senses.

Further Reading: L. Nochlin, *Realism* (1971). Mainly concerned with the 19th century, but the first chapter remains one of the most lucid and intelligent accounts of the broader philosophical and critical issues.

Reality See HOPPER, EDWARD.

Rebatet, Lucien See PEINTRES DE TRADITION FRANÇAISE.

Rebay von Ehrenweisen, Baroness Hilla See GUGGENHEIM, SOLOMON R.

Rebel Art Centre (Cubist Centre) Organization founded by Wyndham *Lewis in April 1914 at 38 Great Ormond Street, London, after he had quarrelled with Roger *Fry and broken with the *Omega Workshops. The centre was intended to be a place in which artists and craftsmen could meet, work, and hold discussions, lectures, and classes. Lewis issued a prospectus in which he said the centre would be based on 'principles underlying the movements in painting known as *Cubist, *Futurist and *Expressionist'. Financial backing came from the painter Kate Lechmere (1887–1976). Other members included *Dismorr, Frederick Etchells (1886–1973), better known for his subsequent career as an architect and translator of *Le Corbusier, *Nevinson, Helen Saunders (1885–1963), and

*Wadsworth. A group exhibition of Rebel Art Centre work was held at the *Allied Artists' Association in June 1914; the centre closed the following month, but *Vorticism grew out of it.

Rebeyrolle, Paul (1926–2005) French painter, born at Eymoutiers, Haute-Vienne. Rebeyrolle had painted from childhood and took up art seriously when he moved to Paris in 1944, studying at the Académie de la Grande Chaumière. He had grown up in the countryside with a love of hunting and fishing and often painted rural themes; the Vaugirard slaughterhouses, near where he lived, also provided some of his subjects, which he treated in earthy colours in a robust style, with a caricature-like approach to faces and bodies. With a number of like-minded painters he founded the *Social Realist group *Homme-Témoin in 1948. He won the Prix de la Jeune Peinture in 1950 and the Prix Fénéon in 1951 and became regarded as a leader in the realist tendency—in opposition to the prevailing abstraction—in post-war French painting. His work also had a notable influence on young British realists of the time. In 1956 Rebeyrolle started to develop a looser style and in the 1960s his subjects were sometimes barely legible among his splashed and swirling paint.

Recaltati, Antonio *See* AILLAUD, GILLES.

Redon, Odilon (1840–1916) French painter and graphic artist, one of the outstanding figures of *Symbolism. He led a retiring life, first in his native Bordeaux, then from 1870 in Paris, and until he was in his fifties he worked almost exclusively in black and white—in lithographs and charcoal drawings. In these he developed a highly distinctive repertoire of weird subjects—strange amoeboid creatures, insects, and plants with human heads—influenced by the writings of Edgar Allan Poe. He remained virtually unknown to the public until the publication of J. K. Huysmans's celebrated novel *A Rebours* in 1884: the book's hero, a disenchanted aristocrat who lives in a private world of perverse delights, collects Redon's drawings, and with his mention in this classic expression of decadence, Redon too became a figurehead of the movement. During the 1890s he turned to painting and revealed remarkable powers as a colourist that had long lain dormant. Much of his early life had been unhappy, but after undergoing a religious crisis in the early 1890s and a serious illness in 1894–5, he was transformed into a much more buoyant and cheerful personality, expressing himself in radiant colours in visionary subjects, flower paintings, and mythological scenes (*The Chariot of Apollo* was one of his favourite themes). He showed equal facility in oils and pastels, and after 1900 also carried out a number of decorative schemes, the largest of which (1910–11) was for the library at the former abbey of Fontfroide, Narbonne, the home of one of his patrons, Gustave Fayet. The two main panels in this scheme represent *Night* and *Day*. Redon's flower pieces, in particular, were much admired by *Matisse, and the *Surrealists regarded him as one of their precursors. By the end of his life he was a distinguished figure (he was awarded the Legion of Honour in 1903), although still a very private person. A collection of his writings was published posthumously in 1922 under the title *A Soi-même*; it contains personal material such as diaries as well as art criticism.

Redpath, Anne (1895–1965) Scottish painter. She was born in Galashiels, the daughter of a tweed designer (she later described how she used flecks of colour in a manner similar to tweed makers: 'I do with a spot of red or yellow in a harmony of grey, what my father did in his tweed'). In 1913 she studied at Edinburgh College of Art and in 1920 she married James Beattie Michie, an architect with the War Graves Commission in France, where they lived for the next fourteen years. During this time she did little painting, devoting herself to her family (she had three sons). In 1934 she returned to Scotland, living first in Hawick and then from 1949 in Edinburgh (she became gradually estranged from her husband, who worked in London). From the 1950s she attained a distinguished position in the Scottish art world and was awarded various honours. Her main subjects were landscapes and still-lifes, richly coloured and broadly handled in the tradition of the *Scottish Colourists (in her later work there is sometimes a hint of *Expressionism). She travelled a good deal, painting landscapes in, for example, Spain and Portugal.

Reed, John and **Sunday** *See* ANGRY PENGUINS.

Refus global *See* AUTOMATISTES.

Regionalism A movement in American painting, flourishing chiefly in the 1930s, concerned with the depiction of scenes and

types from the American Midwest. The term is often used more or less interchangeably with *American Scene Painting, but Regionalism can be more precisely thought of as the Midwestern branch of this broader category. Like all American Scene painters, the Regionalists were motivated by a patriotic desire to establish a genuinely American art by using local themes and repudiating avant-garde styles from Europe. Specifically they were moved by a nostalgic desire to glorify, or at least to record, rural and small-town America, and it was on this that their widespread popularity depended. The period when they flourished coincided with the Great Depression, and at this time of profound national doubt, they reasserted America's faith in itself, giving the public pictures with which they could readily identify. Robert *Hughes has pointed out the irony 'that Regionalism, supposed to be the expression of American democracy, was in its pictorial essence the kissing cousin of the official art of 1930s Russia. If *socialist realism meant sanitized images of collective rural production, green acres, new tractors, bonny children and muscular workers, so did the capitalist realism [of Regionalism]...Both were arts of idealization and propaganda.'

The three major Regionalists were Thomas Hart *Benton, John Steuart *Curry, and Grant *Wood, who were all Midwesterners but differed greatly in temperament and style. They scarcely knew one another personally, but the idea of a group identity was skilfully promoted by Maynard Walker (1896–1985), a Kansas-born art dealer. Walker got a Benton self-portrait on to the cover of the Christmas 1934 issue of *Time* magazine and this largely created the image of Regionalism in the public eye; thus, as Robert Hughes writes, 'it became the only art movement ever launched by a mass-circulation magazine', or as Benton put it: 'A play was written and a stage erected for us. Grant Wood became the typical Iowa small towner, John Curry the typical Kansas farmer, and I just an Ozark hillbilly. We accepted our roles.' Benton was the most vociferous of the group and in his autobiography *An Artist in America* (1937) he summed up the attitudes he shared with the other Regionalists: 'We objected to the new Parisian aesthetics which was more and more turning away from the living world of active men and women into an academic world of empty pattern. We wanted an American art which was not empty and we believed that only by turning

the formative processes of art back again to meaningful subject matter, in our cases specifically American subject matter, could we expect to get one.' The fanatically patriotic critic Thomas Craven (1888/9–1969) was an even more strident spokesman for the Regionalists: 'He attacked not only the contemporary French painters but American expatriates, and tossed in New Yorkers for good measure: they were all iniquitous and effete, compared with the artistic renaissance taking place west of the Mississippi. Craven undoubtedly overpraised these painters. Wood and Curry, at least, died unhappy, haunted by the contrast between Craven's claims of greatness for them and their own knowledge of themselves' (E. P. Richardson, *A Short History of Painting in America*, 1963).

On the fringes of the Regionalist movement were Charles *Burchfield and Ben *Shahn. Burchfield's work has a streak of fantasy absent from that of the others, and Shahn was driven by a spirit of social protest. Among the other artists who are sometimes considered part of the movement are painters of the rural scene in other parts of the USA during this period, for example Peter Hurd (1904–84), brother-in-law of Andrew *Wyeth, in New Mexico and Paul Sample (1896–1974) in Vermont. Specifically local styles did not develop anywhere and Regionalism died out in the 1940s in the more international spirit that prevailed during and after the Second World War, although individual artists, notably Benton, continued working in the style long after this (Curry and Wood were both dead by 1946).

Rego, Paula (1935–) Portuguese-born British painter and printmaker. Her parents were Anglophiles and sent her to London, where she studied at the *Slade School, 1952–6. It was at the Slade that she met her husband, the painter Victor Willing (1928–88). They lived in Portugal from 1957 to 1963, divided their time between the two countries from 1963 to 1975, then settled in London.

A Dubuffet exhibition in London in 1960 made a strong impact on Rego, encouraging a freeing of the imagination. Subsequently she made considerable use of collage, frequently cutting up her own drawings as raw material. While her paintings of the 1960s appear abstract, there is an element of figuration deriving from the mechanistic humanoids of *Duchamp and *Ernst. *The Firemen of Alijo* (1966, Tate) was inspired by the sight of firemen in traditional Portuguese coats, huddled

together during an exceptionally cold winter. There are also fighting angels in the picture, derived from medieval art. Her paintings have frequently referred to her Portuguese background under the dictatorship of Salazar—a socially privileged environment, but one which gave little scope for the advancement of women. In a 1991 film she spoke of her distaste for a situation in which wealthy women were admired for how little they did while poor women had to cope with terrible burdens and this is reflected in much of her work. Sometimes the relationship between the genders is portrayed with extraordinary brutality, as in the series dating from 1981 about the red monkey and his wife, in which toy animals enact a cruel saga of domestic violence and betrayal on both sides. These paintings still had a graffiti-like quality which reflected Dubuffet's influence, but her best-known works are closer to *Magic Realism. These again centre on the role of women in society. In some, women engage in domestic tasks—the plucking of a goose, the polishing of a policeman's boot—but seem to hold some sly secret. The most poignant of this series is *The Family* (1988, Saatchi collection): a prone, perhaps lifeless male on a bed is attended to by his wife and daughter who appear to be attempting some kind of revival while a smaller girl prays by a window. The work was made at a time when Willing was dying of multiple sclerosis, which had severely debilitated him for several years. Rego herself has suggested that it be thought of as a Resurrection subject. The religious symbolism, however, is cryptic. In the background a toy theatre has a figure of St Michael slaying the dragon.

From the 1990s onwards Rego's large-scale works tended to be made in pastel. In spite of living in London she has continued to be preoccupied with Portuguese society. One series of works attacks that country's anti-abortion laws. Rego has also made etchings, including a series based on the case of the 'Pendle witches', hanged for witchcraft in the early 17th century. She once said: 'I get inspiration from things that have nothing to do with painting: caricature, items from newspapers, sights in the streets, proverbs, nursery rhymes, children's games and songs, nightmares, desires, terrors.' She is one of the most widely admired painters working in Britain today and her preoccupation with women's experience has made her work of special interest to *feminist critics such as Germaine *Greer (Rego's

1995 portrait of her was commissioned by the National Portrait Gallery), and Marina Warner (1946–). In 1990 she was appointed the first Associate Artist of the National Gallery, London. She painted murals in the restaurant of the gallery's new Sainsbury Wing in 1991, and in 1992 she became the first living artist to be given an exhibition in the gallery.

Further Reading: Serpentine Gallery, *Paula Rego* (1988)

🌐 SEE WEB LINKS

- Paula Rego interview with John Tusa, BBC website.
- Commentary by Elizabeth Manchester on *The Firemen of Alijo*, Tate website.

Rego Monteiro, Vicente do *See* SEMANA DE ARTE MODERNA.

Reid, Alexander *See* HUNTER, LESLIE.

Reid, Jamie *See* SITUATIONIST INTERNATIONAL.

Reid, Sir Norman (1915–2007) British painter (mainly of still-life) and administrator. He was born in London of Scottish descent and studied at Edinburgh College of Art. During the Second World War he served with the Argyll and Sutherland Highlanders. In 1946 he joined the staff of the *Tate Gallery, London; he became deputy director in 1954 and he was director from 1964 until 1979. His appointment was controversial, as other candidates including Lawrence *Gowing and Bryan Robertson (*see* WHITECHAPEL ART GALLERY) had a far stronger public profile. Nonetheless, he deserved some of the credit for the speed with which the Tate responded to and reflected the contentious developments of the late 1960s such as *Conceptual art. During his directorship, a much-needed extension was opened and *Rothko's Seagram murals, now regarded as among the great treasures of the collection, were donated by the notoriously prickly artist. Reid's work at the Tate left him little opportunity for his own painting, but after his retirement he returned to it full-time, and he had his first one-man exhibition in 1991.

Reid, Robert *See* TEN, THE.

Reid Dick, Sir William *See* DICK, SIR WILLIAM REID.

Reinhardt, Ad (1913–67) American painter and writer on art, born in Buffalo, New York, the son of German and Russian immigrants. He studied art history under Meyer *Schapiro at

Columbia University, New York, 1931–5, and in 1936–7 had lessons with the abstract painter Carl *Holty and at the National Academy of Design. From the beginning of his career Reinhardt's work was abstract, but it changed radically in style over the years. During the 1930s he worked in a crisp, boldly contoured geometrical style that owed something to both *Cubism and the *Neo-Plasticism of *Mondrian. In the 1940s he passed through a phase of *all-over painting which has been likened to that of Mark *Tobey, and in the late 1940s he was close to certain of the *Abstract Expressionists, including *Motherwell, with whom he jointly edited *Modern Artists in America* (1950), a book based on conversations with contemporary artists. From 1942 to 1947 he worked as an artist–reporter on the avant-garde newspaper *PM*.

During the 1950s Reinhardt turned to geometric and then monochromatic paintings, influenced by Josef *Albers, with whom he taught at Yale University, 1952–3. At first his monochromatic paintings were usually blue or red, but from the late 1950s he devoted himself to all-black paintings with geometrical designs of squares or oblongs barely perceptibly differentiated in value. From 1960 onwards these paintings were all on five-foot-square canvases with nine almost identical black squares (the colouristic differences are frequently exaggerated in reproduction). Charles Harrison has argued that such paintings were quite deliberately difficult for the casual viewer: he describes *Abstract Painting No. 5* (1962, Tate) as a 'very slow painting', which will 'disclose its colours and the divisions of its surface only to those who attend to it to the exclusion of all else'. The reduction of Reinhardt's work to 'pure aesthetic essences' reflects the painter's belief in the complete separation between art and life—'Art is art. Everything else is everything else.' This purity was hard to maintain. He recalled three occasions when paintings on exhibition were 'marked up', that is to say accidentally damaged by scratching. Irving Sandler writes (*Abstract Expressionism*, 1970): 'In some respects, Reinhardt's intentions resembled those of *Newman, *Still, and *Rothko. Like them, he wanted to create an absolute, timeless, suprapersonal art, and his stance was as moralistic as theirs. Unlike them, however, he renounced extra-aesthetic associations in favor of a purist approach.' His views, indeed, were extremely uncompromising and he was an outspoken critic of the 'false and synthetic forms' (Harri-

son) provided by society as substitutes for the properly consummated experience of art. Such substitutes included the idea of art as self-expression or as a kind of research activity as an aid to industrial design. Not even fellow abstractionists were spared. Barnett Newman once unsuccessfully sued him for libel after being described as 'artist-professor and traveling-design salesman . . . avant-garde-huckster handicraftsman'. His views were entertainingly, if sometimes obscurely, expressed in numerous satirical cartoons. For most of his life he was a somewhat marginalized figure, but he was to be a major influence on *Minimal and *Conceptual art.

Further Reading: C. Harrison, 'Disorder and Insensitivity', in D. Thistlewood (ed.), *American Abstract Expressionism* (1993)

L Lippard, *Ad Reinhardt* (1981)

B. Rose (ed.), *Art-as-Art: The Selected Writings of Ad Reinhardt* (1991)

Reiss, Winold *See* DOUGLAS, AARON.

Rejlander, O. G. (Oscar Gustav) *See* PHOTOMONTAGE.

René, Denise (1919–) French art dealer. She established her first gallery in the Rue La Boétie, Paris, in November 1944, soon after the city was liberated from the Germans, and in the years immediately after the war it was a rallying point for geometrical abstraction at a time when the type of spontaneous abstraction known as *Art Informel was becoming dominant in France. This was typical of René's independence of spirit, for she followed her own interests rather than prevailing fashion (she disparagingly likened Art Informel to 'flaking walls, decomposing flowers, and patches of earth'). In 1955 she mounted probably the most famous exhibition of her career—'Le Mouvement', the show that launched *Kinetic art as a movement. A few years later her gallery became the centre of activities for the *Groupe de Recherche d'Art Visuel, founded in 1960, one of the best-known associations of Kinetic artists. René also took the lead in promoting *Op art in France (indeed *Vasarely, the father of Op art, had been the subject of her first exhibition in 1944). During the 1960s her reputation became international and she organized several shows abroad. In 1966 she opened a second gallery in Paris, located in the Boulevard Saint-Germain, specializing in graphic art and *multiples. This was called the Galerie

Denise René Rive Gauche, while the original became known as the Galerie Denise René Rive Droite. In 1967 and 1971 she opened galleries in Krefeld and New York respectively, but she later closed these, retaining only the Paris galleries. In 2002 the *Pompidou Centre held a special exhibition in her honour.

• Daniel Abadie on Denise René, on the website of the Galerie Denise René.

Renoir, Pierre-Auguste (1841–1919) French painter and (late in his career) sculptor. He was one of the original *Impressionists and is now one of the best loved, for his characteristic subjects—pretty children, flowers, beautiful scenes, above all lovely women—have instant appeal, and he communicated the joy he took in them with great directness. Like several of the other Impressionists he endured great hardship early in his career, but from about 1880 he prospered and by the turn of the century he was internationally famous. In the 1890s he began to suffer badly from rheumatism (worsened when he broke an arm falling from his bicycle in 1897) and from 1903 he lived mainly on the French Riviera for the sake of the warm climate; in 1907 he bought an estate called Les Collettes at Cagnes, near Nice. From 1912 he was confined to a wheelchair, but he continued to paint, his brush pushed between his crippled fingers by his nurse. In the 1880s he had turned from contemporary themes to 'timeless' subjects—particularly nudes, but also young girls in unspecific settings. He also took up mythological subjects (*The Judgement of Paris*, c.1913–14, Hiroshima Museum of Art). His late paintings are typically much hotter in colouring than those of his classic Impressionist days, with very full, rounded forms and supple handling. It was these monumental nudes rather than his Impressionist work that were to be especially influential immediately after his death, matching closely the taste of the *Neoclassical revival.

In 1907 Renoir made his first sculpture and in 1913 he took up the art seriously. By this time he was incapable of manipulating the necessary materials himself, so he directed assistants to act as his hands. The first and most important of the assistants (who was found for Renoir by Ambroise *Vollard) was the Spanish-born Richard Guino (1890–1973), a pupil of *Maillol. (Renoir and Guino parted

company not entirely amicably in 1918, and half a century later—in 1968—Guino successfully sued Renoir's heirs to have his 'co-authorship' of the sculptures he had worked on recognized.) Renoir made about two dozen sculptures in this way, the best known being the bronze *Venus Victorious* (c.1914), a very ample life-size nude, influenced by Maillol (he and Renoir greatly admired each other's work). Casts of the *Venus* are in the Tate collection, at Renoir's home at Cagnes (now the Musée Renoir), and elsewhere.

One of Renoir's sons was the celebrated film director Jean Renoir (1894–1979), who wrote a lively and touching biography published in 1962 in both French and English (*Renoir, My Father*). Some of his films, including *La Fille de l'eau* (1926) and the unforgettable *Partie de campagne* (1936), directly evoke the imagery of his father's paintings.

Further Reading: A. Callen, *Renoir* (1978)

R. Golan, *Modernity and Nostalgia: Art and Politics in France Between the Wars* (1995). For Renoir's influence on French painting.

Renqvist, Torsten (1924–2007) Swedish painter, sculptor, printmaker, and writer on art. He was born at Ludvika, Kopparberg, and studied in Copenhagen and Stockholm. In the 1950s he became recognized as one of his country's leading exponents of *Expressionism on account of his vigorous paintings, with their harshly contrasting colours, and his writings in Swedish art journals, in which he opposed geometrical abstraction. Landscapes expressing the desolate grandeur of the Lafoten Islands were among his characteristic works of this time. In the mid-1960s he began to make sculpture, working with metal and wood in a deliberately crude style that sometimes verged on abstraction. He was also active as a printmaker and it was in this field that he often showed his social commitment, as in his series of etchings *Insurrection*, inspired by the Hungarian uprising of 1956. In 1964 he represented Sweden at the Venice *Biennale and he had a major retrospective at the Moderna Museet, Stockholm, in 1974. He carried out several large public commissions in Sweden, for example the sculpture *Scarecrow* (1971, City Library, Gothenburg).

Repentigny, Rodolphe de See PLASTICIENS.

Repin, Ilya (1844–1930) The most celebrated Russian painter of his day, equally

renowned for his portraits (his sitters included many of his most famous contemporaries) and for his dramatic scenes from Russian history, painted in a colourful, full-blooded style. He became professor of history painting at the St Petersburg Academy in 1894 and was an influential teacher, his pupils including *Serov, *Jawlensky and *Werefkin. Repin had a country estate at Kuokkala (now renamed Repino afer him), which is near St Petersburg but at this time was in Finland. After Finland declared independence from Russia in 1917, he spent the rest of his life cut off from his own country, but he remained a figure of massive authority there. With the imposition of *Socialist Realism in the 1930s he was established as the model and inspiration for the Soviet painter. His home at Repino is now a museum dedicated to him.

Réquichot, Bernard (1929–61) French painter, sculptor, and poet, born in Asnières-sur-Vègres. His family moved to Corbeil, just outside Paris, in 1934. He was educated in religious schools and in 1941 he began making paintings on Christian themes. Later in his career he adopted the form of the reliquary box for certain works. He began studying painting formally in 1947 at the Académie Charpentier, where he met another young painter Jean Criton (1930–), with whom he formed an idealistic association that campaigned for peace and the abolition of national boundaries. After completing his military service, he made his first distinctive paintings: studies of bulls in a geometric manner and an untitled painting of 1952 in which a man confronts a dog of his own height on its hind legs. Such work announced what was to be the prime theme of Réquichot, the disturbing fusion of human, animal, plant, and object. This was realized in a number of ways. Collaged surfaces suggest an eruption of life under the stone, and spiral lines evoke microscopic life forms. Most haunting of all are the sculptures made of curtain rings, curled into spirals, the everyday objects taking on the aspect of nightmare. This vision of the world was shared with other artists with whom he was friendly, Dado (*see* SURREALISM) and Yolande *Fièvre. Réquichot committed suicide by jumping from the window of his Paris studio, 48 hours before the opening of his solo exhibition at the Galerie Daniel Cordier.

Further Reading: Centre Nationale d'Art Contemporain, *Bernard Réquichot* (1973)

Research *See* EXPERIMENTAL ART.

Restany, Pierre (1930–2003) French critic, chiefly known as the ideologist of the *Nouveau Réalisme movement, which he launched with a manifesto in 1960 (he had devised the term earlier that year for an exhibition in Milan). The following year he organized an exhibition of work by the Nouveaux Réalistes at the Galerie J in Paris, run by his wife, Jeanine Restany. It was entitled '40° au-dessus de *Dada' (40 Degrees above Dada), and this offended one of the leading members of the group, Yves *Klein, who disliked having his work—which he regarded as highly spiritual—linked to the anarchy of Dada. Restany had intended to convey the idea that it was necessary to go beyond the nihilism of Dada, that impassioned revolt was no longer appropriate. Instead, artists should 'create a language based on the industrial world of today', which should be regarded not as oppressive, but as a source of poetry. Restany's output included monographs on *César (1976) and Klein (1984), as well as an autobiography, *Une Vie dans l'art* (1983).

Reth, Alfred (1884–1966) Hungarian-born painter who settled in Paris in 1905 and became a French citizen. In 1910 he began exhibiting with the *Cubists, and an exhibition of his work at the *Sturm Gallery in Berlin in 1913 helped to make him 'influential in the rapid diffusion of Cubist ideas in Central Europe before the First World War. He may also have produced between 1909 and 1912 some of the earliest purely abstract drawings' (George Heard *Hamilton). In the 1920s his work was influenced by *Surrealism and in the 1930s he made abstract constructions in wood and metal, calling them *Formes dans l'espace* (he became a member of *Abstraction-Création in 1932). Reth's work is often notable for his experimentation with materials: he incorporated sand, cement, egg-shells, plaster, and pebbles in his paint.

'return to order' *See* NEOCLASSICISM.

Reverdy, Pierre *See* ROSENBERG, LÉONCE.

Reverón, Armando (1889–1954) Venezuelan painter, born in Caracas. Reverón was a strange character but also 'the best Venezuelan painter of the first half of the century' (Edward *Lucie-Smith, *Latin American Art of the 20th Century*, 1993). He was raised in a

foster home in Spain after his parents' marriage broke up. Following a childhood attack of typhoid fever he became melancholic and irascible, and retreated into a private fantasy world for which he found an outlet in his art. In 1908–11 he studied painting at the Academy in Caracas, then went to Spain, where he studied first at the School of Fine Arts, Barcelona, then at the Academy in Madrid. After a trip to Paris in 1915, he returned to Caracas. In 1921 Reverón moved to the coastal town of Macuto with his wife and model Juanita and a monkey; he built a home and studio of wood, palm leaves, and thatch, where he lived and worked in primitive seclusion. His most characteristic paintings are of two main types—local landscapes and nude or semi-nude female figures, singly or in groups. His style was soft-edged and *Impressionistic, somewhat in the manner of *Bonnard, but with colours bleached by the fierce tropical light. Besides Juanita and local types, Reverón used as models life-size rag dolls, which he made himself and posed as if they were real people. In spite of his isolation, his work was widely exhibited (in France and the USA as well as Venezuela) and he won several awards, including a medal at the Paris Exposition Universelle in 1937. His mental instability became increasingly severe and in 1953 he entered a sanatorium, where he died the following year.

Revold, Axel (1887–1962) Norwegian painter, born at Ålesund. He studied in Paris under *Matisse, 1900–10, and in 1919–20 he returned to Paris to learn the technique of fresco, having won a competition for the mural decoration of the Exchange in Bergen. This he carried out in 1921–3, and it was the first of a number of commissions in which he led a revival of fresco painting in Norway; others included the library of Oslo University (1933) and the New Town Hall in Oslo, a very large scheme (begun 1938) on which he collaborated with Alf *Rolfsen and other artists. In both his frescos and his easel paintings, Revold's style was influenced by the strong colours of Matisse and to a lesser extent by *Cubism. His favourite subjects were Norway's countryside and everyday life. He was a professor at the Academy in Oslo, 1925–46, and its director, 1935–46.

Révolution surréaliste, La *See* SURREALISM.

Rewald, John *See* BARNES, ALBERT C.

Reynolds-Stephens, Sir William *See* NEW SCULPTURE.

Rhythm Group A group of British and American painters working in Paris in the circle of J. D. *Fergusson in the years immediately before the First World War and influenced by the bright colours of *Fauvism. The name comes from the magazine *Rhythm* (1911–13), of which Fergusson was art editor. Among the members of the group was the American-born painter Anne Estelle Rice (1877–1959), who lived in Paris from 1906 to 1911, then settled in England. Fergusson painted several portraits of her, including *Blue Beads* (1910, Tate). The group exhibited together at the Stafford Gallery, London, in 1912.

The Rhythm (RTYM) Group was also the name of an association of Polish artists, active formally from 1922 to 1932 and informally for several years after its disbandment. The group had no clear artistic policy but was associated particularly with the *Art Deco style (the members produced a good deal of commercial design as well as paintings).

Rice, Anne Estelle *See* RHYTHM GROUP.

Rice, John Andrew *See* BLACK MOUNTAIN COLLEGE.

Richards, Ceri (1903–71) British painter, printmaker, designer, and maker of reliefs, born at Dunvant, near Swansea, into a Welsh-speaking family (he did not learn English until he was about five or six). From his father, a tin-plate worker, he inherited a love of music and poetry, which often inspired his work. Richards was apprenticed as an electrician before studying at Swansea School of Art, 1921–4, and the *Royal College of Art, London, 1924–7. He lived in London for the rest of his life except during the Second World War, when he was head of painting at Cardiff School of Art (earlier he had taught at Chelsea School of Art and later he taught successively at Chelsea, the *Slade School, and the RCA until 1960). In 1934 he exhibited with the *Objective Abstractionists and in 1936 at the International Surrealist Exhibition in London. He said that *Surrealism 'helped me to be aware of the mystery, even the "unreality", of ordinary things', and at this time he was also strongly influenced by *Picasso, notably in a series of semi-abstract relief constructions begun in 1933. After the Second World War his painting drew inspiration from the large

exhibition of Picasso and *Matisse at the Victoria and Albert Museum in 1945. His best-known works include the *Cathédrale engloutie* series, based on a Debussy prelude (which Richards used to play on the piano) and '*Do not go gentle into that good night*' (1956, Tate) based on a poem by Dylan Thomas (whom he once met). Richards's work also included book illustrations, theatre designs, mural decorations for ships of the Orient line, and designs for stained glass and furnishings for the Blessed Sacrament Chapel in Liverpool Roman Catholic Cathedral (1965).

His wife, **Frances Richards**, née Clayton (1903–85), a fellow student at the RCA whom he married in 1929, was a painter, printmaker, illustrator, and pottery designer (she came from Stoke-on-Trent, heart of the British pottery industry). She taught at Camberwell School of Art, 1928–39, and Chelsea School of Art, 1947–59.

Further Reading: M. Gooding, *Ceri Richards* (2002)

Richardson, Sir Albert *See* ROYAL ACADEMY OF ARTS.

Richardson, John (1924–) British writer, editor, art dealer, and lecturer. Originally he trained to be a painter, studying at the *Slade School. In 1949 he moved to France, where he lived with Douglas *Cooper in the Château de Castille, near Avignon, which they turned into a private museum of *Cubist art. Richardson became a friend of several leading artists, above all *Picasso, whom he saw regularly during the 1950s: 'I had already envisaged writing a book about him, and so, whenever possible, I noted down his answers to my questions, as well as scraps of his conversation.' After quarrelling with Cooper (as many people did), Richardson settled in New York, where he worked for Christie's, 1964–72, and subsequently for other leading firms in the art trade. From 1981 to 1991 he was editor-at-large of *House and Garden*, and from 1990 to 1994 he was contributing editor to *Vanity Fair*. In 1995–6 he was Slade professor of fine art at Oxford University. Richardson's literary output has included brief but highly regarded monographs on Manet (1958, revised edn 1982) and *Braque (1959, in the 'Penguin Modern Painters' series), as well as various articles, but all his previous writings have been overshadowed by his magisterial *Life of Picasso*, the first volume of which (covering the period up to 1906) appeared in 1991.

This was immediately acclaimed not only as the essential source on Picasso's early life, but also as one of the most impressively thorough biographies ever devoted to a major artist. The second volume (1907–17) was published in 1996 and the third (1917–32) appeared in 2007.

Richier, Germaine (1902–59) French sculptor, born at Grans, near Arles, the daughter of a vineyard owner. She had a traditional training as a carver, studying first at the École des Beaux-Arts, Montpellier, 1922–5, and then privately under *Bourdelle in Paris, 1925–9. However, from about 1940 she began to create a distinctive type of bronze sculpture. Her figures became long and thin, combining human with animal or insect (and sometimes vegetal) forms. The surfaces of these powerful and disquieting works have a tattered and lacerated effect, creating a macabre feeling of decomposition, and she was one of the pioneers of an open form of sculpture in which enclosed space becomes as important and alive as the solid material. Such figures were extremely difficult to cast and she showed great technical resourcefulness in bringing them to completion. The public sometimes found her work shocking, especially her *Crucified Christ* (1950, church of Notre-Dame-de-Toute-Grâce, Assy), which caused a storm of controversy. Nevertheless, her international prestige grew steadily in the postwar years and in 1951 she won the Sculpture Prize at the São Paulo *Biennal. In 1947 she began to make engravings, from 1951 she made a few sculptures with coloured backgrounds painted by Hans *Hartung or other artists, and in the last two years of her life she took up painting herself. She died of cancer. Her first husband, whom she married in 1929, was the Swiss sculptor Otto Bänninger (1897–1973) and during the Second World War she lived in Switzerland; her second husband, whom she married in 1955, was the French writer René de Soulier, whose books include *L'Art fantastique* (1961).

Richmond, Sir William Blake *See* FRY, ROGER.

Richter, Gerhard (1932–) German painter, born in Dresden. After working as an advertisement and stage painter he studied at the Academy in Dresden, 1952–6. In 1961 he moved to West Germany and studied at the Academy in Düsseldorf, 1961–3. He recalled that one of the factors which encouraged him

to move was the 'sheer brazenness' of the paintings by *Pollock and *Fontana he saw at the 1959 *documenta. In 1963 he participated in an event entitled *Manifestation for Capitalist Realism*. This was a kind of combination of a *Happening and an art exhibition, held in a furniture store. Visitors were given numbers, told to 'report' to the address at 8 pm, and instructed to see the work when called in strict rotation. Richter's subsequent report on the event stated that by 8.30 the instructions were being ignored and everyone crowded into the room. He had already begun making paintings from found photographs. Unlike most *Photorealist paintings, these emphasize the imprecision of photography as a medium rather than its capacity for revealing detail. *The Gizeh Sphinx* (1964) is taken from a photograph in an old book which appears to have been retouched by hand for reproduction purposes. Combined with the weathering of the sphinx itself over 4,500 years, this produces a strange mixture of exactitude and mystery underlined by the prosaic gesture of including the illustration's original caption. *Administration Building* (1964) is a blurred image of a gaunt structure, reminiscent of the East Germany he had left. Richter has applied this method to many subjects. In 1975 he made a series of paintings from magazine photographs from blow-ups of an amateur cine film of the death of a tourist who left his car in a safari park and was eaten alive by a lion. The disturbing event becomes distanced by the process and, without knowledge of the story, the images are hard to decipher. The most famous of Richter's paintings of this kind are the series he exhibited in 1989 from photographs of the bodies of members of the Red Army Faction, the German terrorist organization, who had been found hanged in their prison cells. The official story that this was suicide has still not received universal assent, but Richter's paintings of the event are not obviously polemical. The artist summed up his own feelings in an interview by saying, 'We're always both: the State *and* the terrorist.' In the catalogue of the 2007 documenta Kaja Silverman pointed out the visual echoes between the dead terrorists and the tender portrait of his daughter Betty made in 1977, the year of the events commemorated by the artist twelve years later. Richter has described the difference between photography and painting by saying that the former provokes horror and the latter grief.

Richter has deliberately avoided being identified too closely with any personal style and has also made abstract paintings. Sometimes these are constructed on a system, as in *No 350/1* (1973). This is a grid of 1,024 panels in different tones. The number was chosen by a process of multiplication by four $(4 \times 4 = 16, \times 4 = 64,$ and so forth). Beyond a certain number of tones the division between one and another would no longer be clear. Each tone is painted just once, but there is an element of randomness. Richter calculated that to use every combination would have taken him over 400 billion years. In other works, he has applied a similar technical virtuosity to abstraction as he has to figuration. In some pictures, paint is scraped across a large canvas to suggest a scratched mirror and produces an effect of a multi-layered surface (*St John*, 1988, Tate).

The difficulty Richter has created for anyone who attempts to pin down his style reflects his attempt to reject any ideology. His interest in the Red Army Faction, he has explained, was not the result of any sympathy with their thinking but with 'the why and wherefore of an ideology that has such an effect on people'. His outlook may result from his contempt for the rigid artistic system of East Germany where he spent his youth. He described art there as 'A painting which creates nothing; which simply makes variations on what GDR cultural policy makes available for the purpose—namely the so-called cultural heritage'. Not even a painter such as Werner *Tübke, admired in the West but described by Richter as 'phoney', was exempt. The contempt was extended to those artists in West Germany who 'lurk as parasites' in the academy. Although Richter himself has worked as a teacher, such an attitude links him to younger German artists such as *Kippenberger who sought to build careers outside the academic framework. Richter's enormous status in the art world may be a result of his technical skill and inventiveness, but it also owes something to the way in which his theory and practice manifest a sense of the limitations of art or ideology to transform society. This accords with a certain contemporary pragmatism; in this respect Richter provides the greatest possible contrast to Germany's previous artistic hero, Joseph *Beuys. For Richter, 'Art is human only in the absolute refusal to make a statement'.

Further Reading: G. Richter, *The Daily Practice of Painting* (1995)

Tate Gallery, *Gerhard Richter* (1990)

Richter, Hans (1888–1976) German-born painter, sculptor, film-maker, and writer who settled in the USA in 1941 and became an American citizen. He was born in Berlin and studied at the Academy there and at the Academy in Weimar. In his early work he was involved with various avant-garde movements and after being wounded and discharged from the German army in 1916 he moved to Switzerland, where he became a member of the Zurich *Dada group. In 1918 he began collaborating with *Eggeling on abstract 'scroll' drawings, which presented sequential variations of a design on long rolls of paper. After quarrelling in 1921, each of them extended their experiments independently into film, and Richter's *Rhythmus 21* (1921) is generally regarded as the first abstract movie. In 1920 Richter moved back to Germany, where he founded the *Constructivist periodical *G* in Berlin in 1923. From 1932 to 1941 he lived in Switzerland and France, then moved to the USA. In 1942 he became head of the Institute of Film Techniques at the City College of New York, retiring in 1956. His later films included *Dreams that Money Can Buy* (1944–6), which is *Surrealist in style, made up of sequences by himself, Alexander *Calder, Marcel *Duchamp, Max *Ernst, Fernand *Léger, and *Man Ray. He also made a film about Calder's work (1963). Richter continued to paint, his later works featuring rhythmic effects of movement over large canvases. He wrote several books on film and art, notably *Dada: Kunst und Anti-Kunst* (1964), translated as *Dada: Art and Anti-Art* (1965).

Ricketts, Charles (1866–1931) British painter, designer, sculptor, collector, and writer on art. He was born in Geneva to an English father and a French mother and brought up mainly in France and Italy. In 1882 he began studying wood engraving at Lambeth School of Art and there met fellow student Charles *Shannon, who became his lifelong companion. They lived first in Kensington and Chelsea (at this time a cheap area of London) and moved to Richmond (1898), Holland Park (1902), and finally St John's Wood (1923) as their fortunes improved. Ricketts initially made his mark in book production, first as an illustrator, then as the driving force behind the Vale Press (1896–1904), one of the finest private presses of the day, for which he designed founts, initials, borders, and illustrations. After the closure of the press (following

a disastrous fire), Ricketts turned to painting and occasional sculpture, and in 1906 he began to make designs for the theatre. His paintings—typically rather melodramatic, heavy-handed figure subjects—have not worn well, but his colourful stage designs are still much admired. He had a great reputation as an art connoisseur and in 1915 turned down the offer of the directorship of the National Gallery. Later he regretted this decision, but he served as adviser to the National Gallery of Canada in Ottawa (1924–31).

Further Reading: J. Darracott, *The World of Charles Ricketts* (1980)

Rickey, George (1907–2002) American painter, sculptor, and writer on art, born at South Bend, Indiana, the son of an engineer. In 1913 he moved with his parents to Scotland and he took a degree in history at Balliol College, Oxford, in 1929. Before returning to the USA in 1930 he also studied art at the Ruskin School, Oxford, and under *Lhote in Paris. In the USA he taught at various universities, while continuing to keep in touch with Europe through visits. Until he was in his early 40s he was primarily a painter, his work including murals for Olivet College, Michigan, and the Post Office at Selinsgrove, Pennsylvania. In 1949, however, he began to make *mobiles, and thereafter he devoted most of his energies to this type of *Kinetic sculpture. He worked first in glass and then from 1950 in metal, usually stainless steel. Originally he used simple rod-like forms, then in 1965 he began experimenting with planes based on regular forms such as the rectangle or cube—with 'emphasis on surfaces rather than lines'. His sculptures are often designed to be situated out-of-doors and usually rely on air currents to set them in motion. He had numerous public commissions in the USA and elsewhere. His writings include the book *Constructivism: Origins and Evolution* (1967); this was once regarded as a standard work on the subject, although its use of the term would now be regarded as so wide-ranging as to be confusing.

Rietveld, Gerrit See STIJL, DE.

Riley, Bridget (1931–) British painter and designer, rivalled only by *Vasarely as the most celebrated exponent of *Op art. She was born in London and studied there at *Goldsmiths College, 1949–52, and the *Royal

College of Art, 1952–5. Her interest in optical effects came partly through her study of the *Neo-Impressionist technique of pointillism, but when she took up Op art in the early 1960s she worked initially in black and white. She turned to colour in 1966. By this time she had attracted widespread attention (one of her paintings was used for the cover to the catalogue of the exhibition 'The Responsive Eye' at the *Museum of Modern Art, New York, in 1965, the exhibition that put Op art on the map), and the seal was set on her reputation when she won the International Painting Prize at the Venice *Biennale in 1968.

Riley's work shows a complete mastery of the effects characteristic of Op art, particularly subtle variations in size, shape, or placement of serialized units in an overall pattern. It is often on a large scale and she frequently makes use of assistants for the actual execution. Although her paintings often create effects of vibration and dazzle, she has also designed a decorative scheme for the interior of the Royal Liverpool Hospital (1983) that uses soothing bands of blue, pink, white, and yellow and is reported to have caused a drop in vandalism and graffiti. She has also worked in theatre design, making sets for a ballet called *Colour Moves* (first performed at the Edinburgh Festival in 1983); unusually, the sets preceded the composition of the music and choreography. Riley has travelled widely (a visit to Egypt in 1981 was particularly influential on her work, as she was inspired by the colours of ancient Egyptian art) and she has studios in London, Cornwall, and Provence. She writes of her work: 'My paintings are not concerned with the Romantic legacy of Expressionism, nor with Fantasies, Concepts or Symbols. I draw from Nature, although in completely new terms. For me Nature is not landscape, but the dynamism of visual forces—an event rather than an appearance—these forces can only be tackled by treating colour and form as ultimate identities, freeing them from all descriptive or functional roles.'

Further Reading: P. Moorhouse, *Bridget Riley* (2003)

Rilke, Rainer Maria *See* BALTHUS.

Rimbert, René *See* NAIVE ART.

Ringgold, Faith (née **Jones**) (1930–) American painter, sculptor, *Performance artist, *Fibre artist, lecturer, and writer whose work has been much concerned with black and feminist issues. She was born in New York, where she studied at City College under *Gwathmey and *Kuniyoshi, completing her studies in 1959 after having two children. During the 1960s her paintings often depicted the oppression of blacks, using bold, strongly coloured, stencil-like shapes, as in *Die* (1967, artist's collection), a huge scene of a street riot. She sometimes used the American flag as a background and was prosecuted for desecrating it. Since 1970 she has been primarily concerned with feminist issues, campaigning vigorously and successfully for greater representation of women artists in exhibitions at venues such as the *Whitney Museum of American Art. She was one of the organizers of the exhibition 'Where we at' in New York in 1971, which was the 'first group show of professional black women artists in known history'. In the early 1970s she painted a large mural, depicting successful women, in the women's prison on Riker's Island, New York, but she then changed her way of working and from 1973 began to produce fabric figures, through which she hoped to reach a wider audience than through painting (they were made easily portable, so they could be used in her lectures and performances). She used traditional African craft techniques and said 'I emulate the nameless women who worked with paint and dyes, yarn and cloth and other soft and impermanent materials'. In the late 1970s she began making 'story-quilts', collaborating with her mother Willy Posey, a dress designer.

Riopelle, Jean-Paul (1923–2002) Canadian painter, sculptor, and graphic artist. Riopelle was considered the leading Canadian abstract painter of his generation, although he spent most of his career in Paris. He was born in Montreal, where he had lessons with a local painter, Henri Bisson, from the age of six. His early works were landscapes, but he turned to abstraction under the influence of *Borduas and became a member of his group Les *Automatistes in 1946 before settling in Paris in 1947. *Breton, *Mathieu, and *Miró gave him encouragement in his early days there. He had his first one-man show in 1949, at the Galerie Nina Dausset, Paris, and many others followed in the 1950s as he built up an international reputation. His paintings of the late 1940s were in a lyrical manner, but in the 1950s his work became tauter, denser, and more powerful, the paint often applied

with a palette knife, creating a rich mosaic-like effect (*Pavane*, 1954, NG, Ottawa). Later his handling became more calligraphic. Riopelle was a prolific artist and at home in various media: he worked in watercolour, ink, crayon, and chalk, as well as oil, and also produced prints (etchings and lithographs), sculpture, and huge collage murals. In spite of his long residence in France, he kept up a close association with his native country: in 1962 he represented Canada at the Venice *Biennale, where he was awarded the UNESCO prize, and after 1970 he spent a good deal of time in Montreal. After the death of his companion, the painter Joan *Mitchell, in 1992, he made his last major work, a series of thirty panels stretching to about 40 metres, painted with aerosol, *Homage to Rosa Luxemburg* (Musée du Quebec).

Rippl-Rónai, Josef See NABIS.

Rissanen, Juho (1873–1950) Finnish painter and graphic artist. His training included periods of study as a private pupil of *Schjerfbeck and under *Repin at the St Petersburg Academy. He had his first one-man exhibition in 1897 and thereafter his work was widely exhibited in Finland, where he was a member of the November group (*see* SALLINEN), and elsewhere (his work won a bronze medal at the Paris World Fair of 1900). Until 1908, when he first visited Paris, Rissanen concentrated on Finnish peasant subjects, based on his childhood environment. These are considered his finest works, depicting life's fateful procession with power and dignity. Subsequently, under a variety of international influences, his work gained in urbanity what it lost in force and originality. Among his public commissions were murals for Helsinki's City Library (1909) and National Theatre (1910) and for the Museum at his birthplace Kuopio (1928). Between the two world wars Rissanen lived mainly in Paris, and in 1939 he emigrated to the USA, settling in Florida, where he died.

Rist, Pipilotti (1962–) Swiss *Video and *installation artist, born in Rheintal. Born Charlotte Rist, she changed her name to Pipilotti in 1986, the year she began studying video at Basle College of Design, as a reference to the popular children's book *Pipi Longstocking*. Her colourful work draws on popular culture, and in Switzerland and Germany she has attained something of the status of a pop star. *I'm not the girl who misses much* (1986)

shows the artist dancing ecstatically to the distorted singing of a John Lennon song. When a little over half-way through the actual voice of Lennon is heard, the warmth of the sound has an overwhelming impact. The original words are '*You're* not the girl who misses much': Rist has dramatized the effect of music on the psyche in a remarkably original manner. *Ever is Over All* (1997, MoMA, New York), projected on two screens across the corner of a room, is described by Michael Rush as 'a life-affirming breezy feminist tract'. On one screen there are shots of flowers, on the other there is a city street. Down this strides Rist in a flowing dress carrying a stick with flowers at the end, revealed to be a metal club when she uses it to smash car windows. Rist is also a rock singer with the band Les Reines Prochaines.

Further Reading: A. Seleanu, 'Pipilotti Rist at the outer frontiers of video', *Artfocus/69* (August 2000)

Rivera, Diego (1886–1957) Mexican painter, the most celebrated figure in the revival of monumental fresco painting that is his country's most distinctive contribution to modern art. He was born in Guanajuato, to educated parents of liberal views. In 1892 the family moved to Mexico City, and in 1896 Rivera enrolled in evening classes at the Academy of San Carlos whilst still at school. He became a full-time student there two years later; one of his teachers was Dr *Atl. In 1907 he went to Madrid on a four-year scholarship. He visited Paris in 1909 and after a brief return to Mexico he settled there from 1911 to 1920. During this time he became one of the lions of café society and was friendly with many leading artists. He became familiar with modern movements, but although he made some early experiments with *Cubism, for example, his mature art was firmly rooted in Mexican tradition. At about the time of the Russian Revolution he had become interested in politics and in the role art could play in society. In 1920–21 he visited Italy to study Renaissance frescos (already thinking in terms of a monumental public art), then returned to his homeland, eager to be of service to the Mexican Revolution.

In 1920 Alvaro Obregón, an art lover as well as a reformist, had been elected president of Mexico, and Rivera, who was an extremely forceful personality, swiftly emerged as the leading artist in the programme of murals he initiated glorifying the history and people of the country in a spirit of revolutionary fervour. Many examples of his work are in public

buildings in Mexico City, and they are often on a huge scale, a tribute to his enormous energy. His first mural, the allegorical *Creation*, was painted for the National Training School in 1922. His most ambitious scheme, in the National Palace, covering the history of Mexico, was begun in 1929; it was still unfinished at his death, but it contains some of his most magnificent work. Rivera's murals were frankly didactic, intended to inspire a sense of nationalist and socialist identity in a still largely illiterate population; their glorification of creative labour or their excoriation of capitalism can be crude, but his best work has immense vigour and shows formidable skill in choreographing the incident- and figure-packed compositions, in combining traditional and modern subject-matter, and in blending stylized and realistic images.

In 1927 Rivera visited the Soviet Union and in 1930–34 he worked in the USA, painting several frescos that were influential on the muralists of the *Federal Art Project. His main commission in America was a series on *Detroit Industry* (1932–3) in the Detroit Institute of Arts; another major mural, *Man at the Crossroads* (1933), in the Rockefeller Center, New York, was destroyed before completion because he included a portrait of Lenin. It was replaced with a mural by *Brangwyn. Throughout his career Rivera also painted a wide range of easel pictures, in some of which he experimented with the encaustic (wax) technique. There is a museum of his work at Guanajuato.

Rivera was an enormous man (standing over 6 feet and weighing over 20 stones), and although he was notoriously ugly he was irresistibly attractive to women. He had numerous love affairs and was married three times, his second wife (and his third, for they divorced and remarried) being the painter Frida *Kahlo. Her parents said 'it was like a marriage between an elephant and a dove', and a biographer wrote: 'Part of his appeal was his monstrous appearance—his ugliness made a perfect foil for the type of woman who likes to play beauty to a beast—but the greater attraction was his personality. He was a frog prince, an extraordinary man, full of brilliant humour, vitality, and charm.'

Further Reading: D. Rochfort, *Mexican Muralists* (1998)

Rivera, José de (1904–85) American abstract sculptor, born at West Baton Rouge, Louisiana. Before taking up art he worked in industry as a machinist, blacksmith, and tool and die maker, and he brought to his sculpture consummate skills in metalworking. He studied at night classes at the Studio School, Chicago, 1929–30, and began making sculpture in 1930. In 1931–2 he travelled in Europe (where he was impressed by the work of *Brancusi) and Egypt, then settled in New York. He worked for the *Federal Art Project, 1937–8, his work under its auspices including a sculpture entitled *Flight* (1938) for Newark Airport, New York. In 1938 he began making completely abstract sculpture using curved metal sheets, which he sometimes painted. His first one-man show was at the Mortimer Levitt Gallery, New York, in 1946. From the mid-1950s his most characteristic works featured very elegant flowing linear forms in highly polished metal. Some of them were designed to be exhibited on slowly rotating turntables, for example *Construction No. 67* (1959, Tate). In 1961 he said: 'What I make represents nothing but itself. My work is really an attempt to describe the maximum space with the minimum of material.'

Rivera, Manuel *See* EL PASO.

Rivers, Larry (1923?–2002) American painter, sculptor, graphic artist, and designer, regarded as one of the leading figures in the revival of figurative art that was one aspect of the reaction against the dominance of *Abstract Expressionism. Born in New York as Yitzrock Loiza Grossberg, he changed his name in 1940 when he embarked on a career as a jazz saxophonist. In 1942–43 served in the US Army Air Corps, before being discharged on medical grounds. He began painting in 1945 after seeing a painting by *Braque, studying at the Hans *Hofmann School, 1947–8, and at New York University under *Baziotes, 1948. In 1950 he had a long stay in Paris, where he was impressed not by the masters of early modernism he expected to admire but by 19th-century painting. He recalled in his autobiography: 'Cubism told a young man from the Bronx he didn't know very much. Cubism didn't know about him or his nights walking all over Greenwich Village with his big horn slung over his shoulder...Cubism certainly didn't smoke pot or get high, Cubism was history in which he played no part.' His work of the early and mid-1950s continued the vigorous painterly handling associated with Abstract Expressionism, but was very different

in character. Some of his paintings were fairly straightforwardly naturalistic, like the powerful and frank nude study of his mother-in-law, *Double Portrait of Berdie* (1955, Whitney Museum, New York), but others looked forward to *Pop art in their quotations from well-known advertising or artistic sources, their use of lettering, and their deadpan humour. An example is *Washington Crossing the Delaware* (1953, MoMA, New York), based on the famous painting by the 19th-century German-American painter Emanuel Gottlieb Leutze, one of the icons of American history. This was a provocative gesture on a number of levels. Any suggestion of mockery of the heroic theme was suspect to a wider public during the patriotic fervour of the period. Yet Rivers, who had written to his close friend Frank O'Hara that he had intended to paint 'the most controversial painting of our time', maintained that the public were less outraged than his fellow painters, who christened the work '*Pascin crossing the Delaware'. Barbara Rose has commented that this work is not just the progenitor of Pop but shows Rivers as the last great history painter. In the late 1950s and 1960s his work came more clearly within the orbit of Pop, sometimes incorporating cut-out cardboard or wooden forms, electric lights, and so on, but his sensuous handling of paint set him apart from other American Pop artists, and indeed some standard histories of the subject consider him of marginal significance to the movement. Rivers also made sculpture, collages, and prints, designed for the stage, acted, and wrote poetry. His autobiography, *What did I do?*, was published in 1992.

Further Reading: B. Rose, 'What he did: Barbara Rose on Larry Rivers', *Artforum International* (November 2002)

Roberts, Tom (1856–1931) British-born Australian painter. He was the most important figure in introducing *Impressionism to Australia and he is regarded as the father of the country's indigenous tradition of landscape painting. In 1869 he emigrated from England with his widowed mother; they settled in Melbourne, where he studied at the National Gallery of Victoria's School of Art, 1874–81, while working as a photographer's assistant. In 1881 he returned to England to study at the *Royal Academy, and during a walking tour of Spain in 1883 he first acquired some knowledge of Impressionism through meeting artists who had studied in Paris. Roberts returned to Mel-

bourne in 1885 and was soon the leading figure of the *Heidelberg School, whose work was based on open-air painting. As well as landscapes (and portraits—with which he earned a major part of his living), Roberts painted scenes of rural genre and history (including outlaw life), in which his 'imagination runs parallel to the prevalent tone of Australian writing in the nineties ... [celebrating] ... virtues of mateship, courage, adaptability, hard work and resourcefulness ... Their use indicates a growing sense of cultural identity. These virtues were thought distinctively— even uniquely—Australian' (Robert *Hughes, *The Art of Australia*, 1970).

In 1903 Roberts returned to London, where he completed his most prestigious commission, the enormous *Opening of the First Commonwealth Parliament* (1901–3, British Royal Collection, on loan to High Court of Australia, Canberra). Many find that its size is equalled by its dullness and Roberts himself felt that after it he went through a 'black period' of depression and artistic uncertainty. However, he continued to enjoy reasonable success in Europe, exhibiting his work at the *Royal Academy, the Paris Salon, and elsewhere. He did not return permanently to Australia until 1923, when he settled at Kallista, near Melbourne.

Roberts, William (1895–1980) British painter, chiefly of figure compositions and portraits. He was born in London and had his main training at the *Slade School, 1910–13. After travelling in France and Italy, he worked briefly for the *Omega Workshops, then in 1914 joined the *Vorticist movement, signing the manifesto in the first number of *Blast*. His style at this time showed his precocious response to French modernism and was close to that of *Bomberg in the way he depicted stiff, stylized figures through geometrically simplified forms. After the First World War (in which he served in the Royal Artillery and as an *Official War Artist) his forms became rounder and fuller in a manner reminiscent of the 'tubism' of *Léger. Often his paintings showed groups of figures in everyday settings. As such he became something of a chronicler of British life. For instance *Cinema* (1920) was an update of the music hall subjects so beloved of *Sickert. However, his most famous work is *The Vorticists at the Restaurant de la Tour Eiffel: Spring 1915* (1961–2, Tate), an imaginative reconstruction of his

former colleagues celebrating at a favourite rendezvous to mark the publication of the first issue of *Blast*. In response to the exhibition 'Wyndham *Lewis and the Vorticists' at the Tate Gallery in 1956, Roberts wrote a series of pamphlets (1956–8) disputing Lewis's claim (in the catalogue introduction) that 'Vorticism, in fact, was what I, personally, did, and said, at a certain period.' He remained active as a painter as well as a controversialist, working until the day of his death.

Further Reading: A. G. Gibbons, *William Roberts: an English Cubist* (2005)

Roberts, Winifred *See* NICHOLSON, BEN.

Robertson, Bryan *See* WHITECHAPEL ART GALLERY.

Robinson, William Heath (1872–1944) British cartoonist, illustrator, and writer, born in London, son of an illustrator and wood engraver, Thomas Robinson. He studied at Islington School of Art and briefly at the *Royal Academy (1890). Initially he tried to make a career as a landscape painter, but failing to make much progress in this, he went into book illustration, following his father and his two elder brothers, **Charles Robinson** (1870–1937) and **Thomas Heath Robinson** (1869–1950). He illustrated a great variety of material, including John Bunyan and Shakespeare, and in his early work had a strong line in grotesque horror, notably in a two-volume edition of the complete works of Rabelais (1904). However, he became best known for his humorous work, in particular for his drawings of absurdly ingenious machinery designed to perform inappropriately trivial tasks such as shuffling cards or serving peas. The phrase 'Heath Robinson', used to describe eccentric machinery, had entered the language by the First World War (the earliest citation in the *Oxford English Dictionary* is of 1917). His other books include an autobiography, *My Line of Life* (1938), *Let's Laugh: A Book of Humorous Inventions* (1939), and *Heath Robinson at War* (1942). Although he could hardly be described as a modernist, his fantastic machines find echoes in the work of *Dadaists such as *Duchamp and *Picabia as well as more recent artists including Wim *Delvoye, *Fischli and Weiss, and Rebecca *Horn.

Roca Rey, Joaquín (1923–2004) Peruvian sculptor, born in Lima, where he studied at the National School of Fine Arts. Between 1948

and 1952 he lived in Europe, exhibiting in Florence, Madrid, Paris, and Rome. On his return to Peru, he became his country's leading artist in introducing modern trends in sculpture, his figures being influenced by the simplified rounded forms of *Arp and Henry *Moore. He worked in a variety of materials, including metal, stone, and wood, and had numerous public commissions, including the figure of Simón Bolívar (1970) at the University of Caracas.

ROCI *See* RAUSCHENBERG, ROBERT.

Rockefeller, Abby Aldrich (1874–1948) American collector and patron, born Abby Aldrich in Providence, Rhode Island. In 1901 she married **John D. Rockefeller Jr** (1874–1960), son of the immensely wealthy founder of Standard Oil. She had broad artistic interests, but in the 1920s she began to specialize in modern painting, collecting work by *Cézanne, *Matisse, *Picasso, and numerous American artists, among them *Demuth, *Hopper, and *O'Keeffe. In 1928 she staged an exhibition in her New York home of the work of George Overbury 'Pop' Hart (1869–1933), a colourful bohemian figure who made impromptu pictures of scenes observed on his travels, and the show belatedly established his reputation. The following year she was one of the founders of the *Museum of Modern Art, New York. She was its first Treasurer and gave generous financial support; MoMA acknowledged her great contribution to its early development by naming its Print Room (1949) and Sculpture Garden (1953) after her. She supported various other cultural institutions, and during the Depression she helped several artists, including *Shahn and *Sheeler, by giving them commissions. Her husband was also greatly interested in art, although mainly in earlier periods (he provided the funds for the Metropolitan Museum, New York, to buy the medieval collection of George Grey *Barnard). His most notable contribution to 20th-century art was commissioning Rockefeller Center, New York, a huge office complex (begun 1929) featuring some superb *Art Deco interiors and Paul *Manship's famous figure of *Prometheus* which overlooks the skating rink. **Blanchette Hooker Rockefeller** (Mrs John D. Rockefeller III) (1909–92), the daughter-in-law of Abby and John, was also a collector, mainly of contemporary work, and patron. On a visit to

r

Japan in 1959 she bought sculptures by Masayuki *Nagare, and his first visit to the USA in 1962 was made at her invitation. From 1959 to 1965 she was president of the Museum of Modern Art.

Rockwell, Norman (1894–1978) American illustrator and painter, born in New York. He left school at sixteen to study at the *Art Students League and by the time he was eighteen was a full-time professional illustrator. In 1916 he had a cover accepted by *The Saturday Evening Post*, the biggest-selling weekly publication in the USA (its circulation was then about 3 million), and hundreds of others followed for this magazine until it ceased publication in 1969. He also worked for many other publications. Rockwell's subjects were drawn from everyday American life and his style was anecdotal, sentimental, and lovingly detailed: he once described his pictorial territory as 'this best-possible-world, Santa-down-the-chimney, lovely-kids-adoring-their-kindly-grandpa sort of thing'. Such work brought him immense popularity, making him a household name in the USA, indeed something of a national institution: in 1943 an exhibition of his work raised more than $100 million for war bonds, and his books, such as *Norman Rockwell, Illustrator* (1946) and *Norman Rockwell, Artist and Illustrator* (1970), were bestsellers (the latter is said to have sold over 50,000 copies in six weeks at $60 a copy). For most of his career critics dismissed his work as corny, but late in life he began to receive serious attention as a painter. In his later years, too, he sometimes turned to more weighty subjects, producing a series on racism for *Look* magazine, for example. From 1953 until his death he lived at Stockbridge, Massachusetts, where a large museum of his work opened in 1993.

Rodchenko, Alexander (1891–1956) Russian painter, sculptor, industrial designer, and photographer, one of the leading *Constructivists. He was born in St Petersburg and studied at the art school at Kazan, 1910–14, then at the Stroganov Art School in Moscow. After the 1917 Revolution he was one of the leading spirits in *Narkompros and *Inkhuk. His artistic evolution was rapid, as he moved from *Impressionist pictures in 1913 to pure abstracts, made with a ruler and compass, in 1916. He was influenced by *Malevich's *Suprematism, but was without Malevich's mystical leanings, and he coined the term '*Non-Objective' to describe his own more

scientific outlook; his *Non-Objective Painting: Black on Black* (1918, MoMA, New York,) is a response to Malevich's *White on White* paintings, using curvilinear rather than rectilinear forms. In 1917 he began making three-dimensional constructions under the influence of his friend *Tatlin, and some of these developed into graceful hanging sculptures. Like Tatlin and other Constructivists, however, Rodchenko came to reject pure art as a parasitical activity ('The art of the future will not be the cosy decoration of family homes'), and after 1922 he devoted his energies to industrial design, typography, film and stage design, propaganda posters, and photography. His only journey outside Russia came in 1925, when he went to Paris to supervise part of the Soviet contribution to the 'Exposition Internationale des Arts Décoratifs et Industriels Modernes' (the exhibition that gave *Art Deco its name). In the mid-1930s, after *Socialist Realism had become the official art style of the Soviet Union, he returned to easel painting. Initially he produced circus scenes, but in 1943 he began to paint abstract 'drip' pictures that prefigure those of Jackson *Pollock.

Rodchenko's photography is probably the most original and enduring part of his output. It was geared towards reportage and creating a pictorial record of the new Russia, but much of it is remarkable for its 'abstract' qualities, partly created by his novel exploitation of unusual angles and viewpoints (he was accused of the deadly sin of *formalism by some Soviet critics). Often he pointed his camera sharply upwards or downwards to create a powerful play of diagonals—'Rodchenko perspective' and 'Rodchenko foreshortening' became current terms in the 1920s—and his dramatic use of light and shadow influenced, for example, the great Soviet film director Sergei Eisenstein.

Rodchenko's wife, Varvara Stepanova (1894–1958), was a painter and designer. Of all the leading members of the avant-garde who switched to industrial design in the early 1920s, she was the only one who had received professional training in the applied arts. She is perhaps best known for her sports clothes, in which she used loud contrasts of colour (for purposes of identification) while rejecting as superfluous all ornamental or 'aesthetic' elements. She also wrote poetry and collaborated with her husband on various journalistic projects.

Rodin, Auguste (1840–1917) French sculptor and draughtsman, one of the greatest and most influential European artists of his period.

No other sculptor of the 19th century achieved such fame among contemporaries and he is often given a status in the history of sculpture comparable to that of the *Impressionists in painting. He struggled early in his career (he was rejected by the École des *Beaux-Arts three times) and his work was often the subject of controversy, but after a large exhibition devoted to him at the Paris World Fair in 1900 he was widely regarded as the greatest living sculptor. His most characteristic works were figures or groups of a historical, literary, allegorical, or symbolic nature. At the centre of his career was a commission he received from the French state in 1880 to make a set of bronze doors for a proposed Musée des Arts Décoratifs. Rodin never definitively finished the huge work—*The Gates of Hell* (he worked on it intermittently until 1900 and the museum never came into being in the proposed form)—but he poured some of his finest creative energy into it, and many of the nearly 200 figures that are part of it were the basis of famous independent sculptures, most notably *The Thinker* and *The Kiss* (the marble version of *The Kiss* in the Tate collection was carved by an assistant in 1901–4; *see* DIRECT CARVING). The several casts that exist of the complete structure of the *Gates* were made after Rodin's death. The overall design is a kind of Romantic reworking of Ghiberti's 15th-century *Gates of Paradise* at the Baptistery of Florence Cathedral, the twisted and anguished figures, irregularly arranged, recalling Michelangelo's *Last Judgement* and Gustav Doré's illustrations for Dante's *Inferno* (1861). The modelling is often rough and 'unfinished' (unlike the smooth finish of the marble *Kiss*) and anatomical forms are exaggerated or simplified in the cause of intensity of expression.

These traits were taken further in some of Rodin's other monuments, most radically in his statue of Balzac. This was commissioned by the Société des Gens de Lettres in 1891, but Rodin's design was so unconventional—an expression of the elemental power of genius rather than a portrait of an individual—that it was rejected, and the monument was not finally cast and set up until 1939—at the intersection of the Boulevards Raspail and Montparnasse in Paris. It ranks as the most original piece of public statuary created in the 19th century, and *Brancusi wrote that it was 'indisputably the starting point of modern sculpture'. Rodin himself described it as 'the sum of my whole life'. After 1900 he

completed no more major monuments: one to commemorate *Whistler never achieved a form acceptable to the commissioning committee. His later sculpture consisted of portrait busts, including many of eminent personalities, and studies of the body in motion such as *Nijinsky* (1912). In this period he was also a prolific draughtsman, mainly of the female nude, but he also made a series of Cambodian dancers, revealing a capacity as a colourist that in a second life might have made him one of the great decorative painters. Some of the drawings are highly erotic. (He was famed for his sexual appetite, sometimes seen as an aspect of his Olympian stature; his lovers included Camille *Claudel and Gwen *John.) He also made etchings and published two books: *L'Art* (1911), a series of his conversations (translated as *On Art and Artists*, 1957); and *Les Cathédrales de France* (1914), which shows his love of the art of the Middle Ages (translated as *The Cathedrals of France*, 1965). Rodin left his own collection of his works to the state to found the Musée Rodin in Paris, opened in 1919. It has examples of virtually all his sculptural work, and many other museums around the world have examples, thanks to the large number of casts; there is a Rodin Museum in Philadelphia and there is a fine collection in the Victoria and Albert Museum, London. His villa at Meudon (now a suburb of Paris) is an annex to the main Musée Rodin; the sculptor is buried in the garden, with a cast of *The Thinker* overlooking his grave.

It has become such a cliché to place Rodin's work at the start of any history of modern sculpture that it might innocently be assumed that he was virtually its single-handed progenitor. However, his status is really more comparable to that of *Monet than that of *Cézanne or *Gauguin. In his later years he was very much a figure to react against: his work was seen as over-literary and insufficiently concerned with *formal values. Sculptors such as *Maillol, Brancusi, and *Lipchitz constituted what George Heard *Hamilton aptly described as a 'loyal opposition' who 'had to reject his method and his programme in order to assert their independence'. However, he left some potent legacies, such as his sense of movement and his use of the partial figure. Most radically of all, some of his most challenging work, such as *Iris, Messenger of the Gods* (1890–91), puts forward the possibility that sculpture might be, above anything else, a piece of material, an object. As a

sculptor of a later generation, William *Tucker, put it, 'It is no longer anatomy but the action of the hand in clay that determines the form of the figure'. Tucker writes that his 'commitment to clay signalled a total responsibility for the work at every stage, in contrast to the prevailing use of marble by academic sculptors', but this represents only the side of his practice that *modernist sculptors have found most appealing. Like other sculptors of his day, he produced sculpture with the use of assistants, notably in the carving of the marble versions of his works. The subsequent debates over the contribution of collaborators, notably Camille Claudel, might be less bitter if they were accompanied by a more realistic sense of Rodin's actual studio practice and an understanding that, like other leading sculptors of his day (and almost any subsequent sculptor who has worked on a grand public scale), he could not have produced his output single-handed.

Rodin was as much the climax of a strand of Romantic sculpture, traceable through François Rude (1784–1855), Antoine-Auguste Préault (1809–75), and Jean-Baptiste Carpeaux (1827–75), as the beginning of a new era. He saw himself very much as the survivor of a tradition of sculpture going back to the Middle Ages; furthermore this was a tradition nearing its end because of the effects of industrialization. His preferred successors would not have been the modernists, but his assistants Camille Claudel and Emile-Antoine *Bourdelle. The one had her career tragically curtailed by madness, the other was to become the leading French monumental sculptor of his day and even he did not follow his mentor uncritically.

Yet Rodin's modernity is not just in his form and style but in his approach to subject-matter and his exploration of the relationship of sculpture to viewer. *Balzac* deals with the artist, neither as public figure nor as recipient of divine inspiration, but in defiant creative solitude. *The Burghers of Calais* (inaugurated 1895, casts in Calais, Victoria Tower Gardens, London, and elsewhere) gives a disturbing and morally challenging, direct confrontation with the viewer. This is especially true when the work is displayed in either of the two ways that Rodin envisaged: without any plinth on the ground; or, as was done in a memorable installation at the Musée Rodin in 2005, at well above eye level. For Rosalind *Krauss, writing with the hindsight of *Minimal art, what was so prophetic about Rodin was his resistance

both to the clear narrative of classical sculpture and also to readily grasped visual coherence. She concludes her discussion of *Minimal and *Land art by writing that 'the transformation of sculpture—from a static, idealized medium to a temporal and material one—that had begun with Rodin is fully achieved'.

Further Reading: R. Butler, *Rodin: The Shape of Genius* (1993)

A. Elsen, *Rodin* (1974)

Krauss (1977)

Royal Academy of Arts, *Rodin* (2006)

W. Tucker, *The Language of Sculpture* (1974)

Roerich, Nikolai (1874–1947) Russian painter, designer, archaeologist, anthropologist, and mystical philosopher, born in St Petersburg, where he first studied law before training at the Academy, 1893–7. He was a prolific painter of landscapes and of imaginary historical scenes that evoke a colourful pagan image of Russia's past. They reveal the same feeling for exotic splendour and bold, sumptuous colour that he displayed in his set and costume designs for *Diaghilev's Ballets Russes, notably for Stravinsky's *Rite of Spring* (1913), for which Roerich created the scenario with the composer. A man of immense energy, Roerich combined his career as an artist with one as an archaeologist and anthropologist. In 1925–8 he made a 16,000-mile expedition in Central Asia accompanied by his wife and his elder son, who spoke Chinese, Mongolian, Tibetan, and several Indian languages; his 'investigation of the cultures of the region [is] still the bedrock of anthropological studies of Central Asia' (*The Times Atlas of World Exploration*, 1991). From 1928 until his death Roerich directed a Himalayan research station at Kulu in India, and many of his later paintings feature mountain landscapes.

Rogers, Claude (1907–79) British painter of portraits, landscapes, and genre scenes. He was born in London and studied at the *Slade School, 1925–9. With William *Coldstream and Victor *Pasmore he founded the *Euston Road School in 1937 and he became one of the leading upholders of its sober figurative tradition, although in his later work the underlying abstract quality of the composition became of more importance. During the Second World War he served in the Royal Engineers until he was invalided out in 1943. He then taught part-time at Hammersmith and *St Martin's Schools of Art, and after the war he continued his teaching career at Camberwell School of

Art, 1945–9, the Slade School, 1949–63, and Reading University, where he was professor of fine art, 1963–72. He was married to the painter Elsie Few (1909–80).

Rohlfs, Christian (1849–1938) German painter and printmaker, born at Niendorf, Holstein. He turned to painting after a boyhood accident led to the amputation of one of his legs, forcing him to abandon plans to take over his father's farm. From 1901 he lived mainly in Hagen. Until he was well over 50 he painted in a fairly traditional naturalistic manner, but he then discovered the work of van Gogh, whose brilliant colour and intense personal feeling were a revelation to him. He became one of the pioneers of *Expressionism in Germany, and in 1905–6 he painted with Emil *Nolde. Rohlfs's favourite subjects were views of old German towns, colourful landscapes, and flower pieces. There were also powerful renderings of religious subjects such as *The Creation* (1916, Städtisches Museum Abteiberg, Mönchengladbach). He preferred the technique of tempera, but, unusually for an artist working in this medium, he sought an atmospheric quality rather than hard, precise outline. Towards the end of his career he approached abstraction. Rohlfs's work in his new style won him considerable acclaim: in 1924 numerous celebrations were held to mark his 75th birthday, and in 1925 a museum of his work was founded in Hagen. A year before his death, however, he was declared a *degenerate artist by the Nazis and forbidden to exhibit.

Rohner, Georges (1913–2000) French painter, born in Dijon. One of the leading figures in the *'Forces Nouvelles' movement of the late 1930s, he specialized in robust, bulky representations of peasant life. Romy Golan (*Modernity and Nostalgia*, 1995) has argued that his broad fork and proletarian cap of his *Man with Pitchfork* (1936) demonstrates leftist sympathies. Themes of rural life were common in French art of the period, a tendency partly stimulated by the rediscovery of 17th-century 'painters of reality' such as the Le Nains. During the war, Rohner spent some time in the prison camp at Trèves, where he decorated the chapel with a painting of *Christ among the Prisoners*. After his release, he continued working in the same monumental style, the best-known example being *The Potato Pickers* (1956, Pompidou Centre, Paris).

Roland, Browse & Delbanco *See* BROWSE, LILLIAN.

Rolfsen, Alf (1895–1979) Norwegian painter, printmaker, draughtsman, and writer on art, best known as one of his country's leading muralists. He was born in Christiania (now Oslo) and had his main training at the Copenhagen Academy, 1913–16. In 1919–20 he studied in Paris, where he met Diego *Rivera, with whom he discussed the relationship between painting and architecture. Rolfsen made several other visits to Paris and he was influenced by modern French painting, particularly *Cubism and the work of *Derain. His first fresco commission, for the Telegraph Building in Oslo, was carried out in 1922. Many others followed, notably work at Oslo Town Hall (1938–50), where he was one of a team of painters including Axel *Revold. His last fresco was for the Hansa Brewery in Bergen (1967). Rolfsen also produced easel paintings (including landscapes, portraits, and figure compositions), as well as lithographs and book illustrations, and he wrote and lectured on art. His writings include material about mural painting and a book on the Danish painter Georg Jacobsen (1887–1976), published in 1956.

Roman School (Scuola Romana) A trend in Italian painting centred on the work of *Mafai and *Scipione, who were opposed to the empty rhetoric prevailing in much Italian art of the 1920s and 1930s (*see* NOVECENTO ITALIANO). Mafai and Scipione exhibited together in 1928 (this is regarded as the date of the launch of the Roman School) and the term 'Scuola di via Cavour' (after the site of Mafai's studio in Rome) was applied to them and the sculptor Marino Mazzacurati (1907–69) by the critic Roberto Longhi in 1929. Although different in temperament and methods, the two painters were close friends and united in the desire to replace the ponderous classicism of the Novecento with a new Romantic *Expressionism inspired by artists such as *Soutine. The ideals of the Roman School lived on into the second half of the century in the work of such painters as Toti Scialoja (1914–98), Giovanni Stradone (1911–81), and Renzo Vespignani (1924–2001).

Romantic Conceptualism *See* KABAKOV, ILYA.

Rome, Galleria Nazionale d'Arte Moderna *See* GALLERIA NAZIONALE D'ARTE MODERNA.

Ronald, William (William Ronald Smith) (1926–98) Canadian-American painter and radio and television presenter, a leading figure in the development and acceptance of abstract art in Canada. He was born in Stratford, Ontario, and studied under Jock *Macdonald at Ontario College of Art, Toronto, 1947–51. In 1953 he was the driving force behind the formation of the Toronto group of abstract artists *Painters Eleven, but in 1955 he moved to New York, where he enjoyed considerable success among the second generation of *Abstract Expressionists; in a work such as *Central Black* (1955–6, Robert McLaughlin Gallery, Oshawa, Ontario), the slashing brushstrokes recall the work of Franz *Kline. Ronald lived in the USA until 1965, becoming an American citizen in 1963, but he retained a large following in Toronto and exerted a strong influence on painters there. With the decline in Abstract Expressionism his popularity waned, but after his return to Canada he achieved success as a radio and television celebrity, presenting a chat-show called *The Umbrella*. A survey by the broadcaster CBC discovered that over half the viewers tuned in because he was so annoying. Following incidents such as an on-air threat of physical assault on a guest who described most modern work as 'trash', his show was dropped, although he later returned to television. He also developed a kind of roadshow performance in which, dressed in immaculate white, he painted on stage before an audience to the accompaniment of rock music and a go-go dancer. In the 1970s he returned to more conventional painting and in 1983 he completed a series of pictures inspired by Canada's prime ministers.

Further Reading: R. Belton, *The Theatre of the Self: The Life and Art of William Ronald* (1999)

Rosai, Ottone (1895–1957) Italian painter, born in Florence, where he studied briefly at the Institute of Decorative Arts and the Academy of Fine Arts. He was precocious and had his first exhibition of graphic works in Pistoia in 1911 and an exhibition of paintings in Florence in 1912. In 1913 he met *Soffici and under his influence was associated with the *Futurists. After the First World War (during which he served in the Italian army) Rosai was briefly influenced by *Metaphysical Painting, but by 1920 he had developed a distinctive personal style in which he depicted scenes of urban life, principally working-class Florence, in a quasi-*naïve manner. From about 1930 Rosai painted large landscapes and townscapes in which forms were influenced by mild *Cubist stylization. His work was widely exhibited in Italy and he was one of the most popular Italian artists of his day.

Rosati, James (1912–88) American sculptor, born at Washington, Pennsylvania. Originally he was a violinist (he played with the Pittsburgh Symphony Orchestra, 1928–30) and he was self-taught as a sculptor. He settled in New York in 1944 and had his first one-man show there—at the Peridot Gallery—in 1954. Rosati worked in various media as both a carver and a modeller and was described by the American art historian Dore Ashton as 'one of the most versatile sculptors of his generation'. Typically his work is abstract and block-like, sometimes with minimal allusions to the human figure. He won numerous awards and public commissions.

Rose, Barbara *See* COOL ART.

Rosenberg, Harold (1906–78) American writer, lecturer, and administrator, one of the most influential critics in the field of contemporary art from the 1950s until his death. He was born in Brooklyn, New York, and studied at City College, New York, 1923–4, then at St Lawrence University, graduating with a law degree in 1927. From 1938 to 1942 he was art editor of the *American Guide* series published for the Works Progress Administration (*see* FEDERAL ART PROJECT) and he later held various other government posts. Early in his career he wrote poetry and essays on literary and general cultural issues (his first book was a collection of poems entitled *Trance Above the Streets*, 1943), and it was not until 1952 that he published his first important work devoted to the visual arts—an essay in *Art News* in which he coined the term *Action Painting. This label became particularly associated with Jackson *Pollock, but the artist Rosenberg most favoured among the *Abstract Expressionists was Willem *de Kooning. This was one of the many ways in which he differed from the other great spokesman for Abstract Expressionism, his rival Clement *Greenberg. Whereas Greenberg came to be concerned only with formal values, Rosenberg had an ethical and political conception of art, believing that the

critic should less 'judge it' than 'locate it', subordinating visual analysis to intellectual understanding. He thought that authentic modern art should be perpetually disruptive (*see* AVANT-GARDE) and he attacked the manipulative fashions created by both the marketplace and the museum—*Pop art, for example, he treated with disdain.

Rosenberg was art critic of *The New Yorker* magazine from 1968 until his death, and he also wrote for a wide range of other journals, from *Encounter* to *Vogue*. He was a visiting lecturer or professor at several universities and won various academic awards. His numerous books include collections of essays, notably *The Tradition of the New* (1959), critical works, among them *The De-Definition of Art: Action Art to Pop to Earthworks* (1972), and monographs on de Kooning (1974), Arshile *Gorky (1962), Barnett *Newman (1978), and Saul *Steinberg (1978).

Rosenberg, Léonce (1877–1947) and **Paul** (1881–1959) French art dealers, brothers. In 1906 they took over the Paris gallery of their father, Alexandre Rosenberg, who had set up in business in 1872, specializing first in Old Masters and later in *Impressionist and *Post-Impressionist pictures. However, in 1910 they split the business, and for the next few years Léonce was primarily a collector rather than a dealer. He returned to dealing during the First World War, when *Kahnweiler's forced absence in neutral Switzerland allowed him to become the main advocate of *Cubism by giving contracts to *Braque, *Gris, and *Léger. In 1918 he opened the Galerie de l'Effort Moderne, which for a few years was a powerful force in promoting avant-garde art. Between 1924 and 1927 it issued the *Bulletin de l'Effort Moderne* (forty issues), which provided a forum not only for his own views, but also, for example, for those of Giorgio *de Chirico, Theo van *Doesburg, and the critics Maurice Raynal (1884–1954) and Pierre Reverdy (1889–1960). Soon after the war, however, several of the leading artists Rosenberg represented (including *Picasso) went over to his brother Paul, and Léonce made himself unpopular in the early 1920s when he acted as an expert for the French government's sale of Kahnweiler's confiscated pre-war stock: this outraged many people in the art world, as it gave Rosenberg 'a chance to liquidate the stock of his commercial rival at knock-down prices and take advantage of his privileged

position to expand his own' (catalogue of the exhibition 'The Essential Cubism', Tate Gallery, London, 1983). During the 1930s his business was badly hit by the Depression.

Paul Rosenberg's gallery was distinctly up-market and he concentrated on promoting established artists rather than fostering new talent. Picasso (1918), Braque (1922), and Léger (1927) all moved from Léonce to Paul, and in 1936 he also became *Matisse's dealer. In the period between the world wars he maintained a branch of his gallery in London, and in 1940 he moved his business to New York, where his son Alexandre acted as manager.

Rosenberg, Lev See BAKST, LÉON.

Rosenblum, Robert See ABSTRACT SUBLIME.

Rosenquist, James (1933–) American painter, born in Grand Forks, North Dakota, one of the major figures in the development of *Pop art. After studying at the Minneapolis School of Art and the University of Minnesota, he won a scholarship to the *Art Students League, New York (1955–6), where he met Robert *Indiana, Jasper *Johns, and Robert *Rauschenberg. During the 1950s he supported himself for several years as a commercial artist and billboard painter, and he later recalled his excitement on entering an advertising factory for the first time in 1954 and seeing 'sixty-foot long paintings of beer glasses and macaroni salads sixty-feet wide. I decided I wanted to work there.' He was the only major Pop artist who knew this part of the advertising world as an insider. In 1962 he had his first one-man exhibition (at the Green Gallery, New York), in which he adapted the imagery of his advertising work, juxtaposing fragments of objects in unrelated scales. Rosenquist often chose images from the 1950s. 'If I chose the front end of a new car there would be people who would be passionate about it, and the front end of an old car might make people nostalgic'. His best-known painting is the 86-foot *F111* (1964–5, MoMA, New York). Made to cover all four walls of the Leo *Castelli Gallery, it is dominated by the image of an American bomber that spans its length and passes, among other things, a tyre, a little girl under a hairdryer and an atomic explosion. American Pop did not usually make such explicit political statements as this: it points out the relationship between military power and everyday economics. As Rosenquist himself

put it, 'A man has a contract from a company making the bomber...and he plans his third automobile and his fifth child because he is a technician and he has work for the next ten years.' Its status as a piece of contemporary political painting was confirmed when in 1968, after it had been on a world tour, the New York Metropolitan Museum of Art displayed it alongside Jacques-Louis David's *Death of Socrates* and Poussin's *Rape of the Sabine Women* in an exhibition of history painting. Rosenquist has also made environmental and three-dimensional works. These have sometimes dealt with the way in which, as he said, 'nature becomes increasingly modified by man until the natural and artificial blend into each other'. So *Tumbleweed* (1963–6) combines wood, barbed wire, and neon light. Rosenquist has also worked as a printmaker. Even here his love of gigantism has not left him. *Time Dust* (1992) at 7 by 35 feet is thought to be the largest print in the world.

Rosenthal, Sir Norman See ROYAL ACADEMY OF ARTS.

Rosler, Martha (1943–) American photographer, *Video, *installation, *Performance artist, and theorist, born in Brooklyn. In 1974 she gained a master's degree in Fine Arts from the University of California, where a number of other artists concerned with the critical use of mass media images have studied. In the late 1960s she made a series of *photomontages entitled *Bringing the War Home: House Beautiful*. Addressing the issue of Vietnam, they confronted images of consumerism with the war. In one there is a close-up of a woman applying make-up with her eye covered by the photograph of a soldier pointing a gun in the back of a blindfolded female prisoner. In another, two soldiers search the interior of a luxurious house. Rosler was concerned with the fallibility of sign systems. In 1973 she made a series entitled *The Bowery in Two Inadequate Descriptive Systems*. This is an area popularly associated with poverty and drunkenness. Pictures of 'Bowery bums' are a cliché of photojournalism. Rosler chooses to avoid these, instead showing fragments of the area without figures. Each photograph is accompanied by a second panel on which is inscribed a number of synonyms for drunkenness. Craig Owens, in his discussion of these works, argues that the 'concerned' photographer 'necessarily functions as an agent of the system of power that silenced these people

in the first place'. He further argues that Rosler's work upsets the 'belief in vision as a privileged access to certainty and truth'.

Rosler's practice as a Video artist deals with themes of gender identity and social control. *Semiotics of the Kitchen* (1975) shows Rosler with various kitchen implements, picking them up as demanded by an off-screen voice. Her gestures with the objects become increasingly frenetic, suggesting both the frustrations of female domesticity and that the implements might also be weapons.

Further Reading: C. Owens, 'The Discourse of Others: Feminists and Postmodernism', in H. Foster (ed.), *The Anti-Aesthetic: Essays on Postmodern Culture* (1983)

Rossetti, Dante Gabriel See PRE-RAPHAELITISM.

Rosso, Medardo (1858–1928) Italian sculptor, born in Turin. He was virtually self-taught, for he was dismissed from the Brera Academy in Milan in 1883 after only a few months' training when he appealed for drawing to be taught from the nude model rather than casts of statues. In 1884 he first visited Paris, and he lived there from 1889 to 1897, the period of his most intense creative activity. It is indeed with French rather than Italian art that his work has affinity, for he created a sculptural equivalent of *Impressionism, depicting everyday subjects and capturing a feeling of movement, atmosphere and transitory effects of light. (He liked to have his sculptures displayed among paintings; he thought that they benefited from coloured light reflected from the surfaces of the pictures.) His favourite medium was wax, which he used with great subtlety to express his view that matter was malleable by atmosphere: 'We are mere consequences of the objects that surround us.' His subjects included portraits, single figures, and groups in contemporary settings (*The Bookmaker*, 1894, MoMA, New York; *Conversation in a Garden*, 1893, Galleria Nazionale d'Arte Moderna, Rome).

In his early days in Paris Rosso struggled to earn a living (he made funerary monuments for his basic income), but his career blossomed in the 1890s, partly because of the patronage of Henri Rouart (a friend of *Degas), who helped Rosso find clients as well as purchasing works himself. *Rodin, too, tried to help him, but Rosso was suspicious of him and thought he was trying to steal his ideas (it has been suggested that the

'Impressionistic' handling of Rodin's celebrated Balzac monument is indebted to Rosso). In 1897 Rosso returned to Italy and thereafter made almost no new sculpture, devoting his time instead to organizing exhibitions of his work throughout Europe. Through these, and the championship of critics such as Ardengo *Soffici, his work became extremely well known, and after Rodin's death in 1917, *Apollinaire spoke for many when he described him as 'beyond doubt the greatest living sculptor'. His reputation remains high and he is considered one of the most original artists of his time (not even Rodin challenged so decisively the traditional preoccupations of sculpture). He was particularly influential on the *Futurists, who took over and developed many of his ideas; in the *Manifesto of Futurist Sculpture* (1912) *Boccioni called him 'the only great modern sculptor who has attempted to open up a larger field to sculpture, rendering plastically the influences of an ambiance and the atmospheric ties which bind it to the subject'. Rosso's output was fairly small; examples of his sculptures and a collection of his drawings are in the Museo Medardo Rosso at Barzio in Italy.

Further Reading: South Bank Centre, *Medardo Rosso* (1994)

Roszak, Theodore (1907–81) American painter and sculptor, born at Poznań, Poland. He emigrated to the USA with his family in 1909 and studied at the Art Institute of Chicago, 1922–4, and the National Academy of Design, New York, 1925–6. In 1927 he returned to Chicago, where he was a part-time instructor at the Art Institute until 1929. He then went to Europe and worked in Prague, where he was influenced by *de Chirico and the *Surrealists. In 1931 he returned to the USA and settled in New York. From this point in his career sculpture gradually gained prominence in his work. In 1938–40 he taught at the Design Laboratory, New York, which was inspired by the *Bauhaus, and developed an interest in geometrical abstraction that lasted until the mid-1940s. From this time he continued to work in welded steel and bronze, but his style changed to one of expressive abstraction involving quasi-organic forms; this brought him within the group of sculptors, including *Ferber and *Lassaw, whose work paralleled that of the *Abstract Expressionist painters. Examples of his work in this mode are *Whaler of Nantucket* (1952, Art Institute of Chicago) and *Sea Sentinel* (1956, Whitney Museum, New York).

Rot, Diter See ROTH, DIETER.

Rotella, Mimmo (Domenico) (1918–2006) Italian painter, born at Catanzaro, Calabria. He studied at the Academy in Naples, then in 1951–2 at the University of Kansas on a Fulbright Scholarship. After his return to Europe he lived and worked firstly in Rome, then moved to Paris in 1964, and to Milan in 1980. In 1954 he began exhibiting collages made up of fragments of posters torn from walls, calling them *Manifesti lacerati*, and he wrote: 'Tearing posters down from the walls is the only recourse, the only protest against a society that has lost its taste for change and shocking transformations.' The French *affichistes, through whom he became associated with *Nouveau Réalisme, worked in a similar manner, but Rotella seems to have arrived at the technique independently. His posters tend to concentrate more on popular commercial imagery taken from film posters, while the French preferred more political images. James Kirkup recounts that 'he became like some obsessed creature in an early silent movie—roaming the streets of Rome and tearing at the walls'. (In 1999 the mayor of his native city, Cantanzaro, signed an order allowing Rotella to tear down any posters he chose.) He also used a technique for blowing up photographs on to sensitized canvas (*see* MEC ART). These usually reflect contemporary political events such as the assassination of J. F. Kennedy but also include erotic subjects, as in *Operation Sade* (1966). The journal *Art and Artists* printed only the top half in their special issue on erotic art (November 1966) but doubtless many readers could imagine the rest. In his autobiography *Autorotella* (1972), Rotella conceded that 'many thought I was sick and that my tastes were strange'.

Further Reading: J. Kirkup, obituary, *The Independent* (12 January 2006)

C. Masters, obituary, *The Guardian* (19 January 2006)

Roth, Dieter (Diter Rot) (1930–98) German painter, printmaker, and designer, born in Hanover of a Swiss father and a German mother. He moved to Switzerland in 1943 and was apprenticed as a graphic designer in Berne, 1947–51. In 1955–7 he lived in Copenhagen, and from 1957 was based mainly in Reykjavik, Iceland, though he continued to travel a good deal and in 1964–7 lived in the

USA, where he taught at Yale University and elsewhere. His work was extremely varied and included objects incorporating edible materials such as chocolate. However, his best-known works are his prints: 'Roth's random accretions of compositional ideas have produced a large body of graphic and multiple work, often in unorthodox media and in collaboration with other artists' (Riva Castleman, *Prints of the 20th Century*, 2nd edn, 1988). The artists with whom he collaborated include Richard *Hamilton.

Rothenberg, Susan (1945–) American painter, born in Buffalo, New York. She is known for large paintings of horses on canvases divided by horizontals, verticals and diagonals. She has described these divisions as 'the main fascinators—there before the horse'. She has maintained that her interest in the horse image is because of its formal qualities saying that 'it divides right. Each half can hold its own and I can get as much weight out of the back half as I can from the head half'. She was included in Richard Marshall's *'New Image Painting' exhibition of 1978. In the catalogue introduction, he praised the 'rich, sensuous, and flowing surface' of her paintings.

Rothenstein, Sir William (1872–1945) British painter, graphic artist, writer, and teacher, born in Bradford. In 1888-9 he studied at the *Slade School in London and in 1889–93 at the *Académie Julian in Paris. There he became a close friend of *Whistler and was encouraged by *Degas. His best works are generally considered to be his early Whistlerian paintings such as *The Doll's House* (1899, Tate) in which Augustus *John and Rothenstein's wife model as characters in a tense scene evoking Ibsen's play *A Doll's House*. From about 1898, however, he specialized in portraits of the famous and those who later became famous. In the latter part of his career he was much more renowned as a teacher than as a painter. His outlook was conservative (he regarded pure abstraction as 'a cardinal heresy') and as principal of the *Royal College of Art, 1920-35, he exercised an influence second only to that of Henry *Tonks at the Slade School. Rothenstein's publications include various collections of his portrait drawings and lithographs and three volumes of memoirs—*Men and Memories* (2 vols, 1931-2) and *Since Fifty*

(1939). His brother **Albert Rothenstein** (1881–1953) was a painter (*see* CAMDEN TOWN GROUP), designer, and prolific book illustrator. In 1914 he changed his surname to Rutherston because anti-German feeling made 'Rothenstein' a handicap.

William's son, **Sir John Rothenstein** (1901–92), was a distinguished art historian. He was director of the *Tate Gallery, 1938–64, in which capacity he was engaged in a very public dispute with Douglas *Cooper. He was also the author of numerous books on art, mainly on 20th-century British painting. His best-known publication is the three-volume series *Modern English Painters* (1952, 1956, 1973; new edition of the whole work, 1984). This contains stimulating essays on some sixty leading British painters from *Sickert to *Hockney, almost all of whom Rothenstein knew personally. His other books include *British Art Since 1900: An Anthology* (1962) and monographs on Edward *Burra (1973), Augustus John (1962), John *Nash (1984), Paul *Nash (1961), and Matthew *Smith (1962).

John's brother, **Michael Rothenstein** (1908–93), was a painter, graphic artist, and writer, best known as a printmaker. He worked in a variety of techniques, in both abstract and figurative styles, and liked to experiment with materials. His books include *Frontiers of Printmaking* (1966).

Rothko, Mark (1903–70) Russian-born American painter, one of the outstanding figures of *Abstract Expressionism and one of the creators of *Colour Field Painting. He was born Marcus Rothkowitz in Dvinsk and emigrated to the USA in 1913; he changed his name at about the time that he acquired American citizenship in 1938. After dropping out of Yale University in 1923 he moved to New York and studied at the *Art Students League under Max *Weber, but he regarded himself as essentially self-taught as a painter. A far stronger influence than Weber was almost certainly Milton *Avery, whom Rothko praised at his memorial service as 'a great poet-inventor who had invented sonorities never seen nor heard before'. From 1929 onwards, Rothko was engaged in the teaching of art to children. He followed the theories of Frank *Čižek, the Viennese educator, who argued that children had an innate sense of form which should be allowed to develop freely. Rothko's surviving paintings of the 1930s tend to feature attenuated figures. The New

York subway was one theme, but from the end of the decade he worked in a mode increasingly concerned with myth. This preoccupation signalled a turning away from the politically committed realism which marked much American painting of the time. In the 1930s Rothko was a strong supporter of radical left-wing causes. However, he was also one of the leading figures in the opposition to the Communist-leaning *American Artists' Congress in 1940. His stance hardly represented a rejection of political commitment as such. In the wake of the Hitler–Stalin pact and the Russian invasion of Finland, which the Congress implicitly supported, it was arguably a highly principled stance that did contradict his early radicalism. Nonetheless his development was symptomatic of the way in which the Abstract Expressionist generation turned their backs on *Social Realism and its associated politics.

The paintings of the 1940s often bear titles taken from classical mythology, such as *Antigone* or *The Syrian Bull*. They retain references to the human figure and remind some viewers of underwater scenes or geological strata. In 1943 Rothko wrote to *The New York Times* in association with Adolph *Gottlieb (with the uncredited assistance of Barnett *Newman), stating that 'the subject is crucial and only that subject-matter is valid which is tragic and timeless'. The letter claimed 'spiritual kinship with primitive and archaic art' (*see* PRIMITIVISM). Later that year, in a radio broadcast, Rothko and Gottlieb expanded on this theme: 'If we profess a kinship to the art of primitive men, it is because the feelings they expressed have a particular pertinence today...All primitive expression reveals the constant awareness of powerful forces, the immediate presence of terror and fear, a recognition and acceptance of the brutality of the natural world as well as the eternal insecurity of life.'

Even in 1947, after his paintings had become considerably more abstract, Rothko spoke of them as 'dramas; the shapes in the pictures are the performers'. The paintings after 1949 feature large rectangular expanses of colour arranged parallel to each other, usually in a vertical format. The colour changes just short enough of the canvas edge to deny the spectator a figure-ground reading but far enough in so that they register as shapes rather than colour washes. The handling is hazy and atmospheric but never to the degree that the sense of two-dimensional surface disappears. The intensity he achieved was unfortunately sometimes dependent on the use of highly fugitive pigments. One series of paintings made for Harvard University in 1963 was ruined by exposure to light in only ten years. The format varied little, but the colour sense became more sombre from the late 1950s onwards. Some commentators detected a tragic mood in the paintings. In 1961 Peter Selz wrote that 'These apparently quiet, contemplative surfaces are only masks for underlying turmoil and passion', while Dore Ashton compared his work to Greek tragedy.

After 1950, Rothko became unwilling to speak or theorize about his work, believing that 'to tell the public how the pictures should be looked at and what to look for' would 'lead to a paralysis of the mind and imagination (for the artist a veritable entombment)'. He certainly preferred critical comments such as those of Robert *Goldwater or Robert *Rosenblum which went beyond the *formalist analyses of his supporter Clement *Greenberg. In an ill-tempered exchange with the journalist Seldon Rodman he declared 'I'm not an abstract artist...I'm not interested in the relationship of colour or form or anything else. I'm interested only in expressing basic human emotions—tragedy, ecstasy, doom and so on. And the fact that a lot of people break down and cry when confronted with my pictures shows that I can communicate these basic human emotions...The people who weep before my pictures are having the same religious experience as I had when I painted them' (*Conversations with Artists*, 1957).

Rothko was poor for much of his career, but his reputation grew in the 1950s. In 1954 he was tipped as a promising investment by *Fortune* magazine, an event which led directly to estrangement from his erstwhile allies Clyfford *Still and Barnett Newman. In 1961 he was given a major retrospective exhibition at the Museum of Modern Art, New York. In spite of his soaring reputation (and the money it brought), Rothko was plagued by depression. He had a prickly temperament, drank heavily, took barbiturates to excess, was fearful and suspicious of younger artists, had two unhappy marriages, and felt he was misunderstood. It is not hard to associate this mood with the darkening tones of his later work, especially those of the final years of his life. He died by his own hand, cutting his wrists in his studio. After his death there was a public scandal concerning the handling of his work by his

dealer *Marlborough Fine Art. The court action resulted in their having to return many paintings to the artist's family.

Further Reading: D. Ashton, *About Rothko* (1996)
A. Borchardt-Hume, *Rothko* (2008)
P. Selz, *Mark Rothko* (1961)

Rouault, Georges (1871–1958) French painter, draughtsman, printmaker, and designer who created a personal style of *Expressionism that gives him a highly distinctive place in modern art. He was born in Paris, the son of a cabinet-maker, and from 1885 to 1890 was apprenticed to a stained-glass maker, his work including the restoration of medieval glass; the vivid colours and strong outlines characteristic of the medium left a powerful imprint on his work. In 1891 he entered the École des *Beaux-Arts, where with *Matisse and *Marquet he was a pupil of Gustave Moreau (1826–98), a brilliant and sympathetic teacher. He was Moreau's favourite pupil and became the first curator of the Musée Moreau in Paris, opened in 1903. At about the same time he underwent a psychological crisis, and although he continued to associate with the group of artists around Matisse who were later known as *Fauves, he did not adopt their brilliant colours or their typical subjects; instead he painted characters such as clowns, prostitutes, and outcasts, in sombre but glowing colours. These subjects expressed his hatred of cruelty, hypocrisy, and vice, depicting the ugliness and degradation of humanity with passionate conviction. His familiar cast of characters also included judges (*The Three Judges, c.*1936, Tate), on the subject of which he said: 'If I have made them such lamentable figures, it is doubtless because I betrayed the anguish which I feel at the sight of a human being who has to pass judgement on other men.'

Rouault's work initially disturbed the public, but he achieved financial security after *Vollard became his agent in 1917 and during the 1930s he gained an international reputation: in 1937, for example, he had a one-man show at the Pierre Matisse gallery in New York, and in 1938 there was an exhibition of his prints at the Museum of Modern Art, New York. He worked in various printmaking techniques, often for book illustrations commissioned by Vollard. Vollard also funded the publication of *Miserere* (1927), a suite of fifty-eight prints forming a meditation on death. Rouault, who had conceived the idea for the

project in 1912, himself created the captions for the prints, using phrases from the Bible. From about 1940 he devoted himself almost exclusively to religious art. In addition to his prolific output of paintings, drawings, and prints, his work also included ceramics and designs for tapestry, for stained glass, and for *Diaghilev's ballet *The Prodigal Son* (1929), for which the music was written by Prokofiev. By the time of his death Rouault was a much honoured figure and he was given a state funeral.

Further Reading: S. Whitfield, *Georges Rouault: The Early Years* (1993)

Rousseau, Henri (Le Douanier Rousseau) (1844–1910) French painter, the most celebrated of *naive artists. His nickname refers to the job he held with the Paris municipal toll-collecting service (1871–93), although he never actually rose to the rank of 'Douanier' (Customs Officer). Before this he had served in the army—he later claimed to have seen service in Mexico, but this seems to be a product of his imagination. He began to paint as a hobby, self-taught, when he was about 40, and from 1886 he exhibited regularly at the *Salon des Indépendants. In 1893 he took early retirement so he could devote himself to art. His character was extraordinarily ingenuous and he suffered much ridicule (although he sometimes interpreted sarcastic remarks literally and took them as praise) as well as enduring great poverty. However, his faith in his own abilities never wavered. He tried to paint in a traditional academic style, but it was the innocence and charm of his work that won him the admiration of the avant-garde. He was 'discovered' by *Vollard and members of his circle in about 1906–7 and in 1908 *Picasso gave a banquet, half-serious, half-burlesque, in his honour. His first one-man show was arranged by Wilhelm *Uhde in a furniture shop in the rue Notre-Dame-des-Champs, Paris, in 1909, and in 1910 Max *Weber (who had become friendly with Rousseau a few years earlier) organized an exhibition of his work at *Stieglitz's 291 gallery in New York.

Rousseau is now best known for his jungle scenes, the first of which was *Tiger in a Tropical Storm (Surprised!)* (1891, NG, London) and the last *The Dream* (1910, MoMA, New York). These two paintings are works of great imaginative power, in which he showed his extraordinary ability to retain the utter freshness of his vision even when working on a large scale and with loving attention to detail. He claimed

such scenes were inspired by his alleged experiences in Mexico, but in fact his sources were illustrated books and visits to the zoo and botanical gardens in Paris. His other work ranges from the jaunty humour of *The Football Players* (1908, Philadelphia Museum of Art) to the eerie, mesmeric beauty of *The Sleeping Gypsy* (1897, MoMA, New York). Rousseau was buried in a pauper's grave, but his greatness began to be widely acknowledged soon after his death; a retrospective exhibition of his work was organized at the Salon des Indépendants in 1911.

Further Reading: C. Green and F. Morris, *Jungles in Paris: The Paintings of Henri Rousseau* (2005)

Roussel, Ker-Xavier (1867–1944) French painter, born at Lorry-les-Metz. From schooldays he was a friend of *Denis and *Vuillard (whose sister he married in 1893) and he met *Bonnard at the *Académie Julian in Paris, where he enrolled in 1888. With these and several other friends he formed a group of *Symbolist painters called the *Nabis. The group drifted apart after its last exhibition in 1899 and from this time Roussel concentrated on bucolic subjects from pagan antiquity, painted in a late *Impressionist manner, with nervous brushwork and sparkling colours. He also did several large decorative commissions, including a curtain for the Théâtre des Champs-Elysées, Paris (1913), and murals for the Palais des Nations at Geneva (*Pax Nutrix*, 1936) and the Palais de Chaillot in Paris (*La Danse*, 1937).

Rowat, Jessie (Jessie Newbery) *See* GLASGOW SCHOOL OF ART.

Roy, Jamini (1887–1972) Indian painter. He was born at Baliatore in rural Bengal and studied at the Government School of Art in Calcutta, 1906–14. At the beginning of his career he painted portraits in an academic style, and he was later influenced by *Post-Impressionism, but in the late 1920s he turned to the local folk art tradition as a source of inspiration, seeing in it a way to recapture an archaic innocence that had been pushed aside by Western influence. His work became very popular in India and was discovered by Allied troops and other Westerners who found themselves in Calcutta during the Second World War. In this way he became one of the few modern Indian artists whose work was known outside his own country. To Westerners it had some of the same attraction as European *naive painting. His style was imitated (and generally coarsened) by many followers, including his sons.

Roy, Pierre (1880–1950) French painter, illustrator, and designer, born at Nantes. His family had connections with that of the writer Jules Verne, whose stories made a great impression on Roy as a boy and may have had some influence on the direction that his art took in later life. After working in an architect's office, where he learned precise draughtsmanship, he moved to Paris in 1904 and studied at the École des *Beaux-Arts, the *Académie Julian, and the École des Arts Décoratifs. His early work was *Neo-Impressionist and in 1908 he came into the circle of the *Fauves, but in about 1920 he discovered the work of *de Chirico and began moving towards the *Surrealist style with which he is most closely associated. He took part in the first Surrealist group exhibition—at the Galerie Pierre in Paris in 1925—and in several of their other group shows. His work is in a similar vein to that of *Dalí and *Magritte, creating a sense of the bizarre or mysterious through strange juxtapositions of objects. Perhaps his best-known painting is *The Dangers of the Stairway* (1927–28, MoMA, New York), showing a large snake winding its way down a staircase in an otherwise scrupulously boring middle-class interior. His other work included designs for theatre and ballet sets and book illustrations in lithograph and woodcut. Roy's 'oldest and most faithful friend' (in his son's words) was Boris *Anrep, whom he met in Paris in 1908. Anrep bequeathed one of Roy's pictures to the Tate Gallery, London.

Royal Academy of Arts (RA), London. The national art academy of England, founded in 1768. It was first based in Pall Mall, and after moving to Somerset House (1780) and then to the National Gallery's premises in Trafalgar Square (1837), it transferred to its present home in Burlington House, Piccadilly, in 1869. The artists who founded the RA aimed to raise the status of their profession by establishing a sound system of training and expert judgement in the arts and to arrange for the exhibition of works attaining an appropriate standard of excellence. The Academy's annual summer exhibition, to which anyone can submit works, has been held every year since 1769, and the RA Schools have also existed

from the beginning. They were unchallenged as Britain's main training ground for artists until the opening of the *Slade School in 1871, but by this time the teaching at the RA had become slipshod and out-of-date, based on drawing from plaster casts of antique statues rather than from the live model.

In the late 19th and early 20th centuries other organizations, such as the *New English Art Club (1886) and the *London Group (1913), were formed to give progressive artists alternative venues at which to show their work. Adventurous work was rarely shown at the Academy's exhibitions (where traditionalism ruled to such an extent that top hats and tail coats were required dress on private view days until 1940), and in the 1930s there were several notable instances of leading artists resigning from the Academy because of outmoded views and taste. In 1935 *Sickert (elected a full Academician only the previous year) resigned because the president, Sir William Llewellyn (1858–1941), refused to sign a letter to *The Times* protesting against the threatened destruction of *Epstein's sculptures on the British Medical Association building, and in the same year Stanley *Spencer resigned his associateship when two of his paintings were rejected by the hanging committee of the summer exhibition (he did not return until 1950); in 1938 Augustus *John similarly left in protest after Wyndham *Lewis's portrait of T. S. Eliot was rejected (John rejoined two years later).

After the presidency (1944–9) of Alfred *Munnings, who was notorious for his opposition to modern art, the Academy's policy became more liberal, and the gap between official and progressive art narrowed. The Schools, too, have won back some of their former distinction. But something of the reputation for resistance to modernism continued up to the 1970s, and the Academy's aim at its inception to provide exhibitions of the best contemporary work from year to year has long been challenged by commercial galleries and by bodies such as the *Arts Council. However, the RA's annual summer exhibition still remains a popular event. In recent years, there has been a general increase in the allotment of space given to Academicians, if anything enhancing the appearance of a private establishment club, dominated by artists who did their best work when they were on the outside. The Academy also regularly organizes major loan exhibitions (the first was in 1870). They have included several recent large survey shows of 20th-century art: 'German Art in the 20th Century' (1985), 'British Art in the 20th Century' (1987), 'Italian Art in the 20th Century' (1989), and 'American Art in the 20th Century' (1993). In terms of international art world impact the most significant was probably 'A New Spirit in Painting' (1981), which brought *Neo-Expressionists like *Schnabel and *Baselitz up against modern 'Old Masters' such as *Picasso and *Bacon. More than any other exhibition it ushered in the international painting revival of the 1980s. These exhibitions were initiated by Sir Norman Rosenthal (1944–), appointed as Exhibitions Secretary in 1977. Some scepticism has been expressed as to whether the Royal Academy will continue to be as adventurous following his departure in 2008. The programme was marked by his strong commitment to international contemporary art (he had previously worked at the *Institute of Contemporary Arts), and was not always agreeable to some Academicians, four of whom resigned in the wake of the controversial *'Sensation' exhibition of 1997. Many of the artists in that event have subsequently exhibited at summer exhibitions: in 2007, the courtyard was dominated by dinosaur sculptures by the *Chapman brothers. Perhaps their cheerful and brutal nihilism represents the outlook of the current British ruling class as accurately as did the aristocratic swagger of Reynolds or the populist patriotic history of Wilkie or Millais in their respective times.

The presidents of the RA in the 20th century were: Sir Edward *Poynter, 1896–1918; the architect Sir Aston Webb (1849–1930), 1919–24; Sir Frank *Dicksee, 1924–8; Sir William Llewellyn, 1928–38; the architect Sir Edwin Lutyens (1869–1944), 1938–44; Sir Alfred Munnings, 1944–9; Sir Gerald *Kelly, 1949–54; the architect Sir Albert Richardson (1880–1964), 1954–6; Sir Charles *Wheeler, 1956–66; Sir Thomas Monnington (1902–76), 1966–76, the first *abstract artist to hold the office; the architect Sir Hugh Casson (1910–99), who was also a watercolourist, 1976–84; Sir Roger de Grey (1918–95), 1984–93; and the architect Sir Philip Dowson (1924–), 1993–9. The subsequent election of Phillip *King marked a final acceptance of modernism. He was succeeded in 2004 by the architect Sir Nicholas Grimshaw (1939–).

Further Reading: J. Fenton, *School of Genius: A History of the Royal Academy of Arts*

S. R. Hutchinson, *The History of The Royal Academy* (1968)

Royal College of Art (RCA), London. Britain's pre-eminent training school for artists and designers. Since 1967 it has been a postgraduate university institution, but it has had many changes of status, name, and location since it was founded in 1837 at Somerset House as the Government School of Design. Originally it was a school of industrial design, the fine arts being the province of the *Royal Academy. In 1852 it moved to Marlborough House and was renamed the Central School of Practical Art. It became part of the Government Department of Science and Art in 1853 and in 1857, renamed the National Art Training School, it moved to join the Museum of Ornamental Art (now Victoria and Albert Museum) in South Kensington. In 1863 it moved to Exhibition Road, and in 1896 it was renamed the Royal College of Art by Queen Victoria and allowed to grant diplomas. At this time the principal (or headmaster as the post was sometimes known) was John Sparkes (1832/3–1907); he was succeeded by Walter *Crane, 1897–8, and then by Augustus Spencer (1860–1924), who held the position until 1920.

By the turn of the century the college had turned much more to fine art, away from industrial design, and in 1900 it was divided into four schools: Mural and Decorative Painting; Sculpture and Modelling; Architecture; and Design. The original heads of these schools (who were called 'instructors', then from 1901 'professors') were respectively Gerald Moira (1867–1959), whose work included murals at the Central Criminal Court (Old Bailey) and other public buildings in London; the French-born Edward Lantéri (1848–1917), who was influential in training exponents of the *New Sculpture; Beresford Pite (1861–1934), a founder member (1884) of the Art Workers' Guild, which aimed to increase understanding and collaboration between different branches of the visual arts; and W. R. Lethaby (1857–1931), one of the outstanding art educators of his day. Lethaby brought with him several specialist teachers, most notably Edward Johnston (1872–1944), the celebrated calligrapher, who taught writing and illumination at the RCA for almost 40 years. Among the other distinguished and long-serving teachers was Frank *Short, who was in charge of etching from 1891 to 1924.

Spencer was followed as principal by William *Rothenstein, 1920–35, whose conservative values were highly influential, and he was

succeeded by Percy Jowett (1882–1955), 1935–47. During the Second World War the RCA was relocated to Ambleside in the Lake District, 1940–5. By the time of its return to London the college had become somewhat stagnant. It was given new life by Sir Robin Darwin (1910–74), who was head from 1948 to 1971 (in 1967 his title changed from principal to rector). Darwin introduced many new departments, including fashion design and photography and thus aligned the college more closely with industry. It was during his long period in charge that the college moved to its present home, a new building in Kensington Gore (1961), and that it was given a Royal Charter and empowered to award degrees (1967).

Although the RCA had some highly illustrious students early in the 20th century, most notably Barbara *Hepworth and Henry *Moore, its golden age is usually reckoned to fall within Darwin's period in charge. In 1987 Sir Christopher Frayling (1946–), professor of cultural history at the college (he became rector in 1996), published *The Royal College of Art: One Hundred & Fifty Years of Art & Design*, in which he named the period 'roughly 1948–1968' as 'the days . . . when the RCA couldn't do anything wrong if it tried'. In the realm of painting, its absolute peak of esteem came in the late 1950s and early 1960s with the generation of students who were largely responsible for launching British *Pop art—Derek *Boshier, David *Hockney, Allen *Jones, R. B. *Kitaj, Peter *Phillips (*see* YOUNG CONTEMPORARIES).

Rozanova, Olga (1886–1918) Russian painter, designer, writer, and administrator, born at Malenki in Vladimir province. She was an energetic figure in the avant-garde in the most momentous period of 20th-century Russian art, but her career was cut short when she died suddenly of diphtheria at the age of 32. After studying at the Bolshakov Art College and the Stroganov Art School in Moscow, 1904–10, she became a member of the *Union of Youth in 1911. In an essay published in the Union's journal in 1913 she was among the first Russians to advocate abstract art. Her painting at this time was *Futurist in style and she illustrated many Futurist books, often in collaboration with her husband Alexei Kruchenykh (1886–1968), a poet and critic who was one of the leading theorists of the movement. By the time she illustrated his book *Universal War* (1916) her style had become purely abstract in a manner close to *Suprematism (she also

experimented with other abstract styles). Kruchenykh subscribed to a theory of poetry called 'transrationalism', which 'proclaimed the liberation of words from their conventional meanings and resulted in a kind of abstract sound-poetry . . . Rozanova's success in transposing the abstract qualities of Kruchenykh's poems into the medium of collage depended in large measure upon her acceptance of his theories. In breaking down syntax and in his use of part-words and letters Kruchenykh destroyed literal meaning in his poems and found himself free to experiment with a wide range of associations aroused by both the sound of his poem and its image on the paper' (M. N. Yablonskaya, *Women Artists of Russia's New Age*, 1990).

After the 1917 Revolution, Rozanova (who was an ardent public speaker) devoted much of her energy to the reorganization of industrial art, travelling widely throughout the country, which was in a state of chaos. She was mainly responsible for creating a special subsection of *Narkompros dealing with industrial art and she drew up a plan for Moscow's museums in this field that was put into practice after her death. Her idea of reconciling art and industry was realized in the *Constructivist movement.

Rubbo, Anthony (Antonio) **Dattilo** (1870–1955) Italian-born painter who settled in Australia in 1897 and ran an art school in Sydney from 1898 to 1941. He also taught for many years at the Royal Art Society School, Sydney. Rubbo admired the work of the *Post-Impressionists and his teaching helped to promote an advanced style based on their work. His pupils included three of the pioneers of modernism in Australia—Roy de *Maistre, Grace Cossington *Smith, and Roland *Wakelin. Wakelin wrote of him: 'Rubbo, with his virile personality and tremendous enthusiasm, was an inspiration to us all.'

Rubinstein, Helena *See* NADELMAN, ELIE.

Ruche, La ('The Hive') A twelve-sided, three-storey building in the rue Dantzig in Paris, near the Vaugirard abattoirs, opened in 1902 with the idea of forming the centre of an artistic community. It was the brainchild of Alfred Boucher (1850–1934), an undistinguished painter and sculptor who bought some land in 1895 and built a few studio huts on it; he was encouraged to erect something more ambitious when he acquired various pieces of pavilions that had been dismantled after the 'Exposition Universelle' in Paris in 1900. The main building originally had twenty-four cramped wedge-shaped studios, but 140 others were eventually erected on the site. They were badly built and without conveniences such as water and gas, but they were extremely cheap. Many foreign artists found a home there during their early careers in Paris, among them *Archipenko, *Chagall, *Lipchitz, *Modigliani, and *Soutine. Some French artists also had studios there for a time (*Delaunay, *Laurens, *Léger) and some poets and writers lived there (Guillaume *Apollinaire, Blaise Cendrars, Max *Jacob). Political refugees also found shelter at La Ruche. The building was scheduled for demolition in 1966, but it was saved because of its important historical associations, and after restoration was reopened as studios in 1978.

Rückriem, Ulrich (1938–) German sculptor, born in Düsseldorf. He was apprenticed as a stonemason and worked at the Cathedral Restoration workshop in Cologne (1959–61). For some years his work as an independent sculptor was highly eclectic: he made portraits and gravestones, as well as more abstract pieces including constructions in coloured metal close to the work of British sculptors such as Anthony *Caro. In 1968 he encountered the sculpture of Carl *Andre and returned to work in stone but with the minimum of intervention. The stones are split, sometimes in saw mills, according to his precise instructions and sometimes by the artist's hand, and then arranged back together again. This introduces an element of time as well as space into the work. Tate has two related sculptures from the same dolomite stone, *Untitled* (1989) and *Double Piece* (1982). One work has been split with a drill and bolster (a large chisel) and the other broken by hammer, an instance of the significance that the artist attaches to physical process.

Ruff, Thomas (1958–) German photographer, born in Zell am Halmersbach. He was a student of Bernd Becher at the Düsseldorf Academy (1977–85) and shared his interest in large-scale photography, but he is far more sceptical as to the 'documentary' or 'truth' value of the medium. He first achieved a wide reputation with a series of highly enlarged colour photographs of the heads and shoulders of fellow students, presented neutrally with a

totally even light (1983). These were followed up with *Haus*, photographs of anonymous grey apartment blocks, and a series of 1992 which used the night photography technology developed for warfare. Later work has been more concerned with the use of existing images. The *Plakat* series (1997) used computer manipulation to parody the mechanisms of political propaganda. The *Jpeg* series (2004–5) presents blow-ups of images taken from the internet, frequently ones which imply destruction and disaster, such as volcanic eruptions or the 2001 attack on the World Trade Center.

Rumney, Ralph *See* DENNY, ROBYN.

Ruralists, Brotherhood of *See* BROTHER-HOOD OF RURALISTS.

Ruscha, Ed (1937–) American painter, printmaker, designer, and photographer. He was born in Omaha, Nebraska, and studied at the Chouinard Art Institute, Los Angeles, 1956–60. His work has been varied and experimental, often using unconventional materials (such as blood and foodstuffs), but he is best known for his books of deadpan photographs of banal features of American life, which are early examples of *Book art. The first was *Twentysix Gasoline Stations* (1962). 'Mimicking the way in which Americans use their cameras, these collections of snapshot-like pictures question the medium's artistic potential and raise broader issues about our society's strange affair with photography. Ruscha's books are so simple they become profound' (George Walsh, Colin Naylor, and Michael Held, eds, *Contemporary Photographers*, 1982). Some of his more conventional paintings and prints are representative of *Pop art, depicting advertising signs in a bold, brash manner (*Large Trademark with Eight Spotlights*, 1962, Whitney Museum, New York). Although Ruscha was once regarded as one of the less significant Pop artists, he is now seen as an important link to the subsequent wave of *Conceptual art, because of his use of language and photography.

Ruskin, John *See* DIRECT CARVING; TRUTH TO MATERIAL(S).

Russell, John (1919–2008) British art critic and exhibition organizer. He was born in London and studied at Magdalen College, Oxford. After war service at the Ministry of Information and the Admiralty, he became a journalist and was the regular art critic of *The Sunday Times*

from 1949 to 1974. He then moved to New York as art critic of *The New York Times*. His numerous books (mainly but not exclusively on art) include *Paris* (with photographs by *Brassaï) (1960), *Max *Ernst* (1967), *Henry *Moore* (1968), *The World of *Matisse* (1970), *Francis *Bacon* (1971), *Edouard *Vuillard* (1971), and *The Meanings of Modern Art* (1981). They combine accessibility and an admirably fluent style with sensitivity and sound scholarship. As a member of the art panel of the *Arts Council from 1958 until 1968 he organized three exhibitions at the Tate Gallery, London: *Modigliani (1964), *Rouault (1966), and *Balthus (1968); he was also co-organizer of the exhibition '*Pop Art' at the Hayward Gallery in 1969.

Russell, Morgan (1886–1953) American painter, active mainly in Paris; with Stanton *Macdonald-Wright he was the founder of *Synchromism, one of the earliest abstract art movements. Russell was born in New York, the son of an architect. Originally he intended following his father's profession, but on a visit to Paris in 1906 he was overwhelmed by the Michelangelo sculptures he saw in the Louvre and decided to become a sculptor. After returning to New York he studied sculpture at the *Art Students League and painting under Robert *Henri. In 1908 he settled in Paris, where he met Gertrude and Leo *Stein and through them *Matisse, at whose art school he briefly studied. By 1910 Russell was turning away from sculpture and devoting himself increasingly to painting, and in 1911 he met Macdonald-Wright, with whom he developed theories about the analogies between colours and musical patterns. In 1913 they launched Synchromism, and Russell's *Synchromy in Orange: To Form* (1913–14, Albright-Knox Art Gallery, Buffalo) won him considerable renown in Paris. His later work, in which he reintroduced figurative elements, was much less memorable than his pioneering abstract paintings. From about 1930 much of his work consisted of large religious pictures. He lived in Paris until 1946, then returned to the USA.

Russolo, Luigi (1885–1947) Italian painter and musician, born at Portogruaro in the Veneto, son of the local cathedral organist. His only formal training as a painter was as an assistant to a restorer who was working on Leonardo da Vinci's mural of *The Last Supper* in Milan. Russolo was one of the signatories of

the two *Futurist painters' manifestos in 1910, but he has become best known as 'the most spectacular innovator among the Futurist musicians' (*New Grove Dictionary of Music and Musicians*, 1980). In 1913 he published a manifesto *L'Arte dei rumori* ('The Art of Noises', expanded in book form in 1916) and later in that same year he demonstrated in Modena the first of a series of *intonarumori* ('noise-makers'), which produced a startling range of sounds. In 1913–14 he gave 'noise concerts' in Milan (causing a riot), Genoa, and London, and others followed after the First World War, notably in Paris in 1921. They were highly controversial, but *Mondrian praised the Paris performances in the journal *De *Stijl* and several leading composers, notably Ravel and Stravinsky, seemed to think that they opened up interesting new possibilities. Russolo indeed has been regarded as a pioneer of today's electronic music. Unfortunately his handful of noise compositions have been lost and the machines were all destroyed during the Second World War while they were in storage in Paris; one recording survives, but of very poor quality. In 1927–32 Russolo lived in Paris as a refugee from Fascism. After a brief period in Spain, he returned to Italy in 1933 and settled at Cerro di Laveno on Lake Maggiore. His early paintings had made rather crude use of the Futurist device of 'lines of force'; after the First World War his style became more naturalistic.

Rustin, Jean (1928–) French painter, born in Montigny-lès-Metz. After the Second World War he settled in Paris, where he studied at the École des *Beaux-Arts, 1947–53, and built up a successful career as an abstract painter, culminating in a retrospective at the Musée d'Art Moderne de la Ville de Paris in 1971. However, he then changed direction dramatically and began producing bleak and disturbing figurative works, typically showing aged, decrepit nudes—men and women—in bare, cell-like rooms. Their odd proportions have much to do with the disquieting animal-like quality. Rustin especially tends to paint the nostrils too high, leaving too much distance between nose and mouth. They are sometimes compared with Francis *Bacon's paintings, but Rustin's vision—though just as despairing—is much quieter. He has stated that his essential subject as an artist is solitude and he relates this to political disillusion. He told an interviewer: 'Once I believed in social-

ism, that there was going to be a revolution and everyone was going to be happy. That started to change when the Russians invaded Hungary in 1956.'

((⊕)) SEE WEB LINKS
- J. Toledo, 'Jean Rustin's artistic solitude', on BBC website.

Rutherston, Albert *See* ROTHENSTEIN, SIR WILLIAM.

Rutter, Frank (1876–1937) British art critic, born in London, the son of a solicitor. After taking a degree in Semitic languages at Cambridge University in 1899 he became a professional art critic in 1901. He was one of the staunchest British supporters of *Impressionism and of modern French painting in general, and he denigrated the *Royal Academy, which he thought outmoded. In 1908 he was one of the founders of the *Allied Artists' Association and in 1909 he launched and edited its journal, *Art News*. Roger *Fry's first *Post-Impressionist exhibition in 1910 inspired Rutter to write a short book entitled *Revolution in Art: An Introduction to the Study of *Cézanne, *Gauguin, Van Gogh, and Other Modern Painters* (1910), in which he equates artistic radicals with political ones, incorrectly identifying Cézanne as a Communist. From 1912 to 1917 he was curator of the City Art Gallery in Leeds, where he was an early mentor of Herbert *Read, who assisted Rutter on his illustrated quarterly periodical *Art and Letters*, which ran from 1917 to 1920. In 1917 he returned to London and worked for the Admiralty until the end of the First World War. Rutter's numerous books include *Evolution in Modern Art: A Study of Modern Painting, 1870–1925* (1932), *Art in My Time* (1933), and *Modern Masterpieces: An Outline of Modern Art*, posthumously published in 1940. He also wrote much of the text of *Orpen's *The Outline of Art* (1923), although in the original edition he is credited only with the final chapter.

Ryder, Albert Pinkham (1847–1917) American painter of imaginative subjects. He lived most of his life as a solitary and dreamer in New York, and his methods and approach as an artist were largely self-taught. His pictures reflect a rich inner life, with a haunting love of the sea (he was born at the fishing port of New Bedford, Massachusetts), and a constant search to express the ineffable: 'Have you ever seen an inch worm crawl up a leaf or twig, and then

clinging to the very end, revolve in the air, feeling for something to reach something? That's like me. I am trying to find something out there beyond the place on which I have a footing.' This imaginative quality and eloquent expression of the mysteriousness of life is expressed typically through boldly simplified forms and eerie lighting (*The Race Track* or *Death on a Pale Horse, c.*1896, Cleveland Museum of Art). In spite of his self-imposed isolation, Ryder's works became well known in his lifetime and he has been much imitated and faked. His own paintings have often deteriorated because of unorthodox technical procedures.

Ten of Ryder's pictures were included in the *Armory Show of 1913 and he has been seen as a precursor of *Expressionism and abstract art. He was greatly admired by Jackson *Pollock, who in 1944 said 'Ryder is the only American painter who interests me', and the critical and popular favour Ryder enjoyed in the 1950s and 1960s was linked to the success of *Abstract Expressionism.

Further Reading: E. Brown, *Albert Pinkham Ryder* (1989)

Rylov, Arkady (1870–1939) Russian painter and graphic artist, active mainly in St Petersburg/Leningrad, where he studied (1894–7) and later taught (1918–29) at the Academy. He was primarily a landscape painter and is remembered mainly for *In Blue Space* (1918, Tretyakov Gallery, Moscow), showing swans flying over the sea; it 'has been hailed as the first expression of the new sense of freedom and the joyous outlook brought about by the Revolution' (Mary Chamot, *Russian Painting and Sculpture*, 1963). In the 1920s some of Rylov's paintings had a luscious breadth (*Forest River*, 1929, Russian Museum, St Petersburg), but in the 1930s his work became less interesting as it fell into line with the propagandist ideals of *Socialist Realism (*Tractor: Timber Cutting*, 1934, Tretyakov Gallery). His *Reminiscences* was posthumously published in 1954.

Ryman, Robert (1930–) American painter, born in Nashville, Tennessee. After settling in New York, he made his first totally monochrome paintings in about 1955. Although he always works in white and in a square format, there is an enormous variation in the work because of differences in medium, support,

handling, and scale. Sometimes coarse canvas is used, sometimes paper, sometimes metal. *Untitled* (1959) has an unusually large signature. Ryman explains that this element of the work, accepted as conventional in painting, aims to avert any suggestion of symbolism and prevent assumptions that the painting is trying to say something. His paintings received little attention until the late 1960s and tended at that time to be linked with *Conceptual art. This is far from Ryman's intentions, as he is concerned not with idea but with painting itself. He wrote in 1975: 'What is to be done with paint is the essence of all painting.'

Further Reading: R. Storr, *Robert Ryman* (1993)

Rysselberghe, Théo van (1862–1926) Belgian painter, graphic artist, designer, and sculptor, born in Ghent. He studied at the Academies of Ghent and Brussels and during the 1880s and 1890s he travelled a great deal, visiting Africa and the Far East as well as various parts of Europe. In 1886 he was impressed with the work by Georges Seurat he saw at the final *Impressionist exhibition in Paris; by the following year he had adopted Seurat's pointillist technique and he became the leading Belgian exponent of *Neo-Impressionism. In 1898 he moved to Paris, where he was friendly with the *Symbolist circle of artists and writers: his painting *A Reading* (1903, Museum of Fine Arts, Ghent) shows several leading literary figures including André Gide, Maurice Maeterlinck, and Émile Verhaeren. During his time in Paris he kept up close contacts with his native country, forming an important artistic link between Belgium and France (he was responsible for having works by several of the *Fauves exhibited at La *Libre Esthétique in Brussels in 1906). In 1910 he settled at St Clair in Provence, where he abandoned Neo-Impressionism for a broader style of painting. His work is well represented in the Rijksmuseum Kröller-Müller at Otterlo. Apart from paintings, his output included a variety of design work, including furniture, jewellery, and stained glass, much of it for Siegfried Bing's Paris gallery L'Art Nouveau, the establishment that gave the *Art Nouveau style its name. Late in his career he also took up portrait sculpture. His brother **Octave van Rysselberghe** (1855–1929) was one of Belgium's leading Art Nouveau architects.

Saatchi, Charles (1943–) Iraqi-born British businessman and art collector. In 1970 he was co-founder with his brother Maurice of Saatchi & Saatchi, which became the world's largest advertising agency. He has devoted much of his enormous wealth to buying contemporary art on a huge scale. In the early years, he bought *Minimal art, *Neo-Geo, *Neo-Expressionism, and a substantial collection of *Warhol, including some major early works. While Saatchi's patronage has been welcomed by many (not least the artists who have benefited from it), others have been critical of the way in which his bulk buying has given him such power in the art market. He is sometimes referred to, usually by detractors, as a dealer rather than a collector, because over the years he has sold much of his collection at a profit. The earliest sustained criticisms of his role came about as a result of an exhibition at the *Tate Gallery of Julian *Schnabel in 1982. Most of the paintings came from Saatchi's own collection. Because Saatchi was on the steering committee of the Tate's Patrons of New Art, there were accusations of improper influence. Since that time there has been a perception that it has been his ambition to make a kind of 'alternative Tate'. His activities were satirized in a 1985 painting by Hans *Haacke, *Taking Stock*, in which the most famous client of Saatchi as an advertiser, the Conservative leader Margaret Thatcher, is depicted in the style of a Victorian portrait, complete with elaborate classical frame. Cracked plates (an aspect of Schnabel's 'signature style') bear the images of Saatchi and his then wife, Doris.

In 1985 the Saatchi Collection was opened to the public in a new gallery (converted from a warehouse) in St John's Wood, North London. The premises were relatively difficult of access and only open at weekends: their existence was not obvious to the casual passer-by, and the visitor had to ring for entry, passing through a formidable metal door as though into a maximum security prison. Only a small part of the collection was on view at any time, but a glossy museum-style catalogue, with essays by leading critics, was produced. In 1997 a selection of work by British artists from the Saatchi Collection was loaned to the *Royal Academy as an exhibition entitled *'Sensation', an event which, more than any other, drew the *Young British Artists, including *Hirst, the *Chapman brothers, and *Taylor-Wood, to the attention of a wide public. Quite apart from the character of the work, which was extremely controversial, there was the question about the enormous influence of a single collector.

The St John's Wood gallery closed in 2003 and new premises opened at County Hall, the old headquarters of the Greater London Council, a very public venue which was also only a few minutes' walk from the Hayward Gallery (*see* ARTS COUNCIL). A number of important exhibitions were held there, including a whole series entitled 'The Triumph of Painting', but the period was also marked by the disastrous fire at the Momart warehouse in 2004, in which much of the collection, alongside many other important works by British artists, was destroyed. Following a legal dispute with the landlord, Saatchi vacated the County Hall premises. A new gallery opened in Chelsea in 2008 with an exhibition of contemporary Chinese art.

Further Reading: S. Kent, *Shark Infested Waters: The Saatchi Collection of British Art in the 90s* (2003)

Sage, Kay (1898–1963) American *Surrealist painter, born in Albany, New York, to wealthy parents. She was mainly self-taught as an artist. In 1900–14 and 1919–37 she lived in Italy (she was married to an Italian prince, 1925–35), and Giorgio *de Chirico was an early influence on her work. In 1937 she moved to Paris, where she met Yves *Tanguy in 1939. He followed her to the USA in 1940 and they married later that year. From the time of her

return to America, architectural motifs became prominent in her work—strange steel structures depicted in sharp detail against vistas of unreal space—and her pictures also included draperies from which faces and figures sometimes mistily emerged (*Tomorrow is Never*, 1955, Metropolitan Museum, New York). Sage also made mixed-media constructions. Tanguy's sudden death in 1955 cast a shadow over her last years and she committed suicide. In 1957–62 she published four collections of her poems, one of which, *Mordicus* (1962), was illustrated by *Dubuffet.

Sainsbury Centre for Visual Arts, Norwich. Gallery and study centre presented to the University of East Anglia (together with an endowment to maintain it) by Sir Robert Sainsbury (1906–2000), president of the family supermarket chain, his wife, Lisa, and their son David (who paid for the building). It was opened in 1978. The collection it houses, begun by Sir Robert in the 1920s, is very diverse but is particularly strong in contemporary art (especially sculpture) and in primitive art (including African, Oceanic, and Pre-Columbian). Among the artists whose work Sir Robert most avidly collected were Francis *Bacon (he patronized him when he was virtually unknown), John *Davies, Alberto *Giacometti, and Henry *Moore. The building, designed by Sir Norman Foster, is a leading example of High Tech architecture and has often been compared in appearance to an aircraft hangar.

Saint-Gaudens, Augustus (1848–1907) The leading American sculptor of his generation. He was born in Dublin of a French father and an Irish mother, who settled in America when he was an infant. His training included a period of six years studying in Paris and then Rome, after which he settled in New York in 1874. His preferred medium was bronze and he was primarily a maker of public monuments, although he also did a good deal of work on a smaller scale, including busts, medallions, and the design of the US $20 gold piece (1907). His style was vigorously naturalistic. Most of his work is in the USA, but there are good examples elsewhere, notably a statue of Charles Stewart Parnell in Dublin and a life-size bronze relief of Robert Louis Stevenson (1904) in St Giles Cathedral, Edinburgh. Saint-Gaudens was a highly important figure in the development of American sculpture: he

turned the tide against Neoclassicism and made Paris, rather than Rome, the artistic Mecca of his countrymen. From 1885 he spent his summers at Cornish, New Hampshire, and settled there in 1900; his studio was declared a national historic site in 1964. Casts of most of his works can be seen there.

St Ives School A loosely structured group of artists, flourishing particularly from the late 1940s to the early 1960s, who concentrated their activities in the Cornish fishing port of St Ives. Like *Newlyn, St Ives had been popular with artists long before this: in the winter of 1883–4 *Whistler and *Sickert had spent several weeks painting there; Helene *Schjerfbeck and Anders *Zorn spent the winter there in 1887–8; the St Ives Arts Club had been founded in 1888, the St Ives Society of Artists in 1927 (it had its own sales gallery to cater for the tourist trade), and the St Ives School of Painting in 1938. In 1920 Bernard Leach (1887–1979), probably the most famous British ceramicist of the 20th century, established a pottery there. However, St Ives did not become of more than local importance in painting and sculpture until Barbara *Hepworth and Ben *Nicholson moved there in 1939, two weeks before the outbreak of the Second World War. They were anxious that their children should be safely outside London, and their friend Adrian *Stokes, who lived at Carbis Bay (virtually a suburb of St Ives), invited the family to stay with him. Hepworth lived in St Ives for the rest of her life (her studio is now a museum of her work) and Nicholson (who had discovered Alfred *Wallis on a day-trip to St Ives in 1928) lived there until 1958. They formed the nucleus of a group of avant-garde artists who made the town an internationally recognized centre of abstract art, and it is to these artists that the term 'St Ives School' is usually applied, even though many of them had little in common stylistically, apart from an interest in portraying the local landscape in abstract terms. The one with the greatest international prestige was Naum *Gabo, who lived in St Ives from 1939 to 1946.

After the war a number of abstract painters settled in or near the town or made regular visits. The residents included Bryan *Wynter, who moved there in 1945 and settled at Zennor, about five miles away, Terry *Frost, who lived there intermittently (at first in a caravan) from 1946 to 1963, and Patrick *Heron, who rented a cottage in St Ives every summer from

1947 to 1955 and then bought a house at Zennor; the visitors included Roger *Hilton (who eventually settled in St Ives in 1965), Adrian *Heath, and Victor *Pasmore. Peter *Lanyon was the only notable abstract artist to be born in St Ives. For many of the more abstract painters the attraction was as much in the quality of the light as in the scenery. Patrick Heron talked of the 'light that goes round corners', comparing it to that of Greece. This quality is the result of the exceptional purity of the air as well as the strongly reflective power of the sand and the sea.

Many of the avant-garde artists became members of the St Ives Society of Artists, and there was some antagonism between them and the traditionalists. In 1946 the modernists showed their work separately in the crypt of the Mariners' Chapel in St Ives and were consequently known as the Crypt Group. The group held two more exhibitions, in 1947 and 1948, but in 1949 the Penwith Society was formed in an attempt to reconcile traditionalists and abstractionists (the name comes from the district of Cornwall in which St Ives is situated). It was intended as a tribute to Borlase Smart (1881–1947), a leading light of the St Ives Society of Artists, who was a traditionalist himself but sympathetic to modern ideas. It became more associated with the modernists, however (Herbert *Read was the first President), and organized Britain's first post-war exhibitions of abstract art. It was largely thanks to its activities that St Ives attracted so much attention in the 1950s and early 1960s from artists, critics, and dealers (American visitors included the painters Larry *Rivers, Mark *Rothko, and Mark *Tobey, and the critic Clement *Greenberg).

The heyday of the St Ives School was over by the mid-1960s, but the town continued to be an artistic centre. In 1993 the Tate Gallery opened a branch museum there (Tate St Ives), housing changing displays of the work of 20th-century artists associated with the town. The building includes a stained-glass window commissioned from Patrick Heron.

Further Reading: Tate Gallery, *St Ives 1939–64* (1985)

St Martin's School of Art, London. Art college founded in 1854 in Shelton Street, London, near the church of St Martin-in-the-Fields, which initially provided sponsorship. It became independent of the church in 1859. In 1913 it moved to Charing Cross Road, which is still the site of one of its its principal buildings (it also occupies premises nearby in South-

ampton Row, Long Acre, and elsewhere). St Martin's developed into one of the largest art schools in the country, and in the 1960s it became famous for its sculpture department, where Anthony *Caro was a highly influential teacher, encouraging a generation of artists to question the nature of sculpture. By the early 1960s a certain kind of 'house-style' of colourful large-scale sculpture, displayed on the ground without a plinth, was recognizable in the work of Phillip *King, William *Tucker and others but before the end of the decade artists such as Richard *Long, Barry *Flanagan, and *Gilbert & George were embarking on a still more radical course which paralleled the challenge to the art object in *Conceptual art. William Tucker, by then a tutor, commented angrily that 'I have found it more or less impossible to persuade students at St Martin's to actually *make* anything at all. They have been so busy taking photographs, digging holes, or cavorting around in the nude.' In the early 1980s the department became known for figure sculpture in forged iron by sculptors such as Katherine Gili (1948–) and Anthony Smart (1949–). By that time the sculpture department had acquired a reputation for dogmatism (or, to its supporters, rigour), quite in contrast to the adventurous spirit of the 1960s. This inspired a memorable cartoon in the style of H. M. *Bateman which appeared in *Artscribe* captioned 'The student who mentioned *Picasso at St Martin's' (the issue being that at St Martin's, Picasso was not considered a 'serious' sculptor). In 1989 St Martin's amalgamated with the Central School of Art and Design (founded in 1896 as the Central School of Arts and Crafts) to form Central Saint Martins College of Art and Design. This is now one of six colleges that make up the University of the Arts, London, the others being Camberwell College of Arts (formerly Camberwell School of Art and Crafts), Chelsea College of Art and Design (formerly Chelsea School of Art), the London College of Fashion, the London College of Printing and Distributive Trades (formerly London College of Printing and Graphic Art), and Wimbledon College of Art. In 2003 the Byam *Shaw School of Art became part of St Martin's.

St-Paul-de-Vence, Fondation Maeght *See* MAEGHT, AIMÉ.

St Petersburg, Hermitage *See* MOROZOV, IVAN; SHCHUKIN, SERGEI.

Saint Phalle, Niki de (1930–2002) French sculptor, painter, graphic artist, and filmmaker, one of the great entertainers of modern art and also one its the most provocative figures. She was born at Neuilly-sur-Seine, Paris, the daughter of a banker, and was brought up in New York, where her family settled in 1933. After being expelled from various convent schools and working briefly as a model (she appeared on the cover of *Vogue*), she eloped with an aspiring poet when she was eighteen. In 1951 she and her husband moved to France, settling in Paris, and in 1952 she started painting without formal artistic training. Early paintings were close in style to the figure paintings of *Dubuffet and tend to deal satirically with the theme of the bourgeois family.

She began making reliefs and assemblages in 1956. Aggressive objects like hammers and cleavers are attached to the surface. *Pink Nude with Dragon* (c.1956–8, Sprengel Museum, Hanover) is an alluringly naive image, gorgeous in colour, until one notices the subject (a woman lost in the mountains being disembowelled by a dragon's teeth), and then the rusty nails, attached point outwards to the dragon's skin. She first came to public prominence in 1960 with 'rifle-shot' paintings that incorporated containers of paint intended to be burst and spattered when shot with a pistol. The shootings were often staged in public; noted art world figures like Robert *Rauschenberg and Jasper *Johns were invited to try out their marksmanship. She commented 'It was an amazing feeling shooting at a painting and watching it transform itself into a new being. It was not only EXCITING and SEXY, but TRAGIC – as though we were witnessing a birth and a death at the same moment'. The paintings reflect the anxious political climate of the period in which nuclear annihilation was threatened. *King Kong* (1963, Moderna Museet, Stockholm), a great panorama largely in black and white, reads from images of birth and childhood innocence, through the serpent in the garden of Eden, to wartime destruction, symbolized by another of Saint Phalle's vicious dragons. Contemporary political figures (Kennedy, Khrushchev, and Castro), the main protagonists in the Cuban missile crisis which came close to plunging the world into war, together with Abraham Lincoln, are represented by party masks. As a result of these paintings Saint Phalle came to the attention of Pierre *Restany and she was invited to join the *Nouveaux Réalistes. Subsequently she embarked on a series of life-size figures, gaudily painted, entitled *Nanas*, which explored the experience of women, in marriage and childbirth.

After Saint Phalle separated from her husband in 1960, she lived with and subsequently married Jean *Tinguely, whom she had first met in 1955 and with whom she collaborated on numerous projects, notably the enormous sculpture *Hon* (Swedish for 'She'), erected at the Moderna Museet, Stockholm, in 1966; the Swedish artist Per Olof Ultvedt (1927–2006) also worked on *Hon*. It was in the form of a reclining woman (more than 25 metres long), painted like the *Nanas*, whose interior was a giant *environment reminiscent of a funfair; visitors entered through the vagina. The attractions inside included a milk bar in one of the breasts and a cinema showing Greta Garbo movies. In 1973, in collaboration with the director Peter Whitehead (1937–), Saint Phalle made the film *Daddy*, which explored her resentments at male power. From 1979 onwards she worked on a huge sculpture garden—the Tarot Garden—at Garavicchio in Italy, which was finally opened to the public in 1998. In 1983 she created, in collaboration with Tinguely, her most enduringly popular work, the fountain outside the *Pompidou Centre, Paris, in celebration of the composer Igor Stravinsky. Later projects included a touching book on AIDS addressed to her son (*AIDS: You Can't Catch it Holding Hands*, 1987) and a huge figure of the Loch Ness Monster made for an exhibition of her work in Glasgow in 1992.

(())) SEE WEB LINKS

• Website of the Niki Charitable Art Foundation.

Saint-Point, Valentine de *See* FUTURISM.

Saito, Yoshishige (1904–2001) Japanese painter and maker of constructions, born in Tokyo. Self-taught as an artist, in 1920 he saw an avant-garde Russian art exhibition in Tokyo and it was there that he met David *Burliuk. His interest in Russia was political as well as artistic and 1928 he joined a Marxist seminar group. In 1931 he began making reliefs in plywood under the influence of *Dada and *Constructivism. He came to prominence in 1956 with his series of *Oni* paintings featuring Japanese demons, and he had his first one-man show at the Tokyo Gallery in 1958. From then he was recognized as one of the leading exponents of abstract art in Japan. From *Lyrical Abstraction he turned to a more novel

S

mode, working with an electric drill on plywood covered with a uniform colour. Such works brought him an international reputation. Later he made abstract constructions in wood on an environmental scale. He won numerous awards at international events including the São Paulo *Bienal in 1961. From 1964 to 1973 he was professor of art at Tama College of Art, Tokyo.

Salcedo, Doris (1958–) Colombian sculptor and *installation artist, born in Bogotá where she lives and works. Her art reflects the political climate of her country, which has been ravaged by civil war. The violence tends to be suggested indirectly. At the Venice *Biennale in 1993, she showed a work in which a stack of white shirts, neatly pressed and stiffened with plaster, had been run through with a bayonet. Salcedo has said, 'The objects were moulded from the experience of forty women who had witnessed their men being killed on their very doorstep . . . the marks left behind by the violent act in these places are sometimes evident and sometimes imperceptible, although, in any case, indelible.' She had gone into remote villages and talked to survivors of violence. The shirts referred both to the care taken by the women of the now dead men and the Colombian custom of wearing white shirts at a funeral. She has also made sculptures by filling furniture with concrete, so suggesting the violation of domestic space: *Untitled* (1998, Tate) uses a wardrobe with a chair on its side to suggest the traditional subject of the Pietà. In 2002 she staged an event at the Palace of Justice in Bogotá, which in 1985 had been the site of the burning to death of many people, the result of conflict between guerrillas and the state. Salcedo witnessed the atrocity and she has traced the politicization of her art practice to that event. Her proposal was, on the seventeenth anniversary of the day, to lower chairs down the walls of the building, the piece to begin with a single chair at the exact moment when the first victim died. In 2007 Salcedo mounted *Shibboleth* in the Turbine Hall of *Tate Modern. This consisted of an immense crack made in the concrete floor. The intention was to draw attention to the divisions of racial hatred and economic disadvantage which exist in the apparently smooth surface of the western world, although much of the press attention was directed towards speculation as to how the work had been achieved.

Further Reading: D. Salcedo, *Shibboleth* (2007)

Salisbury, Frank O. (1874–1962) British painter and stained-glass designer. He was born in Harpenden, the son of a plumber and glazier, and was apprenticed to his brother in a stained-glass workshop in St Albans before winning a scholarship to the *Royal Academy, London, where he studied 1892–7. A scholarship to visit Italy in 1896 and his admiration for Renaissance frescos helped establish his taste for large scenes of pageantry. He painted numerous murals in buildings in London and elsewhere and also produced easel pictures of historical events and religious and allegorical scenes. In addition he had a successful career as a portraitist, painting five British prime ministers, five US presidents, and many other notables (including Mussolini on a visit to Italy in 1934), all in a solid, traditional style. He published his memoirs, *Portrait and Pageant*, in 1944. Kenneth *Clark writes that Salisbury 'dressed like a Harley Street gout specialist . . . He lived in Hampstead in a sham Jacobean house which he had built for himself, and everything in the house was sham, including things that might just as easily have been genuine. It had a marvellous consistency.'

Salle, David (1952–) American painter, born in Norman, Oklahoma. He studied under John *Baldessari at the California Institute of Arts, Valencia. When his painting was first seen widely in the early 1980s it was usually associated with the international *Neo-Expressionist tendency and usually coupled with the work of Julian *Schnabel. In fact, although the success of his work was part of a general revival of art world interest in painting during this period, the idea of 'self-expression' is particularly inappropriate to Salle, who is much closer to the stylistic pluralism of Sigmar *Polke to than the deliberate wildness of Georg *Baselitz. His paintings combine images from photographs and the history of art in a way that defies, at least for most commentators, any kind of coherent narrative. The best interpretative model is probably the concept of 'pastiche' as theorized by Fredric Jameson (*see* POSTMODERNISM). *Byron's Reference to Wellington* (1987) draws together a photographically illusionist picture of a young woman holding an outsize crown of thorns from a 17th-century Dutch painting and a scene of erotic dalliance from the 18th century. This is overlaid by other elements, including an image of an ear. Consultation of Byron's

Don Juan, in which Wellington is described as 'the best of cut-throats', tends to add to the mystery rather than solve it.

Sallinen, Tyko (1879–1955) The outstanding Finnish *Expressionist painter. He was born at Nurmes, the son of a tailor who belonged to a strict fundamentalist religious sect (the Hihhulit), and his unhappy and repressive early years later formed the background for some of his paintings. After running away from home at the age of fourteen, he spent several years as an itinerant jobbing tailor in Sweden, then studied art in Helsinki, 1902–4. In 1909 and 1914 he visited Paris, where he became acquainted with avant-garde French painting, particularly *Fauvism. Its influence can be seen in what is probably his most famous picture, *Washerwomen* (1911, Ateneum, Helsinki), a work that caused an outcry because of its bold colours and very rough handling. Sallinen's favourite subjects were scenes of Finnish peasant life such as this and also views of the harsh Karelian landscape. He was the leading member of the November Group, founded in 1917 just one month before Finland's declaration of independence from Russia, and came to be regarded as the nationalist Finnish painter par excellence. His fame spread outside Finland and his work was widely exhibited. From the 1930s he also painted several murals.

Salmon, André (1881–1969) French writer—a poet, novelist, art critic, biographer, and memoirist. He was born in Paris, the son of an engraver, and grew up in St Petersburg, where his father had found work. After returning to France to do military service he settled on a literary career in Paris, seeing himself mainly as a poet, but writing art criticism to earn a living. In 1904 he met *Picasso, and along with two other noted writers—*Apollinaire and Max *Jacob—became one of his intimate circle of friends. He is credited with the title of *Les Desmoiselles d'Avignon*. Salmon was a progressive and prolific but not particularly distinguished critic. In addition to Picasso and the *Cubists, he wrote about *Modigliani, helping to establish his reputation and legend, and *Rousseau. In 1920 he published *La Négresse du Sacré Coeur*—a *roman à clef* about the artists and writers he had known in the *Bateau-Lavoir, with Picasso thinly disguised as a painter called Sorgue. He also describes this world in the first volume of his memoirs,

Souvenirs sans fin: Première époque (1903–1908) (1955; two more volumes followed, 1956 and 1961), a book that is evocative but not always trustworthy. John *Richardson in his *Life of Picasso* describes it as 'garrulous, self-promoting, diffuse' and suggests that the reason for its flaws is to be found in Salmon's subsequent bad relations with Picasso, brought about by the writer's support for Franco and work for a collaborationist newspaper during the German occupation.

Salomé (1954–) German painter and *Performance artist, born in Karlsruhe as Wolfgang Cilarz. He moved to Berlin in 1973 and studied painting at the Hochschule für Bildende Künst. With his partner Rainer *Fetting, with whom he shared a studio, he co-founded the Galerie am Moritzplatz. He was one of the 'Neue Wilden' group of *Neo-Expressionists, and his work as both painter and performer played on themes of gay sexual identity. He performed heavily made up, with rouged cheeks and dark glasses. On one occasion he appeared for twelve hours in a Berlin gallery window wrapped in barbed wire. This represented Salomé's view of the lot of the homosexual in modern society who must 'live in a concentration camp'.

Salon d'Automne Annual exhibition founded in Paris in 1903 as a more progressive alternative to the official Salon and other current exhibiting venues, including the *Salon des Indépendants; it was held in the autumn (October or November), so as not to clash with these other shows, which took place mainly in spring and summer. The founders were a group of painters and poets, among them Carrière (*see* ACADÉMIE), *Renoir, *Rouault, and *Vuillard, led by the architect Frantz Jourdain (1847–1935), now best remembered for his Samaritaine department store in Paris, a masterpiece of *Art Nouveau. The early Salons d'Automne played an important role in establishing the reputations of *Cézanne and *Gauguin. There was a small Gauguin exhibition in 1903 (the inaugural show) and a major retrospective in 1906; Cézanne was strongly represented in 1905 and was given a memorial exhibition in 1907 that made a powerful impact on many members of the avant-garde. However, the Salon d'Automne is famous above all for the sensational launch of *Fauvism at the 1905 exhibition.

S

In 1913, Herwarth Walden, Berlin's leading promoter of avant-garde art, gave the name 'First German Salon d'Automne' (Erster Deutscher Herbstsalon) to the greatest of the exhibitions he organized at his *Sturm Gallery.

Salon des Indépendants Annual exhibition held in Paris by the Société des Artistes Indépendants, an association formed in 1884 by Georges Seurat (*see* NEO-IMPRESSIONISM) and other artists in opposition to the official Salon. There was no selection committee and any artist could exhibit on payment of a fee. This meant that many interesting avant-garde works were shown, but also that they ran the risk of being swamped by a sea of mediocrity. It became the main showcase for the Neo-Impressionists (Henri *Rousseau was also a regular exhibitor) and was a major art event in Paris up to the First World War. By then, however, it had been challenged by the smaller but more discriminating *Salon d'Automne.

Salt, John (1937–) British painter and graphic artist. He studied at the College of Art in his native Birmingham and at the *Slade School, London. After teaching at various art colleges, he moved to New York in 1967 and lived there until 1978. In the USA his style changed abruptly from a mechanical style of abstraction to *Superrealism and by the mid-1970s he had become one of the best-known artists working in this vein. His main theme is the automobile, particularly cars that have been wrecked or abandoned and left to rust (*A-OK Auto*, 2002–3, City Art Gallery, Southampton).

Samaras, Lucas (1936–) Greek-born sculptor and *installation artist who settled in the USA in 1948 and became an American citizen in 1955. He studied at Rutgers University under Allan *Kaprow, then in 1959–62 did postgraduate work in art history (specializing in Byzantine art) at Columbia University, New York. His work has been highly varied in scale, medium, and approach. In 1959 he took part in Kaprow's first *Happening at the Reuben Gallery, New York, and his own work of this time included figures made from rags dipped in plaster and pastels combining *Surrealist fantasy with *Pop art imagery. During the 1960s he worked a good deal with *assemblages, creating bizarre and sometimes sinister objects studded with nails and pins. He also worked with light and reflection, notably in his *Mirrored Room* (1966), an *environment with mirrors in which the spectator was reflected endlessly. Perhaps his best-known works are his 'Autopolaroids'—intimate photographs of his own body that he began making in 1970 and which brought him considerable notoriety.

Samba, Chéri (1956–) Congolese painter, born in Kinshasa. He began working as a sign-painter in the 1970s and was the founder of a school of 'popular painting' which derives its subjects from contemporary life. He became widely known in the West, especially France, after appearing in the 1989 Pompidou Centre exhibition 'Les Magiciens de la Terre' (*see* PRIMITIVISM) and in 1997 was the first contemporary African artist to have a solo exhibition in the Musée d'Art d'Afrique et d'Océanie in Paris. His paintings have often dealt with the plight of Africans in Europe as well as issues in his native country. *Frontier Airport: Country in the Process of Development* (1979) shows a Western tourist bribing an official in an African country while being self-righteous about the corruption he himself is contributing to. *Paris est propre* (1996) draws attention to the role played by African immigrants in doing dirty work cleaning the capital city of rubbish, urine, and dog excrement. The Eiffel Tower is illuminated in the background and Samba ingeniously takes the livid green of the plastic brooms as a colour key for the whole composition. He emphasizes the didactic function of his paintings, which is often reinforced through captions.

Further Reading: M. Diawara, 'Chéri Samba', *Artforum* (November 1997)

Sample, Paul *See* REGIONALISM.

Sander, August (1876–1974) German photographer, born in Herdorf, Siegerland. He attempted to document German society with his project *People of the Twentieth Century*, which he embarked on in the early 1920s and published in a partial form as *Face of our Time* in 1929. When the Nazis came to power the unsold copies of the book were destroyed. Sander's project was totally at odds with Nazi ideology in that people were defined by their social identity rather than their race. The expressionist writer Alfred Döblin (1878–1957), introducing the photographs, invited the viewer to contemplate the effects of life, work, and social change on the countenance of Sander's subjects.

Generally the subjects are identified by their profession or status rather than as individuals and the images emphasize this, sometimes with a degree of humour: the corpulent pastry cook has obviously enjoyed too much the product of his own labour; the Communist leader models his pose and appearance on Lenin. Sander divided his photographs into seven categories, namely *The Farmer, The Skilled Tradesman, The Woman, Classes and Professions, The Artists, The City,* and *The Last People.* This final section dealt with society's discards and outcasts. Sander's brochure for the book provided a schema which proceeded 'from the earthbound man to the highest peak of civilization, and downward according to the most subtle classifications to the idiot'. As Ian Jeffrey points out this scheme emphasizes artists and architects as the highest form of civilization. In the Nazi era, Sander worked on a less contentious project documenting the history of Cologne but continued to work clandestinely on portraits of the victims of political and racial persecution.

Further Reading: *August Sander: Visage d'un époque* (1990)

Sandle, Michael (1936–) British sculptor and printmaker, active mainly in Germany. He was born in Weymouth, the son of a naval officer, and studied at Douglas School of Art and Technology, Isle of Man, 1951–4. After doing his National Service in the Royal Artillery, he studied printmaking at the *Slade School, London, 1956–9, then briefly worked as a lithographer in Paris. During the 1960s he taught at various art colleges in Britain and Canada, then in 1973 settled in Germany to teach at Pforzheim. In 1980 he became professor of sculpture at the Karlsruhe Academy. Sandle has concentrated on producing large, elaborate, carefully crafted works (typically in bronze) that echo the tradition of 19th-century public monuments but in a modern idiom and an anti-authoritarian vein; instead of glorifying events, they attack the abuse of power. The best known is probably *A Twentieth Century Memorial* (1971–8, Tate), a gigantic Mickey Mouse with a machine gun in bronze, brass, and wood, a savage commemoration of the Vietnam War. As a protest against the Iraq War, in 2006 he showed a large drawing at the *Royal Academy summer exhibition of Tony and Cherie Blair being expelled from 10 Downing Street like Adam and Eve from the Garden of Eden. In 1997 he had resigned from the Academy in protest against its showing a

controversial exhibition of contemporary art (*see* SENSATION), but he was re-elected in 2004.

Further Reading: F. Maddocks, 'In the Studio: Michael Sandle RA', *RA Magazine* (autumn 2007)

Sandler, Irving (1925–) American art critic and historian, born in New York. He is the author of the pioneering study **Abstract Expressionism: The Triumph of American Painting* (1970). It is a valuable source of information, especially useful for some of the lesser-known artists. Sandler codified the distinction between two branches of the movement, *gestural and *Colour Field, for which it has been criticized by later writers such as David Anfam (*Abstract Expressionism,* 1990) who see this as being too *formalist an approach. The book has also been the object of attacks arising from the ill-tempered debates about the political significance of the movement, which Sandler, it has been argued, misrepresents. Nonetheless it has proved remarkably hard to supplant as a standard guide to the movement and this may continue to be the case until the polemics have died down sufficiently to make possible some kind of canonical account. The great value of Sandler's writings is that he can speak both as a witness and as an historian. This is manifested in subsequent books such as *The New York School* (1978) and *American Art of the 1960s* (1988). He published his memoir, *A Sweeper up after Artists,* in 2003. The title refers to his period working at the Tanager Gallery, an artists' co-op, when he was young.

Further Reading: R. Storr, 'Good fella', *Artforum international* (April 2004)

Sands, Ethel (1873–1962) American-born painter, patron, and hostess who became a British citizen in 1916. She was born at Newport, Rhode Island, and settled in England with her wealthy socialite parents in 1879. In 1894 she went to Paris, where she studied for several years under Carrière (*see* ACADÉMIE) and met her lifelong companion, the painter Anna Hope ('Nan') Hudson (1869–1957), who was also American-born. 'They were basically two independent, individual women, whose mutual love and understanding rescued them from the loneliness of spinsterhood' (Wendy Baron, *Miss Ethel Sands and Her Circle,* 1977). Sands's father died in 1888 and her mother in 1896, leaving her a substantial fortune that enabled her to spend lavishly on entertaining. From 1898 to 1920 her main

home was the Manor House at Newington in Oxfordshire, but she also spent much time in London and France. In 1905 she met *Sickert and like many in his circle became a founder member of the *London Group in 1913 (as did Hudson). Her paintings are mainly interiors and still-lifes, very much in the manner of Sickert, who often gave her advice. She is more important, however, as one of the leading artistic hostesses of her time. From 1913 to 1937 her London home was at 15 The Vale, Chelsea. Boris *Anrep created a mosaic floor for the entrance hall; Sickert was commissioned to carry out decorations but never did the work. In both world wars Sands served as a nurse in France.

San Francisco Museum of Modern Art (SFMOMA)
The largest collection of 20th-century art in the USA apart from the *Museum of Modern Art, New York. The museum was founded in 1935 and was originally called the San Francisco Museum of Art (the change to its present name—recognizing the fact that its collections were devoted almost entirely to the 20th century—was made in 1975). It has had various changes of home, and in 1995 it moved to a spectacular new building designed by the Swiss architect Mario Botta. The museum is particularly strong in American art, but it also has good representations of other schools.

Sant'Elia, Antonio
See FUTURISM.

Santayana, George
See ABSTRACT ART.

Sant, Tom Van
See SKY ART.

São Paulo Bienal
See BIENNALE.

Saqqakheni
See ZENDEROUDI, CHARLES-HOSSEIN.

Sargent, John Singer
(1856–1925) American painter, chiefly famous as the outstanding society portraitist of his age—*Rodin called him 'the Van Dyck of our times'. He was born in Florence, the son of wealthy parents, and he had an international upbringing and career—indeed he has been described as 'an American born in Italy, educated in France, who looks like a German, speaks like an Englishman, and paints like a Spaniard' (William Starkweather, 'The Art of John S. Sargent', *Mentor*, October 1924). His 'Spanishness' refers to his deep admiration for Velázquez, for although he was encouraged to paint directly

by Charles Carolus-Duran (1838–1917), with whom he studied in Paris, 1874–6, the virtuoso handling of paint that characterized his style derived more particularly from Old Masters such as Velázquez and Frans Hals (he visited Madrid and Haarlem to study their work in 1879–80). From 1885 he was based in London, but he continued to travel extensively and often visited America. The lavish elegance of his work brought him unrivalled success, and his portraits of the wealthy and privileged convey with brilliant bravura the glamour and opulence of high-society life. He was one of the last great exponents of the 'swagger portrait', a tradition going back to Van Dyck. Even in his lifetime he was deprecated for superficiality of characterization by some critics and fellow artists (who no doubt found it easy to be jealous of his success), but although psychological penetration was not his strength, he was admirably varied in his response to each sitter's individuality, and for sheer beauty of brushwork his portraits are unsurpassed in 20th-century art.

As with many successful portraitists, Sargent's heart lay elsewhere; indeed he came to hate portrait painting, referring to it as 'a pimp's profession', and after about 1907 he took few commissions. Despite his sophistication and charm and the entrée to high society that his success gave him, he was a very private person, who never married and led a quiet life. He loved painting landscape watercolours, showing a technique as dashing in this medium as in his oil paintings, and from 1890 he devoted much of his energies to ambitious allegorical mural schemes in the Public Library and the Museum of Fine Arts in Boston: 'Landscape I like, but, most of all, decoration, where the really aesthetic side of art counts for so much more.' For the Library his subject was *The History of Religion*. Sargent began work in 1890 and the paintings (in oil on canvas) were installed in stages between 1895 and 1916. They led to the commission from the Museum, for which he painted subjects from classical mythology between 1916 and 1925, completing the work shortly before his death. (As models for the *Danaides* he used dancing girls from the chorus-line of the Ziegfeld Follies.) His murals are in a high-flown, sometimes rather dreary *Symbolist manner and have evoked mixed reactions. A very different side to his talents is revealed in the enormous *Gassed* (1918–19, Imperial War Museum, London), which he painted as an

*Official War Artist. It has remarkable tragic power and is one of the greatest pictures inspired by the First World War. Sargent's reputation plummeted after his death (in 1929 Roger *Fry called him 'undistinguished as an illustrator and non-existent as an artist'), but it has soared again since the 1970s.

Sartre, Jean-Paul (1905–80) French philosopher, novelist, playwright, critic, and political activist, a highly influential figure in his country's intellectual life in the 1940s. Before the Second World War he held various teaching posts; during the war he served in the army, was captured by the Germans, and after being released, worked for the Resistance; after the war he was a full-time writer. His energetic involvement in many of the important issues of the time and his unceasing concern with moral problems won a worldwide audience for his ideas. He was a leading spokesman for existentialism, a system of ethical thought that stresses the importance of personal experience and individual responsibility in the face of a meaningless universe. His writings on the visual arts form a small part of his output and are mainly concerned with a few painters or sculptors who particularly interested him, notably Alexander *Calder, Alberto *Giacometti, and the painter Robert Lapoujade (1921–93), who in 1961 had an exhibition of abstract works inspired by the French-Algerian conflict (Galérie Pierre Domec, Paris) for which Sartre wrote a lengthy catalogue introduction. The artist most closely associated with Sartre is Giacometti: his isolated, emaciated figures are often seen as embodiments of the existentialist spirit, and Sartre wrote the introduction to the catalogue of the exhibition that established Giacometti's reputation in the USA (Pierre Matisse Gallery, New York, 1948). Some of Sartre's other writings on art were published in English in *Art News, and his *Essays in Aesthetics*, selected and translated by Wade Baskin, were published in 1963; Baskin writes that 'Sartre approaches art with an open mind but seeks always to fit his findings into his philosophical scheme'. Apart from Calder and Giacometti, the famous artists among Sartre's friends included André *Masson, who designed the sets for his play *Morts sans sépulture* in 1946.

Saryan, Martiros *See* BLUE ROSE.

Sash, Cecily (1924–) South African painter and teacher, born in Delmas, a small town in the Transvaal. She trained as an art teacher at the Witwatersrand Technical College Art School in Johannesburg, 1943–6, had a year of study in London and on the Continent, 1948–9, and later took a degree in fine art at the University of Witwatersrand, Johannesburg, 1952–4. After teaching for some years at a girls' school she returned to the University of Witwatersrand as senior lecturer in charge of design. In 1965 she received an Oppenheimer grant and spent a year studying attitudes to art education in Britain and the USA, becoming recognized as an expert on the subject in South Africa. Her work as a painter has been varied. In spite of periods of abstraction, it has often reflected her environmental preoccupations, especially with plants and wildlife. She has also designed mosaics and tapestries. In 1974 she settled in Britain, but she has maintained contact with her homeland: in 1999 to celebrate her seventy-fifth birthday, an exhibition of her work was shown in the galleries of three South African universities.

Saunders, Helen *See* REBEL ART CENTRE.

Saura, Antonio (1930–98) Spanish painter and graphic artist, born in Huesca and active mainly in Madrid. He began to paint during a long illness in 1947 and was self-taught. His early work was *Surrealist and while he was living in Paris from 1953 to 1955 he met the founder of the movement, André *Breton. Back in Spain, however, he quickly adopted a violently expressive semi-abstract style that has been seen as one of the most forceful protests against the Franco regime (the change in direction was partly inspired by the brutal suppression of student demonstrations soon after his return to Madrid). The stormy atmosphere and thickly textured figures in his work create a feeling of tortured humanity (*Great Crucifixion*, 1963, Boymans–van Beuningen Museum, Rotterdam). In 1957 he was one of the founders of the *El Paso group. Apart from paintings his work included drawings in ink and gouache, collages, and prints of various kinds (etchings, lithographs, screenprints), and he wrote numerous articles on artistic and social issues.

Savage, Augusta Fells (1892–1962) American sculptor, born in Florida. She was trained at Cooper Union, New York. Early in her career she suffered discrimination on account of being an African-American, in 1923 being refused a scholarship to study

in France on racial grounds. In the 1920s she modelled portrait busts of black leaders Marcus Garvey and W. E. B. Du Bois. She finally went to Paris in 1929 and while there her work became less naturalistic. On her return to New York she devoted most of her energies to the Savage Studio of Arts and Crafts in Harlem, where artists such as Jacob *Lawrence and Norman *Lewis studied. However, in this period she also produced her best-known work, *The Harp*, for the New York World Fair of 1939. This was commissioned to symbolize 'The American Negro's Contribution to Music, Especially to Song'. The original, which was never cast in bronze, was lost after the fair closed, but many replicas were sold.

Saville, Jenny (1970–) British painter, born in Cambridge. She studied at *Glasgow School of Art, graduating in 1992. She was patronized early in her career by Charles *Saatchi, who commissioned fifteen paintings after seeing her work in London and showed them in his gallery in 1994. Her paintings were also included in the *'Sensation' exhibition (1997). Her characteristic subject is the female nude, nearly always Rubenesque in proportion and presented in extreme close-up, with special attention paid to the colouring of the flesh. Alison Roberts has written: 'her feminism lies in a clear-eyed and unromantic view of the average female form – undistorted by sexual desire or notions of idealised femininity' (*The Guardian*, 20 April 2003). Saville has also made work in collaboration with the photographer Glen Luchford, depicting her own body pressed against glass. She now lives in Palermo, where, as she told an interviewer in 2007, she has found the local meat market provides subjects even more enticing than the people.

Further Reading: S. Greenberg, 'Out to Lunch: Jenny Saville R.A.', *R.A. Magazine* (winter 2007)

Savinio, Alberto (Andrea de Chirico) (1891–1952) Italian musician, writer, painter, and designer, born in Athens, brother of Giorgio *de Chirico. He studied music at the Athens Conservatory (graduating when he was only twelve) and in Munich under Max Reger. As a composer he concentrated on theatrical works, writing his first opera, *Carmela*, when he was fifteen. From 1910 to 1915 he lived in Paris with his brother, to whom he was devoted; he adopted his pseudonym in 1912 to distinguish himself from Giorgio. When Italy

entered the First World War in 1915, Savinio was posted to Ferrara and then Salonika, where he worked as an interpreter. After the war he began to write articles for the periodical *Valori plastici* in which he helped to define the character of *Metaphysical Painting; other writings by Savinio helped to inspire the imagery of the faceless mannequins that appear in so many of his brother's paintings. In 1926 Savinio moved back to Paris and began to paint seriously (earlier he had made drawings for the stage and some collages). Jean *Cocteau organized the first exhibition of his work, at the Galerie Jacques Bernheim, Paris, in 1927. His work was in a rather heavy-handed *Surrealist idiom, often using mythological imagery. In 1933 he returned to Italy, where he continued to paint and work on a wide variety of artistic activities, including writing semi-autobiographical novels such as *Capitano Ulise* (1934). After the Second World War he worked mainly for the theatre, as writer, composer, designer, and producer.

Saytour, Patrick *See* SUPPORTS-SURFACES.

Scarfe, Gerald (1936–) British caricaturist, designer, sculptor, printmaker, painter, filmmaker, and writer, born in London. He suffered from severe asthma throughout most of his childhood and took up drawing during long periods of confinement in bed. After a brief period working for an advertising agency he became a freelance caricaturist, working for *Punch* from 1960, *Private Eye* from 1961, *The Daily Mail* from 1966, and *The Sunday Times* and *Time* magazine from 1967. The first of many collections of his drawings, *Gerald Scarfe's People*, was published in 1966. His work is varied in subject, style, and technique, but he is best known for line drawings in which he grotesquely distorts his subjects' features: 'I like to see how far I can stretch a face and still make it recognizable.' He has also worked in other media in a similar vein and has been widely exhibited (a large, highly entertaining exhibition of his sculpture was held in the Festival Hall, London, in 1983, for example). He has done a good deal of stage and film design (he won an Olivier award for best stage costumes in 1994) and he has also worked on animated films, including the Disney movie *Hercules* (1997). His autobiography, *Scarfe by Scarfe*, was published in 1986.

Scarlet Rose *See* BLUE ROSE.

Schad, Christian (1894–1982) German painter, born at Miesbach, son of an affluent lawyer who encouraged his interest in art. He studied briefly at the Academy in Munich but learned more by frequenting Schwabing, the artists' quarter of the city. After avoiding military service by inventing a heart complaint, Schad lived in Switzerland (first Zurich, then Geneva) from 1915 to 1920 and was involved in the *Dada movement there. His work of this period included photograms—photographic images made without a camera or lens by placing two- or three-dimensional objects on sensitized paper and exposing the arrangement to light. The technique was not new (indeed it predates photography proper), but Schad was evidently the first to make abstract images in this way. The poet Tristan Tzara, his fellow Dadaist, coined the punning term 'Schadograph' for these images, which Schad first made in 1918. In the 1920s the technique was taken up by *Man Ray (who called his versions 'Rayographs') and by *Moholy-Nagy. In 1920 Schad returned briefly to Germany, then lived in Rome and Naples until 1927. He then spent two years in Vienna before settling in Berlin in 1927. In the next few years he gained a reputation as one of the leading exponents of *Neue Sachlichkeit, specializing in chillingly decadent portraits and nudes from the sophisticated world in which he moved. In 1935, however, Schad more or less abandoned painting for business, and although he took up art seriously again after the Second World War, he never made the impact that he had done with his earlier work.

Schamberg, Morton L. (1881–1918) American painter and photographer, born in Philadelphia. He was a pioneer of modernism in America, but his promising career was cut short when he died aged 36 in the terrible influenza epidemic of 1918. After studying architecture at the University of Pennsylvania (1899–1903), he went to the Pennsylvania Academy of the Fine Arts (1903–6), where he was taught by *Chase and became a friend of *Sheeler. Between 1906 and 1912 he made several trips to Europe, during which he was influenced by various modern movements, particularly *Cubism. In the next few years he moved towards abstraction; his machine-like imagery derived partly from *Picabia and looked forward to *Precisionism. He met Picabia through Sheeler, who also introduced him to Marcel *Duchamp and *Man Ray. Apart

from Man Ray, Schamberg was the first American to create work that was directly related to *Dada. The best-known example, *God* (c.1917, Philadelphia Museum of Art), an assemblage of plumbing pipes (his only sculpture), was made in collaboration with the Baroness Elsa von Freytag-Lovringhausen (*see* DADA). From 1913 Schamberg earned his living mainly as a photographer.

Schapire, Rosa *See* SCHMIDT-ROTTLUFF, KARL.

Schapiro, Meyer (1904–96) American art historian. He was born in Lithuania into a scholarly Jewish family, emigrated to the USA with his family when he was three, and became an American citizen in 1914. For the whole of his lengthy career he was associated with Columbia University, New York, where he studied (BA, 1924; MA, 1926; PhD, 1929) and then taught, rising from lecturer in 1928 through various grades of professor; after his retirement in 1973 he was emeritus professor.

Schapiro was a distinguished medievalist, making important contributions to the study of Early Christian and Romanesque art, but he also wrote and lectured on modern painting and sculpture and was friendly with numerous artists, who found him an intellectually stimulating companion because of his wide-ranging socio-cultural knowledge and his openness to varied traditions and methodologies. He was interested in Freudian analysis and Gestalt psychology, for example. Controversially and influentially, he applied a psychological reading to van Gogh's *Wheatfield with Crows* (1890, Van Gogh Museum, Amsterdam), sometimes assumed to be his last painting, seeing it as an image of the artist's personal entrapment.

Even more than psychology, Marxism was an influence on Schapiro's practice. It was particularly to affect his important essays on modern art published in the 1930s, entitled 'The Social Bases of Art' (1936) and 'Nature of Abstract Art' (1937). Although the second essay, the one which Schapiro chose to reprint in his *Selected Papers*, is far more positive about modernist art, they both seek to argue against the notion, shared by both supporters of *abstract art and its detractors in the *Socialist Realist camp, that by rejecting figuration artists were detaching themselves from society. In the first of the essays, he criticizes the vaunted individual freedom of the modern

artist as a 'conception restricted to small groups who are able to achieve such freedom only because of the oppression and misery of the masses'. The second essay looks more closely at the ideological bases of abstract art and, in so doing, effectively refutes the *formalist idea that the development of art can be understood purely in terms of the reaction of one style against another. Here he was arguing against Alfred *Barr's emphasis on the 'purity' of *abstract art. Schapiro saw this as a misunderstanding both of abstract art, which still had its roots in the social world, and of figurative painting, which, by such a contrast, could be devalued as a simple mechanical reproduction of appearances. A sign of his influence was that even Clement *Greenberg (who shared Schapiro's allegiance to Marxism in the 1930s) found it necessary to frame his arguments on the historical inevitability of abstraction within a sociological context.

Further Reading: Harrison and Wood (2002)

M. Schapiro, *Selected Papers, Vol 2, Modern Art: 19th and 20th Centuries* (1978)

Schapiro, Miriam (1923–) American painter and maker of collages. She was born in Toronto, Canada, and had her main training in art at the State University of Iowa, 1943–9. Subsequently she taught at several colleges and universities. Her early work was *Abstract Expressionist, but she then turned to a *Hard-Edged geometrical style (*Big Ox No. 2*, 1968, La Jolla Museum of Contemporary Art). In the late 1960s she became active in the feminist movement and in 1971, with Judy *Chicago, she founded the Feminist Art Program at the California Institute of the Arts, Valencia. Her most characteristic later works are large, dynamic collages that she calls 'femmages', made up of buttons, sequins, pieces of embroidery, and other materials from the history of women's 'covert' art (*Black Bolero*, 1980, Art Gallery of New South Wales, Sydney).

Schendel, Mira (1919–88) Brazilian *Kinetic artist. Born in Zurich, she moved with her family to Milan. To escape persecution as a Jew, she left for Sarajevo in 1941, moving to Brazil in 1949. Much of her work was ephemeral. In 1966 she exhibited her *Droghinas* ('druglets' or 'little nothings') made of knotted rice paper, at the Museo Arte Moderna in Rio de Janeiro. They were merely left in a heap on the floor. For Guy Brett they 'seem to express a passionate search for how little can act as a stimulant to the perception of space' (*Kinetic Art*, 1968). Other *Droghinas* were suspended, gravity playing its part in their formation. Like other Brazilian artists (*Oiticica and Lygia *Clark), she was engaged in explorations of indeterminacy which bring her close to the *anti-form ideas of Robert *Morris. Her interest in *Concrete poetry led to works in which letters were arranged between sheets of acrylic. When her work was shown at *documenta 12 in 2007 it was interpreted in the catalogue by the Brazilian psychoanalyst and cultural critic Suely Rolnik as a reflection of her troubled early life. Moving from country to country through different languages and social universes, 'she has inhabited the transience of things since her childhood'.

Further Reading: Hayward Gallery, *Force Fields: Phases of the Kinetic* (2000)

Scheyer, Galka *See* BLAUE VIER, DIE.

Schiele, Egon (1890–1918) Austrian painter and draughtsman, born in Tulln, near Vienna. He studied at the Vienna Academy, 1906–9, and in 1907 met *Klimt, who was a strong influence on his early *Art Nouveau style. By 1909, however, he had begun to develop his own highly distinctive style, which is characterized by an aggressive linear energy expressing acute nervous intensity. He painted portraits, landscapes, and allegorical works, but he is best known for his drawings of nudes (including several self-portrait drawings), which have an explicit and disturbing erotic power—in 1912 he was briefly imprisoned on indecency charges and one of his drawings was publicly burnt. The figures he portrays are typically lonely or anguished, their bodies emaciated and twisted, expressing an aching intensity of feeling. During the First World War he served in the Austrian army, but he was able to continue painting and drawing during his military service. His work was much exhibited, and he was beginning to receive considerable acclaim when he died in the appalling influenza epidemic of 1918 (three days after his wife).

His posthumous reputation was long confined mainly to Austria, but he became well known in Britain and the USA during the 1960s (an exhibition at the Boston Museum of Contemporary Art in 1960 was the first major showing of his work in the English-speaking world). He has since come to be generally regarded as one of the greatest

masters of *Expressionism, and only Klimt and *Kokoschka are better known among modern Austrian artists. His work is admired for its powerful mastery of line as well as for the intensity with which he treats his obsessions with sex, death, and decay.

Further Reading: F. Whitford, *Egon Schiele* (1980)

Schjerfbeck, Helene (1862–1946) Finnish painter, born in Helsinki, where she began her training at the Finnish Fine Art Association's Drawing School as a precocious eleven-year-old. In the 1880s she travelled widely, working mainly in France but also in St Ives (*see* ST IVES SCHOOL) and St Petersburg, making a name with open-air scenes notable for their fresh colouring. From about 1900 her health (always delicate) began to fail badly (although she lived into her 80s) and she adopted a solitary life at Hyvinkää, developing a much more simplified style in which the subtle colour harmonies recall those of *Whistler. For several years she was more or less forgotten in Helsinki, but in 1917 she had a one-woman show there, organized by Gösta Stenman, an art dealer and journalist, and after this she was recognized as one of the pioneers of modernism in Finland. John Boulton-Smith (*Modern Finnish Painting and Graphic Art*, 1970) describes her as 'a genuine, small, highly civilized master' and writes that 'no painter in Scandinavia made a more intelligent and original contribution to the early modern movement, save only *Munch'. Her work included landscapes, still lifes, figure compositions, and portraits, notably a long series of self-portraits that are regarded as being among her finest achievements.

Schlemmer, Oskar (1888–1943) German painter, sculptor, stage designer, and writer on art. He was born in Stuttgart, where he trained in marquetry and then studied at the Academy under Adolf *Hölzel, 1906–11. During the First World War he served in the infantry and—after being wounded—as a cartographic draughtsman. From 1920 to 1929 he taught at the *Bauhaus, in the metalwork, sculpture, and stage-design workshops. Later he taught at the Breslau Academy, 1929–32, and at the State School for Fine and Applied Arts in Berlin, 1932–3. In 1933, however, he was dismissed by the Nazis, who declared his work *degenerate. He lived in Switzerland from 1933 to 1937 and from 1940 spent most of his time in Wuppertal, where a manufac-

turer of lacquer had invited him to establish a laboratory for experiments in lacquer technique. He died of a heart attack.

Schlemmer had a mystical temperament and his ideas on art were complex. Some of his early work was influenced by *Cubism and he showed a deep concern for pictorial structure; characteristically his paintings represent rather mechanistic human figures, seen in strictly frontal, rear, or profile attitudes set in a mysterious space (*Group of Fourteen Figures in Imaginary Architecture*, 1930, Wallraf-Richartz-Museum, Cologne). He rejected what he considered the soullessness of pure abstraction, but he wished to submit his intuition to rational control: 'Particularly in works of art that spring from the imaginative faculty and the mysticism of our souls, without the help of external subject-matter or content, strict regularity is absolutely indispensable.' His cool, streamlined forms are seen also in his sculpture. Schlemmer did much work for the theatre, notably designs for the *Constructivist *Triadic Ballet*, to music by Paul Hindemith, which was performed at the Bauhaus in 1923. The range of his activities in both art and design exemplifies the ideals of that institution. His ideas on teaching are expressed in his book *Man: Teaching Notes from the Bauhaus* (1971). Also available in English translation is *The Letters and Diaries of Oskar Schlemmer* (1972).

Schlichter, Rudolph (1890–1955) German painter, illustrator, and writer. He was born at Calw and studied in Stuttgart and Karlsruhe. During the First World War he was called up for armed service, but he was dismissed after going on hunger strike. After the war he settled in Berlin, where he lived until 1932. He took part in *Dada activities and earned his living mainly as a book illustrator, but he is remembered chiefly for his paintings in a *Neue Sachlichkeit vein. His subjects—taken mainly from the city's streetlife and bohemian subculture—included portraits and scenes of sexual violence and deviation (particularly shoe fetishism). His brushwork was loose and vigorous rather than in the detailed manner usually associated with Neue Sachlichkeit. In 1932 he moved to Rottenburg. He was critical of the Nazis and in 1937 some of his paintings were included in the infamous exhibition of *degenerate art. In 1938 he was imprisoned for three months. He settled in Munich in 1939 and after the Second World War his work was

influenced by *Surrealism. 'Characteristic of his sharp writing style are his books, *Das widerspenstige Fleisch (The Recalcitrant Flesh,* 1932), and *Das Abenteuer der Kunst (An Adventure in Art,* 1949). The first includes astonishingly frank sex confessions, the second polemicized all abstract art...in which he saw cultural ruination, or at best a merely ornamental value' (Roh).

Schlock art *See* KITSCH.

Schmidt-Rottluff, Karl (né Schmidt) (1884–1976) German *Expressionist painter, printmaker, and sculptor, born at Rottluff near Chemnitz (he added 'Rottluff' to his name in 1906). In 1905 he began to study architecture at the Technische Hochschule, Dresden, but soon turned to the figurative arts and in the same year was one of the founders of Die *Brücke. He was the most independent member of the group, participating to only a limited extent in its activities, and his style was harsher than that of the other members. It was particularly forceful in his woodcuts, which are amongst the finest representatives of Expressionist graphic art. Their bold, abrupt manner was reflected in his paintings, with their flat ungraduated planes of contrasting colours. In 1906 Schmidt-Rottluff stayed with *Nolde on the island of Alsten, Norway, and in 1907 he painted with *Heckel at Dangast on the coast north-west of Bremen (he visited Dangast again each summer until 1912). Apart from landscapes, such as the ones he painted in these places, his subjects included portraits, figure compositions, and still-life. In 1911, like the other members of Die Brücke, he moved to Berlin, where he lived for most of the rest of his life (although he spent the years 1915–18 serving in the army on the Eastern front). In the 1910s and 1920s his work was influenced by the stylized forms of African sculpture. Later, perhaps under the influence of *Kirchner or as a result of a trip to Paris in 1924 and a longer stay in Italy in 1930, his style became somewhat more naturalistic.

Schmidt-Rottluff's work was declared *degenerate by the Nazis and in 1941 he was forbidden to paint (he was placed under the supervision of the SS). In 1943 he retired to Chemnitz, but after the war he returned to Berlin and he became a professor at the Hochschule für Bildende Künste in 1947. In 1967 he presented a large collection of his own works to found the Brücke Museum in Berlin.

A good collection of his graphic works was presented to the Victoria and Albert Museum, London, by his friend the art historian Dr Rosa Schapire (1874–1954); she left his painted portrait of her (1919) to the Tate Gallery, London. Another fine collection of his prints (he made etchings and lithographs as well as woodcuts) is in the New Walk Museum and Art Gallery, Leicester.

Schmithals, Hans *See* ABSTRACT ART.

Schnabel, Julian (1951–) American painter, sculptor, and film director. He was born in Brooklyn, New York, studied at the University of Houston, graduating in 1972, and had his first one-man show at the Contemporary Arts Museum, Houston, in 1976. In 1979 two exhibitions at the Mary Boone Gallery, New York, brought him his first notable success. As early as 1982 he had a retrospective exhibition at the Stedelijk Museum in Amsterdam, one of the world's leading museums of modern art, and it became common for the press to treat him more like a pop star than a painter. His paintings are large and in a *Neo-Expressionist vein; often they are on unusual materials such as carpet or velvet, and some of them are encrusted with broken crockery (*Humanity Asleep,* 1982, Tate) or incorporate other three-dimensional objects (sometimes the supports themselves are three-dimensional, with central projections like a chimney breast). Mythical and religious symbols frequently occur and there is a preoccupation with self-inflicted ordeals and martyrdom. In a series of paintings of 1987, entitled *The Recognitions,* tarpaulin banners were emblazoned with names such as Ignatius Loyola and *Artaud. Schnabel writes of his work: 'My painting is more about what I think the world is like than what I think I'm like. I'm aiming at an emotional state, a state that people can literally walk into and let themselves be engulfed by.' His early success brought more than the usual measure of jealousy and resentment: when one of his paintings failed to attract even a single bid at an auction in 1990, the audience broke into spontaneous applause. His critical reputation, too, has not always matched his commercial success. Robert *Hughes, for example, writes that 'Schnabel's work is to painting what Sylvester Stallone's is to acting—a lurching display of oily pectorals—except that Schnabel makes bigger public claims for himself.' Donald

Kuspit takes a more favourable view, seeing him as a brilliant synthesizer of styles, almost to the point of summarizing major aspects of the post-war American tradition in his fusion of the examples of *Pollock and *Rauschenberg. In 1983 Schnabel began making sculpture. In recent years he has achieved considerable success as a film director. *Basquiat* (1996), about the Graffiti artist Jean-Michel *Basquiat, has the solid merit of being made with inside knowledge of the world it depicts. *The Diving Bell and the Butterfly* (2007) gained critical acclaim for its depiction of the life of a paralysed man.

Further Reading: D. Kuspit, *The New Subjectivism: Art in the 1980s* (1993)

Schneemann, Carolee (1939–) American *Performance artist, film-maker and painter. She began her career as a painter but became involved in avant-garde Performance in New York in the early 1960s. From this period dates *Meat Joy* (1964), performed in both Paris and New York, a multimedia event in which men and women, dressed only in special fur-lined underwear, crawled over each other, handling raw meat. Marcel *Duchamp, in the Paris audience, called it the messiest thing he had ever seen. *Fuses*, a film completed in 1967, used explicit erotic scenes with her lover, the composer James Tenney, with their cat looking on. The footage was, in Schneeman's words, 'heavily collaged, with feathers, inks, different textures glued on to the film'. The result has since been acclaimed as a classic piece of *feminist erotica in that it is concerned with the female experience of love-making as opposed to providing voyeuristic pleasure to the male spectator. Both film and performance were certainly a contrast to the squeaky clean sexual imagery provided by both *Pop art and the mass media in the 1960s. Schneeman's most notorious performance was *Interior Scroll* (1975). In this piece she stood naked in front of the audience, extracting a forty inch scroll from her vagina from which she read a text detailing the discrimination and disdain suffered by women artists. Since that time she has continued to work in a variety of media and has been regarded as an inspirational figure by younger feminist artists.

Schneider, Gregor See INSTALLATION.

Schoenberg, Arnold See BLAUE REITER.

Schöffer, Nicolas (1912–92) Hungarian-born sculptor and *Kinetic artist who settled in Paris in 1937 and took French nationality. Early in his career he made sculpture in the *Constructivist tradition and in 1948 he began making 'spatiodynamic' constructions—open towers constructed of plexiglass or thin metal plates from which light was reflected. To these he added movement (in 1950) and sound (in 1954). Financed by the electrical firm Philips and helped by their technicians, he created his first 'cybernetic' sculpture in 1956. This was a robot, *CYSP 1*, which responded to colours and sounds. In 1957 he gave a 'lumino-dynamic' spectacle at Grand Central Station, New York, and in 1961 at Liège he built a luminous, sound-emitting tower 52 metres high. His most ambitious schemes remained on paper: cities of leisure raised on pylons above the ground and other grandiose projects involving the conditioning of living-space by the most sophisticated technological means. However, Schöffer also made much smaller pieces, intended to be mass-produced and offered for sale at moderate prices. He was awarded the Grand Prix at the Venice *Biennale of 1968.

Scholz, Georg See NEUE SACHLICHKEIT.

Schönebeck, Eugen (1936–) German painter, born in Heidenau, near Dresden. He initially studied in East Berlin but moved to the West in 1956, studying at the Hochschule für bildende Künste until 1961. He met Georg *Baselitz, another refugee from the Communist East in 1957. They worked closely together, giving their first 'Pandemonium' exhibition in a derelict house in 1961. After two solo exhibitions, also in Berlin, Schönebeck gave up painting for good in 1966 and took up work as a postman. It is usually assumed that the decision represented a disillusion with the commercialism of the art world. In spite of his personal absence from the scene, since the early 1980s his paintings have been regarded as important forebears of *Neo-Expressionism. In the early 1960s he made paintings and drawings of mutilated, crucified figures which have been compared to those of *Bacon. His final paintings are heroic representations of revolutionary heroes such as *Siqueiros, *Mayakovsky, and Ho Chi Minh.

School of Altamira See GOERITZ, MATHIAS.

School of London An expression coined by R. B. *Kitaj in 1976 and given wide currency when it was used as the title of a British Council exhibition that toured Europe in 1987—'A School of London: Six Figurative Painters' (the six were Michael *Andrews, Frank *Auerbach, Francis *Bacon, Lucian *Freud, Kitaj himself, and Leon *Kossoff). In 1989 the term was used as the title of a book by Alistair Hicks—*The School of London: The Resurgence of Contemporary Painting*. The book covers other artists apart from the original six, including Gillian *Ayres and Howard *Hodgkin, so extending the term beyond the original loose definition of figurative painting to a point where it had little meaning beyond a marketing tool.

School of Paris See ÉCOLE DE PARIS.

Schrimpf, Georg (1889–1938) German painter, born in Munich. He was self-taught as an artist; in his early years he worked as a baker's apprentice and a labourer and for a time he led a wandering life in Italy. His early paintings were *Expressionist, but after revisiting Italy in 1922 his style became much more classical. He painted in the precise, detailed manner associated with the *Magic Realist vein of *Neue Sachlichkeit, but his subjects were mainly calm and gentle (women, children, animals, landscapes) and his forms were smoothly rounded. 'Some of his pictures exude simplicity and a quiet grandeur; others are much too insipid, for something of the amateur painter remained in this sincere man. His naive insights often hit the nail on the head, and at the time he was particularly popular with the complicated intellectual' (Roh). From 1926 to 1933 Schrimpf taught at the School of Applied Art, Munich, and later at the Schöneberg Academy, Berlin.

Schum, Gerry See VIDEO ART.

Schütte, Thomas (1954–) German sculptor and painter, born in Oldenburg. He studied at the Düsseldorf Art Academy. Early in his career he worked as both a painter and a sculptor but he concentrated on sculpture for health reasons after 1989: a few years earlier he had suffered a breakdown, partly as the result of poisoning by lacquer paint. His last paintings were a series of mock banners including images such as a crowned potato and outsize musical notes. One aspect of his work deals with the distorted figure. *United Enemies* (1993) are a series of sculptures presented under glass jars in which antagonistic figures are bound together. In the context of the period in which they were produced it is hardly surprising that they have been interpreted as commenting on the reunification of Germany. He has also made sculpture of buildings. *Casino* (1990) is a castle and it has an almost fairytale quality. This is, however, undermined by the title. Schütte explained that this was a reference to the similarity of the image to the 50 Deutschmark note and to the drawings strewn underneath, which looked like casino chips on baize. If one side of Schütte's activity has been making the monumental small, he has also moved in the other direction. He said in an interview in 1990 that he admired the *Minimalist artists of the 1970s because they 'address the fundamental problems—of lighting, material, meaning, and space'. In 1987, as part of the *Münster Sculpture Project, he showed a giant sculpture of cherries in a square. Such work is reminiscent of Claes *Oldenburg. Schütte is concerned with the end of commonly shared ideals of Utopia. 'Everyone', he says, 'is a realist, everybody is pragmatic, especially in the art world.'

Further Reading: I. Blazwick, J. Lingwood, and A. Schlieker, *Possible Worlds* (1990)

Schwabe, Randolph (1885–1948) British draughtsman, etcher, lithographer, and teacher, born in Manchester of German descent. He studied at the *Royal College of Art, 1899, the *Slade School, 1900–6, and the *Académie Julian, Paris, 1906. In the First World War he was an *Official War Artist. After the war he taught at Camberwell and Westminster Schools of Art, then from 1930 until his death was professor at the Slade School, where his gentle manner was a contrast to his frequently terrifying predecessor, *Tonks. He specialized in architectural and figure subjects, and his work also included designs for the theatre and book illustrations, notably for Francis M. Kelly's *Historic Costume* (1925) and *A Short History of Costume and Armour* (1931).

Schwarzkogler, Rudolf (1940–69) Austrian *Body and *Performance artist. Like the *Vienna Actionists, with whom he was associated, Schwarzkogler was often concerned with violence and pain (he sometimes used medical instruments, recalling his father, a doctor who committed suicide in 1943 after losing both legs in the Second World War). Schwarzkogler was the most retiring of the

group and unlike the others, who deliberately incited public scandal as part of their project, he performed his actions in the privacy of his home to a select invited audience or simply in order to produce the photographic documentation. He achieved a place in the pantheon of great artistic oddballs by reputedly cutting off his own penis as part of a performance; however, the story depended on a misreading of the photographic documentation of the work (the object that is shown in close-up being cut with a razor blade is in fact a dead fish). The photographs first became widely known when they were exhibited at *documenta 5 in 1972, with the portentous caption 'Rudolf Schwarzkogler 1940–1969' implying a causal link between the actions and the artist's early death. One of the critics who launched the legend (with an article in *Artforum*) had the appropriately cutting name of Lizzie Borden, although the 'credit' should perhaps really be given to the exhibition's director, Harald *Szeemann, who was ultimately responsible for arranging the photographs in a sequence which encouraged the reading. Among the other critics who discussed the issue was Robert *Hughes, who described Schwarzkogler as 'the Vincent van Gogh of Body Art', who 'proceeded, inch by inch, to amputate his own penis, while a photographer recorded the act as an art event'. The true version of events is documented in the catalogue of an exhibition of Schwarzkogler's work shown at the Pompidou Centre, Paris, and elsewhere in 1992 1. Schwarzkogler, though, did undoubtedly abuse his body through dietary experiments, and he died after falling from a window. It is still unclear whether this was accident or suicide. It has been suggested that he was attempting to emulate Yves *Klein's leap into the Void or that he was under the influence of hallucinogens.

Schwitters, Kurt (1887–1948) German painter, sculptor, maker of constructions, writer, and typographer, a leading figure of the *Dada movement who is best known for his invention of 'Merz'. The word was first applied to collages made from refuse, but Schwitters came to use it of all his activities, including poetry. He used the word as a verb as well as a noun: the painter and designer Georg Muche (1895–1987) was nonplussed when Schwitters asked him to *merz* with him, and he wrote an article entitled 'Ich habe mit Schwitters gemerzt'.

Schwitters was born in Hanover and studied there at the School of Arts and Crafts, 1908–9, and then at the Dresden Academy, 1909–14. In his early work he was influenced by *Expressionism and *Cubism, but after the First World War (in which he served for a time as a draughtsman) he became the chief (indeed, virtually only) representative of Dada in Hanover. In 1918 he began making collages from refuse such as bus tickets, cigarette wrappers, and string, and in 1919 he invented Merz. The name was reached by chance: when fitting the word 'Commerzbank' (from a business letterhead) into a collage, Schwitters cut off some letters and used what was left. He called the collages Merzbilden (Merz pictures) and in about 1923 began to make a sculptural or architectural variant—the Merzbau (Merz building)—in his house in Hanover (it was destroyed by bombing in 1943 but has been reconstructed in the Sprengel Museum, Hanover). From 1923 to 1932 he published a magazine called *Merz* and in this period he was much occupied with typography. In 1937 his work was declared *degenerate by the Nazis and in the same year he fled to Norway, where at Lysaker he began a second Merzbau (destroyed by fire in 1951). When the Germans invaded Norway in 1940, he moved to England, where he lived for the rest of his life—in London (after release from an internment camp) from 1941 to 1945, and then at Ambleside in the Lake District. In an old barn at Little Langdale, near Ambleside, he began work on his third and final Merzbau, with financial aid from the Museum of Modern Art, New York. It was unfinished at his death and is now in the Hatton Gallery, Newcastle upon Tyne. The day before he died, Schwitters became a British citizen.

Further Reading: J. Elderfield, *Kurt Schwitters* (1985)

Scialoja, Toti *See* ROMAN SCHOOL.

Scipione (Gino Bonichi) (1904–33) Italian painter, born at Macerata near San Marino. He was the son of a soldier and adopted his pseudonym (in 1927) in homage to Scipio Africanus, the great Roman general who defeated Hannibal. In 1909 his family moved to Rome and he studied briefly (1924–5) at the Academy there before being expelled with his friend Mario *Mafai. With Mafai he was the founder of the *Roman School, which introduced a romantic *Expressionist vein into Italian painting in opposition to the prevailing pomposity

of much art that was favoured under Mussolini's Fascist government. His subjects were mainly scenes of modern Rome, painted with violent brushwork and a feeling of visionary intensity. His career was very short, virtually ending in 1931, when he made the first of several visits to a sanatorium to treat the tuberculosis that caused his early death. After his death, retrospectives at the Venice *Biennale in 1948 and the Galleria Nazionale d'Arte Moderna of Rome in 1954 enhanced his reputation and, as Emily Braun put it, 'he became regarded as a symbol of heroic individuality in the context of the Fascist period'.

Scott, Tim (1937–) British abstract sculptor, born at Richmond, Surrey. He studied at the Architectural Association, London, and at *St Martin's School of Art under Anthony *Caro, then lived in Paris from 1959 to 1961, working in the studio of *Le Corbusier. After his return to London he began teaching at St Martin's and became head of the sculpture department there in 1980. Scott was one of the artists who made a great impact at the *New Generation exhibition at the Whitechapel Art Gallery in 1965. His work at this time consisted mainly of constructions of blocks and slabs of varied materials including wood and plastic. He said of such sculpture: 'I wanted to create a sculpture which would be shapeless—a sculpture which would be free from my personal imprint'. Scott was interested in the idea of architectural scale in sculpture. The massive stainless steel *Cathedral* (1971–2) was inspired by a visit to Fountains Abbey, Yorkshire. While working on the piece he was introduced to methods of forging by a blacksmith and later in the 1970s he made compositions of rusted or painted steel bars and girders; they were bolted or riveted into forms that were less chunky and more flowing than the ones he had previously used. The reference point of his sculpture shifted from architecture to the movements of the human body. More recent sculpture such as *The Fish* (2001) uses forged steel to evoke animal movement. Scott now lives in Yorkshire and Sri Lanka.

Scott, William (1913–89) British painter. He was born at Greenock, Scotland, of Irish and Scottish parents and was brought up in Ulster. He studied at Belfast College of Art, 1928–31, and the *Royal Academy, 1931–5. In 1937–9 he lived in France (mainly Pont-Aven and St-Tropez) and he found a sense of kin-

ship with a tradition of French still-life painting which linked Chardin in the 18th century with *Braque. His work continued to be based on still-life, but even when, for a time in the 1950s, he painted pure abstracts, he continued to relate what he did as a painter to that tradition. They featured forms such as circles and squares, but they were not geometrically exact and were bounded by sensitive painterly lines. In the late 1960s and 1970s his style became more austere. Although his work was restricted in range and undemonstrative in character, Scott came to be regarded as one of the leading British artists of his generation. He won several awards, including first prize at the 1959 *John Moores Liverpool Exhibition. His work is represented in Tate and many other collections in Britain and elsewhere, and there is a large mural by him in Altnagelvin Hospital, Londonderry (1958–61). He lived mainly in London and Somerset.

Further Reading: N. Lynton, *William Scott* (2007)

Scottish Colourists A term applied to four Scottish painters who in the period c.1900–14 each spent some time in France, where they were strongly influenced by the rich colours and bold handling of recent French painting, notably *Fauvism. They are F. C. B. *Cadell, J. D. *Fergusson, Leslie *Hunter, and S. J. *Peploe. The term was popularized by a book by T. J. Honeyman dealing with Cadell, Hunter, and Peploe (*Three Scottish Colourists*, 1950), but it is usual to add Fergusson to their number, even though he stands apart from the rest in that he returned to live in France after the First World War, whereas the other three remained in Scotland. All four painters knew each other, and they exhibited together as 'Les Peintres de l'Écosse Moderne' at the Galerie Barbazanges, Paris, in 1924, but they did not function as a group. They can be regarded as the successors of the *Glasgow Boys and they have been described as the first 'modern' Scottish artists; certainly they were the main channel through which the influence of advanced French painting reached their country. None of them was represented in Roger *Fry's *Post-Impressionist exhibitions of 1910 and 1912, but this reflects insular English attitudes towards Scottish art rather than the quality of their work.

Scottish National Gallery of Modern Art, Edinburgh. Collection of 20th- and

21st-century art founded in 1960 as an extension of the National Gallery of Scotland. Before the *Tate Gallery split up into Tate Britain and Tate Modern, the Scottish National Gallery of Modern Art was the United Kingdom's only national museum devoted solely to modern art. The original nucleus of the collection consisted of 20th-century paintings and sculptures that happened to be owned by the National Gallery of Scotland. They were nearly all by Scottish artists, but the gallery has since built up a wide-ranging international collection in which most of the major movements and many of the greatest figures are represented. It is particularly strong in *Dada and *Surrealism, and in 1994 its importance as a centre for the study of these movements was greatly enhanced by the purchase of Sir Roland *Penrose's library and archive. The following year it bought twenty-five works of art from Penrose's collection. The original home of the gallery was Inverleith House, a modestly sized Georgian mansion in the Royal Botanical Gardens. This was always intended as a temporary measure, but it was not until 1984 that the gallery re-opened in its present premises, an impressive Greek Revival building dating from 1825 that was formerly John Watson's School. *See also* CURSITER.

screenprinting A printing technique based on stencilling, originally used for commercial work but popular with artists for creative printmaking since the 1960s. The essence of the technique is that a fine mesh screen, stretched tightly over a wooden frame, is placed above a sheet of paper and colour is forced through the mesh with a rubber blade called a squeegee. Usually the screen is made of silk—hence the term silkscreen printing, which is often used in the USA; however, as the screen can also be made of cotton, nylon, or metal, the more inclusive term is useful. Some exponents prefer instead to use the term serigraphy (from *sericum*, Latin for silk) to distinguish artistic printmaking from purely commercial applications. There are various ways of applying the design to the screen. The earliest and most basic was to attach a cut-out stencil to it; this is an improvement on the simple stencil where, for example, a letter O required connecting pieces to prevent the centre falling out—a problem that does not arise when the stencil is supported by the mesh. A refinement of this method is to paint the design directly on the screen with a glue-

or varnish-like substance that blocks the holes in the mesh. The blocked-out areas form the negative part of the design, the colour being squeezed through the untouched parts of the screen. However, more sophisticated methods enable the artist to create a positive design directly on the screen with a waxy or water-proof medium that is eventually dissolved to allow the ink through only in the parts that have been so treated. Photographic images can be used in the design by shining a light through a transparency on to a chemically treated mesh. Screenprints are almost invariably coloured, a different screen generally being used successively for each colour.

The origins of screenprinting are murky, but the technique seems to have come to Europe from Japan in the late 19th century. It was soon adopted for advertising purposes, and photographic images were first used in the medium in about 1916. Rowland *Hilder is said to have produced a screenprint in Britain as early as 1924, but the technique was evidently first seriously used for original printmaking by American artists in the 1930s, when its cheapness was probably an important factor during the Depression years. Ben *Shahn was an exponent at this time, and Jackson *Pollock made a few screenprints in the early 1950s, but it was not until the early 1960s that the medium made an important impact in the art world. It was especially favoured by *Pop artists, whose bold images were well served by its capacity for strong, flat colour and its relative crudeness of detail (subtle handling is discouraged because of the texture of the mesh). Moreover, for artists who took their imagery from the world of popular culture, it was particularly appropriate to use a medium with such strong commercial associations and one that could incorporate ready-made cultural references in the form of photographs. The artist who more than any other put screenprinting on the map was Andy *Warhol, whose background in commercial art gave him an affinity with the technique. *Op artists too found its relative impersonality suited their aesthetic. Other leading American artists of the time who took up screenprinting include Roy *Lichtenstein and Robert *Rauschenberg. Both Warhol and Rauschenberg extended the technique by screenprinting a design on to a canvas to serve as the basis of a painting.

In Britain screenprinting took off as a creative medium at very much the same time as in

the USA. The *Institute of Contemporary Arts launched a project to commission screen-prints from leading artists in 1962 and it proved a great success. Richard *Hamilton, Eduardo *Paolozzi, and R. B. *Kitaj all used the medium to combine second-hand images as a kind of *collage technique. Subsequently artists of many different styles and outlooks have used screenprinting. Among the most remarkable prints—and certainly the most technically complex—are those of the Ameri-can *Superrealist Richard *Estes, who has sometimes used as many as eighty screens in one work.

Scull, Robert *See* POP ART.

Scully, Sean (1945–) Irish-born abstract painter who became an American citizen in 1983. He was born in Dublin and after an apprenticeship as a commercial engraver he studied at Croydon College of Art and then (1968–71) at the University of Newcastle upon Tyne, where he subsequently taught (1971–3). In 1973 he moved to New York. His work is uncompromisingly abstract, typically featuring dense, richly coloured latticeworks of stripes. He considers abstraction 'a non-denominational religious art. I think it's the spiritual art of our time.' In 2007 he published *Walls of Aran*, a book of photographs.

Scuola Romana *See* ROMAN SCHOOL.

Seago, Edward (1910–74) British painter, writer, and illustrator, born in Norwich. He was confined to bed for much of his childhood (he suffered from a mysterious heart com-plaint), had little formal education, and was mainly self-taught as an artist. From 1928 to 1933 he travelled with circuses in Britain and abroad, and he wrote three illustrated books on the circus in the 1930s. However, he be-came best known for landscapes and portraits. During the Second World War he served as a camouflage officer and after being invalided from the army in 1944 he was invited by Field Marshal Alexander (a keen amateur artist) to paint scenes of the Italian campaign (repro-ductions of his paintings were published in book form as *With the Allied Armies in Italy* in 1945). In 1953 he was appointed an official Coronation artist and in 1956–7 he accompa-nied the Duke of Edinburgh on a world tour. An exhibition of the pictures he painted on this tour was held at St James's Palace in 1957. The books Seago illustrated included

three by his friend John Masefield, among them *Tribute to Ballet* (1938). His style as a painter and illustrator was fluid but rather facile.

Searle, Ronald (1920–) British graphic art-ist, born in Cambridge, where he studied at the Cambridge School of Art, 1936–9. After the Second World War (most of which he spent in Japanese prisoner-of-war camps) he settled in London and established his reputation with *Forty Drawings* (1946), a record of his captivi-ty. However, it is as a caricaturist and humor-ous illustrator that he has become famous; in particular, his creation of the fiendish school-girls of St Trinian's (who first appeared in book form in *Hurrah for St Trinian's!* 1948) has made him a household name in Britain. The St Trinian's characters typically blend mock horror and grotesque distortion with efferves-cent humour. The idea spawned a popular series of films which kept the concept alive long after Searle stopped drawing the girls; the most recent was released in 2007. His work was widely used in advertising in the 1950s and became so familiar that this decade in Britain has been described as the 'Searle decade'. Certainly for anyone growing up there at that time, he is likely to have been the first artist known by name. In 1960 Searle settled in France, supposedly to escape the notoriety which St Trinian's had brought, and in 1973 a major exhibition of his work was held in the Bibliothèque Nationale in Paris; he was the first living foreign artist to be so honoured. Searle is also a painter, etcher, and lithographer, and has worked on the design of several films, notably *Those Magnificent Men in Their Flying Machines* (1965).

Section d'Or Group of French painters who worked in loose association between 1912 and 1914, when the First World War brought an end to their activity. The members included *Delaunay, *Duchamp, *Duchamp-Villon, *Gleizes, *Gris, *Léger, *Metzinger, *Picabia, and *Villon. Their common stylistic feature was a debt to *Cubism. The name of the group, which was also the title of a short-lived magazine it published, was suggested by Villon. It refers to a mathematical propor-tion known as the golden section, in which a straight line or rectangle is divided into two parts in such a way that the ratio of the smaller to the greater part is the same as the greater to the whole (roughly 8:13). The proportion has

been studied since antiquity and has been said to possess inherent aesthetic value because of an alleged correspondence with the laws of nature or the universe. The choice of this name reflected the interest of the artists involved in questions of proportion and pictorial discipline. They held one exhibition, the 'Salon de la Section d'Or' at the Galerie la Boétie, Paris, in October 1912; *Apollinaire gave a lecture here at which he is said to have introduced the term *Orphism to describe the work of several of the members of the group. Although *Kupka's name is not included in the catalogue, there is some evidence that he showed work at the exhibition and he is generally included among the Orphists.

Sedgley, Peter (1930–) British *Op and *Kinetic artist, born in London. He had no formal artistic training and until 1959 he worked as an assistant in various architectural practices. He then joined the RAF and was discharged with ignominy in 1960. He began to paint in 1963, influenced by Bridget *Riley, with whom in 1968 he set up S.P.A.C.E. (Space Provision, Artistic, Cultural and Educational), a scheme for providing studio space for young artists. In 1967 Sedgley began to incorporate lights in his work, for example in his 'videorotors'—painted rotating discs on which a variety of electronically programmed light patterns were played. From about 1970 he has experimented with combining sound with colour; often he works on a large scale, creating environments in which spectator movement triggers photoelectric cells, causing colours to change. Since the early 1970s Sedgley has lived mainly in Germany and he has an international reputation as one of the most inventive artists in his field.

Segal, George (1924–2000) American sculptor, born in New York. His career was slow to mature. He studied at various art colleges and took a degree in art education at New York University in 1950, but until 1958 he worked mainly as a chicken farmer, painting *Expressionist nudes in his spare time. In 1958 he made his first sculpture and in 1960 he began producing the kind of work for which he became famous—life-size unpainted plaster figures, usually combined with real objects to create strange ghostly tableaux. Examples are *The Gas Station* (1963, NG, Ottawa), *Cinema* (1963, Albright-Knox Art Gallery,

Buffalo), and *The Restaurant Window* (1967, Wallraf-Richartz-Museum, Cologne). The figures were made from casts taken from the human body; he used his family and friends as models. Occasionally he incorporated actual works of art: the sculptor John *Chamberlain is cast working on one of his own sculptures, while the collector and dealer Sidney *Janis is preserved in plaster perpetually contemplating a real Mondrian (1967, MoMA New York). In the 1970s Segal began to incorporate sound and lighting effects in his work. Although his work has been linked to *Pop and *Environmental art, his vision is closer to that of Edward *Hopper. His figures and groups dwell in a lonely limbo in a way that captures a disquieting sense of spiritual isolation. From the late 1970s he also made public monuments, notably *The Holocaust* (1982, Lincoln Park, San Francisco), in which the figures are cast in bronze.

Further Reading: P. Tuchman, *George Segal* (1985)

Segall, Lasar (1891–1957) Lithuanian-born painter and graphic artist who settled in Brazil in 1923 (following a visit in 1912) and became a Brazilian citizen. Before and after the first journey to Brazil he lived in Germany (mainly Berlin and Dresden), where he developed an *Expressionist style. He was the first to exhibit Expressionist pictures in Brazil and had a great influence on younger painters there. His work often expresses his compassion for the persecuted and downtrodden, particularly the Jews who suffered under Nazism. After his death his home and studio in São Paulo were converted into a museum of his work, opened in 1970.

Segonzac, André Dunoyer de *See* DUNOYER DE SEGONZAC, ANDRÉ.

Seiki, Kuroda *See* FOUJITA, TSUGOUHARU.

Sélection An art shop and exhibition gallery in Brussels, opened by the writers André de Ridder and Paul-Gustave van Hecke in 1920 and operative until 1931. Their bulletin, also named *Sélection*, grew to become the most important avant-garde art periodical in Belgium; the last twelve numbers, issued between 1928 and 1931, took the form of monographs. Most of the leading Belgian *Expressionists showed their work at Sélection, and from 1927 to 1931 several of them—including van den *Berghe, de *Smet, and *Tytgat—were

under contract to submit half their output to the gallery.

Self, Colin See POP ART.

Seligmann, Kurt (1900–62) Swiss-born painter, graphic artist, designer, and writer who became an American citizen. He was born in Basle and studied at the École des Beaux-Arts in Geneva and the Academy in Florence. From 1929 to 1938 he lived in Paris, where he became involved with the *Surrealist movement. His paintings of this time had a magical and apocalyptic character, with hazy shapes and swirling draperies fading into the landscape. He also made various Surrealist *objects. In 1939 he emigrated to the USA and settled in New York, where he taught at Brooklyn College and the New School of Social Research. His work in his new country included sets for ballet and modern dance and a series of pictures called 'Cyclonic Forms' in which he purported to express his reactions to the American landscape. He made a serious study of the occult and wrote a book called *The Mirror of Magic* (New York, 1948); a British edition appeared in 1971 entitled *Magic, Supernaturalism and Religion*. Seligmann died of a self-inflicted gunshot wound. Officially this was ruled an accident, but suicide has been suspected.

Semana de Arte Moderna (Modern Art Week) A series of events held in the Teatro Municipal, São Paulo, Brazil, from 13 to 17 February 1922, representing the country's first major public expression in the field of modern art. The centrepiece was an exhibition, in which the participants included the painters Emiliano di *Cavalcanti (one of the organizers of the Semana), Annita Malfatti (1889–1964), and Vicente do Rego Monteiro (1899–1970) and the sculptor Victor Brecheret (1894–1955). Their work provoked a hostile reception from the press and was indiscriminately labelled 'futurist', as *Futurism was the only modern movement whose name was at least vaguely familiar in Brazil at this time (the organizers of the Semana imitated the kind of polemical slogans typical of Futurism). Much of the work on show was tentative, but the desire to create an art that was both authentically modern and authentically Brazilian was realized later in the decade in the work of Tarsila do *Amaral (who married one of the Semana's organizers, the poet Osvald de Andrade).

Sensation Exhibition of contemporary British art held at the *Royal Academy of Arts in 1997. It included work by, among others, Jake and Dinos *Chapman, Tracey *Emin, Damien *Hirst, and Rachel *Whiteread, members of the loose-knit group sometimes identified as *Young British Artists. The exhibits all came from the collection of Charles *Saatchi. Great controversy was generated in the press by the provocative nature of what was on display, although the influence of one single collector was also an issue. Marcus *Harvey's portrait of the child killer Myra Hindley was a particular target, although the issue was as much a moral one about the hurt to the families of the victims as the usual 'modern art outrage'. Four Royal Academicians resigned in protest. One of these, Michael *Sandle, who would not normally be identified as one of the Academy's more conservative members, told an interviewer later 'I felt we were dealing with a tsunami of rubbish, art as part of the fashion industry' (*RA Magazine*, August 2007). When the exhibition travelled to New York to be seen at the Brooklyn Museum in 1999 the controversy shifted to Chris *Ofili's *Holy Virgin Mary* because of its conjunction of elephant dung with religious imagery. New York's mayor, Rudolph Giuliani, who described the work as 'sick stuff', threatened to cut off the museum's public funding if the show went ahead. The funding was restored only after a legal battle. A man who smeared Ofili's picture with white paint was fined $250 and ordered by the judge not 'to enter the museum with paint brush in hand'.

Séraphine (Séraphine de Senlis, Séraphine Louis) (1864–1942) French *naive painter. After being orphaned very young, she passed her youth as a farm-hand and later entered domestic service in Senlis. She began painting when she was about forty and was 'discovered' by Wilhelm *Uhde in 1912. Her pictures are mainly fantastic, minutely detailed compositions of fruit, leaves, and flowers. She was intensely devout and painted in a trance-like state of religious ecstasy, regarding her works as offerings to the Virgin Mary. In the late 1920s her reason began to fail and she became obsessed with visions of the end of the world. She died in a home for the aged at Clermont.

Serial art A term that from the 1960s, especially in the USA, has been applied to two

types of art (although the two types may over-
lap and have in common the fact that they are
usually produced by mathematically minded
artists). First, it has been used to describe a
kind of *Minimal art in which simple, uniform,
interchangeable elements (often commer-
cially available objects such as bricks) are
assembled in a regular, easily apprehended
arrangement. Carl *Andre is a noted exponent
of this kind of work. Secondly, more broadly,
the term has been applied to works of art that
are conceived in series or as part of a larger
group; often the individual work is regarded as
incomplete in itself, needing to be seen within
the context of the whole. 'Whether an artist
produces the same work in an edition or in
different materials [Tony *Smith, for example],
or a continuous image over a long period of
time [Paul *Feeley], or where the overall struc-
ture takes precedence over each individual
work, the thrust of serial art is the same:
away from the uniquely conceived work of
art—the "original", the "masterpiece" ... The
works in a series interact and reinforce each
other, so that the whole is greater than any
part and is the sum of the parts' (Eugene C.
Goossen in *Britannica Encyclopedia of Ameri-
can Art*, 1973). The term was popularized by
two exhibitions in the USA: 'Art in Series' at
Finch College Museum (1967) and 'Serial Im-
agery' at Pasadena Art Museum (1968).

Serigraphy See SCREENPRINTING.

Serota, Sir Nicholas (1946–) British mu-
seum curator. He was director of the Museum
of Modern Art, Oxford (*see* MODERN ART,
OXFORD) (1973–6), then the *Whitechapel
Art Gallery (1976–88), the fortunes of which he
revived with an extensive building programme,
energetic fundraising, and major exhibitions.
These included a massive two-part exhibition
of British sculpture in the 20th century (1981)
and, considerably more controversial, 'Art for
Society' (1978), which reflected the debates
raging at the time about the need for a politi-
cized art practice. In 1988 he was appointed
director of the *Tate Gallery. Under his director-
ship, the gallery has experienced an unprece-
dented expansion, with the opening of Tate
Modern on Bankside in 2000.

Serov, Valentin (1865–1911) Russian
painter and graphic artist, born in St Peters-
burg, son of the composer Alexander Serov.
He studied privately under *Repin and then in
1880–85 at the Academy in St Petersburg,

where he became a friend of *Vrubel. His
work includes landscapes, genre pictures,
and historical scenes, as well as book illustra-
tions, but he is best known as the finest Rus-
sian portraitist of his generation. Like his
contemporary *Sargent, he was a cosmopoli-
tan figure, used to moving in high society, and
he brought to his work something of the same
quality of aristocratic authority and poise as-
sociated with the American's portraits. Like
Sargent, too, he painted with superb technical
freedom and finesse, and it was only after his
death that an exhibition of his work, including
a large number of studies, showed the amount
of labour he put into what seemed like the
effortless expression of a natural gift. He was
just as good with informal portraits as with
grand showpieces. His two most famous
paintings (both in the Tretyakov Gallery, Mos-
cow) are intimate early works: the breathtak-
ingly beautiful *Girl with Peaches* (1887) and
the almost equally lovely *Girl in the Sunshine*
(1888). Later, as his fame grew, he painted
many of the leading Russian celebrities of his
time, particularly artists, musicians, and wri-
ters. Serov was a member of the *World of Art
group and some of his later work shows a
tendency towards flat *Art Nouveau styliza-
tion. The most remarkable example is a
nude, almost monochromatic portrait of the
dancer Ida Rubinstein (Russian Museum, St
Petersburg), painted in Paris in 1910.

Serpentine Gallery, London. *See* ARTS
COUNCIL.

Serra, Richard (1939–) American sculptor,
born in San Francisco, the son of a dockyard
worker. He studied at the University of Cali-
fornia at Berkeley and Santa Barbara, graduat-
ing in 1961, and then at Yale University, where
he was taught by Josef *Albers. In 1965–6 he
lived in Paris and Florence with his first wife
Nancy *Graves, then settled in New York. His
early work was varied: the materials he used
included wooden logs, molten lead splashed
along the base of a wall, and vulcanized rub-
ber sheets (arranged so that the weight of the
material was allowed to determine the shape
of the piece). Much of this work has been
described as *Process art. The most striking
examples were the lead pieces which
exploited the weight and softness of the mate-
rial to enable the sculpture to hold together
without any welding of the parts. In about
1970 the direction of his art changed as he

began to use industrial materials, often on a gigantic scale in works intended for specific sites. His sculptures have often aroused controversy, most notably *Tilted Arc* (1981), a huge slab of curved, tilted steel—120 feet (36 metres) long and 12 feet (3.6 metres) high—commissioned by the General Services Administration for Federal Plaza, New York. It was hated by many people who worked in the area not only on aesthetic grounds (it was described as a 'hideous hulk of rusty scrap metal') but also because it interfered with the social activities of the plaza. After highly publicized legal proceedings it was removed in 1989. Serra refused to consider a proposed relocation to one side of the plaza, as it had been conceived for one particular position: 'Every site has an ideology... what I try to do is expose that ideology.' He claims that 'it's not the business of art to deal with human needs'. The conflict over the work reflects the fact that Serra's aesthetic is a confrontational one. When his public is an involuntary one, it can be argued that the usual considerations of artistic freedom might need to be reconsidered. In the museum context, Serra's work has been more generally approved. The massive torqued ellipses in steel which form *The Matter of Time* at the *Guggenheim Museum in Bilbao prompted *Robert Hughes (*The Guardian*, 22 June 2005) to claim that Richard Serra was 'the best sculptor alive... his achievement has been to give fabricated steel the power and density, the emotional address to the human body, the sense of empathy and urgency and liberation, that once belonged only to bronze and stone, but now no longer does'.

Further Reading: K. McShine et al., *Richard Serra Sculpture: Forty Years* (2007)

Serrano, Andres (1950–) American photographer, born in New York. His colour photographs have consistently aroused controversy on account of their themes. *Piss Christ* (1987) was one of a series involving various fluids. In this a crucifix was viewed through a golden veil of urine in which it had been placed. In 1989 a number of United States senators protested, not just at the work itself but at the use of public money, through the National Endowment for the Arts, to support it. In particular Serrano was attacked by Jesse Helms (1921–2008) from North Carolina, a politician with a long record of extreme conservatism. 'I do not know', he said, 'Mr Andres

Serrano... and I hope I never meet him. Because he is not an artist, he is a jerk' (*Congressional Record*, 18 May 1989). Serrano is gay and Hispanic and Helms has frequently been accused of homophobia and racism. Interpretations other than the deliberate courting of offence and controversy are plausible. As critic Charles Darwent put it, 'Finding not just beauty but propriety in the contents of your bladder must count as a triumph of love' (*The Independent*, 14 October 2001). Serrano was brought up as a Catholic and has told an interviewer that he still has no problem with being considered a Christian. He is also a collector and admirer of Baroque religious artefacts. Following the 'fluids', Serrano made other series. In 1990 he exhibited *Nomads*, portraits of homeless people in New York, alongside imposing photographs of Ku Klux Klan members in their robes and masks.

Further Reading: C. Fusco, 'Shooting the Klan: An interview with Andres Serrano', *High Performance* (fall 1991)

Sert, José Lui *See* MAEGHT, AIMÉ.

Sérusier, Paul (1864–1927) French painter and art theorist, born in Paris. In 1888, while he was a student at the *Académie Julian, he met Émile *Bernard and *Gauguin at Pont-Aven. He was converted to their *Symbolist views and with *Bonnard, *Denis, *Vuillard, and others he founded the *Nabis, a group inspired by Gauguin's expressive use of colour and rhythmic pattern. With Denis, Sérusier became the principal theorist of the group, and after visiting the school of religious painting at the Benedictine monastery at Beuron in Germany in 1897 and 1903 his ideas were permeated with concepts of religious symbolism. His early paintings had generally featured Breton peasants, but from about 1900 he concentrated on religious subjects. However, his paintings are generally considered of less interest than his ideas on art, which he set out in his book *ABC de la peinture* (1921), dealing with colour relationships and systems of proportion. From 1908 he taught at the *Académie Ranson.

Servaes, Albert (1883–1966) Belgian painter, born in Ghent. He attended evening classes at the Ghent Academy, but he was essentially self-taught as a painter. In 1905 he joined the artists' community at the nearby village of *Laethem-Saint-Martin. Servaes found the mystical fervour of the community congenial

and he changed from brash *Impressionist pictures to scenes from the Bible and rustic life, featuring heavy figures painted in sombre earth colours—works that have won him a reputation as one of the founders of Belgian *Expressionism. The tragic bitterness of his religious paintings aroused the hostility of the Roman Catholic authorities, which regarded him as an extremist, and several of his works were removed from churches. In 1945 he settled in Switzerland; his work after this time seldom reached the intensity of his earlier paintings.

Servranckx, Victor (1897–1965) Belgian painter, sculptor, designer, and writer on art, born at Diegem, near Brussels. From 1912 to 1917 he studied at the Académie des Beaux-Arts in Brussels, where his fellow students included *Magritte and Pierre-Louis Flouquet (1900–67). Servranckx was a brilliantly successful student (he won the Académie's Grand Prix) and while still very young he was one of the pioneers of abstract art in his country: his first one-man show—at the Giroux Gallery, Brussels in 1917—was the first exhibition in Belgium to include abstract art. His early works often carried a suggestion of machine imagery (like those of his fellow pioneer Flouquet). In about 1927 his style changed under the influence of visionary experiences, and he tried to celebrate what he regarded as the essential cosmic unity of life in sinuous, whirling forms. After the Second World War he returned to a more sober style, but freer and more flexible than his early work. Servranckx also made abstract sculpture and worked as a designer of carpets and furniture. From 1932 he taught at the École des Arts Industriels et Décoratifs d'Ixelles in Brussels.

set-up photography See PHOTO-WORK.

Seuphor, Michel (1901–99) Belgian-born painter, graphic artist, writer, and editor who became a French citizen in 1954. He was born in Antwerp as Fernand Berkelaers (his pseudonym was chosen as an anagram of 'Orpheus') and in 1925 moved to Paris, where he was one of the founders of the *Cercle et Carré association of abstract artists in 1929 and editor of its journal. His own paintings were in a geometrical abstract style (he also made prints in a variety of techniques), but he is better known for his writings. The most important is his pioneering study of Mondrian, first published in 1956 (English edition, 1957). There are also *L'Art abstrait: ses origines, ses premiers maîtres* (1949) and dictionaries of abstract painting (1957) and modern sculpture (1959), all of which have been translated into English. Seuphor also wrote poetry.

Seurat, Georges See NEO-IMPRESSIONISM.

Seven & Five Society An association of progressive British artists, originally consisting of seven painters and five sculptors, formed in 1919 and disbanded in 1935. Ivon *Hitchens was the only significant artist among the founder members (he was also the only original member to survive to the society's demise). Charles Harrison sarcastically describes the association as originally 'an expedient alliance of young ex-Servicemen reluctant to resume their education or to re-enter their professions' (*English Art and Modernism: 1900–1939*, 1981). The first exhibition of the society was held at Walker's Galleries, London, in April 1920, by which time the membership had grown to eighteen. The members regarded themselves as being in rebellion against academic art, but in retrospect their work seems timid and provincial. However, the membership changed radically and in the late 1920s and early 1930s the society was Britain's most important association of avant-garde artists. After Ben Nicholson joined in 1924 (he became chairman in 1926) the society turned increasingly towards abstraction. In 1934, at Nicholson's suggestion, the name was changed to 'Seven & Five Abstract Group', and the final exhibition (the fourteenth) held at the *Zwemmer Gallery in October 1935, was the first all-abstract exhibition to be held in England. Apart from Nicholson and Hitchens, the artists represented included Barbara *Hepworth and Henry *Moore (both of whom had exhibited with the group since 1932).

Seven-Seven, Twins (Prince Taiwo Olaniyi Oyewale-Toyeje Oyekale Osuntoki) (1944–) Nigerian painter, born in Ibadan, the son of a dyer and cloth-merchant. He is the best-known artist to emerge from the Oshogbo Workshop, a Nigerian art school in which untrained persons were simply given paints and materials. Several students, and in particular Seven-Seven, produced impressive work characterized by subjective fantasy and rich decorativeness. His paintings have been exhibited in Europe and the USA as well as Africa, and the income from sales has helped

to finance his other wide-ranging artistic activities in music (he is a singer and songwriter) and the theatre.

Severini, Gino (1883–1966) Italian painter, designer, and writer on art, active for much of his career in Paris. He was born in Cortona, moved to Rome in 1899, and decided to become a painter after meeting *Boccioni in 1901. Another important early influence on Severini was *Balla, who introduced him to *Divisionism. In 1906 he settled in Paris, where he became a friend of his fellow Italian *Modigliani, and he played a key role in transmitting the ideas of the French avant-garde to the *Futurists. He signed both the Futurist manifestos of painting in 1910 and he remained active in the movement until the First World War. Like other Futurists, he was much concerned with showing movement, but he was distinctive in his subject-matter, favouring scenes of colourful Parisian night life in which—influenced by *Cubism—he broke up forms into a multitude of contrasting and interacting shapes suggesting the rhythm of music and dance (*Dynamic Hieroglyphic of the Bal Tabarin*, 1912, MoMA, New York). His most spectacular work in this vein was *The Pan-Pan at the Monico* (1911–12, destroyed in the Second World War; second version, 1960, Pompidou Centre, Paris), which *Apollinaire described as 'the most important work painted by a Futurist brush'.

During the First World War Severini was excused military service because of poor health, but he painted some of the most dynamic Futurist pictures inspired by the conflict. In contrast, his other wartime work included still-lifes in the manner of Synthetic Cubism, reflecting his friendship with *Gris and *Picasso (*Still Life*, 1917, Metropolitan Museum, New York). In some of his work he came close to pure abstraction, but he was also influenced by the 'return to order' (*see* NEOCLASSICISM) that the war helped to inspire in many avant-garde artists. He became interested in mathematical proportions and compositional rules, publishing a book on the subject in 1921, *Du Cubisme au classicisme* (a scholarly Italian edition appeared in 1972). In the 1920s his style became more traditional and he carried out several decorative commissions, including murals for churches in Switzerland. He also worked as a theatrical designer. Severini returned to Italy in 1935, but in 1946 he settled permanently in Paris.

In the late 1940s his style once again became semi-abstract. His later work included more large-scale decorative work, notably murals in the Palazzo dei Congressi, Rome (1953). His writings include the autobiographical *Tutta la vita di un pittore* (1946).

Further Reading: S. Fraquelli and C. Green, *Gino Severini: From Futurism to Classicism* (2000)

Sewell, Brian (1931–) British art critic. His father committed suicide before he was born, and his mother, a painter and musician, brought him up with stifling possessiveness. After studying history of art at the *Courtauld Institute, he worked at Christie's auction house, 1958–66, then briefly set up as a dealer on his own. He became famous overnight in 1979 when he acted as spokesman for his friend and former teacher Anthony *Blunt, who had been sensationally exposed as a wartime Soviet spy. With his extraordinarily plummy voice, Sewell fitted to perfection the public image of an upper-class aesthete, and after the Blunt scandal died down he continued to be a familiar media figure. In 1984 he became art critic of the London *Evening Standard*, and soon made a controversial reputation with uncompromising attacks on work that he regarded as worthless or pretentious (which included the products of several highly regarded contemporary artists). On 5 January 1994 the *Standard* published a letter signed by thirty-five of his opponents, accusing him of a 'dire mix of sexual and class hypocrisy, intellectual posturing and artistic prejudice'. The signatories included John *Golding, Eduardo *Paolozzi, and Rachel *Whiteread. Later in the year, however, Sewell showed that he had strong support when he achieved the rare distinction of becoming 'critic of the year' in the British Press Awards for the second time (the first was in 1989). A collection of his writings, *The Reviews that Caused the Rumpus*, was published in 1994 (revised edn, entitled *An Alphabet of Villains*, 1995). Edward *Lucie-Smith, one of the fellow-critics with whom he has crossed swords, describes him as 'a mixture of Lady Bracknell and the mannerisms of an offended llama'.

Sezession A name adopted by several groups of artists in Germany and Austria who in the 1890s broke away ('seceded') from the established academies, which they regarded as too conservative, and organized their own, more avant-garde exhibitions. The first of these groups was formed in Munich in 1892,

its leading members being Franz von *Stuck and Wilhelm Trübner (1851–1917). There were Sezessionen also in Vienna (1897), with Gustav *Klimt as first president, and Berlin (1899), led by Max *Liebermann. When in 1910 a number of young painters were rejected by the Berlin Sezession—among them members of Die *Brücke—they started the Neue Sezession under the leadership of Max *Pechstein.

Shahn, Ben (1898–1969) American painter, illustrator, photographer, designer, teacher, and writer, born at Kovno, Lithuania, at that time part of Russia. His family emigrated to the USA in 1906 and settled in New York. In 1913–17 he was apprenticed to a commercial lithographer and he worked in this profession until 1930. However, he also took evening classes at various colleges in New York, studying biology, 1919–21, then painting, 1921–2. In 1924–5 and 1927–9 he travelled in Europe and North Africa. Shahn's background (his father had been sent to Siberia for revolutionary activities and he grew up in a Brooklyn slum) gave him a hatred of cruelty and social injustice, which he expressed powerfully in his work. He first made a name with a series of pictures (1931–2) on the Sacco and Vanzetti case (these two Italian immigrants had been executed for murder in 1927 on very dubious evidence, and many on the left believed that they had really been condemned for their anarchist political views). The Sacco and Vanzetti paintings are in a deliberately awkward, caricature-like style that vividly expresses Shahn's anger and compassion. He did a similar series in 1932–3 on the trial of the labour leader Tom Mooney, which had taken place in 1916.

In 1933 Shahn was assistant to Diego *Rivera on the latter's murals for the *Rockefeller Center, New York, and he subsequently painted a number of murals himself, notably for the Bronx Post Office, New York (1938–9), and the Social Security Building, Washington (1940–41). From 1935 to 1938 he worked as an artist and photographer for the Farm Security Administration, a government agency that documented rural poverty. During the Second World War his work included designing posters for the Office of War Information. After the war he returned to easel painting and was also active as a book and magazine illustrator and as a designer of mosaics and stained glass. His later work tended to be more fanciful and reflective and less concerned with social issues. From the 1950s he gave more time to teaching and lecturing and in 1956–7 he was Charles Eliot Norton professor of poetry at Harvard University. His Norton lectures were published as *The Shape of Content* (1957), in which he summarized his humanistic, antiabstract artistic philosophy. His other writings include various essays and the book *Paragraphs on Art* (1952).

Further Reading: S. Chevlowe et al., *Common Man, Mythic Vision: The Paintings of Ben Shahn* (1998)

Shalev-Gerz, Esther *see* GERZ, JOCHEN.

Shannon, Charles (1863–1937) British painter, illustrator, and collector, born at Quarrington, Lincolnshire, the son of a country parson. In 1881–5 he studied wood engraving at Lambeth School of Art, where in 1882 he met Charles *Ricketts, who became his lifelong companion. They lived together for almost fifty years until Ricketts's death in 1931. Ricketts had the more dominant personality. A friend of the couple, the poet, critic, and wood engraver Thomas Sturge Moore (1870–1944), wrote that 'between Ricketts and Shannon existed the most marvellous human relationship that has ever come within my observation, and in their prime each was the other's complement, but neither easily indulged the other; their union was more bracing than comfortable'. Shannon's output as a painter consisted mainly of portraits and imaginative subjects treated in a lush style based on 16th-century Venetian art. They were highly regarded in their day but have dated badly. He made lithographs in a similar vein. In 1929 he fell from a ladder while hanging a picture and injured his brain; although he lived for eight more years, he never fully recovered and often did not recognize Ricketts.

shaped canvas A term that began to be used in the 1960s for paintings on supports that departed from the traditional rectangular format. Non-rectangular pictures were of course not new at this time: Gothic and Renaissance altarpieces often had pointed tops, the oval was particularly popular in the Baroque and Rococo periods, and so on. In the context of modern art, however, the term 'shaped canvas' usually alludes specifically to a type of abstract painting that emphasizes the 'objecthood' of the picture, proclaiming it as

something that exists entirely in its own right and not as a reference to or reproduction of something else. Various artists have been claimed as the 'inventor' of the shaped canvas in this sense, but its most prominent early exponent was undoubtedly Frank *Stella, who has used such shapes as Vs, lozenges, and fragments of circles. Subsequently Elizabeth *Murray has been perhaps the most original and committed devotee. The leading exponent in Britain has been Richard *Smith. He was one of the artists represented in an exhibition entitled 'The Shaped Canvas' at the *Guggenheim Museum, New York, in 1974, organized by Lawrence *Alloway. Shaped canvases have also been used occasionally by modern figurative painters, notably Anthony *Green.

Shaw, John Byam (1872–1919) British painter and illustrator, born in Madras, the son of a high court official. He came to England in 1878 and studied at St John's Wood School of Art and the *Royal Academy Schools. His style was heavily influenced by the *Pre-Raphaelites and he was at his best with medieval subjects, although at one time his most famous picture was probably *The Boer War* (1901, City Art Gallery, Birmingham), showing a young woman musing on the death of a loved one. In 1910 he founded the Byam Shaw and Vicat Cole School of Art in Kensington with the painter Rex Vicat Cole (1870–1940), a close friend who later wrote *The Art and Life of Byam Shaw* (1932). Among the teachers was another close friend, Eleanor Fortescue-Brickdale (1872–1945), likewise an upholder of the Pre-Raphaelite tradition. The school still continues today as the Byam Shaw School of Art, although it is now located in north London. In 2003 it merged with *St Martin's School of Art.

Shchukin, Sergei (1854–1936) Russian collector and patron, born in Moscow. He was a member of a large merchant family with diverse business interests, and he had four brothers who also were enthusiastic art collectors. His serious collecting career began in 1897 when he bought a *Monet (*Lilacs at Argenteuil*, 1873, Pushkin Museum, Moscow) at *Durand-Ruel's gallery during a business trip to Paris. After this he became devoted to modern French painting and filled his magnificent house in Moscow with choice examples. Like the other great Russian collector of such

works, Ivan *Morozov, he commissioned new works as well as buying from dealers. Among the *Impressionists and *Post-Impressionists Shchukin had particularly fine representations of the work of *Cézanne, *Gauguin, Monet, and *Renoir, but the artists who figured most prominently in his collection were *Matisse (37 paintings) and *Picasso (51 paintings, mainly *Cubist works). In 1909 Shchukin commissioned large decorative panels of *The Dance* and *Music* from Matisse, and the artist visited Moscow in 1911 to supervise the installation of his work. Shchukin referred to the pink drawing-room, which was devoted to Matisse's work, as 'my fragrant garden', and at this time he undoubtedly had the finest representation of his paintings in the world: in 1914 the Russian art historian and critic Yakov Tugendkhold (1882–1928) wrote, 'In spite of the exhibitions I had seen in Paris and the number of his works in his own studio, it was not until after my visit to Shchukin's house that I could say that I really knew Matisse.' His collection was more accessible than Morozov's, being open to the general public at certain times. After the Russian Revolution both collections were nationalized and amalgamated administratively under the title Museum of Modern Western Art, although they remained in their original homes for several years. In 1928 they were brought together under one roof in Morozov's former home, but in 1948 the Museum of Modern Western Art was dissolved and the paintings were divided between the Hermitage, Leningrad (now St Petersburg), and the Pushkin Museum, Moscow.

Sheeler, Charles (1883–1965) American painter and photographer, the best-known exponent of *Precisionism. He was born in Philadelphia, where he studied at the Philadelphia School of Industrial Art (1900–03) and at the Pennsylvania Academy of the Fine Arts (1903–6) under William Merritt *Chase. Between 1904 and 1909 he made several trips to Europe (the final one in company with his friend Morton *Schamberg), and he gradually abandoned the bravura handling of Chase for a manner influenced by European modernism—the paintings he exhibited at the *Armory Show in 1913, for example, were much indebted to *Cézanne. In 1912 Sheeler took up commercial photography for a living while continuing to paint, and in 1918 he moved to New York. He worked for a while in fashion

photography, but his shy and undemonstrative personality was not suited to this world, and he concentrated more on very mundane subjects such as plumbing fixtures. The clarity needed in such work helped to transform his style of painting to a meticulous smooth-surfaced manner that was the antithesis of his early approach. He began to paint urban subjects in about 1920 and over the next decade shifted from simplified compositions influenced by *Cubism (on 'the borderline of abstraction' in his own words) to highly detailed photograph-like images. In 1920 he made an experimental film, *Manhatta*, in collaboration with Paul *Strand. In 1927 he was commissioned to take a series of photographs of the Ford Motor Company's plant at River Rouge, Michigan (he also made paintings of the plant). His powerful photographs, presenting a pristine view of American industry, were widely reproduced and brought him international acclaim (he was invited to photograph factories in Russia, but declined the offer). Increasingly, also, he was recognized as the finest painter in the Precisionist style, his work standing out as much for its formal strength as for its technical polish (*American Landscape*, 1930, MoMA, New York).

Sheeler's paintings continued in this realistic vein in the 1930s, but in the mid-1940s his style changed dramatically: he began using multiple viewpoints and bold unnaturalistic colours, although his brushwork remained immaculately smooth (*Architectural Cadences*, 1954, Whitney Museum, New York). In 1959 he suffered a stroke and had to abandon painting and photography. His work is represented in many major American collections.

Further Reading: C. Brock, *Charles Sheeler: Across Media* (2006)

Shepherd, David (1931–) British painter and wildlife conservationist, born in London. He started his career with aviation subjects, but in 1960 he began painting African wildlife and it is in this area that he has become internationally famous—not only with his paintings (and *popular prints reproduced from them), but also through his fundraising activities to preserve endangered species. He has published several books on his work and also an autobiography entitled *The Man Who Loves Giants* (1975, second edition 1989); this was also the title of a BBC television documentary on his life. Apart from wildlife, his great passion is steam locomotives—likewise a favourite subject in his paintings (the 'Giants' in the title of his autobiography refers to both elephants and engines). Shepherd has also painted portraits and occasional religious works.

Sher-Gil, Amrita (1913–41) Indian painter, born in Budapest, the daughter of an aristocratic and scholarly Sikh father and a mother who came from a cultured Hungarian family. Her very short life was divided fairly evenly between Europe and India. From 1921 to 1929 She lived in Simla. She showed a talent for drawing from childhood, and from 1929 to 1934 she studied painting in Paris, first at the Académie de la Grande Chaumière and then at the École des *Beaux-Arts. Although she immersed herself in the bohemian life of the city, she did not identify with any of the avant-garde movements of the day, developing instead a romantic love of India. She declared that it was her artistic mission 'to interpret the life of Indians, and particularly the poor Indians, pictorially'. However, her interest in the poverty and pathos of her country was aesthetic rather than motivated by any sense of *Social Realism. Her bold flattened forms show the influence of *Gauguin and Indian miniatures, but her work has a personal sensibility. She already had a considerable reputation at the time of her death at the age of 28 (possibly as the result of a botched abortion) and she has subsequently become something of a national heroine in India. The best collection of her work is in the National Gallery of Modern Art, New Delhi.

Sherman, Cindy (1954–) American artist who specializes in photographic tableaux which usually feature her own body variously transformed or even disguised. She was born in Glen Ridge, New Jersey. As she has pointed out, she was of the first generation to watch television constantly. References to the mass culture of the 1950s, the Eisenhower era in which consumerism was allied to the Cold War, were to be an important feature of her work. She studied photography and painting at State University College, Buffalo, New York, and has lived and worked in New York ever since. From 1977 to 1979 she made her series of 69 *Untitled Film Stills*. These black and white photographs all included herself but as model in different guises. Their power resides partly in the way that they suggest different narratives by their similarity to shots from

stereotypical but unidentifiable Hollywood films.

Subsequently she has made large-scale colour prints. Sometimes these parody the conventions of the centrefold glamour photograph in a men's magazine; others draw on images of women in Old Master paintings. Often these quote their sources more literally than the film stills. *Untitled#205* (1989) is modelled on Raphael's *La Fornarina*. In other works, prostheses and make-up are used to transform the image of the artist into something horrific, such as a woman with a pig's snout. Sometimes the body disappears under puddles of vomit and blood. From 1992 onwards she started to use anatomical models as a substitute for her own body. In a series of works of 2003 she dresses up as a clown.

Unlike the photographic montages of *Gilbert & George, which produce the impression of consistent personalities behind the work, there is no sense of a 'real' Sherman, only a series of masks. As Arthur Danto put it, the 'photographs are of her only in the reduced sense in which Delacroix's *Liberty Storming the Barricades* is of the model who posed for Liberty' (*The Nation*, 15 August 1987). Laura Mulvey, one of a number of commentators who have written about Sherman from a *feminist angle, coined the phrase 'phantasmagoria of the female body' to describe her work (*New Left Review*, July–August 1991). Mulvey's argument is that femininity is defined by a series of masks.

Sherman has tended to be circumspect in providing interpretations of her work. 'I just want to be accessible', she has said. 'I don't like the elitism of a lot of art…where you must get the theory behind it before you can understand it.' However, she has recalled how, when coming to New York for the first time, she soon discovered the need to adopt a kind of special persona to survive in the street, quite different from that she would take on at home, implicitly endorsing Mulvey's reading.

In 1997 Sherman directed a film entitled *Office Killer*, starring Carol Kane, a black comedy about a series of apparently random murders at a magazine publisher. It has not achieved the acclaim accorded to her still photographs, perhaps because the rather obvious metaphor (the murders complement the ruthless downsizing suffered by the office staff) does not leave the same space for the spectator's imagination.

Further Reading: R. Krauss, 'Cindy Sherman: Untitled', in *Bachelors* (1999)

Shevchenko, Alexander (1882–1948) Russian painter, born at Kharkov. He studied in Paris, 1905–6, then in Moscow at the Stroganov Art School and the Moscow School of Painting, Sculpture, and Architecture, 1906–9, and he evolved a style combining influences from both Russian peasant art and French *Cubism (*see* NEO-PRIMITIVISM). In line with these two interests he wrote two theoretical tracts, both published in Moscow in 1913: *Neo-Primitivism: Its Theory, its Possibilities, its Achievements* and *The Principles of Cubism and Other Modern Trends in Painting of All Times and Peoples*. At around this time he contributed to several avant-garde exhibitions, including *'Donkey's Tail' and *'Target'. From 1918 to 1930 he was a professor at *Vkhutemas, and in 1921 he became a member of *Makovets.

Shinn, Everett (1876–1953) American painter, illustrator, and designer, born in Woodstown, New Jersey. He studied at the Pennsylvania Academy of the Fine Arts, 1893–6, while at the same time working as a reporter-illustrator on *The Philadelphia Press*. His colleagues on the newspaper included *Glackens, *Luks, and *Sloan, who like Shinn became members of The *Eight (1) and the *Ashcan School in New York (he moved there in 1896). Shinn differed from his associates in his choice of subject, preferring scenes from theatre and music-hall to everyday working-class imagery. However, in 1911 he did murals on local industrial subjects for Trenton City Hall, New Jersey, and these have been described as the earliest instance of *Social Realist themes in public mural decoration.

Shirlaw, Walter *See* ART STUDENTS LEAGUE OF NEW YORK.

Shkolnik, Iosif *See* UNION OF YOUTH.

Shonibare, Yinka, MBE *See* PHOTO-WORK.

Shore, Arnold *See* BELL, GEORGE.

Short, Sir Frank (1857–1945) British engraver in various techniques, born at Wollaston, Worcestershire. He was the son of an engineer and trained to follow his father's profession; his scientific background gave him a deep understanding of materials, and he made his own tools and invented new ones.

He once stated, 'An artist must be a workman; and an artist afterwards, if it please God.' His main artistic training was at the *Royal College of Art. Short revived aquatint and mezzotint as both creative and reproductive media, and his etchings were praised by *Whistler, who often visited Short's studio for advice on technical matters. From 1891 to 1924 he taught at the Royal College of Art.

Shterenberg, David *See* NARKOMPROS.

Sickert, Walter (1860–1942) British painter, printmaker, teacher, and critic, one of the most important figures of his time in British art. He was born in Munich of a Danish-German father and Anglo-Irish mother and he remained cosmopolitan. The family settled in London in 1868. Both his father and his grandfather were painters, but Sickert—after a good classical education—initially trained for a career on the stage, 1877–81. He toured with Sir Henry Irving's company but never progressed beyond small parts and in 1881 he abandoned acting and became a student at the *Slade School. In the following year he became a pupil of *Whistler (who taught him etching as well as painting), and in 1883 he worked in Paris with *Degas. Between 1885 and 1905 Sickert spent much of his time in Dieppe, living there 1899–1905, and also visited Venice several times. From 1905, when he returned to England, he became the main channel for influence from avant-garde French painting in British art, inspiring a host of younger artists with the force of his personality as well as the quality of his work. The *Allied Artists' Association (1908), the *Camden Town Group (1911), and the *London Group (1913) were all formed largely by artists in his circle. In 1918–22 Sickert again lived in or near Dieppe, then settled permanently in England, living in London and Brighton before moving to Broadstairs, Kent (1934), and finally to Bathampton, near Bath (1938).

Sickert took the elements of his style from various sources but moulded them into a highly distinctive manner. From Whistler he derived his subtle modulations of tone, although his harmonies were more sombre and his touch rougher, using thick crusty paint. To Degas he was indebted particularly for his method of painting from photographs and for the informality of composition this encouraged. His favourite subjects were urban scenes and figure compositions, partic-

ularly pictures of the theatre and music-hall, nudes, and drab domestic interiors (Sir William *Rothenstein wrote that he was 'fastidious in his person, in his manners, in his choice of clothes', but his 'genius for discovering the dreariest house and the most forbidding rooms in which to work was a source of wonder and amazement to me'). Sickert himself wrote in 1910 that 'The more our art is serious, the more will it tend to avoid the drawing-room and stick to the kitchen'. This attitude permeates his most famous painting, *Ennui*, a compelling image of a stagnant marriage, of which he painted several versions, that in Tate (*c*.1914), being the largest and most highly finished.

Sickert's later works—often based on press photographs or Victorian illustrations—are very broadly handled, painted in a rough, vigorous technique, with the canvas often showing through the paint in places. The colour is generally much higher-keyed than in his earlier work and sometimes almost *Expressionist in its boldness. The prevailing critical opinion for many years was that these late works marked a significant decline, but they are now highly regarded, particularly since the 1981 *Arts Council exhibition 'Late Sickert: Painting 1927 to 1942'.

Sickert was highly prolific as a painter, and his work is represented in many public collections. In addition he was an outstanding and resourceful printmaker (he experimented with various techniques and with coloured papers, trying to capture the rich tonal effects of his paintings) and a brilliant although somewhat dilettante teacher (he opened seven private art schools, each of brief duration, and also taught part-time at Westminster School of Art, 1908–12 and 1915–18). He was celebrated for his wit and charm and was a stimulating talker and an articulate writer on art; Osbert *Sitwell edited a posthumous collection of his writings entitled *A Free House!* (1947). Sickert was married three times; his third wife (from 1926) was the painter Thérèse *Lessore. His brother **Bernard Sickert** (1862/3–1932) was a landscape painter and etcher.

Further Reading: M. Sturgis, *Walter Sickert: A Life* (2005)

Sierra, Santiago *See* INSTALLATION.

Sieverding, Katharina *See* FEMINIST ART.

Signac, Paul (1863–1935) French painter and writer on art. After the death of Georges

Seurat in 1891 he became the acknowledged leader of the *Neo-Impressionist movement, and in 1899 he published *D'Eugène Delacroix au néo-impressionisme*, which was long regarded as the authoritative work on the subject. The book, however, was more in the nature of a manifesto in defence of the movement than an objective history. It reflected Signac's use of more brilliant colour from about 1890, as he moved away from the scientific precision advocated by Seurat to a freer and more spontaneous manner. His work had a great influence on *Matisse, who visited him at St-Tropez in 1904 (a keen yachtsman, Signac spent a good deal of time on the Mediterranean and French Atlantic coasts; harbour scenes were his favourite subjects).

Signals *See* KINETIC ART.

silkscreen *See* SCREENPRINTING.

Sillince, Wiliam *See* TRUTH TO MATERIAL(S).

Simberg, Hugo (1873–1917) Finnish painter and graphic artist, born at Hamina. After training at the Finnish Fine Arts Association in Helsinki, he studied privately with *Gallen-Kallela, on whose advice he made a tour abroad in 1896, visiting London, where he admired the work of the *Pre-Raphaelites, and Paris. In 1897–8 he travelled in Italy, and in 1899 he visited the Caucasus. Although he painted fairly straightforward landscapes and portraits, most of Simberg's work is in a highly distinctive *Symbolist vein. Drawing on his country's rich folk traditions, he depicted a vividly imaginative world in which devils and angels and personifications of Death and Frost mingle with humans. In such work his style was colourful and bizarre, sometimes with an almost *naive quality of freshness. Gallen-Kallela wrote that Simberg had a 'quite wonderful gift, completely in the character of the Old Masters of the thirteen or fourteen hundreds. And it is a genuine, not affected, naivety. His works seem like sermons that everyone must listen to, and they stick in the memory.' Simberg usually worked on a small scale (his output includes many watercolours, drawings, and etchings), but in 1904–7 he did impressive monumental work, including frescos and stained glass, for the newly-built church (now cathedral) at Tampere, Finland's second largest city. His later career was marred by illness.

Simmons, Edward *See* TEN, THE.

Singier, Gustave (1909–84) Belgian-born painter, designer, and printmaker who settled in Paris in 1919 and became a French citizen. He had a family background of craft, for his father was a joiner and his mother a weaver. Early in his career he worked as a commercial designer-decorator (mainly for shops and apartments), painting in his spare time and taking evening classes at various art academies. However, in 1936 he met the French painter Charles Walch (1898–1948), who encouraged him to take up art professionally, and from that year he began exhibiting regularly at commercial galleries and avant-garde salons. He had his first one-man exhibition in 1949, at the Galerie Billiet Caputo, Paris, and from 1951 to 1954 he taught at the *Académie Ranson. Singier's early work combined elements from *Cubism, *Expressionism, and *Fauvism. After the Second World War his painting became completely abstract, featuring flat, patchwork-like patterns in bright colours (*Provence I*, 1957, Tate). He often worked in watercolour as well as oils. Apart from paintings, his work included prints (etchings and lithographs) and designs for stained glass, tapestry, and the theatre.

Siqueiros, David Alfaro (1896–1974) Mexican painter, one of the trio of muralists (with *Orozco and *Rivera) who dominated 20th-century Mexican art. He was born in Chihuahua, the son of a lawyer, and was a political activist from his youth. In 1914 he abandoned his studies at the Academy of San Carlos in Mexico City to join the revolutionary army fighting against President Huerta. His services were appreciated by the victorious General Carranza, who in 1919 sponsored him to continue his studies in Europe, where he was friendly with Rivera (later they became rivals). On returning to Mexico in 1922 he took a leading part in the artistic revival fostered by President Alvaro Obregón. Siqueiros was active in organizing the Syndicate of Technical Workers, Painters, and Sculptors and was partly responsible for drafting its manifesto, which set forth the idealistic aims of the revolutionary artists: 'our own aesthetic aim is to socialize artistic expression, to destroy bourgeois individualism ... We proclaim that this being the moment of social transition from a decrepit to a new order, the makers of beauty must invest their greatest efforts in the aim of

materializing an art valuable to the people, and our supreme object in art, which today is an expression for individual pleasure, is to create beauty for all, beauty that enlightens and stirs to struggle.'

Siqueiros's political activities led to his imprisonment or self-imposed exile several times; from 1925 to 1930 he completely abandoned painting for political activity and he later fought in the Spanish Civil War. In 1940, he led an armed band to attack the house of the dissident Russian revolutionary leader Leon Trotsky, then in exile in Mexico City. Siqueiros claimed in court that he had not been attempting assassination but only seeking evidence that Trotsky was taking money from the American newspaper proprietor William Randolph Hearst. As the house was assaulted with machine guns and explosives, the explanation is somewhat implausible.

It was not until 1939 that he eventually completed a mural in Mexico—*Portrait of the Bourgeoisie* for the headquarters of the Union of Electricians in Mexico City (his slow start had prompted Rivera to retort in answer to criticism from him: 'Siqueiros talks: Rivera paints!'). Thereafter, however, Siqueiros's output was prodigious. He painted many easel pictures as well as murals, and though he insisted they were subordinate to his wall paintings, they were important in helping to establish his international reputation. His murals are generally more spectacular even than those of Orozco and Rivera—bold in composition, striking in colour, freely mixing realism with fantasy, and expressing a raw emotional power. In contrast with the sense of disillusionment and foreboding sometimes seen in Orozco's work, Siqueiros always expressed the dynamic urge to struggle; his work can be vulgar and bombastic, but its sheer energy is astonishing. He often experimented technically, working with industrial materials and equipment, including spray-guns, cement-guns, and blow-torches (his use of unconventional methods influenced Jackson *Pollock, who attended the experimental workshop Siqueiros ran in New York in 1936). In his late years he was showered with honours from his own country and elsewhere: he received the Lenin Peace Prize in 1967, for example, and in the following year became the first president of the newly founded Mexican Academy of Arts. His final major work, the Polyforum Siqueiros (completed 1971) in Mexico City, is a huge auditorium integrating architecture, sculpture, and painting.

Further Reading: D. Rochfort, *Mexican Muralists* (1998)

Sironi, Mario (1885–1961) Italian painter, sculptor, designer, caricaturist, and writer, born in Sassari, Sardinia. The year after his birth his family moved to Rome. In 1902 he began studying engineering (his father's profession), but he abandoned it for painting in 1903. At life classes at the Academy in Rome he became friendly with *Balla, *Boccioni (with whom he shared a flat in Paris in 1908), and *Severini, and in 1914 he moved to Milan and joined the *Futurists. However, his association with the movement was for ideological rather than stylistic reasons: his paintings of the period were often concerned with modern urban life, but they are solid rather than dynamic in feeling. After the First World War, in which he served at the front, Sironi returned to Milan and was briefly influenced by *Metaphysical Painting. In 1922, the year in which Mussolini gained power, he joined the Fascist Party and was a founder of *Novecento. Until the fall of Mussolini in 1943 he was the leading caricaturist for the Fascist press, to which he also contributed much writing, including art criticism. He came to regard easel painting as a bourgeois anachronism and in the 1930s devoted much of his energies to propaganda work and didactic murals, including *Italy between the Arts and Sciences* (1935) for the University of Rome and *Law between Justice and Strength* (1936) for the Palace of Justice, Milan. His style in these murals was anti-naturalistic, based on such sources as Roman and Byzantine mosaics and Romanesque sculpture. It was denounced in some quarters as degenerate and prompted a heated debate in the press on the appropriate style for Fascist art. After the fall of Mussolini, Sironi returned to easel painting. His work also included sculpture and design for opera. A retrospective exhibition of his work was staged at the Venice *Biennale the year after his death.

Sisley, Alfred *See* IMPRESSIONISM.

site-specific Term applied to art that is dependent for its meaning or effect on the particular place in which it is sited. This might be a natural environment, as in the *Valley Curtain* of *Christo and Jeanne-Claude, or a public place in the city, as in Rachel *Whiteread's *House*. If a museum or gallery is the site, as in

certain work by Michael *Asher or Hans *Haacke, part of the intention is usually to draw attention to the architectural or political nature of the space.

Sitte, Willi *See* SOCIALIST REALISM.

Situation ('Situation: An Exhibition of British Abstract Painting') An exhibition staged in September 1960 at the Galleries of the Royal Society of British Artists, London, by a group of predominantly young British painters who were united by their admiration for American *Abstract Expressionism. The catalogue listed twenty artists, but only eighteen in fact showed their work. Paintings included had to be totally abstract and at least 30 square feet (about 3 square metres) in size; the name of the exhibition came from the participants' idea that an abstract painting that occupied the whole field of vision would involve the spectator in an 'event' or 'situation'. Robyn *Denny was the organizing secretary and other artists represented included Gillian *Ayres, Bernard and Harold *Cohen, John *Hoyland, Bob *Law, Richard *Smith, and William *Turnbull. These artists felt frustrated by the lack of exposure given to large-scale abstract works by commercial galleries, and in organizing the exhibition themselves they aimed to bypass the dealer system. The following year, however, the London dealers *Marlborough Fine Art staged an exhibition featuring sixteen of the eighteen who had participated in the original show, with the addition of the sculptor Anthony *Caro; this was entitled 'New London Situation: An Exhibition of Abstract Art'. In 1962–3 the *Arts Council organized a touring exhibition of the work of the group entitled 'Situation: An Exhibition of Recent British Abstract Art'. The three exhibitions marked a move towards a more international context for British painting.

Sometimes the artists who took part in the exhibitions are called 'Situationists' (for example in Daniel Wheeler's *Art Since Mid-Century*, 1991), but this usage is regrettable, as it runs the risk of confusion with the *Situationist International.

Situationist International A radical political and cultural movement, centred in France but international in scope, that flourished from 1957 to 1972. It shared with *Dada and *Surrealism a desire to disrupt conventional bourgeois life, and the Situationist International had its moment of glory in 1968 when its ideas were for a short time put into practice, playing a part in the student revolts in Paris and France's general strike. The Situationists differed from other revolutionary movements in not seeking to take control of the state and the economy, but in demanding 'a revolution in everyday life' which would transform attitudes to culture and the family.

The Situationist International (Internationale Situationniste) was formed in 1957 by the amalgamation of two cultural groups: the Movement for an Imaginist Bauhaus (descended from *Cobra) and the Lettrist International (Lettrism, which has some kinship with *Concrete poetry, is defined in the *New Shorter Oxford English Dictionary* as 'a movement in French art and literature characterized by a repudiation of meaning and the use of letters (sometimes invented) as isolated units'). The chief spokesman of the Situationists was Guy Debord (1931–94), editor of the journal *Internationale situationniste* (twelve issues, 1958–69). The other main Situationist periodical was *Spur* (seven issues, 1960–61), produced by a group of the same name in Munich. In addition to journals such as these, the Situationists created posters and films, and Debord promoted street events that he hoped would jolt passers-by out of their normal ways of looking and thinking. The key concept of the Situationists was the *dérive*, a disruption of the expected, achieved by the experience of random travels through the city, bringing to mind the Surrealists' perambulations of Paris in search of the 'marvellous'. In such a project they were up against the plans to reorganize and rebuild Paris, which threatened their old bohemian and proletarian haunts on the left bank and in Les Halles. Among the visual artists associated with the movement, the best known was Asger *Jorn, who exhibited pictures that were painted over partially obliterated reproductions of works of art, intending thereby to call into question the value of originality. In 1962 Debord denounced art as just another aspect of 'the spectacle'. The Situationists disbanded in 1972. A large exhibition on the movement was held at the Pompidou Centre in Paris in 1989. Its greatest impact has been on those manifestations of popular culture which have styled themselves as subversive, such as the 'punk' movement in music and fashion in the late 1970s, as well as on certain graphic designers such as Jamie Reid (1940–).

Further Reading: P. Wollen, 'The Situationist International', *New Left Review* (March–April 1989)

Sitwell Family of British writers, patrons, and collectors. **Sir George Sitwell** (1860–1943) was an antiquarian and genealogist. He had three children, who formed probably the most famous literary family of the 20th century: **Dame Edith Sitwell** (1887–1964), **Sir Osbert Sitwell** (1892–1969), and **Sir Sacheverell Sitwell** (1897–1988). They grew up at the family seat, Renishaw Hall, Derbyshire, and are seen as children in *Sargent's group portrait *The Sitwell Family* (1900), which is still at Renishaw. All three of them published numerous prose and verse works. Edith is best known as a poet, Osbert as an autobiographer, and Sacheverell for his writings on art and architecture, including several pioneering books on Baroque art, which was little appreciated in Britain when he started his career; *Southern Baroque Art* (1924) was the first of these books. The Sitwells were outspoken critics of culture they regarded as outmoded and they became vigorous champions of modernism in art, literature, and music, particularly in the 1920s and 1930s (after the Second World War their reputations and influence generally declined). Their most famous protégé was the composer William Walton, who collaborated with Edith on *Façade* (1922), a suite of 'abstract poems' or 'patterns in sound'; it was greeted with abuse when first performed in public in 1923 but subsequently became popular in the concert hall and recordings. The Sitwells also helped to promote *Diaghilev's Ballets Russes and in 1919 they sponsored an exhibition of 'French Art 1914–17' at the Mansard Gallery, London, which included work by *Derain, *Dufy, *Matisse, and *Modigliani. They patronized numerous artists, including several who made illustrations for their books. Osbert, who inherited Renishaw Hall when his father died, commissioned John *Piper to make a series of paintings of the house and estate, many of which were reproduced in his autobiography (5 vols, 1944–50, with a sixth volume appearing in 1962).

There are many portraits of the Sitwells, particularly Edith, whose extremely flamboyant style and melancholy visage made her an inviting subject. The aquiline nose, so tactfully disguised by Sargent, was the delight of artists who portrayed her as an adult, among whom were Roger *Fry (1918, City Art Gallery, Sheffield), the Chilean-born Alvaro Guevara (1894–1951) (*c.*1919, Tate), Wyndham *Lewis, whose version remained unfinished (*c.*1923–35, Tate), and Pavel *Tchelitchew (several pictures—she had an unrequited passion for him). The photographer and stage designer Sir Cecil Beaton (1904–80) took many pictures of her, and she also appears in Boris *Anrep's mosaic floor in the National Gallery, London (as 'Sixth Sense' in *The Modern Virtues*). Osbert Sitwell, too, appears in Anrep's floor (as 'Apollo' in *The Awakening of the Muses*), but the best-known portrait of him is the brass head by Frank *Dobson (1923, Tate).

Further Reading: J. Pearson, *Façades* (1989)

Sjöö, Monica See FEMINIST ART.

Skeaping, John (1901–80) British sculptor and draughtsman, born at South Woodford, Essex, the son of a painter. At the age of thirteen he went to Blackheath School of Art, London, and subsequently studied at *Goldsmiths College, the Central School of Art and Design, and in 1919–20 the *Royal Academy Schools. He won several awards and scholarships, including the Prix de Rome in 1924; Barbara *Hepworth was runner-up. The couple married in Rome in 1925 and were divorced in 1933, by which time Hepworth was living with Ben *Nicholson. During their marriage Skeaping was influenced by Hepworth's advocacy of *direct carving, making works in which he tried to exploit the natural qualities of stone and wood: 'Perhaps I was jealous of her admiration for *Moore and felt that she didn't really think much of my work.' In the 1930s, however, he reverted to a more traditional style and worked mainly as an animal (particularly horse) sculptor in bronze. He published several books, including *Drawn From Life: An Autobiography* (1977).

Skira, Albert (1904–73) Swiss publisher, born in Geneva. After working in a bank and as an entertainments organizer in luxury hotels, he set up business as a bookseller and in 1931 began his publishing career with Ovid's *Les Métamorphoses*, illustrated by *Picasso. This was quickly followed by further luxury editions of poetry illustrated by *Dalí, *Matisse, and other distinguished artists. He also began publishing art books with high-quality colour illustrations. From 1933 to 1941 he lived in Paris, where he published the avant-garde periodical *Minotaure* (1933–9; thirteen

numbers appearing irregularly); it covered contemporary artistic and literary trends, particularly *Surrealism, as well as primitive art and anthropology. The journal was beautifully produced, the illustrations including original prints. In 1941 Skira returned to Geneva, where he published *Labyrinthe* (1944–6; twenty-three issues); it covered the same type of subjects as *Minotaure*, but was much less lavish in presentation—in fact it was printed as a newspaper. It showed Skira's desire to reach a wide readership, but he also continued with his luxury products, in which he demonstrated an almost fanatical devotion to achieving the highest possible standards. In this he was matched by Matisse, and they spent seven years on *Florilège des Amours de Ronsard* (Anthology of the *Amours* of Ronsard), from the initial agreement in 1941 to publication in 1948, overcoming what Alfred H. *Barr describes as a series of 'extraordinary trials and misadventures' to achieve the exact results they wanted in design and typography. The book features 126 lithographs in brown crayon on grey-tinted paper, illustrating the love poems of Ronsard. By this time Skira was publishing books on a wide range of artistic subjects, and from the 1950s he produced various series of beautifully illustrated books on the history of art in which he brought his high standards to a mass audience: they include 'The Great Centuries of Painting' and 'The Taste of our Time'. *See also* LIVRE D'ARTISTE.

Sköld, Otte *See* MODERNA MUSEET.

Sky art A term coined in 1969 by the German artist Otto *Piene to describe works, generally large in scale, that are viewed in or from the sky. It has been used to embrace traditional activities such as kite-flying and firework displays and also works using highly advanced technology. Examples by Piene include *Olympic Rainbow* (1972), consisting of five helium-filled polythene tubes each 600 metres long, produced for the Munich Olympic Games, and *Sky Kiss* (1981–6), in which Charlotte Moorman (1933–91), who also worked with Nam June *Paik, played her cello whilst suspended from helium-filled tubes. Among the artists who use high technology is Tom Van Sant (1926–), whose work includes *Desert Sun* (1986), in which a series of mirrors reflected sunlight to the sensors of a satellite orbiting the earth.

Slade School of Fine Art, London. A training school for artists founded in 1871 as part of University College London. It is named after the art collector Felix Slade (1788–1868), who in his will endowed chairs of fine art at the universities of London, Oxford, and Cambridge. At Oxford and Cambridge the Slade professorships involve only the giving of lectures for a general audience (many distinguished art historians have held the posts), but in London (where Slade also endowed six scholarships) the college authorities added to his gift by voting money to fund a teaching institution giving practical instruction in painting and graphic art (and from 1893 sculpture). The first Slade professor was Sir Edward *Poynter, 1871–5. His successors have been: Alphonse *Legros, 1876–92; Frederick *Brown, 1892–1917; Henry *Tonks, 1918–30; Randolph *Schwabe, 1930–48; Sir William *Coldstream, 1949–75; Sir Lawrence *Gowing, 1975–85; Patrick *George, 1985–7; Bernard *Cohen, 1988–2000; and John Aiken, from 2000. Poynter introduced the French system of working direct from the living model at an early stage and so founded the tradition of outstanding draughtsmanship that came to characterize the Slade. It rapidly took over from the *Royal Academy (where the teaching was considered arid and academic) as the country's leading art school and had its finest period during the long professorship of Brown, the heyday lasting from about 1895 until the outbreak of the First World War. The most influential figure was probably Tonks, the ex-surgeon, originally employed to teach anatomy. His students included some of the most illustrious names in 20th-century British art—among them David *Bomberg, Mark *Gertler, Spencer *Gore, Duncan *Grant, Augustus and Gwen *John, Wyndham *Lewis, Matthew *Smith, Paul *Nash, Ben *Nicholson, William *Orpen, Stanley *Spencer, and Edward *Wadsworth. After the war the *Royal College of Art began to rival the Slade in importance and it went through a fairly quiet period in the 1930s and 1940s under Schwabe, followed by a resurgence under Coldstream. He brought with him the influence of the *Euston Road School and a kind of painting and drawing dependent on measurement and close observation. This became identified as a particular feature of Slade painting, the measurement marks left visible on the canvas in the work of artists such as Euan *Uglow being seen by detractors as

something of a mannerism. Apart from the professors themselves, many other distinguished artists have taught at the Slade, including Philip *Steer, who was on the staff from 1893 to 1930, and Reg *Butler, who taught sculpture from 1951 to 1980. Lectures in art history were first given in 1890, and Roger *Fry was among the leading critics and scholars who have delivered them. In 1960 a course in the study of film was introduced and a professorship in the subject was established in 1967. A centre for electronic media was established in 1994. The school is still in its original location, part of the main building of the college, built in 1827–9, but an extension was completed in 1995.

Sleigh, Sylvia (1916–) British painter, active mainly in the USA, born in Llandudno, Wales. She studied at Brighton College of Art but for a time gave up painting for nursing at the insistence of her father. In 1961 she moved to New York with her husband, the art critic Lawrence *Alloway. Sleigh is a figurative painter and her work has been acclaimed for her *feminist approach to pictorial genres which have traditionally been monopolized by a male perspective. Her most famous work is *The Turkish Bath* (1973, David and Alfred Smart Museum of Art, University of Chicago), which revisits the famous painting of that title by Ingres in the Louvre, but using identifiable male figures (including Alloway) rather than female nudes. The obvious criticism is that Sleigh is 'objectifying' the male nude just as Ingres did the female, but, unlike the 19th-century French painter, Sleigh presents the figures as strongly individualized, as the feminist art historian Linda Nochlin put it, 'down to the most idiosyncratic details of skin tone, configuration of genitalia or body hair pattern'.

Slevogt, Max (1868–1932) German painter, printmaker, and illustrator, with *Corinth and *Liebermann one of his country's leading exponents of *Impressionism. He was born at Landshut, Bavaria, into a well-connected family (his father, who died when Slevogt was two, was a friend of Prince Luitpold, the future regent of Bavaria). From 1885 to 1889 he studied at the Munich Academy, and then spent a few months at the *Académie Julian, Paris, 1889–90. In 1901 he moved from Munich to Berlin, where he taught at the Academy from 1917. Slevogt's early work was sombre, but from about 1900 his style became lighter,

looser, and more colourful. His subjects included landscapes, portraits, and scenes from contemporary life; he loved the theatre and his best-known works include a number of portrayals of the Portuguese baritone Francesco d'Andrade in his most celebrated role as Mozart's Don Giovanni (an example, 1902, is in the Staatsgalerie, Stuttgart). Slevogt's vigorous brushwork, bold effects of light, and energetic sense of movement give his work great dash, but he never adopted the fragmentation of colours typical of the Impressionists and always retained something of the Bavarian Baroque tradition. He also differed from the Impressionists in that he devoted a good deal of his time to large decorative schemes; these included a fresco of *Golgotha* in the Friedenskirche at Ludwigshafen (1932; destroyed in the Second World War) that was often considered his masterpiece. He was a prolific illustrator, both for journals such as *Jugend* and *Simplicissimus* and for books, and also made many independent prints (etchings and lithographs).

Sloan, John (1871–1951) American painter and graphic artist. He was born in Lock Haven, Pennsylvania, and grew up in Philadelphia, where from 1891 he worked as an illustrator on various newspapers and periodicals, particularly *The Philadelphia Press*. In the early 1890s he also attended classes at the Pennsylvania Academy of the Fine Arts, and in 1896 he began to paint seriously, influenced by Robert *Henri. In 1904 he settled permanently in New York, where he and Henri were among the members of The *Eight (1). Sloan was the most political member of the group and as well as taking his most characteristic subjects from everyday lower-class New York life, he did illustrations for socialist periodicals, including *The Masses*, of which he was art editor from 1912 to 1916. However, he was not interested in using his art for what he called 'socialist propaganda', and he resigned from the magazine after a dispute over policy. Sloan's paintings of the pre-First World War period are generally solid, broadly brushed, and low-keyed in colour, typically featuring street scenes or domestic interiors; however, he could also be sharply satirical and occasionally he expressed himself in a totally different vein, as in *Wake of the Ferry* (1907, Phillips Collection, Washington), a hauntingly melancholic marine picture. After the *Armory Show (1913) he broadened the scope of his work beyond

urban subjects to include landscapes and nudes and his style became harder and brighter. He also made etchings throughout his career, and *Bellows called him 'the greatest living etcher'.

Sloan's 'impact on the art scene came not only through his art but also through his quick tongue, dedication to causes, leadership of organizations, and popularity as a teacher' (David W. Scott in *Britannica Encyclopedia of American Art*, 1973). For most of the period from 1914 to 1937 he taught at the *Art Students League, his students including Alexander *Calder, Barnett *Newman, and David *Smith. He was director in 1931–2 but resigned because of the organization's unwillingness to hire foreign teachers. Sloan also taught at the art schools run by *Archipenko and *Luks, and from 1918 until his death he was president of the *Society of Independent Artists. In 1939 he published an autobiographical-critical book, *Gist of Art*. His wife, Helen Farr Sloan (1911–2005), one of his former pupils, presented examples of his work to various institutions, particularly the Delaware Art Museum.

Sluyters, Jan (Jan Sluijters) (1881–1957) Dutch painter, born in 's-Hertogenbosch and active mainly in Amsterdam, where he trained at the Academy. He was one of the best-known artists in the Netherlands in the inter-war period and the one in whom French modernism is most variously reflected. His early works show the influence of his countrymen van Gogh and George Hendrik Breitner (1857–1923), the leading Dutch *Impressionist, and also of *Fauvism. He also experimented with *Cubism before finally developing a lively personal style of colourful *Expressionism that is best seen in his nudes—he had a predilection for painting nude children. His other work included portraits (*Self-Portrait*, 1924, Stedelijk Museum, Amsterdam) and still-lifes. Many Dutch museums have examples of his work.

Smart, Anthony *See* ST MARTIN'S SCHOOL OF ART.

Smart, Borlase *See* ST IVES SCHOOL.

Smet, Gustave de (1877–1943) One of the leading Belgian *Expressionist painters. He was born in Ghent, where he studied at the Academy, 1888–95. In the first decade of the 20th century he spent much of his time at the artists' colony of *Laetham-Saint-

Martin. His early work was *Impressionist in style, but he was influenced towards Expressionism by Jan *Sluyters and Henri *Le Fauconnier, whom he met in Holland when he took refuge there during the First World War. He returned to Belgium in 1922 and lived successively in Kalmthout, Ostend, Bachte-Maria-Leerne, Afsnee, and Deurle, where he died. Typically de Smet painted scenes of rural and village life in which forms are treated in a schematic way owing something to *Cubism, and there is often an air of unreality reminiscent of that in *Chagall's work (*Village Fair*, c.1930, Museum voor Schone Kunsten, Ghent). In the catalogue of the exhibition 'Nine Flemish Painters 1880–1950' (Royal Academy, London, 1971) he is described as 'the most classical of the Flemish expressionists, and the most humane'. With Frits van den *Berghe and Constant *Permeke he had great influence on Belgian painting in the inter-war period. His home in Deurle is now a museum dedicated to his work. Most of the paintings on view there are from his less admired later period. His brother **Léon de Smet** (1881–1966) was also a painter.

Smith, Bernard *See* ANTIPODEANS.

Smith, David (1906–65) American sculptor, painter, and draughtsman. He was one of the most original and influential American artists of his generation and is widely considered the outstanding American sculptor of the 20th century. He is almost certainly the most inventive. His work reveals a constant outpouring of ideas, any one of which would provide a 'signature style' to sustain the career of a lesser artist. Born in Decatur, Indiana, he began studying art at Ohio University in 1924 but soon dropped out of the course, and in the summer of 1925 worked at the Studebaker motor plant at South Bend, Indiana, where he acquired the skills in metalwork that stood him in good stead later in his career. From 1926 to 1931 he studied painting intermittently at the *Art Students League, New York, while supporting himself by a variety of jobs. His main teacher was the Czech-born abstract painter Jan Matulka (1890–1972), whom he described as 'a guy I'd rather give more credit than anyone else'. Among his friends at this time were Arshile *Gorky and Willem *de Kooning. In the early 1930s he began to attach objects to his paintings, and from this he moved on to sculpture, making his first

welded iron pieces (probably the first by any American artist) in 1933. These were inspired by the work of Julio *González, which first made him realize the potential of iron as an artistic material (John *Graham showed Smith illustrations of González's work in *Cahiers d'art*). From 1935 Smith concentrated on three-dimensional work, but he always maintained that there was no essential difference between painting and sculpture and that although he owed his 'technical liberation' to González, his aesthetic outlook was more influenced by *Kandinsky, *Mondrian, and *Cubism. He continued to paint throughout his life and was a prolific draughtsman.

In 1935–6 Smith made an extensive tour of Europe. On his return to the USA he worked for the *Federal Art Project and also began making a series of relief plaques called *Medals for Dishonor* (1937–40), which stigmatized the rise of Fascism and exposed parallels in American society. These were originally made in dental plaster and carved with a variety of tools including jeweller's equipment and dentist's drills before being cast in bronze. Smith was partly inspired by medals made for propaganda purposes in First World War Germany by Ludwig *Gies and Karl Goetz (1875–1950). In 1938 he had his first one-man exhibition, at the East River Gallery, New York. By this time he was producing sculpture of considerable originality, constructing compositions from steel and 'found' scrap, parts of agricultural machinery, etc. He had a love of technology and wrote: 'The equipment I use, my supply of material, comes from factory study, and duplicates as nearly as possible the production equipment used in making a locomotive . . . What associations the metal possesses are those of this century: power, structure, movement, progress, suspension, destruction, brutality.' In 1940 he settled at Bolton Landing in upstate New York, where he built a studio he called 'Terminal Iron Works'. This was his home for the rest of his life, and he alternated sustained periods of lonely creativity with brief binges in New York City.

Smith was employed as a welder on defence work, 1942–4, then returned to sculpture. From this time he began to build up an international reputation, his work being shown in numerous one-man and group exhibitions (including a retrospective at the Museum of Modern Art, New York, in 1957 and a representation at the Venice *Biennale in 1958). However, he also found time to teach at various colleges. During the 1940s and 1950s his sculpture was predominantly open and linear, like three-dimensional metal calligraphy. Perhaps the best-known work in this style is *Hudson River Landscape* (1951, Whitney Museum, New York). In other works there are more personal, autobiographical elements, as in the disquieting *Home of the Welder* (1945, Tate), one of a number of Smith's sculptures in which there is a strong suggestion of sexual violence. From the early 1960s, however, his style became more monumental and geometrical, with boxes and cylinders of polished metal joined at odd angles (*Cubi XIX*, 1964, Tate). Although the forms are often massive, the effect they create is not one of heaviness, but of unstable dynamism, the exhilarating sense of freedom being enhanced by the reflection of sunlight from the bright burnished stainless steel surfaces (they are generally intended for outdoor settings).

In 1962 Smith was invited by the Italian Government to make a sculpture for the 'Festival of Two Worlds' in Spoleto. In the forge shop he produced not one but twenty-six sculptures in thirty days. These were exhibited together in the Roman amphitheatre. By this time he was becoming something of an establishment figure. He exhibited with the prestigious *Marlborough Gallery and, although he was one of the most outspoken political radicals of the artists of his generation, he was appointed by President Johnson to the National Council on the Arts. Like Jackson *Pollock he was killed in a motor accident, but unlike Pollock he died in full creative flow.

For Clement *Greenberg, Smith was the only sculptor whose work could be placed alongside the best contemporary American painters, standing far above *Moore or *Giacometti, whose reputations he considered inflated. Whereas, within Greenberg's scheme of history, modernist painting had to resist the third dimension, sculpture had to break away from the dependence on the monolith, and it was Smith who took the decisive step. As might be expected from his *formalist standpoint, Greenberg had little to say about the sinister imagery in much of Smith's work. This was, however, addressed in the writing of his one-time student Rosalind *Krauss, who saw Smith's anti-monolithic tendency as prefiguring radical developments in *Minimal and *Land art.

Further Reading: R. Krauss, *Terminal Iron Works* (1979)
J. Lewison, *David Smith: Medals for Dishonor* (1991)
J. Meckert, *David Smith: Sculpture and Drawings* (1986)

S

Smith, Edwin *See* NEO-ROMANTICISM.

Smith, Grace Cossington (1892–1984) Australian painter, born in Sydney. In 1910 she began taking lessons at Dattilo *Rubbo's art school, and in 1912–14 she visited England (where she briefly attended the Winchester Art School) and Germany. After her return to Sydney in 1914, she became one of the students interested in *Post-Impressionism who attended Rubbo's painting classes at the Royal Art Society of New South Wales School. Her painting *The Sock Knitter* (1915, Art Gallery of New South Wales, Sydney), exhibited at the Royal Art Society show in 1915, is—in its flattened space and *Fauve-like colours—arguably the first 'modern' picture painted and exhibited in Australia. In the early 1920s Smith was briefly influenced by Max *Meldrum's all-pervasive tonal theory of painting, but she reverted to richer colour and to the application of paint in crisp, juxtaposed strokes. In the 1930s she turned increasingly to light-filled interiors of her own home. Although her work was influenced by artists such as *Matisse and later *Cézanne, Smith never regarded herself as a particularly radical or innovatory artist. Her interest in modernism was inspired not by its intellectual prescriptions, but because for her it constituted a more lively approach to painting.

Smith, Jack (1928–) British painter (and occasional sculptor), born in Sheffield. He studied at Sheffield College of Art, 1944–6, and then (after doing National Service) in London at *St Martin's School of Art, 1948–50, and the *Royal College of Art, 1950–53. In the mid-1950s he was a leading figure of the *Kitchen Sink School. A typical work of this period is *Mother Bathing Child* (1953, Tate), which does in fact feature a kitchen sink. It is set in a crowded house that Smith and his family at this time shared with another Kitchen Sink painter, Derrick *Greaves, and the sculptor George *Fullard. Apart from interiors with figures such as this, he also painted still-lifes and seascapes. Even at this time he attached as much importance to formal qualities as to the nature of the subject-matter. He was later to comment: 'This had nothing to do with social comment. If I had lived in a palace I would have painted the chandeliers.' In the 1960s his work became completely abstract. 'The closer the painting is to a diagram or graph, the nearer it is to my intentions. I like

every work to establish a fact in the most precise, economical way', he wrote in 1963. Typically his abstracts feature sharply defined shapes arranged against a plain ground in a way that suggests musical analogies—he writes of 'The sound of the subject, its noise or its silence, its intervals and its activities'. Smith won first prize at the first *John Moores Liverpool Exhibition in 1957 and his work has been widely exhibited in Britain and abroad.

Smith, Joshua *See* DOBELL.

Smith, Kiki (1954–) American sculptor, *installation artist, and printmaker, born in Nuremberg, Germany, the daughter of Tony *Smith. Her earliest experience of making art was helping her father construct cardboard models for his geometric sculptures, but another important formative influence was her upbringing in the Catholic Church. Her work is usually discussed in the context of *feminist art. It plays on the relationship between kinds of material traditionally associated with 'feminine' craft—including wax, fabric, and lace—and extreme visceral imagery. An example is *Tail* (1992), a female figure on all fours, which leaves a long trail of excrement. The ambiguity between human and animal is characteristic. In 2005 she held an exhibition in a Venetian palazzo in which she placed among the opulent 18th-century furnishings porcelain figurines including 'a sort of undressed Red Riding Hood mounting the wolf' (C. Drake, *Artforum International*, December 2005). Smith has commented that 'In the early 90s I said I don't want to make humans any more . . . But then I started to think about how our identity was constructed around nature and animals and how many metaphors we use in thinking about ourselves in relation to animals' (*School Arts*, January 2004).

Smith, Sir Matthew (1879–1959) British painter, born in Halifax, Yorkshire, the son of Frederick Smith, a successful wire manufacturer. Frederick was a cultivated man who wrote poetry and collected violins, but he was apprehensive about Matthew's passion for art, especially because he showed only very modest talent in his early years. He worked for four years in his father's factory before studying design at Manchester School of Art, 1900–4, and painting at the *Slade School, 1905–7. From 1908 to 1914 he spent much of his time in France, studying briefly (1911) under *Matisse, and he came to identify

strongly with French art. During the First World War he served in the army (despite being initially rejected as unfit) and was wounded, but he was still able to paint. Indeed it was during the war that he first began to show maturity and confidence in his work (*Fitzroy Street Nude, No. 1*, 1916, Tate) and it was at this time that he met *Sickert, who encouraged him and whom Smith considered 'full of uncommon sense'. After the war Smith lived intermittently in France until 1940, mainly in Paris and Aix-en-Provence. He was delicate in health and of a nervous disposition, but this is hardly apparent from his work, which uses colour in a bold, unnaturalistic manner echoing the *Fauves. His lush brushwork, too, has great vigour, and he was one of the few English artists to excel in painting the nude, his dark saturated colours and opulent fluency of line creating images of great sensuousness; his favourite model for his nudes was the painter Vera Cuningham (1897–1955), with whom he had an affair. He also painted landscapes (most notably a series done in Cornwall in 1920) and still-lifes.

Smith had his first one-man exhibition in 1926, at the Mayor Gallery, London, and after this his reputation steadily grew: in 1928 Augustus *John described him as 'one of the most brilliant and individual figures in modern English painting'. Frank *Auerbach and Francis *Bacon are among the many other artists who have admired Smith's painterliness: Bacon said he was 'one of the very few English painters since Constable and Turner to be concerned with painting—that is, with attempting to make idea and technique inseparable'. His work is in many public galleries, the best collection being in the Guildhall Art Gallery, London.

Further Reading: P. Hendy, *Matthew Smith* (1944)

Smith, Richard (1931–) British painter, born at Letchworth, Hertfordshire. He studied at the Luton School of Art, 1948–50, and after doing National Service in Hong Kong, at St Alban's School of Art, 1952–4, and at the *Royal College of Art, 1954–7. From 1957 he spent a good deal of his time in the USA (he settled in New York permanently in 1976). In his early work he was influenced by both the vigorous handling of *Abstract Expressionism and the brash imagery of American advertising, with allusions to billboards and packaging, so linking the preoccupations of the *Situation group, with whom he exhibited,

to those of *Pop through a fascination with the rhetorical power of sheer scale. From about 1963 he used *shaped canvases, which he sometimes made project from the wall, turning the picture into a three-dimensional object. This led to further experimentation with the support, and some of his most characteristic paintings use a kite-like format in which the canvas is stretched on rods that are part of the visual structure of the work (*Mandarino*, 1973, Tate). In these the colouring is usually much more subdued and soft than in his early work, sometimes with a watercolour-like thinness of texture and vague allusions to nature.

Further Reading: Tate Gallery, *Richard Smith: Seven Exhibitions* (1975)

Smith, Tony (1912–80) American sculptor, painter, and architect, born at South Orange, New Jersey. After studying at the *Art Students League, New York, 1933–6, and the New Bauhaus, Chicago, 1937–8, he served an apprenticeship in architecture as clerk of works to Frank Lloyd Wright and practised as an architect from 1940 to 1960, during which time he also painted. He began to take an interest in sculpture around 1940, but although he taught at various colleges in the 1940s and 1950s (in addition to his architectural career) and was closely associated with leading avant-garde figures such as Barnett *Newman, Jackson *Pollock, Mark *Rothko, and Clyfford *Still, he did not exhibit sculpture publicly until 1964. His work was sometimes very large in scale, composed of bold geometrical shapes (often repeated modular units) that he had industrially manufactured in steel. The most influential was *Die* (1962), a steel cube displayed with a tiny gap between its bottom and the floor so as to be legible as a sculpture rather than a wall. The scale of 6 foot was chosen for its relationship to the human body. Smith explained this through a dialogue. 'Q: Why didn't you make it larger so that it would loom over the observer? A: Because I was not making a monument. Q: Then why didn't you make it smaller so that the observer could see over the top? A: I was not making an object.' Many of Smith's works were placed outdoors, helping to bring to American sculpture a new interest in the environment. *Gracehoper* (1972, Detroit Institute of Arts) is a piece one can walk through. The punning title is a homage to James Joyce's *Finnegans Wake*. Kiki *Smith is his daughter.

Further Reading: S. Wagstaff, jr, 'Talking with Tony Smith', *Artforum*, vol. 5 no. 4 (December 1966)

Smithson, Robert (1938–73) American sculptor and *Land artist. He was born at Passaic, New Jersey, and studied at the *Art Students League, New York, 1955–6, and then briefly at the Brooklyn Museum School. His practice as an artist had its origins in the *Minimalist preoccupation with the context around the object and the same mistrust of the marketable art object that had been one of the motivations for *Conceptual art. In 1968 he began a series of 'Sites' and 'Non-Sites'. The latter consisted of photographs and plans of locations he had visited (particularly derelict urban or industrial sites) displayed with specimens of rock or geological refuse he had gathered there, arranged into random heaps or in metal or wood bins: 'Instead of putting a work of art on some land, some land is put into the work of art.' Smithson then moved on to large-scale earthworks, the best-known of which is the enormous *Spiral Jetty* (1970), a spiral road running out into Great Salt Lake, Utah (it has periodically become submerged and then reappeared with changing water levels). One aspect of Smithson's thinking was the idea of 'entropy', that the world inevitably moves towards disorganization, and his work as an artist incorporates this. 'He built forms to be unbuilt', as Carter Ratcliff put it. In *Partially Buried Woodshed* (1970) at Kent State University, Ohio, masses of soil were loaded on to a shed which broke the beam which supported it, this event marking the point at which the work was considered complete. Smithson was killed in a plane crash when he was surveying a work in progress, *Amarillo Ramp* in Texas. It was completed according to his plans by his wife, Nancy *Holt, also a sculptor and Land artist, and his friends Richard *Serra and Tony Shafrazi. Smithson wrote many articles expounding his views on art. These include 'Cultural Confinement' (1972), a response to *documenta 5, which protested against the practice of limiting the understanding of an artist's work to an idea predetermined by the curator.

Further Reading: L. Alloway, 'Robert Smithson's Development', *Artforum* (November 1972)

N. Holt (ed.), *The Writings of Robert Smithson* (1979)

Smyth, Ned *See* PATTERN AND DECORATION MOVEMENT.

Snow, Michael (1929–) Canadian filmmaker, painter, sculptor, and musician, born in Toronto. He studied design at the Ontario College of Art, Toronto, then in 1953 travelled in Europe, working as a jazz musician. Back in Toronto he had his first one-man exhibition as a painter at the Isaacs Gallery in 1957, but he earned his living as an animator with a small film company, Graphic Associates. Here he met his future wife Joyce Wieland (1931–), a painter, film-maker, experimental artist, and maker of stuffed wall-hangings and quilts. They married in Paris in 1960 and spent most of the following decade in New York. Each began making films in 1963 and Snow became regarded as a leading figure in the American Underground. At the same time he continued to exhibit as a painter and sculptor in Toronto and became well known for his 'Walking Woman' series (1962–7), executed in various media, featuring a generalized silhouette of a young woman caught in midstride (shiny life-size metal versions were shown at Expo 67 in Montreal). Dennis Reid (*A Concise History of Canadian Painting*, 1973) accords Snow an extraordinarily high status: he describes him as 'the giant figure of painting in Toronto' and writes that 'a number of informed observers look upon Snow as one of the greatest innovative geniuses film has ever attracted'. He has continued to be a leading figure in Canadian art, and in 1994 his work was conspicuously displayed in various parts of Toronto as 'The Michael Snow Project'; this included, for example, enormous sculptures on the exterior of the Skydome sports stadium.

Soby, James Thrall (1906–79) American art historian, administrator, and collector, born in Hartford, Connecticut. In 1926, having abandoned his studies at Williams College, Williamstown, he visited Paris, where he made his first purchases of contemporary art. From 1928 to 1938 he worked at the Wadsworth Atheneum in Hartford, and during this period built up a collection that included works by such illustrious figures as *Ernst, *Matisse, *Miró, and *Picasso. In 1943 he began a long association with the *Museum of Modern Art, New York. He was briefly director of painting and sculpture, 1943–4, and was a trustee until his death, organizing a number of exhibitions on major artists (including *Rouault in 1947, *Modigliani in 1951, *Balthus in 1956), as well as group shows (notably 'Twentieth-Century Italian Art', 1949, on which he collaborated with Alfred H. *Barr). He also wrote a number of

books unconnected with exhibitions, including *After Picasso* (1935) on the French *Neo-Romantics, and two on Ben *Shahn (1957 and 1963), and he contributed a monthly column on art to *The Saturday Review of Literature* in the 1940s and 1950s. His art collection, together with most of his archive material, was bequeathed to the Museum of Modern Art.

Socialist Realism The name of the officially approved type of art in Soviet Russia and other Communist countries. This involves in theory a faithful and objective reflection of real life, to educate and inspire the masses, and in practice whatever at any given time served the political needs of the State, normally its compulsory and uncritical glorification. In the Soviet Union, the subordination of the aesthetic to the political was implicit in the programme of the Revolution. As early as 1920 Lenin had rejected 'in the most resolute manner...all attempts to invent one's own particular brand of culture'. Although the establishment of Socialist Realism involved the repression of movements such as *Constructivism, it has been argued that the imposition of Socialist Realism has much in common with the totalizing demands for change made by the *avant-garde. Socialist Realism was given a formal definition under the dictatorship of Stalin, who was leader of the Soviet Union from the death of Lenin in 1924 until his own death in 1953. Alan Bird writes that 'He saw all aspects of avant-garde culture, including painting, as subversive infiltrations of the purity of Soviet life' and that his chief cultural commissar, Andrei Zhdanov (1896–1948), 'made himself responsible for imposing an iron control on artistic expression'.

The principles of Socialist Realism began to take shape in the 1920s, notably in the activities of *AKhRR. From this time date its earliest and probably artistically best exemplars, such as *Petrov-Vodkin's *Death of the Commissar* (1928, State Russian Museum, St Petersburg). The principles were proclaimed in the 1932 decree 'On the Reconstruction of Literary and Art Organizations' (before this, the term 'Heroic Realism' had often been used, but 'Socialist Realism' now became the official label). Socialist Realism was never defined specifically in terms of style, but increasingly it became associated with stereotyped images painted in a conventional academic manner. The practice was validated by a theory, constructed during the 1930s, based on the precepts of Lenin. Socialist Realism was defined according to four tenets. These were *narodnost* (orientation towards the people), *ideonost* (ideological content), *klassnost* (class content), and, overriding all the others, *partiinost* (the 'task of educating workers in the spirit of communism'). As Matthew Cullerne Bown has pointed out, because the party was 'the representative of the people's interests, the purveyor of ideology, the leader of the class struggle', these other concepts meant 'only what the party wanted them to mean'.

In the 1930s there were four main types of Socialist Realist paintings: domestic scenes, portraits (*see* GERASIMOV), industrial and urban landscapes, and scenes on collective farms (*see* PLASTOV). During the Second World War, patriotic scenes from Russian history were added to the list, following the success of Sergei Eisenstein's famous film *Alexander Nevsky* (released 1938, withdrawn at the time of the German–Soviet pact in 1939, and shown again after the German invasion of Russia in 1941). In sculpture, the most typical products of Socialist Realism were heroic statues, the leading artists in this field including Sergei *Merkurov and Vera *Mukhina. After the death of Stalin there was some relaxation of strictures, but the system still remained stifling to creativity, and any form of experiment remained extremely difficult (*see* UNOFFICIAL ART). In the West, Socialist Realism remained synonymous with repression, and its products were generally regarded as morally tragic and aesthetically comic (although the merits of many of the artists are now being recognized). The titles alone of some pictures are crushingly dispiriting, for example *Comrade Stalin together with the Leading Workers of the Party and Government Inspect the Work of a Soviet Tractor of the New Type*.

Socialist Realism spread to the remotest parts of the Soviet Union, one of the most praised painters of the Stalin era being Semyon Chuikov (1902–80), who worked in Kirgizia in the extreme south of the country, near the Chinese border. His most famous work is *A Daughter of Soviet Kirgizia* (1948, Tretyakov Gallery, Moscow, and other versions), showing a schoolgirl, book in hand, walking proudly through a vast landscape: 'She embodies in her resolute progress across the expanse of her native land, the future hopes of a small, once backward nation, now offered—under Soviet power—the benefits of a modern educational programme' (Bown).

S

Socialist Realism had an equally powerful grip on Russian literature and even music. In 1934 the constitution of the Union of Writers stated that Socialist Realism 'demands from the artist a true and historically concrete depiction of reality in its revolutionary development . . . combined with the task of educating workers in the spirit of Communism', and in 1948 several leading Soviet composers (including the two greatest, Prokofiev and Shostakovich) were censured for *formalism and had to make a grovelling public apology. They wrote a joint letter to 'Dear Comrade Stalin' in which they said: 'We are tremendously grateful . . . for the severe but profoundly just criticism of the present state of Soviet music . . . We shall bend every effort to apply our knowledge and our artistic mastery to produce vivid realistic music reflecting the life and struggles of the Soviet people.'

Outside the Soviet Union the practice of Socialist Realism has taken different forms. Within the Soviet bloc, the developments in the DDR (East Germany) were particularly intriguing both aesthetically and politically. After the erection of the Berlin Wall in 1961, when contact with the West became almost impossible, Socialist Realism tended to the form of what was known as the 'Problembild', which engaged critically with social issues using elaborate and complex symbolism; the most important exponents were Bernhard *Heisig, Wolfgang *Mattheuer, Willi Sitte (1921–), and Werner *Tübke. Such art was sometimes taken in the West as a sign of a certain openness. Sitte, the president of the Artists' Union of the DDR, in a speech in 1983 argued that Socialist Realism was 'the expression of an attitude to reality' and that, as that reality changed, so would Socialist Realism. He continued: 'If we talk about "diversity and breadth" in relation to Socialist Realism it is not in order to appear liberal', but because a 'comprehensive approach to the complications of life and to the diversity of the artistic needs of the public does not permit any restrictions of content or form'. This might be regarded cynically as an elaborate way of saying that, as 'reality' was defined by the Party, there was no definition for Socialist Realism, apart from political expediency. Sitte's own paintings ranged in subject-matter from the traditional Socialist Realist portraits of the worker to fairly brutal images of eroticism, all in a post-*Expressionist manner reminiscent of Lovis *Corinth. Sitte's

'diversity and breadth' did not include unofficial artists like A. R. *Penck who worked outside the Artists' Union. Certainly, in spite of its superficial liberalism, artists who left the DDR for the West were notably bitter about the official art system in their original country. In 1977 both Gerhard *Richter and Georg *Baselitz boycotted the *documenta in protest at the inclusion of East German official art. (At the time both artists were considerably less celebrated outside Germany than they would later become, so they would certainly have benefited from the international exposure at the exhibition.) The official art of the DDR became popular with some West German collectors, including Peter *Ludwig.

In China, Socialist Realism generally jettisoned the traditional values of Chinese art in favour of photographic illusionism. The most spectacular example was the sculptural tableau *The Rent Collector's Courtyard* (1965, Sichuan Academy of Art) made by an anonymous collective at the time of the Cultural Revolution. It recreates the courtyard of 'a rapacious former landlord . . . a harrowing scene that had been only too familiar to the tenant-farmers before Liberation' (M. Sullivan, *The Arts of China*, 1973). In a paradoxical development, the work was illustrated alongside Western artists such as Edward *Kienholz and Paul *Thek as an example of an interactive tableau in Adrian Henri's *Environments and Happenings* (1974), a book published at a time when Western naivety about Maoism was at its height.

For Communist parties outside Communist countries, the issue could be problematic. In France in the years following the Second World War, many leading artists were party members including *Picasso, *Léger, and *Pignon. They would sometimes address subjects which met the political criteria of Socialist Realism, as in Picasso's *Massacre in Korea* (1951, Musée Picasso, Paris) or Léger's *Les Constructeurs* (1950, Musée Fernand Léger, Biot). Although more accessible in style than many of these artists' works, they nonetheless had no truck with the photographic realism characteristic of official Soviet art. Some lesser known painters such as *Fougeron or *Taslitzky adopted a more literal application of Socialist Realism. This double nature of French Socialist Realism was not necessarily a sign of liberal views on art; indeed, many party members adversely criticized the portrait of Stalin by Picasso published as a

tribute after the dictator's death. The presence of artists such as Picasso was nonetheless of considerable political value in maintaining the support of intellectuals: the Communist writer Louis *Aragon described Picasso as 'a man whom the enemy furiously envies us'. By the late 1960s, however, most politically radical artists in the West had little interest in Socialist Realism and instead looked to such forms as *Arte Povera or *Conceptual art to make an artistic expression of their opposition to the capitalist system.

Socialist Realism has now become a rich source for parody in the work of artists such as *Komar & Melamid and Erik *Bulatov from Russia, artists from the former DDR such as Neo *Rauch or in China *Wang Guangyi. Christine Lindey has argued that the 'Socialist Realist method still embodies fine, humanist ideals' but only in the context of an 'uncensored, pluralist cultural climate'. This may be as contentious as determining whether it is any longer possible to disentangle Marxism as a political theory from the history of the states which claimed to embody it. *See also* SOTS ART; TOTALITARIAN ART.

Further Reading: Bird (1987)
Bown (1991)
Harrison and Wood (2002)
Lindey (1991)

Social Realism A very broad term for painting (or literature or other art) that comments on contemporary social, political, or economic conditions, usually from a left-wing viewpoint, in a realistic manner. Often the term carries with it the suggestion of protest or propaganda in the interest of social reform. However, it does not imply any particular style: Ben *Shahn's caricature-like scenes on social hypocrisy and injustice in the USA, the dour working-class interiors of the *Kitchen Sink School in Britain, and the declamatory political statements of *Guttuso in Italy are all embraced by the term. Proponents tend to make a strong distinction between 'Social Realism' and *'Socialist Realism'. Detractors tend to compound the two. *See also* REALISM.

Société Anonyme, Inc. (or a Museum of Modern Art) An association founded in 1920 by Katherine *Dreier together with Marcel *Duchamp and *Man Ray for the promotion of contemporary art in America by lectures, publications, travelling exhibitions, and the formation of a permanent collection.

In French the term 'société anonyme' means 'limited company', so the name—suggested by Man Ray—was intended as a tautological *Dada jest: as Miss Dreier loved to explain, it meant 'incorporated corporation'. However, the work of the society was serious and trailblazing. Its museum, which opened at 19 East 47th Street, New York, on 30 April 1920, was the first in the USA, and one of the earliest anywhere, to be devoted entirely to modern art (although as it existed mainly for temporary exhibitions, the Phillips Collection (*see* PHILLIPS, DUNCAN) has the distinction of being the first *permanent* museum of modern art in the USA). Between 1920 and 1940 the Société organized 84 exhibitions, the largest—at the Brooklyn Museum in 1926—being the most important in the field since the *Armory Show in 1913. The emphasis of the exhibitions was on avant-garde and abstract art and it was through them that such artists as *Klee, *Malevich, *Miró, and *Schwitters were first exhibited in America. To some extent, therefore, the Société carried on the tradition that had been started by the 291 Gallery of *Stieglitz in the years before the Armory Show, and to some extent also it prepared the way for the *Museum of Modern Art, which was founded in 1929. The Museum of Modern Art soon eclipsed the Société Anonyme and Miss Dreier's finances were in any case badly hit by the Depression, but she continued to serve as president (as Duchamp did as secretary) until the Société officially closed in 1950. Nine years earlier, in 1941, they had presented the superb permanent collection that the Société had built up (over 600 works) to Yale University Art Gallery.

Society of Independent Artists An association formed in New York in December 1916 as a successor to the Association of American Painters and Sculptors, which had been dissolved—its task accomplished—after mounting the *Armory Show in 1913. The aim of the Society of Independent Artists was to give progressive artists an opportunity to show their work by holding annual exhibitions in rivalry with the National Academy of Design, which was regarded as a bastion of conservatism. These exhibitions were organized on the model of the French *Salon des Indépendants, without jury or prizes, giving anyone the right to show their work on payment of a modest fee. The first exhibition, held at the Grand Central Palace in New York in April 1917,

S

was the largest, featuring about 2,500 works by about 1,200 artists (mainly Americans, but including leading Europeans such as *Brancusi and *Picasso). It was known as 'The Big Show' and was probably the largest art exhibition held in the USA up to that time. The exhibits were arranged alphabetically to preclude the kind of judgements associated with a hanging committee. However, the exhibition is remembered mainly because of a work that was not shown, for Marcel *Duchamp (one of the society's officials) resigned after his *ready-made in the form of a urinal was rejected. The first president of the society was William *Glackens; he was followed by John *Sloan, who held the post from 1918 until his death in 1951. Annual exhibitions continued to be held until 1944, but they soon declined in terms of quantity and quality; the 1919 exhibition had only about a third of the number of works of the inaugural show.

Soffici, Ardengo (1879–1964) Italian critic and painter, born at Rignano in Tuscany. He studied at the Academy in Florence, then from 1900 to 1907 spent his formative years in Paris, where he wrote for avant-garde periodicals and knew such figures as *Apollinaire, *Braque, *Modigliani, and *Picasso. In 1907 he settled in Florence and in the period before the First World War he was prominent in introducing the discussion of modern art—particularly *Cubism—to Italy; in 1913 he published three of his articles in book form as *Cubismo e oltre*. He championed the work of *Rosso, but initially he was hostile to *Futurism; however, under the influence of *Boccioni and *Carrà, he became converted to the movement in 1913. After the war his views became increasingly conservative and he joined Carrà and *de Chirico in the attacks they made on Cubism and Futurism in their journal *Valori plastici*. Soffici's own work as a painter reflects his changing critical outlook, but it is not considered to have much independent merit.

Soft art Term applied to sculpture using non-rigid materials. The materials employed have been very varied: rope, cloth, rubber, leather, paper, canvas, vinyl—anything in fact that offers a certain persistence of form but lacks permanent shape or rigidity. The earliest example of Soft art was perhaps the typewriter cover that Marcel *Duchamp mounted on a stand and exhibited in 1916. However, this belongs rather to the category of *readymades, and Soft art as a movement is generally traced to Claes *Oldenburg's giant replicas of foodstuffs (ice-cream sundaes, hamburgers, slices of cake, etc.) made from stuffed vinyl and canvas. The practice has some affinity with the idea of *anti-form as proposed by Robert *Morris and the use of such materials can be found in *Kinetic art and *Arte Povera. An exhibition on the theme, in which some sixty artists were represented, was staged in Munich and Zurich in 1979–80.

Solomon, Holly *See* PATTERN AND DECORATION MOVEMENT.

Solarization *See* MAN RAY.

Sonderbund An organization founded in Düsseldorf in 1909 to mount exhibitions of contemporary art; the full name was Sonderbund Westdeutscher Kunstfreunder und Künstler (Special League—or Federation—of Art-lovers and Artists in Western Germany). The 'art-lovers' included collectors, dealers, museum officials, and writers, the first president of the Sonderbund being Karl Ernst Osthaus (1874–1921), a banker, collector, and critic. He was one of the first Germans to support the *Post-Impressionists (he had personally travelled to Aix-en-Provence to buy directly from *Cézanne) and he founded the Folkwang Museum in Hagen (opened 1902 in a building remodelled by Henry van de *Velde), one of the earliest public museums of contemporary art in Germany. (After Osthaus's death, the contents of the museum were transferred to Essen, and the building in Hagen, much altered, is now the Karl Ernst Osthaus Museum.) Four Sonderbund exhibitions were held—the first three in Düsseldorf (1909, 1910, 1911) and the final one in Cologne (1912). The Cologne exhibition—held at the Kunsthalle from May to December—was by far the most important. Its aim was to provide 'a conspectus of the movement that has been termed *Expressionism'. Van Gogh was the central figure of the exhibition, and Cézanne, *Gauguin, and *Munch were also very well represented. In an anteroom were paintings by El Greco, a great forerunner of Expressionism. German painters (especially those of Der *Blaue Reiter and Die *Brücke) were naturally to the fore, but the exhibition was international in scope, with artists from eight other countries on show. It was influential on the planning of the *Armory Show,

which took place the following year. Originally an all-American exhibition had been envisaged, but when Arthur B. *Davies saw the Sonderbund catalogue he wrote to Walt *Kuhn: 'I wish we could have a show like this.' Kuhn immediately set out for Europe, just managed to catch the exhibition as it was being dismantled, and picked up valuable advice from artists and dealers. However, Kuhn was much more interested in French than in German painting, and German art was poorly represented in the Armory Show.

Sorolla y Bastida, Joaquín (1863–1923) Spanish painter and graphic artist, active mainly in his native Valencia and in Madrid. He was a prolific and popular artist, working on a wide range of subjects—genre, portraits, landscapes, historical scenes—and producing many book illustrations. His early paintings depicted grim aspects of contemporary reality with didactic titles. *Sad Inheritance* (1899, Caja de Ahorros de Valencia) shows crippled children on the sea shore. The bulk of his work was of far more appealing topics and was marked by brilliant high-keyed colouring and vigorous brushwork, representing a kind of conservative version of *Impressionism. An exhibition at the Petit Palais, Paris, in 2007 made an illuminating comparison between him and *Sargent. His ability to represent light and atmosphere came particularly to the fore in seaside subjects. The best known is probably *Promenade Beside the Sea* (1909, Museo Sorolla, Madrid). He was well known outside Spain, and in 1910–20 he painted a series of fourteen large mural panels for the Hispanic Society of America in New York, representing scenes typical of the various provinces of Spain. The great reputation that he enjoyed in his lifetime faded quickly after his death, but his work has again become popular. His former home in Madrid is now a delightful museum dedicated to his work.

Further Reading: J. M. F. Garcia-Bermejo, *Joaquín Sorolla* (2002)

Soto, Jesús Rafael (1923–2005) Venezuelan *Kinetic artist, active mainly in Paris. He was born in Ciudad Bolívar and in 1942–7 he studied at the School of Fine and Applied Arts in Caracas; his fellow students included *Cruz-Diez and *Otero, who like Soto were among the pioneers of abstract art in Venezuela. In 1947–50 he was director of the School of Fine Arts in Maracaibo, then settled in Paris, where

he initially earned his living as a guitarist. His early works included geometrically patterned paintings and in 1952 he began making constructions using perspex sheets marked with lines or designs over a patterned surface; the movement of the spectator produced apparent movement in the work. He incorporated real movement for the first time in 1958 in his *Vibration Structures*, in which flexible rods or wires (which could be made to vibrate by the spectator) were hung in front of bands of closely meshed lines (*Horizontal Movement*, 1963, Tate). In the 1960s he gained an international reputation and he had numerous public commissions, including two murals for the UNESCO Building in Paris (1970) and several works in Caracas, notably the ceiling of the Teresa Carreno Theatre (1983). In 1973 he founded a museum of modern art in his home city.

Sots art (Sotz art) A type of *Unofficial art practised in the Soviet Union in the 1970s and 1980s in which the officially sanctioned style of *Socialist Realism was undermined by treating its conventions in an ironic or mocking way (the term derives from the Russian for Socialist Realism—Sotsialisticheskiy Realism). Among the best-known exponents of this kind of work were Erik *Bulatov and the team of *Komar & Melamid.

Soulages, Pierre (1919–) French abstract painter, printmaker, sculptor, and designer, born at Rodez. He was mainly self-taught and did not take up painting in earnest until 1946, when he settled in Paris (during the Second World War he had served in the army, then worked as a farmer). His first one-man show was at the Galerie Lydia Conti, Paris, in 1949, and from that time he quickly gained a reputation as one of the leading exponents of *Tachisme. His paintings characteristically feature broad, powerful, sombre strokes; originally he worked entirely in black and white, to which he subsequently added subdued blues, browns, and greys. His preference for such a solemn palette exemplifies his view that 'the more limited the means, the stronger the expression'. The primitive force of his work reflects his love of the prehistoric and Romanesque art of the Massif Central region in which he was born, but the forms of his paintings sometimes also resemble blown-up hieroglyphs or Chinese characters (in 1957 he won the grand prize at the Tokyo *Biennial and in

S

1958 he visited the Far East, where he admired Oriental calligraphy). In the 1980s he began making completely black paintings, sometimes consisting of several panels. Apart from paintings, his work has included bronze sculptures, etchings, lithographs, and designs for the stage. He also designed a series of stained-glass windows for the abbey at Conques (1994). There is a large collection of his work, donated by the artist, in the Musée Fabre, Montpellier.

South Bank Exhibition See FESTIVAL OF BRITAIN.

South Bank Style See CONTEMPORARY STYLE.

Soutine, Chaïm (1893–1943) Russian-born painter who settled in France in 1913 and became one of the leading *Expressionists of the *École de Paris. He was born in the village of Smilovichi, near Minsk in Belarus, the son of a poor Jewish clothes-mender, and he had to contend with the Orthodox Jewish prohibition on image-making (the money to go to art school came from damages after he was beaten up by the son of a rabbi). In 1910–13 he studied at the School of Fine Arts in Vilnius, Lithuania, his fellow students including Michel Kikoïne (1892–1968) and Pinchus Krémègne (1890–1981), with whom he kept up friendships in Paris. His other friends in the circle of expatriate artists there included *Chagall and also *Modigliani, who painted a memorable portrait of him (1917, NG, Washington). Soutine suffered from depression and lack of confidence in his own work (he was reluctant to exhibit and sometimes destroyed his own pictures), and he endured years of desperate poverty until the American collector Dr Albert C. *Barnes bought a number of his paintings in 1923. Thereafter he had a successful and prosperous career.

Soutine's work included landscapes, portraits, and figure studies of characters such as choirboys and page-boys. His style is characterized by thick, convulsive brushwork, through which he could express tenderness as well as turbulent psychological states. There is something of an affinity with van Gogh, although Soutine professed to dislike his work and felt more kinship with the Old Masters, whose work he studied in the Louvre: his pictures of animal carcasses, for example, are inspired by Rembrandt's *Flayed Ox*. How-

ever, the gruesome intensity of works such as *Side of Beef* (1925, Albright-Knox Art Gallery, Buffalo) was not gained simply through study of similar pictures, for Soutine visited abattoirs and even brought a carcass into the studio. His neighbours complained of the smell of the rotting meat and called the police, whom Soutine harangued on the subject of how much more important art was than sanitation. The filthy state in which he lived during his years of poverty was notorious: André *Salmon recalled that Soutine consulted a specialist about earache and that 'In the canal of the painter's ear the doctor discovered, not an abscess, but a nest of bed bugs'. In 1941–3, during the German occupation, Soutine lived at Champigny-sur-Veude in Touraine, but he died in Paris after going there for an emergency operation on a stomach ulcer.

Further Reading: N. Zimmer, *Soutine and Modernism* (2008)

Soutter, Louis See ART BRUT.

Souza, Francis Newton (1924–2002) Indian painter, born in Goa. After being expelled from the Jamshetjee Jeejebhoy School of Art, Bombay, in 1943, he joined the Communist Party of India and painted for a short while in a *Social Realist manner. In 1946 he founded the Progressive Artists' Group to promote modern art. He left India for London in 1949, after two of his paintings were removed from a Bombay exhibition on the grounds of obscenity. Following some difficult years, he had a number of successful exhibitions at Gallery One, London. His style was *Expressionist, his subject-matter was the city, the nude, and, most powerfully of all, religious images, as in *Crucifixion* (1959, Tate). Following public scandal over his marriage to a much younger woman in 1964, Souza went to New York. His reputation declined in later years. When his work was seen at the Hayward Gallery's 'The Other Story' exhibition in 1989 (*see* ARAEEN, RASHID) there was some discussion as to whether this was the result of racism or of the general swing from interest in Expressionist art during the 1960s. Nonetheless he continued to paint prolifically, over-prolifically according to Tate curator Tuby Treves: 'He could paint three or four works a day and think that three of them were masterpieces.' He died in Mumbai.

Further Reading: M. Thomas, 'London Calling', *Bonhams Magazine* (spring 2006)

Sovart *See* UNOFFICIAL ART.

Sow, Ousmane (1935–) Senegalese sculptor, born in Dakar. He lived for a time in Paris where he was much impressed by the work of *Giacometti. He returned to his native country in 1985. He works as a figure sculptor, making vivid and vigorous depictions of African life. His Nubian wrestlers have been especially admired, making an enormous impact at *documenta in 1992. An exhibition of his work was held outside the Louvre in 1999, including a multi-figure composition, *The Battle of Little Big Horn*.

Soyer, Moses (1899–1974) and **Raphael** (1899–1987) Russian-born painters, twins, who became American citizens in 1925. They were born in Borisoglebsk, emigrated to America with their family in 1913, and studied at various art schools in New York. They are best known for their *Social Realist subjects, particularly those of the Depression years of the 1930s, in which they depicted the lives of working people with sympathy and at times a touching air of melancholy, as in Raphael's well-known *Office Girls* (1936, Whitney Museum, New York). From 1936 they were employed by the *Federal Art Project, their work including collaborating on murals for the Post Office at Kingsessing, Pennsylvania (1939). Both brothers also did many self-portraits and wrote on art. In the 1930s Moses wrote articles defending Social Realism and attacking *Regionalism. Raphael published several autobiographical volumes and a book on Thomas *Eakins (1966). He taught at the *Art Students League, 1933–42, and at other schools in New York. Another brother, **Isaac** (1907–81), who came to America in 1914, was also a painter.

S.P.A.C.E. *See* SEDGLEY, PETER.

Spanish Realists Name given in the 1970s to a group of five Spanish artists, active mainly in Madrid and linked by ties of family or friendship, who worked in a detailed naturalistic style, sometimes akin to *Superrealism: Francisco López (1932–); Antonio López García (1936–); Antonio López Torres (1902–87), uncle of López García; Maria Moreno (1933–), wife of López García; and Isabel Quintanilla (1938–), wife of Francisco López. All of them are painters, except for Francisco López, who is a sculptor and draughtsman. Antonio López Garcia was the subject of a 1993 film, *The Quince Tree Sun*, directed by Victor Erice, which recorded the artist's meticulous working processes.

Spare, Austin *See* AUTOMATISM.

Sparkes, John *See* ROYAL COLLEGE OF ART.

Spatialism (Spazialismo) A movement launched by Lucio *Fontana in Milan in 1947, in which he grandiosely intended to synthesize colour, sound, space, movement, and time into a new type of art. The main ideas of the movement were anticipated in his *Manifesto Blanco* (White Manifesto) published in Buenos Aires in 1946. In it he spoke of a new 'spatial' art in keeping with the spirit of the post-war age. On the negative side it repudiated the illusory or 'virtual' space of traditional easel painting; on the positive side it was to unite art and science to project colour and form into real space by the use of up-to-date techniques such as neon lighting and television. The new art of Spatialism would 'transcend the area of the canvas, or the volume of the statue, to assume further dimensions and become … an integral part of architecture, transmitted into the surrounding space and using new discoveries in science and technology'. Fontana's holed canvases (beginning in 1949) and slashed canvases (from 1959) are considered to exemplify Spatialism and he was one of the first artists to promote the idea of art as gesture or *Process, rather than the creation of an enduring physical work. Several Italian artists joined Spazialismo, among them Roberto *Crippa, Enrico Donati (1909–2008), Gianni Dova (1925–91), and Cesare Peverelli (1922–), but as a movement it was short-lived (the last of the six manifestos was in 1952).

Spear, Ruskin (1911–90) British painter, born in Hammersmith, London, the son of a coach-painter. He studied at Hammersmith School of Art, 1926–30, and the *Royal College of Art, 1931–4, and subsequently taught at various art schools, notably the RCA, where he was a tutor from 1948 to 1977. During the Second World War (when he was exempt from military service because of the after-effects of childhood polio) he took part in the 'Recording Britain' scheme (at this time he also played in various bands—he was an accomplished jazz pianist). Spear was best known for his portraits (including many of celebrities) and landscapes, especially views of Hammersmith:

S

in the introduction to the catalogue of Spear's retrospective exhibition at the Royal Academy in 1980, his friend the painter Robert Buhler (1916–89) remarked that 'one could say that Ruskin Spear has done for Hammersmith what *Sickert did for Camden Town'. Characteristically his pictures are broadly brushed, with a spontaneous, improvisatory look. Less typical works include an altarpiece (the *Annunciation*) for the church of St Clement Danes, London (1958), replacing one destroyed in the Second World War, and murals for the liner *Canberra* (1959). Like Sickert, he sometimes worked from news photographs. This tends to make many of his portraits meditations on the public image of his subjects, most famously in his painting of the Prime Minister Harold Wilson (1974, NPG, London), in which he is seen wreathed mysteriously by pipe smoke. Appropriately no modern Prime Minister has been so subject to rumour.

Further Reading: J. Jones, 'Harold Wilson, Ruskin Spear', *The Guardian* (2 June 2001)

'specific objects' *See* JUDD, DONALD.

Speer, Albert *See* NATIONAL SOCIALIST ART.

Spence, Jo *See* PHOTO-WORK.

Spencelayh, Charles (1865–1958) British painter. He was born in Rochester, Kent, and studied at the *Royal College of Art and in Paris. Spencelayh specialized in anecdotal domestic scenes in the tradition of Victorian genre painting, most typically showing old codgers pottering around in junk shops or other cluttered interiors. From 1892 until the year of his death he exhibited fairly regularly at the *Royal Academy, a record for longevity that has rarely been exceeded. Critics generally regarded his work as trivial and outmoded, but the public voted his *Why War?* (Harris Museum and Art Gallery, Preston) 'Picture of the Year' at the RA exhibition in 1939 (in wartime he often appealed to national sentiment by depicting patriotic themes or including patriotic details). He appreciated the value of a good title: part of his income came from reproduction of his works on calendars, greetings cards, and so on, and he once altered the title of a picture (showing a man reading a bank statement) from *Overdrawn at the Bank* to *A Good Balance*, changing it from a nonseller to one that he said 'went like hot cakes'.

Further Reading: A. Noakes, *Spencelayh* (2007)

Spencer, Augustus *See* ROYAL COLLEGE OF ART.

Spencer, Gilbert *See* SPENCER, SIR STANLEY.

Spencer, Niles *See* PRECISIONISM.

Spencer, Sir Stanley (1891–1959) English painter, one of the most original figures in 20th-century British art. He was born in Cookham in Berkshire and lived for most of his life in this village, which played a large part in the imagery of his paintings. His education was fairly elementary, but he grew up in a family in which literature, music, and religion were dominant concerns (his father was an organist and music teacher), and his imaginative life was extremely rich. He said he wanted to 'take the inmost of one's wishes, the most varied religious feelings . . . and to make it an ordinary fact of the street', and he is best known for pictures in which he set biblical events in his own village. For him the Christian religion was a living and present reality, and his visionary attitude has been compared to that of William Blake.

Spencer studied at the *Slade School, 1908–12, winning a composition prize in his final year. From 1915 to 1918 he served in the army, first at the Beaufort War Hospital in Bristol, then in Macedonia. He was appointed an *Official War Artist in 1918, but his experiences during the war found their most memorable expression a decade later when he painted a series of murals for the Sandham Memorial Chapel at Burghclere in Hampshire (1927–32), built to commemorate a soldier who had died from an illness contracted in Macedonia. The arrangement of the murals consciously recalls Giotto's Arena Chapel in Padua (c.1305), but Spencer painted in oil, not fresco, and he concentrated not on great events, but on the life of the common soldier, which he depicted with great human feeling. There is no violence, and Spencer said that the idea for one of the paintings—*The Dug-Out*—occurred to him 'in thinking how marvellous it would be if one morning, when we all came out of our dug-outs, we found that somehow everything was peace and the war was no more'.

By this time Spencer was a celebrated figure, his greatest public success having been *The Resurrection: Cookham* (1924–6, Tate) which when first exhibited in 1927 was hailed by the critic of *The Times* as 'the most important picture painted by any English artist in the

present century ... What makes it so astonishing is the combination in it of careful detail with modern freedom of form. It is as if a *Pre-Raphaelite had shaken hands with a *Cubist.'

Spencer was again an Official War Artist during the Second World War, when he painted a series of large canvases showing shipbuilding on the Clyde (Imperial War Museum, London), memorably capturing the heroic teamwork that went into the war effort. His career culminated in a knighthood in the year of his death, but his life was not a smooth success story, and in the 1930s he somewhat alienated his public with the expressive distortions and erotic content of his work. In 1935 he resigned as an Associate of the *Royal Academy when two of his pictures, considered caricature-like and poorly drawn, were rejected for the annual summer exhibition, but he rejoined the Academy in 1950. He had problems with his personal as well as his professional life. In 1937 he divorced his first wife, Hilda *Carline, and married Patricia Preece (1900–71), a painter whose personal and professional life was strongly bound to that of Dorothy Hepworth (1898–1978), with whom she had studied at the *Slade School, London. The second marriage was a disaster and Hilda continued to play a large part in his life: he painted pictures in memory of her and even wrote letters to her after her death in 1950. Some of his nude paintings of Patricia vividly express not only the sexual tensions of his life, but also his belief in the sanctity of human love; the best known is the double nude portrait of himself and Patricia entitled *The Leg of Mutton Nude* (1937, Tate). In his later years Spencer acquired a reputation as a landscapist as well as a figure painter. The landscapes, notable for an almost Pre-Raphaelite accumulation of detail, were the most saleable of his works, and were made largely on the insistence of his dealer Dudley Tooth. He also occasionally did portraits. There is a gallery devoted to him at Cookham, containing not only paintings, but also memorabilia such as the pram that he used for pushing his painting equipment around the village. He cut an eccentric figure, although it is hard to think of a more practical way of doing the job of carting the materials over uneven ground.

His younger brother **Gilbert Spencer** (1892–1979) was also a painter of imaginative subjects and landscapes, working in a style close to that of Stanley. He is especially noted for his murals, including *The Scholar Gypsy*

(1956–8) for University College London and *An Artist's Progress* (1959) in the restaurant of the *Royal Academy of Arts. In 1961 he wrote a biography of his brother and in 1974 published an autobiography, *Memoirs of a Painter*.

Further Reading: D. Robinson, *Stanley Spencer* (1993)

Spero, Nancy (1926–) American artist, born in Cleveland, Ohio, known for her political and *feminist work. This often takes the form of long scrolls using a mix of images and words to protest at political and gender repression. An example is *Torture of Women* (1976). Consisting of fourteen paper panels it extends for 133 feet if displayed continuously. It juxtaposes accounts from Amnesty International of torture of women with historical myths which 'delineate a relentless history of violence and oppression against women' (Susan Jenkins). From 1983 onwards Spero began using the image of the Sheela-na-gig, an 'exuberantly vaginal female figure' based on a type of lewd 12th-century carving found in English and Irish churches. Spero has also been a political activist: as a member of the *Art Workers Coalition, she has been involved in protests against discriminatory practices in the art world. She was married to the painter Leon *Golub.

Further Reading: J. Withers, 'Nancy Spero's American-born Sheela-na-gig', *Feminist Studies* (spring 1991)

Sperone, Enzo *See* ARTE POVERA.

Spielmann, M. H. (Marion Harry) *See* NEW SCULPTURE.

Spilliaert, Léon (1881–1946) Belgian painter and draughtsman, born at Ostend, the son of a perfume dealer. He was self-taught as a painter, and although he belonged to several artists' associations he was an independent figure (it is notable that he was completely uninfluenced by the work of *Ensor, Ostend's most famous artist). His work combines elements of *Art Nouveau, *Expressionism, and *Symbolism in a distinctive personal vision. He depicts a world of dreamlike solitude, often showing a single figure in a state of anguish or helplessness: a woman seen against a bleak expanse of sea or sky was a favourite subject. He worked mainly in watercolour, ink, and coloured chalk, rather than oils, with sparse and economical draughtsmanship characterized by billowing wavy lines and broad, flat surfaces. One of his most reproduced works is *Vertigo, Magic*

Staircase (1908, Kunstmuseum aan Zee, Ostend), a scene of nightmarish intensity showing a silhouetted woman beginning to descend a mysterious and terrifyingly steep structure. There is in his work a striking hallucinatory quiet, the result of a strong psychic concentration. Man and nature are absorbed in a rarefied timelessness' (catalogue of the exhibition 'Ensor to *Permeke: Nine Flemish Painters, 1880–1950', Royal Academy, London, 1971). The *Surrealists were impressed by his work.

Spilliaert lived in Ostend until his marriage in 1916, when he moved to Berchem-Sainte-Agathe near Brussels. In 1931 he returned to Ostend, then in 1935 he settled permanently in Brussels. From 1904 he made regular visits to Paris, where he had numerous artistic contacts and sometimes exhibited his work, for example at the *Salon des Indépendants.

Spoerri, Daniel (Daniel Feinstein) (1930–) Swiss sculptor, *Performance artist, designer, writer, publisher, dancer, and choreographer. He was Romanian by birth, but he fled with his family in 1942, after the death of his father, and was adopted by his Swiss uncle, Théophile Spoerri. Between 1950 and 1954 he studied ballet in Zurich and Paris, and from 1955 to 1957 he was principal dancer with the Berne Opera. He also worked in other theatrical roles, notably as a stage designer and choreographer, and from 1957 to 1959 he was assistant director of the Landestheater in Darmstadt. In 1959 he moved to Paris, where he set up a firm called Editions MAT (Multiplication d'Art Transformable) that produced *multiples by artists including Alexander *Calder, Marcel *Duchamp, and Jean *Tinguely. Through Tinguely (whom he had known in Switzerland), Spoerri met Yves *Klein, and these three were among the founder members of the *Nouveau Réalisme group in 1960. In the same year, Spoerri made his first trap picture ('tableau piège'), consisting of everyday items fixed to a support and hung on a wall. He often collaborated with other artists, and was briefly associated with the *Fluxus group. In 1966–7 he lived on the island of Simi, near Rhodes, then moved to Düsseldorf, where he opened the Restaurant Spoerri in 1968. Two years later he founded the Eat Art Gallery in premises above the restaurant and held exhibitions of works made of food by artists including *Arman, Joseph *Beuys, *César, and Niki de *Saint Phalle. Such enterprises have won him a reputation as one of the leading showmen in contemporary art.

Further Reading: W. Schmied, *Daniel Spoerri: Coincidence as Master* (2003)

Spur A group of German artists active in Munich from 1958 to 1966. The founders of the group were the painters Heimrad Prem (1934–79), Helmut Sturm (1932–), and Hans-Peter Zimmer (1936–92), and the sculptor Lothar Fischer (1933–2004). The name 'Spur' (German for 'track') was adopted in 1958 when they happened to be thinking about footprints they had made in the snow. Their work was semi-abstract, but they advocated an art of social protest and were influenced by the vivid portrayal of suffering that is often seen in late medieval German art. Another important influence was Asger *Jorn, who encouraged them and helped them to exhibit their work. From 1959 to 1962 they were part of the *Situationist International, and their journal *Spur* (seven issues, 1960–61) was one of the leading Situationist publications. In 1962, however, they were expelled by the movement, a not unusual distinction.

Staeck, Klaus *See* PHOTOMONTAGE.

Staël, Nicolas de (1914–55) Russian-born painter and printmaker who became a French citizen in 1948. He was born in St Petersburg, son of Baron Vladimir Ivanovich de Staël-Holstein. In 1919 his family was forced to leave Russia because of the Revolution (he would later become incensed if anyone suggested they had 'fled') and moved to Poland. Both parents had died by 1922 and Nicolas and his two sisters were adopted by a family of Russian expatriates in Brussels, where he studied at the École des Beaux-Arts, 1932–6. In the next two years he travelled widely (France, Italy, Spain, North Africa), then in 1938 settled in Paris, where he studied briefly with *Léger. On the outbreak of war in 1939 he joined the Foreign Legion and was sent to Tunisia. He was demobilized in 1941 and moved to Nice, where he turned from figurative to abstract art, although the forms he used were usually suggested by real objects. In 1943 he returned to Paris, where he had his first one-man exhibition the following year at the Galerie L'Esquisse. After the war he quickly gained a reputation as one of the leading abstract painters of the *École de Paris, his work showing a sensuous delight in handling paint

that was unrivalled at the time. Typically his works feature luscious blocks or patches of thick paint (often applied with a knife), subtly varied in colour and texture. In 1951 he began to reintroduce figurative elements into his work, his subjects including suggestions of landscapes and still-life (*Landscape Study*, 1952, Tate). From 1952 he spent much of his time working in the bright light of the South of France, and his late works are often very intense in colour. In spite of critical and financial success, de Staël felt that he had failed to reach a satisfactory compromise between abstraction and figuration, and he committed suicide.

Further Reading: R. Wollheim, 'Yellow Sky, Red Sea, Violet Sands', *London Review of Books* (24 July 2003)

staged photography *See* PHOTO-WORK.

Stahly, François (1911–2006) French sculptor. Born in Konstanz, Germany, he moved to Paris in 1931, studying at the *Académie Ranson. In 1939 he showed at the 'Témoignage' exhibition in Paris. This was a group formed in Lyon in 1936 by the art dealer, poet, and anarchist Marcel Michaud which rejected materialism and sought to reinject art with the 'spirituality lost since the Renaissance replaced the myth of God with that of Man'. Stahly remained attracted to secret rites and pagan cults. During the years of occupation he made abstract wood sculptures in secret, and later work in bronze or stone such as *Serpent de Feu* (1956) retains the forms of knotted wood. Like *Richier he explored metamorphosis between the inanimate and animate: a bird and a tree trunk become fused in his drawing *Portrait de l'oiseau qui n'existe pas (pas encore!)* (1980, Pompidou Centre). In the 1970s he made more block-like sculptures in terracotta. He died in Meudon.

Stain Painting *See* COLOUR FIELD PAINTING.

Stamos, Theodorus (1922–97) American painter, born in New York to Greek immigrant parents, one of the minor figures of the first generation of *Abstract Expressionists. He was considerably younger than most of the other members of the group, a reflection of the precocity that won him a scholarship to study sculpture at the American Artists School, New York, in 1936, when he was only fourteen. Soon after this he took up painting, self-taught, and he had his first one-man exhibition in 1943, at the Wakefield Gallery, New

York (run by Betty *Parsons). In the same year he met *Gottlieb and *Newman (he already knew *Gorky). At this time Stamos's painting was influenced by *Surrealism, often suggesting mysterious underwater forms (a characteristic he shared with *Baziotes). In 1948 he travelled in Europe, and after he returned to New York his work became more abstract, although he continued to find inspiration in natural forms and ancient mythological symbols. Many of his subsequent paintings belonged to extensive series, such as the *Sun-Box* series, which ran through much of the 1960s and featured his most austere and geometrical works. After 1970, most of his paintings were part of his *Infinity Field* series, which incorporated several subgroups, such as the *Lefkada* series, named after a Greek island that he often visited. Apart from paintings, Stamos made book illustrations and tapestry designs, and he taught at various art schools, including *Black Mountain College (where Kenneth *Noland was among his students) and the *Art Students League, New York.

Stankiewiesz, Richard *See* JUNK ART.

Starling, Simon (1967–) British artist. He was born in Epsom, Surrey, and lives in Germany. In his art, it is the process of making which is as significant as the final object. Indeed much of his work derives its power from the sense that the artist's intervention in the material is in itself part of a much larger historical and material process. In a work of 1996 he cut in half a silver ladle, converting half of it into fake twenty pence pieces. The ladle itself was a survival from a lost tradition of craftsmanship. The 'fake' pieces of money were paradoxically of higher value than 'real' ones. Starling has looked critically at the legacy of the *Modern Movement, especially in the area of design and architecture in which it made such emancipatory claims. *Pleçnik Union* (2000) had its origins when Starling discovered a smashed lamp in Ljubljana, alongside the beer bottle which had broken it. The lamp was a classic modern design from around 1900. Both lamp and bottle were put together again from the fragments by Starling. *Home-made Eames* (2002, Guggenheim Museum, New York) is a reconstruction by hand of another classic modern design, a chair by Charles Eames which was the first to be mass produced in plastic. As such it

S

was a landmark in the supposed 'democratization' of modern design, but the originals are now precious collectors' items. Starling comments on this transformation by returning the chair to individual craft production. Although Starling's work can be related to the *ready-made in a changed world where mass production is the norm, he concentrates not on the commonplaceness of the object but on its singularity. This is made clear in his best-known work *Shedboatshed (Mobile Architecture no. 2)* (2005) in which he dismantled a shed on the banks of the Rhine, converted it into a boat, and carried it downstream to Basle, where he reconstituted it in the museum. He was awarded the Turner *Prize in 2005.

Further Reading: G. Mann, 'Simon Starling', *Frieze*, issue no. 94 (October 2005)

Stażewski, Henryk *See* BLOK.

Steadman, Ralph (1936–) British caricaturist, illustrator, printmaker, designer, and writer, born in Wallasey, Cheshire. He studied through a postal course and part-time at the London College of Printing. From 1956 to 1959 he worked as a cartoonist for Kemsley (Thomson) Newspapers, then turned freelance. He has been highly prolific, working for numerous magazines and newspapers, including *Private Eye, Punch*, and *The Daily Telegraph*, and illustrating many books. The books include several that he wrote himself, among them *Sigmund Freud* (1979, reissued as *The Penguin Sigmund Freud*, 1982) and *I, Leonardo* (1983). These show his anarchic humour, but he is also capable of savagery and moral indignation, as in a cover illustration for *Weekend Magazine* in 1978 protesting against sealhunting: it shows a woman in a sealskin coat symbolically spattered with the blood of the slaughtered animals. With Gerald *Scarfe (his exact contemporary), Steadman is regarded as one of the outstanding satirical draughtsmen in British art. However, whereas Scarfe is essentially a portraitist, Steadman is more of a social commentator, who 'transforms appearances in a quasi-surrealistic way, using the new shapes as metaphors for character' (Edward *Lucie-Smith, *The Art of Caricature*, 1981). Typically he works in pen-and-ink in a swift, fluid style.

Stedelijk Museum (Municipal Museum), Amsterdam. One of the world's outstanding collections of international mod-

ern art. It had its origins in the bequest of Sophia de Bruyn-Suasso to the city in 1890. A handsome building was erected to house the bequest and also modern pictures for which there was no room in the city's foremost museum, the Rijksmuseum, and it was opened as the Stedelijk Museum in 1895. A new wing was added in 1954 and there have been further extensions. The collection of painting and sculpture ranges from about 1850 to the present day. It is rich in Dutch works and has other areas of great strength, notably the world's finest representation of *Malevich's paintings.

Steer, Philip Wilson (1860–1942) British painter (of landscapes and occasional portraits and figure compositions), born in Birkenhead, son of an undistinguished portrait painter, Philip Steer (1810–71). With *Sickert (his friend and exact contemporary), Steer was the leader among the progressive British artists in his generation who looked to France for inspiration. He turned to painting after giving up a job in the Department of Coins and Medals in the British Museum in 1878 and had his main training in Paris, 1882–4, first at the *Académie Julian and then the École des *Beaux-Arts. He revisited France on several occasions, but unlike Sickert he never mastered the language (indeed he left the École des Beaux-Arts when—to reduce numbers—new regulations were introduced forcing all foreign students to take stiff examinations in French). With other admirers of French painting, he was one of the founders of the *New English Art Club in 1886 and he regularly exhibited there. In 1892 George *Moore wrote 'it is admitted that Mr Steer takes a foremost place in what is known as the modern movement', and around this time Steer was indeed at his peak, producing the beach scenes and seascapes that are regarded not only as his finest works but also as the best *Impressionist pictures painted by an Englishman. They are remarkable for their great freshness and their subtle handling of light, and unlike Sickert's paintings they are devoid of any social or literary content. Among them are several depicting the seaside resort of Walberswick in Suffolk, where he had friends and often stayed at this period.

After about 1895 Steer's work became more conventional and more closely linked to the English tradition of Gainsborough (especially in portraits), Turner, and Constable. In the 1920s he turned increasingly to watercolour.

He taught at the *Slade School from 1893 to 1930 and in 1931 was awarded the Order of Merit. His sight began to fail in 1935 and he had stopped painting by 1940. In character he was benign, modest, and drily amusing, inspiring affectionate regard in almost everyone who knew him.

Further Reading: B. Laughton, *Philip Wilson Steer* (1971)

Stefánsson, Jón *See* THORLÁKSSON, THÓRARINN B.

Steichen, Edward J. (1879–1973) American photographer, painter, and curator, born in Bivange, Luxembourg. He moved to the United States in 1881 and was initially self-taught as an artist and photographer, although he studied briefly at the *Académie Julian. His early photography was highly atmospheric, strongly influenced by *Impressionism, especially *Monet, and *Symbolism. In 1902 he made a series of photographs of *Rodin—one shows the artist in misty half light echoing the pose of his sculpture *The Thinker*. Steichen was one of the first to experiment with colour photography. Even before the autochrome process was introduced in 1907, photographs such as *The Pond—Moonlight* (1904) created the effect of colour by the manual application of layers of light sensitive gums to the surface. Alfred *Stieglitz was an early supporter and his 291 Gallery was in Steichen's old studio. From 1906 to 1914, Steichen was in Paris, where his contacts with the leading artists enabled their work to be seen in Stieglitz's gallery. In the First World War he served as commander of the photographic division of the Expeditionary Forces Air Service. His increasing interest in photojournalism led to a breach with Stieglitz. In 1922 Steichen finally committed himself unequivocally to photography with a ceremonial burning of his remaining paintings. In 1923, he became chief of photography for Condé Nast publications, producing glamorous images for *Vanity Fair* and *Vogue*. During the Second World War he organized two exhibitions, 'Road to Victory' (1942) and 'Power in the Pacific' (1945) for the New York *Museum of Modern Art. In 1947 Steichen abandoned his own photographic work completely to become director of the department of photography in the museum. His most celebrated achievement there was the enormously popular exhibition 'The Family of Man' (1955), which subsequently toured the world.

Stein, Gertrude (1874–1946) American writer, collector, hostess, eccentric, and self-styled genius, born at Allegheny City, now part of Pittsburgh, into a wealthy family. After abandoning medical studies she settled in Paris in 1903, returning only once to the USA, for a lecture tour in 1934. Her home at 27 rue de Fleurus became famous as a literary and artistic salon; many distinguished American visitors to Paris found it their introduction to modern French painting. With her brother, the art critic **Leo Stein** (1872–1947), who lived with her from 1903 to 1912, she was one of the first collectors of the work of *Braque, *Matisse, and *Picasso (who painted a well-known portrait of Gertrude, 1906, Metropolitan Museum, New York); another brother, **Michael** (1865–1938), and his wife, **Sarah** (1870–1953), were also collectors. Gertrude's writings, which she claimed to be a literary counterpart to *Cubism, are often opaque in style, concerned with the rhythm and sound of words rather than their meaning. The best-known and most approachable of her many books is *The Autobiography of Alice B. Toklas* (1933), which in fact is her own autobiography, composed as though by Miss Toklas (1877–1967), her secretary and companion from 1907. Alfred H. *Barr writes that Leo Stein was 'the critic who first felt that Matisse *and* Picasso were the two important artists of his time', but Leo later turned his back on their work, describing Cubism as 'god-almighty rubbish'. Clive *Bell maintained that 'Neither Gertrude or Leo had a genuine feeling for visual art . . . Pictures were pegs on which to hang hypotheses.' On her death, Gertrude's art collection passed to Miss Toklas, and when she in turn died in 1967 it was sold. Several of the paintings eventually went to leading public collections, including the Museum of Modern Art, New York.

Steinbach, Haim (1944–) American sculptor. Born in Rechovot, Palestine, he moved with his family to New York in 1957. He is associated with the *Neo-Geo school, his work involving the *appropriation of everyday consumer objects, usually arrayed on a shelf. For instance, in *UltraRed # 2* (1986, Guggenheim Museum, New York), lava lamps are juxtaposed with a tower of red pots and a group of digital clocks with bright red LED displays: strictly utilitarian objects are combined with those which suggest 'a druggy form of leisure' (Joselit), yet they are united

by the same brilliant red colour. Steinbach is concerned not just with the appearance of the objects but with their role as indicators of status. In the 1992 *documenta he made a work out of the possessions of the exhibition's director.

Steinberg, Leo (1920–) American art historian. He was born in Moscow, grew up in Berlin, settled in England in 1933, and emigrated to the USA in 1945. After several years as a freelance writer and teacher of drawing, he turned to art history and gained a PhD from the Institute of Fine Arts, New York University, in 1960. He was subsequently a professor of art history at Hunter College, City University of New York, then moved to the University of Pennsylvania in 1975. His learned, stimulating, and sometimes provocative writings have ranged from the Renaissance to contemporary art. A collection of his pieces on modern art was published in 1972 as *Other Criteria: Confrontations with Twentieth-Century Art*. The title essay is a key document in the reaction against the *formalist writing of Clement *Greenberg. There are also three essays on *Picasso, whose late work he was among the first to accord serious treatment, and an influential account of the work of Jasper *Johns. This was unusual at the time in its honesty in describing the difficulties of confronting challenging new art, although its account of the false starts and confusions involved have now become something of a cliché of art criticism. *See also* AVANT-GARDE.

Steinberg, Saul (1914–99) American draughtsman and painter, born at Râmnicul-Sârat in Romania. He studied architecture in Milan, taking a doctorate at the Reggio Politecnico there in 1940, and emigrated to New York in 1942. Steinberg had begun publishing cartoons in 1936 (in the Milanese magazine *Bertoldo*) and in the USA he became one of the most celebrated cartoonists of his day, famous particularly for his work for *The New Yorker* magazine. He worked in a variety of styles, often parodying modes of both traditional and modern painting. Matthew Baigell (*Dictionary of American Art*, 1979) described him as 'a serious observer of modern life, aware of the masks and roles people must assume to cope with contemporary conditions. His point of view is not that of a cartoonist illustrating one-liner jokes, but of a perceptive individual profoundly and humorously engaged in illu-

minating the corners of the modern mind.' Several collections of his drawings were published, including *All in Line* (1945), *The Art of Living* (1949), *The Labyrinth* (1959), and *The New World* (1965). His other work included *collages, *assemblages, and paintings of various kinds, notably a mural for the United States Pavilion at the 1958 Brussels World's Fair.

Steiner, Michael *See* HIDE, PETER.

Steir, Pat *See* NEW IMAGE PAINTING.

Stella, Frank (1936–) American painter, printmaker, and writer on art, a leading figure of *Post-Painterly Abstraction. He was born in Malden, Massachusetts, a suburb of Boston, and began to paint abstract pictures while he was at school at Phillips Academy, Andover. In 1954–8 he studied history at Princeton University and also attended painting classes. At this time he was influenced by *Abstract Expressionism, but after settling in New York in 1958 he was impressed by the flag and target paintings of Jasper *Johns and the direction of his art changed completely. He began to emphasize the idea that a painting is a physical object rather than a metaphor for something else, saying that he wanted to 'eliminate illusionistic space' and that a picture was 'a flat surface with paint on it—nothing more'. These aims were first given expression in a series of black 'pinstripe' paintings in which regular black stripes were separated by very thin lines. They made a big impact when four of them were shown at the Museum of Modern Art's '16 Americans' exhibition in 1959, inspiring a mixture of praise and revulsion. Soon after this he began using flat bands of bright colour (*Hyena Stomp*, 1962, Tate), then, to identify the patterning more completely with the shape of the picture as a whole he started working with notched and *shaped canvases, making use of metallic paint. One important supporter was Michael *Fried, who praised his paintings, alongside those of *Noland, for their discovery of 'a new mode of pictorial structure based on the shape rather than the flatness of the support' (*Artforum*, November 1966). In noting this, Fried was identifying a development beyond that anticipated by his mentor *Greenberg, who asserted above all the acceptance of the flatness of the picture plane as the precondition of modernist painting. (Greenberg admired Noland but not Stella). In the 1970s Stella began to work on paintings that

included cut-out shapes in relief and he abandoned his impersonal handling for a spontaneous, almost graffiti-like manner (*Guadalupe Island, Caracara*, 1979, Tate).

Stella has been an influential figure not only in painting but also on the development of *Minimal sculpture (his friends have included *Andre and *Judd). In 1983–4 he delivered the Charles Eliot Norton lectures at Harvard University, which were published in 1986 as *Working Space*.

Further Reading: R. Rosenblum, *Frank Stella* (1971)

Stella, Joseph (1877–1946) American painter, born at Muro Lucano, near Naples, Italy. He emigrated to the USA in 1896, and after abandoning medicine as a career he studied from 1897 to 1901 at the *Art Students League and the New York School of Art. He was an excellent draughtsman and for several years earned his living as an illustrator. From 1909 to 1912 he lived in Italy and France, where he had his first significant contacts with modern art. He was particularly influenced by *Futurism and he became the leading American exponent of the style. His first and most famous Futurist painting was *Battle of Lights, Coney Island, Mardi Gras* (1913–14, Yale University Art Gallery), a densely fragmented portrayal of a crowded amusement park at night. In such paintings Stella gave a romanticized image of the industrialized townscape of New York. In particular he was obsessed with Brooklyn Bridge, which he described as 'a shrine containing all the efforts of the new civilization of America' (*Brooklyn Bridge*, 1917–18, Yale University Art Gallery). Stella soon abandoned the Futurist idiom, but industrial and urban themes continued to inspire him. He was active in the administration of two leading avant-garde associations—the *Society of Independent Artists and the *Société Anonyme—and in the early 1920s he experimented with various styles, including *Precisionism. In the 1920s and 1930s he spent much of his time in Italy and France (he lived in Paris 1930–34). From the mid-1920s his work grew more conservative and included mystical and sacred subjects. By the time declining health forced him to give up his studio in 1942 his reputation had faded greatly.

Stenberg, Vladimir (1899–1982) and **Georgy** (1900–33) Russian painters and designers, brothers, who worked together until Georgy died in a motorcycle accident. They were born in Moscow, where they studied at the Stroganov Art School, which was reformed in 1918 as the Free State Art Studios (*Svomas). After the October Revolution in 1917 they were vigorous participants in avant-garde activities. In 1918, for example, they worked on agit-decorations (*see* AGITPROP ART) for May Day and for the first anniversary of the Revolution. They were members of *Obmokhu and *Inkhuk and allied themselves with the *Constructivists: they made *Structures* of materials such as iron and glass, and their 'cinema and theatrical advertisements and posters were pioneer examples of Constructivist typography and design' (Camilla Gray, *The Great Experiment: Russian Art 1863–1922*, 1962). In the 1920s they worked much as set and costume designers for the stage. From 1929 to 1932 they taught at the Architecture-Construction Institute, Moscow. After Georgy's death Vladimir worked mainly as a poster designer, sometimes in collaboration with his sister **Lydia Stenberg** (1903–62) and later his son **Sten Stenberg**.

Stepanova, Varvara *See* CONSTRUCTIVISM; RODCHENKO, ALEXANDER.

Sterilists *See* PRECISIONISM.

Stern, Irma (1894–1966) South African painter. From 1913 to 1920 she studied in Germany, mainly in Berlin, where she was a member of the *Novembergruppe. She was influenced particularly by *Pechstein's *Expressionist style and she was the most important artist in introducing European modernism to South African, where her work initially caused outrage. Her prolific output consisted mainly of figure subjects, including scenes of African villages, but she also painted still-lifes of fruit and flowers. Her home in Cape Town is now a museum dedicated to her. It houses not only examples of her own work, but also African, European, and South American art she collected.

Stieglitz, Alfred (1864–1946) American photographer, editor, writer, publisher, and art dealer who during the first two decades of the 20th century did more than anyone else to bring European avant-garde art before the American public. He was born in Hoboken, New Jersey, the son of a successful German immigrant businessman, and in 1881 was sent to Berlin to study mechanical engineering. While he was there he developed an interest

in photography and by the time he returned to the USA in 1890 he already had an international reputation. In 1905, with another eminent American photographer, Edward *Steichen, he opened the Little Galleries of the Photo-Secession, which later became known as 291 Gallery (from its address at 291 Fifth Avenue, New York). It soon branched out from photography, and Stieglitz devoted much of his energy to promoting modernist painting and sculpture: the gallery presented the first American exhibitions of *Matisse (1908), Toulouse-Lautrec (1909), *Rousseau (1910), *Picabia (1913), *Severini (1917), and the first one-man exhibition of *Brancusi anywhere (1914). It also gave the first exhibition of children's art and the first major exhibition of African art in America. Stieglitz also championed American artists, among them Georgia *O'Keeffe, whom he married in 1924.

From 1903 to 1917 Stieglitz edited the journal *Camera Work*, which he published from the 291 Gallery. At first devoted exclusively to photography, it was later extended to cover all the visual arts and opened its pages to avant-garde American writers. He also published a short-lived *Dadaist magazine called 291 (1915–16). The 291 Gallery was closed in 1917 when the building was pulled down, but Stieglitz continued his work with the Intimate Gallery (1925–9) and An American Place (1929–46). In spite of all his other activities, Stieglitz found time for his own photography and he is regarded as one of the most important figures in the history of the medium, playing a large part, through teaching and lecturing as well as his own practice, in establishing it as an independent art form. His subjects included landscapes, views of New York, and studies of Georgia O'Keeffe, whom he lovingly depicted hundreds of times, often concentrating on details such as her hands or her torso. He rejected retouching and other forms of manipulation, believing that vision was more important than technique, although he insisted on using the best materials. His collection of art and photographs has been distributed to various collections, including the Art Institute of Chicago and the Metropolitan Museum, New York.

Stijl, De (Dutch: The Style) The name of an organization of mainly Dutch artists founded in 1917 and of the journal they published to promote their ideas. It was a very loose association (the 'members' did not exhibit together and some of them scarcely knew each other), and it was held together mainly by Theo van *Doesburg, who was a tireless propagandist for its ideas. The other 'collaborators' (in Dutch, 'medewerkers') were, like van Doesburg, principally painters (notably *Huszár, van der *Leck, and *Mondrian), but they also included the sculptor *Vantongerloo and several architects, among them Gerrit Rietveld (1888–1964), who is now perhaps best known for his furniture designs. Their common aim was to find laws of equilibrium and harmony that would be applicable to life and society as well as art, and the style associated with De Stijl was one of austere abstract clarity (*see* NEO-PLASTICISM). Ultimately the distinction between art and life would be abolished.

The journal was founded by van Doesburg and Mondrian in Leiden in 1917 and van Doesburg continued to edit it until 1928 (it appeared roughly monthly, but irregularly; the place of publication—befitting van Doesburg's peripatetic career—also varied, the editorial offices at one time being in Weimar). It rarely sold more than about 300 copies, but its circulation was widespread. A final issue (no. 90) was published by Mme van Doesburg in memory of her husband, after whose death in 1931 the association disbanded. At first the journal was devoted to the principles of Neo-Plasticism, but in 1921 van Doesburg welcomed *Dadaists such as *Arp and *Schwitters as contributors and later edited a Dadaist supplement called *Mécano* (four issues, 1922–3). Mondrian did not contribute to De Stijl after 1924, and soon afterwards dissociated himself from the group because of van Doesburg's launching of a splinter movement that he called *Elementarism.

By this time van Doesburg had also quarrelled with most of his original collaborators, but despite the lack of cohesion, De Stijl was probably the most influential of the many avant-garde publications in Europe between the two world wars. It was influential on artistic practice as well as theory, but it was in architecture and the applied arts (including furniture design and typography) that it had its greatest impact. This is seen particularly in the work of the *Bauhaus and in the clean-lined architectural style known as 'International Modern' (*see* MODERN MOVEMENT), of which Rietveld's Schroder House in Utrecht (1924) is an early and famous example. In the fields of painting and sculpture, geometric abstraction in Western Europe and the USA largely derives from its example.

In spite of its claims to universal values, it can be argued that De Stijl had specifically Dutch characteristics. Hans Jaffé points out that in Dutch the word 'schoon' stands for 'clean' and 'pure' as well as 'beautiful'. He proposes that the beauty of the works of De Stijl lies in their 'utter sobriety', a feature shared with 17th-century Dutch masters such as Vermeer and Saenredam. *See also* ABSTRACT ART.

Further Reading: M. Friedman, *De Stijl: Visions of Utopia 1917–1931* (1982)

Still, Clyfford (1904–80) American painter, one of the major figures of *Abstract Expressionism but the one least associated with the New York art scene. He was born in Grandin, North Dakota, and studied at Spokane University (graduating in 1933) and Washington State College, Pullmann, where he taught until 1941. After working in war industries in California, 1941–3, he taught for two years at the Richmond Professional Institute, Richmond, Virginia. He then lived briefly in New York (1945–6), where he had a one-man exhibition at Peggy *Guggenheim's Art of This Century gallery in 1946. Although he stood somewhat apart from the other Abstract Expressionists, he was friendly with Mark *Rothko (they had met in 1943), the two men sharing a sense of almost mystical fervour about their work. In 1946–50 he taught at the California School of Fine Arts in San Francisco (*see* BAY AREA FIGURATION), then lived in New York, 1950–61. By the time he returned to New York, Still had created his mature style and had a rapidly growing reputation. He was one of the pioneers of the very large, virtually monochromatic painting. But unlike *Newman and Rothko, who used fairly flat, unmodulated pigment, Still used heavily loaded, expressively modulated impasto in jagged forms. His work can have a raw aggressive power, but in the 1960s it became more lyrical. In 1961 Still moved to Maryland to work in tranquillity away from the art world. Scorning galleries, dealers, and critics, and rarely exhibiting, he considered himself something of a visionary who needed solitude to give expression to his high spiritual purpose, and he gained a reputation for cantankerousness. His comment on his painting *1953* (1953, Tate) is typical of his high-flown prose, but also demonstrates an interest in colour symbolism which would be alien to most Abstract Expressionists: 'there was a conscious inten-

tion to emphasize the quiescent depths of the blue by the broken red at its lower edge while expanding its inherent dynamic beyond the geometries of the constricting frame . . . In addition, the yellow wedge at the top is a reassertion of the human context—a gesture of rejection of any authoritarian rationale or system of politico-dialectical dogma.' Still and his widow presented large groups of his paintings to the Albright-Knox Art Gallery, Buffalo, the Metropolitan Museum, New York, and the San Francisco Museum of Modern Art. The bulk of his output, however, remains the property of his estate. Still made stringent demands in his will on the recipient, which had to be an American city: a special museum had to be created for his work, nothing was to be sold, and no other artist's work could be shown there. Eventually the city of Denver agreed to house the paintings and the museum is scheduled to open in 2010.

Further Reading: D. Anfam, *Clyfford Still Paintings 1944–1960* (2001)

Stockholder, Jessica (1959–) American painter and installation artist, born in Seattle. She studied painting at the University of British Columbia, Vancouver, and at Yale University. She is known for colourful constructions on an environmental scale, incorporating plastics and found objects including carpets and furniture, which break the boundaries between painting and sculpture. Adrian Searle has described her work as 'not painting' but 'something like the memory of a painting' (South Bank Centre, *Unbound*, 1991). The artist has commented that 'My work has grown from an attempt to gain a sense of control of, or at least comfort with, the material world'.

Stockholm, Moderna Museet *See* MODERNA MUSEET.

Stockwell Depot *See* HIDE, PETER.

Stokes, Adrian (1902–72) British writer and painter. He was born in London and studied politics, philosophy, and economics at Magdalen College, Oxford, 1920–23. In the winter of 1920–21 he first visited Italy and he returned there many times over the next decade, leading to his first important book *The Quattro Cento* (1932), in which he articulated his 'love of stone'. This preoccupation led him to friendship with a number of artists—particularly Barbara *Hepworth and Henry *Moore—to whom

*direct carving was important. In 1936 Stokes took up painting and in 1937 he studied at the *Euston Road School. From 1939 to 1946 he lived at Carbis Bay, Cornwall, and by encouraging Hepworth and Ben *Nicholson to settle near him at the outbreak of the Second World War he helped to bring about the heyday of the *St Ives School. After the war he lived briefly in Switzerland, then returned to England in 1950, settling permanently in London in 1956. He continued to write and paint up to his death. His books sold badly, but he had a loyal following, and some of his admirers today consider him the most eloquent and poetic British art critic since John Ruskin. Others find his prose hard going. An intensely subjective writer, with an interest in psychoanalysis, Stokes responded passionately, even ecstatically, to art, believing its task was to show the 'utmost drama of the soul as laid-out things'. His books include *The Stones of Rimini* (1934), *Colour and Form* (1937), *Art and Science* (1949), *Three Essays on the Painting of our Time* (1961), *Painting and the Inner World* (1963), and *Reflections on the Nude* (1967). *The Image in Form: Selected Writings of Adrian Stokes* was published in 1972, edited by his friend Richard Wollheim (*see* EXPERIMENTAL ART) and *The Critical Writings of Adrian Stokes*, edited by Lawrence *Gowing, appeared in three volumes in 1978. Stokes also wrote poetry. As a painter his work included still-lifes (which Patrick *Heron said had 'a kind of luminosity which seems to derive from the inside of objects') and landscapes. There are examples in Tate, and an Arts Council exhibition of his work was held at the Serpentine Gallery in London in 1982.

He is not to be confused with another **Adrian Stokes** (1854–1935), a landscape painter and author of *Landscape Painting* (1925).

Stölzl, Gunta *See* BAUHAUS; FIBRE ART.

Stoop, Frank *See* TATE.

Stott, Edward *See* NEW ENGLISH ART CLUB.

Stradone, Giovanni *See* ROMAN SCHOOL.

Strand, Paul (1890–1976) American photographer and film-maker. Born in New York, he enrolled on a photography course with Lewis *Hine in 1908. While a student he visited Alfred *Stieglitz's 291 gallery. Stieglitz organized the first exhibition of Strand's work at his gallery in 1916 and published it in *Camera Work*. Strand rejected the pictorialism (*see* TONALISM) then promoted in 'artistic' photography for a sharper focus manner, influenced by *Cubist painting, in which unexpected angles or shadows converted images of the city into near-abstract patterns. *Wall Street* (1915) is one of the best known. Here a degree of social criticism can be read from the image: the figures in the foreground are dwarfed by giant black windows. However, Strand was drawn more towards the human subject. A series of close-up images (*Man, Five Points Square, New York*, 1916) remove the aesthetic distance between viewer and subject which the more abstracted photographs so carefully constructed. After the First World War, Strand grew more concerned with the social role of photography; this eventually led to a break with Stieglitz. He also became involved with film-making: *Manhatta* (1921), a poetic view of New York, in collaboration with Charles *Sheeler, and *The Wave* (1932–4), about the conditions of life in a Mexican fishing village. He visited the USSR in 1935 and, although never a party member, he remained a loyal, indeed uncritical, supporter of Soviet Communism. The effect of his politics on his work has been the subject of debate among historians, but from 1949 onwards he lived and worked in France, effectively an exile from Cold War America.

Further Reading: M. Stange (ed.), *Paul Strand: Essays on his Life and Work* (1991)

Strang, William (1859–1921) British painter, etcher, and draughtsman. He was born in Dumbarton, where he was briefly apprenticed to a shipbuilding firm before moving to London (he lived there for the rest of his life) and studying at the *Slade School, 1876–80. Under the guidance of Alphonse *Legros he took up etching and it was in this field that he originally made a name for himself. By the mid-1890s he had an international reputation, but from this time he turned increasingly to painting, and after the turn of the century he was regarded more as a painter-etcher than an etcher-painter. At first he concentrated on imaginative (often allegorical) scenes in a pseudo-Venetian manner influenced by his friends *Ricketts and *Shannon, but he came to specialize mainly in portraits—one of the most striking examples is *Lady with a Red Hat* (1918, Kelvingrove Art Gallery, Glasgow), in which the sitter is the writer Vita Sackville-West. He made

highly finished portrait drawings as well as paintings and etchings. Strang also painted some rather strange modern allegories, combining 'real' and 'dressed-up' figures, but he is now probably best remembered for a much more modest genre scene, *Bank Holiday* (1912, Tate), a memorable piece of social observation showing a handsome but awkward young couple making an outing to a restaurant. Strang's work was unfashionable for many years after his death, but an exhibition devoted to him in 1981 (shown at the Graves Art Gallery, Sheffield, the Kelvingrove Art Gallery, Glasgow, and the NPG, London) did much to put him back on the map.

His son **Ian Strang** (1886–1952) was an etcher, draughtsman, and painter, mainly of architectural and landscape subjects. He wrote *The Student's Book of Etching* (1938). Another son, **David Strang** (1887–1967), was a painter and etcher.

Street art *See* GRAFFITI.

street photography Term given to photographs taken spontaneously on the street with or without the permission of their subjects. It is especially applied to the work of American photographers of the 1950s and 1960s, including Robert *Frank, Garry *Winogrand, and William *Klein.

Streeton, Sir Arthur (1867–1943) Australian painter. He was a prolific landscape painter, working in an *Impressionist style similar to that of his friend Tom *Roberts. From 1090 to 1924 he spent most of his time abroad (in 1918 he was an *Official War Artist with the Australian forces in France). His work became stereotyped, but he was enormously popular in his own country, regarded as the foremost portrayer of the remote and awesome Australian landscape. By the end of his career he had long enjoyed the status of a national institution. *See also* HEIDELBERG SCHOOL.

Strudwick, John Melhuish *See* PRE-RAPHAELITISM.

Struth, Thomas (1954–) German photographer, born in Geldern, Niederrhein. He studied at the Düsseldorf Academy under the painter Gerhard *Richter and the photographer Bernd *Becher. As with other students of Becher, his large-format photographs relate as much to fine art as photography: this is especially true of his best-known series, which

he embarked on in the late 1980s, depicting art galleries and the interiors of churches. These photographs originated in his interest in Renaissance painting and record the reactions of visitors to the works and to each other. For instance in *Art Institute of Chicago II, Chicago* (1990, Art Institute of Chicago) the attitude of visitors actually appears more formal and posed than the figures in the self-consciously 'photographic' street scene by the minor *Impressionist Gustave Caillebotte (1848–94) which dominates the image. *San Zaccariah* (1995) shows a Venetian church containing a celebrated and elaborately framed altarpiece by Giovanni Bellini, but most of the visitors look in another direction, guided by the architecture and the pews in which they sit. For these photographs, Struth used a large-format camera on a tripod mounted on wheels, working at a certain distance from the visitors so as to establish a sense of the interior space. He has also made family group portraits and images of streets which have been compared to the work of *Atget.

Further Reading: J. Millar, 'When you're strange', *Frieze* (March–April 1994)

Strzemiński, Vladislav (1893–1952) Polish abstract painter and art theorist. He was born at Minsk in Belarus and fought in the Russian army in the First World War, losing an arm and a leg in 1915. In hospital he met the sculptor Katarzyna Kobro (1898–1951), also Russian-born, who became his wife. After the war he studied in Moscow, 1918–19, then was assistant to *Malevich at the art school in Vitebsk before settling in Poland in 1922. In 1923 he organized the first exhibition of modern art in Poland, in Vilnius (now in Lithuania), and in 1924 he was one of the founders of the *Constructivist group *Blok, which published a magazine of the same name. He wrote several theoretical works, of which the most important, published in 1928, was the book *Unizm w malarstwie* (Unism in Painting), in which he expounded a new system of painting called 'Unism'. He claimed that in order to be seen as an optical unity a canvas should not be divided into sections by lines, masses, or rhythms, but instead should consist of an all-over pattern. 'Line divides— the purpose ought not to be the division of the picture, but its unity, presented in a direct way: optically.' Therefore the painter must renounce line, rhythm ('because it exists only in the relations of independent parts'),

oppositions, contrasts, and division ('because it concentrates and intensifies the forms around the contour, and cuts the picture in sections'). He claimed that with Unism he had gone beyond Malevich in abstraction, because not only were his pictures *'non-objective' in the sense of having no subject, they had no images either (i.e. he had banished Malevich's squares and similar basic forms). In this way he anticipated *Minimal art.

In 1930 Strzemiński helped to found another avant-garde group, a.r. (revolutionary artists), in Łódź. After the Second World War he painted a series of vividly coloured works in which he depicted 'after-images'—images left in the eye after it has been looking at a bright light source. From 1945 to 1950 he taught art history at the Higher School of Fine Arts in Łódź. His work is well represented in the Sztuki Museum, Łódź.

Stuck, Franz von (1863–1928) German painter, sculptor, and graphic artist, born at Tettenweis, Bavaria. He studied in Munich and in 1892 was a founding member of the *Sezession there. In 1895 he became a professor at the Munich Academy, where *Kandinsky and *Klee were among his pupils. His favourite subjects were mythological and allegorical scenes, often treated in a morbidly erotic *Symbolist style: he did at least eighteen pictures of a naked woman entwined with an enormous snake under such titles as *Sensuality, Sin*, and *Vice*. He had an extraordinarily high reputation in his day (now badly faded) and enjoyed a princely lifestyle. The house in which he lived in Munich is now a museum dedicated to him. He designed and decorated the house himself, attempting to create the ideal of the Gesamtkunstwerk ('total work of art').

Studio, The Monthly journal of contemporary art first published in London in 1893. It soon became the leading English-language journal in its field, with an international circulation. The cover of the first issue was designed by Aubrey Beardsley (1872–98), one of the outstanding exponents of *Art Nouveau, and in its early days the journal was particularly associated with this style—so much so that in Germany the term 'Studio-Stil' gained currency for a while as a synonym for it. The title of the journal announced an intent that it was primarily to be written by artists. Comparable British publications of the period such as

Magazine of Art, edited by the poet W. E. Henley, and *Art Journal* were dominated by figures from the world of literature. In *Studio* the 'lay figure', i.e. the non-artist (a piece of word-play, as the phrase also describes the articulated dummy used by artists in the absence of a live model), was rather patronizingly permitted a say on the final page. From 1897 to 1921 and from 1927 to 1939 an American edition was published concurrently under the following titles: *The International Studio* (1897–1921), *Creative Art, incorporating the Studio of London* (1927–31), *Atelier* (1931–2), and *The London Studio* (1932–9). Thereafter only the British edition was published. As one editor, Peter Townsend, put it, for much of its existence 'what it has done best is to chronicle the fluctuations of middle-class taste'. Notoriously, one can work through the entire run of the journal in the 1930s and find scarcely a trace of the work of artists such as Barbara *Hepworth and Henry *Moore. Issues of the 1950s and early 1960s suggest that its most important constituency at that time was that of art teachers and amateur painters, generally suspicious of the 'expert' and still looking towards Paris rather than New York as the centre of art. In 1964 the title was changed to *Studio International: Journal of Contemporary Art*; it acquired larger pages and a generally glossier appearance. During the late 1960s and early 1970s, under the editorship of Peter Townsend, it established itself as one of the world's leading organs of modern art, with a unique mix of contributions from artists, scholars, and journalists, both reflecting the passing scene and publishing material of lasting value, including Joseph *Kosuth's seminal essay 'Art After Philosophy' (1969). In 1975 Townsend was replaced by Richard *Cork, whose editorship reflected a strong commitment towards political art. Townsend went on to found another magazine, *Art Monthly*, a far less glossy affair. After a series of financial crises, *Studio International* ceased publication in its print version in 1987, although a website still exists.

Studio 35 *See* SUBJECTS OF THE ARTIST SCHOOL.

Sturm, Der (German: The Storm) The name of a magazine and an art gallery in Berlin, both of which were founded and owned by Herwarth Walden (1878–1941?), a writer and composer whose aim was to promote avant-garde art in Germany. The magazine ran from 1910

to 1932 and the gallery from 1912 to 1932. They became the focus of modern art in Berlin, publicizing the *Expressionism of the *Blaue Reiter group, for example. Other activities associated with Sturm included an art school, 1916–32. The gallery held more than a hundred exhibitions, the most important being the 'First [and only] German *Salon d'Automne' (Erster Deutscher Herbstsalon), held in the autumn of 1913. It covered almost the entire range of avant-garde painting and sculpture at that time, including some 360 works by more than eighty artists from twelve countries. George Heard *Hamilton wrote that it 'ranks with Roger *Fry's [*Post-Impressionist] exhibitions of 1910 and 1912 as one of the few occasions when one individual comprehended the fundamental directions of the modern movement and was able to demonstrate them with paintings and sculpture, many of which are still of primary artistic and historical importance'. Walden's activities extended also to publishing art books and portfolios of prints, organizing lectures and discussions, and experiments with Expressionist theatre. In 1932 he left Germany because of the economic depression and the rise of Nazism and moved to the Soviet Union, where he is said to have died as a political prisoner in 1941.

Sturm, Helmut See SPUR.

Štyrský, Jindřich See TOYEN.

Subjects of the Artist School A short lived (1948–9) school at 35 East 8th Street, New York, aimed at promoting avant-garde art, especially *Abstract Expressionism (the name was intended to convey the idea that there was meaning in abstract art). The founders were William *Baziotes, David *Hare, Robert *Motherwell, Barnett *Newman, and Mark *Rothko. They organized lectures that were open to the public, the speakers including *Arp, *Cage, *de Kooning, *Glarner, *Gottlieb, and *Reinhardt. The lectures were well attended, but the school failed financially and closed in spring 1949. Later that year the venue was taken over by three professors from New York University's School of Education, who under the name Studio 35 used it as studio and exhibition space for their students. Studio 35 also continued the tradition of lectures, but it too was short-lived, closing in spring 1950. The most important consequence of the Subjects of the Artist School was that it

was the cradle of 'The Club', a loose-knit discussion group for artists and writers that was founded in 1949 and met weekly during the 1950s.

Suh Do-Ho (1962–) Korean installation artist, born in Seoul, the son of **Suh Se Ok** (1929–), a leading painter who pioneered the merging of traditional Korean and modern art. Do-Ho Suh studied Eastern painting at Seoul National University in the early 1980s, a period the artist has described as 'a turbulent, militaristic time in Korea' (*Artkrush*, 1 October 2008). After performing obligatory military service he left Seoul in 1992 to study in America at the Skowhegan School of Painting, the Rhode Island School of Design, and Yale University. He now lives in Seoul and New York. His work frequently comments on the conformity of Korean society. The installation mounted in 1998 at Lehman Maupin Gallery, New York entitled *High School Uniform* was an ensemble of the military-style uniforms, regulated by law and first imposed during the Japanese occupation (1910–45), compulsory in schools during Suh's youth. They were joined at the shoulders, forming the impression of hollow bodies, compared by M. Kwon, a Korean art critic who experienced the educational system herself, to 'a massive scarecrow' (*Frieze*, January–February 1998). Elsewhere, Suh has made works on the theme of architectural space. *Seoul Home/LA Home/New York Home/Seattle Home* (1999, Museum of Contemporary Art, Los Angeles) is a reconstruction in diaphanous silk of the artist's home in Korea. In *Fallen Star* (2008), exhibited at the 2008 Hayward exhibition 'Psycho Buildings', a traditional Korean house crashes into the corner of an American brownstone building. The artist has commented on the 'distinct separation between nature and the artificial space' in Western architecture in contrast to the sense 'that architecture is very porous' in Korea. He represented Korea at the 2001 Venice *Biennale.

Süli, András (1897–1969) Hungarian *naive painter, born in Algyö. A basket-weaver by trade, he began to paint in 1933, but in 1938, disappointed at lack of recognition, he burned most of his pictures and abandoned art. It was not until the 1960s that he was 'discovered'; in 1969, the year of his death, several of his pictures were shown at the First Triennial Exhibition of Naive Art in Bratislava. Since then his

work has been included in a number of international exhibitions of naive art and he has won a reputation as Hungary's leading naive painter. Only about thirty of his pictures are known to exist. They are based on the world around him (domestic scenes, farm life, and so on), brightly coloured with the flat decorative quality of a child's sampler.

Sultan, Donald *See* NEW IMAGE PAINTING.

Superflat *See* MURAKAMI, TAKASHI.

Superrealism Style of painting (and to a lesser extent sculpture), popular particularly in the USA and Britain in the 1970s, in which subjects are depicted with a minute and impersonal exactitude of detail. Hyperrealism and Photographic Realism (or *Photorealism) are alternative names, and some artists who practise the style do indeed work from photographs (sometimes using colour slides projected on the canvas); sharpness of detail is evenly distributed over the whole picture (except where out-of-focus effects in the photograph are faithfully recorded), but the scale is often greatly enlarged, as when portrait heads are blown up to giant size. (Some critics prefer to use the terms 'Photographic Realism' or 'Photorealism' only when a picture has been painted direct from a photograph, but most are not so restrictive.)

The immediate progenitor of Superrealism was *Pop art: banal subject-matter from the consumer society was common to both, and certain artists, such as Malcolm *Morley (who suggested the name Superrealism) and Mel *Ramos, overlap both fields. The kind of humour found in Pop is very rare in Superrealism, however, which tends to be cool and impersonal, with subjects often chosen because they are technically challenging (involving multiple reflections, for example). Like Pop, Superrealism was a commercial hit and it achieved for a time a popularity with the public and collectors far beyond contemporary movements such as *Conceptual and *Minimal art. Peter *Ludwig, for instance, formed a substantial collection. Some critics, however, regarded it as involving a great deal of painstaking work but very little else; others think that its exponents can achieve a strange kind of intensity, the effect of the indiscriminate attention to detail being—somewhat paradoxically—to create a strong feeling of unreality.

The leading American Superrealist painters include: Chuck *Close; Robert Cottingham (1935–), whose most characteristic works are close-ups of advertising signs and who says he aims for 'a detached unsentimental observation of a piece of our world'; Don *Eddy; Richard *Estes; Audrey Flack (1931–), who is unusual in that she aims for emotional effect in her still-lifes of religious symbols and images of vanity and death; and Howard Kanovitz (1929–2009), whose work used figures that appear to have been cut out and pasted on a background. Painters who are often labelled Superrealist but who stand somewhat apart because of the imaginative element in their work are Jack *Beal, Alfred *Leslie, and Philip *Pearlstein.

British Superrealist painters include Graham Dean (1951–), Michael English (1943–), David Hepher (1935–), Diane Ibbotson (1946–), Michael Leonard (1933–), whose work includes highly detailed portrait drawings in a style mimicking the Old Masters, and John *Salt.

Although it is particularly associated with the USA and Britain, Superrealism has spread to other countries. Claude Yvel (1930–), who specializes in paintings of motorcycles, is a noted French exponent, for example; in Germany there is the work of Gerhard *Richter; and the *Spanish Realists are sometimes described as Superrealists.

The leading Superrealist sculptors have been the Americans John *De Andrea and Duane *Hanson, whose work often uses real clothes or props and shows attention to minutiae such as body hair. The British sculptor John *Davies is sometimes called a Superrealist, but his work is too fantastic for this label.

In the 1930s the term 'Superrealism' was occasionally used as an alternative to *Surrealism, but this usage has died out.

Further Reading: E. Lucie-Smith, *Superrealism* (1979)

Supports-Surfaces A group of French painters, active from 1967 to 1972, who in reaction against *Conceptual art and other avant-garde forms of expression, placed emphasis on the practice and materials of painting. They held several exhibitions (the first to use the group name was at the Musée d'Art Moderne de la Ville de Paris in 1970), and in 1971 they founded a journal, *Peinture, cahiers théoriques*, as their mouthpiece. While their theorizing was highly elaborate, involving notions of class struggle as well as technical

matters, their paintings tend towards bland abstraction. The leading figures in the group included Daniel Dezeuze (1942–), Patrick Saytour (1935–), and Claude Viallat (1936–).

Suprematism A Russian abstract art movement, created by and chiefly associated with *Malevich. He claimed that he began Suprematism in 1913, but he coined the name in 1915 in a pamphlet manifesto accompanying the exhibition in Petrograd (St Petersburg) at which the movement was officially launched: '0.10: The Last Futurist Exhibition' (*see* POUGNY). The pamphlet was originally called *From Cubism to Suprematism in Art, to New Realism in Painting, to Absolute Creation*, but it was republished in expanded form the following year as *From Cubism and Futurism to Suprematism: The New Realism in Painting*. As these titles suggest, Malevich acknowledged a debt to *Cubism and *Futurism, but he aimed to go beyond them in abandoning all reference to the visible world and expressing the supremacy of pure form: 'Suprematism is the rediscovery of pure art which, in the course of time, had become obscured by the accumulation of "things".' His Suprematist paintings were indeed the most radically pure abstract works created up to that date, for he limited himself to basic geometric shapes—the square, rectangle, circle, cross, and triangle—and a narrow range of colours. Malevich divided the development of Suprematism into three stages, black, coloured, and white. The last of these was manifested in a series of white on white paintings (*c.*1918) which stood for an extinction of colour and 'pure action'. In 1920 he announced that 'Painting has long since been overcome' and charged architects with the development of the Suprematist system. However, he continued to make occasional Suprematist paintings during the 1920s.

In his original manifesto Malevich wrote that 'Forms must be made which have nothing in common with nature', but also that he sought through Suprematism 'a world in which man experiences totality with nature'. He stated that 'The Suprematists have deliberately given up the objective representation of their surroundings in order to reach the summit of the "unmasked" art and from this vantage point to view life through the prism of pure artistic feeling'. Malevich, as well as other artists, applied Suprematist designs to functional objects, such as textiles and pottery. However, he rejected the idea of the 'culture of

materials' associated with *Tatlin, maintaining the primacy of form over matter. Malevich's work was influential for a time even on materialistically minded artists such as El *Lissitzky and Alexander *Rodchenko. Suprematism, indeed, made a powerful impact on the avant-garde in Russia until the Soviet regime demanded work that was socially useful (*see* CONSTRUCTIVISM) and later had great influence on the development of art and design in the West.

Surrealism Artistic, political, and literary movement which originated in Paris during the 1920s and has had an enormous impact on culture ever since. It went through too many changes to be defined in terms of a single style, but the fundamental feature was an engagement with Sigmund Freud's ideas of the unconscious (*see* PSYCHOANALYSIS). Freud believed that there was a deep-rooted conflict between the desires of the unconscious and the need to live in a socialized world. Whereas he sought, as far as possible, to heal the rift between the unconscious and society, Surrealism saw in his theories a basis from which that society could be attacked. Therefore Surrealism was not just a movement in art, and an understanding of Surrealism often requires the spectator to consider its products from a more than aesthetic point of view. The poet André *Breton, the group's guiding figure, wrote that 'the movement's main ambition is to produce a general *crisis of consciousness* both in the intellectual and moral realm' (*Second Surrealist Manifesto*, 1929).

Surrealism grew out of *Dada, as it had developed in Paris in the early 1920s. It became apparent to Breton and others that Dada's nihilism had reached a point where it could no longer take even itself seriously and that therefore any critical power it might have was fatally blunted. The Surrealist movement was officially launched by Breton in 1924. In that year he published the first *Surrealist Manifesto*, originally conceived as a preface to a text entitled *Soluble Fish*. Like much of Breton's writings, the manifesto presents difficulties for the reader, but it also provides a kind of point of rest within its polemics where Breton provides an unequivocal statement. Dictionary-fashion, he defines 'Surrealism' as 'pure psychic *automatism'. In later theory and practice, this definition was to be both refined and extended, but at this point Breton saw it in

terms of the 'automatic writing'—*Soluble Fish*
was an example—on which he and fellow poet
Philippe Soupault (1897–1990) had been en-
gaged. This was a device to enter the world of
dream and the imagination which, according
to Breton, had been opened to investigation to
an unprecedented extent by the discoveries of
Freud. A more general account of the state of
mind that Surrealism was trying to induce
comes from this recollection of his first Surre-
alist experience. 'It was in 1919 and in com-
plete solitude and at the approach of sleep,
that my attention was arrested by sentences
more or less complete, which became percep-
tible to my mind without my being able to
discover . . . previous volitional effort'. The
name 'Surrealist' was chosen in homage to
the recently dead Guillaume *Apollinaire,
who had used the term to describe his play
Les Mamelles de Tirésias. Generally, in spite of
Breton's enthusiasm for the visual arts, it was
literature which at this stage provided the
main point of reference. The Surrealists ad-
mired especially the writings of the Comte de
Lautréamont (Isidore Ducasse, 1846–70),
whose prose poem *Les Chants de Maldoror* is
full of violence, irrationality, and blasphemy.
One phrase of Lautréamont, in particular, has
come to stand for what the Surrealists were
trying to achieve: 'Beautiful as the chance en-
counter of a sewing machine and an umbrella
on a dissecting table.'

A Bureau of Surrealist Research was formed
in 1924 to gather information on the workings
of the unconscious mind. At this time Breton,
who had a background in medicine, was con-
sidering Surrealism as a quasi-scientific activ-
ity. Also in that year, the journal *La Révolution
surréaliste* (twelve issues, 1924–9) was pub-
lished for the first time. In contrast to the
exuberant graphic design of *Dada publica-
tions, this deliberately took on the appearance
of a sober scientific journal. Breton had parti-
cipated in Dada manifestations in Paris and
was anxious to establish distance between
Surrealism and a movement which he now
saw as discredited. The journal published au-
tomatic texts and accounts of dreams and was
illustrated by photographs, drawings, and
paintings. All these had the status not so
much of works of art but as 'evidence' of ex-
ploration into the unconscious.

'Evidence' had already been provided for
Breton by the visual arts. When, for instance,
La Révolution surréaliste illustrated a painting
by Paul *Klee, the point was not so much to

say 'Klee is a Surrealist artist' but that the
painting, alongside the other visual material,
was proof of Surrealist activity. A series of
articles in the early issues of the journal were
to provide the basis for *Surrealism and Paint-
ing*, a book Breton continued to add to
throughout his life. The Cubism of *Picasso
represented for him neither a new kind of
realism nor a stepping stone to abstraction. It
was instead the path to a new liberty of seeing.
Breton, predictably, treats with withering sar-
casm the notion of a 'cubist discipline'.

Even before the first *Surrealist Manifesto*
there were other examples of proto-Surrealist
painting. Giorgio *de Chirico's mysterious
paintings of shadowy city squares, which had
already been championed by Apollinaire,
were admired by Breton. Certain paintings of
Max *Ernst, such as *Celebes* (1921, Tate),
which are very much an elaboration of his
Dada photomontages, are sometimes re-
garded as the first fully Surrealist works of
visual art. Both de Chirico and Ernst used
relatively conventional pictorial techniques to
make plausible the worlds of the irrational,
and this stylistic conservatism was to be a fea-
ture of some later Surrealist art. The Surrealist
paintings which followed the first *Surrealist
Manifesto* combined a degree of automatism
with a more structured approach. André *Mas-
son would frequently begin with an architec-
tural framework, an almost *Gris-like grid,
from which would emerge fantastic images.
In Joan *Miró's paintings such as *Birth of the
World* (1925, MoMA, New York) apparently
random splashes of paint give rise to evocative
shapes. It is now known that these paintings of
Miró are less 'automatic' than one might as-
sume and that he worked from preparatory
drawings. Nonetheless they suggest a gateway
into a world of imagination and dream. Ernst
stimulated the imagination with rubbings of
uneven surfaces, the technique known as frot-
tage. Lurking in those paintings there is fre-
quently an element of violent erotic fantasy. In
1926 a 'Galerie Surréaliste' opened on the left
bank in Paris, so establishing Surrealism as an
artistic movement, however much some of its
adherents might deny it.

Both artistically and ideologically, Surreal-
ism was initially at odds with the post-war era
in France. After the militant secularism of the
pre-war Third Republic, the French state in
war time had sidled up to the Catholic Church.
The Surrealists were vehemently atheist
and blasphemous: a famous image in *La*

Révolution surréaliste shows 'Our Collaborator Benjamin Péret Insulting a Priest'. Artistically, the early 1920s were generally marked by a return to classicism and a cult of order (*see* NEOCLASSICISM), not without a strong nationalist and conservative strain, which for a time even affected Picasso. In this context, Breton took the Surrealist movement increasingly from a generalized anti-authoritarian and libertarian stance to specific political commitment. The group protested against French imperialism in north Africa and in 1927 they announced their adhesion to the Communist party. The relationship would be a difficult one. Two of Breton's closest early allies, the poets Louis *Aragon and Paul *Éluard, would eventually renounce Surrealism for Communism.

This emphasis on political discipline was accompanied by a rethinking of the principle of automatism, which was to be redefined in the *Second Surrealist Manifesto* of 1929, in which there was a greater emphasis on social and political revolt. This followed a series of expulsions from the movement of those considered half-hearted in their attitude to collective action or too concerned with their artistic or literary careers. Among those expelled was André Masson, whose allegiance had shifted to Georges *Bataille, excoriated with special force in the second manifesto. Bataille, the editor of *Documents*, was very much a rival to Breton's leadership, and proposed a version of Surrealism based not so much on the imagination and dream as on base materialism. The expulsions and anathemas of 1929 have, more than anything else, given Breton a reputation for intolerance which, for some, sits at odds with the libertarian claims of the movement. He notoriously placed Surrealist purity above any personal friendship. Christopher Green has argued that Breton was influenced by the ruthless group discipline of the Communist Party and that 'He learned from the Party to treat others as they treated him'. After the Second Manifesto Breton wanted Surrealism to be 'occulted', making it available only to the most committed. *La Révolution surréaliste* was to be replaced by *Le Surréalisme au service de la révolution* (six issues, 1930–3), a far more austere publication with the visual material relegated to the back pages.

The events of 1929 revealed a tension central to Surrealism. 'Everything tends to make us believe that there exists a certain point in the mind at which life and death, the real and imagined, past and future, the communicable and the incommunicable, high and low cease to be perceived as contradictions' (*Second Surrealist Manifesto*). The motivation of Surrealism was 'the finding and fixing of this point'. The 'finding' might be achieved when the will was at its weakest. The 'fixing' was the result of control. The different manifestations of Surrealism need to be understood in terms of this dilemma.

'Finding' might be achieved as in the early days of Surrealism through automatic procedure and through dreams. It was essentially a passive process by which the Surrealist was 'open' to the discovery of 'that certain point'. Photography was important to Surrealism as a potential 'objective' evidence of that point. Breton's novel *Nadja* (1928) was illustrated by photographs, and photography was to become a significant form of Surrealist activity in the work of such figures as *Man Ray, Claude *Cahun, and Raoul *Ubac. The art historian Rosalind *Krauss has controversially argued that photography rather than painting should be seen as central to Surrealism.

Discovery of the point might also be sparked off by an *object, encountered in dreams, or perhaps in wandering about Paris (French Surrealism was uncompromisingly urban in its vision). One account by Breton conflates the two experiences as though there were no distinction between them. 'Thus recently, while I was asleep, I came across a rather curious book in the open-air market at Saint-Malo'; he goes on to describe the book with great precision, the spine being formed by 'a wooden gnome, whose white beard, clipped in the Assyrian manner, reached to his feet'. The finding and choosing of objects as an alternative to making them had been developed in *Dada, especially by Marcel *Duchamp, but whereas he claimed 'indifference', the point of the Surrealist object lay in its affective and psychic charge. The object might be found in a flea-market, like the spoon ending in a shoe, photographed by Man Ray, or it might be constructed. Some of the early works of *Giacometti, associated with the movement in the early 1930s, should, for all the technical skill involved in their making, be thought of as 'objects' rather than sculptures in the normal sense of the term. Part of Dada's legacy to Surrealism was also this indifference to the traditional cult of painting. Louis Aragon wrote an essay entitled *A Challenge to Painting* in which he extolled the

S

*collages of Picasso and the *ready-mades of Duchamp. An exhibition of Surrealist objects was held in Paris in 1936.

The most dramatic event for visual Surrealism at the end of the 1920s was the arrival of Salvador *Dalí. Initially associated with the rival group around Bataille and *Documents*, he brought to Surrealism a dazzling technical skill, an extraordinary flair for publicity, and above all, an obsessive imagination. His paintings and flamboyant personality were increasingly to become the most public face of Surrealism, somewhat to the chagrin of Breton, who also strongly rejected his right-wing political stance, which included fascination with Hitler and support for Franco. Nonetheless Dalí's literal renderings of the dream experience, knowingly filtered through psychoanalytic theory, are now the movement's best known products.

In spite of Breton's authoritarian stance, the exact boundaries of Surrealism are not easy to draw. The Belgian Surrealist movement, with René *Magritte at its centre, operated in a largely independent manner and was more concerned to undermine the bourgeois sense of the real than to probe the unconscious. It also tended to be far more orthodoxly Stalinist in its political line. Other artists, like *Balthus, Paul *Delvaux, or Frida *Kahlo, have been claimed for Surrealism, were published in Surrealist journals, or admired by Breton, even if they did not necessarily subscribe to Surrealist thinking. Some publications, especially older ones, place Marc *Chagall within the orbit of Surrealism, although the religious nature of much of his work is quite foreign to Surrealist values and his work deals with nostalgia and conscious memories more than the dream. Two special cases were Picasso and Duchamp, figures for whom Breton had such high regard that they were exempt from the usual vitriolic criticism when they failed to support fully his position.

The movement's influence spread widely in the 1930s. This was partly achieved through Surrealist exhibitions, an especially important one taking place in London at the New Burlington Galleries in 1936 with the assistance of Herbert *Read and Roland *Penrose. Advanced British artists such as Paul *Nash and Henry *Moore were already influenced by Surrealism, but this exhibition, which coincided with increased political radicalization among the British avant-garde, brought wider public awareness of the ideology behind the art. Paradoxically, in Britain, this originally very urban movement led to new ways in representing the landscape. In a rather different category was the exhibition staged at the *Museum of Modern Art, New York, entitled 'Fantastic Art, Dada, Surrealism'. By incorporating Surrealism into a wider tradition of irrationality in modernist art, it provided an important alternative to the visions of the modern as abstract and mechanistic which had been presented by previous MoMA events such as 'Machine Art' and 'Cubism and Abstract Art', but it necessarily, and probably deliberately, diluted the political force of the movement. In 1938 the International Exhibition of Surrealism in Paris, a kind of environment in which the paintings were shown among coal sacks, brought further notoriety to the movement. Also significant in bringing Surrealism into the artistic mainstream was the journal *Minotaure* (1933–9), a far glossier affair than its predecessors and a publication which, to some extent, succeeded in reconciling Surrealism's warring factions. The political stance of Surrealism shifted during the decade. Breton broke with the Communist Party in the mid-1930s in protest against political repression in the Soviet Union, especially its imposition of *Socialist Realism, although he remained committed to Marxism and political revolt. He met the dissident Russian revolutionary Leon Trotsky in Mexico in 1938; the upshot was the publication of the *Manifesto: Towards a Free Revolutionary Art*. This was nominally signed by Breton and Diego *Rivera, although the real authors were Trotsky and Breton.

Paris remained the centre of Surrealism until the Second World War, when the emigration of many artists to the USA made New York its new hub. The exhibition 'First Papers of Surrealism' was held there in 1942. It had a spectacular *installation by Duchamp in which the entire room was criss-crossed by string, an early example of this form of art, and presented Surrealism as a very broad church indeed, with works by Chagall and even *Mondrian. Through the work of *Gorky and *Pollock, the process of 'automatism' became a crucial component of *Abstract Expressionism.

Surrealism lost much of its prestige in post-war Paris. Nonetheless, an exhibition at the Galerie *Maeght, Paris, in 1947, organized by Breton and Duchamp, reunited some of the original members. A further exhibition, dedicated to EROS, was held in

Paris in 1959; this included American artists such as Louise *Nevelson and Robert *Rauschenberg, to emphasize the continuing influence of the movement. Some of the most significant artists in post-war Paris, including Giacometti and *Dubuffet, had strong Surrealist backgrounds. The impact of Surrealism on younger Parisian artists could be found in the strange world evoked by semi-abstract means in the works of *Wols, Yolande *Fièvre, and Bernard *Réquichot, or the Yugoslav-born Dado (1933–), who transformed the traumatic memories of war into compositions in which human and animal, organic and inorganic, merge in an appropriately Surrealist manner. Surrealism did not so much die as fracture into a number of distinct tendencies and groupings, such as *COBRA and Lettrism, which itself became one of the sources of the *Situationist International. The artistic legacy of Surrealism can be found even today, for instance in the 'object sculptures' of Richard *Wentworth or the bizarre juxtapositions of images surviving from the wreckage of Communism in the paintings of Neo *Rauch.

The term 'surreal' has entered ordinary language as a way of describing anything strange. 'An almost surreal experience' is liable to be heard from members of the public in any news programme. This can lead to a simple equation between Surrealism and the unusual, which tends to obscure the real political and artistic force of the original movement. The moral and political dimension of Surrealism has remained controversial. Some feminist critics, such as Xavière Gauthier in her study *Surréalisme et sexualité* (1971), have alleged that Surrealist artists objectified women. In response to this, there has been considerable research into the contributions of women artists to the movement, although by and large these participated in the later stages and were not the innovators. Surrealist politics have continued to be debated with passion, as happened in the wake of an article by the French art historian Jean Clair (*Le Monde*, 21 November 2001), in which he accused the movement of complicity in the demoralization of the West. Written in the aftermath of the 11 September attacks on the World Trade Center in New York, this argument was widely condemned as ahistorical in its ignoring of the context of the anti-colonial politics of the inter-war period, but it did have the effect of taking Surrealism out of the realm of the high

cultural reliquary and drawing attention back to its iconoclastic origins.

Further Reading: Durozoi (2005)
Green (2000)
Krauss (1986)
Mundy (2000)

Surréalisme au service de la révolution, Le *See* SURREALISM.

Survage, Léopold (Léopold Sturzwage) (1879–1968) Russian–French painter. Born in Moscow of a Finnish mother and a Danish father, he began a course in architecture there, but in 1908 settled in Paris to study painting under *Matisse. However, he was more attracted by the *Cubists and exhibited with them at the *Salon des Indépendants in 1911. Survage became a minor but individual figure in the movement. He preferred townscapes to the more usual Cubist still-lifes and he had a curious spatial sense that gave his work a suggestion of mystery foreign to the more orthodox Cubist work. In the 1920s he abandoned Cubism and adopted a mild form of *Surrealism. He had a gift for large-scale decoration and in 1937 he painted three panels 20 metres long for the Railway Pavilion at the Paris Exposition Universelle, for which he was awarded a gold medal. After the Second World War he began painting abstracts. He was made a member of the Legion of Honour in 1963.

Sutherland, Graham (1903–80) British painter, printmaker, and designer, born in London, the son of a high-ranking civil servant. He abandoned an apprenticeship as a railway engineer to study engraving and etching at *Goldsmiths College, London, 1921–6, and up to 1930 he worked exclusively as a printmaker, specializing in landscape etchings in the visionary Romantic tradition of the 19th-century artist Samuel Palmer. From 1926 to 1935 he taught engraving at Chelsea School of Art, and from 1935 to 1940 he taught composition and book illustration there. In the early 1930s, following a decline in the market for prints, Sutherland began working in oils, and by 1935 he had turned mainly to painting. Again he initially concentrated on landscape, his paintings showing a highly subjective response to nature, inspired mainly by visits to Pembrokeshire, where he went every summer from 1934 until the outbreak of the Second World War. His landscapes are not topographical, but semi-abstract compositions of

haunting and monstrous shapes rendered in distinctive acidic colouring, evoking what he called the 'exultant strangeness' of the place (*Entrance to a Lane*, 1939, Tate). During the 1930s Sutherland also designed posters, and it was at an exhibition of posters in 1935 that his work first attracted the attention of Kenneth *Clark, who became an important patron, critical supporter, and close friend.

From 1940 to 1945 Sutherland worked as an *Official War Artist, mainly recording the effects of bombing: his poignant pictures of shattered buildings rank among the most famous images of the home front. Soon after the war he took up religious painting and portraiture, and it was in these two fields that he chiefly made his mark in his later career, showing his characteristic love of a fresh challenge: 'I have never disliked working outside my normal scope and it interests me to try and solve new problems.' His first religious work (or his first since student days) was a large and powerful *Crucifixion* (1946) for St Matthew's, Northampton (the commission was given to Sutherland when he was present at the unveiling of Henry *Moore's *Madonna and Child* in this church in 1944). Sutherland's first portrait was that of Somerset Maugham (1949, Tate), commissioned by the sitter. It has an almost caricature quality (Maugham's friend Sir Gerald *Kelly said it made him look 'like an old Chinese madam in a brothel in Shanghai'), and another famous portrait, that of Winston Churchill (1954), was so hated by the sitter (who thought it made him look 'half-witted') that Lady Churchill had it secretly destroyed. Sutherland's most celebrated work, however, has become widely popular—it is the immense tapestry of *Christ in Glory* (completed 1962) in Coventry Cathedral. In addition to such figure subjects Sutherland continued to paint landscapes—many of them inspired by the French Riviera, where he lived for part of every year from 1947—and late in his career he returned to printmaking, producing coloured lithographs. He was prodigiously hardworking, his output also including ceramics and designs for stage sets and costumes.

Sutherland was one of the most celebrated British artists of the 20th century and he received many honours, notably the Order of Merit in 1960. Douglas *Cooper described him as 'the most distinguished and the most original English artist of the mid-20th century'. He had a high reputation outside Britain: in 1952, for example, he had retrospectives at the

Venice *Biennale and the Musée National d'Art Moderne, Paris. Indeed in his later career he was generally more admired by foreign than by British critics, who tended to find his work old-fashioned. Even Cooper's support significantly diminished. A retrospective exhibition held at the Tate Gallery in 1982 tended to confirm the impression of a sharp decline in the quality of his work in later years.

Further Reading: R. Alley, *Graham Sutherland* (1982)
M. Hammer, *Graham Sutherland: Landscapes, War Scenes, Portraits* (2005)

Suvero, Mark di *See* DI SUVERO, MARK.

Svomas (Svobodniye gosudarstvenniye khudozhestvenniye masterskiye, Free State Art Studios) The name of art schools founded in several Russian cities, including Moscow and Petrograd (St Petersburg), after the 1917 Revolution. Their very liberal regimes soon resulted in chaos. The Moscow Svomas was founded in 1918 from an amalgamation of the Moscow School of Painting, Sculpture, and Architecture with the Stroganov Art School. In 1920 it was renamed *Vkhutemas. The Petrograd Svomas was created in 1919 from the Petrograd Free Art Educational Studios (Pegoskhuma), which had been formed a year earlier when the St Petersburg Academy was abolished. In 1921 the name reverted to Academy.

Sydney 9 *See* OLSEN, JOHN.

Sylvester, David (1924–2001) British writer, broadcaster, lecturer, and exhibition organizer. He was born in London, where he attended University College School. Although he won a place at Trinity College, Cambridge, he turned this down in favour of journalism, beginning his career with articles published in the left-wing journal *Tribune* in 1942. Subsequently he wrote for many other journals, including *Encounter*, *The Listener*, *The New Statesman*, *The Observer*, and *The Times*. Almost all his work on art was devoted to 20th-century topics ('I wish I had had the nerve to write more about old masters'), but he ranged widely within his chosen field. He also wrote on the cinema and sport—'two areas which had obsessed me from the time I was about eight'. From 1951 he organized many major exhibitions, including a retrospective of Henry *Moore's work at the Tate Gallery, London (he had previously spent a few months as Moore's part-time secretary

but said 'this had to stop because we spent too much time arguing about art').

This argumentative streak is best remembered by the lengthy debate over realism with John *Berger in the 1950s. Sylvester, strongly influenced by *Sartre's existentialism, admired artists such as Francis *Bacon who used the figure to communicate general ideas about the human condition. The Marxist Berger demanded that the specific social circumstances be shown, so he supported the painters whom Sylvester had contemptuously christened the *Kitchen Sink School.

Sylvester was a visiting lecturer at the *Slade School, 1953–7, and at the *Royal College of Art, 1960–70, and he made several films and many radio broadcasts including interviews with artists. Some of these interviews have been printed as articles or in exhibition catalogues, and those with Bacon (who became a close friend) were made into a book, *Interviews with Francis Bacon* (1975, enlarged edn, 1980). His other books include two monographs on *Magritte (1969 and 1992), and he was editor and co-author with Sarah Whitfield of a five-volume catalogue raisonné of Magritte's work (1992–97). This took him, with interruptions, twenty-five years. Afterwards he wondered whether, like Proust's Swann, he had not spent years of his life on someone who was not 'his type'. Sylvester is admired for his lively and accessible style, which is well illustrated in *About Modern Art: Critical Essays 1948–1996* (1996, revised edn, 1997). Unlike many critics, he did not become disenchanted with contemporary art as he grew older: one of his last projects was an interview with the *Video artist Douglas *Gordon.

Further Reading: J. Hyman, *The Battle for Realism* (2001)
L. Jobey, obituary, *The Guardian* (20 June 2001)

Symbolism A loosely organized movement in literature and the visual arts, flourishing *c.*1885–*c.*1910, characterized by a rejection of direct, literal representation in favour of evocation and suggestion. It was part of a broad anti-materialist and anti-rationalist trend in ideas and art towards the end of the 19th century and specifically marked a reaction against the naturalistic aims of *Impressionism. Symbolist painters tried to give visual expression to emotional experiences, or as the poet Jean Moréas put it in a Symbolist Manifesto published in *Le Figaro* on 18 September 1886, 'to clothe the idea in sensuous

form'. Just as Symbolist poets thought there was a close correspondence between the sound and rhythm of the words they used and their meaning, so Symbolist painters thought that colour and line in themselves could express ideas. Symbolist critics were much given to drawing parallels between the arts, and *Redon's paintings, for example, were compared with the poetry of Baudelaire and Edgar Allan Poe and with the music of Claude Debussy. Many painters were inspired by the same kind of imagery as Symbolist writers (the *femme fatale* is a common theme), but *Gauguin and his followers (*see* SYNTHETISM) chose much less flamboyant subjects, often peasant scenes. Religious feeling of an intense, mystical kind was a feature of the movement, but so was an interest in the erotic and the perverse: death, disease, and sin were favourite subjects. Stylistically, Symbolist artists varied greatly, from a love of exotic detail to an almost primitive simplicity in the conception of the subject, and from firm outlines to misty softness in the delineation of form. A broad tendency, however, was towards flattened forms and broad areas of colour—in tune with wider tendencies in advanced art.

Although chiefly associated with France, Symbolism had international currency, and such diverse artists as *Hodler and *Munch are regarded as part of the movement in its broadest sense. Symbolist sculptors include the Belgian Georg *Minne and the Norwegian Gustav *Vigeland. George Heard *Hamilton comments that 'the Symbolists, by freeing painting from what Gauguin called "the shackles of probability", created the philosophical as well as practical premises for much twentieth-century art'.

Synchromism An abstract or semi-abstract movement in painting, closely related to *Orphism and founded in 1912 by Stanton *Macdonald-Wright and Morgan *Russell, two young American artists living in Paris. The term, meaning literally 'with colour' or 'colours together', was coined by Russell on the analogy of 'symphony'. As it suggests, he and his colleague were primarily interested in the abstract use of colour (they met in 1911 when studying colour theory with the Canadian painter Percyval Tudor-Hart (1873–1954)). In 1912 Russell said that he wished to do 'a piece of expression solely by means of colour and the way it is put down in showers and broad patches, distinctly separated from each

other, or blended... but with force and clearness and large geometric patterns'. Similarly, Macdonald-Wright said 'I strive to divest my art of all anecdote and illustration and to purify it so that the emotions of the spectator can become entirely "aesthetic", as in listening to music'. The Synchromists were influenced by scientific writings on optics and by the paintings of the *Neo-Impressionists and *Fauves; they were working in a similar direction to the Orphists but fairly independently. Compared with most other pioneer abstractionists, they were scientifically minded in their choice of colours, relying more on predetermined scales of colour than on intuition.

Russell's *Synchromy in Green* (destroyed), exhibited at the *Salon des Indépendants in 1913, was the first painting to bear the Synchromist name. Later that year Russell and Macdonald-Wright exhibited together at the Neue Kunstsalon, Munich (June), and then at the Galerie *Bernheim-Jeune, Paris (October). At both exhibitions they issued a brash manifesto in which they claimed that 'it is the quality itself of form that we try to explain and reveal by colour, and for the first time colour appears in that role'. They argued that, in contrast to theirs, Orphist paintings were purely decorative and did not express volume, a distinction not registered by most critics of the period who were inclined to dismiss them as followers of their European counterparts. The First World War separated the founders of Synchromism (Macdonald-Wright moved to London and Russell stayed in Paris), but they exhibited together at the Carroll Galleries, New York, in 1914, and their work influenced a number of American painters over the next few years. Among them were Thomas Hart *Benton (who sometimes used the word 'Synchromy' in the title of his paintings) and Patrick Henry *Bruce.

Synthetism Term applied to a manner of painting associated with *Bernard, *Gauguin, and their associates at Pont-Aven in Brittany. It involved the simplification of forms into large-scale patterns and the expressive purification of colours. Bernard believed that form and colour must be simplified for the sake of more forceful expression. 'Anything that overloads a spectacle... occupies our eye to the detriment of our minds. We must simplify in order to disclose its [i.e. Nature's] meaning... reducing its lines to eloquent contrasts, its shades to the seven fundamental colours of the prism.' Gauguin too spoke much of 'syn-

thesis', by which he meant a blending of abstract ideas of rhythm and colour with visual impressions of nature, and he advised his disciples to 'paint by heart' because in memory coloured by emotion forms became more integrated and meaningful. Bernard and Gauguin each claimed credit for developing Synthetism. It is likely that it was Bernard who provided a theoretical rationale for Gauguin's intuitions while it was Gauguin, by far the superior painter, who gave the theory brilliant visual expression. Synthetism was at its most vital between about 1888 and 1894, but some artists working at Pont-Aven continued the style well into the 20th century.

Systemic art Term coined by the critic Lawrence *Alloway in 1966 to refer to a type of abstract art characterized by the use of very simple standardized forms, usually geometrical in character, used either in a single image or repeated in a pattern arranged according to a clear principle of organization. Alloway originated the term when he organized an exhibition called 'Systemic Painting' at the *Guggenheim Museum, New York, in 1966; the artists represented—all American—included Al *Held, Ellsworth *Kelly, Kenneth *Noland, Larry *Poons, and Frank *Stella. Systemic art has been described as a branch of *Minimal art, but Alloway extended the term to cover *Colour Field Painting.

Systems Group *See* CONSTRUCTIVISM.

Sze, Sarah (1966–) American sculptor and installation artist. Born in Boston, she lives in New York. She creates installations made from delicately balanced accumulations of household objects. The critic Eliza Williams describes the effect as 'inviting the viewer to look closely but certainly not touch—for fear of bringing the entire ensemble crashing to the ground' (*Art Monthly*, November 2007). These installations are usually achieved on site. Her public project *Corner Plot* commissioned by the Public Art Fund was mounted in a plaza outside Central Park, New York, in 2006. It appeared that a building identical in design to a nearby white brick apartment block had sunk into the pavement. Through the windows could be seen an interior vista which appeared to have been colonized by objects.

(⊕) SEE WEB LINKS

• Article on *Corner Plot* on the Public Art Fund website.

Szeemann, Harald (1933–2005) Swiss curator, art historian, and critic. He is frequently credited with being the first to make a career of being an 'independent curator', unattached to any institution and using the curating of exhibitions as a creative form of criticism. In 1961 he was appointed director of the Berne Kunsthalle, where in 1968 he permitted *Christo and Jeanne-Claude to achieve their first wrapping of a public building. In 1969 he staged the famous exhibition 'When Attitudes Become Form: Live in your Head' which brought together *Conceptual, *Process, and *Minimal art: this subsequently travelled to London. Following the success of this event, Szeemann boldly resigned his post in Berne and became a freelance curator, a hitherto unknown profession. In this capacity he organized *documenta 5 in 1972, probably still the most famous of this long-running series of exhibitions, and established a pattern, now common in the exhibition and criticism of contemporary art, of bringing artists together according to theme rather than nationality or style, a mode which, he admitted to an interviewer in 1994, eventually became a convention of its own to be resisted. He continued this pattern throughout his career, which included curating the Venice *Biennale in 1999 and 2001. The first of these was of special significance in that it introduced to the Western art world important new Chinese artists. His obituary by Marcia Vertrocq (*Art in America*, April 2005) describes him as 'ever animated and open-minded' and points out that 'Szeemann's generous legacy includes no style name, no catchphrase, no "post"- or "neo"-anything that would corral or impede the unfolding of the new in art.'

Further Reading: J.-P. Bordaz, 'Entretien', in Centre Georges Pompidou, *Hors Limites* (1994)

Szénes, Arpad *See* VIEIRA DA SILVA, MARIA ELENA.

Taaffe, Philip *See* NEO-GEO.

Tabrizian, Mitra Iranian photographer and film-maker, born in Tehran. In 1977 she moved to London, where she has worked ever since, although she has said that she has never felt part of the British art scene, as there is more interest in her work elsewhere. Her *Border* series of photographs deals specifically with Iranian exiles in London. Although they have a documentary element and are accompanied by the stories of the individuals involved, the style of the photographs is highly formalized. Other photographs have been inspired by the French philosopher Jean *Baudrillard's vision of a society of simulation in which nothing is real any longer, although, unlike those artists and theorists of the 1980s who embraced these ideas with enthusiasm, she is concerned with the human cost of the situation. One photograph from the series *Beyond the Limits* (2000–01) shows recognizable art world figures furiously networking at an opening without noticing the complete disappearance of the art from the walls.

Further Reading: M. Tabrizian, *This is the Place* (2008)

Tachisme (Tachism) A style of abstract painting popular in the late 1940s and the 1950s characterized by the use of irregular dabs or splotches of colour ('tache' is French for spot or blotch). The term was first used in this sense in about 1951 (the French critics Charles Estienne and Pierre Guéguen have each been credited with coining it) and it was given wide currency by Michel Tapié in his book *Un Art autre* (1952). In its intuitive, spontaneous approach, Tachisme has affinities with *Abstract Expressionism (although initially it developed independently of it), and the term is often used as a generic label for any European painting of the time that parallels the American movement. However, Tachisme was primarily a French phenomenon (associated particularly with the *École de Paris)

and Tachiste paintings are characteristically more suave, sensual, and concerned with beautiful handling ('belle facture') than the work of the Abstract Expressionists, which can be aggressively raw in comparison. Leading exponents of Tachisme include Jean *Fautrier, Georges *Mathieu, and Pierre *Soulages, together with Hans *Hartung and *Wols, who were German-born but French-based.

The terms 'abstraction lyrique' (*Lyrical Abstraction), *'Art Autre (other art), and *'Art Informel' (art without form) are often used more or less synonymously with Tachisme, although certain critics use them to convey different nuances, sometimes corresponding with niceties of theory rather than observable differences in practice. It seems reasonable, however, to regard Tachisme as one aspect of the broader notion of Art Informel. (To add to the confusion of terminology, the word 'tachiste' was used differently in the 19th century, being applied pejoratively to the *Impressionists.)

Taeuber-Arp, Sophie (née Taeuber, Tauber) (1889–1943) Swiss designer, textile artist, painter, sculptor, and editor, the wife and frequent collaborator of Jean *Arp. She was born at Davos and studied textile design at the School of Art in St Gallen, 1908–10. After continuing her studies in Munich (where she also trained as a dancer) and in Hamburg, she taught weaving and textile design at the School of Arts and Crafts in Zurich from 1916 to 1928. She met Arp in 1915 and they evidently fell in love at first sight, although they did not marry until 1922. From 1915 until Arp's departure for Cologne in 1919 they collaborated on works of various kinds—mainly abstract collages—and were leading lights of the *Dada movement in Zurich. Arp wrote that 'In 1915 Sophie Taeuber and I carried out our first works in the simplest forms, using painting, embroidery and pasted paper', and he often paid tribute to the inspiration she gave

him: 'It was Sophie Taeuber who, through the example of her clear work and her clear life, showed me the right way, the way of beauty.' Herbert *Read defined the difference in their personalities and approach thus: 'Her ideal was always clarity. But Arp, early in his Dada days, discovered "the law of chance", the part that could be played in art by the unconscious' (*Arp*, 1968). Sophie played an important part in Arp's career not only because of artistic stimulation, but also because in the 1920s her income from teaching and design (including clothes and jewellery) was their chief means of support.

In 1927–8 the Arps collaborated with van *Doesburg on the decoration of the Café Aubette in Strasbourg, then settled at Meudon, near Paris, living there from 1928 to 1940. They were members of the abstract groups *Cercle et Carré and *Abstraction-Création, and Sophie founded and edited a periodical of abstract art, *Plastique*, of which five numbers appeared in 1937–9, published in Paris and New York. The first number was devoted to *Malevich and the third to American art. The Arps left Meudon following the German invasion, and from 1941 to 1942 they lived at Grasse in southern France. In 1942 they fled to Switzerland, where Sophie died the following year in an accident, asphyxiated by fumes from a leaking stove. She was little known as a painter in her lifetime, but over 600 oils by her came to light after her death.

Taft, Lorado (1860–1936) American sculptor, writer, and teacher, born in Elmwood, Illinois. He studied at the École des *Beaux-Arts in Paris, 1880–86, and taught sculpture at the Art Institute of Chicago, 1886–1929. In his day Taft was well known for portraits and allegorical public sculpture, particularly fountains such as the Fountain of Time (Washington Park, Chicago, 1922), but he is now remembered mainly for his books, *The History of American Sculpture* (1903), the first comprehensive work on the subject, and *Modern Tendencies in Sculpture* (1921), in which he defended the academic tradition and attacked abstraction. Taft's studio in Chicago has been preserved as a national monument.

taille direct See DIRECT CARVING.

Takahashi, Tomoko (1966–) Japanese installation artist, born in Tokyo. She studied at *Goldsmiths College and the *Slade School and now lives and works in London. Her work consists of installations of accumulated detritus. While working on a project, she insists on being on site for twenty-four hours a day. Like *Schwitters and *Buren, she bases her practice on fusing the studio and the place of exhibition. She is actually highly selective in her obsessive collecting, tending to avoid objects with logos and powerful brand images. For an installation at the Serpentine Gallery in 2005, *my play station at the Serpentine*, she made it known that she was interested in collecting old games but not dolls. She also used items from the Royal Parks, including a rusty boat, various items from the gallery's stores, and refuse from renovation work at the nearby Victoria and Albert Museum. On the final day the public were invited to take part in the dismantling of the exhibition by taking objects home. Some find the sheer lack of any obvious narrative or logic in the installations frustrating. The critic Jonathan Jones went so far as to describe her career as a 'cruel joke played by the art world on someone you suspect may be a complete innocent' (*The Guardian*, 28 February 2005). However, Rochelle Steiner has argued that objects are not merely stacked up and points to the repetitive visual rhythms and use of sound and light as evidence of a subtle artistic organization.

Further Reading: R. Steiner, *Tomoko Takahashi* (2005)

Takamatsu, Jiro See HI-RED CENTER.

Takis (Panayotis Vassilakis) (1925–) Greek *Kinetic artist. He was born in Athens and was self-taught as an artist, making his first sculptures in 1946. Since 1954 he has lived mainly in Paris, although he has also spent a good deal of time in Athens. After a period making hieratic figures under the influence of early Greek art and *Giacometti, Takis began to introduce real movement into his sculpture with his 'Signals'. Initially, like *Signal: Insect Animal in Space* (1956, Tate), these were long wires with weighted heads which could move gently in response to air currents. There was a continuity of interest here, as Giacometti's work had been interpreted by Jean-Paul *Sartre as challenging the static conventions of traditional sculpture. In 1959 Takis exhibited for the first time sculptures in which objects were suspended in the air by magnetism. These were called by the critic Alain Jouffroy 'Télésculptures'. In November 1960, shortly after Yves *Klein made his famous leap into 'le Vide', Takis staged an event at the Iris *Clert

Gallery in which the poet Sinclair Beiles was suspended in space. Beiles read out a 'magnetic manifesto', in part a protest against nuclear weapons. Takis has subsequently elaborated the basic principle of the sculptural use of magnetism. Sometimes objects are simply suspended, sometimes they quiver gently. In the works most popular with spectators they swing and collide unpredictably. In one series, sound is introduced when a needle vibrates against a taut wire. In *Antigravity* (1969) the spectator is invited to participate by throwing nails at a magnetic target. Takis enthusiatically embraced the concept of *multiples, producing *Signals* with unpredictably flashing lights on the end of long stalks. The art historian Yves-Alain Bois has said of one of these works that 'it blinks at us as if trying to convey a message in Morse code sent from God knows where' (*Artforum*, November 2000). Takis has also incorporated music into his environments. Kinetic art is often regarded as the development of the logical *Constructivist strain in modern art. The work of Takis, like that of *Tinguely owes as much to the *Surrealist attempt to use vision to go beyond the visual and the rational.

Further Reading: Galerie Nationale du Jeu de Paume, *Takis* (1993)

Tal-Coat, Pierre (1905–85) French painter, born at Clohars-Carnoët, Brittany, of a family of fishermen. He was originally called Pierre Jacob, but he adopted the name Tal-Coat in 1926. After working as a blacksmith's apprentice and a lawyer's clerk, he was briefly employed moulding and painting ceramics in a pottery factory, but he was self-taught as an artist. From 1924 to 1926 he did military service in Paris and then moved to Doëlan, near Pouldu. He returned to Paris in 1931 and became a member of the *Forces Nouvelles group. In 1936–9 he did a series of powerfully expressive *Massacres*, based on incidents in the Spanish Civil War. They have something in common with *Picasso's *Guernica*, and Tal-Coat was strongly influenced by him at this time. In the early 1940s, however, his work changed direction radically, as he developed the type of picture for which he is best known: starting from the impression of a natural scene he took this to the point of abstraction, suggesting the interplay of light and movement without specific representation. In 1947 André *Masson introduced him to Chinese landscape painting, which subsequently influ-

enced his work. From the early 1950s his painting took on a mystical character. By this time he was a leading figure in the school of *Lyrical Abstraction that dominated the *École de Paris in the late 1940s and 1950s.

Taller de Gráfica Popular (TGP) A printmaking establishment founded in Mexico City in 1937 as 'a collective work centre' by three left-wing artists: Luis Arenal (1908–85), Leopoldo Méndez (1902–69), and the American Pablo O'Higgins (1904–83); the name means 'People's Graphics Workshop'. A short Declaration of Principles issued by the founders explained some of their aims and beliefs. They wanted to help 'the Mexican people defend and enrich their national culture' and believed that 'in order to serve the people, art must reflect the social reality of the times'. They aimed to 'co-operate professionally with other cultural workshops and institutions, workers' organizations, and progressive movements and institutions in general' and to 'defend freedom of expression and artists' professional interests'. The work of the TGP was part of a tradition of socially committed printmaking of which *Posada was the most famous representative and it paralleled the concerns of the contemporary Mexican muralists, *Orozco, *Rivera, and *Siqueiros. In the 1940s and 1950s there were usually about twelve to fifteen artists working at the TGP at any one time, teaching printmaking as well as producing their own work. They issued their prints as single images, in portfolios, or as posters. Various techniques were used, including lithography, but woodcut and linocut tended to be favoured because of their cheapness. The subject-matter included attacks on Fascism and the exploitation of the poor, and after the Second World War the TGP became involved in the government's literacy campaign. *See also* CATLETT.

Tamarind Lithography Workshop *See* PRINT RENAISSANCE.

Tamayo, Rufino (1899–91) Mexican painter, printmaker, sculptor, and collector, born at Oaxaca into a Zapotec Indian family. Apart from the trio of great muralists—*Orozco, *Rivera, and *Siqueiros—he was probably the most eminent Mexican artist of the 20th century, but his work was very different from theirs: he was concerned with pictorial values rather than with political messages. Although

he acknowledged the muralists' 'distinguished qualities', he thought that their desire 'to produce, above all, art that was Mexican, led them to fall into the picturesque, and be careless of the really plastic problems'.

Tamayo was orphaned when he was eleven and moved to Mexico City to live with an aunt and uncle. He attended drawing classes at the Academy of San Carlos, but he was essentially self-taught. In 1921 he was appointed chief of the department of ethnographic drawing at the National Archaeological Museum, where his duties included drawing works of Pre-Columbian art in the collection. From 1926 to 1928 he lived in New York, where he had his first one-man exhibition at the Weyhe Gallery in 1926. After his return to Mexico City, he taught under Rivera at the National School of Fine Arts and the Academy of San Carlos, 1928–30. At this time he was living with María Izquierdo (c.1902–55), whose paintings—mainly still-lifes in a richly coloured, almost *naive style—influenced his work. This was only one of many influences that Tamayo absorbed from modern European movements, particularly *Surrealism, as well as from native traditions. The individuality in his work comes partially from his powerful sense of colour and texture. From 1936 to 1950 Tamayo lived in New York, although he returned regularly to Mexico, and from 1957 to 1964 he lived in Paris, then settled permanently in Mexico. By this time he was internationally famous, with a list of major exhibitions and distinctions to his credit, including the Grand Prize for Painting at the 1953 São Paulo *Bienal. His work was varied in subject, including still-lifes, portraits (notably many of his pianist wife, Olga), nudes, animals, and scenes of the culture and myths of the Mexican Indians. He did several murals in Mexico, but usually worked on canvas affixed to the wall rather than in fresco. His work also included a large number of prints in various techniques and sculpture in bronze and iron. Some of his late sculptures were very large (*Conquest of Space*, 1983, San Francisco International Airport). Throughout his life Tamayo was an ardent collector. He donated his collections to his native city of Oaxaca to form museums of Pre-Columbian art (1974) and contemporary art (1981).

Tan, Fiona (1966–) Indonesian photographer and *Video artist, born in Pekan Baru. She emigrated to Australia as a girl and now

lives and works in Amsterdam. There is a strong anthropological dimension to her interests; the results can also be strikingly beautiful. Her best known work is *St Sebastian* (2001, Tate). This depicts the 'Toshiya' archery competition in Kyoto, held once a year for twenty-year-olds from all over Japan. Although men and women are involved, Tan shows only the latter in a kind of traditional rites of passage ceremony. It is presented as two parallel projections on different sides of the same screen. One shows the preparations and the other close-ups of the actual shooting. Her installation *Countenance* (2002) is both a homage and a critique of August *Sander's famous series of photographs of German society in the 1920s, using 16mm film to document contemporary inhabitants of Berlin.

Further Reading: M. Glover, 'Fiona Tan: The Truth About Human Nature', *The Independent* (15 April 2005)

Tanguy, Yves (1900–55) French-born painter who became an American citizen in 1948. He was born in Paris, the son of a naval officer, and was a schoolfriend of *Matisse's son Pierre, who later became his dealer in New York. In 1918 he joined the merchant navy, then did military service before returning to Paris in 1922. Whilst working at various odd jobs he began sketching café scenes that were praised by *Vlaminck, and in 1923 he decided to take up art seriously after being greatly impressed by the work of *de Chirico (he is said to have jumped from the platform of a moving bus, at the risk of serious accident, when he saw one of his pictures in a dealer's window). He had no formal artistic training. In 1925 he met André *Breton and joined the *Surrealist group. His work developed quickly and by the time of his first one-man exhibition, at the Galerie Surréaliste in 1927, he had already created a distinctive style. Characteristically he painted in a scrupulous technique reminiscent of that of *Dalí, but his imagery is highly distinctive, featuring marine or lunar-like landscapes whose ghostly plains are scattered with structures that suggest giant weathered bones arranged into fantastic pylons (he was fascinated by the kind of strange rock formations he saw in Africa during his merchant navy days). In 1939 Tanguy met the American Surrealist painter Kay *Sage in Paris; he followed her to the USA and they married in 1940. The couple lived first in New York and from 1942 at Woodbury, Connecticut. In that year his work was included in the 'Artists in Exile' exhibition at Pierre Matisse's gallery—a

show that helped to introduce the expatriate Surrealists to an American audience. After the Second World War he built up an international reputation: in 1953 he had one-man exhibitions in Paris, Milan, and Rome. In America his work continued in the style he had established before the war, but his pictures tended to become bigger and more boldly coloured.

Tanner, Henry Ossawa (1855–1937) American painter, born in Pittsburgh, one of the first African-American artists to achieve international success. He studied at the Pennsylvania Academy of Fine Arts and took drawing lessons from Thomas *Eakins. In 1891 he travelled to Paris, where he lived and worked for most of the rest of his life, except for a brief return to Philadelphia in 1893 when he exhibited what was to become his most famous painting, *The Banjo Lesson* (1893, Philadelphia Museum of Art). He explained his reasons for depicting the subject in these terms: 'To his mind many of the artists who have represented Negro life have only seen the comic, the ludicrous side of it and have lacked sympathy with and affection for the big warm heart within such a rough exterior.' As Frances Pohl points out, Tanner drew on the example of Rembrandt, painting the picture in a loose style so that the viewer will concentrate on the figures and their interaction rather than on incidental detail. She describes the banjo as 'a conduit, a connection from one generation to the next'. Subsequently Tanner concentrated on religious paintings. *Resurrection of Lazarus* (1896, Musée d'Orsay, Paris) won a gold medal at the Paris Salon in 1897. Tanner was the son of a bishop and his paintings of religious subjects have been related to the sermons of African-American preachers. His manner was very much in the Western academic tradition and towards the end of his life this earned him some criticism from Alain Locke (*see* HARLEM RENAISSANCE), who argued that 'the generation of Negro artists succeeding Mr. Tanner had only the inspiration of his greatness to fire their ambitions but not the guidance of a distinctive tradition to focus and direct their talents'.

Further Reading: F. Pohl, 'Black and White in America', in S. F. Eisenman (ed.), *Nineteenth Century Art: A Critical History* (1994)

Tanning, Dorothea (1910–) American painter, sculptor, designer, and writer, born at Galesburg, Illinois. Except for two weeks of classes at the Art Institute of Chicago in 1930 she was self-taught as an artist. In 1935 she settled in New York, where she worked at odd jobs (including being a model and film extra) to support herself whilst she learned about art by visiting galleries and reading voraciously. She was deeply impressed by the exhibition 'Fantastic Art, Dada, Surrealism' at the Museum of Modern Art in 1936 and this set her on the road as a painter. Her early work was in the hyper-realistic vein of *Surrealism; most characteristically she depicted the strange fancies of young girls in the creepy atmosphere of the Gothic novel (*Eine Kleine Nachtmusik*, 1943, Tate). In 1942 she met Max *Ernst at the Julien Levy Gallery (where she had her first one-woman exhibition two years later) and in 1946 she married him. Initially they divided their time between New York and Arizona, then from 1949 lived mainly in France, settling there in 1955. The work of her famous husband had virtually no influence on Tanning. She continued in her highly detailed style until the mid-1950s, when her work became semi-abstract, with mysterious imagery of an erotic or violent nature seen through a kind of subtly-coloured mist. In the 1960s she began to make Surrealist sculpture from textile materials. Her work also includes stage design and a novel entitled *Abyss* (1977). She was still painting into the 21st century but by then was concentrating more on writing. Her autobiography, *Between Lives: An Artist and Her World*, was published in 2002.

Taos Colony A loose group of American painters who worked in and around Taos, New Mexico, from about 1910. Taos, a community consisting of three villages (the biggest of which is San Fernando de Taos, generally known simply as Taos), was an early Spanish settlement and it has a picturesque atmosphere attractive to painters and writers. The painter most closely associated with the community was Ernest Blumenschein (1874–1960), who first visited it in 1897, later often spent the summer there, and settled permanently in 1919. Marsden *Hartley and John *Sloan were among the visitors in the 1920s. The Taos artists often depicted Indian life and their work also included landscapes and still-lifes, but no particular style was associated with the colony.

Tapié, Michel *See* ART AUTRE.

Tàpies, Antoni (1923–) The best-known Spanish painter to emerge in the period since

the Second World War. He was born in Barcelona and grew up in a cultured environment (his father was a lawyer and his mother came from a family of booksellers). From 1943 to 1946 he studied law at Barcelona University and he was largely self-taught as an artist. In 1948 he became a member of the avant-garde group *Dau al Set, and in 1950 he had his first one-man exhibition, at the Galeries Laietanes, Barcelona. He lived in Paris 1950–51 on a French government scholarship and has often returned there, but Barcelona has remained the centre of his activities. His early works were in a *Surrealist vein, influenced by *Klee and *Miró, but in about 1953, after turning to abstraction, he began working in *mixed media, in which he has made his most original contribution to art. He incorporated clay and marble dust in his paint and used discarded materials such as paper, string, and rags (*Grey and Green Painting*, 1957, Tate). By the end of the 1950s he had made an international reputation: in 1958, for example, he won first prize for painting at the *Carnegie International in Pittsburgh and the UNESCO and David E. Bright prizes at the Venice *Biennale. From about 1970 (influenced by *Pop art) he began incorporating more substantial objects into his paintings, such as parts of furniture. He explained his belief in the validity of commonplace materials in his essay *Nothing is Mean* (1979). Tàpies has travelled extensively and his ideas have had worldwide influence. Apart from paintings, he has also made sculpture, etchings, and lithographs. There is a foundation dedicated to his work in Barcelona.

Further Reading: B. Catoir, *Conversations with Antoni Tàpies* (1991)

Tappert, Georg *See* MORGNER, WILHELM.

Tarbell, Edmund C. *See* TEN, THE.

Target exhibition Exhibition organized in Moscow by *Goncharova, *Larionov, and *Malevich in March 1913 at which *Rayonism was launched. Malevich also showed paintings in his *Cubo-Futurist style.

Tarsila do Amaral *See* AMARAL, TARSILA DO.

Taslitzky, Boris (1911–2005) French painter. He was born in Paris, the son of Russian political refugees who had left after the abortive 1905 revolution. A political militant, in 1933 he joined the Association of Revolutionary Writers and Artists and in 1935 the French Communist Party. He responded to the demands of the Communist writer Louis *Aragon for a 'revolutionary romanticism' in his painting *The Strikes of May 1936* (1936, Tate), which celebrated the strikes which followed the election of the Popular Front government. Christopher Green has stated that such paintings contributed to the 'folklore' around the mass industrial action of that time. In November 1941 Taslitzky was arrested and later was sent to the concentration camp at Buchenwald, where he made clandestine drawings. These were published in 1946 as *111 Drawings from Buchenwald*. After the war he initially painted in a highly photographic manner, following closely *Socialist Realist prescription, as in *Les Délégués* (1948) depicting miners who had been involved in the strikes of that year. *The Death of Daniele Casanova* (1950; 1949 study in Tate) showed the death of the wife of a Communist party official like a secular Pietà. At the Salon d'Automne in 1951, *Riposte* (Tate), which depicted striking dockers in Marseilles, was removed by the police. In 1952 he travelled to Algeria, then still a French colony, to make paintings exposing the poor conditions under which the people lived.

((🌐)) SEE WEB LINKS

• M.-J. Sirach, 'A time when Boris Taslitzky drew the unspeakable', in *L'Humanité* (12 December 2005).

Tate (formerly *Tate Gallery*), London The national collection of British painting from the mid-16th century onwards and of modern art from *c.*1900 to the present day. It is named after Sir Henry Tate (1819–99), the sugar tycoon, who in 1889 offered the nation his collection, consisting mainly of the work of Victorian contemporaries, on condition that the government found a suitable site for the gallery. Following great controversy over where it should be located, the Tate Gallery opened at Millbank, overlooking the Thames, in 1897, on a site previously occupied by part of Millbank Prison. The building is an undistinguished classical structure designed by Sidney R. J. Smith, an architect who is otherwise virtually unknown. It originally had eight galleries and housed Tate's gift of sixty-seven paintings and three bronze sculptures, together with about 100 other works, including eighteeen of his own paintings presented by

George Frederic Watts (1817–1904), the Grand Old Man of British art.

At the time of its opening, the Tate was not the independent gallery that had been envisaged by its founder. It was subordinate to the National Gallery and was intended only for recent British art (its official title was the National Gallery of British Art, although it was referred to as the Tate Gallery from the beginning and this name was formalized in 1932). Complete independence from the National Gallery did not come until 1954, but the Tate was given its own board of trustees in 1917, by which time it had begun to take on its dual character of historical British collection and general modern collection. Two key developments in this respect were: first, the opening of a wing in 1910 to accommodate most of the paintings left by J. M. W. Turner in his studio at his death (1851), which had previously been housed (but in the main unexhibited) at the National Gallery; and secondly, the deliberations of the Curzon Committee (chaired by Lord Curzon), set up in 1911 to enquire into various matters concerned with the nation's art collections. The committee published its report in 1915, and two of its recommendations were that the Tate should extend its coverage to become 'a National Gallery of British Art in all its branches' and that a gallery of modern foreign art should be added on vacant land behind the Tate. Caution was expressed, however, over what kind of modern art should be displayed there: 'We have not in our mind any idea of experimentalising by rash purchase in the occasionally ill-disciplined productions of some contemporaneous continental schools, whose work might exercise a disturbing and even deleterious influence upon our younger painters.'

The Curzon Committee's report happily coincided with Sir Hugh *Lane's bequest of thirty-nine modern paintings, mainly French, including outstanding *Impressionist works. Lane's collection went on show at the Tate in 1917 and made a powerful impact on Samuel *Courtauld, who in 1923 gave the Tate £50,000 for the purchase of Impressionist and *Post-Impressionist pictures. Thanks to Lane and Courtauld, the Tate had an excellent representation in this field by the time the new galleries for the display of modern foreign art opened in 1926 (they were paid for by the picture dealer Sir Joseph Duveen (1869–1939), later Lord Duveen of Millbank). The first significant influx of 20th-century art came in 1933, with the

bequest of the Dutch-born collector Frank Stoop, which included works by *Braque, *Cézanne, *Matisse, *Modigliani, *Picasso, and *Rousseau. However, Stoop's taste was generally confined to the period before the First World War, and when an abstract by *Kandinsky (*Cossacks*, 1910–11) was presented to the Tate in 1938 (by Hazel McKinley, Peggy *Guggenheim's sister), Kandinsky remarked that it was 'the first truly modern painting in the famous museum in London'. (It was also the first German *Expressionist painting to enter a public collection in Britain.)

During the Second World War the Tate concentrated on building up the British collections (an understandable policy at a time of patriotic fervour and when the country was isolated from the Continent), and it was not until 1949 that a really positive attitude towards acquiring modern foreign works began to emerge. In that year the gallery bought two *Cubist Picassos, a *Léger, a *Matisse, a *Rouault, and two paintings and a sculpture by *Giacometti (a sculpture gallery had been added in 1937, paid for by Lord Duveen). In spite of this, during the early 1960s most of the modern foreign collection was relegated to basement galleries, accessible only by an inconspicuous staircase. During the 1950s the Tate started venturing into post-war art—first mainly *École de Paris, later American—and at the same time many of the finest 19th-century paintings were moved in stages to the National Gallery. In 1958 the Friends of the Tate Gallery was founded to raise funds to help with the purchase of works, and from about this time there began a sustained attempt to build up a modern collection that was representative of the range and variety of modern art, containing as far as possible works from all the major movements and leading artists (during the 1960s, 20th-century British works were absorbed into the modern collection, taking their place in an international context). In 1974 a print department was established. Among other departments are a library and an archive, a major resource for scholarship in British art. In recent years the remit of the collection has been expanded to include photography.

Considering its limited funds in a time of rocketing prices for art, the Tate has succeeded well in its aim of broad coverage, although many other museums have richer collections in specific areas. Nevertheless, the gallery has often been attacked for purchasing works that are outside (or ahead of) public taste. The most famous example is the outcry

in 1976 over Carl *Andre's 'Tate bricks', but this was preceded by anger and abuse directed at works that have now taken their places in the pantheon of 20th-century art, notably Matisse's *L'Escargot* (bought in 1962) and Picasso's *The Three Dancers* (bought in 1965). In retrospect a more accurate charge would be that during the 1950s when prices were relatively low the gallery was over-cautious. In addition to purchases, the Tate's holdings have been enhanced by several outstanding bequests from collectors and artists: in 1968–69, for example, Mark *Rothko presented nine of his paintings and in 1977 Naum *Gabo gave a large collection of his work in various media.

The enormous postwar growth in the size of the gallery's collections and the scope of its activities posed severe problems of space, in spite of several extensions to the building. In 1988 a branch of the Tate was opened in Liverpool and in 1993 another one in *St Ives, but most of the gallery's holdings still remained in storage. In 1994 the Trustees therefore announced a bold decision to create a new museum—the Tate Gallery of Modern Art—in the decommissioned Bankside Power Station, a huge, starkly magnificent building occupying a prime site on the Thames opposite St Paul's Cathedral. It was designed by Sir Giles Gilbert Scott and built in 1947–63; the remodelling into a gallery was entrusted to the Swiss architects Jacques Herzog and Pierre de Meuron. The building opened to the public in 2000 and is known as Tate Modern. An extension is scheduled to open in 2012. The original Millbank building became Tate Britain. Tate Modern has been a major public success, although the initial arrangement was controversial because of the jettisoning of the traditionally accepted 'isms' in favour of broader categories, namely 'Landscape, Matter, Environment', 'Still life, Object, Real life', 'History, Memory, Society', and 'Nude, Action, Body'. It was rather too close to the old notion of 'subject genres'. The consequent juxtapositions inevitably tended to emphasize subject-matter, so denying, it can be argued, what was most distinctive about modern and contemporary art in contrast to that of preceding centuries. The conjunction of a Richard *Long wall piece in splashed clay and a *Monet *Waterlilies* did no favour to either artist. The display has now reverted to the more usual stylistic grouping, although still suggesting broad themes which cut across chronology and geography. Visitors even see an Alfred H.

*Barr style chart of the development of modern art, although this is pointedly handwritten to emphasize its provisional nature. More general approval has greeted the series of installations in the spectacular main space (the Turbine Hall) by artists including Louise *Bourgeois, Bruce *Nauman, and Doris *Salcedo.

Tate Britain continues to show some 20th-century work and remains the usual venue for the *Turner Prize. Its displays have tended to follow closely the British Government's obsession with defining 'national identity'.

The first keeper of the Tate Gallery, 1897–1906, was Sir Charles Holroyd (1861–1917), a painter, etcher (he was a favourite pupil of *Legros), and writer on art. He left to become director of the National Gallery and was succeeded at the Tate by D. S. *MacColl, keeper from 1906 until 1911, when he moved to the Wallace Collection. The next keeper (who during his tenure, 1911–30, assumed the title of director) was Charles Aitken (1869–1936), previously in charge of the *Whitechapel Art Gallery. He was succeeded as director by J. B. *Manson, 1930–38; Sir John *Rothenstein, 1938–64; Sir Norman *Reid, 1964–79; Sir Alan *Bowness, 1980–88; and Sir Nicholas *Serota, appointed in 1988.

Further Reading: F. Morris, *Tate Modern: A Handbook* (2006)

F. Spalding, *The Tate: A History* (1998)

Tatlin, Vladimir (1885–1953) Russian painter, designer, and maker of abstract constructions, the founder of *Constructivism. He was born in Kharkov in Ukraine, the son of a railway engineer. His mother, a poet, died when he was two and he had an unhappy childhood, disliking his father—a stern disciplinarian—as well as his stepmother. These circumstances left him with a distrustful nature and he was later constantly suspicious of rivals such as *Malevich. Tatlin's training was somewhat sporadic, and for some years he combined art with occasional voyages as a merchant seaman to earn his living; many of his early pictures are of maritime subjects, notably *The Sailor* (1911–12, Russian Museum, St Petersburg), which is a self-portrait. His main period of study was at the art school in Penza, 1904–10, after which he enrolled at the Moscow School of Painting, Sculpture, and Architecture. From this time he exhibited in several avant-garde exhibitions, experimenting with a number of styles, and he was closely associated with *Goncharova and *Larionov.

In 1914 (not 1913 as long believed) Tatlin visited Berlin and Paris. He haunted *Picasso's studio and on his return to Russia began making a series of abstract *Painted Reliefs*, *Relief Constructions*, and *Corner Reliefs* inspired by Picasso's sculptural experiments. Very few of these revolutionary works survive, most being known only from photographs. He used a variety of materials—tin, glass, wood, plaster, etc., and Camilla Grey writes: 'For the first time in Tatlin's constructions we find real space introduced as a pictorial factor; for the first time inter-relationships of a number of different materials were examined and coordinated' (*The Great Experiment: Russian Art 1863–1922*, 1962). After the October Revolution of 1917, Tatlin's constructions made from 'real materials in real space' were felt to be in accordance with the new 'culture of materials' and he threw himself wholeheartedly into the demand for socially oriented art, declaring: 'The events of 1917 in the social field were already brought about in our art in 1914, when material, volume and construction were laid as its basis.' He became one of the most prominent figures in the art world and in 1918 he was made director of the Moscow section of IZO *Narkompros. In 1919 he was commissioned to design the Monument to the Third International (the organization set up by the Bolsheviks to co-ordinate the activities of Communist movements throughout the world). The huge monument—in the form of a leaning, openwork, spiral tower—was intended for a position in the centre of Moscow; it was to be in glass and iron, and parts of it were to revolve. It was designed to be both functional and symbolic, housing various offices of the revolutionary government and including such features as an immense projector for throwing propaganda images on to clouds. Tatlin described it as 'A union of purely plastic forms (painting, sculpture and architecture) for a utilitarian purpose'. A model was exhibited in December 1920 at the exhibition of the VIIIth Congress of the Soviets. *Gabo condemned the design as impracticable and it was never executed (it was intended to be much bigger than the Eiffel Tower), but it is recognized as the outstanding symbol of Soviet Constructivism. (The original model has been destroyed, but there is a reconstruction in the Moderna Museet, Stockholm.)

The Monument to the Third International was the culmination of Tatlin's career, and the rest of it is something of an anticlimax. He continued to be active in teaching and administration, and his own work was mainly in the field of applied art, designing furniture, workers' clothes, etc. In the late 1920s and early 1930s he devoted his energies to designing a human-powered flying machine that was a combination of bicycle and glider; he called it Letatlin (a compound of his name and the Russian verb 'to fly'). In the early 1930s he took up painting again, working in a fairly conventional style, but his main activity from this time was theatre design. His later years were spent in lonely obscurity; in 1948 as part of the campaign for *Socialist Realism he was indicted as an 'enemy of the people'. There has even been some suspicion that he lived for several years after his official death date.

Further Reading: J. Milner, *Vladimir Tatlin and the Russian Avant-garde* (1983)

Tauber-Arp, Sophie *See* TAEUBER-ARP, SOPHIE.

Taylor-Wood, Sam (1967–) British artist in photography and video, born in London. She graduated from *Goldsmiths College in 1990. Her work is a kind of hybrid of photography, video and installation. The series of *5 Revolutionary Seconds* (1995–2000) are panoramic images of large rooms photographed by a camera turning 360° in which incidents take place, sometimes dramatic, sometimes banal, in apparent isolation. The effect arises from the contradiction between the viewer's logical certainty of the spatial coherence of the image and the apparent disjunction of the different events. In the *Self-Portrait Suspended* series (2004) she used digitally enhanced photography to enable her to appear floating in her studio. Her work is marked by references to the history of art. *Wrecked* (1996) is a banquet scene with twelve men at a table with a naked woman in the centre mimicking the composition of Leonardo's *Last Supper*. More subtly *Self-Portrait as a Tree* (2000), made when the artist was suffering from cancer, refers to the allegorical landscapes of the German Romantic Caspar David Friedrich. Certain constant themes emerge across the technical variety of her work. One of these is mortality and decay, as in the video work *Still Life* (2000). The rotting of a beautiful bowlful of fruit is speeded up to three minutes from the first appearance of white mould to livid putrescence. The impact is made more potent by placing in front, one of the most disposable of manufactured

objects, a cheap ballpoint pen, which, of course, retains its material integrity to the end.

Taylor-Wood has achieved widespread public celebrity, including the accolade of an appearance on the popular radio programme *Desert Island Discs* in 2005. On this occasion she caused some stir by her frank account of the difficulties of her early life, including abandonment by both parents. The appearance of celebrities in her work has been much noted. In 2002 she wrapped the London department store Selfridge's with a 60-foot high photographic frieze populated by mass-cultural icons, with Elton John in the centre holding court. The artist regarded it as a contemporary version of the Parthenon frieze. The *Crying Men* (2002) is a series of videos of weeping film stars including Paul Newman and Robin Williams. *David* (2004, National Portrait Gallery) is a one-hour video of the well-known footballer David Beckham asleep.

Further Reading: M. A. Crutchfield (ed.), *Sam Taylor-Wood* (2008)

Tchelitchew, Pavel (1898–1957) Russian-born painter and stage designer who became an American citizen in 1952. He was born at Kaluga into an aristocratic family. In 1918, following the Revolution, the family fled to Kiev, where he studied at the Academy and was encouraged by *Exter. His work at this time was abstract, in a *Constructivist vein. In 1921–3 he lived in Berlin, working mainly as a theatrical designer, then settled in Paris from 1923 to 1934. He soon abandoned abstraction, but throughout his life he was a ceaseless experimenter and his style changed restlessly. During his Paris years he continued to build his reputation as a stage designer (he worked for *Diaghilev and the Russian-born choreographer George Balanchine among others), and he also became one of the leading exponents of *Neo-Romanticism in painting. His subjects included landscapes, portraits, and figure compositions (among them circus scenes recalling *Picasso's work in his Blue period). Some of his paintings were fairly naturalistic, but others used multiple images and violent distortions of perspective. His friends in Paris included Gertrude *Stein and through her he met the English writer Geoffrey Gorer, who helped to arrange Tchelitchew's first one-man exhibition, at the Claridge Gallery, London, in 1928. He painted a portrait of Gorer's mother (*Mrs R. A. Gorer*, 1930, Tate) and the poet Edith *Sitwell was among his other

sitters. Sitwell fell in love with Tchelitchew, but her passion was thwarted because he was homosexual; however, they became great friends and she helped to promote his career. In 1934 Tchelitchew settled in New York, but he continued to spend the summers in Europe until the outbreak of the Second World War. In America he was again in demand as a stage designer, but he grew tired of this kind of work and gave it up in 1942 to concentrate on painting, in which he continued to try out new styles and approaches. The best-known picture of his American period is probably *Hide and Seek* (1942, MoMA, New York), a *Surrealist-like work in which strangely coloured children's heads weirdly metamorphose into vegetable forms (such subjects reflect something of his belief in the occult—he thought he possessed magical powers). From 1949 he lived mainly in Italy and he died at Grottaferrata, near Rome. By this time he was an international celebrity.

Further Reading: P. Tyler, *The Divine Comedy of Pavel Tchelitchew* (1969)

Télémaque, Hervé (1937–) Haitian painter. Born in Port-au-Prince, he left for New York in 1957. Early paintings were influenced by *Abstract Expressionism. However, for Télémaque, Abstract Expressionism was hardening into academism and in 1961 he moved to Paris, where he has lived and worked ever since. In spite of the greater distance from his homeland, he felt closer to Francophone culture. He became known in the 1960s for large paintings in which *Pop imagery is treated with cartoon-style violence to satirize American political power, as in *My Darling Clementine* (1963, Pompidou Centre).

Further Reading: J. Broussard, 'Hervé Télémaque: art tells the story of our time on earth', *UNESCO Courier* (November 1996)

Temoignage See STAHLY, FRANÇOIS.

Ten, The (Ten American Painters) A group of well-established American painters from Boston and New York who exhibited together from 1898 to 1919 after resigning from the Society of American Artists, whose exhibitions they considered too conservative and too large. Most of the members of the group had studied in Paris in the 1880s and the common factor in their work was an interest in *Impressionism. They were Frank W. Benson (1862–1951); Joseph R. De Camp (1858–1923); Thomas W. Dewing (1851–1938); Childe

*Hassam; Willard L. Metcalf (1858–1925); Robert Reid (1862–1929); Edward E. Simmons (1852–1931); Edmund C. Tarbell (1862–1938); John H. Twachtman (1853–1902); and Julian Alden Weir (1852–1919). After the death of Twachtman his place was taken by W. M. *Chase. Between 1898 and 1917 the group held twenty annual exhibitions in New York (at various galleries) and these were sometimes shown in other cities; a final exhibition was shown in Washington in 1919. Although their art was not particularly radical, they were important in the context of modern art in helping to establish a tradition of setting up exhibiting organizations independent of official bodies, foreshadowing such ventures as The *Eight (1) and the *Armory Show.

The Ten was also the name of a group of American *Expressionist painters who exhibited together from 1935 to 1939. *Gottlieb and *Rothko were the best-known members. Most were figurative painters, but a few were members of *American Abstract Artists.

Further Reading: Spearman Gallery, New York, *Ten American Painters* (1990)

Tenison, Nell See CUNEO, TERENCE.

Tériade (Efstratios Eleftheriades) (1897–1983) Greek critic, editor, and publisher, active in France. In 1915 he moved to Paris to study law, but he turned to art, working for *Cahiers d'art*, founded by his countryman Christian Zervos, and then from 1933 to 1936 serving as artistic director on Albert *Skira's *Minotaure*, a journal that became famous for its superb production values. He worked on other publishing projects for Skira, and in 1937 founded the bilingual (French and English) review *Verve*, which continued until 1960 (38 numbers appearing irregularly, with publication suspended in 1940–43). This covered a wide range of artistic and literary subjects, with a good deal of material on contemporary French art, and it was opulently produced, featuring numerous high-quality colour illustrations. Its success enabled Tériade to set up a publishing company called Éditions Verve, whose output included 26 *livres d'artistes (among them three by *Chagall that had been commissioned by *Vollard but left unfinished at his death in 1939). Éditions Verve's other publications included albums of photographs by Henri *Cartier-Bresson. Tériade wrote a book on *Léger (1928) as well as art criticism that

was published in various journals. An exhibition devoted to him was held at the Grand Palais, Paris, in 1973.

TGP See TALLER DE GRÁFICA POPULAR.

Tharrats, Joan Josep (1918–2001) Spanish painter and art critic, born at Gerona. In 1948 he was a founder member of the association *Dau al Set in Barcelona and he was responsible for the designing and printing of its magazine of the same name. He also worked as an art critic for the Barcelona newspaper *Revista*. Tharrats took up painting in about 1950 with imaginary landscapes that had affinities with *Metaphysical Painting. In about 1956, however, he turned to expressive abstraction and developed a richly colourful manner of *Art Informel, describing his paintings as *maculaturas* ('smudges').

Thek, Paul (1933–88) American painter and sculptor, born in Brooklyn, New York. His best-known work, now lost after suffering damage while on tour, was *Death of a Hippie* (1967). This was not the artist's choice of title (he preferred *The Tomb*). Cast from the artist's own body, the recumbent effigy with severed fingers was in an entirely pink environment and strewn with flowers. This work was an extension of Thek's interest in illusionistic casting; earlier works had consisted of wax models of meat in *Minimalist boxes. However, it had a greater resonance as a product of the so-called 'summer of love', as a kind of lament for the inevitable demise of the drug-induced idealism of the young. How much Thek himself actually sympathized with the culture represented by the hippies is doubtful. His recorded views veer from a highly authoritarian leftism to a yearning for a return to the Catholicism in which he was brought up. Thek continued to make environments, although none had the same impact. He died of AIDS in New York.

(((⊕))) SEE WEB LINKS
• Paul Thek biography.

Theophilos (Theophilos Hadjimichalis) (*c.*1870–1934) Greek *naive painter, the most famous produced by his country. He was born at Varia, near Mytilene, on the island of Lesbos, and earned his living as an itinerant craftsman, travelling from village to village decorating shops and houses. His subjects were mainly from ancient Greek history, the

War of Independence against Turkey, and idealized representations of Greek soldiers, peasant women, etc. He was 'discovered' in 1929 in consequence of the vogue for naive painting, which was then at its height, and thereafter he worked on panel paintings rather than popular murals (most of which have been destroyed). In the 1930s he was exalted as a model of authentic Greekness and the first monograph on him was published in 1939. His countryman *Tériade promoted him in Paris as a Greek equivalent of Henri *Rousseau. Several substantial exhibitions have been dedicated to Theophilos (Athens, 1947; Berne, 1960; Paris, 1961) and a museum of his work opened at his birthplace in 1965.

theosophy *See* ABSTRACT ART.

Thiebaud, Wayne (1920–) American painter, born at Mesa, Arizona. From 1938 to 1949 he worked as a cartoonist and advertisement designer in New York and Hollywood, with an interval for service in the US Army Air Force, 1942–6. He then studied at Sacramento State College, graduating in 1951, before teaching in the art department of Sacramento City College (1951–9) and subsequently as professor of art in the University of California at Davis. In 1961 he began painting the kind of picture for which he is best known: still-lifes of cafeteria foodstuffs—cakes, pies, pastries, ice-cream cones, etc.—depicted against an empty background, emphasizing by monotonous repetition their synthetic, assembly-line character. They have the bright colours, strong outlines, and well-defined shadows of advertisement and poster art, bringing them within the orbit of *Pop art, but Thiebaud uses thick, juicy paint that distinguishes him from most other Pop artists. In 1963 he began painting figures in a similar vein of mass-produced anonymity.

Thoma, Hans (1839–1924) German painter and administrator. Early in his career he specialized in landscapes—mainly scenes from his native Black Forest—and these are now considered his best works. Later he turned to figurative subjects, including Wagnerian themes; these won him an immense reputation in his day, but are now considered rather ponderous. From 1876 to 1899 he lived in Frankfurt, but he was a member of the Munich *Sezession. In 1899 he moved to Karlsruhe to become director of the Kunsthalle, which has the largest collection of his work. By this time he was one of the most famous of German artists, and in his later years he was showered with honours. He published two autobiographical books (1909 and 1919).

Thomson, Tom (1877–1917) Canadian landscape painter, one of the main creators of an indigenous Canadian school of painting. He was born in Claremont, Ontario, and in 1904 settled in Toronto, where he spent most of his career as a commercial artist. Encouraged by J. E. H. *MacDonald and others, he began to paint seriously in about 1907, but it was only in 1914 that he was able to devote himself to art full time. He did much of his painting out of doors, notably a series of fluently spontaneous oil sketches he produced in Algonquin Provincial Park, a huge wilderness park (covering almost 3,000 square miles) north-east of Toronto (during the summer months he combined his painting with working there as a fireranger and guide). Among his more formal paintings, the most famous is the bold and brilliantly coloured *Jack Pine* (1917, NG, Ottawa), which has become virtually a national symbol of Canada. Thomson's career ended tragically when he was mysteriously drowned in Algonquin Park, but his ideals were continued by the artists who formed the *Group of Seven, to whom he was an inspiration (he knew most of them well). His death was probably an accident, but the uncertainty surrounding it helped to establish him as a legendary figure in Canadian art.

Thorak, Josef *See* NATIONAL SOCIALIST ART.

Thorláksson, Thórarinn B. (1867–1924) Icelandic painter, a pioneering figure in his country's art. He had been interested in drawing since childhood and in 1885 he gave up his career as a bookbinder to devote himself to art. There being nowhere to train in Iceland, he went to Copenhagen and studied first at the Academy and then at a private school. On his return to Iceland in 1900 he had a one-man show in Reykjavik—the first exhibition by an Icelandic artist ever to be held in Iceland. For the rest of his life he was the leading spirit in Icelandic art, notably in helping to found the Listvinafélag (Friends of Art Society), which was established in Reykjavik in 1916 and built the country's first exhibition hall, the Listvinahús. His work included portraits, interiors, and moody, almost mystical views of the Icelandic landscape, imbued with national feeling (Iceland was at this time struggling for

independence from Denmark). He exerted a great influence on the next generation of Icelandic painters, including Ásgrímur Jónsson (1876–1958), Jóhannes Kjarval (1885–1972), and Jón Stefánsson (1881–1963). His work is well represented in the National Gallery of Iceland, Reykjavik.

Thorn Prikker, Johan (1868–1932) Dutch painter and designer, born in The Hague, where he studied at the Academy of Fine Arts, 1883–7. Early in his career he passed through phases of *Impressionism and *Neo-Impressionism, then changed to an elaborate linear style with which he became a leading exponent of *Symbolism and *Art Nouveau, as in his most famous painting—the mystical, exotic *The Bride* (1893, Kröller-Müller Museum, Otterlo). From 1895 he concentrated on the design of mosaics, murals, and stained glass, mainly for churches, continuing in this vein after he settled in Germany in 1904. He taught at several art schools in Germany and was a major force in the development of modern religious art. His masterpiece is perhaps the cycle of windows in the Romanesque church of St George in Cologne, completed in 1930. The American stained-glass artist Robert Sowers comments that here 'lead lines are used with a graphic eloquence and deep smouldering colours with a monumental gravity that have no parallel even in the greatest medieval windows'.

Thornton, Leslie (1925–) British sculptor, born in Skipton, Yorkshire. He first attracted attention with spiky figures in welded metal rods made in the 1950s. These works can be related to the *Geometry of Fear tendency in British sculpture of the post-war period, although, as much as with existential (*see* SARTRE) anxiety, they are concerned with the uneasy encounter between the human body and the world of things. *Man Falling off a Chair* (1959) is a characteristic subject. Thornton took part in the 1956 'This is Tomorrow' exhibition (*see* WHITECHAPEL ART GALLERY), contributing a screen in plaster on wire mesh with objects embedded. In the 1960s his work became more abstract and colourful. He has had a distinguished teaching career, being for many years head of sculpture at North Staffordshire Polytechnic.

Thornycroft, Sir Hamo (1850–1925) British sculptor, one of the leading exponents of the *New Sculpture. Both his father, Thomas

Thornycroft (1815–85), and his mother, Mary Thornycroft (1814–95), were sculptors. Early in his career he concentrated on idealized figures in which he expressed a 'poetic mood' praised by the critic Edmund *Gosse; the best-known example is probably *The Mower* (1884, Walker Art Gallery, Liverpool; there are also many small-scale casts). From the 1890s, however, he was increasingly preoccupied with portrait sculpture and above all public monuments, becoming perhaps the most distinguished British practitioner in this field in the early 20th century. His statues, dignified and thoughtful in tone, include those of Oliver Cromwell outside the Houses of Parliament, London (unveiled 1899), Alfred the Great in Winchester (1901), Gladstone in the Strand, London (1905), Lord Armstrong in Newcastle upon Tyne (1906), Lord Curzon in Calcutta (1912), and Edward VII in Karachi (1915).

Further Reading: E. Manning, *Marble and Bronze: The Life and Art of Hamo Thornycroft* (1982)

391 A *Dada periodical founded by *Picabia in Barcelona in 1917; subsequent issues were published in New York, Lausanne, Zurich, and Paris until 1924. The name was meant to recall *Stieglitz's short-lived periodical *291*, to which Picabia had contributed. Although *391* was mainly literary in content, it also included visual material. Issue no. 12 (March 1920) featured *Duchamp's mustachioed *Mona Lisa* on the cover and contained one of Picabia's best-known iconoclastic statements—a large inkblot labelled 'La Sainte Vierge'.

Throbbing Gristle *See* P-ORRIDGE, GENESIS.

Tibble, Geoffrey *See* OBJECTIVE ABSTRACTIONISTS.

Tiffany, Louis Comfort *See* ART NOUVEAU.

Tihanyi, Lajos *See* ACTIVISTS.

Tillmans, Wolfgang (1968–) German photographer, born in Remscheid. Since the late 1980s, he has lived and worked in Britain. He studied at Bournemouth and Poole College of Art and Design but considers himself as self-taught except for the acquisition of colour printing skills. He began his career photographing for youth market magazines such as *I-D* and *The Face*. Young people at music festivals and

protests remain a significant subject, although he has also photographed landscape and still-life. He uses a raw snapshot style and Jeremy Millar has praised the 'casual beauty' of his work and pointed to 'the sense of tragedy that trickles and stains the everyday'. This extends into the presentation of his work at exhibitions, in which the images can be displayed unframed and unmounted, quite unlike the fine art preciousness of most photography displays. Nonetheless the form of display can be, in practice, carefully planned. The *Truth Study Centre* (2005) is installed as tables upon which photographs are placed dealing with issues such as HIV and Holocaust denial. Tillmans has said that he likes the 'sculptural aspect' of the work. As part of his 2007 retrospective in Washington he displayed a *Memorial to the Victims of Organised Religion* consisting of a grid of 48 black and dark blue photographs. Tillmans commented that 'in a town full of memorials, [it] seemed to be the one that was missing'. He won the *Turner Prize in 2000. An anthology of his work entitled *if one thing matters, everything matters* was published in 2003 to coincide with an exhibition at Tate Britain.

(((⊕))) SEE WEB LINKS

• J. Millar, 'Casual Beauty', in *Tate*, no. 5.

Tilson, Joe (1928–) British painter, sculptor, and printmaker, born in London. After working as a carpenter and cabinet-maker, 1944–6, and serving with the RAF, 1946–9, he studied at *St Martin's School of Art, 1949–52, and at the *Royal College of Art, 1952–5. He won the Rome Prize in 1955 and spent three years in Italy and Spain, then taught at St Martin's, 1958–63 (he has also been guest lecturer at various universities in Britain and abroad). In the 1960s Tilson was associated with *Pop art, his most characteristic works being brightly coloured wooden reliefs that included words or lettering among the pictorial symbols (*9 Elements*, 1963, Scottish NG of Modern Art, Edinburgh). An inventive graphic artist, he has worked in various printmaking techniques, including etching, screenprinting, and woodcut.

Further Reading: M. Compton and M. Livingstone, *Tilson* (1994)

Tinguely, Jean (1925–91) Swiss sculptor and *Kinetic artist. He was born in Fribourg and studied at the Basle School of Fine Arts, 1941–5. In 1952 he settled in Paris, then after a year in Düsseldorf moved to New York in 1960. Tinguely's work was concerned mainly with movement and the machine, satirizing technological civilization. His boisterous humour was most fully demonstrated in his auto-destructive works (*see* METZGER), which turned Kinetic art into *Performance art. The most famous was *Homage to New York*, presented at the Museum of Modern Art, New York, on 17 March 1960. The object on which the work was based was constructed of an old piano and other junk; it failed to destroy itself as programmed and caused a fire. Tinguely was an innovator not only in his combination of Kineticism with *Junk sculpture, but also in the impetus he gave to the idea of spectator participation, as in his *Cyclograveur*, in which the spectator mounts a saddle and pedals a bicycle, causing a steel nail to strike against a vertically mounted flat surface, and the *Rotozazas*, in which the spectator plays ball with a machine. Such works have been interpreted as ironic ridicule of the practical functions of machines. Satire in his work was also directed against the art world. In 1959, the year which saw the consecration in Paris of informal gestural abstraction, Tinguely produced his *Metamatic* machines for turning out 'spontaneous' gestural abstractions to order. A close friend of Yves *Klein, he became part of the *Nouveau Réalisme group in 1960. Tinguely's most famous work is the exuberant Beaubourg Fountain (1983) outside the *Pompidou Centre, Paris, done in collaboration with his wife, Niki de *Saint Phalle; it features fantastic mechanical birds and beasts that spout water in all directions.

Further Reading: C. Tomkins, *The Bride and the Bachelors* (1965)

Tobey, Mark (1890–1976) American painter and draughtsman, born in Centerville, Wisconsin. Apart from a few lessons at the Art Institute of Chicago, he had no formal training in art. From 1911 he divided his time for several years between New York and Chicago, working as a fashion illustrator, interior decorator, and portrait draughtsman. In 1918 he became a convert to the Baha'i faith and much of his subsequent work was inspired by an interest in Oriental art and thought. From 1922 to 1930 he lived mainly in Seattle (apart from a period in Europe, 1925–6) and from 1931 to 1938 he was artist-in-residence at Dartington Hall, a progressive school in Devon, England. During this period he also travelled extensively, notably to China, where

he spent a month in a Zen monastery in 1934. From 1938 to 1960 he lived in Seattle again, then settled in Basle, Switzerland, where he died. Following his visit to the Far East in 1934–5, Tobey developed a distinctive style of painting that he called 'white writing', characterized by calligraphic white patterns overlying dimly discerned suggestions of colour beneath. Although he painted representational pictures in the style, he turned increasingly to abstractions (*Northwest Drift*, 1958, Tate). Their *'all-over'* manner anticipated and perhaps influenced Jackson *Pollock, but unlike *Action Painters, Tobey believed that 'painting should come through the avenues of meditation rather than the canals of action'. After the Second World War he built up an international reputation. Unusually for an American painter, he was more highly esteemed abroad than in his own country, and he was influential on French *Tachisme in the 1950s. He won the City of Venice painting prize at the 1958 Venice *Biennale and the first prize for painting at the 1961 *Carnegie International.

Further Reading: W. Schmied, *Mark Tobey* (1966)

Toft, Albert *See* NEW SCULPTURE.

Toklas, Alice B. *See* STEIN, GERTRUDE.

Tomkins, Calvin (1925–) American writer and editor who has had a distinguished career in art journalism. He was born in Orange, New Jersey, and studied at Princeton University, graduating in 1948. From 1955 to 1959 he worked at *Newsweek* magazine, and in 1960 became staff writer at *The New Yorker*. His first book was *The Bride and the Bachelors* (1965), a collection of profiles that features *Cage, *Duchamp, *Rauschenberg, and *Tinguely. He became friendly with Duchamp whilst interviewing him and in 1966 published *The World of Marcel Duchamp*, in the Time-Life Library of Art series, a popular account of the artist. A full-scale biography of Duchamp by Tomkins appeared in 1996. His other books include *Living Well is the Best Revenge* (1971) (about Gerald *Murphy), *Off the Wall: Robert Rauschenberg and the Art World of Our Time* (1980), and *Post- to Neo-* (1988).

Tomlin, Bradley Walker (1899–1953) American painter. He was born in Syracuse, New York, and studied at Syracuse University, 1917–21. In 1922 he moved to New York City and for the next ten years earned his living

mainly as a commercial artist. During this time he made three journeys to Europe: 1923–4, 1926–7, and 1928. The Depression affected his commercial work, so he turned to teaching (at various schools) from 1932 to 1941. In his early work he experimented with a variety of styles, but he destroyed many paintings in the 1930s when he began to question himself as an artist. In the late 1930s he began to find a more individual path with semi-abstract still-lifes that blend elements of *Cubism and *Surrealism (*Still-Life*, 1939, Whitney Museum, New York). By 1947 his work had become completely abstract and in the last years of his life he developed into one of the minor masters of *Abstract Expressionism. His paintings of this time typically feature a rich but coolly coloured *all-over pattern of cryptic dashes, dots, and crosses (*Number 9: In Praise of Gertrude Stein*, 1951, MoMA, New York).

Tonalism A trend in American painting, *c.*1880–*c.*1910, in which subjects (particularly landscapes) were treated in a muted, romantic, idealized manner akin to the type of soft-focus, impressionistic style of photography known as Pictorialism (or Pictorial photography) that was popular at the same time. The term 'tonalism' (or 'tonalist') was evidently first used in print by the painter Samuel Isham (1855–1914) in his book *The History of American Painting* (1905), but it did not really catch on until it was used by the art historian Wanda Corn in the title of an exhibition at the M. H. de Young Memorial Museum, San Francisco, in 1972: 'The Color of Mood: American Tonalism, 1880–1910' (earlier the term 'Quietism' had sometimes been used to describe the trend). Corn described Tonalism as 'a style of intimacy and expressiveness, interpreting very specific themes in limited color scales and employing delicate effects of light to create vague, suggestive moods'. In its use of soft brushwork and blurred outlines, Tonalism was related to *Impressionism, which developed at more or less the same time in the USA, but the Tonalists can be distinguished from the Impressionists because of their preference for subdued colouring and for creating a mood of mystery or poetic reverie (scenes were often depicted at dusk or in mist, rather than in the clear daylight chiefly associated with the Impressionists). The painters who are considered to typify Tonalism include Thomas Dewing (*see* TEN), who specialized in interiors rather

than in landscapes, George Innes (1825–94), probably the most famous American landscapist of his generation, and Dwight Tryon (1849–1925). *Whistler, too, is sometimes embraced by the term, although he spent most of his career in Europe.

Tonks, Henry (1862–1937) British painter, draughtsman, and teacher, born in Solihull, Warwickshire. Tonks trained as a doctor and rose to the position of senior resident medical officer at the Royal Free Hospital in London. He had been interested in art since childhood, however, and in 1888 (the year in which he became a Fellow of the Royal College of Surgeons) he began attending evening classes at Westminster School of Art under Fred *Brown. When Brown was appointed professor at the *Slade School in 1892 he invited Tonks to become his assistant, and in 1893 he abandoned his successful medical career for the more precarious life of an artist and art teacher. (However, he worked in plastic surgery during the First World War.) Tonks remained at the Slade until 1930, succeeding Brown as professor in 1918, and became the most renowned and formidable teacher of his generation. Under him the Slade maintained its position as the dominant art school in Britain (although it was now challenged by the *Royal College of Art), and he was a major influence as an upholder of traditional values and an opponent of modern ideas: 'I don't believe I really like any modern development.' He set high standards for his pupils, particularly in figure drawing (his own forte) and he got on well with them, in spite of being notorious for his sarcasm and abruptness. The duality in his nature came out in other ways, too: he was secretive, touchy, suspicious, and resentful of criticism, but capable of close friendships, as, for example, with his fellow-teacher *Steer. Because of his refusal to move with the times he was increasingly looked on as a back number by more progressive artists and students, but he remained a dominant presence in the art world and is mentioned in virtually all artists' memoirs of the period.

Tonks's own paintings are mainly figure subjects, often consciously (sometimes self-consciously) poetic in spirit: 'A painter who is not a poet ought to be put in the stocks.' Sir John *Rothenstein refers to 'the sheer prettiness of much of his art', but his pictures often look rather laborious, partly because of his technique of 'Tonking', which involved using an absorbent material to soak excess oil from the canvas after each day's work and so produce a dry surface for the next session. His best-known work is probably the conversation piece *Saturday Night in The Vale* (1928–9, Tate) which shows George *Moore reading aloud to a gathering at Tonks's studio in The Vale, Chelsea. Moore complained that he had been made to look like a 'flabby old cook', whereas Tonks had depicted himself as a young and elegant 'demi-god'.

Further Reading: L. Morris, *Henry Tonks and the 'Art of Pure Drawing'* (1985)

Tooker, George (1920–) American painter, born in Brooklyn, New York. After graduating in literature from Harvard University in 1942, he served in the US Marines, then studied at the *Art Students League, 1943–4. His teachers there included Reginald *Marsh, and it was from him and Paul *Cadmus (with whom he studied privately) that he acquired his preference for painting in egg tempera. His technique is scrupulously detailed in the manner of the Old Masters, but his subjects express the spiritual desolation and debilitating uniformity of modern life. The figures in his paintings all look more or less like one another and go through life as if on a conveyer belt, tense and drained of energy. They are physically close to one another, but emotionally distant. *Subway* (1950, Whitney Museum, New York) is perhaps his most famous work—a terrifying vision of Kafkaesque isolation.

Toorop, Charley (1891–1955) Dutch painter, the daughter of Jan Toorop, christened Annie Caroline Pontiflex Toorop. She was initially drawn to music, but began exhibiting as a painter in 1909 in Amsterdam. In 1912 she married the anarchist freethinker Henk Fernhout, although her father disapproved strongly. They had three children, but the marriage did not last and in 1917 she moved to Amsterdam, living subsequently in Paris, Brussels, and Utrecht, before finally in 1932 moving into a studio in Bergen designed for her by Gerrit Rietveld. (Despite being a figurative painter she had close ties to De *Stijl, through her friendship with *Mondrian.) She remained in Utrect for the rest of her life. Her early paintings were strongly influenced by van Gogh: Jean-Luis Andral suggests that this was a counterweight to the strong influence of her father. Her later works, portraits, still-life and allegories, are precise and powerfully

modelled. Her self-portraits have been especially admired. *Three Generations* (1941–50, Boijmans van Beuningen Museum, Rotterdam) is a haunting image showing a massive bust of her father, her son Edgar (also a painter), and Charley in the foreground, raising her brush and with the intense staring eyes, characteristic of all her self-portraits. Her best-known painting is *The Clown* (1941, Kröller-Müller Museum, Otterlo), a poignant image of the 70-year-old Bembo, whose house and possessions were destroyed in the bombardment of Rotterdam and who was reduced to posing in his clown's outfit and make-up. The artist regarded it less as a portrait and more of a general comment on the disastrous turn of events for the bourgeoisie.

Further Reading: Institut Néederlandais, *Magie et réalisme* (2000)

Toorop, Jan (1858–1928) Dutch painter, graphic artist, and designer. He was born in Java (at this time a Dutch colony; his mother was a Javanese princess) and moved to the Netherlands with his family when he was fourteen. Toorop's work reflected many of the main stylistic currents of his time and he was a leading figure in the *Symbolist and *Art Nouveau movements. His most characteristic paintings are literary subjects depicted with flowing lines, as in his masterpiece, *The Three Brides* (1893, Kröller-Müller Museum, Otterlo), a ghostly scene with an exotic feeling that recalls his origins in Java. In 1905 he was converted to Catholicism and thereafter concentrated mainly on religious works. Toorop's prolific output included book illustrations, designs for stained glass, and posters; his influence was considerable in the Netherlands and extended to Glasgow, where it is visible in the work of Charles Rennie *Mackintosh.

Toroni, Niele (Enrico) (1937–) Italian painter, born in Muralto-Locarno. He has worked principally in France. Since 1967, he has consistently painted according to a single programme. Single brushstrokes from the same size brush are placed at regular intervals of 30 centimetres. He was a member of the group BMPT, which also included Daniel *Buren, Olivier Mosset (1944–), and Michel Parmentier (1938–2000), all trying to explore the material basis of painting. Although Toroni's painterly gesture has been consistent, he has used a variety of surfaces, not only canvases but also walls. Therefore the space and

context is as much on exhibition as the painting. One example is a room on permanent display in the *Musée d'Art Moderne de la Ville de Paris.

Torr, Helen *See* DOVE, ARTHUR.

Torres García, Joaquín (1874–1949) Uruguayan painter and art theorist, born in Montevideo. Most of his life was spent in Spain, to which he moved with his family in 1891 (his mother was Uruguayan, but his father was a Spanish immigrant). He lived mainly in Barcelona, where he moved in avant-garde circles that included the young *Picasso; his work there included the design of stained-glass windows (1903–7) for the church of Sagrada Familia, in collaboration with the building's architect, Antoni Gaudí. In 1920–22 TorresGarcía lived in New York, where he was patronized by Gertrude Vanderbilt *Whitney and met Marcel *Duchamp. From 1924 to 1932 he lived in Paris, where he developed a severely geometrical, two-dimensional *Constructivist style, and in 1929 founded the review *Cercle et Carré* in conjunction with Michel *Seuphor. In 1934 he returned to Uruguay, settling in Montevideo, where he established an art school. He wrote an autobiography, *Historia de mi vida* (1939), and various works on art theory, and by his example and teaching did much to promote Constructivist and *Kinetic art in South America. There is a museum of his work in Montevideo.

Tosi, Arturo (1871–1956) Italian painter, primarily of landscape but also of still-life. He was born at Busto Arsizio and worked mainly in nearby Milan. Tosi has been called a 'natural' or 'instinctive' painter and his work shows a spontaneous feeling for the poetical interpretation of nature uncomplicated by intellectual theories. His early work was in the *Impressionist tradition. Later he was influenced by *Cézanne and his handling became somewhat *Expressionist, but his work retained its freshness and spontaneity. He was an eminent figure in his lifetime: in the catalogue of the exhibition 'Twentieth-Century Italian Art' held at the Museum of Modern Art, New York, in 1936 he was referred to as 'the dean of living Italian painters'. However, his reputation has declined since his death.

Totalitarian art A term which has been applied to art produced in the 20th century

in authoritarian states that refuse to tolerate any form of expression that does not conform to official ideology. It is applied particularly to art in Nazi Germany, Fascist Italy, and Soviet Russia, so the 1930s can be seen as marking the peak of Totalitarian art (an exhibition at the Hayward Gallery, London, in 1995 was entitled 'Art and Power: Europe under the Dictators, 1930–45'). There is a good deal in common between the artistic policies of Nazi Germany and Soviet Russia, both of which fostered subjects that glorified their respective countries, depicted in a style of academic realism (*see* NATIONAL SOCIALIST ART and SOCIALIST REALISM), but Fascist Italy was comparatively liberal in this respect: it had no official artistic policy, using both conservative and avant-garde styles for propaganda (*see* FUTURISM and NOVECENTO ITALIANO). Igor Golomstok's book *Totalitarian Art* (1990) includes the People's Republic of China as well as Germany, Italy, and the Soviet Union. He identifies the cult of the leader as a common factor. The arguments of this Russian émigré art historian are controversial and even provocative to those who have continued to object to any equation between the dictatorships of the left and the right. Golomstok does, however, draw attention to many similarities in the kind of art which was demanded, especially in the insistence of the cult of leader, at times reaching a quasi-religious level, combined with the demand for aesthetic conservatism.

Reviewing the 1995 Hayward exhibition, the art historian Julian Stallabrass argued that the concept of totalitarianism as a blanket term to cover Nazi Germany and the Soviet Union was primarily a product of the West's Cold War propaganda (*Art Monthly*, December 1995–January 1996). On the cultural front, at least, the perception of an equation precedes the Second World War. It was apparent in responses to the sculpture at the 1937 Paris International Exhibition, at which massive figures by Joseph Thorak and Vera *Mukhina were in confrontation, like prizefighters sizing each other up. Clement *Greenberg's 1939 essay '*Avant-garde and *Kitsch' examined the relationship between dictatorship and the imposition of artistically conservative culture, which he saw as a means by which those who had little interest for the welfare of the masses flattered them by accommodating their tastes. It should be noted that neither Golomstok's nor Greenberg's arguments are entirely comforting to Western liberalism. For the former

there are uncomfortable affinities between Totalitarian art and the avant-garde's demands for art as a tool for the radical transformation of society. Greenberg, writing at the time as a Trotskyist, saw the mass culture of America as just as much a manipulative force as the art imposed by the dictators.

Toulouse-Lautrec, Henri de *See* ANQUETIN, LOUIS; CONDER, CHARLES.

Toupin, Fernand *See* PLASTICIENS.

Tousignant, Claude (1932–) Canadian abstract painter, born in Montreal. From 1948 to 1951 he studied at the Montreal Museum of Fine Arts School, where he was introduced to geometrical abstraction. In 1952 he went to Paris, but he was not impressed by current French painting and returned to Canada the following year. Tousignant's work is rigorously abstract and concerned primarily with colour: 'What I wish to do is to make painting objective, to bring it back to its source—where only painting remains, emptied of all extraneous matter—to the point at which painting is pure sensation.' His most characteristic works of the 1950s employed clear, intense colours, laid on in long, closely packed, asparagus-like forms. In 1959, with three other Montreal painters, he founded the group *Nouveaux Plasticiens, whose work tended towards *Hard-Edge abstraction. On a visit to New York in 1962 he was impressed by the work of Barnett *Newman and in pursuit of his aim 'to say as much as possible with as few elements as possible' he adopted large, austere rectangular shapes. This in turn led to concentric 'target' images and to the use of circular canvases in 1965. Tousignant has also made sculpture.

Tower of Glass *See* AN TÚR GLOINE.

Town, Harold (1924–90) Canadian abstract painter, printmaker, and sculptor, born in Toronto, where he spent most of his life. He studied there at Ontario College of Art, 1942–5, and in 1952–9 was a member of *Painters Eleven. This was a channel for the influence of *Abstract Expressionism in Canada, but he subsequently worked in a variety of abstract styles, often developing themes in long series over a number of years. His work included murals for several public buildings, for example Toronto International Airport (1962). In 1956 and

1964 he represented Canada at the Venice *Biennale.

Townsend, Peter *See* ART MONTHLY.

Toyen (1902–80) Czech/French *Surrealist painter, born in Prague as Maria Čermínová. She adopted the name Toyen while still an adolescent. It is genderless and may have associations with 'citoyen'. In the early 1920s she joined the *Devětsil* group of radical artists and writers, and went to Paris in 1925 with her partner, the poet and painter Jindřich Štyrský (1899–1942). In 1926 they exhibited what they called 'artificialist' paintings. On returning to Prague they moved closer to Surrealism and became drawn to revolutionary politics. Štyrský died in 1942 during the German occupation. In 1947, Toyen moved to Paris where she remained until her death and was acclaimed by André *Breton. She was fascinated by the Marquis de Sade. His ruined ancestral home, the Château de la Coste, appears in many of her paintings, including her most celebrated work, *Au Château de la Coste* (1946). In this a wolf emerges from the cracks in the crumbling fungus-ridden wall to crush a bird. A film about her life by the Czech director Jan Němec was released in 2005.

(((⊕))) SEE WEB LINKS

- P. Hames, 'Jan Němec: *Toyen*', 2006, on the *Kinokultura* website.

Trafalgar Square *See* WALLINGER.

'Tramway V' *See* POUGNY, JEAN.

Transavantgarde (Trans-avant-garde)
A term, translated from the Italian *transavanguardia* (beyond the avant-garde), originated by Achille Bonito Oliva in *Flash Art* (October–November 1979) and originally associated with Italian *Neo-Expressionist painters such as *Clemente and *Chia. It was later extended by the critic to include American artists such as Julian *Schnabel and Jeff *Koons, representative of respectively 'hot' and 'cold' versions, to become a virtual synonym for *Postmodernism. Considerable controversy still surrounds the term. It has been argued that the tendency represents a depoliticization of the aspirations of *Arte Povera and as such stood for a general turn to conservatism in Italian society. Now that some of the polemics have died down and the issue of painting as opposed to new media is no longer such a burning one, a great deal of continuity can be noted between the two tendencies. Chia and Clemente had both worked as *Conceptualists and for all its links with Neo-Expressionism the return to painting in Italy was much concerned with the revival of the classical past which had also been a preoccupation of Arte Povera artists such as *Pistoletto and *Kounellis.

Transcendental Group of Painters *See* HARRIS, LAWREN STEWART.

trap picture *See* SPOERRI, DANIEL.

Traylor, Bill (1854–1949) American painter, born into slavery near Benton, Alabama. For most of his life he worked on the plantation. At the age of 82 he left for the city of Montgomery, where he was discovered by the American painter Charles Shannon (1914–96) drawing on discarded pieces of cardboard. Shannon supplied him with materials and organized an exhibition of his work in 1940. Traylor's drawings are highly simplified, sometimes just a black silhouette, but intensely vital. At first concentrating on objects from the blacksmith's shop, his repertoire expanded into acute observation of the life around him.

Treasury Relief Art Project (TRAP) *See* FEDERAL ART PROJECT.

Tretchikoff, Vladimir (1913–2006) Russian-born painter who settled in South Africa in 1946 and became a citizen of the country, one of the most financially successful but also one of the most critically reviled artists of the 20th century. He was born in Petropavlovsk, Kazakhstan, the son of a wealthy landowner. After the 1917 Revolution the family fled to Harbin in north China. After the Second World War, Tretchikoff settled in Cape Town, where he held a one-man exhibition (the first of many in his new country) in 1948. His most famous work is *The Chinese Girl* (1952), depicting an Oriental beauty whom he described as 'refined and demure, and with all the charm and infinite promise of the East'. He did many other works in a similar vein, with titles such as *Balinese Girl* and *Miss Wong*, and his other favourite subjects included African tribesmen and tribeswomen portrayed as the noble savage (*Zulu Maiden*), and flower pieces, generally consisting of a single bloom, accompanied by tear-like drops of water and with titles such as *The Bleeding Lily, The Lost Orchid*, and *The Weeping Rose*.

Tretchikoff's enormous popular success depended not only on his choice and treatment of subject, but also on his skilful marketing. As well as showing extensively in South Africa, he organized several tours of his work in Britain, Canada, and the USA between 1953 and 1973 (the peak period of his fame), exhibiting in major department stores rather than galleries. The paintings themselves were generally not for sale, but reproductions of them (*see* POPULAR PRINTS) sold in vast quantities. Attendance figures at the exhibitions were phenomenal: according to Tretchikoff's autobiography, *Pigeon's Luck* (1973), 205,000 people visited his show at Harrods in London during its four-week run in 1962, and in Winnipeg in 1965 a third of the city's population saw his show 'in spite of snow storms'. To most critics, however, his work is excruciatingly vulgar, and he has been dubbed the 'King of *Kitsch'.

Trockel, Rosemary (1952–) German painter and sculptor. Born in Schwerte, she lives and works in Cologne. She originally intended to study as a biologist but turned to art and trained at the Werkkunstschule in Cologne. At this time she suffered from agoraphobia and she found it extremely difficult to leave her apartment. German painting in the early 1980s was dominated by the overwhelmingly male *Neo-Expressionists, although the painters with whom she associated in Cologne, such as Walter *Dahn and Martin *Kippenberger, took a more ironic stance towards the activity of painting. Some of her work during this time was based on knitting. This is, of course, stereotypically a feminine activity, but Trockel undermined the associations in two ways. First she used a computerized knitting process, so removing it from craft to industry. Second she introduced motifs such as the hammer and sickle or the *Playboy* logo. Sometimes the knitted pieces are displayed like painted panels on the wall, but certain works can be worn, for instance as balaclava helmets. Trockel has never been an easy artist to pin down and at an early stage she clearly rejected the idea of a 'signature style': a spread on her work published in *Flash Art* in May 1987 reproduces a knitted piece, a painting (presumably a self-portrait although this is unspecified) and a vitrine rather in the manner of Joseph *Beuys. Writers on Trockel have tended to see her early work as unified by *feminist preoccupations with the image of woman, but there has been less agreement as to the meaning of her later work. Rachel Withers reported on a 1998 exhibition in London at the Whitechapel Art Gallery, in which much of the work was based on eggs, that it had 'left UK critics cold and visitors baffled'. However, in Germany, Trockel is one of the best-known contemporary artists.

Further Reading: 'Rosemary Trockel talks to Isabelle Graw', *Artforum* (March 2003)
R. Withers, 'Rosemarie Trockel', *Artforum* (March 1999)

Trouille, Clovis (1889–1975) French painter, born in La Fère. He was associated with the *Surrealist group and his paintings were preoccupied with anti-clerical themes. He encountered the group after exhibiting his painting *Remembrance* in the Salon des Artistes et Écrivains Révolutionnaires in Paris in 1930, which combined eroticism with anti-militarism. Here, a cleric in stockings and suspenders piously sprinkles holy water on dead German and French soldiers, while a contorted female nude in the sky drops medals. *La Complainte* (1933) equates the repressive power of church and state with images of a bloody guillotine, a skull with a bishop's mitre, and a weeping woman. In spite of the lurid and politically charged subject-matter of his painting, Trouille said that what interested him most was the intrinsic values of colour and material, whereas for André *Breton what was most significant was the story. For this reason and because of his distaste for the internal squabbles of the group, he kept some distance from the Surrealists for much of the time

Trova, Ernest (1927–2009) American painter and sculptor, born in St Louis. A self-taught artist, after a period influenced by the work of *Pollock and *Dubuffet, he discovered the 'falling man' theme which preoccupied him throughout his career. This is a kind of mannequin which is repeated in sequence in paintings such as *Falling Man 80* (1963, Tate) and arose from an interest in the idea of being trapped in a technological world. It was also inspired by the artist's fascination with comic character toys. This image reappears in sculpture in chrome and bronze. He gave 40 of his sculptures to the city of St Louis, which opened a sculpture park to display them. There is a bronze plaque dedicated to him in the St Louis Walk of Fame.

Trübner, Wilhelm *See* SEZESSION.

Truitt, Anne (1921–2004) American sculptor. She was born in Baltimore as Anne Dean and from 1947 onwards lived in Washington. Her exhibition at the André Emmerich Gallery, New York, in 1963 is regarded as one of the earliest instances of *Minimal art, and she was admired by Clement *Greenberg, who was generally opposed to Minimalism. He commented that 'it was hard to tell whether the success of Truitt's best works was primarily sculptural or pictorial, but part of their success consisted precisely in making that distinction irrelevant'. Her characteristic works were vertical blocks of wood between five and seven feet high painted in many layers of acrylic. This was a laborious process carried out by hand and it was one feature which distanced her from the Minimalists, who generally employed industrial techniques. She was also far closer socially and professionally to the Washington-based *Colour Field Painter Kenneth *Noland, who helped install her 1963 exhibition. In the mid-1960s, at the very point when Minimal art was achieving recognition, she spent four years in Japan with her husband, a leading journalist, a circumstance which may have impeded the recognition of her significance. Truitt was also known as a writer of autobiographical works and an exceptionally well read and learned person. James Meyer, an art historian who visited her late in her life, said that Truitt 'can leave one painfully aware of the gaps in one's education'.

Further Reading: J. Meyer, 'Grand Allusion', *Artforum* (May 2002)

truth to material(s) A belief, particularly associated with Henry *Moore, that the form of a work of art should be inseparably related to the material in which it is made. The origins of the concept, although not the phrase, are found in the writings of the British critic John Ruskin (1819–1900), especially in his book *The Seven Lamps of Architecture* (1856). His interpretation of the idea is distinct from Moore's, for he relates this 'truth' to the knowledge and expectations of the spectator, as opposed to some inner quality of the material itself. In 1934, in *Unit One*, Moore wrote that 'Each material has its own individual qualities... Stone, for example, is hard and concentrated and should not be falsified to look like soft flesh... It should keep its hard tense stoniness.' Although in theory the idea could be applied to any material, in effect it was used

by Moore as an argument for *direct carving, as practised by himself and contemporaries such as Barbara *Hepworth and John *Skeaping. Some other sculptors of the period, such as *Brancusi and *Epstein, even when not dogmatically committed to carving, made a clear distinction in handling in their respective treatments of bronze and stone.

Moore later came to believe that the idea of truth to materials had become a fetish and in 1951 he conceded that it should not be made into a criterion of value, 'otherwise a snowman made by a child would have to be praised at the expense of a *Rodin or a Bernini'. (A virtuoso in marble cutting, Bernini was renowned for his skill in creating lifelike effects and therefore exemplified the kind of 'falsification' Moore had criticized in *Unit One*: commenting on the elaborate curls of the wig in his bust of Louis XIV, Bernini—according to a contemporary report—said that it was 'no easy thing to attain that lightness in the hair to which he aspired, for he had to struggle against the contrary nature of the material'.) The extreme 'anti-Bernini' position that Moore argued against was satirized in a *Punch* cartoon of 1954—by William Sillince (1906–74)—in which two artistic types looking at a snowman admire the child's 'instinctive understanding of the right use of a medium', unaware that they are about to be pelted with snowballs from behind. The *New Generation sculptors such as Phillip *King and William *Tucker made a point of rejecting the principle by using anonymous materials like fibreglass and plastic, then painting them. However, something of the concept survived in the emphasis on form as the expression of process and material found in the work of *Minimalists and *Post-Minimalists such as Robert *Morris and Richard *Serra.

Tryon, Dwight See TONALISM.

Tübke, Werner (1929–2004) German painter, born in Schönebeck, one of the best-known but also one of the most controversial figures in the art of the Communist DDR. He joined the Artists' Union in 1952 as well as the East German Communist Party. His relations with the authorities could be problematic. In 1959 he was criticized for 'concessions to modernist views of art'. His style drew on medieval and Renaissance sources and was far closer to the *Magic Realism of Western Europe in the interwar period than to *Socialist Realism. In

early paintings he combined religious imagery with state-approved political subjects. The *Portrait of the Cattle Breeder Brigadier Bodlenko* (1962, Museum der Bildenden Künste, Leipzig), an equestrian portrait in the style of a medieval knight but sporting a modern wristwatch, was attacked as 'a ghostly, bizarrely estranged relationship to life in a country that is engaged in building a communist society'.

In 1965 he produced a cycle of paintings entitled *Die Lebenserinnerungen des Dr. jur. Schulze* (Nationalgalerie, Berlin). Although not a commissioned work, it followed official ideology in depicting continuity between the Nazi regime and the present-day politics of West Germany. The principal figure is a judge who, having perverted the judicial system during the Third Reich, remains a lawyer in the Federal Republic. The jumble of images has been compared by Richard Pettit to the apocalyptic scenes of Bosch and Bruegel. Tübke was vehemently criticized for 'idealism' and especially for proximity to Surrealism. By the 1970s the complexity of such work had become sanctioned by official criticism under the category of *Simultanbild* (Painting of Simultaneous Images) or 'dialogical pictures', which depended upon an intellectual dialogue with the spectator. The acceptance of Tübke's art was one manifestation of a change in official cultural policy in which artists of the past such as Albrecht Dürer and Lucas Cranach were celebrated. In this context, Tübke, by then one of the leading figures in East German art, was commissioned in 1970 to paint a gigantic panorama entitled *Early Bourgeois Revolution in Germany*. It depicts the Battle of Frankenhausen (1525), which led to the defeat of the peasants, and is housed in a specially constructed building in Bad Frankenhausen. Tübke's ambition was to link the Reformation, the Renaissance, and the Peasants' War. The work was completed in 1987. Although he trained his own team of assistants, most were unable to cope with the demands of the project, the largest painting in Germany according to the *Guinness Book of Records*, and Tübke executed approximately two thirds of the work himself. His leading critical supporter in West Germany, Edward Beaucamp, wrote in 1993 that in the panorama 'the artist in the end triumphs over the sponsor' and that he 'transformed the state monument into a pure art monument'.

By the time Germany was unified in 1989, Tübke already had a substantial reputation in

the West. As early as 1972, West German curators had surreptitiously tried to persuade him to defect. His relationship to the Old Masters was very much in accord with the vogue for *Postmodern quotation in the 1980s. Nonetheless, his most important post-Communist work, a three-winged altarpiece for the church of St Salvatoris in Clausthal-Zellerfeld (1997), was attacked by the critic Peter Iden as 'devotional kitsch'. Alongside Fritz *Cremer, Wolfgang *Mattheuer, and others, Tübke exemplifies the problems of making simple distinctions between conformists and nonconformists among the artists of the DDR, let alone of making moral judgements on their conduct.

Further Reading: R. W. Pettit, 'Werner Tübke and the Frankenhausen Panorama Painting', in M. S. Deshmukh (ed.), *Cultures in Conflict: Visual Arts in Eastern Germany since 1990* (1998)

(⊕) **SEE WEB LINKS**

• The official website devoted to the Frankenhausen Panorama.

Tucker, Albert (1914–99) Australian painter and printmaker, born in Melbourne. Because he could not afford full-time training, he was mainly self-taught as an artist. In the 1930s and 1940s he took a vigorous part in controversies about modern art in Australia, contributing several articles to *Angry Penguins. Although he was a member of the Australian Communist Party for a brief period, he was opposed to their demands for *Socialist Realism, especially that artists should take part in promoting the Allied war effort. He complained that 'They were trying to turn the artist into an illustrator of political concepts and this was simply not on'. He served in the army during the war, and in 1947 he visited Japan, where he worked briefly as an official artist to the Allied occupation forces. Later that year he moved to Europe, where he lived in London (1947–8), France (1948–50), Germany (1951), Italy (1952–6), and London again (1956–8). He then spent two years in New York before returning to Melbourne in 1960. Tucker's early work, influenced by *Expressionism and *Surrealism, is marked by a highly personal interpretation of social, political, and psychological concerns, as in his *Images of Modern Evil* series (1943). These depictions of the physical and psychological effects of war were attacked by the *Communist Review* in 1944 on the grounds that they 'reflected the panic of those members of the upper and middle

classes who are terrified of the enormity of war and the necessity of sacrifice'. In 1952, whilst living in Italy, he painted a series of religious pictures, and in 1955 (partly because of contact with *Nolan in Rome) he turned for the first time to themes of the Australian frontier: bushranging, exploration, and the desert. These toughminded works reveal the impact of *Art Brut and the textural pictures of *Burri and *Tàpies. During the 1960s and 1970s Australian imagery became dominant in his work, as in the *Bush* series, but in the 1980s he turned more to portraiture.

() SEE WEB LINKS

- J. Christian, 'Artist of a Turbulent Era dies' (8 January 2000), World Socialist Website.

Tucker, Marcia *See* NEW MUSEUM OF CONTEMPORARY ART.

Tucker, William (1935–) British abstract sculptor, writer on art, and teacher; he was born in Cairo, settled in the USA in 1976 and later became an American citizen. After reading history at Oxford University, 1955–8, he studied in London at the Central School of Art and Design and *St Martin's School of Art, 1959–60. In 1965 he was among the artists included in the *New Generation exhibition at the Whitechapel Art Gallery, which marked the emergence of a new British abstract sculpture, inspired by the teaching of Anthony *Caro. Of all the sculpture in this exhibition, Tucker's work was the most logically organized. As Ian Dunlop pointed out in the catalogue, the function of colour for Tucker was not to work as an element in its own right but to minimize the importance of the material by covering it with a skin and bringing out an aspect of the structure. Tucker was the most theoretically sophisticated of these artists. In 1974 he published *The Language of Sculpture*, a series of studies of early 20th-century sculptors which emphasizes the *formal issues around their work. What Tucker was seeking was a feature which defined sculpture in the way that the flat surface defines painting. He found it in the idea of gravity and the way that sculpture as a physical substance relates to this. So he puts forward as positive examples in the book those works by *Rodin that can be felt most fully to be lumps of metal, and sculpture by *Matisse and *Degas which operate as arabesques in space. By this time his own work had become more concerned with the physicality of mate-

rials. Sculptures were made of hinged wood like *Shuttler B* (1970, Tate) or out of twisted tubes of iron like *Beulah i* (1973, Tate). In 1975 he organized a major *Arts Council exhibition at the Hayward Gallery, London, entitled 'The Condition of Sculpture: A Selection of Recent Sculpture by Younger British and Foreign Artists', which focused on abstract work. In 1976 he began teaching at the University of Western Ontario, Canada, and in 1978 moved to Columbia University, New York. Later sculpture, like *Sleeping Musician* (1998, Tate), is generally in bronze and has the lumpy quality reminiscent of the aspects of Rodin that Tucker most admires.

Tudor-Hart, Percyval *See* SYNCHROMISM.

Tugendkhold, Yakov *See* SHCHUKIN, SERGEI.

Tuke, Henry Scott (1858–1929) British painter, born at York into a distinguished Quaker family. He studied at the *Slade School, 1875–80, then in Italy and Paris, where he was strongly influenced by contemporary French 'plein-air' painting. Tuke had known and loved Cornwall since childhood and after he returned to England in 1883 he settled there, living first at Newlyn (*see* NEWLYN SCHOOL) and then from 1885 in a cottage near Falmouth. His favourite subject—which he made his own—was nude boys in a sunlit atmosphere against a background of sea or shore. At first the freshness of these works—so different from the frigid studio nudes to which the public was accustomed—caused prudish objections (Tuke was a founder member of the *New English Art Club in 1886 and the sight of one of his paintings caused the dealer Martin Colnaghi to withdraw his financial backing for the group's first exhibition). However, they soon became favourites with the public and are now placed among the finest and most individual works of English *Impressionism. Tuke also painted portraits throughout his life.

Tunnard, John (1900–71) British painter and designer, born at Sandy, Bedfordshire, son of the painter J. C. Tunnard. After studying design at the *Royal College of Art, 1919–23, he worked as a textile designer until 1929, when he started painting. A year later he moved to Cornwall. In 1933 he had his first one-man exhibition at the Redfern Gallery, London, and from then on his work was seen in many

individual and group shows. From the mid-1930s he was influenced by *Surrealism, particularly by *Miró. His paintings often combined forms from both technology and the natural world (he was an amateur naturalist) in semi-abstract compositions.

Further Reading: R. Glossop and M. Glazebrook, *John Tunnard* (1977)

Tunnicliffe, Charles Frederick (1901–79) British engraver, illustrator, and painter, born in Langley, near Macclesfield, Cheshire. After growing up on a farm he studied at Macclesfield School of Art, 1915–21, and the *Royal College of Art, London, 1921–5 (Frank *Short was among his teachers). From 1925 to 1929 he taught part-time at Woolwich Polytechnic and during the the Second World War he was assistant art master at Manchester Grammar School, but apart from these two periods he was a freelance artist. After the war he settled at Malltreath in Anglesey. Tunnicliffe specialized in natural history subjects, particularly birds, and was best known as a book illustrator. He made his name with his wood engravings for Henry Williamson's *Tarka the Otter* (1932), and he illustrated almost a hundred other books. He worked in etching and scraperboard as well as wood engraving and also made detailed bird studies in watercolour. In 1978 he won the gold medal of the Royal Society for the Protection of Birds. He showed his work at the *Royal Academy every year from 1934 to 1978, and the Academy devoted an exhibition to him in 1974.

Turcato, Giulio (1912–95) Italian abstract painter. He was born in Mantua and studied in Venice. In 1943 he settled in Rome, where he joined *Forma in 1947 and edited its journal. Through this and other publications he became a leading spokesman for the cause of abstract art. Turcato's paintings were highly varied. In his early work he was influenced by *Cubism, *Expressionism, and *Fauvism, and in the 1950s he turned to the looser, more *gestural style of *Art Informel. Subsequently he experimented with unusual supports, including 'rough pockmarked sheets of foam rubber that gave to me the sense of the surface of the moon'. The paint he used on them included fluorescent and phosphorescent pigment: 'I was searching to make painting visible in the dark because, for me, it is absurd that one cannot see a painting or a wall in the dark.'

Turk, Gavin (1967–) British artist, born in Guildford. He studied at the *Royal College of Art but was denied his MA certificate after leaving his exhibition space empty and hanging simply a blue plaque, in the style used in London to commemorate the dwellings of the famous, saying 'Borough of Kensington. Gavin Turk Sculptor Worked Here 1989–1991'. His subsequent work has usually played on ideas about authenticity, through activities such as plagiarizing the signature of Piero *Manzoni. His best-known work is *Pop* (1993), a lifesize waxwork of Turk playing the Sex Pistol Sid Vicious taking on the pose of Elvis Presley as cowboy as appropriated by Andy *Warhol.

Turnbull, John See GROUP X.

Turnbull, William (1922–) British sculptor, painter, and printmaker born in Dundee. He left school at fifteen and worked as an illustrator on detective and love stories for the local publishing house of D. C. Thomson whilst studying art at evening classes. After serving as an RAF pilot in the Second World War he studied at the *Slade School, 1946–8, then in 1948–50 lived in Paris, where he saw a good deal of his fellow Scot and Slade student *Paolozzi and met such illustrious figures as *Brancusi and *Giacometti. In 1950 he had his first exhibition (a joint show with Paolozzi) at the Hanover Gallery, London, and was included in the selection of 'New Aspects of British Sculpture' (see GEOMETRY OF FEAR) at the 1952 Venice *Biennale. He was also a member of the *Independent Group, although his interest was less in popular culture than in challenging linear and progressive views of the development of art. In fact Turnbull's favoured sources have frequently been from the early periods of artistic development such as archaic Greek or Cycladic sculpture. His work as a sculptor evolved from spindly Giacometti-like forms to pieces in painted metal, but he has been consistently preoccupied with basic simple form: 'How little will suggest a head?' he once asked. Although he has sometimes been grouped with the *New Generation sculptors, who likewise used colour and were collected by Alastair McAlpine, he was a contemporary, not a student, of Anthony *Caro and his aesthetic was fundamentally different, being closer to *Minimal art, because of his interest in repetitive sequence. As a painter he was one of the first British artists to respond to the example of the American *Colour Field

Painters (he helped to organize the *'Situation' exhibition in 1960). His work in all media is distinguished by a particular sensitivity to the qualities of materials, the moist slithery patination of his bronzes being especially treasurable. In 1960 he married the Singapore-born sculptor Kim Lim (1936–97). She carved in wood and stone, sharing Turnbull's close engagement with materials.

Further Reading: Serpentine Gallery, *William Turnbull: sculpture and paintings* (1996)

Turner, John Doman *See* CAMDEN TOWN GROUP.

Turner Prize An annual prize (originally £10,000, in 2008 £25,000) for British achievement in the visual arts, named after the great English painter J. M. W. Turner. It was established in 1984 by the Patrons of New Art, a body founded two years earlier (as part of the Friends of the Tate Gallery) to encourage the collection of contemporary art. The regulations have changed somewhat since the prize was inaugurated. Originally it was awarded for 'the greatest contribution to art in Britain in the previous twelve months' and was open to critics and administrators (who were shortlisted but never won) as well as artists; since 1991 those eligible are British artists under the age of 50 who have had 'an outstanding exhibition or other presentation of their work' in the previous twelve months. The work of shortlisted artists (originally six, now four) is exhibited at Tate before the winner is announced. For the first three years the prize was supported by an 'anonymous patron' (the collector Oliver Prenn), and from 1987 it was backed by the American financiers Drexel Burnham Lambert. This firm suffered a financial collapse in 1990 and the prize was suspended that year; since then it has been sponsored by Channel 4 Television, which broadcasts the award ceremony live from Tate. On one occasion, this permitted the singer Madonna, presenting the prize, the privilege of swearing five minutes before the nine o'clock 'watershed' agreed by British broadcasters. In 2007, poor ratings made Channel 4 relegate the event to a news item, but in previous years an hour-long programme gave artists the opportunity to present their work in some depth. Until 2007 the director of the gallery was always on the jury that made the award. After the opening of Tate Modern in 2000, the event continued to be staged at Tate

Britain, although in 2007 it was held at Tate Liverpool.

Like the Booker Prize in literature, the Turner Prize attracts a great deal of publicity, although much of it has taken the form of hostile attacks. In spite of this the exhibitions have been generally well attended and a more pointed criticism might well be that the concentration on younger artists has made it harder to come up with four outstanding figures for the shortlist each year. It is certainly doubtful whether a selection of artists more acceptable to those critics who have little interest in contemporary art anyway would attract comparable public and media interest.

The winners of the Turner Prize have been: 1984, Malcolm *Morley; 1985, Howard *Hodgkin; 1986, *Gilbert & George; 1987, Richard *Deacon; 1988, Tony *Cragg; 1989, Richard *Long; 1990, prize suspended; 1991, Anish *Kapoor; 1992, Grenville *Davey; 1993, Rachel *Whiteread; 1994, Antony *Gormley; 1995, Damien *Hirst; 1996, Douglas *Gordon; 1997, Gillian *Wearing; 1998, Chris *Ofili; 1999, Steve *McQueen; 2000, Wolfgang *Tillmans; 2001, Martin *Creed; 2002, Keith *Tyson; 2003, Grayson *Perry; 2004, Jeremy *Deller; 2005, Simon *Starling; 2006, Tomma *Abts; 2007, Mark *Wallinger; 2008, Mark Leckey (1964–), an artist who works in a variety of media to explore the fascination exercised by the moving image.

Further Reading: V. Button and A. Searle, *The Turner Prize* (1998)

Turrell, James (1943–) American *installation and *Land artist, born in Los Angeles. He studied experimental psychology before he embarked on his career as an artist and his installation work is concerned with the problems of perception. Viewers enter controlled environments in which they experience pure colour. For instance a work entitled *Change of State* is a small colourless booth with dials which enable the viewer to modulate hue and intensity. *The Gloaming* (2001) is a completely dark space into which only two visitors are allowed at a time. After adjustment to the darkness a light appears, and seems to ebb and flow and dance around. This is, in fact, a complete illusion, the result of the eyes thinking that they are seeing. Since the 1970s Turrell has been transforming Roden Crater in Arizona into an artwork. It is scheduled to open in the early 22nd century.

Further Reading: M. Heim, *Virtual Realism* (1998)
J. Rose, 'James Turrell', *Artforum International* (May 2001)

Tuttle, Richard (1941–) American sculptor, painter, and printmaker born in New Jersey. Early in his life he formed a close friendship with the veteran painter Agnes *Martin, whom he described as 'an artist who is going to take 100 years for the world to catch up to what she is actually doing'. He shares her restrained approach to art. Among his early works are monochrome cloths, dyed rather than painted, and shaped into stretched octagons, the only internal incidents being slight irregularities of colour and surface bumps made by the dying process. When his work was seen at the *Whitney Museum in 1975, Hilton *Kramer was famously vituperative. Playing on Mies van der Rohe's dictum that 'less is more' he concluded that 'so far as art is concerned, less has never been less than this.' The curator Marcia Tucker (*see* NEW MUSEUM OF CONTEMPORARY ART), who eventually had to leave the Whitney as a result of the furore over the exhibition, replied by making a virtue out of the apparent slightness of the work: 'Tuttle's pieces are insistent; their often small size, visual frailty and blatant disregard for the kind of technical refinement found in 'major' art stubbornly, even perversely command attention'. In the long term Tucker seems to have been right. Tuttle's work has been highly influential on other artists, including David *Hammons and Jessica *Stockholder. Robert Storr describes him as the 'lyric poet of the ephemeral'.

Further Reading: R. Storr, 'Just Exquisite? The Art of Richard Tuttle', *Artforum* (November 1997)

Tuymans, Luc (1958–) Belgian painter, born in Mortsel. He studied fine art in Brussels and Antwerp between 1976 and 1982 and then art history between 1982 and 1986. After finishing his studies, he gave up painting for filmmaking for two years. His subsequent work as a painter has been frequently interpreted in the light of a supposed crisis in the continuing relevance of and possibilities for painting. In that he often uses photography as a source, he has sometimes been compared to Gerhard *Richter. Yet his approach could hardly be more different. There is none of the meticulous mimicry of the photographic surface. The works are broadly painted in a way that permits Tuymans to be selective as to what is shown and concealed. He uses a pale tonality, sometimes close to monochrome. This suggests a faded or damaged picture, withholding some of its significance. In certain works he induces cracks in the surface of the painting,

so suggesting a further degeneration of the image. He generally completes a painting in a single day of intensive work.

The result of this is a kind of painting which has undeniable physical seductiveness, but this alone does not account for the power of his work and the level of critical debate it has inspired. Tuymans, by implying more than he states, explicitly raises issues about the way that meanings are associated with pictures. An early example is a painting of 1989 which shows the simplified outline of a cat's head, a box like a cat box, two stylized images of a lawn, and two purely arbitrary spots. The material was taken from a commercial catalogue and it was the artist's wife who was struck by its implied violence and gave it the name *Child Abuse*. Elsewhere there is the sense of the uncanny evoked by the partial figure or the absence of human presence. A powerful example of the latter is *Silent Music* (1993, Stedelijk Museum, Amsterdam), a deserted room with an unmade bed. The pastel pinks and blues suggest a child's room, but in the words of Tuymans it is 'a sort of universal kid's room turned into a prison, a cell'.

The image in these paintings is never innocent of associations. Certain works allude cryptically to the Holocaust. One group of works refers to the militant Flemish nationalism which was resurgent in the late 1990s. At the Venice *Biennale in 2001 Tuymans showed a series of paintings entitled *Mwana Kitiko*. This was the contemptuous name (beautiful white boy) given by the Congolese to the Belgian king at the time of the anticolonial struggle in the 1950s. The feet of the king are seen in one painting, which is dominated by a leopard-skin rug. There is no explicit horror in the paintings, but there are allusions to political violence. In one painting two chalk hands are held out, each with a small yellow spot. A knowledge of the history is needed to point out the significance. When the first prime minister of the independent Congo was assassinated, all that was left of the body was two gold teeth fillings.

Further Reading: E. Dexter and J. Heynen, *Luc Tuymans* (2004)

U. Loock, *Luc Tuymans* (1996)

Twachtman, John H. *See* TEN, THE.

Twombly, Cy (1928–) American abstract painter, sculptor, draughtsman, and printmaker born in Lexington, Virginia, as Edwin Parker Twombly Jr. 'Cy' was a nickname given

by his father. He studied at the school of the Museum of Fine Arts, Boston (1948–9) and the *Art Students League, New York (1950–51), where he met Robert *Rauschenberg, with whom he was to have a close relationship. They studied together at *Black Mountain College in 1951–52 as well as travelling together to Italy and north Africa. In 1957 he settled in Rome, a move that signalled his allegiance to a classical European culture and may for a long time have damaged his reputation in America. As Robert *Hughes put it in 1994, 'He had sided with the beautiful Italian losers, against history.' Twombly is an artist whose work arouses extreme reactions and which depends for its effect absolutely on its physical presence. During the 1960s and 1970s he was far more highly regarded in Europe than in America. Now it is apparent that his work represents a response to the legacy of *Abstract Expressionism just as original as that of Rauschenberg or Jasper *Johns. His paintings have the character of being half-way between drawing and writing and have sometimes been compared to graffiti. Some works consist of perpetual loops which bite into a painted surface. One series is made on blackboards, but there is nothing of the somewhat authoritarian didacticism of Joseph *Beuys in his use of the medium. In some of the earlier paintings, hidden among the scrawls, are coded references to genitalia. Later paintings evoke the literature of classical antiquity, of which his view is far from the austere detachment of *Neoclassicism. His choice of themes tends to the emotive and the erotic. *Achilles Mourning the Death of Patroclus* (1962, Pompidou Centre, Paris) is a powerful example. Like the *Arte Povera artists, in resistance to contemporary consumer culture, he returns both to basic materials and gestures and to the invocation of classical antiquity. In his early work Twombly was a master of greys and whites. In later years he has become one of the boldest colourists of contemporary art. His work has been fascinating to critics concerned with language, such as Roland *Barthes, who admired art as representative of a kind of writing which emanated from the body.

Further Reading: N. Serota (ed.), *Cy Twombly: Cycles and Seasons* (2008)

291 Gallery *See* STIEGLITZ, ALFRED.

Tworkov, Jack (1900–82) Polish-born American painter. He emigrated to the USA in 1913, took a degree in creative writing at Columbia University in 1923, and studied at the National Academy of Design, New York, 1923–5. His early work was influenced by *Cézanne, but in the 1930s he worked for the *Federal Art Project and reluctantly had 'to salve my social conscience at the expense of my aesthetic instincts'. During the Second World War he worked as a tool designer, and when he returned to painting he began to reject European modernism for a more personal manner. An important factor in this was his friendship with Willem *de Kooning. They had met in 1934 and in 1948–53 they worked in adjacent studios in New York. Under de Kooning's influence Tworkov abandoned his figurative style and turned to *Abstract Expressionism, but around 1960 his style changed again and he moved to more geometrical designs. His paintings of the 1970s, with their closely hatched brushstrokes within a geometrical framework, represent his most individual statements. In 1974 he wrote that he aimed at 'a painting style in which planning does not exclude intuitive and sometimes random play'. Tworkov taught at several institutions, notably Yale University, where he became chairman of the department of art in 1963.

Further Reading: Solomon R. Guggenheim Museum, *Jack Tworkov, Fifteen Years of Painting* (1982)

Tyler, Kenneth *See* PRINT RENAISSANCE.

Tyson, Keith (1969–) British artist, born in Ulverston, Cumbria. He trained at Carlisle College of Art and the University of Brighton. His work demonstrates a fascination with scientific systems and also their limitations, 'the difference between the scientific reductionist view and experience'. One theme is the idea of unpredictability. *The Thinker* is a powerful computer without any connection to a display that would provide a way of knowing just what it is 'thinking'. This is contrasted with Tyson's own wall drawings, which make visible his own thought processes and responses to external events. Another work is a tower of newspapers. Tyson had bought up every copy of every newspaper on sale at London Bridge station on a certain day. The work was the effect on all those people who would normally have bought and read those newspapers, who would now have to find something else to do. *The Art Machine* was a device to generate instructions for Tyson to produce art. The demands were sometimes precise,

sometimes vague, and sometimes wildly impractical, as when it instructed to make a painting with pigment 18 inches thick or bounce a Morse code message off the moon. As Tyson admits, there is an element of trust involved in this and the viewer cannot be certain the artist has not simply found a way of rationalizing what he would like to do anyway. Tyson won the *Turner Prize in 2002.

Further Reading: 'Where the banal and bizarre collide', *The Daily Telegraph* (16 January 2002)

Tytgat, Edgard (1879–1957) Belgian painter, printmaker, and writer, born in Brussels, the son of a lithographer, who gave him his initial training in art. He began his career painting portraits, landscapes, and interiors in an *Impressionist style, and during the First World War he worked as a book illustrator in London, where he printed a memorial volume to his friend Rik *Wouters. After the war he returned to Belgium and turned to painting subjects such as circus and carnival themes in a mildly *Expressionistic, consciously *naive way. His work often drew on popular prints and folk art and it has a quality of humour that sets it apart from that of the other Belgian Expressionists. In 1923 he settled at Woluwe-St-Lambert. He wrote a good deal, including reminiscences of his childhood, but only part of his output has been published.

Further Reading: Museum Voor Moderne Kunst, Ostend, *Edgard Tytgat* (1998)

Tzara, Tristan *See* DADA.

Ubac, Raoul (1910–85) Belgian painter, sculptor, graphic artist, photographer, and designer, born in Malmedy and active mainly in France. Between 1928 and 1934 he travelled extensively in Europe and his artistic training was irregular and varied. From about 1934 to 1942 he concentrated on photography, joining the *Surrealist group in Paris and contributing Surrealist photographs to the journal *Minotaure*. It is for this work that he is now best remembered. He deformed the image of the body by attacking the photographic image chemically, either by *Man Ray's process of 'solarization' or by treating the emulsion of the negative with a burner, as in the mysterious *Woman Cloud* (1939, Pompidou Centre, Paris). In 1942 he abandoned both Surrealism and photography, and, like another ex-Surrealist, *Giacometti, for a while concentrated on intense observation, in his case on drawings of still-life. In 1946 he began to make double-sided reliefs in slate. These led to a distinctive style of abstract painting in which ribbons of brilliant azure colours are intriguingly coiled. Apart from paintings and sculpture, he did a large amount of graphic work, including woodcuts and book illustrations, and also made designs for tapestry (notably a series for the Nouveau Palais de Justice, Lille, 1969) and for stained glass (including work done in collaboration with Georges *Braque for a church at Varengeville). In 1957 he settled in L'Oise. *See also* HARE.

Further Reading: Krauss and Livingstone (1986)

Udaltsova, Nadezhda (1886–1961) Russian painter, born in Orel. Her family moved to Moscow in 1892. In 1908 she visited the *Shchukin collection and in 1912 went to Paris with her friend Liubov *Popova, studying with Henri *Le Fauconnier, Jean *Metzinger, and André *Dunoyer de Segonzac. On her return to Moscow she worked in the studio of *Tatlin and took part in the *Knave of Diamonds exhibition in 1914. Her paintings of this period—the best

known is *At the Piano* (1914, Yale University Art Gallery)—were strongly influenced by *Cubism, especially in the overlapping planes and use of stencilled letters. For Udaltsova, Cubism was closely linked with the environment of Paris. She wrote to Olga *Rozanova about 'the cubes of its houses and the interweavings of its viaducts, with its locomotive smoke trails, airborne planes and dirigibles' and how 'the architecture of the houses with their ochre and silver tones found their embodiment in the Cubist constructions of *Picasso'. After 1916 she began describing herself as a *Suprematist rather than a *Futurist and became committed to the primacy of painting. In 1916, at the exhibition 'The Store', she and Popova put up a poster reading 'Room for Professional Painters'. This was certainly a rebuke to her one-time colleague Tatlin, who had abandoned painting for construction. Her work became increasingly abstract, close in style to that of *Malevich. During the 1920s she taught textile design. Her work was seen outside Russia in Berlin in 1922 and at the Venice *Biennale in 1924. With the rise of *Socialist Realism her work was criticized for '*formalist tendencies'.

Her husband, Alexander Drevin (1886–1938), was also a painter and was shot in Stalin's purges.

Further Reading: V. Rakitin, 'Nadezhda Udaltsova', in J. Bowlt and M. Drutt (eds.), *Amazons of the Avant-garde* (1999)

Uecker, Günther (1930–) German painter, sculptor, designer, and *Kinetic artist, born at Wendorf, Mecklenberg. He studied at the Academies of Berlin-Weisensee, 1949–53 (East Germany), leaving for West Berlin in 1955 and studying in Düsseldorf, 1955–8. In 1957 he began using nails in his work and most of his subsequent work has included them. His first nail paintings have been interpreted as political metaphors of the injuries inflicted by the Nazi era and the need for a new beginning. At first the nails were driven into

panels—usually painted white—and then into various spatial constructions or existing objects such as chairs or a television set. The patterns of nails set up rhythms of light and shade, rather like wind passing through a field in sunshine. It was this quality of interaction between the art object and external light which first linked his work to Kinetic art, although he has subsequently made motorized and light sculptures. In 1961 he joined the *Zero Group. His other work has included set and costume designs for opera. In 1999 he designed the prayer room for the Reichstag in Berlin. In 1974 he became a professor at the Düsseldorf Academy.

Uglow, Euan (1932–2000) British painter. He was born in London of English and Welsh parents and studied at Camberwell School of Art, 1948–51, and the *Slade School, 1951–4 (in 1952–3 he spent much of his time travelling on scholarships, mainly in Italy and Spain). From 1961 he taught part-time at Camberwell and the Slade. Uglow painted landscapes, portraits, and still-lifes, but he is best known for his carefully composed nudes, in which the obsessively observational tradition stemming from the *Euston Road School, with its system of precise measurement with string and plumb line (*Coldstream was one of his teachers at Camberwell and the Slade), is combined with geometrical precision of composition. In 1972 he won first prize at the *John Moores Liverpool Exhibition with *Nude: 12 Vertical Positions from the Eye* (University of Liverpool Art Gallery), an extreme example of his fanatically methodical approach in which he observed the figure from twelve different points moving gradually downwards. His procedures had in a sense as much in common with *Process art as more traditional figurative painting. Sir John *Rothenstein wrote that 'He is probably the slowest of professional painters; it sometimes takes him three-quarters of an hour even to pose the model in the precise position he requires ... His output is therefore exceptionally small, sometimes amounting to no more than three or four canvases a year.' The close attention to a single object over a long period could lead to bizarre results such as *Diary of a Pear* (1982), in which the collapse through decay of the fruit is charted on the surface of the canvas. In spite of his small output and his aversion to publicity, he built up a strong reputation as a figurative painter, although he was always most highly regarded by his fellow artists. Myles Murphy wrote that

'many of the paintings take on a hallucinatory air like something seen either for the first time or the last, a mixture of wild surmise and the valedictory attempt to impress for ever upon the mind the features of a scene'. Critics could be less enthusiastic. Peter *Fuller dismissed his work as 'mannerist and without merit' and Adrian Searle described his work and attitude to art as 'horribly bleak' with 'its rules, its measurements, its endless difficulty, its unsmiling pleasures'. He lived a notoriously austere life, once telling an interviewer: 'I'm not a pop artist. I don't have a television. I've got a wind-up gramophone that's gone kaput. I have a wireless.'

Further Reading: A. Searle, 'Must try softer', *The Guardian* (8 July 2003)

Whitechapel Art Gallery, *Euan Uglow* (1974)

Uhde, Wilhelm (1874–1947) German collector, dealer, entrepreneur, and writer on art, active mainly in France. He was born in Friedeberg in the Neumark and studied in Munich and Florence, abandoning law for the history of art. In 1904 he settled in Paris and the following year he was buying pictures by *Braque and *Picasso at a time when these artists were practically unknown. He formed a strong friendship with Picasso which ended when the painter objected to Uhde's turgid book *Picasso et la tradition française* (1928). Uhde knew many other distinguished avant-garde figures and was a link between French and German artists: when *Klee visited Paris in 1912, Uhde introduced him to leading *Cubist painters, including *Delaunay, whose work made a great impact on Klee. (Uhde was homosexual, but in 1908 he had made a brief, unconsummated marriage of convenience to Sonia *Delaunay-Terk, so she could escape from her Russian family.)

Following the outbreak of the First World War in 1914 Uhde's collection was seized (and later sold) by the French, as he was considered an enemy alien, and he was forced to leave France. After the war Uhde returned to Paris and took up dealing again, becoming well known for discovering and encouraging *naive artists (earlier he had been one of the first to appreciate Henri *Rousseau, publishing the first monograph on him in 1911 and organizing the first retrospective of his work in 1912). In 1947 he published his best-known book, *Fünf primitive Meister*, dealing with *Bauchant, *Bombois, Rousseau, *Séraphine, and *Vivin.

Uhlmann, Hans (1900–75) German sculptor, born in Berlin. He studied at the Institute of Technology, Berlin, 1919–24, and in 1926, after working in industry, he began teaching electrical engineering there. He started making sculpture in 1925 and had his first one-man show at the Galerie Gurlitt, Berlin, in 1930. In 1933 he exhibited with the *Novembergruppe. From 1933 to 1935 he was a political prisoner and after his release was forbidden by the Nazis to exhibit. He went back to work in industry, but continued to produce sculpture and became the first German to make abstract constructions, using metal sheets, rods, and wires (he had visited the Soviet Union in the early 1930s and was influenced by Russian *Constructivism). Characteristically these sculptures are austere but elegant, sometimes painted. They were first exhibited at the Galerie Gerd Rosen, Berlin, where Uhlmann had a one-man show in 1947; subsequently he exhibited frequently in Germany and abroad, so bridging the gap between the avant-garde art of pre-Nazi Germany and the dominance of abstraction in the post-war period.

Ultvedt, Per Olof See SAINT PHALLE, NIKI DE.

Umělecký měsíčník (Art Monthly) See GROUP OF PLASTIC ARTISTS.

Underground art See UNOFFICIAL ART.

Underwood, Leon (1890–1975) British sculptor, painter, printmaker, teacher, and writer, born in London, the son of an impoverished dealer in antiquities and coins. He studied at the Regent Street Polytechnic, 1907–10, the *Royal College of Art, 1910–13, and (after war service as a camouflage officer in the Royal Engineers) at the *Slade School, 1919–20. A versatile and original figure, Underwood was out of sympathy with abstraction, which he described as 'artfully making emptiness less conspicuous'. Nevertheless, from the early 1960s critics began to speak of him as 'the father of modern sculpture in Britain', in view of the streamlined stylized forms of his carvings and bronzes in the 1920s and 1930s and the influence of his teaching. He taught part-time at the Royal College of Art (where Henry *Moore was one of his pupils) from 1920 to 1923, resigning after an argument with the principal, William *Rothenstein, and at his own Brook Green School in Girdlers Road, Hammersmith, which he opened in 1921 and ran intermittently until 1938. Underwood travelled widely and wrote several books, including three on African art. Like Moore he was strongly influenced by the Pre-Columbian art of Mexico (he had visited the country), but it was as much a reflection of his fascination with the culture as the formal values of the art. In *Art For Heaven's Sake* (1934) he expressed his ideas about the superiority of intuition and imagination over technology, often in pithy, epigrammatic form: 'Type your circulars and keep a pen for your love letters.' He illustrated his own books (and a few by other authors) with etchings and woodcuts. His painting, which was sometimes influenced by *primitive art, was generally less interesting than his sculpture. In 1931 he edited a short-lived periodical (four issues) called *The Island*, whose contributors included Henry Moore, Eileen *Agar, and Mahatma Gandhi, who provided a short statement on the alliance between religion and art and wishing the project well.

Further Reading: B. Whitworth, *The Sculpture of Leon Underwood* (2000)

Ungerer, Tomi (1931–) French illustrator, born in Strasbourg. His work demonstrates a subversive spirit: his classic children's book *The Three Brigands* (1967) brilliantly combines black humour and sentiment but also makes a political statement about anarchism and socialism. His background in Alsace has given him a particular perspective on the fraught relations between France and Germany, who have each laid claims to the territory. He dealt with these in an exhibition held in Berlin in 2000, 'Marianne and Germania', which included drawings made by Ungerer as a child in Colmar at the time of the Nazi occupation. In 2001 a museum of his work opened in Strasbourg.

Union of Youth (Soyuz Molodyozhi) An association of Russian avant-garde artists founded in St Petersburg in late 1909; it was established formally in February 1910 and broke up in 1914. The Union, which was sponsored by the businessman and collector Lerky Zheverzheyev (1881–1942), existed primarily as an exhibition society and to promote public discussions and spectacles relating to modern trends in the visual arts. Most of the leading members of Russia's avant-garde were associated with it in one way or another. It held six exhibitions between 1910 and 1914, the first put on in St Petersburg and Riga, the others either in

St Petersburg or Moscow. Various styles were represented at these exhibitions, but the Union became principally a centre of the Russian *Futurist movement. On consecutive evenings in December 1913 at the Luna Park Theatre in St Petersburg it staged two works that were remarkable for their Futurist decor: Vladimir *Mayakovsky's first play *Vladimir Mayakovsky: A Tragedy*, with a backcloth by *Filonov and Iosif Shkolnik (1883–1926) assisted by *Rozanova, and the Futurist opera *Victory over the Sun*, for which *Malevich designed the sets and costumes. It was to these designs that Malevich traced the beginning of *Supermatism.

Unism *See* STRZEMIŃSKI, VLADISLAV.

Unit One A group of eleven avant-garde British artists formed in 1933. Its birth was announced in a letter to *The Times* by Paul *Nash, published on 12 June of that year. The members were the painters John *Armstrong, John Bigge (1892–1973), *Burra, *Hillier, Nash, *Nicholson, and *Wadsworth; the sculptors *Hepworth and *Moore; and the architects Colin Lucas (1906–84) and Wells Coates (1895–1958), who was also one of the outstanding industrial designers of the day. Douglas *Cooper was secretary. In April 1934 the group published a book, *Unit One: The Modern Movement in English Architecture, Painting and Sculpture*, edited by Herbert *Read, which was originally intended as the first of a series. Coinciding with the publication of the book, they held their only group exhibition, at the Mayor Gallery, London (founded in 1933 by Fred Mayor (1903–73), one of the most progressive British art dealers of this period). Between May 1934 and April 1935 a reduced version of the exhibition toured to six provincial venues (Liverpool, Manchester, Hanley, Derby, Swansea, and Belfast). Despite their 'mutual sympathies', the artists of Unit One had no common doctrine or programme and the group was breaking up by the time the exhibition tour ended. However, although it was short-lived, Unit One made a considerable impact on British art of the 1930s, and the two main trends it represented (abstraction and *Surrealism) were shown in two major exhibitions in London in 1936: 'Abstract and Concrete' at the Lefevre Gallery, and the International Surrealist Exhibition at the New Burlington Galleries.

Further Reading: Mayor Gallery, *Unit One: Spirit of the 30s* (1984)

Universal Limited Art Editions *See* PRINT RENAISSANCE.

Unofficial art A term for art produced in the Soviet Union that did not conform to the ideals of *Socialist Realism, which became the officially sanctioned style of the state in 1932. Any form of artistic independence was virtually impossible, indeed physically dangerous, under the rule of Stalin (1924–53), but there was a slight thaw under his successor Nikita Khrushchev, who in 1956 denounced Stalin's abuse of power. Unofficial art began to appear in public a few years after this, in about 1960, and in 1962 one of its leading figures, the sculptor Ernst *Neizvestny, had a public confrontation with Khrushchev about the validity of modern art. The authorities could still be highly repressive, however, and in 1974 an open-air exhibition of Unofficial art in a field near Moscow was broken up with water cannon and bulldozers, causing it to be dubbed the 'Bulldozer Show'. Unofficial art was stylistically varied and individualistic, often reflecting avant-garde Western movements, but from about 1970 a distinctive strand emerged within it—*Sots art, in which the conventions of Socialist Realism were mocked. During the 1970s such art began to be seen in the West (for example at an exhibition at the *Institute of Contemporary Arts, London, in 1977); several Unofficial artists were allowed to leave the Soviet Union and a few achieved success in Europe and the USA, notably Neizvestny and the team of *Komar & Melamid. During the late 1980s, the much more liberal policies of Mikhail Gorbachev (Soviet leader 1985–91) brought great changes and eventually the Soviet authorities came to see the benefits—financial as well as cultural—of exporting art to the West. By the time the Soviet Union broke up in 1991 there was even a company called Sovart that placed Soviet artists with Western galleries. 'Sovart' is also one of several names that have been used as alternatives to 'Unofficial art'; others are 'Non-Conformist art' and 'Underground art'.

Utrillo, Maurice (1883–1955) French painter, born in Paris, the illegitimate son of Suzanne *Valadon. He took his surname from the Spanish painter Miguel Utrillo (1862–1934), who legally recognized him as his son in order to help him (his real father, according to some sources, was the Symbolist painter Pierre Puvis de Chavannes, who was 40 years

older than Valadon). Utrillo began to paint in 1902 under pressure from his mother, who hoped it would remedy the alcoholism to which he had been a victim since boyhood (in 1934 the Tate Gallery wrongly stated in a catalogue that he had died of drink in that year, resulting in a libel suit, settled out of court). Valadon gave him his first lessons, but he was largely self-taught. He first exhibited his work publicly at the *Salon d'Automne in 1909 and had his first one-man show in 1913, at the Galerie Blot in Paris. This received little attention, but in 1923 a joint exhibition with his mother at the Galerie *Bernheim-Jeune in Paris was a success, and thereafter he became prosperous and critically acclaimed. In 1937 he settled at Le Vésinet on the outskirts of Paris and in his final years gave as much time to religious devotions as to painting.

Utrillo was highly prolific, painting mainly street scenes in Montmartre, although he also did numerous views of churches and cathedrals (*Church at St Hilaire*, c.1911, Tate). The period from about 1910 to 1916 is known as his 'white period' because of the predominance of milky or chalky tones in his pictures (he sometimes mixed plaster with his paint), and it is generally agreed that he did his best paintings during this time. They subtly convey solitude and emotional emptiness and have a delicate feeling for tone and atmosphere, even though he often worked from postcards rather than directly from the motif. His later work is livelier and more freely painted, but less touching. Utrillo's work is in many museums and (no doubt because of the deceptive simplicity of his paintings) he is among the most forged of modern artists. In 1976 the Greek-Cypriot dealer Paul Pétridès (1901–93), who had been Utrillo's exclusive agent since 1935 and was the recognized authority on his art, was convicted of handling stolen paintings, and this cast doubt on his probity in authenticating works by the master.

Further Reading: A. Werner, *Utrillo* (1981)

Utter, André *See* VALADON, SUZANNE.

Vaisman, Meyer *See* BICKERTON, ASHLEY.

Valadon, Suzanne (1865–1938) French painter, born at Bessines-sur-Gartempe, near Limoges. She was the illegitimate daughter of a maid and was brought up in Paris in bleak and unaffectionate circumstances. As a girl she worked as a circus acrobat, but she had to abandon this after a fall and then became an artists' model and the reigning beauty of Montmartre. The artists she posed for included *Renoir, Toulouse-Lautrec, and the *Symbolist painter Pierre Puvis de Chavannes (each of whom numbered among her lovers). She had drawn since childhood, and Toulouse-Lautrec brought her work to the attention of *Degas, who encouraged her to develop her artistic talent. In 1896 she married, and the financial support of her husband allowed her to work full-time as an artist. Her first one-woman show was in 1915 and after the First World War she achieved critical and financial success. She had no formal training and owed little to the influence of the artists with whom she associated, her painting showing a fresh and personal vision. Her subjects included still-life and portraits (including self-portraits in which she brings out her formidable strength of character), but she was at her best in figure paintings, which often have a splendid earthy vigour and a striking use of bold contour and flat colour (*The Blue Room*, 1923, Pompidou Centre, Paris, on deposit with Musée Municipal de l'Evéché, Limoges). She has been compared with the writer Colette for her sharpness of eye and avidity for life. After divorcing her first husband, in 1914 she married the painter André Utter (1886–1948), who was a friend of her son Maurice *Utrillo and some twenty years younger than her. In her final years she was estranged from both Utter and Utrillo and her health was ruined by the excesses of her life.

Further Reading: J. Warnod, *Suzanne Valadon* (1981)

Vale Press *See* RICKETTS, CHARLES.

Valette, Adolphe *See* LOWRY, L. S.

Vallotton, Félix (1865–1925) Swiss-born painter, printmaker, illustrator, sculptor, and writer who became a French citizen in 1900. He was born in Lausanne and after attending evening classes in art locally he moved to Paris in 1882 to study at the *Académie Julian. Paris remained his home until his death, but he often visited Switzerland and made numerous other journeys abroad. In his early days in France he copied and repaired paintings and did illustrations for popular journals to earn a living, and in the 1890s he worked a good deal in woodcut; apart from *Gauguin, he was the most important French pioneer of the revival of this medium. His woodcut style was less forceful and more polished than Gauguin's, although still very striking. Typically he used very strong contrasts of black and white to create a vigorous sense of pattern. He made illustrations for the left-wing periodical *L'Assiette au beurre*. His anarchist sympathies were especially apparent in his work in print form, in which he depicted police brutality (*The Anarchist*, 1892). He was a friend of *Bonnard and *Vuillard and in the 1890s he sometimes exhibited with their *Symbolist group the *Nabis. In 1899 he married into the *Bernheim-Jeune family of picture dealers, and the financial security this brought him enabled him to concentrate on his painting. In his canvases he took over something of the simplifications of form and sharp contrasts between blocks of light and shadow that characterize his woodcuts. His subjects included landscapes, portraits, nudes, and interiors. Vallotton often worked at Honfleur, and from 1920 in the south of France, especially at Cagnes (*Road at St Paul*, 1922, Tate). He wrote art criticism and also a posthumously published novel, *La Vie meurtrière* (1930), which is illustrated by himself.

Further Reading: M. Ducrey, *Felix Vallotton* (2007)

Valori plastici An art periodical published in Rome from 1918 to 1921 in both Italian and

French editions (it was originally a monthly but became bi-monthly). The editor and publisher was Mario Broglio (1891–1948), a critic and painter, who was conservative in outlook. The first number contained articles by *Carrà, *de Chirico, and *Savinio setting forth the ideals of *Metaphysical Painting. It published articles on *Cubism and De *Stijl but the main tenor of the journal—supported by Carrà and de Chirico—was in favour of a return to the Italian classical tradition of naturalism and fine craftsmanship, and European avant-garde movements were criticized for forsaking the principles of that tradition. Although the journal was not published after Mussolini came to power in 1922 this policy coincided closely with much of the official art of the Fascist period. *See also* NEOCLASSICISM.

Valtat, Louis (1869–1952) French painter, born in Dieppe. He entered the École des *Beaux-Arts, Paris, in 1877, and subsequently studied at the *Académie Julian. His early work was in a *Neo-Impressionist style, but by the mid-1890s he was painting with pure, strong colours in a manner that anticipated *Fauvism. He later exhibited with the Fauves, notably at the famous *Salon d'Automne exhibition in 1905 at which they acquired their name, but he was never a formal member of the group. While most of the Fauves abandoned the style after a few years, Valtat continued to explore the use of pure colour throughout his life. Until 1914 he spent much of his time in the South of France, then lived in relative seclusion in the valley of the Chevreuse near Paris. He maintained a substantial output of landscapes, still-lifes, figure studies, portraits, and flower pieces, but disappeared from the public gaze. In 1948 he went blind. It was only after his death that he was recognized as a significant precursor of Fauvism.

Vancouver School Group of Canadian artists including Stan *Douglas, Rodney *Graham, and Jeff *Wall who have, since the 1980s, developed distinctive practices in photographic and *Video art, combining a critical view of the mass media with considerable skill in exploiting its techniques.

Vanguard *See* AVANT-GARDE.

Vanni, Samuel (1908–92) Finnish painter, born at Viipuri (now Vyborg in Russia). He trained at various art schools in Finland and elsewhere, notably the *Académie Julian, Paris. His early work included landscapes, portraits, and still-lifes, but after the Second World War he became one of the pioneers of abstract art in Finland. Initially he moved to abstraction through simplifying natural forms, but in the 1960s his style became more geometrical and his work sometimes verged on *Op art. Vanni's output included several large murals in public buildings. He was influential not only through such works, but also through his teaching at art schools in Helsinki.

Van Sant, Tom *See* SKY ART.

Vantongerloo, Georges (1886–1965) Belgian sculptor, painter, architect, and writer on art, active mainly in France. He was born in Antwerp and studied at the Academy there and at the Brussels Academy. In 1914 he was wounded whilst serving with the Belgian army and from 1914 to 1918 was interned in the Netherlands. There he joined the De *Stijl group in 1917 and turned from the conventionally naturalistic style he had previously practised to abstract sculptures in which he applied the principles of *Neo-Plasticism to three dimensions (*Interrelation of Volumes*, 1919, Tate). From 1919 to 1927 he lived in the French Riviera resort of Menton and then for the rest of his life in Paris, where he was a member of *Cercle et Carré and in 1931 one of the founders of *Abstraction-Création. From 1928 Vantongerloo began to design ambitious (and unrealized) architectural projects, including a 'Skyscraper City' (1930), whose cubiform structure resembles that of his sculptures. In the 1940s his sculpture became more varied as he began using wire and perspex, exploring effects of reflection and refraction. His paintings were based on horizontal and vertical lines until 1937, when he introduced rhythmic curving lines. He was a close friend of Max *Bill, who organized several exhibitions of his work and became his executor.

Vantongerloo was one of the pioneers of a mathematical approach to abstract art. He rejected his friend *Mondrian's idea that only constructions based on the right angle reflect the harmony of the universe, believing that this was only one way among many of achieving formal relations that would embody spiritual values. Some of his art theories are expressed in his collection of essays *L'Art et son avenir*, published in 1924.

Vargas, Alberto *See* AIRBRUSH.

Varley, Fred See GROUP OF SEVEN; MACDONALD, JOCK.

Varo, Remedios (1908–63) Spanish painter and designer, active for most of her career in Mexico. She was born at Anglés, near Girona, the daughter of a hydraulic engineer, and studied at the Academy in Madrid. From 1930 to 1932 she lived in Paris, then settled in Barcelona. In 1936 she met the French *Surrealist poet Benjamin Péret, who was fighting with the Republicans against the Fascists in the Spanish Civil War. When the Republicans were defeated, the couple moved to Paris, where they married in 1937 (Varo had earlier been briefly married to a fellow student in Madrid). Through her husband, Varo was drawn into the Surrealist movement: she exhibited in the International Surrealist Exhibition in Paris in 1938, for example, and her paintings were reproduced in *Minotaure*. In 1942 the couple fled German-occupied France and settled in Mexico City, where several exiled Surrealists had already taken up residence, notably Leonora *Carrington (who became a close friend of Varo) and Wolfgang *Paalen. Varo separated from Péret in 1948. Initially she earned her living in Mexico as a commercial artist and designer, and did not paint full time until 1953; most of her surviving paintings therefore date from the last decade of her life. Characteristically they depict strange, delicately painted figures set in a weird fantasy world; the atmosphere is often claustrophobic, but sometimes accompanied by a sense of whimsical humour rather than of menace, drawing on imagery from the tarot and from alchemy.

Vasarely, Victor (1906–97) Hungarian-born painter, sculptor, and designer who settled in Paris in 1930 and became a French citizen in 1959, the main originator and one of the leading practitioners of *Op art. He studied in Budapest at the Poldini-Volkman Academy of Painting and the Mühely School (known as the *Bauhaus of Budapest) before he settled in Paris in 1930. For the next decade he worked mainly as a commercial artist, particularly on the designing of posters, showing a keen interest in visual tricks and space illusions. From 1943 he turned to painting and he had his first one-man exhibition in 1944, at Denise *René's gallery. About three years later he adopted the method of geometrical abstraction for which he is best known. Typically he created a hallucinatory impression of movement through visual ambiguity, using alternating positive–negative shapes in such a way as to suggest underlying secondary shapes. His fascination with the idea of movement led him to experiment with *Kinetic art and he also collaborated with architects in such works as his relief in aluminium for Caracas University (1954), and the French Pavilion at 'Expo '67' in Montreal, hoping to create a kind of urban folk art. From 1961 Vasarely lived mainly in the South of France, where he founded two museums devoted to his work—the Fondation Vasarely at Aix-en-Provence, which he designed himself, and the Château and Musée Vasarely at Gordes (both are now closed). There are two Vasarely museums in Hungary, in Budapest and his birthplace Pecs. According to his obituary in *The Times*, 'To him the artist was simply an artisan who creates his artefacts at will and in volume, so that they can be accessible to the ordinary person'.

(((●))) SEE WEB LINKS
• The official website.

Vaughan, Keith (1912–77) British painter, draughtsman, designer, and writer, born in Selsey, Sussex. In the 1940s, with his friend John *Minton, he was one of the leading exponents of *Neo-Romanticism, characteristic works of this time being coloured drawings of moonlit houses. His post-war work, in which he concentrated on his favourite themes of landscapes and male nudes in a landscape setting, became grander and more simplified, moving towards abstraction (*Leaping Figure*, 1951, Tate). Some of his late pictures are almost pure abstracts, the rich slabs of paint giving only the merest suggestion of natural forms. He had numerous one-man shows of his paintings, and his output also included textile designs and book jackets. His varied activities brought him critical and financial success, but he felt deep insecurity about his work and his role in life, as is revealed in his journal, especially in the explicit version published posthumously in 1989. As well as containing many perceptive comments about art, it gives a remarkably frank (and often highly amusing) account of Vaughan's homosexual and masturbatory activities and movingly chronicles the struggle with cancer that led to his suicide.

Vautier, Benjamin See BODY ART.

Vauxcelles, Louis (1870–1943) French art critic. In the period between the turn of the century and the First World War, he was probably the most widely read of French critics, his work appearing in many newspapers and periodicals, particularly *Excelsior* and *Gil Blas*, for which he was the regular art correspondent. However, he is now remembered solely because he gave rise to the names of two of the 20th century's most famous art movements—*Fauvism and *Cubism. He said of *Braque, 'Let us not make fun of him since he is honest', but he soon became identified with vociferous opposition to Cubism, and by 1918 he was even spreading false rumours that *Picasso and *Gris were disillusioned with the movement. Because of this he has sometimes been pigeonholed as an arch-conservative, but although he was hostile to certain types of avant-garde art (particularly abstraction) he was broadly anti-academic in his sympathies. For instance, he was an early supporter of Julio *González. His later years are obscure and his date of death has only recently came to light.

Vedova, Emilio (1919–2006) Italian painter and graphic artist, born in Venice, where he spent most of his career. He had no formal training as an artist, but he painted from an early age and began to exhibit in 1936. From the beginning a main theme of his work was social injustice and in 1942 he joined the anti-Fascist association *Corrente in Milan. The influences on his early work included *Rouault and *Picasso's *Guernica*, but also sources close to home in the dynamic spaces of Venetian churches and in the paintings of Tintoretto. After the Second World War (during which he worked with the Resistance in Rome) Vedova turned to abstraction. He was a signatory of the manifesto *Beyond Guernica* (1946), which urged the engagement with reality without naturalism. Initially his style was geometric, but he developed a violent, improvisatory manner with which he gained a reputation as one of the leading Italian exponents of *Art Informel. He continued to express his political convictions in his abstract works (they often have titles such as *Cycle of Protest* and *Concentration Camp*) and critics have seen them as the expression of a passionate impulse for freedom and claustrophobic dread of oppression. In the 1960s he worked with projectors and electronic instruments to create effects of moving and superimposed lights. He collaborated with another politically committed artist,

the composer Luigi Nono (1924–90), on the opera *Prometheus* at La Fenice Theatre, Venice, for which he designed a light setting. Christopher Masters commented on him that despite the embrace of the political establishment, which included the title of Cavaliere di Gran Croce della Repubblica Italiana and a commission for a tapestry in the Italian senate, 'he remained to the end a left-wing icon, the bearded, bespectacled hero of radical Italian art'. Vedova won numerous awards for painting and graphic art, including the Grand Prize for painting at the 1960 Venice *Biennale.

Further Reading: C. Masters, 'E. Vedova', *The Guardian* (26 November 2006)

Velde, Bram van (1895–1981) Dutch painter and printmaker, active mainly in France. He was born at Zoeterwoude, near Leiden. In 1907, at the age of twelve, he was apprenticed to an interior decorator, who was so impressed with his talent that in 1922 he sent him to *Worpswede to complete his artistic education. He moved to Paris in 1925, and apart from the years 1932–6, which he spent in Majorca, he lived there until 1965. During the Second World War he was reduced to abject poverty and virtually stopped painting between 1940 and 1945. He had his first solo exhibition in 1946 (at the Galerie Mai, Paris), but he did not achieve substantial recognition until 1958, when there was a retrospective exhibition of his work at the Kunsthalle, Berne. In 1965 he moved to Switzerland and settled in Geneva.

At Worpswede van Velde was deeply influenced by German *Expressionism and his work remained Expressionist in spirit throughout his career. On his arrival in Paris he adopted a *Fauvist palette, painting landscapes and flower pieces in vivid colours, and he later incorporated formal simplifications derived from *Cubism. But even before 1930 the subject of his paintings would often recede and virtually disappear behind flecks and lines of colour, and these early works have therefore been regarded as anticipating the abstract manner he adopted in the late 1930s. By 1945 he had developed his mature style, characterized by vaguely defined fluid shapes that trigger off associations of figures, faces, masks, and objects but obstinately refuse identification. His paintings have been said to embody the spirit of existentialism, and the writer Samuel Beckett—an early champion—characterized his work as 'primarily a painting of the

thing in a state of suspense...the thing alone...the thing immobile in the void.' Van Velde's paintings give the feeling of dynamic spontaneity, but in fact he worked slowly and deliberately, often taking months to complete a picture. Consequently his œuvre is fairly small—about 200 paintings. A good collection of them is in the Musée d'Art et d'Histoire in Geneva.

His brother **Geer van Velde** (1898–1977) was also a painter and likewise active mainly in France. He was self-taught as an artist. In 1925 he moved to Paris and lived in or near the city for the rest of his life, apart from the war years, which he spent at Cagnes. His most characteristic works are abstracts painted in light, translucent colours, often delicate shades of blue. His compositions are more geometrical than those of his brother; behind the lines and abstract shapes there appear to lie vague suggestions of still-lifes or interiors.

Velde, Henry van de (1863–1957) Belgian architect, designer, painter, writer, and teacher, one of the chief creators and exponents of the *Art Nouveau style and a key figure in the development of art teaching in the 20th century. He was born in Antwerp, where he studied painting at the Academy, 1880–83, but he gave up painting in about 1890 because he decided that 'what is of use to only one person is close to being of use to no one, and in the near future only what is of use to *all* will be considered useful'; thereafter he devoted himself to architecture and applied art. In 1896 he carried out decorations for Siegfried Bing's Paris shop Maison de l'Art Nouveau, from which the name of the new style derived. Van de Velde's work for Bing featured the sinuous curves typical of Art Nouveau, but he believed in a rational use of form, unencumbered by tradition, and thought that ornament should grow naturally from the structure rather than being mere superficial decoration. In 1897 some of his work was exhibited in Dresden to great acclaim, leading to several commissions in Germany, where he moved in 1900. From 1902 to 1917 he lived in Weimar, where he was appointed head of the new Kunstgewerbeschule (School of Arts and Crafts). The teaching here was novel in that pupils—instead of studying the art of the past—were encouraged to think in terms of the needs of the modern world. Van de Velde's successor in Weimar was Walter *Gropius, who developed his

ideas at the *Bauhaus. In 1917 van de Velde moved to Switzerland, then in 1920 the Netherlands, where he began to work for Helene *Kröller-Müller, for whom he later designed the celebrated museum at Otterlo (1937–54).

Venice, Palazzo Grassi See HULTEN, PONTUS.

Venice Biennale See BIENNALE.

Venturi, Robert See POSTMODERNISM.

Vergeaud, Armand See CORPORA, ANTONIO.

Verism An extreme form of realism in which the artist tries to reproduce the subject with rigid truthfulness and scrupulous attention to detail, repudiating idealization and imaginative interpretation. The term has been applied, for example, to the most realistic Roman portrait sculpture. In the context of 20th-century art it has been applied to *Superrealism (sometimes also called Photorealism) and rather less justifiably to *Magic Realism and the 'hand-painted dream photographs' of *Dalí and other *Surrealists working in the same vein. The phrase 'Veristic Surrealism' is sometimes used to characterize this last type. The notion that verism represents a privileged vision of reality or even of appearances hardly stands up to examination in the light of theories of perception and representation. Indeed many practitioners, either by accident or design, suggest not everyday reality but the 'uncanny', as with Meredith *Frampton or Carel *Willink.

Verkade, Jan See NABIS.

Ver Sacrum Periodical (a miscellany of literature, illustration, and graphic work) published in Vienna from 1898 to 1903 as the journal of the Vienna *Sezession; the name means 'sacred spring'. It is described by Peter Vergo (1975) as 'from an artistic and literary standpoint...one of the outstanding periodicals of its day. The editors...sought to realize new conceptions of layout and design, to create a unity out of the printed page, subordinating the individual processes of ornamentation and typography to a single purpose. An important role was played by the illustrative material; there were reproductions of works by corresponding members of the association from abroad, as well as

valuable photographs of the Secession's own exhibitions.' Several leading poets wrote for the journal and 'There were also frequent musical contributions, reinforcing the image of artistic unity *Ver Sacrum* sought to propagate'. For the first two years it was published monthly, then from January 1900 every two weeks. The tighter schedule had an adverse effect on the quality of the later issues.

Vespignani, Renzo *See* ROMAN SCHOOL.

Vettriano, Jack (1951–) Scottish painter, born in St Andrews, Fife. He left school at sixteen and was self-taught as an artist. His career as a painter began in 1989 when two works he submitted to the Royal Scottish Academy sold immediately. His first solo exhibition was in 1992. He specializes in thinly painted, sexually charged images of men and women. His paintings have become known principally through reproduction, especially on calendars and greetings cards. There is an enormous disparity between the popularity of his work with a wide public and his standing with most art professionals and, as with Beryl *Cook, there has been considerable discussion as to whether his work should be represented in museum collections. For instance, in 2005 the head of the Scottish *Arts Council called for him to be represented in Scotland's national collections, although the curators had consistently rejected his work on grounds of quality. Later that year a Scottish newspaper discovered that the figures in his most popular painting, *The Singing Butler* (1992), had been lifted from an illustrator's manual. Paradoxically this was probably more problematic for his admirers than for the specialist contemporary art world, in which the practice of *appropriation is an accepted device and the impossibility of total originality is taken for granted. The gulf between the uncritical admiration of his supporters and the lack of any serious attention from more specialist circles has resulted in there being little critical examination of the appeal of his paintings. It has been noted that they depend on Vettriano's skill in suggesting a kind of sexual interaction between the figures. They also evoke a period, the interwar years, and as in *The Singing Butler* are often located at the seaside (and a very British one it is, hence the umbrellas). The seaside has been, especially since the 1930s, identified as the place of popular leisure. In Vettriano's paintings it is virtually deserted

and appropriated as a place for erotic games by a social elite. The viewer sees all this from a servile low viewpoint. There is a case for considering the political agenda of Vettriano's art more troubling than its artistic quality. *See also* POPULAR PRINTS.

(((●))) SEE WEB LINKS

● The artist's website.

Viallat, Claude *See* SUPPORTS-SURFACES.

Viani, Alberto *See* FRONTE NUOVO DELLE ARTI.

Video art An umbrella term that can be conveniently applied to all art which uses the moving image, even where the support is film or, as is most usually the case today, digital disc. It can range from work that can perfectly well be viewed in conditions close to that of normal commercial film to works that employ moving images as part of an installation or performance. Somewhere between there is a kind of work which, while it consists only of a video image, is intended to be viewed within a gallery space, rather like a painting, but one which happens to move. In this final case, appreciation of the work rarely depends on it being seen from start to finish like an ordinary narrative film. Instead the spectators tend to come and go at will, as with any other kind of artwork. Some of the problems which spectators have had with Video art have come from difficulty in distinguishing the first and third types. Younger audiences, more familiar with the convention, do not have the same difficulty and very quickly grasp whether or not the work requires to be viewed from beginning to end.

Lightweight video equipment which could be used by artists became available in the mid-1960s, but before that there was a tradition of experimental film made by directors close to *avant-garde circles as well as by artists in traditional media. It is probably only the expense of the film medium and the tight commercial structures that control its production and distribution which have made the examples comparatively rare. The most famous instances are *Un Chien Andalou* (1929) and *L'Age d'Or* (1930), the result of collaboration between Salvador *Dalí and Luis Buñuel. Despite the fact that these masterpieces of *Surrealism really work best when the audience sits down to watch them in a normal cinema situation, they are now often

screened on the walls in modern art museums. There have also been a number of totally abstract films, such as those of Viking *Eggeling and Hans *Richter. Paradoxically, what might have been the death blow for this tradition was the success of the long abstract sequence in Stanley Kubrick's science fiction film *2001: A Space Odyssey* (1968). The independent low-budget avant-garde simply could not compete with the spectacle it offered.

Early use of the video camera by artists tended to be technically crude, but this was almost an advantage when Video art was presented as an oppositional alternative to the institutionalized slickness of television. Only black-and-white was available in the early years, colour being too expensive except for professional broadcasters. The technology, notably the introduction of the Sony Portopack in 1965, arrived at a time when *Conceptual art opened up the possibilities of new media, but also demoted the significance of visual pleasure. This was fortuitous for the early development of Video art, as in examples such as Bruce *Nauman's *Bouncing Balls* (1969). At the same time Nam June *Paik was exploring the possibilities of combining video with sculpture and performance. The links with television were developed by Gerry Schum (1938–74), who ran a video gallery in Düsseldorf and tried to place experimental video on broadcast television. The most conspicuous success was the *Self-Burial* (1969) of Keith Arnatt (1930–). Still photographs of the artist gradually sinking into the ground were inserted without warning over a period of days on West German television. The sequence of nine photographs is now one of the best-known examples of Conceptual art and was, in fact, not originally intended for television, but as a sequence of photographs which commented on the disappearance of the art object.

Later Video art has been less puritanical in its willingness to indulge narrative and visual pleasure. Portable colour equipment became available in 1974. Other technical advances, including video projection and DVD, have made practical the hybrid form of 'video installation art'. This can involve the use of multiple screens or the combination of video with objects and environment. Some artists have projected video on to objects. For instance the American Tony Oursler (1957–) combines video and sculpture by projecting moving faces on egg-shaped solids suspended from poles. The

American Gary Hill (1951–) in his *Tall Ships* (1992) set up a dark corridor on which were projected the images of people. By computer technology these images would approach viewers as they passed by and return to the background as they moved on. The Belgian Marie-Jo Lafontaine (1950–) sometimes makes use of multiple monitors, either for contrast or repetition. *The Burial of Mozart* (1986) juxtaposes a cock fight with a Sicilian funeral. *The Tears of Steel* (1986, Museum für Neue Kunst, Karlsruhe) encases monitors screening identical pictures of a body builder inside a giant black framework designed to suggest both a torso and an exercise device. Even when there is no installation other than the projected image, Video artists such as Bill *Viola, Stan *Douglas, and Rodney *Graham make their work on continuous loops so as to emphasize the distance from conventional narrative cinema and encourage a kind of viewing in an open-ended time frame closer to that normally given to a painting, photograph, or sculpture.

While some artists have specialized in video, others, such as Mark *Wallinger, have made it an element of a wider artistic practice. The dividing line between Video art and ordinary cinema is increasingly hard to define with precision and perhaps it is no longer important to do so. Video artists such as Steve *McQueen and Douglas *Gordon are part of a history which is as much to do with cinema as the older visual arts. Links with commercial cinema can, sometimes, extend to the use of star performers. The Irish artist James Coleman (1941–) exhibited *Retake with Evidence* at the 2007 *documenta. It showed Harvey Keitel, the American actor, in a studio with bits of classical ruin, speaking an unidentified prophetic text. The work was projected in an empty room on a screen larger than that of most modern cinemas. Video art is customarily far more elliptical and illusive in its approach to narrative than ordinary cinema. An example is the work of the British artist Tacita Dean (1965–), who continues to prefer to use 16mm film. *Disappearance at Sea* (1996) uses images of lighthouses filmed at dusk when the lights are switched on. It is the title that brings to mind the stories of the mysterious disappearances both of the yachtsman Donald Crowhurst and the artist Bas Jan *Ader.

The video game has now been added as a potential form of Video art, as in the work of Chinese artist Feng Mengbo (1966–). He has drawn on the standard commercial 'shoot 'em

up' formula. However, this technology has been applied to serious purpose in the work of Langlands and Bell (Ben Langlands, 1965– , and Nikki Bell, 1969–). In *The House of Osama Bin Laden* (2003), the viewer can use a joystick to explore a bleak, semi-derelict building in which the notorious terrorist leader once lived. The work depends on the tension between the pleasures of game play and the horrific associations of the name.

In contrast to the rhetorical effects of the large video screen within the gallery space, the internet has made artists' video increasingly available to a wide public, especially since the establishment of YouTube in 2005, although this has had the unfortunate effect of making artists vulnerable to piracy, just like big media corporations who are far better able to fight their corner.

Further Reading: Rush (2007)

Vie et Lumière *See* LUMINISM.

Vieira da Silva, Maria Elena (1908–92)

Portuguese-born painter, graphic artist, and designer who settled in Paris in 1928 and became a French citizen in 1956. She studied sculpture with *Bourdelle and *Despiau, then painting with *Bissière, *Friesz, and *Léger, and engraving with *Hayter. In 1930 she married the Hungarian painter Arpad Szènes (1900–84), who became her principal artistic mentor. In the mid-1930s she began to attract attention with pictures consisting of flecks of colour against a greyish or neutral background. These works, which evoke a sense of landscape, giving the impression of space without recourse to traditional devices of perspective, have something in common with Bissière's paintings, but Vieira da Silva's spiky linear organization is her own. From 1940 to 1947 she lived with her husband in Brazil, where her reputation grew. After her return to France she rapidly gained recognition as one of the most gifted painters in the style of *Lyrical Abstraction that dominated the *École de Paris at this time. From 1948 she exhibited frequently in London and New York and her work is represented in many of the world's major collections of modern art. She won numerous awards, among them the Grand Prix at the 1961 São Paulo *Bienal. Apart from paintings her work included prints and designs for stained glass and tapestries.

Vienna Actionists (Viennese Actionism, Wiener Aktionismus)

Names applied to a group of Austrian artists who worked together in the 1960s. Their work had as its sources *Action Painting and the American *Happening, even the Wagnerian idea of the 'total work of art', but they took this into areas which many have found unsavoury and shocking. The work used as materials blood, excrement, the abused human body, and the slaughter of animals. The three main members of the group were Gunter *Brus, Otto *Muehl, and Hermann *Nitsch, who first collaborated in 1961 and in 1966 began calling themselves the Institut für Direkte Kunst (Institute for Immediate Art). As such they took part in the Destruction in Art festival in London in 1966. Other people associated with them included Brus's wife Anni Brus, the actor Heinz Cibulka, VALIE *EXPORT, and Rudolf *Schwarzkogler. Their performances led to the arrest of the participants on several occasions. Nitsch was the chief spokesman of the group. He described their work as 'an aesthetic form of praying' and maintained that it could bring liberation from violence through catharsis: 'All torment and lust, combined in a single state of unburdened intoxication, will pervade me and therefore YOU. The play-acting will be a means of gaining access to the most "profound" and "holy" symbols through blasphemy and desecration.' The critic Lea Vergine has argued that this art includes an element of 'ferocious misogyny' and that this is especially true of 'those scatological actions where the ingestion of urine, feces and other products of elimination stands as a symbol for an envy of the womb and functions as a kind of exorcism of the terror of openly competing with the female genitals' (*Body Art and Performance: The Body as Language*, 2000).

The painter Per *Kirkeby recalled that 'I didn't find the works themselves very powerful. But when in 1983 I was working in Austria...I understood: it had to be done. It's a society so unbelievably clerical, conservative, I'd say literally Fascist! What they did had to be done. That's why ever since I've held the Viennese Actionists in high esteem.' A retrospective exhibition of the group was scheduled to be held in Edinburgh in 1988, but it was cancelled because it was thought likely to prove too shocking. However, in 2001 the work of the Actionists was on display at the Louvre. In an exhibition entitled 'La Peinture

comme crime', their work was presented as the culmination of a transgressive tradition of art which included Goya and *Redon.

Further Reading: R. Fleck, 'L'actionisme viennois', in Centre Georges Pompidou, *Hors limites: l'art et la vie 1952–1994* (1994)

Vigeland, Gustav (1869–1943) The most famous of Norwegian sculptors. Born in Mandal, he studied in Oslo and Copenhagen and then (1892–5) in Paris (spending a few months with *Rodin) and Italy. At this time he worked in a painstakingly naturalistic style, but in 1900 he began studying medieval sculpture in preparation for restoration work on Trondheim Cathedral and this led to his work becoming expressively stylized. In the same year he made his first sketches for the massive project that occupied him for the rest of his life—a series of allegorical groups at Frogner Park, Oslo. The project was not completed until 1944, after the sculptor's death. Originally only a fountain was planned, but with the help of assistants Vigeland went on to create numerous other groups, including a 17-metre-high column composed of intertwining bodies. The symbolism of the scheme is not clear, but essentially it represents 'a statement of the doubt, disillusion, and physical decline that beset humanity in its passage through the world' (George Heard *Hamilton).

Villanueva, Carlos Raúl See OTERO, ALEJANDRO.

Villeglé, Jacques See AFFICHISTE.

Villers, Gaston de See BERNHEIM-JEUNE.

Villon, Jacques (1875–1963) French painter, graphic artist, and designer, born at Damville in Normandy, the elder brother of Marcel and Suzanne *Duchamp and of Raymond *Duchamp-Villon. His original name was Gaston Duchamp, but he changed it in 1895 because of his admiration for the 15th-century poet François Villon. In 1894 he moved to Paris to study law (his father's profession), but he soon abandoned it for art, initially earning his living mainly as a newspaper illustrator. He was one of the founders of the *Salon d'Automne in 1903 and in 1905 he shared an exhibition with his brother Duchamp-Villon at the Galerie Legrip, Rouen. From about this time he began devoting more attention to painting, initially working in a *Neo-Impressionist style, and from 1910 it was his main

concern. In 1911 he began experimenting with *Cubism, and the following year he was one of the founders of the *Section d'Or group, whose name he coined (*see also* PUTEAUX GROUP). He exhibited (and sold) nine paintings at the *Armory Show in New York in 1913. After the First World War (during which he served in the army) he began painting geometrical abstracts (*Colour Perspective*, 1921, Guggenheim Museum, New York), but in the 1920s he earned his living mainly as a printmaker (he was an expert etcher). In 1921 he had a one-man exhibition at the *Société Anonyme, New York, and for most of the interwar period he was probably better known in the USA than in Europe. During this time he moved back and forth between abstraction and a highly schematized type of figuration (*Portrait of the Artist's Father*, 1924, Guggenheim Museum). After the Second World War Villon enjoyed substantially greater recognition than in the earlier part of his career, winning first prize at the *Carnegie International in 1956 and the grand prize for painting at the Venice *Biennale in 1958, when he was in his 80s. In 1955 he designed stained-glass windows for Metz Cathedral.

Vine, Stella (1969–) British painter, born in Alnwick, Northumberland, as Melissa Robinson. She changed her name in 1995. After a career as actress, cleaner, waitress and stripper she studied at Hampstead School of Art in the late 1990s. She first came to public attention when Charles *Saatchi bought two of her paintings for his 'New Blood' exhibition in 2004. One of these depicted Princess Diana. The artist had just read a newspaper report in which Paul Burrell, Diana's butler, revealed a letter in which she spoke of her fears of assassination. Some of the power of the picture derives from the disjunction between the royal accoutrements (Diana has her tiara) and the desperate inscription: 'Hi Paul, can you come over? I'm really frightened.' The subject of the other painting was even more contentious. *Rachel* showed the drug addict Rachel Whitear, whose death had caused anguished national debate. The faces of both subjects had blood dripping from their mouths. Not only the subject but the artistic merit of the paintings was attacked. Dave Lee wrote that 'you could laugh it off as the work of somebody who lived on a council estate', giving vent to the kind of class prejudice most critics today make some attempt to self-censor.

An alternative view might be to see Vine as directly in the line of Sarah *Lucas and Tracey *Emin (both of whom she reveres), a female artist who rawly exposes emotions and anxieties. She has also spoken of the singer PJ Harvey as an influence. Vine's initial success and acclaim were followed by a difficult period of financial problems and drug addiction. However, controversy has given way to a certain art world acceptance. An exhibition of her paintings was held at *Modern Art, Oxford, in 2007 with a catalogue introduced by Germaine *Greer.

Further Reading: L. Barber, 'Vine Times', *The Observer* (8 July 2007)

Vingt, Les See LIBRE ESTHÉTIQUE.

Viola, Bill (1951–) American *Video artist, known for his spectacular installations. Born in New York, he studied at Syracuse University, where he became especially interested in electronic music. He made his first video tape in 1972, *Wild Horses*, which contained alternating images of wild and tamed horses. In the early 1970s he exhibited alongside such pioneers of Video art as Nam June *Paik and Bruce *Nauman. In the late 1970s and early 1980s he travelled widely, including trips to Fiji and the Himalayas recording traditional music. During this period he became highly critical of the privileging of European art in conventional histories of the subject. Since 1978 he has worked in close collaboration with his wife, Kira Petrov.

Viola's work tends to engulf the spectator. He has been deeply involved with Buddhism but also affected by other spiritual traditions. Alongside the frequent references to Old Master paintings, this has made Viola in some way the 'acceptable face' of Video art in relatively conservative environments: his work has been seen in Durham Cathedral and in the National Gallery, London. (This spiritual emphasis has also been strongly criticized by some other Video artists such as Susan *Hiller.) His installation *Room for St John of the Cross* (1983, Museum of Contemporary Art, Los Angeles) was dedicated to the Spanish poet and mystic (1542–91) who was imprisoned for nine months in a tiny room for his beliefs. It combines a kind of reconstruction of the room in which the saint's poems can be heard and a larger space outside, on one wall of which images of a mountain range are projected. In the background, a roaring sound is heard. For Viola, the mystic is a kind of outsider in religion, in some way analo-

gous to the artist. The religious theme is again explicit in *Emergence* (2002, J. Paul Getty Museum, Los Angeles), a literal re-enactment of the Resurrection. *Nantes Triptych* (1991) used the format of Renaissance religious painting by employing three-screen projection to represent the cycle of life. On either side there were images of birth and death (a real birth and an old woman on her deathbed). The central panel shows a figure engulfed in turbulent water.

Further Reading: M. L. Syring, *Bill Viola: Unseen Images* (1992)

Viola, Manuel See EL PASO.

Virius, Mirko See HLEBINE SCHOOL.

Visser, Carel (1928–) Dutch sculptor and printmaker, born in Papendrecht, near Rotterdam. For much of his career he has worked principally in iron, initially making animals and insects under the influence of *González and *Giacometti. In the mid-1950s he moved into a more *Constructivist phase, introducing a highly symmetrical and methodical structure. In the 1960s he made sculptures which involved the cutting and welding of iron pieces. *Hanging* (1966, Tate) is a typical example. Here, a bar has been cut in two halves: one has been left intact, the other has been cut into eight pieces, sliced like a sausage. Rewelded, it hangs over the edge of the base held only by a thin weld to the uncut piece. This preoccupation with weight, balance, and material brought Visser close to *Minimal art and it was during the 1970s, when his work could be compared to artists such as *Andre and *Serra, that Visser had his greatest international exposure. (For most of his career his reputation has been highest in his home country.) Some sculpture of the 1970s combined iron with leather or allows iron sheets to bend like slightly stiffened fabric. Visser said that he equated the cube with certainty, order, and establishment, even Calvinism, and that this was why his work attacked it. Certainly in his subsequent sculptures the insects and animals have taken over again in somewhat whimsical multimedia works with a surreal edge (*Winged Umbrella*, 1979, Groninger Museum, Groningen).

Further Reading: Whitechapel Art Gallery, *Carel Visser* (1978)

Vivancos, Miguel García (1895–1972) Spain's best-known *naive painter, born in Mazarron, Murcia. He worked in Barcelona

at various jobs (chauffeur, docker, glazier), then after fighting in the Spanish Civil War escaped to France in 1938. During the German occupation he was held in a concentration camp. In 1944 he settled in Paris, where he was employed in a clothing firm as a painter on silk and began to paint on his own. He attracted the attention of André *Breton, who wrote about him and introduced his work to dealers. During the 1950s he had one-man shows in several Paris galleries and was included in international exhibitions of naive art. He painted mainly architectural subjects and cityscapes in a manner akin to that of *Vivin.

Vivin, Louis (1861–1936) French *naive painter. He had a passion for painting from childhood but could not devote himself to it regularly until he retired from his job in the Post Office in 1922. In 1925 he was 'discovered' by Wilhelm *Uhde and thereafter he won wide recognition. His work included genre scenes, flower pieces, hunting scenes and views of Paris, notable for their charmingly wobbly perspective effects.

Vkhutemas (Vysshie Khudozhest-venno-Tekhnicheskiye Masterskiye) (Higher Technical-Artistic Studios) An art school in Moscow set up after the Revolution by combining the former School of Painting, Sculpture, and Architecture with the Stroganov Art School; when it was founded in 1918 it was called *Svomas, but it was renamed Vkhutemas in 1920. Among the artists who had studios and taught in the Vkhutemas were *Kandinsky, *Malevich, *Pevsner, and *Tatlin. *Gabo was not officially on the staff, but he taught sculpture there. The programme of the Vkhutemas was controlled by the Institute of Artistic Culture (*Inkhuk). In 1925 the name was changed from Vkhutemas to Vkhutein (Higher Technical Institute) and in 1930 the school was reorganized under central Communist Party control.

Vlaminck, Maurice de (1876–1958) French painter (mainly of landscape and still-life), printmaker, and writer, born in Paris, to a Flemish father and a French mother. He left home in 1892 at the age of sixteen, and from 1893 to 1896 was a professional racing cyclist (he was a large and athletically built man), enjoying the attention his success at the sport brought him: 'At that time women admired us in the same way as today they admire an airman.' An attack of typhoid fever ended this career, and after doing his military service, he earned his living for the next few years mainly as a violinist in nightclub orchestras (both his parents were musicians). A colourful and many-sided character, he also did other jobs, including playing billiards semi-professionally, and in 1902 he published his first novel, *D'un lit dans l'autre* ('From One Bed to Another'), with illustrations by *Derain (they became friends after they were both involved in a minor railway accident, and they shared a studio in 1901–2). All the while Vlaminck painted in his spare time. Apart from a few lessons from a family friend when he was a boy, he had no formal instruction in art, and he liked to inveigh against all forms of academic training, boasting that he had never set foot in the Louvre: 'I try to paint with my heart and my loins, not bothering with style.'

In 1901 he was overwhelmed by an exhibition of van Gogh's work at the Galerie *Bernheim-Jeune in Paris: 'I was so moved that I wanted to cry with joy and despair. On that day I loved van Gogh more than I loved my father.' This turned him decisively towards art as a career, and in 1905 he exhibited with Derain, *Matisse and others at the 1905 *Salon d'Automne that launched *Fauvism. At this time his work showed a love of pure colour typical of the movement; often he used unmixed paint squeezed straight from the tube. However, his northern background can be detected in his preference for a dark tonality. Whereas the Fauve paintings of Matisse and Derain tend to celebrate the sun through a brilliant use of white, Vlaminck unified his Fauve canvases with a deep Prussian blue. From 1908, his palette became more restrained and his work more solidly constructed, under the influence of *Cézanne. In 1910–14 he was also mildly influenced by *Cubist stylization, although he came to dislike *Picasso and even regard him as a charlatan.

During the First World War Vlaminck was briefly mobilized, but he spent most of it working in war industries. Soon after the war he moved out of Paris and in 1925 settled in a farmhouse in Eure-et-Loir. Thereafter his subjects were taken mainly from the surrounding countryside. His work became rather slick and mannered, but his reputation grew steadily in France and abroad during the interwar years. After the German invasion of France in 1940, he—like several other well-known artists—was courted by the Nazis for propaganda

V

purposes, and in 1941 he visited Germany as part of a group that included Derain, *Despiau, van *Dongen, *Dunoyer de Segonzac, and *Friesz. In 1944, immediately after the Liberation, he was arrested and interrogated, and although no action was taken against him, the suspicions of collaboration damaged his career. By the end of his life, however, he had been more or less rehabilitated. In addition to novels, Vlaminck wrote several volumes of memoirs. He was a pioneer collector of African art, although this only briefly influenced his style.

Vollard, Ambroise (1866–1939) French dealer, connoisseur, publisher, and writer, one of the most important champions of advanced art in the early 20th century. He was a lawyer by training and began his career in the art world by buying prints from the quayside stalls along the River Seine. He opened a gallery at 39 rue Laffitte, Paris, in 1893, moving to better premises at 6 rue Laffitte in 1895. In 1894 he bought four *Cézannes, which he sold within a year for twice the price. In 1895 he gave the first major exhibition of Cézanne's work, the event which marked the major turning point in the artist's reputation. In the same year he held an exhibition of the work of van Gogh (see EXPRESSIONISM). He also showed the work of Paul *Gauguin. Until the outbreak of the First World War the gallery was one of the city's most important centres of innovative art, other landmark events including the first one-man exhibitions of *Picasso (1901) and *Matisse (1904). Picasso later recalled that the pictures were hung to the ceiling and that some were unframed or even unstretched. The clientele included some of the leading collectors of the day, among them *Barnes, *Morozov, and Gertrude and Leo *Stein.

Vollard sometimes took an active role in shaping an artist's work: in 1906 he sent *Derain to London to paint the Thames, presumably in an attempt to emulate the earlier success of *Monet in this subject. In addition to buying and selling paintings, he played an important role as a publisher by encouraging his artists to work as printmakers: he commissioned them to illustrate books (literary classics as well as contemporary works) and also issued independent portfolios of prints: 'My idea was to order engravings from artists who were not professional engravers. What might have been looked upon as a hazardous venture, turned out to be a great artistic suc-

cess.' These publications (often commercial failures) were a kind of private passion, financed by his successful picture dealing, and he spared neither time nor money to achieve the finest results. The first work to bear his imprint was a portfolio of twelve colour lithographs by *Bonnard entitled *Quelques Aspects de la vie de Paris* (1895), and his most famous publication was Picasso's *Vollard Suite*, consisting of 100 etchings on various themes (notably *The Sculptor's Studio*) made between 1930 and 1937. It was Vollard who prompted *Maillol's move into sculpture and arranged for the assistance of Richard Guino to facilitate the sculpture of *Renoir's last years. He also encouraged his artists to work on painted ceramics, although this was less commercially successful. His writings include books on Cézanne, *Degas, and Renoir and the autobiographical *Recollections of a Picture Dealer* (1936); a slightly expanded French version, *Souvenirs d'un marchand de tableaux*, appeared in 1937. Vollard's image is familiar through numerous portraits. Cézanne painted him in 1899, taking 115 sittings. He appears clutching the easel in Maurice Denis's *Homage to Cézanne* (1900, Musée d'Orsay, Paris). Picasso unforgettably defined the dome of his bald head in *Cubist angles in his portrait of 1909–10 (Pushkin Museum, Moscow). Renoir also painted him, on one occasion affectionately, holding a Maillol statuette (1908, Courtauld Gallery, London), on another, quite ludicrously, in the guise of a toreador (1917, Nippon Television Corporation, Tokyo). Vollard died in a motor accident.

Vordemberge-Gildewart, Friedrich (1899–1962) German-born abstract painter who settled in the Netherlands in 1938 and became a Dutch citizen; he was one of the first artists to work in an abstract style throughout his entire career. Born in Osnabrück, he moved to Hanover in 1919 to study architecture and sculpture. He began making abstract reliefs in the same year. In Hanover he met *Arp, *Lissitzky, *Schwitters, and most importantly van *Doesberg, through whom he joined De *Stijl in 1924. Vordemberge-Gildewart was to remain faithful to the ideas of De Stijl for the rest of his life. In 1925–6 he lived in Paris and had several other stays there in the next few years, during which he had his first one-man show (in 1929 at the Galerie Povolozky) and became a member of *Abstraction-Création (in 1932). He

moved from Hanover to Berlin in 1936, then in 1937 left Germany because of the Nazis, going first to Switzerland and then settling in Amsterdam in 1938. As well as painting, his work in the Netherlands included designing window displays for department stores, and he also taught at the Academy in Rotterdam. In 1954 he returned to Germany when Max *Bill appointed him head of the department of visual communication at the Hochschule für Gestaltung in Ulm, and he died in Ulm eight years later.

Vordemberge-Gildewart aimed to link art and technology. His work was severely geometrical, influenced by *Suprematism and *Constructivism (he sometimes added relief elements—such as sections of picture framing—to his paintings) and then most deeply by De Stijl. His austerity extended to the naming of his works, which were given numbers rather than conventional titles, as in *Composition No. 15* (1925, Tate).

Vorticism An avant-garde British art movement launched in 1914; it was related to *Cubism and *Futurism and was mainly concerned with the visual arts, but it also embraced literature (its central figure, Wyndham *Lewis, was a writer as well as a painter, and its name was suggested by the American poet Ezra *Pound, to whom the vortex represented 'the point of maximum energy', an expression of the dynamism of modern life). Vorticism was highly aggressive in tone, celebrating movement and the machine, and attacking what Lewis considered the complacency and sentimentality of contemporary British culture. It was short-lived, its vigour being dissipated by the First World War, but for a time it had a powerful, revitalizing impact.

Although Vorticism was not officially launched until 1914, the movement started to take shape in October the previous year, when Lewis and several of his associates left the *Omega Workshops because of a quarrel with Roger *Fry. In April 1914 Lewis formed the short-lived *Rebel Art Centre, and the names of several of the leading 'rebel' artists were used (without permission) by *Marinetti in his Futurist manifesto *Vital English Art*, published in *The Observer* on 7 June 1914 while he was visiting London. This unauthorized appropriation of his name stung Lewis into producing the first issue of his magazine *Blast: Review of the Great English Vortex* (dated June, but published in July), in which he made a bitter attack on *Vital English Art* in the shape of his own *Vorticist Manifesto*. In addition to Lewis, the signatories included Jessica *Dismorr, Henri *Gaudier-Brzeska, Pound, William *Roberts, and Edward *Wadsworth. The manifesto attacked ('blasted') a wide range of targets in an attempt to jolt Britain out of its insularity and rid it of its lingering Victorian values.

Although Lewis dissociated himself so vehemently from Marinetti, the exuberant typography of *Blast* was clearly influenced by Futurism, which was also one of the main sources for the paintings and sculptures produced by the Vorticists (even the word 'vortex' had been used by the Futurists, notably in the title of some of *Boccioni's paintings). Lewis criticized Futurism as melodramatic, but it—like Vorticism—was essentially concerned with showing the energy of modern life. However, while Futurist paintings often involved blurring of forms to suggest speed, Vorticist paintings were characteristically hard, harsh and angular, evoking what *Blast* called 'the forms of machinery, factories, new and vaster buildings, bridges and works'. Because Vorticism shared some of the loud aggressiveness of Futurism, the word is sometimes associated with ceaseless, swirling energy, but to Lewis the vortex was a still centre in the maelstrom of life, and however explosive his paintings are, they are always lucidly constructed, with a feeling of intellectual rigour rather than emotional abandon. Lewis attacked *Cubism as well as Futurism, but the fragmentation of forms characteristic of Vorticiom was undoubtedly indebted to Cubism.

The Vorticists held only one exhibition, at the Doré Gallery, London, in June 1915. Apart from the formal members, the artists taking part included David *Bomberg and Christopher *Nevinson. Jacob *Epstein was not included, but his work was reproduced in *Blast* and he is generally considered an associate of the movement. The second (and final) number of *Blast* appeared in July 1915, by which time the war was scattering the Vorticists and breaking up the movement (Gaudier-Brzeska had already been killed in action). Pound did his best to keep its spirit alive. He persuaded the American collector John *Quinn to buy Vorticist works and he encouraged the American-born photographer Alvin Langdon Coburn (1882–1966), who had settled in Britain in 1912, to experiment with semi-abstract photographic equivalents of Vorticist

paintings—'Vortographs', produced by taking the image through a prismatic arrangement of mirrors. When Lewis returned from war service he made rather half-hearted plans for a third issue of *Blast*, but nothing materialized, and his attempt to revive Vorticism in 1919 as *Group X was a failure.

Further Reading: J. Beckett, *Blast: Vorticism, 1914–1918* (2000)

Vostell, Wolf (1932–98) German artist, born at Leverkusen, best known as one of Europe's leading organizers of *Happenings. He studied graphic techniques and typography in Cologne (1950–53) and Wuppertal (1954–5), then painting at the École des *Beaux-Arts, Paris (1955–7), and the Düsseldorf Academy (1957–8). In 1954 he devised the term 'décollage' for collages he made from fragments of torn posters (a technique influenced by the *affichistes). He derived the term from a newspaper report of an air disaster: the word means both the take-off and the 'unsticking' of the aircraft. Subsequently he applied the word to other works (as in 'Décollages-Happenings') and in 1962–9 he published a magazine called *Dé-coll/age*. The *Nein-9-décollagen* Happening held in Wuppertal (1963) involved bussing the spectators to nine different parts of the city to events which included crashing a Mercedes car into a train travelling at 80 miles an hour. He first organized Happenings in Paris in 1958 and thereafter in numerous other cities, including Berlin and New York. In 1962 he joined the *Fluxus movement. Much of his work was politically motivated, with the accent on violence and destruction. *Heuschrecken/Grasshoppers* (1969–70, Museum Moderner Kunst Stiftung Ludwig, Vienna) consists of a wall-size photomontage of a naked female couple making love with an image of a Soviet tank on a Prague street confronting a demonstrator. There is a bank of television screens at the base. Vostell commented that 'governments have driven men to destruction in wars' and described the student riots in Paris in 1968 as 'the greatest Happening of all'.

Further Reading: G. O'Brien, 'TV Guide—Wolf Vostell', *Artforum* (April 2001)

Vrubel, Mikhail (1856–1910) Russian painter and designer, the outstanding exponent of *Symbolism in his country. He was born in Omsk of Danish and Polish ancestry and had a wide experience of European art

and literature (he had a very thorough academic education and visited France and Italy in 1876, 1892, and 1894). After graduating in law (his father's profession) he studied at the St Petersburg Academy, 1880–84. He then moved to Kiev, where he worked on the restoration of paintings in the ancient church of St Cyril—in his subsequent career he showed an affinity with the spirituality of medieval religious art. In 1889 he moved from Kiev to Moscow and there was taken up by the wealthy art patron Savva Mamontov (1841–1918); a portrait of him by Vrubel (1897) is in the Tretyakov Gallery, Moscow. In 1890 Vrubel began to do interpretations of Mikhail Lermontov's poem *The Demon* and the theme became central to his work. In treating it he passed from fairly naturalistic depictions to highly idiosyncratic anguish-ridden images rendered in brilliant fragmented brushwork that recalls the effects of medieval mosaics. The obsessive treatment of the theme reflected his own emotional instability: in 1902 the first symptoms of approaching insanity became apparent, in 1906 he went blind, and he died in a lunatic asylum.

An independent and solitary figure, Vrubel was little appreciated in his lifetime, when he was more admired by writers than painters, but he stands out as the great precursor of much that was best in 20th-century Russian painting. His work is well represented in the State Museum of Russian Art, Kiev, the Tretyakov Gallery, Moscow, and the State Russian Museum, St Petersburg.

Vuillard, Édouard (1868–1940) French painter, draughtsman, designer, and lithographer, born in Cuiseaux, Saône-et-Loire. His family moved to Paris when he was ten and he went to school with Maurice *Denis and Ker-Xavier *Roussel (his future brother-in-law). All three of them studied at the *Académie Julian, and together with other students—including *Bonnard, *Sérusier, and *Vallotton—formed a group of painters called the *Nabis, whose work was predominantly *Symbolist. The group flourished throughout the 1890s, and at this time Vuillard painted intimate interiors and scenes from Montmartre, his sensitive patterning of flattish colours owing something to *Gauguin but creating a distinctive manner of his own. He also designed posters and theatrical sets. From about 1900 he turned to a more naturalistic style and with Bonnard he became the main practitioner of *Intimisme, making use

of the camera to capture fleeting, informal groupings of his friends and relatives in the intimate settings of their homes and gardens. He had several close female friends and preferred painting women and children to men. His work also included landscapes and portraits. Although he was financially successful, he lived modestly, sharing an apartment with his widowed mother until her death in 1928; she often features in his paintings. He was reserved and quiet in personality, although affectionate and much liked. After the First World War he seldom showed his paintings, except at the gallery of his dealer *Bernheim-Jeune, and his subsequent work remained little known to the public until a retrospective exhibition at the Musée des Arts Décoratifs in Paris in 1938. Shortly before this he had done decorative paintings for the Palais des Nations at Geneva (1936) and the Palais de Chaillot in Paris (1937), in both cases working with Roussel. He died at La Baule while fleeing the German invasion. For many years he kept a detailed journal (there are 48 volumes of it in the Institut de France, Paris), in which he revealed his thoughtful attitude towards art and life.

VVV A *Surrealist journal edited by David *Hare and published in New York, 1942–4 (four issues), during which period it was a rallying point for the European Surrealists who had taken refuge from the Second World War in the USA. Two of these exiles, André *Breton and Max *Ernst, were editorial advisers to the journal, and they were joined from the second issue by Marcel *Duchamp. The journal's subheading was 'Poetry, Plastic Arts, Anthropology, Sociology, Psychology', and the title was explained by Breton as a reference to a rather obscure passage containing the words Victory, View, and Veil. *VVV* was carefully produced, but because of wartime conditions it was necessarily less luxurious than *Minotaure*, its predecessor as the main Surrealist journal. It continued *Minotaure*'s practice of having specially commissioned covers: no. 1 was designed by Ernst; the double issue 2 and 3 by Duchamp; and no. 4 by *Matta.

Waddington, Leslie *See* ART MONTHLY.

Wadsworth, Edward (1889–1949) British painter, printmaker, draughtsman, and designer, born at Cleckheaton, Yorkshire, son of a wealthy industrialist. He took up painting while he was studying engineering in Munich, 1906–7, and had his main training at the *Slade School, 1908–12. In 1913 he worked for a short time at Roger Fry's *Omega Workshops, but he left with Wyndham *Lewis and joined the *Vorticist group. At this time his work included completely abstract pictures, such as the stridently geometrical *Abstract Composition* (1915, Tate). Close in style to his paintings of this time were his impressive angular woodcuts of ships and machinery. In the First World War Wadsworth worked on designing dazzle camouflage for ships, turning his harsh Vorticist style to practical use. This experience provided the subject for one of his best-known paintings, the huge *Dazzle-ships in Drydock at Liverpool* (1919, NG, Ottawa). The lucidity and precision seen in this work were enhanced when Wadsworth switched from oil painting to tempera in about 1922. At the same time his style changed, as he abandoned *Cubist leanings for a more naturalistic idiom. He had a passion for the sea and often painted maritime subjects, developing a distinctive type of highly composed marine still-life, typically with a *Surrealistic flavour brought about by oddities of scale and juxtaposition and the hypnotic clarity of the lighting (*Satellitium*, 1932, Castle Museum, Nottingham). Wadsworth travelled widely on the Continent and in 1933 contributed to the Paris journal **Abstraction-Création*. In the same year he was a founder member of *Unit One. About this time he again painted abstracts (influenced by *Arp), but he reverted to his more naturalistic style in 1934. Throughout his career his highly finished craftsmanship won admiration even from those who were not usually sympathetic to avant-garde art.

Further Reading: J. Lewison (ed.), *A Genius of Industrial England: Edward Wadsworth 1889–1949* (1990)

Wagemaker, Jaap *See* MATTERISM.

Waggstaff, Sam *See* MAPPLETHORPE, ROBERT.

Wakefield Gallery, New York. *See* PARSONS, BETTY.

Wakelin, Roland (1887–1971) Australian painter, born at Greytown, New Zealand. In 1912 he settled in Sydney, where he studied under *Rubbo. Although his work was unexceptional by European standards, it was too advanced for local taste. When the Royal Art Society rejected Wakelin's *Down the Hills to Berry's Bay* (1916, Art Gallery of New South Wales, Sydney) 'Rubbo was furious; he challenged a committee member to a duel, with pistols, swords or fists; the picture was hastily hung' (Robert *Hughes, *The Art of Australia*, 1970). For a short period around 1919 Wakelin produced abstract paintings; apart from Roy de *Maistre, he was the first Australian to do so.

Walch, Charles *See* SINGIER, GUSTAVE.

Walden, Herwarth *See* STURM, DER.

Walker, Dame Ethel (1861–1951) British painter and occasional sculptor, born in Edinburgh, the daughter of a prosperous ironfounder. She was interested in art from her schooldays but did not take up painting seriously until she was in her late twenties. Her main training was at the *Slade School under Frederick *Brown, 1892–4. Afterwards she attended evening classes under *Sickert and returned to the Slade on and off until 1921, partly to study sculpture. In 1900 she became the first woman member of the *New English Art Club and it was there that she mainly exhibited, building a reputation as one of the outstanding British women artists of her period. She painted portraits, flowerpieces, interiors, and seascapes in an attractive *Impressionist style, but her most individual

works are large decorative compositions inspired by her vision of a Golden Age. They show the influence of French *Symbolist painting as well as her interest in philosophy and religion, and they are sometimes tinged with a suggestion of Orientalism (*The Zone of Hate*, 1914–15, and *The Zone of Love*, c.1930–32; both Tate).

Walker, John (1939–) British painter and printmaker, born in Birmingham. He studied at Birmingham College of Art, 1955–60, then at the Académie de la Grande Chaumière, Paris, 1960–61. Although predominantly abstract, much of his work invokes ambiguous effects of space and volume. *Study* (1965, Tate) is on the scale of the *Post-Painterly work current at the time, but, in contrast to the flatness and brilliant hues cultivated by such work, it makes use of pictorial illusionism (the surface appears to fold open) and an earth-based colour scheme. Walker also makes self-conscious references to art history. The *Juggernaut* series of the early 1970s suggests the accumulations of jagged planes in *Cubist collage, while the *Numinous* series of 1977–8 was within a tradition of balcony paintings by Goya, Manet, and *Matisse. His work has been much concerned with texture and he has sometimes included substances such as chalk dust and collaged pieces of canvas in his pictures, producing a battered, time-worn effect. Since 1970 he has worked mainly in the USA and he has also spent a good deal of time in Australia. His awards include first prize at the *John Moores Liverpool Exhibition in 1976.

Further Reading: Arts Council of Great Britain, *John Walker* (1985)

Walker, Kara (1968–) American artist, born in Stockton, California. Her father, **Larry Walker** (1935–), is a painter. Kara Walker is one of the most controversial American artists of her generation because of her provocative treatment of race and gender, especially in her addressing of the historical legacy of slavery in the American South. Her work frequently depicts acts of violence and sex, using the silhouette technique, a craft associated with middle-class ladies in the 19th century, although the actual imagery relates to the continued evocation of slavery in pornographic literature. Reproductions give only a partial idea of the disturbing impact of the works when they are displayed as large-scale installations in a gallery setting, creating an illusory space which

implicates the viewer. Part of the disquiet engendered by her art is surely the strong sense of residual anger speaking through the apparent *Postmodern irony of the practice.

Further Reading: G. DuBois Shaw, *Seeing the Unspeakable: The Art of Kara Walker* (2004)

Walker, Maynard *See* REGIONALISM.

Walkowitz, Abraham (1878–1965) American painter, born at Tyumen in Siberia. In 1889 his family emigrated to New York, where he studied at the National Academy of Design. He travelled in Europe in 1906–7, studying at the *Académie Julian in Paris. He returned to New York a convinced modernist; and he was one of the most influential among the foreign-born artists who introduced avant-garde movements to America in the years leading up to the *Armory Show. He had his first one-man exhibition in 1908 (at the Julius Haas Gallery), and *Stieglitz gave him several shows at his 291 Gallery between 1912 and 1917. He was also included in the Armory Show and in the *'Forum' exhibition (1916). His work of this time (consisting mainly of drawings) was restlessly experimental—often rhythmically abstract and somewhat *Futurist in effect, with an energetic mesh of criss-crossing lines. In the 1920s Walkowitz began to work mainly in oils and turned to figurative subjects, sometimes with overtones of social concern. In the 1930s eye trouble forced him to give up painting and his contribution to the development of modernism in the USA was largely forgotten until very late in his life. His ideas on art were set out in his book *A Demonstration of Objective, Abstract, and Non-Objective Art* (1945).

Wall, Brian (1931–) British sculptor, born in London. From 1954 to 1958 he was assistant to Barbara *Hepworth. He has worked mainly in welded steel, making abstract sculptures in this medium in the 1950s—a period when the bulk of British sculpture was still figurative and in bronze. In early works, sheets of metal tend to be suspended in the air on stalks. The later, larger pieces are placed on the floor like those of Anthony *Caro. Wall lives in California and France.

Wall, Jeff (1946–) Canadian photographer, born in Vancouver. His photographs are displayed as giant transparencies in light boxes, a technique often used in advertising, although his work owes far more to art history than

mass culture. He was once a student of art history at the *Courtauld Institute and his references can be knowing and erudite. *Picture for Women* (1979) is a homage to the mirrored structure of Manet's painting *A Bar at the Folies-Bergère* (1882, Courtauld Gallery, London), with Wall and his camera taking the place of the figure with top hat in the original. *A Sudden Gust of Wind (After Hokusai)* (1993, Tate) is a virtuoso rendering of a celebrated Japanese print. Indeed, Wall's work can be read as an attempt to produce a contemporary version of Baudelaire's aspirations for 'a painting of modern life' (*see* MODERNISM). He is one of the leading exponents of what Michael *Fried has defined as 'large-scale, tableau-sized photographs that by virtue of their size demand to be hung on gallery walls in the manner of easel paintings'. Although some of his images are staged, Wall also practises what he calls 'near documentary'. One example is *Restoration* (1992), which depicts restorers at work on a panoramic painting in Lucerne, Switzerland. Wall's image is itself panoramic and is achieved with the aid of invisible computer manipulation to join different sources seamlessly.

Further Reading: C. Burnett, *Jeff Wall* (2005)

Wallinger, Mark (1959–) British artist, born in Chigwell, Essex. He studied at Chelsea School of Art and *Goldsmiths College. His work in a great variety of media is unified by an interest in British society and especially class. This has intersected with a personal fascination with horse racing. A series of *Superrealist paintings of race horses were entitled *Race Class Sex* (1992). *Royal Ascot* (1994, British Council) is a video installation of four monitors each showing the repeated ritual of the Queen and Prince Philip waving to the crowds at the exclusive race meeting. Wallinger first attracted a wider public with *Ecce Homo* (1999), one of the series of sculptures by different artists (others have included Rachel *Whiteread and Marc *Quinn), designed for an empty plinth in London's Trafalgar Square. This portrays, in striking surface naturalism, Christ before Pilate. In 2007 Wallinger was awarded the *Turner Prize for an installation at Tate Britain entitled *State Britain*. His most contentious work politically, it recreated in detail the one-man protest against the Iraq War that had been staged outside the Houses of Parliament by Brian Haw against the Iraq war since 2001. The artist claimed, highly questionably, that the work was technically illegal under the Serious Organized Crime and Police Act, which prohibited unauthorized demonstrations within a mile of Parliament. In any case, the work remained in place for several months without any legal intervention.

Further Reading: R. Grayson et al., *Mark Wallinger* (2008)

Wallis, Alfred (1855–1942) British *naïve painter of sailing ships and landscapes, born in Devonport. He went to sea as a cabin boy and cook at the age of nine, and from 1880 worked as a fisherman in Cornwall. In 1890 he opened a rag-and-bone store in St Ives, and after retiring from this did a few odd jobs, including selling ice-cream. He began to paint in 1925 to ease the loneliness he felt at his wife's death and was discovered by Ben *Nicholson and Christopher *Wood in 1928, the unselfconscious vigour of his work making a powerful impression on them. They introduced his work to friends, including H. S. *Ede (whose collection of Wallis's paintings can be seen at Kettle's Yard, Cambridge) and Herbert *Read. Wallis painted from memory and imagination, usually working with ship's paint on odd scraps of cardboard or wood. Although he rapidly became the best known of British naïve artists, he died in a workhouse. His admirers in the art world arranged for the great potter Bernard Leach to design his gravestone in Barnoon Cemetery, St Ives. The inscription on it reads: 'Alfred Wallis, Artist and Mariner'.

Further Reading: S. Berlin, *Alfred Wallis: Primitive* (1999)

Wang Guangyi (1956–) Chinese painter, born in Harbin in the area that used to be known as Manchuria. He was associated in the 1980s with the 'North Art Group', which aimed to promote the 'masculine strength' of northern Chinese culture, born of a more challenging climate, against both the weakness of traditional Chinese culture, related to the more temperate zone of the south, and modern Western civilization. At this time he painted highly formalized versions of famous Western paintings. A version of Jacques-Louis David's 1793 *Death of Marat* (1987) derives from the famous image of the French revolutionary martyr, painted in muted greys and doubled mirror fashion to enhance the sense of abstraction and stylization. Gao Minglu writes that 'This rationalization of sacrifice as an instrument of a more perfect social order employed art like religion to depict a purified Chinese world.' Wang responded to the

political changes in China by developing a kind of 'Political *Pop'. In *Mao Zedong No. 1* (1988), a grid is superimposed over the image of the leader. The work could comment on imprisonment within an ideology or it might simply be read as a nod towards Western *Minimal art. Elsewhere he juxtaposes revolutionary imagery with the logos of Western commerce such as Coca-Cola. These paintings have become very popular with collectors outside China, but unlike the Russian *Sots art painters who have moved to the West, he and other artists who have successfully practised the same style have tended to remain in China as part of the growing upper middle class.

Further Reading: Gao Minglu, 'Post-Utopian Avant-Garde Art in China', in A. Erjavec (ed.), *Postmodernism and the Postsocialist Condition* (2003)

War Art *See* OFFICIAL WAR ART.

Ward, John (1917–2007) British painter and illustrator. Described in an obituary as an 'establishment painter par excellence', he is best known for his portraits of royalty. Born in Hereford, the son of an antiques dealer, he studied at the *Royal College of Art, where his tutors included Barnett *Freedman. After service in the Royal Engineers during the Second World War, he moved to Kent, where he remained for the rest of his life. He found work as an illustrator for the fashion magazine *Vogue*. When he left that post in 1952, he had built up a career as a fashionable portraitist with a penchant for glamour. His portrait of Princess Anne (1987, NPG, London) is typical. The royal photographer Norman Parkinson advised him that he should 'make a fuss of his models'. Ward would maintain that pretty women were the hardest to paint because the lines of their face had not yet been drawn for the artist. In 1962 he was invited by the Queen to sketch at Balmoral and he gave the Prince of Wales painting lessons in Venice. His home was an Elizabethan farmhouse. An Associate of the Royal Academy in 1957 and a full member in 1967, he resigned on his 80th birthday in 1997. He was protesting at the *'Sensation' exhibition, saying 'they've taken advantage of us, written "bum" on the walls, and they call it art'.

Further Reading: S. Fenwick, obituary, *The Guardian* (21 June 2007)

Warhol, Andy (1928–87) American painter, printmaker, sculptor, draughtsman, film-maker, writer, and collector, one of the most famous and controversial artists of the 20th century. He was born in Pittsburgh to Czechoslovakian immigrant parents; his surname was originally Warhola. After studying painting and design at the Carnegie Institute of Technology, Pittsburgh, 1945–9, he settled in New York. In the 1950s he was enormously successful as a commercial artist (specializing in shoe advertisements): he twice won the Art Directors' Club Medal (1952 and 1957) and by 1956 he was earning $100,000 a year. At the same time he was exhibiting drawings (to little critical attention) and he published six books of reproductions of them between 1954 and 1959.

In 1960 Warhol began making paintings based on mass-produced images such as newspaper advertisements and comic strips. A friend, the film-maker Emile de Antonio (1919–89), gave him invaluable advice at this point. Warhol showed him two paintings of a Coca-Cola bottle, one with *Abstract Expressionist brushwork, the other completely dead-pan. De Antonio told Warhol 'One of these is a piece of shit, simply a little bit of everything. The other is remarkable—it's our society, it's who we are, it's absolutely beautiful and naked.' Then in 1962—at the suggestion of another friend, who charged him a $50 consultation fee—he started using dollar bills and Campbell's soup cans as his subjects. The soup can pictures were first exhibited in the summer of 1962 at the Ferus Gallery in Los Angeles, then in the autumn of the same year at the Stable Gallery, New York. The second exhibition was a sensational success and Warhol soon became the most famous figure in American *Pop art. At first he painted freehand, but he soon adopted the *screenprint process, which allowed unlimited replication. His practice was very different from the fine art limited edition screenprint as produced in the period by artists such as *Paolozzi and *Kitaj. He worked on a large scale on canvas rather than paper, so giving his works the presence of major oil paintings. Furthermore the aim was not to produce multiples of an identical image. Instead, the imperfections in the process were courted to give every example a unique character. This had an especially potent effect when he added faces to his repertoire, nearly always images of stars such as Elvis Presley, Elizabeth Taylor, Jackie Kennedy, and, most famously of all, Marilyn Monroe. The expressive effect was

W

the consequence of accident and contingency, not intention and control. This was especially obvious when a whole sequence of images, identical except for incidental smudging, was presented in a single work (*Marilyn Diptych*, 1962, Tate). Even the Mona Lisa was subject to this treatment. The choice of this painting as a 'star' image is an interesting one. Obviously it has a status as 'the most famous painting in the world', but the part of that status which is not dependent on the culture and tourist industries derives from certain peculiar characteristics of the image itself. As E. H. *Gombrich points out (*The Story of Art*), the feature which most fascinates the spectator—that the expression appears to change before our eyes—is the result of the way that Leonardo has introduced a certain indefinite mistiness around the eyes and the mouth. What the Renaissance artist did with supreme craftsmanship, Warhol's practice implied was an effect produced every day by the mass media. We see the same image of Monroe or the Mona Lisa as happy or tragic. It is all a trick of printer's ink and our own expectations.

In a series of disaster paintings (suicides, car accidents, and so forth), Warhol tended to use, not the images reproduced in the newspapers, but those rejected as too gruesome: the shot which catches the moment when the jumper from a high building is still in mid-air, the crash victim impaled on a telegraph pole or still alive trapped under the wreckage. Where he used published images, their authority is questioned. *Race Riot* (1963) uses three images from a photo story showing a demonstrator attacked by a police dog. The narrative is displaced, the viewer becomes aware not so much of chronological sequence, but of a series of alternative angles on the same event. We look for clues in the demeanour of the police handlers. In one image we catch a vindictive expression; in another it appears that the police are trying to restrain the dog. As well as paintings and prints, he produced sculptures, notably of Brillo soap pad boxes (first exhibited in 1964).

Warhol expressed opposition to the idea of a work of art as a piece of individual craftsmanship, hand-made and expressing the personality of the artist: 'I want everybody to think alike. I think everybody should be a machine.' In keeping with this outlook he turned out his works like a manufacturer, and called his studio 'The Factory'. There he was surrounded by a crowd of helpers and hangers-on, described by Robert *Hughes as 'cultural space-debris, drifting fragments from a variety of sixties subcultures'. In 1965 Warhol announced his retirement as an artist to devote himself to films and to managing the rock group The Velvet Underground. It should be remembered that this was the heyday of Bergman, Godard, and the Beatles, and that film and rock music were at that time exciting, creative forms. As a filmmaker, Warhol became perhaps the only 'underground' director to be well-known to the general public. His first films were silent and virtually completely static: *Sleep* (1963)—a man sleeping for six hours; and *Empire* (1964)—the Empire State Building seen from one viewpoint for eight hours: 'I like boring things.' *Chelsea Girls* (1966) was designed to be projected on two screens, showing parallel scenes from the lives of the denizens of the Chelsea Hotel, New York. The more commercially oriented films, such as *Flesh* (1968) and *Trash* (1970), were actually directed by his associate Paul Morrissey (1938–). Some of their popularity certainly derived from their frank treatment of sex and drugs. On at least two occasions screenings of the films in London were the target of police raids.

In 1968 Warhol was shot and severely wounded by Valerie Solanas (1936–88), a bit-part player in one of his films and the founder and only member of SCUM (the Society for Cutting Up Men), an incident that only added to his legendary status. In the years that followed he became as famous for his celebrity-courting, partying lifestyle and deliberately bland persona as for his art. He published a celebrity magazine called *Interview*, and several books appeared under his name, some genuinely written by him, others put together from tapes. They include *a, A Novel* (1968) and *The Philosophy of Andy Warhol (From A to B and Back Again)* (1975). *The Diaries of Andy Warhol* appeared posthumously in 1989. In spite of his early declarations, Warhol never gave up painting, although much of his later production has generally been found disappointing, even by admirers of his work. In the 1970s and 1980s he made an enormous amount of money with commissioned portraits of wealthy patrons: in 1986 the Christmas catalogue for Neiman-Marcus (department stores) advertised a portrait session with him for $35,000 ('Become a legend with Andy Warhol'). In the 1980s he sometimes collaborated with other painters, including the *Graffiti artist

Jean-Michel *Basquiat, and LeRoi Neiman (1927–) who is best-known for his illustrations in *Playboy*. However, Warhol's creativity was not entirely swamped by commerce. Shortly before his unexpected death (following a routine gall bladder operation), he exhibited a series of self-portraits in which his now ghostly head, with trademark platinum wig manipulated into an eerie lop-sided quiff, is superimposed with camouflage patterns. Warhol had again found a way of exploiting the expressive power of the arbitrary, an expressive power which, very much in line with the then popular arguments of *Barthes's 'Death of the Author' (*see* APPROPRIATION), seemed to owe nothing to artistic intent.

Warhol's celebrity has become a cliché of arts journalism. Bernard Levin described him as 'that one-man demonstration of the triumph of publicity over art', but better informed voices, more committed to contemporary art, have also found his achievement a disquieting one. The art critic Donald Kuspit argues that contemporary art is bound in a struggle between the media and therapeutic functions of art. Joseph *Beuys stands for the therapeutic, Warhol for the media. 'I am for Beuys', Kuspit writes, and when the issue is put in this way it is hardly a surprise. When Warhol painted the German artist with a sparkly diamond surface, he emphasized that Beuys too was a 'superstar' who needed to operate within the virtual arena called 'celebrity'. The idea of the mass media as the essential public space in which the artist must operate has been adopted by successful younger artists such as Jeff *Koons and Damien *Hirst. Warhol's own statements have functioned to support the idea of a radical transformation of art into commerce. 'I started as a commercial artist and want to finish as a business artist', he said in 1985. Yet both those who applaud and those who deplore Warhol as an exemplar of a new function of art as business may be assigning to his career a historical weight which it cannot bear. He is hardly the first artist in history to have followed up innovatory early work with facile commercial practice.

In purely financial terms his success was prodigious. At his death he left a fortune estimated at $100 million, most of which went to create an arts charity, the Andy Warhol Foundation. In 1994 a museum dedicated to his work opened in his home town of Pittsburgh, and the Warhol Foundation has helped to finance the building of a museum of modern

art at Medzilaborce in Slovakia, near to the village of Mikova, where his parents once lived.

Further Reading: G. Garrels (ed.), *The Work of Andy Warhol* (1989)

D. Kuspit, 'Beuys or Warhol?', *The New Subjectivism: Art in the 1990s* (1992)

E. Shanes, *Warhol: The Masterworks* (1991)

Washington, DC, Hirshhorn Museum and Sculpture Garden *See* HIRSHHORN MUSEUM AND SCULPTURE GARDEN.

Washington, DC, Phillips Collection *See* PHILLIPS, DUNCAN.

Watson, Homer *See* CANADIAN ART CLUB.

Watt, Alison (1965–) Scottish painter of portraits, figures, and still-life, born in Greenock. She studied at *Glasgow School of Art from 1983 to 1988, and like Stephen *Conroy, who was a year ahead of her there, she had achieved substantial success before she completed her postgraduate studies, winning the John Player Portrait Award in 1987. In 1989 she was commissioned by the National Portrait Gallery, London, to paint a portrait of the Queen Mother. Duncan Macmillan has argued that her success has been due to her alignment with a figurative tradition represented by *Coldstream and *Freud, although she herself has a particular admiration for the French painter Jean-Auguste-Dominique Ingres (1780–1867), whose attention to detail and immaculate surfaces she emulates. In 2008 she showed the results of her residency at the National Gallery, London, in an exhibition entitled 'Phantom'. The paintings were monumental canvases depicting folded cloth, sometimes suggesting a human presence underneath. She was inspired especially by the work of the 17th-century Spanish painter Francisco de Zurbarán, whose draperies she describes as 'almost like a living mass'.

Further Reading: Duncan Macmillan, *Scottish Art in the 20th Century* (1994)

Watts, George Frederic *See* TATE.

Wayne, June *See* PRINT RENAISSANCE.

Wearing, Gillian (1963–) British *Video artist and photographer, born in Birmingham. She graduated from *Goldsmiths College in 1990 and has been identified as one of the *Young British Artists who came to the attention of a wider public as a result of the

*'Sensation' exhibition. Her work looks at issues of identity and the limitations of 'documentary' truth. A famous series of photographs, crudely plagiarized by the 'creatives' of the advertising industry, has passers-by who were invited to write captions showing their real feelings. In *10–16* (1995) adult actors lip-sync the voices of children. What makes the work disturbing is the nature of some of the confessions. Wearing was awarded the *Turner Prize in 1997.

Further Reading: R. Ferguson, *Gillian Wearing* (1999)

Webb, Sir Aston *See* ROYAL ACADEMY OF ARTS.

Weber, Max (1881–1961) Russian-born American painter, sculptor, printmaker, and writer, whose work more than that of any other American artist synthesized the latest European developments at the beginning of the 20th century. He was born in Belostok (now Białystok, Poland) and emigrated to New York with his parents when he was ten. After studying at the Pratt Institute, New York, from 1898 to 1900, he taught in schools for several years, then travelled in Europe, 1905–08. In Paris he studied briefly at the *Académie Julian and with *Matisse, fell under the spell of *Cézanne, admired the early *Cubism of *Braque and *Picasso, and became a friend of Henri *Rousseau (in 1910 he arranged the first American exhibition of Rousseau's work at *Stieglitz's 291 Gallery). After his return to New York in 1909, Weber rapidly became a controversial figure—no other American avant-grade artist of the time exhibited his work more widely or was more harshly attacked by the critics. His work was influenced by *Fauvism and *primitive art (he was one of the first American artists to show interest in it—specifically in Native American art), but most importantly by Cubism (in sculpture as well as painting). After about 1917, however, Weber's work became more naturalistic. During the 1930s his subjects often expressed his social concern, notably in pictures of refugees (in 1937 he was national chairman of the left-wing *American Artists' Congress), and in the 1940s his work included scenes with rabbis and Jewish scholars—mystical recollections of his Russian childhood. He published several books, including *Cubist Poems* (1914), *Essays on Art* (1916), and the autobiographical *Max Weber* (1945). In the 1920s he taught at the *Art Students League, his most important pupil being Mark *Rothko.

Wegman, William (1943–) American photographer, *Video artist, sculptor, and painter, born in Holyoae, Massachusetts. He studied painting at Massachusetts College of Fine Art and the University of Illinois. In the early 1970s he made video works sometimes involving performances with dogs. For instance in *Used Car Salesman* (1972) he sits with a large dog on his lap attempting to persuade the viewer that the situation is evidence of his decency and sincerity. Wegman speaks as a car salesman but he indirectly comments on the trust demanded by the artist. He is best known for his large-format colour photographs made in collaboration with his Weimaraner dogs Man Ray (named after the Dadaist photographer) and Fay Ray (a pun on the name of *King Kong* star Fay Wray), whose litter became a supporting cast. Wegman's tableaux with his dogs have a certain humour, deriving from the incongruity of the lugubrious animals and the absurd situations in which they appear. These sometimes include art-historical jokes. *Blue Period with Banjo* (1980) parodies an early *Picasso. Wegman has achieved with this work something of the popular success of artists who worked with mass reproduction in mind (*see* POPULAR PRINTS), not only in books and calendars but even with appearances on the children's television programme *Sesame Street*.

Weibel, Peter *see* EXPORT, VALIE.

Weight, Carel (1908–97) British painter of portraits, landscapes, townscapes, and imaginative figure compositions, born in London, partly of German and Swedish descent. Originally he trained to be a singer, but he gave this up for painting and studied at Hammersmith School of Art, 1928–30, and at *Goldsmiths College, 1930–33. He exhibited at the *Royal Academy from 1931 and his first one-man exhibition was at the Cooling Gallery, London, in 1933. In the Second World War he served with the Royal Engineers and Army Education Corps and was appointed an *Official War Artist in 1945, working in Austria, Greece, and Italy. He began teaching at the *Royal College of Art in 1947 and was professor of painting there from 1967 until his retirement in 1973. His work is highly individual, introducing psychological tension into apparently mundane situations by heightened colour and subtly distorted perspectives. Weight

himself wrote of his work in 1979: 'I aim to create in my painting a world superficially close to the visual one but a world of greater tension and drama. The products of memory, mood and imagination rise upon a foundation of fact. My art is concerned with such things as anger, love, fear, hate and loneliness, emphasized by the ordinary landscape in which the dramatic scene is set.'

Further Reading: Royal Academy of Arts, *Carel Weight RA* (1982)

Weiner, Lawrence (1942–) American artist, born in the Bronx, New York. He was one of the most influential figures in the establishment of *Conceptual art through works in which an artistic idea could be presented purely in verbal form. In a statement of 1969 he proposed that 'The artist may construct the piece; the piece may be fabricated; the piece may not be built'. In the early pieces the ideas generally had the possibility of some kind of physical realization, for instance *The Residue of a Flare Ignited on a Boundary* (1968–9), and Weiner has claimed that his work is as much sculptural as verbal. Although such works could be bought by collectors, they could, in a sense, be possessed simply by knowing them. The later work has also used verbal language, often in the context of installation. Weiner has also worked as a musician, graphic designer and film-maker.

Further Reading: A. Albero et al., *Lawrence Weiner* (1998)

Weir, Julian Alden See TEN, THE.

Wentworth, Richard (1947–) British sculptor, born in Samoa. He studied at Hornsey College of Art and the *Royal College of Art and also, for a time, worked with Henry *Moore. One of the artists identified with *New British Sculpture, he uses objects in a paradoxical manner. He has commented that 'I try very hard to make my objects look matter of fact', and unlike much sculpture made from detritus, his work has a clean, precise look to it. *35°9, 32°18* (1985, Tate) consists of a bent steel ladder, recovered from a building site, combined with a cable ladder. Placed against the wall, one looks like a shadow of the other. The title is the latitude and longitude of the site, thought to be the place where Jacob had his dream of the ladder ascending to heaven. *Making Do and Getting By and Occasional Geometries* (1973–2007, Tate) is a long-running series of photographs of 'accidental

sculptures' found by Wentworth on the streets, such as an old desk crammed in a doorway or a drink can and a plastic tray spiked on railings. The work can be regarded as an extension of the *Surrealists' discovery of poetic moments on the streets of Paris, but it also follows from the enquiries of British sculptors during the late 1960s, such as Richard *Long and Bruce *McClean, as to how far the conception of sculpture could be taken.

Further Reading: M. Warner, *Richard Wentworth* (1994)

Werefkin, Marianne von (1870–1938) Russian painter, born at Tula, near Moscow. She studied under *Repin in St Petersburg and in 1891 met her fellow-student *Jawlensky, who became her companion for the next 30 years. They shared a dislike of the historical realism practised by Repin and in 1896 moved to Munich in search of a more sympathetic environment. They were founder members of the *Neue Künstlervereinigung in 1909 and in 1914 they settled at Ascona in Switzerland. Werefkin finally parted from Jawlensky in 1921 when he moved to Wiesbaden; she remained at Ascona for the rest of her life. A museum of her work opened there in 1967.

Werefkin's early painting was influenced by *Symbolism, but in Germany she developed an *Expressionist style characterized by bright, flat colours and often a rather mystical mood. George Heard *Hamilton writes that her 'enthusiasm for French Symbolist poetry and painting, her belief in the necessity for a new art more immediately expressive of individual personality, and her encouragement of her companions were important contributions to the development of the new ideas in Munich, more important than her own paintings and drawings, which she herself considered secondary to the work of her friends'.

Wéry, Marthe (1930–2005) Belgian painter, born in Brussels. Her studies in Paris included time at S.W. *Hayter's Atelier 17. After passing through phases of *Lyrical and geometric abstraction, she came under the influence of *Minimal art and was especially impressed by the 'Unism' of Wladislaw *Strzemiński. She subsequently devoted herself to monochrome work and exhibited at the important 'Fundamental Painting' exhibition, which consisted entirely of monochromes, at the Stedelijk Museum, Amsterdam, in 1975. For her, abstract painting was something which referred only to itself: flatness and colour

were the essential elements. To this end she tended to treat paintings as objects. They could be propped against the wall, sometimes in close stacked groups, or even supported on low trestle tables at angles to the ground, as in her exhibition at the abbey of Tournus in Burgundy (1991). The undifferentiated surfaces for which she was best known were modified in some late paintings by the exploration of the scraped surface (*2000*, Musée d'Ixelles, Brussels). Wéry stated that the elements of painting included 'the environment in which it is set': the ways in which the works respond to changes in light and angle of viewing are crucial to their effect. Her last exhibition during her lifetime was held in the Musée des Beaux-Arts, Tournai. The building is an architectural masterpiece by Victor Horta which uses balconies to allow the spectator to view works of art from unexpected directions, and Wéry took special pleasure in the consequences. The art historian Thierry de Duve expressed the hope that 'Marthe Wéry's painting will be included among the work of painters who have managed to get painting through one of the most dangerous crises it has ever known.'

Further reading: T. de Duve et al., *Marthe Wéry: A Debate in Painting* (1999)

Wesselmann, Tom (1931–2004) American painter, sculptor, and printmaker, born in Cincinnati. He studied psychology at the University of Cincinnati, 1951–2 and 1954–6, and during the latter period also took classes at the Art Academy of Cincinnati. From 1956 to 1959 he continued his studies in art at the Cooper Union, New York. Originally he had intended becoming a cartoonist, but he turned to painting. In 1961 he had the first of many one-man exhibitions at the Tanager Gallery, New York, and soon afterwards he emerged as one of the leading figures in American *Pop art. He often incorporated elements of *collage or *assemblage in his work, using household objects such as television sets and sometimes including sound effects. His subjects are characteristically aggressively sexual and he is best known for his long-running series *Great American Nude* (begun 1961), in which the nude becomes a depersonalized sex symbol set in a realistically depicted commonplace environment. He emphasized the woman's nipples, mouth, and genitals, with the rest of the body depicted in flat, unmodulated colour. In other works he isolated parts of the body still

further, as in his *Smoker* series, in which the mouth—often depicted on a huge scale—becomes a provocatively erotic symbol. In the 1980s he began making massive 'drawings' cut from sheets of aluminium or steel. He also made prints in a variety of techniques.

Further Reading: Michael McNay, 'Tom Wesselmann', *The Guardian* (23 December 2004)

West Coast Figuration *See* BAY AREA FIGURATION.

West, Franz (1947–) Austrian sculptor, born in Vienna. As a young artist he was interested in *Minimalism, even though in Austria he could only see such work in photographs. He started to make what he called 'Passstücke' ('adaptives', literally 'passport pieces'). These were concave and convex forms which the viewer could pick up and move around. West described this as like a 'do-it-yourself *body art'. Much of West's sculpture is visibly hand-crafted, made of material like plaster or papier mâché and roughly painted. He has also made anti-functional furniture, which operates as art. Public works have included sculpture in lacquered aluminium, temporarily installed in the Lincoln Center, New York, in 2002. Despite their resemblance to intestines, according to Eleanor Heartney, 'the public happily sat on and climbed over these works'. The visceral qualities of West's sculpture have prompted comparisons to the *Vienna Actionists who dominated the Austrian scene when West was a young artist. Although West has said 'I'm not a member of that school, I'm not a member of that generation', he has also equated his sculpture with bones and meat.

Further Reading: I. Blazwick, J. Lingwood, and A. Schlieker, *Possible Worlds* (1990)

Weston, Edward (1886–1958) American photographer, born in Highland Park, Illinois. He studied at Illinois College of Photography in 1908. In 1911 he opened a photographic studio in Tropico (now Glendale), Los Angeles. Between 1923 and 1926 he shared a studio in Mexico City with his model Tina *Modotti, returning permanently to California and his old studio in 1926. In the early 1920s Weston reacted against the soft-focus 'pictorialist' style favoured by *Stieglitz and the early *Steichen in favour of a sharp-focus approach with affinities to the *Precisionist school of American painting. This change in his work was marked by his first images of an industrial

subject, a steel mill in Ohio (1922). A degree of abstraction is sometimes achieved by unexpected cropping, as in *Torso of Neil* (1925). In the still-life photographs, such as *Pepper no. 30* (1930), Weston employs a meticulous lighting technique to reveal every detail of the surface. In spite of the associations with bodies, Weston strongly resisted any metaphoric, let alone erotic, interpretation of his work. When friends saw photographs of shells as erotic, he maintained, 'I am not sick and I was never so free from sexual suppression—which if I had, might easily enter into my work. ...No! I had no physical thoughts—never have. I worked with clearer vision of sheer aesthetic form.' In the late 1930s he turned to nudes and sand dunes as subject-matter. A retrospective exhibition of his work was held at the Museum of Modern Art, New York in 1946. In 1948 he was afflicted with Parkinson's disease and his photographic activity ceased.

Wheeler, Sir Charles (1892–1974) British sculptor (and occasional painter). He was born in Codsall, Staffordshire, and studied at Wolverhampton School of Art, 1908–12, and the *Royal College of Art, 1912–17. Although he came to be regarded as the ultimate establishment sculptor, as a young artist he did engage with what was then the adventurous practice of *direct carving: *Mother and Child* (1926, Wolverhampton Art Gallery) is a fine example. Wheeler did many portrait busts, but the major part of his output was devoted to public sculpture: his biggest commissions were for the Bank of England, for which he did various works between 1930 and 1937, including three bronze doors and a series of giant stone figures on the exterior. His style could be rather ponderous, although Dennis Farr justly praises the Jellicoe Fountain, Trafalgar Square (begun in the late 1930s, unveiled 1938), as a 'delightful monument in a period not well endowed in this respect'. From 1956 to 1966 Wheeler was president of the *Royal Academy in which capacity he is best remembered for the controversial sale of Leonardo da Vinci's cartoon of *The Virgin and Child with St Anne and St John the Baptist*. His autobiography, *High Relief*, appeared in 1968.

Whistler, James McNeill (1834–1903) American painter and etcher, active mainly in England, where he was one of the key artistic figures of his period. He was celebrated as a wit and a dandy as well as an artist and he

loved controversy. His art is in many respects the opposite of his often aggressive personality, being discreet and subtle, but the creed that lay behind it was radical. He believed that painting should exist for its own sake, not to convey literary or moral ideas, and he often gave his pictures musical titles to suggest an analogy with the abstract art of music: 'Art should be independent of all claptrap—should stand alone, and appeal to the artistic sense of eye or ear, without confounding this with emotions entirely foreign to it, as devotion, pity, love, patriotism and the like. All these have no kind of concern with it, and that is why I insist on calling my works "arrangements" and "harmonies".' He was a laborious and self-critical worker, but this is belied by the flawless harmonies of tone and colour he created in his paintings, which are mainly portraits and landscapes (including many views of the Thames). His work is related to *Impressionism (although he was more interested in evoking a mood than in accurately depicting the effects of light) and to *Symbolism, and it was strongly influenced by Japanese art, but his exquisite taste allowed him to combine disparate sources in a novel, almost abstract synthesis.

In his book *Modern Painting* (1893) George *Moore gives a good indication of Whistler's importance in turn-of-the-century British art: 'More than any other painter, Mr Whistler's influence has made itself felt in English art. More than any other man, Mr Whistler has helped to purge art of the vice of subject and belief that the mission of the artist is to copy nature.' He was a magnetic personality and had a powerful impact on the life and work of many of his contemporaries. Those who were most immediately influenced by him included his pupils Walter *Greaves, Gwen *John, and Walter *Sickert, together with his laudatory biographer Joseph Pennell (1857–1926).

Whistler, Rex (1905–44) British painter, graphic artist, and stage designer, born at Eltham, Kent. His main training was at the *Slade School, 1922–6, and he also studied in Rome. He is best known for his decorations in a light and fanciful style evocative of the 18th century, notably the series of murals *In Pursuit of Rare Meats* (1926–7) in the restaurant of Tate Britain. He also did numerous book illustrations and much work for the stage, including ballet and opera. In 1940 he was

commissioned in the Welsh Guards and he was killed in action in Normandy. His brother **Sir Laurence Whistler** (1912–2000), a writer and glass engraver, published several books on him.

Whitechapel Art Gallery An art gallery in Whitechapel High Street, in the East End of London, devoted to temporary exhibitions, mainly of modern art (there is no permanent collection). It had its origins in the activities of Canon Samuel Augustus Barnett, rector of St Jude's Whitechapel from 1873 to 1894; he was a noted social reformer who from 1881 organized art exhibitions as one of his means of bringing spiritual uplift to his parish, described by his bishop as 'the worst in the diocese, inhabited mainly by a criminal population'. Private individuals who admired Barnett's work, notably the philanthropist John Passmore Edwards, financed a permanent gallery, which was built in 1897–9. The architect was Charles Harrison Townsend, and the façade is one of the best examples of his free and vigorous Arts and Crafts style. The interiors are very simple, with top daylighting to the main gallery. The Whitechapel opened in 1900, with Charles Aitken as first director. In its early years it was a stimulus to several notable artists living in the East End, notably David *Bomberg and Mark *Gertler, and in 1914 Bomberg organized an exhibition there entitled 'Twentieth Century Art—a Review of Modern Movements'. During the 1930s the gallery ran shows of local amateur art that contrasted with the elitism of West End exhibitions. Madge Gill (see AUTOMATISM) was one of the artists who took part in these shows. In 1938 it was the London venue for the international tour of *Picasso's *Guernica*. The Whitechapel continues to be one of the country's leading venues for exhibitions of modern art. Of particular significance was the period between 1952 and 1969, when the director was Bryan Robertson (1925–2002). Major exhibitions of Jackson *Pollock (1958), Robert *Rauschenberg, and Jasper *Johns (both 1964) were held, also the innovatory environmental 'This is Tomorrow' (1956), often credited with launching British *Pop, and the *'New Generation' exhibitions which brought to public attention some of the most significant young British painters and sculptors of the 1960s. The gallery is an independent charitable trust and receives support from the *Arts Council and other bodies. A major extension opened in 2009. *See also* SEROTA.

Further Reading: F. Borzello, *Civilising Caliban* (1987). This contains a fascinating, if polemical, account of the activities of Canon Barnett

White Cube A London gallery founded in 1992 by Jay Jopling which has shown many of the most significant contemporary artists, especially those associated with the *Young British Artists, as well as major international figures such as Anselm *Kiefer and Jeff *Wall. It originally had premises in Duke Street, just south of Piccadilly, the area which is at the heart of the trade in Old Master paintings. The idea was to provide a space in which an artist could present a single work or linked group of works. The thinking behind this was closely related to the rise of *installation art. This gallery closed in 2002 after spacious new premises were opened in Hoxton Square, East London, in 2000. In 2006 further premises were opened in Mason's Yard, close to the original site. The modernist building is in distinct contrast to the surroundings.

Whiteley, Brett (1939–92) Australian painter, born in Sydney, where he studied at the Julian Ashton Art School, 1957–9. In 1960 he travelled to Europe on a scholarship and after a few months in Italy moved to London in 1961. At this time there was something of a vogue for Australian art in Britain and he quickly achieved success: he won the international prize at the Paris *Biennale for Young Artists in 1961 and had his first one-man exhibition in 1962, at the Matthiesen Gallery, London. After spending a year and a half in New York and a year in Fiji, he returned to Sydney in 1970. Whiteley's work was based on the human figure but often came close to abstraction. His imagery was sometimes erotic or violent: in 1964–5, for example, he did a series based on the crimes of the infamous sex murderer Christie, who was executed in London in 1953. Whiteley's later life was marred by personal problems, including divorce and a battle with addiction to alcohol and drugs: he died from an overdose of drugs. Christopher Allen (*Art in Australia*, 1997) writes that Whiteley was the artist who most 'truly speaks for middlebrow Australian culture in the seventies and eighties... the media loved him and his every sketch met with adulation... With his brilliant facility, bright colours, images of sun, sea and sexual passion, he became the acceptable face of modernism and his pictures, though growing steadily worse and more vacuous, continued to fetch higher and higher prices.'

W

Whiteread, Rachel (1963–) British sculptor, born in London. Her mother, **Pat Whiteread** (1931–2003), was an artist in various media: 'I'm a Christian socialist feminist artist, and it doesn't matter to me what the medium is, as long as it's the right one.' Gordon Burn has commented that the serious-mindedness of this background has rubbed off: Whiteread has a reputation for earnestness not shared by many of her well-known contemporaries. She studied at Brighton Polytechnic, 1982–5, and the *Slade School, London, 1985–7. In 1988 she began making a novel type of sculpture consisting of casts of domestic features or the spaces around them (such as that under a bed). Her first exhibition was in a window looking on to a north London street and it consisted of furniture in the Utility style, imposed by government decree during the years of war and austerity in the 1940s, filled with plaster. In 1990 she cast an entire room, calling it *Ghost*. These pieces, carrying 'the residue of years and years of use', culminated in *Untitled (House)* (1993), a concrete cast of an entire house in Grove Road in the East End of London. The house itself was demolished once the cast was made, leaving Whiteread's ghostly replica on the site. She won the *Turner Prize in 1993, partly for *House*, and generated so much publicity that it made her probably the most famous artist in Britain apart from Damien *Hirst (although, unlike Hirst, she does not court media attention). The Turner jury praised the work for 'its combination of austere monumentality and immediacy of reference to the everyday world', its 'haunting qualities' and its 'poetic strangeness'. There was already controversy about the fate of *House*, which had only temporary planning permission. Some supporters regarded it as a masterpiece that should be preserved at all costs, but other people thought it was an eyesore. It attracted many visitors during its short life. In spite of a vigorous campaign to save it, the work was demolished in 1994: ultimately, the reasons for its destruction were more to do with bureaucracy than aesthetics. Following her success as the first woman to win the Turner Prize, in 1997 Whiteread became the first woman to represent Britain with a solo show at the Venice *Biennale (Barbara *Hepworth in 1950 and Bridget *Riley in 1968 had shared the British Pavilion). In 2000 her monument to the Holocaust was unveiled in the Judenplatz in Vienna. It evokes a library turned to stone, a possible reference to Nazi book burnings. In 2001 she used the empty plinth in Trafalgar Square, a site regularly used for temporary commissions, by placing a cast of the plinth itself on top, upside-down. It was made in transparent resin, so it created a link between the stone and the water fountains around it. In 2005 she mounted an installation in *Tate Modern's Turbine Hall, filling the space with white cardboard boxes. Her aim in the work was that it should not be just 'a room full of cardboard boxes' but 'full of light and space'.

Further Reading: G. Burn, 'Still Breaking the Mould', *The Guardian* (11 October 2005)

Tate Gallery, Liverpool, *Rachel Whiteread: Shedding Life* (1997)

Whitford, Frank (1941–) British writer, teacher, and broadcaster, born in Bishopstoke, Hampshire. He studied at Wadham College, Oxford, the *Courtauld Institute of Art, London, and the Freie Universität, West Berlin. For several years he worked as a cartoonist for *The Sunday Mirror* and the London *Evening Standard*, then from 1970 taught at various institutions, including the *Slade School and the *Royal College of Art. His books (mainly on German and Austrian art) include **Expressionism* (1970), *Japanese Prints and Western Painters* (1977), **Bauhaus* (1984), and monographs on **Kandinsky* (1971), **Schiele* (1981), Kokoschka (1986), and **Klimt* (1990 and 1993). They combine high scholarly standards with an accessible style. *See also* MELLY.

Whitney, Gertrude Vanderbilt (1875–1942) American sculptor, patron, and collector, the founder of the Whitney Museum of American Art. She was born in New York, the daughter of Cornelius II Vanderbilt, an immensely wealthy railroad magnate. In 1896 she married Harry Payne Whitney, a financier and world-class polo player. After her marriage she turned seriously to art, her training as a sculptor including periods at the *Art Students League, New York, and in Paris, where she knew *Rodin. She won several major commissions, notably for monuments commemorating the First World War. Her style was traditional, but she was sympathetic towards progressive art and is much more important as a patron than as an artist. In 1930, after the Metropolitan Museum, New York, turned down her offer to donate her collection of about 500 works of American art, she announced the founding of the

Whitney Museum and it opened the following year at 10 West 8th Street. Originally the museum aimed to cover the whole span of American art, but it now concentrates on art since 1900. In 1954 the museum moved to a new building at 22 West 54th Street on land provided by the *Museum of Modern Art, and in 1966 to its present home—a spectacular building designed for it by Marcel Breuer at 945 Madison Avenue. The museum now has the largest and finest collection in the world of American art since 1900, including, for example, some 2,000 works by Edward *Hopper donated by his widow. Every other year it holds the Whitney Biennial, a major showcase for work by living artists (this began in 1973; previously the exhibition had been annual).

Gertrude's nephew **John Hay Whitney** (1904–82) was a publisher, diplomat (he was ambassador to Great Britain, 1956–60), and collector of paintings, including 20th-century works. From 1946 to 1956 he was chairman of the Museum of Modern Art, New York, and he was the anonymous patron behind the Unknown Political Prisoner sculpture competition in 1953 (*see* BUTLER), a project which reflected his strongly anti-Communist views.

Wickey, Harry *See* MYERS, JEROME.

Wieland, Joyce *See* SNOW, MICHAEL.

Wiener Aktionismus *See* VIENNA ACTIONISTS.

Wiener Werkstätte (Viennese Workshops) Arts and crafts studio established in Vienna in 1903 by members of the *Sezession. The designers and craftsmen working there, like the British designer William Morris (1834–96), aimed to combine usefulness with aesthetic quality and to reach a wide public. Again like Morris, they were defeated in the last aim because their prices were necessarily high. They made everything from jewellery to complete room decorations (including mosaics) and in the early years of the operation often worked in an *Art Nouveau style. The workshops closed in 1932. *See also* KLIMT.

Wilding, Alison (1948–) British sculptor and printmaker, born in Blackburn, Lancashire. She studied at the Ravensbourne College of Art (1967–70) and the *Royal College of Art (1970–73). One of the representatives of

the loosely defined *New British Sculpture tendency which was identified at the beginning of the 1980s, she worked in a manner rather more abstract than most of her contemporaries. She made use of sheet metal, sometimes treated with chemicals to produce lustre, sometimes burnished, and cut and pressed into shapes like wings or propellers. A striking example is *Locust* (1983, Tate), which consists of a copper sheet wrapped around a wooden post. This is crowned by Wilding's characteristic wings, a flight of fancy in contrast to the austere form of the bulk of the work. She has also made work on a larger scale. *Assembly* (1989) consists of a steel tunnel closed at one end placed beside a similar form made from slotted sheets of PVC. The sculptor has said that it is a contrast between 'a tunnel with no light at the end' and one of 'Light, Liquid, and Life'.

Wild Painting *See* NEO-EXPRESSIONISM.

Wilenski, R. H. (Reginald Howard) (1887–1975) British writer on art (and occasional painter). He was born in London and studied at Balliol College, Oxford. From 1923 to 1926 he was art critic for the London *Evening Standard*, and he later wrote for *The Observer* and other newspapers. Much of his writing was devoted to modern art, and in the 1920s and early 1930s (until overtaken by Herbert *Read) he ranked as the leading spokesman for Britain's artistic avant-garde, particularly in sculpture. He was a vigorous champion of *Epstein at a time when he received routine abuse from many critics, and he was an early supporter of *Moore (on whom he published the first substantial article, in *Apollo* in 1930) and of *Hepworth. His books of this period include *The Modern Movement in Art* (1927) and *The Meaning of Modern Sculpture* (1932). In the latter he made a vehement attack on the cult of Greek sculpture, which he regarded as concerned only with 'the desirability of beautiful boys and pretty girls'. This he contrasted with the austere 'creed' of the modern sculptor, who—influenced by Negro art—valued abstract form and personal engagement with the material through *direct carving. Wilenski published many other books in his long career, generally smoothly written popular works. His best-known book is probably *Modern French Painters* (1940, 2nd edn, 1945). In his celebrated *History of Impressionism*, John Rewald

calls it 'an interesting but completely unreliable book'.

Wilfred, Thomas (Richard Edgar Løvstrøm) (1889–1968) Danish-American experimental artist, born at Naestved. After studying music and art in Copenhagen, London, and Paris, he settled in the USA in 1916. Wilfred was one of the leading pioneers of *Light art, probably the first person to conceive of light as an independent art medium, through which he aimed to create a kind of abstract visual music. He began experimenting with light patterns in 1905, starting with 'a cigar box, a small incandescent lamp, and some pieces of glass'. In 1919 he built his first 'Clavilux', in which light passed through an assembly of adjustable mirrors and coloured glass slides—controlled by keyboards—before being projected on a screen, where it could be made to produce subtle and complicated gradings and mixtures of colour. He first demonstrated his invention at the Neighbourhood Playhouse in New York in 1922, and subsequently made more than twenty works of this kind and many other light structures. In 1930 he founded the Art Institute of Light in New York for scientific research into the artistic uses of light, and this carried on until 1943. Wilfred called his new art form 'Lumia' and in an article he wrote in 1948 he spoke of using it to 'express the human longing for a greater reality, a cosmic consciousness, a balance between the human entity and the great common denominator, the universal rhythmic flow' ('Composing in the Art of Lumia', *Journal of Aesthetics and Art Criticism*, December 1948). He made tours with his light projections in the USA, Canada, and Europe, but until the 1960s he was generally regarded more as a curiosity than a serious artist.

Williams, Frederick (1927–82) Australian painter and printmaker, regarded as the most original portrayer of his country's landscape. He studied at the National Gallery School in his native Melbourne, 1944–9, then in London at Chelsea School of Art (where John *Berger was among his teachers) and the Central School of Arts and Crafts, 1951–6. His earliest etchings, often with music-hall subjects, were produced at about this time. He returned to Australia in 1957, and from the late 1950s began to produce landscapes revealing a distinctly personal vision of the country's landscape, such as *Charcoal Burner* (1959, NG of

Victoria, Melbourne). By increasing reductivism his paintings of the 1970s became powerfully evocative of a sense of primeval mystery and remoteness. Unlike other modern Australian artists who had memorably portrayed aspects of their country's landscape (notably Arthur *Boyd, Russell *Drysdale, and Sidney *Nolan), Williams rarely featured the human figure in his paintings. Bernard Smith notes that 'Williams does not seek to convey an impression of a particular place but a region, or something about the character of the bushland more general still' (*Australian Painting 1788–1990*, 1991).

Williams, Sir Kyffin (1918–2006) Welsh painter and printmaker. After being advised to take up art by a doctor on account of his 'abnormality' (epilepsy), he studied at the *Slade School, 1941–4. He taught at Highgate School, London, 1944–73, then retired to his native Anglesey. His most characteristic pictures are lyrical Welsh landscapes with simplified forms, the paint richly applied with the palette knife. He had numerous one-man exhibitions. His autobiography, *Across the Straits*, was published in 1973.

Williamson, Curtis *See* CANADIAN ART CLUB.

Willing, Victor *See* REGO, PAULA.

Willink, Carel (1900–83) Dutch painter, born in Amsterdam, associated with *Magic Realism. He initially studied medicine, then architecture, but, after deciding that he wanted to be a painter, moved to Berlin to study painting. He exhibited with the *Novembergruppe, before returning to Amsterdam in 1924. He passed through *Expressionist and *Futurist phases, but by the mid-1920s was painting in a sharp-focus style influenced by German *Neue Sachlichkeit, initially applying it to portraiture with a certain fantastic edge. His best-known work dates from the 1930s: moodily atmospheric paintings like *The Last Visitors to Pompeii* (1931, Boymans-van Beuningen Museum, Rotterdam) reflect a pessimistic outlook on the future of Western civilization. In other paintings, such as *The Preacher* (1937, Centraal Museum, Utrecht) he seems to suggest austerity as an antidote to the woes of society. In the 1970s he acquired considerable notoriety for extra-artistic reasons. His wife, Mathilde, nearly forty years his junior, was a well-known society figure,

W

noted for her extravagant dress sense. After Carel had affairs with a model and the sculptor Sylvia Quiël, they divorced and Mathilde threatened suicide in a television interview, if the settlement was insufficient. She was found dead a few months later, shot with the gun in her hand. A documentary on her life, *Mathilde Willink Superpoes*, was released in 2002.

Wilmarth, Christopher (1943–87) American abstract sculptor, born in Sonoma, California. He worked as a studio assistant to Tony *Smith before studying at the Cooper Union, New York, where he graduated in fine art in 1965; in 1969 he began teaching there. His early work was in wood (for a time he earned his living as a cabinet-maker), but his favoured materials were glass and steel. Unlike many sculptors who used these materials, however, he aimed for poetic rather than industrial effects (the French poet Stéphane Mallarmé was one of his greatest inspirations). His forms were fairly minimalist, but he made subtle play with the qualities of glass—its reflectiveness, translucency, transparency, or opacity. Wilmarth committed suicide.

Wilson, Richard *See* INSTALLATION.

Wilson, Scottie (1891–1972) British self-taught painter of imaginative subjects, born Lewis (later changed to Louis) Freeman in Glasgow of working-class parents. A colourful character, he joined the army at fifteen, serving in Africa, and later, during the First World War, in France. He worked as a peddler and shopkeeper in London for several years and lived in Canada from 1930 to 1945. He started to draw in the 1930s and had his first one-man exhibition in 1943, in Toronto. At the end of the Second World War he returned to Britain and became something of a character in the London art world, although he turned increasingly reclusive as he grew old. He was barely literate and fond of the bottle, and his appearance suggested either a music-hall comedian or a near-vagrant—'mended spectacles, grog-blossom nose, canny expression, cloth cap, muffler, boots, and an habitual Woodbine between his fingers' (George *Melly, *It's All Writ Out For You: The Life and Work of Scottie Wilson*, 1986). Although he lived in very modest lodgings, he made a good living selling his pictures to dealers.

Unlike the work of most *naive painters (with whom he is sometimes grouped), his pictures are not 'realistic' renderings of scenes from the daily life with which he was familiar, but decorative fantasies (often in coloured inks) incorporating stylized birds, fishes, butterflies, swans, flowers, self-portraits, and totem heads. The last of these he saw in Canada, and some critics rather fancifully suggested that they represented the powers of evil in contrast to the powers of good symbolized in the images taken from nature. All his work, however, was intended to be decorative rather than symbolic. He is represented in a number of major collections, including Tate, the Museum of Modern Art, New York, and the Pompidou Centre, Paris.

Further Reading: A. J. Petullo and K. M. Murrell, *Scottie Wilson: Peddler Turned Painter* (2004)

Winogrand, Garry (1928–84) American photographer, born in New York, where he did most of his work. He originally studied as a painter but became one of the most important exponents of 'street photography'. He was prodigiously productive: his technique was to shoot vast amounts of film, sometimes using an entire roll passing a single block, looking for the unexpected moment in the passing scene. This was combined with a boldness in dealing with his subjects. It is recorded that he would move in close, stand right in front of them, and, rather than trying to be invisible, would gain their implicit assent with a wink or a nod. He had an eye for the grotesque and it has been noted that his work owes as much to caricature as to photojournalism. His first anthology, entitled *The Animals* (1969), was of photographs taken in zoos and exploits such juxtapositions as a young couple being eyed by a wolf in a cage.

(((◉))) SEE WEB LINKS

- F. Von Riper, 'Garry Winogrand: Huge Influence, Early Exit', on *The Washington Post* website.

Wise Gillian *See* CONSTRUCTIVISM.

Wiszniewski, Adrian *See* GLASGOW SCHOOL.

Witkin, Isaac (1936–2006) South African-born sculptor who moved to England in 1956. In 1957–60 he studied under Anthony *Caro at *St Martin's School of Art and subsequently worked as assistant to Henry *Moore. He took part in the *'New Generation' sculpture exhibition at the Whitechapel Gallery in 1965. As with other artists in the exhibition his

work was brightly coloured, large, and abstract, but it was more organic in form than that of his contemporaries and he expressed a preference for wood as a material over fibreglass and iron, which he regarded as 'cold and impersonal'. In 1965 he went to the United States to teach at Bennington College, Vermont, and spent most of his subsequent life there. In the late 1970s he evolved an innovative method of bronze sculpture, pouring the molten metal directly and freely into sand.

(⊕) SEE WEB LINKS

• The artist's website.

Witkin, Joel-Peter (1939–) American photographer, born in New York. He has developed a highly individual form of staged photography (*see* PHOTO-WORK), bringing to the fore human oddities and amputees, arranged to evoke Old Master paintings. The photographs have an elaborately aged look, which he achieves by roughening the negative and coating it with beeswax, bringing them close to the appearance of painting. In 1985 he advertised for models: 'Pinheads, dwarfs, giants, hunchbacks, pre-op transsexuals, bearded women, people with tails, horns, wings, reversed hands or feet, anyone born without arms, legs, eyes, breasts, genitals, ears, nose, lips. All people with unusually large genitals. All manner of extreme visual perversion. Hermaphrodites and teratoids (alive and dead). Anyone bearing the wounds of Christ.' Most controversially his work has involved the manipulation of severed limbs and even corpses, as in *The Kiss* (1982), showing a man's head split down the middle and arranged so that the two halves look like a kissing couple. Witkin has commented 'It is my sacred work, since what I make are my prayers', although his work has been attacked by the religious right as blasphemous and by others as exploitative of its subjects.

Woestijne, Gustave van de *See* LAETHEM-SAINT-MARTIN.

Wölfflin, Heinrich *See* FORMALISM; POST-PAINTERLY ABSTRACTION.

Wölfli, Adolf *See* ART BRUT.

Wollheim, Richard *See* EXPERIMENTAL ART; STOKES, ADRIAN.

Wols (Alfred Otto Wolfgang Schulze) (1913–51) German-born painter, graphic artist, and photographer, active mainly in France.

He was born in Berlin, the son of a distinguished lawyer, and grew up in Dresden, where his father was appointed head of the Saxon State Chancellory in 1919. His interests included music and he considered a career as a violinist. He also showed a talent for drawing from early childhood, but it was not until 1932, when he studied briefly at the *Bauhaus in Berlin, that he was converted to a serious interest in art. On *Moholy-Nagy's advice he moved to Paris in that year. He met leading artists such as *Arp, *Giacometti, and *Léger, but earned his living as a photographer, working under the name Wols, which he adopted from a mutilated telegram. In 1933 he moved to Spain, and his refusal to return to Germany for labour service resulted in lifelong expatriation. After being imprisoned in Barcelona in 1935 for political activities, he returned to France, where he was official photographer to the 1937 International Exhibition. Long forgotten, his work as a photographer has been reassessed in recent years: special attention has been paid to a remarkable series of *Surrealist-influenced kitchen pictures, close-ups of vegetables, utensils, and skinned animals, made at the end of the 1930s.

As a German citizen, he was interned at the outbreak of the Second World War but was liberated in 1940 and lived in poverty in the south of France. While there he embarked on a series of drawings which evoke a mysterious world in microcosm. At the end of the war he returned to Paris, where he had his first one-man show at the Galerie René Drouin in 1945. He was befriended by the writers Jean-Paul *Sartre and Simone de Beauvoir, for whose books he did illustrations. Wols said 'My pictures are not in revolt against anything. In spite of misery, poverty, and the fear of being blind one day, I love life', but there were affinities between his world view and that of the existentialists. Wols practised a kind of *automatism and tried to depict in his art unnameable things. (Titles were nearly always added later, not by Wols.) By the late 1940s he was beginning to make a name for himself as a painter (Drouin had persuaded him to take up oils). His early death has sometimes been attributed to drinking and to overwork, but in fact he died of food poisoning at a time when he had begun to control his alcoholic intake. His posthumous fame far outstripped his reputation during his lifetime and he came to be regarded as the 'primitive' of *Art Informel and one of the most original masters of

expressive abstraction, sometimes considered a European equivalent of Jackson *Pollock. He never worked on Pollock's scale, but in his oils there was a remarkable invention in handling, exploiting varying textures as the pigment is scratched and dribbled across the surface.

Further Reading: C. Mehring, *Wols Photographs* (2001)

Wood, Christopher (1901–30) British painter, mainly of landscapes, harbour scenes, and figure compositions. He was born at Knowsley, near Liverpool, and briefly studied architecture at Liverpool University. In 1921 he studied at the *Académie Julian in Paris and subsequently travelled widely on the Continent. He was influenced by modern French art (*Cocteau, *Diaghilev, and *Picasso were among his friends), but the 'fashionable clumsinesss' (Gwen *Raverat) of his work is characteristic of the *Seven & Five Society, with which he exhibited. In a remarkably short time he achieved a position of high regard in the art worlds of London and Paris, but he was emotionally unstable and his early death was probably suicide (he was killed by a train). After this he became something of a legend as a youthful genius cut off before his prime—the introduction to the catalogue of the 1978 Arts Council exhibition of his work (by William Mason) is typically rhapsodic in its praise: 'His painting was ageless and young, and represented for his generation and for future generations all of the vigour, joy and exuberance of youth coupled with a freshness of vision and sense of colour as strong as if his life had been spent within a rainbow.' Much of his best work was done in Cornwall, where he and his friend Ben *Nicholson discovered the *naïve painter Alfred *Wallis in 1928. There are several examples of Wood's work in Tate.

Further Reading: V. Button, *Christopher Wood* (2003)

Wood, F. Derwent (1871–1926) British sculptor, born in Keswick. He trained in Karlsruhe, then in London at the *Royal College of Art, the *Slade School, and finally the *Royal Academy, where he won a gold medal in 1895. While still a student he was employed as an assistant by Sir Thomas Brock. In 1896–7 he worked in Paris, then taught at *Glasgow School of Art, 1897–1901, before settling in London. In the First World War he served in the Royal Army Medical Corps and was in charge of making masks for plastic surgery at Wandsworth Hospital. From 1918 to 1923 he

was professor of sculpture at the Royal College of Art. Wood's sculpture consisted mainly of portraits and memorials. His best-known work is the monument to the Machine Gun Corps (1925) at Hyde Park Corner in London, featuring a svelte, languorous nude bronze figure of David (an inscription explains this choice: 'Saul hath slain his thousands, and David his tens of thousands'). To Susan Beattie (1983) it represents 'a weary and corrupted tradition' contrasting with the 'searing realism' of Sargeant *Jagger's nearby Royal Artillery Monument, but to many people—for all its 'sickening irrelevance'—it is a beautiful figure.

Wood, Grant (1892–1942) American painter, one of the leading exponents of *Regionalism. He was born on a farm near Anamosa, Iowa, and spent most of his life in his native state, mainly at Cedar Rapids. His training in art was varied but uneven: as a painter he was largely self-taught, although he studied at the *Académie Julian, Paris, in 1933, during one of his four visits to Europe (the others were in 1920, 1926, and 1928). Early in his career he was something of an artistic jack-of-all-trades, employed as a metalworker, interior decorator, and teacher, as well as a painter (and in his army service during the First World War he did camouflage work). The turning-point in his life came when he obtained a commission to make stained-glass windows for the Cedar Rapids Veteran Memorial Building in 1927 and went to Munich to supervise their manufacture the following year. Influenced by the Early Netherlandish paintings he saw in museums there, he abandoned his earlier *Impressionist style and began to paint in the meticulous, sharply detailed manner that characterized his mature work (he has been called 'the Memling of the Midwest').

Wood's subjects were taken mainly from the ordinary people and everyday life of Iowa: 'At first I felt I had to search for old things to paint—something soft and mellow. But now I have discovered a decorative quality in American newness.' He came to national attention in 1930 with his painting *American Gothic*, depicting a farming couple (his sister and dentist were in fact the models) in front of a farmhouse with a pointed Gothic-style window; he had seen such a building in southern Iowa and said that 'I imagined American Gothic people with their faces stretched out long to go with this American Gothic house'. The painting won a bronze medal at an exhibition at the Art Institute of

Chicago (which now owns the work), but it aroused violent controversy because many people regarded it as an insulting caricature of plain country folk. However, it later won great popularity and is now one of the most familiar and best-loved images in American art. Wood never again achieved quite the same bite and freshness of his masterpiece, but his other work included some highly distinctive and original pictures. Among them are *The Midnight Ride of Paul Revere* (1931, Metropolitan Museum, New York), which has a captivating air of fantasy, and *Daughters of the Revolution* (1932, Cincinnati Art Museum), which Wood described as 'the only satire I have ever painted'. It was his pictorial revenge on members of the Daughters of the American Revolution, who had opposed the dedication of his stained-glass windows in Cedar Rapids because they had been made in Germany—America's recent enemy. As described by members of the Sons of the American Revolution, the painting showed 'three sour-visaged, squint-eyed and repulsive-looking females, represented as disgustingly smug and smirking because of their ancestral claim to be heroes of the American Revolution'. Wood also painted some vigorous stylized landscapes, and he supervised several Iowa undertakings of the *Federal Art Project. In 1934 he became assistant professor of fine arts at the University of Iowa. He died of cancer.

Further Reading: W. M. Corn, *Grant Wood: The Regionalist Vision* (1983)

Woodrow, Bill (1948) British sculptor, born in Henley-on-Thames, Oxfordshire. He first attracted attention at the beginning of the 1980s as one of the representatives of *New British Sculpture, producing work made of scrap objects which were transformed by cutting out the contours of other objects like a dress pattern and then reconstructing them. The skins of twin-tub washing machines and spin dryers were cut away to become bicycle frames or chain saws. As these became more elaborate an element of overt political comment entered his work. *English Heritage: Humpty Fucking Dumpty* (1987, Tate) is made from a vaulting box, the sections of which are at a precarious angle to each other, propped up by a book, a plough, a clocking-in machine, and a box marked with the radiation hazard sign. Astride this sits a sheet metal ball with legs, the Humpty Dumpty in the nursery rhyme who 'had a great fall'. The sculpture should be seen in the context of the elevation of history and 'heritage' as a political value in Britain at the time it was made, especially the revival of patriotism that followed the Falklands War. By turning to bronze, the traditional medium of the public monument, in later works he has continued to present a satirical view of tradition. In the 1990s he made a number of works on the theme of the Ship of Fools, including an anchor and a cannon supposedly dredged from its wreck.

Further Reading: J. Roberts, *Bill Woodrow: Fools' Gold* (1996)

Woollaston, Sir Mountford Tosswill ('Toss') (1910–98) New Zealand painter, who with Rita *Angus and Colin *McCahon pioneered a move away from conventional figuration in his country's art. He was born at Toko, Taranaki, studied at various art schools, and lived mainly in the Nelson and Greymouth districts. His work combined influences from *Cézanne and *Expressionism and is mainly devoted to landscapes and portraits of family and friends. He spoke of his painting as 'a very quiet song hummed or murmured to myself', and the poet Charles Brasch called him 'one of the first to see and paint New Zealand as a New Zealander'. Woollaston set out some of his ideas on art in a lecture delivered at the City Art Gallery, Auckland, in 1960; two years later it was published as a pamphlet entitled *The Far-Away Hills: A Meditation on New Zealand Landscape*. In 1979 he became the first New Zealand painter to be knighted. His autobiography, *Sage Tea*, was published in 1981.

Workers' Council for Art (Arbeitsrat für Kunst) See NOVEMBERGRUPPE.

Works Progress Administration (WPA) See FEDERAL ART PROJECT.

World of Art (Mir Iskusstva) The name of an informal association of Russian artists and of the journal they published from 1899 to 1904; the association was formed in St Petersburg in 1898 and in its original form lasted until 1906 (it was revived in 1910 as an exhibiting society, and this lasted until 1924). Sergei *Diaghilev was the journal's editor, and his contributors and collaborators included Léon *Bakst and Alexandre *Benois. The group encouraged interchange with Western art (many articles in the journal had previously appeared in European magazines) and became the focus for avant-garde developments in Russia. In particular it promoted the *Art Nouveau

W

style. Some of the artists involved in the group (notably Nikolai *Roerich) were also interested in evoking the spirit of ancient Russia, and this synthesis of old and new was best expressed in the decor for Diaghilev's ballet company, which revolutionized European stage design when he brought it to Paris. The revived World of Art—with Benois providing the initial impetus—held 21 exhibitions between 1910 and 1924 in St Petersburg, Moscow, and elsewhere. Among the artists who showed work at them were leading avant-garde figures including *Chagall, *Kandinsky, *Lissitzky, and *Tatlin.

Worpswede *See* MODERSOHN-BECKER, PAULA.

Worringer, Wilhelm (1881–1965) German art historian and aesthetician, professor at the universities of Bonn (1920–8), Königsberg (1928–46), and Halle (from 1946). His writings, which tend to be somewhat metaphysical in tone, encouraged a more sympathetic response to non-realist styles and *Expressionist distortion in art. His best-known books are *Abstraktion und Einfühlung* (1908) (translated as *Abstraction and Empathy*, 1953) and *Formprobleme der Gotik* (1912), which has been translated in an American edition as *Form Problems of the Gothic* (1919) and in an English edition, with an introduction by Herbert *Read, as *Form in Gothic* (1927). Charles Harrison and Paul Wood write that *Abstraktion und Einfühlung* was 'continuously reprinted for over forty years. It was influential in countering what Worringer called the "European-classical prejudice of our customary historical conception and valuation of art". It also furnished theoretical support for that widespread modern tendency in which enthusiasm for so-called *primitive art was conjoined with interest in modern forms of abstraction' (*Art in Theory 1900–2000*, 2002).

Wotruba, Fritz (1907–75) The leading Austrian sculptor of the 20th century; also a designer and architect. He was born in Vienna and trained there as an engraver, 1921–4, before studying sculpture under Anton Hanak (1875–1934). His masterly craftsmanship soon won him acclaim, as when his work was shown in an exhibition of Austrian art in Paris in 1929: Aristide *Maillol is said to have refused to believe that such work could have been done by a 22-year-old. After the annexation of Austria by Nazi Germany in 1938, he took refuge in Switzerland. He returned to Vienna in 1945 and was made professor and later rector at the Academy. In his most characteristic works he carved directly in stone (*see* DIRECT CARVING), preferring a hard stone with a coarse texture. He began his career working in a naturalistic style reminiscent of Maillol, but moved towards abstraction by reducing the figure to bare essentials. It was essentially the method used by *Brancusi, but in contrast to Brancusi's smooth, subtle abstractions, Wotruba's figures are solid, block-like structures. They were left in a rough state, creating a feeling of primitive power (*Feminine Rock*, 1947–8, Middelheim Open-Air Museum of Sculpture, Antwerp). He also worked in bronze (*Standing Man*, 1949–50, Tate). His work was admired and imitated by many younger Austrian artists, bringing about a revival of sculpture in his country, and was much acclaimed elsewhere. It is represented in numerous major public collections.

Wouters, Rik (1882–1916) Belgian painter, sculptor, and printmaker, born in Mechelen (Malines), the son of an ornamental sculptor. In spite of his tragically brief life, he is regarded as his country's leading *Fauve painter. He learned woodcutting in his father's workshop and studied sculpture in Brussels, but he was essentially self-taught in painting, which became his main occupation from 1908. His work is less violent in colour than that of the French Fauves and often has a quality of serene intimacy, notably in portraits of his wife, Nel, who was his favourite model (*The Artist's Wife*, 1912, Pompidou Centre, Paris; *Woman in Blue with Amber Necklace*, 1912, Musées Royaux, Brussels). His best-known sculpture, the life-enhancingly vigorous *La Vierge Folle* (1910–12, Middelheim Open-Air Museum of Sculpture, Antwerp) was inspired by the dancing of Isadora Duncan, although as usual his model was Nel. In 1912 he had a successful one-man exhibition at the Galerie Giroux, Brussels, and this enabled him to visit Paris. He was called up for military service at the beginning of the First World War, but he deserted. After being released from internment in the Netherlands, he settled in Amsterdam, where he died following a series of operations for cancer which left him disfigured and cost him an eye.

WPA *See* FEDERAL ART PROJECT.

Wright, Frank Lloyd *See* MODERN MOVEMENT.

Wright, Willard Huntington (1888–1939) American art and literary critic and novelist, brother of the painter Stanton *Macdonald-Wright. He was born in Charlottesville, Virginia, grew up in California, and studied at Harvard University. In 1912 he moved to New York, where he worked as a journalist, and in 1913 (soon after seeing the *Armory Show) he joined his brother in Paris, where he lived for the next two years. One of the first articles he sent back from Paris was 'Impressionism to *Synchromism' (*The Forum*, December 1913), in which he discussed the avant-garde movement recently founded by his brother. In 1915 Wright returned to New York, via London, and his book *Modern Painting: Its Tendency and Meaning* was published in both cities that year. The hero of the book is *Cézanne; Wright rated him far above van Gogh, 'who did little more than use a borrowed and inharmonious palette to express ideas wholly outside the realm of art'.

In 1916 Wright organized the 'Forum' exhibition in New York, one of the most important avant-garde shows of its period, and in the same year he published an article ('The Aesthetic Struggle in America', *The Forum*, February 1916) in which he attacked conservative critics. Wright's last notable contribution to art literature was *The Future of Painting* (1923). Soon after it was published he became dangerously ill, the result of his drug addiction; during a lengthy convalescence he was forbidden serious reading, so he got through hundreds of detective novels. Convinced he could do better, he took up the genre himself and in 1926—under the pseudonym S. S. Van Dine—he published *The Benson Murder Case*, the first of a series of books featuring the super-sleuth Philo Vance, whose scholarship and urbanity were modelled on Wright's own. The books were immensely popular and earned him a fortune.

Wyeth, Andrew (1917–2009) American painter, son of **Newell Convers Wyeth** (1882–1945), a highly successful illustrator of children's books. Wyeth had lessons from his father and later learned tempera technique from his brother-in-law Peter Hurd, a *Regionalist painter, but he considered himself largely self-taught, saying 'I worked everything out by trial and error.' His paintings consist almost entirely of depictions of the people and places of the two areas he knew best—the Brandywine Valley around his native Chadds Ford,

Pennsylvania, and the Port Clyde area of the Maine coast, where he had his summer home. He usually painted in watercolour or tempera, with a precise and detailed technique, and often he conveyed a sense of loneliness and nostalgia (trappings of the modern world, such as motor cars, rarely appear in his work). He had his first solo exhibition at the Macbeth Gallery in New York in 1937, when he was only nineteen. It was a sell-out success, and he became famous with *Christina's World* (1948), which was bought by the Museum of Modern Art, New York, in 1949 and has become one of the best-known American paintings of the 20th century. It depicts a friend of the artist, Christina Olson, who had been so badly crippled by polio that she moved by dragging herself with her arms. She is shown in a field on her farm in Maine, 'pulling herself slowly back towards the house'. The unusual viewpoint and the heavily charged atmosphere are typical of Wyeth's work. Because Christina is seen from the back, some viewers assumed that she was an attractive young girl frolicking in the grass, and were shocked when they saw Wyeth's portraits of the gaunt, middle-aged figure.

Building on the fame of *Christina's World*, Wyeth went on to have an enormously successful career. He won numerous awards and in 1976 was the first native-born American artist to be honoured with a retrospective exhibition at the Metropolitan Museum, New York. There is a wide disparity of critical opinion about him, however: J. Carter Brown, one-time director of the National Gallery in Washington, has called him 'a great master', whereas Professor Sam Hunter, one of the leading authorities on 20th-century American art, has written: 'What most appeals to the public, one must conclude, apart from Wyeth's conspicuous virtuosity, is the artist's banality of imagination and lack of pictorial ambition. He comfortably fits the commonsense ethos and non-heroic mood of today's popular culture, despite his occasional lapses into gloomy introspection.' The dichotomy was wittily summed up by the art historian Robert Rosenblum who, when asked to name the most overrated and underrated artists of the 20th century nominated Wyeth in both categories. David Anfam intriguingly compares the sense of a figure within an encompassing field in certain Wyeth paintings (*Winter*, 1946, North Carolina Museum of Art) with some effects in *Abstract Expressionist painting, a comparison which would probably

not have pleased the artist. Wyeth himself explained his popularity by saying, 'It's because I happen to paint things that reflect the basic truths of life: sky, earth, friends, the intimate things.'

(⊕) SEE WEB LINKS

- H. Adams, 'Wyeth's World', *The Smithsonian* (June 2006).

Wynne, David (1926–) British sculptor, born at Lyndhurst, Hampshire. After serving in the Royal Navy, 1944–7, and studying zoology at Trinity College, Cambridge, he became a sculptor in 1949 with no formal art training. His work is fairly traditional in style (he thinks that art should be beautiful and 'remind people of heaven') and he is best known for animal sculpture. His many public commissions—often on a large scale—include the 2-ton black marble *Guy the Gorilla* in Crystal Palace Park, London (1963), the bronze *Tyne God* (3 tons) and *Flying Swans* at the Civic Centre in Newcastle upon Tyne (1968), and the Queen Mother's Gates in Hyde Park, London (1993). He has also made portrait busts of many famous sitters (for example, Sir Thomas Beecham, 1957; casts in the Festival Hall and NPG, London, and elsewhere). His other work includes the design of the Common Market 50 pence piece (1973), showing a ring of clasped hands.

Wynter, Bryan (1915–75) British painter, born in London. He studied at Westminster School of Art, 1937–8, and at the *Slade School, 1938–40. In 1945 he settled at Zennor, Cornwall (*see* ST IVES SCHOOL), and he taught at the *Bath Academy, 1951–6. During the decade 1946–56 his work consisted mainly of gouache landscapes, but in 1956 he began painting the abstracts that are his best-known works. They remain tenuously based on nature and have an affinity with the work of Roger *Bissière: 'The landscape I live among is bare of houses, trees, people; is dominated by winds, by swift changes of weather, by moods of the sea; sometimes it is devastated and blackened by fire. These elemental forces enter into the paintings and lend their qualities without becoming motifs.' In 1964 Wynter moved to St Buryan in Cornwall, and at about this time his style changed, his work becoming more decoratively patterned and less intense. In the 1960s he also began producing *Kinetic constructions that he called IMOOS (Images Moving Out Onto Space), making use of convex mirrors to create spatial ambiguities.

Further Reading: C. Stephens, *Bryan Wynter* (1999)

W

Xenakis, Iannis (1922–) French composer, architect, and *experimental artist, born at Bräila in Romania to Greek parents. His family returned to Greece in 1932 and he began to study engineering at Athens Polytechnic. The war intervened and after the German invasion of Greece in 1941 he fought in the Resistance, losing the sight of an eye when he was badly wounded in 1945. In 1947, after completing his engineering course, he settled in Paris, where he assisted *Le Corbusier in his architectural practice from 1948 to 1960. He became a French citizen in 1965. Xenakis is best known as a composer; his works 'are examples of a new and individual kind of musical thinking, based on models drawn from architecture, physics, and mathematics' (*New Oxford Companion to Music*, 1983). In the visual arts he is notable for being among the most prominent creators of 'total environments' involving both spectacle and sound, in particular for pioneering the use of multiple lasers in light environments. For the French Pavilion at 'Expo '67' in Montreal he created a vast 'Polytope' made up of large concave and convex mirrors suspended on electrified cables, producing 'visual melodies' by the action of light sources. In 1972 he created a still more strange and elaborate form of total spectacle at the Roman Baths off the Boulevard St Michel in Paris.

Xu Beihong (Hsü Pei-hung) (1895–1953) Chinese painter, teacher, and administrator, the most important figure in introducing Western ideas about art to his country. After the death of his father (a painter and village teacher) in 1915, Xu moved from his home in Jiangsu province to Shanghai, where he made a living by painting whilst studying French at university. From 1919 to 1927 he lived in Europe (with one brief trip home), travelling widely and studying in Paris (at the École des *Beaux-Arts) and Berlin. After his return to China he held a variety of teaching and administrative posts in Shanghai, Beijing, and Nanjing, and when the country became the People's Republic of China in 1949 he was appointed director of the newly founded Central Academy of Fine Arts and chairman of the National Artists' Association. His career was ended by a stroke in 1951. Xu's most characteristic works were large historical compositions. They were decidedly old-fashioned by European standards or even by the standards of his only rival in importance in introducing Western art to China—Liu Haisu (1896–1994), who was influenced by *Impressionism and *Post-Impressionism and who caused a scandal by introducing drawing from live models in his teaching at the Shanghai Academy. However, Xu's style was novel to most Chinese eyes and it was highly influential, proving completely compatible with the Soviet-inspired *Socialist Realism that became the official style in Communist China in the 1950s.

Xu Bing (1955–) Chinese artist, born in Chongqing. He moved with his parents to Beijing in 1957. Being surrounded by books as a child was an important influence. The experience of the Cultural Revolution was a significant one. His father, the head of the history department at Beijing University, was humiliated and forced to wear a dunce's cap. Xu Bing was sent to the countryside, 1974–7, but he regarded this as in some ways a positive experience, because of his contact with the Chinese traditions still retained by the villagers. Subsequently he studied printmaking at the Central Academy of Fine Arts in Beijing and through the early 1980s began to build up a reputation for his woodcuts. In 1988 he exhibited the first completed section of *A Book from the Sky* (Queensland Art Gallery). The final work, which took Xu Bing four years to complete, consists of bound books covering the floor, and sheets of paper posted on walls and suspended from the ceiling, inscribed with Chinese-style characters which

are, in fact, meaningless, being entirely the invention of the artist. Recalling the daily newspapers which are publicly posted in China, the work has generally been seen as a political protest at the corruption of language. After the repression which followed the Tiananmen Square demonstrations, Xu Bing became the subject of official criticism for 'bourgeois liberalism' and he was compared to a 'ghost pounding the walls'. This epithet became the title of a further piece made from a hand-rubbed impression taken from the Great Wall of China. He moved to the USA in 1990 and his work has continued to explore the theme of language. In 2008 he showed in London sheets of apparently authentic Chinese calligraphy which, on examination, turn out to be English words. In an interview to accompany the show (*The Times*, 10 May 2008) he said that in spite of his early experiences, China now 'has the best soil for contemporary art'. In 2008 he was appointed Vice President of the China Central Academy of Fine Arts in Beijing.

Xul Solar (Oscar Agustín Alejandro Schulz Solari) (1887–1963) Argentinian painter, born at San Fernando, near Buenos Aires. He was the son of Latvian-Italian immigrants, hence his rather jumbled name, which he compressed to Xul Solar. From 1912 to 1924 he travelled widely in Europe (in Italy he was a friend of his fellow-countryman *Pettoruti), then returned to Buenos Aires. Although he had absorbed features from European movements such as *Cubism and *Dada, he was self-taught as an artist and his work has a highly personal sense of fantasy and humour befitting his visionary and mystic outlook. He worked on a small scale, chiefly in tempera and watercolour, rarely exhibited, and sought no honours. His work has been divided into three phases. The first runs from 1917 to 1930, when his paintings featured colourful forms of geometric tendency, stylized emblems and signs, sometimes with numerals, letters, and words spelling out the subject of the picture. Many pictures of this period also feature double or multiple transparent images. The second phase runs from 1930 to 1960, when he often treated architectural and topographical themes, featuring sparse modelling, nearly traditional perspective, and more restrained colour. The third phase runs from 1960 until his death three years later; during this period he returned to the lyrical colour of his early work and focused on the alphabet, his pictures being interwoven with words from two languages he invented—a universal language he called *Panlengua* and a Pan-American language, *Neocriolla*. He also invented a very complicated game based on chess, which he called *Panjuego* (Pangame, i.e. universal game). Xul Solar's friend the writer Jorge Luis Borges referred to his paintings as 'documents of an extraterrestrial world, of a metaphysical world in which the gods take on the shape of the imagination of the artist who dreams them up'. The works of his 'alphabetical' phase have sometimes been compared with Paul *Klee's pictographic compositions. Xul Solar was given a major retrospective exhibition at the Museo Nacional de Belles Artes in Buenos Aires in 1964 and has had a powerful influence on younger Argentinian artists.

Yakulov, Georgy *See* BLUE ROSE.

YBAs *See* YOUNG BRITISH ARTISTS.

Yeats, Jack Butler (1871–1957) The best-known Irish painter of the 20th century, born in London, the son of **John Butler Yeats** (1839–1922), a barrister who became an unremarkable but successful portrait painter, and the brother of the celebrated poet William Butler Yeats. He had an idyllic childhood in Sligo, his ancestral home on the north-west coast of Ireland, and studied at various art schools in London, notably Westminster School of Art under Fred *Brown. From 1910 he lived in Dublin. Early in his career he worked mainly as an illustrator; he did his first oil paintings in about 1897 (the year of his first one-man exhibition in London), but he did not work regularly in the medium until about 1905. The subjects he painted included Celtic myth and everyday Irish life (including scenes of fairs and horse races), and through these he contributed to the upsurge of nationalist feeling in the arts that accompanied the movement for Irish independence. His early work as a painter was influenced by the French *Impressionist pictures he saw in the collection of Hugh *Lane, but in the 1920s he developed a more personal *Expressionist style characterized by high-keyed colour and extremely loose brushwork (there is some similarity to the work of *Kokoschka, who became a great friend in the last decade of Yeats's life). Yeats was immensely prolific, producing more than 1,000 paintings and a great many drawings. His work is represented in numerous galleries in his country, notably the National Gallery of Ireland, Dublin City Gallery: The Hugh Lane, and the Model Arts and Niland Gallery, County Sligo, which has material relating also to his father and brother. There are also numerous examples in the USA, where he has long been popular. Yeats was a writer as well as a painter—the author of several plays, novels, and volumes of poetry, as well as *Life in the West of Ireland* (1912) and *Sligo* (1930).

Yoshihara, Jiro (1905–72) Japanese painter and entrepreneur, born in Osaka. He was a wealthy industrialist and was mainly self-taught as an artist. During the 1930s he was a pioneer of abstract art in Japan, but he is best known as the central figure of the *Gutai Group, which he founded in 1954 and sustained with his wealth for the rest of his life. In 1957 Yoshihara was awarded first prize at the Tokyo *Biennale. His paintings of this time are 'a sophisticated mixture of Eastern and Western modes. They mingle Zen, and Zen versions of traditional oriental calligraphy, with things learned from American *Abstract Expressionism' (Edward *Lucie-Smith, *Visual Arts in the Twentieth Century*, 1996).

Young British Artists (YBAs) An imprecise term applied to a number of highly publicized British artists active from the late 1980s, several of whom are well known for their glamorous lifestyles as well as the often provocative art they create; they do not form an organized group and their work is diverse, but there are ties of friendship linking many of them and they have been supported chiefly by Charles *Saatchi. The name derives from a series of exhibitions held at his gallery in 1992–6 ('Young British Artists I' to 'Young British Artists VI'). These artists are sometimes also referred to as the 'Freeze' generation, in reference to the exhibition organized by Damien *Hirst in 1988 that first brought them media and art world attention. Subsequently there have been several other exhibitions featuring their work, most notably *'Sensation' at the Royal Academy, London, in 1997. As well as Hirst, artists identified with the phenomenon include Tracey *Emin, Sarah *Lucas, Marc *Quinn, Gary *Hume, Chris *Ofili, and the *Chapman brothers. In spite of the public image, many critics claim a seriousness of purpose in the work of many of the artists, in

their addressing of issues of sexuality and mortality. Julian Stallabrass, a critic generally hostile to the phenomenon, has proposed the designation 'High Art Lite' for their work, in a book of that title first published in 1999.

Young Contemporaries Exhibition of works by British art students held in London since 1949 on a roughly annual basis (lack of funds or organization—the shows are generally arranged by the students themselves—has sometimes prevented them taking place). The first Young Contemporaries show was held at the Royal Society of British Artists (RBA Galleries). Other venues have included the *Institute of Contemporary Arts, and some of the exhibitions have toured the provinces. The most famous Young Contemporaries exhibition was that of 1961, when British *Pop art first appeared in force in the work of Derek *Boshier, David *Hockney, Allen *Jones, R. B. *Kitaj, and Peter *Phillips, all of them students or former students at the *Royal College of Art. In 1974 the name was changed to 'New Contemporaries'.

Youngerman, Jack (1926–) American painter, sculptor, graphic artist, and designer, born in Louisville, Kentucky. After studying at the universities of North Carolina, 1944–6, and Missouri, 1947, he attended the École des *Beaux-Arts, Paris, 1947–8, and remained in Europe until 1956, when he settled in New York. He is known for colourful *Hard-Edged Paintings inspired by *Arp and *Matisse, with affinities to the work of Ellsworth *Kelly, whom he first met as a student in Paris. Apart from paintings his work has included brilliantly coloured lithographs and screenprints, with sharply outlined abstract shapes, and he has also made sculpture from aluminium and painted wood reliefs.

Yuon, Konstantin *See* AKHRR.

Yvaral (Jean-Pierre Vasarely) (1934–2002) French painter and *experimental artist, born in Paris, son of Victor *Vasarely. He studied graphic art and publicity at the École des Arts Appliqués, Paris, 1949–51, and adopted the name Yvaral as a partial anagram of his father's name in 1950. In 1960 he was a founder member of the *Groupe de Recherche d'Art Visuel (GRAV), and like the other members he approached art in a scientific spirit: 'All my work can be reduced to systems of organization used by contemporary scientific research.' He was strongly influenced by his father and much of his work can be classified as *Op art. Characteristically he used devices such as moiré patterns of approaching and receding forms within a shallow depth dimension. His work also included *Kinetic sculpture, *screenprints, and *multiples. From 1975 he introduced digital imaging into his work and between 1989 and 1995 applied this technique to images of Marilyn Monroe and other celebrities. He also worked in an architectural context: one of the most striking examples is an enormous image of St Vincent de Paul (1987) on the side of a five-storey apartment block in the tenth arrondissement of Paris, made from thin steel plates of varying depth, so as to be visible only from an angle or when the sun is low.

Yvel, Claude *See* SUPERREALISM.

y

Zadkine, Ossip (1890–1967) Russian-born sculptor who worked mainly in Paris and became a French citizen in 1931. He was born in Vitebsk and grew up in Smolensk. His father was a classics teacher and his mother came from a Scottish family of shipbuilders. In 1905 Zadkine was sent to Britain (where he had relatives on his mother's side) to learn 'English and good manners'. Taking advantage of his independence, he pursued his love of sculpture (which had distracted him from academic studies in Russia), attending lessons at Sunderland College of Art, and then in London, where he moved in 1906. In 1909 he settled in Paris and after spending a few months at the École des *Beaux-Arts he worked independently. By 1912 he was friendly with many leading figures in avant-garde art, among them *Apollinaire, *Archipenko, *Brancusi, *Lipchitz, and *Picasso. He deeply admired *Rodin, but *Cubism had a greater influence on his work. His experiments with Cubism, however, had none of the quality of intellectual rigour associated with Picasso and *Braque, for Zadkine's primary concern was with dramatically expressive forms. The individual style he evolved made great use of hollows and concave inflections, his figures often having openings pierced through them.

In 1915 he joined the French army but was invalided out after being gassed. He worked in Paris during the 1920s and 1930s and spent most of the Second World War in New York (where he taught at the *Art Students League), returning to Paris in 1944. Often Zadkine's work can seem merely melodramatic, but for his greatest commission—the huge bronze *To a Destroyed City* (completed 1953) standing at the entry to the port of Rotterdam—he created an extremely powerful figure that is widely regarded as one of the masterpieces of 20th-century sculpture. With its jagged, torn shapes forming an impassioned gesture mixing defence and supplication, it vividly proclaims anger and frustration at the city's destruction and the courage that made possible its rebuilding. This work gave Zadkine an international reputation and many other major commissions followed it, including monuments in Amsterdam and Jerusalem. Zadkine also painted, made lithographs, and designed tapestries. The house in which he lived in Paris is now a museum devoted to his work.

Further Reading: J. Berger, 'Ossip Zadkine', in *Selected Essays of John Berger* (2001)

Zahrtmann, Kristian *See* GIERSING, HARALD.

Zao Wou-Ki (1921–) Chinese painter, born in Beijing, active in France. He had his first exhibition in his native country in 1940 and was already established as professor of drawing at Hangzhou University when he left for France in 1948 with the ambition of establishing himself as a painter in Paris. His lithographs came to the notice of Henri *Michaux, who introduced him to his dealer. Zao Wou-Ki assimilated the influence of Paul *Klee, as well as leading figures of the post-war *École de Paris such as *Vieira da Silva, but combined this with a distinctively Chinese calligraphic manner and a range of tones suggesting vistas of mist and marsh. He spent time in New York working alongside *Abstract Expressionists such as *Gottlieb and *Kline. Under their influence he worked on a larger scale without an easel. He returned to China for the first time in 1983 for an exhibition of his work at the Beijing Museum of Fine Art.

Zborowski, Léopold *See* MODIGLIANI, AMEDEO.

Zeisler, Claire *See* FIBRE ART.

Zemlja *See* HEGEDUŠIĆ, KRSTO.

Zenderoudi, Charles-Hossein (1937–) Iranian artist, born in Tehran. He graduated from Tehran's School of Fine Arts in 1959, and

in 1961 moved to Paris, where he has worked ever since. He has been associated with the *Saqqakheni* (*Sagha Khaneh*) movement. This literally means 'water fountain' and has religious connotations within the Shi'a tradition. Venetia Porter writes that it 'sought to integrate popular symbols of Shi'a culture in art'. Invariably, this involved the use of calligraphy, although Zenderoudi has denied that it was simply an issue of using writing, describing it as 'an attitude' and declaring his interest in the 'conceptual heritage' of Iranian art. As Pierre *Restany, who related his work to *Arman and Andy *Warhol, pointed out, he arrived in Paris at a time when gesture and calligraphy were still in vogue. At the same time Zenderoudi has had considerable success and acclaim in the Islamic world. He has made tapestries and monumental paintings for Riyadh and Jeddah airports, Saudi Arabia. In 2002 he had a retrospective exhibition at the Tehran Museum of Contemporary Art.

(((((🌐))) SEE WEB LINKS
• The artist's website.

Zero A group of *Kinetic artists formed in Düsseldorf in 1957 by Heinz *Mack and Otto *Piene, who were joined in 1961 by Günter *Uecker (there were other members from time to time, but these three formed the core). Their views were put forward in a periodical, also called *Zero* (two numbers appeared in 1958 and a third in 1961). Although they were interested in technology, they stressed the importance of working with nature, rather than against it, and carried out several environmental projects. They also—unlike many Kinetic artists—valued the intrusion of the irrational in their work. The group disbanded in 1966.

0.10 ('Zero–Ten') *See* POUGNY, JEAN.

Zervos, Christian *See* CAHIERS D'ART.

Zhdanov, Andrei *See* SOCIALIST REALISM.

Zhang Xiaogang (1958–) Chinese painter born in Kumming. He has achieved a worldwide reputation with his 'blood line' series of paintings. These are deadpan images in monochrome or a restricted range of colours, showing full-face head and shoulders portraits of individuals or groups wearing the costumes of the Mao era. Usually there is an uneven patch spreading over the image, recalling the ageing of a photograph. Although there is no

obvious comment made, for many spectators the paintings speak powerfully of the nightmare of the Cultural Revolution of the late 1960s. The critic Yan Shanchan commented: 'When personal feelings have to be expressed in disguise, communication with the past inevitably becomes distorted.' The artist is rather more ambivalent, describing the 'big family' as both something we need to learn to 'protect ourselves from' but also something which embodies 'power, hope, life, envy, lies, duty, and love'.

Zheverzheyev, Lerky *See* UNION OF YOUTH.

Ziegler, Adolf *See* NATIONAL SOCIALIST ART.

Zimmer, Bernd *See* FETTING, RAINER.

Zimmer, Hans-Peter *See* SPUR.

Zittel, Andrea (1965–) American artist, born in Escondido, California. She studied painting and sculpture but she works in a territory between fine art and visionary design. She has worked in two sites, one which she called A-Z East, in Brooklyn, New York, and the other A-Z West, where most of her later efforts have been concentrated, in the California desert. These are intended not just as working places but as spaces in which her ideas are lived out and tested. Her work reflects preoccupations with the effects of consumerism on the environment. For instance she designed clothes intended to be worn without change for months at a time. The *A-Z Comfort Units* are intended to provide everything necessary for life in a small space. The *A-Z Escape Vehicle*, a kind of miniature caravan, could be customized by the user, although the exteriors were identical. Her own was reminiscent of the grotto designed by the mad King Ludwig of Bavaria. At stake is a re-thinking of the Modern Movement idea of functionalism, which had, for a short period between the wars, united the aspirations of many architects, designers, and artists, for a *Postmodern age of pluralism and fragmentation.

Zorach, William (1889–1966) Lithuanian-born American sculptor. His family emigrated to the USA when he was four and he was brought up in Cleveland, Ohio, where he was apprenticed to a commercial lithographer and attended evening classes at Cleveland Institute of Art. In 1907 he moved to New York and studied at the National Academy of Design.

z

After living in Paris for a year, 1910–11, he returned to Cleveland, then settled permanently in New York in 1912 (from the 1950s he also had a summer home in Bath, Maine). Initially Zorach worked as a painter in a *Fauvist style, but he took up sculpture in 1917 and abandoned painting (apart from watercolours) about five years later. His sculpture is figurative and its salient characteristics are firm contours, block-like bulk, and suppression of details: 'I owe most', he said, 'to the great periods of primitive carving in the past—not to the modern or the classical Greeks, but to the Africans, the Persians, the Mesopotamians, the archaic Greeks and of course to the Egyptians.' He was a pioneer in America of *direct carving in stone and wood and in this as well as in his formal austerity he exercised a powerful influence on modern American sculpture. He had numerous major commissions, including relief carvings for the Municipal Court Building, New York (1958). His most famous work is not a carving, however, but the aluminium *Spirit of the Dance* (1932) for Radio City Music Hall, New York—a heroic female figure that was banished for a time because of its nudity but reinstated through public pressure. Zorach taught at the *Art Students League from 1929 to 1966. He wrote two books, *Zorach Explains Sculpture* (1947) and a posthumously published autobiography, *Art is my Life* (1967), as well as numerous articles on art; two of his articles on his own work were put together in book form as *William Zorach* (1945).

His wife, **Marguerite Thompson Zorach** (1887–1968), was one of America's leading modernist painters in the years immediately before and immediately after the *Armory Show (1913), in which both she and her husband exhibited. At this time she painted in a style influenced by Fauvism and *Expressionism. In her later career, however, much of her time was spent selflessly helping her husband with his sculptural commissions, producing many of the preliminary drawings for his work.

Zorio, Gilberto (1944–) Italian artist associated with *Arte Povera, born in Andorno Micca, Piedmont. In 1965 he encountered the work of Pino *Pascali, which represented for him an alternative to the 'rather gloomy' atmosphere in Italy at the time. He interprets Arte Povera not as the use of rough raw materials but as a kind of *materismo*. This meant working with materials for their associations

and visual qualities with regard to the way they might be transformed by their environment. For instance in *Column* (1967) there is a mixture of plaster and cobalt chloride which changes colour in response to the humidity, itself affected by the number of people in the room. Spectator participation was also involved in a 1969 installation *To Purify Words*. The participant spoke through a tube, which then passed the words through alcohol, stimulating flashing headlights. Most dramatic is the *Phosphorescent Fist* (1971, Pompidou Centre, Paris), a wax model suspended in space which glows bright green when the lights are switched off. The associations with political militancy are surely not accidental.

Zorn, Anders (1860–1920) Swedish painter, etcher, and occasional sculptor, born at Mora. He studied at the Stockholm Academy, 1875–81, leaving because of its restrictive and outdated ideas. For the next fifteen years he lived mainly outside his own country, becoming the most cosmopolitan Scandinavian artist of his time and an international success. He was based in London (1882–5), then Paris (1888–96), and he visited Spain, Italy, the Balkans, North Africa, and (on several occasions) the USA, where he painted three presidents and many other prominent figures. Originally he worked almost exclusively in watercolour, but in the late 1880s he abandoned the medium for oils (he began to use them seriously in the winter of 1887–8, when he stayed in *St Ives). In 1896 he returned to Sweden and settled at Mora (although he continued to travel), building his own house, which is now a museum dedicated to him. Zorn's paintings are of three main types: portraits, genre scenes (often depicting the life and customs of the rural area in which he lived), and female nudes. It is for his nudes—unashamedly healthy and voluptuous works—that he is now best known. He often placed his figures in landscape settings and he delighted in showing vibrant effects of light on the human body, depicted through lush brushwork that recalls the handling of his friend Max *Liebermann. Zorn also gained a great reputation as an etcher and he occasionally made sculpture, including one large work: the statue of Gustavus Vasa in Mora (1903). His work is well represented in the Zornmuseet at Mora and the Nationalmuseum in Stockholm. Between 1907 and 1914 he wrote some autobiographical notes, which were published in 1982.

Zucker, Joe (1941–) American painter, born in Chicago. He was associated with *New Image Painting and included in the 1978 Whitney Museum of American Art exhibition which identified the trend. His early paintings were made from dyed cotton fabric and derived from weaving patterns. In 1971 he began painting by building up the image from paint-soaked cotton balls to produce colourful cartoon-like images. Some of these depicted plantation life and so the painting described its origins, essentially a form of *process art. Zucker has been drawn to themes from myth and history. *Merlin's Lab* (1977, Whitney Museum, New York) shows the time-travelling wizard surrounded by the instruments of alchemy, including an alligator, which Zucker commented 'offers a lot of tactile opportunities for a painter'. In the 1980s cotton was replaced by aluminium in a series of paintings inspired by the career of Juan Ponce de León, a 16th-century Spanish explorer who discovered Florida but spent much of his life in a futile search for the Fountain of Youth. The critic Michael Brenson has located Zucker's work in the American tradition of Mark Twain in his use of 'everyday, down-home language to narrate adventures that are filled with humour, speculation and satire' (*The New York Times*, 30 August 1985).

Further Reading: R. Marshall, *New Image Painting* (1978)

Zuloaga y Zabaleta, Ignacio (1870–1945) Spanish painter, born at Eibar in the Basque Pyrenees. He came from a long line of craftsmen, his father being a metalworker, and he was mainly self-taught as an artist. In 1890 he visited Paris and subsequently spent much of his career there. He was on friendly terms with *Degas, *Gauguin, and *Rodin, but this did not affect his work, which was strongly national in style and subject-matter. Bullfighters, gypsies, and brigands were among his favourite subjects, and he also painted religious scenes and society portraits (these were one of the main sources of the considerable fortune he earned). His inspiration came from the great Spanish masters of the past, notably Velázquez and Goya, and he is credited with being one of the first to 'rediscover' El Greco. He was extremely popular in his lifetime (unusually for a Spanish artist, his reputation was higher abroad than at home), but his work now often looks rather stagy. Highlights of his career include a resoundingly successful one-man show in New York in 1925 and the award of the main painting prize at the Venice *Biennale in 1938. In Spain he worked mainly in Madrid (where he died), Segovia, and Seville, and later in the Basque fishing port of Zumaya; there are museums featuring his work in Segovia and Zumaya.

Zwemmer, Anton (1892–1979) Dutch-born bookseller, publisher, and art dealer, active in England. In 1916 he became the manager of a foreign-language bookshop in Charing Cross Road, London, and in the 1920s he developed it into a specialist art bookshop that played an important role in spreading knowledge and appreciation of modern art in Britain in the inter-war years. From 1929 to 1968 the Zwemmer Gallery operated in Lichfield Street, adjacent to the bookshop. It held many important exhibitions of contemporary art, including *Dalí's first one-man show in Britain (1934) and the final exhibition of the *Seven & Five Society (1935), which was the first all-abstract show to be held in England. Later, it exhibited John *Bratby after he had parted company for financial reasons with the Beaux Arts Gallery (*see* LESSORE). Zwemmer also published books, including the first monograph on Henry *Moore (1934, by Herbert *Read). There remains a specialist art book company trading from the Charing Cross Road site, although Zwemmer's itself went into receivership in 2003.

Bibliography

Even short entries in this book can derive from a number of sources. In addition to the specific citations given in the body of the entries or as 'Further Reading', the following works have been drawn on throughout the text.

(⊕) SEE WEB LINKS

Online sources

To access the websites listed below, go to the dictionary's web page at http://www.oup.com/uk/reference/resources/modernandcontemporaryart, click on the **Web links** in the Resources section and click straight through to the relevant websites.

- The Archives of American Art.
- Artcyclopaedia. Provides links to the most significant museum sites.
- *Frieze*. An online journal of contemporary art.
- Kunstkompass. A methodologically sophisticated ranking system for contemporary artists, noted but not followed slavishly by the present book.
- Museum of Modern Art, New York.
- Oxford Art Online.
- Réunion des Musées Nationaux. A valuable source for visual references.
- Tate.
- Ubu web. A useful source for Conceptual and Performance art.

Printed sources

Ades, D., *Dada and Surrealism Reviewed* (Arts Council of Great Britain, 1978)

Ades, D., *The Art of Latin America* (South Bank Centre, 1989)

Ades, D. et al., *Art and Power: Europe under the Dictators 1930–45* (South Bank Centre, 1995)

Ades, D. and Baker, S., *Undercover Surrealism* (South Bank Centre, 2006)

Affron, M. and Antliff, M., *Fascist Visions: Art and Ideology in France and Italy* (Princeton University Press, 1997)

Alsop, J., *The Rare Art Traditions: The History of Art Collecting and its Linked Phenomena* (Harper & Row, 1982)

Anfam, D., *Abstract Expressionism* (Thames & Hudson, 1990)

Antliff, M. and Leighten, P., *Cubism and Culture* (Thames & Hudson, 2001)

Arnason, H. H., *History of Modern Art* (Abrams, 5th ed., 2003)

Baigell, M., *Dictionary of American Art* (John Murray, 1980)

Baker, K., *Minimalism* (Abbeville, 1988)

Bann, S. (ed.), *The Tradition of Constructivism* (Thames & Hudson, 1974)

Baron, S., *German Expressionist Sculpture* (University of Chicago, 1984)

Battcock, G. (ed.), *The New Art* (Dutton, 1966)

Battcock, G. (ed.), *Minimal Art* (University of California, 1995)

Battcock, G. and Nickas, R. (eds.), *The Art of Performance* (Dutton, 1984)

Beattie, S., *The New Sculpture* (Yale, 1983)

Bird, A., *A History of Russian Painting* (Phaidon, 1987)

Bown, M. C., *Art under Stalin* (Phaidon, 1991)

Bowness, A., *Modern Sculpture* (Studio Vista, 1965)

Bowness, A., *Modern European Art* (Thames & Hudson, 1972)

Bowness, A. et al., *Post-Impressionism* (Royal Academy of Arts, 1979)

Braun, E. (ed.), *Italian Art in the 20th Century* (Royal Academy of Arts, 1989)

Bright, S. and Williams, V., *How We Are: Photographing Britain* (Tate Publishing, 2007)

Brighton, A. and Morris, L., *Towards Another Picture: An Anthology of Writings by Artists Working in Britain 1945–1977* (Midland Group, Nottingham, 1977)

British Council, *English Art Today* (Electa, 1976)

Brown, M. S., *The Modern Spirit: American Painting 1908–35* (Arts Council of Great Britain, 1977)

Buccloch, B., Guilbaut, S., and Solkin, D., *Modernism and Modernity* (Nova Scotia College of Art and Design, 1983)

Butler, R. (ed.), *Wack! Art and the Feminist Revolution* (MIT, 2007)

Castleman, R., *Prints of the 20th Century* (Thames & Hudson, 1988)

Causey, A., *Sculpture Since 1945* (Oxford, 1998)

Centre Georges Pompidou, *Hors Limites: L'art et la vie 1952–1994* (1995)

Centre Georges Pompidou, *Face à l'histoire 1933–1996: L'artiste moderne devant l'événement historique* (1996)

Centre Georges Pompidou, *Cher Peintre: Peintures figuratives depuis l'ultime Picabia* (2002)

Chadwick, W., *Women Artists and the Surrealist Movement* (Thames & Hudson, 1985)

Chipp, H. B., *Theories of Modern Art* (University of California, 1970)

Clark, T., *Art and Propaganda* (Weidenfeld & Nicolson, 1997)

Collins, J., *Sculpture Today* (Phaidon, 2007)

Compton, S. (ed.), *British Art in the 20th Century* (Royal Academy of Arts, 1987)

Cone, M., *Artists under Vichy* (Princeton, 1992)

Cooper, D. and Tinterow, G., *The Essential Cubism 1907–1920* (Tate Gallery, 1983)

Cowling, J. and Mundy, J., *On Classic Ground: Picasso, Léger and the New Classicism 1910–1930* (Tate Gallery, 1990)

Crow, T., *The Rise of the Sixties* (Weidenfeld & Nicolson, 1996)

Crow, T., *Modern Art in the Common Culture* (Yale, 1998)

Curtis, P., *Modern Sculpture 1900–45* (Oxford, 1999)

De Oliveira, N. et al., *Installation Art in the New Millennium* (Thames & Hudson, 2003)

Dorival, B., *The School of Paris* (Thames & Hudson, 1962)

Dunlop, I., *The Shock of the New* (Weidenfeld & Nicolson, 1972)

Durozoi, G., *History of the Surrealist Movement* (University of Chicago, 2005)

Egbert, D. D., *Social Radicalism and the Arts: Western Europe* (Duckworth, 1970)

Elderfield, J., *The Wild Beasts: Fauvism and its Affinities* (MoMA, New York, 1976)

Elsen, A. E., *Modern European Sculpture 1918–1945: Unknown Beings and Other Realities* (George Braziller, 1979)

Elsen, A. E., *Origins of Modern Sculpture: Pioneers and Premises* (Phaidon, 1974)

Farr, D., *English Art 1870–1940* (Oxford, 1978)

Flood R. and Morris, F., *Zero to Infinity: Arte Povera 1962–1972* (Tate Gallery, 2002)

Foster, D. (ed.), *The Anti-Aesthetic: Essays on Postmodern Culture* (Bay Press, 1983)

Frascina, F. and Harris, J., *Art in Modern Culture* (Phaidon, 1992)

Fried, M., *Art and Objecthood* (University of Chicago, 1998)

Fruitmarket Gallery, Edinburgh, *Reckoning with the Past: Contemporary Chinese Painting* (1996)

Fry, E., *Cubism* (Thames & Hudson, 1978)

Geldzahler, H., *New York Painting and Sculpture 1940–1970* (Pall Mall, 1969)

Gibson, A. E., *Abstract Expressionism: Other Politics* (Yale, 1997)

Gillen, E., *German Art from Beckmann to Richter: Images of a Divided Country* (Yale, 1997)

Golan, R., *Modernity and Nostalgia: Art and Politics in France Between the Wars* (Yale, 1995)

Goldberg, R., *Performance: Live Art 1909 to the Present* (Thames & Hudson, 1979)

Goldberg, R., *Performance: Live Art Since the 60s* (Thames & Hudson, 2004)

Golding, J., *Cubism: A History and an Analysis 1907–1914* (Faber, 3rd ed., 1988)

Golding, J., *Visions of the Modern* (Thames & Hudson, 1994)

Goldwater, R., *Primitivism in Modern Art* (Belknap Press, 1986)

Golomstok, I., *Totalitarian Art* (Collins Harvill, 1990)

Gray, C., *The Russian Experiment in Art* (Thames & Hudson, 1986)

Green, C., *Cubism and its Enemies* (Yale, 1987)

Green, C., *Art in France 1900–1940* (Yale, 2000)

Grenier, C. et al., *Britannica: 30 ans de sculpture* (La Différence, 1988)

Groom, S., *The Real Thing: Contemporary Art from China* (Tate Liverpool, 1997)

Haftmann, W., *Painting in the 20th Century* (Lund Humphries, 2nd ed., 1965)

Hamilton, G. H., *Painting and Sculpture in Europe 1880–1940* (Penguin, 1967)

Harrison, C., *English Art and Modernism* (Allen Lane, 1981)

Harrison, C. and Wood, J., *Art in Theory 1900–2000* (Blackwell, 2002)

Heartney, E., *Art & Today* (Phaidon, 2008)

Hopkins, D., *After Modern Art 1945–2000* (Oxford, 2000)

Hughes, R., *The Art of Australia* (Penguin, 1970)

Hughes, R., *Nothing if Not Critical* (Harvill, 1990)

Hughes, R. *The Shock of the New* (Thames & Hudson, 1991)

Institut Néerlandais, *Magie et réalisme: Tendances réalistes dans la peinture Néerlandaise de 1925 à 1945* (2000)

Jeffrey, I., *Photography: A Concise History* (Thames & Hudson, 1996)

Joachimides, C. et al. (eds.), *German Art in the 20th Century* (Royal Academy of Arts, 1985)

Joachimides, C. and Rosenthal, N. (eds.), *American Art in the 20th Century* (Royal Academy of Arts, 1993)

Johnson, E. (ed.), *American Artists on Art 1940 to 1980* (Harper & Row, 1982)

Joselit, D., *American Art Since 1945* (Thames & Hudson, 2003)

Kent, S., *Shark Infested Waters: The Saatchi Collection of British Art in the 90s* (Philip Wilson, 1994)

Kettle's Yard, Cambridge, *1965 to 1972—when attitudes became form* (1983)

Krauss, R., *Passages in Modern Sculpture* (MIT, 1977)

Krauss, R. and Livingstone, M., *L'Amour Fou: Photography and Surrealism* (Arts Council, 1986)

Krens, T. et al., *Refigured Painting: The German Image 1960–88* (Prestel, 1989)

Lane, J. and Larsen, S., *Abstract Painting and Sculpture in America 1927–1944* (Abrams, 1983)

Langui, E., *Expressionism in Belgium* (Laconti, 1971)

Licht, F., *Sculpture: 19th and 20th Centuries* (Michael Joseph, 1967)

Lindey, C., *Art in the Cold War* (Herbert Press, 1991)

Lippard, L., *Six Years: The Dematerialization of the Art Object* (Studio Vista, 1973)

Lippard, L., *From the Center: Feminist Essays on Women's Art* (Dutton, 1976)

Lippard, L., *Overlay: Contemporary Art and the Art of Prehistory* (Pantheon, 1982)

Livingstone, M., *Pop Art: A Continuing History* (Thames & Hudson, 1990)

Lodder, C., *Russian Constructivism* (Yale, 1985)

Lucie-Smith, E., *Cultural Calendar of the 20th Century* (Phaidon, 1979)

Lucie-Smith, E., *Latin American Art of the 20th Century* (Thames & Hudson, 1993)

Lucie-Smith, E., *Art Today* (Phaidon, 1995)

Lynton, N. et al., *Towards a New Art: Essays on the Background to Abstract Art* (Tate Gallery, 1980)

Macmillan, D., *Scottish Art in the 20th Century* (Mainstream, 1994)

Mellor, D., *A Paradise Lost: The Neo-Romantic Imagination in Britain 1937–1955* (Lund Humphries, 1987)

Mellor, D., *The 60s Art Scene in London* (Phaidon, 1993)

Meyer, U. (ed.), *Conceptual Art* (Dutton, 1972)

Michalski, S., *Public Monuments: Art in Political Bondage 1870–1997* (Reaktion, 1998)

Morris, F., *Paris Post-War: Art and Existentialism* (Tate Gallery, 1993)

Mundy, J. (ed.), *Surrealism: Desire Unbound* (Tate Publishing, 2000)

Nairne, S., *State of the Art: Ideas & Images in the 1980s* (Chatto & Windus, 1987)

Orvell, M., *American Photography* (Oxford, 2003)

Palmer, M., *Art Belge 1880–2000* (Racine, 2002)

Patton, M. F., *African-American Art* (Oxford, 1998)

Polcari, S., *Abstract Expressionism and the Modern Experience* (Cambridge University Press, 1991)

Porter, V., *World into Art: Artists of the Modern Middle East* (British Museum, 2006)

Powell, R., *Black Art: A Cultural History* (Thames & Hudson, 2002)

Read, H., *A Concise History of Modern Sculpture* (Thames & Hudson, 1964)

Reid, D., *A Concise History of Canadian Painting* (Oxford, 2nd ed., 1989)

Roh, F., *German Art of the 20th Century* (New York Graphic Society, 1968)

Rose, B., *American Art Since 1900* (Thames & Hudson, 1975)

Rosenblum, R., *On Modern American Art* (Abrams, 1999)

Rosenthal, N. (ed.), *Sensation: Young British Artists from the Saatchi Collection* (Thames & Hudson, 1998)

Rush, M., *Video Art* (Thames & Hudson, 2007)

Sandler, I., *Abstract Expressionism* (Pall Mall, 1970)

Sandler, I., *American Art in the 1960s* (Harper Collins, 1990)

Smith, B., *Australian Painting 1788–1990* (Oxford, 1991)

Sonfist, A. (ed.), *Art in the Land* (Dutton, 1983)

Spalding, F., *British Art Since 1900* (Thames & Hudson, 1987)

Stallabrass, J., *High Art Lite: British Art in the 1990s* (Verso, 1999)

Stiles, K. and Selz, P., *Theories and Documents of Contemporary Art* (University of Chicago, 1996)

Taylor, B., *The Art of Today* (Weidenfeld & Nicolson, 1995)

Vergine, L., *Body Art and Performance* (Skira, 2000)

Vergo, P., *Art in Vienna 1898–1918* (Phaidon, 1975)

Whitechapel Art Gallery, *British Sculpture in the 20th Century* (1981)

Wood, J., Hulks, D., and Potts, A., *Modern Sculpture Reader* (Henry Moore Institute, 2007)

Yorke, M. S., *The Spirit of Place: Nine Neo-Romantic Artists and their Times* (Tauris, 2001)